THE HISTORY OF ART

THE HISTORY OF ART

GALLERY BOOKS

An Imprint of W. H. Smith Publishers Inc.
112 Madison Avenue
New York City 10016

Contributors

Ernesto d'Alfonso : Nineteenth-century architecture

Maria Teresa Benedetti : Impressionism

Fabio Benzi : Metaphysics and a return to order – Dada and Surrealism – Expressionism

Eugenio Busmanti : Neo-classicism

Enrico Crispolti : Futurism

Anna Maria Damigella : Symbolism and Art Nouveau

Sergio Donadoni : The art of ancient Egypt

Gloria Fossi : Carolingian and Ottonian art

Richard Fremantle : Gothic art

Italo Furlan : Romanesque art – Early Christian and Byzantine art

Marco Goldin : Roman art

Giorgio Gualandi : The artistic civilization of Greece and the Aegean

Antonio Invernizzi : The ancient Near East

Karl Jettmar : The art of the Steppes

Caterina Limentani Virdis : The Renaissance in Europe

Gabriel Mandel : Islamic art – Chinese art – Japanese art – Pre-Columbian art
 The art of Black Africa – The art of Oceania

Massimiliano Mandel : Indian art

Riccardo Pacciani : Baroque and Rococo

Roberto Pasini : Chronological tables

Stella Patitucci Uggeri : Etruscan art

Mauro.Pratesi : Twentieth-century sculpture

Antonella Sbrilli : From Romanticism to Realism – Avant-garde, Fauve, Cubist art

Vittorio Sgarbi : Introduction – The Renaissance in Italy – Current trends

Sandro Sproccati : Abstract and informal art – Avant-garde art (1960–1975)

Claudio Strinati : Mannerism in Europe

Virgilio Vercelloni : Twentieth-century architecture

Alda Vigliardi : Prehistoric art

Italo Zannier : The history of photography

Copyright © 1988 Arnoldo Mondadori Editore S.p.A., Milan
English translation copyright © 1989 Arnoldo Mondadori Editore S.p.A., Milan

Translated by Geoffrey Culverwell, Graham Fawcett, Mary Fitton, Paul Foulkes, John Gilbert, Helen Glanville Wallis, Iain Halliday, Sara Harris, Judith Landry, Simon Pleasance, Elizabeth Stevenson, Pamela Swinglehurst

Published in the US by Gallery Books, an imprint of
W.H. Smith Publishers, Inc.
112 Madison Avenue
New York, New York 10016

Gallery Books are available for bulk purchase for sales promotions and premium use. For details write or telephone the Manager of Special Sales, W.H. Smith Publishers, Inc., 112 Madison Avenue, New York, New York 10016 (212) 532-6600.

ISBN 0-8317-4488-X

Printed and bound in Spain
D.L.TO:974–1989

Contents

Introduction

The history of art is both a history of individual works and one of ideas. It differs in this from the history of literature or music; the latter appeals more to the senses and liberates the passions, but cannot take on a tangible form. The history of art, on the other hand, deals with specific, concrete works that have an existence of their own.

No one can fail to respond to beautifully preserved works created by artists long since dead. The freshness of the colours on a Chardin canvas, or a Bosch panel, cannot but surprise and move us. They exist as independent objects, with an awe-inspiring, separate existence from the artists who created them. We can best appreciate them through sight and touch, and books on the history of art are the introduction to this process of visual and tactile discovery. While no text can of course claim to offer a foolproof method of analyzing art, there is nevertheless always a place for books on art history and essays on individual works. These continue to abound because, even in the hypervisual society we live in today, works of art are enveloped in an almost impregnable silence. Because they cannot speak to us, the spoken and written word are of crucial importance in a study of art. Hence the proliferation of biographies, critical essays, and interpretations that seek to penetrate the intentions of the artist and to unveil the overall mystery. The history of art asks questions, researches answers, suggests a chronology. Often only such a study can offer an answer when the work of art remains stubbornly silent.

Art is, in a sense, more widespread and more popular than literature. It is present in our daily lives in many different ways, on practical, ornamental and decorative levels, because it involves the creation of a concrete object, and in this process it creates its own universe. Civilizations reveal themselves to a greater or lesser degree through their artistic output, which on an abstract plane, aims to attain a supreme ideal, but also, more practically, depicts life, enabling the viewer to reconstruct the aesthetics and morals of an age.

The study of Greek vases or Impressionist artists, for example, nourishes our vision of a past society; it unfolds multiple elements that, when fused into the perfect form of a work of art, constitute documentary evidence of that society. Thus, to be an art historian is not merely to interpret images but to give them the power of speech, to perceive them as witnesses to those civilizations that live on through them.

Museums are enchanted places where Persian, Spanish, Tuscan and Flemish artists coexist as in a welcoming city where different quarters are the province of different ethnic groups. It is tiring to walk through them, sometimes difficult to understand their contents, but at each step they seduce us, impelling us to stop and admire, because art, unlike languages, puts up no communication barrier. The work of an art historian is at once simple and complex; it provides an instrument to be perfected, transformed, and tested by a past reality of a future, ever-changing one.

This book offers a collection of texts that seek to present artistic output over dozens of centuries. It is rich in information, and, of necessity, selective, proving once again that the past is always part of the present, and lives on through art.

Vittorio Sgarbi

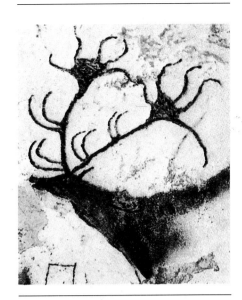

Prehistoric Art

Art is so magnificent a wonder of this world that the only way to know its true value is to see it in the context of its history, across the whole range of artistic expression, from its beginnings in Europe during the final phase of the most ancient period in human cultural history, the Palaeolithic, dating from a time which the latest research findings put at around 30,000 years ago. Prehistoric art had its origins in that distant age, an age which continued to provide us, through the Mesolithic, Neolithic, Bronze and Iron Ages which followed, with a record of life and culture unparalleled in its fascination and variety; it is rich aesthetically and also as an expression of ideological messages, though these are the more difficult to interpret, belonging as they do to a people who have not left us their thoughts and ideas in written form.

For a whole host of reasons, prehistoric art is an almost inexhaustible area of exploration and study. The language and criteria of modern theories of beauty have been used to identify the main features of its style. One could say the same of the art of any other period in history. But when it comes to understanding how prehistoric works of art relate to the cultural and social frameworks that are their context, the task is fraught with difficulties. And why? The main reason is that it is simply not possible, every time an item of historical evidence comes to light, to link that archeological "exhibit a" to a specific culture;

nor, for that matter, to draw parallels that will assign it its rightful place in the chronological table of prehistoric civilizations. There is no shortage of archeological finds for which it would be impossible to write out and tie on labels saying to which culture they belonged and how long ago. But it has also been possible to point to the existence of certain rules of style and method, and also to particular ingredients, which serve as distinguishing features of some cycles of art, both from the Palaeolithic and later on in prehistory.

Even more challenging than the problem of classifying works of art is the need to attempt to say what they mean and to diagnose what spiritual requirements could have prompted the making of them; in other words, to understand the role that art had at the time, over and above the obvious (though certainly not exclusive) one of giving expression to an aesthetic sense. It is an attractive and inviting proposition, but the process it involves immediately falls foul of an insurmountable problem: how

Above: Head of a deer from the Lascaux cave, Dordogne (France) probably dating from the Solutrean era, note the abnormal, idealized development of the animal's horns.

can one be objective when applying our "modern" ways of thinking to an understanding of people who lived so very long ago?

Of all the ranges of artistic output during the different periods of prehistory, that of the Palaeolithic is outstanding for the sheer quantity and variety of product, quality of form, fascinating use of imagery, and the broad sweep of its territorial distribution. The dating of Palaeolithic sites spans something like twenty thousand years, while their geographical spread takes in the whole of the central part of the continent of Europe, from France to the Urals, and the Mediterranean area. The largest number of finds has been made in central southern France and northern Spain, hence the adjective "Franco-Cantabrian" to indicate their artistic province of origin.

The works of art themselves fall into two categories: "personal" or "movable" art is the classification for portable objects; "cave" art is the grouping for works of art found on cave walls and rock-faces. Almost all of the main artistic techniques were used in the creation of these works, including engravings or graffiti, figurines made out of pieces of bone, sculptures in full relief, bas-relief and high-relief, statues modelled in clay, and paintings.

Figure-work is the most prevalent feature of art in the Palaeolithic period. The style is extremely realistic, looking to nature for its inspiration and keeping as close as possible to life: to start with, the subjects were human

figures, mostly female – these were particularly common during the initial phase of this art – and animal figures, generally mammals, which predominated in subsequent phases. There are also quite a lot of small drawings, some of which are stylized or diagrammatic impressions of actual objects, although quite what they might mean is now obscure.

If you look at the range of this engraved and painted figurative art inspired by nature, you can appreciate the achievement in form: an ever-increasing mastery of stylistic elegance and variety of subject, combining to produce a stunning world of images. It was a gradual victory which over thousands of years of experiment since the earliest times brought Palaeolithic art to its highest point, the stylistic and technical perfection of its period of fullest development, which began about 14,000 years ago, during the Magdalenian cultural epoch.

Typical of the paintings and engravings from the very earliest phase are the animal shapes, stiff-looking, incorrectly drawn and unfinished. Later, the outlines became more confident and flowing, with the result that it is possible to tell which animal you are looking at; later still, Palaeolithic artists learned how to

Right: one of the earliest examples of Palaeolithic drawing from the Gravettian era, the figure of an ibex engraved on a rock-face in the Pair-non-Pair cave, Gironde (France).

Below: female figurine in limestone from the Gravettian era, found at the Austrian site of Willendorf, near Krems; it is one of the most famous examples of anthropomorphic sculpture from the Palaeolithic, and is believed to have been linked to a maternity or fertility cult.

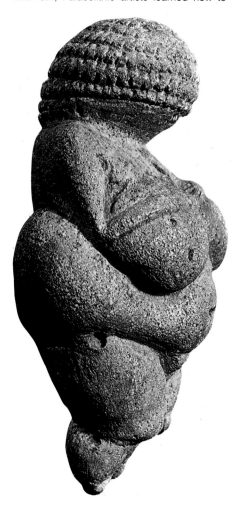

use true perspective for individual parts of these figures, like the horns or the four limbs, as well as equipping the body of the creature with all the anatomical details. In painting especially, the early simple outlines of animals were followed by the practice of filling the outlined shapes completely with paint, and shading or cross-hatching these areas so as to give a greater prominence to the image. This trend culminated in what was the high point of Palaeolithic painting technique, a use of polychromy that showed both skill and sophistication.

The process of evolution we have been describing did not apply to sculpture; here, from the outset, there was a maturity about the work produced, with a clear style and an already developed technique, at a time when drawing, whether in engraving or painting, was still at a rudimentary stage.

Another evolutionary process was taking place in non-figurative drawing, which had been in evidence from the very earliest times but which came to the forefront particularly during the Magdalenian period. Less of these drawings have survived than the naturalistic ones, but they are still of considerable interest as an indication of the creative ability of Palaeolithic artists. Some of these drawings appear to be diagrammatic representations of actual objects, like weapons or snares, while others, either geometric or abstract, elude all attempts at interpretation. With other drawings,

however, it has been possible to piece together how they derived from naturalistic elements through a series of gradual transformations. In fact, the increasing stylization of animal figures influenced the development of specific modules to portray the various parts of their anatomy; these underwent a process of simplification during the Magdalenian period and later became dissociated from whole figures altogether, so that they ended up as isolated graphic features that were symbolic in meaning.

Palaeolithic art is looked upon as expressive of a whole gamut of magico-religious ideas that were fundamentally linked to the exigencies of everyday life. The female figurines of the Gravettian phase of art are thought to have been part of a fertility or maternity cult; representations of the animal world have suggested ritual practices geared to making hunting propitious, animals being a primary source of sustenance for hunter clans, though they might also be attempts to re-create what happened in certain myths and legends about men and beasts. In fact, from the days of the Solutrean period (about 17,000 years ago), painted caves look as if they were used as carefully planned sanctuaries, to judge by the impression of sacredness conveyed by the fascinating images in their dark recesses still visible to the present-day visitor.

Between 13,000 and 12,000 years ago, toward the end of the Magdalenian culture, the

Right: detail of a painting from the caves at Lascaux, probably dating from the Solutrean era; it represents a cow jumping, above a group of young horses. Note the technical expedient that the artist had recourse to in order to depict the animal's rear left leg, i.e. by overlaying the animal's body with a highlighted outline of the limb.

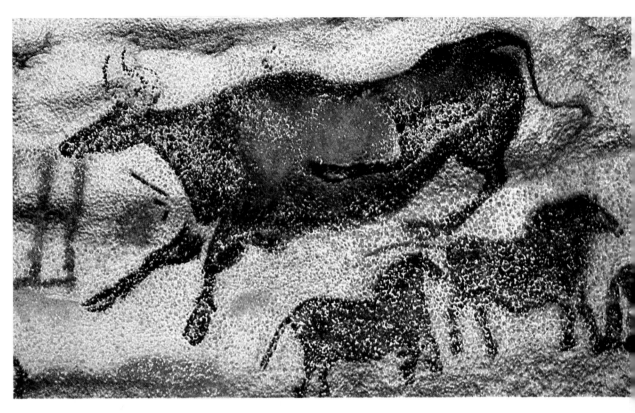

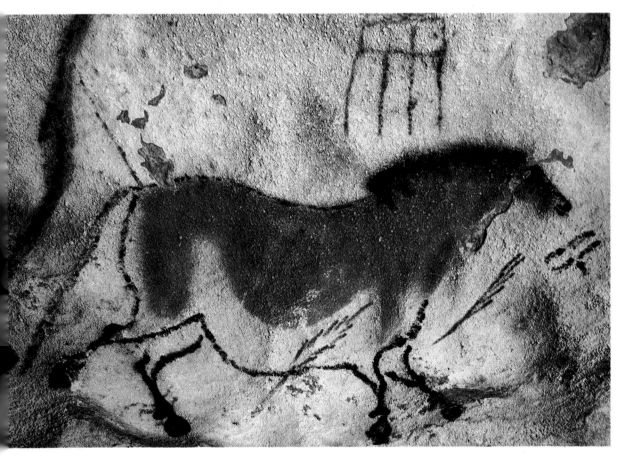

Left: also from the Lascaux cave site, the bichrome figure of a horse. The paintings from this Franco-Cantabrian phase of art are remarkable for the animation and spontaneity of their poses. Note the rectangular marks, which are thought to be snares, and the feathered arrows pointing at the figure of the horse.

great naturalistic cave-art tradition vanished; the practice of doing engravings on objects continued for some time after that, still featuring shapes inspired by the animal world, though these no longer showed the stylistic perfection of earlier examples. In this last phase of Palaeolithic naturalism there are, however, a number of exceptional finds that would appear to provide evidence of the beginnings of a new advance in the field of figurative technique in which the subjects were being seen in perspective instead of almost exclusively in profile, as had been the practice until then. Some of the engravings, in fact, are of animals viewed from in front, or foreshortened, while others are composite studies in which several figures are arranged on different planes, thus providing a third dimension of depth.

The naturalistic art of the Palaeolithic disappeared not only in the Franco-Cantabrian artistic "province," where it had been most prolific, but also in other art-producing areas active at the same time, such as that of the Mediterranean. For example, in Italy at that period a number of groups of rock engravings of great artistic value were produced, taking their theme from the animal world and using an outstanding realistic style, even if it was not as well developed as that to be seen in comparable French engravings. The special feature of "Mediterranean" art, however, is evident in the large amount of geometric and abstract drawings engraved on shapeless fragments of stone and bone from its earliest phase (the Gravettian) onward. This non-figurative art flourished in the Mediterranean area, displaying its own original motifs and lasting for a long time there. The fine naturalistic style seems to have dwindled to nothing here before the end of the Palaeolithic, at a moment in prehistory not very far removed from the time when the same thing happened north of the Alps.

The combination of powerfully realistic images, naturalism and a pervasive religious sense make the whole cycle of Palaeolithic art a fairly uniform one, even taking into account the incidence of symbolic and abstract forms of expression that developed particularly in the Mediterranean area.

Still in Europe, another interesting focus of artistic activity, though on a very much smaller scale and confined to the area along the east coast of Spain, was linked to the hunting peoples of the subsequent cultural phase, the Mesolithic, which began about 10,000 years ago during the Holocene era, when the present climate and natural environment were established. This was the so-called "Levantine art," which consisted of a range of naturalistic paintings unlike those of the Palaeolithic, even though there are obvious similarities between the two in the way each portrayed the animal world. But unlike Palaeolithic art, Levantine art was invested with a powerful dynamism, which found expression in particularly animated

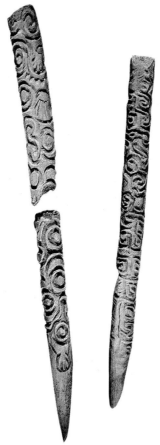

Left: staffs made of bone from the Magdalenian period from Isturitz (Basses-Pyrenees, France), decorated with stylized motifs symbolizing anatomical details of zoomorphic figures (the eye).

Below: one of the celebrated polychrome bison painted on the roof of the cave at Altamira (Santander, Spain); before being painted, a fine engraving of the figure was made. It belongs to the culminating phase (evolved Magdalenian) of Franco-Cantabrian art.

Opposite: one of the most beautiful examples of naturalistic cave or rock art of the Palaeolithic, from the Mediterranean area of artistic activity, is this bull from the Riparo del Romito near Papasidero, Cosenza (Italy); beneath it is another, unfinished, bovine figure.

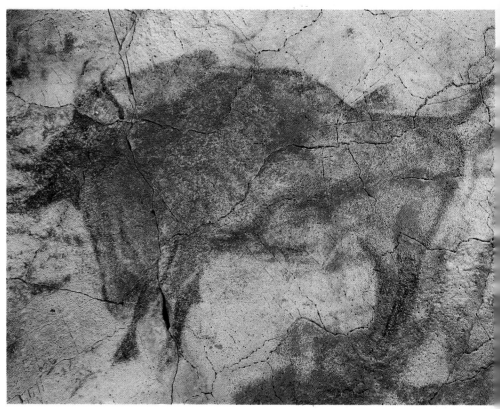

scenes of hunting, battle and family life in which the human figure was the dominant feature; its characteristics were simplicity of technique, the use of monochrome and flat tones, and very effective, rapid brushstrokes in the painting of small, stylized figures that were invariably shown caught in mid action and which were part of complex compositions in which the narrative element was uppermost. What this amounted to was a form of "impressionism" that was manifesting itself in the framework of a society that had changed the ways in which it related to the world of nature, its own outlook and its creative gift. And with the onset of the next cultural stage, the Neolithic, the era of the farming and animal-breeding peoples, which in Europe began during the sixth millennium B.C., this led to the radical transformation of human society in every respect, both cultural and ideological. It was a period that gave rise to artistic activity of various kinds and each with a different geographical distribution both in Europe and outside it.

The most telling evidence in the task of reconstructing the evolutionary process of pre-historic art, however, is to be found in cave-painting, examples of which have survived in several places in Europe and which leave no doubt as to the importance of symbolism and abstraction to the original painters. The most outstanding instances of this form of art are the caves of Lascaux in France, Altamira in Spain

Below: a composition made up of linear marks, their meaning obscure, engraved on a large stone, from the Grotta del Cavallo (cave of the horse), Uluzzo, Lecce (Italy); it is a typical example of abstract art from the Mediterranean area at the end of the Palaeolithic.

Right: Archer in the act of taking aim (his bow is barely visible): a detail from a group of paintings at Cueva de Civil, Valltorta (in the Spanish province of Castellon), an example of the Mesolithic art of eastern Spain. Note the extremely stylized depiction of the figure.

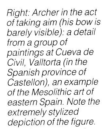

and Porto Badisco, near Otranto in the Italian province of Puglia. The paintings in the Porto Badisco caves are realistic in style, with hunting scenes in which the subjects, even though they have been drawn schematically, bear witness to the survival of figurative art, but it is the symbolic and abstract drawings which proliferate here. Several of the paintings at Porto Badisco offer us a key to the interpretation of features that appear to be abstract but whose symbolic meaning can actually be understood, i.e., the idea that the painter intended to express through them, by means of a series of transitions from images that clearly represented human beings or animals to increasingly simplified drawings of these subjects, or even to motifs that were quite dissociated from them. In fact, the evolution of the drawing process that by streamlining and hiving off certain aspects of figures taken from nature created graphic elements in isolation, was already in evidence during the advanced phase of Palaeolithic art, though in that context it had a concrete meaning exclusively

confined to the world of animals. With the Neolithic the symbolism is different, conceptual, and even more obvious in some other painted surfaces at Porto Badisco; complex compositions that bring together extreme graphic simplifications of human or animal subjects, expressing the idea of "community."

Other instances of very important artistic evidence derive from later prehistory: one only has to think, first of all, of the astonishing series of cave and rock paintings from various periods, from the Neolithic onward, that have come to light in the region of the Sahara in Africa, including engravings and paintings, whose naturalistic achievement is so outstanding, it alone can stand comparison with that of Palaeolithic art, animated scenic compositions and schematic studies; or think of the thousands of rock-engravings to be found in European sites and dating from as far back as the Neolithic through to the Metal ages, featuring human beings, animals and objects expressed by using special modules to represent them, and in a schematic style, all these

subjects brought together in scenes of everyday life, hunting and battle, and also in compositions of a magic, religious or mystical character.

This general survey of surviving examples of prehistoric art, one man's view of the development of that art from the Palaeolithic to the Neolithic, and inevitably concentrating on the most important and significant examples to be found in Europe and giving greater prominence to those to which the origins of art itself can be traced, has illustrated how each age is distinguished by the prevalence of specific art forms: the Palaeolithic by the most true-to-life figurative work and the most developed sense of realism, the Mesolithic by a strongly idealized figurative art, and the Neolithic by the high profile of symbolic schematic art and also of abstraction, of which the earliest examples could already be seen toward the end of the first phase in the prehistory of art.

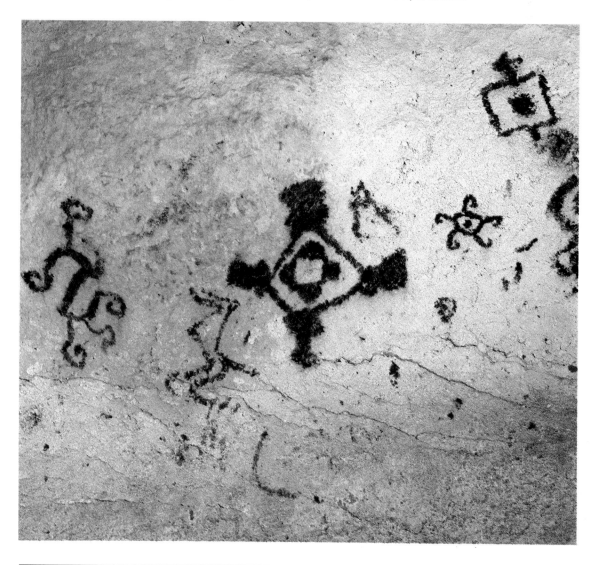

Left: Neolithic paintings from the cave at Porto Badisco, Otranto, near Lecce (Italy): to the left is a schematization of a human figure built up from spiral shapes; in the center and on the right are drawings that have been interpreted as anthropomorphic "communities."

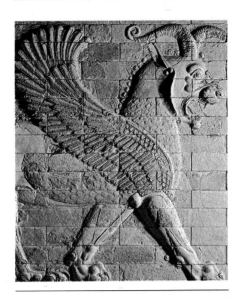

The Ancient Near East

The proto-urban age

The first great Mesopotamian civilization emerged at the end of the formative process that had taken place during the prehistoric age. The earliest great artistic manifestations of Sumer, the southern part of the land between the Tigris and the Euphrates, determined the character of the art and architecture of the peoples who steadily settled in that country and raised its civilization to the high level of the classical civilization of the Ancient Near East. Indeed, Mesopotamia exercised a fundamental influence on the neighbouring regions, from Syria to Anatolia, from Elam to Iran.

We find the first impressive evidence of art and architecture in the last centuries of the fourth millennium B.C. at Uruk, where the temple had acquired a central function in society. It was a complex infrastructure that controlled and administered all aspects of the life of the Proto-Sumerian people, both spiritual and economic. At Uruk we discover two monumental sanctuaries where later would be worshipped Anu, the sky god, and Inanna, goddess of love. These represent the earliest stages in the development of future Mesopotamian architecture: the low temple well documented in the Eanna, the sanctuary of Inanna, and the temple on a high terrace.

Using mud-brick, that humble building material used universally in the Ancient Orient,

they constructed mighty edifices that would later be hard to equal, decorated with techniques of an artistry that has never since been surpassed. Mosaics and simple linear and geometric motifs, achieved with many-coloured cones of stone or terracotta used like nails, carpet the walls of the huge edifices and line the recesses and fluting on their façades. Even where there are no mosaics, the regular alternating recesses and delicately modelled pilasters soften the massive walls with a fringe-like effect of incredible technical skill.

The delicate colourings of the mosaics and the *chiaroscuro* produced by the architectural detail of the walls are the inventions of an artistic sensitivity to natural surroundings, a way of giving concrete substance to buildings that for most of the year stood in blinding sunlight that flattens form.

In the Eanna, the cult edifice, the low temple is an isolated building, "man-sized" despite its dimensions, admirable in its geometric proportions: a parallelepiped divided into three

Lion-griffin in glazed brick from the palace of Darius at Susa (fifth century B.C.) Paris, Musée du Louvre.

spaces. This arrangement – a central chamber between two wings of smaller rooms – has its roots in the earlier culture of the prehistoric age, and the Sumerian temple of the protodynastic period was a direct development of it. Furthermore, with ingenious modifications it is still the basis of all contemporary public and domestic architecture.

The same early tradition also influenced their domestic architecture, producing the courtyard house which, with all its variations, has endured for thousands of years in the south of the country. Center of the daily life of the family, the courtyard, whose position in the heart of the house is the most convenient for access from the surrounding rooms, was also to become the basic nucleus of building design.

The low temples served a different cult purpose from the high temples, of which the White Temple "of Anu" on the high terrace is the best-preserved example. The different nature of the two city sanctuaries throws considerable light on the complex rites and beliefs of the first great Mesopotamian civilization.

In itself, the high temple does not substantially differ from the low temple – both share the same tripartite layout – but it is clearly distinguished by being built on a high terrace or platform which raises it above other buildings and the surrounding countryside, bringing it closer to the seat of the gods in the heavens. The high terrace, still irregular in

shape, has evolved from earlier ones and now has established proportions and features: a long ramp that leads up to the temple on the summit, sloping walls decorated with engaged pilasters, mosaics or cornices of small clay tubes.

The White Temple – where the god descends by a special stairway whose first step is over a meter (three feet) high – must have been used for different ceremonies from those of the low temple. This perhaps reflects a religious belief that expresses a fundamental aspect of the naturalism at the root of the Mesopotamian civilization: its close relationship to the so-called Edifice of Stone – a hypogeum constructed at the foot of the high terrace, which is perhaps the cenotaph of the god who dies and rises again with nature – celebrates that principle of fertility which holds a central place in later religious literature.

To satisfy the spiritual and lay needs of a complex society, monumental architecture was accompanied by the birth of great figurative art, great in concept but certainly not in size, since from its very beginnings Mesopota-

mian art produced works of decidedly modest dimensions, very different from those somewhat gigantic works of other civilizations such as Egypt. Mesopotamian art always reflects a "man-sized" approach: images are rarely life-sized; indeed, it is usual for statues to be quarter-size or less, and the figures in votive or celebrative reliefs are on a modest scale. This characteristic is not only due to a chronic shortage of good materials, which has to be transported over long distances. The reduced format better translates the spirituality of this artistic vision, especially in the proto-urban and protodynastic periods: the intensity of man's relationship with the eternal, expressed in the fixed stare of the eyes.

The typical statue embodies the worshipper in an attitude of reverence, arms respectfully crossed at the waist, an iconographic model for future epochs. The human figure now has a realism far removed from the sketchy representations of prehistory. Even when the taste for stylization and simplification of form prevails, the structure of the image reflects a precise and very mature creative process.

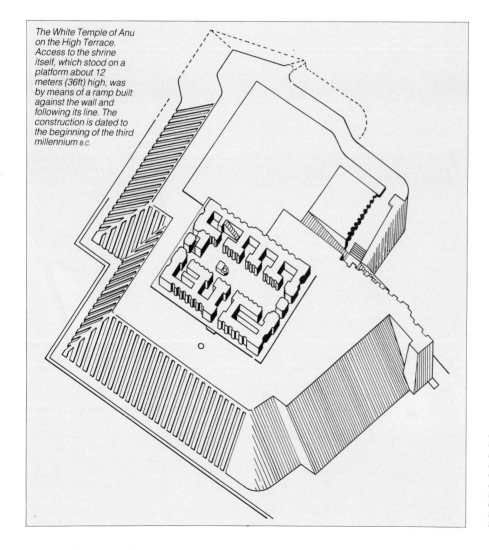

The White Temple of Anu on the High Terrace. Access to the shrine itself, which stood on a platform about 12 meters (36ft) high, was by means of a ramp built against the wall and following its line. The construction is dated to the beginning of the third millennium B.C.

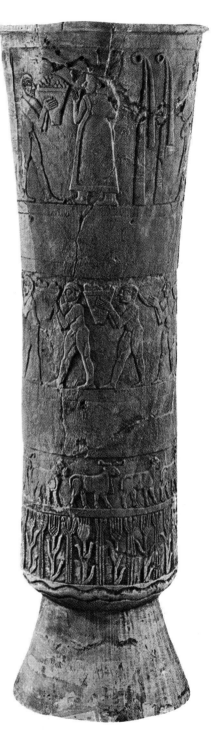

The large ritual vase in alabaster from Uruk is considered one of the most significant works of Proto-Sumerian art and culture; on the one hand because the subject of the scenes depicted constitutes the summa of the religious thinking of the period; on the other because it is the first known example of the use of the register to convey sometimes complex concepts. Baghdad, Iraq Museum.

The figures shows a naturalistic modelling, both sensitive to the gentle planes of the flesh and tautened to define the outline of forms more clearly, together with an extensive application of coloured inlays. These were used for certain basic elements in the figure, especially the eyes which, made from materials ranging from shells to lapis lazuli, express all the transcendent strength of the image.

But figurative art does not express only the personal relationship between the individual and the eternal. In a relief the artist of Uruk can also illustrate thoughts and concepts of considerable complexity. The great ritual vase of the Eanna is the first work that documents the invention of the register to give figurative form to very complex concepts. The procession of the people of Uruk to the temple of Inanna is depicted on the tall vase in groups hierarchically separated in superimposed bands or registers, thereby establishing a perfect correspondence between the conceptual and figurative aspects of the representation.

In this way the different aspects of the religious ideology portrayed on the vase are clearly distinguished: the protection of the goddess guarantees the fertility of nature, in which water, the beginning of life, brings fruitfulness to the plant and animal world (depicted in the two lower registers above the wavy line of the water). These are the reasons for the prosperity of the people of Uruk, who in the next register proceed in ritual nakedness, carrying vases and baskets of offerings, toward the temple. Here, in the upper and most important register, the priest-king stands in the presence of the goddess or her high priestess, the beginning and end of the natural cycle. The register, a simple but great invention in composition, thus allowed the greatest clarity of representation, and its infinite possibilities caused it to remain a basic formula in the figurative language of Antiquity.

The temple is also host to other basic inventions, in particular the cylinder seal, the unmistakable sign of Mesopotamian society in every age. It answered the practical demands of the administration and control of community goods, which was the priests' responsibility. The mark could be made to cover the clay used to seal jars and other objects by rolling the cylinder far fewer times than would be necessary to obtain the same result with a stamp seal, thereby simplifying the procedure and saving time.

By no means secondary to the practical superiority of the cylinder seal are its artistic advantages. Contrary to the stamp seal, whose small size necessarily restricts the size of the design, the cylinder, albeit small in itself, offers more scope, producing in effect a miniature frieze.

The most popular style in the mid-proto-urban age was the naturalistic style proper to "major" art, but soon designs appeared featuring rows of human figures or abstract decorative motifs, summarily incised but nevertheless effective, on seals probably intended for use by certain departments of city administration more strictly concerned with business and commercial affairs.

The formation of the proto-urban civilization is a historical phenomenon associated essentially with southern Mesopotamia and its closer neighbouring areas, such as Susiana, where Susa appears to rival Uruk in complexity, developing the features of a distinct but closely related civilization known as Proto-Elamite.

The other regions seem to have no art manifestations comparable to those of Sumer, which indeed tried to control the main sources of the raw materials that were scarce in the great plains. What we see is an attempt by Uruk to control the Syrian area of the Euphrates through colonies which, like Habuba Kabira and Jebel Arude, show features of the Sumerian civilization in a native environment that was not always favourable.

The protodynastic age

The first Sumerian dynasties, which followed one another throughout most of the third millennium B.C., were reflected in significant changes in Mesopotamia. Under their respective rulers many centers now struggled for dominance in Sumer and international victory. The number of cities increased, not only in the alluvial plain but also in the north of the country and in neighbouring regions, especially Syria. Besides Uruk, there were the cities of Ur, Lagash, Kish in Sumer, Assur in the north, Mari on the middle Euphrates, and Ebla in Syria.

This naturally had a direct effect in the field of art, especially in the latter part of the period, when – historical sources becoming more numerous, and strong rulers contesting for predominance – we see the development of new motives for the dedication of monuments.

In this changed situation artisitic life is therefore also characterized by an increasing number of centers, from Sumerian schools to Syrian schools, each with its own characteristics but closely related and linked by a similar stylistic tone. This is most apparent in figu-

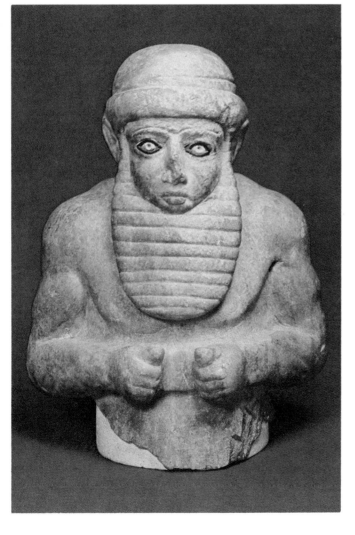

The so-called Torso of Uruk, *also known as the* Bearded Man *(3500– 3100 B.C.), represents one of the earliest examples of sculpture in the round dating from the proto-urban period. The grouping to which the example reproduced on the right (Baghdad, Iraq Museum) clearly belongs is that of the dignitary in an attitude of worship before the god: characteristic are the figure's frontal pose and the fixed stare of the eyes, conventions that were to be inherited by the ensuing ages.*

Left: the Oval Temple of Khafaje retains to a certain extent the model of the "high temple" of the preceding period. It stands on a terrace (about 6 meters [18ft] high) in a rectangular courtyard; the whole is then surrounded by two walls enclosing other rooms that were also indirectly associated with the cult. It is generally thought that this model of temple complex was designed to separate the temple clearly from the surrounding lay buildings.

sacred edifice from the surrounding houses and which can be structurally incorporated in the temple and thus defined as a courtyard.

The most typical features of the place of worship remain consistent, from the holy city of Nippur and the centers of the Diyala to those of the north, such as Assur, emphasizing the cultural unity of the Mesopotamian region. The Sumerian culture spread intensively in Syria itself, particularly in the middle regions of the Euphrates, at Mari, in a largely Semitic environment.

But the temple is no longer the only monumental edifice: among the city dwellings, now clearly distinguishable from the sanctuaries, is the palace, center of political power and seat of both administration and public economy.

The palace stands in a sprawling built-up area, crossed by straggling narrow streets that testify to the unplanned growth of the city which consists of close rows of houses, gener-

rative art, less so in architecture, which more closely reflects the nature of the surroundings. Thus in different areas the use of locally available materials offers different possibilities: Syria, for example, is distinguished by its greater preference for stone and wood and by the development of its own particular style.

In religious architecture the variety of designs naturally increased to match the diversification of rites. In Mesopotamia the Eanna continued its function as the center for the spread of culture. Here we see the high terrace conforming to a standard formal plan, a regular quadrangle sometimes decorated in entirely new ways with wall reliefs.

Elsewhere the high terrace is at the end of a wide courtyard within an oval enclosure, which often surrounds other buildings, as in the Oval Temple of Khafaje. On the high terrace there was only enough space for a modest edifice. None of these is known to us, but they must certainly have been simpler versions of the low temples.

On the other hand a certain number of low temples have survived, so that we have been able to amass more evidence about the worship of the people, even in an outlying area such as that of the river Diyala. In these centers numerous cult edifices stand close to the ordinary houses, and are not always distinguishable by size or by any particular plan.

The protodynastic temple – such as the temple of Sin at Khafaje or the temple of Abu at Eshnunna – was a direct development of the tripartite layout of the proto-urban age, with a trend to abolish one of the wings and give greater importance to the main cella and the antecella, one of the row of rooms in the access wing. The cella remains the most important room and is now reached through an open doorway on the long side, near the end opposite the side against which the altar is placed, so that the entrance route follows a characteristic bent-axis approach. Outside the antecella is an empty space that isolates the

Right: female figurine in semi-transparent green alabaster with face in gold leaf, from the temple of the goddess Inanna at Nippur, dating from nearly five thousand years ago (2750–550 B.C.). This is one of the most significant examples of the maturity already attained by Mesopotamian craftsmanship in very early periods: the expressive face with staring black eyes and the modelling of the figure, with the detailed engraving of the woollen robe, are high evocative; the impression is heightened by the luminosity imparted to this figurine by the material used. Baghdad, Iraq Museum.

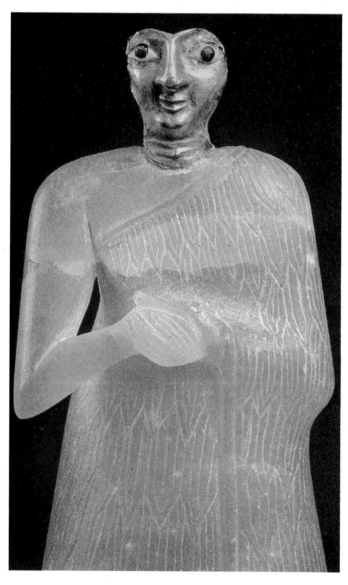

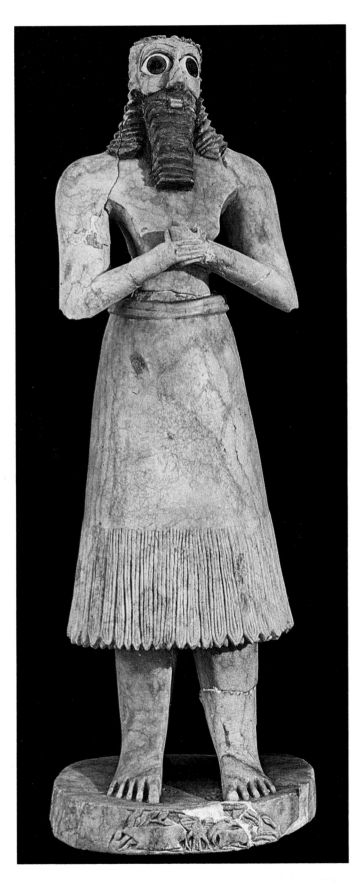

ally small and with some form of courtyard, but often reduced to the essential rooms. Only the great religious and palatine edifices were built according to plan.

Like the major temples, the palace was protected from the sprawling city by thick buttressed walls with towers and imposing gateways. Because of its size, the entire building cannot be appreciated at a glance. It consists of several sections intended for specific uses: residential, administrative, for audiences, public economy, trade. These sections are often arranged around courtyards and connected by courtyards and long passageways, the internal space being regularly divided by enclosed blocks of rooms.

The Mesopotamian palace is thus an extensive building designed to accommodate different functions within the same walls. Its height was rarely extended by the construction of

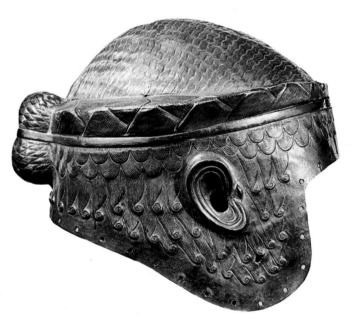

Above right: the helmet of King Meskalamduq from a tomb in the Royal Cemetery of Ur (Baghdad, Iraq Museum). All in gold (or, more accurately, in electrum, argentiferous gold containing silver), it is worked with an already very sophisticated technique. It is one of the many objects recovered from these tombs that testify to the magnificence of the minor arts, in both the value of the materials used and the quality of the workmanship.

upper floors: only in exceptional cases did certain units allotted to trade have an upper storey.

The temple and the palace were the great centers of Sumerian life, and by commissioning and receiving offerings they were the catalysts of the artistic life of the city. We can gain some idea of the splendour of the palace from the lavish furnishings of the royal tombs in the Royal Cemetery of Ur, which illustrate the variety of luxury objects and the exceptional skill of the craftsmen. The personal ornaments of the dead – necklaces and bracelets, earrings and diadems and richly decorated raiments – are mainly of precious stones such as lapis lazuli and cornelians and precious metals such as gold and silver. Gold was at this time worked mainly in gold leaf, but the remarkable development of the bossing technique was to

lead to the production of works of inimitable refinement in the early Babylonian age.

Conspicuous among the grave treasures are the great lyres, their sounding-box inlaid with highly original decoration. Small, thin plates of lapis lazuli, fixed in place with bitumen as an adhesive, are overlaid with cutout fragments of shell, bone, or limestone composing scenes with figures, processions, mythological groups, sometimes forming complex friezes.

One of the favourite themes, the sacred victory banquet, was a typical subject for the votive stone slabs which had a hole in the middle so that they could be hung on the temple walls. The strict limitatons of these slabs were overcome with the help of registers: the principal subject, the royal couple seated at the banquet surrounded by their courtiers, is in the place of honour in the first register; the victory ceremonies, often including processions, musicians, and ritual wrestling, are shown in the lower registers.

The possible variations offered by the repertoire of votive slabs cannot be compared with those of the seals, even in a more restricted repertoire than in the preceding and following periods. The subjects are firstly dominated by series of wrestling contests between heroes and animals, and then again by the ritual banquet, a favourite theme because it was central to the life of a society closely bound up with the temple.

Toward the end of the period a completley new type of monumental relief appears: the celebratory stele, an upright slab of stone, rounded at the top, of which the Stele of the Vultures is the most famous example. On the two sides of the slab Eannatum King of Lagash is shown celebrating his own achievements, with either a written inscription or with illustrative scenes in registers. Among the latter, particular prominence is given to the scene depicting his battle with the rival king of Umma. At the head of his phalanx of warriors the king is shown defeating his enemy, while the limbs of the enemy's dead warriors are seized by the vultures that fly within the arch of the stele in an original and dramatically effective composition. The king has triumphed through the action of the god who towers on the main face of the stele, grasping a cudgel in his left hand and in his right hand holding a net with the lifeless corpses of the defeated warriors protruding through the mesh.

In the last part of the protodynastic period, society reached the decisive point in its development that led to the creation of the first empire of the east by Sargon of Akkad. Something of this new favourable climate is reflected in statues such as the Stele of the Vultures, which have a vigour that contrasts strongly with the reverent and almost remote attitude of earlier statues which followed the tradition established in the proto-urban age.

The statues of the first protodynastic period show a stylistic sensitivity – the so-called Mesilim style (named after Mesilim, King of Kish) – characterized by two-dimensional, sharply defined figures and a preference for woodcarving. The proportions of the flattened bodies are far from naturalistic, with broad shoulders, small hands, and very pointed elbows. The chief interest is in the face, which is dominated by sometimes enormous staring eyes that express the transcendence of the image.

The Mesilim style gradually became more realistic, and the second half of the period is dominated by a tendency toward naturalism: the figures become more realistic, the bodies acquire volume, the proportions become more balanced and harmonious: while the actual modelling softens, lending movement to body and clothing.

The Akkadian age

Political and social change and the evolution of the concept of kingship reached fruition with the creation of a great empire by the Semite Sargon, who in about 2300 B.C. concluded a successful career at the court of the Sumerian King of Kish by assuming power and founding a new capital, Akkad, in central Mesopotamia. From here the King of Akkad planned not only to dominate Sumer and the north but also to gain control of the powerful neighbouring states, from Elam in the east to Syria, where the power of Ebla came to an end. Great kings such as Sargon and Naramsin led the

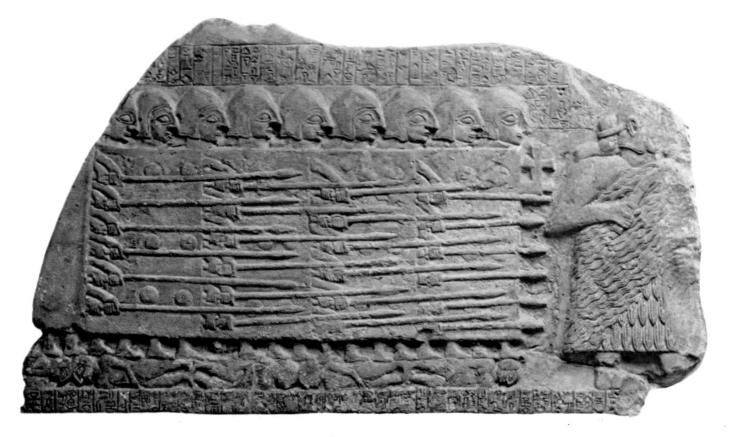

Opposite: on the Stele of the Vultures, *which perhaps represents the first attempt to document a historical event (the victory of Eannatum of Lagash over the city of Kish), the battle is not depicted realistically, but the figure of the king stands out hugely at the head of his army, rendered in rather stylized form by row upon row in registers of heads, shields, and lances, and feet trampling on the fallen enemy warriors (second half of the third millennium B.C.). Paris, Musée du Louvre.*

Right: head of Akkadian king, probably Sargon I himself, from Nineveh (Baghdad, Iraq Museum). Modelled in bronze, almost life-sized, it can be considered a masterpiece of its period. Although linked with Sumerian models (for example in the fashion of the hair), the facial features and the style clearly introduce the Semitic element into Mesopotamian art (second half of the third millennium B.C.).

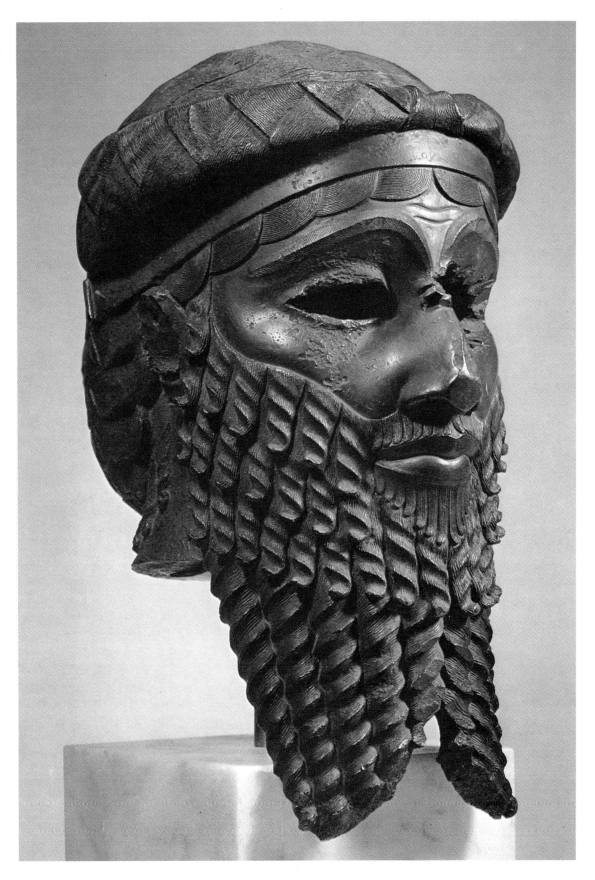

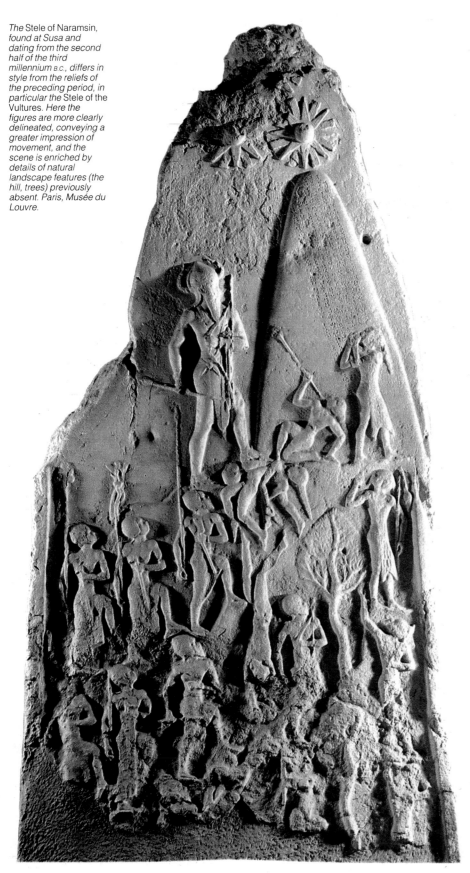

The Stele of Naramsin, found at Susa and dating from the second half of the third millennium B.C., differs in style from the reliefs of the preceding period, in particular the Stele of the Vultures. Here the figures are more clearly delineated, conveying a greater impression of movement, and the scene is enriched by details of natural landscape features (the hill, trees) previously absent. Paris, Musée du Louvre.

Mesopotamian armies to the Mediterranean, to the Persian Gulf, to the mountains in the north and the east, in their bid to dominate both regions of high civilization and also bordering unstable areas often inhabited by unruly nomads. So it was not a territorial empire but dominion upheld by continual wars that made Akkad a great city, with a fluvial port that harboured ships laden with precious trade goods from India.

As the capital has not yet been located, little is known about this age that was so crucial to the history and art of the Ancient East. What we do know we owe, by an irony of fate, to the sacking of the city at a much later date by Elamite rulers who stood the statues and steles of the Akkadian kings in Susa as trophies. But it is clear that Akkadian art brought a decisive change, catalyzing a number of forces already at work in the cosmopolitan Sumerian cities. The harmonious blending of all these forces brought the art of the Ancient East to one of its highest peaks.

Akkadian art developed the naturalistic trend of the late protodynastic period, but with a leap in quality that is at once apparent if one compares the fragments of the stele of Sargon with the Stele of the Vultures. The naturalistic concept now invests the very structure of the figure and the relationship between the figures of a scene. The compact and static representation of the army of Eannatum is now contrasted by the individuality of the Akkadian figures. From the king to the defeated warriors, they are still hierarchically placed in the scale of social values but are on the same artistic plane, treated with the same consideration. They move in direct relationship with each other: the two blocks of opponents in the Sumerian battle are shown in a series of hand-to-hand fights or, in the stele of Naramsin, the figures are integrated with their surroundings.

The pride of the Akkadian rulers compared to the piety of the Sumerian kings, albeit in the same attitude of worship, is confirmed by fragments of statues exceeding the usual protodynastic dimensions, almost life-sized. Again this is not only indicative of the political and economic power of the ruler, who was able to import great blocks of precious stone from far away. The choice of size accords perfectly with an artistic vision that exalts the power of the king above man, in continual stages that led Naramsin to assume divine status and have himself represented on his own stele on a separate level, beneath the symbols of divinity.

The quality of the modelling is exceptional, above all in the definition of form, favoured by the simple clothing then in fashion. The clothing is always all one with the body, following the line of the human form beneath, but the pleats and folds of the material give a naturalistic movement to the drapery, so that it has a lifelike quality.

Statues are sculpted in the round – even though the image is still in the conventional

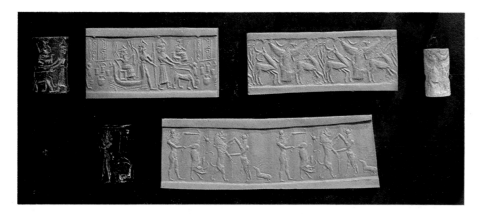

frontal pose – with harmonious, sensitive modelling. The artistic miracle of the proto-urban age was being repeated: the achievement of a highly effective balance between naturalistic modelling, the fixed structure of the image, and the formalism of facial features inlaid with other materials.

Whilst we have only fragments of major art, the glyptic art illustrates the imagination and inventiveness of those artists whose work has survived. The growing number of themes, subjects, and compositions does not relate solely to the increasingly widespread use of the seal in different strata of society. It is also a response to an internal artistic need, connected with the artists' imagination and the taste of those who commissioned their work.

Akkadian glyptic art reached new artistic heights in both inventiveness of composition and quality of execution. Even though there was a trend to define figures in technically skilful but more formalized and colder ways, the figures are still full of natural tension, of movement held back or unleashed.

The artistis' inventiveness was exceptional. In contrast with the Sumerian repertoire, which was restricted to a limited number of themes, the Akkadian repertoire covered the widest variety of fields, from heraldic compositions, static or full of movement, to free compositions which introduce a whole new gallery of characters. Naturally the gods take pride of place: they are the new Semitic gods, assimilated with the Sumerian gods but presented in a new iconographic raiment, for example the ceremonial garment with flounced skirt and the crown with one or more pairs of horns according to rank, which were to be lasting acquisitions.

In contrast with the rarity of representations of the gods in the Sumerian age, now a whole pantheon of major and minor gods comes onto the scene: an entire hierarchy of superior beings who participate in various activities or else are worshipped by princes and kings. Particularly widespread is the so-called Scene of Presentation, in which the worshipper is introduced into the presence of the major god, generally enthroned, through the intercession of a divinity of more accessible rank, who admits the worshipper into the sight of the major god, leading him by the hand.

The love of movement typical of Akkadian art could not but have its equivalent in the repertoire of subjects, in which myths at last take their place. For the first time, and in considerable numbers, there appear scenes that are traceable to a religious or mythological literature which we cannot always understand because of the lack of texts. Even when it is not possible to attribute names to the characters represented, the scenes are nevertheless clear: ceremonies at the celestial court, mythical struggles between heroes or divinities alternate with representations of a more symbolic character such as the rise of Shamash, the Sun, from the eastern mountains. And in some cases it is possible to trace the representation to literary works that have come down to us. The entire myth of Etana who is borne up to the sky by an eagle is condensed into the tiny space of a small seal, and the Akkadian artist incorporates the characters of the story in the details.

The Sumerian renaissance and the paleo-Babylonian age

No sooner had the glory of the powerful Akkadian empire reached its peak than it abruptly ended. Not so, though, for the splendid artistic flowering that took place at the Court of Akkad, whose fruits were long to nourish the art of Mesopotamia even when political dominance was taken again, and for the last time, by the Sumerians.

After the brief flowering of the dynasty of Gudea of Lagash – who first restored the fortunes of Mesopotamia, bringing traditional Sumerian subjects to the fore again – the success of Ur led the rulers of the Third Dynasty to follow the Akkadian model not only on the political level, with the assumption of titles including epithets such as "Ruler of the Four Regions of the World" and "God," but also in the artistic field on the iconographic and conceptual level.

Moreover it was impossible to ignore the conquests of Akkadian and indeed post-Akkadian art, especially at the Court of

Above: some examples of seals of the Akkadian period; it was in glyptic art that this age reached its highest artistic expression both for quality of execution and wealth of themes treated, from more traditional religious subjects to mythological scenes and figures of imaginary creatures (c. 2300 B.C.). Baghdad, Iraq Museum.

Right: this Head of Gudea, ruler of Lagash, is one of numerous versions of the same subject attributable to the period of Sumerian renaissance, also known as the "Gudea period," datable to about 2100 B.C.. The survival of certain Sumerian traditional values is seen both in the material used, diorite, and in the firmness and weight of the modelling. Boston, Museum of Fine Arts.

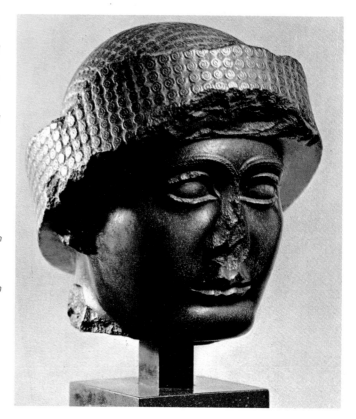

Lagash, through the insistence on certain religious themes, on the level of style and iconography – a kind of Sumerian renaissance more properly described as Sumerian-Akkadian art, to which the innovations of the empire impart marked vitality and vigour.

The more properly Akkadian aspects become ever clearer with the renewed influx into Mesopotamia from the west of successive waves of Semitic tribes. Like the Akkadians in their time, these new arrivals in the paleo-Babylonian age ended by gaining political power, first through the dynasty of Larsa and then through the Babylonian dynasty, beginning (but it may be more correct to say continuing) the series of victors conquered by the culture of the vanquished. It is a fact that Sumerian-Akkadian art, as redefined in the neo-Sumerian period, is the basis of development for a way of thinking that was to evolve along distinct lines.

Hence, whether in the stele of Gudea of Lagash or the stele of Urnammu of Ur, the clarity and formal strictness of the presentation of the figures in registers, the naturalness of their attitude, would have been unthinkable without the Akkadian influence. And even though the religious thematic idiom might appear to be deliberately drawing on the Sumerian tradition, it is now profoundly nourished by the ideas introduced in the Akkadian age.

The statuary too maintains the fresh the-

an uninterrupted transition to those of the paleo-Babylonian epoch.

Glyptic art also followed in the Akkadian wake – drastically reducing the subjects, however, and decreeing the triumph of the Scene of Introduction, which with the passing of time is increasingly reduced to its essential components. In the Babylonian age this simplification was to be taken to its extreme, with the abolition of the majority of the figures until they were reduced to one alone.

The tendency for the Scene of Introduction to become stereotyped, together with its progressive reduction to essentials, favoured the inscription which by this time frequently accompanied representations. More and more space was given to it, also because, with the increasingly widespread use of the seal in Mesopotamian society, the inscription acquired importance as a means of identification.

Although we do not know the achievements of the Akkadian kings in the building of the capital, their influence on the evolution of a new language of architecture must have been no less significant. In the neo-Sumerian age, in fact, we find a substantial change from protodynastic architecture – a change that must have taken place during those missing years, reflecting as it does that same crucial change in both religious and political thinking that is demonstrated in figurative art.

The most obvious changes are to be seen in

period, is replaced, from the period of Ur III onward, by a wide cella with the entrance in the middle of the long side, reached via an antecella of the same shape. The shrine is on the front side of a courtyard whose function is akin to that of the courtyard of the Babylonian house, with access, often axial, from outside. So the new cella becomes more exposed than it had been in protodynastic times: the statue of the divinity placed against a shallow niche in the center of the room is now visible from the courtyard when the doors are open, at the end of a straight path of variable length. The continually interrupted access route of the protodynastic age is replaced by a direct straight path from the outside to the statue of the divinity. In the shrine the statue is seen in a previously unthinkable monumental setting, enhanced by the succession of large arches over the gateways along the processional way.

This new feature, which takes the cult statue out of the protodynastic half-light, obviously presupposes a fundamental change in the concept of rites, which now exalt the majesty of the god, the more impressive the further the god is removed from mere mortals by an elaborate intermediate hierarchy. This change mirrors exactly the concept of godlike sovereignty suggested by documents from the end of the protodynastic age.

The divinity is, moreover, also becoming more remote on the high terrace, which we find now transformed into a monument of clearly

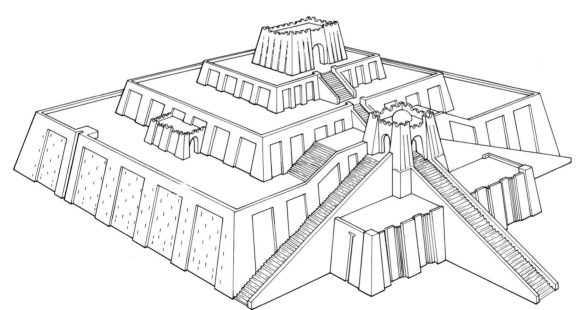

The ziggurat *of Ur (opposite, a photograph of the remains that have come to light and, left, a reconstruction) is a typical creation of Mesopotamian architecture. It is constructed on three terraced levels, connected by access stairways leading to the top platform which also formed the base of the actual shrine. The prototype of this construction may be considered the temple on terraces of earlier periods, but the adoption of this model is also a response to the changing religious concept that was distancing the god from common man by placing him in a high place, visible even from a distance.*

matic idioms of the Akkadians, developing them in the natural pose and naturalistic concreteness of the image, starting with the seated figure of Gudea the Architect, so named because of the drawing-board engraved with the plans of a temple that lies open on his knees. The figures created under the dynasties of Ur III and Isin are the bridge of

religious architecture, especially in what is the most important conceptual and expressive nucleus of the temple. The arrangement of cella and antecella determined the form of the shrine in southern Mesopotamia throughout the course of the Babylonian civilization.

The long cella with the entrance at the corner, characteristic of the protodynastic

defined structure: the ziggurat. Perhaps the most typical Mesopotamian monument is a quadrangular raised structure of mud-brick often faced with a coating of burned, glazed brick or tile, consisting of three stepped terraces with high, inward-sloping walls. A triple arrangement of stairways on the façade, consisting of a central ramp at right angles to two

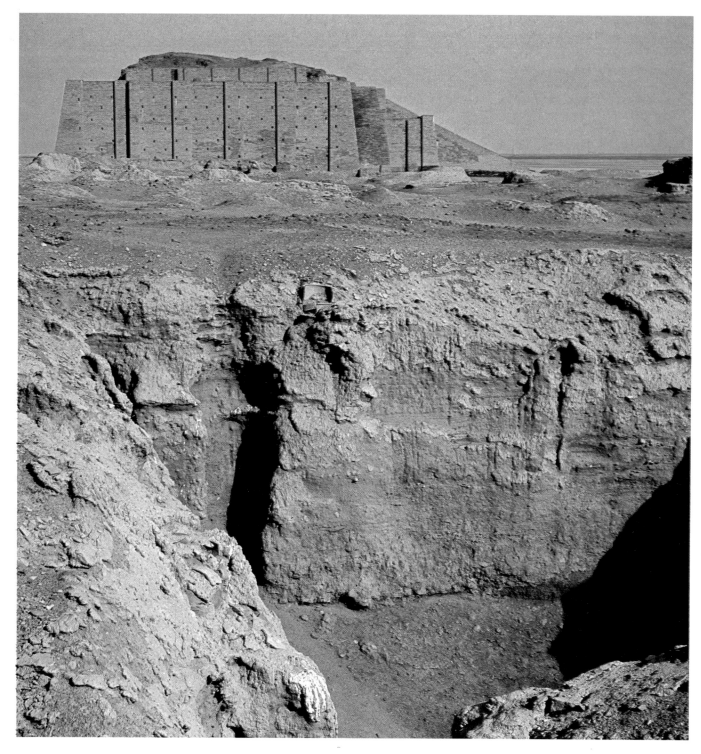

flights of steps at each side, gave access to the shrine built on the summit.

There was also a marked development in architecture, to judge by the palace of Urnammu at Ur: not a large edifice but symmetrical and harmonious in its proportions, enclosed within a perimeter wall with only one entrance. It is as a building of strictly logical design especially in the use of internal space, in the bipartite division into an external section with very large rooms and courtyards, suitable for receiving public representations, and a section divided into a larger number of rooms better suited for private residential purposes.

The paleo-Babylonian age continued and developed the features of the post-Akkadian age. It is characterized by the strengthening of the Semitic influences brought into Mesopotamia by the Amorite tribes who came from the Syrian desert, which lend a particular international flavour to the first centuries of the second millennium. On the political plane, different city-states were still warring with one another until unification by Hammurabi of

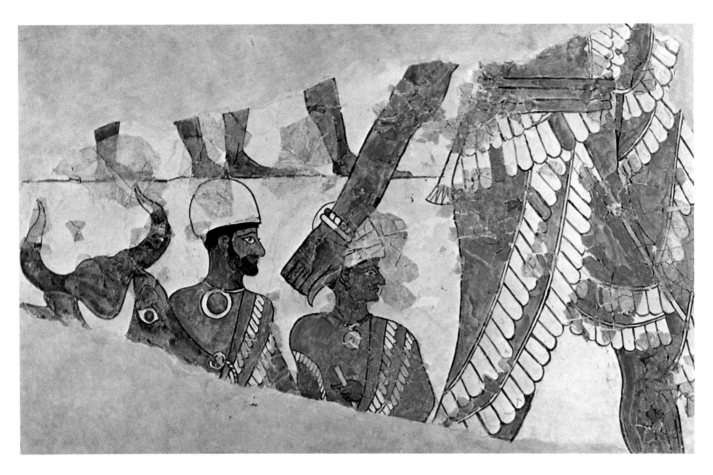

Babylon, who in about 1750 B.C. defeated his last powerful adversary, Zimrilim of Mari.

We know hardly anything of Hammurabi's Babylon because excavations have hitherto revealed little, albeit enough for us to imagine the grandeur of the Etemenanki ziggurat, "The House of the Foundation of Heaven and Earth," which dominated the sanctuary of the city god Marduk. On the other hand it is in fact from the destroyed city of Mari, and especially from its huge royal palace, that we have been able to learn about the splendour of this age.

This palace is the greatest of the Ancient Orient, the model of the Mesopotamian palace which almost formed a small city within itself, not only because of its size but because of the numerous functions carried out within its walls. The main part of the palace — which was certainly not erected in a single stage but was the result of continual additions — is composed of official quarters arranged around two vast courtyards embellished with wall paintings, and with small chapels and shrines for special ceremonies.

On the southern side of each courtyard is the main room, a long hall decorated with wall paintings which opens onto a further courtyard, a large, wide room designed as a temple cella but duplicated, in the case of the more internal courtyard, by an even larger and more splendid room behind. Here were held the

most important ceremonies connected with godlike sovereignty, as shown by the wall paintings depicting the Investiture of Zimrilim and the fountain-statue of the Goddess of the Flowing Vase.

But the whole palace is an extraordinary rational complex, despite the fact that its construction was not homogeneous. Its sections are designed in different ways to meet the widest requirements – residential quarters, kitchens, administrative offices, stores of different kinds, and of course the palace chapel.

Figurative art also followed the path laid down in the preceding period and innovations related primarily to new themes, resulting from Amorite ideas being grafted onto the Sumerian-Akkadian repertoire. In the emblematic scene at the top of the stele of Hammurabi's code of laws – in which the sovereign stands before Shamash, god of justice, seated upon his throne – we can see a similarity with the abbreviated Scene of Introduction as modified by post-Akkadian simplifications. The unusual feature of the scene is the formal treatment of the figures and their attitudes. The development of Akkadian principles is also visible in the statues of the kings of Eshunna, the state in the Diyala valley that was one of Hammurabi's last adversaries.

Among the most original works of the period are those of the craftsmen whose terracotta

figurines and small plaques brought new skill and artistry to what had been one of the main expressions of art in the prehistoric age.

The Ancient Near East after Hammurabi

The Hammurabi dynasty too was long to remain guarantor of peace and prosperity, but with the first Amorite age we see in the Ancient East the forming of states able to create their own autonomous centers of cultural influence, starting with the Assyria of Shamshi Adad I, a vassal prince under Hammurabi. But it was especially from the middle of the second millennium and onward that a series of states was formed of great political as well as cultural importance: the Hurrite empire of Mitanni in Mesopotamia and northern Syria, which flourished in the fifteenth–fourteenth centuries B.C.; the Kassite state, which from the fifteenth century brought a new flowering to Babylonia, as southern Mesopotamia was now called; the empire of the Hittites in the mountains of Anatolia, which became so powerful that in 1531 it conquered Babylonia itself, bringing the Hammurabi dynasty to an end; the state of Assyria, which reached its greatest splendour in the fourteenth–thirteenth centuries; and lastly Elam in the thirteen–twelfth centuries. Each of these states was the center of a very

lively cultural tradition.

The empire of Mitanni gained its impetus from the new war techniques made possible by the horse and the war chariot and succeeded in extending its power throughout most of Mesopotamia and northern Syria, with its political center in the Mesopotamian part where the capital Washshukanni must have stood, although its location has not yet been determined with certainty. The art and architecture of the state of Mitanni, whose population was chiefly of Hurrian stock, are thus known to us chiefly from provincial centers such as Nuzi in Mesopotamia and Alalakh in Syria, and reflect the different cultural traditions of these two countries.

In its size and complexity, the palace of Nuzi resembles the other huge palaces of Mesopotamia, although it shows certain original features. In Syria, however, the palace of the fourth level of Alalakh reflects a very different concept: it is very limited in extent and has an upper floor and a variable grille division of the ground-floor space, enhancing the size and position of the main room, which is not directly accessible from the entrance. However, the most characteristic feature of this Syrian architecture is the so-called *bithilani*, the portico with pilasters or columns that opens on the façade between two wings of plain walls.

The statue of King Idrimi of Alalakh has a distinctly primitive and archaic look, with its clumsy flat structure and large inlaid eyes that give the image an appearance far removed from Akkadian naturalism. Glyptic art also is characterized by apparently unplanned compositions which fill the available space with a medley of human and mythological figures and secondary motifs, without any perspective, almost as if they are dangling in midair.

On the other hand, other works approach Aegean art in their freedom and freshness of representation: for example the painted decoration, using mainly floral motifs, of luxury pottery, which conventionally takes the name of Nuzi. Fragments of wall paintings from Nuzi palace show cornices with masks, ox-skulls and stylized trees that bear witness to the complexity of the art of Mitanni, open to a diversity of influences: Anatolian, Babylonian, Aegean, and Egyptian.

The Kassites, once they had taken power in Babylonia, founded a new capital at Dur Kurigalzu, not far from modern Baghdad, where the palace and the large sanctuary have been brought to light. Continuing the local tradition, the palace is very vast but shows the features of the new age in the way the space is divided, in the symmetry of its rooms which are arranged around the sides of a huge courtyard and dominated by large monumental halls. To the specific functions traditionally associated with the palace was now added the seemingly new function of a section devoted to royal tombs and funerary rites.

Opposite: fragment of painting with scenes of sacrifice from the palace of Zimrilim at Mari (first half of the eighteenth century B.C.). The palace was richly decorated with wall paintings. Paris, Musée du Louvre.

Above: terracotta statuette of a lioness (from Dur Kurigalzu). A striking naturalism characterizes Kassite works in terracotta, which show a predilection for animal subjects (fourteenth–thirteenth century B.C.).

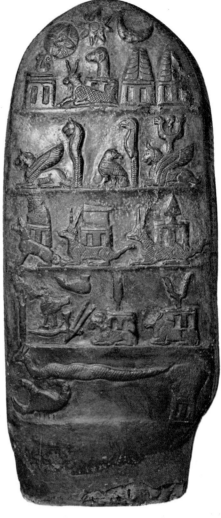

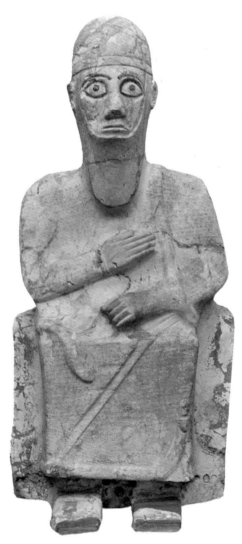

Left: Statue of Idrimi, King of Alalakh, datable to the middle of the second millennium B.C. A rather enigmatic historical figure, vassal of the Hurrite empire of Mitanni, in his endeavour to resist the expansionism of the Egyptian pharaohs of the New Kingdom he ended by building his own personal empire in northern Syria. This much we have been able to learn from the cuneiform inscription that covers the front of the figure, itself a clumsy and primitive piece of carving. London, British Museum.

Above: the kudurru is the most typical form of sculpture of the Kassite age. Discovered mainly in Susa (probably taken there as booty of war), they date from the late Kassite period, at least the technically more elaborate ones. Since it is rather exceptional to find anthropomorphic representations of divinities in Kassite art, the religious content of these reliefs is rendered by means of the abstract symbols or animal figures (more or less stylized) attributed to them (thirteenth century B.C.). Paris, Musée du Louvre.

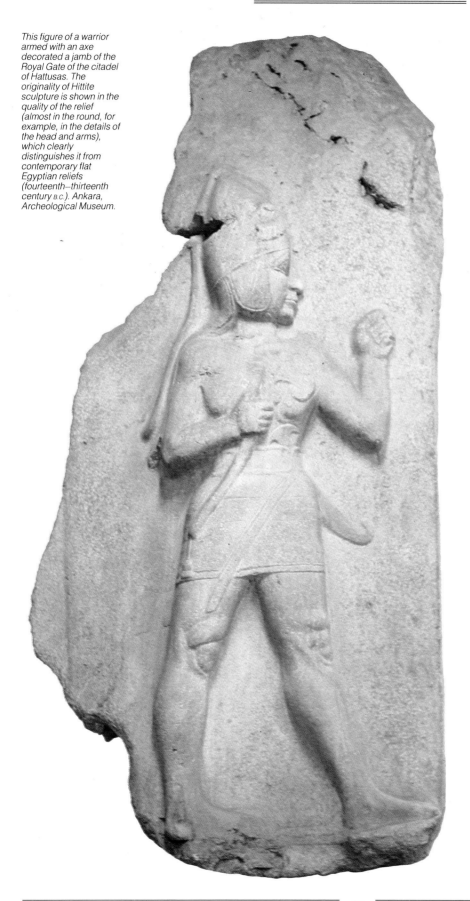

This figure of a warrior armed with an axe decorated a jamb of the Royal Gate of the citadel of Hattusas. The originality of Hittite sculpture is shown in the quality of the relief (almost in the round, for example, in the details of the head and arms), which clearly distinguishes it from contemporary flat Egyptian reliefs (fourteenth–thirteenth century B.C.). Ankara, Archeological Museum.

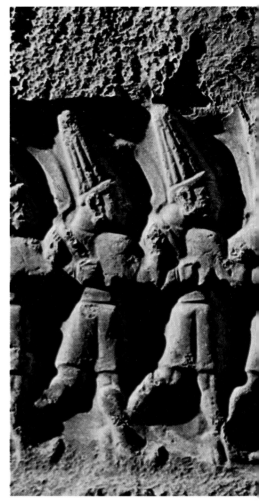

In religious architecture, too, the Kassites introduced new features while preserving tradition. The great sanctuary of Dur Kurigalzu is dominated by a very high ziggurat, with the characteristic huge protruding central stairway and two lateral stairways on each side that ascended from the corners of the façade to meet at the desired height. The huge core itself, blocks of mud-bricks alternated with layers of reeds and tied with thick reed ropes, is covered with baked bricks forming a series of broad, flat buttresses.

On the other hand, the small temple of Inanna built by Karaindash in the Eanna area at Uruk is an entirely novel concept, not only in plan but also in exterior decoration. Beyond the small antecella-atrium, the cella is a long, axial room similar in plan to the Assyrian model and very different from the Babylonian. The cella is also isolated from the outside walls of the small building by two long corridors. The compact internal proportions are matched by a rich external baked-brick decoration which forms a plinth about two meters (six feet) high, in which male mountain gods and female deities bearing laden vases are placed alternately in narrow recesses, linked by a

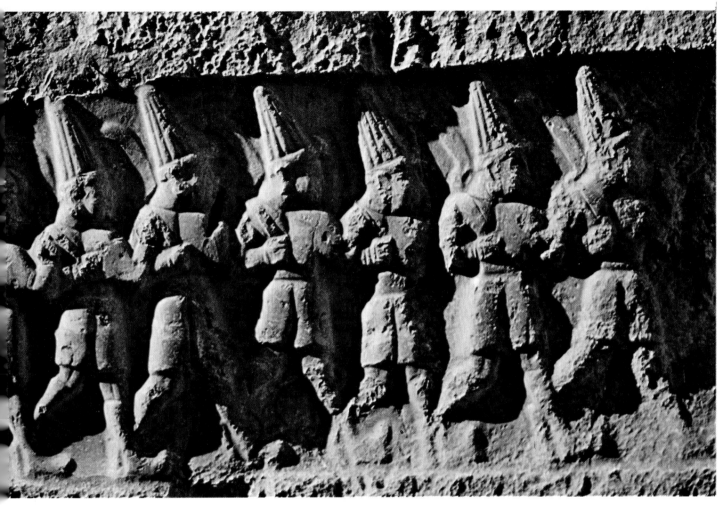

motif of wavy lines that "bind" the figures in a single frieze.

The appearance of the court itself must have been no less splendid, with its refined jewellery of gold filigree and bossed gold and enamel. The royal palace was decorated with a frieze representing a procession of stiff dignitaries, all alike and of clumsy proportions, but some of the terracotta figurines that have been found show a lively naturalism and more vivid and precise modelling, especially in animal subjects.

Of the stonework of the period only the *kudurru*, the sculpted boundary stones, survive. These were erected to mark the limits of fields and in honour of the ruler who donated the fields to the owner. They are generally covered with reliefs which only exceptionally represent scenes from Babylonian tradition. Generally their uneven surface is covered in rows or registers, with the emblems of the gods who guarantee the ruler's gift; it is the exception for a wider theme to be sculpted, as in the Kudurru of the Musicians, which shows the walls of the city of the other world and the symbolic procession of musicians above its battlements. This liking for symbols is charac-

teristic of the Kassite age, when they were also commonly used in glyptic art.

We are in very different country – in terms of art as well as of natural surroundings – with the Hittite empire, which came into power at the beginning of the sixteenth century B.C. and reached its greatest artistic flowering in the thirteenth, just before the sudden fall of its capital, Hattusas (Boghazköy).

The rugged Anatolian mountains naturally had an influence very different from that of the Mesopotamian plain. Stone and wood are the materials of Hittite architecture, blending perfectly with the environment and adpating themselves to the mountainous slopes and mountainlike features of the cult sites themselves.

The Hittite temple within the city is also very different from the Mesopotamian city temple, although both had a range of functions besides purely religious ones. The Great Temple I, for example, shows the economic power of the Hittite temple inasmuch as the cult edifice is surrounded by a ring of separate buildings that served as storehouses. There was a narrow street between these and the sacred edifice, which was thus secluded from the

The so-called Relief of the 12 Gods from the rock sanctuary of Yazilikaya. It is one of the reliefs sculpted on the rock itself, decorating the walls of the two galleries that form the temple proper, while other buildings were successively constructed to block the access to it. The arrangement of the figures, one next to the other, seems not so

much for stylistic reasons (for example, the representation of motion) as reasons connected with the cult (for example, the hierarchy of the Hittite divinities) (thirteenth century B.C.).

surrounding city, but other temples were more closely surrounded.

At the center of the edifice we again find a courtyard, which is entered from outside through a large gatehouse on the side opposite the shrine. On the courtyard the wing of the shrine appears with a colonnade, behind which the cella is not, however, in the axial position. The shrine can be reached only by a twisting path and is very different from the Mesopotamian shrine – not only in size and position, but above all because it is filled with light from the windows in the outer back wall.

A feeling for nature prompted the Hittites to incorporate natural features in their sanctuaries, as in the rocky sanctuary of Yazilikaya, close to Hattusas, where the buildings enclose a natural gap between the rocks and the rock faces are sculpted with processions of gods and religious scenes.

Also highly original is the royal palace built on the acropolis surrounded, like the city, by mighty stone walls. It has nothing in common with the Mesopotamian palace, and is composed of a series of separate buildings arranged around sloping terraces crossed by the climbing pathway. Each of these buildings, sometimes resting on mighty foundations, had a different function, including residential quarters, archives, storehouses, perhaps a small temple, and above all the main building, the Hall of Audiences, of which only the foundations remain but which must have been a large, square hypostyle hall.

Few examples of figurative art have survived, but those that have are on a monumental and grandiose scale, whether the rock reliefs of Yazilikaya or the figures that flank some of the city gates. These gate figures of lions or sphinxes have a massive grandeur very different from that of the Egyptian sphinxes, but the surface modelling is remarkable, the fine engraving of the hair causing light to refract.

The figure of the warrior god who protects the Royal Gate is sculpted in high relief on one of the best-decorated orthostats. This technique of architectural decoration is typical of the Syrian-Anatolian area at the end of the second millennium, and was to find highly original interpretation in the neo-Assyrian empire. The plastic modelling of this figure is remarkably lifelike in its rendering of the torso and the bare legs, and helps our reading of the rock reliefs which are much more damaged by weathering.

The originality of Hittite art is also seen in its iconography. The most characteristic theme shows the king being embraced by the divinity, corresponding to the Mesopotamian representations of the king in converse with the god. Glyptic art too developed its own particular style of large royal stamp seals.

In the city of Assur, which freed itself from Mitannian domination toward the mid fourteenth century, the great Middle Assyrian artistic flowering led to the birth of Assyrian national art. This is characterized in particular by a distinctive figurative style that is unmistakably Assyrian, despite its points of contact with Kassite and Syrian art. The few examples which have survived, mainly of glyptic art, are of very fine quality and in no way inferior to Akkadian glyptic art in their lively rendering of movement, in the plastic naturalism of the figures, and in the inventiveness of themes and composition.

Relief sculpture of the period has also bequeathed to us remarkable works such as the altar of Tukulti Ninurta I, on which the king is portrayed with typically Assyrian iconographic and stylistic features. The particular interest of this work lies in the fact that the king is first shown as he approaches and then immediately as he kneels before the altar, which is carved with the symbol of the god Nabu, as in two successive frames of a film. In this abolishing the unity of time, the scene heralds the great narrative development of neo-Assyrian art in the first millennium.

In architecture too there are great innovations. Although features of Babylonian architecture, such as the courtyard and broad cella, were adopted, they were incorporated in an innovative and typically Assyrian combination of units. In the temple of Kar-Tukulti Ninurta, for example, the low temple is actually built up against the ziggurat, which in Assyria was decidely smaller than in Babylonia, with a recess cut into its body. Consequently access to the tower was possible only from the roof of the low temple.

The most characteristic Middle Assyrian temples have a deeper long cella, with the entrance on the short side giving a bent-axis approach. Also typically Assyrian is the double temple, that is to say a temple dedicated to two gods. In the south, too, the temples of course served the cult of more than one god, but the characteristic feature of the Assyrian shrine is that it gave equal importance to both cults, so that two identical cellae were constructed, either side by side or facing each other across the courtyard. This equality even extended to the construction of two separate ziggurats, when these were present.

The last region – last also in the chronological sense – that flourished in the second millennium (thirteenth–twelfth centuries) was Elam, which was restored to great power with kings such as Untash-Gal and Shutruk-Nahhunte, who was responsible for removing so many Akkadian and Babylonian works of art to Susa.

Above: part of the central panel that decorates a wall of the main gallery at Yazilikaya. The scene represents the meeting of two processions which, extending along parallel walls, converge at the center of the north wall; it shows the encounter between the two supreme divinities of the Hittite religion, supported by the animals sacred to them and surrounded by other divinities of inferior rank (thirteenth century B.C.).

Opposite: head of human-headed winged bull which decorated one of the gates of the north-west palace of Assurnasirpal II at Nimrud. The gates of Assyrian cities were often decorated with sculpture of this kind – bulls, lions, or other animals – primarily acting as guardians, but also intended to inspire awe in those who were about to be admitted into the presence of the king (ninth century B.C.).

Middle Elamite architecture is known to us chiefly from the center of Dur Untash, dominated by a great ziggurat of completely original design. Instead of the typical Mesopotamian feature of three external stairways against one side, it has an internal staircase on three of its sides. The actual construction technique is completely autonomous, the foundations of the terraces, of which here there are four, being built not as a single united core but each independently of the other, the outer ones covering the inner. The ziggurat's exceptional regularity is matched by that of the palace complex of Dur Untash, characterized by large square courtyards in the center of the different quarters, with a particularly clear arrangement of rooms.

Few figurative works of art have survived, but they are of very high quality and show exceptional development in metalwork. The life-sized bronze statue of Queen Napirasu is a triumphant realization of three-dimensional

form through perfect geometric ideals. The body has a perfectly regular bell shape, and its surface is given vitality and movement by the lines of the engraving that reproduce the fringe of the raiment. The torso itself, alas incomplete, has an internal strength beneath its rounded surfaces.

Arameans, Assyrians and Babylonians

The last centuries of the second millennium are characterized by events of great historical significance, by migratory movements of peoples, among them the so-called Peoples of the Sea, who overran the settled lands of the Syrio-Anatolian regions. At the conclusion of these movements the arrival of the Arameans, people of western Semitic stock, was heavy with consequences for Syria and Mesopotamia. In fact on the one hand these ethnic groups were an integral part of the "neo-

Hittite" or Aramaic kingdoms whose principal centers such as Carchemish, Malatya, Zinjirli, and Tell Halaf were later subjugated by the Assyrians; on the other hand they penetrated eastward and, checked by the Assyrians, integrated with the indigenous peoples in Babylonia and so brought about the last flowering of classical Mesopotamian civilization in the neo-Babylonian or Chaldean period which ended with the dynasty of Nebuchadnezzar.

At the courts of the kingdoms that flourished in northern Syria and south-east Anatolia until they were absorbed by the Assyrian empire, there developed a highly interesting art characterized by a fusion of iconographic and stylistic features of the Hittite tradition on the one hand, and typically Syrian on the other. Monumental architecture follows the lines of the Syrian buildings dominated by the *bit-hilani*, which is sometimes splendidly embellished, with caryatids instead of pilasters. The severe, very large figures, often supported on animal bases, show generally stiff and clumsy plastic modelling.

Temples and palaces were decorated in a typical manner with orthostats sculpted with figures in low relief. The subjects partly reflect Hittite themes, but their characteristic method of composition was based on the separate presentation of each figure, no motif or scene spreading over more than one stone. Even when the subject is a long procession, it is treated as a row of separate figures or groups. With the Assyrian conquest, from the eighth century onward the influence of the conquerors becomes apparent in the rendering or stylistic execution, but only superficially modifies the actual substance of the indigenous traditional subjects.

In the first millenniumn Anatolia proper saw the formation of two powerful states. The kingdom of Phrygia, with its main centers at Gordion and Boghazköy, occupied the central lands of the Hittite empire, but relatively little is yet known about the surviving evidence. Urartu, a strong warrior state often at war with the Assyrians, stretched from eastern Anatolia as far as Armenia and Iranian Azerbaijan.

Urartian architecture is dominated by the heavily fortified buildings of the royal citadels and the strongholds which strew the high ground in the eastern regions. These are fortifications with many towers, sometimes with several perimeter walls, serving essentially military purposes. But in the city centers a characteristic monumental architecture developed, with the hypostyle hall as the royal audience room – a plan widespread in Iran up to the time of the Achaemenians – and with smaller square temples serving essentially to house the statue of the god.

Chief among the surviving objects of Urartian art that are known to us are those in metalwork: full-dress weapons and metal belts finely decorated in a manner not unlike the Assyrian style but quite distinctive, metal de-

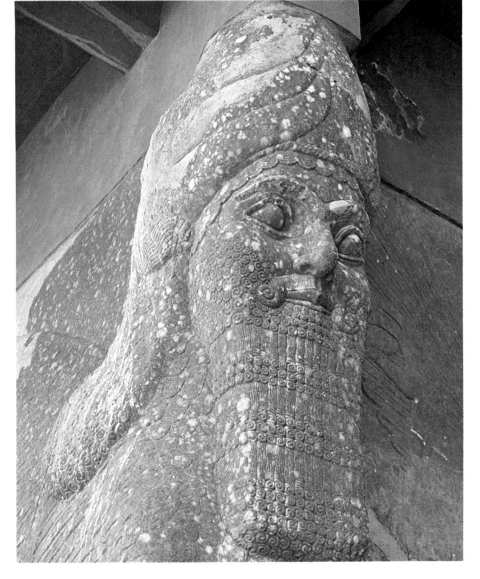

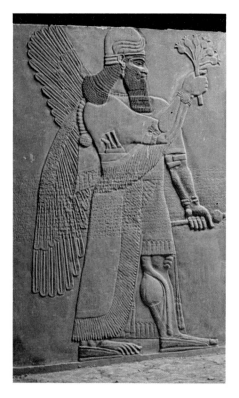

corative motifs and even figures on furnishings which, like the cauldrons with the characteristic figured handles, testify to the mastery of the Anatolian metalworkers.

After the succession of alternating centers of power in different regions which characterized the Middle East in the second millennium, the ninth century saw the creation of a political power that truly dominated the international scene: the Assyria of Assurnasirpal II.

With this king there also came about a splendid artistic flowering which received tremendous impetus with the transfer of the capital to Calah (Nimrud), where the king built a magnificent palace, the first of a succession of others.

The NW Palace of the Nimrud citadel was the model for the development of the architecture and art of the neo-Assyrian age, whose fundamental features were imposed by the great Middle Assyrian kings. Its plan, wholly rational in its simplicity, was to be adopted also by future kings who modified only its proportions and dimensions in accordance with the supply of materials available for the construction of their own palaces. The distinguishing feature of the neo-Assyrian palace is the clear separation between external and internal quarters arranged around two courtyards (the *babanu*, entrance, and the *bitanu*, residential) and at the same time their cohesion, the link between them being the great throne-room itself, matched on the *bitanu* side by a hall of slightly less monumental proportions.

The *babanu* courtyard – which is the larger and more developed in that it is surrounded by a greater number of rooms – is the most accessible and gives space to the view from the throne-room. The long side of the throne-room faces onto the courtyard and has two huge entrances near the corners, one near the throne, which is placed against the short side of the room.

The *bitanu* courtyard is not so large, and the quarters that surround it do not serve solely as the king's private residential apartments. In fact they also include large, magnificently decorated state rooms, evidently used for ceremonies which involved a lesser number of dignitaries and citizens.

The great kings who followed after the founder of Assyrian power also built enormous palaces, and they too transferred their residential city to new centers: Sargon II to Dur Sharrukin (Khorsabad) and Sanherib and Assurbanipal to Nineveh, for example. These conformed to the plan of Assurnasirpal, which evidently answered the needs of court etiquette and the requirements of Assyrian regality.

The palace of Sargon is a small citadel in itself, raised on a platform astride the city walls and connected by a bridge with stone arches to the platform on which stood the religious acropolis. It is a huge complex in both extent and elevation, and in addition to the quarters corresponding to those of the Nimrud palace it also comprises the triple temple of Sin, Shamash, and Ningal with corresponding ziggurat (but at Nimrud the temple of Ninurta, with its ziggurat, stands immediately outside the *bitanu*) and a quarter with large rooms jutting out toward the bastions.

But the splendour and magnificence of the palaces is most strikingly conveyed by the decoration of their walls with orthostats depicting historical or legendary scenes, and by the sumptuous furniture fittings. Assurnasirpal had also set the standard for interior decoration. The great king conceived an ambitious decorative scheme by the systematic use of orthostats, slabs of local chalky stone (the so-called alabaster of Mossul), to cover the lower parts of the thick rough walls. He had these orthostats sculpted with bas-reliefs depicting variations on a single ritual theme, extolling divine blessing through the acts of the king.

Thus on the walls of many rooms we see winged genii standing or kneeling beside the sacred tree, an abstract construction of palm leaves and various plant features. The genii, or winged gods, are tending the tree, holding in one hand a fir-cone sprinkler and in the other a cylindrical holy-water bucket, in the act of ritual lustration. The king may replace the sacred tree as the object of the genii's ministrations and hence the focus of the dignitaries' attention, but it is Assurnasirpal himself who is represented to the right and left of this symbolic central relief which occupies the niche behind the throne in the great audience hall. It is yet another of the countless iconographic versions of the fertility principle that underlies the Mesopotamian view of life. Here the theme is developed in an unusual way, the particular emphasis on the subject perhaps relating to specific ceremonies.

However, the splendour of this series of ritual orthostats was not sufficient for the glory of the king, whose own campaigns are recorded on a series of slabs that occupies only the middle of the main wall of the throne-room, a minimum of decoration which nevertheless is of maximum interest because here Assurnasirpal created the new Assyrian historical relief.

In two registers, separated by a band of carved inscription recounting the deeds of the

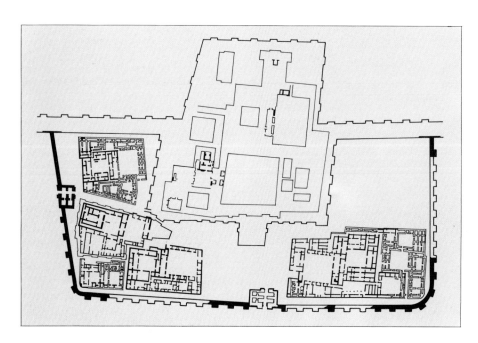

Opposite above: winged genius, relief from the palace of Assurnasirpal II at Nimrud (ninth century B.C.). These mythical beings, sculpted in bas-relief with the characteristic forward twist of the shoulders in relation to the profile stance, decorated the walls of the palace rooms.

Opposite below: plan of the citadel of Khorsabad, built with great splendour by Sargon II from about 720 B.C. onward and abandoned after the king's death (in 705 B.C.) in favour of a new capital, Nineveh. The large complex included – in addition to the royal palace – temples, administrative buildings and, presumably, other buildings intended as houses for the people.

On this page: bas-relief from the royal palace at Khorsabad, depicting King Sargon II and an official. Slabs of chalky stone are also widely used for decorative purposes, to clad the walls of the rooms of this palace, a technique already used in the royal palace at Nimrud. An apparent innovation over the preceding period is the progressive substitution of narrative reliefs commemorating historical events, mainly extolling the king, in place of the depiction of purely ritual subjects (seventh century B.C.). Paris, Musée du Louvre.

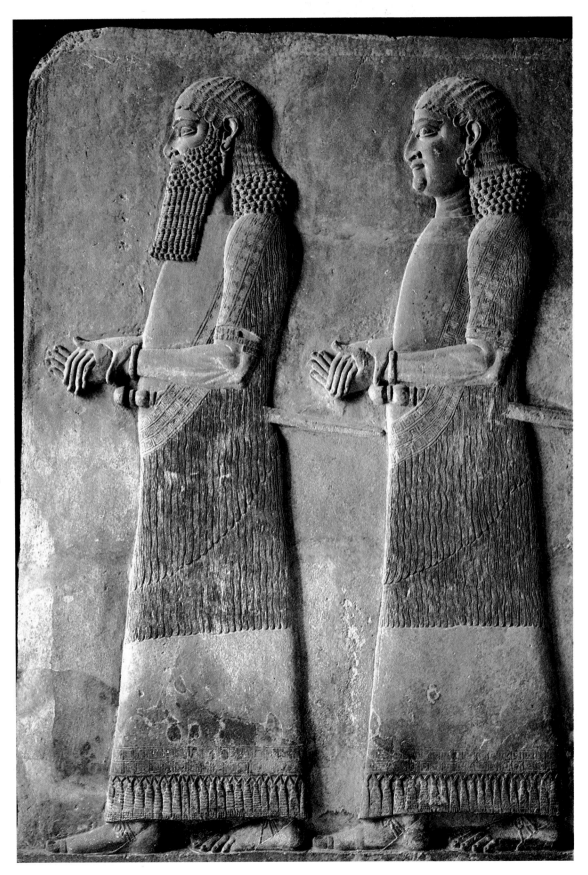

Right: conquest of the Palestinian city of Lachish, from the palace of Sennacherib at Nineveh. Here the potential of the large stone slab is fully exploited, as can be seen from the different planes on which the king and his warriors are placed, emphasizing the greater interest in narrative art that had developed by this time (seventh century B.C.).

Opposite: this Phoenician-style work in ivory, known as the "sphynx of Nimrud," together with numerous other examples, comes from the royal palace of the Assyrian city of that name. The royal residences were the most suited to house the best works of such refined craftsmanship (eighth century B.C.). Baghdad, Iraq Museum.

ation uses composition formulas that sometimes become repetitive, this is because it sets out to illustrate specific events in a direct, not a generic way. In other words, the representation places in the foreground the distinguishing elements of the event as it really took place.

The character of this representation, the way in which it unfolds on the walls, is in fact strongly narrative, because it is the unfolding of the events themselves, with all their episodes, that is related on the walls above and below the written account. It is a continuous narration because the scenes depicting single episodes follow in unbroken succession, without external interruptions such as frames, and are linked to each other by the flowing lines of the composition.

The revolutionary innovation of narrative relief developed during the cycles of Sargon II, Sanherib, and Assurbanipal with an incredible richness, proportionally replacing the ritual subjects but above all emphasizing the narrative content in such a way as to overcome the narrow limits of the register, introducing the landscape settings in which the events took place and thereby creating extremely complex cycles of scenes that unfold on several successive slabs and contain a whole historical microcosm.

The urge to decorate the royal palaces, which were entered through gateways guarded by huge lamassu – winged genii with a human head and the body of a bull – was so strong that it was reflected in the residences of provincial governors. Here the techniques employed were more ephemeral, as in the palace of Til Barsnip, where the wall paintings share the repertoire of the paintings and reliefs in the king's palace, but show no less originality.

Compared with the importance and original-

king, we see the unfolding pictorial record of his exploits: the wars, the army marches, the sieges of cities, the tributes of the conquered, the hunts and libations – all the events of contemporary life. The repertoire of subjects unfurls in an extremely varied manner with fresh scenes, allowing the sculptors' imagination to invent new compositions and new ways of expressing themselves.

Assyrian relief – in so far as it had hitherto been produced in Mesopotamia – is distinguished not only by its actual subject matter, which stemmed from an unwonted desire to extol kingship, but by much deeper artistic qualities – above all by the way in which history is described, inasmuch as specific events in the king's reign are the subjects of representation. If this represent-

Right: this remarkable detail of the "wounded lioness" belongs to the cycle of reliefs that share the theme of King Assurbanipal and the hunt. These bas-reliefs in alabaster decorated the royal palace of Nineveh, and were designed primarily to extol the king's greatness. Unfortunately the decoration in royal palaces is almost all that has come down to us of the artistic output of the Assyrian people (seventh century B.C.). London, British Museum.

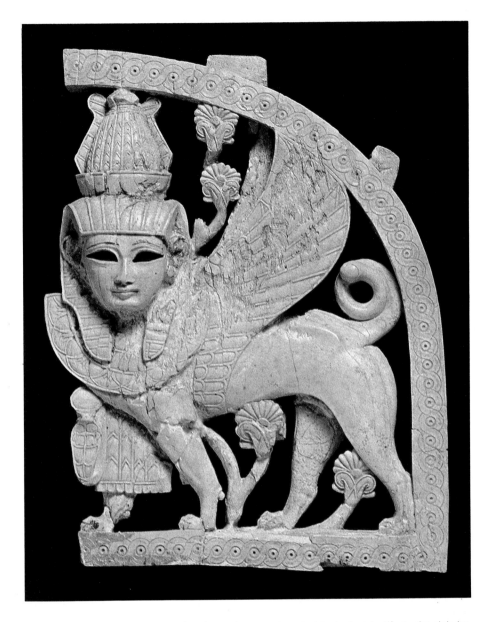

the round that served as an element in the decoration of items of furniture such as beds, thrones, and chairs – objects also produced by the Phoenicians, but in a different manner. The Syrian workshops produced stylistically more varied pieces, often working in very high relief and choosing religious themes such as processions and sacrifices, or else imaginary subjects, sometimes covering the figures with gold leaf or cutting away parts of the surface in a honeycomb pattern and filling some of the hollows with a brown glass-paste.

The Phoenicians made wide use in their repertoire of motifs of Egyptian origin such as sphynxes, genii, divinities, often transformed or used inconsequentially for their decorative value in contexts improper from an Egyptian point of view. The Phoenician ivory carvers, who also made skilful use of the openwork technique, are distinguished by the particular polished finish of their products and by their subtle use of colours – reds, blues, and greens as well as gold – to enliven the surfaces.

But these great Assyrian palaces, the repositories of such art treasures, were to be more or less totally destroyed at the end of the seventh century B.C. under the combined attack of the Medes and the Babylonians. Babylon soon took the advantage and, with the dynasty of Nebuchadnezzar, replaced Nineveh as the great power in the Ancient Near East, reconquering Phoenicia, Syria, and Palestine.

It is the Babylon of the seventh–sixth centuries that has been partly brought to light by excavations – astounding in its size, with two perimeter walls, its royal palace situated in a key position, astride the inner walls near the main gate, the Ishtar Gate. This was where the processional way entered the city, a straight paved road that was a revolutionary piece of town planning.

The great palace of Babylon is the most mature product of the Babylonian architectural tradition, noteworthy for its huge size and the very regular clear division of the internal spaces, the different quarters being clearly distinguished both by function and by architectural features. The main courtyard is reached only after traversing a number of minor courtyards, but it must have been a splendid sight, dominated by the huge throne-room, a wide room with its façade entirely covered in glazed bricks decorated with a row of very tall stylized trees.

The preference for abstract motifs and for the juxtaposition of figures which had been typical of the Kassite age is here given pride of place. In the decoration of the Ishtar Gate – and the processional way, too – there is a measured succession of lions on the former, bulls and dragons along the latter, without any attempt at narrative but simply repeating, with the animal symbols, divine attributes.

We also have Herodotus's description of the ziggurat of the temple of Marduk, a gigantic structure with its seven storeys in different

ity of the relief decoration the royal steles and obelisks take second place, since they do not permit adequate development even when they are decorated with scenes. But such was the interest in narrative art that even the huge gates of the palaces and temples, such as those that Salmanasser III commissioned for the temple of Mamu in the small center of Balawat, are covered with bronze bands engraved and embossed with detailed historical scenes, an outlet for an inexhaustible mine of subjects and plans of composition.

The Assyrian palaces were also the most worthy places to receive the articles of furniture created by the most refined craftsmanship of all the subject peoples, especially those in ivory. With this precious material the different workshops active in this empire, at Kalhu itself or in the cities of Syria and Phoenicia, produced objects that testify to the rich imagination and technical virtuosity of the craftsmen.

The ivories are divided into three main groups, according to style and purpose. The Assyrian group shows typically Assyrian subjects and style, often with rather cursive engraving but sometimes finely and delicately modelled with results comparable to high relief. They are thin plaques of various sizes, probably inlays from small objects such as boxes. Whether made by Assyrian craftsmen or by local craftsmen working in the style commissioned by the king, these ivories form only a limited group.

The majority of the ivory fragments that have survived belong to the Syrian and Phoenician groups. The former includes small containers for toilet articles, ciboriums, pieces carved in

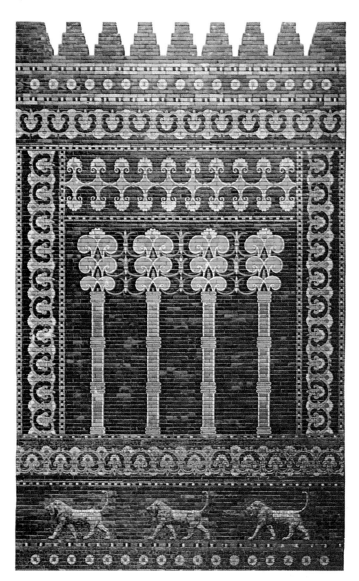

Left: panel in coloured glazed bricks from the throne-room of Nebuchadnezzar in Babylon (seventh–sixth century B.C.). This period saw a strong revival of the taste for abstract and stylized decorative motifs.

with decorative refinements: the fluted shaft of the column rests on a bell-shaped base while the highly original capital is composed of two corollas, one drooping and the other erect, topped by yet another parallelepiped plinth decorated on each side with vertical volutes, and finally the true capital: twin animal fore-quarters back to back, so that the ceiling rafters are supported on their head and back.

The column is fundamental in an architec-

colours, but the remains of the foundations tell us only that there were two huge separate enclosures in whose courtyards stood the ziggurat and the main temple.

The Persian empire

The triumphant entry of Cyrus the Great into Babylon in 539 marked the most decisive stage of the Persian conquest of the Ancient Near East as far as the Aegean, before Egypt. Cyrus – and above all his successors, Darius and Xerxes – moved the political center of the Near East to the Iranian plateau, at Pasargadae and at Persepolis, where the artistic manifestations have a splendour worthy of the monarchs of the Near East.

Achaemenid architecture gives monumental expression to its own traditions together with the traditions of the Medes, enriched by the cultural and technical contribution of the

peoples of the empire. We see architectural projects allied to the expression of regality: in the palaces that Cyrus built at Pasargadae, huge pavilions set in a vast park, and in the ceremonial and administrative buildings of the citadel of Persepolis. This is a real testament to Achaemenid regality – a complex of palaces used mainly at the New Year celebration, the *noruz*, which entailed great festivities in the spring, whereas the cult worship, performed partly in the open air in accordance with the nature of the Persian religion, had as its typical building the small square tower of the Fire Temple.

The earliest Achaemenid art created by Cyrus was based on technical perfection in cutting the stone for the smooth rounded sections of the very tall columns and their torus bases with fluted plinth, work certainly entrusted to expert Western craftsmen such as the Ionians. At Persepolis, under Darius and his successors, this technique was enriched

ture in which the walls are of perishable material around a frame of stone elements, and the buildings often consist of a single majestic square hall crowded with a forest of columns, such as the Hall of the Hundred Columns at Persepolis. This is a square of ten rows of ten columns between walls that are a series of stone doorways and windows connected by mud-brick walls. The splendour of the interior is heralded by its front portico with two rows of columns.

The *apadana* or audience hall of Darius, with more widely spaced columns, is an equally impressive structure. This huge edifice stands on a plinth decorated with reliefs, and consists of a large square pillared hall with four square corner towers and porticoes on three sides, one facing the high terrace on which stands all Persepolis, the others served by great stairways; while the fourth side at the back connects with the adjacent buildings.

But even in less demanding mud-brick

architecture, such as the administrative buildings and the so-called Treasury, the Achaemenid architects made wide use of the same layout, especially the square halls, only substituting the stone columns with wooden supports.

Figurative art also served the glory of the king and was subservient to the architecture's ceremonial purposes. Examples of sculpture in the round are extremely rare but architec-tural relief is common, naturally in the material best suited to the building technique of the edifice to be decorated. However, at Susa, the king's winter residence, the reliefs are in glazed brickwork, as in Babylon, and con-spicuous among these is the long procession of the archers of the royal guard. At Persepolis, on the other hand, the reliefs are in stone.

The main edifices are profusely decorated with reliefs that reflect their official function and specific use. On the door and window jambs are large figures of the king or of dignitaries, or of the king struggling with mythical animals, and also emblematic representations of the peoples of the empire supporting the royal throne, which are also seen on the sculptured façades of the rock tombs. The great entrance vestibules, on the other hand, are protected by huge winged bulls, the Persial version of the Assyrian *lamassu*.

Opposite right: bull's head, fragment of a capital, from Persepolis. The generous use of columns, characteristic of Achaemenid architecture, also involved a corresponding use of the capital as a decorative architectural element. These capitals are generally shaped like animals, simple or composite: lions, bulls, or griffins.

On this page: detail of the staircase of the Tripylon with decoration in bas-relief depicting the procession of Median dignitaries. The imposing architectural complex of Persepolis presents many reliefs similar to this, distributed on all the buildings but concentrated in greater number and with a greater profusion of decorative elements in the apadana, or *audience hall, of Darius and Xerxes. At Persepolis we see one of the best examples of integration between architecture and decoration (sixth–fifth centuries B.C.).*

However, the greatest decorative development is visible on the plinth of the *apadana* and on the parapets of the stairs, where we find a procession of delegates of the subject peoples bearing their tributes, shown on the stairway parapets, in the act of climbing the steps – a happy integration with the architecture. The reliefs' style of execution is certainly essentially Persian. The subject peoples, however, did not only contribute their skilled workmanship: they influenced the iconography of many themes – especially the Babylonians and Assyrians, the latter contributing the winged sun disk as the symbol of divinity or the king's immortal glory.

No less splendid, at the courts of this first territorial empire in the Ancient Near East, was the flowering of craftsmanship in the minor arts, particularly toreutics. This stemmed from a widespread tradition in the preceding centuries in the north-west regions of the Iranian plateau and produced gold and silver vases decorated in relief or in the round, especially with figures of animals.

Parthians and Sassanids

The army of Alexander the Great brought about the fall of the Achaemenid empire, together with its court art, while Hellenistic art spread triumphantly into central Asia, finding different situations in the varied regions over which the authority of the Seleucids now extended.

The prosperity of the cities founded by the Greeks – such as Seleucia on the Tigris, which inherited the metropolitan role of Babylon – enabled Hellenistic culture to survive the loss of the Orient, gradually conquered by the Parthians as far as Mesopotamia (mid-second century B.C.). With the Arsacid dynasty these Iranian tribes founded a state that was not truly centralized, so that its artistic experiments were swayed between East and West. Alongside a fairly strong Hellenistic influence, the Eastern reaction is seen not so much in any inspiration from the iconographic themes and motifs of the past – the social environment being anyway much changed by this time – as in an interpretation of the new environment through a sensibility in which old Eastern attitudes still survive.

Below: Sacrifice of Conon, *from the temple of the Palmyra gods at Dura Europos (end of the second century* A.D.*). Although in the Hellenistic type of* architectural cornice, the figures are treated in the frontal pose so dear to Eastern Parthian culture.

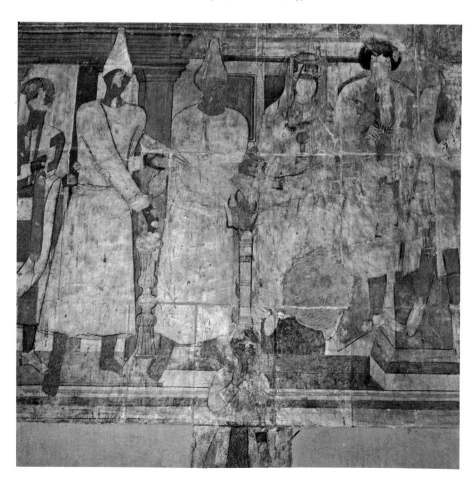

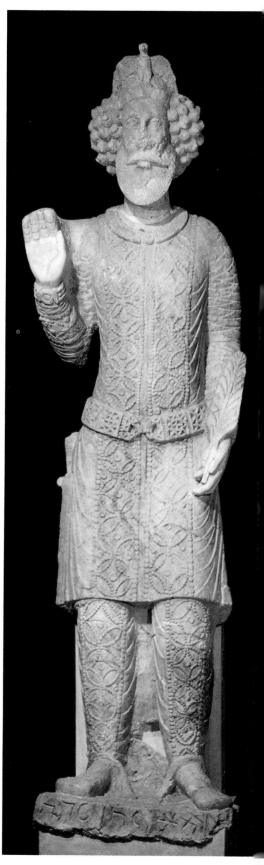

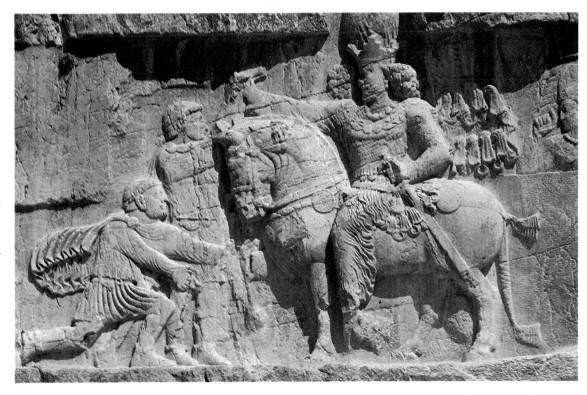

The Arsacid court itself – whose splendid remains were brought to light by the excavations of its first capital, Nisa, now in Turkmenistan – shows in its architecture on the one hand features of the indigenous and Achaemenid tradition, and on the other of the Hellenistic tradition. The influence of the latter can be seen not only in overall schemes, as in the Round Hall, but also in the vocabulary of ornamentation, the architectural arrangements being stripped of their Hellenistic structural value and becoming applied decorations. A similar situation prevails in the figurative and minor arts and above all in the splendid ivory *rhyta* produced in Bactria (Afghanistan), vessels of the Iranian type with figured decorations of Hellenistic subjects and style, often adapted to express foreign – Iranian – ideas.

With the expansion of their empire toward the west, the Arsacids came to dominate regions of ancient and different civilization, moving their capital to Ctesiphon opposite Seleucia, whose court arts were inspired both by vassal princes and by cities which, like Palmira, were never part of the Parthian empire. The heterogeneity of the cultural situation and the varying distribution of the Greek element, always strong, determined a certain variety of results in the different regions alongside the establishing of certain common characteristics.

Unfortunately we have no first-hand knowledge of court art, which in the Orient is always the paradigm of an age, but beyond the particularism and the eclecticism we can glimpse a historical evolution which enables us to appreciate the capital importance of this age, not only for the Orient but for our own civilization. Indeed, it is in the Orient of this age that we find the beginnings of the great spiritual movements, from Mithraism to Christianity, which contributed to the radical change in Roman society; here also was created the anti-Classical artistic vision that only later produced the phenomenon of Late Antique art in the Mediterranean Basin.

The Parthians were not only responsible for founding ancient and modern traditions; they created a new style in architecture based on the *ivan*, the reception room in the house as well as the palace, whose short side is completely open, giving onto a courtyard. The palace of the Parthian governor of Assur is constructed around this feature, which dominates interior façades decorated with a series of orders superimposed by small columns of an absolutely non-Greek type, framing the great arch of the *ivan*.

There are differences in religious architecture, often within the same city, because of the variety of rites. Thus in Hatra, an Arabic city in northern Mesopotamia, behind the peripteral temple of Hellenistic inspiration the vassals of the King of Kings adopted the monumental *ivan* in stone for the Great Temple, a grandiose series of huge arches alternating with smaller ones on two levels. For the Square Temple they had recourse to yet another Iranian overall scheme, the square hall surrounded by a corridor; they would also dedicate the statues in the large room, themselves of Babylonian tradition, in the small mud-brick temples among the houses in the city.

There were revolutionary innovations in figurative art. While the statues – to judge by the statue of Hatra or the large bronze of Shami – had a remarkable feeling of solidity, simple in structure but with a wealth of detail in the garments, the reliefs and paintings show the figure in the frontal pose even in scenes depicting actions. The relationships between the figures are purely paratactic: they all look straight ahead, regardless of the gestures they are making, and if the subject is a sacrifice to the statue of the divinity, the priest is shown at the side but facing forward, not toward the god. The figure's frontal pose is derived from the Hellenistic repertoire – whereas in the Ancient Orient figures are normally in profile – but the Oriental sensibility offers us an interpretation quite contrary to the sense of life inherent in the Hellenistic model, with a result that negates the action.

The variety and freedom of the artistic manifestations of the Parthian age ended with the overthrow, in about A.D. 226, of the Arsacid dynasty by the Sassanids, feudatories of Fars, cradle of the Achaemenids. With them came a return to a strongly centralized empire in which, even in the artistic field, the court was the undisputed protagonist.

Palace architecture continued the Parthian tradition, making great technical and expressive advances. In Fars, at Firuzabad and Bishapur, great stone palaces were built with splendid stucco covering. A great hall with a cupola roof was now often the main room, and this form of roof also became used on halls of

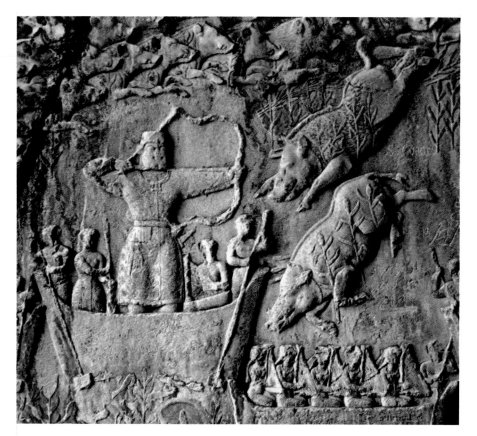

practice and the use of historical reliefs – so important as political propaganda for them too – must have given great impetus to the figurative political propaganda of the King of Kings, but the narrative technique and mode of expression are wholly Iranian: Sassanid.

Sassanid relief sculpture overcomes the Parthian convention of the frontal pose by adopting its own representational conventions – which also differ from the Achaemenid conventions – that focus on the clarity of the actions represented. The style too is highly innovative, dominated by the stately royal attire of Parthian origin but especially by the drapery, which consists of a series of wavy folds on a flat surface and creates a remarkable impression of movement even in static figures.

Large relief sculptures also extolled the king in times of peace; in the *ivan*-shaped cave in the park of Taq-i Bustan the king, in armour on horseback, is sculpted almost in the round against the back wall, and scenes depicting stag-hunting and boar-hunting in the marshes stretch like two great tapestries along the sides – ancient Eastern subjects revived in a completely new way in this bird's-eye-view composition.

Sassanid art is the ultimate expression of an Eastern empire on the threshold of the Middle Ages. With the fall of the Sassanid empire under the onslaught of the Arabs in the name of Mohammed, a whole world came to an end and a new one began under Islam.

lesser proportions and in the typical Chahar Taq, the small Fire Temples with their "four arches." But in the great palace of Chosroes I at Ctesiphon, built entirely of baked bricks, the *ivan* is a huge hall opening beneath a gently curved parabolic arch between two wings decorated with rows of slender circular pilasters and cornices, one of the boldest pieces of architecture of all time.

The court was also the destination of figurative art, expressed mainly in relief, and minor art, especially toreutics, often intended for gifts of state. Relief sculptures, which showed great development of an Iranian tradition cultivated also by the Parthians, were sculpted on rocks, especially in Fars, near sites of crucial importance for the dynasty: from Naqsh-i Rustam, site of the tombs of the Achaemenid kings, to Bishapur, the city of Shapur I which was largely built with the labour of Roman prisoners.

The themes of the rock reliefs glorify the sacred kingship of the Sassanids with scenes of investiture, on foot or on horseback, or victory scenes. Shapur I gave great importance to the reliefs commemorating his victories over Philip the Arabian, Gordian III, and Valerian toward the middle of the third century A.D. The Roman emperors are shown beneath the hooves of his horse prostrating themselves in humble submission, witnessing the scene of his triumph, which covers a large square in several registers. Certainly the Romans' own

Above: the other important cycle of reliefs of the Sassanid period is that sculpted in the ivan-shaped cave in the Taq-i Bustan area. Here we can see the left-side decoration depicting the wild-boar hunt: the king, standing in a boat, is shooting arrows at the boar, while below, on the right, another boat with musicians can be glimpsed. These scenes are very animated and perpetuate an ancient tradition, the theme of the hunt, for long one of the most popular subjects, rendered here with new vivacity and technique (fifth century A.D.).

Right: the theme of the royal hunt again dominates the decoration of Sassanid silver cups and plates: the inside of this cup, with the figure of the king hunting a lion, shows both the themes of acknowledged Achaemenid tradition and undeniable Hellenistic and Roman influences (fourth–fifth century A.D.). London, British Museum.

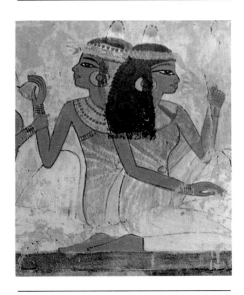

The Art of Ancient Egypt

Cultural background

The civilization which flourished in the Nile Valley from the third millennium B.C. onward has been reconstructed from a remarkably rich and varied collection of relics. Archeological discoveries can often tell the story of the customs, habits, technology, skills and attitudes of the Ancient Egyptians, and in this region more than any other a happy combination of circumstances has meant that the finds have been able to withstand the ravages of time through the centuries.

But this capacity to communicate directly with the spectator has not been the same throughout the ages. Egyptian art has been regarded and assessed in different ways during the long period when scholars have turned their attention to these works, and this was already true in ancient times when someone like Plato – who was constantly in awe of Egypt – admired a certain kind of sculpture whose dimensions and symmetrical proportions were established and almost exclusively implemented by the sculptors themselves. If you take away the "philosophical" aspect of this approach and bring it down to a concrete evaluation of the works of art, it is late Egyptian art which is most in keeping with the Platonic vision, given its highly developed technical expertise and its liking for imitation and reproduction of models. But it is certainly not mere chance that this was the type of

statue most prolifically exported from Egypt during the Greek and later the Roman period to decorate the numerous temples to the goddess Isis (who had at that time risen from being an Egyptian deity to play an ecumenical role): the cold but exemplary perfection of artistic production during that period was a fitting expression of both the universality of those works of art (with the evident purity of technique involved) and their equally evident peculiarity, seen in the exotic nature of the designs.

The re-establishing of contact with Egyptian antiquities in a coherent cultural context took place in the Renaissance, through Platonism and the neo-Platonic thought of Marsilio Ficino. In Ficino's eyes the revelation contained in the esoteric writings, which may have originated from, and were certainly set in Egypt, bearing an aura of late pagan mystique, under the name "Pimander," corroborated the revelations of Moses. The archeological work which started at that time unearthed antiquities which

Above: Festive Scene, *detail from the Tomb of Nakht in Thebes (eighteenth dynasty).*

either were Egyptian or had been identified as such, as well as creating others which were fakes or imagined to be from the land of the Pharaohs. In addition to "Pimander," however, another piece of writing had found its way to the West: this was a short treatise in Greek, believed to have been written by an otherwise unknown writer by the name of Horapollon in Egyptian and translated by an equally unknown translator called Philip. He provided a catalogue of images, for each of which he added an explanation of its meaning in Egyptian hieroglyphic script. Now we know that this catalogue is not completely reliable, and we are also aware of how it was compiled. When it was first discovered, it provided a seemingly incontrovertible key to understanding what the illustrated monuments signified: mystique and symbol became the key to Egyptian antiquities. The object and the image were absorbed completely by their "meaning" and the form they had been given, their figurative wrapping, was actually irrelevant. So that just as the reading of the ancient classics served as a model for the new works in their languages in which the rhetoric of humanism was expressed, so the hieroglyphics of Horapollon were now joined by others, conceived along similar lines – and the place of Ancient Egypt was taken by the world of "exploits" and the lifelike images in which the late Renaissance and the Baroque period took such pleasure.

It is clear that in this all too wholesale

assumption of Egypt into the culture of the time the characteristic features disappear, and what remains is that aspect of the typology of Egyptiana which can be put into words, is weird, allusive, demanding to be interpreted much more than simply looked at. It is during the neo-Classical period that this interest – at best an antiquarian one – in things Egyptian gives way to a livelier sense of the formal qualities of what Ancient Egypt produced. There came a point when the most informed experience of Egyptiana stemmed from Napoleon's Egyptian campaign (as a result of which allusions to Egypt at that time take on a delicately commemorative tone); but of much greater importance was the fact that the neo-Classical concept of balance through restraint, clear symmetry, and ready reliance on a basic rule found an authoritative precedent in what was produced during the late Egyptian period. That age imitated the Classical in its culture as

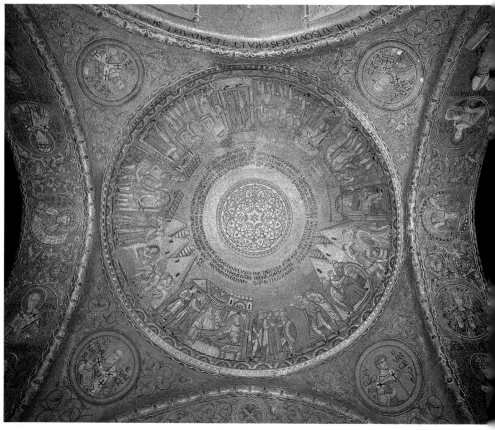

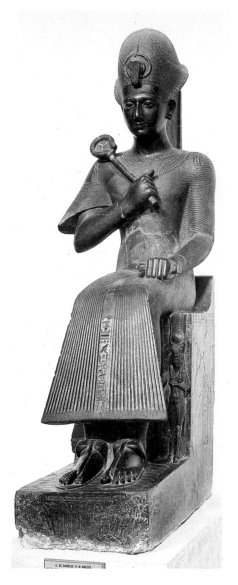

it was instinctively felt to be a directly assimilable quality, and became a means by which to taste the explicit symbolic elements of that culture rather than a theoretical, conceptual message.

The interpretation of Egyptian art from these points of view could obviously be restrictive: but its importance is that it provides a basis for assessing the characteristics of language instead of dubious theories of what it may be expressing. This makes it imperative to look at the works of Egyptian art – not just describe them, let alone conjure up mental pictures of them.

It was this change in cultural perspective which caused the romantic experience of Egypt to erupt, while at the same time it became possible to read and understand the hieroglyphic scripts. As a result, the overall problem of Ancient Egypt could be presented in fresh terms which were much more reliable than the traditions to which it had hitherto been necessary to give credence. Egyptian works of art became the testimony of a nation.

Evidence. At this point, though, we have to ask ourselves what basis we have for our real knowledge of the arts of Egypt: what, in short, is the documentary weft as opposed to the interpretative warp. The experience of Ancient Egypt actually comes down to us in a way which is very different from that of Classical antiquity: after a complete break, and through

objects salvaged by pure chance. Greek and Roman monuments and texts have come down to us within the framework of a tradition and, very often, as the result of an intentional act, possibly in a new context of meaning. In the Nile Valley, first Christianity and then Islam became established independently of any link with the earliest indigenous culture, which, in any case, had already been considerably compromised by its coexistence with Greek and later Roman culture. It is almost symbolic of this situation that in medieval Egypt the pyramids were linked to the story of Joseph in Egypt: they were Pharaoh's granaries in view of the years of famine mentioned in the biblical account. In other words, perhaps the most impressive monuments handed down to us from the age of the Pharaohs were worth only what they looked to the eyes of a people whose culture was completely different but who lived in what had once been the country of the Pharaohs.

This lack of a direct link means that what evidence there is of Ancient Egyptian civilization has resulted exclusively from the chance survival of the physical material; and in this respect it should be said that we are remarkably fortunate. Egypt consists of a narrow valley, hollowed out by the passage of the Nile and regularly inundated by that river, within the desert tableland of the Sahara which extends across the whole of Northern Africa. Thus

Egypt has a particularly dry climate in which materials which almost anywhere else would be likely to disintegrate rapidly may be preserved: wood, paper, plants, and organic substances of all kinds do not decay, colours stay fast, and inks are unaffected by damp. On the other hand, as a precaution against the river's annual flooding and in order to free the flooded fields along the narrow valley for use solely as agricultural land, the dwellings of men, gods, and the dead were usually situated above the normal reach of the Nile waters on higher, potentially desert ground. This sort of area could then eventually be used again for housing wherever necessary or appropriate, but not subjected to the much heavier, constant and multipurpose use required by agriculture.

This was how the materials on which we can base our research were preserved in towns and villages, sanctuaries and necropolises, and handed down to us as the result of archeological excavations. Not all the towns and villages have survived, however, for the simple reason that the places where they were built were the most suitable geographically. Consequently inhabitants have continued to develop on those sites, building in the ruins of their ancestors and using their materials down the ages to the present day. In some Egyptian centers of population, like present-day Qift and the ancient Coptos-Qebti, it would be possible to trace the history of the place for more than five thousand years if only it were not still a thriving and busy town, hardly suited to systematic, comprehensive excavation layer by layer.

The urban sanctuaries are generally an exception here. They were often built of stone, unlike the town houses made of unbaked bricks; in more than one instance they have been reused as places of worship for the new religion which supplanted the old or as a place of refuge for the civilian population who put up their very modest dwellings there. Here salvage and plunder have gone hand in hand, but the most recent rescue work has restored groups of buildings like those at Edfu or Denderah. It is obvious that the temples have been stripped of anything which could realize a high price commercially: objects in precious and nonprecious metals, documents, utensils, woodwork, and so on. But very often the objects which have been left untouched in the temples are those in which the new occupants or thieves had no interest: statues, stelae, etc. This is why temples have been an essential agency for the conservation of statuary and building materials.

The main supply of materials, however, has come down to us from another source, the necropolises. These were – and still are – located in the desert, set apart from daily life,

Opposite left: the grey-granite statue of Rameses II (thirteenth century B.C.) dates from a phase in Egyptian sculpture which broke with the tradition of a figure representing the sovereign as an idol and made him look instead as if he was more a part of everyday life – by giving him clothes like the ones people usually wore, and changing his body language, so that he bows his head slightly toward the onlooker. Turin, Museo Egizio.

Opposite above: Venice, San Marco. The story of Joseph. The biblical tradition was, throughout the Middle Ages (and not only during that time) the principal line of access to the cultures of Ancient Egypt. The detail of the thirteenth-century mosaics illustrates the pyramids in the classical interpretation of them as Pharaoh's granaries.

Right: the "mammisi" of Edfu. In some late Egyptian temples there is an annexe where the god Horus is born of his goddess mother, and this Coptic word "mammisi" means place of birth. The one at Edfu is particularly well preserved, as is the rest of the temple, which has been a place of dwelling and refuge through the centuries and, as a result of this use, has been the better protected (first century B.C.).

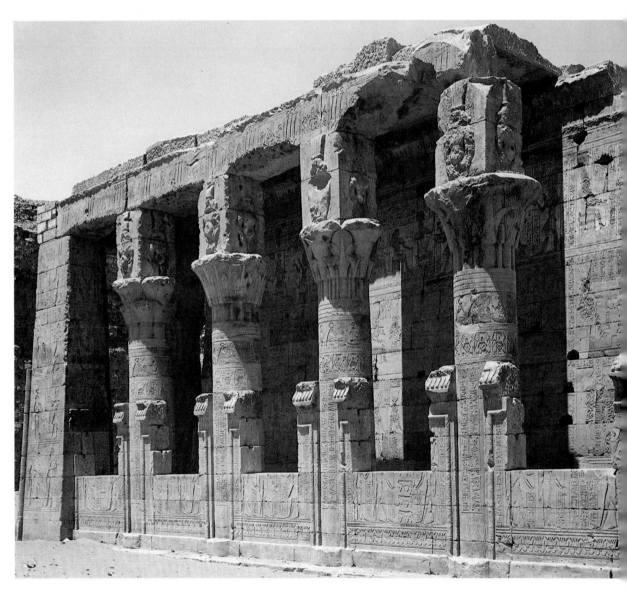

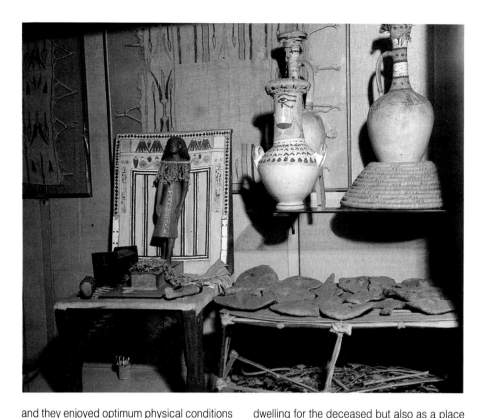

Left: the complete
furnishings of the tomb
of an architect who lived
at Thebes in court
circles around the
fifteenth century B.C. were
discovered by an Italian
archeological expedition
and are now in the
Museo Egizio collection
in Turin. The tomb
contains everything that
might make life
comfortable and
pleasant in a Theban
house at that time: from
clothing to provisions
(even these have been
miraculously preserved),
toiletries, furniture, and a
cubit made of gold, a
Pharaoh's gift to his
architect.

Opposite above: the
tomb of the vizier
Rekhmire, Thebes,
eighteenth dynasty,
offers plenty of detail to
illustrate the skills and
activities of artisans in
very different fields, and
is a particularly
distinguished and varied
example of
representations of

different production
methods. Here you can
see the weighing of
gold, the preparation of
wooden ritual objects,
and the sculpture and
preparation of metal and
stone pots.

Opposite below: the
tomb of Nakht, an
eighteenth-dynasty
official, includes these
scenes of vine-growing
which summarize the
whole process of making
wine from the harvesting
of the grapes to the
storing of the wine in
amphorae.

and they enjoyed optimum physical conditions for conservation. In addition, Egyptian concepts of burial have meant that these necropolises have accumulated a much greater potential for providing information than would usually be the case with other civilizations. In Ancient Egyptian eyes, the tomb was a place of residence for an unlimited period: consequently, the factors governing its survival will be very different from those influencing the houses of the living, which are affected by being passed on from generation to generation and by the attendant changes. This means that tombs were potentially indestructible museums of a kind of decoration and artefact which served to keep alive the dead inside them. First and foremost, the deceased survived as an individual in his or her own right, retaining personality and still having to cope with the demands of everyday life. Immortalized by the techniques and ceremonies of mummification, the body has to be supplied with everything which will offer the chances of survival for all eternity: from daily provisions, like bread or meat or beer, to household furnishings similar to those in the dead person's own house – and in more than one instance probably taken from that house. It is by this secondary route, then, that we have come by this evidence, which the houses themselves are no longer able to give us direct and which is frequently invaluable in identifying a certain level of culture or taste as demonstrated in the daily life of a household.

But this is not the only treasure the tombs can deliver up. For they served not just as a

dwelling for the deceased but also as a place where he or she maintained relationships with living members of future generations. In the accessible parts of the tomb, illustrations represent the deceased as the recipient of offerings, every one of which is featured in a pictorial narrative which tells where they come from and whether they are natural or manmade (from the sowing of cereals to the making of bread or beer, for instance); and other sections of these paintings give a detailed picture of the deceased's profession or career (the tomb of an officer will be decorated with relevant scenes from military life). The whole range of everyday reality thus had a chance of being included in these tomb paintings, which in some periods made no reference at all to death; in others gave prominence to visual accounts of burial rites and the life beyond as an obvious complement to the description of our own world.

Artists and techniques. Throughout the ancient world – and not only there, either – the artist was above all the vehicle of a skill: a craftsman. Behind him there was invariably a tradition which he had to show he was aware of and of which he also had to get the measure. One piece of evidence has survived relating to the pride which was taken in craftsmanship: the autobiographical inscription of an "artist" living in or around the twentieth century B.C., in which he lists his various abilities as a portrayer. Parallels to this uniquely interesting text should not, however, be sought in other confessions or declarations by artists, but in a

group of autobiographical inscriptions more or less from the same period, in which – at a time when an eclipse of centralized power offered more scope for individual advance – people from relatively modest walks of life went on record about their abilities and how these affected their fortunes.

In the Ancient Egyptian mind, the work was much more important than its creator. This meant that people rarely worked alone: there was a workshop or "studio" where they would work in teams under the supervision of an overseer whose job it was to co-ordinate the various group activities. Egyptian sculptors exercised their imagination and ability using various different materials. Of these the foremost was stone – or, rather, stones. Egypt was a country in which are found soft white limestone and golden sandstone – these formed the basic geological framework, so to speak – but also a number of different kinds of rock, volcanic and nonvolcanic, which the Egyptians have searched for and quarried in the deserts or around the Nile Cataract with particular energy: red and yellow quartzite in the neighbourhood of modern Cairo, the alabaster of Middle Egypt, the granites of the Cataract, the greenstone of Nubia, coloured schists, cornelians, agates, silicified wood and so on are used to skilful effect by allowing the intrinsic quality of the material itself to dictate the crafting process.

We owe what we know of the working technique of Ancient Egyptian sculptors to the reasonably large number of statues left unfinished to which we still have access. The

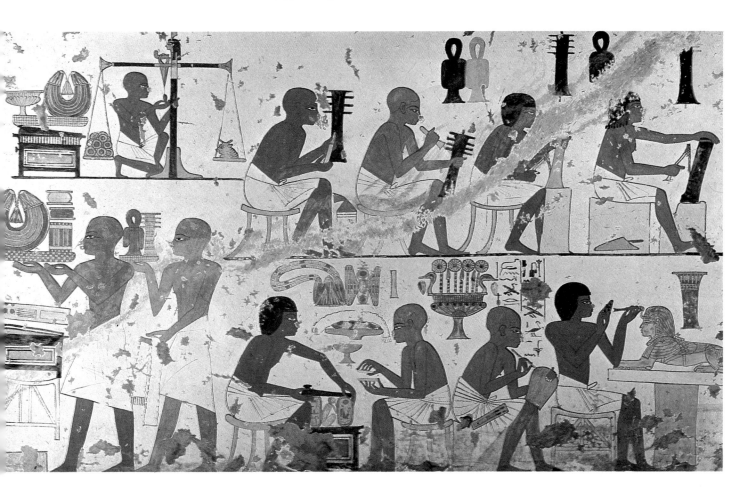

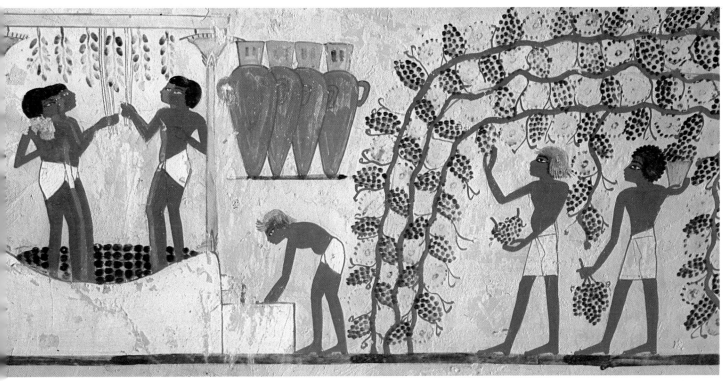

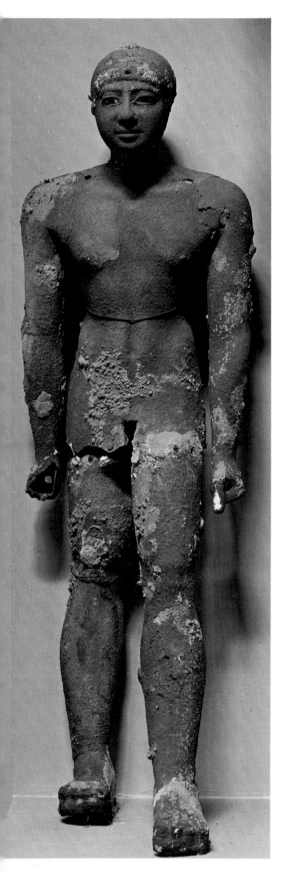

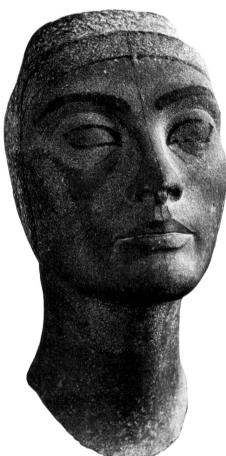

outline of the image which the craftsman wanted to attain was drawn on the front and sides of the block of stone, then the remaining stone was knocked away, before the outline drawing was repeated – several times – each time always more in close-up, as it were, and chiselling more and more intensively until the final shape was perfected. The limestone statues were then ready to be covered in the colours which completed them. Those made of rarer and more valuable materials, whose existing beauty of colour and luminosity was a source of pleasure in itself, were given a colour finish which highlighted certain physical features (the eyes, the mouth) or dress (necklaces, crowns) – often to the point of capriciousness. In the late period of Ancient Egyptian art, this technique, which almost had the effect of continually reinventing the statue, was replaced by another, which involved a model made of plaster which was then reproduced using dividers and compasses. This method is still used today; it makes a much more marked distinction between design and execution, and turns the "extracting" of the image from the block of stone into something more instrumental than conceptual.

Sculptures were done in wood as well as in stone. They ranged from the tiniest statuettes carved out of small blocks of valuable wood like ebony to figures larger than life size. The material chosen related to the ways of portraying the subject: the statues in wood were more free-flowing and more firmly positioned in a more varied spatial context; they were often finished in a different material, and sometimes even wore actual clothes.

Far less recurrent and much less significant than the practice of sculpture was that of modelling. Clay, baked or unbaked, was used only for modest popular figures, while "faïence" (refractory earthenware covered in vitreous enamel which acted like an outer skin) was reserved for amulets, funerary figurines, or even articles with a purely decorative function.

Instances of objects of real importance in copper and in bronze (the former was used before the latter) are extremely rare, for the same reasons that there is an extreme scarcity of three-dimensional figures in gold: the intrinsic value of the raw material, and the ease with which a stolen object can lose its original recognizable appearance if it is melted down to an ingot or recast in another form greatly reduced the chances of linking a number of pieces together in a coherent and meaningful group (with the exception of the small cult statues of the late period of which there were very large numbers, some of them very remarkable). The oldest examples of metal statues show that they were made by hammering the metal in separate sections which were then joined together with metal studs. It was a laborious process, but it none the less produced some masterpieces. Later on, the more manageable technique of *cire perdue* became more popular. The implications of this transition are comparable to those relating to sculpturing in stone, which to start with meant that the artist had to pit his wits against the material in which his finished sculpture would be made, but subsequently had to deal with soft plaster or even softer wax, so that he had more scope for changing his mind during the planning stage, and his imagination was under less pressure while he was working on the sculpture proper.

In addition to three-dimensional standing figures, there are flat ones. This is a description which can properly be used for relief work and painting in Ancient Egypt, where they were very much less dissimilar from each other as concepts than they are for us today. Egyptian relief, in fact, was always conceived needing paint to finish it, while Egyptian painting very often looked like a simplified version of a painted relief. Nevertheless, on more than one occasion the innermost formal possibilities of "relief" and "painting" spurred the imagination and the hand of the artist to the realization of unprecedented effects which then became, to some extent, part of the ongoing tradition.

The preparation of a relief is a very complex operation and would probably require different sorts of expertise. First of all, the artist draws the usual guidelines he is going to work to, like a grid or a series of frames of reference. Then

Opposite left: bronze statue of Pepi II (?), sixth dynasty. It is part of a group which depicts the future sovereign with her father and is a very rare example of large-scale bronze sculpture. The structure is the same as for statues made of stone, but (as often with wooden statues) there are signs of greater agility which indicate that the sculptors had more faith in this material: for example, the gap left unfilled between the two legs of a moving figure. Egyptian Museum, Cairo.

Opposite right: quartzite head of Queen Nefertiti from Tell el Amarna. This was planned as a statue which would be made of various different materials, a common fashion in sculpture at the end of the eighteenth dynasty. It comes from a sculptor's workshop, is unfinished, and still clearly shows the signs which tell how it was made: e.g. the drawn outlines and the surfaces which had not been given the finishing touches. Egyptian Museum, Cairo.

Right: The Tomb of Amenemhet, at Luxor. The pictures show the three stages of preparatory drawings for a fresco in a tomb; paintings in funerary buildings are among the most beautiful in Egyptian art, as well as being the best preserved.

Far right: the storerooms of the Ramasseum, which is the name given to the funerary temple of Rameses II at Thebes, nineteenth dynasty, are a reminder that temples were actually complex centers of administrative and economic life, not only for worship. The fact that they were not monumental meant that they could be built not of stone but using less formal materials like unbaked bricks; the roof had to be in the form of vaults because it would have been too heavy made of stone, and too expensive in wood.

the figures are drawn in black on a white wall. A more experienced artist then checks over the drawing and corrects it in red (these two colours, inasmuch as they can still be seen on works which were never finished, provide us with evidence of how the technique proceeded). The next stage is to lower the tone of the background, leaving the figures in light relief. These are then given their finishing

touches: the three-dimensional details of the generic profile to which they had been reduced earlier on. It is only at this point, and after the relief has been coated with a suitable primer, that the painter takes a hand, painting the background blue (this was the colour originally used – later changed to yellow or white) and the individual figures in colours which would help to identify their themes and special features: these colours were to some extent conventional, as the Egyptian painter's palette offered a very limited choice (white, black, red, blue, green, and yellow). This teamwork clearly did not leave much scope for personal vision or expression, and the "creator" has to be able to co-ordinate a number of activities and delicate changeovers. Here is the first fundamental difference between relief and painting in Egypt, because relatively speaking painting offers an immediacy of execution which has its influence on formal expression.

Lastly, architecture. The Ancient Egyptian science of building has had to solve a very wide range of often very challenging problems by using different materials, each with its own requirements. The dwelling-houses, from the simplest hut to the royal palace, are built of unbaked clay, mud-bricks and straw – an apparently very perishable material but one

which in practice, given the climatic conditions in Egypt, can endure for centuries. The buildings were covered in a plaster whose durability was the main reason why the fabric of the masonry lasted so long.

The thickness of the walls is related to their height and there are often false barrel vaults in the roof, created with series of brick arches sloping toward and resting on the back wall. Temples and tombs built of unbaked bricks, have also been found, although the Egyptians usually tended to make them of stone. In the earliest period, the material most often used was limestone: it was cut into fairly homogeneous blocks (perfect isodomons came later) and gravity, not mortar, was relied on to make them hold together. From the middle of the second millennium B.C. onward, the preferred material for temple buildings was sandstone: this allowed the builders to make architraves which were longer than had been possible when they had been using limestone, and paved the way for alternative architectural modules. Alabaster and, more often, granite highlighted details of the architectural structure like the floor or, more typically, the main doors. With some exceptions, particularly in the earliest period, the monumental buildings (and, as far as we can judge, private ones, too) had an abundance of decoration on their walls as well as accommodating sculptures which in more than one instance were an integral part of the overall structure: take, for example, the statues supported by pilasters in the courtyards of some temples, or those which can put the finishing touch to the design of the approach to these temples (like the sphinxes flanking the *dromos*).

This type of building, whose inspiration and significance are clearly religious, is naturally bound by requirements which had already been laid down, and the construction work had a ritual aspect to it in that there were specific ceremonies to accompany the different stages of building, and also special design features. Although we do have information from technical documents relating to the building of these temples, the various monuments themselves reveal a great degree of similarity, as seen in any form of building with a specific function, but at the same time including variations. The theoretical side comes into its own more at the planning stage, which entails a long preliminary process of drafting the ground plan and elevation to measurements in keeping with the space available and the materials to be used, and – equally important – in the organization of the building site with its dual role as a facility for completing the work and as a focus for community activity. Archeology has enabled us to get to know some of these sites, which are particularly good sources of detailed information. But it nevertheless remains largely a matter for conjecture exactly how feats like the pyramids or the sculpting and erection of obelisks were accomplished, especially if we remember that the Ancient Egyptians had no

practical knowledge of the wheel nor access to timber for building. Much of it must have been achieved by simple methods, like the construction of auxiliary ramps made of unbaked bricks; but there are many questions whose answers still elude us.

What still eludes us, to some degree, is an understanding of the theoretical bases of the Ancient Egyptian building we have before us. If we wanted to develop the argument further along these lines, we would have to confront some even deeper issues, distinguishing features of this artistic world we are trying to see in close-up. Perhaps we are no longer accustomed to thinking it obvious that what really matters in Egyptian representations or works of art is not the "author" but the representation or work itself (its reality, its characteristics, its ability to serve a purpose). With a very few exceptions (which were not due to chance), the whole of Egyptian art, including the litera-

ture, is anonymous: it stands or falls on its own merits. Where we would normally tend to identify stories relating to a particular personality being revealed through the end products of the authors' artistic activities, here the human situations, the psychology, and the interests of the authors are unknown to us; the artist's identity is completely submerged in the work in hand, every time, and not a trace of him is left behind. This could be an impoverishment of the art or a purification of it: but any attempt to step out of this context and attach significance to the few instances where certain works could be grouped together under a common denominator would probably only have the effect of introducing an inappropriate line of questioning.

So these – to us – independent works of art were neither a game nor a diversion: they took their place among the world's many realities, and had their own life. Ancient Egyptian

statues were subjected to an "opening of the mouth" ceremony when they had been finished, and ritual observances accompanied the growth of buildings, each marking a different stage in its construction. The doors and the colossuses of the temples had a name of their own, and sometimes a special cult; images of deities were clothed, purified, and fed; statues of the damned were mutilated. The work of art had a vitality of its own which demanded, first and foremost, to be given form and substance by the artist. This is why purely stylistic effects (arabesques) have no place in Egyptian art. The statues are invariably either of someone who is actually named or of someone carrying out an act of obvious value (sometimes a combination of the two): they are never abstract images, what the Greeks called *agàlmata*. As a result they are associated with a renewed sense of the visual, and a familiarity with nature.

Right: it was in the tomb of Neferronpet in Thebes (nineteenth dynasty) that the discovery was made of this dramatic moment in a funeral, the ceremony of "opening the mouth" which restores breath to the deceased person. This is accomplished through the statue, which acts as a substitute for the deceased person throughout eternity.

Below: the entrance of the temple of Luxor. This massive sandstone building is the setting for a flourishing figurative decoration of reliefs with traditional subjects, while the façade is enlivened by colossal statues and obelisks.

Although the kind of abstraction represented by the arabesque was avoided, it was, however, permissible for the two-dimensional portrait to be juxtaposed with a very different, intricate abstract form, that of writing. Writing too was a representative art, entailing an evocative and documentary process which for us is quite separate from those techniques involved in representation, but which in the Ancient Egyptian system of writing was, on the contrary, very closely related. The symbols in the writing, or "hieroglyphics," were well-defined images, in their own right, of beings (sometimes seen carrying out a particular action) or of objects: but as a rule they also had another function, either phonetic – or classificatory. They were, in other words, "read" – evaluated in a different way from that which they immediately suggested to the onlooker – and existed as part a flow of information which communicated itself independently of their image. But then, in more general terms, any form of flat representation could be like this hieroglyphic image which verges on writing, to the extent that it has to incorporate conventional aspects of portrayal in converting from the three dimensions of reality to two. The connection with writing stems from the fact that here in Egypt these conventional elements are rational and explanatory rather than illusionistic. Beings and objects were assessed for the individual characteristics by which they would most readily be identified. This is why heads were seen sideways on, like legs, feet, and hands, whereas the torso and stomach were seen from the front. Landscapes were represented in terms of their individual features, separated out into sequences which stated (instead of merely "suggesting") the relative place each had in that landscape. If part of an object was obscured by another part, then the hidden part was shown as well, without worrying about perspective, yet with rational clarity. Colour often plays a descriptive – as opposed to naturalistic – part: men are shown in brick

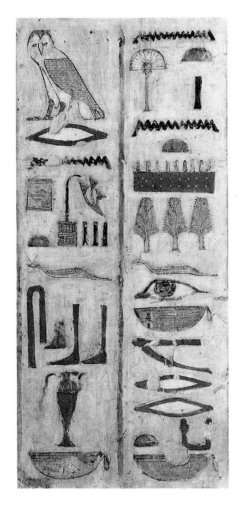

Left: hieroglyphics from the tomb of the vizier Rekhmire, Thebes, eighteenth dynasty. It is difficult to remain indifferent to the figurative precision of each of these symbols which, even though they are actually units of writing, retain their personality as images to the full.

Opposite: the temple of Medinet Habu is one of the best-preserved Theban necropolises and to this day can still give an idea of what it must have felt like to be a frequent visitor to buildings like these. It is the work of Rameses III (twentieth dynasty) and comprises so spacious a site that an entire city finally settled there. It faithfully reproduces the plan of the temple of Rameses II (the Ramesseum) not far away and thus has the effect of being a tribute to that most ancient Pharaoh.

Right: the so-called "Louvre Scribe" from Sakkara, fifth dynasty. Images of a dead person dressed as a scribe are a constant feature in Egyptian art and emphasize the civilian character of this culture. Paris, Musée du Louvre.

red, women as yellowish; wood is red, the desert pink with red spots; plants are green, and so on. Even when the colours are in fact the ones we would expect (like green for plants), they none the less follow convention, as indicated by the fact that they allow for very little variation (a papyrus plantation will always be entirely one shade of green).

Among the aspects and values to be taken into account in understanding Ancient Egyptian works of art in their origins and the importance of their expressive ability there is certainly one which in many respects is very difficult to assess – their "meaning." The fact that a figure is dressed in a particular way is fundamentally meaningful. The fact that the figure is depicted striking a particular pose (for instance, acting like a scribe) could underline his role in society. If the figure is shown to be healthily plump, then this means that the person concerned is important, and has been well rewarded because he is able and active. In this way, the statues have different connotations depending on which material they have been made of (culminating in the custom of restricting the use of greenstone, which was sought after in the middle of the desert in distant Nubia, for the portrayal of the ruler, in

ancient times). The fact that the pyramid of Mycerinus was covered in red granite at the bottom and white limestone at the top quite possibly alludes to the two colours of the royal crowns of the Delta and the Valley of the Nile respectively, the "United Kingdom" of Egypt.

In these instances, to disregard these features is to devalue the expressive range of the work being considered; and a style of architecture which borrows designs and measurements from another style (as happened with some funerary temples of some rulers) points to a wish to pay tribute and represents the political statement, whereby a previous king is taken as a model – which adds up to something very different from an indolent, unenterprising repetition of formulas.

The propaganda role of some of the attitudes adopted by figures has to be identified in order to investigate its source. It is evident in that unique art form the historical relief, in which a wealth of detail is used to celebrate specific things rulers did; it can be less obvious to us in other instances, or outside the royal context. We can sense it where architecture emerges from conciseness on a human scale to explode into the colossal dimension which is the proverbial hallmark of the Phar-

aohs, but in reality this is exceptional and is linked, in every case, to moments at which the ruler was making much of the divine aspects of his position: in the fourth dynasty with the pyramids; at the end of the eighteenth dynasty with temples of Amenophis III at Luxor and Karnak; in the reign of Rameses II with Abu Simbel, the hypostyle at Karnak, and the colossuses of the Ramesseum (which Rameses III imitated later at Medinet Habu).

A historic outline

The earliest evidence we have about Ancient Egypt comes from tomb furnishings and consists mainly of ceramic ware in various forms, bearing different kinds of decoration. This evidence has been graded and ordered within a fairly conventional chronology, one which has lent itself to tracing the developments and changes it has undergone. The first period was characterized by forms which (to put it nonanalytically) were enlivened by a simple combination of red and black obtained just through baking the clay, and also by figured decorations (these were geometric, but also featured animals, plants, and people). Then

came a period in which the forms set great store by tectonic elements, fully accentuating the structural properties of a pot and using them to determine decoration, both geometric and figurative. In both these periods we come across theriomorphic pots which represent an early experiment in modelling; and there are earthenware pots as well as pots made of stone. The stone was often particularly durable or had a special luster to it, and had been worked with an extraordinary firmness of technique: this was the beginning of a fashion for appreciating the intrinsic qualities of stone, and of a liking for the evidence of a sure touch in handling stone which would remain a constant feature throughout Egyptian history. Also typical of the period is the production of stone palettes, on which they used to make the powder for eye make-up: these palettes can also be arranged in chronological sequence and point to a taste ranging from the straightforward, clear geometric outline to the stylized representation of animals, especially – though not exclusively – aquatic creatures.

Alongside these products of (for want of a better phrase) manufacturing industry, there is also a series of works which are unique both in modelling (especially earthenware models) and in two-dimensional representation. One remarkable example is a painting found at Hierakonpolis in Upper Egypt, possibly in a tomb: it is a disjointed narrative of many different events (hunts, battles, sea voyages) executed with a lightning simplicity.

The most interesting monuments from this dawn of Egyptian civilization, however, belong to the period in which Egypt's official "history" was about to begin, with the founding of the United Kingdom of Upper and Lower Egypt. They are a selection of cosmetic palettes, absolutely incongruous in size and clearly intended as votive offerings. The different scenes which have been sculpted on them were obviously put there to commemorate specific events, possibly the same events which led to the presentation of the offerings. They indicate the existence of patrons who exerted much more influence than usual, and a level of artistic achievement which could easily be identified: they are "narratives" – there is a wealth of detail, the symbols are already integrated in a way which resembles writing, and they show a clear feeling for composition. The most famous of these palettes is the one which – probably – commemorates the union of the Two Worlds under one ruler, which marks the official birth of Egyptian history. This work also establishes a number of compositional traits (like the ruler striking his enemy with his staff) which would continue to be used until the Roman age.

The period of the creation of the state of Egypt is represented in monumental form by two parallel necropolises, one in Middle Egypt near Abydos, the other at Sakkara near the ancient city of Memphis and that of present-day Cairo: one was intended for the bodies of

the dead rulers, while the other was to accommodate their cenotaphs. Not much of the structure of either necropolis is left, though some of the basic features can still be discerned: the use of baked brick in low niches along the walls, the arrangement of separate burial chambers for the body and for the offerings, and the practice of making walls meet at right angles, excluding curved surfaces.

Some sculptural monuments pay tribute to the occupants of the tombs: they are royal statues in ceremonial costume, and particular attention has been given to the portrayal of the head, as compared with that of the body. In at least one instance, the plinth on which the statue is standing bears a graffito representation of the decomposed bodies of dead enemies, in everlasting memory of the statue subject's victories, or at least of his power. A few rare statues of people not of royal descent are technically less elegant, but show the same interest in the head rather than the body.

The outstanding work which almost sets the seal on this period is the funerary complex dedicated to King Djoser (third dynasty) at Sakkara. This has as its centerpiece a structure with six steps leading up to it which stands

like a mound over the burial chamber; it unites a very strange group of buildings which commemorate royal ceremonial, and thus perpetuates the sovereignty of the deceased for all eternity through their symbolic and metaphorical role. This leap into the future is underlined by the use of stone for the construction of this colossus, and stone is experimented with here for the first time from a single block. Also from this site is a life-sized statue of the king which combines the qualities already mentioned in the animated appearance of the head, originally enlivened by naturalistic eyes. It is important to understand that this statue, which was found in its original position, was not visible but concealed inside a secret hidey-hole in the burial sacrarium, from where it could "see" all that was being done in its honour through two holes at eye level. This complex, and this statue, provide us with some kind of key for interpreting all this art. The statues are substitutes for the dead, while the buildings represent certain situations and meet certain requirements. The thing that justifies the whole and each of its parts is its ritual quality, and each element can be experienced – and sometimes explained – as having a particular value, both semantically and in

terms of practical efficacy. The steps of the pyramid suggest the primordial tumulus over which the sun rose at the beginning of time to initiate its never-ending journey through the heavens; the wall containing the tomb is known as the "White Wall," the official name of the stronghold of Memphis, and in this way the dead king continues to live and reign for ever in his capital city. Not everything about it is clear, but it does look as though every detail has a meaning and a life (like the snake-friezes along the tops of the walls, or the columns sculpted with tresses and breasts like living beings): every product of this art "exists" and "lives" before being seen by anyone.

It is of the greatest significance and interest to notice that this particular style is, as it were, used up in the creation of the tomb of Djosser.

In the age which came immediately after, architecture, and sculpture appear to have been conceived in such different (even diametrically opposed) ways as almost to give the impression that they have been programmed. The human figure is traced in the fullest expression of its every limb, measured in clearly composed proportions; the faces become expressionless, and the heads are no longer given more weight than the rest of the body; the architecture is simplified to the point where it favours elementary and distinct solid geometrical forms. "Meanings" are now fully acquired, and their vitality assured. The culture of the fourth dynasty (and of the two which came after it) exorcised the excess of vitality which characterized the preceding one by accentuating a formal rationality and putting its

faith in measurement, basic rules, and the possibility of concentrating on comprehensible structures.

In architecture this approach seems evident in the typical building projects of this age, the pyramids and the so-called mastabas. The three great pyramids of Gizeh (fourth dynasty) were built in accordance with the simplest of ratios between base and height, and dominate the surrounding desert with their abstract geometry. The temples connected to them reveal little of the ambiguous allusiveness of Djoser: squared, undecorated blocks of stone impress the spectator with their intellectual authority as he casts his eye over the brilliant definition of each edge and surface. The private tombs, planned in an orderly pattern which symbolically re-creates the hierarchies of the Court in the Afterlife, consist of stone parallelepipedons tapering toward the top (known as a mastaba — the word means "bench") inside which are openings almost hollowed out of the stone. These have no real relation to the appearance of the exterior which was clearly of great importance and is also devoid of decoration itself.

We do not actually have any temple buildings from this era (apart from some untypical sanctuaries to the Sun and the funerary temples). The source of our knowledge about the sculpture and two-dimensional figurative art is therefore the tombs, where statues continue to be the ritual substitutes for the deceased and the figurations on the walls commemorate and perpetuate the offering, telling the story of the stages through which it passed to get there. This narrative purpose, however, is governed by formal rules of a distinct syntax of composition and rational structural evidence. Statues like those of Rahotep and Nofret are in sharp

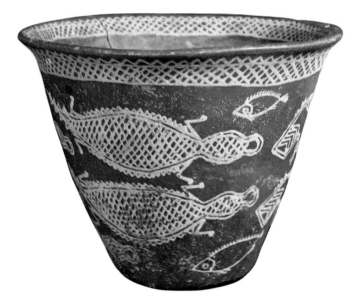

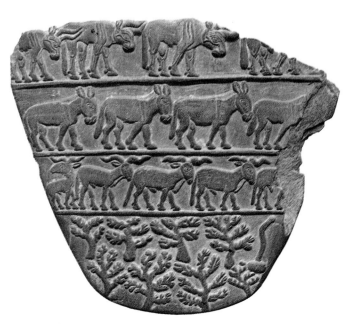

Left: predynastic pottery is of primary importance in the overall context of artistic production at that time: in this it differs from subsequent epochs, when ceramic ware rarely has a special and independent artistic value even when made by artisans. (End of fourth millennium B.C.; Egyptian Museum, Cairo.)

Below left: the Palette of Libyan Spoils *is so called because it depicts series of animals (oxen, donkeys, and sheep) and plants made to look like spoils of war. Among the plants is a written character which means "Libya" (c. 3200 B.C.). Egyptian Museum, Cairo.*

Above right: the realistic head of the statue of Djoser (from the tomb of the same name) and its intensity are a reminder of the vital function originally given to the image of a person as a substitute for him or her. Egyptian Museum, Cairo.

Opposite: the funerary buildings of Djoser at Sakkara (third dynasty) present a number of problems as to their original conception, technical construction and the meanings they were intended to convey. They are the embodiment, however, of an eternal longing which is undoubtedly linked to a reordering of the structure of the Egyptian state.

contrast with those which predate them in the exactness of the ratios between the different limbs, each of which has clearly defined measurements, and far removed from that vague overall flow which was such a conspicuous feature of earlier statues. Even the female figure, which can at a first glance appear to have more in common with that way of seeing form, only has to be looked at a little more closely to reveal a different structure, one which has been articulated and given movement on the basis of exact geometrical relations beneath the cloak wrapped provocatively about her. The possible tendency to coldness through this use of geometry – a basic formula which can be seen to good effect in the most commonplace and uninspired works of art, whose existence, however, should never be overlooked – is redeemed by a curiosity about reality which is always being reawakened: the statue of Sheikh el Balad (in wood, and for this reason more free-flowing than others) has an obviously geometric structure – geometry clearly inspired it – and also a self-assured ability to capture real, live features which lose their rough-and-ready coarseness in this formal transfiguration.

This same tension between "what is being said" and "style" – so to speak – is evident in the relief figurations, where the incidents of life and sometimes the feelings they can arouse are all conveyed by the use of structures which have a rhythm about them: lively hunting scenes, amusing details, pastoral idylls, fights between boatmen, and moments from the world of nature come together in settings made all the more lively by the constant addition of inscriptions giving the title of the scene or even the words being spoken by the figures in the picture – and, as a whole, in every case set in a context of precise directions within the structure.

One very evident intellectual feature is the reference to a particular kind of basic culture which conceived of concrete events and also the universal rules within which to set them: this was the culture of the Court as a center for the organization of the whole country, geared to bringing more than just an administrative unity to the multiple nature of the everyday and the ephemeral. This ordered society, through its own process of development, broadens its base and gradually loses more and more of its need to be centralized as powers which have

been delegated outward take on a separate organizing initiative and turn themselves into power bases. The absolute and divine monarchy of the age of pyramids slowly evolved into a society which (with all the necessary provisos about using so specific a term) could be called feudal. Provincial princes organized their own courts, and royal functionaries, appointed and promoted by the sovereign on the basis of his own assessments, were replaced by families whose positions were hereditary.

This had the effect of undermining the cultural base of the age of pyramids: and the backlash in the arts was dramatic. Literature was freed from the strict pattern of ritual and sapiential language and developed motifs, experiments, and narratives which had a sentimental individuality. The collective identity was eroded – it became instead an aggregate of individuals – and sought to break away from general stereotypes. In the figurative arts, the ethos of the balanced composition was lost (though to some extent this could have been foreseen or, at least, some hint of it could have been picked up) and a restless experimenting with nonstandard forms, freakish ingenuity, improvisations and distorted descriptiveness discarded all trace of what still survived of the ancient typology, dissipating elegant traditions of skill and their standards of composition and manual dexterity.

When a unitarian state was reconstituted

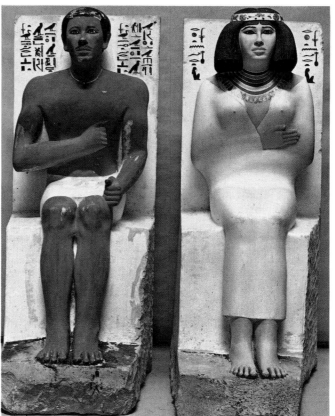

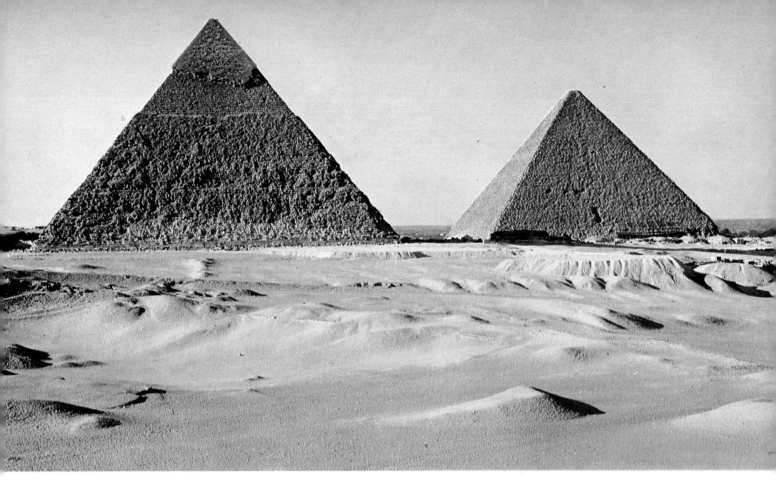

around the time of the twelfth dynasty and, from its provincial beginnings (it grew up in Thebes), sought to become heir to the centralist tradition, it presided over a gradual stifling of feudal rights. The local princes of olden times were replaced by royal functionaries; in fact, functionaries of all kinds, organized into an intricate hierarchy, covered the entire country with a new administrative network. It appeared to be a return to the sort of state framework which had operated in Memphis: almost symbolic of this desire was the renewal of the practice of building pyramids as tombs for dead kings, surrounded as before by orderly necropolises. But time had moved on, and this dynasty was confronted by a different kind of Egyptian race over whom and through whom to exercise its power. These kings methodically reorganized centers of education at Court, including both literature and the figurative arts in the curriculum, and official ideals were based on Memphis models. But in this we can see the fecundity of the irregular experimenting that went on in the feudal age: the prescribed models were being reinterpreted – this became increasingly clear – by modifying their abstract rationality with the concrete logic of physical organic unity. The Memphite desire for geometry in architecture, statuary, and relief gave way to a wish to make the spectator feel involved not only in the end result but also in the process necessary for its achievement: to include him in a discovery of the ways in which the artist has seen and

represented the world, and in which the world itself comes into being and exists.

The consequences of this in architecture led to the building of temples to a complex design and on a modest scale. The most elegant example of a building achievement which dates from this period (reconstructed with salvaged blocks which had been reused in a later building, this one had managed to preserve the character of the earlier one by anastylosis, or the reconstruction of a monument from fallen parts) is a pavilion which acted as a stopping-off point for the procession near the temple of Karnak. The solidity of the parallelepipedon structure is wholly enlivened and invigorated by its absolute perviousness, the constant and visible connection between the outside and the inside of the building, which can be seen in the endless succession of doors and windows, and walls turned into pilasters.

The two-dimensional decoration has some interesting features too. The reliefs from the Memphite tradition are still being used, some of them ostentatiously echoing classical traditions in contrast with the formal liberties of the feudal age; but a more typical element is the development of a wall decoration painted directly onto the plaster of the wall itself, without using any sculpting tool to prepare the surface first. Bearing in mind how complicated that technique was, it is possible to see how the alternative of painting the decoration on allowed for a much more immediate contact

between the artist and his work. Here too the forcefully and brusquely colloquial style of painting in the feudal age is an obvious point of reference, though now it has been enriched by a feeling for colour used to give definition not only to the surfaces but also to the nature of the objects and beings represented. But it is in the rich series of sculptures, both royal and private, in full relief that the distinguishing features of the era are most explicit. There was a radical renewal of this final Memphite art form when the court workshops resumed production in accordance with the models and techniques which originated in Memphis. The geometric and intellectual structure of mass and volume which had – in different ways, but always coherently – been the basic element employed by sculptors in the Old Kingdom, was for the most part retained in the external typology; but mass could no longer be interpreted in terms of the geometric solid figures to which it alluded (the cube, the sphere, the cylinder); rather in terms of their internal structure, their own nature (cheekbones, eyesockets, bones). As a result, the surface of the piece offers an awareness of something other than itself; it is no longer a study in different planes or well-proportioned curves but is broken up, throbs with life, lends itself to light and shadow. By this route, the art of that time inclined toward the portrait, a wish which had grown out of the experience of individuality born in the feudal age and which provides us in this period with examples possessing a

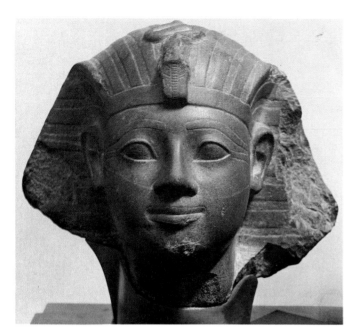

namic and alert sense of organic unity which must be found within not through the intellectual abstraction of something outside.

The trends in Egyptian society during this period are very complex and finally undermined, yet again, the traditional framework of the state. Troops of Asiatic origin were quartered in the Nile Delta, indicating a new emphasis on military structures connected with Egypt's first experiments in empire-building. These troops retained the cultural heritage they had brought with them, as often happens in the case of mercenary soldiers who are not expected to become absorbed into the population of the country for whom they are fighting. They gained an increasing amount of authority, and reinforced the importance of their position with the arrival of fresh shipments of their fellow-countrymen, until the point was reached where they were able to exercise

Opposite: the temple of Rameses at Abu Simbel has been restored as one of the official wonders of Egypt, since the new Aswan Dam made it necessary for the temple to be transferred and rebuilt higher up. But the role as an object of wonder has been integral to it from the beginning because of its unparalleled siting, all but buried in the side of the mountain. It is undoubtedly the masterpiece of Ramesside Baroque (nineteenth dynasty).

remarkable lifelike quality. On the other hand, the extension of a generally administrative role to a very large number of people gave many the wherewithal to have themselves immortalized in their specific capacity; as a result a great many more small statues were produced, the vast majority of which have been recovered from the city of Abydos in Middle Egypt, where these modest but very animated votive offerings jostle together in perpetual pilgrimage around the legendary tomb of Osiris, the Egyptian god of the dead.

If we were to attempt a quick – and therefore somewhat unenterprising – definition of the character of this age, we would stress its having salvaged ancient formal values, getting back into touch with these by way of a dy-

Above left: this head of a monarch (Amenophis II) is an early example of qualities which would become typical in the eighteenth dynasty: a mild tranquillity of expression, the cleanness of the technique, a smattering of conventional mannerism (the eyes), and the relish for fine material openly expressed. Egyptian Museum, Cairo.

Right: the priest Pahery and his wife, in their Theban tomb, are seated in front of an offertory table. There is a mirror and an alabastron under the wife's chair. Both are wearing cones of sweet-smelling fat on their heads (eighteenth dynasty).

Left: there was a major break in the history of Egyptian art between the rules of Amenophis III and Amenophis IV Akhnaton (eighteenth dynasty). The reaction to elegance and blissfulness comes in the form of a dramatic and restless vision of reality, clearly visible in this fragment of a colossus from Karnak. Egyptian Museum, Cairo.

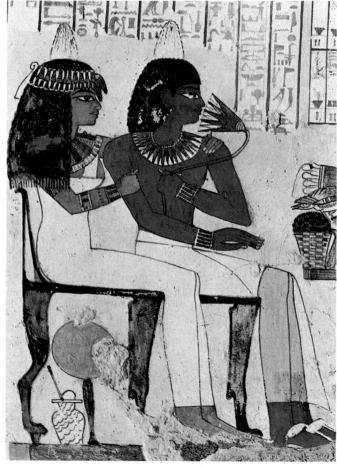

power as an autonomous and dominant force. The condition attached to this, naturally enough, was that they adopt at least some of the attitudes and ways of life of the "host" country over whom they intended to exercise this power. These "Asiatics" – as they are referred to in documents dating from shortly after that time – or Hyksos – to use the term from the later tradition (the name literally

means "Princes from Foreign Lands") gave an added stimulus to Egyptian society, a sense of its peculiarity when compared with other countries; came up with new patterns for living, and awakened its desire to measure itself against other societies which were worlds apart. The Hyksos, to judge from the archeological evidence, were a combination of Egyptian and foreigner. They did not manage to bring about a comprehensive new political reality, however, because their range of influence excluded the southern region of the country, the so-called Thebaid.

It was to the Theban rulers of the eighteenth dynasty that Egypt owed its newly discovered unity and the founding of an empire which at its height extended from the Euphrates to the fourth cataract of the Nile in the middle of Sudan. New ways of organizing Egyptian so-

ciety grew up around their campaign to win back all their national territory and institute a loose system of protectorates. The army became a key factor and was made up of hereditary groups of soldiers who were assigned modest parcels of land over which they had user-rights, together with a certain number of slaves from the ranks of prisoners of war. Officials of all kinds supervised and administered assets which included not only the country's products and the fruits of exchange, but also tributes and the spoils of war. The temples, whose deities had been in favour of these victorious enterprises, were entitled to a tenth of the fruits of these triumphs and used the additional income so as to have, in addition to their own priest, a series of lay workers comparable with that which helped to support the administration of the state. There was an

increase in wealth, and at the same time a wider distribution of it, as well as direct experience of other civilizations no less illustrious than that of Egypt. The demand for artistic assets, so to speak, was no longer restricted to a small sector of the population and certain particularly famous cities and towns: the spread of a middling prosperity and the custom of internal migration which increased the possibilities of choice and an awareness of them gave craftsmen a broadly based and exacting clientele. It was precisely this taste for craftsmanship, for things that were well made, pleasant and stylish, and for easy success, which was at the root of all the artistic output of the period, including that which strictly speaking could hardly be described as craftsmanlike. The common features of three-dimensional or pictorial figurations during this

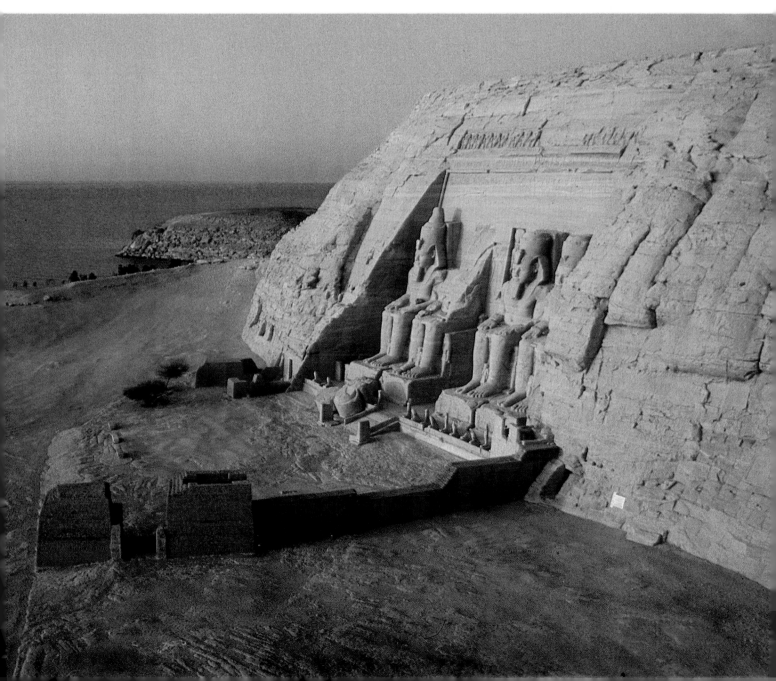

This is the plan of an Egyptian temple of the New Kingdom (rebuilt as the Sanctuary of Amon at Karnak): an avenue lined with sphinxes leads to the so-called pylon, the gateway flanked by two towers tapered toward the top, where pennants with colours fly in the wind. Through the pylon is the courtyard, often surrounded by a colonnade. The side on a line with the temple is higher and serves as an introduction to the hall of columns, twice as wide as it is long, and usually called a hypostyle. Beyond these areas, which are in one way or another open to the public, are other parts of

the temple to which only the priests have access: the cell where the portrait of the god is kept in a tabernacle which is sometimes carried in procession on a boat, and sacristies of various kinds. In many cases the sacrarium is a triple one, to accommodate also the spouse and son of the god to whom the shrine is dedicated.

torial figurations during this time were a smiling serenity of expression, free-flowing lines, soft surfaces, and elegant garments. Lovability, physical beauty, were *de rigueur* in this society, or at least in its official representation of itself. Naturally the standards achieved by individual works of art could be very varied, and one can trace a maturing of taste from the immature gracefulness at the beginning of the dynasty through to the universally acknowledged hedonism which distinguished the end of this stage of Egyptian art. The architecture of the time was also structurally clear and

straightforward, open to the light and also to being frequently visited, and continued the spirit which we have already sensed in the Middle Kingdom.

Only at the end of the dynasty did architecture witness the introduction of new designs and a conspicuous inclination toward building on a colossal scale which was not in evidence in the civilization of Ancient Egypt from the age of pyramids on. Under Amenophis III was built the magnificent sanctuary at Luxor which contained unprecedented areas within huge colonnades, and also a funerary temple which is

now lost except for the two statues which used to stand to either side of the entrance and are known as the "Colossi of Memnon." Not far from this site, and connected with it, is a harbour and a royal palace the size of a city, at Malqata, demonstrating how the florid development of style in this period was set aside. Behind these buildings lies an obvious desire to stun the onlooker's imagination and reduce him to a state of speechless awe. Over and above the artistic language of the time there is a new vision of the ruler, who was the initiator and driving force for these works, and as different and far removed from ordinary life as the opposite ends of the earth are from each other. The "bourgeois" style of Egyptian society at that time was no longer of use to the rulers, who were seeking to win back their divine role as intermediaries between mankind and heaven, a role which was seriously compromised by their more tangible function as central figures providing a link between the

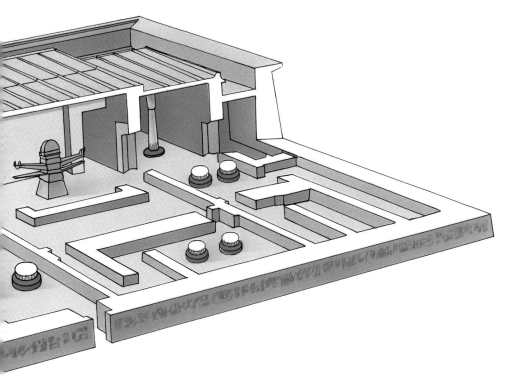

are swollen, seemingly too heavy for the fragile bases they stand on; they are hollowed out as the sculptor experiments with the effects of light and develop broken-up, bold outlines which create the impression of frenetically awkward movement. The portrait, in the most accurate sense of the word, has come to replace idealized typification. In the field of relief, new themes of celebration find ready expression in spacious compositions which are often indifferent to the traditional structures and arrangements they knew of from records. Under Amenophis III Malqata had been built as a city-palace, and now a similar function was given to a city in Middle Egypt, Tell el Amarna, which is the source for most of the documentation of the period.

The idioms and forms of this revolution were too violent to last, and had made too coarse an impression on a social reality which could no longer be driven backward in time toward old concepts of theocratic monarchy. With the death of the king, the particular forms advocated by the movement came to an end and the craftsmanship displayed immediately after that period in the treasures of Tutankhamen retained only faint echoes of its style.

The tendency to mythologize the figure of the sovereign, in the context of the civilian society as it had been taking shape, nevertheless remained. This could not have been more fully demonstrated than a few years later, during the long reign of Rameses II, who consciously adopted attitudes which had been idiosyncratic to the last rulers of the dynasty

different institutions (the administration, the army, the temple, and the empire). By asking their architects and artists to reintroduce the extolling of royal authority as the ambition to be served by their powers of expression, the rulers provided the framework for a revolution which in artistic terms could immediately be seen as a revolution in form. And then, no sooner had Amenophis III been succeeded by his son Amenophis IV Akhnaton than a total subversion of Egyptian society was caused by a revolution in religion. Egyptians rejected the gods they had worshipped hitherto and replaced all of them with a single divine figure, the Sun as a being, belonging to elementary mythology and accessible to mankind only through the godlike figure of the ruler carrying out his bidding and his purposes on earth, and thus taking on the joint role of mediator and provider.

This renewed meaning of royalty, which was the direct opposite of ordinary humanity and threatened to erase the bourgeois style which had been gaining ground in the society, made itself felt formally in an ostentatious repudiation of those qualities which had dominated the art of the eighteenth dynasty: in contrast with the emphasis on beauty, attention was now being directed to disagreeable features; solid and straightforward balance was superseded by more angular constructions and bodies which

Right: the return to normality in the experience of Tell el Amarna can be seen in many of the works of supreme craftsmanship from the tomb of Akhnaton's successor, Tutankhamen. His return to Theban orthodoxy brought with it a resumption of the mild, attractive features of the preceding tradition. An example of this is the chair-back in the picture, which shows the sovereign and his wife in a domestic scene of affection and simplicity such as had been very much in vogue at Tell el Amarna (eighteenth dynasty). Egyptian Museum, Cairo.

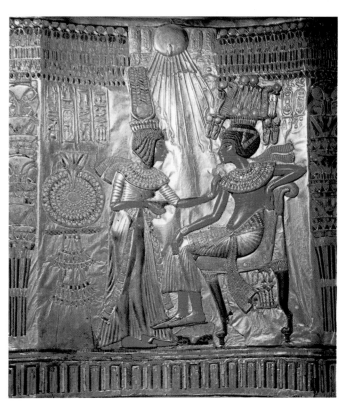

before. The taste for the colossal and the unpredictable has magnificent witnesses in the pair of temples at Abu Simbel, the Ramesseum, and the thrilling hypostyle hall at Karnak. A desire to amaze or at least to surprise is undoubtedly behind a certain style which could be described as "Baroque" for the richness and open-mindedness of the imagination it displayed. The kind of elegance and refinement found in the previous dynasty went out of fashion, but there was an increase in the possibilities of giving prominence to a sensuality in the blending of light and in the richness of contours which are reminiscent of the example of Tell el Amarna, but without its heroic aspects.

As in architecture, and perhaps other spheres of art, the wish to establish contact with the onlooker is clear from a series of reliefs which, from the time of Rameses II's father until the days of his successors, commemorated specific war exploits of the rulers in intricate figurative narratives describing what happened in a sequence of events. This perpetuated and reinforced the propaganda

function with which the figurative arts had been entrusted from the time of Amenofi III, and the style that developed was terse, quick, and attentive to the pictorial realism which made these reliefs the most captivating and also lifelike of their kind in the whole of Ancient Egyptian art.

Under Rameses II's successors, Egypt's supremacy slowly began to wane. The end of the empire came about as people of influence from other countries who had been able to get hold of power in Egypt gained the upper hand while actually on Egyptian soil. The first of these were Libyan mercenaries, who (in the manner of the Hyksos in olden times) elected themselves rulers and took on the Egyptian way of life. Then came the Nubian conquerors, who reunited what had formerly been Egypt's empire in Africa, but with a much more southerly center, in distant Sudan. Then, as a result of battles between different empires, Egypt was occupied by the Assyrians and the Persians, though not without long periods not only of autonomy but of independence, relative greatness, and obvious prosperity. It was the arrival of Alexander the Great which caused an influx into Egypt of foreign power and Greek culture to such a degree that its original situation was changed; this was even more true with the coming of the Romans from Augustus onward. Christianity led to the ultimate end of those aspects of classical Egyptian civilization which had been kept alive and retained their significance even during the Hellenic and Roman periods.

The historical process which we have made so bold as to summarize in a few pages here actually lasted for a thousand years, and can be understood in more depth by looking at each of its different phases and pinpointing its essential features in terms of substance and form, how they differed and were sometimes diametrically opposed to each other, from the elegance of the Libyan era to the robust simplicity of the Nubian, and on to the neo-Classical refinement of the last of the native Egyptian rulers, which became harsher and weaker during the age of the Ptolemies, and took on a degree of roughness in Roman times.

Nevertheless, it is possible to identify something of a common underlying feature which transcends and at the same time explains the conventional elements: a nostalgia for a far-off past, particular moments of which are remembered from time to time in erudite and detached commemorations. The sculptural monuments of the Libyan age often possessed a grace which the age of Rameses had not wanted to inherit from the eighteenth dynasty; the monuments of the Nubian age reintroduced austere elements like those of bygone ages, which were exalted with intellectual approval during the Saitic period (and even more under the Ptolemies). The phenomenon was not only figurative but also affected language, religion, and so on. The cults of

Left: Statue of Petosinis *from Memphis. Egyptian Museum, Cairo.*

Above: Statue of a Ramesside princess. *Egyptian Museum, Cairo.*

ancient rulers were brought back again, texts were copied from which rare, archaic words were singled out, and sculptors copied the statues and reliefs of other ages.

But behind this nostalgic thirst for the past and for tradition, there is the dependability of the formal Egyptian education, its respect for reality, which ensured that the teachers in this extended period of history were a very long way from presenting themselves as a distortion of a culture, and actually provided an added ingredient of cultural meanings to the more obvious conventional values. These allusive literary and historical sixth senses are often overlooked by a modern observer, just as they were by Greek and Roman critics of Egyptian art, who none the less – as we said at the beginning – have frequently shown that they actually preferred the monuments of this era and in this way sensed the wealth of historical sedimentation which determined their character.

The Art of the Steppes

Until recently, wide areas within the steppe zone of Eurasia were used by cattle-raising nomads; though sound herdsmen, they protected the land. This limited their scope of expressing artistic urges through lasting monuments (castles, cemeteries, sculptures or rock carvings): they preferred epic poetry. During a rather short phase of their varied history, in the last few centuries B.C., they did, however, develop a craftsmanship whose best products are now valued by collectors and researchers as among the greatest examples of human art. This even though they served to adorn warriors, their weapons and also their horses. Women's ornaments or ceremonial objects are rarer.

One can speak of a decorative system. Animals are its preferred element, including hybrid creatures like griffins. The animal may be pictured in part, alone, or figuring in scenes like an attacking predator or a fight between monsters. Though characteristic features are rendered schematically, the composition clearly reveals the influence of a strong spiral style. What is fixed is not the movement but the tense moment before the start. Sometimes the body is twisted through 180 degrees, seen only in dead animals after the chase (inversion), or with the various limbs joined in a ring (rolling animals). One also finds volutes, often on the loose folds of skin. This helps the carving technique known as the skew cut. Often the limbs are dragged under the body,

useful in carving a piece of limited size (horn or bone). There are only a few *leitmotifs* recognizable in animal carvings, in spite of the many variants found in the huge area between the Black Sea and the Ordos district in the bend of the Hoangho, between the edge of the Taiga in the north and the mountain chains of central Asia. Not long ago experts discovered another "province" of this style on the upper Indus, mainly in terms of rock carvings. But a few finds, including a bronze plaquette, show that the makers were nomad horsemen who came from the Pamir and migrated across the high passes to the Indian plains, where from about 200 B.C. they established historically attested principalities.

The enormous spread of comparable forms presupposes contacts through war and migration, but perhaps also through peaceful trade. It is about the same area as that covered by the historically attested Scythians: a people of horsemen warriors, mostly of North-Iranian tongues. There is no political

Above: detail of a tapestry from kurgan 5 at Pazyryk (Altaï Mountains), mid fourth century B.C. Hermitage, Leningrad.

unity, but they must have shared the same material and mental background, witness the almost simultaneous transition to the "Scythian triad" (similar weapons, harness and animal style). From whence did they come and how did they live? Contrary to a long-held view, it is now clear that the nomad herdsmen, attested to since the third millennium B.C. by sparse and widely scattered finds, used the horse, but did not at first develop into warriors. A center of the still unmounted herdsmen (though they had carts) was in the Black Sea area, and radiated eastward. Other herdsmen may have developed alongside cultivators in the border zone of the Iranian plateau. Agricultural surplus led to the rise of almost urban settlements there, and to extensive expansion. As early as the fourth millennium B.C., Serafshan saw such a "city" with developed metallurgy, and very likely there were similar stations in the Tarim basin and even in Kansu. The spaces in this network of oasis cultures were used by herdsmen, who exchanged their own products with the settlers and also worked the carrying trade. A similar symbiosis between herdsmen and settled tribes is reflected in the Old Testament, along with the scope for conflict.

In this first phase of central Asian cattle-breeding, rock carvings appeared, over a huge area, of a male figure, often a bowman, driving a two-wheeled cart. One thinks of the sun-god Helios in the Greek pantheon. Some pictures of carts are so like the Chinese

pictogram for "cart" that a link seems clear. The only reason why we know little about the links with China, where the cart symbol also became highly considered, is probably because only part of the transit areas lie within the sites under excavation.

We may take it that the steppes on the edge of Chinese high culture shared in this development. Perhaps that is where the next transition, to the military stage, took place. The rulers of the Chou dynasty, in the late eleventh-century struggles that supplanted the Shang, relied on auxiliary tribes, whose weapons and gear were decorated in the style of the known Karasuk culture of southern Siberia, sometimes with animal sculptures cast on the pommels of bronze daggers and knives. Observations from widely separate areas can be explained only by assuming a common center in present Mongolia, a culture of cattle-breeders used to covering vast distances.

A little later the horses of Chinese battle wagons were sometimes supplied with snaffle-bits, forerunners of which are attested to in far-off Europe. Some have inferred from this a "Pontic migration" (from the Black Sea). From the steppes also came the aggressors who forced the Chou to move their capital city eastward in 771 B.C.

Toward the end of the eighth century B.C., warriors from the steppes appear on the periphery of the Near East. Above all the military powers Urartu and Assyria used these dangerous allies, thus sealing their own doom. The danger was finally turned away by the Medians.

The phase of Arzan – variety and assimilation

A royal grave (dated seventh century B.C.) still shows vital details of the conditions of warrior horsemen in their formative phase. This is the grave at Arzan in Tuwa, opened under the guidance of the Nestor of Siberian archeology, M. P. Grjaznov. It must once have looked like a

Left: pierced bronze plate, 25cm (approx. 10in) across, from Arzan kurgan in Tuwa. (Before 600 B.C.) Rolling animals are among the oldest motifs of the developing animal style, probably from Eastern Asia. After a transparency left by M. P. Grjaznov.

Below left: The newly discovered animal style province on the Indus is attested to by petroglyphs and a bronze plaquette, 45 × 42mm (1¾ × 1½in), from an illicit dig, obtained in the Kandia valley. Ibex with a glass pheasant on his horns. Bar this detail, all elements can be attested to in the Pamir in objects of Sakian nomads. National Museum, Karachi. (After 300 B.C.)

Right: plan of the Arzan kugan in Tuwa (seventh century B.C.). Model of a city in the beyond, into which the deceased will move.

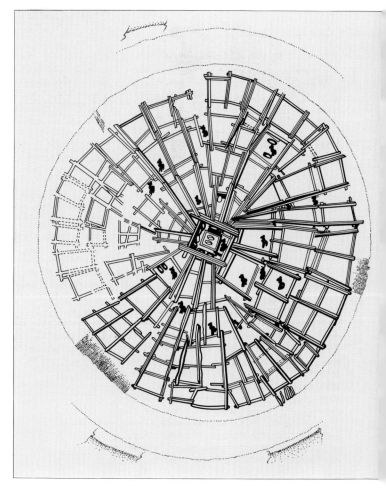

round platform, 105m (344ft) in diameter and up to 4m (13ft) high. After removal of the stone mantle, a complex wooden construction was found. In its center were two mutually incapsulated chambers. The inner one contained the buried prince and his wife, both completely stripped by robbers. In the outer, also in tree coffins, lay six dignitaries. Wooden partitions had been set up for two more bodies. On one side, the horses had been deposited that belonged to personal outfits. The central grave was surrounded by a network of seventy concentrically arranged chambers with walls bounded by loosely stacked tree trunks. Some parts of the chambers were filled with up to thirty horses. In the same area the co-interment of further dignitaries was observed. Grajznov gave the probably correct explanation that the equine sections were honorific gifts from tribes subject to the prince buried there. Oddly enough they are fitted with snaffle-bits belonging to quite different traditions not hitherto attested. However, one bit from the eastern European steppes is readily identifiable. It is therefore certain that the prince ruled over subjects whom one cannot assign to a uniform culture, nor probably to the same tribe. Hence the variants in ritual (tree

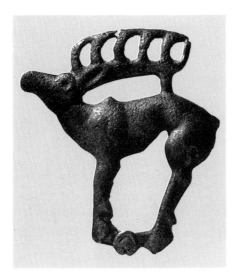

coffin/wooden partition). Because grave robbers have left only daggers, pennant heads and a very large platter representing a rolling animal, we have no foundation for the stylistic analysis. Still, the filling of the stone mantle contains a fragment from a stele decorated with pictures of animals, whose peculiar stance, as if on tip-toe, was not characteristic of the people whose prince was buried here.

A little later, in the Aral area, graves were built whose inventories show a similar wealth of distant connections, as well as a cult revealing greater claims to power by those buried. Much is clearly borrowed from the Far East,

Above left: buckle showing a realistic stag, approx. 6cm (2¼in) high, from kurgan 41 at Ujgarak (After a transparency left by S. P. Tolstov.) Hermitage, Leningrad.

Above: pennant crown from the Ul' kurgan, Kuban district, South Russia. The quadruped combined with birds' heads, almost like a picture puzzle, occurs also in central Asia (seventh and sixth centuries), 27cm (approx. 10½in) high. Hermitage, Leningrad.

while other features have parallels in the earliest nomad graves of eastern Europe. One consequence of these observations is that given such diverse antecedents we can no longer assume a uniform origin for the animal style. There must have been several traditions fond of alien animal pictures. Near the Aral Sea the discrepancy shows even in graves dug close together. In kurgans 27 and 28 of Ujgarak, diggers found bronzes whose animal pictures, in shallow relief, were formed by the combination of concentric rings. The bodies found in graves 41, 47 and 66 are, however, endowed with objects that arc marked by

Krylgan-kala in Khorasan, built in the fourth century B.C.

The unifying and levelling federation of tribes, whose ruler was buried at Arzan, remains nameless. However, we know of far-flung unions between Scythians and Massagetes who opposed Persian kings. In the Pontic steppes, the Scythian union arose, which the Greeks, by working with it, came to know so well. It must have had precursors. The huge kurgan of Ul' in the Kuban area must be assigned to the leader of such a union. Here even more horses were co-interred than in Arzan (meanwhile the number there has risen to over 160).

The phase of Pazyryk – peak of the decorative animal style

Within the great tribal federation and beyond it there must have been at least temporary political equilibria; although fighting did not stop, it assumed the character of a regulated ritual. This severed the sharp initial links of different stylistic variants of individual tribes: designs became generally available to be used according to the taste of artist and client. In the fifth and fourth centuries B.C., the inhabitants of the Altai built hill graves; their contents of perishables were preserved by being frozen in a film of ice. Thus we see scenes of animals fighting whose prototypes are borrowed from the Near East, but which are used to decorate

modelled animal bodies. Often a double counter-spiral underlies an animal picture, but the design also appears in the abstract, as does the comma sign.

The decorative use of animal figures is not peculiar to steppe peoples. In the Near East we know of many prototypes: Urartarans and Assyrians, in Medic and Persian art. These influences may have reached central Asia via Bactria, which at times had relations with the Assyrian Empire. They figure in the legend that under King Ninus and his wife Semiramis, this military power had tried to conquer Assyria. In

Chinese art, too, pictures of animals initially played a great role, but they were not incorporated in scenes.

Arzen itself gives a clear hint of how quickly these artistic norms were unified. The complex structure of graves reveals that the prince was suzerain over tribes of various origins because of his religious legitimacy. In this he followed an example that has been attested to by Soviet excavations (in Afghanistan) of ceremonial castles; habitations being on a radial plan. That in such an "ideal" city there could be burials is shown by the mortuary castle of Koj-

Right: left side of a buckle representing a warrior resting under a tree with his head in a woman's lap. The warrior's quiver is hung on the tree; a man sits holding the reins of a saddled horse (third–second century B.C.). Hermitage, Leningrad.

Opposite above: detail of saddle cloth in painted felt showing an elk, from the second Pazyryk kurgan (fifth-fourth century B.C.). Hermitage, Leningrad.

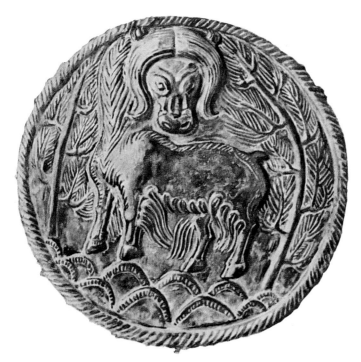

Above: round embossed silver plate representing a yak between two pine-trees on a series of small hills; from kurgan 6 at Noin Ula (southern Mongolia); first century A.D. Hermitage, Leningrad.

Right: gold dagger and sheaths with animal designs, studded with turquoise and probably used during sacrificial rites. Animals in relief are seen tearing each other apart. From tomb 4 at Tillja-Tepe (northeast Afghanistan); beginning of Christian era. National museum, Kabul.

objects made specifically for burials (saddle blankets of felt), alongside realistic representations of indigenous hoofed animals such as maral (red deer) and elk. With felt appliqué, bold linear designs of spiral type suit the material.

In contrast to earlier works of art, in which we might see a special link between the animal pictured and the first owner of the work, the wealth of motifs observed in the Altai kurgans makes it unlikely that animal pictures represent mythical beings, divinities or even mere benevolent spirits. Rather, the heroes' striving for recognition of their victories, and the display of their riches favour a constant flowering of their imagination. One might say that the Altai people lived in a stratified military society. Indeed, the number of horses given to a dead man seems to be a measure of his dignity. Merit feasts and the royal cult need not be incompatible. Perhaps, though, the urge for prestige grew most where no central power existed.

The dead, moreover, received grave gifts of no practical use; doubtless in imitation of foreign examples. Neither the stringed instruments nor the hashish inhalers found in the Altai could actually have been used. Furthermore, southern Russian finds amply show that there was a tendency to hire foreign craftsmen for decorating the grave goods. Thus, the

animal style was structurally changed by the shaping typical of Greek work; however, the tendencies that were already present in the origins of this style were taken up again.

By contrast, in central Asia the element of draftsmanship comes to the fore again. Witness fantastic animal figures cut on one side of medallion-shaped bronze mirrors (fourth–third century B.C.).

Animal style as aristocratic art

Assuming that competition within a federation of nomadic tribes not yet articulated into classes was the basis on which the animal style developed, we can see why this sort of decoration vanished from the equipment of the mounted warrior as early as the third century B.C.: an aristocracy was forming. Instead there was a growing tendency to represent scenes of the natural habitat: mountains and trees; people appear in settings that are described in heroic myths at a resting stage, fighting or hunting. There are parallels with Han art in China, where the narrative element comes to the fore. The so-called anecdotal girding plates, which represent actions, were favoured not only in the steppes but also by the guardians of the Chinese border. Grjaznov emphasized that as a hereditary steppe aristocracy emerged, epics came to the fore: craftsmanship was left to dependents or aliens. Their own creative power developed in textile art, which was practiced by their womenfolk.

Maybe so, but ruling families long preserved select animal motifs as their ancestral heritage. This might be linked with the memory of mythical beings claimed as "totemistic" ancestors. The huge kurgans of Noin Ula in the

Above: gold buckle showing a lion-griffin, winged and armed with horns, attacking a horse; the lion's tail ends in a leaf and reveals Persian influence. (Width: 12cm [4¾in]; fifth–fourth century B.C. or even contemporary to Tillja-Tepe). Hermitage, Leningrad.

Below: hollow figurine in gold of a mouflon; from tomb 4 of Tillja-Tepe. A brilliant piece of gold-work with remarkably realistic results, dated to the Greek-Bactrian period. Height 52mm (2in). National museum, Kabul.

north of the Mongolian People's Republic, which is evidently the burial place of Hunnish princes who had managed to unify all the eastern nomadic tribes, show this distinctly. Animal style as court art existed with the Sarmatian princes of southern Russia too. Here animals as well as trees were used as symbolic pictures, as parts of the same concept.

The royal graves of Tillja-Tepe in North-east Afghanistan were built about the turn of our era by one of the five dynasties that divided the heritage of Hellenistic Bactria. Indeed, the very rich inventory (20,000 gold objects, mostly very small) contained not only objects from Greek workshops but also Indian imports, Parthian coins and the like, as well as animal style objects: no doubt they are of religious import. Soterial signs of various origins are mixed, for example, swastika and animal picture. Some motifs are eastern Asian and confirm the indications from Chinese texts that Tocharians displaced by Huns formed the ruling layer of the nomadic conquerors, on a broad Sakian base.

Workshops specializing in "nomadic" art objects used turquoise from the same cutters who supplied Hellenistic establishments. This revives the question of whether Peter the Great's treasure (dated globally to the Pazyryk phase by Rudenko) might not contain a few heavy cast gold platters no older than the Christian era. Nostalgic strains in later work have misled many.

The animal style replaced

In later periods, shortly before the Huns held sway in Europe, nomadic art went back to simple basic forms. Thus women's diadems were originally headbands stitched with pearls. Transformation into precious metal, a preference for red jewels (almandines), and omission of detail led to magnificent effects. Archaic animal designs reappear in the later art of the Avars.

About the mid first millennium A.D. the nomadic peoples of the steppes (mostly of Turkish origin) developed a new set of coherent decorative systems, often called "geometric tendril decoration." These systems arose from cultural exchange with workshops of settled tribes. Often these were simply imports from areas of Byzantine or Sogdian influence.

The symbols for clans or individuals now become almost abstract in form, and they are explained as cattle brandmarks, the so-called tamgas. Still, it may not be by chance that the noblest of these signs, allocated to the clan that founded the empire of the Kokan Turks, simply represents an ibex, more austere than in the animal-style period, but not without sweep and elegance.

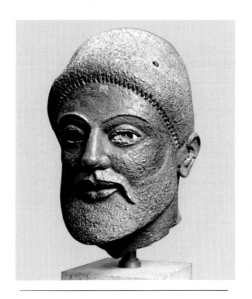

The artistic civilization of Greece and the Aegean

One of the main criteria used when judging ancient Greece has been the vast amount of monumental and figurative works of art, frequently of very high quality, that have survived to the present day. As a consequence, people have often adopted an attitude of admiration, sometimes tinged with uncritical acclaim, toward the so-called Greek "miracle." This is especially true of those periods of history during which "Greekness," particularly in the Classical sense, has been examined and studied in depth.

Although during Winckelmann's day, in particular, people came to regard Greek art as something unique and unrepeatable, an incomparable aesthetic criterion, a universal rule to be followed when striving for an ideal type of beauty, it is only in more recent times that we have begun to realize the need to see the artistic civilization of Greece within a precise historical context and to view it against a cultural background containing wide variations of light and shade.

The natural landscape and geomorphic conformation of Greece and the Greek islands may conjure up a variety of mental images, but, from a historical point of view, the most important thing is to examine, on the one hand, the interaction of the ancient Greeks with their natural environment and, on the other, the consequences of their geographical position within the Mediterranean area: most of the Greek mainland lies within easy reach of the

sea and the Greeks were astute and skilful enough not only to exploit the resources offered by the land, but, more importantly, to take advantage of their position at the crossroads between East and West, making the most of their territory's manufacturing and commercial possibilities.

The term "Greek art" is now widely used and accepted, but its origins are not very ancient: it derives, in fact, from the word *Graeci*, the name given by the Romans to all the inhabitants of Greece, starting with the Attico-Boeotian peoples. The name used by the Greeks for their homeland, at least as far back as the sixth century B.C., was *Hellas* and they called themselves *Hellenes*, to distinguish themselves from foreigners or *barbaroi*. According to Greek mythology it was the Thessalian Hellen, the son of Deucalion and Pyrrha, whose offspring were the ancestors of the Dorians, Aeolians, Achaeans and Ionians.

There are certain crucial events in the broad sweep of Greek history that also affected the

arts: one thinks of the great Dorian or Aegean migrations, the destruction of Troy, the Persian wars, the Peloponnesian War, the meteoric rise of Alexander the Great and, finally, the Roman conquest.

The Cycladic civilization. The advent of metalworking, particularly using an alloy of copper and tin to make bronze, determined the rise of a special sort of artistic manifestation, the most notable examples of which were created during the second millennium B.C. in the Aegean archipelago of the Cyclades. As a result, the adjective "Cycladic" has come to be used to define a cultural era that coincides in part with the Minoan culture of Crete. The most significant products of the Cycladic era are the "idols," which exploit the technical possibilities of marble, as well as displaying a desire to create images with no sense of depth, but with a strict formal coherence and a strong geometrical quality. The elementary structure of these likenesses of the mother goddess or, more rarely, musicians, which were originally enlivened with colour, reveal a desire to abandon improvisation and spontaneous expressiveness in order to discover a rational system of formal rules.

The Minoan civilization (second millennium B.C.). The culture known as "Minoan," the name of which derives from the mythical dynasty of Minos, lord of a hundred cities, appears to

have been essentially maritime in nature and dedicated mainly to trading. The Minoan civilization developed basically in Crete, an island ideally situated in relation both to the area gravitating toward the Aegean and also to such ancient centers of civilization as the Nile valley, the land lying between the Tigris and Euphrates and the island of Cyprus, but it is a comparatively recent archeological discovery: it was not until the beginning of the twentieth century, in the wake of the wave of enthusiasm excited by research into the Homeric world, made physically real by the unearthing of Mycene, that scholars began to also turn their attention to the island of Crete, traditionally believed to have been the seat of an important civilization that had flourished at the very dawn of Aegean history.

The importance and historical significance of the Minoan culture appear even more remarkable when one considers the geographical area in which it developed: a relatively restricted island environment, with limited natural resources derived from the cultivation of olives and vines and, most important of all, the exploitation of pine and cypress groves, since wood was a scarce and much-prized commodity in the Aegean world. The Minoans' control of the sea was one of the reasons for the extraordinary development of their civilization, which was particularly dominant in the Aegean area, and it also explains their unique form of independence and autonomy, both on the socio-political and also on the artistic and productive level. The sea could be used for a variety of purposes, such as the production of purple dye, for example, but, although it also acted as a very real means of defense, it never led to Crete becoming isolated.

So much has been made of the grandiose palaces of the Minoan world, because of their size, their functional layout and their decoration, that an erroneous belief has grown up that there were very few cities in Crete and very few inhabitants. And yet the inordinate amount of attention paid to the island's dynastic residences is in keeping with a society that revolved entirely around a centralized source of political and economic power: the palace (one thinks immediately of the examples at Knossos, Phaistos and Mallia), which was the hub of all political and administrative, economic and commercial, religious and entertainment activities.

The palaces, which lay at the heart of the Minoan political system, were built piecemeal around a central open space (the vast courtyard), with no effort to establish a feeling of symmetry, but rather with the aim of creating a series of subtle links between architecture and landscape, as, for example, in the view of the jagged outline of Mount Ida obtained from the central courtyard at Phaistos. Their entrances, sometimes given a feeling of monumentality by the addition of stairways and ramps, lead, via passages interspersed with right-angled corridors, to residential quarters, reception

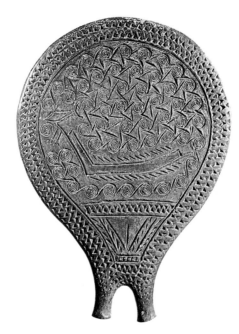

Terracotta object of unknown use (stove, ritual plate or mirror), made at Syros (3000 B.C.), is decorated with stylized motifs concerning the sea: continuous spirals representing waves, rowing ship. National Museum, Athens.

rooms, small chapels devoted to worship, and vast storehouses. Their internal layout skilfully exploits the natural contours of the ground, creating terraces on different levels which are linked together by vast light-wells, with particular attention being paid to creating a comfortable and practical living environment.

Society was arranged like a pyramid: at the top was the lord, surrounded by nobles, whose residences were situated either around the great palaces or scattered through the countryside. It was these men who built the many tombs that have been discovered, which, although of different types, were used for centuries. Ample space was reserved for workshops, still within the context of the centralized structure: because of the large numbers of sheep raised on the island there was a great deal of weaving, in addition to metalworking, hardstone-carving and potterymaking. The vast quantities of ceramics that have been excavated would seem to suggest that the island's clay deposits were extensively worked, as well as presupposing the existence of a class of master potters with skilled knowledge of firing techniques and also, at a time when the potter's wheel was becoming widely used, capable of creating elegantly shaped vases and of achieving near-perfect technical results, as in the type of vase whose very thin walls are known as "eggshell."

The overall feeling is that of a seigneurial,

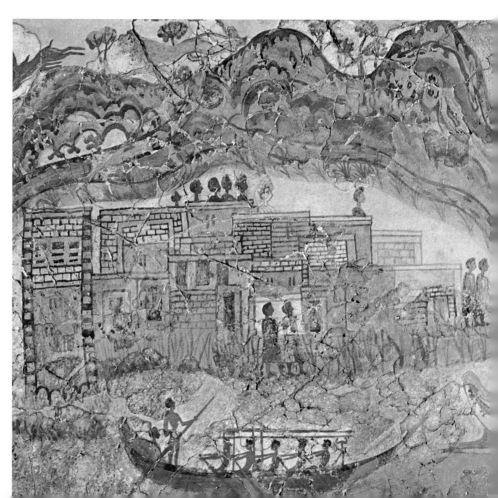

almost feudal, society, characterized by a taste for luxury, a great love of life and the ability to enjoy its accumulated riches in a highly sophisticated way, as would seem to be suggested by the scenes depicted in wall paintings and reliefs. The latter, which take the form of very lively and inventive portrayals of processions, entertainments, tournaments and games, almost invariably eschew any feeling of formalized ceremonialism and reveal no intent to celebrate historical or mythological events. The human figures, animals and landscapes, which are endowed with a timeless quality, seem to convey the sort of happy, dream-like atmosphere that would make people forget all the work and effort needed to repair the damage caused by the earthquakes that shook the Aegean area on several occasions; one thinks, for example, of the numerous portrayals of the acrobatic prowess of young girls and boys shown vaulting over the horns of charging bulls. This sort of jousting has sometimes been interpreted as a form of sacred ritual, but should really be regarded as a sporting entertainment quite clearly performed during religious festivals. The capture of a bull and of oxen in a meadow are the subject of the decoration on two gold cups found on the Greek mainland, at Vaphio, but which are of Minoan manufacture.

There is a greater feeling of spontaneity and popular narrative in the more humble products, mainly made of clay, designed to be

Above: statue of harpist (2000 B.C.), showing the essential volumes. Cycladic marble (period of Keros–Syros). National Museum, Athens.

Below: fresco from Thera. This shows a historic episode with amazing realism: a naval expedition against a Lybian village drawn in vivid detail (c. 1500 B.C.). National Museum, Athens.

offered up in the small sanctuaries that formed part of the Minoan religion, a cult that is lacking in any great architectural monuments. The interior of one bowl, from Palaikastro, is completely covered in a miniaturized relief scene depicting a shepherd with his flock, arranged in semicircular lines that follow the shape of the pot. There is one particular form of populist religious expression which reflects the realities of daily working life and which is linked to the lowest strata of Cretan society: the latter turned faithfully toward their deity, offering up clay votive statuettes of animals, including that of the bee, because of its supposed ability to ward off diseases caused by parasites, and also human figurines, in which men and women are differentiated not only by their clothing, but also by colour, white and brown respectively, in keeping with an ancient Egyptian convention that was subsequently adopted by Greek Late Archaic art. The Minoan civilization, which, judging by the archeological finds, was an essentially peaceable one, also expanded beyond the boundaries of Crete to Melos, a rich source of obsidian, and to Rhodes and Miletus. Its most remarkable colony, however, was on the island of Thera (modern Santorini), where exceptional discoveries have been made by Greek archeologists, who have unearthed a sort of "Aegean Pompeii": on this small, crescent-shaped island, near the town of Akrotiri, a Minoan village has been excavated from be-

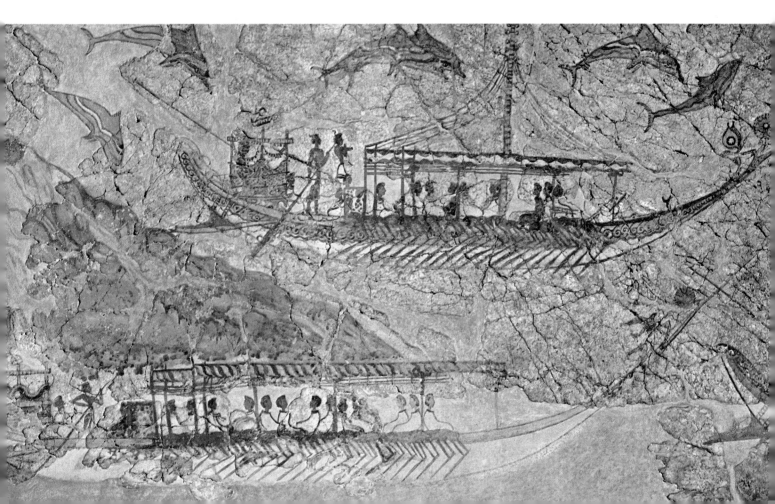

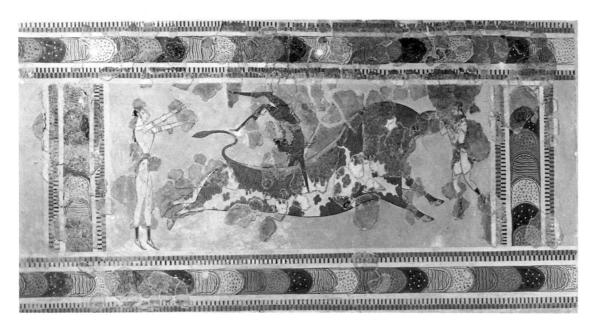

Left: fresco fragment from the palace at Knossos (1600–1400 B.C.): ritual ceremony or test of skill, in crude perspective. Young man somersaulting on leaping bull, between two white-skinned girls wearing jewels. Heraklion Museum.

Below: on the face of a corpse from tomb IV of circle A at Mycenae, a mask was shaped in gold leaf (sixteenth century B.C.). The large, open eyes and the faithful rendering of the features suggest a magic purpose. National Museum, Athens.

neath a layer of volcanic ash some 40–50m (130–160ft) thick, deposited by a violent eruption that took place in around 1500 B.C. This natural disaster, which has been linked to the myth of Atlantis, allowed for the perfect preservation of a habitat containing houses with several storeys, a series of warehouses and small workshops at street level; their upper floors, which contained the living quarters, possessed walls bearing frescoes of astonishing naturalism, whose subject-matter reveals links with the worlds of Egypt and Libya, as well as bearing witness to the population's considerable wealth and to the existence of professional painters. Similar natural disasters also caused widespread destruction in Crete, sounding the death knell of the great Minoan palaces in around 1400 B.C.: the deciphering in 1953 of the Linear B script, examples of which have also been discovered at Knossos, revealed the presence of Mycenaeans on the island.

The Mycenaean world (sixteenth to twelfth century B.C.). The civilization of the Mycenaeans cannot be explained without reference to that of the Minoans, with which it overlaps chronologically and from whom it imported decorative motifs, produce and perhaps even craftsmen. Centered on the southern tip of the Greek mainland, its origins can be ascribed to an Indo-European people speaking a form of archaic Greek, as has been revealed by the deciphering of Linear B. The term "Mycenaean" is itself derived from the name of the city ruled over by Agamemnon, the most powerful of the kings who took part in the Trojan campaign celebrated by Homer in his epic poems. The latter, which describe the exploits of the Achaeans, the Danai and the Argives, were used by Schliemann as the starting-point for his archeological discoveries, which provided physical evidence of their existence.

The Mycenaeans, or Achaeans, who had a different social structure from the Minoans, represent the first true historical culture on the Greek mainland, as well as a quantum leap in quality. A question mark, however, hangs over their development and their origins, which have been a source of many different theories and interpretations: it has been suggested, for example, that they arrived from the north, via the Balkans, in around 2000 B.C., that they came from the East, across the Anatolian plateau, or that they were warlike invaders, such as the Hyksos, who were chased out of Egypt at the beginning of the sixteenth century B.C.. What is known is that at a certain stage in Greek history there emerged a powerful military force, skilled in horsemanship and the use of war chariots and able to weld the forces of the individual kingdoms into a single army, which succeeded in destroying the city of Troy in around 1260 B.C..

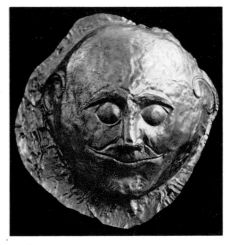

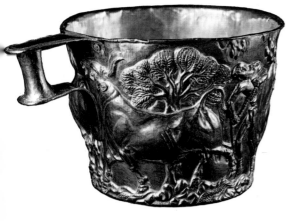

Far left: on a gilded cup from a tomb at Vaphio, a continuous frieze represents the catching of bulls. The Mycenaean artist, inspired by Minoan art, made this precious object using a masterful technique and a sure touch of composition: man and beast meet in a wooded landscape (1500 B.C.). National Museum, Athens.

Opposite below: fragment of female head with profile detached from blue ground; the dominant wavy lines are brought out by the big frontally treated eye (thirteenth century B.C.). Remains of a fresco representing a procession, on a wall of the last palace at Tiryns. National Museum, Athens.

Opposite top: from a house at Mycenae, this sphinx's head in stuccoed terracotta is enlivened by rudimentary use of colour (thirteenth century B.C.). National Museum, Athens.

The fortified acropolis became a tangibly imposing symbol of the undisputed suzerainty of the ruler (*vanax*) and the palace became a fortress, closed to the outside world: it renounced its integration with the countryside in order to physically embody, through structural massiveness based on the monolithic grandeur of its building blocks and the technical efficiency of its design, the new concept of the ruler's status. The latter was no longer bathed in an aura of divinity: he was a solid, physical presence, the supreme administrator who participated in a concrete way in affairs of both peace and war. The focal point of the palace was no longer a vast open space, but a *mégaron*, with a hearth at the center, around which were ranged tall columns supporting a roof whose central section was left open to allow smoke to escape and also to ensure that the necessary draught reached the fire. The *mégaron* did not lead directly to the outside world, but through a series of "filters," such as arcaded antechambers accompanied by a succession of rooms, whose arrangement was determined by the amount of space available, used for ceremonial audiences, services, defense (guardrooms, soldiers' quarters, covered passageways), storage and, should the need arise, water cisterns, some of them subterranean.

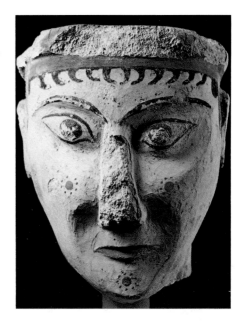

During the Late Mycenaean period, particularly between the second half of the fourteenth century and the end of the twelfth century B.C., the outer walls of the palaces at Mycenae, Tiryns and Pylos and of the Acropolis at Athens became so massive that a legend developed, recorded by the ancient Greeks, which attributed their building to supernatural forces such as the Cyclops. These daunting displays of defensive capacity, which did not, however, prevent the collapse of the Mycenaean civilization, except for the case of Athens, are echoed in the wealth of military equipment, evidence for whose existence is provided by the inventories inscribed in Linear B on tablets in royal archives, by the relief portrayals on funerary stelae and also by the defensive and offensive bronze weapons interred alongside the dead as part of their burial goods.

The ability of the Mycenaeans to overcome the problems posed by the dearth of natural resources in their homeland by fearlessly plying the sea routes of the Mediterranean, from the coasts of Italy to the countries of the Levant, is substantiated by archeological discoveries: an intensive involvement in trade, in the transport and barter of materials, both raw and processed, and finished objects, whether precious or utilitarian, played an important part in the Mycenaean world. As a result, its fortified citadels, one of the best examples of which can be seen at Mycenae itself, were bounded by vast structures used for the purpose of trade and commerce, activities that were not always dependent on the royal administration, but were still controlled by it.

The large quantities of vases made by Mycenaean potters, which have been found in all the main Greek archeological sites and which were frequently exported to other areas within the Mycenaean sphere of influence, have led scholars to assume the existence of numerous pottery-making centers scattered throughout the Argolis, traces of which have also been discovered outside the Greek mainland, as on Rhodes, for example. Mycenaean ceramics achieved extraordinarily high standards of quality, both technically, in the refinement of the clay, and also in terms of shape, colour and decoration; if in its early stages the decorative motifs were similar to those found on Minoan ceramics, from which they were derived, they very soon developed a more selective style, a stylized geometricality that replaced the freedom and fantasy of Cretan art with a new pictorial syntax based on increasingly abstract and symbolically allusive motifs and on a search for ornamental symmetry and

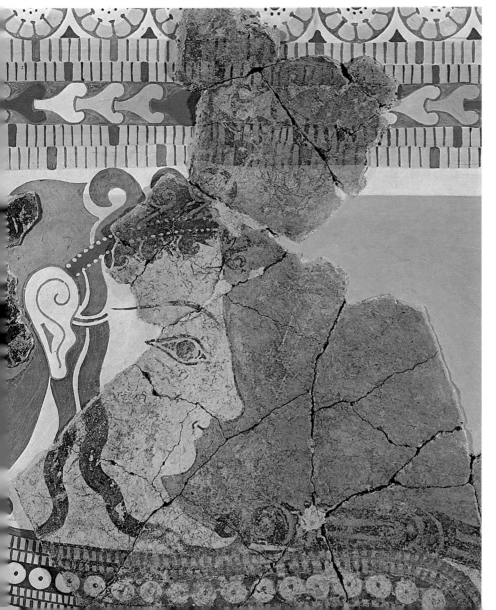

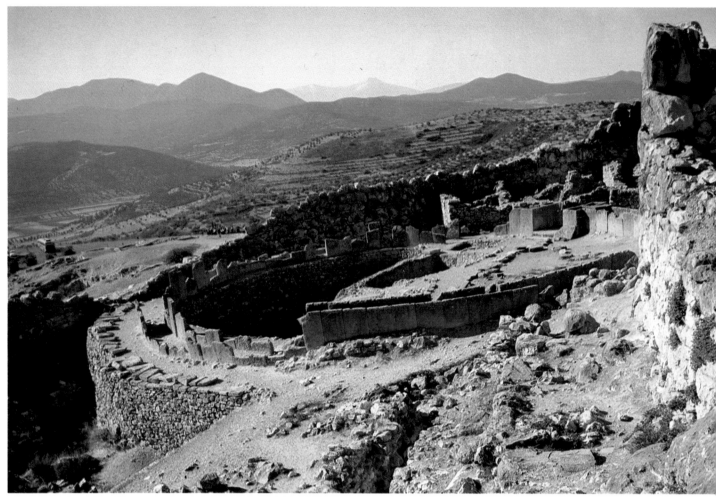

repetition. Vases for the table and for the kitchen, as well as those designed to contain scented oils and balsams, achieved orginality both in their shape (as in the case of the small, stirrup-shaped amphora with an opening at the side from which to pour the liquid) and also in their decorative repertoire, which included scenes portraying figures, such as those showing parades of soldiers, an allusion to warriors either setting out or returning from the wars. A precise division of specialized labour is revealed by the large quantities of clay tablets bearing Linear B script discovered in a royal archive at Pylos: below the king, the commander of the army, the landowners and the local governors, there appear lists of carpenters, masons, joiners, bronze-workers, potters and goldsmiths, whose presence had already been suspected by archeologists. Other categories are also recorded: spinners, weavers, dyers, perfumers, doctors, heralds and, finally, slaves, whose places of origin, clearly slave markets, are also recorded (Lemnos, Cnidos, Miletus, Cythera). In addi-

tion, there must have been scribes, whose job was to deal with the detailed administration of the palaces.

The royal tombs of Mycenae, which still impress the modern visitor and which were erroneously ascribed by Schliemann to Agamemnon, Clytemnestra and Aegisthus, have yielded no written information, although they clearly reveal the care taken in preparing burial chambers and the religious respect shown for cemeteries. The funerary rites can be reconstructed and have indeed been de-

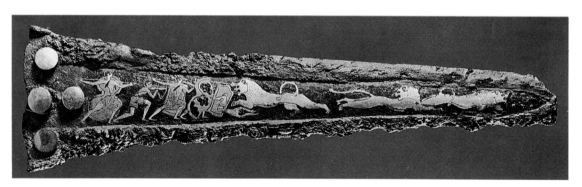

Left: ceremonial dagger (fifteenth century B.C.) from tomb IV of circle A at Mycenae. On the bronze blade, with niello decoration bringing out the colour, a lion hunt using formal Minoan designs but close to Mycenaean themes. National Museum, Athens.

The tombs at Mycenae defined as royal were those in Circle A and Circle B (the latter, which is slightly older, can be dated to the end of the seventeenth century B.C.), mainly on the basis of the quantity, the richness and the workmanship of the objects found by the bodies of the departed, most of which were discovered as a result of the recorded history of the burial area. As well as elaborately made objects revealing stylistic contacts with Minoan culture, there was an abundance of ornaments made of precious metals, the most famous of which are the gold death masks, believed by some scholars to be related to Egyptian funerary practices. The other important feature of the burial sites at Mycenae are the great *thólos* tombs, monumental burial chambers preceded by an access corridor (*drómos*) and opening out into a vast circular chamber dug into the side of a hill and covered by stone corbelling, the whole structure hidden beneath a mound of earth.

Opposite above: near the Lion Gate at Mycenae, the circle of tombs. In 6 trenches, 19 royal persons were buried there between 1580 and 1510 B.C. The double circle of limestone plaques marks the sacred import of the site.

Left: Mycenaean pottery resumes Minoan motifs, in simplified schematic form, as in the three-handled-amphora of Deiras (Argolid), which on the bulge has a stylized palm in the "palace" style. National Museum, Athens.

Right: Ivory statue of nude goddess. Ornament on wooden box from a tomb in the Athenian Dipylon cemetery. Nudity and frontal representation, oriental in origin, are rendered in geometric style, with harmoniously scanned rhythms. National Museum, Athens.

scribed on several occasions by well-known scholars who base their vivid accounts on later literary evidence and on the study of excavated remains, helped in certain instances (as in the *thólos* at Dendra) by the lucky discovery of tombs that have escaped the depredations of grave-robbers, whether ancient or modern, lured by dreams of hidden "treasure."

The funerary rituals and different types of tomb reveal their own peculiar characteristics: take the famous tombs at Mycenae, for example, in which it is possible to detect two distinct shapes and two distinct periods. The first consists of Grave Circle A, excavated by Schliemann in 1876, and Grave Circle B, excavated in 1951–54, which take the form of groups of deep graves, numbering 6 and 24 respectively, arranged in no special order within a circular area bounded by stone structures. It was a family burial ground, characterized by the presence at ground level of stelae decorated with relief carving and set clearly apart from the surrounding areas, almost as a tangible indication of the importance of the people buried there, as well as to inculcate a feeling of power and religious reverence. This element of religious respect

must have endured over the centuries, given the fact that Circle A, which can be dated to the sixteenth century B.C., was later included within the city's powerful walls, close to the Lion Gate (twelfth century B.C.), and was intentionally kept visible, albeit with necessary adaptations that consisted of raising the level of the ground within the walls in order to compensate for the way in which the earth had been trodden down.

The sacredness of the place, respected in successive alterations to the city, not only lasted for the whole historical span of the Mycenaean world, but was also kept alive by oral tradition until finally being immortalized in an erudite note by the insatiably curious traveller Pausanias, who in the second century A.D. described all the antiquities of Greece. This Greek writer recorded the existence, near the walls, of the tombs of people who had been killed on the occasion of Agamemnon's return from the Trojan wars, also specifying the exact number of burials, (five), and it was on the basis of this that Schliemann halted his searches after unearthing the fifth underground grave, thus failing to complete his exploration.

The epicenter of the Mycenaean world was the Argolid, the most densely populated and enterprising of the Achaean settlements, but the southern areas of the Peloponnese (Laconia and Messenia, Attica and Boeotia) also played an important part. However, the Mycenaeans, who were skilled sailors, also expanded beyond the Greek mainland, reaching not only the islands of the Aegean but also the coasts of Asia Minor, Cyprus, the Levant, southern Italy and Sicily, creating what has come to be known as the Mycenaean empire or *koiné*.

The Geometric style (eleventh to eighth century B.C.). The Geometric style characterizes the historical period following the decline of the Mycenaean civilization (the Greek Middle Ages), which also saw the development of Classical Greek civilization, but we must discard the theory that there was a clean break between the Greek and Mycenaean worlds. It was an evolutionary period, which witnessed the fall of the Hittite empire: a time of great migrations, coinciding with the Dorian invasion of Greece and the passage from a feudal to a tribal society. The conquest of new areas led to a lengthy period of adjustment, during which the Dorian element became the most important influence. A military aristocracy also emerged, together with a social division between those who created the wealth and those who enjoyed its benefits.

Scholars have attributed the birth of the Geometric style to a variety of different experiences in Mycenaean art, which during the final period took on an abstract quality that reflected a complicated fusion of decorative influences: Asiatic elements, Helladic motifs and patterns inspired by prehistoric and mainland Greek art.

The Geometric style is documented mainly by ceramics, but partly by the small plastic arts (there is no large sculpture and very little architecture). The small statuettes in terracotta, stone and cast metal reveal a tendency toward the schematic, but they also display a lively representational style; the extremities of the bodies, for example, show a much greater attention to detail than the sinuous, concentric figures of Myceno-Minoan art or the static, block-like forms favoured by the Mesopotamians and Egyptians. Thin, almost thread-like figures were followed by compact shapes, erect figures with a cylindrical sense of volume, whose arms stretch down the sides of the body.

The most important cities of the Geometric period were Corinth, Argos and, in particular, Miletus and Athens. Attic art, which displayed the greatest spirit of invention, originality and consistency, clearly shows the transition from the Late Mycenaean to the Geometric. Ceramics of the Proto-Geometric period (1025–900 B.C.) reveal a more selective range of vase shapes, which had been very numerous during the Mycenaean period; a phenomenon that indicates a decrease both in

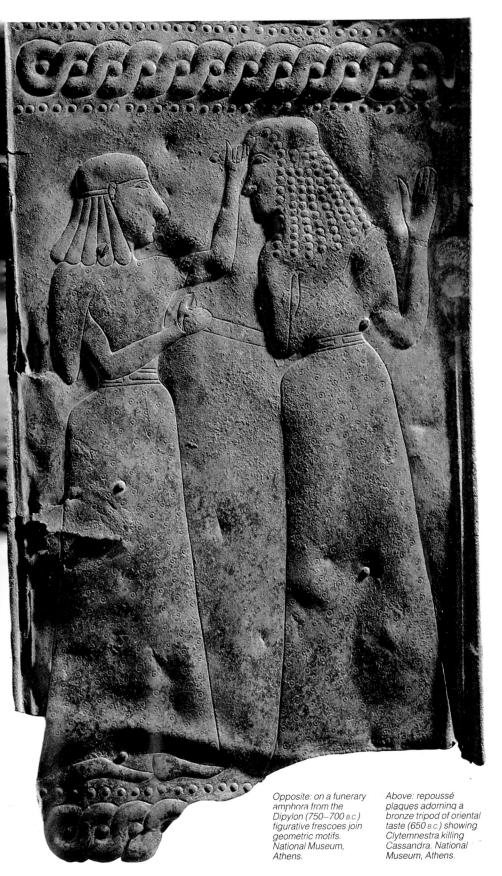

demand and in economic resources, as well as a period of reassessment and reorientation. Decoration became stricter and more measured, emphasizing the different shapes of the vase's elements, while the vases themselves grew in size during the Geometric period (900–725 B.C.). The geometric motifs imposed a strict division of space. Accentuation of the vertical axis is matched by a horizontal element, in which the figurative decoration is concentrated, so as to emphasize the internal equilibrium of the composition. The feeling of monumentality is not derived from size, but from proportional relationships. The horizontal bands of decoration, executed with great strictness and geometrical precision, underline the vase's structure. It was this striving for rationalism that replaced the imprecision of free-hand painting with the use of ruler and compass. This geometricality initially revealed itself in shapes derived from a process of abstraction and composed in a carefully syntactical way. The motifs inspired by animal shapes, which were linked to Eastern influence (the Geometric world was not a closed one), were arranged in rhythmically decorative lines. Figurative interest was concentrated on man, but the reduction of the human figure to a mere silhouette is not an abstraction in the sense of a disintegration of an organic form: it is an expression of the form's essential composition.

The Orientalizing style (725–610 B.C.). The statuette from the Temple of Hera at Olympia marks the end of the pure Geometric style and the advent of what has quite justifiably come to be known as the "Orientalizing" style, because it contains many elements derived from the oriental world, meaning the Near East and Egypt, which were reworked by the Greeks and used to decorate weapons, ornaments and utensils.

We now possess a number of definite dates relating to the Orientalizing period. The first Orientalizing objects entered Etruria when Greeks from Sicily and southern Italy established colonies in the area during the middle of the eighth century B.C. A tomb at Tarquinia dating from the closing decades of the eighth century contains Geometric objects alongside Orientalizing ones, as well as an Egyptian vase bearing the cartouche of the Pharaoh Bocchoris, which dates the tomb to 728 B.C. The most likely reconstruction of the historical events that led to the formation of this tomb's burial goods are as follows: since the time of their colonization of Sicily, and perhaps even earlier, the Greeks learned that the coastal areas lying to the north of the Tiber contained much-needed minerals, especially copper. They therefore opened up trading routes, initially overland. The road used was the one that still runs through Frosinone and the Sacco valley, which at the time was protected by the chiefs of the tribes living in the Praeneste region. The latter exacted tribute from the caravans in the form of precious objects made

Opposite: on a funerary amphora from the Dipylon (750–700 B.C.) figurative frescoes join geometric motifs. National Museum, Athens.

Above: repoussé plaques adorning a bronze tripod of oriental taste (650 B.C.) showing Clytemnestra killing Cassandra. National Museum, Athens.

later adding the oriental style of human figure. A good indication of the influence that the East had on Greece is the fact that the very hairstyle of statuettes is enough to date either a design or a culture during the Orientalizing period. They possess hair in wavy layers, just like the statues of deities supporting the ring-handles of cauldrons found in Etruria and at Olympia, which repeat oriental models. According to the latest researches it was the Ionians who first began trading with the East, and indeed the name Yawani became the generic term for Greeks among the Egyptian and Semitic peoples. It was the Ionians who introduced naturalistic art to such important centers as Rhodes and Crete and, later, Corinth. It is likely that the port most frequently visited by them was on the site of modern Mina, near Antioch, where archeological finds have revealed the existence of an Ionian colony or at least trading post. The products that flowed into this port were hybrids, but made in the oriental

Left: famous Egyptian vase in vitrified ceramics bearing the name of Pharaoh Bocchoris (720–715 B.C.) found in an Etruscan tomb at Tarquinia; a sign of commercial links between the East and Greece and the western Mediterranean. National Museum, Tarquinia.

Right: funerary amphora of Melos (650 B.C.), a good example of oriental style on the islands. On the ample surfaces, a constant succession full of imagination and rhythmical and curvilinear coloured decorations. Two scenes stand out: on the neck, the duel of Achilles and Memnon describes an epic moment; on the sides, Apollo leaving on a chariot drawn by winged horses with fan-shaped nostrils while Artemis is approaching holding a dead stag by the antlers; a scene of deliberate tension. National Museum, Athens.

taste and also manufactured in the East, albeit in lesser towns rather than the great historical centers. It appears that Armenia specialized in embossed bronzes and Syria in ivories. In Greece, one of the areas in which Orientalizing artefacts have been discovered is Crete, where excavations in the cave-sanctuary on Mount Ida have revealed large numbers of shields decorated not only with figures of animals but also with Babylonian and Egyptian deities combined in a way that has no bearing on the original.

One major factor in the development of Greek art was the establishment of different pottery-making centers, particularly those producing ceramics in the proto-Corinthian style, which appear to have existed not only at Corinth, but also at Sicyon. This was followed by the production of wares at Corinth itself, which are found throughout the Mediterranean area, partly because they were used as containers for the perfumes that Corinth produced

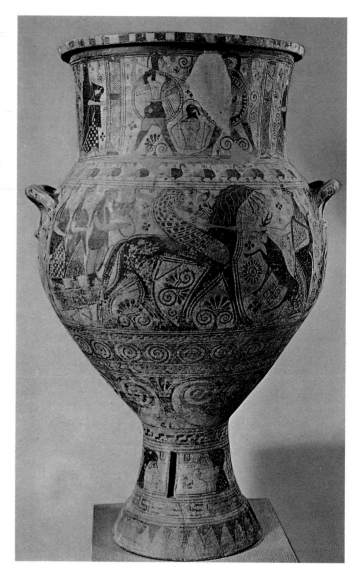

of gold, ivory and silver, of a type that has been discovered in royal tombs, and they would also certainly have acquired large amounts of textiles. The majority of these objects appear to be Greek in origin, but many show clearly oriental characteristics, which leads us to the inevitable conclusion that the Greeks first acquired precious goods of this type from Eastern markets and then copied them. The Etruscans were the final link in the chain, imitating the Greek objects that were themselves derived from oriental models. We can now tell with a fair degree of certainty that the end of the Geometric style occurred during the fifty years between 750 and 700 B.C. Oriental art, meaning the art of Egypt and the Near East, is renowned for making extensive use of naturalistic motifs, as well as displaying a very orderly quality, both in its composition and in the delineation of shapes. The same sense of discipline also lay at the basis of Geometric art, and it is thus understandable that the Greeks, once they had emerged from the isolation into which they had retreated following the collapse of the Mycenaean empire, so losing their mastery over the seas, should have absorbed the influences of a naturalistic style of art capable of enriching their own schematic repertoire. They first adopted the rows of monsters and animals,

and exported. The favourite subject was grazing animals, portrayed with black silhouettes by the potters of mainland Greece and with the head left in the colour of the original clay by the Greeks of Asia Minor.

The Daedalic style and the primitive taste. The Daedalic taste can be described as "primitive" because it reveals the same freshness as that found in primitive Italian works, which is expressed in a fondness for decorative richness and colour, in a search for lively facial expression and in the ingenuity with which the artist relies on the imagination of the onlooker to complete the picture. During this happy period, in which the Greeks recovered their spirit of adventure and overseas expansion, they developed an almost childish love of doll-like statues, with no sense of movement, but full of life in the rich colours of their embroidered clothing, in their faces, characterized by large, bulging eyes conveying an underlying feeling of humour, and in the constant smile playing on their upturned lips.

Following the example of Egypt, Mesopotamia and Syria, colossal or large-sized statuary was created: Egypt provided the model for the statues of cloaked and seated figures with their hands spread out on their thighs and for the likenesses of young men dedicated to the gods, while Mesopotamian art provided the costume of the female figures, the models for the abstractly decorative composition of the beard and hair, and also their expressive impact; in other words the strong, staring gaze, obtained by large, bulbous eyes, and the stereotypical smile. These models, which in the East owed their monumentality purely to their size, in the hands of Greek artists achieved a spiritual vigour and a strong feeling of life.

The Greeks also displayed a strong predilection for mythological narrative. Excavations in Athens have revealed a large number of statues, which originally decorated pediments, made of stucco-covered stone and certainly often painted. Their primitive quality lies in their paratactical composition, which takes no account at all of the internal logic of the tale inasmuch as the height of the figures is determined by the slope of the roof. No allowance is made for the importance of the individual figures, which can be large or small, depending on the position they occupy within the triangular area of the pediment.

Sculpture during the Orientalizing period was represented by bronzes imported from the East and by imitations, but also by other, normally tiny, works, which show how the Greeks reacted against the massive, static structures of the East in order to express a feeling of inner life that is not changeless but nervous and restless. This early form of experimental statuary gives a clearer idea of the stylistic ideals held by the three main currents of Greek art, the Peloponnesian, the Ionian and the Attic. The first reveals an overwhelming

Above: detail of a fight between hoplites, on the high part of a pitcher known as the Olpe Chigi; from an Etruscan tomb of Veii. A masterpiece of Corinthian art, unique for its size, decoration, execution, composition and design. Note the careful rendering of space with elementary perspective and the group movement of the opposing soldiers in distinct ranks. Museum of Villa Giulia, Rome.

Right: bronze statue, probably from the sanctuary of Apollo at Thebes, with a first person inscription on its legs proudly stating that it is a votive gift to Apollo of the silver bow. By Mantiklos (700 B.C.). Modelled as a stack of flattened masses, marking the vertical and the main divisions of anatomy. Museum of Fine Arts, Boston.

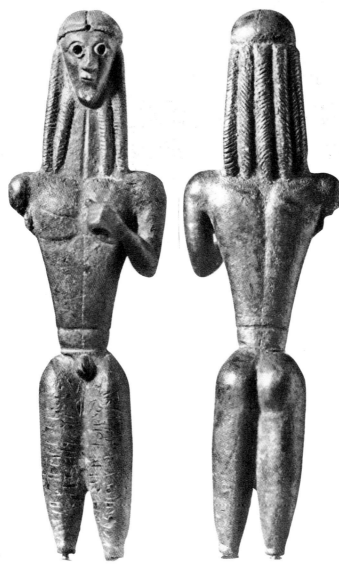

1 ramp
2 peristasis, peribolos
3 euthynteria
4 foundation
5 stylobate
6 column
7 column neck
8 armilla
9 echinus
10 abacus

11 architrave
12 transom
13 capital
14 listel or fillet
15 triglyph
16 metope
17 Doric frieze
18 acroterion
19 mutule
20 cyma

21 skew cornice
22 cornice
23 tympanum
24 pediment
25 antefix
26 central acroterion
27 roof
28 edging tiles
29 lion-head gargoyle

26
25
27
18
29
28
25

Section of the Doric
peripteral temple of
Aphaia at Aegina (early
fifth century B.C.). The
goddess's cult may be
compared with that of
the Cretan Britomartis.
Most of the pediment
sculptures are in the
Glyptothek at Munich.
The east part of the
temple was damaged
soon after being built
and in 480 B.C. or soon
after a new pediment
was put up, whence the
different style of figures
in the two pediments,
which represented the
fight between gods and
giants with Athena in a
dominant position.

interest in the physical structure of the
body, concentrating more on anatomical de-
scription than spiritual analysis, the second
strove, through the painterly shading of sur-
faces, to express warmth and gentleness,
while the Attic skilfully blended a feeling of
physical solidity with a delicately modelled
quality.

During the sixth century B.C. the taste for
Orientalizing decoration faded and then van-
ished completely. The processions of animals
and monsters were replaced by mythological
scenes, which appear on large vases, es-
pecially craters, and also on smaller drinking
vessels, most notably calyxes or stemmed
cups, whose shapes became more and more
highly refined. The potters of Corinth may have
anticipated their Athenian counterparts in the
decoration of large vases, in the form of
column craters decorated with mythological
scenes, but they were very soon forced to
cease production in the face of Athenian
competition. From the middle of the sixth
century and throughout the fifth, Athens was
the largest exporter of vases to both the
eastern and western Mediterranean, particu-
larly Etruria.

The Doric order of architecture showed the
artistic eagerness of the Greeks to create
proportions that would appeal to the aesthetic
sensibilities not only of the chosen few but of
everybody, non-Greeks included. The so-
called "Temple of Neptune" at Paestum in
southern Italy, for example, which represents
the high-point of the style, still fills the modern
visitor with wonder, so perfectly does it
embody that quality known to the Greeks as
"symmetry," meaning the proportional re-
lationship of all measurements to a single
fundamental. In the Doric style this fundamen-
tal is represented by the lower module of the
pillar, which formed the base measurement
used to determine not only the height of the
pillar itself, but also the entire height of the
building as far as the roof. The rectangle
created by the interaxes of two pillars and the
tip of the frieze never changed its proportions,
because when the height of the pillar's shaft
was extended, that of the entablature, in other
words the frieze and the architrave, was less-
ened. The lower module of the pillar, as well as
determining the height of the structure, also
fixed the dimensions of its ground plan, be-
cause Greek architects established six as
being the perfect number of pillars on the
façade. Tetrastyle temples, meaning ones with
four pillars, were built only on sites decreed by
religious tradition that were too narrow to
accommodate a hexastyle building. This was
the case with the sanctuary of Athena at
Lindos on Rhodes, where religion demanded
that a temple be raised on the top of the
acropolis, where there was very little space
available. The Parthenon had a façade with
eight pillars because great care had to be
taken to ensure that there was enough room
for the cella around the statue.

The basic problem concerning the develop-
ment of the Doric temple is that of the origin of
the peristatis. The most common theory is that
it represents an extension of the temple in
antis, meaning the addition of two pillars
between two antae at the front in order to
create a more imposing effect, but this hypoth-
esis would only be valid if the peristasis were
added when the Doric temple with a single
cella in antis already possessed its conical
form in stone. In this case the outer order, in
the form of a colonnade and entablature with
pediment, could be interpreted as a repetition
of the inner one. We know, however, that the
first examples of a peristatis were made of
wood, since that is indicated by the remains of
the Temple of Apollo at Thermos and the
Temple of Hera at Olympia.

The Doric temple was conceived as a solid
geometrical form, a parallelepiped sur-
mounted by a prism, but were it really a
geometrical solid it would not arouse the same
feelings of aesthetic pleasure that we experi-
ence when contemplating the Temple of Nep-
tune at Paestum or the Parthenon at Athens.
We experience these feelings because the
Greeks enlivened the straight lines by gently
curving them, inclined the walls and pillars
inward and gave the outline of the pillars a
more fluid quality by gently tapering them in a
technique known as entasis. Another element
that imparts a feeling of movement is the
echinus, the part of the pillar that occurs below
the abacus.

The Ionic style developed in the eastern
Mediterranean, as is shown by the earliest
capitals, which take the form of a stylized
palm. The two largest Ionic temples, namely
the Temple of Artemis at Ephesus and the
Temple of Apollo at Didyma near Miletus, were
hypaethral, meaning that they were open to
the sky. As in the courtyard-temples and the
palaces of Mesopotamia, there was also a
chapel dedicated to the divinity, a further
indication of Eastern influence.

The Archaic Period (619–480 B.C.). Whereas
Sparta firmly closed its gates to art, concen-
trating its energies on establishing hegemony
over the Peloponnese, even extending its
influence beyond the Isthmus of Corinth,
Athens began the inexorable rise that was to
lead to its becoming the effective capital of
insular Greece and the moral capital of Greeks
everywhere, vigorously affirming the validity of
the institution of the democratic polis, the
indivisible trinomial of state, people and re-
ligion. The diligent defense of freedom, seen
as the basis of human dignity, provided that
ethical element which found its highest expre-
ssion in the marbles of Olympia and the works
of Phidias. In order to achieve the establish-
ment of a republic in all its egalitarian aspects
Athens had to overcome the political crisis that
brought to power Pisistratus, a ruler who,
rather than being a tyrant in the modern sense
of the word, laid the foundations of Athens'

commercial and maritime power and cultivated that love of culture and refinement which came to characterize the people of Attica. The tyrannical nature of the government of his successor Hippias led to a revolution and to the constitution of Cleisthenes.

During the Daedalic period only tentative and peripheral attempts were made at achieving artistic naturalism. Colour and decorative detail were of greater concern than accurate representation; constant progress was made in the anatomical delineation of the naked body, but even greater strides can be detected in the creation of more fluid contours, although there is still no linear portrayal of folds in the drapery and the sole means of expression is the sort of staring, smiling quality used by children when playing games.

When, in around the mid fifth century, Greek artists began to make a more determined effort to acquire a naturalistic language, the Daedalic style, in the sense of the earliest Greek artistic language, can be said to have ended and we can begin to use the term "Archaic," meaning a style of art that strove to master the elements that have come to define Classicism: the expression of ethical qualities; harmony between outer and inner reality; the establishment of dimensional relationships through the selection of the most beautiful physical forms; and the elegant portrayal of drapery. Classicism, which meant the creation of an ideal of beauty, drew on three artistic currents: the Peloponnesian, which revelled in the portrayal of the athletic body and revealed its expertise in the numerous statues of athletes who had been victorious in the games held to honour the gods, which were modelled mainly in bronze and thus known to us from literary records and inscriptions; the Attic, noted for its expressive qualities, and the Ionian, the true creator of sculptural drapery.

During the second half of the sixth century, in the Greek areas of Asia Minor, where people had always worn light linen robes that hung in thin folds, a fashion developed for the tightly clinging *chiton*, generally topped by a cloak worn either over the shoulders or as a cape, which in sculpture created extensive drapery that was enlivened with colour. This was the garment worn by the *korai* on the Acropolis at Athens, statues of Athenian girls dedicated to the goddess which were destroyed by the Persians. On returning to their city, the Athenians placed them in a deep ditch on the Acropolis, together with other sculptures deemed to have defiled by the invaders. It was this famous hoard that allowed Europeans, hitherto accustomed to seeing only Roman copies, to admire not just these original works, but also the Parthenon marbles.

The largest *kore*, which could almost be classed as monumental, bears the signature of Antenor, probably the greatest sculptor during the closing decades of the sixth century B.C., who is known to have created the first group of Tyrannicides, following the explusion of Hip-

pias. It is possible that the sculpture was erected soon after Cleisthenes' period as archon to symbolize the victory of democracy and as a warning to tyrants. Because of the similarity between this *kore* and the female figures on the eastern façade of the Temple of Apollo at Delphi, the latter, which are of imposing monumentality, have also been attributed to him. This hypothesis is plausible because it is known that the temple was rebuilt by an Athenian family, the Alcmaeonidae, and it is understandable that they should have chosen a sculptor from their home city, especially since he would have been more skilled at working in marble than a Peloponnesian sculptor used to working in bronze. Its composition and figurative language reveal

Above: around 500 B.C., votive reliefs on the Acropolis of Athens are numerous. Here, the goddess Athena in a chiton with elegant linear folds wears a helmet, and receives the offerings of the devout. Acropolis Museum, Athens.

Opposite far right: young girl (kore); small statue in polychrome marble. An example of the vigorous work of island sculptors in Athens toward 500 B.C.

Acropolis Museum, Athens.

Opposite: the Cavalier Rampin, mid sixth century B.C., celebrates Athenian aristocracy. The simple modelling of the deliberately inclined bust is crowned by the head with its elaborate hair. The head is in the Louvre, the bust and horse in the Acropolis Museum, Athens.

new elements worthy of a great artist, as well as a search for rationality that effectively marks the end of the Daedalic era. The height of the figures is no longer illogically conditioned by the vertical coordinates: the triangular space is used in such a way that where they are seen as erect they possess the correct stature. Athena is at the center, a fitting position for the mistress of the temple, while at the sides Zeus and Hercules are shown in a diagonal position, fighting kneeling giants, with two further giants lying dead in the corners. The rhythmical passage of the masses from the vertical to the oblique and the horizontal, together with the strong sense of volume and the strength of its structure, create the sort of colossal impression required of a Gigantomachy. The new feeling of space can also be seen in the composition of the central group. Athena is no longer Polias, the severe and powerful protectress of her city: she is the warrior who kills the giant Enceladus. She is shown here running him through with a lance, an action that requires force and passion. A feeling of violent movement is achieved by showing the goddess advancing toward us, her head lowered; in other words, she is portrayed in a natural, spontaneous way. In order to achieve this slanting effect the artist has had to resort to foreshortening, a technique never practiced

by Daedalic artists, who, like their public, used their imagination to compensate for any shortcomings in the composition and to see movement even in the most rigid of figures. Daedalic artists were capable of portraying the trunk of a body from the front and the legs in profile, because they believed in legends; during the Archaic age the Greeks still believed in legends, but they regarded them as having taken place in the real world, where images appear to the onlooker on a parallel or normal level, with similar visual effects, such as foreshortening. It is true that the foreshortening of the figure of Enceladus is not entirely successful, but the intention is clear.

Two other major advances on the road to a naturalistic language relate to the achievement of rhythmical modelling. In the earliest *kouroi* the naked body has a sectional quality, with the frontal and lateral views meeting at an angle, but figures of the Archaic era attain a feeling of fluency, with the different views blending into each other in a naturally rounded way. This technique had already been mastered during the previous phase, but it became more firmly established in the early Archaic period, thus putting an end to a manneristic trend in which the taste for thin figures and extravagant decorativism led to a sort of decadent refinement. The most famous example of this short-lived trend is the Rampin horseman. The rhythmicality derives from the abandonment of a rigidly axial structure, with the result that there is no longer any strict bilateral symmetry and the outline differs in its two halves. This effect occurs when a leg is flexed, so that one side of it is flattened and the other arched, an imbalance that also causes the muscles to alter their appearance and create new variations of light and shade. This new discovery meant that the Greeks had to carefully investigate the structure and anatomical details of the human body in order to be able to portray even the smallest changes caused by the abandonment of its rigidly axial stance. In their eagerness to achieve perfection, Greek artists attained a high level of anatomical knowledge, and this applies also to vase painters, who between 500 and 480 depicted athletes with an extraordinary amount of anatomical detail.

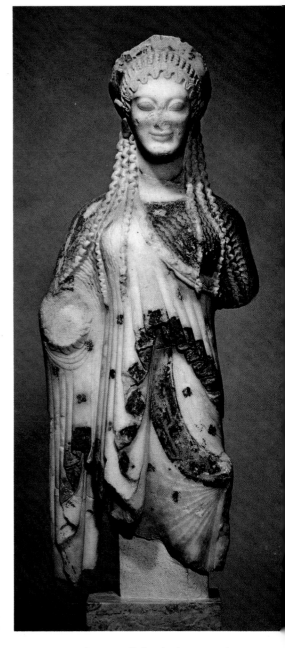

Early Classicism – the Severe style (480–450 B.C.). This period, which lasted for a generation, coincides exactly with the years that followed the victories over the Persians, paving the way for the political and cultural triumph of Periclean Athens. It was the time of the great tragedies of Aeschylus and Sophocles, whose works synthesized Greek religious thinking and the new relationship between divinity and humanity. Greeks of the preceding era had been led to see their own life reflected in the lives of the gods, not just in its heroic aspects but also in its failures, some of which verged on the ridiculous; but this did not reduce the status of the gods to that of mere mortals,

because the former still inspired awe and reverence and still demanded respect or *time*. Zeus could be a womanizer, but as guardian of oaths he was feared because people knew of his implacable nature. In the same way, Apollo could be seen as a man crossed in love, but as god of the oracles he was held in great awe. After the Persian wars the Greeks still believed in the power of divinity, but without the crude limits on their sphere of activity imposed by their ancestors: they now based their religious beliefs, and hence also their moral code, on the relationship between *hubris* and *nemesis*, convinced that "violence" would not go unpunished, because it provoked the anger of the gods. The tragic myths,

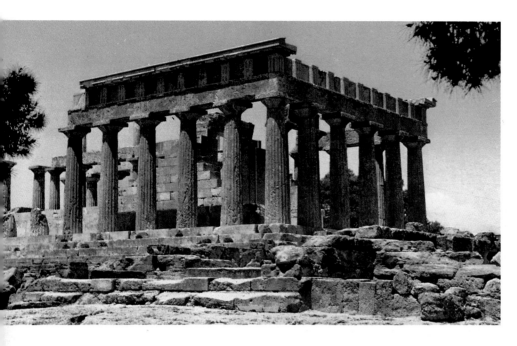

sured way, adopting a severe stylistic language that manifested itself in an extremely dignified and thoughtful form of naturalness. This severity can be seen in the downcast faces, in the well-ordered hair and in the drapery no longer made of light, clinging material but of heavy woollen cloth that falls in broad folds, while awareness of the complementary nature of the concepts of goodness and beauty led to a continuous study of the nude, both in its proportions and in its muscular conformation. The generation that preceded Phidias was that of the athletes celebrated in verse by Pindar: they were an image of physical, even spiritual, beauty, because the athlete embodied the concepts of honour, loyalty and self-respect. Within the substantial idealism of the Severe style the statue once again came to be regarded as an *agalma*, a gift pleasing to the gods, or as an *anathema*, an image placed in a sacred place to honour a victorious athlete, but which, rather than identifying an individual, represents the citizen who has honoured his fatherland, but

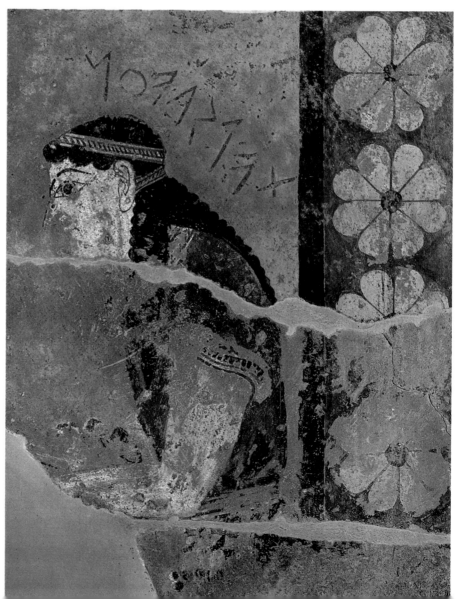

which were used by the tragedians as the subject of their plays, were symbols, paradigms of these axioms. There was, however, still a disquieting element in the inscrutability of the divine will, which decreed that the just man must expiate the sins of his ancestors.

Another subject for the Greeks to ponder was the realization that, following their victory over the Persians, they now had a civilizing mission to fulfil: their role was similar to that of the gods, who had destroyed the giants, forces of evil, and of the heroes, who had vanquished monsters like the Lapiths, or the Achaeans, who had destroyed the barbarian city of Troy, or Theseus, who had conquered the Amazons. As a result, these symbolic scenes were often portrayed in conjunction with each other. Political events at the beginning of the fifth century had led to the concentration of initiative in the hands of a few leading states; the skill with which the rulers of Athens exploited victory over the Persians gave the city its thalassocracy and turned it into the center of a vast league of cities.

The fifth century was a period when the Greeks concentrated on a few specific problems, and creativity became the domain of a small number of personalities. It also marked the renunciation of Archaic decorativism and the laying aside of the Ionic style (even the Ionian city of Athens concentrated its architectural activities on the Doric temple). The central position of the human figure and personality was reaffirmed, but we should perhaps not speak so much in terms of the crisis of archaism as of the varying abilities of artists to react in the face of different requirements and different technical advances.

Art, like poetry, reflected the hopes and spiritual anxieties of the day in a very mea-

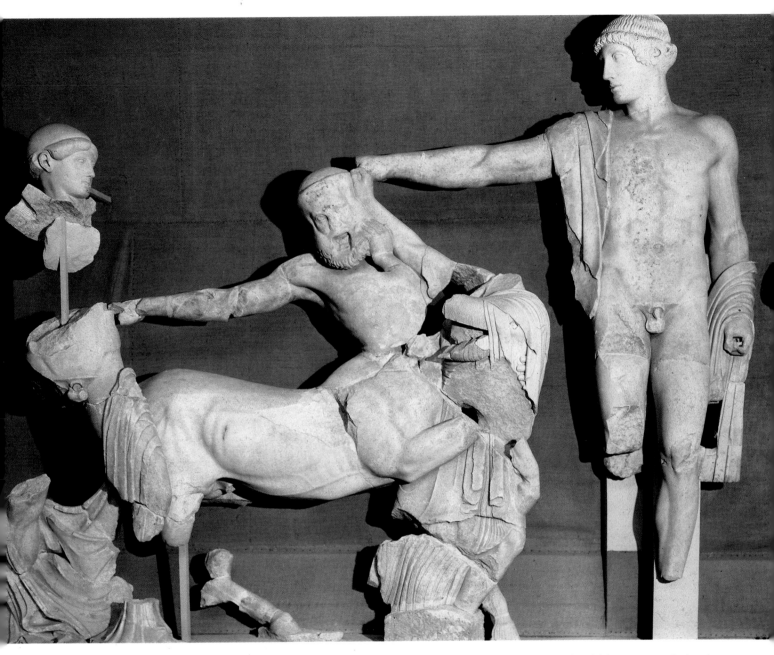

Opposite above: Temple of Aphaia, Aegina, built with careful regard to the island's rocky landscape, early in the fifth century B.C. The structure is harmoniously balanced on a graceful linear pattern.

Opposite below: Corinthian artists, inspired by vase painting, painted these metopes on the Apollonium of Thermos (seventh–sixth century

B.C.). The profile of Chelidon (identified by the inscribed name) stands out from the background. National Museum, Athens.

Above: pediment sculptures from Olympia, masterpieces of Greek art (c. 460 B.C.). The anonymous artist admirably renders the austere and imperious image of Apollo in the mythical battle of Centaurs. Museum of Olympia.

who shares the same rights and duties as his fellow citizens and should therefore not be distinguished by either physical features or spiritual expression. The single distinguishing feature was the inscription on the base, which bore the name of the figure being represented. Just as the ideal nude form was that of the vigorous athlete with taut, prominent muscles, so the faces betrayed no hint of emotion to disturb the calm and measured composition of the structure.

As can be seen in the metopes at Thermos, painting was already highly prized in the seventh century. We know from Pliny, our best source of information on the subject, that there was an artist called Boularchos painting on

panel during the eighth century B.C. During the seventh century Kleanthes of Corinth and, in the sixth, Kalliphon of Samos painted scenes from the *Iliad*; we can get an idea of what this early art was like from Etruscan painting. During the early decades of the century Eumares and Kimon of Kleonai, to whom Pliny attributes certain technical perfections that revealed a decisive advance toward naturalism, were working in Athens.

The greatest Early Classical painter, however, was Polygnotos of Thasos, who in that period of grandiose sentiments preferred the broad sweep of wall painting to painting on panel and, in deference to contemporary symbolism, which linked the defense of liberty by

mortals to the defense of civilization against the barbarians, chose subjects such as the Battle of Marathon, the destruction of Troy and Theseus fighting the Amazons. He was greatly inspired by Homeric themes, whose less spectacular and more poignant aspects he interpreted, choosing sad episodes such as the Nekyia from the Odyssey or Odysseus after the slaying of the Proci. In other paintings he left the battle scenes to his collaborators Mikon and Panaenus, the brother of Phidias, reserving the portrayals of grief and suffering for himself. Aristotle says of him that he was *ethographos* and *ethikos*, meaning a painter of moral subjects and a spiritual man himself.

The same strong ethical emphasis recurs in the great sculptural complex in the Temple of Zeus at Olympia, which also reveals the lively symbolism typical of an era that loved myths. At the center of the two pediments stood Zeus and Apollo, the former on the eastern and the latter on the western, symbolizing the two great sanctuaries in which the sacred laws were kept, but portrayed in different attitudes. Zeus gathers up his cloak and twists his head away from the sight of Oenomaos as he pronounces a silent condemnation on the criminal who broke the vows of hospitality and betrayed the bonds of loyalty by killing his daughter's suitors during a chariot race. Apollo does not condemn, but merely expels the brutally drunken Centaurs with a broad sweep of his arm: Zeus is thus judge, while Apollo is god of civil order. The entire left side of the eastern pediment, which portrays Oenomaos, is filled with dark portents: the king wears no cuirass, thus appearing in the iconographical guise of a dead warrior, naked in the heroic fashion, while an old seer, probably one of the founders of the two priestly families of Olympia, makes a gesture of despair; nearby, a naked youth, Sosipolis, the demon of Olympia, points a finger at the ground, indicating the Hades to which Oenomaos will go. The horses are no longer harnessed and even the charioteer is missing. There is, by contrast, a mood of quiet confidence in the section depicting Pelops, who is shown as a self-assured youth clad in a fine cuirass, while the horses, which are in harness, are attended by a groom and a charioteer, who stands quietly by observing the scene. An ingenious gestural language allows us to recognize the queen and the princess. The queen is shown performing the everyday act of disrobing before retiring with her husband, as a maid unlaces her sandals, while the princess is portrayed making that shy, nervous gesture, common among young girls, of twisting the top of her dress.

In the western pediment the symmetry of the two sections is even more pronounced, with the result that the austere and finely sculpted figure of Apollo appears to be flanked by a rhythmical chorus. Here, too, ingenious devices allow us to identify the different elements: the brutishness of the Centaurs is

conveyed by their uncouth faces and evil expressions, while the mountain-dwelling Lapiths have coarse faces, similar to that of the groom in the eastern pediment, which contrast with the delicate features of the princes Theseus and Pirithous and Princess Deianira.

Pausanias tells us that the man responsible for the eastern pediment was Paionios of Mende, and that Alcamenes, one of Phidias' fellow artists, created the western one. The erroneous attribution to Paionios, who postdates Phidias, arose from the fact that he did play a part in the decoration of the façade, creating the central acroterion; the same can also be said of Alcamenes, inasmuch as two of the figures in the central pediment were completed after the building of the temple, since they are made of Pentelic marble. It may well be that they were actually carved in Athens.

There is nothing to disprove the theory that they came from Alcamenes' workshop, but they are unlikely to be by his own hand because they are not of the highest quality.

In fact, it was the Master of Olympia who created both pediments: the proof of this lies in his unmistakable style, in the thick texture of the drapery and the modelling of the naked bodies, both of which were designed to receive broad expanses of colour. In both the clothing and the bodies he reveals painterly sensibilities; the network of abdominal muscles is particularly reminiscent of the figures on the vases of Polygnotos, and there are further echos of Polygnotos, both in the mood of tragic calm that pervades the eastern pediment and in the composition of the Centauromachia. If we add the fact that the best comparisons, as far as the drapery and nudes

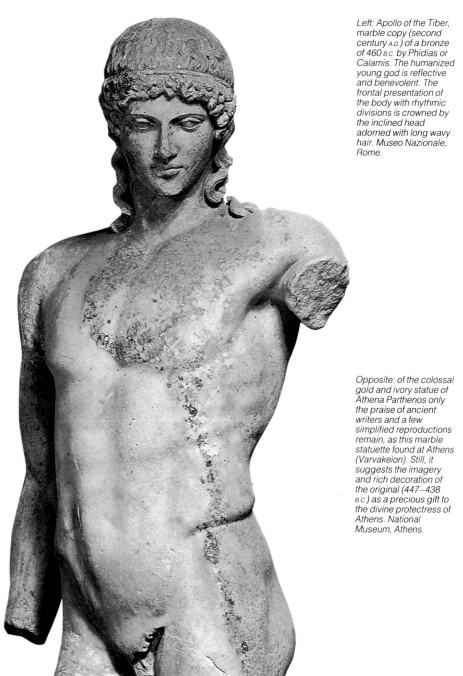

Left: Apollo of the Tiber, marble copy (second century A.D.) of a bronze of 460 B.C. by Phidias or Calamis. The humanized young god is reflective and benevolent. The frontal presentation of the body with rhythmic divisions is crowned by the inclined head adorned with long wavy hair. Museo Nazionale, Rome.

Opposite: of the colossal gold and ivory statue of Athena Parthenos only the praise of ancient writers and a few simplified reproductions remain, as this marble statuette found at Athens (Varvakeion). Still, it suggests the imagery and rich decoration of the original (447–438 B.C.) as a precious gift to the divine protectress of Athens. National Museum, Athens.

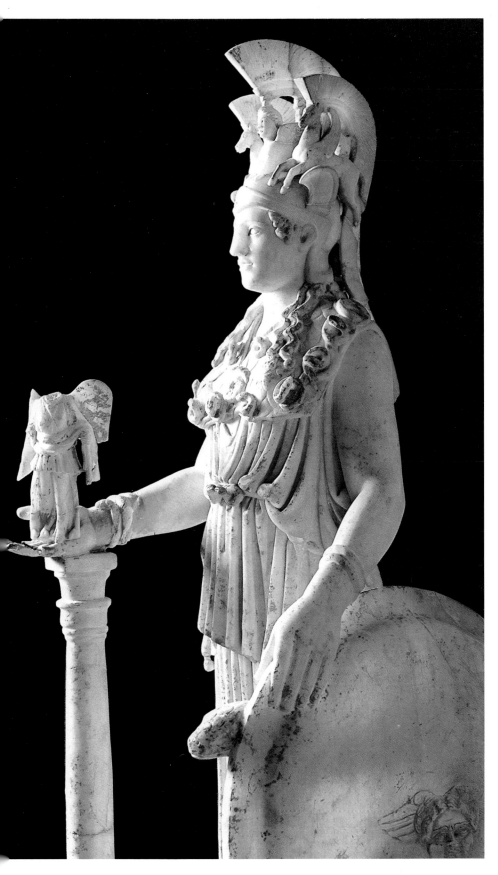

are concerned, are to be found in insular sculpture, meaning that of the Ionian world, to which Polygnotos also belonged, it seems legitimate to hypothesize that he was a follower of the great artist. The Master of Olympia was a painter by origin and certainly also a "coroplasta." In the two pediments he celebrated the sanctuaries; in the metopes, through his portrayal of the Labours of Hercules, constantly supported by his sister Athena, he recalled the great city that had conquered the Persians. The Master of Olympia marked the end of the age of the Severe Style, the age of Aeschylus and of solemn myths, with a splendid outburst of poetry. The art of Phidias was to have a great poetical quality, but it would also contain a philosophical element, just like the civilization of his day.

The Classicism of Phidias (450–420 B.C.). It would have been difficult for anyone living in the last century to reconstruct the personality of Phidias, let alone to assess his humanity and relate to him as a man rather than as some quasi-mythical being. He is mentioned in numerous sources, many works are attributed to him and critics have enthusiastically praised his artistic abilities, although any critic raised in the nineteenth-century school of positivist philosophy would have had to declare himself baffled by any attempt to reconstruct the figure of Phidias. We know that his greatest works were colossal chryselephantine statues, small reminders of which have survived in the shape of extraordinarily small illustrations. We also know that he was commissioned by Pericles to supervise the building of the Parthenon. Very little can be said about the other statues attributed to him: this is because during his lifetime such a high degree of stylistic balance and uniformity was attained that it becomes very difficult to ascribe any one statue of a divinity to a particular sculptor, even though their names are known.

Phidias had the idea of erecting beautiful buildings in which to bring together all the little shrines that superstition had raised over the centuries to lesser divinities. His plans, however, were thwarted. The Propylaea in which he hoped to assemble some of these deities was never completed. The small temple of Athena Nike, which was to have been aligned in accordance with a plan that would have integrated it with the other buildings on the Acropolis, was placed at an angle in order to coincide with the axis of the old, pre-existing altar, which was not moved; even worse, work was never completed on the building of the Erechtheum, which was to have housed all the most ancient relics of Athens, because of opposition from traditionalists, who could not countenance the destruction of the old temple of Athena, which by then was in a state of almost total ruin, thus blocking the view between the Parthenon and the Erechtheum that we enjoy today and obscuring even the Erechtheum's finest element, namely the portico

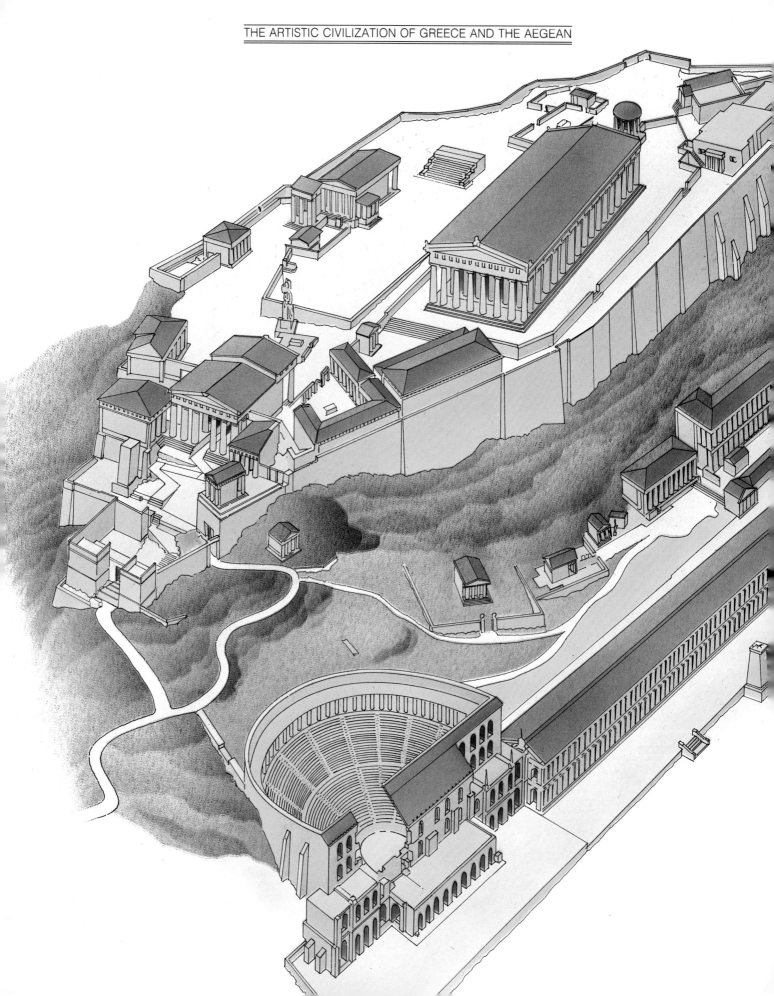

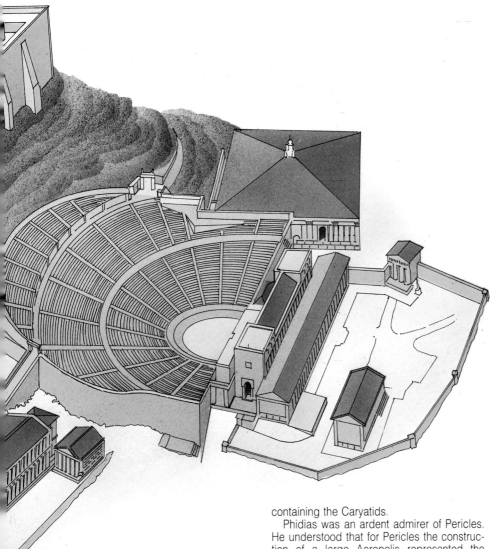

The monumental layout of the Acropolis of Athens. Graphic reconstruction of a high point of Greek art, inspired in its projects, skilled in execution and supported by architects, sculptors, painters and craftsmen. Dismantled by the Persians, the Acropolis was the project of Pericles, following a program full of political, economic, religious and cultural implications, as a living symbol of the rule of Athens. In a few decades from 477 B.C., the rocky plateau became a spatial composition in which the rational harmony of volumes was gradually exploited and enhanced by measured inclusion of figurate decorations; the excellence of the whole was not altered by the few later additions.

as an expression both of divine order and of the inexorable and perpetual flow of time. He portrayed the birth of Pandora, the world's first woman, who arrived between the rising of the sun and the setting of the moon, and, among the stars themselves, that of Aphrodite, the creator of love, and then, in a more grandiose fashion on the pediment of the Parthenon, the birth of Athena *Nous* from the head of primeval order, in other words Zeus, again between the rising of the sun and the setting of the moon.

Phidias the man has thus been fairly well outlined against the background of the times in which he lived, but we must now deal with his personality. There is a statue of Apollo at Kassel that differs from the others of the Severe period. It possesses a voluminous hairstyle, full of curls, and a well-built body. Its pose is at once majestic and flexible: the god seems to have come to rest in the middle of mankind after flying through the ether and to be looking for the target of his wrath. He is the very personification of the avenging Apollo described in the first canto of the *Iliad*.

According to written sources, during the building of the Parthenon Phidias supervised the creation of the colossal chryselephantine figure of the Parthenos, a work that was at the same time both grandiose and delicate, because both the choice of subject-matter and the use of precious materials were monitored by the faction opposed to Pericles.

We now come to the question of when he turned his attentions to the construction of the statue of Zeus at Olympia, very detailed descriptions of which can be found in the writings of Pausanias. Any reconstruction of Phidias' personality depends to a great extent on whether it can be established if this colossal statue of Zeus was erected before or after the one in the Parthenon. The written sources are in disagreement and even the most diligent historians have stopped trying to make a precise interpretation of the facts on a philological basis.

The most pressing need is to establish what part Phidias played in the decoration of the Parthenon. Plutarch says simply that Pericles made him responsible for all the works and that he also had master craftsmen at his disposal to assist him. We also know that the plastic decoration had a certain chronological sequence: the first elements to be created on site were the metopes, which were inserted between the triglyphs and therefore did not need to be made in any particular order; next came the slabs forming the east and west friezes, also created on site, on which all the master craftsmen cooperated, trying to achieve a stylistic note in harmony with the two friezes on the long sides, which were worked while already in position, but by lesser artists, with the more important ones acting as supervisors. The last step involved the sculptures on the pediments, which could not be installed until the temple was finished and the roof put on.

containing the Caryatids.

Phidias was an ardent admirer of Pericles. He understood that for Pericles the construction of a large Acropolis represented the perfect religious embodiment of a grand political idea, namely the affirmation of the democratic and cultured *polis* as a model for all the other *poleis* of Greece so that a single ideology would bring about national unity.

Phidias reflected elements of both Pericles and Anaxagoras. In deference to Pericles he represented Athena three times on the Acropolis: once in a thoughtful pose, carrying her helmet in her hand to signify that she was not thinking of battle, once as *Promachos*, ready to defend her city by force of arms, and once as *Parthenos*, but also *Polias*, in a colossal, ivory and gold statue encrusted with jewels which portrayed her as the truly majestic protectress of a city that was well on its way to becoming capital of all Greece. He crowned his career by creating a representation of *kosmos* in the form of his statue of Zeus in the temple at Olympia. Like all great artists who succeed in effortlessly capturing the spirit of their day, he also understood Anaxagoras, and on three occasions portrayed that circular course of the stars which the philosopher saw

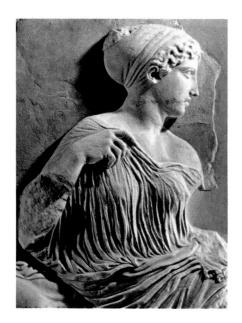

The metopes, the first elements to be created, show that sculptors of different schools were employed: followers of different traditions, some of them even pupils of the authors of Tyrannicides, others of Myron. The unmistakable style of the Parthenon was thus not imposed by one artist at the start of work: it evolved during the construction of the building. It therefore follows that if the reproductions of Phidias' statue of Zeus display characteristics of the mature Parthenon style, then the former does not predate the building of the Parthenon, but is later, which would mean, as some reliable sources suggest, that it was Phidias' last work.

The colossus was constructed in a workshop (*ergasterion*) in the Altis or Sanctuary at Olympia, which was discovered in the earliest excavations and recently re-excavated: the same site also yielded the clay moulds used to colour the gold for Zeus' cloak and the clothing of the Nike he was holding in his hand. The colouring of the plaster in these moulds shows that there was nothing archaic about the drapery.

We can thus reconstruct Phidias' personality: as a young man he created the Kassel Apollo, which already displays the same need for grandeur that was to manifest itself later, while at the end of his days he achieved that sublime quality recognized by the ancients in his statues of Zeus which marked the culmination of his art. He certainly had not previously executed the carvings on the Parthenon be-

Above: in the east frieze of the Parthenon, sitting gods (among them Artemis, shown here) await the arrival of the Panathenaean procession. Acropolis Museum, Athens.

Below: young water-carriers, north frieze of the Parthenon, a happy episode in the choral story devised by Phidias. Acropolis Museum, Athens.

cause it would have been too great an undertaking for one man on his own and also because he had to attend to the creation of his statue of Athena, but he was nevertheless wholeheartedly involved in the project. In the first place he provided the ideas, which are still conventional in the metopes and include symbols of the myths representing civilization's fight against the barbarians; they then suddenly achieve a strongly poetical quality in the frieze glorifying his own, and Pericles', native city, which depicts Athens with its people, dignitaries, religious devotees and its goddess's sacred maidens, all of whose expressions and clothes make them equal to the gods until the eastern pediment, where the gods are happy and where their divinity lies

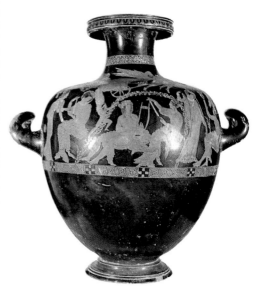

both in the way that they are not concerned with man and also in the fact that, were they to stand up, they would be twice as tall as any mortal. They are happy and unconcerned with mankind: they are merely a symbol, an abstract representation of their benevolence toward the city. As at Olympia, the eastern pediment reaches out toward eternity and is calm, with a single figure, Athena, standing sharply out to affirm her dominion over humanity; the others display the calmness befitting gods. In the western pediment, which is devoted to mortals, tumult reigns: all the figures, apart from the two participants in the struggle for Attica, namely Athena and Poseidon, are mortals, members of the two families of the Cecropidai and Erectheidai, who look us straight in the eye, whereas in the eastern pediment the gods look away. Such a grandiose design must have been the product of a single mind, just as a single mind must have been responsible for the consistently grandiose style that was absorbed by the others working on the complex.

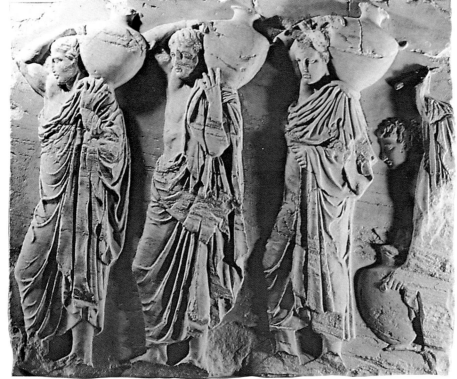

Opposite right: echoes of Phidias' style, though mannered, appear in the graceful scene of the myth of Phaon painted on the Meidias hydria (410 B.C.). Archaeological Museum, Florence.

Below: the Parthenon owes Phidias and his school the frieze, metopes and the two pediments. Here we see the east corner on which were shown in the round the birth of Athena, with Dionysus half stretched out and the horses of the rising sun.

Right: statue of Riace (Calabria), proof of skill in bronze-working c. 440 B.C. with a high level of formal and technical knowledge. The artist has not been traced, but the quality of this heroic warrior is undoubted. From a group of votive figures in a public place. National Museum, Reggio Calabria.

Sculpture of the age of Phidias. The great personality of Phidias, apart from always having been placed at the pinnacle of Greek sculpture, as is shown by the case of the bronze figure found at Riaci, wielded such an overwhelmingly strong influence on his contemporaries that nowadays we are unable to identify, from among the names provided by written sources, the authors of the original works known to us solely through Roman copies, generally of mediocre quality. All these works reveal Phidias' great feeling of moral calm, his taste for tightly curling hair and for clothing that hangs in copious folds, sometimes creating extensive effects of light and shade and sometimes clinging to the body, revealing its contours: in other words they

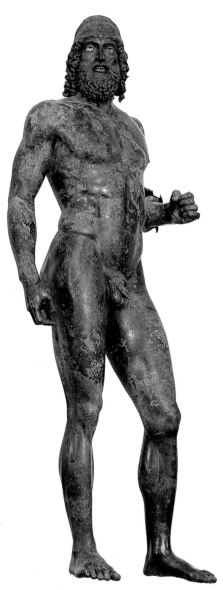

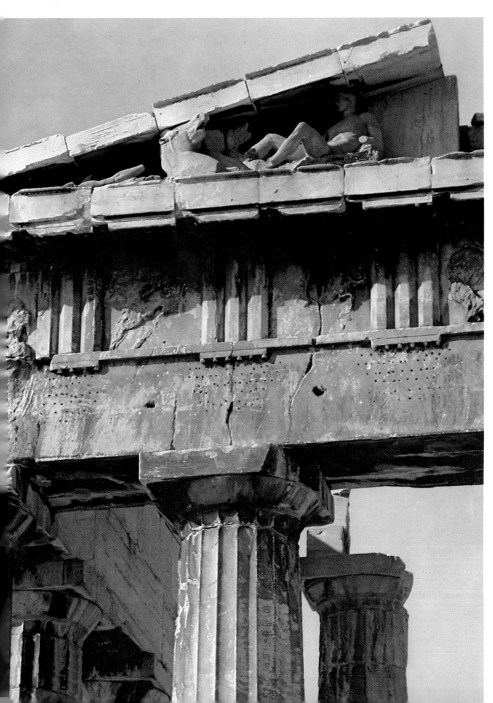

display all the features of that style known to some as "Parthenonic." As always happens with art everywhere, imitation degenerated into "mannerism" and Greek artists began to no longer express their own personalities or even to create copies: they merely worked "in the manner of…" The result was that the end of the century saw the disappearance of that beautiful, almost "wetted" style of drapery found in the Aphrodite in the eastern pediment of the Parthenon and the emergence of a new type, so lacking in any feeling of consistency that the folds seem to emerge from the skin. This mannerism occurred in both sculpture and ceramics, where the portrayal of myths acquired a graceful quality that was almost rococo in style. Apart from anything else, following the tragic experience of the Peloponnesian War, which showed clearly the inability of the Greeks to overcome their regional rivalries, as well as creating great economic hard-

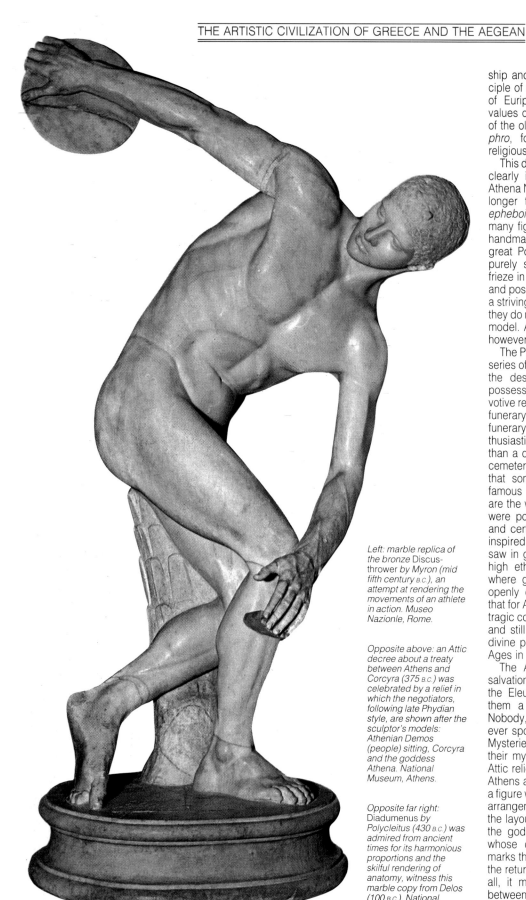

Left: marble replica of the bronze Discus-thrower *by Myron (mid fifth century* B.C.*), an attempt at rendering the movements of an athlete in action. Museo Nazionle, Rome.*

Opposite above: an Attic decree about a treaty between Athens and Corcyra (375 B.C.*) was celebrated by a relief in which the negotiators, following late Phydian style, are shown after the sculptor's models: Athenian Demos (people) sitting, Corcyra and the goddess Athena. National Museum, Athens.*

Opposite far right: Diadumenus *by Polycleitus (430* B.C.*) was admired from ancient times for its harmonious proportions and the skilful rendering of anatomy, witness this marble copy from Delos (100* B.C.*). National Museum, Athens.*

ship and inflicting a serious blow to the principle of democratic freedom, and in the wake of Euripides' tragic scepticism toward the values of religious ethics, very little remained of the old beliefs and myths. In Plato's *Euthyphro*, for example, Socrates calls all the religious beliefs of the past "ancient fables."

This decline in ancestral beliefs can be seen clearly in the balustrade of the Temple of Athena Nike, in which the figure of Victory is no longer the ancient goddess to whom the *epheboi* devoted themselves: there are now many figures of Victory (*Nikai*), acting as the handmaidens of Athena, herself no longer the great Polias, but a youthful goddess with a purely symbolic value who appears in the frieze in several different places. All the robes and poses, both of Athena and the *Nikai*, show a striving for gracefulness and detail, although they do not differ substantially from the Phidiac model. All in all, there is a mannered feeling, however restrained.

The Phidiac influence can also be felt in that series of carvings which, although not meriting the description "popular," nevertheless do possess a cursive character; they consist of votive reliefs bearing texts of Attic decrees and funerary reliefs, especially the famous Attic funerary stelae, which were greeted so enthusiastically when they were unearthed more than a century ago during excavations of the cemetery in the Kerameikos district of Athens that some of them were attributed to very famous names. In fact, none of these stelae are the work of great sculptors, although they were possibly designed by first-class artists and certainly carved by craftsmen who were inspired by the rhythmicality and drapery they saw in great sculptures. As regards the very high ethical content of the funerary stelae, where grief for the dear departed is never openly declared, it should be remembered that for Athenians death did not have the same tragic connotations as it had for other peoples, and still has today because of the terrors of divine punishment instilled during the Middle Ages in particular.

The Athenians possessed the means of salvation in that they had all been initiated into the Eleusinian Mysteries, which guaranteed them a peaceful journey to the hereafter. Nobody, not even the most daring sophists, ever spoke in ironical terms of the Eleusinian Mysteries, which shows the depth of belief in their mystical properties. At the head of one Attic relief, recording a treaty signed between Athens and Corcyra in 375 B.C., there appears a figure which, in the rhythm of its pose and the arrangement of the folds of its peplos, repeats the layout of a very beautiful statue depicting the goddess Eirene with the infant Ploutos, whose date it thus determines. The latter marks the end of post-Phidiac mannerism and the return to a feeling of solemnity, but, above all, it marks a renewed sense of harmony between body and clothing that brings it closer to human concepts. We know that the

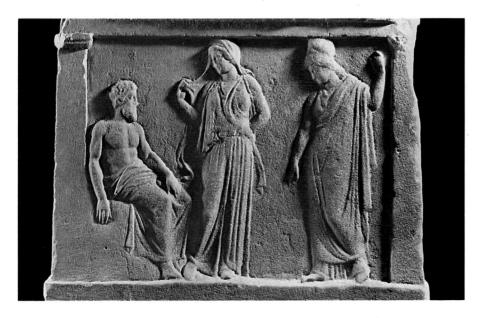

ever, is already there, which means that the problem of lightness was solved by Polycleitus in stages, first by freeing his figures from their earth-bound quality and then by concentrating on their proportions.

The "sentimental" Classical style. Before finally flowing into realism, Greek art first had to undergo a further two human experiences, no longer linked to a search for the divine but to the investigation of sentiment and grief. It had to enter that phase of spirituality that has quite justifiably come to be known as "romantic." Praxiteles represents the aspirations of a society that no longer believed in the ancient gods and that did not even have that sense of Hellenic mission possessed by Phidias: he belonged to a society that had been drained by the experiences of the Peloponnesian War and that was beginning to seek a leader, not an uncrowned king like Pericles, but a true monarch.

Praxiteles followed in the wake of Polycleitus, who had already instilled a feeling of movement into human statues, and he grasped the importance of this discovery, which allowed figures to shed their feeling of heaviness. Sculptors were now able to create figures with more slender limbs, with graceful rhythms that could express the gentleness of youth and achieve an almost dream-like quality. One of his earliest works, depicting a satyr pouring a drink, shows his desire to give the figure a sinuous shape and so create a religious rhythm with a delicacy befitting the

group depicting Eirene and Ploutos was the work of Cephisodotus and there are good grounds for supposing that this sculptor was the father of Praxiteles.

Polycleitus. Polycleitus, born perhaps at Sicyon but active in Argos, was no less important than Phidias in the development of Greek art; he practiced the chryselephantine technique and also sculpted in marble, but he worked mainly in bronze, in keeping with the Peloponnesian tradition, from which he also derived his love of pure structure and his fondness for the portrayal of athletic nudes. The ideal Phidiac nude has a feeling of relaxation, whereas that of Polycleitus is epitomized by precise proportional harmony, as exemplified by his most famous work, the *Doryphorus*, which for this reason is also known to artists as the "Canon."

We have already seen how the Doric temple in its definitive form possessed an extraordinary feeling of lightness, being based on an initial measurement that was either multiplied or divided into submultiples in accordance with the quintessentially Greek concept of "symmetry," and Polycleitus used the same system to build the human body. In this way he may be classed as an architect as well as a sculptor; but whereas we know that the *metron*, or basic measurement of a temple, was the pillar, the one used in Polycleitus' statues is still a secret: we can only say that the two works that can definitely be attributed to him, the *Doryphorus* and the *Diadumenus*, of which there exist many replicas, achieve an extraordinary feeling of lightness, although they are by no means slender. In fact, their proportions are so broad that up until a few years ago people believed that the adjective *quadratae*, used by Varro to describe Polycleitus' statues, referred to their extended dimensions, whereas we now know that it was

a translation of the Greek word *tetragonos*, which, although it does indeed mean "square" (*quadratus*), was also a term used in rhetoric to describe the chiastic balancing of words and phrases. In the *Doryphorus* this chiasmus is formed by the arms and legs, with the outstretched right arm being balanced by the flexed left leg, and vice versa in the case of the other two limbs. This procedure allowed the artist to impart a sense of perfect equilibrium to his figure, even though it is shown moving and sharply bending one leg, and also to let it touch the ground with just the tip of the toes.

By achieving a feeling of movement, Polycleitus made the most important artistic advance since the introduction of naturalism. It was not, however, the openly abrupt movement portrayed by Myron: it was of a subtle, internalized type, which freed figures from the weight of gravitation without actually showing them walking. There would be no point in trying to determine whether the *Doryphorus* is moving or not since Polycleitus' intention was merely to demonstrate that a statue can be given a feeling of lightness without any need to "humanize" it by means of some sort of action. The *Doryphorus* is an exemplary statue, a teaching model, the "idea" of man turned into bronze. Although it reveals exceptional anatomical knowledge, particularly in the smooth and subtle modelling of the body, and despite the fact that some of the minor details have been omitted, this nude's substantial idealism gives it a spare, tectonic quality, with no painterly overtones. There is the same tectonic quality in the hair, which, without being stylized, does not disturb the outline of the head.

The *Diadyomenos*, which shows a young man fastening a band round his head, must be regarded as earlier than the *Doryphorus*, because its proportions are not as perfect as the latter's; the feeling of inner movement, how-

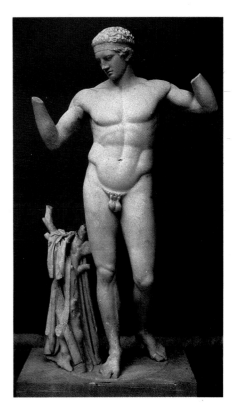

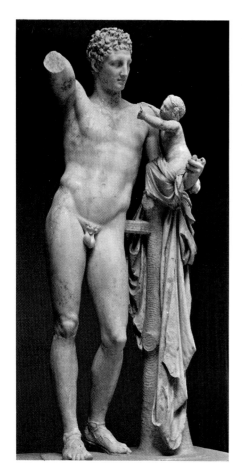

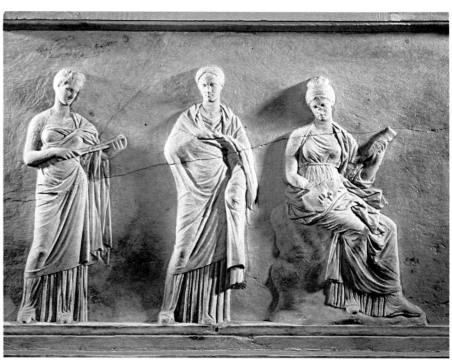

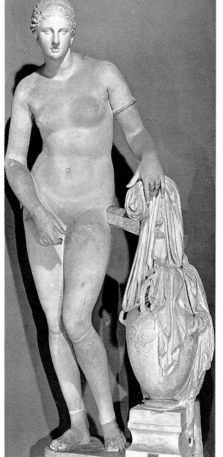

body of a youth who was no longer a savage dweller of the wild but a creature of the poets.

The work destined to make him famous was the *Aphrodite of Cnidos*, which we know only from decidedly mediocre copies and which appears in reference books in a late first-century B.C. variant created by the Tralles school. In the original, Praxiteles had to overcome a static problem: he needed to discover a way of anchoring to the ground a figure to which he wanted to impart a gently inclining quality and thus avoid a feeling of solemnity. In other words, he was trying to make it "human." He did not want to create a bronze statue because he wanted his Aphrodite to possess the glowing whiteness of marble. The poses that can be achieved in marble sculpture are, however, very limited because the figures bend at the knee, and so Praxiteles hit upon the idea of placing a long cloak in the goddess's right hand, which would fall over a small water-jar and thus convey the act of bathing. This cloak, which would act as a support for the statue, would also form part of the subject rather than giving the appearance of a purely technical device. The goddess does not look straight at the onlooker, but neither is her gaze fixed on any particular object: there is no feeling of concentration nor of any personal interest. Her face is unmarked by any express-

ive characteristics, with the result that the work derives its spiritual aura purely from its rhythms and volumes.

Because of this substantial idealism, the *Aphrodite of Cnidos* is still truly a goddess and, although naked, her nudity seems totally natural. She is also a goddess in the way she faces out at us, but she does not belong to our world because her face is devoid of expression. Nobody familiar with the beautiful Cnidos peninsula as it juts out into the bright blue, permanently sunlit sea could help but imagine that Praxiteles was representing the goddess as she descended into the waves, suffused with light, or that it was the beauty of nature and the warmth of the sun that gave her her dream-like expression.

The same feeling of detachment can also be seen in Praxiteles' statue of *Apollo Sauroctonos*, where the support again forms part of the composition rather than being simply a technical expedient. It takes the form of a tree-trunk by which the young god stands as he prepares to kill a lizard with one of his arrows. The original must have been in bronze, so that the point of contact with the support would have been barely noticeable, since the statue needed only to touch it with two fingers: this inspired idea of a support meant that Praxiteles was able to give his figure a gently curving quality that linked in with the delicacy of its limbs and the almost feminine smoothness of its face. By achieving this physical feeling of lightness Praxiteles also overcame the problem of spatiality, regardless of the fact that he appears not to have been striving for any sense of realism since the god displays no

sense of involvement. And yet he is not the terrifying Apollo of the Homeric era or the daunting figure found at Delphi: he is a poetic being. If the *Hermes* found at Olympia were really by Praxiteles, then we would be in possession of an important piece of documentary evidence, but it cannot be an original work because no great artist would ever create a statue to prop it up against a support, just as no architect would build a house and then immediately add a buttress to prevent it falling over. From this we can deduce that the *Hermes* is an excellent copy of a Praxitelean original.

Praxiteles worked at Athens and in Asia Minor and was certainly the oldest of the three great fourth-century artists, even though his early work depicting a satyr pouring a drink links him to the Classicism of the fifth century.

Scopas can be dated to a few decades later, although he used to be regarded as older, on the basis mainly of literary evidence, inasmuch as it was believed that the sculptural decoration of the Temple of Athena Alea at Tegea, rebuilt after the fire of 395 B.C., according to the date fixed firmly by Pausanias, would not have been postponed for long, thus suggesting a date of 375 B.C.

It has been possible to reconstruct Scopas' personality because of the discovery of texts, as well as of items of sculpture created by him for the Temple of Athena Alea at Tegea. These are massive images, with heads that could almost be described as cubic, with deeply carved eye sockets and eyes cast upward. They are images of a grief that belongs not to the individual but which could almost be described as cosmic. These original works have enabled scholars to identify some of the likenesses described by ancient writers, such as that of the young Hercules, which shows how strongly Scopas fell under the influence of Polycleitus in his portrayal of anatomy. His beautiful statue of Meleager has a Polycleitan quality as well as recalling the anatomical delicacy of Praxiteles, just as his *Pothos* has a Praxitelean quality in the delicacy of the naked body and also in the way that the artist has disguised the support by blending it in with the composition.

Scopas wielded a great influence on Hellenistic sculptors, particularly those of the Middle Hellenistic period, whose compositions and expressions of pathos he inspired.

Lysippus and realism in Greek art. Greek

civilization now graduated from naturalism to individualistic realism because orators, politicians and philosophers were seeking a leader, maintaining that history could be made by a single individual as well as by the collective decision of the *polis*. Lysippus interpreted this realistic concept of life in two ways: by placing man on his own, without onlookers, and by creating a sense of inner movement that called for a different proportional canon and no longer allowed artists to ignore the play of light on the body.

Written sources tell us that he was originally a metal-founder who later learned the art of sculpture and also that he sought advice from a Sicyonian on which subjects to choose and that the latter pointed to the people moving in front of his workshop. We know that he acknowledged no master, apart from the *Doryphorus:* we can deduce this because, if the *Doryphorus* had been the artistic embodiment of Polycleitus' search for the ideal proportions, it is clear that it must also have been the starting-point for Lysippus when he established another canon, in which there existed not just frontal movement but also movement within space, within all three dimensions.

In any case, it seems clear that Lysippus was exposed to Polycleitus' influence, whom

Opposite left: the group of Hermes and Dionysus, *a signal work of late Classicism.*

Opposite right: inspired by Praxiteles, the relief of the Muses, refined decoration on the socle from Mantinea (330–320 B.C.). National Museum, Athens.

Opposite below: Aphrodite of Cnidus, a famous marble by Praxiteles (350 B.C.). The novel imagery, the nude goddess, the wavy rhythm and the subtle treatment of volumes make this a masterpiece. Vatican Museum, Rome.

Above right: Lysippus transformed and renewed the classic rendering of the athlete: Apoxyomenus, in bronze, by the posture of the arms marks the conquest of three dimensions (330–320 B.C.). Vatican Museum, Rome.

Right: statue of Hygeia, attributed to Scopas (370 B.C.), in the temple of Alea Athena (winged Athena) at Tegea. National Museum, Athens.

he would even have been able to have met, given the fact that we know from written sources that he died at a great age. This would mean that in 400 B.C. or slightly later he would have been a young man.

Both in its anatomical structure and its overall concept, his statue of *Agias* betrays strong Polycleitan influences, as does another work by him, known from coins and reproductions, the *Heracles* made for Sicyon. His famous statue of Alexander carrying a spear was also, assuming that the small bronze in the Louvre is truly a reproduction of it, based on the study of Polycleitan models.

His true artistic originality can be seen in the *Apoxyomenos*. Here the feeling of movement in the legs, which also occurs in the *Agias*, is matched by outstretched arms and a twisting head and torso, so that the movement is no longer two-directional, but multidirectional or helicoidal. The *Apoxyomenos*, which was definitely his greatest work, also reveals the artist's basic sense of realism in that the face, rather than displaying the impassiveness found in statues of athletes from the Classical era, has a nervous quality. The features are rendered in such a way as to express a feeling of individuality rather than being just a conventional portrayal, while the hair, without being "baroque," matches the nervousness of the body. The body itself, although not slender, has a feeling of flexibility and, because it portrays an Apoxyomenos, a man scraping off a mixture of sand and oil from his body, probably represents a wrestler.

We know from written sources that Lysippus represented not only facial characteristics in a realistic way but also the psychological complexities of the human character, as in his portrayal of Alexander carrying a spear, which exuded a feeling of imperiousness and strong emotion. Under Lysippus, therefore, Greek art, entered the realms of realism.

Painting of the second half of the fifth century. No paintings of this period have survived, but we do possess a great deal of information on four of the most important painters of the day, two of whom achieved particular fame.

Agatharchos of Samos is credited with having perfected the technique of portraying foreshortening in true perspective, meaning the convergence at a single point not only of the lines of the figures but also of the objects surrounding them. It cannot yet have been a truly scientific form of perspective, since that would not be achieved until the Hellenistic era: it must have been a form of spatial experimentation arising from the experiments that had already been made during the time of Polygnotus. He painted the scenery for a tragedy of Aeschylus in Athens and also decorated the house of Alcibiades in 420 B.C.

The invention of *chiaroscuro* is attributed to Apollodorus, the *skiagraphos*, and was then developed by the great Zeuxis. It is believed that a painting from Herculaneum depicting

young girls playing knucklebones is a copy, signed by Alexander of Athens, of a painting from the time of Apollodorus. The girls have no shading in their hands or faces, but there are strong shadow effects in their clothing. The same feature also recurs in Attic *lekythoi* from the second part of the fifth century.

Prior to Zeuxis, the most important painter recorded in literature was Parrhasius of Ephesus, an Ionian in both appearance and temperament, famed for his soft and luxurious lifestyle, who strangely enough never chose effeminate subjects, preferring to portray

legendary heroes, many of them doomed to meet tragic fates.

In his *Memorabilia*, Xenophon refers to a conversation between Socrates and Parrhasius in which the philosopher asks the painter if he paints just the body or also the mind. When the latter replies that things with no dimensions cannot be represented, Socrates explains to him that the face expresses the good and evil impulses of the mind, projecting virtue or degeneracy, and that Parrhasius should recognize that psychological attitudes can indeed be portrayed. This passage is important because it shows the great advances made by Parrhasius in the movement toward portraying character started by Polygnotus, giving his figures individual expressions and also expressing pathos and other complex emotions. In his *Philoctetes* the grief was expressed by a tear in the eye: the personification of the Athenian *demos*, he appeared as a figure full of contrasts, unjust and merciful, lofty and humble, fierce and timid.

Parrhasius' greatest discovery, however, was the line we would nowadays call "functional," meaning that it serves to modify the outline, itself an abstraction designed to reproduce the reality of the human body, a structure composed not of lines but of surfaces and volumes, and so convey an idea of the space surrounding the figure. Pliny, in stating that Parrhasius deserved to be praised for having portrayed the contours of the body, adds that "the outline should in fact turn on itself, as it were, and end in such a way as to allow us to imagine other planes and other lines beyond, as though its aim were to somehow also indicate that part which of necessity remains hidden."

The other great painter from the age of the Peloponnesian War, Zeuxis, also appears in conversation with Socrates, in the *Protagoras* to be precise, a dialogue which is thought to have taken place before 429 B.C. because Pericles' two sons were still alive. Pliny dates his artistic heyday to alternatively 425 and 397 B.C., but the former is more likely. Lucian says that he did not paint common, popular subjects and rarely portrayed heroes, gods and battles, but always strove to create something new, adding that when he depicted something strange and unusual he also revealed his artistic dexterity.

As an example of this search for the fantastic Lucian cites his painting of the Centaur's family. The mother Centaur was shown suckling her young, one with the breast of a horse, the other with the breast of a woman, while their father stooped smilingly over the children, entertaining them by shaking the remains of a lion. The Centaur had a fierce yet smiling face, while his wife was of extraordinary beauty. Lucian also records that when the painting was displayed, the public, attracted by the strangeness of the subject, applauded loudly, whereupon the artist ordered it to be

removed, stating that it was not a painting's subject that mattered, but its formal perfection. Another famous story, recalling the contest between Parrhasius and Zeuxis, when the latter painted a bunch of grapes that were so realistic that birds pecked at them and he himself ordered the picture to be destroyed, shows that he loved *genre* subjects and favoured a very lifelike style. We know from other sources that his paintings also had a monumental and majestic quality.

Basically, it can be said that painting at the time of the Peloponnesian War achieved major advances in the field of naturalistic represent-

Opposite: a lekythos *for storing perfumes; also for funerary uses, as shown by the white ground on which the scene of a tomb visit stands out, with two tormented hints at the theme of death. In the center, the grave stele with the small offerings (small lekythoi, festoons, crowns); on the left, the image of the young deceased, clad in a short cloak, is clear and precise in outline (440 B.C.). From Eretria. National Museum, Athens.*

Right: Philoctetes wounded, on a stamnos signed by the Attic vase painter Hermonax (460 B.C.). Not only is the subject rare, but the figures are foreshortened, as in large paintings. The Greek hero's suffering is deftly expressed by the details of the three-quarter face. The sympathy of his companions is shown by gestures of help or grief. Musée du Louvre, Paris.

mathematician. Other painters of this school were equally erudite, producing theoretical works on art and technique for their pupils, who formed a college in which the course lasted twelve years. They painted mainly using encaustic wax.

Pausias of Sicyon gave a particular glaze to his colours and painted garlands of flowers because, according to one account, he was in love with the flower-seller Glicera, whom Pliny says he also depicted in a famous painting entitled the *Stephaneplokos*. From passages referring to other paintings we learn that he knew how to paint faces behind glass and

ation, *chiaroscuro* and the use of the "functional" line, but that it lost its taste for great heroic compositions. Large-scale wall painting disappeared and easel painting took over, portraying scenes that were graceful, but lacking in any feeling of ethical depth.

Painting in the fourth century B.C. During the fourth century two great schools flourished, the Sicyonian and the Thebo-Attic, the first of which lasted for four generations and began with Eupompos. The true founder, according to Pliny, was Pamphilos, who was also a skilled

achieve vivid foreshortening effects by means of *chiaroscuro* alone, without "lights."

Another member of the Sicyon school was Apelles, a native of Colophon, who is regarded as the most important painter of Antiquity; he was court painter of Alexander and praised for his *venustas* in painting. From the anecdote concerning the contest held between himself and Protegenes of Rhodes to establish which of them could trace the thinnest line, it could be deduced that he was a perfect draughtsman but not colourist, whilst another story, which tells of how, in a fit of rage at his inability

to clearly portray the bloody foam on the mouth of a horse, he threw the wet sponge at the painting, would seem to suggest that he was interested in *chiaroscuro*. The fact that he was a colourist could also be deduced from the fact that his most famous painting, of Aphrodite Anadyomene, owed its reputation to its wonderful pink flesh-tones. We also know that he experimented with the effects of light because his portrayal of Alexander with a thunderbolt had a dark body and a face lit up by the thunderbolt.

A third painting by him, of Calumny, was also famous in Renaissance times because of the exact description provided by Lucian. Botticelli, who was familiar with Poliziano's Greek text, made a reconstruction of it in his famous painting in the Uffizi. The founder of the Attic or Thebo-Attic school was Aristides of Thebes, one of whose followers, Nikomachos, was the master of Philoxenos of Eretria, which brings us into the Hellenistic era. Another of Aristides' followers was Euphranor of the Isthmus, who was also a sculptor and wrote a treatise on colour and symmetry. From his statement that Parrhasius had painted a Theseus made of roses and that he had painted one of flesh and blood we may conclude that he was a realist, which is understandable in view of the fact that he was still active in 340 B.C.

Hellenism (325–310 B.C.). The art of the closing decades of the fourth century, which marked the early beginnings of Hellenism, still lived in the shadow of the great masters, particularly Praxiteles and Lysippus, both of whom had left flourishing schools behind them. The soft modelling and "smoky" quality of Praxiteles, however, became rather mannered, with the result that surfaces lost their consistency. Similarly, the delicacy of the female nude became rather affected and contrived. The Medici Aphrodite, for example, is no longer a goddess like the Aphrodite of Cnidos.

The realism of Lysippus and a sense of spatiality formed the basis for what can be called centralized rhythms, since figures were constructed in such a way as to take up the least possible amount of space. They are solids enclosed in compositions in which line and volume converge on a fulcrum, as exemplified by the Antioch *Tyche* of 300 B.C. and the *Demosthenes* of 280. The latter represents history's first "intimate" portrait, and it was only a short while later, or perhaps even contemporaneously, that the Greco-Asiatic world began to embark on the great "colourist" experiment.

The style of Lysippus was esentially tectonic. His portraits, even when destined to express the complex spirituality of Alexander, were spare, sober and concise. In his likeness of Epicurus there is a slight feeling of movement in the interplay of light and shade, with the result that its expression achieves a feeling of dynamism that the measured serenity of

Classicism had never sought to convey. There is no reason to suppose that the many surviving replicas of the Epicurus are not derived from the portrait created by him in 260 B.C.

Not long after, a Bythinian sculptor, Doidalsas, created the bronze statue of Zeus of Nicomedia, known to us through coins and a small marble reproduction, which must have had a great feeling of inner dynamism and nervousness. The second statue that made him famous was his one portraying Aphrodite washing herself. There is a great feeling of sensuality in the goddess's gently rounded contours, while her parted lips have an almost girlish quality and her hair is beautifully portrayed in tangled curls. The lushness of her body is still that of a goddess, although she has an even more earthly quality than the Aphrodite of Cnidos, whose divinity lies in the rhythm of her pose, which conveys the idea that she is manifesting herself to mankind.

One particularly charming group, dubbed "invitation to the dance," in which a satyr playing the kroupezion with his foot beckons to a nymph, who is shown unlacing her sandal, appears on a coin from Cyzicus. The position of the figures shows that the artist had learned the technique of achieving an effect of centralized rhythm through a composition based on triangular masses, but the scene equally reveals a lively colouristic sense in the nude, in the hair and also in the nymph's clothing. Its subject-matter displays the Hellenistic taste for the idyllic and epigrammatic.

In order to explain the main characteristics of Asiatic art more fully we should add that the Hellenistic era was one of great learning and that for this reason the nudes of the period are not only rich in "colour" and a feeling of inner energy but also reveal an exceptional degree of anatomical knowledge.

Many of the works that resulted from this move toward expressive dynamism, which we know only from copies, can be attributed to schools in Asia Minor not only because of their similarity to original fragments discovered in the area but also by a process of elimination. The great Eastern conquests of Alexander the Great brought about a halt, if not in the culture of mainland Greece then certainly in her art, since all her greatest talents, whether artistic or not, emigrated to those lands that had always been rich, but had now been opened up to the prodigious genius of the Greeks. As a result, during the whole of the third century Greece proper appears almost bereft of works of art. The great emporium of Alexandria, on the other hand, revealed an art rich in painterly evocations that could justifiably be called "Impressionistic," but which, for this very reason, lay outside the Classical tradition. It was, above all, an art without names.

From the beginning of the third century, the rich and well-ordered republic of Rhodes played host to a large number of artists, who worked in bronze and created works that were probably of outstanding quality, but of which

no trace remains today. In any case, Rhodes' artistic output, which was linked to that of the nearby island of Cos, which was rich in marble, only really developed after the two islands attained considerable economic power following the victories, achieved in alliance with Rome, over Philip V of Macedon and Antiochus III of Syria, in other words, after the Battle of Magnesia in 190 B.C. It was during this period that Cos, whose inhabitants had previously built in travertine, was able to acquire a wealth of fine new buildings by opening up its marble quarries.

The new Hellenistic dynasties were eager to give the appearance of being heirs to a truly Greek tradition, partly, but not solely, in order to link themselves to the idea of their being the saviours of Western civilization, just like Athens after the victories of Marathon, Salamis and Potidaea. At that period Greek pride, particularly in the case of Athens, had reached a high point and, in order to show how the *polis*, because of its spiritual importance, had vanquished the Persian barbarians, they linked this historical victory to the mythical ones of the Gigantomachy, the Amazonomachy and the Centauromachy, all of them symbols of defeats suffered by barbarians at the hands of civilized men.

Next to the Temple of Athena Polias, whose name recalled that of Athens, Attalus I of Pergamum wanted to also represent his victories over the barbarians, in other words the enemies of civilization. These barbarians were the Galatians, who roamed the lands of Asia Minor threatening the security of the kingdom of Pergamum. They were portrayed in their natural state, at their most violent, as warriors, naked except for a cord round the waist or perhaps a gold torc around the neck, although we know that other Gauls fought in clothes or even wearing full hoplite dress. The artists, who wanted to portray the Galatians at their most savage, wearing no clothes, have depicted them in very violent attitudes and with great dramatic power: one wounded man is shown fallen over his war-trumpet. The pose is magnificent and the feeling of agony is very clearly expressed, but little attention is paid to anatomical detail. It may be that the artist was trying to achieve too realistic a portrayal of the way that the muscles of a white-skinned northern European would not have been so readily visible on the surface of the body. The feeling of agony, however, is very vividly conveyed. The "Dying Gaul" is now in the Capitoline Museum, Rome, whereas the group portraying a Gaul killing himself after having first killed his wife is in the Terme Museum. Both these works were excavated in Rome and are made of Asiatic marble, and there can thus be no doubt that they are copies made on site, replicas of that same votive offering referred to above.

This votive donation can be dated: literary sources clearly state that it was ordered by Attalus I and also mention the names of the artists, while excavations have shown that the

sculptures were placed next to the Temple of Athena. The realism of these works shows a firm mastery of form, but also a tendency toward historical glorification that was to become even more evident in later Pergamene works.

The sculptor Myron also worked on this commission according to Pliny, who says that he created the statue of a drunken old woman, which was famous at Smyrna. Copies of this statue have survived and it is also reproduced on a figured vase from Scyros, which bears an inscription in letters that can be dated to the second century B.C. Assuming that this work could be dated to around 180 B.C., we find ourselves in possession of an extremely interesting piece of evidence enabling us to assess an artistic trend, which, although originating in Ionia, could have found its way to Rhodes. The old woman is stooped and carries a *lagenos* in her arms. She cuts a pathetic figure, but her clothing comes as a complete contrast: it falls gracefully around the base, with folds arranged in an almost decorative way. But what name should be given to this style of art? I myself favour a definition first introduced some thirty years ago: "virtuoso realism." It cannot be doubted that the artist who sculpted the drunken old woman knew all there is to know about human anatomy and that he would also have been able to portray rags, but he possessed that yearning for the ornamental that made him stop short of pure representationalism, which is basically not true art at all because it is too photographic.

In the same way, Rhodian artists succeeded in portraying the deepest aspects of physical pain in the first and second of Laocöon's sons, and also in Laocöon himself, who has been seized by the serpent, as well as displaying an exemplary knowledge of human anatomy. And yet the sculptors did not abandon their ornamentalist tendencies in that they arranged their figures against a background and created ornamental drapery between the different elements. This combination of ornamentalism, academicism and realism is what I would call "virtuoso realism."

We have to go back a bit to recall the history of Pergamum's artistic flowering. Eumenes II, the successor to Attalus, started work on his capital following the victory over Philip V of Macedon and Antiochus III of Syria, to be more precise, following the Battle of Magnesia in 190 B.C. The old city walls surrounding the hilltop were extended by the addition of two new ones made of fine masonry blocks, after which he built agoras, gymnasia and sanctuaries on the different terraces. He also endowed his city with a library and a university that rivalled the one in Alexandria. Around the Temple of Athena he erected a portico with a *pronaos* containing two orders of pillars, the first example of an architectural feature that has since been extensively copied. The balustrading of the portico was decorated with representations of Greek and barbarian

weapons, so detailed that they recalled chased metalwork.

Later, probably in 181 B.C., when the Nikephorian festivals in honour of Athena Nikephoros were instituted, he began building a great altar, which, in my opinion, must have replaced a much earlier, perhaps prehistoric, one. Together with the Altar of Zeus at Olympia and the one at Samos dedicated to Hera, it was considered to be the most venerable in the Greek world because it was formed of the ashes of animals offered up in sacrifice. The altar of Pergamum reveals a disconcerting sense of disharmony between the heavy plinth beneath and the thin colonnade above.

An altar discovered in the city of Camirus on Rhodes was found to be filled with ashes contained within small pillars: if we imagine that the original altar at Pergamum was originally made of rough stone with the accumulation of ashes contained by wooden posts, it becomes clear that, in the monumental reconstruction, these could have been transformed into thin, rather low pillars. We also know that the ancient altar of Hera on Samos was rebuilt on several occasions, right up until the Hellenistic era, to give it a more monumental quality.

There is another piece of evidence which would seem to validate the theory that the Pergamene altar represents a reconstruction of a much earlier one: the fact that on a coin from the reign of Septimius Severus, which definitely portrays the Altar of Pergamum, there is also a canopy depicted. This could be easily explained as a temporary structure to contain the ashes, which after three and a half centuries would have formed a sizeable mound.

The altar was built to honour Zeus and Athena, the two great deities who had granted the Pergamenes victory over their enemies. The choice of divinities in itself illustrates the desire of the king of Pergamum to identify himself with the history of Athens by paying tribute to the city's two protectors during the Periclean age, while the grandeur of the shapes, the nudes and the drapery recalls the Parthenon. However, because Eumenes was affected by the passionate emotions of Hellenism, he was unable to reproduce the ethical quality of Phidias. The turmoil of a generation that had to win its battle for freedom can be felt not only in the violent contrasts of light and shade and in the voluminous drapery, but also in the poses of the figures, which have nothing calm about them: they all either slant, move in violent diagonals or, as in the majority of cases, form part of twisting spirals.

The Altar of Pergamum evoked a forgotten

Toward 250 B.C., the sculptor Doidalses from Bythnia made a bronze figure of Aphrodite squatting in the bath. The tight if slightly sensual build of the body, the graceful posture of the arms and the tilt of the richly adorned head are evident in this marble copy from Rome. Vatican Museum, Rome.

myth, which had been brilliantly portrayed in the Siphnian treasury at Delphi shortly after 500 B.C. and which Phidias had also depicted because it was a great symbol of civilization's victory over the barbarians. As the ethic linked to the ancient myths weakened during the post-Socratic period, this legend too had been forgotten. It was taken up again by Eumenes in order to bring to mind Pericles and Phidias and the greatness of Greece.

The frieze on the great altar was a work of great beauty and originality, because the aim of the many artists of different races who worked on it, and who also placed their signatures at the base of the slabs, was to create a celebratory homage to a highly ambitious dynasty that wanted to defend the originality of Greek creativity from Rome, the new patron of the arts. It is my belief that the mood of violence that pervades the altar's carvings reflects the rebellion of the old allies, Pergamum and Rhodes, against Rome, the new master of the East, which had acted so correctly and diplomatically that it had not even asked for any recompense for its victories in the region, but was effectively the true lord of the Aegean, as well as being scrupulously correct in its conduct. The Romans felt strong ties with a vanished Greek world, the Classical one that had existed prior to Alexander the Great, and had become very disillusioned with the Greece they had encountered in their wars, which they found quarrelsome, disunited and, in their opinion, possessing few pretensions to legality.

The expert marble-workers responsible for the balustrade of the portico of Athena, with its decoration of arms, also created the marvellous detail in the figures of the Gigantomachy, which seem to possess metallic reflections. Younger craftsmen scupted the figures on the plinth (the ones at either side of the steps leading up to the altar proper), which were placed in position later, partly because of the order in which the building was carried out. They also created the frieze of Telephus that decorated the far wall of the colonnade, which was the last element to be adorned with carvings, again for technical reasons. Some people see this frieze, which recounted the adventures of Telephus, the founder of Pergamum, as being the work of another school, whose style was almost the antithesis of the Pergamene style. The relationship between the work carried out by the younger men who sculpted the great frieze and the Telephus frieze does, however, reveal strong stylistic similarities. The reason that the technique of the latter appears to be more cursive and more rapidly executed lies in the fact that, as in the Heröon at Gölbaşi, the frieze of Telephus was intended to be painted.

It has been quite rightly surmised that this large and opulent monument contained a rich display of art, the so-called "second votive offering" of Pergamum. We know from Pausanias that a man described simply as

"King Attalus of Pergamum" was responsible for erecting a number of statues, of modest dimensions, portraying Greeks, Pergamenes, Amazons, Giants, Persians and Galatians, along the north wall of the Acropolis at Athens:

this was clearly an attempt to draw a parallel between the victories of Pergamum over the Galatians and the ones over uncivilized peoples symbolized during the Classical era by the Gigantomachy, the Amazonomachy and the victories of the Greeks over the Persians. In fact, replicas of these images, of the same size as those described by ancient writers, have survived to the modern day, although they are not made of Attic marble as one would have expected but of Asiatic marble: this means that the offering made by "King Attalus" to the Acropolis at Athens did not take the form of original works, but of copies, while the originals were kept in Asia Minor. During the building of the Altar of Pergamum a change was made to the plans and a podium was attached to the far wall of the colonnade, which had already been fitted with a base cornice. There is no reason not to suppose that this podium served to support the figures presented in the second offering, perhaps following the new victory by the Attalid dynasty over the Galatians in 165 B.C.

These replicas, which are of relatively high quality, reveal the work of artists from different backgrounds and with different stylistic aims, but similar to those displayed in the Gigantomachy frieze in the great Altar of Pergamum, which has led me to conclude that the artists who worked on the great altar were the same as those who created the second votive offer-

ing. On the one hand we can detect a violent, almost baroque "colourism," and, on the other, a more analytical and realistic quality: some of the artists carried on the traditional Ionian form of pictorial representation, while others

Above: Eumenus II, king of Pergamum transposing historical events to a mythical plane, erected a monumental altar to all the gods and thus celebrated his victory over Syria. The grandiose frieze shows a dynamic battle of giants, the highlight being Alcyoneus laid low by Athena, crowned by a Winged Victory. The design rests on the brash crossing of diagonals and the marked chiaroscuro of the shaped volumes. Pergamon Museum, Berlin.

Opposite below: Dying Gaul, Roman copy of part of a bronze group, dedicated to Attalus I (c. 230 B.C.) on the Acropolis of Pergamum, showing the barbarians defeated. Capitol Museum, Rome.

reflected their training in the more measured school of the great Classical artists.

We have already mentioned the Rhodian school, which produced a large number of named artists, but no really significant works. It was, however, during this period that a marvellous sculpture, the *Victory of Samothrace*, was created, which is definitely Rhodian since it is perched on the prow of a bireme made of Rhodian stone. It is thought to be a votive offering made by Demetrius Poliorcetes to the sanctuary of the Kabeiroi on Samothrace, following his victories in 306 B.C. at Salamis off Cyprus, because the emblem of a ship also appears on one of his coins. Nobody, however, has been able to explain how he could have dedicated an offering at Samothrace, an

island that had always been hostile to him. Nor, on the other hand, is it possible to make any stylistic comparisons between the *Victory* in the Louvre and other works from the end of the fourth century. In the twisting spiral of its posture, however, and in the strength of its body, there are clear analogies with the figures on the great Altar of Pergamum: one thinks, for example, of the figure of Nyx. In Rhodes, heir to an ancient Classical and Ionian tradition, where artists were not interested in the celebratory *chiaroscuro* effects of their Pergamene counterparts, the clothing could not have the contrasting masses found in the Altar of Pergamum. Cicero once said of the orators of Rhodes "Neque attice pressi, neque asianice abundantes," and the same could be said of the man who sculpted the *Victory*. A sea-wind swells the folds, outlining the figure's fine, strong limbs, and its whole youthful appearance seems to reflect the happy state of a maritime republic characterized by wise laws and an eagerness to build. The sculptures discovered on Rhodes and particularly Cos, which possessed marble quarries, would seem to show that Rhodes, at the height of its power, during the first half of the second century B.C., was also the capital of that taste which I have called "virtuoso realism" and which others have called "rococo."

As well as the different treatments of the naked body to which we have already referred, other artistic achievements of the highest possible caliber were made in the portrayal of drapery, in which artists attempted to create truly astonishing effects, trying to make the folds of the linen *chiton* show through the surface of the cloak. Magnificent examples of this difficult technique have been found on Cos and in neighbouring localities: for example, in a cylindrical altar of Cos marble at

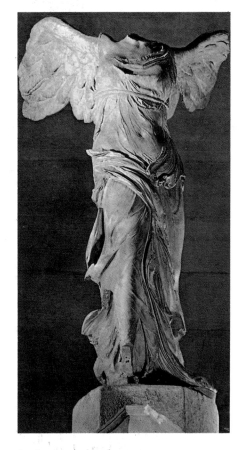

Above: to celebrate a naval victory, the Rhodians erected at Samothrace the marble statue of Victory setting her right foot on the prow of a ship; the clothes blown by the wind are draped round the body. Musée du Louvre, Paris.

Halicarnassus and a relief at Priene bearing a portrayal of Apollo and the Muses, in which this sort of painterly drapery is expressed with extraordinary delicacy. Large numbers of replicas and copies of these very graceful figures have been discovered in the Asiatic environs of Rhodes and later versions have also been found in Rome. Works of this sort were artistic *tours de force*, which also reflected a strong landscape element because they were designed to be arranged on rocks representing Mount Helikon: they fall within the Rhodian sphere of influence.

The friendship between Rome and the Greek states could not last long. Rome had given its conquered territories to its allies Pergamum and Rhodes and had proclaimed the freedom of Greece, but there was a feeling of distrust because of the vast difference that existed between the great, solemn and spiritual Greece that they had studied in the classics and the Greece with which they had come into contact. In addition, the wealth and luxury of the oriental world was radically transforming the rustic Roman aristocracy. It could be said, without exaggerating, that the rough and ready sons of Rome were beginning to feel a sense of Imperial *angst*.

As compensation for these economic and political humiliations Rome restored Athens to its role of spiritual leader, making it the most important university in the Mediterranean world and also one of the wealthiest cities of the day. The Athenians rewarded this generosity by reviving that style of Classical art which the Romans had always so loved and admired, creating copies, imitations or even new works, but all of them possessing a distinctly academic quality and a cold formal elegance.

This return to Classicism was also felt by the schools of Asia Minor in the form of a reduction in inventiveness, but not in actual displays of stagnation. The passage from the dynamic shapes of the "baroque" to those embodied by Classical ideals was not a rapid one: artists still felt drawn toward a feeling of pathos, with the result that many works clearly show the strenuous efforts made to accommodate the swirling rhythms of middle-period Hellenism to the Classical laws of frontalism. This can be seen in the *Venus of Milo*, for example, which has been attributed to Scopas because of the affectionately warm yet measured expression on the goddess's face. It is my belief that the figure was sculpted in Asia Minor during the second half of the second century B.C. because a small reproduction of it, which epigrammatically accompanies the goddess with a figure of Eros, was discovered on the island of Cos, and I would also link the *Venus* to a fine statue of Apollo found at Tralleis in Asia Minor.

Given the excellent quality of this replica, it has been thought that Praxiteles created two versions of his work, one slightly different from the other, but I personally do not believe this theory, because whereas the statue with the large amphora does not have the touch of

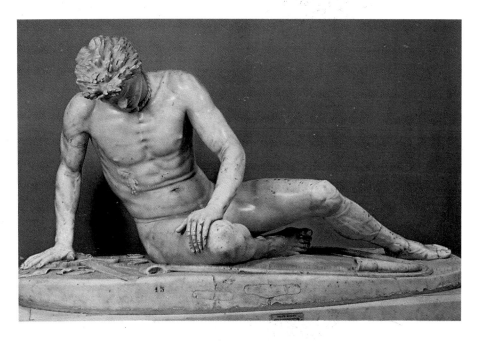

genius, the other one, although known only in extremely poor replicas, reveals the true greatness of Praxiteles. His aim was to create dreaming creatures, enveloped in a mood of gentle calm, but for this purpose he could not use the formal rhythms of his predecessors, even those employed by Polycleitus, the last great student of structure, who was his recent predecessor and whose teachings Praxiteles followed in his early works. In order for a figure to possess a relaxed and dream-like quality it has to free itself from reliance on axial symmetry and from any feeling of ponderous weight, but it is extremely difficult to create marble figures that do not rely on axial symmetry. Supports are needed because otherwise the sculpture would tend to break at the knees. Praxiteles, who wanted his Aphrodite to be of marble, so that it would radiate a feeling of warmth, and to endow it with a feeling of almost total freedom through a gentle and graceful sense of rhythm, invented a support that did not give the appearance of being a disruptive technical device, but became an integral part of the subject. The thick cloak that the goddess grasps in her left hand, as well as suggesting the act of bathing, acts as a very real buttress, anchoring the figure and preventing it from toppling over to the right.

None of these elements appears in the Aphrodite with the large amphora, which thus cannot be derived from a second work by Praxiteles, but is a variant created by an extremely fine sculptor, who in my opinion was from Tralleis, because all the works that have been discovered from that area, although Classically inspired, are not lifeless imitations.

The degree of finesse with which the artists of Tralleis interpreted Classical works can be seen in the "young boy" from Tralleis in Istanbul Museum. The figure's head, which has an essential, tectonic quality, mirrors the teachings of Polycleitus; its dress, which reveals no decorative intent, recalls the sober realism of Lysippus, while the gentle rhythmicality of the modelling is derived from Praxiteles. This fusion of different influences is achieved in such a way that one cannot speak in terms of academicism but of Classicism interpreted with great originality. With this sculpture we are already in the Imperial era.

Hellenistic architecture. When considering Hellenistic architecture we have to bear in mind one very important factor, apart from that of architectural orders and the internal arrangement of buildings, namely the advent of a new science, that of town-planning, founded, it may be said, by Hippodamus of Miletus, who lived toward the end of the fifth century B.C. He was a great theorist, which means that, as well as establishing canons and models, he must also have investigated the distribution of population on the basis of wealth and type of work: in other words, he must also have been a sociologist. Ancient writers attribute him with having invented the system of dividing cities

up into *insulae* within a grid of streets with regular, right-angled intersections. It should be immediately pointed out that this sort of arrangement cannot have been his invention because it had already existed for centuries, even millennia, throughout the East. The new ideas introduced by Hippodamus must have consisted, above all, in the use of the quadrangular *agora*, regarded as the hub of the street system, as the focal point, and in having laid out the streets in a parallel grid regardless of the natural contours of the terrain.

There is one portico in the sanctuary of Athena of Lindos on Rhodes which gives an excellent idea of the mathematical strictness achieved by Hellenistic symmetry. Above the foundations, made of blocks measuring three-quarters of a cubit by one and a half cubits, the façade rears up, the back walls of which have blocks of the same dimensions, while the height of each section of the pillars in front is exactly equal to the height of two wall blocks.

It is strange that Hellenism, which enjoyed such extraordinarily widespread popularity in

The famous Venus of Milo, *attributed to the Rhodian school of sculptors at the time (late second century B.C.) when they took note of Classical models, giving them an original touch.*

The sinuous movement is halted by the tight frontal arrangement, a rhythm accompanied by a refined contrast between the nude body and the moving drapery. Musée du Louvre, Paris.

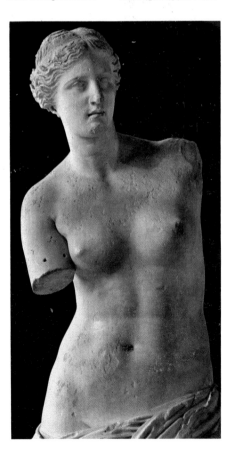

the East, did not exploit the Ionic style, but instead favoured the Doric. This may perhaps have resulted from the fact that the Hellenistic age was the age of the portico, with airy porticoes in which there were two aisles and whose median beam was supported by an Ionic column that could be much taller than the Doric one on the façade. In addition, Hellenism favoured large spaces between columns, in order to create lively contrasts of light and colour between the open and walled sections. The slim, somewhat insubstantial Ionic column would have found difficulty in supporting the weight of long architraves. It is for this reason that Hellenism preferred the Doric style, but not of the type found in Classical art, because, as we have already mentioned, as the centuries passed by the columns became more rigid through *entasis* and also taller, thus obliging the entablature to reduce in height. Despite all that, the Doric column was still more solid than its Ionic counterpart and for that reason it was preferred.

One of the strangest manifestations of the Ionic style in Asia Minor can be seen in the Temple of Artemis Leukophriene at Magnesia on the Maeander, designed by Hermogenes, an architect mentioned by Vitruvius. The temple is dipteral, meaning that it possesses a *peristasis* so far from the *cella* as to give the impression of a second inner portico. Because of the lightness of the style, however, the whole colonnade has a very airy quality. Above the colonnade there was a freize of an Amazonamachy and there were no statues on the pediment, just three windows. It was once believed that Hermogenes lived at the end of the third century B.C., but he is now placed a century or even more later, because of the fact that the Ionic order of the Artemisium at Magnesia has a clearly neo-Classical quality.

Funerary edifices with a colonnade above a tall podium were still being built in Asia Minor, some of which also had half-columns along the base. It was only a short step from this innovation to the elimination of the walls between the half-columns, so as to give both the lower and upper levels a similarly open appearance. This gave rise to the introduction of the two-tier portico.

Hellenistic architects did not discover the use of mortar, which meant that they were unable to create either large arcades or large vaults, but their skill in using masonry was unmatched. Their temples, whether in marble or stone, have layers of perfect blocks and their visual appeal is enhanced by the different ways in which these ashlars are worked: some of them are smooth and others chiselled, either hammer-dressed, gently convex or rusticated. The supporting arches were covered by vaults with shaped blocks, using no cement binding. Imperial Roman architecture inherited the rectilinear style from Hellenism, but the Republic had already adopted the Hellenistic type of town layout with parallel terraces of buildings linked together by steps.

Etruscan art

Spreading across a great part of the peninsula from their homelands between the Arno and the Tiber into the Po valley and Campania, the Etruscans held a leading position in the politics and culture of pre-Roman Italy. They developed a highly-organized civilization in their city-states – twelve by tradition in Etruria proper and as many more around Padua and in the south – and were prominent in Mediterranean affairs until the end of the third century B.C. Then, defeated by Rome, they entered the Roman political orbit and lost political independence, though culturally they were long a force to be reckoned with.

Our knowledge of their civilization is severely limited, for no evidence survives of their history and literature. Archeology has more to tell us of their art, their material life and tastes. Essentially it reveals the very complex features resulting from a combination of diverse influences – those of Ionia and Attica in particular – refashioned in original ways upon the responsive Etruscan foundation. The division into periods adopted in these pages reflects the main historical, economic and artistic changes occurring between the eighth and third centuries B.C.

Interest in the Etruscans began among the Humanists of the Renaissance and reached a peak in the eighteenth century, on which it left its cultural mark, together with some exaggeration of the importance of the Etruscans in pre-Roman history. This, however, has been corrected by more detailed modern study.

Villanovan period

First identified in the nineteenth century at the village of Villanova near Bologna, the proto-Etruscan culture of the Iron Age flourished between the ninth and eighth centuries B.C. It was socially and economically advanced, and coincided to a remarkable degree with the later centers of Etruscan development.

The crafts of this pre-urban civilization, especially those producing perishable goods from animal skins, wood, woven material or clay, were what we should term cottage industries. In ceramics this was certainly the case at least until the arrival of Greek potters who brought new technology and improved levels of quality. Metal-craft, too, was widely practiced, and the mastersmiths and metal workers were probably accorded considerable social status.

Tomb of the Ogre I (350 B.C.), Velia Spurinai, Tarquinia (detail).

Pottery. Most Villanovan pottery has been found in tombs, where cremated bones are placed in biconical urns. These urns are of rough impasto, or unrefined clay, and of two distinct periods. In the first phase, from the ninth to the early eighth centuries, forms may be those of the later Bronze Age, with simple impressed and incised geometrical patterns – meanders, swastikas, angled lines and squares – to emphasize the shape. Shapes are more various in some of the second-phase tombs (that is, dating from the rest of the eighth century), and may include cups, food-dishes and containers for liquids. They suggest that the banquet was now an accepted part of funeral custom, and that social differences were arising. Vases are decorated and enriched with human or animal figures, and the vase itself may be of animal shape – that of a duck or bull, for instance. Geometrical patterns decrease, though concentric circles are introduced and the schematic bulls and ducks of Bronze Age art make a reappearance. The actual clay, in competitive response to the refined and much-admired metal products of the time, becomes thinner and smoother, and may have a surface polish.

Metal-craft. True works of art were produced in the supreme material, bronze. In sheet bronze for scabbards, shields and helmets, belts and armlets, tableware for banquets, ritual and funerary objects and biconical urns; in cast

bronze for spears, swords, daggers, the decorative parts of larger pieces, and for personal ornaments. The sheet bronze was enriched with a lavish and subtly executed repertoire of motifs, including the "ship of the sun," and some from the animal kingdom (geese and other birds).

The Villanovan style was thus predominantly geometrical, though it admitted figurative designs blending easily with the geometrical culture of Greece, with which the Villanovan area was increasingly in contact from the beginning of the eighth century onward.

The Orientalizing period

Between the last two decades of the eighth century and the beginning of the sixth lies what archeologists call the Orientalizing period, since it saw the wide importation, and consequent imitation, of goods from the East.

As early as the eighth century Phoenician merchants had brought small, exotic luxury objects – of vitreous paste, for example, or of "faience" – into the area, while Greeks from Euboea had traded mostly in Greek geometric pottery and small articles from the Orient. From

Right: painted tile from a building in zone G at Acquarossa near Viterbo (c. 650 B.C.). The white-painted motifs, arranged as metopes, show animals (horses, herons, snakes), recalling sub-geometric ceramics of the time, particularly those of Cerveteri. National Museum of Villa Giulia, Rome.

Below: cinerary terracotta vase from Montescudaio (early seventh century B.C.). The biconic belly is covered by a cap. A seated figure adorns the handle, and a banquet scene the lid. Archeological Museum, Florence.

the end of the ninth century, however, these traders were joined by others from the Greek colonies in Italy (Magna Graecia), principally from Cuma. The development of large cities and the expansion of urban life in Etruria led to the further establishment of trading stations on the Tyrrhenian coastal fringe, where Populonia, Vetulonia, Vulci, Tarquinia, Caere (Cerveteri) and Veii became the most important centers for the reception and distribution of precious things from foreign lands. An emerging aristocracy seized upon imported exotica as a splendid means of proclaiming its rank by external display, and created an enormous demand for jewellery, valuable dishes and table-vessels, scepters, fans, toilet accessories and so forth. By an elementary law of economics this demand bred, as it grew, a vast local industry dedicated to the reproduction of the luxury goods that had set the mode.

The main market was an urban one, for by now the Villanovan villages had developed into walled towns. The wall was either, as typically in Latium, a simple *agger* with a defensive ditch, or built of unbaked brick as at Roselle. The walls of Rome, which archeology tells us were raised in about 510 B.C., are, significantly, attributed to Rome's Etruscan king Servius Tullius. Cities in the Orientalizing period were unplanned, spontaneous growths of already inhabited sites, and only at its end do they include buildings specifically designed for religious or municipal purposes. Again it is remarkable that an Etruscan king of Rome should be the traditional founder of the temple of Jupiter on the Capitol, as well as provider of

the Circus Maximus and *Cloaca Maxima*, all amenities suggesting a deliberate organization that goes far beyond the phase of haphazard city growth.

Architecture. Houses excavated at Acquarossa, together with the slightly earlier palace at Murlo near Siena and the older chamber-tombs of a type first hollowed out at the beginning of the seventh century and modelled on contemporary dwellings, are the sole examples we have – and these exclusively domestic – of the architecture of the Orientalizing period. Until the last half of the seventh century at least house structure is substantially Villanovan: rectangular, its wooden framework filled with litter and straw, the dividing walls and roof of light materials, but in mid century a revolution in building methods introduced considerable changes in architecture and layout. Interior walls were now solid and the wooden frame supported a tiled roof. The rectangular House at Acquarossa is of this later type, and its upper part was elaborately decorated. Moulded clay slabs covered the lintel and the sloping rafters of the roof, while tiles and antefixes were painted with animal motifs in white, and the big central *acroterion* has monsters symmetrically "affronted," as in heraldry.

In another modification of the house plan toward the end of the seventh century a larger central room is flanked by two lesser rooms – a layout well adapted to the pomp and ceremonial of the new ruling class of *principes* whose authority, on a system perhaps derived from Lydia, was exercised through the magis-

The luxury trade. As we have seen, luxury goods, regarded as symbols of power, prestige and position, were bought in huge quantities at this time by Etruscan aristocrats and members of the emergent ruling class.

It is not always easy to distinguish the imported objects of gold, silver and ivory from imitations, whether Greek or of local provenance. Examples of goldsmiths' work – then exhibiting new techniques, such as the delicate granulation found from the end of the seventh century – are jewels from the royal burials in the Regolini-Galassi tomb at Cerveteri and the Bernardini tomb at Praeneste (Palestrina). Such treasures are thought to have come from Ischia, the Pithekoussai of the Greeks, since Strabo mentions the gold of that island.

Some of the many silver cups and dishes from the richer tombs are also oriental imports. Others, such as the Phoenician-Cypriot *paterae*, were made in Etruria by immigrant craftsmen of an Eastern, or an orientalized Greek, tradition; while yet others are locally produced imitations.

Princely grave-goods show that ivory from the East was equally admired by wealthy

tracies. The tomb-chambers of Cerveteri are replicas of this arrangement, the best instance of which is found in the second phase (580 to *c.* 500 B.C.) of the great palace discovered at Murlo. Here sets of three rooms radiate from a spacious central courtyard, and the obviously oriental origin of the decoration confirms the sources of contemporary architecture, whose Eastern flavour was taking over Etrurian taste in matters of building and architectonic ornament.

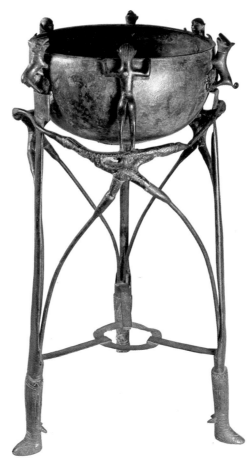

Above: gold fibula from the Regolini-Galassi tomb at Cerveteri (c. mid seventh century B.C.). Decorated with granules and repoussé motifs of animals (lions, geese), plants and geometric patterns; refined product of Orientalizing Etruscan art. Vatican Museum.

Above right: bucchero vase from the Cerveteri necropolis. National

Museum of Villa Giulia, Rome.

Right: bronze tripod from the Bernardini tomb, Palestrina (early seventh century B.C.). The vessel is decorated with silhouettes in the round of men and dogs after oriental models but with traces of Villanovian style. National Museum of Villa Giulia, Rome.

Etruscan patrons, but there was a minor local industry imitating the imported articles, and to it we should probably attribute most of the ivories from Marsiliana d'Albegna. Local manufacture is further proved by the existence of unworked chunks of ivory in a tomb at Vetulonia, a chief town of seventh-century Etruria.

Importation of bronzes was on a much smaller scale. Thanks to the previous tradition of bronze-making, large objects of sheet bronze such as *lebetes*, or cauldrons, on conical stands could be produced at home, though some additions – applied ornament from Greece, or even Anatolia, for the cauldron-rims, or Cretan components for the stands – still came from abroad. Despite occasional lapses and misapprehensions as to form and iconography, the Etruscan artists quickly learned the oriental idiom from their models, often with the happiest results, as Eastern elements were blended with the old Villanovan tradition.

By the mid Orientalizing period of 650–630 B.C. bronzes seem to have assimilated this Eastern idiom completely, as do the most typical of the luxury products, those in gold and ivory; and whereas in the orientalized art of Greece the human figure gradually assumes the lead, here the dominant motifs are animal, vegetable or geometrical.

Painted pottery. This, too, shows the same adoption of foreign models and their blending with the artistic tradition of the preceding century. Pottery of the Orientalizing period is of three kinds: impasto, bucchero (both used for

tableware) and sub-geometric. Impasto, which continues the traditions of the previous period, was, at the end of the eighth century, being made on the wheel by the new method from Magna Graecia, and incorporating the new shapes and decoration as they evolved. The small indigenous amphora with spiral ornament is supplemented by containers of later shape, their forms derived from Greece or from the Orient. Incised decoration still includes the established geometrical patterns, but there are fish and herons borrowed from contemporary pottery, while the Eastern repertoire contributes its typical rosette and plaited motifs, as well as rare figurative scenes.

Bucchero-ware, invented at Cerveteri toward the middle of the century, appears, in both form and in its colouring of black or grey, to derive from metal prototypes. The thinness, delicacy, and precisely drawn designs of its earliest phase ensured its appeal, so that production centers multiplied and its market

grew. But, as ever, increasing demand resulted eventually in hastier workmanship and the laborious procedure of incised decoration gave way to the speedier process of moulded relief.

The end of the eighth century saw the settlement at Vulci and Tarquinia of craftsmen from Euboea and the Cyclades. Their sub-geometric pottery soon attracted imitators, who at first worked chiefly in the archaic geometric style of Villanova. During the mid Orientalizing period they adopted from Greece the typically Eastern motifs of herons, fish and snakes, though not without such stylistic misunderstandings and accommodations, as occurred in the bronze-making of the period.

These developments in ceramic painting are reflected in the one example of mid Orientalizing wall painting that has come down to us, in what is known as the Tomb of the Ducks at Veii. Its frieze of ducks, executed entirely in red and yellow, is clearly related to the herons of contemporary Italo-geometric pottery.

The last phase

In the latest Orientalizing phase, from about 630 B.C. onward, Greek products dominated the markets of Etruria. It was a time of innovations, the most significant being the introduction of monumental stone sculpture with its diversity of stylistic sources. Sculptures of this kind are the enthroned figures in the Tomb of the Five Chairs at Cerveteri and the large Mourners, or guardians, from the Pietrera tumulus of Vetulonia. At Vetulonia there is much use of the Greek Daedalic style, with its ancient and widespread Eastern motif of the labyrinth – a borrowing from Greek plastic art well established in Etruria by the end of the seventh century. The *Centaur of Vulci* is more closely reminiscent of Peloponnesian sculpture.

Ceramics, too, were revolutionized, exchanging the Cycladic and Euboaen influence for that of Corinth, whose pottery was for a hundred years more extensively exported than was any other Mediterranean type. Corinthian-trained artists, such as the Painter of the Bearded Sphinx, were active at Vulci – leader, with Cerveteri, in acquiring Greek culture – and imitations of Corinthian pottery in what is called the Etruro-Corinthian style had distinct commercial success. Its animal friezes accord with an ingrained regional taste for zoomorphic themes, though important mythological subjects are not lacking.

In the same style are the few large-scale tomb paintings known from this period. They include frescoes from the Tomb of the Painted Lions at Cerveteri, that of the Ship at Tarquinia, and from the Campana tomb at Veii, which dates from the end of the century.

During this final Orientalizing phase, then, there grew up in Etruria a far-reaching network of artists and craftsmen able to satisfy much of

Above: terracotta statuette of a person seated on the tomb of Five Seats at Cerveteri (late seventh century B.C.). The figure has a triangular face, large almond eyes, a receding forehead and a mop of short hair. Draped in a lozenge-decorated cloak tied on the left shoulder, the figure rests its left hand on its hip and extends the right. An ancestral portrait, like two similar statuettes in London based on archaic Ionian models. Conservators' Museum, Rome.

Right: centaur from the necropolis of Vulci (c. 600 B.C.). This statue, which served to guard the sepulcher, is a fine example of Etruscan statuary inspired by Daedalus. National Museum of Villa Giulia, Rome.

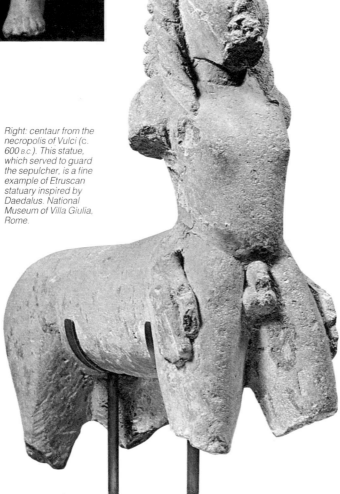

the local demand for manufactured articles, from ceramics for covering building surfaces to pottery and decorative sculpture. Toward the end of the period, which lasted into the first twenty years of the sixth century, commercial success stimulated the development of simpler and more rapid processes. These are particularly evident in bucchero-ware and in architectonic terracottas, where, in addition to the ever more careless and repetitive techniques of Etruro-Corinthian pottery, relief ornament is widely used.

The Archaistic period

The century or so between 570 and 480 B.C. is the period of archaism, marked by social and intellectual change, when new and specialized forms were developed in the artistic centers of the Etruscan world and the products of each city were recognizably its own. The making of bucchero, with relief decoration, was concentrated at Tarquinia, Orvieto and Vulci, bronze-working at Vulci, Orvieto and Cerveteri. Greek trade with the East had collapsed under Persian pressure, from the conquest of Lydia by King Cyrus in 547 to the Ionian revolt against Persia in 494, but the consequent wave of refugees from Ionia was to benefit both Aegina and the arts of Etruria in this period; nor should the role of Magna Graecia be overlooked, both as channel of the Ionian diaspora and as transmitter of the Greek culture of southern Italy. Ionian influence, which had escaped the late-Orientalizing phase, was thus decisive on Etruscan art throughout the sixth century, coming mainly by way of the great coastal cities of southern Etruria – Gravisca, the port of Tarquinia, or Pyrgi, the port of Cerveteri. It was here the foreign craftsmen landed, from here they spread to settle, find fertile soil for their talents and leave their traces in fine works of art, from pottery to mural painting.

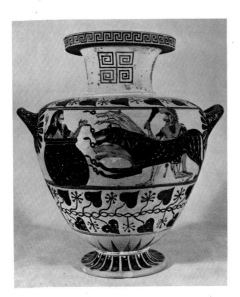

Right: acroterial terracotta statue from the temple of Portonaccio at Veii (c. 510–500 B.C.). It formed part of a group showing Apollo's fight with Heracles for the Cerynean stag. Work of a great Ionian-trained artist adding the attainments of Greek image-makers. National Museum of Villa Giulia, Rome.

Below: hydria from Cerveteri, showing the myth of Heracles and Cerberus (late sixth century B.C.). Part of a set by an Ionian artist working at Cerveteri. Refined in style, lively in invention and harmoniously decorated in colour. National Museum of Villa Giulia, Rome.

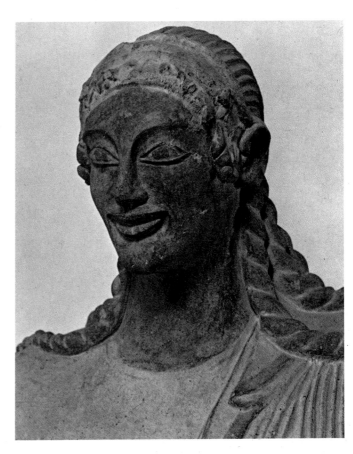

Town development and architecture. In this period the scattered Etrurian villages were replaced by regularly planned towns. Our best and clearest examples of the new organization of urban space are in the Po valley, now being "colonized" from Tyrrhenian Etruria farther south. Thus the chief thoroughfare of Marzabotto is laid out, in the Etruscan manner, on a north–south axis, with three transverse streets and a dense system of smaller streets parallel to it. At Spina, founded in the last quarter of the sixth century, the plan is likewise orthogonal, its orientation determined by astronomy.

The important architectonic developments occur in the structure of temples, for most architectonic decoration was created for temples up to the end of the sixth century, and all of it thereafter. Temples were of two main types: one was the single rectangular chamber of *cella*, with or without a portico; the other might have three *cellae* and a double-columned portico in the "Tuscan" mode, or present the simpler arrangement of central *cella* with two flanking *alae*, or "wings" – this latter to be a popular form of Romano-Italic temple. Such a building stood on a high podium, a feature retained by the Romans, and was richly decorated. For the elaborate decoration of Etruscan temples a whole specialized ceramics industry provided huge

schemes that included roof ornaments, or *acroteria*, and terminal plaques for rafters.

Sculpture. Though few large bronzes have come down to us, the *Capitoline She-wolf* is evidence that the new technique of hollow casting was derived from that of pottery, and of the magnificent results achieved by the end of the sixth century. We may guess, moreover, what the large bronzes were like from the numerous surviving pieces of cast bronze, such as votive statuettes (most frequent in northern Etruria), from tripods, cups, bowls and wine-jugs (*oinochoai*) and similar objects for the table. These commanded a ready market and were widely distributed. Vulci was the leading center, and its bowls, candelabra and tripods, with their exuberant decoration and consummate craftsmanship, were welcome in Greece itself. Subsidiary to Vulci were the bronze industries of Orvieto, renowned for embossed work, and Chiusi. Very little is known of production at Cerveteri, though the beautiful figured bronzes, of an Ionic elegance, discovered at S. Valentino di Marsciano and at Castel S. Mariano, probaby originated there.

The most important three-dimensional art of Etruria in the second half of the sixth century was that of pottery, with its main centers at Cerveteri and Veii. From Cerveteri came de-

corative elements for buildings – stamped or painted tiles, *acroteria* and antefixes – in enormous quantity, as well as the "sarcophagus" urns with man-and-wife figures of the dead whose delicate modelling and rounded faces recall the Ionian style. At the end of the period the huge, highly dramatic and pictorial decorative scheme of painted terracotta from the temple at Satricum (*c.* 480 B.C.) is also Caeretan.

We can judge the sculpture of Veii chiefly by a series of statues from the roof-ridge of the Veiian shrine of Apollo at Portonaccio: an Apollo, a Heracles and a female statue with a child. These date from the 590s and the group is among the triumphs of Etruscan art. Its subject, the contest of Apollo and Heracles over the Cerynean stag, has Delphic associations suitable to the god's oracular nature and is treated by the artist, Vulca of Veii, with stark grandeur and subtle mastery. He indulges in no inessential surface detail, yet we feel the movement immanent in his statues. They are unrivalled in that age, and he is the only Etruscan artist whose name we know. The coloured terracotta sculpture of Cerveteri and Veii in fact goes back to the most ancient traditions of bronze-making in Etruria.

Stone sculpture was never of very large figures, and its use was limited. The main ateliers were at Vulci and Clusium (Chiusi), where the soft local stone was respectively *nenfro*, a grey limestone, and the sandstone called *pietra fetida*, since it gave off an unpleasant smell when scraped. Sculpture from Vulci includes sizeable protective funerary statues, or "tomb-guardians," such as a sphinxes, winged lions, or men riding seahorses: motifs from the Orientalizing repertoire here interpreted with an Ionian accent. The influence of Ionia is plain in the receding profiles and full, sinuous curves, and in the entirely surface decoration.

The highly reputed bas-relief funerary sculpture of Chiusi was produced over a longer period, and the Chiusan school influenced the more provincial stone sculpture of Volterra and Fiesole.

Pottery and mural painting. Bucchero ware was still made in quantity, especially at Chiusi and Orvieto, in fresh types and with new ornamental motifs. Decoration is now in moulded relief, its medley of themes inherited in part from the Orientalizing period and partly borrowed from Ionia.

Painted pottery, too, changed profoundly as imports of Corinthian-ware dwindled and ceased and the main traffic was in fine vases from Attica, Euboea and Ionia. The Etruro-Corinthian type is not made after the mid sixth century, and foreign artists and craftsmen, settlers from Ionia, were probably at work in Vulci and Cerveteri the great centers of southern Etruria. Production of the so-called "Pontic" type of small vases – more carefully executed at first than later – began at Vulci in

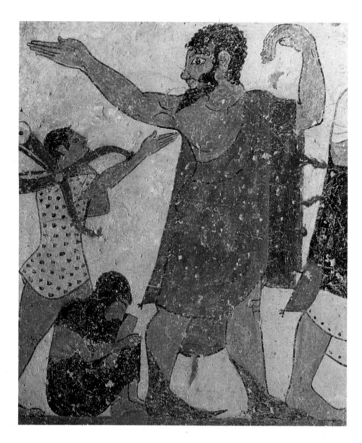

Tomb of the Augurs, detail from the right wall with a man (c. 530 B.C.), Tarquinia. The painted decoration of the tomb, with funerary farewell scenes and games in honour of the deceased, was executed by one of the foremost Etruscan painters, trained in Ionia but with a vigorous style of his own, creating monumental pictures with bold foreshortenings.

the middle of the century with the Paris Painter and his assistants. He, like the Micale Painter in the late sixth and early fifth centuries, copied the black-figure styles of Attica. At Cerveteri the great Master of the Hydriae was certainly of Ionian origin and the Caeretan water-vases, or *hydriae*, in which he specialized are of the most sensitive workmanship. The pictorial and narrative richness of his decoration surpasses anything to be seen in large-scale mural painting.

The large-scale tomb painting is chiefly at Cerveteri and Tarquinia and dates from the second quarter of the sixth century. In the last fifty years of that century the painters of Cerveteri decorated big ceramic panels, or *pinakes*, with huge figurative designs for the walls of tombs and temples.

The largest known complex of tomb paintings is at Tarquinia. In its first phase, roughly 570–530 B.C., the Tarquinian painting is confined to the depiction of heraldic animals on the outer walls of the tomb-chambers. In the last thirty years of the century, however, intricate and forceful scenes of banquets, games and funeral dancing appear on the chamber walls themselves – scenes of family leave-taking, or the joyous illustration of earthly pleasures such as hunting and fishing. The sole mythological subject before the fourth century is in the Tomb of the Bulls, of 540 B.C., and shows Achilles lying in ambush to kill Troilus; in style it is reminiscent of vase-

painting, as though the artist were unused to the less constricted space available. The high and unmatched quality of some of the pictures – those in the Tomb of the Augurs, for instance, of 530 B.C., or in the Tomb of the Baron, from the end of the century – tempts an attribution to immigrant, perhaps itinerant, Ionian artists, for tombs like this were obviously commissioned by rich and important families; the average client would be content with what the local workshops could give him. The ebullience and bright colours subside toward the century's end as a quieter, simpler colour-range and a more restrained ethos herald the "Severe" style to come.

The fifth century

The end of the first quarter of the fifth century was marked by two events of the utmost significance for the future: the victories of Syracuse over the Carthaginians at Himera in Sicily in 480 B.C., and over the Etruscans at the naval battle of Cuma in 474 B.C. For the Etruscans they initiated a period of crisis as the politico-economic axis shifted farther north and inland, from the more southerly Tyrrhenian zone to the area dominated by Volsinii (Bolsena), Orvieto and Chiusi, and to the Po valley. It is this northern Etruria, centered on the Po valley and organized, according to ancient authors, into a dodecapolis, or league of

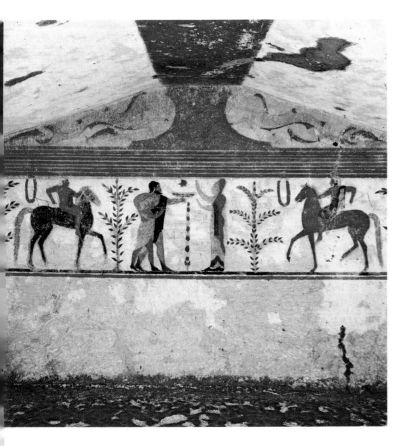

Left: Tomb of the Baron, Tarquinia. Back wall showing a funerary farewell (c. 510 B.C.). Decorated with three simple farewell scenes, it is by an artist whose fine design and skill in colour and technique is close to Eastern Greek painting in contrast with the usual style of Tarquinia.

Below: Tomb of the Bulls, Tarquinia. Back wall of the main chamber (c. 530 B.C.). The artist seems to be more familiar with vase-painting than that on large surfaces, witness the neat, small silhouettes on frieze and tympanum. The treatment of the mythological scene (Achilles and Troilus) seems in comparison clumsy, being out of proportion and retouched.

twelve cities on the model of Etruria proper, which is the richest territory in the fifth century and, from 460 B.C. onward at least, the prime market for the products of Attica. These products were readily exchanged here, thanks to the agriculture and grain-growing of the Po valley and the links it could offer with central Europe beyond the Alps. Thus the city of Spina, founded on the Po estuary in the last quarter of the sixth century, played a leading part in the commerce with Greece for not less than a hundred years; the fact that it maintained a treasury at Delphi, as did Cerveteri, is evidence of its international standing.

Etruscan sculpture. Etruscan sculpture survives from the first decades and from the last thirty years of the fifth century, but there is little of it, and certainly no large pieces, from the middle years, between 470 and 440 B.C. The plastic tradition of Cerveteri finds its last expression in the great terracottas from Temple A at Pyrgi, one of the town's two ports. They are marvellously modelled, in a style suggesting a date of 480–470 B.C., with clear-cut planes recalling those of sculpture in bronze. This modelling derives from the Severe style of Greece – a latecomer to Etruria, since archeology places it from 460 B.C. or thereabouts.

Nor do we know very much of fifth-century bronzes. Such daily necessities as tableware, decorated mirrors and candelabra were still

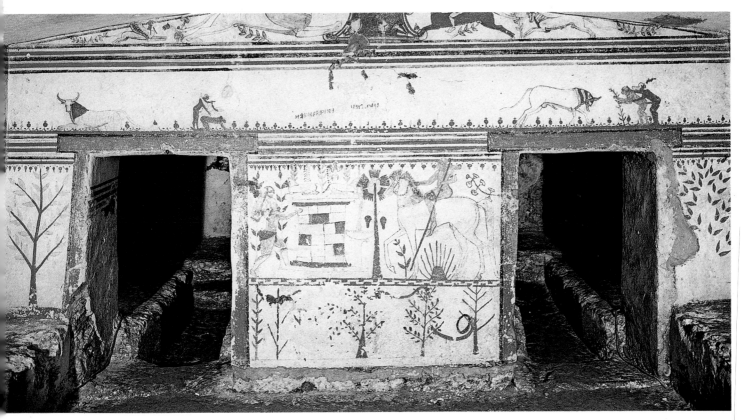

manufactured at Vulci well into the century, and there was a flourishing trade in them, but beyond doubt ateliers elsewhere could produce the same kind of thing. In the Po valley, for instance, the metallurgy of Spina was important from the town's earliest days, and bronze candelabra were made there.

The major inland centers, Orvieto in particular, provide evidence for the last three decades, though all Orvieto bronze is lost and religious terracotta sculpture must supply its likeness. The huge figures from the temples at S. Leonardo and from the Belvedere temple at Orvieto strikingly resemble Greek classical models; while the *Mars of Todi*, the one large bronze surviving from this period, is an ex-voto from the end of the century and corresponds to the rules of the art as codified by Polyclitus of Sicyon in his "Canons of Sculpture."

From Chiusi we have much less. Cippus-urns with bas-relief decoration disappear after 470 B.C. or so. Instead there were big statue-urns – enthroned figures that may have represented the deified dead. Later, at the close of the century, comes the monumental urn on which an effigy of the dead man or woman reclines as on a banqueting-couch. Here adherence to Greek figurative art of the classical period proves less fortunate, and this sculpture is stiffer and more cramped than that of Orvieto.

The Po valley yields yet fewer examples of stone funerary sculpture. Stelae from Flesina (Bologna), ranging from the end of the sixth to the end of the fifth centuries, are of typical horseshoe shape, with somewhat fussy bas-relief decoration in several registers.

Pottery and mural painting. Etruria was one of the main outlets for the Attic pottery that was paramount in the Mediterranean trade of the fifth century, and its local production copied Attic styles. We know, for example, of an establishment at Vulci, chief city of southern Etruria, copying red-figure-ware between 480 and 460 B.C. Its master, Arnthe Praxias, signed his work in Etruscan lettering, and so proclaims himself an Etruscanized foreigner. The accomplished and vividly pictorial drawing unexpectedly ignores the true Attic technique by which figures are "reserved," and they are painted in red over the black ground. Even in pottery, therefore, and despite the presence of foreign craftsmen, Vulci was failing to reach the creative heights of the previous period, and this confirms the decline in the plastic arts, already noticed, that overtook all southern Etruria for fifty years. Only with the Diespater Painter at the end of the century does pottery show signs of any real stylistic recovery. This man was probably from Attica and worked, with great technical ability and sense of tradition, at Falerii, an important center for the ensuing fifty years.

Tarquinia provides most of the fifth-century wall painting known to us, though the painted tombs are now much less frequent than

before. Funerary art, however, had its share of thematic innovation when, for a short time in the first forty years of the century, splendid painting in the "Severe" style was produced at Tarquinia.

The decoration of the Tomb of the Bighe, or two-horse chariots, the finest achievement of Tarquinian painting around the year 490 B.C., is perhaps by an immigrant artist from Ionia who may have set the decorative patterns adopted in local tomb-painting for the rest of the century. His themes include the funeral banquet, with its three couches, or *klinae*, shown on the rear wall of the burial-chamber, and the funeral games and dances on the side walls. Another master, also probably foreign, was the Painter of the Tomb of the Triclinium, who took his models from Attic vase-painting and from artists such as the (red-figure) Kleophrades Painter.

The few tombs decorated during the second half of the century are stylistically and iconographically undistinguished, but signals of revival by its end are due to Attic influence, in mural as in ceramic painting. Banqueting-scenes are scarcer, and there are symbolic allusions to death – thematic changes foreshadowing the different climate and atmosphere of the next century.

Above: terracotta head of a man from the high relief on the pediment of the temple of St. Leonard of Orvieto (c. 400 B.C.). Probably Tinia-Zeus. The work of a great image-maker, it retains some features of Greek statuary of the late fifth century B.C. combined with local notions such as the lush treatment of the laurel crown. Municipal Museum, Orvieto.

Right: funerary stele from the tomb of the Certosa of Bologna (fourth century B.C.). These large stone sculptures in horseshoe shapes are characteristic of Etruscan Felsina. They represent funerary scenes, often on several bands. Work of a modest craft tradition. Municipal Museum of Archeology, Bologna.

Right: man's head in bronze, called Brutus Capitolinus *(early third century B.C.). At the end of the sixteenth century this was identified with the first consul of the Roman republic. It shows a strong search for expressiveness and empathy typical of Italic sculptors of that time. Conservators' Museum, Rome.*

Below: bronze chimera from Arezzo *(early fourth century B.C.). Found in the sixteenth century and restored by Cellini, it represents the wounded monster, set in a startled pose. An inscription on the right front paw shows it to be an ex-voto. Dating is difficult: some aspects suggest archaic models (the drawing of the shock of hair), but the site implies a later date. Archeological Museum, Florence.*

proof of what could be done at Arezzo between the end of the fifth and the beginning of the fourth centuries we have the magnificent *Chimaera*, and bronzes were made there until the end of the third century.

For the more plentiful stone and terracotta sculpture the chief sources are again the coastal cities of southern Etruria, where the contemporary building fervour led the civic authorities of Tarquinia and Cerveteri to have their temples newly ornamented, and private families commissioned elaborate sarcophagi of various types. At Tarquinia the painted terracottas of the great mid fourth-century temple known as the Ara della Regina included the noble horses that stood on the *columen*, or main roof-beam. Cerveteri installed new terracotta groups in the temples of its nearby port of Pyrgi. Some of the high-relief funeral statues in the local stone of Vulci were very fine, but funeral sculpture of the third century, when the level of excellence went down, is more or less limited to the tympana of burial-niches. Tarquinia, on the other hand, was noted for sarcophagi. At first, and unusually, these are of marble, then in local stone.

Figures of the dead are stretched full length on the lids of the earlier specimens, and the sides are soberly decorated. Later, in the third century, the figure reclines as on a banqueting couch, and mythical and processional scenes are carved on the sides. But between the third and second centuries progressively more meager subject-matter and increasing carelessness as to style indicate that the cities were not the powers they had been, though Cerveteri was to some extent an exception.

The fourth and third centuries

The artistic manufactures of fourth-century Etruria reflect the considerable economic and political changes of the time. There was definite recovery in the south Etrurian cities, with specialization of local crafts, while imports of Attic pottery decreased dramatically. Some falling-off in quality and a degree of standardization may not be unconnected with the fact that more and more slaves were employed in the workshops, but Etruscan culture still looked to Greek models and Etruscan society was rapidly being Hellenized. In this Hellenizing process Magna Graecia and Sicily naturally had an important part.

Architecture. The revival of architecture, too, is evident. Every coastal city of southern Etruria built or restored its walls and temples in the fourth century and we find new developments in the structure of tombs. The traditional "Tuscan" temple was unaltered, with no particular innovations save in the design of capitals in the third and second centuries – new forms that were to appear farther afield in Italy. But funeral architecture was modified to reassert the position and privileges of great

clans and families. The head of the family would now lie in a sort of small temple within the burial-chamber, and the ground-level façade of a tomb might resemble a votive or mortuary chapel. Whole cemeteries of such rock-sepulchers exist near Tarquinia and Vulci, most conspicuously at Norchia, Blera and Sovana, with façades carved like temples of the simple Tuscan type. At Vulci itself the rock-tombs are more complex, with two or more storeys and large figures sculpted in the round. This kind of tomb architecture, originating in Macedonia, spread throughout the Hellenized world and continues in the Roman period.

Sculpture. There was a vigorous revival of sculpture in both stone and metal. The established centers of bronzecraft – southern Etruria, Vulci and Orvieto – retained their primacy and were joined by Arezzo. The candelabra and mirrors of Vulci were still in demand, while from south Etruria came such marvels as the portrait-busts, of which the so-called *Capitoline Brutus* is a supreme example. This dates from the early third century: the attentive portrait of an individual by an artist with profound psychological insight. As

Falerii, on the Sabine border, was at this time among the most active cultural centers, building enthusiastically and producing notable coloured terracottas for its temples and those of the surrounding region. This statuary echoes the great traditions of Greek plastic art, though not without occasional stylistic impurities. It is also the culmination of many local influences, reflecting the overall development of the plastic arts of Etruria in the fourth and third centuries B.C.

Pottery and mural painting. Etruscan potters of the fourth century were scattered throughout many centers and in their many workshops imitated the red-figure-ware of Attica and Magna Graecia. Falerii was famous for such ware at this period, together with Cerveteri in southern Etruria and Chiusi and Volterra in the north.

The famous Diespater Painter, who, as we have said, may have been a native of Attica, had his atelier at Falerii by the end of the fifth century. Under his pupils and assistants other workshops made fine red-figure vases, mostly for export and with designs clearly influenced by those of south Italian pottery, but their production was standardized in the latter half of the century. At first it was largely of cups with Dionysiac scenes, then of dishes and different vase-types decorated with simple heads, or with Dionysiac or lively figures. Technical deterioration is obvious, and accompanied by the practice of painting in red straight on to the black background, where formerly patterns had been "reserved" in the colour of the clay. Caeretan red-figure, based on that of Falerii, occurs from about the middle of the fourth century and soon met with commercial success. The chief exports were small dishes and vases for holding liquids; usually decorated with simple heads and of a special form, these were popular in the Hellenistic period. Apparently there were also workshops at Vulci, Tarquinia and Orvieto, though much smaller than those of Falerii and Cerveteri. Their pottery was stylistically inferior and their volume of trade less.

Finally, excellent red-figure vases were made in northern Etruria, at Chiusi and Volterra, the principal type being the column-crater, and these, too, were exported to the Po valley and into southern Etruria.

Late in the fourth century and during the third, pottery is confined to plain black polished ware without painted decoration, though often with motifs impressed into the raw clay, as in the ware from the "workshop of the small mouldings" near Rome. From this time until the end of the century such vases were made all over the Mediterranean area.

As before, Tarquinia, Vulci and Orvieto are the important sources of tomb painting for the period, when new subjects appear and styles are modified. Noble families are now chiefly intent on the celebration of rank, which is emphasized in scenes full of significant mythi-

cal allusion and in visions of the next world in which remote ancestors may be included. At Tarquinia, a terrifying ogre-demon, is portrayed in the Tomb of the Ogre I and Tomb of the Ogre II, of the beginning and middle of the fourth century respectively – tombs belonging to the mighty Spurinna clan, political and military leaders of their day. The earlier paintings are probably by an Attic artist, or one trained in the Attic style. The François Tomb at Vulci, so-called after its discoverer, was that of the aristocratic clan of Saties. It contains impressive paintings of allegorical and historical subjects and is datable to the third quarter of the fourth century. The two Golini tombs at Orvieto – again, intended for noble occupants

Above: high-relief terracotta from the pediment of the temple of Ara Regina, Tarquinia; detail of winged horses (late fourth century B.C.). The majesty of the whole and the refined treatment of surfaces mark a great artist. National Museum, Tarquinia.

Opposite below: terracotta statue from the temple of Scasato at Falerii (end fourth to early third century B.C.). Perhaps Apollo. Clear hints at the style of Lysippus link the work with the statuary of Magna Graecia. National Museum of Villa Giulia, Rome.

– were constructed in the mid fourth century or thereabouts, but are neither artistically nor architecturally so interesting as the others.

The painting of the first half of the century, especially that from Tarquinia and Vulci, makes considerable use of *chiaroscuro*, and may derive from the art of Magna Graecia, whose influence is also present in the contemporary painting of southern Etruria.

During the third century an "impressionist" element is introduced into the funerary wall painting of Tarquinia, and its subject-matter becomes less dramatic. Simple shields and festoons now celebrate the warlike virtues of a dead nobleman, as in the Giglioli Tomb, or in the Tomb of the Garlands. Both are of the early

third century, though demons from the hereafter are still pictured in the actual burial-chambers.

The late Hellenistic period

Though the Etruscan way of life did not finally disappear until the first half of the first century B.C., Etruria in the late Hellenistic period was passively absorbed by the expanding power of Rome. Excluded from the vital economic and political currents of the Italo-Roman world, there was a general decline in the aesthetic level of craftsmanship, and the arts were dull and stagnant. More slave-labour was used than in the previous period, and styles and iconography, especially for articles of great luxury, were for the most part Roman.

Architecture. Among the scanty architectural remains from this time are the two town-gates built into the walls of Perugia and known as the Porta di Augusto and the Porta Marzia. The latter has illusionist sculptural decoration. They date from the first half of the second century, if not from the end of the third.

Sculpture. In sculpture the artistic decline is sadly obvious. The only large bronze surviving from the principal center, Arezzo, is the famous *Orator*, a portrait-statue of the aristocrat Aulus Metellus. Dating from the end of the second century, it reveals the influence of the late-Republican Roman style. Production of votive statuettes in terracotta went on until the end of the second century. Their moulded relief decoration echoes that of their third-century models, and excessive elongation of the figures destroys organic unity.

Most of the sculpture was made for funereal purposes. Sarcophagi and urns in various materials, mainly from Chiusi, Volterra and Perugia, may have reclining figures of the dead on the lids and mythological or leave-taking scenes or illustrations of the soul's

journey in the underworld on the sides. There are hints of stylistic duality in this sculpture, dominated though it is by the Hellenistic Rhodian-Pergamene school, with its emphasis on drapery and muscular volume, for the pictorial interest seems to be in overall effect rather than in detail. We note, too, the same stylistic regression, the same perfunctory execution, in ceramic sculpture: moulded decoration, shoddy style and unimaginative inconography.

Important innovations in architectural terracottas include new motifs for ceramic panels, such as the Doric frieze that was popular in the second century. The pediment as a field for sculpture is also first seen in this period. Nevertheless, most of the decorative reper-

toire looks back to the third century and there is resultant complexity of style.

Pottery and mural painting. Black-gloss pottery was produced until the middle of the first century B.C., when the newer red-coral gloss replaced it in domestic and foreign trade alike.

Most of what little mural painting we have from this period is Tarquinian. Tombs are now of very simple design – typically one large square space with two central pillars. In a few the walls are painted with immense figurative cycles in one or two registers. The Tomb of the Cardinal has sorrowful scenes of departure and of the other-world journey to Hades. The Bruschi Tomb has processional and mourning scenes, the Tomba del Convegno another procession. Stylistically these cycles are so complicated that we can only assign them provisionally to the hundred years from the mid third century onward. But from this time the official processions in Etruscan mural painting recall the great retinues that parade before us in Roman carved reliefs.

Polychrome terracotta sarcophagus of Larthia Selanti, Chiusi (early second century B.C.). Good example of the famous sarcophagi typical of Etruscan sculpture. Archeological Museum, Florence.

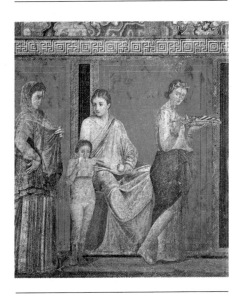

Roman Art

Painting and Sculpture

Rome grew up around a ford across the Tiber, site of the modern Isola Tiberina, where a wooden bridge (*pons sublicius*) was built, protected by the *pontifex* and linking two important areas of the Italian peninsula, the Etruscan north and the south, which was Etruscan as far as the Sele and then Greek. It was here that a community of Iron Age settlers had established a trading post, perhaps at an even earlier date than the one generally attributed to Rome's foundation (753 B.C.), which developed first into a settlement and then gradually into a city-state, a capital without a nation. In the earliest days, in fact, the inhabitants of Rome were not "Latin" at all; nor can they be identified with the other so-called "Italic" peoples.

The oldest Roman coin, which dates from around 335 B.C., very accurately sums up the city's original status: a ship's prow (a motif that later recurs on Constantinople's earliest coinage) underlines the importance of trade alongside farming and the raising of livestock, while the two faces of Janus seem to gaze, on the one hand, toward the powerful Etruscan civilization – whose development owed much to trade links with the Eastern Mediterranean and whose last rulers of Rome, the Tarquinii, had been expelled from the burgeoning Republic in around 507 B.C. – and, on the other, toward the flourishing centers of Greek culture such

as Paestum and the many other cities of Magna Graecia. An acknowledgement of the influence of these two civilizations is fundamental to our understanding of the way in which Roman culture developed, on both an artistic and a political level.

Rome's contacts with the Greeks, which occurred at first hand, date from earliest times: the cult of Vesta (goddess of fire and the hearth) and of Castor and Pollux (484 B.C.) are both of Greek derivation. The fact that the Romans venerated the Dioscuri as protective deities is verified by the inscription on a bronze strip, dating from around 500 B.C., which was discovered amongst the thirteen archaic altars at Lavinium: archeological confirmation of the truth underlying the later legend that links the origins of Rome to the Trojans, to Aeneas's landing on the coast of Latium and to his marriage to a local girl, Lavinia.

Although there had been a weakening of relations with both the Etruscans – defeated at Cumae in 474 B.C. – and the Greeks – as a

Frieze of the Mysteries, a detail showing initiation scenes, from the Villa of the Mysteries, Pompeii (first century B.C.)

result of the invasion of Campania by the Volsci, Aequi and Samnites – only two centuries later a new Greek cult, that of Aesculapius, was introduced from Epidaurus to the Isola Tiberina (293 B.C.). During the intervening years Rome developed contacts with Carthage, with whom she entered into a treaty in 384 B.C.; work began on the building of the "Wall of Servius" following the city's sack by the Gauls; her internal structure was organized and her laws codified (introduction of *decemviri*, establishment of the centurion system in the army, institution of censors and codification of the Twelve Tables).

Against the background of Italic Hellenism, which was common both to the Etruscans and to the other peoples of the peninsula – albeit with local variations and adaptations – there was little to distinguish the artistic language of Rome during the fourth and third centuries from that of Etruria and Campania.

Original Greek works, such as the statues of Pythagoras and Alcibiades (*c.* 290 B.C.), poured into Rome; following successful campaigns against Philip V of Macedon and Antiochus III, large quantities of paintings, engraved vases, furnishings, sculptures, etc., flowed into the city as booty. The treasures plundered by the victorious generals were displayed in the Portico of Metellus (146 B.C.); the homes of the wealthy filled with precious objects, paintings and Greek sculptures, often by great masters. But all this served only to

heighten the Romans' awareness of their inferiority to the Greeks in artistic matters and also to encourage a taste for copies and pastiches.

During the second century B.C. – a time when Rome established control over the Mediterranean through her destruction of Carthage and her occupation of Greece and Asia Minor, whilst at the same time establishing frontiers with the Gauls to the north and founding numerous colonies from Luni to Modena and from Bologna to Aquileia – Roman sculpture reflected the ambitions of the new masters in the face of the Classical-Hellenistic heritage of Greece. The result was an eclectic blend of styles: visible, for example, in the reliefs of the so-called "Altar of Domitius Ahenobarbus" (now divided between the State Collection, Munich, and the Louvre).

The wall paintings in the houses and villas of Pompeii and Herculaneum have allowed scholars to distinguish certain ornamental

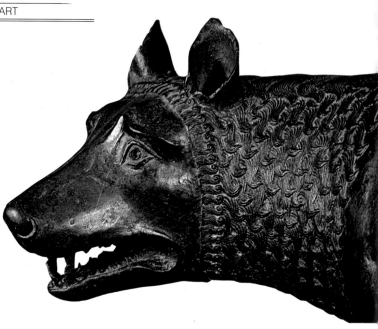

Right: detail of the Capitoline Wolf, Conservatori Museum, Rome. This impressive bronze of the Capitoline Wolf provides important evidence of the cultural ethos prevailing in the capital at the beginning of the fifth century. It was created by a "middle Italic," not necessarily Etruscan, sculptor. The figures of the twins, which may be modelled on an original element, were added during the Renaissance.

Left: The Country of the Laestrygones, Biblioteca Apostolica, Vatican. This fresco forms part of a series depicting episodes from the Odyssey, set in airy landscapes and rich in perspective and naturalistic detail. As well as reflecting the taste of the person who commissioned them, these scenes – painted toward the middle of the first century B.C. – are based on models derived from the Hellenistic tradition prevailing a hundred years earlier: these have been faithfully repeated, or perhaps partly reinvented, by a Roman artist who reveals certain errors in the Greek inscriptions appearing by the figures. Paintings of this sort are recorded by Vitruvius and may be attributable to Alexandrian painters active in Rome during the second century B.C.: men such as Demetrios topographos (painter of landscapes).

typologies of Hellenistic inspiration, which have been classified as "styles." *Trompe l'œil* columns painted in perspective (Casa dei Grifi in the Antiquarium del Palatino, the Casa della Farnesina in the Museo Nazionale, Rome), for example, characterize the "second style," which developed during the age of Sulla; finely executed and purely decorative elements characterize the "third style" (bridging the two centuries), while fantastical perspective views and scenes cover the walls of the "fourth style," in particular after the earthquake of A.D. 62–63. Between the destruction of Carthage (146 B.C.) and the consulate of Caesar (59 B.C.) the area of territory under Roman control was further extended by the annexation of Africa and Greece and by the creation of the provinces of Asia and Syria. Inside the city a series of bitter social upheavals occurred, both above and below the surface, even though they were instigated by a minority: the reforms and murder of Tiberius Gracchus (133

B.C.), the reaction of the Senate and the bloody repression of Sulla (82 B.C.) led, after a few decades, to a mood of increasing authoritarianism, the creation of a Hellenistic style of monarchy, and the introduction of the imperial ideal of the Caesars. The fugitive successes of the different factions and the *angst*-ridden uncertainties of daily life were reflected in a feeling of spiritual disquiet, a growth in imported mystical cults, in astrological and eschatological beliefs and in ritual, and finally in the hope for a *novus ordo*. The ruler for whom Rome was waiting was Augustus Octavius, and the Ara Pacis embodies the spirit of the time.

During the first and second centuries B.C., a new and dynamic wave of Hellenistic influence reached Rome from Alexandria and the eastern provinces. Works of art of every sort sated private collectors' appetites, partly as a consequence of the lifting of privileges and the imposition of taxes on furnishings (43 B.C.).

Historical Scene, *Conservatori Museum, Rome. This fragment comes from an underground burial chamber in the Esquiline district of Rome, and can be dated to about 300 B.C. There are a number of historical scenes, connected perhaps with the wars between the Romans and Samnites, painted on a pale ground in superimposed layers, with the most prominent figures indicated by the inscriptions M. FANNIUS and Q. FABIUS (the latter can probably be identified with Quintus Fabius Maximus Rullianus, commander of the Roman army in the second Samnite war). The fresco, Roman both in its layout and in the way it is painted, reflects the characteristics of the "triumphal" style of painting recorded by Pliny. One member of the Fabius family,* Fabius pictor, *is recorded in around 304 A.D. as painting frescoes for the Templum Salutis in Rome.*

During the reign of Claudius A.D. 41–54, shapes of "neo-Attic" inspiration gave way to a less strongly modelled quality and a more lively use of colour. The reliefs on the Ara Pietatis in the Villa Medici and the very finely worked white stucco decoration of the "neo-Pythagorean" basilica at Porta Maggiore both reveal the sort of "neo-Hellenistic" quality which, expressed in vibrantly coloured surfaces and occurring in both architecture and painting, anticipates the artistic language of the Flavian era.

The portraiture of the Flavian emperors made use of "typological" distinctions in the person being portrayed: the two likenesses of Vespasian in Copenhagen (Ny Carlsberg Glyptothek) and Rome (Museo Nazionale), for example, show the emperor's public and private faces. The scenes of Titus's triumph that wind round his Arch in the Forum at Rome introduced a new spatial dimension. These compositions mark a change in the relationship between the spectator, who is looking at the scene from a fixed point, and the sculpted figures: the latter, which have moved away from the traditionally flat background, are pitched toward the viewer in successive layers.

Tombs, which in Republican times were decorated with paintings commemorating family achievements, now began to contain themes inspired by Greek mythology, sometimes portrayed using stucco, as in the Ponte Mammolo tomb; or they depicted atypical subjects (architectural constructions, building implements), like those sculpted on the walls of the Haterii tomb on the Casilina, which also contains very powerfully realistic portraits. These works reveal a delicate sense of naturalism in the carved details, the sprays of roses, the portrayal of hair, the secondary elements scratched onto the background, etc.: this technical expertise provided a perfect vehicle for the trend toward a more atmospheric quality, a sense of expressiveness that anticipates the mood found in the reliefs on Trajan's Column.

The preference of the wealthy classes for burial rather than cremation led to the development of workshops specializing in the production of sarcophagi; this was true not only of Rome – where coffins, destined for the walls of chamber tombs, were decorated on three sides – but also of Athens and Asia Minor, from whose workshops emerged examples decorated on all four sides for use in tombs designed "in the round."

Felicia tempora was the name given to the years linking the reigns of Nerva (A.D. 96–98) and Marcus Aurelius (A.D. 161–80). A well-drilled army secured further conquests from Dacia to Armenia; a provincial aristocracy developed, integrating administratively with the structures established in Rome; the new principle of adoption was recognized in the system of imperial succession, replacing that of family inheritance, under the influence of

contemporary philosophical theory (philosophers had been expelled from Rome during the time of Vespasian) and intellectuals of the day (Dio, Musonius, Pliny the Younger, Epictetus).

The figure of the emperor, who relied on divine inspiration to fulfil his role as servant of the state, was sacred: his portrait, no longer either realistic or idealized, private or public, now began to express the moral qualities and heroic humanity of the imperial persona. The new sociopolitical ideas and structures encouraged the development of a genuinely "Roman" style of artistic expression, with new formal criteria. The transennae in the Forum, the frieze by the "master of the deeds of Trajan" on the Arch of Constantine and the historical reliefs on Trajan's Column all bear witness to the ability of Roman sculptors to express new narrative scenes – albeit as a vehicle for propaganda and celebration – both ethically and objectively. Sculptural language, linked substantially to the principles of Hellenistic "naturalism," adopted solutions that had first emerged in "plebeian" art (distortion of the organic structure of the human figure), subordinating them to the need for movement.

The expressive innovations introduced during the time of Trajan, in both sculpture and architecture, emerged from the restricted court circle within which the Augustan taste for the "neo-Attic" had flourished. A new artistic impetus affected the Empire, especially the Greek-speaking provinces, as is shown by the clypeate portrait of Trajan in Ankara and the works of the sculptors of Aphrodisias, who

displayed great skill in the use of colour, exploiting the contrast between smooth and *chiaroscuro* surfaces.

Under Hadrian the athletic type of statue appeared, as exemplified by Antinous (the young man loved by the emperor), enriching a

Below: the wall paintings of this room in the eastern part of the Domus Aurea in Rome, executed in the "fourth style" of Pompeii and Herculaneum, reveal figured panels, contained within a network of thin architectonic partitions, which look as though they are hanging like paintings in a modern house.

canon that could be described as Classical with "Romantic" undertones: an extraordinary formal language producing surfaces that combined chromatic restraint and violence. It was, in fact, a formal climate that reflected Hadrian's travels through Greece and the eastern provinces, midway between the political and nostalgia for the ideals of beauty exemplified by Classical tradition.

Hadrian's philhellenism shines through the subjects of the tondi and reliefs inserted in the Arch of Constantine – which celebrate hunting as a *virtus* in keeping with the tradition of Eastern monarchs – and also in the mythological repertoire, taken from Hellenistic painting and adapted to funerary symbolism, found on certain sarcophagi of the day (the myths of Orestes, the Nobids, Actaeon, Alcestis). Some sarcophagi also depict scenes of battles between the Romans and Northern barbarians: there is a particularly fine example from Portonaccio in Rome's Museo Nazionale, which

dates from the time of Marcus Aurelius.

The effective unity of the Empire was matched by an imperial art which, radiating from Rome, was exemplified by extremely fine architectural and sculptural monuments in Africa, Asia Minor and Syria. The character of these works is not, however, "provincial" – unlike some of their counterparts in the Danube area, in Britain and Gaul and in those areas of Italy lying beyond the Po. There was a close political and cultural relationship between Rome and the Hellenistic East, a prelude to the *Constitutio Antoniniana* which in 212 A.D. was to grant Roman citizenship to the inhabitants of the Eastern provinces.

In the Balkans, a cultural region that linked Macedonia, Thrace and Moesia, there began to appear, from the second century onward, votive reliefs and stelae portraying "Thracian" or "Danubian" horsemen (an iconographical subject of remotely Hellenistic origins) which

Opposite above: these paintings, now removed and reassembled in the Museo Nazionale, Rome, once decorated one of the rooms of the Villa of Livia at Prima Porta. As well as the so-called "third style" of decoration, there was also a vogue during the Augustan era for portrayals of open gardens, such as this parádeisos, *filled with fruit trees, flowering plants, and birds, in which we can detect the constant tendency of Roman domestic decoration to break up surfaces by the representation of illusionistic views.*

Above right: Flora *or* Spring, *fragment of a fresco from Stabia (first century* A.D.*), Museo Nazionale, Naples.*

Right: Statue of the Emperor Augustus, *Musei Vaticani, Rome. This marble portrait-statue of Augustus was found in the Villa of Livia at Prima Porta in 1863. Although it was destined for a private house, its studied iconography and classical robes are reminiscent of the features found in a bronze statue made for public display.*

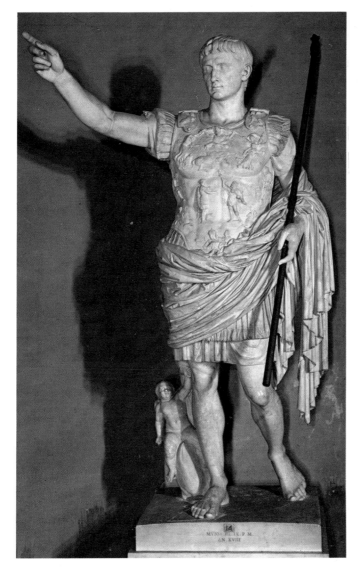

reveal a popular, rather "homespun" style somewhat similar to that of the Roman "plebeian" movement. In the metope of the impressive Tropaeum Traini at Adamklissi (Romania), which commemorates a decisive battle, one can see the translation into "barbaric" language of a historical, anthropomorphic subject derived from Roman art (the statues and portraits in Sophia Museum, the mosaics of Stara Zagora, paintings from the tomb at Silistra). The "barbaric" quality reveals itself in the inclusion of elements detached from the basic narrative theme, repeated as though for assonance, regardless of any temporal or historic relevance. Certain elements of this anti-Classical principle can also be found in official monuments from the period of the Tetrarchy at Salonika, albeit on a different level.

The four-fronted Arch at Salonika (of which two of the four pilasters have survived), erected on the Via Egnatia to celebrate Galerius's victory over the Persians (a fine clypeate portrait of him appears on a small commemorative arch in Salonika's Archeological Museum), was an integral part of the emperor's residential complex (palace, mausoleum, circus). The reliefs appear one after the other, unframed at the corners, amidst heavy, horizontally projecting mouldings formed of swirling foliage and sheaves of laurel: this sort of layout was new to the Late Classical world but was already known in Hittite art, which superimposed "abstract" pictures in a manner predictive of medieval art.

Mauritania and proconsular Africa (modern

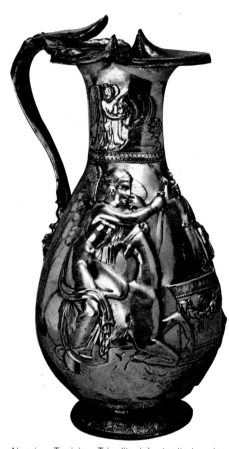

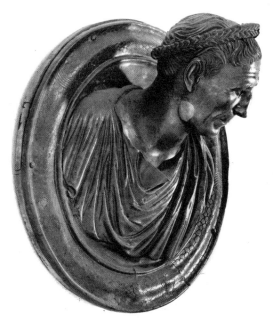

is still Hellenistic in style; others, executed on a geometric ground, contain figured squares and medallions. It was African skills that created the mosaics of the grandiose villa of Piazza Armerina in Siciliy (c. 320–60). Animal heads within crowns decorate the peristyle, the Great Hunting Scene unfolds in the atrium in front of the basilica, while the Labours of Hercules appear in the three-aisled hall of audience. Executed by highly skilled craftsmen, these works were based on "cartoons" prepared in one of the many schools of painting which flourished in different Mediterranean cities and adapted Hellenistic models to conform to contemporary taste. Amongst the finest examples – clearly the work of a highly skilled master – are the "rural works" discovered at Caesarea (Cherchell Museum): perfectly executed and with a very lively sense of movement, they reflect the Eastern cultural environment in which they were created (third–fourth century).

The mosaics of Tripolitania, on the other hand, are for the most part of clearly Hellenistic inspiration (House of Orpheus and Villa of the Nile at Leptis Magna). "Flecked" landscapes in the Alexandrian taste decorate the vault of a villa at Zliten (second–third century). The monuments of Leptis Magna are very important to our understanding of the history of sculpture during the Severan era. It was perhaps a Syriac town planner, with the help of Greek craftsmen and skilled local workers, who extended the first-century city toward the east, constructing a large colonnaded street running parallel to the Hadrianic baths; at the point where it curves there was a large exedra and a nymphaeum, built facing the lighthouse.

It was by the side of this second section that the Severan Forum and Basilica were erected (A.D. 210–16). The splendid, figured pilaster strips of the latter building, fringed by finely carved cornices, appear to have been imported from the workshops of Aphrodisias in Asia Minor: the lacelike carving, which vibrates with colour, is the precursor of the much later Byzantine style of decoration. Four of the friezes on the Triumphal Arch of Severus celebrate the imperial family, who are shown in the presence of their guardian deities, during a sacrifice, with a procession of prisoners and

Algeria, Tunisia, Tripolitania), territories in which Carthaginian civilization had held sway for centuries, gradually became Romanized; Latin, for example, was imposed from the second half of the second century A.D. The local tendency toward a ruggedly expressive quality appears during the third century in sculptures which draw on the Roman repertoire for their subject matter (statues of religious initiates and worshippers and portrait sculptures in the Bardo Museum, Tunis); the same museum also contains a fine sarcophagus of later date depicting the four seasons, which reflects a Constantinian style of Classicism. The artistic culture of this area displays its greatest originality in the numerous mosaics which portray life in the great agricultural estates, both private and imperial, whose main product was grain destined for Rome. The Bardo Museum and the museums at Sousse, Tripoli, Annaba, Tipaza, etc., all contain mosaics depicting views of villas with turrets and porticoes either by the sea or in the countryside, scenes of farming life, hunting or crop-gathering, mythological subjects (Venus, Achilles, Dionysus). They are like large coloured carpets (the "black on white" technique, as practised during the second century at Ostia in the Baths of the Seven Sages, the House of Bacchus and Ariadne, etc., was abandoned), whose motifs unfold with great expressive freedom against a background that

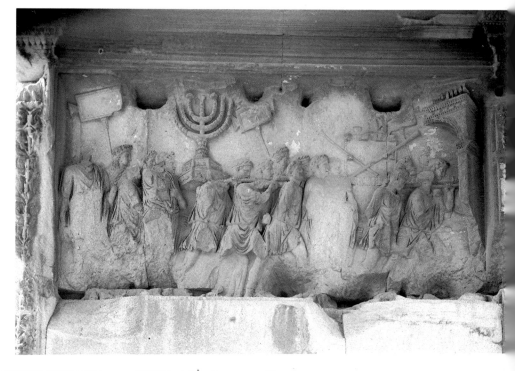

Opposite far left: Boscoreale Carafe, *Musée du Louvre, Paris. Classical shapes and imagery were often reused in items designed for private houses, like this beautiful carafe. The precision and elegance of the chasing convey the mood of Hellenism that characterized the Augustan era.*

Opposite below: Procession with Plunder from the Judean War, *Arch of Titus, Rome. The Arch of Titus was erected by Domitian on the Via Sacra to celebrate the dead emperor's* virtus. *Inside the single barrel vault are two sculpted reliefs portraying the triumph of Titus after the Judean War (*A.D. *70) and the procession of men bearing plunder from the Temple in Jerusalem. The emperor's*

"deification" culminates in the panel at the top of the vault, which portrays the apotheosis of Titus, shown being carried into the heavens by an eagle.

Opposite above right: Bust of Trajan, *Archeological Museum, Ankara. This clypeate bronze depicts the Emperor Trajan at the end of his life, in around* A.D. *117. It is a very "personalized" likeness of astonishing psychological depth, very different from the one created to celebrate his ten years as emperor or the other, posthumous one in the Museum of Ostia, both of which display an idealized, heroic quality.*

Below: One of the Dioscuri Seizing a Daughter of Leucippus, *stucco decoration from the vault of the neo-Pythagorean basilica outside the Porta Maggiore in Rome (first century* A.D.*).*

on a ceremonial *quadriga.* The narrative flow is broken by the rigidly frontal pose of the imperial figure, who now embodies the principle of absolute sovereignty. The fleshy, tactile quality of the figures of Victory that once adorned the arch's extradoses (Tripoli Museum) is formally echoed in the famous statuette portraying Leda at Cyrene. In Cyrenaica the Hellenistic heritage was even more alive, and in sculpture it produced solutions similar to those found in Attica and Asia Minor, as is confirmed by a number of portraits in Cyrene's Museum of Sculpture (fourth century).

The portraits sculpted in Athens for Herodes Atticus (107–78), the wealthy tutor of Marcus Aurelius, and for his circle of followers and friends were inspired by models of the fourth century B.C. and display a soft and elegantly modelled quality (portraits of Herodes Atticus in the Louvre and of Polydeikes in Berlin, etc.). The monumental sarcophagi of Attica bore decoration sculpted almost in the round, in accordance with Classical dictates, with figures whose veiled faces expressed the new mood of pathos. They were exported westward and even to Rome herself: there is one example decorated with the story of Hippolytus and Phaedra in the church of S. Nicola at Agrigento and another depicting the battle of the Amazons in the Archeological Museum, Salonika. The Asiatic type of sarcophagi also reached the West: large marble coffins, their sides decorated with mythological figures such as Hercules, or philosophers and Muses, contained within niches, sometimes adorned with architectural tympani, and with heavy lids topped by a recumbent likeness of the departed. The deeply pierced architectonic decoration creates a tracery of vibrant colour. From the craftsmen of Lycia – where these sarcophagi were made during the second century, with Ephesus apparently the main source of inspiration – the production of these

Above: The Emperor Hadrian Hunting Boar, *Arch of Constantine, Rome. The subject of the eight Hadrianic* tondi *incorporated in the Arch of Constantine is the heroic glorification of hunting as a manifestation of imperial* virtus. *The original location of these reliefs is unknown, but they depict the emperor setting out for the chase, followed by scenes portraying the killing of a lion, a bear, a wild boar and a stag, and the performances of sacrifices to Diana and other deities.*

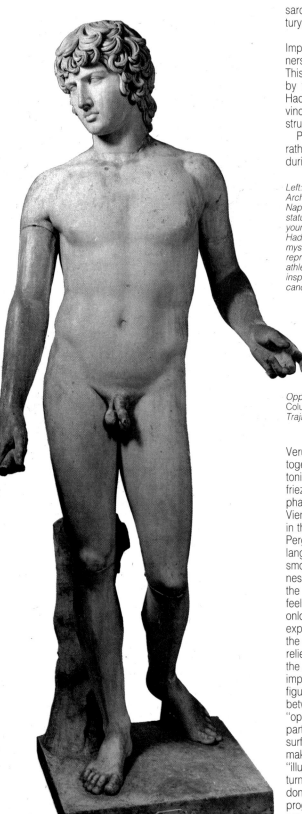

sarcophagi then passed, during the third century, to the more famous center at Sidamara.

Imperial art now emerged from different corners of the Empire, not only from the center. This process of cultural osmosis is exemplified by the reliefs on the cella of the temple of Hadrian, in which personifications of the Provinces appear: symbolic pillars of the imperial structure.

Pathos as an expression of existential *angst* rather than of physical suffering appears during the reign of Marcus Aurelius and Lucius

Left: Antinous, *Archeological Museum, Naples. This fine marble statue of Antinous, the young man beloved of Hadrian who died mysteriously in the Nile, represents a new, athletic style of statue, inspired by Classical canons.*

detail of the coiling, narrative frieze that unfolds for almost two hundred meters (650ft) around the column, work on which began in A.D. 113. The column's base contained the emperor's burial cella while the top was surmounted by a statue, lost during the Middle Ages. The scenes relate to the Dacian Wars. They portray (starting at the top) the Roman army crossing the Danube on boats, the Emperor Trajan on a raised podium receiving ambassadors from the Dacians, and the building and completion of a castrum.

Opposite: Trajan's Column, *The Forum of Trajan, Rome. This is a*

Verus. The latter's victories over the Parthians, together with the glorious deeds of the Antonines, were celebrated in a great figured frieze at Ephesus, later reused in the nymphaeum of the Library of Celsus and now in the Vienna Museum. One of the masters involved in the work, who must have been familiar with Pergamene sculpture, expressed himself in a language that was completely new in the smoothness of its compositional flow, the liveliness of the action portrayed, the boldness of the diagonal layout of the figures, and the feeling of spaciousness which "envelops" the onlooker. There are similar elements – albeit expressed with a realism more in keeping with the plebeian style of Roman historico-narrative reliefs – in the eight Aurelian reliefs inserted in the Arch of Constantine: in the panel depicting imperial *liberalitas* we can see the back of a figure who is taking part in a lively dialogue between personalities situated within an "open" space, in which the onlooker feels he is participating. The treatment of the marble surfaces, pierced and suffused with "colour," makes use of a technique that has been called "illusionistic": it represents an artistic about-turn, a break with tradition, a partial abandonment of Hellenistic naturalism and a formal progression toward the inorganic quality of pre-medieval sculpture. Roman society's impulse toward irrationalism, its attraction to mystical cults, is reflected on the Antonine

Column (completed before A.D. 193) in the representation of a "miracle," a subject that had never before occurred in Classical iconography. It was not given to man to know what mysterious force had unleashed the thunderbolt or brought down the rain: was it Hermes Aerios or Harnouphis the Egyptian priest? Perhaps the aim was to show that not only the god of that mysterious Christian sect, whose members denied the cult of the emperor, was capable of miracles, but that it was a Roman "providence" who ensured the eternity and absoluteness of the Empire. One late biographer attributes the "miracle of the thunderbolt," which took place in A.D. 172, to the prayers of Marcus Aurelius (*Vita Marci*, 24): the concept of the emperor's "divine power" was now firmly rooted in iconography as well.

An effect of lively animation and representational realism has been achieved by using simple technical devices and by introducing a feeling of compositional synthesis. One of the most dramatic episodes depicts villages being burnt, with children clinging to screaming mothers; a strong feeling of emotional involvement is created by the insistent diagonal rhythm of the swords, spears, and curving backs of the barbarians awaiting decapitation. Equally impressive is the grieving face of Marcus Aurelius, lined by the tragic awareness of what is happening: he is, in the words of Bandinelli, a true "lay saint," who openly admits the crisis within contemporary society.

The arch dedicated by the Roman Senate to Septimius Severus and Caracalla in A.D. 203 achieves a great feeling of movement in the interplay of light and shade created by the columns that stand out from the structure, by the many bronze figures that formerly adorned the pediment, the Victories and spirits of the seasons and the Rivers carved in deep relief on the extradoses. The frieze portraying the triumphal procession and the submission of the barbarians to the personification of Rome displays a rather simple style of carving in the massed figures, which have the almost sketchy quality typical of plebeian art. If we are to believe Herodian's account of large paintings of the Parthian campaign arriving in Rome following the conquest of Ctesiphon, it is possible that the reliefs portraying siege scenes, which are composed of "nuclei" of small figures arranged side by side, may be based on these (Rodenwalt). It illustrates the way in which imperial art was prepared to conform to the "tectonic" vision of the world, assuming the role of episodic chronicler.

Evidence of the circulation of ideas between Rome and the East can also be seen in the relief showing Septimius Severus and his wife Julia Domna (a native of Emesa in Syria) performing a sacrifice, on the Porta degli Argentari in the Forum Boarium, Rome, where there is an underlying religious mood of Irano-Parthian influence.

Commodus was regarded as a god-ruler in the Oriental manner, and it was under him that

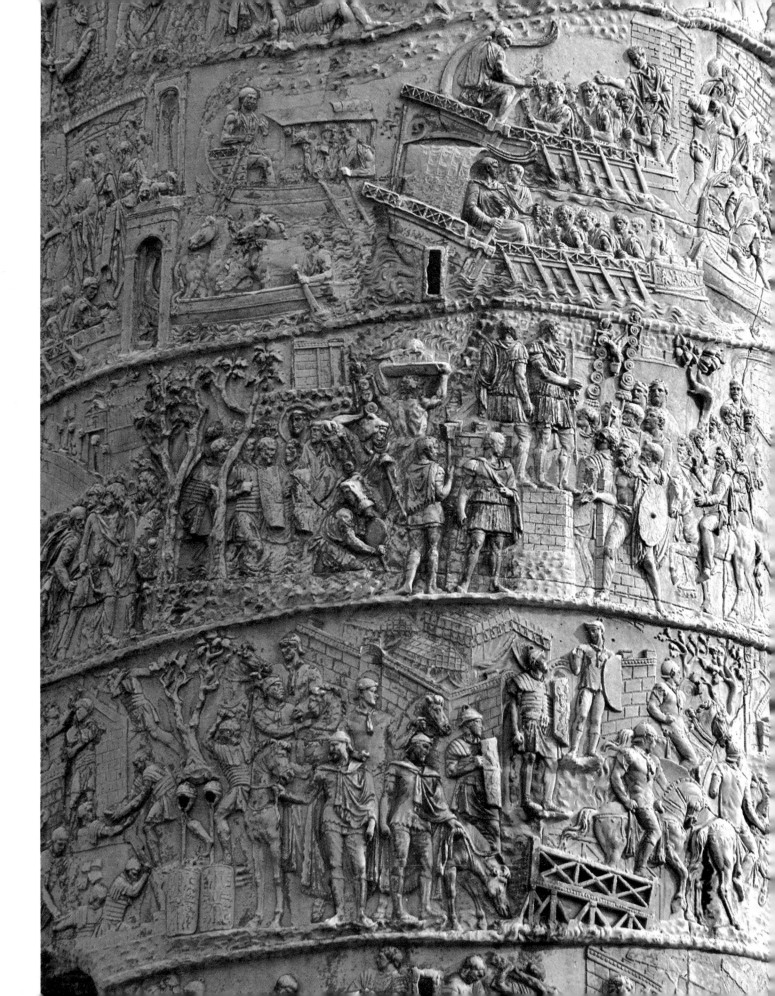

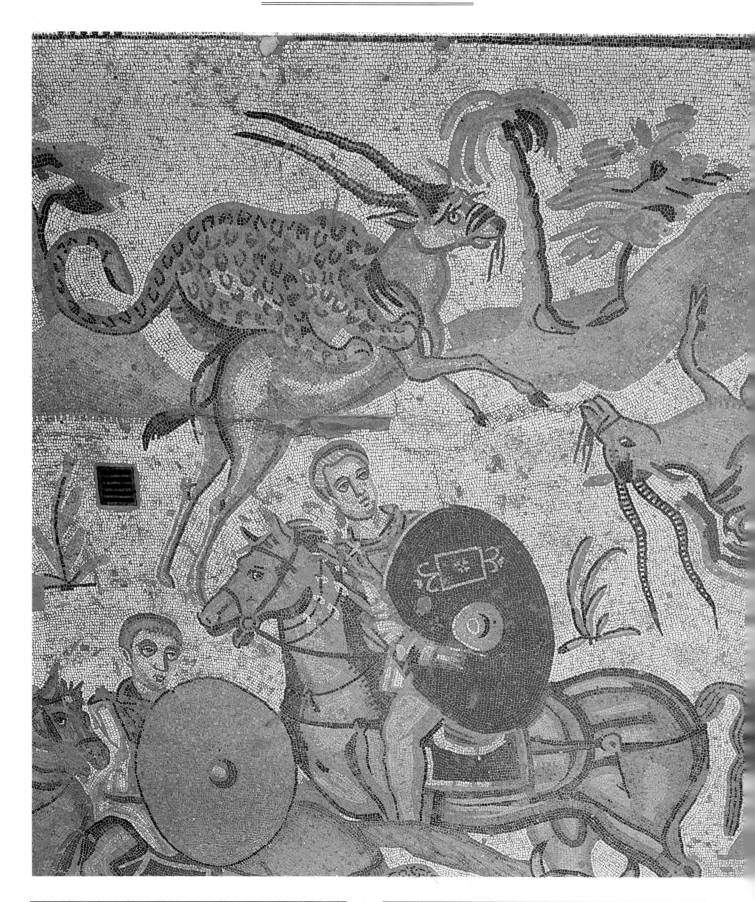

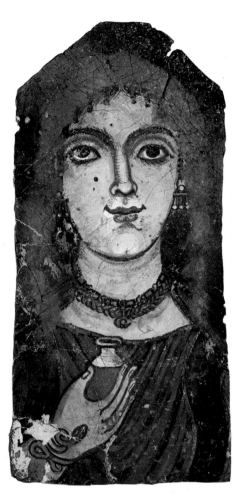

mystical irrationalism became part of the body politic. The histrionic character of the emperor, a devotee of gladiatorial games and rich costumes, led him to embrace first the cult of the great Phrygian mother-goddess Cybele and later that of the Egyptian goddess Isis – although he never became a convert to Christianity, the religion of his concubine Marcia, who obtained from him freedom of the future Pope Callistus. In the portraits of gladiators in the mosaics of the baths built by the bloodthirsty Caracalla we can see the thoughtless indulgence in brutality, which was almost universally accepted, and the fascination with the thin line separating life from death. In fact, the myths represented on second-century sarcophagi reveal the concept of death as the completion of life, the end of everything. During the decades that followed, this concept made way for the practice of invocation, the possibility of penetrating the mysteries of the hereafter (echoed by Marcus Aurelius in his *Meditations*). Death is the gate through which the Psyche, freed of its union with matter, enters immortality. The soul captured in the hereafter is symbolically represented in the myths of the Rape of Proserpina, Ganymede, etc., underlain by that neo-Pythagorean doctrine which existed as early as the first century, as the subterranean basilica at Porta Maggiore shows. Sappho, who symbolizes the soul, is depicted in the apse throwing herself off the cliff at Leucas: purified through her death, which has been caused by the passion of Eros, she arrives in her homeland in a blaze of light. The same can be said of the subjects of Pluto leading Proserpina to the Underworld and Alcestis leading the departed into the garden of Paradise (the syncretist catacomb of Vibia).

In the reliefs on the great sarcophagi carved in Rome during the third century it is possible to detect the thematic and expressive transformations that gradually moulded pagan art, carrying it from the mythical to the transcendent. Already, under Septimius Severus, compositions depicting victorious Romans and dying barbarians had been introduced, and these representations, expressions of unfailing

Left: the Great Hunting ambulatory, detail of the mosaic, showing stags being attacked by wild animals, in the Roman Villa of Casale at Piazza Armerina (Sicily). This forms part of an important cycle of mosaics, dating from the third–fourth century A.D., which deal in particular with the subject of hunting, one of the most popular motifs in Rome at the time, but even more widespread in the provinces.

Above: Portrait of a Young Girl, from El-Fayyum (Egypt), from the fourth century A.D., British Museum, London. There are many examples of similar portraits in museums throughout the world.

triumph rather than historical records, continued during the reigns of Caracalla, Heliogabalus and Alexander Severus. Sarcophagi now began to take the form of large marble coffins with trophies of victory at the corners and, at the center, the figure of the emperor towering over the twisting mass of bodies (for example the Ludovisi sarcophagus, from *c.* 251, in Rome's Museo Nazionale). The same canons are repeated in another group of sarcophagi in which the symbolism of the victorious emperor is transferred to the subject of lion-hunting (sarcophagus in the Palazzo Mattei, Rome). In other examples depicting the tragic death of the central figure (the death of Meleager and the fall of Phaeton on sarcophagi in the Louvre, Penthesilea dying in the arms of Achilles, etc.), the death of the individual is linked to that of the hero. Elsewhere, the Dioscuri flank the recurring motif of the tomb as a doorway leading to the beyond, or there are representations of the seasons to underline the universality of life and death and to show immortality as a reward in the cyclical transformation of matter. Toward the middle of the third century the theme of the lion capturing its prey became a symbol of death itself (one thinks of Decius's fierce

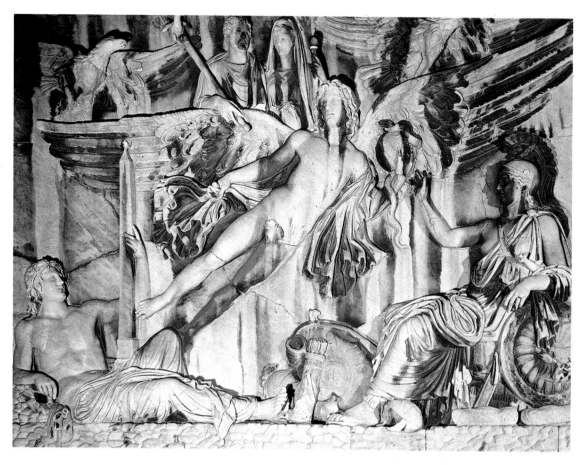

The reliefs from the base of the Column of Antonius Pius (Cortile della Pigna, Vatican) were discovered in the Piazza di Montecitorio in 1703. The scene depicting the apotheosis of Antoninus and his wife Faustina shows the imperial couple, flanked by eagles, being carried to the heavens by a winged male figure, Aion or Absolute Time. Below, at either side, are personifications of Rome at arms and of the Campus Martius, who carries the obelisk of the Augustan solar clock. The other relief portrays a scene from a decursio, an ancient funerary ritual which involved a procession of mounted Pretorians circling the burial mound, followed by parades and mock military fights.

persecution of the Christians which occurred at this time) lions' heads, like masks lying in ambush, replace the figures of the Dioscuri. It was a time of insecurity and fear during which a succession of soldier emperors, many of whom met tragic ends, ruled the Empire. Human fragility and the "will for power" shine through the faces depicted in portraiture, sometimes with features which are barely delineated and almost dissolve into nothing (portrait of Decius in the Capitoline Museum, portrait of a young prince in the Museo Nazionale, Rome); sometimes with expressions of indomitable energy (portraits of Balbinus and of Philip the Arab).

Following the circulation of Plotinus's ideas there was a reaction against the preceding mood during the time of Gallienus, and a new set of subjects was introduced: these now became concerned with philosophical representation (the legend of Eros and Psyche as a symbol of the soul's return to Elysium, freed from the chains of the flesh); with a new interpretation of myths linked to human nature, such as that of Phaeton and Prometheus (the sarcophagus in the Vatican's Museo Pio Clementino), in which the soul descends from its heavenly home to give life to the individual; and with the portrayal of philosophers and men of letters in the company of Muses and disciples (the sarcophagus of Publius Pereg-

rinus in the Museo Torlonia). The master philosopher and his disciples wear beards and hair in the "Cynic" fashion, their faces suffused with inner reflection. The beauty that permeates the likenesses of the young Gallienus seems to be a true personification of the neo-Platonic thinking of Plotinus (portrait in the Museo Nazionale, Rome).

During the post-Gallienus period the representations of immorality become increasingly coarse as a result of the loosening of ties with philosophical thought. The most frequent subjects include Victories carrying a portrait of the departed, or Graces, Eros and Psyche, Cupids and Nereids, etc.; often the figures are carved with a cursive, almost plebeian touch. This eclectic repertoire did not, however, prevent the revival between 280 and 310 of large sarcophagi depicting Selene, Prometheus and Phaeton. At the same time there was an increase in the portrayal of scenes from daily life, based on no fixed models, produced by numerous different workshops: shepherds tending their flocks, peasants with carts filled with grapes or grain, fishermen and hunters, banquets set beneath trees, old men resting on walking sticks and youths playing panpipes, mothers and children, coarse yokels ploughing, herds of horses, etc. Where the mythological element reappears, it takes on an idyllic quality, as in portrayals of

the sleeping Ariadne.

After abandoning the Hellenizing renaissance that had characterized the reign of Gallienus, portraiture during the period of the Tetrarchy, from Diocletian (crowned emperor in 284) to Constantine, revived the sort of pitiless, dynamic likeness that had first appeared during the time of the soldier emperors, adapting it to forms which in Egypt, a province of the Empire, had been applied to porphyry statues of the Augustan emperors and Caesars (repeated in the coinage of Maximinus, minted for the first time in Alexandria), producing an iconography that was simultaneously both simple and aggressive. The way in which the marble was "negatively" worked served to enhance this dual quality: the sculptor "gouged" out the ears, traced the shape of the mouth by means of a line between two holes, carved furrows in the surface to create the folds of the clothing, thus achieving an effect that was visual rather than plastic.

It was under the Tetrarchy that Eastern (Persian) elements first became combined with Western in court ceremonial and also in the monumental art that mirrored it. However, because the latter also contained echoes of the vigorous forms of popular expression inherent in "plebeian" art, its manifestations were readily understood by the masses, upon whom it made a deep impression. It repre-

sents the artistic "formalization" of the autocratic system of government and of the worship demanded by the emperor, as both despot and living god, from his subjects. The iconography of the imperial figure, adorned with *trabea* and diadem and complete with "sacred" purple and "divine" insignia of power, transposed the hieratic and abstract personification of a supernatural force to which were accorded veneration and unconditional obedience. The image of the enthroned emperor now became commemorative and devotional, as well as "official": in his triumphal Arch at Salonika, Galerius is attended not only by court dignitaries but also – and more especially – by personifications of his virtues and his divine powers.

Under Constantine, Roman imperial art acquired a new religious dimension: the victorious emperor is now a "Christian" emperor, because he has received the "sign of victory" from Christ, the "true emperor." The invincible Cross of Golgotha was watched over day and night by the imperial guard in the Lateran Palace: the victory at Mulvian Bridge in 312 was linked closely to the symbolism of the Cross and the name of Christ (made possible by the Edict of Lycinius, promulgated in Milan in 311). But when the Senate and Roman people dedicated an arch to Constantine they were reviving an ancient custom, updated during the Tetrarchy, which excluded any "Christianization" of the triumph, although it did allude to a monotheistic religion in the *instinctu divinitatis* that appears in the dedicatory inscription. The Roman Senate, composed principally of members of noble families who were still pagan, opted for a "neutral" portrayal even though the subject matter expresses an idea of the dynasties of Theodosius and Just-

inian. The significance of the taking of booty and the criteria for its distribution is that both provide a "historical context": Hadrianic reliefs of battle scenes; other, Aurelian ones with political overtones; eight Hadrianic tondi extolling the imperial idea of hunting; figures of Victories with barbarian prisoners and portrayals of Poseidon and Gaea with the seasons as symbols of the constant renewal of the Empire's unity, as well as scenes of the different stages of the war between Constantine and Maxentius and representations of the imperial *adlocutio* from the rostra and the imperial *liberalitas* (the distribution of money to the people). Constantine imposed a new direction on history: *profectio*, the setting-off for war, and *adventus*, the victorious return, are symbolized by the Sun's *quadriga* soaring skyward and the Moon's *biga* entering the sea. This polarity between the Sun and the Moon, which embodied the monument's new religious core, was to inspire Christian iconography for a long time to come.

In that same year, 315, Constantine had a silver medallion struck at Ticinum (Pavia) bearing his own likeness, with the monogram of Christ on the helmet. Most official, state art now became "Christian" by virtue of the fact that the image of the Christian emperor appeared everywhere: on large buildings, in statues and on calendars, ivory diptychs, manuscript covers, etc. Constantine extended the majestic basilica built by Maxentius in the Forum by adding a porphyry colonnade to act as entrance to the Via Sacra, as well as an apse containing a large enthroned statue of himself (*c*. 10m [32ft] high). Constantine's head (together with other parts of the statue in the courtyard of the Conservatori Museum in the Campidoglio), whose feeling of power is

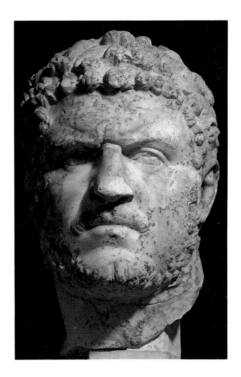

accentuated by its almost stepped construction, stares balefully out at the onlooker through enormous eyes.

These intense, distant, yet abstract images, which a slight shift in emphasis would shortly transform into the Byzantine concept of the Pantocrator, are also echoed in contemporary portraiture, as can be seen in the painted glass pane from Brescia, the two portraits in the Mausolem of Constantine and the other,

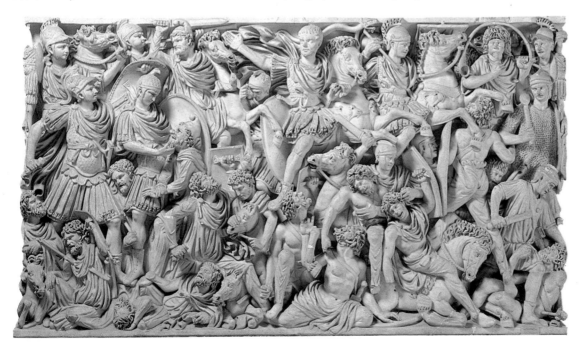

Above: Portrait of the Emperor Caracalla, *Conservatori Museum, Rome. The head conveys, in a most direct and expressive way, the emperor's ruthless and despotic temperament.*

Left: Ludovisi Sarcophagus, *Museo Nazionale, Rome. During the second century A.D. a fashion began for a very lively sculptural decoration on the fronts of monumental marble sarcophagi. The Ludovisi Sarcophagus, which dates from the mid third century, depicts a battle between Romans and barbarians: at the center, the triumphant dux towers over the tumult of battle and the bodies of enemy soldiers, who are either dying or begging for mercy.*

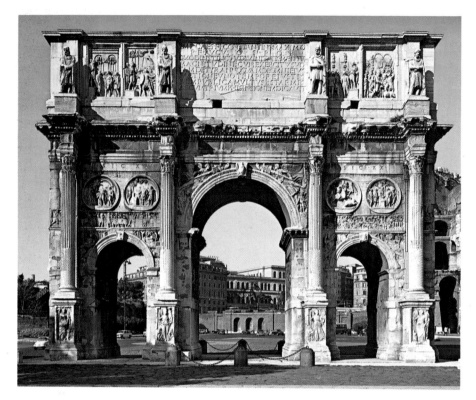

cubicula of the Sacraments and the area devoted to the Popes in the Catacombs of San Callisto, etc.). Via touches of colour that effectively destroy any sense of volume (in sculpture, one can witness the pierced, illusionistic portrayal of the figures on the base of the Tetrarch monument in the Roman Forum, created for the decennial celebratons of 303) and the small, sketchily painted figures which enliven these linear decorations produced figurative compositions with a greater feeling of space and a more softly modelled quality, such as those found in the Mithraeum at Marino, in the mythological scene in the so-called "House of St. John and St. Paul" on the Caelian Hill, in the Mithraeum of S. Prisca (from which comes the opus sectile head of the deified Sun), dating from the first quarter of the third century, and – of slightly later date – the "debate" portrayed in the Hercules complex of buildings at Ostia.

From the fourth century onward the decoration of interiors – to which the linear "red-green" style (executed on a white ground) imparted a sense of spatial unity – achieved a feeling of movement by its division of surfaces into a series of layers comprising a broad wainscot, a large intermediate band containing framed figurative scenes, an upper frieze, and the ceiling. Interiors of the Constantinian

more populist ones in the Theodosian mosaic at Aquileia.

The liturgical nature of court ceremonial and the grandiose open spaces of the new imperial residences called for an appropriate form of interior decoration. Following the first "spatial revolution" that took place in architecture during the reign of Nero, there was a full-scale revival of the fashion for trompe l'oeil wall decoration, with plenty of ornamentation and a great sense of fantasy. Landscapes and other scenes appeared on walls, divided into compartments by painted architectural elements.

Under Antoninus and Commodus Hellenism was a spent force and wall painting became increasingly schematic, aridly repeating the rich decorative repertoire of the preceding era (the yellow room of the "House of Paintings" at Ostia). The old motifs survived, interpreted through the so-called "red-yellow" language of the Antonine era and the "red-blue" language of the Severan (the tomb in the Polimanti columbarium and the tomb of the Octavii), becoming even more abstract during the course of the third century and using a system of red and green lines on a white ground (the house beneath the church of San Sebastiano on the Via Appia Antica, the underground tomb of the Aurelii, the rooms of the Paedagogium on the Palatine, etc.). The decoration on Christian catacombs of the period – which from a formal point of view belongs to the main body of pagan painting and is therefore studied in conjunction with it – displayed similar characteristics (the gallery of the Flavii in the catacomb of Domitilla, the

Above: Arch of Constantine, *Rome. This arch, inaugurated in July 315, incoporates Hadrianic reliefs of battles and other, Aurelian ones of a political nature, as well as eight Hadrianic tondi exalting the imperial idea of hunting, figures of Victory with barbarians and prisoners, Poseidon and Gaea with the seasons as a symbol of the constant renewal of the Empire's unity, episodes from the war between Constantine and Maxentius, the emperor's adlocutio from the rostra, and his liberalitas (the distribution of money to the populace).*

Right: The Tetrarchs, *St. Mark's, Venice. This porphyry group, originally from the Philadelphion at Constantinople, symbolizes the harmonious exercise of power by the Augusti and Caesars during the period of the Tetrarchy (fourth century A.D.).*

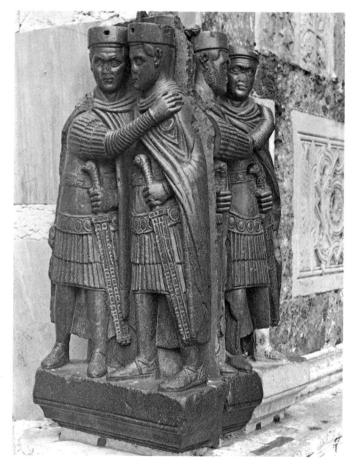

era, rich in marble or *trompe l'oeil* inlay, with their great architectural wall motifs and their coffered ceilings (with square, octagonal or cross-shaped motifs) gave painting – and mosaic in particular – a new impetus. Decoration of this sort, in what is known as the "second Pompeian style," occurred in a basically coherent form throughout the Empire: there are notable examples in the underground burial chamber in the Via Livenza and the Via Latina catacomb in Rome, the Palace of Galerius at Salonika, in the Balkans (tombs in Sofia, Niš, Peč, Salonika), in Asia Minor (Ephesus and the Ionian area) and at Trier, as well as in Christian churches and catacombs. The Roman villas at Desenzano and Verona and the palace at Split all show interesting examples of mosaic pavements. We can gain an idea of the way in which the walls of the basilica of Junius Bassus, consul at Rome in 331, were richly clad in *opus sectile* panels (precious marbles, mother of pearl, serpentine) through the drawings done by Sangallo: in the basilica was a plinth with imperial busts contained within medallions, architraved columns, figured "inlays" (the consul amidst the circus factions, Hylas being carried off by the Nymphs, a calf being attacked by a tiger, etc.) and panels depicting masks, hunting scenes and dog races. The museum at Ostia contains sections of a marble wall covering, similar both in its technique and in its Egyptian-style decoration, which came originally from a Christian building at Porta Marina. The paintings in the Palace of Helena at Trier, which are arranged in a way that reflects the building's architectural composition, portray dancing and flying Cupids and female busts arranged within the rectangular coffers of the ceiling. Funerary paintings were composed of single panels within compartments or niches, like the Labours of Hercules or the death of Cleopatra in the Via Latina catacomb, the building and gardening scenes in the underground tomb of Trebius Justus, etc. The figures, the landscape backgrounds and the narrative elements all increased, and we find an echo of the layout and formal characteristics of these works in contemporary book illustration, both pagan (the Vatican Virgil) and Christian (the Quedlinburg "Itala" in Berlin), in ivory objects (the diptych of Probanius, from 395, in Berlin, and those of Aesculapius and Hygieia in Liverpool) and also in objects made of precious metals.

During this period, which stretched from the second half of the fourth century to the end of the fifth, the creative role of the city of Rome began to decline as far as "profane" art was concerned. It was first Milan and, later Ravenna which gathered up and breathed new life into this part of the Roman heritage, which the New Rome on the Bosphorus was later to translate into a different organic language.

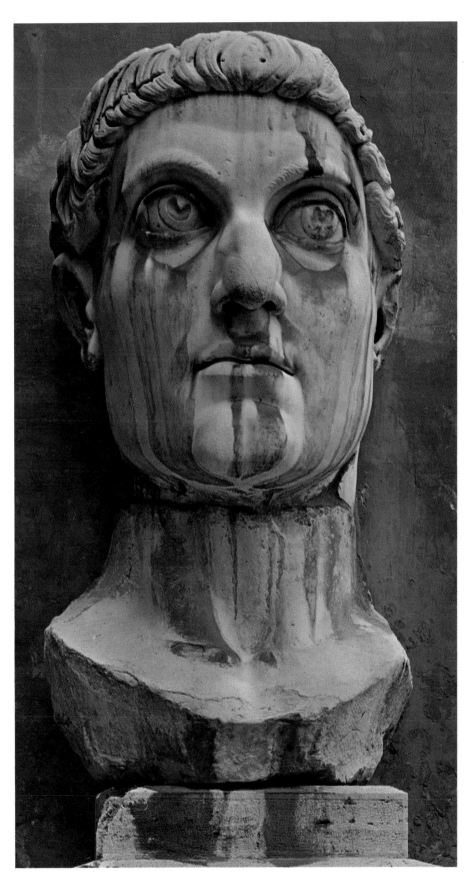

Architecture

The evolution of Roman architecture, like that of all her other artistic manifestations, was moulded by a whole series of historical events linked to significant economic and sociopolitical factors in a constantly expanding territorial area, as well as reflecting her relationship with the other great cultures of the period, ranging from the Etruscan to the Greek and the Syrio-Mesoptamian. The overlap between the use of local and imported materials and of native and foreign building techniques can sometimes make it difficult to assess just how much specifically Roman creativity was involved in any single monument. If, for example, we consider the arch and the barrel vault, both elements fundamental to Roman architecture, we discover that the Romans did not invent them; nor were they the first people to use them. They first appear in the monumental gateways of Babylon and Assyria, whence they entered the Greek architectural repertoire during the fourth century B.C. (the substructure of the theater of Alinde in Caria, the gates at Oiniadai in Acarnania, at Velia, etc.). The use of the arch in monumental gates became rapidly established in central Italy: at Cosa (273 B.C.), Faleri (the Porta di Giove, built after 241 B.C.) and in the Porta Romana and Porta Marzia at Perugia. But in addition to this use of the arch as an independent architectural form, the Romans also combined it as a structural element with the Greek orders, relegating the latter to a purely superficial and decorative role. This meant that the most pressing consideration became the "interior" architecture and the practical realities of the spatial relationships created by it: for the Romans, functionalism was more important than aesthetics. The demands imposed on Rome by her constantly growing society, in both the public and private sectors, led to the introduction of new types of building and new architectural groupings. During the second century B.C., the forum (which until then had been a multifunctional space) began to form the center of a group of buildings that included the basilica, the seat of the Senate (*curia*), the place of public assembly (*comitium*) and later the public archives (*tabularium*), markets (*macella*), storehouses (*horrea*), colonnades, shops, offices, etc. These constructions used mainly *opus coementicum*, a building material that was cheaper than stone masonry and could easily be adapted to create simple vaults. In the Porticus Aemilia (built in 193 B.C. and restored in 174 B.C.), a large storehouse by the Tiber to the south of the Isola Tiberina, some

On page 127: Head of Constantine, *Conservatori Museum, Rome. The large, staring eyes of this colossal head express the same feeling of superhuman strength present in the porphyry group in Venice, and reflect the radical transformation in the concept of imperial power that occurred during the Tetrarchy (fourth century A.D.).*

Above: Death of Dido, *miniature painting from a Late Antique codex, the so-called* Vatican Vergil, *which dates from the fourth–fifth century B.C. Musei Vaticani, Rome.*

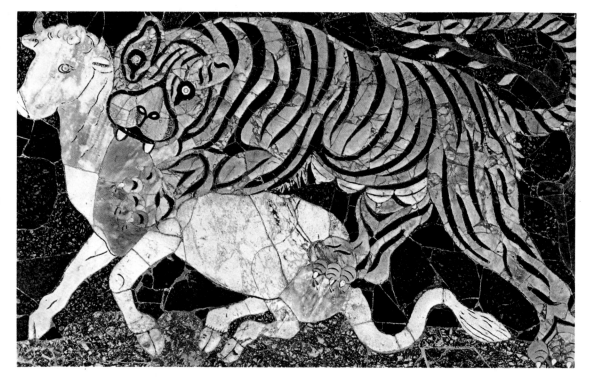

two hundred rooms are covered by barrel vaults that reveal the earliest use of concrete.

Following Rome's territorial expansion to the north of the Apennines and her creation of military colonies and *municipia*, between the third and first centuries B.C., Roman building practices not only became the norm for civil architecture but also established the rules for the layout of roads and towns that were to provide the basis for the urbanization of the West which flourished under the Empire. Her conquest of the Hellenized regions to the south, such as Campania and Sicily, led to a stimulating, if dramatic confrontation between Roman and Greek culture. But it was, in fact, in Campania that late Republican architecture created some of the decisively "Roman" types of building that were later to become the norm throughout the Empire: for example, the amphitheater, baths, houses with an atrium and peristyle, the *macellum* (a central, circular pavilion with a colonnaded enclosure), the theater and the basilica of modified Greek form.

One of the secular buildings of Republican Rome that has survived is the imposing structure known as the *Tabularium* (the state archives), which was erected in 78 B.C. and provides an impressive architectural backdrop to the slopes of the Capitoline Hill. On a platform of tufa-clad *opus coementicum*, above an internal passageway lit by rectangular windows, the stone façade rears up in two

Opposite below: Tiger Mauling a Bullock, *Conservatori Museum, Rome. This is one of the* opus sectile *panels, made of brightly coloured, precious marble inlay, which formed part of the internal wall decoration of the basilica built in Rome by the consul Junius Bassus during the fourth decade of the fourth century A.D. Other similar fragments of wall covering discovered in Rome and Ostia show that this costly form of decoration was fairly widespread.*

Right: Porta Rosa at Velia (modern Elea). This strange arched gate, excavated in recent times, dates from the fourth century A.D. Of Eastern derivation, this shape spread through central Italy (Cosa, Falerii, etc.) through the medium of Greek architecture: the Porta Rosa *is, in fact, regarded as the finest example of civic architecture in all Magna Graecia.*

arcaded layers; the upper one is now missing.

In Latium, three great sanctuaries provide examples of the final phase of Republican architecture. The Temple of Jupiter Anxur at Terracina (built after 80 B.C.) is perched high on a rocky crag and set at an angle to its enclosure to make it visible from the Via Appia and the city; it rests on a terrace supported by twelve large niches and a recessed corridor, both barrel-vaulted and made of *opus incertum* (crushed stone and mortar covered in irregularly cut limestone). Even more monumental, both conceptually and structurally, is the sanctuary of Fortuna Primigenia at Praeneste, Palestrina (second–first century B.C.), whose sacred precinct is situated at the foot of the hill (colonnaded hall with the cave of the oracle), while the upper sanctuary is perched on a series of porticoed terraces now crowned by the Barberini Palace. The architectonic elements (the different tiers, half-columns, niches, etc.), which are treated with an almost "baroque" sense of unorthodoxy, reflect the illusionistic layout characteristic of "second-style" wall painting. The striking visual qualities of the individual elements – albeit within the framework of the complex's overall symmetry – ensure that the group of buildings anticipates such later undertakings as the Forum of Trajan in Rome or in the Temple of Jupiter at Baalbek. The Temple of Hercules at Tivoli (mid first century B.C.), surrounded by porticoes on three sides and fronted by a stepped semicircle, clearly reveals, both in its technique and in its use of vaulted substructures, the influence of the nearby Praenestine complex.

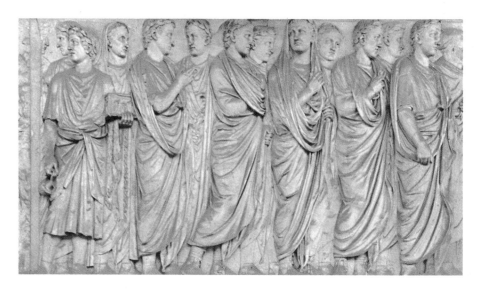

In religious architecture, which remained more traditional, there was an adjustment to Italico-Hellenistic taste, as can be seen in the temple in the Forum Boarium, built by Greeks using Greek materials; another element was the introduction of the circular ground plan, which occurs in the almost contemporary (mid first-century B.C.) Temple of Vesta at Tivoli and the slightly later Temple B on the Largo Argentina, completed in the "Italic" style by a pedimented pronaos.

Augustan patronage transformed Rome from a city of bricks into a city of marble (Suetonius), pursuing a plan originally formulated by Julius Caesar. The Regia was restored in 36 B.C. with marble from Carrara (where new quarries had been opened); the temple of Divus Julius was dedicated in 29 B.C.; while the temples of Saturn and Apollo in the Circus, built within a short time of each other, displayed still different tendencies. The Forum of Augustus, however, and the temple of Mars Ultor and the temples of Castor and Concordia (6 and 10 B.C.) reflect a much greater degree of stylistic uniformity, markedly Classicist in tone and with widespread use of marble.

Marcus Agrippa, a colleague and friend of Octavian, may be said to have supervised the

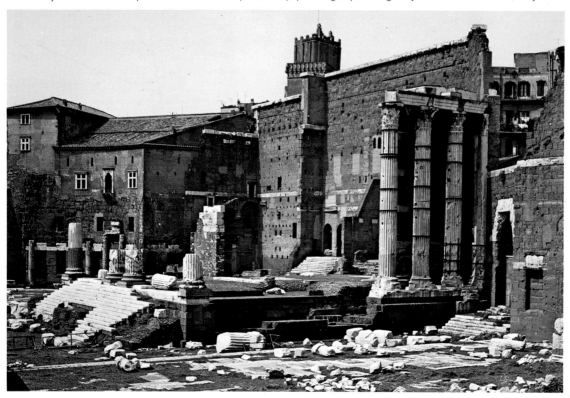

Above: Ara Pacis Augustae, *Rome. This, the greatest of all propagandist monuments (13–9 B.C.), contains a combination of contemporary scenes – such as this ceremonial procession – with others linked to the mythical tradition of Rome: Aeneas and the Penates, Romulus and Remus, personifications of Rome and of Mother Earth.*

Left: Forum of Augustus and Temple of Mars Ultor, *Imperial Forum, Rome. The Forum of Augustus, inaugurated in the second century B.C., has a rectangular layout expanded at the sides by the addition of two semicircular courtyards. On the eastern side stands the temple of Mars the "Avenger," dedicated after the Battle of Philippi (42 B.C.). Built in white marble from the quarries of Luni (Carrara), the building reveals clear Attic influences.*

capital's architectural development. He restored the existing aqueducts and built a new one (Aqua Julia), as well as beginning work on the Campus Martius complex, which included the Saepta Julia, the Pantheon, the basilica of Neptune and the baths, situated between colonnades, gardens and a natural lake. The fire of A.D. 80 destroyed all these works with the exception of the Pantheon, which was restored by Hadrian.

Greek architects had for some time been arriving in Rome: men such as Hermodoros from Salamis and the planner responsible for the extension of the city under Caesar. The skills and expertise of Attic craftsmen can also be seen in the sculpted decoration in the Forum of Augustus, the temple of Mars Ultor and the Ara Pacis. The latter, a visible symbol of the *pax* given by Augustus to the world, conveys the political message desired by the ruling class. Above the great fascia with its acanthus volutes (an element typical of the Attic repertoire) unfolds a procession of members of the imperial family, accompanied by officials and priests, who have assembled for the consecration ceremony. In its architectural qualities the work effectively fulfils its designated aim by linking together structure and carving: its reliefs, which allude to a contemporary event and also to the destiny of Rome, were to be "imitated" in the iconography of later artists. The work of the Attic craftsmen and the almost exclusive use of marble introduced to Augustan architecture techniques and decorative motifs that were to determine the appearance of subsequent public and religious buildings, the aim of which was to display the characteristics of Classical Greek architecture, albeit on a purely superficial level.

Other Roman monuments of the first century A.D. displayed varying degrees of adherence to the Classicist tradition. The Porta Maggiore – a monumental double-arcaded construction at the conjunction of the Via Prenestina and Via Labicana, built during the reign of the Emperor Claudius to support the pipes for two new aqueducts – is characterized by the rustication of the travertine blocks used in the lower section. Vespasian's Templum Pacis – annexed to the imperial forums – in which the trophies taken from Jerusalem were kept – has an open façade with tympanum contained within a porticoed surround, a layout that was to be adopted later for the Library of Hadrian in Athens. Vespasian's Colosseum, whose infrastructure is in squared stone with tufa on the inside and travertine on the outside, represents the acme of Hellenistic-Italic architecture. Concrete, although limited here to the vaults and upper sections of the walls, was used almost invariably by the more creative and innovative Roman architects, for both domestic and utilitarian buildings. The history of this basic building material and how it was used is worth mentioning. The upper part of the wall at Cosa (273 B.C.) consists of crushed

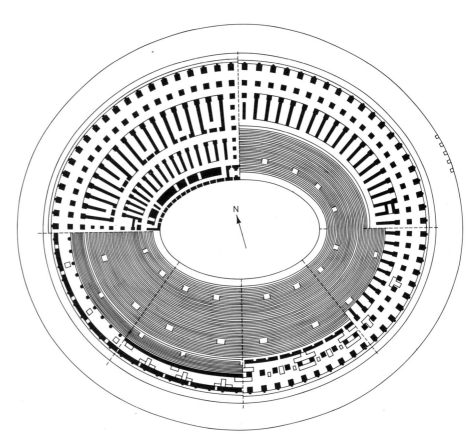

Colosseum, *Rome. The amphitheater, begun by Vespasian in* A.D. *77 and inaugurated by Titus three years later, rests on the bed of an artificial lake within the gardens of Nero's Domus Aurea.*

The short time taken to build such a complicated and grandiose structure (48– 50m [156–163ft] high; 188m [616ft] long; 156m [507ft] wide) shows the

extraordinary degree of technical organization achieved during the Flavian era. The superimposed orders of the exterior, created with travertine, set the seal on

a tradition upheld by the Tabularium in the Theatre of Marcellus. Renaissance builders regarded the Colosseum as almost a compendium of Roman architecture.

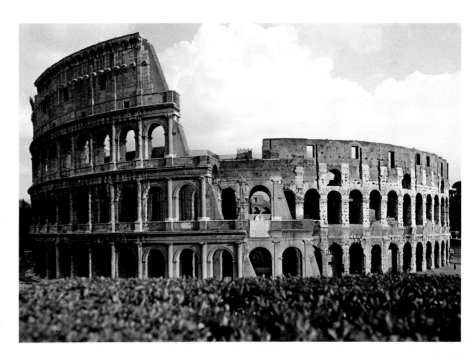

stone mixed with large amounts of a mortar made from slaked lime and common sand; later, in the Porticus Aemilia (193 *B.C.*) and the Temple of Fortune at Praeneste, Roman builders began to experiment with the volcanic sand known as *pozzolana*, which was quarried at Puteoli (modern Pozzuoli) and other volcanic areas of Campania and Latium.

One of the earliest and most daring applications by Roman architecture of this new use of space, which exploited the almost limitless possibilities of concrete, occurred in Nero's Domus Aurea, built by Severus and Celer in the heart of Rome after the fire of A.D. 64.

The east wing of the villa, whose façade was in the form of a portico above a terrace, consisted of a domed, octagonal room from which radiated five rooms covered by barrel and cross vaults. The example set by this imperial residence was used by the new vaulted architecture as the basis for a further series of "official" building enterprises: Domitian's Domus Augustana (designed by the architect Rabirius in A.D. 92), the Trajan baths and markets (the work of Apollodorus of Damascus), the Pantheon, and Hadrian's Villa at Tivoli.

The Domus Augustana on the Palatine com-

prised a nucleus of monumental buildings facing the Forum (Aula Regia, Basilica, Triclinium) and a residential section to the south, situated above the Circus Maximus. The audience hall and the Basilica both show how the apse was used to create an impressive atmosphere. There is a new architectural element inside the main room, whose massive walls are broken up by rectangular and curving niches framed by pilasters with projecting columns, the clear intention being to create a feeling of "lightness." The residential area is arranged on two levels around a square peristyle adorned with a fountain: the new upward growth was the consequence of using vaults instead of the usual wooden roof, in accordance with principles that had already been adopted elsewhere in residential buildings (the Casa dei Grifi). The interplay of curving and rectangular niches in two octagonal rooms on the lower level mark a resumption of the experiment seen in the Aula Regia, aimed at giving a sense of geometrical harmony to closed spaces.

In his plans for Trajan's baths and markets (A.D. 104–109), the engineer and architect Apollodorus of Damascus, like Rabirius, displayed a skilful mastery of the use of concrete. In the markets, which were arranged on the hill on three levels reflecting the different points of access, the architectural shapes projected by Apollodorus for the difficult backdrop of the Forums formed a harmonius whole: although enlivened by the rhythmical interplay of windows and doorways, they were soberly designed and simply decorated. The baths revived traditional architectural imagery, arranging it into what came to be known as the "imperial plan": a center for the cultural and athletic activities that formed an indispensable part of social life, the vast new layout combined baths and a gymnasium, with the addition of a swimming pool and, along the perimeter, libraries, nymphaea, meeting rooms, sculpture galleries, and shops.

So builders using *opus coementicum* and brick facing were able to experiment with entirely new spatial effects (Domus Aurea, Domus Augustana, etc.) and to update traditional themes (baths, utilitarian and domestic buildings): the internal spaces of structures now became more flexible and adaptable. These trends found a harmonious application in that structural symbol of Roman architecture which has always been compared with the Greek Parthenon: the Pantheon, which was rebuilt by Hadrian between 118 and 128. At the far end of a colonnaded courtyard that has since disappeared, preceded by a façade with a tympanum supported by eight monumental granite columns, stands the true building, the Rotunda. The curving sides of its exterior expand outward, looming powerfully over the passer-by, while on the inside the simplicity and grandeur of the coffered dome, resting on its cylindrical tambour and pierced at the top by a shaft of light, makes a lasting

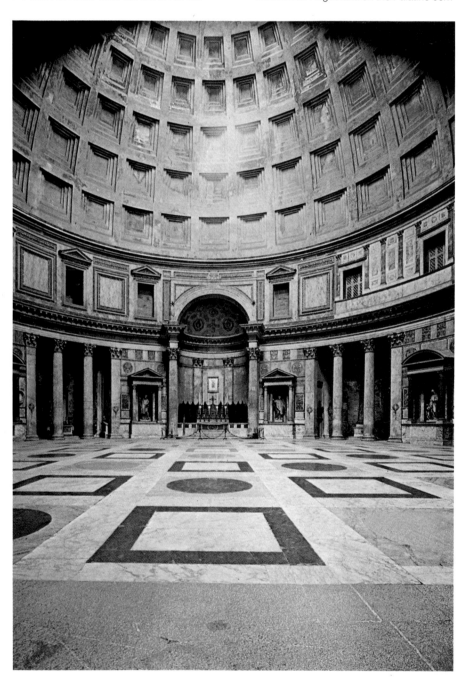

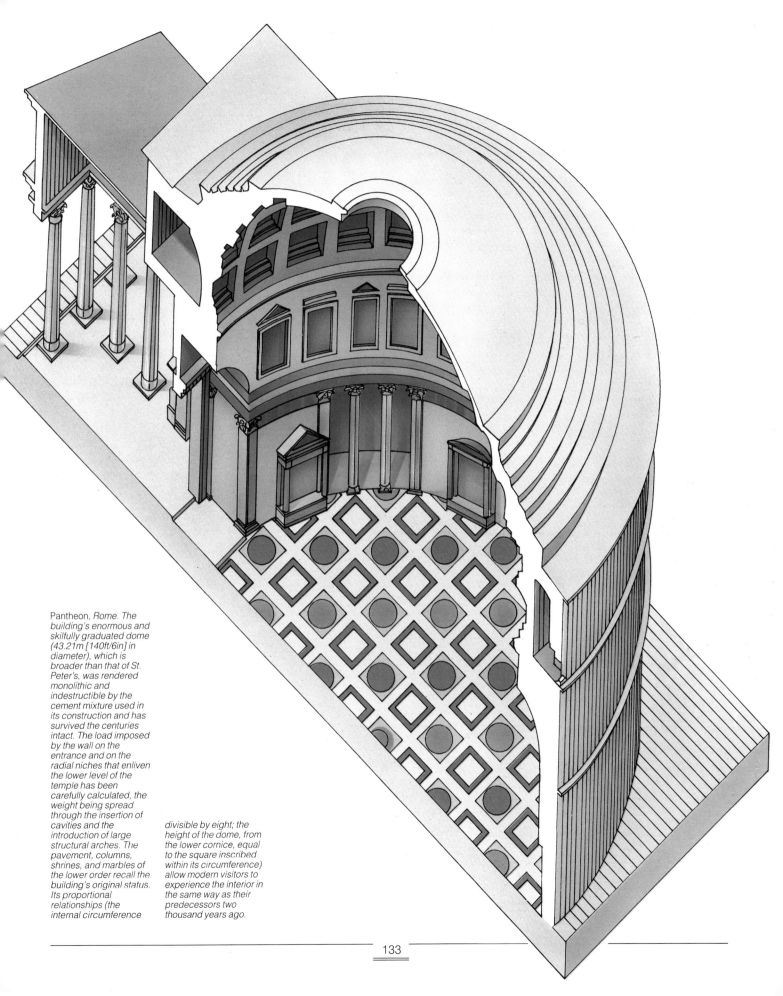

Pantheon, *Rome.* The building's enormous and skilfully graduated dome (43.21m [140ft/6in] in diameter), which is broader than that of St. Peter's, was rendered monolithic and indestructible by the cement mixture used in its construction and has survived the centuries intact. The load imposed by the wall on the entrance and on the radial niches that enliven the lower level of the temple has been carefully calculated, the weight being spread through the insertion of cavities and the introduction of large structural arches. The pavement, columns, shrines, and marbles of the lower order recall the building's original status. Its proportional relationships (the internal circumference divisible by eight; the height of the dome, from the lower cornice, equal to the square inscribed within its circumference) allow modern visitors to experience the interior in the same way as their predecessors two thousand years ago.

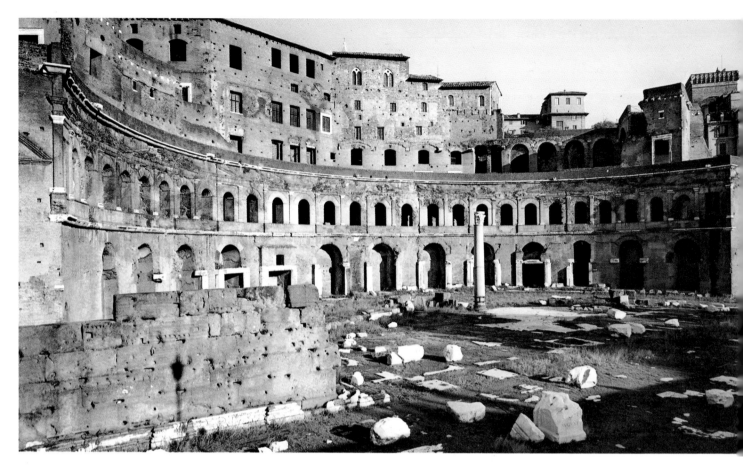

impression on all who enter. The cement mixture, which has been skilfully graduated to maintain constant flexible moment, has enabled this dome – whose circumference (43.21m [140ft 5in]) is wider than that of St. Peter's – to defy the centuries and turned it into a monolithic and indestructible monument.

The group of buildings that make up Hadrian's Villa at Tivoli (A.D. 118–25) embody the "new direction" in Roman architecture: a unique use of curvilinear outline in the Teatro Marittimo and the pavilions of the Academy; the chromatically intense spatial modulations of the baths' interiors, of the *vestibulum* of the Piazza d'Oro and the vaults of the Canopus – both flat and concave section – established principles on which all future architectural experiences were to be based. In the extradoses of niches that have been left "free," it is even possible to detect an early experiment in "external" architecture.

Excavations at Ostia have revealed the late phase of Roman urban buildings, thus completing a panorama whose earlier manifestations are visible at Pompeii and Herculaneum. The different quarters develop in an orderly way, following a model of town planning introduced to Rome after the fire of A.D. 64. The shape of the buildings is flexible, adaptable to a variety of different uses (warehouses, corporative offices, etc.). The development in

their height can be explained by both the growth in population and the increase in land prices. The upper storeys often contained flats, separated by one or more stairs, with balconies and windows opening onto the street; while at street level there were shops and workshops to let.

After a century and a half of uninterrupted building activity, the years between Antoninus Pius and Septimius Severus saw the new style of imperial building spreading out to the provinces (the Antonine baths at Carthage, the Severan forum and basilica at Leptis Magna, etc.). Rome was further embellished by the building of the grandiose Baths of Caracalla, the Column of Marcus Aurelius and the arch of Septimius Severus, all of which were decorated with major sculptural reliefs. In the less innovative field of religious architecture, the Temple of Venus and Rome – built during the reign of Hadrian in Prokonesos marble by Greek craftsmen from Asia Minor – was still a peripteral, Greek-style building, whereas the Temple of Antoninus and Faustina, erected in A.D. 141 on a high podium with its entrance at the front, echoed Italic models. There is a similarly anachronistic quality to the three temples erected during the third century in honour of Eastern divinities whose cults had penetrated Rome: the Temple of Serapis (211–17), built by Caracalla on the Quirinal, the

Trajan's Markets, Rome. This group of buildings, skilfully laid out in a semicircle on the area between the Esquiline and Capitoline hills and crossed by two streets at different levels, formed a new commercial quarter overlooking Trajan's Forum. The complex, a harmonious blend of different, stepped masses, was planned by

Apollodorus of Damascus, who is known also for the famous stone bridge erected over the Danube during the second Dacian campaign.

Temple of the Sun, built by Heliogabalus on the Palatine (218–22), and the third, also dedicated to the Sun, erected by Aurelian in the Campus Martius (273–75).

The reigns of Aurelian, Diocletian and Maxentius, a period lasting from 270 to 312, marked the heyday of the style of Roman architecture known as "Late Antique." The drum of the great circular, domed *calidarium* of Caracalla's Baths is pierced in its upper section by four windows, which create a greater feeling of internal–external dialogue than the single oculus of the Pantheon. The last Roman basilica – that of Maxentius, which was also the first to possess concrete vaulting – repeats the layout of the *frigidarium*, the central nucleus of the baths, and was spanned by three groin vaults supported by barrel-

vaulted lateral aisles. This type of centralized layout, which also occurs in the *frigidarium* of Diocletian's Baths (later transformed by Michelangelo into the Church of Santa Maria degli Angeli), gradually began to incorporate lateral, apse-like areas and circular porticoes that gave a new sense of interest to the interior as well as affecting the exterior, which adapted itself to conform to the logic of the spaces contained within it. The so-called "Temple of Minerva Medica" (in fact, a pavilion in the Horti Liciniani) shows the progress of these innovative ideas in the two phases of its construction. Elsewhere, as in the Aula Palatina at Trier, exteriors displayed a rhythmical combination of tall arcades and carefully arranged apertures that break the blank mass of wall up into alternating areas of open and closed space, creating an interplay of light and shade. This type of external surface was to be adopted by the builders responsible for such Christian basilicas as Santa Sabina in Rome and San Sempliciano in Milan. Clearly, architects could enjoy greater creative freedom in buildings where they were able to ignore the Classical conventions of architecture: the latter survive, for example, in the self-

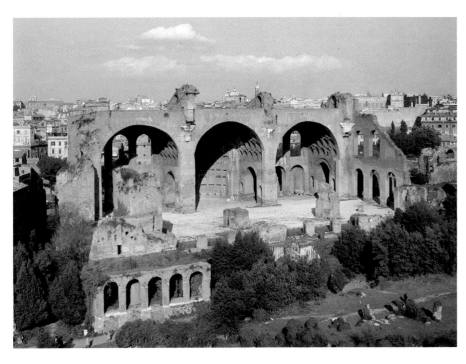

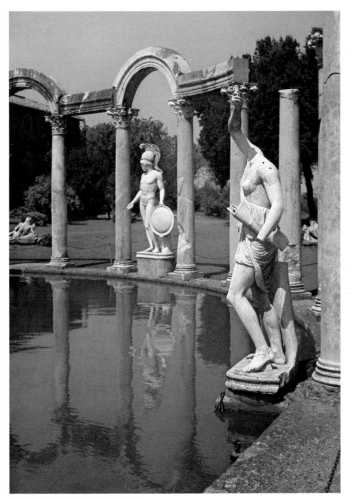

Above: Basilica of Maxentius, *Rome. The illustration shows the three arches in the north wing of the building, whose main entrance was on the east side; the central space was covered by an enormous cross vault, the large support buttresses of which have survived. The basilica, begun by Maxentius between 306 and 310 A.D., was completed by Constantine, who placed his colossal statue in the west aisle.*

Left: Hadrian's Villa, *Tivoli. Between the columns of the Canopus that encircle the reflecting waters, and beneath the arches curving above the architrave, stand statues of the Hadrianic era (now replaced by copies) derived from Greek originals: the two shown here are the figures of Ares and Phidias's Amazon (second century A.D.).*

consciously archaic façade of the Palace of Diocletian at Spalatum (Split), to which the emperor retired in A.D. 305, and in the Porta Nigra at Trier. The Classical order was retained in the interiors of buildings as a decorative repertoire for the walls – whether in mosaic, marble or stucco – and in the dividing colonnades, which could be either arched or rectilinear; the double column (Mausoleum of Constanta) and the springer block became necessary when, with the elimination of the architrave, the upper wall was broader than the column and capital. Only two centuries later, in the Constantinople of Justinian, architects resolved these structural and decorative problems in a unitary manner, using a revolutionary and highly logical system.

One Roman technique in the "external" treatment of domes and half-domes was to leave the extrados open (as at Tivoli, for example): making the curve of the casing visible introduced a new expressive element to the landscape. The domes of Baiae, the half-domes of Trajan's markets, the domes and vaults of the so-called "Hunting Baths" at Leptis Magna paved the way for future experiments, particularly at Byzantium.

During the Tetrarchy, a system devised to tackle the problem of barbarian invasion along the northern and eastern frontiers of the Empire, the regional capitals became the effective seats of government of the two Augustan emperors and the two Caesars. Trier, Milan, Sirmium, Salonika, Nicomedia, Constantinople, and Antioch on the Orontes became the scene of official building programmes and were embellished with the same style of imperial architecture. These peripheral "Romes" were endowed with copies of the

imperial palace overlooking the Hippodrome, the baths and dynastic mausoleums, the fortifications, etc. Structures such as the colonnaded street at Trier (earlier than the one at Leptis Magna) were of Eastern inspiration, just as certain specific building techniques reflected local customs and traditions.

Constantine, having defeated and killed Maxentius at the Malvian Bridge, moved from Trier to Rome in 312. He founded Constantinople in 324 and in May 330 he inaugurated his new residence, moving his court there and later, following opposition from the Roman aristocracy, effective government as well. Particularly after the schism between the Eastern and Western empires that occurred on the death of Theodosius I (A.D. 395), the new capital embraced the creative ideas emanating from Rome, "The cradle of the Empire," which had now been relegated to second place, and – combining them with others inherited from the persistent local Hellenistic-Roman tradition – developed an original style of architecture that was to culminate in the Church of Santa Sophia.

Once the territories along the Mediterranean seaboard had been reunited under Augustus, Roman experience in building roads, aqueducts, bridges, storehouses, drainage systems, gates, etc., began to make itself felt in the Greek regions of the East, which – apart from the recently Hellenized regions – had continued to develop their own structural traditions (Pergamum, Ephesus, etc.). The vaulted *frigidarium* of the baths at Hierapolis, for example, although of Roman design, was still built using square stone blocks. In these regions the traditional repertoire of building types (temples, colonnaded squares, assembly rooms, gymnasia, stadia, etc.) could still satisfy the needs of society. Even later, the characteristics of Roman architecture continued to be suffused with the spirit of Hellenism and linked to local tradition. Athens, for example, contains that small architectural gem known as the "Tower of the Winds," built in the mid first century B.C., and – as confirmation of the Athenian builders' ability to adapt themselves to the requests of foreign patrons – there are also such fine buildings as the Odeon of Agrippa (*c.* 15 B.C.), the Forum of Caesar and Augustus (12–2 B.C.) and the Stoa and Library of Hadrian, all of which have Attic finishing touches.

The aqueduct of Pollio at Ephesus marked the introduction of concrete, a material that had for the most part been ignored in the East because of the poor quality of the local mortar compared with that of central Italy (volcanic sand). As for new types of building, apart from the basilica (the second-century example of Smyrna) and the amphitheater (Syrian Caesarea), neither of which became very widespread, it was the baths that met with the greatest success, because they fulfilled a social need. During the first century, the baths at both Ephesus and Miletus were still linked to

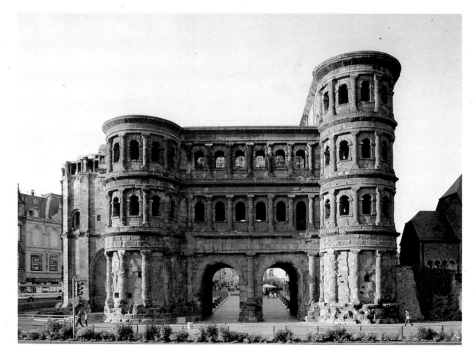

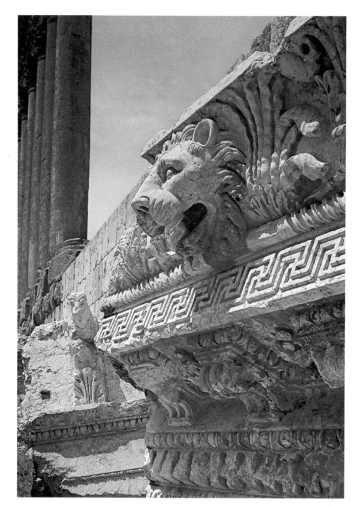

Above: the monumental town gates (Porta Nigra, fourth century A.D.) of Trier, capital and imperial residence of Constantius and his son Constantine, stand at the end of a colonnaded street. The half-columns that flank the arcaded façade reflect the Western taste for archaic-style elements: they recur in the seaward façade of Diocletian's Palace at Split and in the courtyard of the Mausoleum of Maxentius in Rome.

Left: cornice of the Temple of Jupiter, Baalbek. The imposing architrave, with its lion heads, heavy corbels and Greek-key decoration, gives an idea of the typically Roman monumentality of this temple, built on a platform raised 13.5m (44ft) above the courtyard, with ten vast columns (almost 10m [32½ft] high) in the façade. Second–third century A.D.

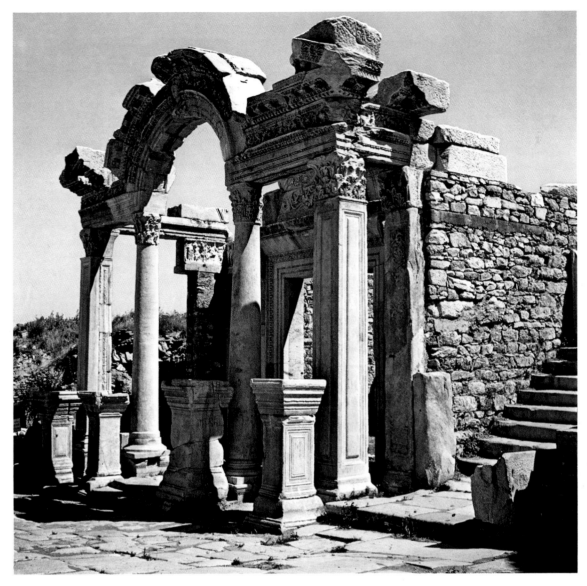

The structure of the Temple of Hadrian at Ephesus, which has a triumphal gateway in the façade, recalls the same emperor's arch in Athens. The man responsible for its construction, which probably began after Hadrian's death (A.D. 138), was Publius Vedius Antoninus, an influential Ephesian and a great benefactor of his city. The building is an elegant expression of the "marble style" of western Asia Minor, which spread rapidly throughout the Mediterranean area.

the traditional Greek gymnasium. Not until the next century did the two become integrated in the building complexes of Ancyra and Sardis: in the latter the structural techniques of Roman architecture (the use of vaults and *opus coementicum*) were adopted, even though the external wall facings reflect local customs and are different in appearance from the Roman brick and *opus reticulatum*. The Late Republican type of theater, found in Rome and Pompeii (the theaters of Pompey and Marcellus), also appears in Syria (Caesarea Maritima) and Asia Minor (extensions to the Hellenistic theaters at Ephesus, Aspendos, etc.).

Basilicas and temples of Italic design occur at Corinth (which became a Roman military colony in 44 B.C.), at Antioch in Pisidia (Temple of Rome and Augustus) and at Pergamum (Sanctuary of Aesculapius). There are Roman proportions, albeit vertically extended, to the Temple of Jupiter at Baalbek (first century A.D.),

which stands high on a podium with a large colonnade encircling the original nucleus; the Temple of Bacchus and the hexagonal forecourt with propylaea that were added in the second century, with their "Baroque" interplay of light and shade, represent one of the most astonishing episodes in Romano-Syrian architecture. The idea of a colonnaded street, a feature common throughout Asia Minor during the second century, was probably of Syrian derivation, as was the motif of an architrave with an arching pediment (which also appears in the small Temple of Hadrian at Ephesus, A.D. 117): a "glorifying" element destined for widespread application in late Roman and Byzantine ceremonial architecture.

In the Eastern regions, where builders were beginning to adopt the new vaulted style of Roman architecture, *opus coementicum* was replaced by a type of air-dried brick that had long been used in Egypt and Mesopotamia. In

the Asklepieion at Pergamum (A.D. 140–75), the lobate rotunda and the temple were designed and vaulted in the Roman style, but made of bricks and locally available materials. Vaults of crushed stone and mortar and walls built of alternating layers of brick and conglomerate (a sort of *opus mixtum*) can be found in baths, rotundas and markets in Asia Minor from the middle of the second century onward (Aspendos, Side, Perge, Sardis, Ancyra, etc.). As in the *pars orientalis*, so in the provinces of Gaul, Spain and northern Italy – which also formed an integral part of the Empire – there was an interchange of ideas with Rome, which began during the reigns of Augustu and Trajan and later became increasingly intensive. The establishment of colonies in Provence, at Lugdunum (Lyons) and Augusta Raurica (Basle) in 44 B.C. marked the start of a building programme that produced a number of outstanding monuments: the Pont

du Gard aqueduct and the Maison Carré at Nîmes, the Temple of Augustus and Rome at Vienne, etc.

The juxtaposition of forum, basilica, and temple became a regular feature of the layout of Western cities – from Veleia to Zadar, from Glanum to Brescia and from Timgad to Sbeitla, all of which display limited variations on the same basic formula.

The architectonic elements that have survived in the provincial centers of the West are of considerable significance, despite the destructions and alterations they have suffered. Examples of town gates from the Augustan era, generally backed by towers and with one entrance for the road and a smaller one for pedestrians, can be seen at Aosta, Turin, Fano, Nîmes, Autun, Trier, etc. Similar to the town gate is the triumphal – or sometimes merely commemorative – arch, frequently used by the Romans to celebrate victories and the apotheosis of the emperor: examples include the Arch of Augustus at Rimini, the Porta Aurea at Ravenna, the arch at Orange, the Arch of Titus in Rome, the arches of Trajan at Benevento, Ancona and Timgad.

There are brickwork theaters from the Augustan era at Arles, Lyons and Orange and an astonishing series of later examples in the

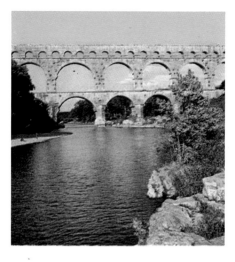

Iberian peninsula (Mérida) and North Africa (Leptis Magna, first century A.D.; Sabratha, 180 A.D.). There are monumental amphitheaters, later in date than the Colosseum, at Verona and Pola, at Arles and at Nîmes in Provence.

Baths – in the sense of a thermal building erected at the site of a curative spring, whether imperial *thermae* or simple *balneae* – can be found wherever Roman civilization penetrated.

Above: Pont du Gard, Nîmes. The exceptional dimensions of this viaduct-aqueduct from the Augustan era reflect a perfect knowledge of the contours of the terrain. Because of the structure's height more than twenty miles of aqueduct could be used, almost all below the level of the countryside, so there was no need for a costly system of pressure pipes. The protruding stones acted as supports for the centering and the planking required during construction.

Left: detail of the theater at Leptis Magna, one of the city's most ancient monuments in that it predates the Severan building programme; of all the many examples in North Africa, this theater is one of the most important. First century A.D.

The same can be said of the basilica, whose layout often betrays its links with the military establishment (*principia castrorum*).

It is interesting to note how every province retained traditional places of worship, linked to local religious practices (cults in Gaul and Carthage, the cult of Mithras, etc.). Similarly, funerary customs were expressed in a variety of different and disparate forms, some local and some imported (burial mounds, underground burial chambers, tombs with towers and pillars, funerary temples, etc.).

With the importation of different types of marble – and also of workmen – from the imperial quarries in the Aegean (Prokonesos, Attica, Euboea, etc.) and Egypt, provincial architecture underwent the same upheaval as had occurred in Rome during the Augustan era. Leptis Magna, in Tripolitania, provides an outstanding example of rebuilding in the "marble style": from the Baths of Hadrian (A.D. 123) to the Severan Forum and Basilica (after A.D. 193) we can observe the revival of various Classical-style elements as a result of the extensive use of imported, prefabricated materials. The same applies to other monuments from the Hadrianic and post-Hadrianic era at Perge and Side in Pamphylia, Constanta on the Black Sea and elsewhere.

After Maxentius's intervention (basilica, rebuilding of the Temple of Venus and Rome, large suburban villa with circus and mausoleum surrounded by a four-sided portico), the Arch of Constantine, the four-fronted arch in the Forum Boarium, and the Basilica of Junius Bassus (destroyed in the seventeenth century) were the last public monuments to be erected in Rome. Although the building of domed mausoleums continued (the Mausoleum of the Gordiani on the Via Prenestina, the mausoleum of Helena and Constantina, the so-called "Temple of Romulus" on the Via Sacra, etc.), it was Christian architecture that began to play an increasingly prominent role. The reinforcement of the walls by Honorius did not prevent the city being sacked by the Vandals and Goths, whilst the letters of Cassiodorus tell us of the restoration works planned by Theodoric (the Colosseum, the Theater of Pompey, the imperial palaces, etc.). However, the cutting of the aqueducts, which occurred during the later siege of Vitige (537–38) rendered the city's baths, fountains, and nymphaea unserviceable, an event that marked the start of Rome's slide into irreversible decline. The last monument in the Forum was the Column of Phocas, erected in 608 by the prefect Smaragdus in honour of the Byzantine emperor who had donated his most prestigious possession, the Pantheon, to the Church of Rome.

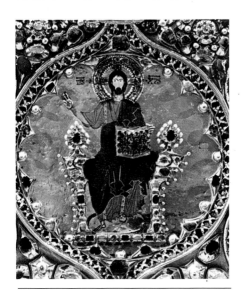

Early Christian and Byzantine Art

Early Christian art

The earliest Christian art, outlined here down to the period of Theodosius, developed with a degree of delay in relation to the acceptance of the new religion by those communities of faithful who had first gathered in the great cities of the Roman Empire. As far as its inner stylistic structure was concerned, it remained firmly linked to the specific history of the Roman Imperial tradition, in both East and West, becoming, as it were, a branch of this tradition. While continuing to show evidence of variations resulting from the circulation of concepts of distinct cultural areas and the action of provincial substrata of the pre-Hellenic and pre-Roman "Mediterranean" world in both East and West, the dawning repertoire of the Christian figurative style took up anti-classical impulses that had already matured in late-classical Roman-Hellenistic art. The rationality of the Graeco-Roman organic plastic syntax was gradually replaced by a rhythmic, chromatic, disconnected "pre-medieval vision."

By the beginning of the third century A.D., evident similarities of an iconographic and doctrinal kind brought together Christian works created in parts of the Empire that were very remote from one another. The linear style of Severus, which inspired many Roman catacomb decorations, giving us the first "sketchy" figures (cemeteries of Lucina, Priscilla, Domitilla, Praetextatus, Saints Peter and Marcellinus; the tomb of the Aurelii, etc.) – which subsequently became more realistic

under Gallienus and settled, around 300 into tetrachic "expressionism" – does not, all in all, emerge as very different from that which, in the same years, inspired the mural paintings of the baptistery of Dura Europos in Mesopotamia. The works are similar in their taste to the forms and techniques of the Roman art current in the cities and regions where they were executed.

The custom of decorating tombs in subterranean necropolises (chambers and *arcosolia*), and the system and range of ornament were borrowed from pagan examples: in tombs such as Porta Maggiore or Porta Latina, the Romans had represented stories and mythological characters as paradigms of salvation in the life to come. Even if examples of early Christian painting before the Edict of Constantine have been preserved mainly in cemeteries with underground galleries, where building was made easier by the tuffaceous nature of the rock (Rome, Naples, Syracuse), they are not confined to these cemeteries alone. Walls and ceilings of overground mausoleums were decorated with the new Christian themes, as shown by the elegant mosaic cycle of the Mausoleum of the Julii beneath St Peter's, with its haloed image of

Christ as the "true sun." The choice of subjects, which, whether painted or sculpted, carved or mosaic, unites representations from Italy to Africa, from Gaul to Syria, presupposes the doctrinally judicious and cautiously imposed intervention of the church, and motives of a religious kind. We see the Good Shepherd, Adam and Eve, the story of Jonah, biblical episodes and the miracles of Christ, orants and Eucharistic symbols such as the fish and bread, as well as Abraham and Isaac, Daniel in the lions' den, the three young Jews in the furnace, etc. These scenes, linked over all to the prayers for the office of the dead, are to be found on sarcophagi and in cemeteries. The paintings of the catacombs show lightly rendered isolated figures, represented frontally, or packed into tiny groups arranged in geometrical fields divided up by means of slender red and green strokes on a cream background. It is an idiom which resolves the problem of representation in terms of an "absolute" surface, in a dimension different from the classical one. Repetition establishes a rhythmic principle similar to that of contemporary columnar sarcophagi.

Toward the year 300 the initially restricted range of themes was joined by the Adoration of the Magi, the Baptism of Christ and the Agape reminiscent of the Eucharist, with reference to the Sacraments that ensure salvation. Rome and Provence, and later Ravenna, Spain, northern Africa and Constantinople, were the most productive centers of the making of sarcophagi.

The Emperor Constantine was favourable to

Christianity from at least 212, after the battle of the Milvian Bridge, and he found a new and different object of attention in the Christian religion, to which he gave such a privileged position and whose powerful protector he became: he had to give it a fitting official "Image." The edicts of toleration and successive imperial institutions raised Christian art from its initial "private" sphere to a much more far-reaching dimension. With religious peace and the transferring of the imperial residence to Constantinople in 330, Christian building activity itensified from the Atlantic to the Euphrates, from Britannia to Nubia, from the Crimea to Mesopotamia. Highly efficient road networks ensured rapid travel throughout the territories of the Christianized empire, and encouraged "pilgrimages" to the *loca sancta* of Palestine, the cradle of the Christian faith and the backdrop to Christ's actions.

With the ever-increasing power of the Church, new conditions emerged for the development of the arts. In the first third of the fourth century there was a broadening of the doctrinal program in painting and sculpture; Christian book illustration was born; architecture finally emerged into the open, with churches and shrines over the tombs of the martyrs springing up everywhere. New Christian buildings arose in the main cities at Constantine's orders, their magnificence revealing a truly "imperial" character. The architectural type predominantly used was the basilica, suited to the Eucharistic gatherings of the congregations, adopted earlier in the Jewish synagogues of Galilee (the Jewish religion was officially recognized by the Roman state): an elongated structure, with a raised presbytery for the clergy, roofed by wooden trusses. However, the basilica was not the only type used: the *Martyria* of the Holy Land, for instance, for specific points of veneration and the commemorative ceremonies relating to them, made use of different solutions as the situation required.

Few Christian buildings from the time of Constantine have survived intact or allowing easy interpretation. Some elements of the very famous complex of the Holy Sepulchre remain, with the adjoining church of the Resurrection on Golgotha, the first in the hierarchy of Christian shrines throughout the Middle Ages. The church of the Nativity in Bethlehem, built at the request of Helena, is almost intact, with just the apse transformed under Justinian, and the roof rebuilt. The Lateran Basilica, the cathedral of Rome, built around 320 on land that Constantine had given to the Church (originally intended for barracks, near the imperial residence), still has foundations and expanses of masonry (saved in Borromini's transformation) that make a reliable reconstruction possible: a well-lit hall with a nave and four aisles, with a transept and a large apse to the west. Around 320 Constantine decided to raze the necropolis that had grown up around the memoria of St. Peter (dating from the second century) and to build the grandiose basilica in honour of the Saint (completed in 329). Of the Christian buildings put up by Constantine in Constantinople, nothing remains of the first Hagia Sophia or the Apostoleion, which was a

heroon-martyrion of the "isapostolic" Emperor, dedicated to the Apostles. Other Christian buildings (known from sources, inscriptions and excavations) were built or completed under Constantius II, Constantine's son: St. Sebastian and the Church of the Holy Cross in Jerusalem; S. Lorenzo, S. Agnese, SS. Pietro e Marcellino in Rome; the church of the Ascension in Jerusalem; the double basilica in Trier and St. Gereon in Cologne; St. Babylas and the Golden Church in Antioch, etc.

Round mausoleums, like that on the Holy Sepulcher, were dedicated to Constantine's mother and daughter, Helena and Constantia. The mausoleum of S. Costanza, linked to the basilica of S. Agnese, has the first large-scale mosaic decoration of a Christian interior of the time. The traditional technique of the fresco was gradually being replaced by that of mosaic, better suited, through its intense colourfulness, to the emphasizing of the boundlessness of the surfaces of the great Christian basilicas; it was applied, after the grandiose prologue of Theodoric's mosaic in Aquileia, to the surfaces of a vault, and an ambulatory (there are pagan precedents at Ostia). Eleven panels – scenes of harvesting, with backgrounds of geometrical designs (crosses, circles, losanges), with human or animal busts ending in plant clusters, with taeniae and sprays entwining Cupids and Psyches and birds in flight, amphoras and basins with drinking doves – divide up the circular ceiling of the ambulatory. This decor-

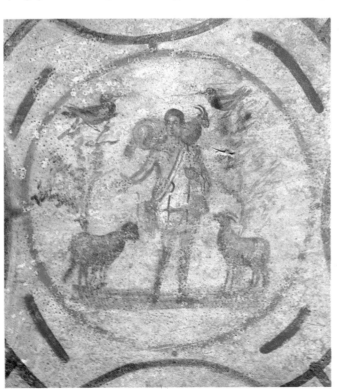

Rome, catacomb of Priscilla. The depiction of the Good Shepherd seen here in a fresco of the first half of the third century, is one of the first and most widespread allegorical images of Christ. In Roman art the shepherd with the lamb was a symbol of man's love for man, of humanitas; Christian iconography used the shepherd to indicate Christ the Redeemer, who saves the lamb, completed by the presence of two other animals, alluding to the flock of the faithful, which is led into the garden of Paradise, represented by trees and birds.

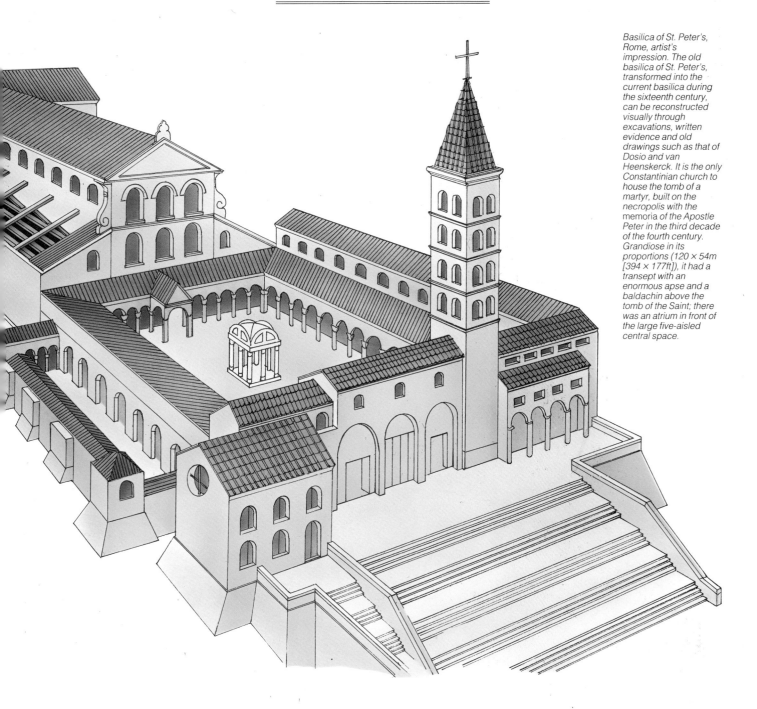

Basilica of St. Peter's, Rome, artist's impression. The old basilica of St. Peter's, transformed into the current basilica during the sixteenth century, can be reconstructed visually through excavations, written evidence and old drawings such as that of Dosio and van Heenskerck. It is the only Constantinian church to house the tomb of a martyr, built on the necropolis with the memoria of the Apostle Peter in the third decade of the fourth century. Grandiose in its proportions (120 × 54m [394 × 177ft]), it had a transept with an enormous apse and a baldachin above the tomb of the Saint; there was an atrium in front of the large five-aisled central space.

ation, which employed a sophisticated technique, linear in design, with solid colour standing out against a light background, psychologically activates the space represented, in dialogue which is consistent with the articulated masses created.

In Ravenna, the new capital from 402 and open to the influences of the Byzantine East, the new style became more consistent, definable in terms of pure colour, in the fifth century. In the mosaics of the Mausoleum of Galla Placidia, the daughter of Theodosius, where one senses a "Greek" influence, the originally

white background becomes an intense indigo blue, with a closer link between architecture and decoration; and on this background the motifs are developed with a new sense of rhythm, not in geometric set pieces but in leaps and bounds of colour. The integration of masonry structure, marble inlay, stuccoes, columns and mosaic decoration is possibly even closer in the Baptistery of Neon: the fantastic group of altars and thrones, laden with Syrian "baroque," the cortège of Apostles and the figures of the Baptism itself (despite the echoes of "classical" canons) here no

longer have any hint of naturalism and thus stand purely as rhythm, as rhetorical figures. Contours of marble and masonry dissolve into colour; in the overall pattern of the architecture, the figures portrayed assume the values of a porphyry column or a pendentive expanding chromatically into a cluster of acanthus: it is one continuous osmosis which reflects the disembodied dimension of the new Christian myth.

The historical-narrative tendency of Roman art, an expression of the empirical attitude of the Latin Mens, consistent in form and content

throughout its whole period (from the fresco of the Esquiline to the imperial reliefs of the columns and the little scenes on funerary stelae), despite the re-emergence of "classicizing" periods under Augustus, Hadrian, Gallienus and Julian, finally replaced the unity of time and place of the Greeks in representation. When it had to give official shape, in pictorial or sculptural form, to events which constituted the essence of its history, Christianity had recourse to a style such as that of the frieze of Trajan's column (with its elimination of frames, repetition, rhythm, its anticipation of the heavily symbolic "set"

schematized into isolated scenes, ambiguously symbolic. The Gospel story becomes a grandiloquent allegory (alluding to the divine motherhood of the Virgin, proclaimed in the Council of Ephesus of 431) on the Sistine arch of the same basilica, with a style of a different formal origin. Similar in character to the mosaics of S. Maria Maggiore is the Christological cycle in S. Apollinare Nuovo in Ravenna, with its twenty-six sections in "Roman" style, liturgically arranged, where the fleetingness of mortal time is redeemed in the eternal and timeless present of sacred events.

In Rome, portrait painting understood the

cal concern for spatial "position" was dying away, and the weight of the spiritual "position" was now being focused on the image.

In the portraits in the catacombs from the third to the sixth centuries, one may follow almost in parallel the transformation of the image that occurred in late Roman art. The dead as orants, Madonnas as matrons, saints as senators, Christ as emperor in the *adlocutio*, reflect this ambiguity, the continual overlapping of the objective and the subjective, through which "the detail given as real then reveals itself as an expression of the mind of the person contemplating the work" (Bet-

Left: mausoleum of St. Constantia, Rome. The ambulatory that surrounded the central domed space of the mausoleum is roofed with barrel-vaulting, entirely covered with mosaics. Eleven panels around the bays of the ambulatory have geometric designs (crosses, circles, lozenges), scenes of the wine-harvest beneath, intertwining vegetation, personages, birds in flight, amphoras and basins with doves drinking from them. This circular corridor leads through twelve arches supported by coupled columns into the light-filled space of the domed baldachin, whose surfaces were covered with mosaics showing the heavenly Jerusalem and with precious marbles.

Opposite: Orthodox Baptistery, Ravenna. Its lower section and the marble facing of its interior dating from about 400, it was roofed with a dome and decorated with mosaics and stuccoes by Bishop Neo around the middle of the fifth century.

scenes of the frieze of Constantine): objective Roman narration was transformed into the subjectivity of the Christian narrative, into a time that was no longer that of the chronicle but already that of myth.

Scenes previously illustrated in catacomb painting now triumphed in the mosaic decoration of basilicas such as S. Maria Maggiore. The wall panels, framed at the end of the sixteenth century, depicted biblical episodes in the style of illuminations (indeed they may possibly have been inspired by book illustrations), whose narrative flow was

image as an expression of physiognomic objectivity, of the individuality of the single person. We can follow its course in portraits from Egypt (panels and canvases used on mummies) in the second and third centuries and, in the absence of pictorial evidence in Rome and elsewhere, through sculpture and plastic art. From the porphyry group in Venice to the "figure wearing a chlamys" in Ravenna, to the sarcophagi of Helena and Constantina, with the development of the tetrarchic style into that of the time of Constantine, the images were frozen in hieratic abstraction: the classi-

tini). Examples of the formal range might include the *Orants* in the Cemetery of Callixtus, the portraits in Theodoric's pavement at Aquileia, the *Orant and Son* in the Coemeterium Majus, the Brescia triple portrait on glass, the *Orants* in the cemetery of Trasone, the *Christ between Peter and Paul* in the cemetery of SS. Pietro e Marcellino."

An origin in portraiture, which one might already be tempted to see as being in the iconic tradition, underlies the *Christ and the Apostles* in S. Aquilano in Milan, with the similar scene in Domitilla, the figures of the

mosaic in S. Pudenziana, in SS. Cosma e Damiano, the two "ecclesiae" in S. Sabina in Rome and the face of St. Victor in the Milanese chapel of S. Vittore, as well as other saints in the cemeteries of the Porziani and of Comodilla. The sarcophagi produced in Rome, above all in the fourth century, often remained "normative" for the products of the workshops of Spain, Africa, Provence (in 345 Arles became the imperial residence instead of Trier, which was threatened by the barbarians); Ravenna, Milan and lastly Constantinople often produced characteristic work of their own, with specific features.

The sarcophagi fronts had superimposed registers, where scenes from the Old and New Testaments were shown in continuous narration (Sarcophagus of the Two Brothers from S. Paolo fuori le Mura), between trabeated columns or with arches and pediments, as in the rare example dated 359 of the prefect Junius Bassus. The central motif with the *Majestas Domini*, an echo of the imperial theme of glorification, is taken up again in a series of Roman sarcophagi, the finest of which is the Lateran no. 174, which is also carved on the sides. There are other sarcophagi with the *Traditio legis*, and variants in Constantinople, Milan and Ravenna: Christ is standing with the scroll of the Law or the Cross, held sometimes by Peter, on the architectural background of the heavenly Jerusalem. The Cross, the crown and monogram, reappears in an important series known as the "sarcophagi of the passion": in them, between columns or trees, scenes of Christ's passion are sculpted, sometimes alongside scenes of the passions of Peter and Paul. Peter led to his torture and the beheading of Paul appear on the unfinished sarcophagus in St. Sebastian: the sculpture is of a high quality, of a "Theodosian" classicism which approaches that of the adolescent Christ of the Museo delle Terme in Rome. Alongside the Christ "cosmocrator," on the sarcophagus of Junius Bassus, is the other triumphal scene of the *Adventus*: the entry of Christ into Jerusalem, a recurrent motif also in the so-called "Bethesda" group of sarcophagi. The developments of the sculpture of the Theodosian era in Constantinople and of the sarcophagi at Ravenna, partly linked to it, belong to the typically Byzantine sphere. Here one should mention the fragments of a door depicting stories of David in S. Ambrogio in Milan and the wooden carving on the door of S. Sabina in Rome: panels, whose order has been rearranged, show scenes from the Old and New Testaments, historical and symbolic subjects of great interest for their relationships with iconographies in Palestine and for the presence of one of the earliest representations of Christ crucified (naked and without a cross).

Toward the end of the fourth century, profiting from the patronage of Theodosius and other markedly orthodox Emperors, Christianity, raised to the dignity of State religion, produced an architecture that was identified quite simply with that of the Christian Empire. Although the death of Theodosius, in 395, marked the de facto division between Eastern and Western empires, in the world of culture there was no sense of a rift between "Roman" and "Byzantine" (a term which did not yet exist). The Imperial cosmos, centered on the Rome on the Bosphorus, co-ordinated the expressive means whose artistic pattern we have just examined, though in terms of experimentalism and a dialectic between courtly forms and popular-based or provincial forces (transformation of figurative time and space).

In the fifth and sixth centuries the first monastic communities were established in Italy, Gaul, Syria and Egypt, giving rise to particular associative forms and a particular type of architecture, which had long-term consequences and developments. In the fifth century the basilican building, by now tantamount to the very notion of "church," underwent a process of generalization over the entire area of the Empire. Its basic elements: atrium, narthex, nave and aisles, transept, tripartite choir with apses, were used together

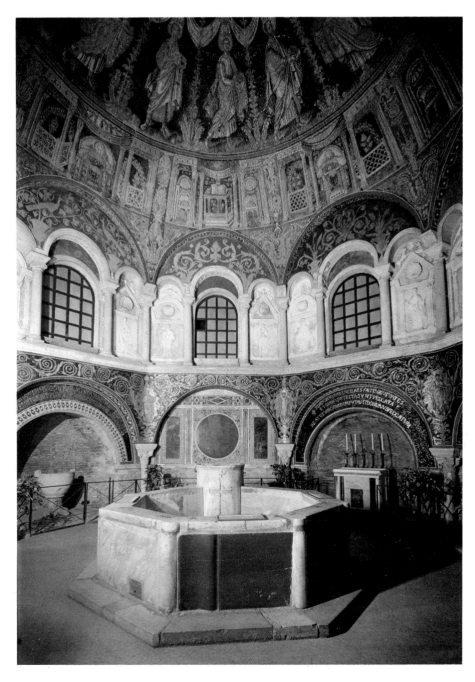

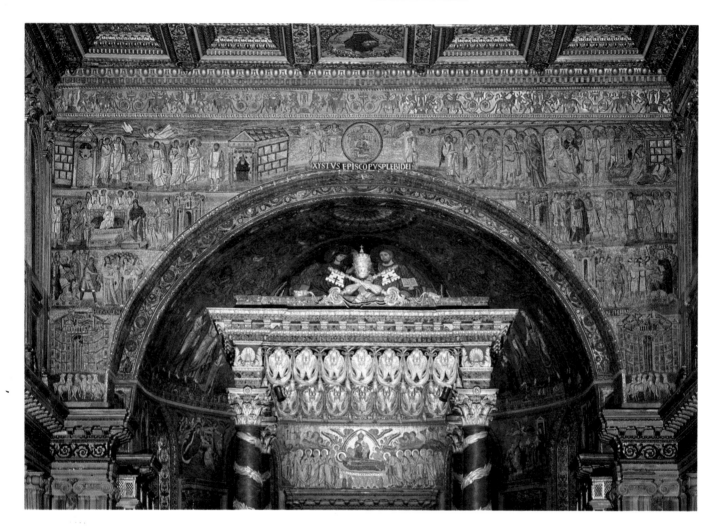

XYSTVS EPISCOPVSPLEBIDEI

or separately, with greater or lesser frequency according to the region. The vastness of the space in S. Paolo fuori le Mura, founded in 388 by Valentinian II and completed in the following century, may give an idea of the Imperial foundations and also of the lost St. Peter's, whose plan and elevation it echoes. Its reconstruction after the fire of 1823 means that the chromatic effect of the original decoration is lost to us: but the four continuous rows of columns, broken by the light-filled caesura of the transept, are sufficient to recreate the triumphant sense of space of similar "courtly" basilicas of the Theodosian era. Within its baroque casing the almost contemporary S. Maria Maggiore (built at the order of Pope Liberius) is still a harmonious space, perfectly proportioned, its walls regally covered with mosaics.

Among the Roman parish churches that punctuate a process of development (changes in proportion, alterations to the window and transept systems, disappearance of the open passage between atrium-narthex-nave), one might mention the elegant and precious decoration of S. Clemente, S. Pudenziana, S. Pietro in Vincoli, S. Agata dei Goti.

The finest of all is S. Sabina, built between 422 and 432 after the sack of Alaric (410): the very lovely columns, bases and capitals are all of looted stone; the marble facing, with chalices and patens, and the mosaic facing whose dedicatory panel is still in place above the entrance, confirm the quality of the Roman projects, both simple and grandiose, of a period of "renaissance" under Sixtus III. This mood also inspired the oldest centrally planned baptistery in Rome, adjoining the Lateran basilica. Built by Constantine and redesigned as an octagon by Pope Sixtus (reminiscent of that of S. Tecla in Milan), the interior has an ambulatory separated from the baptismal font by eight columns, in a double order, forming a sort of baldachin. The cylindrical nucleus of S. Stefano Rotondo, founded by Pope Simplicius, also stands above a trabeated colonnade. Through a series of arches on columns an external ambulatory leads to four alternating and enclosed courtyards: this may possibly be the *martyrium* of the protomartyr Saint.

The Christian architecture in Milan, the capital before Ravenna, has "imperial" connotations in the grandiose palatine complex of S. Lorenzo (a *unicum* that is reminiscent of the

Patriarchal basilica of S. Maria Maggiore, Rome. The majestic space of the basilica, completed during the years of the pontificate of Sixtus III (432–440) ends in a chancel arch covered with mosaics, which allude to the recently proclaimed divine motherhood of the Virgin.

lost golden Church of Antioch), and in the main basilica of S. Tecla, with its pre-Ambrosian baptistery. These buildings, with the four basilicas founded by Ambrose (d. 397) remain basic points of reference for the Christian churches of northern Italy (Verona, Vicenza, etc., up to the dioceses of Aquileia and Parenzo) and, in part, for Ravenna itself, which was the capital from 402. From the Basilica Ursiana, with its nave and four aisles, to S. Giovanni Evangelista, from S. Apollinare Nuovo to S. Apollinare in Classe, the basilicas of Ravenna, entirely built in brick, are generally divided into naves and aisles by two rows of columns and series of arches, roofed with wooden trusses, with a polygonal apse of the Constantinopolitan type. The plan of S. Croce was more original with a single nave and transverse narthex, at the end of which is the domed cruciform sacellum of Galla, Honorius'

sister. Apart from this mausoleum, which, with the other circular mausoleum of Theodoric (in stone) looks back to the family of Roman tombs, there also remain the baptistery of Neon (first quarter fifth century) and the Arian baptistery (about 500), which are octagonal, with peripheral openings on the ground floor and mosaic facing in the interior. Other significant centrally planned churches are the rotunda of S. Angelo in Perugia (end of fourth century) and the fifth-century baptistery of S. Giovanni in Fonte in Naples, with mosaics.

The architecture of Constantinople, the powerhouse of the whole Empire and the seat of the *basileus* of all the Romans, should be included, during the fifth century, in the vast area of the coastal regions of the Aegean and of Greece. The plans of its churches complicate the normal plans with the addition of upper galleries, polygonal apses, transepts flanked by openings or aisles, *synthronon* and *solea* (flights of presbytery steps for the clergy and raised passageways), accessory spaces, and so on. Cruciform *martyria* with one or more naves are found, as well as circular octagons with ambulatories, tetraconch, domed or otherwise. Among many such churches one might mention the Acheiropoeitos in Salonica with its triple arcade (*tribelon*), which leads into the naos from the inner narthex; the church of the Monastery of St. John of Stoudios in Constantinople and its narthex with the splendid carved "Theodosian" marbles (capitals, columns, cornices, etc.); the churches of St. John and of the Virgin at Ephesus; St. Thecla at Meriamlik; the basilica of St. Menas in Alexandria; the church of the Red and White convents near Sohag, in Egypt, with their triconch presbyteries; St. Demetrius and the basilica at Epidaurus (*c.* 400), both with nave and four aisles; the basilica at Nea Anchialos (*c.* 470); St. Leonidas at Corinth (*c.* 450); the African basilicas of Orléansville, Carthage and Tebessa.

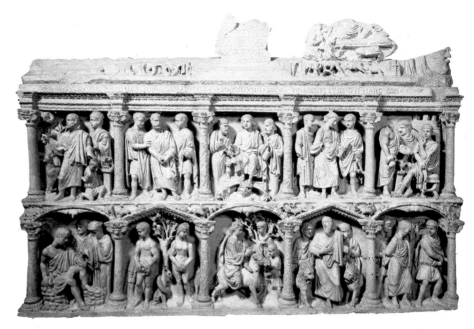

Above: the sarcophagus of the Christian consul Junius Brutus has scenes connected to the Old and New Testaments set within trabeated panels, arches and pediments. "Classical" taste caused the forms to be executed in virtually full relief. Fourth century, Vatican Grottoes.

Below: St. John of Stoudios, Istanbul. This church, with the adjoining monastery, was founded by the senator Stoudios before 463. The columns of green marble with "Theodosian" capitals, support a straight trabeation with galleries (now lost) above.

The Christian buildings of Syria, a flourishing and "cultured" province of the Empire, have a particular beauty because of the precision of their design, their exact volumes, the technically perfect working of the stone (stone was almost always used as a building material), and the rich ornamentation of the cornices of their doors, windows and other architectural elements. The great shrine of Simeon Stylites the Elder, founded toward 480, with adjoining baptistery and monastery, is one of the most astounding achievements of the Syrian architects, whose names in many cases are known. Further east, in Roman Mesopotamia and its centers in Edessa, Amida and Nisibis, parish and monastic churches developed an iconography of their own (tripartite presbyteries, transverse spaces with barrel-vaulting), their ornamental carving being inspired by Syrian examples (Mar Yakub in Nisibis, etc.). The buildings in the vast border area constitute the unitary basis on which the "words" of early Christian "vernacular prose" were woven, around the center, Byzantium, where the difficult court "poetry" was spoken. But from this early Christian prose, the basis of an artistic culture operative throughout the Christian Mediterranean, which absorbed and sometimes dammed up the direct incursions of the style of Constantinople, the Western Romanesque, the modern "historical" style, was to be born.

The art and architecture of Constantinople

The age of Theodosius. Under Diocletian and Constantine, pressing political and administrative pressures brought about the independence of the eastern part of the Roman Empire. This division became a reality at the death of Theodosius, in 395, and the two separate stumps took different, increasingly divergent, paths. The crisis of the third century and the barbarian invasions brought the West to the point of collapse in 476, with the deposition of

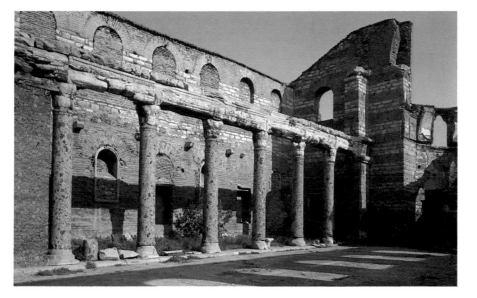

Romulus Augustulus. Constantinople, which was backed by greater economic resources and skilful diplomacy, managed to keep first Persian and then Islamic pressures at bay, though with difficulty and with territorial losses, amid bitter internal political and religious conflicts. But the heir to the Roman state, blessed with a perfect administration, robust judicial statutes and cultural traditions, survived in a new form *vis-à-vis* mother Rome: the basis for the authority of the *basileus* was now placed in the Christian religion, which had become the State religion, and his choice and investiture was placed in the power of the divine will.

Having become the monarchy of a universal religion, Byzantium imbued the body of the Roman state with the spiritual strength and moral totalitarianism of Christianity; identifying itself with the Church, it became the center of a new Holy Empire. On earth, in the name of Christ, its Emperor administered a hierarchy of men and things that reflected the heavenly order.

The new Rome, which Constantine founded in 324 on the south-eastern extremity of Europe, between the Golden Horn and the Sea of Marmara, opposite the coast of Asia Minor, emerged as the center of a new imperial policy directed toward the east. Dedicated in May 330, Constantinople remained the "model" city throughout the Middle Ages, full of gold and relics, the sole repository of the legacy of Rome and of classical culture The uninterrupted building activity from the fourth to the sixth century produced wide-ranging town-planning projects that made Byzantium an incomparable monumental center: the Great Palace and Temple of Divine Wisdom (Hagia Sophia), churches and administrative and political buildings, squares and arcaded streets, aquaducts and cisterns, baths and markets, palaces and houses with several floors, hippodromes and theaters, triumphal arches and columns. Excavations have revealed the mosaic peristyle of the Great Palace, which was articulated into separate nuclei that were built and rebuilt over several centuries, starting with the Constantinian lay-out (palace of Daphne). With the *Book of Ceremonies* written by the Emperor Constantine Porphyrogenitus (912–959) as guide, we may begin from the square of the Augusteion and take an imaginary route, entering the Palace through the Chalke or Brown Gate. Interspersed by courtyards and fountains, we find the variously shaped official and private quarters of the Emperor, functionaries and guards (quadrangular, circular, octagonal in plan, etc.).

This architecture had a particular lay-out, function and decoration, intended for the court liturgy inherited from Rome and which Byzantium developed with punctilious consistency: scenes of a theater where the "court drama" was performed and repeated by Emperors and dignitaries for the exemplary edification of their subjects.

The double circle of walls built at the beginning of the fifth century by the engineers of Theodosius II (the main wall was nine meters [29½ft] high and about five meters [16ft] thick), defended by about a hundred polygonal and square towers, and by a barbican and a moat about twenty meters [65ft] wide, which protected the city along the sides accessible by land (and along the sea-bounded sides, naturally), made use of a revolutionary

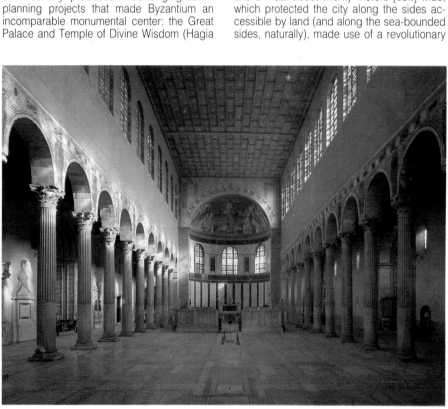

Left: S. Sabina, Rome. This basilica is a superb example of the proportions adopted in fifth-century Roman church building: the apses of the nave and aisles became narrower, longer and higher: arches and windows, now markedly wider, were more numerous, so that interiors could be better lit (422–432).

Above: wooden door of S. Sabina. The panels covering this cypress door, which is incomplete and has been restored, form the most important piece of wood-carving to have survived in the western part of the Empire. There are two distinct styles: one more "courtly," the other simpler and closer to that of the sculpture of the Roman sarcophagi. The figure in the chlamys beside the angel in the enigmatic scene of "acclamation" reproduced here has sometimes been identified as Peter the Illyrian, founder of the church (fifth century).

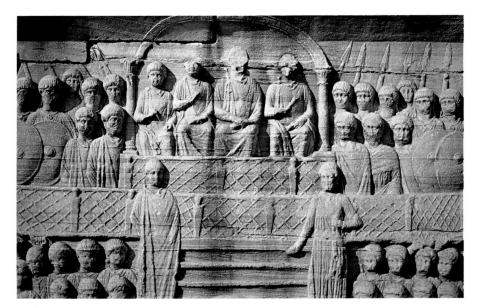

system of defense, a masterpiece of military architecture: the spherical vaulting, barrel-vaulting and herringbone work that roof the towers, faultlessly executed in brick, offer a precedent for the vaulted and domed roofs of later civil and ecclesiastical architecture, and of fortresses along the eastern border such as Amida and Dara. As had been traditional in Rome, the art of imperial "propaganda" continued in Constantinople, now in the novel guise of an osmosis of the secular and the religious. In the center of the *Forum Tauri*, a square built by Theodosius on the extension of the *mesè* (main porticoed thoroughfare), the emperor built a spiral column inspired by that of Trajan. Fragments of the monument, erected in memory of the wars against Scythians and Ostrogoths, culminating in the triumph celebrated at Constantinople in 386, portray battle scenes, boats on the Danube, soldiers on parade or on their knees with shields bearing the *chrismon* (Christ's monogram). A drawing of the late sixteenth century, in the Louvre, connected with the column, shows a triumphal procession moving toward the capital. But the meaning of the historical relief of the columns of Trajan and Marcus Aurelius, which described the *virtus* of the emperor at the head of his army, is different here: a few warlike episodes (now masterminded by generals) have been selected, accompanying the stages of the imperial ceremonial, with the divine figure seen in isolation, far removed from human acts. The concepts that permeate the new scenes are shown in the representations which decorate the base of an Egyptian obelisk placed on the *spina* of the hippodrome toward 390. Panoramic views of two ceremonies performed in the presence of the Emperor, with the groups of guards and dignitaries symmetrically arranged on a single level, against a background of the real architecture of the Forum, had already been de-

picted in the reliefs of the arch of Constantine. In the Constantinopolitan work the registers are superimposed one upon the other and the giant figure of the *basileus*, seen with his family in the *kathisma* (imperial box at the Hippodrome), predominates; while people and things seen below (in reality near the tracks and thus nearer the point of observation) gradually become smaller. In this way the concept of hierarchical proportion emerges (already expressed in the colossal statue of Constantine in Rome) and of the "distance" (not absence) of the historical figure, projected motionless into a limitless dimension: these imperial depictions anticipate the principle of the quality of the image of the sacred icons.

The triumphal arch of Theodosius, a colossal tetrapylon built in 393, and an equestrian statue of him (known through a drawing in Budapest) complete the series of official monuments dating from the Theodosian era. In this group of court statues the sculptors of the capital revert to a restricted "Hellenism," at all events a Hellenism not found in the arches of Constantine and Galerius: slender necks rise from sloping shoulders, supporting noble heads, finely delineated beards, elegantly arranged locks of hair.

The face of the Emperor Arcadius, the son of Theodosius, is preserved in a portrait in the Istanbul museum: it has a faraway expression, midway between naturalism and idealism, the curve of the large eyes echoed in the eyebrows, hair and arched diadem. Examples of portraiture and statuary of an official character are given, from the time of Theodosius and Arcadius to that of Justinian, by a series of heads, busts and statues almost all from Constantinople and centers throughout Asia Minor. Outstanding for its quality is the statue of Valentinian II from Aphrodisias, the *Colossus* of Barletta, which probably represents the Emperor Marcianus, and the portrait of Theo-

dora (or Pulcheria).

Alongside portraiture, and partly throwing light on its stylistic development, are a category of ivory objects which, from the end of the fourth century, were widely circulated in the political and public sphere. These diptychs (so-called because they were made up of two panels folded one over the other) were offered by consuls when they took up their position (disposition of Theodosius in 381). Larger ones, made up of five parts, were intended for the Emperor himself. The series of consular diptychs from Constantinople, which began with examples of Flavius Anastasius' general Areobindus and ended with a diptych of Justinus of 540 (the consulate was annulled the following year), normally presented the magistrate on the *sella curulis* (or sometimes in a *clipeus*) with a scepter in his left hand and a *mappa* in the raised right; he was often flanked by personifications of Rome and Constantinople; the upper part of the tablet bore images,

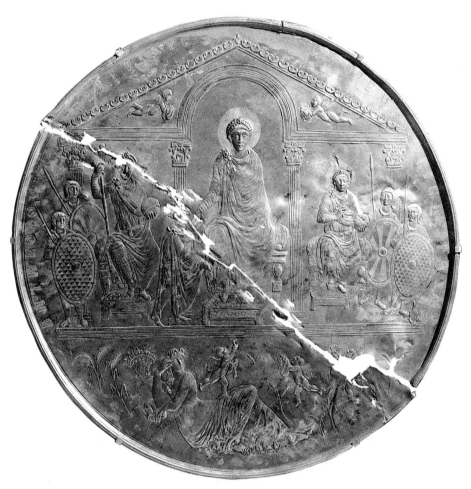

Found in 1847 near Almendralejo in Spain, this large silver dish (74cm [29in] in diameter) which, as the inscription records, celebrates Theodosius' decennalia, shows the emperor flanked by Valentinian and Arcadius. The haloed figures, hieratical and full-face beneath the tribunal, reveal hierarchically differentiated proportions; the emperor is handing an official a diploma. Below is the personification of the Earth (and of Abundance) with the cornucopia, between Cupids, fruit and flowers. Real Academia de la Historia, Madrid.

and hieratic beneath the *tribunal*, during an investiture ceremony. The "renaissance" of the Theodosian era, as we see it in the official monuments and in others dealing with Christian subjects (the fragment of the panel with the healing of the blind man in the Dumbarton Oaks collection, other reliefs with Christ among the apostles, the handing over of the Law and the sarcophagus of a prince from Sarigüzel in the Istanbul museum, the sculpture with St. Peter in Berlin), should be seen in relation to the stylistic counter-movement that was occurring in Rome in the second half of the fourth century, fostered by the pro-pagan trend headed by members of the senatorial class and encouraged by the process of re-evaluation of the monuments and culture of pagan Rome undertaken by the Emperor Julian, known as the Apostate. The diptych of the *Nichomachi and the Symmachi*, a statue of the Emperor Julian in the Louvre, the *Adolescent Christ* in the Museo Nazionale, Rome, express stylistic principles which also underlie official expressions of Constantinopolitan sculpture of the same period. But in the eastern capital one can also see glimpses of a more craftsmanlike yet expressive style in sculptures such as the *Bust of the Evangelist* with *codex*, some fronts of "false sarcophagi" from Taskasap, in a celebratory and not a scenic form as on the sarcophagi of Ravenna.

The *propylon* (outer portico) of the church of Hagia Sophia, rebuilt after a fire around 415, was a trabeated colonnade culminating in a central pediment with a tympanum. The treatment of the four ornamental elements of the classical repertory (here and in later examples of capitals where "openwork" carving is used) implies an independent Constantinopolitan school. At the sides of the tympanum ran a double frieze of six lambs, walking toward palms symbolizing Paradise. It is interesting to note that this motif of lambs, introduced on a monumental scale in Constantinople, reappears in the sarcophagus of S. Nazaro in Milan, in the ivory reliquary box in Pola and then in the apsidal mosaic decorations in Rome and Ravenna. The stuccoes of the Orthodox Baptistery, too, and some of the Ravenna sarcophagi owe a debt, in terms of rhythm, proportions and modelling of the figures, to Byzantine prototypes such as the Sarigüzel sarcophagus.

Decorative sculpture on a monumental

in a *clipeus*, of the emperor and empress, while below would appear scenes at the theater or circus, and of the *sparsio* (distribution of money to the people).

One of the most famous five-part imperial diptychs is the Barbarini ivory: an emperor (Anastasius or Justinian) on horseback, ruler of the world, triumphing over the barbarians (Scythians and Persians) who are bringing him tributes; a general presents him with the image of Victory; the whole world, in subjugation, supports the foot of the *basileus* and Christ blesses his faithful delegate from the heavens. Five-part diptychs, derived from the imperial prototype and produced in Constantinople, Syria and Italy in the fifth and sixth centuries, also served a religious purpose: images of the imperial couple were replaced by those of Christ enthroned between Peter and Paul or Apostles and of the Virgin between Michael and Gabriel; the Cross or bust of Christ, stories from the Old Testament and the Gospels surround these figures.

The ivory chair of Bishop Maximinian (545) in the Archiepiscopal Museum in Ravenna is a composite work by several sculptors: it included frontal panels with St. John the Baptist and the Evangelists; scenes from the life of Joseph, on the sides; scenes of the New Testament on the inner and outer parts of the back; and other decorative strips. Whether it is a product of Alexandria rather than Constantinople is no longer at issue. Within the variety of styles there is a recognizable artistic unity "deriving from the deep inner fusion of the imperial Roman *ars una*" (Bettini): in the sixth century so many different tendencies fused within a single workshop could only be found in the capital.

Imperial ivories (*diptych of Stilicho, Women at the tomb, Ascension*) were produced by workshops in Milan, where Theodosius spent six of the sixteen years of his reign with his court (a fact which led to lively cultural exchanges between Milan and Constantinople). Some splendid Milanese works such as the reliquary box in S. Nazaro (*Christ between the Apostles, the Judgment of Solomon*, etc.), the wooden door of S. Ambrogio with scenes from the life of David (a subject chosen by Ambrose to illustrate the behaviour of the true Christian Emperor to Theodosius), and the Parabiago dish, anticipate the embossed work of the *missorium* of Theodosius with their characteristic modelling, quality of light and elegance of their figures. This dish, which, as the inscription records, celebrates the Emperor's *decennalia* (388), shows the imperial triad, full face

The parchment codex, the most important example of the illuminated herbarium, contains the De Materia Medica by Dioscurides, and other texts. This sumptuous manuscript was presented to Princess Juliana Anicia shortly before 512. Apart from the numerous illustrations of single plants, the beginning of the codex depicts a series of famous physicians and pharmacists. In the illustration here (folio 4v) one sees the personification of discovery (Euresis), who is handing Dioscurides the mandragora. Oesterreichesche Nationalbibliothek, Vienna.

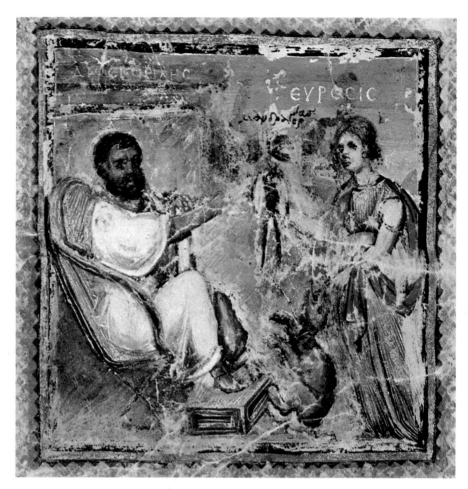

scale had also existed in Constantinople alongside figurative sculpture from the earliest times. The invention, toward the middle of the fifth century, of the so-called "Theodosian" capital, of a composite type with "openwork" parts, was frequently found, partly through export, in the various centers of the Mediterranean area. At the end of the long reign of Anastasius (491–518) a renewed ornamental style appeared: the numerous sculpted elements of the church of St. Polyeuktos, built toward 524, reflect the incorporation into the repertoire of many elements of Persian origin, which had already entered other areas of artistic activity.

The portrait of Juliana Anicia, benefactress of the arts, appears on the frontispiece of a sumptuous *codex*, concerned with medical matters, known as the Vienna *Dioscurides*. Between the second and the fourth centuries the parchment *codex*, quadrangular in shape, relaced the papyrus scroll or *volumen*, which had been the usual form of the book in classical antiquity. In Byzantium the production of illustrated books of both a scientific and a literary kind continued (one might mention the so-called Alexandrian *Chronicle* in Moscow, dating from the fifth century, the Greek *codex* of the *Iliad*, written and illuminated in Alexandria) as well as those dealing with religious matters. The Old and New Testaments were the texts most frequently illustrated.

The golden age of Justinian. The political activity of the Emperor Justinian (527–564) promoted Constantinople from being the first real Christian capital to being the greatest metropolis of the time, a center of events of exceptional importance. The grandiose designs of an autocrat as ascetic, deeply religious, intelligent and bold as Justinian, based on self-interested celebratory propaganda, tackled and largely solved urgent problems: the reaffirmation of religious orthodoxy (the resolutions of the Councils of 546 and 553), the codification of Roman law (534), the reconquest of the West and the defense of the Empire along all its borders, scientific and artistic centralization after the closing of the University of Athens (529). Justinian held command and control through extremely efficient administrative, military and educational apparatus, using trusted men of action and of letters;

he used every prerogative of the *basileus ton Romaion* to revive the myth of ancient Rome in the new Rome and to assert the divine Mission entrusted to him by the sole God of the Christians.

In the basilicas of the Aegean area, throughout the fifth century, reasons of a liturgical order had led to the expansion of the presbytery and *solea* within the nave. During the age of Justinian religious architecture was radically transformed. Architects and engineers in the imperial service began to concentrate their attention on centrally planned buildings (formerly used with the specific function of *martyria*, palatine churches, baptisteries, etc.), adopting this form to create a new type of church in which the main domed nucleus gave form to the place where liturgical actions took place. With St. Polyeuktos, Saints Sergius and Bacchus (527) and Hagia (532–537) the central plan with dome became established as the first truly Byzantine basic contribution to architectural civilization. This scheme became the norm for churches not only during the sixth century and in the main centers of the Empire; for centuries this development, of enormous historical importance, determined the typology of buildings of Greek Orthodox culture in Byzantium, in the Balkans and in Russia, and

in Islamic mosques from Turkey to India.

In Hagia Sophia, built by Justinian after the Nika riots of 532, the designers Anthemius of Tralles and Isidore of Miletus confronted the technical problem – hitherto untackled – of supporting a gigantic dome on four great arches carried by large piers, with spherical pendentives; at the same time they created a building which, beyond its function as a holy place and palatine church, also aimed to be the symbol of the world, an image of the divine light which fell from its lofty sphere upon everything earthly and everyday. Procopius, the greatest historian of the time, perceptively described the building whose progress he personally had witnessed.

To use a term applied to certain icons of the time, one might define Hagia Sophia as an "achiropita" church (not made by human hand), so much are the supporting structures – always emphasized by Roman architecture, which stressed the physical connection of weights and resistences – dissolved within images of light and colour, absorbed into the unreal space of a golden vault which floats on a thousand luminous oculi. The precious materials used in the decoration of the interior, coloured marbles, columns of cipolin and porphyry, melt into a uniquely alluring

penumbra. Capitals and friezes are worked *à jour*: dentils, ovules, plant volutes and corbels no longer have classical proportions. The traditional Corinthian and Ionic forms disappear beneath the thick foliage, deep and clear cut in the background: the capital becomes a geometric element, a truncated cone, whose decoration spreads to the surfaces of the architrave.

On the exterior, the Great Church gradually arranges its geometrical volumes in diminishing order, stiffened though it is, through a series of transformations, in the upper lines of the central dado, originally undulating up to the extrados of the large dome, originally lower and which collapsed in 558, to be replaced five years later by a higher one with ribs.

The use of mosaic, from the Roman tradition onward, acted as a decoration for the architectural surfaces in a way which is not "external" to them but which aims to give particular significance to the space: integrating it, so to speak, with the elements which give it form. In Byzantine churches, where the surfaces tend to be translated into colour, the soffits of the arches or pillars supporting them are covered with mosaics. The vast Thessalonian rotunda of Galerius, formerly Christian, was completely covered with mosaics: the vaults of the ambulatories were strewn with stars, birds and flowers; twenty-four Greek martyrs, hieratic in the gesture of the orant against a background of fantastic architecture (with inscriptions indicating names and the festivals connected to them) appear on the lower fascia of the Theodosian dome; the upper one shows the elders of the Apocalypse (whose feet can still be seen); in the circle at the top, lastly, four angels hold the throne of the Logos. In this cycle, dating from the beginning of the fifth century, the figures' faces still have the idealized features typical of the portraiture of the Roman age in Greece. Also in Salonica is the magnificent apsidal mosaic of the Oratory of Christ Latomos (Hosios David); dating from the same period: the beardless Emmanuel, "fount of living water," is seated among the four evangelists flanked by Ezechiel and Habakkuk; at his feet run the rivers of Paradise, and the personification of the Jordan worships the triumphant Messiah.

From Ravenna to Rome, from Parenzo to Sinai, a series of important mosaics gives an idea of the vanished works in the capital from the time of Justinian. In Ravenna, for example, the imperial panels of S. Vitale, where Justinian and Theodora, with their respective trains of functionaries and ladies-in-waiting, attend the sacrifice of the Mass bringing gifts, reveal the Byzantine style typical of Constantinople; as do the processions added in S. Apollinare Nuovo. In the *Transfiguration* in S. Apollinare in Classe, which has certain features of the style of Justinian, the early Christian manner re-emerges, along with a marked linear stress. In the place of the allegorical cross seen in this latter decoration (derived from the lost mosaic of the chapel of Abraham in the church of the Holy Sepulchre) Christ himself appears in the similar apsidal composition in St. Catherine in Sinai, to reinforce the dogma of the twofold nature of Christ laid down at the Council of Chalcedon, in a church which in reality is dedicated to Mary. The full-length figure of the Virgin stands out in the apse of two churches in Cyprus, decorated toward the end of the sixth century (Kiti and Kanakaria): the Mother, known as *Angeloktistos*, holds the son between two angels holding the earthly globe.

During Justinian's age and in the decades following, the role of the icon became increasingly important: that is, of the anthropomorphic religious images, around which miraculous stories proliferated, in the sphere not only of popular but also official State devotion. These panels, painted in tempera, encaustic and mosaic, were not just ordinary paintings, dealing with random forms and subjects; they not only *showed* a portrait, one or more figures, but they themselves *were* a portrait, a figure. Theirs was a particular veneration which, through the image, was directed at the *prototype*, at Christ himself, at the Virgin and the Saints. This need for real "physical" representation, for a virtual identification with the holy figure, gradually annulled the symbolism (upheld more firmly in the West) of early Christian art: canon 82 of the Quinisextine Council, held at Constantinople in 692, prohibited the representation of Christ in the form of a lamb. In the same years the backs of the coins of the Emperor Justinian II showed Christ with long hair and a thick beard for the first time, in the guise of the *Pantocrator*, which became widespread in the middle Byzantine era (on other coins the Redeemer has the appearance of a young man).

The first examples of the painting of portable icons, widespread throughout the Empire

Hagia Sophia, Istanbul. Capital and axonometric section. Hagia Sophia was to be defined as an "achiropita" building, one not made by human hand, as was said of certain icons of the time. The load-bearing structures – always clearly in evidence in Roman architecture, which emphasized the "physical" connecting of their weights and resistances – vanish within a structure that has become all light and colour, absorbed into the unreal sense of space of a golden vault which floats above a thousand oculi.

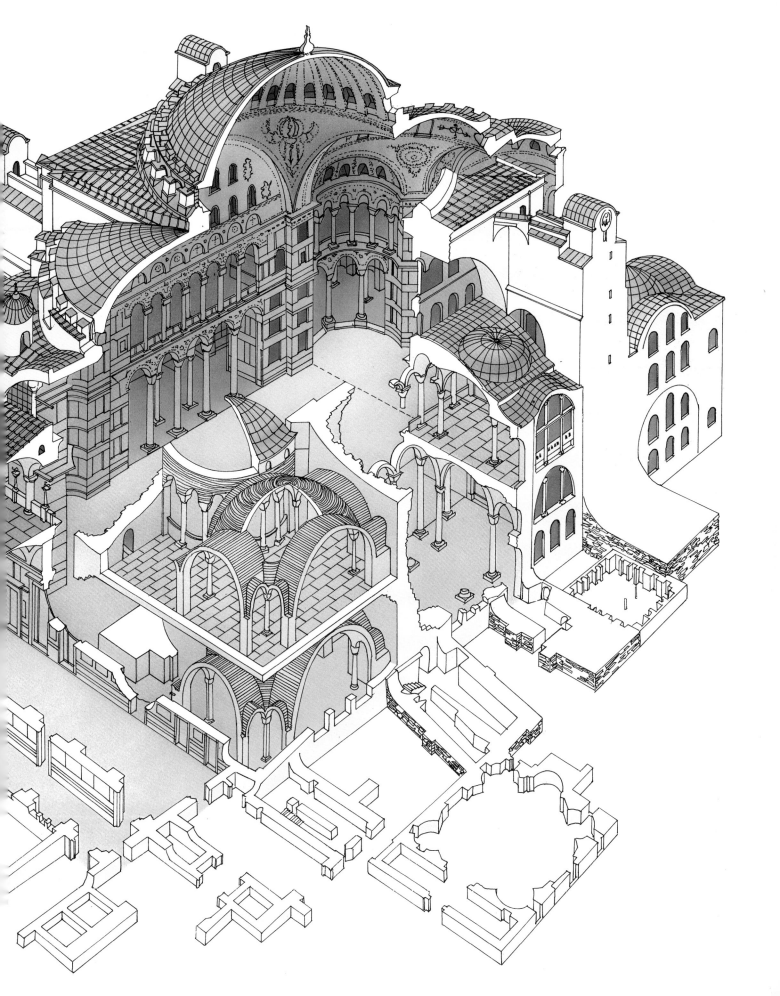

(and which has persisted in Greek Orthodox countries until the present day) are to be found in St. Catherine in Sinai, which was fortified by Justinian. One of them shows St. Peter as Christ's consul, with the cross and scrolls of the gospels instead of a scepter and *mappa*;

in the Hermitage (with Justinian's seal on the back) that a classicism defined in terms of Byzantine "abstraction" appears more clearly. This spirit reappears in a series of dishes from the time of Heraclius, with stories from the life of David; a theme linked to the Emperor's own

still, the sources of production had dried up, the border cities were in a state of decline; all this forced robust imperial dynasties such as those of Heraclius (610–614) first and then that of the Isaurians (717–867) to set up a very firm internal organization. The formation of

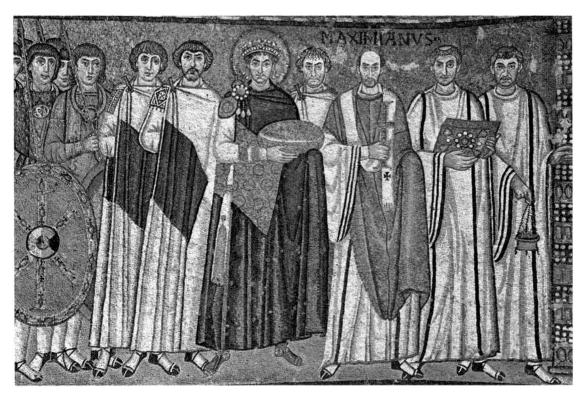

S. Vitale, Ravenna. The two "imperial" mosaic panels symbolically attest the presence of Justinian and Theodora – the only living beings among the figures of the Ravenna cycle – in a procession accompanying an imperial donation, and re-emphasize the unity of the Empire (Italy, including Rome, and part of Africa had just been reconquered) under the power of Byzantium. The style of the mosaics, which can be dated from before 547 (S. Vitale was consecrated in May) was dictated by metropolitan directives.

above the semicircular space behind him, as on the consular diptychs, are three medallions with the busts of the *Pantocrator*, the Theotokos and St. Sergius. The figure of St. Sergius, the national martyr of Syria, together with that of St. Bacchus, appears on another icon from Sinai (now in the Kiev museum): their role was that of officers of the Christian militia accompanying the *dux*, that is, Christ, who is on the *clipeus* shown above.

Two other icons from Sinai, whose soft modelling and Hellenically beautiful faces reflect the characteristics of court painting of the sixth century, depict Christ Pantocrator and the Virgin amidst angels and Saints.

The ownership of portable *objets d'art* spread, during the sixth and seventh centuries, from court and ecclesiastical circles to private ones. Gold and silver furnishings and plate sold fast: "neutral" themes of classical inspiration came back into fashion. In the museum in Istanbul there is a niello dish with a personification of India; in the Dumbarton Oaks collection a fragment of another silver dish, with Justinian's seal, shows Silenus; on a work from the time of Justinian in the Hermitage we find Aphrodite in Anchises' tent, etc.

But it is in the silver dish with the shepherd

undertakings, as conqueror of the Persians, giving him the title "new David." Works of the religious art of the period, too, such as the Annunciation in S. Maria Antiqua in Rome or the mosaic angels in Nicaea and the later frescoes of Castelseprio, reflect this elegant and refined taste through a variety of tones.

The age of iconoclasm. The central apparatus of the State, from Justin II to Phocas, encouraged important artistic and architectural undertakings, though they cannot be compared with the magnificence and breadth of Justinian's program. The empire was embarking upon the most arduous stage in its history, attacked as it was from all sides. At the beginning of the seventh century Avars and Slavs were taking possession of the Balkan peninsula, while the capital, thanks to its mighty circle of walls, resisted their attacks.

The spreading wave of emergent Islam broke upon Syria, Palestine, Egypt, northern Africa and Spain, coming face to face with the Mediterranean region, which, until that time, had been entirely and solely under the power of the Empire. Two difficult centuries awaited Byzantium. There were continual war alerts, building activity was more or less at a stand-

"themes" (administratively independent provinces) under Heraclius, the unyielding despotism and military campaigns of the Isaurians, aimed at containing the assault of the Slavs and of Islam (after a second extremely threatening siege by the Arabs in 717), determined the nature of the new truly Byzantine and medieval State. Greek, spoken by the people and the Church, became the official language of Byzantium. The use of Latin was now lost, as was almost all Italy, between the religious conflict with Rome and the dawn of the Carolingian Empire.

But the role that Constantinople continued to play was that of a center of world politics. The Omayyads, despite their different conception of religion, assimilated forms inspired by Byzantium into the arts and architecture. Buildings such as the Dome of the Rock and the Mosque of Damascus reflect aspects of the contemporary culture of Byzantium: skilled workers and materials (columns, mosaic tesserae, etc.) were sent by the Byzantine Emperor to the caliphs abd Al-Malik (685–705) and Al-Walid at their request. The rise of Byzantine iconoclasm, which sources attribute to the Arabs of Syria, should in fact be seen as arising in the sphere of the delicate

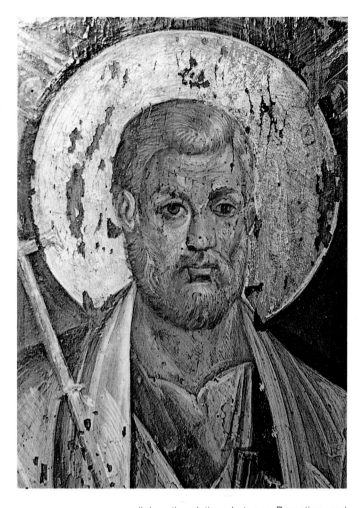

Right: icon of St. Peter (detail). Monastery of St. Catherine in Sinai. The encaustic panel shows the half-figure of St. Peter holding the keys and a staff in the form of a cross. Above are three medallions with the busts of Christ, the Virgin and bluish-purple with a beardless Saint, identified variously as Moses and St. John the Baptist. The composition is based on the iconography of the consular ivory diptychs of the fifth and sixth centuries.

Below: silk textile in white, green, orange and bluish-purple with a motif of lions facing one another within circles. It is part of a group of textiles of the eighth to ninth centuries, possibly produced in eastern Iran, which shows affinities with Sassanian textiles. Similar works also inspired examples produced in Byzantium in the iconoclast age. Museo Sacro Vaticano, Rome.

Theodore Studita, complementing lines of argument already put forward in previous centuries, formulated a precise theory of religious images: in contrast to the iconoclasts who claimed that a religious image was *consubstantial* with the *prototype*, as it were a magical duplicate, the iconodules maintained that it was a *symbol* and that as such it reproduced the appearance (*prosopon*) and not the substance (*ousia*) of the model. For the orthodox the inscription appended to the figure of a Saint authenticated the truthfulness of the image.

The religious architecture of the seventh and eight centuries produced structures of measured dimensions, similar to monastic buildings, once again using the scheme of the square domed space with short arms roofed with barrel-vaulting. With the exception of the church of Dere Agzi in Asia Minor, a far from provincial work which repeats the scheme of Justinian's Hagia Irene (to which a second dome was added after 741), other churches adopted, with variants, the basically similar plan of the nucleus with a dome on narrow arches and a barrel-vaulted presbytery.

The churches of the Dormition at Nicaea and of Hagia Sophia in Salonica (beginning of the eighth century) were more strictly based on the Greek cross, with domes on massive piers placed at the corners of the square central space, and their typology persisted until just after the year 1000. Regional architecture sometimes produced original variants, for instance with the monastic and parish churches of Mesopotamia, the fruit of liturgical studies and local models, and with the various typologies and the "prismatic" volumes developed in Armenia between the sixth and eighth centuries.

The Macedonian renaissance. With the reinstatement of the cult of icons (843) and the emergence of a favourable economic and political situation, the history of Byzantium experienced a period of vigorous renewal and artistic expansion, and entered the territories of the Slavs, Christianized by the Greek monks Cyril and Methodius. In the year when the patriarch Photius excommunicated Pope Nicholas at a council where the autonomy of the Byzantine Church was reaffirmed (867), Basil I, the founder of the Macedonian dynasty, came to power. Leo VI the Wise, a theologian and law-giver; Constantine VII Porphyrogenitus, a cultured artist and writer; Basil II, "slaughterer of the Bulgars" are some of the Macedonian Emperors who gave luster to the Byzantine period (from the second half of the ninth century to the first half of the eleventh), which is generally known as the Macedonian renaissance. Basil I, the "renewer" of the Roman Empire, faced the urgent task of the restoration and redecoration of the many churches whose sacred images had been destroyed by the iconoclasts, an arduous undertaking which went on for years, with somewhat limited economic backing if com-

diplomatic relations between Byzantium and Islam. This doctrine, with its multifarious consequences, came into force with the imperial decree of 726 (or 730) until 780 and once again from 814 to 842. By law, the cult and production of anthropomorphic religious images was prohibited; the icon of Christ on the door of the Imperial Palace was destroyed and the iconodules (worshippers of images) were persecuted, particularly in the capital. The decoration of the churches, stripped of their holy images, was given over, during these decades, to a "neutral" repertoire, which took up motifs used during the fourth and fifth centuries. The mosaics of the peristyle of the great Palace, with hunting scenes and mythological subjects, probably date from this period. If a piece of silk depicting an emperor hunting a lion is indeed a gift from Constantine IV to the abbey of Mozac, we are in possession of a work from an imperial workshop of the iconoclast era. The iconography repeats a model common in Sassanian Persia, from which other motifs found in decorative Byzantine fabrics and sculptures of the seventh and eight centuries derive.

During the period of iconoclasm, orthodox writers such as John of Damascus and

pared to the state resources of the age of Justinian.

Built by the Emperor Basil I within the precincts of the Great Palace as a beginning of the medieval architecture in the capital: the lost but very famous Nea (New Church), with five domes, it was consecrated in 880 and immediately imitated in Constantinople, Salonica and the neighbouring regions. Two later buildings, identified as a monastic church consecrated in 908 by the court functionary Constantine Lips and the Myrelaion or funerary church of Romanus II Lacapenus, reflected the new iconography: a narthex, simple triconch apses, an antechoir and umbrella dome were contained in reduced spaces; the nave and aisles were higher now, lit by one-, two- and three-light windows and oculi; blind niches moulded the outer surfaces; marble facing, mosaics, ceramic tiles and sculptures from the Islamic-inspired repertoire decorated the interior. Two homilies by the patriarch Photius (X and XVII), two sermons by Leo VI (28 and 34) and a description of the church of the Apostles by Constantine of Rhodes give illuminating information about the internal decoration, both figurative and ornate, of contemporary churches; floors of *opus sectile*, marble facing on the walls, mosaics or frescoes on the higher surfaces. The pictorial program, partly developed in the preiconoclastic period, emerges as already systematically formulated: on the main dome was the half-bust of Christ known as Pantocrator; in the apsidal semi-dome the Virgin; the cycle of the major Feasts and single figures, in hierarchical order, were distributed over the walls. The arrangement of the figures was related to the structure of the church, which reflected not only the physical universe but also symbolized Christ's earthly mission and his invisible Church, according to information given in the *Historia Mystagogica* by the patriarch Germanus. The first mosaics in the *sekreta*, on the tympanum and in the apse of Hagia Sophia are poised between an archaic manner and a more courtly tone, reinstating many "signs" of the Hellenistic tradition, also evident in illustrations of books like the Paris *Psalter*, or the *Joshua Roll* in the Vatican Library. Through other single panels in Hagia Sophia – the lunette with the *prokynesis* of Basil before Christ enthroned, the Virgin between Constantine and Justinian, the Pantocrator between the Emperor Constantine IX and his consort Zoë – we can follow a century of the maturing of a style whose structure was to remain basic, both figuratively and semantically, for the whole of the Byzantine Middle Ages. The patterns of the articulation of the mid-Byzantine "decorative system" can be seen today in eleventh-century cycles in Greece and Russia. The first of these mosaic complexes is in the Sanctuary of the Blessed Luke (Hosios Loukas) built above the tomb of the anchorite in the Phocian mountains near Delphi. The harsh line and simplified colour of the figures

do not reflect the style of the capital, rather they look back to certain "realistic" tendencies found in the mosaics in the dome of Hagia Sophia in Salonica, dating from a century earlier. These provincial schemes and tones found a contemporary echo in the first mosaics in Torcello cathedral, restored at the beginning of the eleventh century. In the cycles of the Nea Moni at Chios and at Daphni near Athens, dating from the middle and end of the century respectively, the trends of the capital were better reflected, despite a difference of tone: those of Chios are highly colourful and characterized by an ascetic ideal, those of Daphni are elegantly Hellenistic and look forward to Comnene art.

From the architectural point of view the churches of Hosios Lukas, Cios and Daphni constitute the most significant examples of the dome on an octagon type, that is, built over a square space with corner squinches: this solution, which has similarities with Armenian architecture, seems to have been developed in buildings of the capital such as the lost St. George's at Mangana.

During the Macedonian renaissance the so-called minor or industrial art forms were on a par with medieval Byzantine painting; such products were highly characteristic and widespread: ivories, enamels, glyptics, ceramics, illuminations, etc. Typical ivory objects were triptychs like the Harbaville triptych now in the Louvre (a portable icon with the theme of intercession of the Deisis), the so-called rosette caskets (with their characteristic ornamental borders, for secular and also religious use, and other panels for doors and iconostases with theme of the Feasts of the Church.

As far as enamels were concerned, Byzantium perfected traditions that had flourished in the East, in Greece and also in Rome with the technique of *champlevé* (where enamel fills areas cut in a metal base) and *cloisonné* (where the enamel is poured into compartments formed by small fillets of metal welded to the base). Early examples of this superb phase of enamelling of the Macedonian period are the Eudocia medallion in the Louvre and the reliquary of S. Radegonda in Poitiers. There are splendid examples in the Treasury of St. Mark's: the crown of Leo VI, the sardonyx chalice and the binding of a tenth-century evangeliary, the icon of St. Michael. There is a transition from a sober use of colour – deep blue, wine-red and green – to brighter colours – light blue, violet, red, yellow – which create a magic world that sums up all the various aspects of Byzantine art: an architecture of thread-like ribbing, fields of gold coloured like walls covered with mosaics, figures and faces of extraordinary iconic power. In the ninth century, with the cultural renaissance linked to the reform of the universities and the study of the ancient world, the spread of the minute cursive script made possible the rapid transcription of scientific, religious and philo-

sophical texts in the imperial patriarchal and monastic *scriptoria*: gifted protagonists in this field were John the Grammarian, Leo the Wise, Photius and Areta of Caesarea. Apart from the already mentioned Paris *Psalter* and the *Joshua Roll*, other outstanding examples of quality, both as books and for their illustrations, are the Vatican *Menologius* and the *Psalter* of Basil II, the *Homilies* of Gregory Nazianzen, the *Cinegetica* (treatise on hunting) of Oppian in the Marciana in Venice.

Byzantine art in Europe. The period between 1056, the year the Macedonian dynasty ended, and 1204, the year of the fall of Constantinople to the Venetians and Latins of the Fourth Crusade, marks the gradual decline of the Byzantine Empire, from the political point of view. The disastrous defeat of the imperial troops at Manzikert in 1071 opened the way for the conquest of the plateau of Asia Minor by the Seljuk Turks. The Slavs held sway in the Balkans and in northern Macedonia, Norman kings in Sicily. Despite this state of affairs the culture of Byzantium, its work and its artists were valued and sought after throughout Europe: under the guidance and with the models of the Byzantine masters mosaics were executed at Kiev, Venice and in Sicily, frescoes in the Balkans, Russia and Cyprus, icons and illuminations in Georgia and the Latin kingdom of Jerusalem.

With Alexius (1081–1118) the Comnene dynasty began; after the help given against the Normans at Durazzo, Venice increased its political and military power in the body of the Byzantine Empire, and the apsidal mosaics in the basilica of St. Mark's are the first monumental evidence of Comnene art. In the architectural field the type of domed church on a Greek cross, which had fallen into disuse, was taken up again, as seen in the Gül Cami and Kalenderhane Cami; with ambulatories, as in the reconstruction, after 1065, of the church of the Dormition at Nicaea; with a tetraconch (Panaghia Kameriotissa at Heybeli), etc. The complex of Christ Pantocrator (Zeyrek Cami) in Istanbul includes two churches, with the funerary *heroon* of the Comnene dynasty in the center (1118–36). The architectural appearance of the complex was rich, lively and colourful; niches and openings became longer and narrower, the apses had seven sides, the domes were on an axis; the ornamental elements of the sculptural decoration tended to become more rigid in relation to earlier work.

With the victory of Basil II against the Bulgars in 1018, Thrace and northern Macedonia once again came under Byzantine

Hagia Sophia, Istanbul. Above the "imperial door" leading into the Great Church is the mosaic lunette with Basil I in prokynesis (an act which underlay the iconoclast controversy) before Christ enthroned between the icons of the Virgin and the archangel Gabriel. The depiction, placed at the entrance to Hagia Sophia, confirmed the triumph of Orthodoxy.

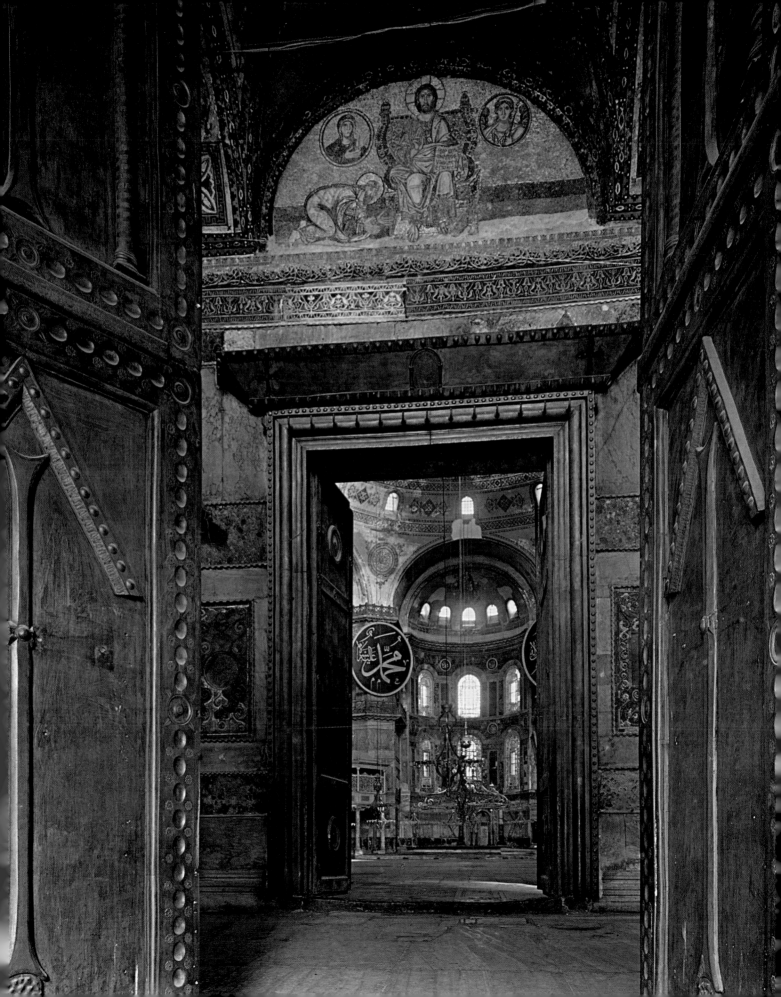

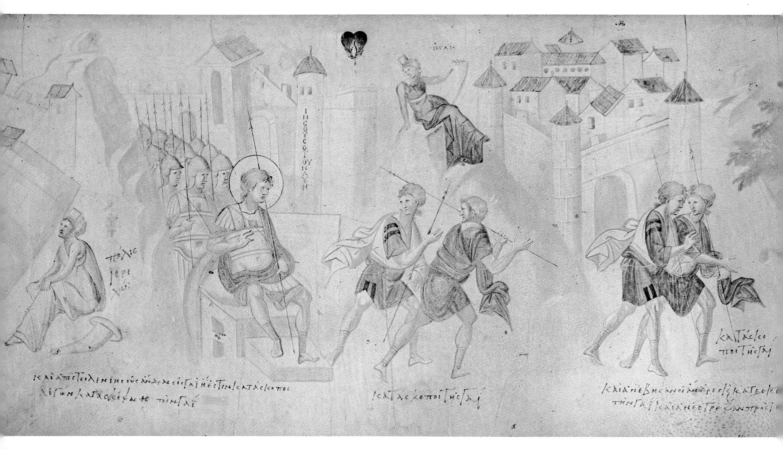

rule, gravitating culturally toward Salonica. Here the Panaghia Chalkeon (Virgin of the Blacksmiths) was built in 1028, all in brick, its volumes plastically animated on the outside, with the two-storey narthex closed in between strongly splayed arches and three high drums with niches. This was an important, though strangely isolated, architectural episode: almost three centuries had gone by since the building of Hagia Sophia, and another three were to go by before the resumption of building activity under the Paleologue emperors. The monastic churches of Mount Athos adopted a triconch plan, with side chapels and a deep atrium.

At Veljusa, in 1080, the Greek Bishop Manuel built an elegant tetraconch (subsequently enlarged) as his funerary chapel. Another Manuel, a member of the imperial family, consecrated the lovely church of St. Pandeleimon in 1164 at Nerezi near Skopje, which once again used the Constantinopolitan type of the inscribed cross with five domes, with internal variants; soon afterward (1168) the church of St. Nicholas near Kursumlija, built by Stephen Nemanja, adopted a different scheme, with recessed brick masonry facing.

The churches of Greece, built from the tenth century onward using the ever more highly perfected *cloisonné* technique (square blocks of stone surrounded by brick) have features of their own in their plan and elevation (ante-

choirs communicating with the apses and eastern corner spaces through broad openings, octagonal and circular drums, a variety of window systems, etc.) and in their ornamental motifs. The two churches of the monastery of Hosios Loukas (tenth to eleventh centuries), the church of the Apostles on the Agora in Athens and the church of Daphni offer a wide range of original solutions, and very lively ornamentation. The Mediterranean sea routes encouraged commercial relations and cultural exchanges with outposts in Asia Minor, Cyprus, Rhodes, Crete, southern Italy, Sicily and Venice. In Venice, which had longerstanding links with Byzantium, the design of buildings like Santa Fosca on Torcello, an octagon on an inscribed Greek cross, and St. Mark's, which used a sixth-century model, the *Apostoleion*, altered in the tenth century, reflect the mid-Byzantine tradition of Constantinople in their spatial sense and in many details.

Elsewhere, with the exception of rare examples like the Tchanliklisse and Üçayak churches near Kayseri (Asia Minor) and St. John on the acropolis at Lindos on Rhodes, the buildings remained extremely "provincial." At the beginning of the twelfth century, "courtly" mosaic painting produced a unique example in Constantinople: the votive panel of John II Comnenus in the southern women's gallery of Hagia Sophia, executed around 1120. The

stylistic link with Daphni, one generation earlier, is clear. The characteristics of the anatomical rendering – the sharply marked cheeks, comb-like lines on the necks, etc. – were taken up against a greater lightness, paraded in a less serried framework and recomposed with a sense of detached, geometrically inclined balance. A discernible change in taste was coming into being in the monumental painting of Constantinople. The signs of this process, not to be found in the capital because of the contemporary "void" there, can be seen with the help of lateral works: icons, and mosaics, illuminations, etc., and works from the vast "province" of Byzantium, from the Sicilian mosaics to the decoration of St. Mark's from Cyprus to the Balkans and Kiev. Through their elegance of execution, the Sicilian cycles commissioned by King Ruggiero, an ambitious rival of the Byzantine Emperor, are related to the mosaics of Daphni. The Cappella Palatina, dedicated to the Apostle Peter, was decorated with mosaics from 1132 onward: the royal tribune, on the north wall of the transept, was the focus of a carefully worked-out iconographical program. Masters from Constantinople executed the oldest part of the decoration, including the bust of the Pantocrator between archangels on the dome, prophets and evangelists on the drum and squinches. The mosaics of the cathedral of Cefalù, too, built by Ruggiero II, have an official and courtly

Opposite: Joshua Roll (cod. Pal. gr. 431). The parchment "rotulus" of the tenth century contains extracts from the Book of Joshua, illustrated with a continuous frieze where episodes of fighting for the conquest of the promised Land predominate. It is painted in light colours, partly restored, and is metropolitan in style. Biblioteca Apostolica, Rome.

Right: the central panel of the icon, in gold, has a relief figure of the archangel Michael, with sword and breastplate. On the outer frame are enamels with the busts of Christ, St. Peter and St. Menas (above) and of warrior saints (at the sides). In this masterpiece of the beginning of the eleventh century, coloured material poured into thread-like ribbing enhances the spirit of Byzantine art. Treasury of St. Mark's Venice.

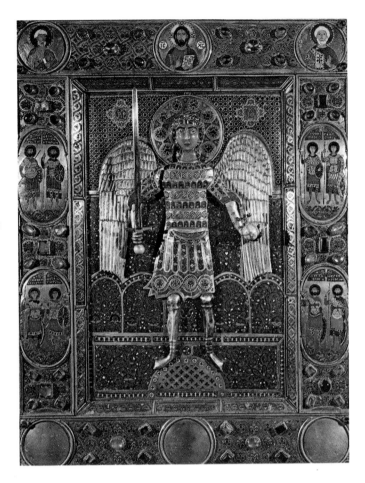

Venice gained possession of a vast part of the crumbling Byzantine Empire and indeed its capital, a cycle from the Old Testament, the *Deisis*, the *Communion of the Apostles*, the *Supper at Emmaus*, the *Prayer in the Garden*, the *Death of the Virgin* and other subjects completed the surfaces of the atrium, now enlarged to the north, the Zen chapel and the basilica itself.

Manuel Comnenus (1443–80), an emperor with a "European" spirit who was enthusiastic about western customs, married to a German princess first and then to a French one, encouraged the opening to western influence of the closed circle of Byzantine courtly art. Metropolitan painting opened to the narrative with a new "illusionistic" style, about which the written sources are more explicit than the surviving monuments. This stylistic development, so perfectly exemplified in the frescoes of St. Pandeleimon at Nerezi (1164) may possibly have occurred in secular rather than religious decoration. The statuary solidity of the Macedonian and early Comnene figures, arranged rhythmically in static compositions with a measured sense of space, is here animated with a vibrant, unquiet movement. The figures are linked to one another in mutual tension, above painted surfaces crossed with lines, in pale colours and very sophisticated in the use of light and shade. The basic starting points of Constantinople are reduced almost to nothing, and one of the hypotheses concerning the birth of this stylistic change is that of a possible influence of the "province" on the

character: the execution of the figures, striking elegant attitudes, is totally Greek. Some mosaic-workers, active in the transept of the Palatina, also worked in the church of the Martorana, completed about 1146. With its central plan, the building was a more suitable setting for the Byzantine iconographical system: the full-length figure of Christ, with adoring angels, on the dome; stories from the life of the Virgin, to whom the church is dedicated, and numerous figures of Saints. Under Guglielmo II skilled workers, mostly local, later decorated the cathedral of Monreale: their mosaics were heavier, stylized into linear distortions, in a markedly narrative context, but with "realistic" touches of a western sensibility.

In St. Mark's, Venice, after those of the choir and entrance portal, other mosaics then covered the five domes with the nearby vaults and bays of the atrium during the twelfth and thirteenth centuries, completing a huge iconographical plan. The *Ascension* and *Pentecost* on two of the domes repeat subjects found at Hosios Loukas and Hagia Sophia in Salonica; the style of the Venetian works, too, largely executed by local craftsmen trained by Greeks, reflects stylistic principles typical of the school of Salonica, though with the occasional western inflection. After 1204, when

Right: monastery church, Daphni, Attica. The awesome mosaic image of the Pantocrator, lord of all things, gazes down from the height of the heavenly dome on all things as they unfold. The Daphni cycle exemplifies one of the more "classical" currents of Byzantine monumental art at the end of the eleventh century.

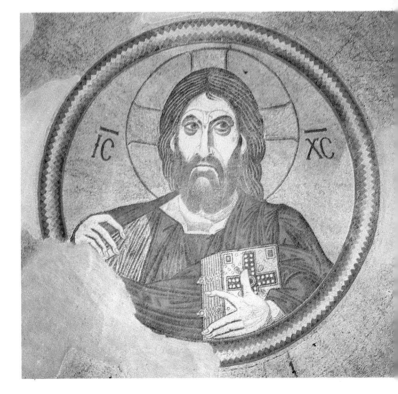

capital. The characteristics of the "style of Manuel Comnenus" would seem to have been anticipated in Macedonia and Thessaly, regions which in the eleventh and twelfth centuries belonged, so to speak, to the "springboard of European Byzantium" (Bettini). In the sphere linking up with Salonica there is no shortage of examples, which, from the cycle of the Panaghia Chalkeon (1028) to the frescoes in Hagia Sophia in Ochrid, from the paintings, similar to and contemporary with those of Nerezi, recently discovered at Hosios David, to those of Kurbinovo (1194), used indubitably Byzantine bases to develop stylistic features comparable to those which characterize the style of the age of Manuel Comnenus. That the repercussions of this culture, which indicates the birth of a regional school, should have been felt as far as the Bosphorus may be true: but once they arrived here, they certainly met with the qualitative filters exerted by the masters of the capital. It was some of these, in Constantinople itself or in the capital-in-exile, Nicaea, during the years of possible cultural aggression from the West (the years of the Latin conquest), who, nostalgically reconsidering the models of their own tradition, produced

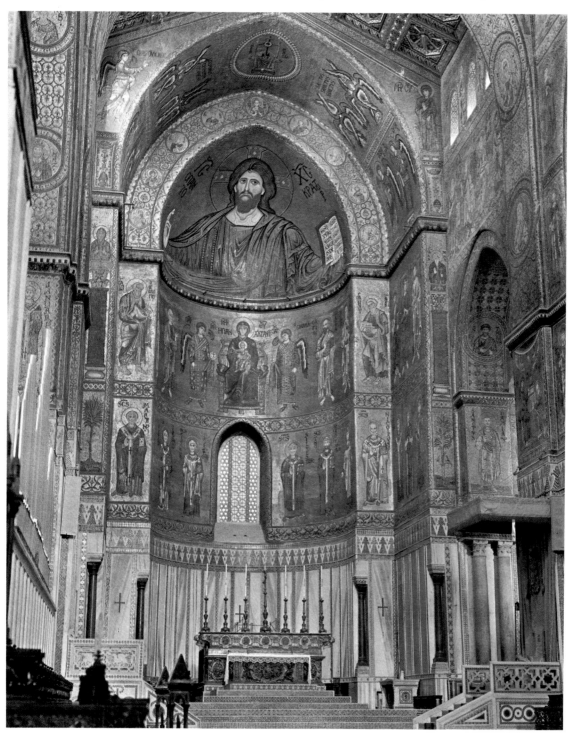

Left: interior of the cathedral of Monreale (twelfth century). The figure of the Pantocrator appears in the hollow of the apse, as in other domeless Sicilian churches. The mosaic cycle is characterized by marked dynamic linear stylization, the expression of a style that was no longer exclusively Greek.

Opposite: Great Deisis, south gallery of Hagia Sophia, Istanbul. The splendid mosaic with the Deisis (a composition with Christ between the Virgin and John the Baptists, a theme of intercession) is the first great official work, bearing all the signs of a new "humanism," after the reconquest of Constantinople (1261) by Michael VIII Paleologue (thirteenth century).

works that were stylistically new, such as the illuminations of a Gospel in the monastery of Iviron (Mount Athos) or those of the Vatican *codex* of the Prophets: imbued with a "Neo-Hellenistic protohumanism," the basis of the Paleologi renaissance.

The Paleologi. When the emperor of Nicaea, Michael III Paleologus, reconquered Constan-

toward the end of the thirteenth century. In the Afendiko at Mistra (after 1300) open galleries top the arms of the transept, going back to pre-iconoclastic models; in Hagia Sophia in Trebizond (the capital of the Empire of the Great Comnenes) the quincunx plan was adopted, lengthening the western part and adding deep porticoes on three sides (1238–63). In Constantinople the church of St. John

key pattern and zigzags on the exterior contribute to the characteristic appearance of this last phase of Byzantine architecture which brings together the traditional and the new in Constantinople as in Mistra, in Ochrid as in Arta, combining typological reprises and transformations. Elements of the western repertoire, favoured by the complex political situation, made headway in the Adriatic and northern area, in Epirus, Macedonia and in the Rascia (present-day Serbia). At this time Salonica was exerting considerable power in the field of architecture. From this center of technical and formal invention – traditionally independent, in more ways than one, of Constantinople itself – buildings like St. Catherine's (end of the thirteenth century), the Holy Apostles (1310–14) and St. Elias (*c.* 1360) proffered new architectural solutions both in terms of proportions and in the quality of the masonry facing.

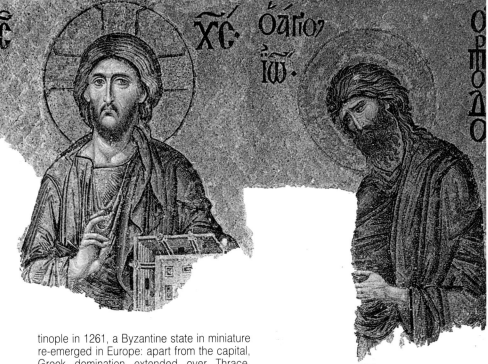

tinople in 1261, a Byzantine state in miniature re-emerged in Europe: apart from the capital, Greek domination extended over Thrace, Macedonia, Epirus, the Peloponnese and half Asia Minor. One century later, after civil and religious wars, Byzantium became an important vassal of the Turkish sultan, who had landed in Europe itself. But this artistic renaissance played an exceptionally significant part in this tragic scenario for over a century, particularly in the field of monumental painting.

In the architectural field the nucleus of the church, the *naos* (or even a pre-existing building), constituted the pole around which other lesser spaces, often domed, were grouped, with varying shapes and functions, arranged on one side or the other, or all around. The buildings were extremely colourful because of their use of brick, light or red stone, and ceramics; their upper contours were broken up by drums, domes, undulating copings; their interior decoration was a harmonious blend of mosaics, sculpture, frescoes, variegated marbles; they were tall and graceful without being monumental. The type of church on an inscribed cross with dome over an octagon was used again in the Parigoritissa at Arta (whose outward appearance is that of a western civil palace), in Hagia Sophia at Monenvasia and in the Holy Theodores at Mistra,

the Baptist, added to the monastic complex of Lips (Fenari Isa Cami) at the end of the thirteenth century by Theodora, the widow of Michael VIII, has a central, square, domed nucleus, communicating with an ambulatory on three sides, preceded by an atrium (incorporating spaces of the Macedonian building); the exonarthex and *parecclesion* (side space) to the south were built after 1300 to unify the whole complex. The principle of the nucleus gathering peripheral spaces around it continued in S. Maria Pammakaristos (Fetiye Cami) with the beautifully proportioned adjoining funerary chapel of Michael Glabas; and in the rebuilding of the Kariye Cami, dedicated to Christ and the Virgin by the powerful minister of the imperial treasury Theodore Metochites. This latter church, known as Our Saviour in Chora, is surrounded by two frescoes *parecclesia* and two narthices with mosaics on the front. Marble facing, sculpted friezes and funerary archivolts, columns with painted capitals, frescoes and mosaics in the interior; masonry with alternating courses of stone and brick, given shape by niches and pierced by three-light windows, decorated with bricks arranged in hanging triangles, the

In the field of pictorial decoration of the Paleologue age we find, first and foremost, the mosaic panel with the great *Deisis* in the south women's gallery in Hagia Sophia. The dense hatching of the faces was still a hangover from the manner of Nerezi; but the spirituality which shines from the faces is the statement of a dramatically conscious feeling for the contemporary. There is also another example of metropolitan decoration prior to 1300, that of the church of St. Euphemia near the Hippodrome, a building too little taken into account despite its considerable value as a piece of formal evidence. It contains the roots of a style which was to have an astounding outcome in the mosaics of the funerary chapel of the Pammakaristos and the Kariye Cami and which, over the "Macedonian" border, was to pervade the style used for several decades by Michael Astrapas ("lightning") and Eutychios in the service of the Serbian King Milutin, starting from the decoration of the Peribleptos at Ochrid in 1295. Furthermore this style, referred to as "cubist," heroic and heavy, is also the one, with obvious personal touches, to be found in the frescoes by the not entirely mythical Panselinos, such as the one in the Protaton; and in the more elegant variant of the chapel of St. Euthymius in Hagios Demetrios in Salonica (1303) and in many contemporary illuminations.

With the mosaic decorations of the church of the Holy Apostles in Salonica the formative process of the Paleologue style came to maturity, to find its expressive apogee in the mosaic and pictorial cycles of the Kariye Cami. The mosaics of the Holy Apostles, to which the frescoes of the atrium are linked in terms of period and quality, are characterized, *vis-à-vis* the works of the capital, by a just discernible sense of greater solidity and vigour: the architecture is less fantastic, the groupings more dynamic, the faces intensely expressive. But it would be difficult to deny that some of the "image-makers" active in Salonica went on, soon afterward, to the site of the Kariye Cami.

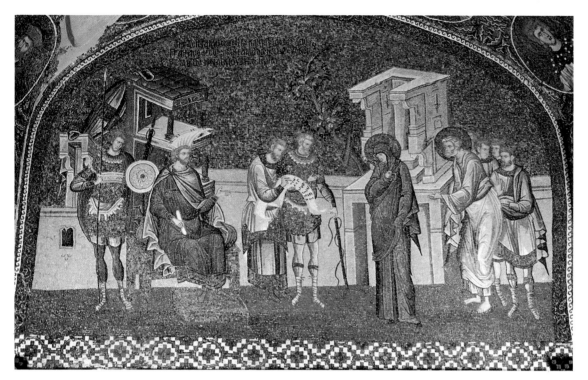

The Saviour in Chora (Kariye Cami, Istanbul). Magnificent mosaic with scenes from the life of Christ and the Virgin, to whom the church is dedicated, cover the two narthices; there are also very fine frescoes in the parecclesion, *designed as a mortuary. The* scene of the census with Mary and Joseph, accompanied by their four sons, before Cyrenius, governor of Syria, adopts a new style, fluid in articulation, and with a wealth of detail in its landscapes (second decade of the fourteenth century).

Below: church of the Virgin Peribleptos, Mistra. The frescoes of the Peribleptos, seen here in a detail from the scene of Joachim, Anne and the rejected offerings, reflect the aristocratic art of Constantinople of the period in the elegance of their figures and delicacy of the lighting (mid fourteenth century).

The mosaics of the stories from the lives of Christ and the Virgin in the two narthexes are executed within unexpected landscapes, amid fantastic scenery; visualized within a vast, uninterrupted narrative unity, to which the restless, minute figures are subordinated in a relationship which is new to the Byzantine tradition. Contemporary with the work of Giotto, this sumptuously coloured work has an underlying humanistic dimension, but in the Byzantine fashion, like its perspective, which is constructed from within rather than without, approached through the transcendental, not the "real." The idea of a mystic, uncreated light, which underlies the doctrine of the Hesychasts at this time, seems to permeate many parts of the mosaics and of the frescoes of the parecclesion, with the shining figure of Christ leading Adam and Eve from the underworld: the light springs from the forms themselves rather than from any natural source and becomes an intermediary element so that the image can draw upon the spiritual essence. The underwater world of light of the Kariye was the inspiration for the brilliant work of one painter, Theophanes the Greek, active in Constantinople, Galatia, Chalcedon (lost paintings) first and then in Russia; his extremely personal style survives in the frescoes in Novgorod, of about 1378, and in other icons. And how, without the Kariye (mosaic of the Koimesis in the *naos*) can one explain the *Dormition*, dated 1333, by Paolo Veneziano? His style during those years, that of a true Paleologue painter, quite simply implied Venice's vocation to establish herself as the suc-

cessor to Consantinople in the realm of the arts, as she subsequently was to do with Crete.

At Mistra, in the Peloponnese, an intellectual center where the Neoplatonist Gemistos Plethon lived and worked, where Bessarion, later the cardinal of the Catholic Church in Italy, studied, the new stylistic principles formulated in the decoration of Chora found fertile ground for development. The church of the Virgin Hodegetria, known as Aphentiko, still has frescoes of great delicacy, similar to those of Kariye, including a group of martyrs executed in a symphony of colour. In the small chapel of the Peribleptos, after the middle of the century, a dense cycle of the New Testament is interpreted almost like an illumination, painterly, lively and intimist in every detail. There is no longer any reason to call this style "Cretan," as it is rather metropolitan; while that of the paintings of the Pandanassa is "Macedonian," extraordinarily colourful and expressive, probably in accordance with the humanism of the local school of philosophy.

Alongside monumental decoration, the Paleologue period also produced extremely sophisticated books such as the Paris *Cantacuzene Codex*; precious and rare mosaic icons in the form of illuminations: the *Diptych of*

the Feasts in the Museo dell'Opera dell Duomo in Florence, *St. John Chrysostom* and the *Forty Martyrs* at Dumbarton Oaks; icons painted on panels (often covered with gold and silver) such as the Ochrid *Annunciation*, the *Group of Apostles and the Death of the Virgin* in the Moscow Museum of Fine Arts, the series of icons for iconostases commissioned by Athanasius Pimen in the Tretyakov Gallery, etc. These examples of the metropolitan style served to educate the painters of Candia (which now belonged to Venice), and they broadcast its formulas with great skill until the island was taken by the Turks (1669). Well-

Left: church of the Transfiguration, Novgorod. The inventive freedom of the highlighting of the face of this saint, belonging to the cycle frescoed in 1378 by Theophanus the Greek, attains a spiritual tension which is both passionate and abstract at the same time. Above: the sophisticated mosaic diptych showing the canonic Feasts (dodekaorton) on its two panels was donated in

1394 to the church of S. Giovanni by the Venetian Nicoletta Grioni, the widow of a chamberlain of the Emperor John VI Cantacuzene. Its metropolitan provenance is certain, and the workmanship of the icon, inspired by illuminations, reveals the extraordinary skill of the Byzantine workshops even in the age of the Paleologue emperors. Museo dell'Opera del Duomo, Florence.

known Cretan artists such as Nicholas Philanthropinus, who was living in Venice in 1435 and provided compositions for mosaics in St. Mark's, and Angelus Arcotantus turned toward the capital, where they went respectively in 1418 and 1436. Another great Cretan, Domenikos Thotokopoulos, El Greco, who was to become one of the greatest painters of all time, also reveals an undeniably Byzantine spirit in his iconographical mannerism, the spiritual nature of his work and his ideas on light.

Left: the frontal of a helmet, in gilded copper leaf, from the Val di Nievole, shows the apotheosis of Agilulf, enthroned between Victory and dignitaries bearing royal crowns. Sixth century. Bargello Museum, Florence.

Ottokar deposed the Emperor Romulus Augustulus, and the Ostrogothic King Theodoric, having defeated Ottokar, settled in Ravenna. Despite Justinian's reconquest in the sixth century, the western Roman Empire was in effect over: three years after the death of Justinian the Lombards came down into Italy (A.D. 568). The artistic production of the nomad peoples, the *ars barbarica* (filigree goldwork, niello, mounted stones, enamel, etc.) that had already become fashionable in the Roman Empire during the third and fourth centuries, constituted a basic premise for the development of medieval art, particularly in the West. The objects of the Goths, from their first emergence from the Baltic to the Black Sea down to their various invasions in the fifth century, have points of formal contact not only with the art of the Scythians and the Sarmatians but also with Iranian art and that of the Hellenistic world. There are extant examples of this so-called barbarian art, which in reality was the independent expression of various nomadic peoples, in gold, silver and iron, produced using techniques similar to those of late Roman and eastern craftsmanship: these were mostly buckles, sword hilts, necklaces, bracelets, earrings, plaquettes, cast or moulded, worked with mounted stones, pastes or enamels, damascened, etc. The ornamental repertoire, dating back to protohistoric times, included zoomorphic or plant representations intertwined with geometric motifs, with rare, always stylized allusions to the human figure. These "barbarian" works, where geometric-abstract forms predominated, interacted with the tendencies of late Roman and Byzantine sculpture and painting. The influence of the "coloured" style is felt, for instance, in the rendering of the lamb in the ivory diptych in the treasury of Milan cathedral: an *opus inclusorium* which could also be seen in the lost breastplate of Theodoric in Ravenna.

The Lombards, who came down from the Pannonia of the original Scandinavian area, established relations with Romans and Byzan-

Barbarian art

The key event of the fifth century was the "barbarian" conquest of almost all the western part of the Roman Empire. The "civilized" world of the time and its great unitary and anthropocentric art, its most recent branch being Christian, were shattered by this; its values, however, survived and was strengthened in the regions controlled by Constantinople, the new capital. Defenseless in military terms, Rome countered the invaders purely with the power of her own culture and her long-tested legal principles. Contact with these institutions, subsequently adopted by the barbarians themselves, began from the third century when Franks and Alemanni, having crossed the Rhine, occupied part of Roman Gaul (A.D. 276) and continued in the following century when the Visigoths defeated the Romans at Adrianopolis. One after the other Vandals and Suevians, crossing Gaul and Spain, took possession of Africa. Alaric and his Visigoths, overcoming the resistance of the general Stilicho, sacked Rome in 410, though the city's churches were spared by the conquerors, who had become Arian Christian. Rome was sacked again in 455 by the African Vandals of Genseric, twenty years after

Above left: gold buckle shaped as an eagle, with mounted almandines, made for female clothing of the Goths, comes from Domagnano (S. Marino). Fifth century. Germanisches Nationalmuseum, Nuremberg.

Right: Cividale del Friuli. Museo cristiano and Tesoro del Duomo. The relief with the Adoration of the Magi *is sculpted on the right-hand side of the altar of Duke Ratchis (king from 744 to 749). In this court work the sculptor, indifferent to spatial relationships, adopts methods and motifs alien to Germanic craftsmanship.*

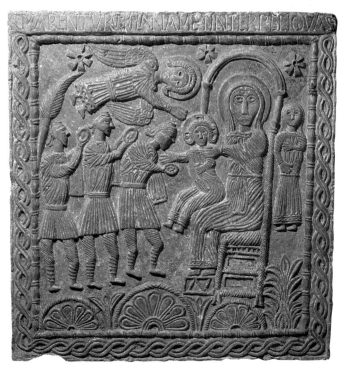

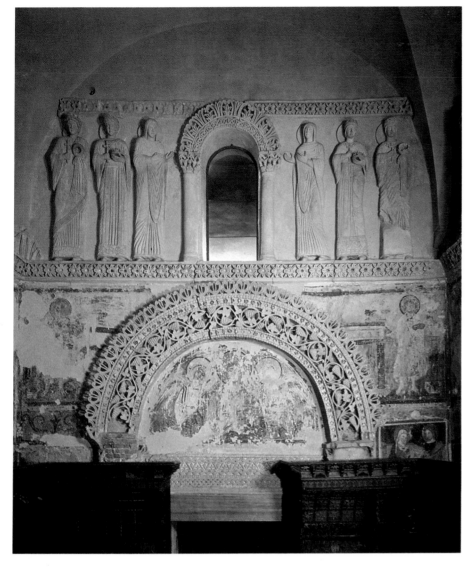

S. Maria in Valle, Cividale del Friuli. The decoration of the interior of the so-called "tempietto" includes marbles, stuccoes and frescoes in accordance with the late Gothic and Byzantine tradition. The very fine archivolt above the entrance frames the bust of Christ between the archangels Michael and Gabriel. Above, at the sides of the window, are six majestic figures of female Saints modelled in stucco, showing an awareness of the legacy of antiquity and of contemporary Byzantium. (Eighth century.)

tines and built up a system of atavic government, laws and customs. We know little of the culture of this conquering people, who arrived in Italy in A.D. 558 and became Arian Christians (we know of Lombard bishops and priests from the sixth to the eighth centuries). The social and legal structures of the new rulers reveal a power exercised hierarchically, and an administration of functionaries and experts of Latin extraction. From the edict of Rotari (543) to the laws of Grimoald (558) and those of Liutprand, Ratchis and Astolph in the eighth century, it seems that the legal–administrative traditions of Rome and Justinian were operative.

The materials of the Lombard necropolises discovered in Italy, often of chance provenence, offer evidence of a fidelity to forms and ornamentation of portable objects of a tradition of their own. The Lombard artistic tradition emerges as similar in typology to that of the Goths (buckles – digitate, s-shaped or round – necklaces, helmets, hilts and sheaths, etc.): asymmetric in the arrangement of the intertwined elements, rich in strips with zoomorphic additions, with the occasional human figure tersely stylized in serpentine and plant forms.

The archeological finds of the "first style" (A.D. 580–600) have characteristics similar to those of Noricum and Pannonia; the influence of elements from Asia Minor and the eastern Roman Empire is explained by the trading activity engaged in by Lombard groups in the Byzantine army during the wars in Italy, Africa and Mesopotamia at first and by their being federates of the Empire from the sixth century onward. A singular document, though not strictly assignable to native Lombard production, is the plaque of gilded copper with the triumphal representation of King Agilulf, which is a concise translation of elements of frontality, symmetry and colour typical of the late-classical Roman style.

Lombard objects of the seventh century reveal a transition from purely abstract patterns to the partially zoomorphic work of a "Germanic" type and, lastly, the synthesis between the Nordic "normal style" and late Roman Mediterranean and provincial ornamentation, with objects worked on in regions between the Alps and the Rhine, of Celtic and Anglo-Saxon origin.

Lombard craftsmen moulded and embossed numerous gold crosses and disks, with partially figurative representations, fine examples of which are in the Museum of Cividale in Friuli; other important artifacts are the *Cross of Desiderius*, the cross of Agilulf and other pieces in the Treasury in Monza cathedral.

In Friuli, in Cividale in particular, there were Lombard workshops specializing in the sculptural carving of stone. The ciborium of the patriarch Callixtus, with its zoomorphic ornament, and the altar of Duke Ratchis, with its Christian representations (*Christ in Majesty*, *Visitation* and *Adoration of the Magi*) are among the most important and best-known examples; these sculptures show similarities with other reliefs in Pavia, Ferentillo (stone slab by the master Ursus), in Modena (relief of the bishop Lopicenus), etc.

The Edict of Rotari, the *Memoratorium* of Liutprand and other Lombard laws are evidence of master-builders operating with firmly established associations. Not much remains of the architecture of the Lombard area, a fact which, if one considers the historical events of the period, is not surprising: successive destructions and transformations also make it difficult to evaluate their originality and to examine the main building technique. The famous S. Maria alle pertiche in Pavia, built by Queen Rodelinda around 667, is known to us through a drawing of the plan by Leonardo. The Baptistery at Lomello, with rectangular semicircular projecting niches, has an octagonal body and windows flanked by blind niches with triangular tops above a cornice with a double denticulation. Many sacred and secular buildings were commissioned in Pavia by the Lombard kings in the seventh and eighth centuries. St. Anastasius, built by Liutprand near his suburban palace, has been lost, but parts of S. Maria delle Cacce remain: blind arches and windows with an outer arched lintel in brick are reminiscent of the contemporary architecture of Milan and Ravenna.

Similarities with the older basilicas of

Ravenna are shown by the church of the Monastery of S. Salvatore in Brescia, founded in 753 by King Desiderius: this important building, possibly by Comacine masters, made use of capitals from the sixth and seventh centuries and column shafts in Greek marble. Equally important are the frescoed cycle on the walls and the sculptured stucco ornamentation. Even more remarkable, in its ornamentation, is the "tempietto" of S. Maria in Valle at Cividale, commissioned by the Duchess Pertruda (772–776).

Among the important works built on Lombard territory in the course of the eighth century, S. Sofia at Benevento is particularly noteworthy: with an octagonal perimeter with two concentric inner colonnades, it has a hemispherical dome on a high drum, with the presbytery space opposite the entrance. It is genuinely inventive and vital in its technique, as is S. Maria delle Cacce, which has distant late Roman roots. The creativity of this century, formerly regarded as one of decline, is further borne out by other buildings in Italy such as the Baptistery of S. Severina Calabra and S. Maria delle Cinque Torri in Cassino.

Goths, Burgundians and Franks, lacking building traditions of their own, brought no "new" civilization to Gaul in the fifth century. At this period, indeed, the tomb furnishings are somewhat impoverished, with the exception of royal tombs. From the middle of the sixth century, with the gradual symbiosis between the indigenous peoples and the descendents of the invaders, artistic production increased in quality and quantity. As we have seen with the Lombard of Italy, one cannot really talk of "Merovingian" or "Frankish" art, but of monuments of the Merovingian or Frankish period; and the same should be said for "Visigothic art" in Spain. In Italy, Gaul, Spain (and in the Anglo-Saxon and Irish countries) the invaders were able to adopt the culture and institutions of the people they had conquered (language, religion, law, etc.); the new kings felt honoured in their encouragement of artistic undertak-

The superb example of goldwork found in the treasure of the royal tomb at Sutton Hoo (southern England), where intertwining and zoomorphic motifs are skilfully combined, bears witness to the great ability of the Nordic goldsmiths during the eighth century. British Museum, London.

Below: this codex from the second half of the seventh century, known as the Book of Durrow from the monastery of the same name, is the oldest Irish illuminated Evangeliary. The text is decorated with full-page illuminations depicting the symbols of the Evangelists and "carpet" plaitwork. Trinity College Library, Dublin.

ings, knowing their effectiveness as "propaganda."

There are, however, some objects which, though linked to "barbarian" sovereigns, such as the Cross of Clothilde and the wooden lectern of Radegonda, have a markedly

"Mediterranean" feel to them.

Merovingian Gaul produced a religious architecture whose forms derive from and continue those of the late Roman Empire ("towers" on the presbytery, porticoes, etc.): these buildings, like their decoration, aim at effect. Many architectural works, mentioned in the sources, have been lost. Despite later modifications, the basilica of St. Peter's built in the fifth century at Vienne retains the unusual arrangement of two orders of arches with superimposed columns along the side walls. At Selles sur Cher the façade of the Romanesque church utilized columns and capitals from the basilica founded there before 558 by King Childebert in memory of the hermit Eusice. The baptistery of St. Jean at Poitiers, built in the seventh century, has considerable originality *vis-à-vis* its illustrious Provençal antecedents, with rich brick ornamentation on the outside and sculpted slabs and capitals inside. A funerary sacellum discovered in a burial ground near the same town, known as the "tomb of the Dunes," throws light on early Gallo-Roman Christianity of the seventh century: although the barrel-vault of the building has collapsed, we can still see steps and doorposts carved with Christian symbols and intertwined snakes, an enigmatic cabalistic inscription on the threshold, the altar and one foot of a cross with the rarely found portrayal of the two thieves. A great deal of tomb sculpture was produced around Toulouse: in the quarries in the foothills of the Pyrenees workshops of marble-workers carved capitals and sarcophagi for export throughout Gaul.

One of the first abbeys built after the mission of the Irishman Columban in the valley of the Marne is the so-called crypt of Jouarre, founded about 630, near Meaux. The church has disappeared, but "looted" columns and "prefabricated" capitals have survived: the "shell" sarcophagus of the foundress, and that of the bishop Agilbert are outstanding.

Among the churches built in Visigothic Spain before the Arab occupation were the church of S. Juan Bautista at Baños, in the province of Palencia, S. Pedro de la Nave in the province of Zamora and the church of S. Maria at Quintanilla de las viñas in the province of Burgos (exterior of the choir, and transept). These are buildings without apses, technically perfect and elegantly proportioned, with very fine decorations, coloured and sculpted on stone.

Some idea of the artistic traffic between the Celtic minorities of the British Isles, Christianized by the Romans from the sixth century and subsequently intermingling with the Germanic invaders, can be given by some pieces from the treasure from the royal burial ground of Sutton Hoo. The illuminated pages of the *Book of Durrow*, the first of a series of wonderful decorated Irish manuscripts, have very terse knotwork with animals, combining derivations from *La Tène* art with features that developed in Germanic northern Europe.

Islamic art

In A.D. 622, the prophet Mohammed – to escape from his persecutors – left Mecca and took refuge in Yathrib (later called Medina). His flight – *hijra*, whence "hegira" – initiated the counting of the years in the Muslim calendar and, in effect, the Mohammedan civilization.

The Arabs (and by Arabs I mean only the population of the Arabian peninsula, not the North Africans or the other Muslim peoples) had never been in possession of a strong unifying culture and this was to be a determining factor in their absorption of Islam and the development of its art.

The Muslim's entire life is based on the Koran, and, by inference, Islamic art has to bear in mind above all that there is no distinction between religious and worldly institutions; between the enjoyment of earthly values and spiritual values. Given that the Koran says *qullu min alaiha fan* ("everything on earth is nothing"), the breaking away from realistic representation, the symbolism, the search for a spiritual life that transcends materialism, place Islamic art on a completely different plane from that – however magnificent – of European art. Islamic art is above all allusive and intimate, subtle yet for the most part uncontrived, subservient to the inspiration: hence craftsmanship that becomes art, architecture steeped in nature, and above all symbolism that can be decoded only if you have the right key: cultural or mystical, but in any case almost always aesthetic.

This, and the fact that for the most part Islamic peoples are of nomadic origin and therefore inclined toward the abstract, is why it is persistently nonfigurative, not because of any religious ban; in fact the Koran does not forbid images and tradition prohibits only any images of God, or images of human beings or animals in places of prayer.

Origins of Islamic art – the art of the Umayyads (661–750)

The pre-Islamic southern Arab kingdoms were already in contact with the great Classical civilizations of the Mediterranean because of their considerable trade. They imported Greek and Roman articles, and manufactured their own imitations. One Yemenite tribe had colonized Abyssinia (now Ethiopia), consequently experiencing the rise of Coptic art; another – the Nabataeans – had pushed as far as the bridgehead of the Great Caravan Route, in Jordan, and there had founded a kingdom that experienced the rise both of Greece and Rome; their capital, Petra, seeing the development of Classical elements, the prelude to Baroque art. While the first Arab conquests led to the annexation of the Fertile Crescent, already completely Byzantine, it was Late

Lion Court, Alhambra, Granada, Spain. Built by Mohamet V (1354–91). Nasrid art.

Antique art that inspired the first Islamic models. As usual, the adaptation of Classical models to the demands of the Islamic cult and the concepts of the new culture led to different forms that became the basic elements of the new art, just as Christian art changed the Roman models.

From the first centuries of the Hegira, new cities, and from time to time new capitals, were founded by the first Muslim dynasty, that of the Umayyads, who came to power with Mu'âwiyya I (d.680). The planning of these new cities shows particular features: the subdivision into socially functional quarters and the grouping together of the different crafts in their own districts are still effectively in evidence throughout the Muslim world.

The synthesis of Islamic and Late Antique architecture was the *Kubbat al-Sakhra* (Dome of the Rock), built in Jerusalem by the caliph 'Abd al-Malik in 688 (the glazed pottery tiles that decorate the exterior were added during the Ottoman period). Its design – a central hall covered by a large dome – was to be a recurring one in Islamic architecture. In 709 the Mosque of Al-Aksa was built in Jerusalem (later to be altered several times) with a line of several naves, a scheme that was also to recur throughout Islam.

The back wall is ritually built facing Mecca, the direction in which all Muslims must face during prayer. In the middle of this wall, a large niche called *mihrab* indicates this direction (*quibla*) and is, generally speaking, the most striking feature of the mosque: a sort of "high altar," usually richly decorated.

Between 706 and 715 the Great Mosque of

Damascus was built on a preexisting Christian church, increasing the number of naves. The mosaic decoration and the structure – arcades supported by pillars that divide the naves – are wholly derived from Byzantine models. Similarly in the Late Antique style are the castles in the Jordanian desert, including Qasr Al-'Amra, with its fine decorative frescoes; Mshatta, with its external walls covered with a wealth of decoration, plants and animals sculpted in bas-relief; Qasr al-Keir al-Gharbi; and the Khirbat al-Mafjar palace, with well-preserved floor mosaics.

A unity of concept can be seen between the architecture and small objects: in the harmonious proportions of the decorative elements, whether vertical modules (be they columns or letters of the Arab alphabet) or repeated modules (generally arches and convexities). The decoration makes use of geometric, plant, and calligraphic elements, in an unmistakably Islamic ensemble – whence our Western term "arabesque." Its essential quality is the visually rhythmic repetition of the modules.

In general, the art of the Umayyads reflects both the need to represent the new power of Islam – for the moment still in the hands of the Arabs – and the attempt to integrate the different traditions derived from their dominion over many varied populations and civilizations, permeated by an ecumenical spirit that respects and reconciles all values. Late Antique, Arab and Sassanid motifs were, so to speak, "demonstratively" assimilated; the predominant qualities of the desert and of nomadism are seen in the brilliant ornamentation, while the Classical and figurative elements become fixed in stereotyped formulas. The fusion of so many influences created a splendid and harmonious effect – above all in the buildings of Muslim Spain, which we shall consider later.

Abbasid art (750–1258)

With the dynasty of the Abbasids, the center of power was transferred from Syrian Damascus to Baghdad in Iraq. Through this political event it seems almost that the Mediterranean legacy was abandoned in favour of the Asiatic, which certainly now becomes the more marked. The models of Central Asia combine with earlier ones, with the absorption of the arts of the Steppes: nomadic art that subsequently emphasized the nonfigurative and decorative style, the harmony of composition, the delicacy of the tracery and aesthetic resolutions. This influence of the Steppes was later to be accentuated with the invasion of the Seljuk Turks.

In architecture, the *iwan* assumed great importance: a kind of entrance hall with a triumphal arch derived from the analogous Sassanid construction, open on one side, which served as the public audience hall in the royal palace.

Baghdad was laid out on a circular plan with

Above: the Khazneh, Nabato-Roman tomb cut from the rock, Petra (Jordan). Pre-Islamic art.

Opposite: Dome of the Rock at Jerusalem, built in 688 (axonometric model). Ummayyad art.

Below: Ymat, protective goddess. Pre-Islamic. Kingdom of Saba, third century A.D. Institute of Oriental Archeology, Amman.

a diameter of 2,700m (2,950yds). Reqqa, in Syria, was a secondary residence, famed for the splendour of the sojourns of Harun al-Rashid (796). Here we find the earliest examples of *muqarnas*: a typical element in Islamic architectural decoration, consisting of a cornice bridging the vertical line of the walls

and the horizontal plane of the ceiling, gradated with stalactites or honeycomb cells. We find *muqarnas* in stone, tiles, wood: in various styles, from the simplest to the most complex.

A third new city, Samarra (from *surra man ra'a*, "happy is he who beholds it"), was founded in 838 by the caliph al-Mu'tasim, principally to house his own Turkish guard. Of the vast urban area that stretched along the banks of the Tigris, with its characteristic, unusual minaret with spiral staircase, 50m (164ft) high, it is chiefly the remains of the Great Mosque that have survived. This was the largest religious edifice of Islam, covering 31,000m² (37,000 sq. yds) (the prayer area, 240 × 156m/787 × 512ft, held a hundred thousand faithful). At Samarra we also find the first Muslim mausoleum, the Qubbat al-Sulaibiyya, built for the caliph al-Muntasir.

Notable is the palace of Balkuwara (854–859) in an enclosure 1,250m (4,100ft) wide. It measures 460 × 575m (1,509 × 1,886ft) and is divided into three great naves with barrel vaults preceded by *iwans*.

The interior of these buildings was decorated with frescoes. Of this wealth of decoration, what remain today are the friezes in stucco, in which for the first time in the history of art we see panels printed with a matrix and finished off with chamfered edging. The decorative elements, mainly plant or geometric motifs, are conventionalized, their harmonious visual rhythm emphasized by the constant repetition of the basic module in a *horror vacui* characteristic of nomadic peoples. Here we see the origin of the purest Islamic arabesque.

The minor arts were equally rich, especially pottery and metalwork. In clear imitation of Chinese T'ang porcelain, we find *graffito* designs in three colours; but the original Islamic creation was faïence lusterware, destined to revolutionize the entire Mediterranean output in the ensuing centuries. We suddenly find a wealth of metallic sheens, from reddish gold to pale silvery gold and green-gold, with a variety of shades in between. From Iraq were imported the lustered faïence tiles that decorate the *mihrab* of the mosque of Sidi Oqba at Kairouan, in Tunisia (862).

Glassware was also varied: rock crystal and glass paste moulded and engraved; glassware decorated with enamel; goblets made of several layers of different-coloured glass, skilfully moulded. Calligraphic decoration, too, was reaching its peak; this is why we can define this period as the birth of real Islamic art.

North Africa and Spain (Umayyads of Córdova, 756–1031; Kingdoms of Talfas; Almoravids and Almohads; Nasrids of Granada, 1231–1492)

Córdova was the center of an exceptionally important civilization. In the palace of Hakam II the library, for public reference, held 400,000

volumes (at that time the largest library in Christian Europe was the Vatican library, with 986 volumes). The Great Mosque of Córdova (786), synthesis of the many Islamic experiences, is a building with eleven naves and a vast court, successively altered and enlarged to become the third largest mosque in the world: 176 × 128m (577 × 420ft). The decoration is comprised of an architectural module repeated 425 times: horseshoe arches of alternate brick-red and ocher keystones resting on slender pillars, and above them a second storey of round arches. Also noteworthy are the Alcazar of Córdova, begun in 784, which became the symbol of Umayyad power; and the mausoleum of Abd al-Rahman I. These constructions also show traces of mosaic decoration in the Byzantine style.

The Berber Almoravids founded Marrakesh, in Morocco, and the great mosques of Algiers and Tlemcen, which were built on the plan of the basilica with multiple naves. When power passed to the Almohads, the center of culture returned to Spain again, contemporaneously creating Hispano-Moresque art and *Mudejar*

art, named after the Muslim artists whose work was commissioned by Christians. Impressive is the Kutubiyya or Great Mosque of Marrakesh (1146), 87 × 58m (285 × 190ft). Particularly elegant are the minarets, which in this area always follow the typological square plan, in particular those of Hassan in Rabat and the Giralda of Seville (1190), 100m (328ft) high.

With the Berber dynasty of the Nasrids were created the last Islamic masterpieces in Spain. In the first half of the fourteenth century, above the town of Granada, they built the Alhambra (the Red Fortress), which in its general layout follows the typical design of the Arab house, with a central courtyard (the *patio* with balcony was later inherited from Spanish architecture). Vistas of richly decorated slender columns, placed in perspective; arches with *muqarnas*, domes with ceilings entirely covered with *muqarnas*, to very beautiful effect, and walls completely faced with finely carved and decorated stuccowork. Load-bearing structures, skilfully distributed, disappear beneath the abundance of decoration. Mullioned windows (*ajmez*) lend visual rhythm to the walls, and the

exuberance of the ornamentation is wedded to the inventiveness and imagination of the architectural decoration in an encapsulation of the Islamic art of the early centuries. This is in contrast with other Islamic buildings (such as the two synagogues of Toledo) in which the art is in the harmonious proportions of large, uncluttered spaces, emphasized by the harmonious curves of the horseshoe arches.

Ceramic art also created new masterpieces, such as the large jars with wing handles, in metallic luster and with fine decoration: work of subtle technique from which was derived the Hispano-Moresque ceramic art of the Christian periods. Muslim-Spanish pottery was exported to Christian Europe from the port of Majorca – whence the name "majolica" given to glazed earthenware. Important centers were Granada, Manises, and Paterna. A masterpiece of the art of metalwork is the *Filigreed Lamp* (1305) commissioned by Mohammed III for the mosque of the Alhambra.

Also important were textiles, as well as knotted carpets with clear patterns showing a heraldic sense of decoration.

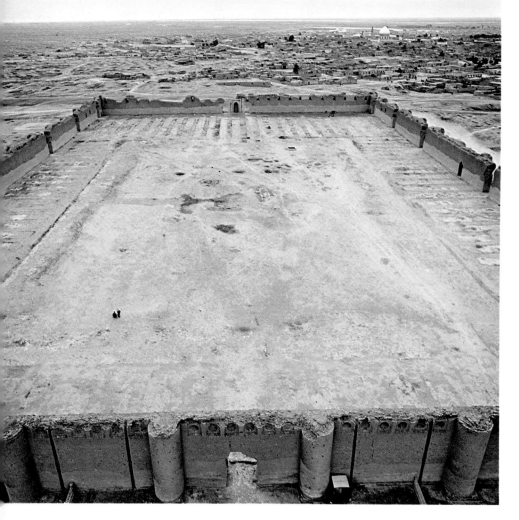

The Tulunids (868–905)

The art of the Tulunids – the dynasty of the viceroy who governed Egypt – derived from Abbasid art. The chief example is the Great Mosque of Ibn-Tulun in Cairo, founded in 876 by Ahmad and built on the plan of the Great Mosque at Samarra, but with a distinctive wealth of decoration in woodcarving, in which the local artists, of Coptic origin, showed a mastery and style which were to remain predominant features of later Egyptian art. Unfortunately lost to us is the great wooden statue of the Tulunids, described by contemporary sources as naturalistic.

The Samanids (819–1005)

The Samanids constitute another branch of the Abbasids which, supported by the Turkish military aristocracy, developed in eastern Iran, Khorassan and Turkestan an art that integrated the traditions of the Caliphate of Baghdad and the Mediterranean with the great traditions of the Sassanids and the Steppes. Consequently, at the Samanid centers of Bukhara, Samarkand and Nishapur, we find an integrated art remarkable for its unusual and inventive features. The mausoleum of Isma'il at Bukhara (892–907), built on the cubic plan with a domed roof, has brick walls laid in patterns that resemble the interwoven wickerwork of nomad huts.

Samanid ceramic art was particularly rich, exploiting the decorative value of beautifully drawn Kufic and cursive scripts, and highly effective in its simplicity and economy of colour: cream with brown and red decorations and lead glazing.

The Fatimids (969–1171)

Already masters of North Africa since 909, the Fatimids – having conquered Egypt in 969 – declared themselves independent of the Absasids. In Cairo, their new capital, they founded the University of al-Azhar (970–72), the oldest surviving university in the world, with its own transept mosque with monumental entrance and the innovation of three domes on the end transept, that of the *mihrab*. This model was followed in the mosque of al-Hakim (1013).

In the mosque of al-Aqmar (1125) we find the first example of *muqarna* decoration on the façade. The most notable example of Fatimid *muqarnas* used to decorate a ceiling, however, is at Palermo (Palatine Chapel, *c.* 1140), the city in which Muslim pavilions were built for Roger II of Altavilla: the Ziza, the Cuba (1180) and the Favara palace, since destroyed. The *muqarnas* of Palermo alone suffice to bear witness to the magnificence of Fatimid decoration: an extremely rich and versatile kind of compendium of the preceding periods. In fact Fatimid art is related to Seljukian art, and together they determined the development in Italy of a Federician architecture and, on a lesser scale, certain principles of Romanesque and Gothic art.

In the important center of Cairo fine pottery was produced, still most commonly decorated with *graffito* designs and lustered. The ivories too were superb, especially the caskets with fretwork motifs (a fine example is the Sicilian one kept in the Treasury of Würzburg Cathedral), which we also find in the magnificent woodcarvings. The characteristic metalwork showed very fine workmanship in gold or silver wire inlay, and was generally embellished with the new "floral" script or else with simple incised decoration (a famous example is the bronze *Griffin*, 1m (3ft 3in) high, today in the Camposanto in Pisa.

Between 970 and 1170 glassware of the highest quality was produced: engraved rock-crystal plates, painted and enamelled lamps, glasses (also exported to Europe, and known in Germany as *Hedwigsglässer*, Hedwig glasses). However, the craft that most truly attained the level of art was weaving. Precious fabrics were woven in state workshops (*tiraz*) or private ateliers, and their techniques spread also to Europe, with traditional centers subsequently being established in Sicily, Tuscany and England. The fabrics were mainly silks of many colours, brocaded satin and brocades. The most famous surviving example of Islamic textile art is the *Coronation Mantle of Roger II* (1133), today in the Crown Treasury in Vienna.

The art of the Seljuks (985–1157)

The Turks came down from Central Asia and settled first at Nishapur, Merv, Rayy and Isfahan, and lastly at Diyarbakir and Konya in

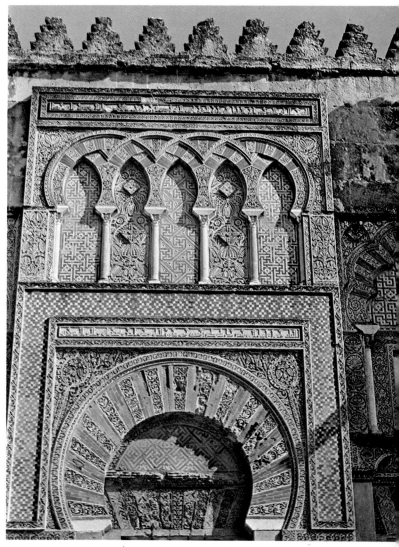

Opposite: Great Mosque of Samarra (Iraq), built by the caliph al-Mutawakkil (847–861). Abbassid art. With its 31,000m² (37,076 sq yds) with formerly twenty-five bays, it could receive 100,000 worshippers. The enclosing walls (790m/ 2,592ft long) are pierced by sixteen doors.

Right: one of the twenty-three outer doors of the Great Mosque of Cordova. Spanish Ummayyed art. Built in several stages between A.D. 786 and 1009 and finally consisting of nineteen bays and six hundred and sixty-four columns.

Turkey and Damascus in Syria. With them they brought the art of the Steppes – that great nomadic art of northern Eurasia from which the Celtic and Barbarian arts of Europe derived – which became integrated with the art of the Afro-Asian peoples. Abstract art, thus combining with figurative art of Classical derivation, shaped one of the richest and most preeminent aspects of the Islamic civilization.

Just as in Europe, Nomadic art took root and tended toward classicism, giving rise (through the transposition of the wooden hut, the *isba* and the *stavkirke*) to Gothic structure, so the felt tents of the nomads became *turbé* (mausoleums) of stone or brick, retaining the same structure, their domes in imitation of the Mongolian *gheer*, richly decorated with a bean-shaped design and, above all, a splendid covering of polychrome tiles.

The Seljuks (best known in the West for "Seljuk" script) enlarged and improved secular buildings, in particular the *madrasa*, which corresponds to the European university. Their

sense of harmony dictated the structure of the square courtyard with four *iwans*, one in the middle of each side. The *iwans*, in their turn, are flanked by two storeys of balconies. The four "paths" or schools of Koranic law (Shafiite, Malikite, Hanifite, Hanbalite) thus have their own precise place, and on each side of the courtyard are the rooms for the teachers and seventy-five students of each school, in addition to the library, baths, hospital, and kitchens. The earliest important madrasas are those of Nur al-Dyn in Damascus (1172) and of al-Halwiya in Aleppo (1148). Like almost all Seljuk buildings, they are constructed entirely of stone and decorated with bas-reliefs.

The most prestigious *iwan* mosque is the Masjid-i Jami in Isfahan (1088), which can be said to have served as the model for those that followed. Its wide, square hall, surmounted by a huge dome, clearly echoes the character of the felt tent. There is a new type of slender "organ-pipe" minaret, at first built apart, later

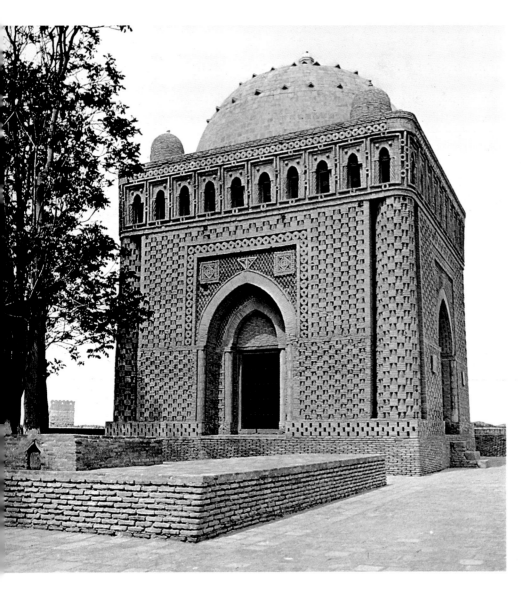

tiles or as glazed bricks or (especially in Turkestan) in a mosaic of varied materials.

From the simple glazed and lustered ceramic with *graffito* decoration of the preceding centuries, we now come to a wealth of techniques and enamel decoration that raise ceramic art to a level where it competes with that of China. From monochrome enamelled or glazed vessels, with reliefs in *barbotine*, incised patterns, perforations, we come to the *lakabi* technique combined with polychrome glazing and the *minai* technique, which uses enamel paints glazed at various temperatures in successive firings. In this latter case the result is miniaturistic. The scenes depicted, very carefully and elegantly, are generally crowded with figures, whereas the usual pottery also uses calligraphic decoration employing a variety of "hands" or scripts (Kufic, Thuluth, Naskhi, etc.). Generally, animal and human figures are in luster, from the kilns of Rayy, Gurgan, Kashan and Garrus. Of importance in this field are the great monumental *mihrab*, true masterpieces of ceramic art, using perforation and calligraphic decoration in relief, architectural modules, capitals, arches, and a wealth of enamels and gold of a third firing, in a fairytale ensemble. One of the greatest ceramic artists, leader of generations of masters, Abdul Kasim bn-Tahiri of Kashan, also wrote a celebrated tract on ceramics, one of the earliest of its kind. Another important ceramic painter was Sayyd Shams al-Dyn al-Hasany (active around 1210), the author of *minai* ceramics today conserved in the major museums of the West.

Painting vies with ceramics in the figurative decoration of the palaces of Rayy and Kashan, while the art of miniature, especially in the centers of Baghdad and Mossul, provides Islam with its first complete examples of this art. Among these artists are Yahya bn-Mahmud al-Wasity, an excellent animal painter, and his pupil 'Alà al-Dyn Helmandy. It

also placed on the *iwan*; and lastly, for symmetry, two small minarets are set on the top of the *iwan*, one per side. Fine examples of this type of minaret are the Kalàn minaret at Bukhara (1127) and the minaret of Jam in Afghanistan (1153), 60m (197ft) high, built by the sultan of Ghor, Ghiyat al-Dyn Muhammad bn-Sam.

Notable are the mausoleums, derived, as mentioned earlier, from the felt tent of the nomads and the domed buildings of the Sassanids, in a remarkable and varied combination: the mausoleum for the Sufi master al-Ghazali in Tus (1111); the mausoleum for the sultan Sanjar in Merv (1175), with one of the earliest examples of a double dome – the inner one round, the outer one conical. In fact, many funerary towers have their dome concealed on the outside by a pointed roof, a common feature also in Turkey.

Almost all the monuments in Persia are coated with polychrome ceramic, either as

Above: Ismail's tomb, Bukhara, Uzbekistan (USSR), built A.D. 892– 907. The brick cladding imitates the willow- weaving customary in the ghers of the steppes. Samanid art.

Right: Arab-Sicilian ivory box made in Palermo, twelfth century A.D. Fatimid art.

is interesting to note that the majority of illuminated texts are now on scientific subjects.

With the Seljuks, the art of metalwork also reached its peak, particularly the incised bronzes of the Khorassan, the perforated incense-burners, generally shaped like animals (an admirable piece by Jafar bn-Muhammad bn-'Aly, 1182, is now in the Metropolitan Museum of New York). Damascene decoration (from *Damascus*) and gold and silver thread inlay were important, with a considerable number of objects of common use; the *Cauldron* of Herat (1163), the work of Ibn-al-Walid and Hajib Mashud, today in the Hermitage in Leningrad; the bronzes of Mossul, in which Ahmad al-Dhaki was preeminent; the gold and

Above: piece of silk brocade called St. Josse's shroud, with an inscription to emir Abu Mansur Bukhtakin (tenth century), probably from Khurasan. Musée du Louvre, Paris.

Above right: minaret of Djam, Afghanistan, built by sultan Ghiyath al-Din Muhammad (1153– 1203). Ghurid art. 60m (197ft) high, it is all that remains of the royal residence of Firuzabad destroyed by Genghis Khan.

Left: ceramic from Garrus incised and glazed (twelfth century). Seljuk art. Fitzwilliam Museum, Cambridge.

silver wire inlays of Syria; the fine jug today in the British Museum in London; and the aquamanile in the Metropolitan Museum of New York, the work of Ibn-Jaldak.

The Seljuks in Turkey

The Seljuks of Rum (Byzantium), with its capital at Konya, succeeded, in half a century, in establishing a highly developed Islamic art in Anatolia. The Great Mosque of Sivas (or Ulu Cami, of limited interest); the hypostyle hall of the 'Ala al-Dyn mosque in Konya, begun in 1156; the Çatak Köprü bridge, in the district of Silvan; the Great Mosque of Mardin (eleventh century); the Great Mosque of Diyarbakir (1092), are of considerable interest and are the first of many examples of this "thirst for beauty" which impelled the Seljuk sultans to build a whole series of great monumental works. Mosques, madrasas, caravanserai (the latter highly functional, for all their beauty) generally have a huge entrance gateway with a vault decorated with *muqarnas* and sides embellished with bas-reliefs of repeated plant, geometric and calligraphic motifs. Some façades, like those of the Divriği complex (1229), were decorated with very effective and highly imaginative ornamentation, with almost surreal projections and overhangs. The same decoration is found in the stone *mihrab* and

the magnificent wooden *mihrab*, to which many artists put their signature.

The most typical minaret is that of the Yivli Mosque of Antalya (1220).

Typical madrasas are the Sirçali in Konya (1224), with a small *iwan* entrance lavishly ornamented with geometric designs in bas-relief; the Çifte Minare in Erzerum (1253); the Büyük Karatay in Konya (1251); and especially the Ince Minare in Konya (1258), with a recessed doorway, from the top of which two bands of inscription fall and are twisted into a knot over the door, in a design of extraordinary inventiveness that is unique in world iconography. It is impossible to enumerate all the remarkable examples of "unique" Seljuk architecture, or all the examples of *turbé* tombs. We must, however, draw attention to the chain of caravanserai strung along the caravan route from Persia to the Mediterranean, the finest of which is probably the Sultanhani in the province of Niğde (1229), with its magnificent gateway decorated with a wealth of stone *muqarnas*. On the other hand, very little of the royal palaces remains: ruins in Konya and on the island in Lake Beyşehir. Their interior walls were richly ornamented with tiles in star and cross patterns. There was also a wealth of stucco decoration (of which few examples have survived), similar to the contemporary unglazed pottery.

The rich decoration with wood panelling also testifies to the great taste and splendour of Seljuk art in general, which is equally apparent in the minor arts. Household pottery includes very finely worked pieces, perforated and glazed. Particularly unusual are the bowls with transparent glaze over the perforations, so that when they were used as lamps (and not for other purposes, as has hitherto been thought), the light shone through the perforations, to great effect.

Notable examples of metalwork are the *Mosque Lamp* with perforations and calligraphs, made by 'Aly bn-Muhammad al-Nisibis of Konya (1280: Ethnographic Museum, Ankara) and the exceptionally large *Vase for Spring Water*, conserved in the Mevleviyya in Konya.

Another field in which we find remarkable pieces is that of carpet-making, with a technique probably brought from Central Asia into Persia and Turkey by the Seljuks themselves. The background of the carpets is decorated with geometric patterns; the wide borders are embellished with highly stylized Kufic script. The best examples, which date from about 1220, come from Konya (today in the Museum of Turkish and Islamic Arts in Istanbul) and are made with the large *Ghiordes* knot, typical of Turkish carpets. Other centers such as Sivas and Kayseri – whose workshops were visited by Marco Polo in 1271 – also produced work of equal "archaic" grandeur, notable for its beauty and value.

Ghaznavid art (962–1186)

The Turkish dynasty of the Ghaznavids, founded by Alp Tegin, reigned over eastern Persia, Afghanistan, western Turkestan and northern India, with their capital, Ghazni, in Afghanistan. It was later deposed by the Seljuks and the Ghorids, who in 1151 conquered Ghazni and in 1186 the last possessions in India.

At the Ghaznavid court were al-Biruni, one of the greatest Muslim scholars, and Firdawsi,

Page from the Kitub al-Diryak (Book of Antidotes), illustrated in Iraq in 1199. Seljuk art. Bibliothèque Nationale, Paris. A hadith of the prophet Mohammed says: "To him who follows the path of a science, God opens the gates of paradise." This predilection for science produced a wealth of treatises beautifully enriched by miniatures.

Many of these books take up, with new commentaries, Greek works unknown in the West, later translated into Latin. Islam was thus in cultural ferment compared with the West.

the greatest poet in the Persian language, author of the huge *Shah Nameh* (*Book of Kings*).

Typical of this art are the minarets built on a stellate plan, their walls richly decorated with bricks laid in mosaic patterns and an ornamental calligraphic relief incorporating glazed bricks (in Ghazni in the minaret of Mas'ud III, 1019–1114, and the minaret of Bahram Shah, 1118–52). The minaret of Delhi, in India, is of the same type.

Of the palaces and many mosques only ruins remain, due chiefly to the invasion of the Mongols of Genghis Khan. Splendid calligraphs ornament the tomb of Mahmud of Ghazni (1030), the plinth of the palace of Mas'ud III in Ghazni (finished in 1111), and what remains of the royal residence of Lashgari Bazar, built by Mahmud (999–1030). Here, perhaps for the first time, was used the plan of square internal courtyard with four *iwans*, one on each side.

The few traces of figurative frescoes nevertheless testify to the importance of pictorial art in the Ghaznavid period. The richest harvest has been brought to light by archeologists working in the ruins of the palace of Ghazni.

An important monument of the period – for the complexity of its layout, which is still apparent even in its ruined state – is the palace of the kings of Hetimandel at Tar-o-Sar, little known because today it is in a desert region.

The art of the Mongols and the Timurids (1256–1502)

Between 1206 and 1227 the Mongols of Genghis Khan conquered almost all the Islamic territories in Asia, demolishing the Muslim civilization, which after all that destruction and all those massacres was never again to regain its splendour. Genghis Khan's successors,

Below: remains of the palace of Masud III (1099–1115) at Ghazni, Afghanistan, with splendid wall relief rich in geometric motifs and inscriptions.

Right: two thirteenth-century carpets from the mosque of Ala al-Din,

Konya. Seljuk art. The first has a border with stylized Kufic script (Mevleviyya, Konya), the second repeats the wader motif. At the Museum of Islamic and Turkish Art, Istanbul, there are similar large carpets from Konya.

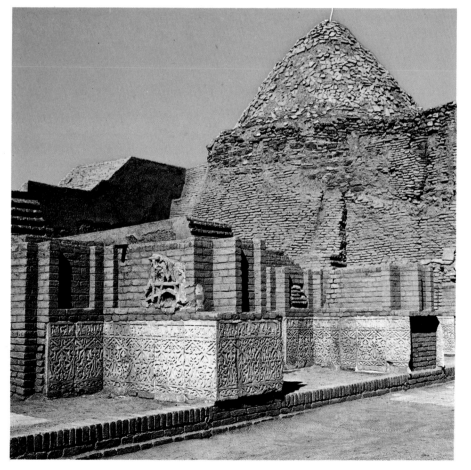

who governed Afghanistan and Persia through viceroys (Khanates), became converted to Islam; this resulted in the fusion of the Chinese art of the central empire with the Islamic art of the subject countries, creating new forms through the synthesis of the delicate art of the Far East with the technical vigour of Muslim art, characterized predominantly by the fairytale, unreal quality of nomad art. Architecture continued to follow the Seljuk models, but the dome became larger, the vertical elements became longer, and the decoration, whether stucco or ceramic, became more superabundant. Especially in the art of miniature-painting the new composite style became prominent, with rich illuminations of minutely detailed calligraphic realism.

Typical of this period are the mosques of Varamin (1322) and of Natanz (1316), the mausoleum of Öljeytü Shah in Sultaniya (1304), and the sanctuary of Pir-i Bakram, all built on the classic Seljuk model.

The wealth of sculpture is evidenced by the stucco *mihrab* commissioned by Öljeytü (1310) for the Great Mosque of Isfahan.

The art of miniature-painting, as has been noted, also has a quality of superabundance together with great technical skill; but perhaps

the most characteristic works are in ceramic (wall panels of Kashan, 1262, today in the Metropolitan Museum of New York; the great *mihrab* of the Madrasa Imami in Isfahan, 1345, also in New York; and the many pottery objects of common use, from the kilns of Kashan and Rayy, signed by great masters).

The Ilkhan dynasty (1256–1336) was succeeded by the short rule of the Muzzaffarids, followed by the Timurids (1378–1502) – Persians who continued Mongol art, with great development of mosques and madrasas and, more especially, of court miniature-painting.

The Mosque of Jauhar Zadé, in Meshed (1418), built by the architect Qiwamed al-Dyn of Shiraz, and the Madrasa of Kharjdir (1445) by the same architect, entirely clad in ceramic panels, are the most representative, followed by the Gök Masjid of Tabriz (1462) and the magnificent mausoleum of Khavaja Abu-Nasr Pashà at Balkh (1460).

The capital of the empire and center of Asiatic art was now Samarkand, but many of its buildings – in particular the Great Mosque – have been destroyed. There remain the edifices that face on to the Registan square: the Ulugh Beg Madrasa (1420), with a large *iwan* on each side; the Shir Dâr Madrasa (1619–35) and the Tala Kari Madrasa (1649). The Bibi Khanun Madrasa, named after Tamerlane's wife, and the large astronomical observatory of Ulugh Beg (1434) are virtually in ruins.

Outside Samarkand, along the Shah-i Zindé road (Street of the Living King), is a row of Timurid funerary monuments that has been described as one of the most beautiful cemeteries in the world. Prominent are the *Gur-i Mir* (Tomb of the King), built by Tamerlane in 1402; the tomb of Tamerlane himself; the tomb of Shah Rukh; the tomb of Ulugh Beg. They all have high domes, mostly bulbous, given elegance by a pronounced tambour, and covered with glazed tiles decorated with Kufic and normal cursive script and motifs of Chinese inspiration and typology.

Miniature painting was important, and there are many examples. Excellent work was produced by the schools of Samarkand, Shiraz, Baghdad, Herat, and Tabriz. Notable masters of the art were Khalil, Ghiyat al-Dyn, Shams al-Dyn, al-Baisunkury, and – the most famous – Bihzad, who was succeeded by a long list of worthy pupils.

Metalwork was also an important Timurid art, with statuesque aquamaniles, jugs and bowls still decorated with Seljuk motifs.

Pottery showed decorative styles and technical qualities of great beauty. The centers were the same as those of miniature-painting, and whole families of artists who signed work of outstanding quality handed down their art through the generations.

Also noteworthy is the woodcarving (in particular the mosque gates in Turkestan); today there are many examples in various museums in Asia, Europe and America. Famed too are the so-called "dragon" carpets of the Caucasus and the Anatolian carpets with animal decoration. Textiles, too, combining Chinese features with Islamic techniques, are of the highest quality and were exported to Europe (Tatar cloth), especially for ecclesiastic vestments.

The art of the Mamelukes (1250–1517)

Saladin (Salah al-Dyn), having defeated the Fatimids in 1171, established in Egypt and Syria the Ayyubid dynasty, which was succeeded in 1250 by the Mameluke Dynasty. Seljuk and Fatimid influences thus combined in a kind of bridge between East and West, spreading models and techniques into Europe, too, in particular through the Crusades.

The mosque of this region is predominantly of the Syrian transept type. The Mameluke masterpiece is the complex adjoining the muristan (hospital) of Quala'un (1284) in Cairo.

The Madrasa of Sultan Hassan (1356–62), which covers a surface area of 8,000 sq m (86,000 sq ft), has the four *iwans* in the courtyard. It owes its charm to the harmonious proportions of the simple arches, with their markedly accentuated vertical structure.

The cemetery of the Mamelukes, one of the most picturesque in the world, includes the Tombs of the Caliphs, where the graceful, austere domes combine to give an impression of calm and uniform monumentality. Alongside is the funerary madrasa of Qait Bey (1472–74), with its clearly articulated and varied harmonious proportions.

Mameluke pottery is important: both the blue and white type in imitation of Chinese porcelain, and the typical pottery with *graffito* designs, a coloured ground and heraldic motifs, further enriched with strong decorative *Naskhi* script.

Bowls and jugs were inlaid with gold and silver threads, and items of great value are

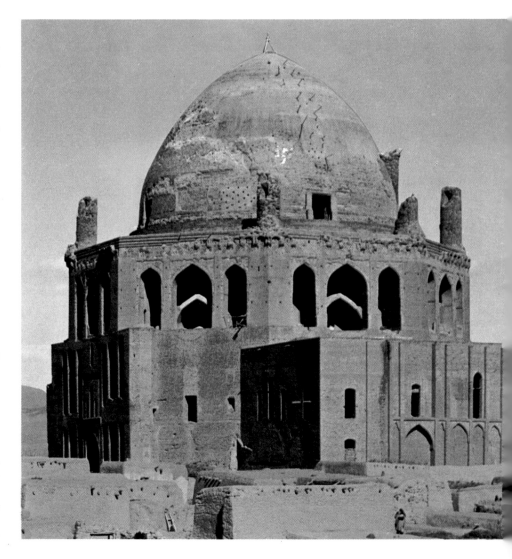

today scattered in the most important museums. The field is crammed with scenes within well-defined areas, with geometric and plant decorations and bands of very carefully written script; but it is the technique that is so surprising – of such high quality that it even surpasses the artistry.

There is a variety of typology and lighter decoration in the enamelled and gilded glassware: *Chalice of Charlemagne* in Chartres Museum; *Mosque Lamps* in the Metropolitan Museum of Art, New York, the Louvre in Paris, the British Museum in London, and the Mevleviye in Konya.

Famous too are the carpets: a wealth of detailed geometric decoration, in a rich variety of shades, within well-defined areas whose borders are embellished with floral motifs. The overall effect is almost kaleidoscopic.

Ottoman art (1299–1923)

Osman I (or *Othman*, in Arabic) founded the Ottoman dynasty in 1302; in 1326 he settled in Bursa, which was made the capital by his son Orkhân. Under Orkhân, in 1354, the Ottoman Turks began their conquests in Europe, and in 1360 Murad I transferred the capital to Edirne (Adrianople) in Thrace. In 1453 Mohammed II conquered Constantinople, the last Byzantine margin of the Eastern Roman Empire; this city became the new Ottoman capital, with the name Istanbul. In the following centuries the Turks extended their dominion to the Russian coasts of the Black Sea (Crimea, 1475); to Greece, Yugoslavia, Egypt (1517), Arabia and North Africa; extending as far as Budapest (1526), Vienna (1529), and Baghdad (1534). Beginning with the siege of Vienna in 1683 (and gradually losing the Roman territories, Egypt, Greece and the Balkan peninsula), Turkey gradually settled within its present boundaries, also suffering foreign invasion, from which it was saved by Mustafa Kemal Atatürk, who, after winning Turkish independence, deposed the last Ottoman emperor in 1922.

These historic events were matched in the field of art, which always reflects and bears witness to sociopolitical situations. The grandeur and progressive character of one of the vastest Euro-Asian empires were thus manifested by an art that remained unified throughout the centuries, notwithstanding the many new influences; although at first Ottoman art

succeeded Seljuk art only through a period of aesthetic confusion.

Steadily more in evidence is the architectural and aesthetic importance of the Ottoman central dome, shallow and wide, covered with metallic tiles and subdivided into slender segments, perfectly counterbalanced by smaller domes and bowl-shaped vaults in an aesthetically harmonious whole.

The lay buildings, although of lesser artistic importance, are also of striking architectural interest; among them the *imaret* (hospice, with hospital or kitchen annexes, refectories, storehouses), which becomes rich and complex (for example, the Nilüfer Hatun Imareti at Iznik, 1388). It is thought that the *imaretler* of Istanbul were able to feed thirty thousand needy people every day, which presupposes a complex organization of buildings.

Among the earliest Ottoman monuments of greatest importance, the Green Mosque of Bursa (c. 1424), with its harmonious plan and balanced decoration, demonstrates the elegance acquired by the new architectural concept. The Great Mosque of Bursa (or *Ulu Cami*, 1379–1421), with its dominant central dome and nineteen lateral domes, is the first example of an aesthetic innovation: the well for ritual ablutions is unusually placed in the middle of the prayer hall, instead of in a large square court before the entrance: an arrangement that was to be repeated in successive Ottoman mosques. The earliest example of a mosque with a large, many-domed hall and a square court in front is at Ephesus (Mosque of Isa Bey, 1375), followed by the more prestigious Mosque of Üç Şerefli at Edirne (1438–47).

The period of greatest splendour was between the sixteenth and seventeenth centuries. It was due to Koja Mimar Sinan (1489–1588), one of the greatest Islamic architects, who in 318 built edifices of great variety that left a complete record of his artistry. His masterpiece is the Selimiye, built at Edirne between 1569 and 1575, its large dome resting on eight huge pillars. Another of Sinan's masterpieces is the Süleimaniye Camii in Istanbul (1550–57). A more intimate mosque, which he built for a court minister, is the Rüstempaşa Camii in Istanbul (c. 1550).

Another Ottoman masterpiece is the *Sultan Ahmet Camii*, or Blue Mosque (1609–16) in Istanbul, the work of Mehmet Ağa. Its huge dome is supported by four enormous central pillars, called "elephant's foot," which, however, do not detract from the overall feeling of lightness, emphasized by the many windows around the tambours of the domes and all along the walls, giving great luminosity to the interior. This mosque has no fewer than six minarets, of the typical tall and slender Ottoman structure known as "needle-shaped."

Typical is the Imperial Palace in Istanbul, the *Topkapi Saray*: a group of single-storey pavilions set in a sloping garden, with a clear separation between living spaces and those of

a sociopolitical nature. The light, airy pavilions are almost entirely covered in ceramic tiles from the workshops of Iznik, the best of their time. The complex starts with the Ceramic Pavilion (*Cinili Köşk*, 1466) and ends with the real Islamic part, the Baghdad Pavilion (1638), via the period of imitation of French Rococo, with accommodation for the court doctor and pharmacist.

From the Baroque period, Istanbul has the Nur Osmaniye Mosque (1775), with its wide dome and floral decorations. Of the same period is the largest Ottoman mosque, the Fatih Mehmet Camii in Istanbul. First built between 1462 and 1470 by the architect Christodoulos, a Greek who had converted to Islam, it was rebuilt in 1767 by Sarim Ibrahim Paşa, in an Italianate style; it is remarkable chiefly for its colossal size.

Of the military buildings, there is the prestigious Yediküle, a large and most beautifully designed fortress built on the European bank of the Bosphorus by Suleiman II in only four months in 1452; but the ordinary Ottoman

houses with wooden walls are also worthy of attention, many of them today restored and preserved by Çelik Gülersöy.

Also important are the baths (*hamam*), now built to a clear plan and showing a fine variety of architecture. They include the famous double bath Haji Hamza (or Murat Hamami) at Iznik, the first example of its type. A notable variant was conceived by Sinan at Khasseki Khurren. The caravanserais were also completely renewed – especially in Istanbul, where they assumed more the function of a hotel than a shelter for caravans They generally have a square courtyard with a small mosque in the center, overlooked by two storeys of rooms with a gallery of typical Ottoman red-brick arches. A fine caravanserai was built by Sinan

Opposite: Mausoleum of Shah Öljeytü (1309–13) at Sultaniya, Iran. Ilkhanid art. Richly decorated with a cover of brick and, formerly, tiles, this architectural gem was later imitated in Persia.

Right: caftan of sultan Bayazid II (1481–1512). Brocade of gold and silk on cream-coloured ground. Ottoman art. Topkapi Saray, Istanbul.

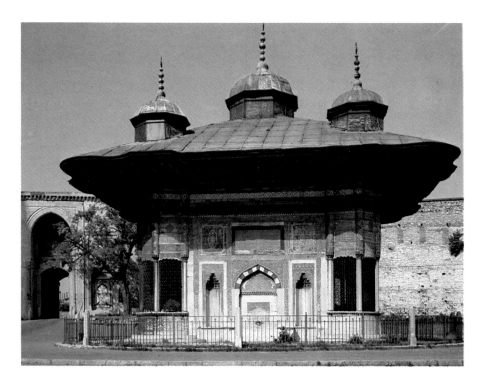

in the Galata quarter for Rüstem Paşa.

The walls are covered with tiles, generally with floral motifs in which the tulip predominates; this flower, first bred and cultivated by expert Turkish gardeners, spread throughout Europe, chiefly through Dutch traders. Also to be admired is the ceramic tableware, with glazes of vivid colours, notably a characteristic thick red, and designs of clouds, plants, flowers and sailing boats. Luxury services were also exported to the courts of Europe: the so-called "Rhodes pottery." After Iznik, the major centers were Kütahya (still active today) and Çanakkale.

There was also a wealth of decorative painting, especially for the houses along the Bosphorus, and miniature-painting in particular. A great master was Siyah Kalem, "Black Pen," probably a Mongol from Central Asia, who decorated the pages of the *Book of the Conquerors* with extraordinarily modern, almost surrealist, scenes: encampments, shaman dances, brightly coloured horses (which call to mind Paolo Uccello's *Defeat of San Romano*) in violent and bizarre postures. Original, too, are the miniatures commissioned by Suleiman I, and those of the *Surnameh* of Murad III executed by Levni of Edirne. It should not be forgotten that Gentile Bellini (*c.* 1429–1507) also worked at the court of Istanbul, leaving the Ottoman miniaturists with a taste for court portraiture. However, the most outstanding art form of this period is calligraphy, perhaps the best in all Islam. Through the centuries many artists devoted themselves to this craft, and their exquisite work was framed and valued as highly as are the paintings of a great artist in Europe. The numerous schools shared cal-

ligraphers of great skill, among whom should be mentioned Şeyh Hamdullah (1429–1520), Karahisâri Ahmed Şemsiddin (?–1556), Hâfiz Osman (1642–98), Mustafa Izzet Efendi (1801–76), Hakki Altunbezer (1873–1946), and Sultan Abdülmecit himself (1823–61). A characteristic Ottoman calligraph is the *tuğra*: the emperor's signature, elaborated and illuminated.

Still important is the art of carpet-making, among the most famous being the Transylvania, the Holbein (so called because they appear in the paintings of this famous German artist), the Ghiordes, the Ladik, the Kula, the Uşak and the Bergama. Embroidery should also be mentioned, especially gold-thread embroidery, together with the very rich art of weaving: silks and brocades, high-quality velvets, especially from the craftsmen of Bursa and Konya. Lastly, we should mention the period of "Turkish Rococo," which toward the end of the eighteenth century saw Istanbul imitating the art of the French court; and the Dolmabahçe palace, built by the architect Balyan for the Ottoman sultan Abdülmecit in frankly neo-Classical and Art Nouveau styles.

The art of the Safavids (1502–1736)

The first capital, Tabriz, and the capital of Shah Abbas, Isfahan, became centers for the spread of an art that, while remaining traditional, integrated Seljukian elements and Chinese influences, and upheld the various Islamic techniques while also having direct links with European art.

The new movement started at Ardebil with

the Shaykh Ishak Safy Mosque (sixteenth–seventeenth century), but established itself with the imperial mosque Masjid-i Shah (1611–16), built by Abbas at Isfahan, which may be considered the most grandiose expression of the splendour of the Safavid empire. The four *iwans* of the central courtyard have become separate, domed buildings, and the whole ensemble is smothered with very fine ceramic mosaic decoration. There are also the large madrasas of Shah Hussain and Madar-i Shah (1706–14), beautifully proportioned and covered with exceptionally harmonious ceramic decoration. Also worthy of note is the Pul-i Khvaji, the bridge over the Zayandé river, built by Shah Abbas (1642–67).

The immense royal square of Isfahan (Maidan-i Shah) is a well-designed urban complex. In the middle of one of the long sides is the Ali Qapu, former imperial palace on several floors (*c.* 1590), with a tribune – a huge open balcony with a roof of extremely fine inlay work, supported by eighteen slender wooden pillars – from which the monarch could view the games that were held in the square below. To the south is the impressive Throne Room, called the "Hall of Forty Pillars" (*Chehil Sutun*): in fact there are twenty pillars, which, reflected in the water basin, appear double.

The walls of the imperial palaces are decorated with paintings, either frescoes or on canvas, of Timurid derivation; and later in the bright and charming art of the Qajari period (1794–1925).

Safavid ceramic art vies with that of China, and often imitates Chinese techniques and decoration; at other times it is inspired by the motifs of miniature-painting, which is perhaps the most striking expression of the period and also, together with the Mogul miniatures, the culmination of this art in all Islam. Among the most famous masters – all, however, followers of Bihzad – we have Mahmud al-Muzahib, Mir 'Aly Shir Nawai, Nizami al-Dyn, Usthad Muhammadi, Aka Riza and, above all, 'Aly Reza Abbasi, who also drew monumental calligraphy used in the decoration of many buildings in the capital. Famous sixteenth-century Safavid calligraphers were Mir 'Aly of Herat, Sultan Muhammad Nur and Mir Imal.

Carpets imitate the ceramic decorations of the buildings and the fairytale motifs of the miniatures, so that we can say that Safavid arts present a stylistic and figurative unity, at the same time attaining a technical perfection that

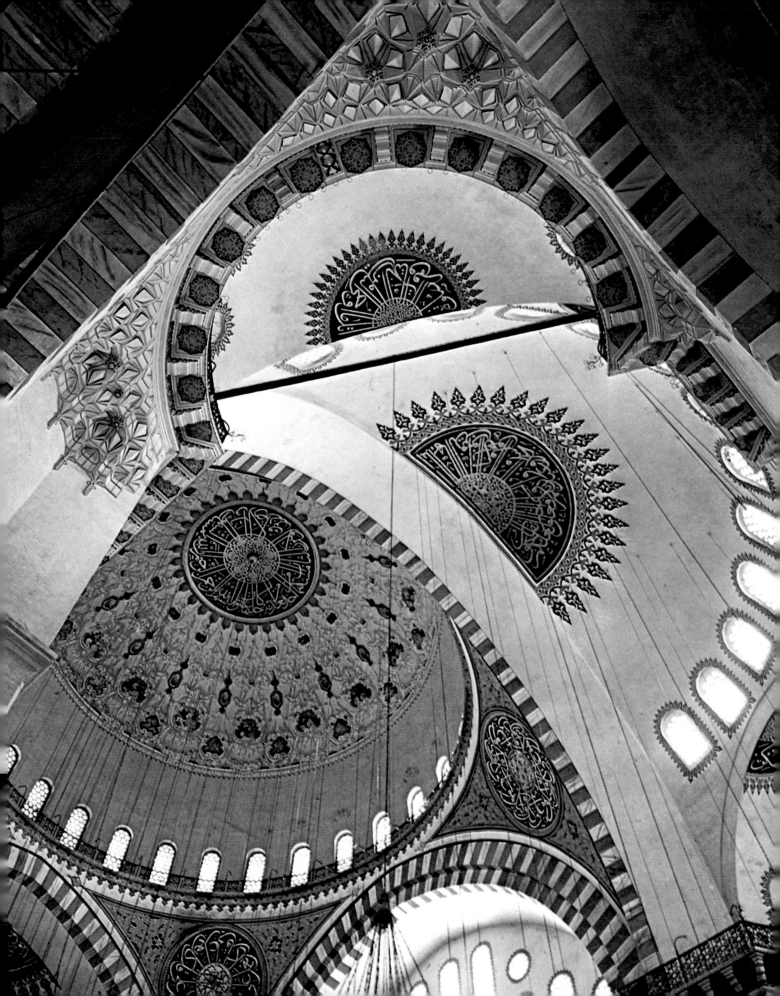

is perhaps to the detriment of their artistic value. The Ardebil, Tabriz, Kashan, Isfahan and Herat carpets, those with gold thread, the textiles with gold thread, the velvets and the brocades are of such quality, taste and design that they are still slavishly copied today.

Islamic art in India

The Arabs reached India at the end of the seventh century. It was conquered, however, by the Afghan dynasties (Ghaznavids, Ghurids, Tughlak, Sayyd, Lodi), supporters of Muslim power rather than general Islamization of the subcontinent, where Hindu art continued to flourish alongside the art of Islam.

On the plain of Delhi, eight imperial cities successively rose and fell. The first monument of great importance was the Victory Minaret (c. 1199), the largest in the Islamic world, 72m (236ft) high. It is built on the polygonal plan, with terraces ornamented with *muqarnas* and horizontal bands of decorative friezes carved in red sandstone.

In 1525, Babur – a descendant of Tamerlane and so declaring himself, wrongly, heir of the Mongol dynasties – founded the vast Mogul empire. His successors, Humayun and Akbar, were the most enlightened and power-

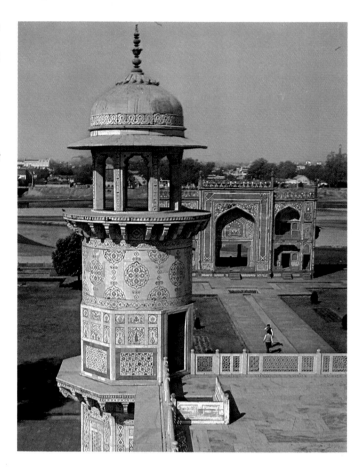

Right: corner minaret on the tomb of Itimad ud-Daula, Agra, North India (built 1628). Mogul art. Richly decorated with marble mosaic and elegant marble-lace balustrades. At the back, in red sandstone, one of the four gates of the outer enclosure.

Below left: woven carpet (kilim) made in Persia in 1601 for Sigismund III, king of Poland, whose arms are in the center. Safavid art. Residenzmuseum, Munich.

ful Mogul emperors, and to them is owed the flowering of an Islamic Indian art of great value. Their descendants, Jahangir, Shah Jahan and Aurangzeb, endeavoured to maintain its splendour, but had to cope with invading European colonialization.

With the Moguls, arches became enriched with a great variety of decorative protuberances; domes, on minarets as well as on buildings, had the characteristic upside-down flower calyx shape with accentuated central swelling.

The imperial palaces (Red Fortress of Agra, 1564; Red Fortress of Delhi, 1648) repeated the layout of the Ottoman and Mongol palaces: many single-storey pavilions, skilfully sited in a vast garden surrounded by heavy walls.

Marble was widely used, sculpted in bas-relief or delicately decorated with inlays of precious stones. In general the architectural structures were emphasized by chromatic bands of red sandstone or other materials. Among the most impressive tombs are the Mausoleum of Humayun in Delhi (1556–72), the Tomb of Akbar in Sikandra (1613) and the Gol Gombaz in Bijapur (c. 1660), an enormous cube with sides measuring 60m (197ft) surmounted by a dome no less than 44m (144ft) in diameter.

Mosques of great importance for their size and harmony of composition are the Masjidi-i

Jami in Delhi (1644–58), the mosque in Agra (1648) and the imperial Badshahi in Lahore (1673).

Magnificent and harmonious is the Taj Mahal in Agra (1630–48), a vast mausoleum in the center of a Mogul garden surrounded by walls with wide entrance gateways; but perhaps the most astonishing, for the elegance of its architectural harmony and its very beautiful marble fretwork, is the smaller mausoleum of Itmad al-Daula (1628) in the same city.

Its buildings and its aesthetic quality certainly make Mogul architecture one of the most precious of Islam and perhaps the one that produced the largest constructions, in contrast with the Islamic concept of "man-sized" art overshadowed by nature, which it does not rival and over which it does not impose itself.

Painting, especially the marvellous Mogul miniature-painting, derives from Persian painting. However, some illuminators at the court of Akbar (Daswanth, Basawan Lal) gave way considerably to European taste, even imitating Baroque models with a realism and an exceptional sense of *trompe l'oeil*. Court portrait painters were Shah Daulat, working for Bichitz, and Abul Hasan, working for Jahangir.

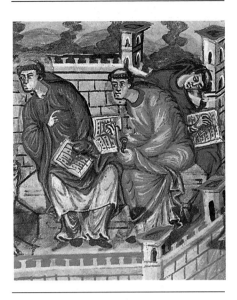

Carolingian and Ottonian art

The re-creation of the antique is a phenomenon that has perennially fascinated historians and researchers. Movements of revival or "renaissance" of the classical style in Western art – to use Panofsky's term – have occurred at various stages of history and it is accepted without challenge that the Carolingian Renaissance of the ninth century is a key point in this progression.

The few surviving imperial buildings, the frescoes, ivories and goldwork and especially the illuminated manuscripts of the Carolingian period all point to a systematic revival of classical forms and values; it was not only the remotest in time but the first such revival on record.

The earliest historical reference to it in Italy goes back to the fifteenth century. Brunelleschi's biographer, Antonio Manetti, credited Charlemagne with having "chased off the last [of the barbarians] who were the Lombards" and with reviving the forms of Roman architecture notwithstanding the inadequacies of the available technology. Manetti was actually referring to some Tuscan monuments belonging to the eleventh and twelfth centuries. Leaving aside chronological inaccuracy, Manetti's observation is important because he was arguing what is commonly accepted by scholars to this day: that Roman and palaeo-Christian buildings are the true antecedents of Tuscan Romanesque, also known as the Tuscan Style; and that being apart from the mainstream of

Italian Romanesque, the Tuscan case has given rise – with justification – to expressions like proto-Renaissance. Similarly there are many features of Carolingian art that make the period seem like a classical "oasis" in a cultural desert. Charlemagne (768–814) and his immediate successors were responsible for an unprecedented cultural revival, extending to the calligraphic arts, whose achievements have handed down to us some remarkable evocations of the past (a process in some measure slowed down by the failure of the grand imperial design and consequent fragmentation of the Empire).

However, if the Carolingian case was exceptional, it was not necessarily anomalous. A close look at the preceding centuries will show that the barbarian invasions did not mark such a decisive break with the grandeur of Rome as is popularly thought and that these centuries cannot be dismissed as altogether "dark." Indeed, the revival of art and literature in the Frankish domains of Western Europe would

School of Rheims, Bible of Charles the Bald, *detail of scribes copying manuscripts*, c. 860. S. Paolo fuori le Mura, Rome.

have been impossible had not some form of monastic culture survived, however sporadically. Furthermore, along with Byzantium, the invaders themselves (especially the Christianized Goths in Italy and southern France in the sixth century) were to some extent instrumental in keeping the Latin language and culture alive. Finally, it should be emphasized that Carolingian emulation of old art forms was not solely of classical inspiration but made up of Byzantine and "Germanic" influences as well.

Why therefore Renaissance – or, more aptly, *renovatio* – and why Carolingian? If we were to choose a symbol of the cultural tendency of the period we would unhesitatingly pick a coin. This coin, a silver Denarius in various versions, portrays Charlemagne. It was minted in the early ninth century and circulated widely in the imperial territories, testifying to the grandiose ideological aspirations that accompanied and underpinned the remarkable flowering in literature and art. One side of the coin shows Charlemagne in profile, crowned with laurel in the imperial manner. The border inscription KAROLUS IMP AUG again emulates Roman custom. The other side shows a cross surmounting a stylized church, or pagan temple, or triumphal arch, and the inscription CHRISTIANA RELIGIO. The Caroline intention of restoring the grandeur of ancient Rome is similarly advertised on seals of the period, which bear the unequivocal legend RENOVATIO IMPERII.

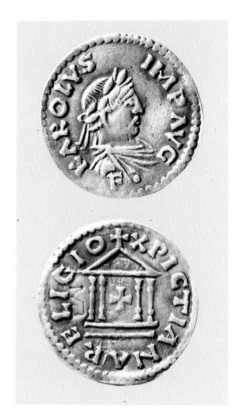

make historical sense. Paradoxically Charlemagne, a man of no culture to speak of, was himself responsible for instituting these seats of learning.

The Anglo-Saxon monk–scholar Alcuin (730–804) was the Emperor's intellectual mentor and one of the greatest of the cultural reformers. In his *scriptorium* at St. Martin de Tours, and in many others decreed by the Carolingian emperors, copies were made of ancient pagan and Christian codices in a new script based on classical handwriting and known as "Caroline minuscule." It became the source of some notorious errors by sixteenth-century humanists, who often mistook these late eighth- and ninth-century illuminated copies for the originals.

History also notes that Charlemagne made his architects study the palaces of Rome and Ravenna, and that many spoils from central Italy were brought back to Aix. In Rome itself, however, it would have been inconceivable for an epitaph of the day to be designed with a framed inscription along classical lines such as the one that Charlemagne sent to Aix in 795 on the occasion of the death of Pope Hadrian I and still sited in the portico of St. Peter's.

The most important of the surviving Carolingian buildings is the Royal Chapel in Aix-la-Chapelle. Consecrated in 805, the chapel is a domed octagon with vaulted aisles and galleries on two levels, along the lines of S. Vitale in Ravenna. We know from Charlemagne's biographer Einhard that the Emperor, with Hadrian's authority, had imported from Ravenna, last important Western seat of the East Roman Empire, marble slabs and probably also bronze gates, which were promptly adapted for use in the new imperial building. It appears that the consignment also included an equestrian statue of the Emperor

Theodoric, which was intended for the courtyard in Aix. The statue is now lost, but in the Louvre there is a small bronze believed to be an equestrian portrait of Charlemagne. Although it has been partially restored, this small statue, whether of Charlemagne or perhaps another Carolingian dignitary, further demonstrates the desire to emulate, in this case the imperial equestrian monument, of which the most famous example is the great bronze of Marcus Aurelius in Rome.

The gatehouse of the abbey of Lorsch, called the *Torhalle*, was built in the second half of the eighth century. The lower part resembles a Roman triumphal arch with three openings. A lost silver reliquary, donated by Einhard to the church of St. Servatius in Maastricht and known from drawings and later models, was also based on the triumphal arch, in this case probably inspired by a combination of the arches of Titus and Constantine. The inscription and the complex iconography of the reliquary represent, through the image of the Cross, transmuted symbols of the new empire. This is especially the case in the elaborate arrangement of the figures. Winged victories have become angels, Charlemagne and Constantine are face to face, evangelists and armed saints take the place of soldiers; a triumph of the Cross, in which Christian concepts are embodied in forms borrowed from the pagan world.

The production methods of Carolingian miniaturists were admirably suited to the purpose of circulating new techniques and different types of illustrated books. The *scriptoria* instituted by Charlemagne and his successors copied old manuscripts brought in from Italy and the East and the earliest copies in the palace school displayed Anglo-Saxon and Greco-Italian decorative techniques. Examples

Three hundred or more years were to pass before imperial Roman coinage was copied again, in the reign of Frederick II of Swabia early in the thirteenth century.

Charlemagne represented the dual ideal of august Roman emperor and first Prince of the Christian Church (Constantine). If Constantinople was for political and religious reasons conceived and created as a second Rome – *Roma secunda* – then Charlemagne's new imperial seat of Aix-la-Chapelle would become the new *Roma secunda* – the Western version of the *sacrum palatium* of Constantinople. It is no chance that the *palatium* of Aix was referred to as the Lateran, after the Lateran Palace in Rome, because there is a traditional belief that the latter palace was the original residence of Constantine the Great, who later endowed it to the Church.

The Carolingian Renaissance was thus no random event, nor can it be classed with other examples of "natural" or unconscious handing down of ancient tradition. It was the result of a grand design, a long-term strategy of political and institutional reform that began with Charlemagne and continued with Louis the Pious and Charles the Bald, under the aegis of the *pax christiana* and within the comfortable embrace of an empire modelled on Rome.

Only by understanding this point can one fully appreciate the sheer scale of innovation, not least in art and architecture. Nor would the creation of the Carolingian court schools, such as the famous *Schola Palatina*, otherwise

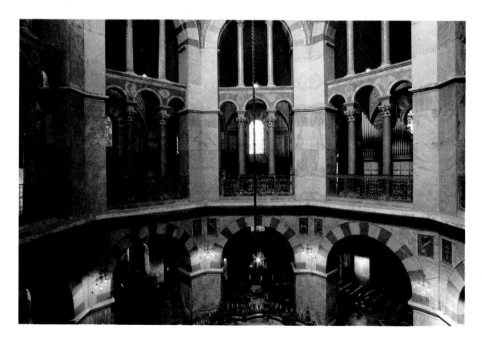

Opposite above: obverse and reverse of a Carolingian silver Denarius minted in Frankfurt after 804. Münzkabinett der Staatlichen Museen, Berlin. The border inscription, the profiled Emperor and the Christianized classical monument point to a program of imperial revival. The coin, representing a standard unit of weight, marked the introduction of a sound silver currency and was in circulation for over a century throughout most of the Regnum Francorum.

Opposite below: Aix-la-Chapelle, Royal Chapel, detail of interior. Dedicated to St. Saviour and the Virgin and begun in approximately 790, the chapel was still incomplete in 798. An old inscription now lost attributed the building to Odo of Metz. Charlemagne's court chapel (in which he was buried) was probably consecrated by Pope Leo III in 805. It has always been compared with the sixth-century imperial model of S. Vitale in Ravenna (last Western seat of the Eastern Empire) though the Carolingian building is more robust, with massive pillars "substituting" the columns of the earlier example. A wooden gallery on several floors joined the chapel to the imperial palace.

Right: Lorsch, gateway to the abbey, c. 784. Above the open, triple-arched ground floor the Torhalle, or guest hall, has fluted pilasters and decoration reminiscent of Roman public buildings.

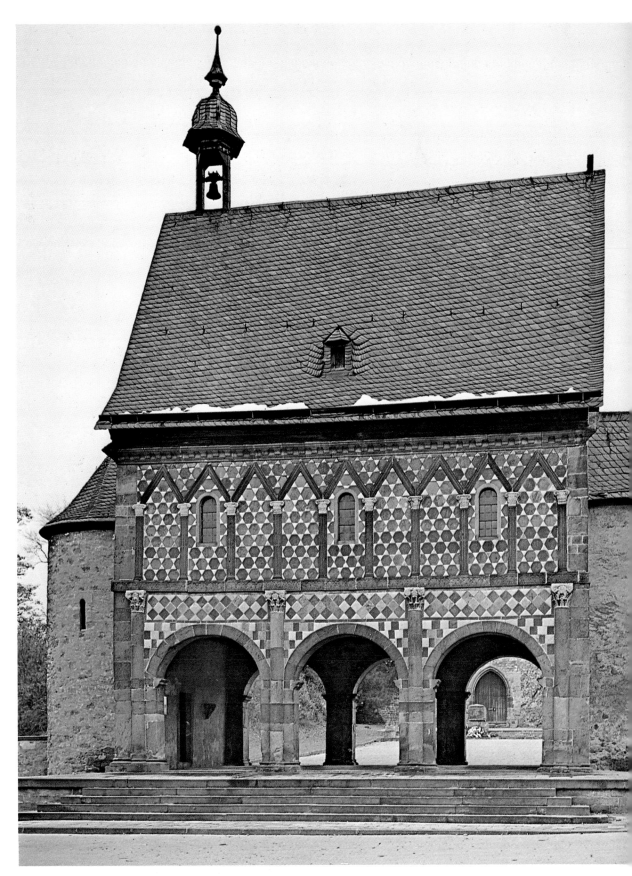

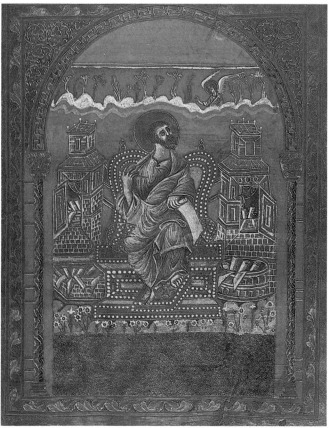

Left: Codex Aureus *of St. Emmeran near Regensburg, miniature from the Gospel of St. Matthew, 870, Bayerische Staatsbibliothek, Munich. The codex, containing the four Gospels, was probably illustrated at St.-Denis in France during the reign of Charles the Bald.*

The same period saw one of the richest and most magnificent examples of the goldsmith's art ever produced in medieval times. The celebrated Golden Altar of Vuolvinius in the church of Sant'Ambrogio, Milan, remains a superb example of the Lombardian contribution to the Carolingian cultural effort. The antependium was probably commissioned by Archbishop Angilbert (824–859), who is portrayed in a silver medallion on the rear face. The altar is clad in gold and other precious metals, while panels of apostles and their symbols and scenes from the lives of Christ and St. Ambrose are encased in colourful enamel enriched with precious stones. Vuolvinius would probably have been the principal craftsman for a large-scale piece of church furniture of this kind serving as altar, sarcophagus and reliquary. The figure panels are in fact not all by the same hand. Those attributed

are Godescalc's Evangeliary of around 781 (Paris, Bibliothèque Nationale), probably illuminated in honour of the baptism of Charlemagne's son Pepin, and the manuscripts copied in the "Ada" Evangeliary (Trèves, Stadtbibliothek).

In Charlemagne's lifetime the literary production of the palace school showed a pronounced tendency toward pictorial classicism, deriving mainly from antique styles of illusionism.

While literature remained within the classical mould, the figurative arts tended toward greater expression and feeling for volume, exemplified in the works of the school of Rheims and of the Abbey of Tours, the latter initially under Alcuin's guidance and reaching its greatest splendour under Abbot Frédugis between 807 and 834.

The art of illumination reached its highest expression during the reign of Charles the Bald. In a Bible produced for Charles in Rheims, probably on commission, the initial letters are sumptuously decorated and scenes throughout are vivid with colour and movement. Among the most important miniatures in the so-called Charles the Bald style are those in the Paris Psalter and the precious *Codex Aureus* of St. Emmeran, now in Munich.

Right: bronze statuette believed to be Charlemagne, Musée du Louvre, Paris, c. 860–70. This equestrian sculpture 23.5cm (9¼in) high is traditionally identified with Charlemagne. The figure, based on an antique model, is more likely to represent some other important Carolingian dignitary. The horse and sword were recast at a later date.

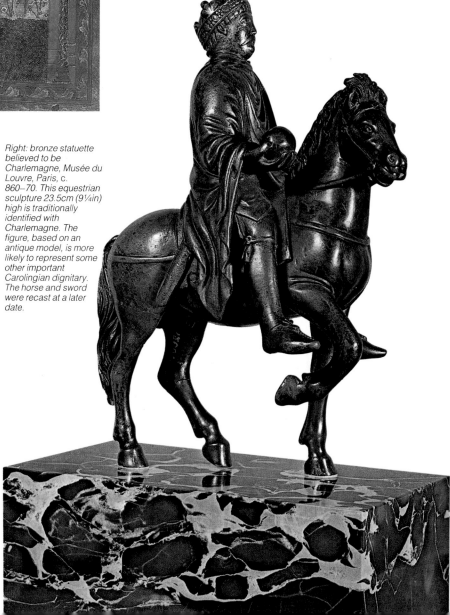

to Vuolvinius show a feeling for perspective illusion in the handling of relief, achieving the impression of volume and space, light and shade, while in other panels, probably the work of a collaborator from a Franco-Western monastery, the pictorial expression and lively movement are reminiscent of the Carolingian drawings in the Utrecht Psalter, c. 830, school of Rheims. The style of the psalter comes near to that of the frescoes at Castelseprio near Milan and in the church of S. Giovanni at Müstair in the Italian Tyrol.

The date of the frescoes in the little church of Sta Maria Foris Portam in Castelseprio is still uncertain. The cycle is based on the apocryphal writings of James and the false Matthew, both well known in the East, suggesting that the artist had Byzantine connections. The frescoes can certainly be dated to before the middle of the tenth century. They are most likely of Carolingian origin, though so Grecian

Right: School of Rheims, detail from Charles the Bald's Bible, c. 860, kept in the church of S. Paolo fuori le Mura in Rome. The codex is decorated throughout with illuminated initials and twenty-four frontispiece illustrations of Old Testament stories. The book is generally associated with the second marriage of the king and survives as the most complete collection of Bible miniatures of the Carolingian period.

Left: Malles Venosta, near Bolzano, Oratory of S. Benedetto, before 881, fragment showing the monk donor (or founder) of the oratory.

The figure, perhaps a true likeness, is an important example of the vivid colours characteristic of Carolingian fresco work.

is their effect that they must be regarded as unique, even taking into account the eventual (and acknowledged) presence of Byzantine influences in Italian territories, particularly Rome.

A word must be said about Roman attitudes to antiquity in the Carolingian period, especially during the pontificate of Pascal I (817–24), when inspirational painting aimed to glorify ecclesiastical authority. The churches of Sta Cecilia in Trastevere, Sta Prassede and Sta Maria in Domenica are all examples of a resurgence of palaeo-Christian art, the art of the time of the martyrs, whose bones lay buried in the city.

The Cross Collection of Pascal I places the same Church-centered ideology above considerations of classicism, technical expertise or even the sense of balance and order associated with the Lombard workshops (for example, the iron crown of Lombardy in Monza).

By contrast, the frescoes in the Lower Church of S. Clemente, dating from the pontificate of Leo IV (847–55), show for the first time an approach to the imperial program of Aix. The so-called First Master of S. Clemente has conveyed in the expression and pathos of the figures a quality akin to the miniatures of the Rheims school.

Similarly, order and symmetry are the hallmarks of the copious production of ivories in Lombardy and other Italian centers, and in

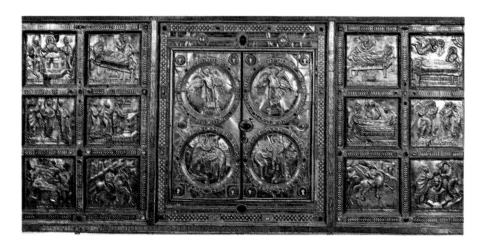

portraits of the two imperial couples (Otto I and his Empress Adelaide and Otto II with the Empress Theophano), was executed in Milan between 972 and 973. At the same time Milanese ivory workers were producing beautiful carved *situlae*, or holy water buckets. Examples like the *situla* of Archbishop Gotfredus or the so-called *Basilewsky situla* show off the meticulous craftsmanship of Ottonian artists in the decades leading to the fateful first millennium.

Above: gold altar of Vuolvinius, mid ninth century, detail of back, church of Sant'Ambrogio, Milan. The lower center

medallions depict the monk Angilbert and the work's author, Vuolvinius.

Below left: iron crown, cathedral treasury, Monza, second half ninth century. The crown consists of six plaques made of gold, iron,

precious stones and enamels. The enamels are stylistically similar to those on the altar of Vuolvinius.

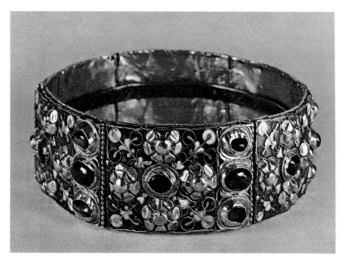

imperial territories north of the Alps. Outstanding examples are the diptychs of Christological scenes with their tendency to imitate, often directly, the works of late antiquity.

Ivory production is also the principle characteristic of Ottonian art of the tenth century, a courtly art which, under the Ottonian kings, took up the classical tradition again after its decline during the break-up of the Carolingian empire.

Space will not permit a discussion of Ottonian architecture, whose elaborate articulation would become a transforming influence and provide the foundation for a new era of monumental building in the eleventh century. One final aspect demands mention: the importance, once again, of the Lombard contribution during the Ottonian period. The finely decorated ciborium of St. Ambrose, with donor

Right: ivory plaque inscribed "OTTO IMPERATOR" with "SANCTUS MAURITIUS" and "SANCTA MARIA" on the sides, tenth century, Castello Sforzesco Museum, Milan. The plaque shows the vigorous quality of Milanese ivory production of the Ottonian period.

Romanesque art

The term "Romanesque," used to describe the art of the eleventh and twelfth centuries (as well as a part of the thirteenth century), was first employed in 1818 by the French historian M. de Gerville. He asserted that the numerous cultures born in the melting-pot of Roman civilization, despite their differences, had one essential feature in common: their art was, above all else, religious. And although the adjective "Romanesque" was eventually understood to embrace many other aspects of these cultures (sometimes far removed in time and space), which themselves assumed a diversity of interpretations, one fundamental, homogeneous principle emerges: life in medieval Europe derived its meaning and direction from faith, even if religious expression assumed a variety of regional forms.

The need felt by people everywhere to build new churches to replace those already standing testifies to a desire to break with the past.

Medieval man was keenly aware of the enigma relating to his origins, and obsessed by the notion of his dual destiny (in this life and in the afterlife), in keeping with the transcendental direction of religious doctrine in the late Middle Ages. He was conscious of his insignificance in relation to divine power, the savage and terrible manifestations of nature and the frequent incomprehensibility of universal laws. For history to be understood in the context of the more humble, everyday preoccupations of the individual, it had to be represented in more

human terms. Thus, in an attempt to fathom the mystery, to discover a glimmer of light or weak link in the chain, art set out to translate themes inspired by the Scriptures into a language that was sometimes popular and genuinely naturalistic. The gaze of the Romanesque artist was still fixed on distant horizons, but he was equally prepared to evoke the "micro-reality" of his surroundings.

The widespread fears aroused by the fateful date of A.D. 1000 had been dissipated, and European Christianity had now entered upon a phase of steady development during which the figure of God reached ever closer to the hearts of the faithful. Indeed, eleventh-century civilization at large was expanding notably. With the practice of livestock rearing reduced to a minimum, and with accelerated deforestation, the economy began to be based exclusively on agriculture. In this context there is a significant anecdote concerning Suger, the abbot of Saint-Denis, who, requiring twelve large trees for use in the reconstruction of the

Nicolaus, frieze portraying the Zodiac (between 1114 and 1130). Parish church of San Michele, Avigliana. This frieze is based on a codex of Arato, probably kept in the abbey library.

abbey, made a direct request to "Seigneur Jésus who had reserved them for him," in view of the fact that all the neighbouring forests had been transformed into cultivable fields. Furthermore, the growing importance of agriculture was fundamental to the creation of villages and a consequent population explosion.

In addition, there was a considerable increase in commercial traffic between Europe and the Near East. Many people were constantly on the move. The feeling for travel is an essential concept for the understanding of Romanesque art. All along the great pilgrimage routes many new places of worship sprang up.

Crowds of pilgrims, spurred on by the vibrant faith that characterized the entire span of the Middle Ages, set off on journeys toward the great centers of religion (principally Jerusalem, Rome and Santiago de Compostela); and following in the wake of this traffic that thronged the highways of Europe, as determined by the course of the old Roman roads, artistic inspiration found expression in so-called "pilgrimage art," exemplified by the building of churches conceived as steps, along a path that was, a progress toward salvation.

It is precisely for this reason that Romanesque architecture – and, in particular, religious architecture – can be recognized as the principal form of artistic expression during a

period that covers several centuries. The churches served not only as guidemarks but also as places of refuge and shelter, as if the ecclesiastical presence itself was reduced sufficiently to be contained within familiar bounds. In Italy, furthermore, the new cathedrals heralded a renaissance of urban activity, exemplified by the increased numbers and growing importance of citizens' associations. A particularly significant instance is that of Modena. The inhabitants themselves resolved to knock down the old cathedral, which symbolized a period when they were denied all power of decision, in order to build the one that survives to this day.

Finally, the places of worship were also centers of cultural activity, especially the bishoprics and monasteries, often built upon the sites of ancient Roman farms. The Abbey of Cluny, in Burgundy, was an exceptionally important focal point for the diffusion of Romanesque art and culture in the widest sense. The abbey building itself influenced the construction of several monasteries which, at that time, were affiliated to Cluny.

The impression exerted by the Cluniac model is so powerful that it sometimes tends to obscure the other sources and factors that have to be taken into account when surveying the vast panorama of Romanesque art. Even today there are many points that require clarification, such as the identification of architects and craftsmen, and the certain dating of particular buildings.

Architecture

Romanesque architecture, as already mentioned, is most completely and beautifully characterized by its churches, just as Greek architecture found fullest expression in its temples. Romanesque churches – scattered all over the open countryside, often far distant from centers of population and hence obligatory halts for pilgrims (marking a symbolic progression toward those even holier places that kept relics of saints) – were an integral part of the medieval landscape.

The most notable architectural innovations appeared in the eleventh century, whereas in the twelfth – when Romanesque art reached its apogee – the quest for strict harmony saw preceding uncertainties resolved in an ordered synthesis. To accommodate ever increasing crowds of the faithful, the proportions of the plans based on Roman basilicas needed to be enlarged considerably. Furthermore, the interiors of the buildings had to be designed in such a way as to permit the performance of a wide range of varied religious activities. Romanesque architecture was derived from the transformation of the original Christian basilica, consisting of a nave surrounded by columns and arcades, which supported a wooden roof (flat or trussed). Woodwork continued to be employed throughout the

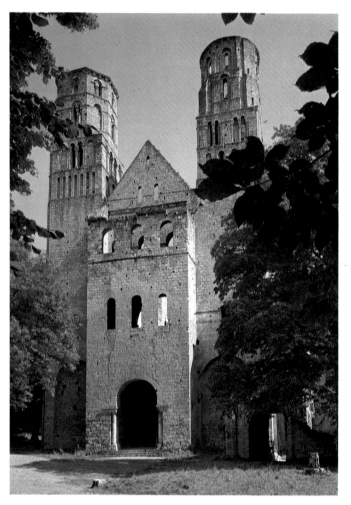

Left: abbey church of Notre-Dame, Jumièges, Normandy (1037–67). Among the various types of façades adopted by Romanesque churches, one of the most original comprised two towers crossed by a transept, which duplicated the presbytery transept. Jumièges is, together with Saint-Étienne, Caen, one of the most remarkable examples of Romanesque art, and deeply poetic.

Opposite: church of Sainte-Foy, Conques (end of eleventh century). The name "pilgrimage church" is given to the buildings constructed along the routes that led to the major centers of worship such as Santiago de Compostela. Sainte-Foy, however, has crossing towers, which were later transformed and heightened. The columns of this large church, basilical in plan, are slender and graceful.

Middle Ages in all churches that lacked original or subsequently added vaults.

The greatest challenge to Romanesque architects, therefore, was to replace the wooden roofing with brick vaulting. It was quickly evident that the cross vault (in which the ribs shared the weight resting on the corner pillars) was much more suitable than the barrel vault. There is an interesting example of this technique in Durham Cathedral, built between the eleventh and twelfth centuries, which served as an architectural model for the whole country.

The Romanesque church comprised a subterranean crypt containing saintly relics which corresponded in plan to the presbytery above, in which the monks conducted their activities and where the high altar was situated. The side altar, reserved for the lay brothers, was located in the eastern part of the nave. From the beginning of the eleventh century a series of secondary chapels, radiating from an enclosing ambulatory, was built around the presbytery. This arrangement was to continue until the end of the Gothic period. The oldest example of the structure is the apse of the church of Saint-Martin, Tours. The system,

however, is rarely found in Italy and Germany. In another type of Romanesque plan, the Latin cross, the presbytery was extended to form the transept, perpendicular to the nave. In certain cases the intersection between nave and transept was surmounted by a cupola, symbolizing the presence of the celestial world inside the church itself, testimony to the peaceful relationship which, for the medieval Christian, existed between man and God.

From the time that Romanesque art first appeared, sculpture went hand in hand with architecture, and craftsmen were often employed to decorate the inside as well as the outside of the church. So there are innumerable examples of carved capitals, pulpits and baptismal fonts, while the façades themselves are richly ornamented in a variety of styles – surmounted by a triangular gable, straight coping, even topped by two towers, necessitating the construction of a second transept, paired with that of the presbytery. The latter case is well illustrated by the abbatial church of Notre-Dame at Jumièges in Normandy. Its eastern part was begun in 1037 and the entire building was finished in 1067. On either side of the central nave, which is narrow and very

high, the aisles and openings of the tribunes are separated in pairs by columns which, in later vaulted churches, were to serve as supporting points for the ribs. At Jumièges, these columns stop just below the roof, which was probably wooden. Another French example of a two-towered façade appears in the grandiose church of Saint-Étienne, Caen, begun in 1064 by Duke William and Duchess Matilda of Normandy, evidently with the purpose of expiating their intermarriage.

Toward the end of the eleventh century work commenced on the building of the three most important Romanesque churches in southern Europe: Sainte-Foi, Conques, and Saint-Sernin, Toulouse, both in France, and the cathedral of Santiago de Compostela in northern Spain. All three, apart from displaying the same basilical plan, have a crossing tower (which was subsequently transformed and heightened) and also vaults halfway up the aisles. This very important innovation was facilitated by the basilical plan inasmuch as the vaults of the central nave and the tribunes support one another like buttresses and thus enable the pilasters to be kept quite slender.

These churches were all known as "pilgrimage churches." Santiago de Compostela, which owed its extraordinary fame to the fact that it housed the relics of St. James, attracted crowds from all over Europe. As already mentioned, other churches (such as those of Toulouse and Conques) were built along the various pilgrimage routes to mark the successive stages toward the goal, strung out like an enormous rosary. The pilgrimages led to an intermingling of people and thus of ideas, and this free interchange has been put forward as an explanation of stylistic similarities among churches of different regions, a theory that is now generally accepted.

The full flowering of Romanesque art is commonly understood to have occurred between the end of the eleventh and the middle of the twelfth century. Many of the buildings that sprang up all over Europe still survive as testimony to a high level of architectural mastery and innovation, the latter most notably manifested in the adoption of vaulting for basilicas.

When William of Normandy conquered the kingdom of England in 1066, Europe's political center of gravity shifted to the British Isles, slowly but surely leading to changes in the artistic sphere. The existing Anglo-Saxon churches were replaced by new and completely different types of religious buildings. Around the end of the century several churches were built both in England and Normandy that were remarkable for their huge and elaborate vaults: they included Lessay, the churches of Caen and, above all, Durham Cathedral. One characteristic feature of the English cathedrals was their exceptional length; this, combined with the height of the side walls, lent them an air of majestic power. With Durham as their model, they almost all

resorted to the system of rib vaulting.

In about 1080, King Henry IV of Germany resumed building work on one of the most important churches in the history of Romanesque architecture: Speyer Cathedral. It had been consecrated in 1061, but probably only the interior was by then completed; and the presbytery alone was covered by a large vault, supported on turrets at each corner of the transept crossing. Now other transepts were added as well as apses, and the central nave in its turn was covered by a vault (each rib of which incorporated two arches of the previous building). The expense involved and the number of workmen employed for the reno-

vation were quite unprecedented; and the final result marked the culmination of many long years of technical development in the architectural field. Furthermore, the use of groin vaults (covering the original side aisles and the new central nave) was to be the rule in many regions from the twelfth century onward.

The reconstruction of the abbey church of Sainte-Madeleine at Vézelay in Burgundy commenced in 1120, with the adoption of the Rhineland type of groin vaulting but without recourse to ribs, as at Speyer. The harmonious proportions of the building as a whole, the cornice that surrounds and divides the nave halfway up, and the elegant decorations of the

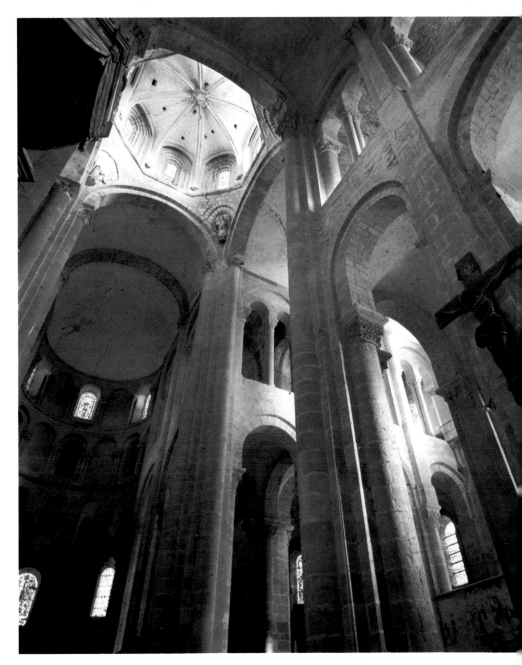

capitals and portals combine to make Vézelay one of the most splendid examples of mature Romanesque art.

Mention should also be made of the numerous churches with a single nave and dome that were built during this fruitful period. Sixty or so are to be found in southern France, and some, like those of Périgueux, Cahors, Solignac and Souillac, are truly majestic. The most interesting – because it displays a complete sequence of architectural techniques – is the cathedral of Saint-Étienne, Périgueux, one of the few (among the bigger examples) to possess a transept. Within this type of church the walls are divided into two levels, the lower part comprising blind arcades resting on pilasters, the upper part containing windows in a row beneath the longitudinal arch.

In Italy, the period of Lombard architecture in the eleventh century is both the oldest and the most original form of Romanesque. Lombard architects did not confine themselves to their own region but also worked in the southern part of the peninsula. In central Italy, however, other influences came into play, and the Romanesque is distinguished there mainly by the revival of Classical and early Christian models. Pisa Cathedral, however, draws on yet other origins and represents something of an exception which was to inspire all the architecture of the provinces of Lucca and Pistoia, its influence extending to Sardinia, Corsica and some of the southern regions such as Apulia and Sicily. In southern Italy, which is likewise a case apart, the Byzantine heritage mingles first with the Lombard style and later the Norman.

It was in northern Italy, nevertheless, in the basilica of Sant'Ambrogio, Milan, that the new architectural concepts were gradually developed and most clearly expressed. The building, begun in the tenth century, was completed in the eleventh. In front of the church is a long, four-porticoed atrium, terminating at the façade in a loggia with three openings, where the communal authorities addressed the crowd. The church vies with Durham Cathedral to be the first to use ribbed cross vaulting, achieved here by means of a series of buttresses set along the entire length of the tribunes and aisles. The large windows of the façade let in a very soft light which permeates the whole interior, gently illuminating the darkest shadowy recesses of the side-aisles and giving the church a special atmosphere.

However, the most remarkable innovations are to be seen in the façade of Sant'Abbondio, Como, consecrated in 1095. Whereas that of Sant'Ambrogio was still derived from the basilical narthex, here the façade is enlivened by projecting arcatures and paired pilasters, while the tiered roofing reflects the different heights of the five interior naves. Thus the spectator standing in the square in front of the church is keenly aware of the spiritual atmosphere.

The ornamentation of the façade of San Michele, Pavia, is a wonder of architectonic invention, full of fantasy and poetry, where masses and voids alternate in a subtle interplay of light and shade. Slender columns here replace pilasters and are arranged in graceful clusters along the entire length of the façade. A high gable with carved friezes lightens the weight of the stone masonry and gives the whole building a strong vertical thrust and a sense of extreme harmony.

The same spirit imbued Lanfranco, who began the construction of Modena Cathedral in 1099. This is one of the most significant buildings not only in the context of Italian Romanesque but also in the entire gamut of European Romanesque architecture. Work on the cathedral was continued a century later by Anselmo da Campione, who slightly spoiled the façade by piercing an incongruous rose window in it. Despite this, the decorations on this façade by the celebrated sculptor Wiligelmo make it one of the most important elements of the whole building. With the addition of a prothyrum surmounted by an ædicule, its structure reflects the inner spatial plan and its pilasters set up an elegant interplay of shadow and light.

The cathedrals of Parma and Piacenza show the influence of Modena. Parma Cathedral is notable for the vast dimensions of its apse, transept and lantern, which anticipate the monumental aspect of many later churches, particularly in northern Italy. These "proto-Gothic" glimmerings are even more clearly exhibited in the adjacent baptistery, begun by Benedetto Antelami in 1196.

The renovation of the church of San Zeno Maggiore in Verona was carried out between 1120 and 1138. Very clear surfaces, with few reliefs, instead of the light and dark contrasts typical of the churches of Emilia, result in an impression of lightness and sobriety that harmonizes perfectly with the splendid faired wooden roofing of the interior.

One of the most famous churches in the world – the basilica of San Marco in Venice – is clearly Byzantine in inspiration. Built on the model of the church of the Holy Apostles in Constantinople (and probably with the assistance of Byzantine craftsmen), it bears witness to the close ties that existed between the city and the Exarchate of Ravenna. To the plan of a Greek cross with five principal domes (plus other smaller ones) was added a large atrium, absent from the Eastern model, which allowed light to play on the interior mosaics, creating a delightful illusionistic effect.

Florentine architecture was distinctive for its high level of local inspiration, seen at its best around the middle of the eleventh century. The recent influence of Lombard architecture blended with classical and early Christian motifs, but the buildings were mainly notable for the use of specific materials to give rhythm and harmony to the surfaces. In Florence itself, the oldest building is undoubtedly the Baptis-

tery, consecrated in 1059 but probably dating back to the fifth century. The octagonal plan, which seems to derive from late antiquity, is accompanied by contemporary Lombard motifs, which are to be found chiefly in the central fascia. Later churches such as San Miniato al Monte, SS. Apostoli and the Badia at Fiesole display a specifically Florentine style. At Fiesole the delicacy of the design and the colours, especially on the façades, contrasts with the light and dark surface effects of other

buildings. The covering of marble with geometrical motifs emphasizes a spirituality that still accords with the transcendental direction of medieval thinking. Subsequently, thanks to the genius of Brunelleschi, the Florentine style would develop its particular hallmark of restrained solemnity.

Florence, nevertheless, was a somewhat isolated case within the broader area of Tuscany. The buildings of Pisa – the Cathedral, Baptistery and Leaning Tower – conform much more closely to the Lombard ideals, while introducing a variant that incorporates more light and more air (as, for example, in the galleries). Construction of the cathedral commenced in 1063, after the Pisan victory over the Saracens that year. Based on the plans of the first architect, Buscheto, it comprises five naves, a three-aisled transept, an octagonal dome and three apses, which point east, north and south. A second architect, Rainaldo, com-

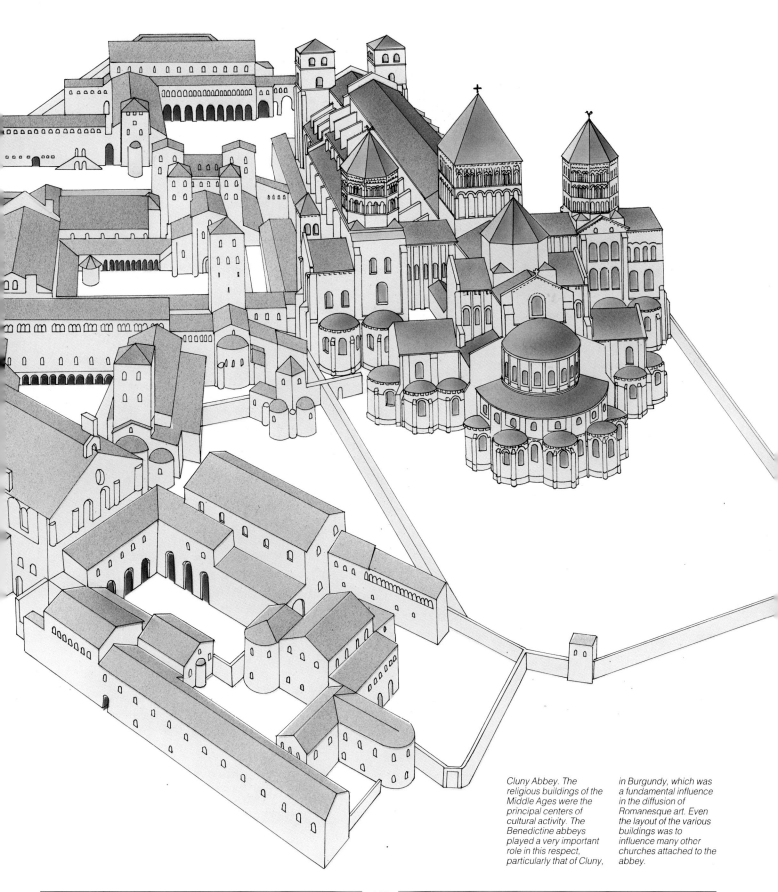

Cluny Abbey. The religious buildings of the Middle Ages were the principal centers of cultural activity. The Benedictine abbeys played a very important role in this respect, particularly that of Cluny, in Burgundy, which was a fundamental influence in the diffusion of Romanesque art. Even the layout of the various buildings was to influence many other churches attached to the abbey.

pleted the building toward the middle of the twelfth century. He was responsible for the galleries so characteristic of the façade, with the evident intention of creating a *chiaroscuro* effect, and which have obvious similarities to those embellishing the façade of the cathedral of San Martino at Lucca. The baptistery, begun in 1153 by Diotisalvi, is circular in plan, its classicism modified by Gothic effects in the course of ensuing work, which involved the participation, among others, of Giovanni Pisano. The vault was not to be added until the fourteenth century. Finally, the erection of the tower, as conceived by Bonanno, was begun in 1173.

Pisan architecture was to leave its mark on numerous later buildings as far afield as Corsica and Sardinia (one example being the splendid church of Santa Trinità di Saccargia, built between 1116 and 1200, forming part of a Camaldolensian abbey). But it is in Pistoia (with the magnificent covering of coloured marble that adorns the cathedral built by the Lombard Guidetto) and, above all, in Lucca that the Pisan style finds richest expression, notably in the cathedral's vast porticoes sur-

Right: the apse of Sant'Ambrogio, Milan. The earliest signs of innovation in Italy are to be seen in Lombard architecture after the year 1000: Sant'Ambrogio may be considered as the symbol of this change. Particularly notable is the vaulted roofing, which was later to become widespread; in this respect the church vies with Durham Cathedral for primacy.

Left: the apse of Speyer Cathedral. Consecrated in 1061, when only the interior was completed, this cathedral prefigured all the future developments of Romanesque architecture. Subsequent additions included the transepts, the apses and the ribbed vaulting over the central nave.

mounted by galleries.

In Rome, representation of the Romanesque period of architecture remains strangely isolated. At the conclusion of the power struggles between the papacy and the Empire, Pope Paschal II certainly initiated the building of several churches, including San Clemente and Santa Maria in Trastevere; but many are more obviously inspired by the early Christian basilica. Moreover, in order to overcome the problem of supporting the principal nave, the architects of San Lorenzo fuori le Mura resorted to an unusual device, which marked a clear step back in relation to the development of Romanesque architecture elsewhere: that of the architrave on Ionic columns.

Despite everything, the decoration of these churches is full of interest. A veritable host of sculptors in marble and mosaic workers (the latter imported from the Byzantine "fief" of Montecassino) was involved. And if some of them, still afflicted by the dust and sterility of Byzantine models, produced barren results, others occasionally distanced themselves from the disappointingly empty intellectualism of their inferiors, as, for example, in the bowl-shaped apsidal vaults of San Clemente and Santa Maria in Trastevere.

In southern Italy architectural styles tra-

ditionally varied according to the different rulers who succeeded one another in those parts. Several layers of culture were thus superposed: ancient Roman, Byzantine, Arab, Norman and, finally, Swabian (Hohenstaufen). But one region, Apulia, escaped these multiple influences and experienced the double impact of Lombardy and Pisa, which local artists sometimes united in harmonious fashion. The celebrated abbey of Montecassino was of special importance. Its workshops, governed by the strictest standards, attracted from Constantinople a steady flow of artists who transformed the abbey into a renowned repository of Byzantine art. One of the many buildings to model itself on Montecassino, both in respect of architectural composition and decoration (principally frescoes), was the church of Sant'-Angelo in Formis, near Capua, begun in 1058 by order of Abbot Desiderius. Throughout the eleventh century, in Campania, other buildings added the stylized elegance of Arab ornamentation to the Montecassino model, like the church of San Domenico in Salerno and, more especially, Ravello Cathedral and the same town's Palazzo Rufolo, where the arcades and windows with interlaced arches are reminiscent of certain aspects of Venetian architecture.

Apulia was an obligatory thoroughfare for all travellers to the Holy Land, pilgrims and crusaders alike. This explains why Lombard influence made such a mark on local tradition. It is seen clearly, for example, in the basilica of San Nicola, Bari, where Lombard motifs (particularly on the façade) mingle with others, Norman and perhaps even Burgundian, as appear in the unfinished towers flanking the façade, the transept, which is raised above the level of the nave, and what has been described as "the towering girdle of the apse," which has affiliations with Norman buildings in eastern Sicily. The design of San Nicola is reflected in that of Trani Cathedral, completed at the end of the twelfth century. Here the supple softness of the façade harmonizes beautifully with the backdrop of the sea, and the whole building is bathed in its dappled light.

In addition to Palermo Cathedral (much transformed later), two other buildings typify Norman culture in Sicily: Cefalù Cathedral and Monreale Cathedral, where touches of Cluniac and Burgundian Romanesque and of Arab architecture soften the Byzantine rigidity of the whole. The apse of Monreale is one of the loveliest examples of these varied cultural influences in harmonious fusion.

Sculpture

Toward the end of the eleventh century, when cultural tremors shook Europe, the pre-Romanesque style of sculpture underwent a profound change, adopting an idiom that took on precise differences and individual tones in diverse regions, so determining the broad lines of Romanesque sculpture itself.

The workshops distributed over central and southern France (Languedoc and Burgundy), northern Italy (Como and Lombardy-Emilia) and, representative of the neo-Classical and Byzantine schools, southern Italy as well as Pisa and Venice, all deployed their individual and well-differentiated styles.

Nevertheless, a kind of "mysterious and deep communication" was gradually established between the sculptural forms of Lombardy-Emilia and those of Languedoc, especially in the workshops of the Toulouse region and Aquitaine. It is still not known by what means these two cultures made contact with each other, or the real extent of the respective exchanges and influences, or where the innovations originated.

There is confirmation, however, that close links existed between the workshop of Wiligelmo in Modena and the new schools of

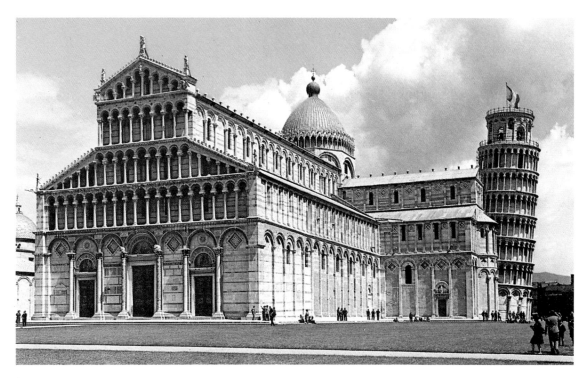

Opposite above: apse of Monreale Cathedral. In this building the amalgamation of the diverse cultures of Norman Italy finds its most perfect expression.

Opposite below: St. Martha Weeping, Musée Rolin, Autun. The distress of the saint, who covers part of her face with a handkerchief, is conveyed in strongly naturalistic terms.

Cluniac and Burgundian sculpture, and that on a wider front there were direct contacts between artisans on either side of the Alps.

The Romanesque artists, as previously mentioned, henceforth reconciled their aspirations to religious transcendence with worldly, even earthy, allusions.

The great sculptural cycles, such as that of the *Last Judgement* on the portal of Sainte-Foy at Conques, also testify to the belief in an ideal path leading from the terrestrial to the spiritual world. The very wall, in these monumental works of art, is transformed into sculpture, whether the stone has been hewn out when already in position (as at Vézelay) or previously (in which case they would have been numbered so as to be mounted later, rather like a gigantic jigsaw puzzle). The portal of Conques displays, among other things, stylistic points in common with those of Lombard stonecutters and bears witness to the effective interchanges that existed with schools south of the Alps.

The evocative power of the portal of Sainte-Foy is again evident in the serene figures of *Peter* and *Isaiah* carved on the south portal jambs of the church of Saint-Pierre at Moissac; and, indeed, a profound feeling of spiritual peace emanates from the church as a whole.

The German style differed considerably from the French, showing affinities with the Carolingian and Ottonian traditions in which sculpture was not a direct tributary to architecture. In spite of the undeniable influences of the classical Romanesque and imperial styles of plastic art, the German school nonetheless remained powerfully original. Examples to cite are scenes from the Old and New Testaments

which Bishop Bernward had carved on the doors of the church of St. Michael at Hildesheim and which exhibit a realism tinged with dream fantasy yet which is still deeply human.

In Italy, the Lombard school was undoubt-

Above: Pisa, the cathedral and leaning tower. Pisan architecture bears certain resemblances to the Lombard school, but displays a different feeling for light. The building of the cathedral was begun in 1063 by Buscheto and continued by Rainaldo. The construction of baptistery and tower commenced between 1153 and 1173.

Right: The façade of Trani Cathedral. This building, completed at the end of the twelfth century, adopted and extended the plan of the basilica of San Nicola, Bari.

edly the oldest, departing from a fairly rigid style and gradually blossoming out in a remarkable display of characteristically zoomorphic forms (which may point to Armenian sources from the late Middle Ages). This is evident, for example, in the *Pulpit* set up at the

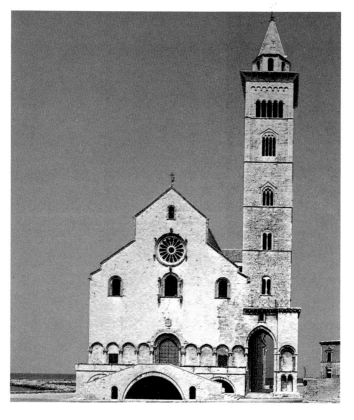

beginning of the twelfth century in Sant'Ambrogio, Milan, and in the churches of San Michele, Pavia, and San Savino, Piacenza.

One of the most talented of these sculptors of zoomorphic subjects was the celebrated Wiligelmo. An inscription that appears on a stone supported by the statues of the prophets Enoch and Elijah, on the façade of Modena Cathedral, reads: "Your works remind us of the honour due to you, O Wiligelmo, sculptor among sculptors." It was, in fact, on the building site of the cathedral that the great artist achieved most of his finest work. Abandoning French example, he set about freeing sculpture from the shackles of architecture, not with a view to rejecting architectural experience but because sculpture was in itself charged with such significance that it could stand on its own and still remain part of the general cultural climate.

Wiligelmo's art was a tissue of inventions that opened up new paths not only to Romanesque sculpture but also (via more distant affiliations) to the whole future of sculpture. It may be that the presence in Modena of an engraver from Moissac had some impact on the evolution of Wiligelmo's style. He may also have been influenced by Romanesque models, for he was to sculpt many fragments (slabs, plinths etc.) recovered from the ancient necropolis of Mutina, not far from Modena.

Besides the statues of Enoch and Elijah, Wiligelmo carved the reliefs of *Genesis* (1099–1106), in which he used his extraordinary talent to re-create a universe pulsating with life and teeming with human figures, animals and plants. The Old Testament episodes succeed one another to form a pictorial narrative, almost filmic in conception, impressing the observer as a kind of lively "human comedy," which by now has abandoned any pretensions to eternity. In the scene of *Adam and Eve Banished from the Garden of Eden*, the sadness and regret of the protagonists seem secondary to the prospect of future wanderings, implying that the subsequent life of toil will be envisaged more in terms of redemption than a punishment.

The Modena workshops soon became the main center for the diffusion of stylistic innovations all over the peninsula and even beyond (as far as Aragon and Catalonia); the throne of San Nicola in Bari may owe its expressive strength, at least in part, to their influence.

Although this luminous, airy sculpture is typically Italian, mention should be made of two other Modena masters who were influenced by France: the so-called Maestro del Veridico, imbued with the spirit of Aquitaine, and the Maestro delle Metope, showing more affinity to the culture and vocabulary of Burgundy, who united (in a manner unique to the age) the "visionary dimension of the great Romanesque period" and the "softness of an ancient Greek."

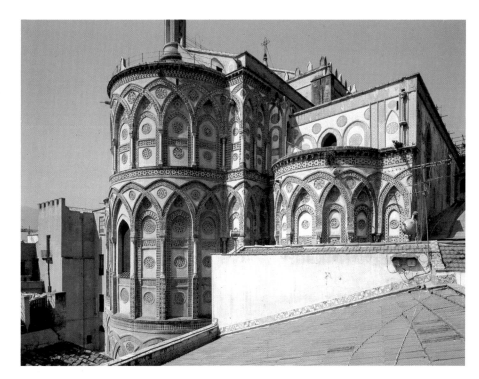

Another quite famous Emilian artist succeeded Wiligelmo and the two aforementioned anonymous masters: Nicolaus (or Niccolò), who engraved his monogram on the portal of Ferrara Cathedral (1135) and the façade of San Zeno, Verona (1138). Notable for his supple treatment of forms, he was probably influenced by the sculpture of Toulouse, and his style (which blends the powerful naturalism of Wiligelmo with an almost classical approach to modelling) was to be a point of departure for many imitators from the middle of the twelfth century onward.

Yet another major sculptor, Benedetto Antelami (1150–c. 1230), is mentioned for the first time in 1178. His name appears, in fact, on a Latin inscription carved on the marble plinth (a fragment surviving from the cathedral destroyed in the sixteenth century) of his *Descent from the Cross*, now in Parma Cathedral. Lombard by origin, Antelami, like Nicolaus, was inspired by French (particularly Provençal) artists and succeeded in conveying the fire of primitive passions within an ordered framework, his style showing a precise sense of measure inherited from outstanding classical models. This style, already very distinct in the *Descent* of Parma Cathedral (which combines expressive strength with formal severity), appears even more clearly in the reliefs carved after 1196 for the baptistery of the same town. This latter cycle takes episodes from the Old and New Testaments, following the sequence of months and seasons; abandoning all Byzantine references, the sculptor now takes a step in the direction of the proto-Gothic style, which makes him the most original figure in this transitional period.

Toward the end of the twelfth century Antelami participated, too, in the decoration of the Borgo San Donnino Cathedral. Here again there is evidence of his acceptance of Provençal techniques (which almost constitutes a "risk of classical academism"), especially in the statues of Daniel and Ezekiel. At the beginning of the thirteenth century he made a journey to France, where he reinforced the proto-Gothic characteristics of his style, as in his last sculptures for the Borgo San Donnino Cathedral (from 1216). He then worked on the church of Sant'Andrea at Vercelli; the *Martyrdom of St. Andrew*, carved in a lunette and endowed with great psychological and introspective strength, can certainly be attributed to him.

The work of Antelami was to inspire a number of highly interesting tendencies, especially in northern and central Italy. In this

Venice. In this city, where Byzantine taste still survived, the Scultore dei Mesi e dei Mestieri (commissioned to work on part of the portal) preferred to evoke the naturalism of Antelami, demonstrating that this vein of inspiration was powerful enough to supplant a now obsolete oriental tradition.

In southern Italy sculpture took a different direction, as already noted. The solid heritage of classical and Byzantine art was here combined with subtle Pisan influences; for example, the bronze door panels made in 1186 by Bonanno Pisano for Monreale Cathedral were modelled on those of the San Ranieri portal in Pisa Cathedral. Having said that, the presence in the south of Pisan masters belonging to the school of Wiligelmo (who in 1161 made the ambo intended for Pisa Cathedral but subsquently kept in Cagliari Cathedral) was not sufficient to make any deep im-

buildings and statues, frescoes have suffered the ravages of time and such works as have survived may be likened to letters in an incomplete alphabet all the more difficult to decipher.

A twelfth-century German author pointed out how the preoccupation of Romanesque art with the terrestrial world (as already noted in the context of architecture and sculpture) signalled the progressive decline of symbolic painting. He argued: "If a column is displaced, the entire building is threatened with collapse; if one destroys a painting, the eye of the observer is grievously injured." This purely aesthetic conception, which interpreted painting as a visual and not an intellectual art, is, for the Middle Ages, an extremely interesting novelty.

In France the most fruitful period of Romanesque painting extended from the end

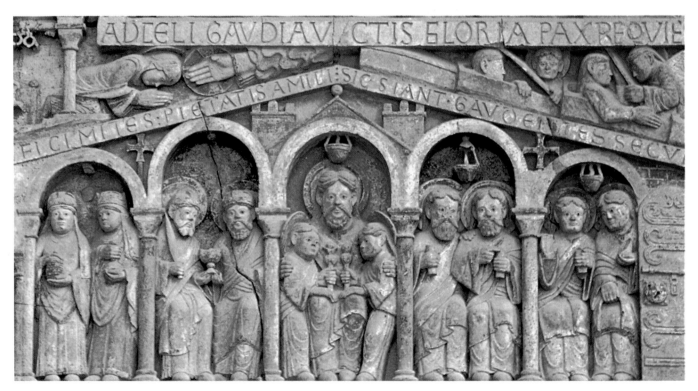

context, one of the most beautiful masterpieces of the thirteenth century is the series of months and seasons sculpted by the so-called Maestro dei Mesi on the side portal of Ferrara Cathedral between 1230 and 1240. Showing an even more pronounced sense of realism than his predecessors, the artist used his strong feeling for nature to carve a sequence of ordinary anecdotes (work in fields, winter scenes and the like), creating a tiny universe of everyday activities and yet conveying a luminous vision of the world.

One of the finest achievements of thirteenth-century Italian sculpture is exemplified by the central doorway of the basilica of San Marco,

pression on the layer of local secular culture.

Painting

Of all the various surviving artistic productions of the Romanesque period, its paintings have always been regarded as rather inferior to its architectural and sculptural achievements. Painting, in fact, had not yet fully blossomed, so that what we find, particularly in the sphere of wall painting, is a body of fairly uniform figurative work in which the very anonymity of the artists prevents us identifying personal touches. Moreover to a greater extent than

of the eleventh century to the first half of the twelfth century. There are many works that show Byzantine and Italian influence, particularly in the frontier and Mediterranean regions that traded with the East. The Italo-Byzantine style, for example, is to be seen in Puy Cathedral in the Auvergne, where the frescoes are reminiscent of those of southern Italy. These influences can be explained here as well by the presence of pilgrimage routes. Mont-Saint-Michel, in Normandy, attracted many pilgrims from southern Italy by way of an intinerary that took them through the whole of France.

Central France, therefore, was the birth-

Opposite: The Last Judgement *(Conques). The sculptures of this church show some influences inherited from Lombard stonecutters.*

Right: Wiligelmo, Adam and Eve Banished from the Garden of Eden, *Modena Cathedral. The Old Testament episodes follow one another at Modena like a pictorial narrative. Wiligelmo was unquestionably one of the greatest figures in the history of Italian and indeed European Romanesque sculpture.*

Far right: B. Antelami, September. *The decorations that Antelami carried out for the baptistery of Parma are clearly proto-Gothic.*

place of a specifically French school of painting that historians have described as "*à fond clair*". The most famous example is that of the frescoes of the abbey church of Saint-Savin-sur-Gartempe, built at the end of the eleventh century. These frescoes are considered to be the most important in French Romanesque art, both from an artistic and iconographic viewpoint. Inside the church, four great cycles decorate the tribunes, the central nave, the crypt and the atrium respectively. The themes are the Passion and Resurrection of Christ, scenes from the Old Testament to Moses, the legendary lives of St. Savin and St. Cyprien, and images of the Apocalypse.

Spain contrasts with the rest of Europe in having preserved a very large number of frescoes and panel paintings, which makes it possible to form a much more complete idea of the evolution of Romanesque painting in this country alone. Despite this, the artistic quality of all these productions is uneven, and only three authentic masterpieces have survived: the frescoes of the apse of San Clemente, Tahull, those of the royal pantheon at León and those of the chapter-house of Sigena.

Spanish painting (or, to be more precise, Catalan painting, since it was in Catalonia that artistic activity was mainly concentrated) exhibits, nevertheless, some very varied features. Toward the end of the eleventh century, local artists benefited not only from antique and Visigothic influences but also from Carolingian and Arab, not to mention the impact of Lombardy and southern Italy. Furthermore, because proximity to France stimulated contacts with Languedoc,

Aquitaine and Provence, a veritable mosaic of styles and tendencies was created from the multiplicity of these sources.

The so-called Master of Pedret, painter of the frescoes of San-Quirce de Pedret, of Santa Maria de Esterri d'Aneu, of San Juan de Tredós and of San Pedro de Burgal, was the artist most obviously influenced by Italy, and especially Lombardy (frescoes of San Vincenzo, Galliano and San Pietro al Monte, Civate). Demus suggests that Lombard painters arrived in Spain during the eleventh century, at the same time as their architectural contemporaries. Some of the vaults of San-Quirce seem to be copies of those at Civate.

The artist responsible for the frescoes in San Clemente, Tahull, who can claim to be the greatest of all Spanish Romanesque painters, had nothing in common with the style of the Master of Pedret and was clearly influenced by the art of southern France. It is impossible to compare the frescoes with wall paintings from the latter region, which have now vanished.

There are undoubted traces of the French style (although not so accentuated) in the royal pantheon of León. The paintings there are nonetheless typically Spanish, particularly the very beautiful fresco of the vault which depicts the *Annunciation to the Shepherds.* The decoration of the chapter-house of the monastery of Sigena (situated at the confluence of the Ebro and the Segre) dates from the end of the eleventh and beginning of the twelfth century. The entire cycle was painted by a miniaturist who came originally from Winchester. Because of this, the work has nothing Spanish about it but displays Byzantine-Sicilian ele-

ments typical of this English school, and already showing the strongly Gothic tendency that was to spread through the whole Iberian peninsula.

In Germany, possibly in keeping with Italian art of the same period, the Romanesque style lasted until well into the thirteenth century, which is clear proof of the resistance offered to Gothic encroachment. German Romanesque painting differs from that elsewhere in Europe by reason of its formal refinement and intellectualism, so much so that Byzantine influences disappear quite early in certain regions. Yet in spite of this, there are echoes, here and there, of Venetian and southern Italian art, the geographical diffusion of which may be easily traced.

The fresco cycle painted right at the end of the tenth century in the church of St. George, Oberzell, on the island of Reichenau, and

representing the miracles of Christ, has a single point of stylistic reference, namely Ottonian art – a pre-Romanesque form that, in various ways, was to influence eleventh-century Lombard frescoes. The Master of St. George was primarily a story-teller intent upon conveying intensity of emotion in the most immediate manner possible, without any aspirations to fine art. There are other interesting examples of German Romanesque painting at Regensburg (Ratisbon), a major artistic center of the time. There the almost austere sobriety of form derives from Ottonian art, but there are hints, too, of the Byzantine style of Sicily.

In Austria, apart from some rare exceptions, Romanesque art is mainly illustrated at Salzburg, and it was in the neighbourhood of this city that an important cycle of frescoes was discovered in the Benedictine church of Lambach. The huge panels show scenes based on the life of Christ, particularly certain episodes seldom represented, like those of the Magi and of Herod.

At Lambach references to themes and models from Byzantine art are so pronounced that it may be supposed that the anonymous master of the cycle had his apprenticeship in a workshop open to oriental influences; probably Aquileia or Venice, as suggested by Demus, who also points out that the Austrian frescoes utilize a technique generally confined to mosaics. The author of the frescoes of the church of Nonnberg at Salzburg was also inspired by Venetian models, which he treated in a spirit typical of Salzburg Romanesque art.

As already noted, thirteenth-century German painting displayed no Gothic trends but preferred to turn back to styles that were now outmoded: Ottonian but also, more especially, Byzantine, even though there were

Right: The Annunciation to the Shepherds, *León.* The royal pantheon at León was decorated under Ferdinand II (1157–88) and the frescoes have survived almost intact. They illustrate scenes from the New Testament.

Below: Noah's Ark, *Saint-Savin-sur-Gartempe.* This work was carried out between the end of the eleventh century and the beginning of the twelfth by a group of artists who shared close affinities. It shows no Byzantine influence but has a quality of pathos stemming from ancient tradition. It may be compared with the Italian frescoes painted at the beginning of the eleventh century in the church of San Vincenzo, Galliano.

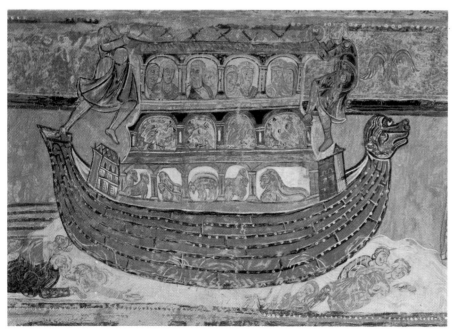

regional variations. Among the major works of this period, mention has to be made of the splendidly decorated wooden ceiling of the central nave in the church of St. Michael, Hildesheim, and the analogous decoration of Brunswick Cathedral in Lower Saxony, constituted by one of the most majestic cycles ever produced in Germany (it was carried out between 1230 and 1250, under the direction of a single master). These two works display evident Byzantine influences, which find expression in a formal elegance that is never superficial but deeply motivated.

In Italy, the persistence of Byzantine tradition led to works that were ever more arid, particularly in regions that were traditionally impervious to the oriental style. Southern Italy remained the focus of this Byzantine heritage. Montecassino continued to play a primary role in artistic evolution, as testified by the church of Sant'Angelo in Formis, built by the celebrated abbot of Montecassino, Desiderius. The so-called "Benedictine" style made a slight impression everywhere, not only in frescoes but also in miniatures.

The much-praised frescoes of the lower church of San Clemente, dating from around 1100 and representing the lives of St. Clement and St. Alexis, do not show great originality. On the other hand, the mosaics of the apsidal half-dome, in the same church, display considerable creative vigour and, together with those of Santa Maria in Trastevere, constitute the first concrete example of a stylistic change in southern Italy.

In northern Italy, the situation was rather different. This region had been less affected than any other by the Byzantine "offensive" and was, by contrast, highly receptive to innovations from across the Alps. The transition from the Ottonian to the early Romanesque style is illustrated in the frescoes of the church of San Vincenzo at Galliano, near Cantù; here, instead of the elegant but sterile calligraphy inherited from the Orient, there is a dynamic force that, although arguably popular, less polished and refined, is far more representative of the new ideas. However, one of the most beautiful masterpieces of wall

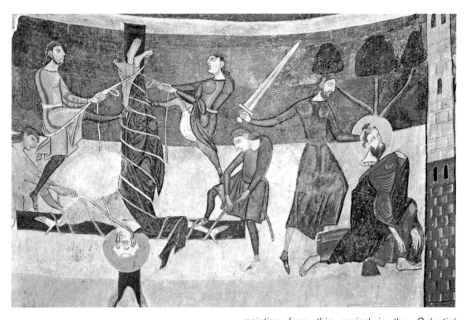

Above: The Crucifixion of Peter and the Decapitation of Paul, *Münster. The decoration of the Benedictine monastery church of Münster was not an eleventh-century creation but a reworking during this period of Carolingian decorations that adorned part of the church. The anonymous master possessed a strong personality and only in the ornamentation was he inspired by Salzburg art.*

Right: Cimabue, Madonna and Child with Angels, *Musée du Louvre, Paris. Cimabue brought the stylistic trends of the entire period to a high point of achievement and indicated the way to future artistic developments. This Madonna in the Louvre, more than any other, has a melancholy softness and charm.*

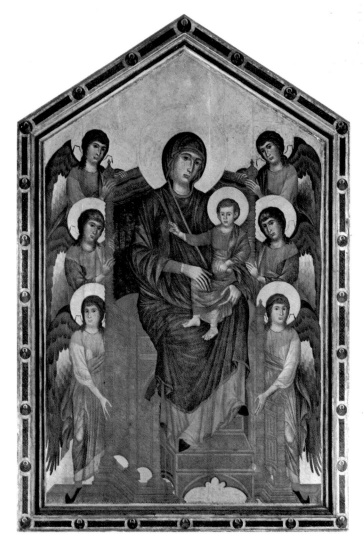

painting from this period is the *Celestial Jerusalem* fresco in the church of San Pietro al Monte, Civate, which shows interesting links with other great centers of European art. The Master of Civate, who painted it, proved his ability to surpass Ottonian art and to give his neo-Byzantine style a distinctively local mountain flavour. This style was to reappear in the Benedictine crypt of Bargusio (the *Benediction of Christ* fresco) and in the chapel of the castle of Appiano, in Alto Adige, where the blend of fantastic images and quiet naturalism creates a kind of local manner that has interesting later developments.

In fact, pictorial art of the thirteenth century had a mixed ancestry. Roberto Lunghi discussed this in his illuminating *Giudizio sul Duecento*: "Given the supremacy of Romanesque sculpture (or architecture, which is the same thing), the fact that thirteenth-century painting was cut off from those lively forces, from that unity, from that identity of expression which links these three arts (in a period which knew exactly what it wanted), could only be blamed on painting alone or, more precisely, on the worthy Vasari and his evil Byzantine and Greek influences, both of which had a sterile effect on much of the period's pictorial art. Lombard and Emilian sculptors had already been speaking our vernacular for more than a century, while poets were still forcing themselves to versify in *langue d'oc* and the painters to paint in late Greek, in Cappadocian, in Armenian and I don't know what, but certainly not in Italian."

There was, nevertheless, a current that avoided this empty, hidebound, repetitive pattern, envisaging a work of art as the autonomous expression of genuine emotions. Cimabue, a Romanesque artist in the truest and fullest sense of the term, and surely its most remarkable exponent, was wholly unfettered in his rejection of all imitation.

Child for the church of Santa Maria dei Servi in Siena and, later, the work regarded as his masterpiece, the celebrated *Crucifix* of San Gimignano, which owes something to Giunta Pisano but with striking additional contrasts of light and shade. In 1270, after returning to Florence, Coppo participated in the mosaic decoration of the Baptistery, producing a *Last Judgement*, violently expressive with touches of naturalistic detail.

The artist who was to bring this period to a conclusion, summarizing all its attitudes and achievements, was Cenni di Pepo, known as Cimabue (1240–1302). Later critics have seen him not merely as the master of Giotto (the role to which Vasari confined him) but also an artist in his own right, with a highy personal style: a kind of "fierce and melancholy patriarch who gave new life to the most ancient ideas and who put age-old dramas on the stage."

One of Cimabue's earliest works was the *Crucifix* in the church of San Domenico at Arezzo, which shows certain affinities with the work by Giunta. Cimabue then painted the *Enthroned Madonna* for the Florentine church of Santa Trinità (Uffizi). The evident Byzantine influence is here transformed by the monumental treatment of the figures.

There is great dramatic tension in the frescoes Cimabue did for the basilica of San Francesco at Assisi, and a lyrical, luminous

quality to the very beautiful *Crucifix* in Santa Croce, Florence, sadly damaged by the flood of 1966. The *Madonna and Child with Angels*, in the Louvre, is extremely charming. Finally, at the very beginning of the fourteenth century, Cimabue worked on some of the mosaics for Pisa Cathedral, where he was to leave the imprint of a still-thriving classicism.

In 1272 Cimabue visited Rome, and it was probably on that occasion that he met the painters who were then working in the capital. Two of them, even though still steeped in tradition, were of more than ordinary interest: Jacopo Torriti and, more especially, Pietro Cavallini. The latter did some of the mosaics in Santa Maria in Trastevere, and his work marks the transition from the Byzantine style to a new form of plasticity that reflects the influence of Arnolfo di Cambio (as can be seen in the frescoes of the *Last Judgement* in the church of Santa Cecilia).

Finally, mention should be made of yet another great anonymous master, who painted the panel of the *Madonna with Child and History of St. Agatha* in the church of Sant' Agata, Cremona. The style employed by the artist was boldly innovative, as if he had no fear, or no suspicion, of overthrowing traditions. But by now Byzantium was far away and forgotten.

If Berlinghiero Berlinghieri and his son Bonaventura never successfully freed themselves of a somewhat starchy provincialism, Giunta Pisano, painter of a long series of crucifixes, proved himself something of an innovator, in some respects anticipating Cimabue. In the *Crucifix* of San Raniero (National Museum of Pisa), Byzantine placidity, so languid that even the grieving protagonists appear lifeless, is here transformed into a deeply human sleep, the treatment dry, almost brutal.

There must be wholehearted agreement, nevertheless, with Longhi's opinion that the finest Italian painter of the first half of the thirteenth century was the third Master of the crypt of Anagni Cathedral whose work shows a decided advance on that of his two predecessors. His fierce energy is far removed from the restrained approach of Giunta Pisano and Cimabue. Another important artist, likewise anonymous, was the Master of San Martino, whose work is worthy to be ranked alongside that of Cimabue. The *Enthroned Madonna* (National Museum of Pisa), undoubtedly painted around 1260, represents him at his best; yet there is a contrast between the central figures of the Virgin and the Child and the little secondary scenes, which are treated with a more touching delicacy and tenderness.

A painter of some talent who was working in Florence before Cimabue's arrival in the city was Coppo di Marcovaldo. Imprisoned by the Sienese after the battle of Montaperti, during his exile Coppo painted the *Madonna and*

Above: Coppo di Marcovaldo, Madonna and Child, church of Santa Maria dei Servi, Siena. Before the arrival of Cimabue, Coppo was a seminal representative of Italian painting. Despite retaining some Byzantine influence, he endeavoured to introduce innovations, although not all his works are marked by the affectation of this one.

Right: P. Cavallini, Angels, Santa Cecilia in Trastevere, Rome. It was certainly after 1293 that Cavallini, with several collaborators, decorated Santa Cecilia with a complete cycle of frescoes in which he exhibited his strong feeling for colour.

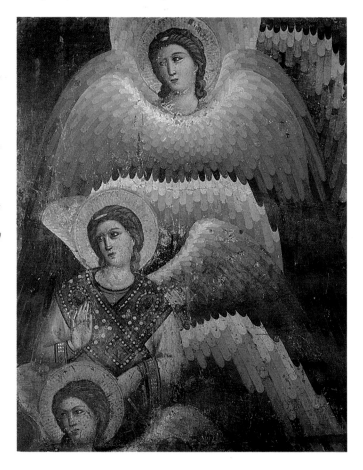

Gothic Art

"Gothic art" is all the architecture, sculpture, paintings and other artistic expressions that were created in Europe between the end of the Romanesque period and the Renaissance.

The greatest body of Gothic art that has survived are the great European cathedrals of that period, abbeys, churches and other religious structures, which employ the pointed arch, the ribbed vault, and – usually, but not always – the flying buttress. These were first built in the twelfth century in England and France, but the style spread to all parts of Europe, and lasted until the Renaissance – which appeared at different times in different places – displaced it.

Together with those religious buildings, Gothic art is all the artistic creations that derive from or were associated with them – sculpture, paintings, stained glass, tapestries – together with all the other arts, major and minor. One speaks, for instance, of Gothic script.

The term is used – less precisely – for civil or military buildings and allied arts, between the Romanesque and the Renaissance, even though they may not show the usual Gothic ecclesiastical characteristics of linearity, a sinuous line or pointedness.

Finally, Gothic can also refer to any art that is reflective or imitative of the original Gothic, such as that which appeared during the Gothic Revival.

Gothic appeared as Europe was beginning to be transformed from a medieval society that was overwhelmingly static and agricultural into a Renaissance one, more mobile and commercial. Its roots are in the Romanesque, but its end is the Renaissance.

The long, predominantly agricultural, ages (A.D. 500–1100) that followed the fall of the Roman Empire in Europe were characterized more and more by a universal belief in Christianity, which, while facing the many trials and depredations of those centuries, preached the pains of this natural world, liberation after death and, hopefully, eternal bliss in a Christian heaven.

During the subsequent commercial age, which developed from some time before 1100, Europeans discovered and increasingly appreciated the reality, wealth and pleasures of the natural world.

At first this discovery of nature's goodness was always seen from within a Christian context, that is, man and nature were manifestations of a Christian God. But as nature's horizons were extended and the true scope

and wealth of the natural world were appreciated, the Christian reference remained too restrictive. Europeans began to believe less in Christianity, with its messages of doom, and more in the goodness of nature and of themselves.

Gothic art is an expression of European life during the first phase of this transition, from about 1150–1400/1500. Whereas the preceding Romanesque period (c. 900–1150) was entirely oriented toward the Christian God and death, Gothic art remained Christian but increasingly appreciated man and nature. As it developed it absorbed into its forms more and more of the phenomena of natural life. During the great shocks and traumas of the fourteenth and early fifteenth centuries, the unquestioned Christian basis to European art failed. The scene was then set for an art that was primarily about man and nature, and only secondarily about Christianity. That was when Gothic art ended and Renaissance art began.

Gothic art ended first in Italy, where Christianity was greatly displaced by trade and travel, by the collapse of the papacy during the Great Schism (1378–1417), by the great economic and social upheavals of the fourteenth century, and by the continuing attraction of the Classical world, the remains of which still lay everywhere. From Italy the Renaissance spread, and the Gothic Christian world slowly faded.

Gothic art, while remaining primarily Christ-

ian and even mystical in its imagery and in its direction, is about man and about nature. Its developing chracteristics are images of man, who becomes more human, more reasonable and ever more freed of the Church fabric, surrounded increasingly by a vast man-made space, filled with light filtered through man-made glass.

Early Gothic is increasingly pointed and linear, straining upward, toward God. Later Gothic becomes intricate, interwoven and decorative, more and more conscious of its own beauty, sealed off from the universals it wishes to reach.

It was logical that the large church building should have been the starting point and the focus of Gothic art. A Gothic sanctuary is Christian and grows from the smaller Romanesque church. But in its vast, harmonious spaces, its filtered and coloured light, in the rich sound of man's chant reverberating along complex pillars and vaults, it is also about nature. And of course these extraordinary structures were built by man's genius, so they are also about man, and for man, and reflect his awakened trust in nature and himself.

The buildings first rose on the plains of northern France and England, opening themselves to new dimensions of air, space and light. It was as though the Christian edifice and the Christian faith were trying to contain the whole of nature, and express a belief that within Christianity there lay an explanation for all the manifestations of the world. Slowly its sculptures, its paintings, its stained-glass windows, the carpets and vestments, the ivories, tapestries, enamels, ceramics, jewellery – everything within the church and without – became in turn more nature-oriented and humanized. Slowly these buildings, with all their accoutrements, spread across Europe.

All the other buildings of European late medieval society became more or less Gothic too, angular, pointed, linear: the castles, the Town Halls, public structures and private dwellings.

Although the pointed arch gradually disappeared as the Renaissance developed, it lingered in many places or was resurrected. In New York City today, the main Roman Catholic church, St. Patrick's, and the main Protestant one, St. John the Divine, are both neo-Gothic churches, the latter still in construction. So is, in a sense, Gaudi's church of the *Sagrada Familia* in Barcelona, also still being built.

"Gothic" is a misnomer. Gothic culture was a completely Christian culture that developed at the end of the Romanesque period, when Europeans began, after hundreds of years of mostly agricultural life, to trade, and to live again in cities. Gothic culture had nothing whatsoever to do with the Goths – the Ostrogoths and Visigoths – northern-European peoples, who invaded and occupied various parts of the Roman Empire in the fourth, fifth and sixth centuries, helping substantially to

bring about the collapse of Italian civilization.

The reasons that the most Christian, most stable, unified and perhaps most artistic age in European history should be called after barbarian people who were nomadic, destructive and momentary, and who had lived hundreds of years earlier, are complex.

In great part, the Renaissance was a reaction against earlier Christian ideas. Because of this, many figures in the Renaissance tended to disparage medieval art. But that disparaging attitude was mostly Italian, as the essence of the Gothic experience was northern European and had to do with the development of Northern peoples and cultures outside the orbit of the Mediterranean and Classical worlds. When northern Europe began to replace Italy as the center of European power, Italians became jealous of a culture that was so distinct from their own.

Also, of course, not very many Italians had ever visited the great Christian sanctuaries of northern Europe, and so had never felt that profound expression of man's search for truth which those buildings represent. As a whole, they may well be the greatest architectural complex ever created by man.

Usually, it is the Italian architect, painter and art historian Giorgio Vasari (1511–1574), builder of the Uffizi in Florence, and author of *Lives of the Painters, Sculptors and Architects*, who is blamed for first using the term "Gothic." He wrote: "There are works of another sort that are called German, which differ greatly in ornament and proportion from the antique and the modern. Today they are not employed by distinguished architects but are avoided by them as monstrous and barbarous, since they ignore every familiar idea of order.... This manner was invented by the Goths, who after the destruction of the ancient buildings and the dying out of architects because of wars, afterward built – those who survived – edifices in this manner: these men fashioned vaults with pointed arches of quarter circles, and filled all Italy with these damnable buildingsGod preserve every land from the invasion of such ideas ..."

But Vasari did not invent the idea that the earlier Christian style was so inferior. His comments summed up a feeling that was noticeable in Italy from the early Quattrocento onward, when Donatello, Brunelleschi and Masaccio "re-formed" art. The whole Renaissance, in turning to the Classical pagan world of Rome and Greece, was in fact rejecting the domination of European culture by Christian ideas and by the Church organization. Obviously, what had gone before – in essence the Gothic Age – was distasteful because it was too Christian.

The sources of the Gothic style are to be found in the enormous changes that took place in European society in the eleventh and twelfth centuries.

Europe had become, from the time of the collapse of Roman civilization in the fifth and

sixth centuries, progressively more agricultural. Successive invaders had destroyed the city-based culture of Rome, leaving Europe a backward agricultural society lacking the means to defend itself. Culture and order were preserved in the Christian monasteries, self-sufficient establishments where farming was combined with study and prayer. Life was seen as a difficult passage toward death, at which the soul would be liberated from its body to go, hopefully, to Heaven.

Once the Roman administration of western Europe had collapsed completely and Europe was controlled by non-Italian peoples, three further groups invaded what had been Roman territory and settled: the Arabs, the Magyars, or Hungarians, and the Scandinavians, or Normans. The first two had little to do with the development of Gothic art, but the third were important.

These last – Scandinavians – were magnificent sailors, energetic and organized. Although at first they raided and raped all the lands bordering on the North Sea and the Atlantic, they settled down in the tenth century, and took on the customs and the religion of the lands they had been plundering. In particular, they settled in what is today part of eastern France – named Normandy after them – and in the British Isles.

By the middle of the eleventh century, the North Sea had become a Scandinavian lake, all the lands on it or near it subject to the wishes of these extraordinary people. In 1066, annoyed by the claim of the old line of English kings to the throne of England, the Normans invaded, unifying the country under one ruler. They also began at once, both in Normandy and in England, to build many large churches.

European society during these generations of Scandinavian ascendancy in the North Sea was also changing considerably. For some unknown reason, after about the year 950, the population of Europe increased dramatically. Perhaps it came from the stability brought by Charlemagne, which grew when the Arab and Magyar invasions were halted in the ninth century. Perhaps it was a cyclical increase in good weather and good harvests, or perhaps it was changes in agricultural methods. It may even have been a stability the Scandinavians themselves brought after they settled down from their raiding and pillaging. And, of course, the stability may have come from all these things, plus others. Whatever caused it, by the year 1000, there were many more people in Europe.

This meant that the old feudal agricultural system of limited plots of land for each family could no longer support larger families dependent upon them. Eventually, the surplus labour had to move, and ended up in the old towns, the new Cistercian monasteries, or in "new towns."

Social stability in Europe brought increased wealth. This caused the great old monastic establishments to become rich and lax, which,

Construction of the Temple at Jerusalem, by Jean Fouquet (Judaic Antiquities, ms 247, f. 163, Bibliothèque Nationale, Paris). One of the great miniatures in the first volume of this work. Fouquet was the main painter in fifteenth-century France. On the ground we see the different phases of Gothic stonemasonry; hoists are visible on the roof. The Gothic vision of space, light and shade stand out clearly.

These new monasteries were run along modern lines, not at all subject to the old feudal systems. Many of them quickly became very large, attracting runaway serfs for whom there was not enough food or space under the old system, and clearing more and more land as their size increased. Farming became centralized, with large fields, orchards and herds, everything produced according to what could best be grown by each particular monastery.

Obviously with this enormous improvement over the old feudal methods of each person trying to grow everything he needed, there were soon large surpluses. These were exchanged with other monasteries, or sold to the expanding towns, and to the new towns.

Trade, the antithesis of the earlier static, agricultural, self-sufficient system, had begun. At first it was merely local. But soon enterprising souls, many of them displaced serfs in the comparative anonymity of the towns or in one of the new monasteries, realized that procuring wanted goods from farther and farther away, by in effect becoming entrepreneurs and traders, they could make money.

This new trade's own success caused it to expand geometrically, bringing further wealth and further movement, destabilizing feudal society. Manufacturing soon followed and new sections were built outside the walls of the old towns called *borgo* in Italian, or *faubourg* in French, and in the new towns, which now sprang up all over Europe.

The new towns were not intrinsically different from the *faubourgs*. But because they were enfranchised, that is had Royal or official licences to trade, their size and number increased with remarkable speed. So, as population and wealth increased, trade did too. The bishops and nobles were masters of vast uninhabited dominions, the same wilderness in which the Cistercians were so successfully establishing themselves. By permitting groups of settlers to live in these areas, in exchange for rent, the lords became partners in the establishment of new towns. Further encouragement was given by permitting escaped serfs to settle unmolested in them: after a year's residence anyone could become a free citizen of one of these towns, a "burgher" or "bourgeois." Obviously, the new towns' attitude was no longer that of the older society, static and agricultural. The burgers' prosperity was based on trading.

In the late eleventh century, too, the Crusades began. These were another enormous stimulus, to trade in particular and to movement in general. Ostensibly religious, these vast expeditions to the eastern Mediterranean by European armies were also the beginnings of modern European colonialism, or, if one prefers, of the expansion of modern European trade. The Europeans who went on them brought back to Europe a mentality and a taste that had been greatly enlarged by contact with another religion and with other peoples.

in turn, caused the first of the many major reforms Christianity was to experience leading to the great Reformation of the sixteenth century. Reformed Benedictines, calling themselves Cistercians, from their first abbey at Cîteaux (south of Dijon, founded 1098), began to establish new, stricter monasteries all over Europe. But, as they lived a simple life, they built their new monasteries in what might be called frontier country, in the wildernesses of Europe where the land was uncleared, and the temptations of the world were far away. In those times, of course, much of Europe had never been cultivated, and was still covered in forest or scrub. The popuation was limited, and the "cities" were nothing more than small towns, even villages, the seat of a bishop or lord. Cistercian monasteries were constructed in a harmonious way, their interiors almost devoid of ornament. And, whereas the earlier Romanesque churches were dark, almost fortified against the outside world, Cistercian churches widened their doors, windows and aisles more and more to admit sunlight.

By the beginning of the twelfth century, the amount of increased movement and new wealth began to affect considerably the European's view of himself and the world and, consequently, to affect both his religious beliefs and the way he wished to see Europe organized.

"Gothic art" is the first great product of that change. While man continued to believe absolutely in Christ and the Christian faith, he nonetheless adapted his comprehension of Christianity to include the new wealth and the movement of trade. Later, in the Renaissance, his love for trade and nature would displace his love for Christ even more, eventually producing a further change in art toward paganism and the Classical world. But in the Gothic Age, the tension created between his skyward vision and his earthward one caused man to search for expressions that would celebrate both, but ensure that the latter was contained within the former.

The Gothic cathedral is exactly this. On the outside, its massive, complex stone structure is a symbol of the natural world; its portals, sacred entrances into heaven. Inside, like the interior of all matter, there is the Spirit, and that spirit is really the absence of matter – perfect harmony and light. In other words, the inside of a Gothic cathedral is not just a symbol of heaven but is also what heaven is, the

presence of God Himself.

It is in the great sanctuaries of the Île de France, where the interior proportions are especially harmonious, where the tension from the counter-thrust of the flying buttresses pushing against the soaring upper vaults is stronger and where the luminosity is more radiant, that this idea is carried to an integration and a completion where idea and expression become one.

Gothic architecture expressed the liberation of man's mind from the solidity and worldliness of the Romanesque. As one passes through the great portal of a French Gothic cathedral,

one leaves all worldly decoration behind and enters into the abstract spiritual world that the Romanesque had only pointed to: a world of light filled with thousands of harmonious colours twinkling and shifting through the stained glass, a world of music, vibrating with the pure harmonies of a chant based on the Golden Section, and a world of spatial balances based on Pythagorian geometry – the secret relationships upon which all matter is constructed.

In general terms, it was the larger population and the new trade that produced the enormous amounts of wealth needed for this vast cultural achievement: there were literally thousands of churches built across the whole of Europe, from great cathedrals, to small parish churches, all of such high quality that they have mostly survived the neglect and destruction of centuries of an increasingly less Christian world. And every one of these churches had at least some sculptural decoration and was filled with hundreds of carefully made artefacts to do with every phase of religious ritual.

In general, too, the great wealth produced by the new trade went not toward civil or private ventures but primarily toward ecclesiastical projects because of both faith and fear. Faith because man believed in the Christian God and the teachings of the Church of Rome; fear because the trade that man loved was, in an essential part, condemned by the Church, desperately trying to maintain its privileged position as minister of the old, static, hierarchical way of life, crumbling under the earthquake of trade and wealth. That essential part was money-lending for interest, called *usury*, which the Church of Rome condemned unequivocally as a mortal sin.

Since commerce could hardly expand without the use of borrowed capital, especially for long-distance commerce, there were bound to be many serious sinners. But such sins could be remitted by good works, one of which was, obviously, the donation of money or works of art to the Church.

This was an extraordinarily successful method of taxing, not the commerce itself, apart from which the Church pretended to stand aloof, but the fruits of that commerce. The great Gothic churches could never have been built without the gifts and legacies of faithful Christians hoping for salvation.

Origins of Gothic structure

The development of French Gothic architecture depended upon the experiences of Romanesque builders, and then of Anglo-Normans. For although French Gothic architecture is different from those earlier buildings, its seed generated among them. And, conversely, Gothic architecture that is not French, or is imitative of the French, rarely shook off an attachment to earlier ideas.

Gothic religious architecture differs from the

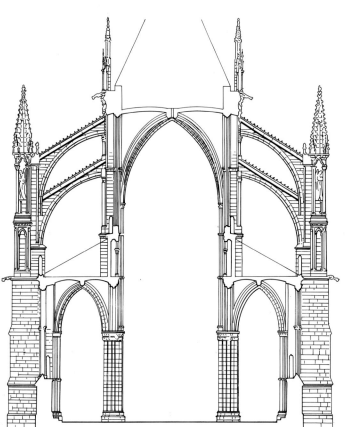

Above: sketch of the ribs of a Gothic vault. The two longest ribs are hemispherical and hold up the main weight. They transfer most of the weight of the roof on to the corners and thence to columns and pillars. The two biggest vaults open on to the side nave.

Left: section of a Gothic church, with the main and two side naves. Rampant arches enclose the upper walls of the nave; the pinnacles seem to fight against the winds that attack walls and windows.

Opposite: interior of Amiens Cathedral (1220–36). Nave, transept and façade were almost wholly built in sixteen years, proof of the skill of Gothic builders. The choir followed. The interior has three levels. The architect was Robert de Luzarches.

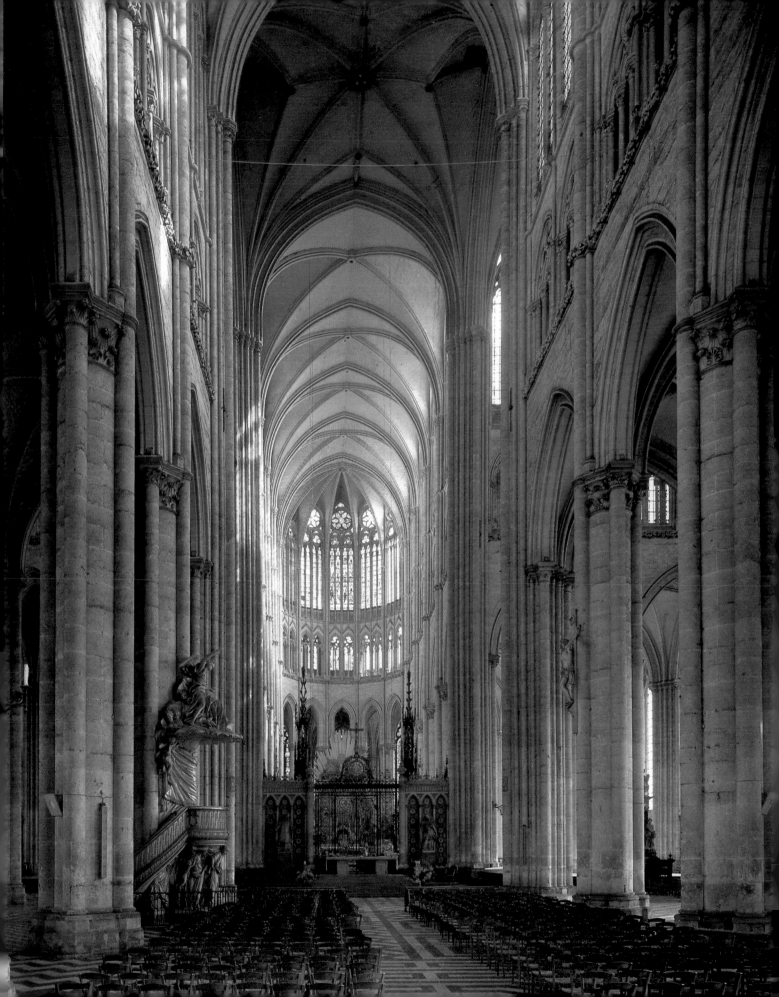

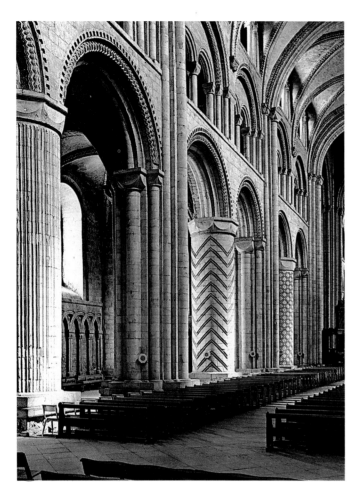

the groin vault. This latter is formed by crossing at right angles two barrel vaults. The ridges formed are called groins, and it is these groin vaults that cover the spaces between most later Romanesque arches.

By first building two crossed stone arches where the groin vault was to be, held up by a keystone, Gothic builders provided themselves not only with a framework on which to hang their vault, so to speak, but also with a strong skeleton along which some of the forces and stresses from the weight above would be distributed and carried down toward the ground below. These ribbed vaults gave the achitecture a distinctive quality, as they frankly emphasized the lines along which dynamic forces were moving.

The third technical distinction between Gothic building and Romanesque is the counter-stress that the exterior "flying buttresses" produce. It is because of this counter-

Opposite left: Laon Cathedral, northwest of Paris, was the first church to be designed and built in Gothic style with ogival arches, ribbed vaults and external flying buttresses. It is one of the most perfect Gothic buildings including an internal structure on four levels.

Opposite right: Reims Cathedral (1211–1430), the east-facing nave. The achitecture is imposing while the sculpture, which is late-Gothic, does not match the grandeur.

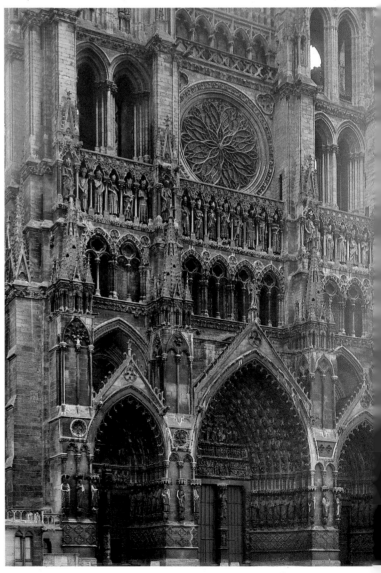

Romanesque by its scale and by the employment of light as an essential part of the interior spaces. These two elements are brought about through the use of the pointed arch, the ogive or ribbed vault, and buttressing on the outside of the structure, called "flying buttresses." Besides, and most importantly, whereas Romanesque church architecture is essentially inert, French Gothic building is one of thrusts and counter-thrusts. Romanesque architecture reflected a static world, Gothic a dynamic one.

No doubt it was the desire to make higher and wider churches, particularly to accommodate the increasing population and the large numbers of pilgrims who travelled about Europe in the tenth and eleventh centuries, that made architects realize the value of the pointed arch: it has considerably less lateral thrust and so needs less thickness in the supporting walls. Besides, since the width and height of a pointed arch can be adjusted to suit many situations, it was possible to make its crown level with the crowns of semicircular, quadripartite or sexpartite vaults, regardless of their spans or any irregularities in the space to be covered.

Gothic architecture's second distinguishing feature, the ribbed vault, is a development of

Above: nave of Durham Cathedral, built c. 1093–96, soon after the Norman conquest. Height and width of internal spaces, though still subject to full Romanesque arches, show a new approach to light and to religious buildings. With its ribbed vaults, it is the oldest extant Gothic church.

Right: façade of Amiens cathedral. Made in 1220–36, the sculptures of doors and the gallery of kings under the rose window are among the best in Gothic art. Under the main portals is the Beau Dieu of Amiens, an image of Christ blessing.

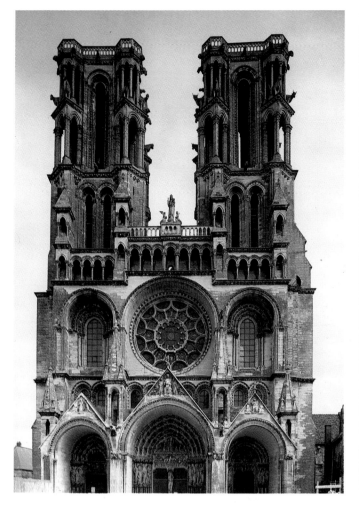

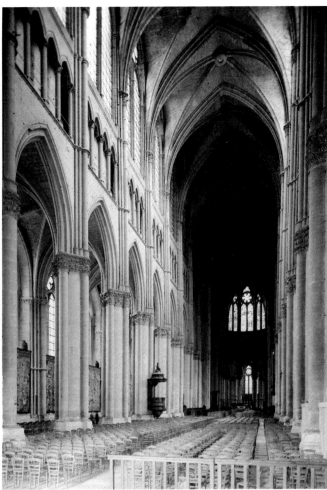

thrust that the walls of Gothic churches can be so thin, that the vaults seem so light, appearing to lift upward, and, consequently, that window area can replace wall.

In Romanesque architecture all the weight travels down from the vaults through the walls, the arches and piers, and then into the ground. In Gothic architecture, the weight of the vaults and the roofs above them not only travels downward into the arches, piers and walls below, but also into the exterior buttresses, which are placed high up, against the nave walls. These brace the wall at the point where the diagonals of succeeding vaults meet, carrying much of both forces, plus some of that of the intermediary arch, over into the ground outside the building.

The weight of the buttress itself, pushing against the exterior of the church, is not insignificant, and produces a counter-thrust that obviously, in pushing against the weights of the vaults and arches as they flow downward, lightens them.

The use of these buttresses, standing free of the main church fabric and "flying" across to it, made it possible to build higher and wider and, at the same time, reduce enormously the

nave wall between each arch, until they were non-supporting curtain walls, which could be filled in with stained glass.

The development of Gothic vaulting involved three technical changes. First of all, the main nave pier took on a complex and eventually very beautiful form, as it changed from being a round column with attached colonettes to a compound pier designed to carry down not only the weight of the upper walls but also that of both the transverse arches on either side of it, and of the four diagonal ribs that came down to it from the nave and the side-aisle vaults.

The second development was that of designing transverse arches across the nave and the aisles only every other column, resulting in oblong vaults, which could then become sexpartite instead of quadripartite.

And this brought about a third change. The long diagonal ribs, which connected every other opposite pier, remained semicircular, or almost, whereas the transverse arches were pointed.

No one really knows who first used pointed arches or how they came to Europe; but that they came from the East seems undeniable.

Muslim culture had used pointed arches from its inception, and they may well have merely carried on the tradition from the Eastern Roman empire.

As often happens when a new solution to a developing problem is needed, it is probable that their use appeared in various different places at more or less the same time. In any case, their use in Christian architecture was almost certainly the result of Norman experience. The Normans had been involved in the Arab-Mediterranean for generations, and in southern Italy and Sicily in particular.

Ribbed vaults may also be of Eastern origin. They seem to have first appeared in Lombardy at Saint'Ambrogio in the last years of the eleventh century, and in Caen at the two abbeys built by the Normans in the years after the Conquest of 1066, *L'Abbaye aux Hommes* (St. Etienne, 1066) and *L'Abbaye aux Dames* (La Trinité, 1077). They are also used at Durham after 1093.

Although the pointed arch, and the groined vaults of the side aisle, considerably reduce the effects of the lateral thrust of the main nave vaults, there still remains a certain amount of outward pressure, particularly where the

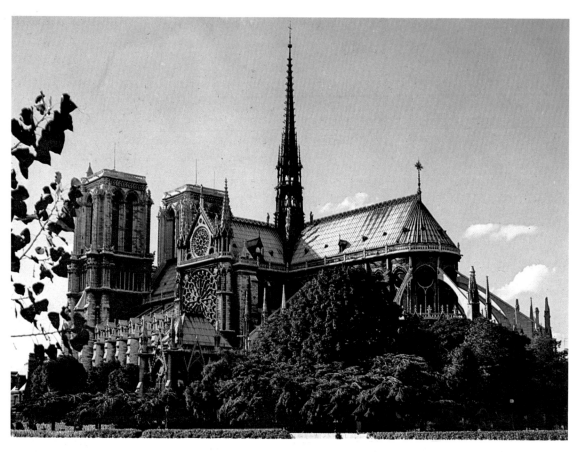

arches begin their "springing" as it is called, that is, where the perpendicular line from the ground begins to curve inward toward the apex of the arch. Buttressing at that point greatly strengthens it, and traditionally this was done with heavy masonry walls, or, as sometimes in the case of Romanesque side-aisle groin vaults, with transverse walls built against the exterior of the building. In both the Caen abbeys there are primitive types of flying buttresses used to support the main vaults.

Buttressing the higher walls of the main nave was also accomplished in advanced Romanesque architecture by building a vaulted passage, called a tribune, over the side aisles. This acted like a series of roofed flying buttresses, and absorbed much of the lateral thrust of the main nave, acting as a web to distribute it.

Contemporary with the new churches at Caen, the Normans used the wealth from their conquest of England to build or rebuild many large churches, often, as in the cases of St. Albans (1077), Norwich (1099), the transepts at Canterbury (c. 1100) and Southwell (1114), among the largest at that time anywhere in Europe. These, however, in spite of their great size and often elaborate decoration, were on the whole conservative in structure. The early ribs at Durham were not followed by any consistent development of an organic Gothic structural system, as happened in France.

Above and right: exterior and interior of Notre-Dame, Paris (1163–1250). The outer view is from the southeast, showing the nave with rampant arches and the central spire. The inner view shows part of the five small naves of the central nave. The Gothic of Île-de-France was essentially royal, linked with the ruling monarchy. Along the Seine in Paris, two great monuments express the start and end of this period: Notre-Dame and the Sainte Chapelle, the former in Early Gothic, begun after Saint-Denis was finished in 1160, the other completed about a century later. Both reflect the notion that the inside of a Gothic church is like paradise, and filtered light like God.

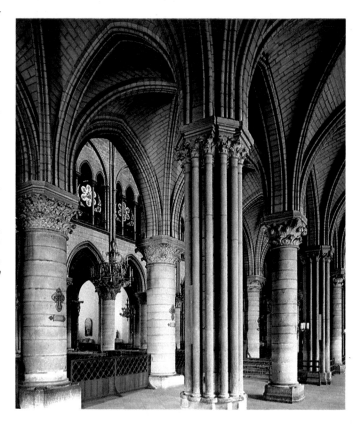

The Normans passed on to the French the essentials of Gothic construction. But it was the French who fused these elements together into an organic system, and then developed the system into a form and an expression unsurpassed in architectural history.

St. Denis and French Gothic

The most regal monastery in France, St. Denis, north-east of Paris, was Benedictine. Today, its church – all that is left of the once vast community – has become the seat of a bishop and is a cathedral. For centuries St. Denis was the holy sanctuary where the kings of France were anointed and buried: the spiritual center of the French monarchy.

In the first half of the twelfth century, at a time when the new trade and wealth of Europe were causing the death-oriented Romanesque to go out of fashion, the Abbot of St. Denis, Suger, decided to rebuild the west front of the church so that it was imposing and regal, an appropriate front to a Royal establishment. Then, between 1140 and 1160, he had the choir of his church rebuilt using the new elements of pointed arch and ribbed vaults. He joined all the chapels of the apse together with an open floor-plan, and installed large windows in their walls, so that the whole apse, the *chevet*, was like a single hall filled with light.

The use of this light, together with the church's and Abbot Suger's special rank (Suger was essentially the private chaplain and closest confidant of the King), transformed St. Denis from being just another of the many new churches that were built or rebuilt in the eleventh and twelfth centuries into a structure destined to be the seed of French Gothic architecture.

Light became a perfect reflection of the spirit pervading all of Christian Europe at that time. It was as though light united Europe and the Christian world. St. Bernard, the great Cistercian preacher of the moment, a Doctor of the Church, attempted to gather up all the energy of the new movement and direct it toward God. "It is not by changing from one place to another that you must seek to approach God, but instead by successive illuminations, and not of the body but of the Spirit. The soul shall seek the light by following light." Scholastic philosophy, displacing monastic philosophy, attempted to reconcile faith and reason – the one static, the other dynamic, the one oriented toward another life, the other toward this one. The Gothic cathedral expresses this, also trying to reconcile the spiritual and the worldly, light and stone.

Because the Île de France was an area that had not been greatly affected by the preceding Romanesque, and because Gothic was essentially an expression of the new philosophy in its schools, this style took root at once. It was also so thoroughly supported by the

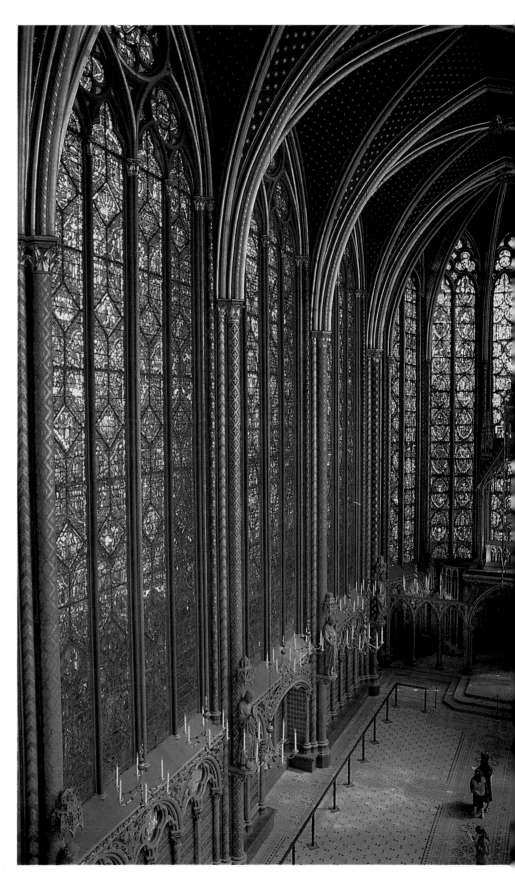

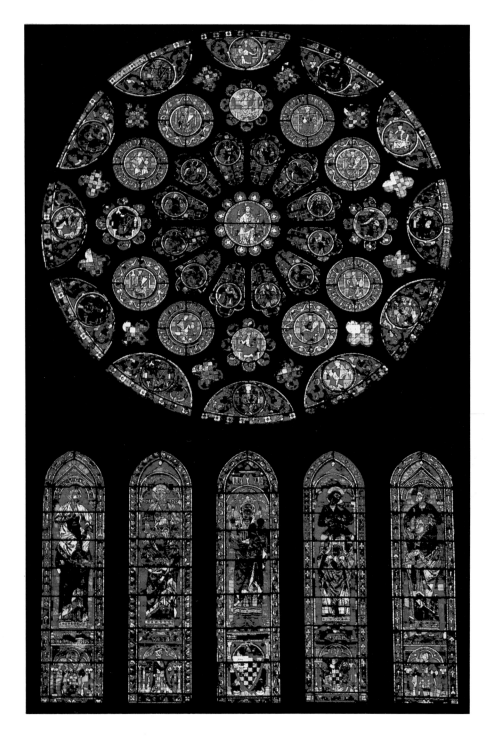

buildings put up between the time of Sens and St. Denis in the twelfth century and Reims, Amiens and Beauvais in the thirteenth century which expresses the parallel effort of the philosophy of the time to fuse together Christian concepts of truth and those obviously manifested by the natural world.

This is true of Gothic architecture all over Europe, but it is especially true of French Gothic. Each expresses, in different ways, aspects of the Gothic search for this reconciliation: Sens (1130–40); St. Denis (1140); Laon (1155–60); Senlis (1155); Noyon (c. 1150); Paris (1163); Chartres (1194); Le Mans (1217); Rouen (1204); Reims (1210); Auxerre (1215); Amiens (1220); Bourges (1210–20?); Soissons (1218); Beauvais (1225); Tours (c. 1235).

Laon, north-west of Paris, is the least known to the usual traveller, and most surprising. In some ways it is the first of the great cathedrals, begun between 1155 and 1160, just as the *chevet* of St. Denis was being completed and before Notre-Dame in Paris was started. The church has a grandeur and a simplicity without equal among the greater Gothic structures, embodying almost perfectly all the earliest Gothic ideals. Its façade, with a great rose window, three canopied portals and perhaps the finest of all the façade towers in France, is already an ideal, uniting the elements without self-consciousness or pretense. Inside, too, its four levels and its structural unity are dazzling.

Notre-Dame in Paris is, of course, the central church of France; however, it was not seen as such when it was built. Cathedrals at Sens and Laon were already taking shape; the choir of St. Denis shone like a royal beacon. But it has become that over the centuries, and with justice. Its stately magnificence, underscored by the vast amount of coloured light passing through the stained glass and moving along the magnificent nave, is a true statement of Gothic intent.

Chartres is the most splendid. It was begun immediately after the fire of 1194, which destroyed all of the preceding building except its new west front (1140–50): the two towers with the portals, windows and arcade of statues between them. By that date, Gothic ideas of construction were so well developed – particularly those relating to exterior buttressing – that it was possible to eliminate the tribunes completely, enlarging and doubling the clerestory windows, as well as adding roses above them. The flying buttresses that permitted this are of an unequalled elegance, while the walls of glass windows are among the loveliest creations of the whole Gothic age, indeed of all European history. The exterior sculpture, too, is of remarkable beauty, rivalling the famous sculpture groups of antiquity, both the earlier statues on the western front, saved from the fire of 1194, and those of the north and south entrances.

As the force and confidence of scholasticism splintered into complex and often pointless and antagonistic currents, the confidence

French monarchy that the Gothic style came to be viewed almost as an expression of the royal house of France. The orientation toward life and light so perfectly reflected the beliefs of the movement and of the monarchy that all the great churches built soon after it copied and amplified the style.

French Gothic architecture never really reaches complete fulfilment in any single building. Rather, it is the whole body of the

Above: window of the south transept of Chartres Cathedral, c. 1255. The central theme is the glorification of Christ. The lower windows represent prophets and biblical figures. The Chartres windows are illustrations of the search for truth

and light as emanations from God. Opposite: vertical section of Chartres Cathedral, showing the west façade, built before 1175, and the south façade, coeval with the reconstruction of the church begun in 1194.

of the original Gothic expression also waned, eventually disintegrating into a more or less decorative Gothic formula. Reason triumphed over faith, leaving Gothic thinking and expression – essentially a triumph of faith over reason – without its life force. When Vasari, in the sixteenth century, was so denigrating toward the "barbarian" Gothic, he is merely expressing a rather precarious confidence of reason over faith, typical of the Italian High Renaissance.

The cathedrals of Reims, begun in 1210, and Amiens, begun in 1220, are probably the next most famous French cathedrals. Reims has monumental sculpture on its façade that outshines the other great churches – 56 colossal figures, each 4m (13ft) high – as well as magnificent sculptures inside. Both churches are enormously homogeneous, and represent the apex of Gothic aspiration. Amiens has

great dignity, a powerful sense of majesty, and a simplicity that is as close to a perfect expression of medieval scholastic philosophy as Gothic architecture reached.

Later, in the hundreds of churches that followed, Gothic often tended either to overreach itself or to become a formula. The vaults at Beauvais, begun just a few years later, were carried to 44m (144ft), but collapsed in 1284. And the Sainte-Chapelle in Paris, begun in 1242–43, for all its exquisite light and beauty, lacks the sense of "searching" of earlier Gothic.

French Gothic of the late fourteenth and fifteenth centuries, is called "flamboyant," and is a period when rich, elegant decoration, particularly of the vaults, displaces any developments of plan or elevation.

Many non-religious monuments from the Gothic age have survived in France: market-

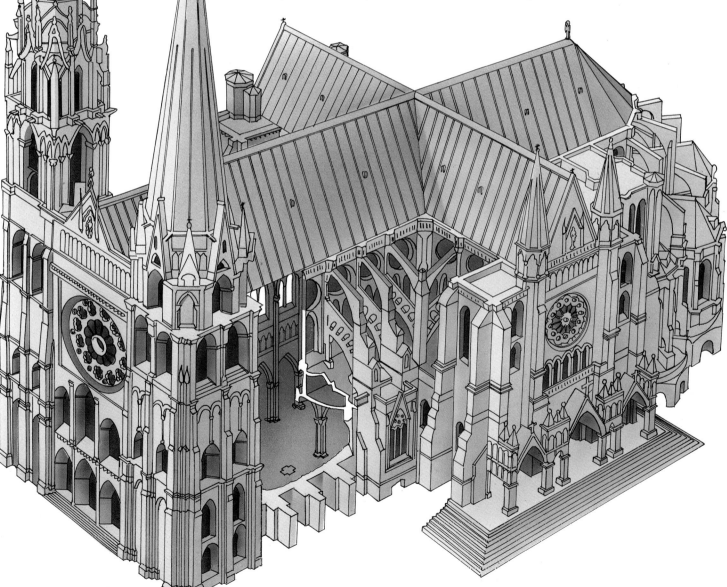

places, hospitals, bridges – such as at Avignon (c. 1180), at nearby Pont St. Esprit (fourteenth century) and at Cahors – castles and private houses. Perhaps the most famous are the walled towns of Carcassonne, rather over-restored by the French architect Viollet-le-Duc in the nineteenth century, and Aigues-Mortes, near Marseilles, built by St. Louis as port for the Crusades. Another famous building is the Jacques-Coeur house in Bourges (1443–51). Two fine Gothic hospitals are at Angers (St. Jean, c. 1190) and at Beaune, from two and a half centuries later. The Palais des Papes in Avignon, where the Popes resided throughout much of the fourteenth century, and the Avignon town walls are other non-religious structures. An exceptional castle that was also a royal residence is the Château de Vincennes (1306–07). There are also a few town halls that have survived in northern France. Examples are at Arras and Douai (both c. 1460) and at St. Quentin.

There also remain a few religious and non-religious Gothic structures in the Near East

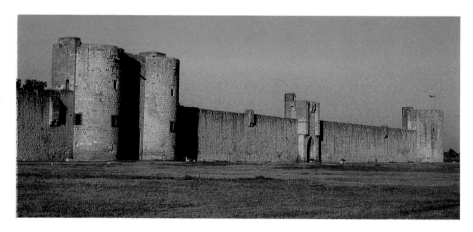

and in the Mediterranean, built under French influence at the time of the Crusades.

Architects. During the Romanesque and Early Gothic periods architects were hardly considered. Only rarely do we know their names. It was – as in the case of Abbot Suger at St. Denis – the patron or the commissioner of a work who was considered to have made it, not the architect. Suger left detailed descriptions of his intentions during the construction of the choir at St. Denis, and as well aware of how

important the work was; but there is no mention of the architect or architects.

This is partly due to an attitude that held craftsmen, even the builders of great structures, in low esteem. Besides, men were equally God's servants, regardless of their

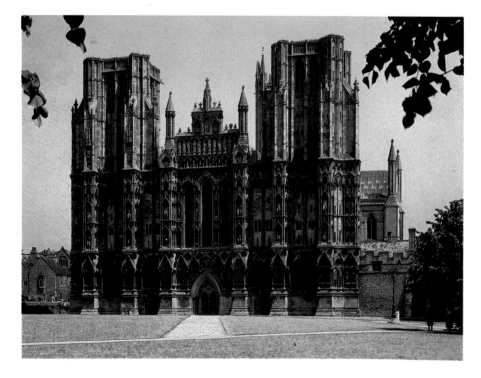

talents But it also springs, clearly evident in Suger's writings, from the concept that an object was an expression of an idea or a wish. It was the person who had an idea and decided to materialize it who was considered to have made an object – not the craftsman. The medieval difference between science and craft was that science was thought, understanding, truth; craft was mere fabrication. As the Gothic period developed, architects came to be recognized not only as master craftsmen but also as artists. Names appear more fre-

Above: outer walls of Aigues-Mortes, south of Nîmes, built c. 1270–75. Like Aix, Aigues means "water" in old Provençal, but the town is inland. The port was controlled by the French Crown and served for the last Crusades as well as trade with Italy.

three hundred of the four hundred original thirteenth-century statues on the façade remain. The arches within are unusual: the chapel of the Virgin and the chapter-hall are fine examples of mature English Gothic.

Left: Wells Cathedral, Somerset (1186–1239). Built at the same time as many big Gothic churches in France, it is smaller and lower than most of them. It goes back to pre-Norman and Norman examples, and to the English taste for decorative architecture:

Opposite: Canterbury Cathedral, Kent (c. 1174–1500). The choir of William of Sens, 1174, is among the oldest Gothic; the cloisters, chapter-hall, chapel of St. Michael and the central tower (its fan-shaped ceiling is shown here) are later Gothic.

quently, until by the end of the Gothic period and the beginning of the Renaissance it is normal to know architects' names and sometimes even their personalities. As man and his doings became more important, so did architects.

Gothic architecture outside France

English Gothic. Just as the arguments used by the scholastic schools of the Île de France to reconcile faith and reason fanned out all over Europe, so did the French Gothic style. But in England, where the monastic Benedictine tradition remained strong, Gothic retained a conservatism and a Romanesque taste for detail. From Norman times onward it expressed England's character and England's Christianity, just as French Gothic expressed France's, hardly heeding outside influences. But, whereas French Gothic, once firmly established at Sens, St. Denis and Laon, became a universal idiom imitated everywhere, English Gothic had

little influence outside England.

It remained essentially local, lacking the force of French structural accomplishments, and preferring decoration to clarity. English Gothic is essentially pragmatic and romantic, springing from feelings; the French is analytical and intellectual and springs from the mind. English is enormously conscious of the material world; French, of space and light. Both grew from earlier Lombard and Norman architecture, but the English was more influenced by the conservatism and materialism of the rich Romanesque Abbey of Cluny, the French by the aestheticism of Cîteaux.

The influence of the Norman churches at Caen is evident in the large pilgrimage church at Durham, begun with ribbed vaults and concealed flying buttresses in 1093, some forty to fifty years before Sens or St. Denis. Then, in the first half of the twelfth century, the Cistercians built Rievaulx (1132) and Fountains (1135), both of which show strong tendencies toward what became Gothic construction: at Rievaulx the arches are pointed,

the vaults are ribbed and the church has three storeys; at Fountains the refectory arches are pointed while the vaults are ribbed, ascending together to form a central vault over five-part compound piers. These, and many other Gothic elements come together to form full Gothic buildings by the end of the century: Worcester (1185), Chichester (1187), Rochester (1190), Wells (1191) and the great cathedral of Lincoln in 1192. These are the same years when Laon, Senlis, Noyon and Notre-Dame in Paris were being built in France.

French Gothic arrived in England from the Île de France in 1174, when William of Sens was employed to rebuild Canterbury Cathedral. He may or may not have been one of the architects at Sens, begun some forty years before, but he can hardly not have known the building. He designed a new choir at Canterbury, which is essentially a French building. But this direct French influence was limited in England. The country's own Anglo-Saxon and Norman architectural tastes were so long established and so well developed that French

ideas were merely incidental to its progress.

In the first half of the thirteenth century, a number of particularly fine structures were built which constitute, together with the earlier structures, the first, Early English phase of three periods of Gothic building in England. The fine cathedrals at Wells and at Salisbury (1220), as well as the Abbey at Westminster in London (1240–63), are examples of this style. English churches are on the whole much longer and narrower than their French counterparts, less high. They often retain the square apse dating from earlier times and a double transept.

Salisbury is the perfect example of this earlier style. It has little of the vertical movement of French structural elements, and whereas the interior light is considerable, there is as much of it below the triforium as above. This contributes to the building's interior horizontality.

The second phase of English Gothic is called Decorated, and is a considerably more ornate phase, characterized by rich interior

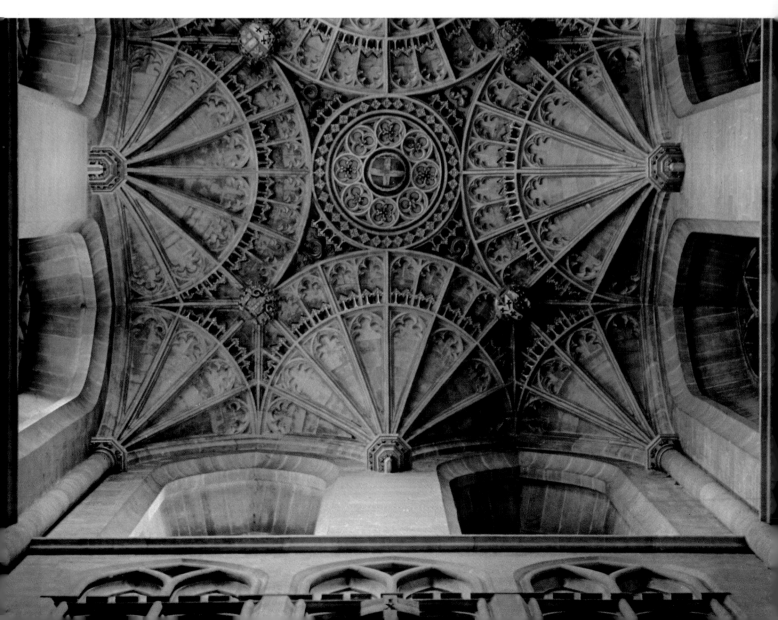

sculpted decoration. The vaults, in particular, become so patterned with ribs that the ceilings lose the rhythm of the succeeding bays. This, and the considerable spatial movement of light falling on very rich decoration, plus the great length of the buildings, emphasizes even further the horizontal tendency of English Gothic. The development of this more ornate style can be seen from the interior of Exeter (c. 1290) and from its lovely sculpted façade. Other fine examples are the gem-like exterior of Lichfield, with its three completed towers, and the magnificent Lady Chapel and Octagon crossing at Ely (1320–30).

Perpendicular, the third and final phase of English Gothic, derives its name from a return to a softer, more dominantly vertical character, broken by horizontals at right angles. There is no finer example of this than the choir at Gloucester Cathedral (1337), where the whole eastern wall has become glass. The Cloister (1351) is a logical extension of this Perpendicular style: beautiful covered walks with intricate fan vaults, which appear almost as a vine-covered pergola.

Parish churches in the Perpendicular style are particularly numerous and beautiful in England, reflecting the shift toward trade and democracy that is characteristic of England. In Suffolk and Norfolk the wealth from wool produced many lovely large churches in small villages, such as that at Stoke-by-Nayland.

Two other remarkable examples of the Perpendicular, which combine the fan vaults of Gloucester Cloisters with the verticality of its choir, are King's College Chapel at Cambridge (1446) and St. George's Chapel at Windsor (c. 1500). Both are purely English and, both being chapels, point to the later patronage of Gothic that displaced the Church: kings, guilds and private patrons.

Worms Cathedral, c. 1182–1234. Not far from Burgundy, it kept in Gothic times a Romanesque flavour, linked with French and English Cistercian churches built fifty years earlier. Miraculously its four towers are extant. The splendid south portal is Gothic and bears magnificent sculptures.

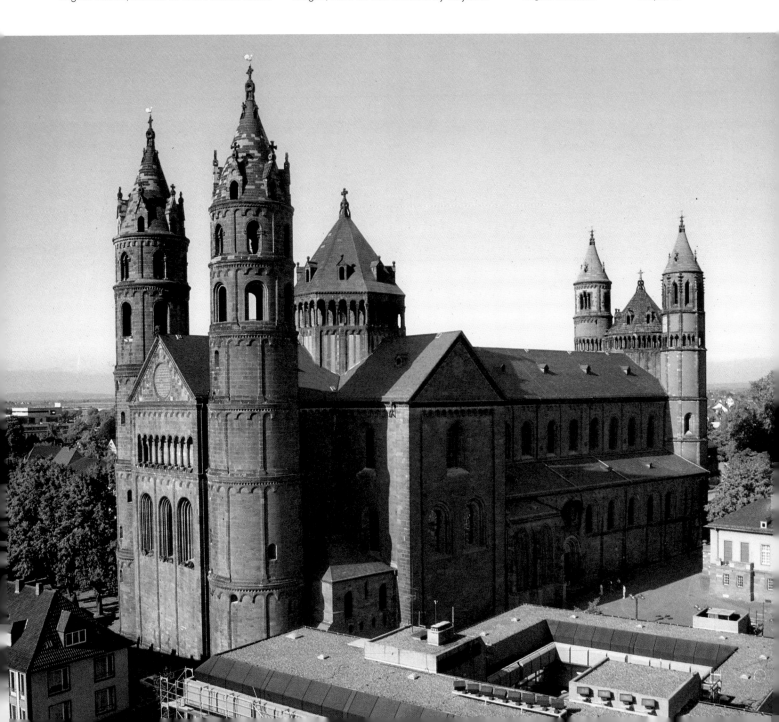

Gothic military architecture that has survived in Great Britain is also very fine. The Tower of London, still in use some 900 years after its foundation, is a foremost example. Dover is another, as are the later castles of Wales: Harlech, Caernarvon, Conway and Beaumaris – built at the end of the thirteenth and beginning of the fourteenth century.

There were other castles developed, more for residence than warfare, such as Penhurst and Ightham Mote in the south of England, as well as manor houses – country residences that were barely fortified.

Colleges such as Eton retain a few of their Gothic domestic buildings, as do some at both Oxford and Cambridge. There are also fine extant examples of Gothic guild-halls.

German Gothic. In the German-speaking world to the north and east of France, and in the countries and territories along the shores of the Baltic, French Gothic took deep root. It appeared late, and expressed there not so much an attempt to reconcile faith and reason, as a firm statement of Christian faith. This was also true in Spain, where the force of the Catholic Gothic was a perfect vehicle to displace the Islamic culture and beliefs of the preceding centuries.

German Gothic architecture can be divided into three main movements. The first is a Cistercian proto-Gothic movement during which the various elements of Gothic are present but not joined into a cohesive system. The second is that which resulted from the influence of Amiens and Rouen. This can be seen in the structure of Cologne Cathedral (1248).

The third movement is what particularly distinguishes German Gothic religious architecture, and is the one that develops fruitfully over a long period. It is based on the concept of the *Hallenkirche* (hall-church). This is a church in which the aisles are of the same height as the nave. This eliminates the nave's triforium and clerestory, essentially uniting the entire interior space into that of a large hall with two or four rows of columns or piers, and tall windows along the sides and in the apse of the building. It also changes the roof arrangement so that there is only a single large roof. One important advantage of this in northern Europe is that the pitch can be made steep enough to cause snow to slide off.

The proto-Gothic period, when Cistercian ideas from Burgundy were brought to Germany, saw the building of the cathedrals at Worms (1185) and Magdeburg (1209), and the abbey at Maulbronn (1201). Cistercian influence also extended southward, into Switzerland (Basel Cathedral 1185). The cathedral at Limbourg an der Lahn (*c.* 1212), and Bonn Cathedral (1220) remind one somewhat of English buildings put up by the Cistercians a hundred years earlier.

The cathedral at Strasbourg, St. Elizabeth's Church at Marburg, and the Liebfrauenkirche in Trier, all from about 1235–1240, signalled the full-blown arrival of French Gothic in Germany. This is also true of the minster at Freiburg im Breisgau, although the building of this church, with its beautiful spire, was seriously interrupted between about 1218 and 1250,

French Gothic spread toward the Baltic (Breslau 1244 and Torun *c.* 1260), and Scandinavia (Uppsala *c.* 1270), to Bohemia (Prague 1356) and Austria (St. Stephens, Vienna, 1304). The cathedral at Cologne, started in 1248 but not finished until the nineteenth century, was meant to be the highest and largest of all the cathedrals, outdoing the French in their own style.

Perhaps the finest of all the buildings in this German tradition of the French Gothic is the minster at Ulm, with its combination of a taller central aisle and four side aisles, almost forming two *Hallenkirchen* within the French Gothic whole.

St. Elizabeth at Marburg is an enormously elegant *Hallenkirche* with two superimposed rows of windows in the outside walls. This taste for large, spacious halls was reinforced in the thirteenth and fourteenth centuries by the arrival of the Franciscans and the Dominicans, with their need for vast preaching spaces. Later examples are the Heiligkreuzkirche (*c.* 1310–20) at Schwabische Gmund, and the Abbey at Zwettle begun in 1343.

Finally, with St. Barbara at Kutna Hora (Kuttenberg), German Gothic of the fourteenth and fifteenth centuries produced a remarkable building, almost its swan-song, combining a traditional Gothic nave with two side aisles and a *Hallenkirche*: the latter forms a second storey, superimposed on top of the former. The roof of this astonishing building appears as a Gothic fantasy, looking like three tents surrounded by the pinnacles and spires of the church buttresses.

The Low Countries. As it did in Germany, the Gothic arrived late in Belgium and Holland. At first, as everywhere, the influence of the Cistercians was important, followed by that of the French Gothic. An early example of the French influence is at Tournai (1242); another is the main church at Brussels, St. Gudule (*c.* 1225); a later one is Hertogenbosch (1280). The cathedral at Utrecht was begun in 1254. There are many surviving churches from the Flamboyant period – for example St. Jacques at Liège and Notre-Dame at Antwerp. Other fine Gothic churches have survived in many Dutch cities.

Although the Gothic style did not develop in those countries until quite late, it was in Germany, Belgium and Holland, as well as in Poland and the Baltic countries, that it lasted the longest and strongest, particularly in civil architecture.

Gothic developed in northern and eastern Europe after Christianity had already lost much of its influence to pressures from commercial society. Fine Gothic town halls and guild-halls were the expression of trade. Many of these still survive in spite of the ravages of the twentieth century. Others have been rebuilt.

The *château* or *burg*, large fortified private houses, are other manifestations of this. Kings, nobles, guilds and towns replaced the church as patrons, especially after the Reformation in northern Europe, when Christianity splintered into many Churches. It is for this reason that smaller parish churches and Guild chapels displaced the big, centralized abbeys or cathedrals as expressions of Christianity.

Lübeck and Tórun still have fine town halls, built over long periods, as do Middleburg and Stralsund, and many other towns in the north of Europe. Cracow still has its Wawel and Prague its St. Charles Bridge. Castles and large houses, romantically harking back to the stability of the twelfth and thirteenth centuries, often remained outwardly Gothic late into the seventeenth and eighteenth, and even into the nineteenth century.

Spanish Gothic. Because of the pilgrimage routes through France to Santiago de Compostela in northern Spain, and the close co-operation of France and Spain during the battles to rid Spain and Portugal of Muslim control, Spain was strongly influenced by the French Gothic. Once this style had become established as a perfect and adaptable replacement for Muslim taste, it embedded itself deeply into Spanish culture.

The pointed arch, which arrived in northern Europe in the second half of the eleventh century, may possibly have been brought there from Spain.

Burgos is the first of the many great Spanish Gothic cathdrals, begun in 1221, at more or less the same time as Amiens and Salisbury. It combines an interior that is almost a copy of a French church with an exterior that shows, particularly in the beautiful twin towers of the western façade, influence from Germany. Three generations of a family of Cologne architects worked on the building, which terminated, so to speak, in the wonderful star-shaped *cimborio* (1540), over the crossing, so reminiscent of Muslim Spain. Burgos, like many of the Spanish cathedrals, has a particularly fine cloister, an element retained from the Arab domination of the Iberian peninsula.

Toledo and León cathedrals succeeded Burgos, in 1227 and 1253, both also greatly influenced by French Gothic, particularly León – which is, again, almost a French church, but inspired by Reims. Toledo, too, is imitative, but shows the Mosque influence by its great width and by certain architectural details. Its other important quality is the great wealth of Gothic and post-Gothic art that the church still preserves inside.

The cathedrals of Barcelona (1298) and Palma (1301), together with the church of Santa Maria del Mar in Barcelona (1328), represent the middle period in Spanish Gothic

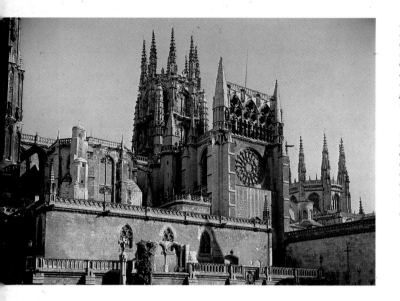

Left: the door of Sarmental on the façade of Burgos Cathedral (1222–60). The interior of Bourges Cathedral is a complex and elegant unity, but that of Burgos joins Moorish decoration to Christian zeal.

Opposite: St.-Marie, Batalha, prime example of Portuguese Gothic church architecture. The cloisters are fifteenth century. Much Portuguese Gothic has fallen victim to wars and earthquakes.

and are particularly Catalan developments. Barcelona has high piers, which rise without capitals to the springing of the vaults. These more or less eliminate the triforium and clerestory, while giving the impression of a single, enormously high hall. Santa Maria del Mar, slightly later, has an integrity and unity that are grand points in Spanish Gothic. Its vaults, on piers that rise 18m (59ft) without a break, are similar to those of the cathedral, but are even more successful in creating a great sense of space covered by extremely light vaults.

At Palma Cathedral, with vaults almost the height of ill-fated Beauvais, the sense of height is lost slightly by the lower side aisles. The exterior, with two smaller chapel buttresses placed between the eight nave buttresses on each side, gives an impression of a Gothic fortress, light and space flowing in and out of battlements.

The cathedral of Seville, begun in 1401 in the sober times before the wealth of the New World started to pour into Spain, is one of the most extraordinary and even exotic buildings in a long period of unusual building. Built on the site of a large mosque, it took more than a century to complete. The plan of the church is large, a high central aisle with an aisle on each side. Its length is 130m (426ft), its width 75m (246ft), with the main nave 40m (131ft) high. There is no triforium, but instead a highly decorative balustrade, which sets the tone for the lavish interior, including intricate and very complex web vaults over the crossing.

Spain in the sixteenth century was the political center of Europe, and the greatest church builder. Although the Gothic style was hardly carried to the New World, in Spain itself building continued unabated throughout most of the century, much of it in a Gothic style. Salamanca Cathedral was started in 1512–15 and Segovia in 1525; both are still essentially Gothic buildings.

Spain has, dating from the fourteenth century onward, many buildings that were designed for civil use – town and guild-halls, private palaces, castles and fortresses – particularly in Catalonia, where Mediterranean trade was highly developed. In Barcelona there is Il Tinell (1359), a fine council room in the Royal Palace. There is also an old Town Hall (1369), and the Palace of Deputies (1416). At Palma, the thirteenth-century Bellver is a remarkable circular fortress, while the Almudaina of 1305 is built on an early Muslim construction. Le Lonje, or Trade Exchanges, of both Barcelona (1380) and Palma (early fifteenth century) are fine examples of civil architecture of the time, as is the Lonja at Valencia (1490). Other notable monuments are the walls at Avila, from the twelfth century, the Alcala de Guadaira from the thirteenth, and the University of Salamanca from the fifteenth.

Portuguese Gothic. As most everywhere Portugal received its first Gothic building from the Cistercians. The finest of the early buildings is at Alcobaça, begun in 1178, a truly noble creation and a fitting monument to those extraordinary reformed Benedictines, who carried such wonderful buildings to every corner of Europe. Alcobaça seems to stand alone. For it is not until the thirteenth century and the arrival of the Franciscans and Dominicans that other Gothic structures appear – the most notable being Santa Clara (of the Franciscan Sister order – the Poor Clares) at Santorém. Sadly, the churches built by the Friars in Lisbon (the most important establishments of the Orders in Portugal) were destroyed in an eighteenth-century earthquake.

In 1388, the finest of these Friars' churches was built at Batalba, a truly remarkable building combining Christian and Muslim influences of the Mozarabic style, but with references to the English Perpendicular.

Compared to the quantity of Spanish Gothic, Portuguese is limited. This was partly due to Portugal's struggles for independence from the Arabs and from Spain. The rich, late phase of Portuguese Gothic is called Manueline (after King Manuel I, 1495–1521), and can be seen in Lisbon at the Jeronimin convent of Belém, begun in 1502. The columns of this ornate hall-church are covered with ornamental sculpture, while the vaults have tightly packed star patterns.

Gothic Art in Italy. Although some of the elements from which Gothic art grew appeared very early in Lombardy, Gothic architecture actually had a limited appeal to the Italians. This was partly due to the Classical remains, which still existed everywhere in Italy and which continued throughout the post-Roman period to appeal to and to affect Italian taste. Classical taste not only reduced the influence of early Gothic but from about 1400 onward displaced any tendencies toward the Gothic with those of the Renaissance. Besides, the Gothic style grew from Cistercian and northern-European ideas about God and light. In Italy light is often overabundant and associated with heat. Churches filled with glass appealed less.

Nor had city life or trade in Italy ever ceased to exist completely. The movement away from a Church-governed or dominated society was already evident in the thirteenth century, with the rise of the Italian city-states, and in the many Italian reform movements. That of St. Francis was a veritable revolution within the Church, based as it was on a personal Christianity and poverty. St. Francis had even preached originally that his followers were to be without any churches or monasteries altogether – they were to have lived begging in the streets: this is the antithesis of Gothic art.

The direction of reform became accelerated in the fourteenth century by the papacy's long residence at Avignon (1309–79), and then by the Great Schism, when there were a number of contemporaneous popes.

It is not surprising that the artistic reforms of Donatello, Brunelleschi and Masaccio happened in precisely the same years and reflect a strong anti-Church sentiment that made any return to the Gothic impossible. The scale of this reform may be judged by the fact that Milan Cathedral was begun in the years of Brunelleschi's childhood and adolescence.

As one would expect in a country in great part dominated not by the Church but by communes, independent principalities and trade, few of the more or less Gothic religious buildings built between the twelfth and fifteenth centuries are as original or interesting as many of the civil structures put up in the same years: fine examples of secular architecture are the Castel del Monte (1240), together with the other castelli in southern Italy and Sicily from the same period – the town halls of Siena (1258), Florence (1298), Perugia (1283),

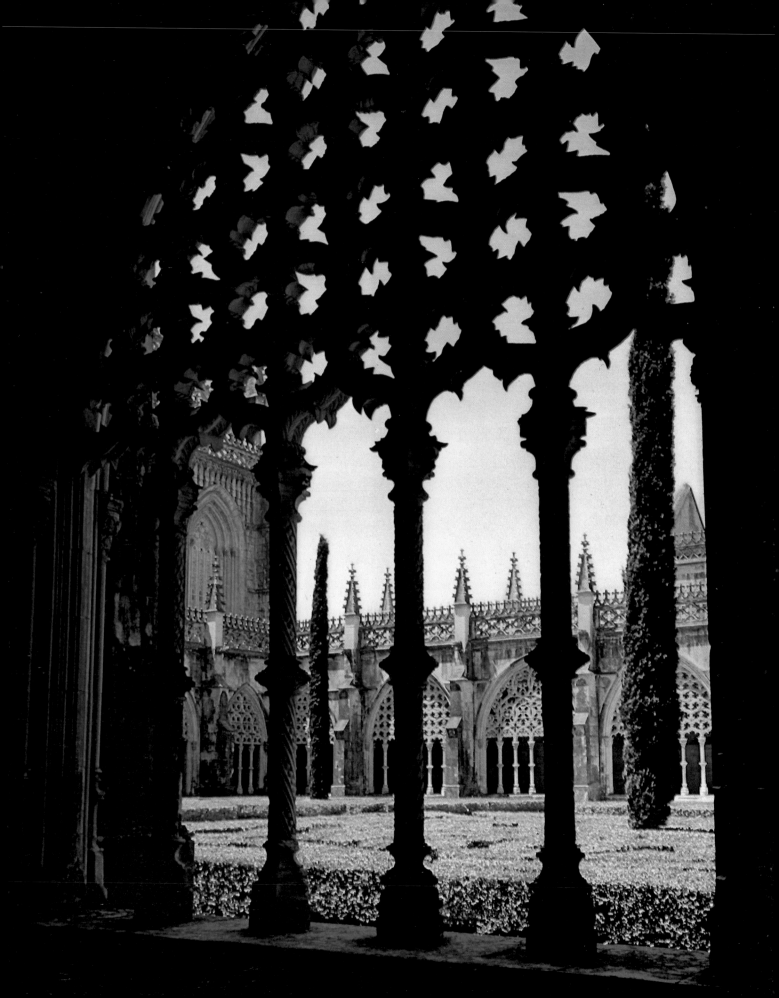

Gubbio (c. 1325), Genova (thirteenth century), Piacenza (c. 1280) and Orvieto (c. 1250), and the palazzo dei Dogi in Venice (1390); there are also remarkable private *palazzi* and *castelli* all over Italy which date from these centuries, particularly in the north, where the Castlevecchio in Verona (c. 1360) and the Castello Visconti in Pavia (c. 1365) can serve as examples, together with the Ca D'oro in

fourteenth century (except for the Cupola), with its vast, hall-like space and its Campanile designed in about 1333 by Giotto. SS. Giovanni e Paolo in Venice and S. Maria della Spina in Pisa, are also fourteenth-century Gothic structures. Toward the end of the century, both San Petronio in Bologna and the Milanese cathedral were started – the latter not to be finished until the nineteenth century.

human Christ, the Virgin and Child, the other Marys, the Apostles, people who only lived twelve or thirteen centuries before. These latter people, although Christian, began to dress and then move like heroic figures from the Roman world. They became classic.

Finally, of course, other figures entered Gothic sculpture – as they entered Gothic paintings: the donor, the dead and the living,

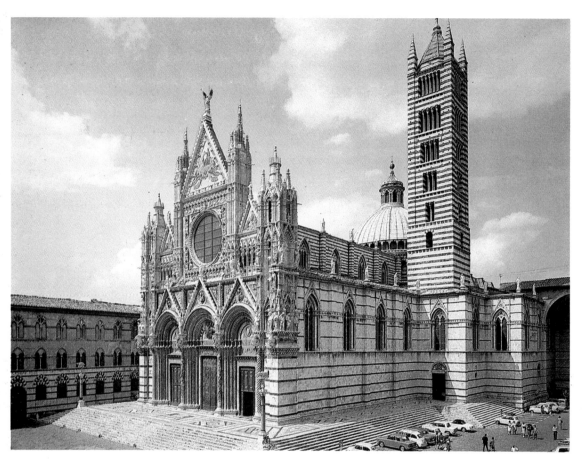

Left: Italian Gothic never developed as in the north, both for spiritual and structural reasons. Light abounds in Italy and this does not lend itself well to suggestive power. Moreover, mercantile society fragmented into city-states was not stable enough for long-term building, and Renaissance ideals soon outgrew foreign Gothic notions. The façade of Siena Cathedral (1285), designed by Giovanni Pisano. Siena, Orvieto and some other churches, particularly at Pavia, are the peak of Italian Gothic.

Below: St. John the Baptist in the Desert, low relief on the south portal of the baptistery at Florence, by Andrea Pisano (1330–36).

Venice (c. 1425).

The Cistercians brought their proto-Gothic church architecture to Fossanova in central Italy in 1187 and to Casamari in 1203. These buildings were followed by fine Italian Gothic buildings which, however, have little of the height or light of northern Gothic: Sant'Andrea at Vercelli (1220), San Galgano (Tuscany, 1227) and San Francesco at Assisi (1228). Other significant Gothic churches of the thirteenth century are Siena Cathedral (c 1250), San Lorenzo in Naples (1270), the Camposanto at Pisa (1277), and in Florence Santa Maria Novella (1278), Santa Trinita (1258–80), and S. Croce – which has neither main vaults nor buttresses, but is considered to be Italian Gothic because of its pointed arches and the date of its construction (c. 1300). The two very Gothic façades of Siena and Orvieto are dated, respectively, c. 1284 and c. 1310. Most of the Florence Cathedral was built in the

Gothic sculpture

This began at Chartres. It grew out of Romanesque sculpture, which served it as a base. But, whereas Romanesque is static and essentially about death and resurrection, Gothic is about human beings and life.

Gothic sculpture began in the neat portals of Gothic churches, which is where Romanesque sculpture ended. And whereas, at first glance, the Gothic figures of the Port Royal of Chartres' western front appear Romanesque, they are not. They are columnar and still deeply attached to the architecture, but they are already something quite different: man about to free himself of buildings and hierarchies, about to step down into the world.

At first, mythological prophets and heroes of the Old Testament were represented. Slowly but steadily Gothic figures came more and more from the New Testament: the adult

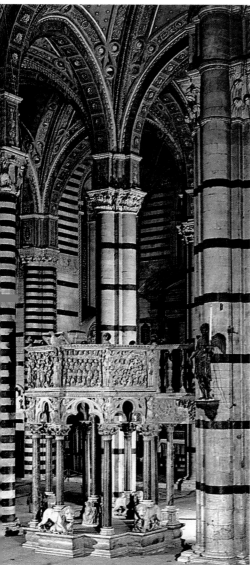

This has, of course, to do with man's changing view of himself. He travelled from a Romanesque world, where he was rigidly attached to a dark and immobile church, a sinner dying in a world of immortal heroes, to a new world where he is himself a hero, striving toward humanism and classicism.

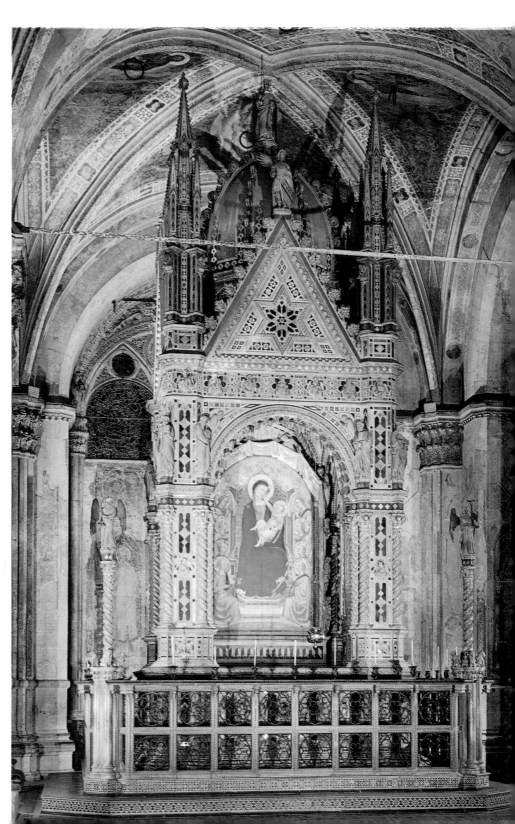

the architect, Everyman. Eventually the balance turned: when sculpture stopped being primarily Christian and secondarily about man and nature, when it began being primarily about man and nature and secondarily about Christianity, then the Renaissance began, and Gothic sculpture ended.

The doorways of Port Royale at Chartres (1140–50), survived the fire of 1194 and were incorporated into the new cathedral. Gothic plasticism, already evident there, continued to develop throughout the 1100s: at Bourges in mid-century, at Le Mans a few years later, on the west front of Angers in 1165, at Paris on the St. Anne tympanum in 1167–75 and at Senlis in 1175–85. Sculpture at Laon and Nantes, on both transept portals at Chartres, and at Reims, all demonstrate the enormous power of fully developed Gothic sculpture – equal to much of that of the Classical world.

Two currents developed. One can be seen on the Virgin Portal at Notre-Dame in Paris, and is naturalistic and almost academic; leading eventually to the linear, painterly, late-Gothic work of Ghiberti. The other is at Reims, in the *Nativity* of 1230–40, the *Resurrection* of c. 1235, and the *Visitation* of c. 1240, where we see the approach of the spacious world of Donatello and eventually of Michelangelo.

In the later thirteenth and in the fourteenth century, French sculpture developed a delicate lyricism. It became concerned with the decorative and even the precious, as though waiting patiently for the arrival of the Renaissance.

Below: Royal Door, Chartres Cathedral, 1145–70. Most of the façade sculptures at Chartres, from the transition period from Romanesque to Gothic, were saved from the fire of 1194. On the right, a statue of Christ on earth; on the left, Christ ascending into heaven. In the center: Christ in majesty surrounded by apostles and others.

Right: detail of the Knight of Bamberg, in Bamberg Cathedral, c. 1235. The image of the knight and of his patron, St. George, are increasingly humanized: the Gothic knight has become a portrait and the statue is quite detached from the architecture. Besides, the statue, inside the church, makes human a space earlier reserved for Christ as God with the Virgin.

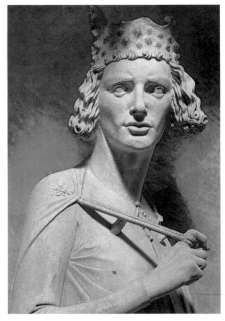

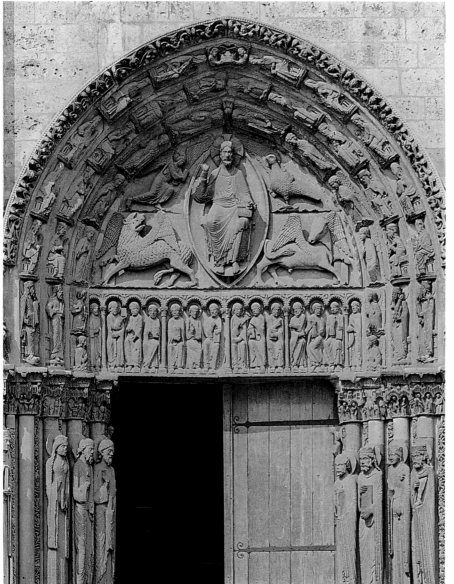

The major exception to this, Claus Sluters, was a Fleming who worked at the end of the fourteenth and the beginning of the fifteenth century for the Dukes of Burgundy. His extraordinarily realistic and monumental work in and near Dijon is a complete break from the Gothic idea of sculpture as part of architecture. He was really an early Renaissance figure who lacked the classicism of the South.

In France at the Revolution, as in England during Cromwell's time, great amounts of decorative Gothic sculpture were destroyed. Nonetheless, it is clear that English Gothic sculpture retained a decorative and romantic quality, much less monumental than the French. The best examples of façades with abundant sculpture are Salisbury, Exeter and Wells. Whereas in France the Gothic continued as an expression identified with the Royal House, in Parliamentary England, it was among the effigies of prominent people, both religious and secular, that the most interesting developments in sculpture occurred. The greatest mausoleum of these figures is Westminster Abbey in London, where a fine panorama of late-Gothic sculpture lies on the many tombs there.

German Gothic sculpture is, at first (Strasbourg c. 1230), fairly dependent upon French models. But whereas the so-called Bamberg Master may have worked at Reims, his naturalistic *Rider of Bamberg* (1235) is such a powerful expression of man's will and personality that, together with the work of the *Master of Naumburg* (1245–50), he set German sculpture into a personal and often mystical mould that lasted well into the Renaissance. Another great master of this period,

who illustrates the steady humanization of Gothic sculpture, is the sculptor of the *Wise and Foolish Virgins* at Magdeburg.

Such sculptors as Nicholas Gerhaert (*c.* 1430–73), Hans Multscher (*c.* 1400–67) and Tilman Riemenschneider (1483–1531) struggled within a less and less Gothic idiom and dealt with an increasingly naturalistic and representational world.

Like Italian architecture of the period, Gothic sculpture in Italy was subject to local influences, in particular Classical ones. From its inception, with the sculpture of Nicola Pisano (1210–78) in the thirteenth century, through that of his son, Giovanni (1248–1314), that of Andrea Pisano (1290–1349) and his son Nino (1310–68), the force of Classical sculpture is always evident. Arnolfo di Cambio (*c.* 1245–1302), Tino di Camaino (*c.* 1280–1337),

Calvary, *or* Well of Moses, 1405–06, Champmol near Dijon. This well is one of the few extant works of Claus Sluter (most of them were destroyed at the French Revolution), greatest Late-Gothic sculptor (c. 1340–50, Haarlem–1406, Dijon). He worked in Brussels and then Burgundy for Duke Philip the Bold as court sculptor. This well was once highly coloured, as were many painted sculptures in northern Europe. Designed as the base

for a Calvary grouping the Virgin, St. John and St. Mary Magdalen, with (below) six biblical figures: Moses, Isaiah, Daniel, Zaccharias, Jeremiah and David. The sculptor executed many other works for his patron, among them parts of the Duke's tomb. Sluter had great influence in the fifteenth century, above all in France, but also in Italy, where the southern sculptor Nicolo dell'Arca reflects the master's realism.

Lorenzo Maitani (*c.* 1275–1330) and Andrea Orcagna (*c.* 1308–68) are other important names in Italian Gothic sculpture, as is Lorenzo Ghiberti, who, right into the fifteenth century continued to produce sculpture that was still Gothic in some of its important features.

Spanish Gothic sculpture was at first imitative of French, as were the cathedrals themselves, particularly León and Burgos. It was the sculpture at Amiens and Reims that provided Spain with the most stimulus in the thirteenth century.

In Portugal the Romanesque remained valid until very late. As with the architecture, sculpture's development was held back by local pressures. Only in the fourteenth and fifteenth centuries – and then mostly in tomb art – did a strong local Gothic style develop.

Spanish Gothic flourished in the fifteenth century under various masters who executed magnificent ornate altar frontals, as well as numerous tombs and funeral monuments. In particular Rodrigo Aleman, Egas Cueman and Gil de Siloe, plus of course the two artists who made the large altar frontal at Seville – Jorge Fernandez and Peter Dancart.

Gothic painting

As with all the arts of the time, Gothic painting changed considerably over the 250 or more years of its development. This was greatly due to changes in patronage, those due in turn, to the increasing development of trade.

We do not know how much painting accompanied the earliest growth of the cathedrals. A great deal has certainly been lost, both altarpieces and wall paintings. But, compared to the intensely active period of painting in the second half of the thirteenth and in the fourteenth century, which accompanied the building of hundreds of Franciscan and Dominican churches all over Europe, the early Gothic period of painting was certainly less accomplished.

Much of the early need for pictorial effect or decoration was fulfilled by stained glass. No doubt frescoes and wall paintings *al secco* existed. But the Gothic ideal in the north of Europe, anyway, was to reduce wall to a minimum, so that painting would be replaced by stained glass wherever possible.

In Italy in the Gothic period mosaics were still used. This was an art that had been practised since Roman times. In Sicily, at Monreale, in San Marco in Venice, in Florence Baptistery, in Rome, and in other places, large mosaic pictures, or series of pictures, were made in the twelfth, thirteenth and fourteenth centuries.

The Church's patronage of painting was succeeded by that of the nobility. Then followed the merchants, individually and in their guilds. Perhaps the greatest monument in all of Europe to commercial patronage is the Arena Chapel in Padua with its *Scenes from*

the Lives of Christ and the Virgin, painted by Giotto for Enrico Scrovegni in 1305 – still succinctly Christian, but also worldly and modern.

Parallel to sculpture, and to a great degree, supplanting it, painting developed from an image of man at first static and hierarchial, but soon a figure independent of the Church, into one – as in works by the Van Eycks – whose essential references are the domestic world of business, with its real space and sunlight.

The extraordinary stained glass that so happily has survived at Chartres, at Bourges and at Paris shows the first stages of Gothic painting. It gives an indication, too, of how wall decoration – for enormous windows are really decorated walls of glass – was supposed to be colourful and vibrant, setting the whole interior tone of a church.

There are still many remnants of the twelfth- and thirteenth-century *fresco* and *secco* paintings, which existed everywhere, in various parts of France, in Spain, in England and all over Italy. *Scenes from the Life of St. Peter* at S. Piero a Grado, near Pisa, is a cycle from the thirteenth century that is still remarkably complete. And in Assisi at S. Francesco, and Rome, in S. Cecilia, there are remnants of frescoes by other masters who preceded Giotto's substantial expansion of the Western painting idiom.

Right: Gothic painting developed in the light of sculpture, as a spatial illusion on flat walls and panels. Here light shines as if from the sun, and man with his feelings and actions dominates nature. Annunciation by the master of Flémalle (Robert Campin) 1425–30, Prado, Madrid. Hubert and Jan Van Eyck and Roger Van der Weyden, transition painters, introduced Renaissance elements but with some Gothic details.

Below: Lamentations on the Dead Christ, Scrovegni Chapel, Padua, fresco by Giotto (1304–13). His scenes are more real than reality, for they breathe the essence of the moment.

Many panels and frescoes survive from the thirteenth and fourteenth centuries which begin to contain a new consciousness of the world's space and light, and an active, dominant man. The primary painters of this period were Italians: Giotto (c. 1267–1337), Duccio (c. 1278–c. 1318), Simone Martini (c. 1284–1344), the Lorenzetti (c. 1280/85–1348).

During the Gothic age, royal and noble patrons commissioned many illustrated devotional books, such as the Psalters of St. Louis in Paris, and the *Bible Moralisé* now in Vienna, with its wonderful image of God as an architect. These books contain exquisite paintings, which, having been made for the private devotions of people involved in the world around them, are often particularly modern in outlook, and point to future developments in painting.

An important figure in miniature painting at the end of the fourteenth century in Paris was Jean Pucelle. In England, at the end of the thirteenth and beginning of the fourteenth century, there was also a large production of illustrated books and manuscripts, many of which show clearly the awakening interest in man and nature.

In the north the transition from Gothic to Renaissance painting was not as sharp as it was in Italy – where Masaccio single-handedly, in the 1420s, established the forms of Western painting that would be valid until the time of Cézanne. The work of Melchior Broederlam, of

Jean Malouel, of the Boucicaut Master and many other northern late fourteenth- and early fifteenth-century painters was late Gothic. That of the Limbourg Brothers – the *Très Riches Heures* made for the Duc de Berry; of the Van Eycks, and of the Master of Flémalle was also Gothic, but the Renaissance interest in the natural world and in man began in their work to outweigh an apparent interest in the Christian faith and in its expression.

Nonetheless, strains of Gothic painting continued well into the fifteenth and sixteenth centuries, both in Italy, with such painters as Masolino (*c.* 1383–1440), Sassetta (*c.* 1400–

Below: miniature from the Très Riches Heures du Duc de Berry, *c. 1416, by the Limbourg Brothers (Condé Museum, Chantilly). This International Gothic tried to found a refined vision of reality. The exotic landscape includes fantastic elements with realistic details such as a view of Notre-Dame, Paris, beyond the hills.*

Right: detail from a fresco of the Church Militant, *by Andrea of Florence, Chapel of the Spaniards, S. Maria Novella, Florence. The Florentine cathedral is shown before the cupola was altered by Brunelleschi. In the center, the two great medieval powers, pope and emperor.*

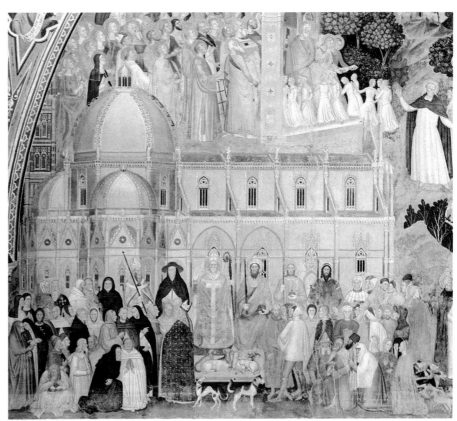

50), Stefano di Verona (*c.* 1370–1438) and Pisanello (*c.* 1395–1455), and particularly in northern Europe with Bosch (*c.* 1450–1516),

Pieter Bruegel (*c.* 1528–69) and Dürer (1471–1528).

Another kind of wall decoration, not painting at all but essentially pictorial and very reflective of the Gothic world, was the art of tapestries. Many of these have survived and are of great beauty, particularly those called the *Apocalypse* at Angers, the *Presentation in the Temple* in Brussels, and those of the Unicorn, the most medieval of all fantastic beasts, now kept at the Cloisters in New York and in the Musée des Thermes, Paris.

Enamel-painting on copper was another art brought to a high degree of perfection during the Gothic age. In 1181, Nicholas of Verdun made for Klosterneuberg, near Vienna, 51 stories of the Old and New Testament. These are full of dramatic expression, with graceful figures outlined with sinuous grace.

Ivories, medals and coins, jewellery, cloth for liturgical vestments, chalices and other vessels – all the so-called "minor" arts were highly developed to serve the religious and secular needs of society. These arts, like everything else, became less Christian and more "realistic" as European life was liberalized by trade.

International Gothic

This is the name given to a phase of late Gothic art *c.* 1375–1425 in which certain aspects of the Gothic, in particular a sinuous line and an attention to naturalistic detail, were emphasized. There is also a courtliness and elegance to the style at variance with the aims of the Renaissance, which begin to appear at this same moment.

By the first half of the fourteenth century, the European world had already moved considerably away from that essentially Christ-centered society of the Gothic age. Man's primary interest was shifting from God to the world. This is evident in all European expression of the time, but the names of Dante, Petrarch, Boccaccio and Giotto in Italy alone will suffice to illustrate how the world around him was becoming man's chief focus: all those artists centered their work on man and his life, rather than on God, the saints and heaven.

But then, during the middle years of the fourteenth century, Europe and particularly Florence, where the Renaissance consequently arrived earliest – suffered a series of traumatic shocks that served to push it out of the Gothic age and into the Renaissance: the Hundred Years War (1337–1453), the vast economic depression of the 1340s, and the Plague of 1348 and after, and the Great

Schism (1378–1419), which so discredited the Church that it never again recovered its former prestige.

International Gothic, which appeared more or less in exactly the years of the Great Schism and continued for some years after it, was a result of the inertia that Europe suffered after all those shocks and the nostalgia for the security and strength of earlier Christian times. It was a courtly, decorative movement, a sort of limbo, when from timidity man concentrated on unimportant details, rather than weighty essentials, before he had gathered up the courage to make the Renaissance.

Lorenzo Monaco's *Coronation of the Virgin* (1414) in the Uffizi in Florence is part of this retro-vision. The predella panels show the artist much freer to join the Renaissance, which was beginning to blossom all around him in the nearly contemporary work of Brunelleschi, Donatello and Masaccio. But in the main scene he painted another world: we see there a lovely testament to the Gothic age.

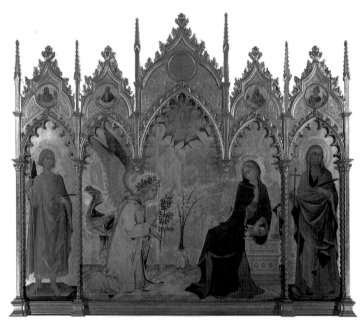

Left: Annunciation *by Simone Martini, Uffizi, Florence, 1333. Made for the Chapel of S. Ansano, in Siena Cathedral. The painter stresses the lines of garments, reducing the volume of bodies to a minimum. The use of gold further reduces space and heightens the tension of the moment more than the bodily features of the figures.*

Below: Effects of Good Government in the City, *by Ambrogio Lorenzetti, active 1324–8. The painter expresses man's growing interest for a natural setting of his own dimensions.*

The Gothic revival

Gothic architecture was almost entirely eclipsed during the Renaissance – in Italy from *c.* 1400 onward, and in northern Europe from *c.* 1500. But the style remained valid in some places where Gothic buildings predominated, and where structures begun in earlier centuries went on slowly being completed.

In the eighteenth and nineteenth centuries, perhaps as a reaction to the industrialization and growing atheism of Europe, a strong nostalgia for the past brought a return to an imitative Gothic style known as the Gothic Revival. Buildings were made to look "Gothic" by the incorporation of a linear quality, pointed arches, stained glass, pinnacles, spires, etc.

But this nostalgia, like most Christianity of the nineteenth century, was preoccupied with exterior appearances rather than internal structure. Gothic Revival architecture – particularly Church architecture – when compared to the Gothic buildings of the twelfth and thirteenth centuries, reflects this superficiality. Many structures from the period have survived: the Woolworth and Chrysler buildings in New York are secular neo-Gothic structures of this century, while such buildings as St.

Mary's, Edinburgh, and the *Votivkirche* in Vienna, both from the last quarter of the nineteenth century, illustrate the enormous popularity of the style for religious buildings.

As mentioned earlier, the Catholic and Protestant cathedrals of New York City – St. Patrick's and St. John the Divine – as well as Gaudi's twentieth-century church of the Holy Family in Barcelona, are all still under construction in a style that is modern Gothic.

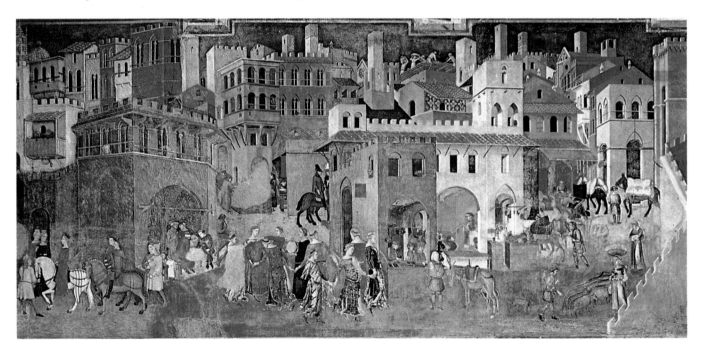

The Renaissance in Italy

The concept of Renaissance, or rebirth, was first postulated in humanist circles when important texts and objects of Greek and Roman civilization were discovered in the second half of the nineteenth century. The term describes the period of Classical revival in Europe from about 1400 to 1540.

The world of antiquity was reborn, bringing the metaphysical world of the divine face to face with the physical world of man, supplanting the medieval spirit by a new, rational order that in the world of the arts first took root in architecture. This chapter therefore opens with Filippo Brunelleschi (1377–1466), lucid theoretician and brilliant expositor of modern perspective, who governed space by the strict application of mathematical principles. These principles, or laws of perspective, enabled Florentine painters to impose a three-dimensional order on a flat image; they came mostly from the Tuscan hill towns and influenced the Renaissance movement to a greater or lesser degree according to the rigour with which they applied these laws.

Brunelleschi perfected the spatial experiments initiated by Giotto and developed by his followers, the Master of St. Cecilia, Taddeo Gaddi and Maso di Banco. Mathematical analysis of space was accompanied by anatomical analysis of the body. Thus, lavish ornament and surplus graphic detail of any kind came to be regarded as old-fashioned survivals of Gothic taste, though persisting in the style, known as International Gothic, of Gentile de Fabriano and Pisanello and their followers, Jacopo Bellini, Antonio and Bar-

tolomeo Vivarini, Jacobello del Fiore, Niccolò Di Pietro and Michele Giambono. Most of these painters were active in the Veneto region, where the Renaissance was slow to develop, taking hold substantially later than elsewhere. They represented various figurative styles perceived with varying degrees of objectivity. Recently historians have devised anti-Renaissance or pseudo-Renaissance categories, such as International Gothic, to accommodate these styles of a generally regressive character which appeared simultaneously with, or even after, the mainstream development of Florentine humanism. Florentine examples are Lorenzo Monaco and Starnina. Monaco's Gothic sophistications appeared at the same time as Brunelleschi's innovative design for the Baptistery doors with its powerful, almost vehement expressivity, his major churches S. Lorenzo and Sto. Spirito, and the choir and dome of Sta. Maria del Fiore (1420–34), a construction of monumental and symbolical significance that placed architecture at the center of the arts, a position of supremacy clinched by Leon Battista Alberti's

Raphael, Madonna of the Goldfinch, 1507. Uffizi, Florence

metaphor in reference to the dome that "casts its shadow over the whole of Tuscany."

Brunelleschi's buildings readily declare his rationalism, his capacity to re-invent the ancient world acquired from an experimental knowledge of imperial Roman architecture. He took a long time to complete them, or handed the designs to younger architects. Sometimes the "Fathers of the Renaissance" worked together, as in the Old Sacristy of S. Lorenzo, a Brunelleschi building with tondi decorations containing stucco figures by Donatello.

Donatello (1382–1466), Brunelleschi's counterpart in sculpture, also looked to ancient models. The Classical blueprint is evident in his Christian themes, a *St. George* (copy) at Orsanmichele and statues in the cathedral church and on the *campanile* of Sta. Maria del Fiore, including a set of *Prophets*, executed in partnership with the older Nanni di Banco, whose style, if transitional, clearly approached Rome. The change of mood in Donatello's middle period is marked by a new sense of character exemplified in the boisterous *cantoria*, or singing gallery, of *c.* 1440 in Florence Cathedral, and a recognition of both secular and spiritual values in the great Padua commissions of the following ten years – the grandiose *Gattamelata*, the first equestrian statue since antiquity, and the high altar of the Basilica of St. Anthony – works at the forefront of an immensely rich period in the figurative arts of northern Italy from about 1450. In the late works, produced in Florence, Donatello's expressivity is heightened with passion and drama, for example the *Judith and Holofernes*

and the extraordinary *Magdalen*, or the unfinished reliefs for the twin pulpits in S. Lorenzo.

Third Olympian of the early Florentine Renaissance was Masaccio (1401–28), in form if not necessarily in content. This extraordinary artist, who knew the architecture of Brunelleschi and the sculpture of Donatello, completely upset the contemporary idiom of International Gothic, exemplified in the minutely elaborate techniques of such gifted artists as Gentile de Fabriano or Masolino da Panicale. A man independent of his peers, he understood, better than Donatello, the value of synthesis. With his plastic vitality and instinct for drama he could capture an action or a scene at the precise moment of its happening; spatial relationships, physical and moral expression and plausibility of background all contribute to that moment. The sheer power of Masaccio's narrative ability can be seen in the frescoes of the Brancacci Chapel in the church of Sta. Maria del Carmine in Florence. Morally, his towering presence cannot help but overshadow the adjacent work of great intensity by the talented Florentine, Masolino da Panicale. A third element has widened the attributional debate with regard to Masaccio and Masolino in Sta. Maria del Carmine; a hand of Classical Roman inspiration, very similar to Nanni di Banco, uncovered in recent restoration work. Masolino and Masaccio were also partners in the decoration of the church of S. Clemente in Rome, while Masolino alone, entrenched in his elegantly decadent plasticism, introduced a sampling of Tuscan vocabulary in Lombardy,

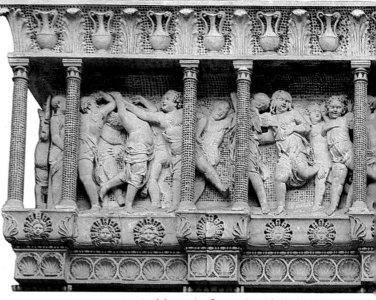

Below: Brunelleschi, cupola of St. Maria del Fiore, 1420–34, Florence. Great example of architecture and technology, it stands for the city and its civilization.

where he worked in the Chapter House and Baptistery of Castiglione Olona.

The one to contrive a natural blend between these two great but different talents, one wholly humanistic, the other imbued with Christian mysticism, was Fra Angelico (1387–1455). His work, largely taken up with decorating the walls of the convent of S. Marco in Florence, designed by Michelozzo, is entirely guided by the principles of Masaccio, though a lighter influence can be seen in the arrangement of forms in *Coronation of the Virgin* in the Louvre and in the courtly accents of the fresco scenes of 1455 in the chapel of Nicholas V in the Vatican.

A more experimental artist was Domenico Veneziano (c. 1400–61). Initially less confident than Masaccio, his exact contemporary, he later adopted a luminous surface technique that enhanced the mental and physical character of the composition. The method was developed to perfection by his pupil, Piero della Francesca, who worked with Domenico on the frescoes of the church of S. Egidio. Domenico's masterpiece, the *St. Lucy Altarpiece*, an intellectual composition dominated by bright pastel tones, anticipates the blend of perspective and luminosity that Piero would make sublimely his own.

The somewhat sparse Domenico legacy yet produced the amazingly comprehensive vision of Piero della Francesca (1410/20–92). Painter and mathematician, Piero developed the scientific perspective approach in art. A man of restless intellect, he instigated the revival of Venetian painting, generated the Ferrara school and influenced the art of Modena with his intricate perspective designs. The monumentality and stillness of his figurative style is paralleled in architecture by Leon Battista Alberti (1404–72).

Having declared architecture at the forefront of the arts, Alberti upheld his opinion by developing its theoretical and mathematical foundations, by reinventing and rationalizing the examples of antiquity. He retained the role of theoretician and intellectual, leaving the execution of his ideas to his pupils and followers. Thus the Palazzo Rucellai in Florence was actually built by Bernardo Rossellino, the Tempio Malatestiano in Rimini by Matteo de-'Pasti, the church of Sant'Andrea in Mantua by Luca Fancelli. All these buildings share a Classical pedigree and a monumental ap-

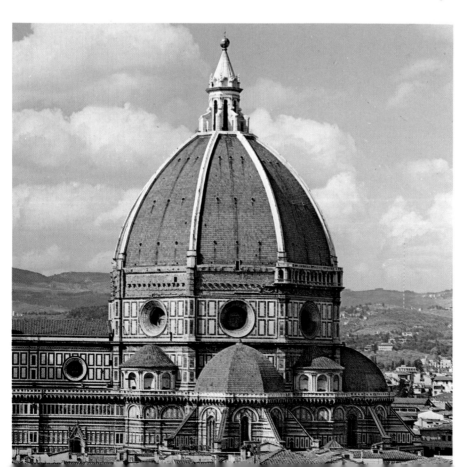

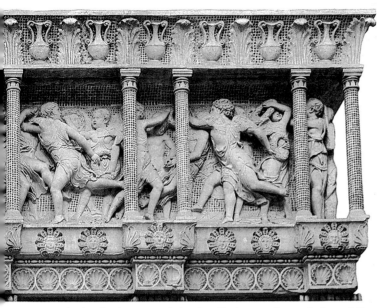

Left: Donatello, Singers' Gallery, 1434–39. Museo dell'Opera del Duomo, Florence. Architecture and sculpture merge in a union of order and euphoria, Dionysiac nature and classical taste; a great early Renaissance monument.

After Masaccio, painting reflected a diversity of talents – Paolo Uccello (1397–1475), Filippo Lippi (c. 1406–69) and Andrea del Castagno (c. 1421–57).

Paolo Uccello was fascinated by the new perspective techniques. His solutions, especially in the paintings with archaic themes, often appear strained because he was more interested in the scientific problem than in the aesthetic result. His main works include the Sir John Hawkwood Memorial in Florence Cathedral; the frescoes for the Chiostro Verde, Sta. Maria Novella, now in the Forte del Belvedere Museum, Florence; the frescoes in the Bocchineri Chapel, Prato, and the three-part Battle of S. Romano, now divided between the Uffizi, the Louvre and the National Gallery in London.

Filippo Lippi emulated Masaccio in his early Tarquinia Madonna in 1437. Later works such as the Coronation of the Virgin and the frescoes in Spoleto Cathedral show a retreat from realism to a tender, more old-fashioned style in which the concept of spatial depth is abandoned in favour of a greater richness of surface.

Andrea del Castagno transformed the robust external features of Masaccio into a rampant, temperamental realism, already pronounced in 1442 when, at the age of nineteen, he collaborated with Francesco da Faenza on the frescoes in the S. Tarasio Chapel in the church of S. Zaccaria, Venice, bringing the first breath of Florentine culture into the lagoon city. His mature work displays a more relaxed, cooler mood matched by simple architectural

proach that in the case of the Sant'Andrea church would serve as a model for Michelangelo, Palladio, Maderno and Bernini.

But the first fruits of Albertian teaching took shape at the court of Urbino, where the architect Francesco di Giorgio and the sculptor Luciano Laurana, along with Piero della Francesca, were giving physical substance to the world of ideas. They showed themselves versed in the laws of harmony and proportion; mathematical space combined with imperturbable rhythms in Piero's Urbino Altarpiece in the

Brera Gallery, Milan, and in his frescoes, especially the Solomon and Sheba, in the church of S. Francesco in Arezzo, or in the Flagellation in Urbino's Galleria Nazionale.

In architecture Michelozzo (1396–1472) immediately adopted the ideas of Brunelleschi and Alberti, whose joint influence shows in the grand Palazzo Medici-Ricciardi in Florence and in the villas of Careggi and Cafaggiolo. Michelozzo is also author of the superb sculptures in the cathedral of Montepulciano and in the church of Sant'Angelo a Nilo in Naples.

Right: Masaccio and Filippino Lippi, Stories of St. Peter, from 1426 on. Cappella Brancacci, Chiesa del Carmine, Florence. The monumental presence of man and his dignity acknowledged by Masaccio through a very clear townscape are rationalized in a lively Florentine chronicle by Filippino Lippi, completing the great decorative cycle begun by Masolino and Masaccio.

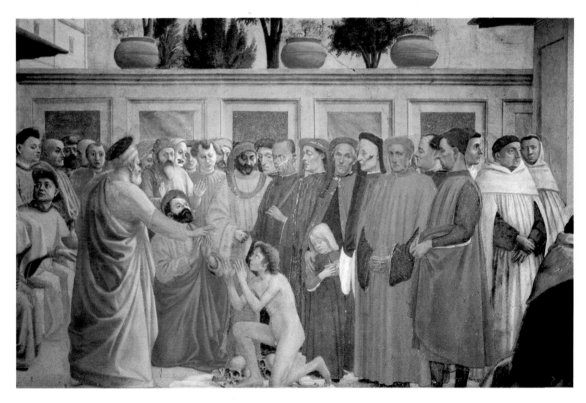

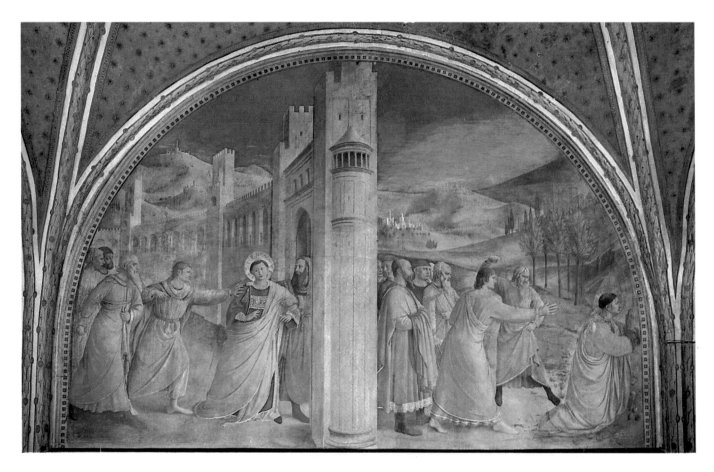

settings, as in the *Last Supper* scene in the frescoes for the monastery of Sant'Apollonia or the *Nicolò da Tolentino Memorial*, pendent of Paolo Uccello's equestrian memorial.

The most representative figures in architecture after Alberti and Michelozzo include Giuliano da Majano, active in Arezzo, Siena, Naples, Loreto and Faenza; Benedetto da Majano, to whom is attributed the design for Palazzo Strozzi in Florence; and Giuliano da Sangallo, whose Classical example can be seen in the detail and proportions of the Medicean villa at Poggio a Caiano, the church of Sta. Maria delle Carceri in Prato and the sacristy in the church of Sto. Spirito in Florence.

Developments in sculpture were not all in keeping with Donatello's expressionism. Lorenzo Ghiberti (1378–1455) sublimely interpreted the transition from Gothic to modern sculpture and his refined, elongated forms suggest a knowledge of the goldsmith's art. The standard comparison between his and Brunelleschi's panels of the *Sacrifice of Abraham*, 1401, with which Ghiberti won the competition for the second Baptistery doors in Florence, shows a development that had more in common with an International Gothic artist like Lorenzo Monaco. Realism is even more attenuated in the narrative design of the squares for the third pair of Baptistery doors.

Luca della Robbia (1399/1400–1482), another sculptor of individual approach, developed in the Classical idiom but along a different path from Donatello. His modern idealizations of ancient Attic forms are charmingly represented in his *cantoria*, facing Donatello's, in Florence Cathedral. Luca invented the technique of applying vitreous glazes to terracotta sculpture, developed fully by his heirs Andrea and Giovanni della Robbia; but even in this softer, translucent medium he retained a reticent, pure style virtually devoid of naturalistic matter.

In distinctive contrast are the accentuated flowing incisions of Agostino di Duccio (1418–c. 1481), who combined the Donatello tradition with a flat-surface technique giving the florid effect seen in his reliefs at the Tempio Malatestiano in Rimini and in the church of S. Bernardino in Perugia. In Rimini, contact with Leon Battista Alberti must have inspired Agostino's liking for architectural themes, a tendency shared by Leonardo Rossellino in his tomb of Leonardo Bruni in the church of Sta. Croce in Florence. Rossellino devoted himself increasingly to architecture, eventually applying Albertian theories to the new town of Pienza commissioned by Enea Silvio Piccolomini, Pope Pius II.

Mino da Fiesole and Benedetto da Majano, both worthy sculptors, achieved a precarious balance between the expressivity of Donatello and the austerity of Luca della Robbia.

An altogether more influential craftsman was Desiderio da Settignano (c. 1430–1464). His marble has a vibrant, tactile quality achieved by the textural play of light, for instance, in the tomb of Carlo Marsuppini in Sta. Croce, modelled on Rossellino, and in several remarkable busts. An even more effective harnessing of light occurs in Andrea del Verrocchio (1435–64), in *Portrait of an Unknown Woman*, Bargello Museum, Florence. Verrocchio developed away from the architecture-sculpture axis of the preceding generation. While he could produce heroic statements like the *Equestrian Monument to Bartolomeo Colleoni*, rivalling Donatello's *Gattamelata*, his main interest lay in investigating the stylistic affinities of painting and sculpture. In the second half of the fifteenth century his workshop in Florence was a magnet for aspiring artists, among them universal figures like Leonardo da Vinci and Michelangelo.

Antonio Pollaiuolo (c. 1431–98) was equally important in laying the foundations of the High Renaissance as sculptor and painter. His style is characterized by strong, energetic lines in paintings such as the *Rape of Dejanira* (Yale Museum), or *Martyrdom of St. Sebastian* (National Gallery, London), and sculptures like *Bust of a Warrior* (Bargello Museum) or the

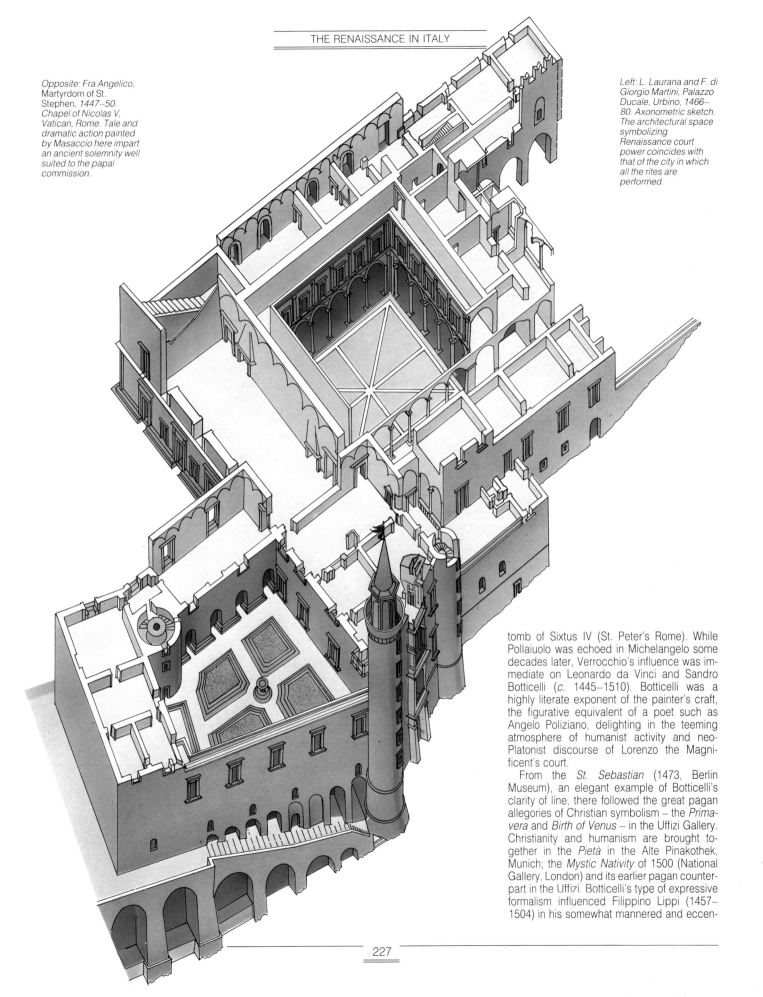

Opposite: Fra Angelico, Martyrdom of St. Stephen, 1447–50. Chapel of Nicolas V, Vatican, Rome. Tale and dramatic action painted by Masaccio here impart an ancient solemnity well suited to the papal commission.

Left: L. Laurana and F. di Giorgio Martini, Palazzo Ducale, Urbino, 1466–80. Axonometric sketch. The architectural space symbolizing Renaissance court power coincides with that of the city in which all the rites are performed.

tomb of Sixtus IV (St. Peter's Rome). While Pollaiuolo was echoed in Michelangelo some decades later, Verrocchio's influence was immediate on Leonardo da Vinci and Sandro Botticelli (*c.* 1445–1510). Botticelli was a highly literate exponent of the painter's craft, the figurative equivalent of a poet such as Angelo Poliziano, delighting in the teeming atmosphere of humanist activity and neo-Platonist discourse of Lorenzo the Magnificent's court.

From the *St. Sebastian* (1473, Berlin Museum), an elegant example of Botticelli's clarity of line, there followed the great pagan allegories of Christian symbolism – the *Primavera* and *Birth of Venus* – in the Uffizi Gallery. Christianity and humanism are brought together in the *Pietà* in the Alte Pinakothek, Munich; the *Mystic Nativity* of 1500 (National Gallery, London) and its earlier pagan counterpart in the Uffizi. Botticelli's type of expressive formalism influenced Filippino Lippi (1457–1504) in his somewhat mannered and eccen-

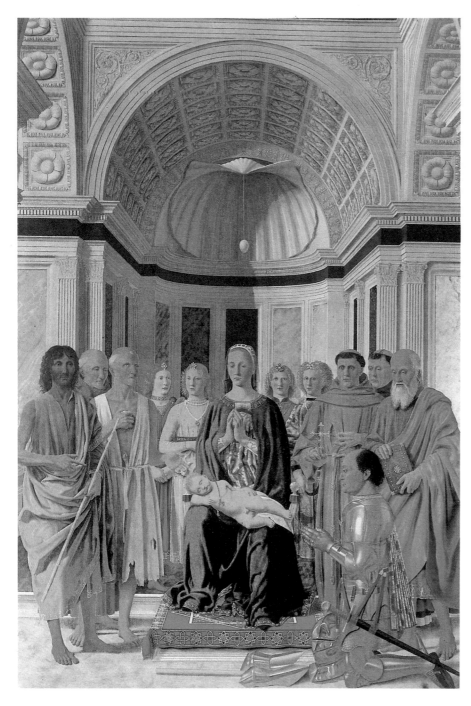

By the turn of the century two outstanding figures – Leonardo in painting, Donato Bramante in architecture – were pointing the way to the climax of the Renaissance. Leonardo da Vinci (1452–1519) inherited the linear dexterity of Verrocchio and Botticelli and imbued it with scientifically informed naturalism. The unfinished and enormously influential *Adoration of the Magi* has the effect of a mind picture inhabited by living, breathing, ghostly forms. A similar unearthly world dominates the portrait of *Ginevra de' Benci* (National Gallery, Washington), the rapt gaze seemingly lit from an inner source rather than transmitted direct. Leonardo's art was so grounded in intellectual and philosophical enquiry that the links with the familiar, linear rationalism of the Tuscan mode were progressively weakened. His presence in Milan from the early 1480s prompted an independent stylistic movement, which for convenience is known as the Lombard school (though "Emilian" would be as apt if it paved the way to artists like Correggio). The style offered features of a local character but in general concerned itself with high intellectual principles. Two cardinal works belong to this period; the *Virgin of the Rocks* of 1483, now in the Louvre, which is virtually a scientific tract, and the famous *Last Supper* in the refectory of Sta. Maria delle Grazie, with its quite unprecedented groupings manifesting the inner drama as Christ reveals his betrayal. Leonardo the artist went hand in hand with Leonardo the scientist, naturalist, inventor, philosopher. Interpretations like *The Mona Lisa*, with her furtive smile and air of abstraction, demonstrate the philosophical ap-

Left: Piero della Francesca, altarpiece of Urbino, c. 1472. Brera, Milan. The intellectual and physical orders coincide in the mathematics of form, where perspective is a philosophic thought and a dimension of the world.

tric fresco cycle of St. Philip in the church of Sta. Maria Novella, Florence. A similar intellectual indulgence underlies the fanciful imagery, half myth half allegory, of Piero di Cosimo (1462–1521). He was a forerunner of the Florentine Mannerists and, in his own way, the first major example of northern European influence on Italian art; this is evident beyond doubt in works like the *Hunt* in the Metropolitan Museum, New York; *Death of Procris* in the National Gallery, London; *Simonetta Vespucci* in Chantilly Museum; *Bacchanalia* in the Fogg

Art Museum, Cambridge, Mass.

Domenico Ghirlandaio, whose stylish and serene frescoes can be seen in the church of Sta. Trinità in Florence and the collegiate building in San Gimignano, was a fine artist among those, including Bastiano Mainardi and Bartolomeo di Giovanni, who were developing in the shadow of the Verrocchio workshop when the brilliant young Botticelli and Leonardo were already making an impact on their fellow trainees Jacopo del Sellaio and Lorenzo di Credi.

proach of a mind in tune with the mysteries of nature; while the large fresco scene of the *Battle of Anghiari*, a work of great potential interest known only from copies that was planned for the Palazzo Vecchio in Florence, represents a major loss to the art world.

Donato Bramante (1444–1514) was a less wide-ranging talent though as universal as Leonardo in the brilliance of his architecture. Born near Urbino, his formation was influenced not only by Leon Battista Alberti but also by artists such as Francesco di Giorgio and Piero della Francesca. Examples of his early career as a painter can be seen in the frescoes of *Men-at-Arms* for Casa Panigarola and in *Christ at the Column*, on wood, all now in the Brera Gallery, Milan. Bramante, like Leonardo, was called to Milan, where he created sophisticated churches with ingenious illusionistic solutions like the perspective "choir" in Sta. Maria presso S. Satiro, and the spatial arrangement of the east end of Sta. Maria delle Grazie. His committed Classicism reached its purest form, foreshadowing Raphael and Michelangelo, in the beginning of the sixteenth century in Rome, for example the Cloister of Sta. Maria della Pace, the Tempietto of S. Pietro in Montorio and his plan for the new basilica of St. Peter's. There is little doubt that Bramante's spatial ideas were inspired by Piero della Francesca, who also had an incalculable influence on the development of Italian painting in general, from Antonello da Messina to Giovanni Bellini and Ercole de'Roberti.

One example was the school of Camerino, where repercussions of Piero and Fra Angelico appeared in the work of Giovanni Boccati and

Right: Filippo Lippi, Madonna of Tarquinia, Palazzo Barberini, Rome. Masaccio's conception of man as a monument is here set in a space of Flemish character, producing unusual tension.

Below: Paolo Uccello, Story of Genesis, c. 1446. Green cloister, Sta. Maria Novella, Florence. Medieval vision is shown in a new setting of perspective taken as a technical achievement rather than as an ideal.

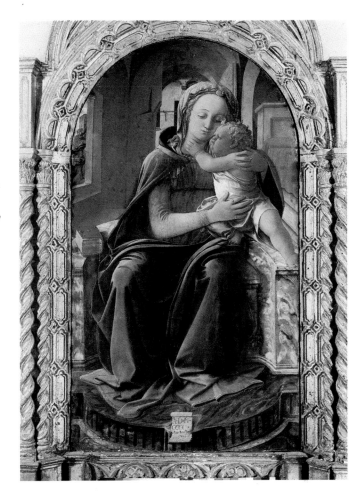

Girolamo di Giovanni, who in turn influenced the so-called Master of the Barberini Panels, an artist whose affinities with Bramante suggest that he was educated in close proximity to architects.

More prominent in the Piero stream was Perugino, trainer of Raphael and Luca Signorelli, whose nudes anticipated Michelangelo. An artist of greater talent, Bartolomeo della Gatta (1448–1502), avoided the contemplative rhetoric of Perugino and the exaggerated violence of Luca Signorelli, while other Piero interpreters following Bartolomeo's restrained approach included Lorenzo da Viterbo, Antoniazzo Romano and Cristoforo Scacco.

Siena was a case apart geographically and stylistically speaking. Far from the workshop atmosphere of Florence and Piero, the Sienese school maintained an independent, archaic stance well into the fifteenth century, even though its foremost exponents were perfectly aware and in tune with the new cultural forms. Probably the most important of these artists was Stefano di Giovanni known as Sassetta (c. 1400–50). His Gothic inspirations were evocative and fanciful in the manner of Paolo Uccello though less robust in form.

A version of Sassetta is to be found in the more Classical accents of Pietro di Giovanni Ambrosi; or, in the other direction, the expressive and somewhat grotesquely busy narrative style of Giovanni di Paolo or the Donatellian expressiveness of Lorenzo di Pietro called Il Vecchietta, who was also a sculptor.

Close to Sassetta, but in a class of his own, was the marvellous Master of the Observance and his weaker imitator, Sano di Pietro, who was perhaps not yet fully mature.

primarily from the sphere of influence of Piero della Francesca, who worked on fresco cycles, now destroyed, for the Ducal Palace and in the church of Sant'Andrea. Other nurturing influences were Pisanello, Jacopo Bellini and Rogier van der Weyden, all of whom worked in the town at one time or other. But the most determining influence, for Ferrara and other northern Italian schools, was the enterprise of a little-known personage, the antiquarian artist Francesco Squarcione, who pro-

moted the cult of the antique and the revival of Classicism. His Paduan circle became a virtual center for advanced studies in the arts. Among his many pupils – Giorgio Schiavone, Nicolò Pizzolo, Ansuino da Forli, Marco Zoppo, Carlo Crivelli, Bartolomeo Vivarini, Girolamo di Giovanni, Nicola di Maestro Antonio di Ancona, Bono da Ferrara, Cosmé Tura, Vincenzo Foppa, Bernardino Butinone – one was destined for a meteoric career, Andrea Mantegna (1431–1506). From the frescoes, now

All these Sienese artists belong to the first half of the fifteenth century. After 1450 there was a decline in sophistication as municipal pride and cultural assertiveness weakened in the face of the barrage of new ideas from Florence. Among the principal names of this period were Neroccio di Bartolomeo Landi, Benvenuto di Giovanni, Girolamo di Benvenuto and Matteo di Giovanni, all of whom produced identifiable, well-characterized works, though certainly not of the innovative quality to be found in their second- and third-generation cousins in Florence. The most prominent figure was probably Francesco di Giorgio Martini (1439–1502), whose style, more Italian than Sienese, flourished (in painting and sculpture) not only in Siena but also in other places, for instance, in the Palace of Urbino, the church of Sta. Maria del Calcinaio in Cortona or the Palazzo Comunale of Tesi.

Ferrara was another area to develop its own artistic identity. The Ferrara school descended

Above: L. Ghiberti, Sacrifice of Isaac, 1401, Museo del Bargello, Florence. Measure, harmony, proportions and ordered development of the tale caused this panel to be preferred to that of Brunelleschi at the 1401 competition for the second door of the baptistery at Florence.

Right: Luca della Robbia, Singers' Gallery, 1432–35, Museo dell'Opera del Duomo, Florence. Rediscovered Classicism, ancient harmony, and pure feeling inform the marble.

largely destroyed, in the church of the Eremitani in Padua Mantegna rose to the heights of Classicism in the illusionistic decoration of the Camera degli Sposi in Mantua, a work of exceptional vitality, physical and psychological naturalism. Paintings like the *S. Zeno Altarpiece* contributed to the climate of architectural romanticism aroused by an imagined world, a mental picture of antiquity such as the epic *Triumphs of Caesar* at Hampton Court, or the allegorical scenes for Isabella d'Este in Mantua.

A more formal though highly inventive style characterizes the work of Carlo Crivelli; his imitator, Nicola di Maestro Antonio di Ancona, was even more fanciful and irrational. Marco Zoppo stayed with the tradition but took a more restrained and in some ways more Classical approach. But the most extreme example of style in this Paduan group, surpassing even Mantegna at his best, was the Ferrara artist Cosmé Tura. His convoluted techniques and spiritual intensity added an extra dimension to the language, very different from Squarcione, practised earlier by Donatello in his ten-year stint in Padua, during which he had completed the superb reliefs of the *Miracles of St. Anthony* for the high altar of the Santo and the Gattamelata monument. Tura used paints like a sculptor or a jeweller and was a tireless inventor of surreal, startling images; his consistent, immediately recognizable style can be seen in the *Allegorical Figure* in the National Gallery, London; the *Organ Shutters of St. George* in Ferrara Cathedral, and the contorted *Pietà*, now in the Louvre, which crowned the Roverella Altarpiece.

Tura is unique in the Renaissance canon. His quirky vision was never imitated except perhaps in the early career of Ercole de'Roberti. The second major artist in Ferrara, Francesco del Cossa, professed a sturdier art in the manner of Piero della Francesca. The fresco series in the Palazzo Schifanoia introduces a note of fantasy in otherwise restrained settings, but this is Cossa's nearest approach to Tura's style, not only in Ferrara but also in Cossa's work in Bologna, where the Ferrara school was to enjoy a second season. Cossa's pupil, the young and gifted Ercole de'Roberti, came to assist him in Bologna, eventually becoming the third major artist of the Ferrara school. Ercole was one of the noblest exponents of the Italian Renaissance. His Ravenna Altarpiece, now in the Brera Gallery, combines the finest detail of Tura with the equilibrium of Piero della Francesca. Ercole's early attempts in the Palazzo Schifanoia and Griffoni Polyptych in Bologna, now dispersed, show affinities with the bright and visionary expressiveness of Nicolò dell'Arca, an interesting Puglian sculptor active in Bologna in the late 1460s who exerted a major influence on the Ferrara artists after the Donatello precedent.

While these three artists stand out, the real character of what Roberto Longhi described as the "Ferrara factory" consisted in the multi-

plicity and variety of its figurative types, from the minor masters in the Schifanoia to great anonymous figures like Vicino da Ferrara, from ambiguous identities like Baldassare d'Este (probably to be identified with Vicino) to the remarkable miniaturists who produced choral manuscripts and the Bible of Borso d'Este as well as considerable painted works that are to this day unidentified.

Sculptors like Domenico di Paris and Sperandio da Mantova belonged to this mixed and civilized company, which also included

Antonio del Pollaiolo, Astrology, tomb of Sixtus IV, 1493. Treasury of St. Peter's, Rome. Dynamic form and great energy mark this artist's work.

the architect and planner Biagio Rossetti. An ingenious personality, Rossetti projected a new Renaissance city doubling the medieval urban space by means of a wall extension known as the "Herculean Addition," commemorated in Burkhardt's definition of Ferrara as the "first modern city in Europe."

The lesson of the major trio of artists, Ercole in particular, culminated in the meditative, complementary styles of Antonio da Crevalcore and Lorenzo Costa. Crevalcore is recorded in Bologna but emulated the fanciful eccentrism of Ferrara, while Costa, from Ferrara, became a Bologna citizen and, with his colleague artist Francesco Francia, inclined toward the suaver Umbrian manner of Perugino.

The miniaturists of the Ferrara school de-

serving particular mention are Guglielmo Giraldi, Francesco de'Russi, Taddeo Crivelli and il Marmitta, author of an altarpiece now in the Louvre.

The Ferrara example spread to Modena. Here, in the last quarter of the fifteenth century, painters like Bartolomeo Bonascia, Agnolo and Bartolomeo degli Erri were active at the same time as the two intarsia craftsmen from Lendinara, Bernardino and Cristoforo, who transformed Piero's perspectives into dazzling geometric displays. An individual example was set by Amico Asperini (1474–1552), whose anti-Classicism of the Ferrara type showed marked northern influences. In Bologna Asperini further developed his anti-Classical stance in a more radical though similar manner to Filippino Lippi's example in Florence.

The Lombard school is another important example in the regional arts of Renaissance Italy. Partly influenced by Padua, its main activity was painting and sculpture. The most important painter was Vincenzo Foppa, who of all Squarcione's followers had the greatest sense of naturalism. His frescoes in the Portinari Chapel, in the church of Sant'Eustorgio in Milan, are the first of a group of works by artists known as "painters of reality." The principal exponents, from Moretto to Savoldo, were active in Foppa's native Brescia. They seemed to directly anticipate the realism of Caravaggio. The commanding physicality of Foppa's Classicism is toned down in the aristocratic elegance of Ambrogio da Fossano, known as il Bergognone, whose relation to Foppa can be

compared with Cossa's relation to Tura. Extending the analogy, the counterpart of Ercole de'Roberti would be the well-tempered Bernardino Butinone, a native of Treviglio, where he and Bernardo Zenale painted the marvellous polyptych in the parish church.

The difference between these "realists" and the rationalism, not to say abstraction, of Bartolomeo Suardi known as Bramantino is explained by the fact that Bramantino was equally accomplished as an architect; his *Ecce Homo* (Thyssen-Bornemisza Collection) can be usefully compared with Bramante's *Christ at the Column* (Brera Gallery).

Beside Bramantino other important Lombard painters were Vincenzo Civerchio, Andrea Solario, Giovanni Antonio Boltraffio and Bernardino Luini; Luini has special significance as the first artist to transform the local tradition under the influence of Leonardo, whose other Lombard followers were Marco d'Oggiono, Ambrogio de'Predis, Giampietrino and Francesco Melzi.

A lone case if somewhat similar in spirit to Foppa was Carlo Braccesco, active in Liguria, where his polyptych, dated 1478, still remains in the Sanctuary of Montegrazie. He is best known for his *Annunciation* in the Louvre, a work of great elegance in the Gothic manner. The more obscure Zanetto Bugatto combined

Above: Piero di Cosimo, Primitive Hunt, c. 1488. Metropolitan Museum, New York. Life represented as early human civilization with unusual humanist naturalism.

Left: Sandro Botticelli, Spring, c. 1478. Uffizi, Florence. The goal of humanist culture merging pagan myth with Christian religion in Neo-Platonism.

the Lombard style with sublime abstract conceptions in works that recall the manner of Antonello da Messina and Ercole de'Roberti; his *Madonna* in the Cagnola di Gazzada Collection shows a knowledge of Flemish art, while clarity and elegance are also the hallmarks of Donato de'Bardi, whose origins have not been established.

Lombard sculpture was dominated by Giovanni Antonio Amadeo, Cristoforo and Antonio Mantegazza, Cristoforo Solari and Agostino Busti known as Bambaja. Amadeo (1447–1522), who was also an architect, worked on the sculptural decorations of the Carthusian monastery in Pavia and gave early proof of his architectural talents in the Cappella Colleoni in Bergamo. Amadeo's plasticism became more abstract in the hands of the Mantegazza brothers, refined artists displaying the intensity of the Ferrara masters, while Bambaja's ornate skills were employed in the celebrated tomb of Gaston di Foix, now dismantled.

Piedmontese art was a Lombard appendage, but it had originality and the advantage of cross-fertilization with French and northern cultural forms. Gian Martino Spanzotti was its main exponent and his principal works are the tryptych in the Galleria Sabauda, Turin, and the frescoes in the church of S. Bernardino in Ivrea.

Defendente Ferrari created somewhat impermeable Gothic images in the modern style, while a more aggressive, dramatic, northern note appeared in Pietro Gremmorseo and an essentially Lombard naturalism in Gaudenzio Ferrari (c. 1475–1546), whose singular sculptures and paintings of the "sacra rappresentazione" type – a kind of mystery play – can be

Right: Leonardo da Vinci, Ginevra Benci, *c. 1474. National Gallery, Washington. Naturalism and heraldic abstraction produce an indefinable suggestion emanating from this precursor of the Mona Lisa.*

Below: Leonardo da Vinci, Last Supper, *1495–97, refectory of Sta. Maria delle Grazie, Milan. Dynamic perspective and psychological content make up an expressive unity.*

seen at Sacro Monte di Varallo.

Venice emerged as a center of the figurative arts several decades after Florence. The two cities were rivals in quality but Venetian art was less wide-ranging than the teeming culture of Florence. The first hint of a new grammar, though still in the idiom of Pisanello and

Gentile da Fabriano, was evinced by the elder Bellini, Jacopo, and Antonio Vivarini in the 1440s. Works like Jacopo's Madonnas, two of which are in the Accademia, are still essentially Gothic; while his two drawing albums, of which one, now in London and once the property of Titian's friend Gabriele Vendramin

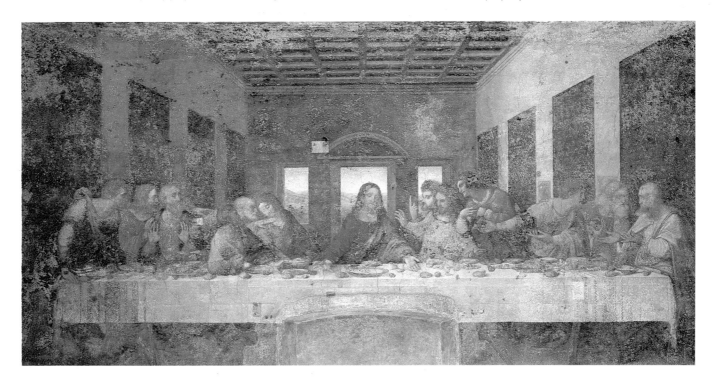

fertility promising the rebirth of the soul in the Resurrection. A less bold humanistic approach is displayed in *Dead Christ Supported by Angels*, where the Mantegnesque ideal of Classical and Christian motifs united in one "cultural" organism is subverted by Bellini's treatment of the background in which a Roman-style city is cut off from the foreground elements by an encircling medieval wall.

Bellini's first mature work is an altarpiece in which the polyptych formula has been converted into a single spatial structure suggesting the influence of Piero della Francesca. The altarpiece was commissioned in Pesaro along the Adriatic coast, an area popular with Venetian artists because Rimini was there and Urbino nearby; and Piero's frescoes for the Tempio Malatestiano were probably known to Bellini, who himself later painted a work in Rimini – *Dead Christ with Four Angels* – formerly in the church of S. Francesco and now in the Pinacoteca Comunale.

The presence of Antonello da Messina in Venice in 1475 and 1476 was a major influence for change in the style and composition of Venetian painting. His clarity of line and precise forms can be seen in the *S. Cassiano Altarpiece* now in Vienna; *St. Sebastian*, now in Dresden, originally part of a tryptych for the church of S. Giuliano; a *Pietà*

Opposite: A. Mantegna, Marriage Chamber, c. 1473. Oculus in the Ducal Palace, Mantua. First example of trompe-l'oeil ceiling; masterly foreshortened perspective.

was kept in the famous "camerino per antica-glie," or antiques closet, were early and influential examples of the new formulations.

Jacopo Bellini developed slowly, on the whole toward the Paduan ideal. Andrea Mantegna was active in Padua in the late 1440s and in 1453 married Jacopo's daughter, Nicolosia. The family link with Mantegna was a determining factor in the formation of Jacopo's two sons Gentile and Giovanni Bellini. Gentile proved it at once in the shutters of the original organ of St. Mark's, now in the church of S. Basso, in which Classical motifs such as festoons, pilasters and blind arches belong entirely to the Paduan repertory.

Giovanni Bellini (c. 1432–1516) from the start of his career relied on nature rather than symbolism as a means of expression. The early dawn setting of his early *Transfiguration* in the Correr Museum, Venice, had never been attempted before. Mantegnan clarity of line is suffused with the light of natural forces, causing human impulse and passion to become accessories to drama rather than the drama itself. In other works in the Correr a similar process of transformation occurs in the *Crucifixion*, clearly inspired by the central predella in Mantegna's *S. Zeno Altarpiece*; landscape is no longer mere background but an integral part of the story as the river with its steeply wooded banks becomes a sign of

Above: F. di Giorgio Martini, Sta. Maria delle Grazie, Cortona, 1485. The high cupola, as if for a centrally planned building, crowns a church with a Latin cross plan, of great structural purity and simplicity of form.

Right: Master of the Observance, Encounter of St. Anthony and St. Paul the Hermit, National Gallery, Washington. Early Renaissance at Siena arose from the dawn of Gothic and translated Christian history into legend.

with Three Angels, possibly for the Ducal Palace, now in the Correr Museum and several portraits of such admirable psychological coherence that they became immediate models for Bellini and painters of the next generation such as Carpaccio and Lorenzo Lotto. Perhaps the most significant of these works is the *S. Cassiano Altarpiece*, which appears to be the prototype of a new style of "Sacra Conversazione," or devotional composition, that would become standard for several decades: saints to either side of the Madonna and Child on a raised throne with musician angels at its base. The group is in a perspective setting that mirrors the church apse; a good example of the type is Bellini's *S.*

Giobbe Altarpiece, in which a high Bramantesque choir recedes to a mosaic apse in an arch springing from pilasters that are illusionistically attached to the marble columns of the altar on which the altarpiece stands.

A fine mainland artist, Giovanni Battista Cima da Conegliano, brought a more detailed and imaginative use of nature to Venetian painting in works such as the *Madonna of the Oranges* in the Accademia, or the altarpieces of St. John the Baptist for the church of Madonna dell'Orto and Incredulity of St. Thomas, now in the Accademia, in which the Bellinian apsidal arch is open on all sides so that the sacred figures are silhouetted against a natural background. In the *Baptism of Christ*

in the church of S. Giovanni in Bragora, the serene contemplation of nature is echoed by Giovanni Bellini in his famous *Baptism* in the church of Sta. Corona in Vicenza, while in the *Nativity* for the church of the Carmini Cima's formal precision is compromised by the powerful new influence of Giorgione.

Another painter in the Antonello-Bellini mould was Alvise Vivarino, son of Antonio and the last and most modern artist of the Murano school. His *Christ Carrying the Cross* in the church of SS. Giovanni e Paolo, of around 1474, is a clear exposition of Bellinian development from the Mantegna tradition.

Giovanni Bellini's experiments with landscape can be seen in his masterly *Transfigur-*

...d in
...ion, New
...s of a modern
...and the world of
...s that would capture the
... of the great Venetian pain-
...sixteenth century. Bellini also intro-
...a modified version of the triptych in the
...saro Altarpiece of 1488 in the sacristy of the
Frari; invented nocturnal settings such as the
*Madonna with St. Mary Magdalen and St.
Catherine*; created a simplified version of the
"Sacra Conversazione" in the S. Zaccaria
altarpiece and in his declining years com-
peted with the work of younger artists and the
external imagery of Cima da Conegliano, for
example in the altarpiece of 1513 for the
church of S. Giovanni Crisostomo.

During the long and extraordinarily produc-
tive career of Giovanni Bellini his brother
Gentile (1429–1507) was developing the first
examples of a vast body of city portraiture in
celebration of the so-called "myth of Venice."
It is worth noting that Giovanni Bellini never
used Venice in his backgrounds, preferring
instead the ancient and medieval monuments
of Verona. After a brief stint as a court painter
to Mehmet II in Constantinople in 1479, Gen-
tile's Venice scenes acquired a distinctly
oriental flavour. His thematic example was
followed in Vittore Carpaccio's decorations for
the various Venetian *scuole* – confraternities

*Right: Ercole Roberti,
Altarpiece at Sta. Maria
in Porto, Ravenna, 1481.
Brera, Milan. Synthesis
of Piero della Francesca
and the imaginative
elegance of Ferrara
painting.*

*Below: Antonioda
Crevalcore, Madonna
and Child, SS. John and
Joseph, c. 1505.
Staatsgalerie, Stuttgart.
Elaborate work of the
great fifteenth century at
Ferrara, expressed by
an unusual and
enigmatic painter from
Bologna.*

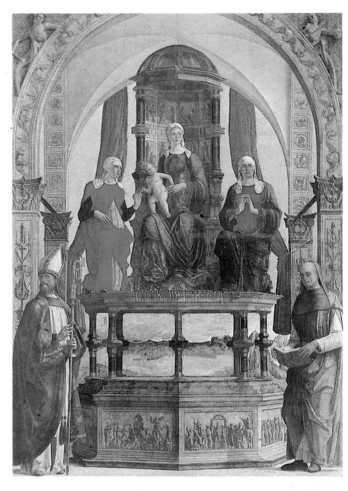

*Opposite below:
Giovanni Bellini, Christ at
the Descent from the
Cross, c. 1475. Museo
Civico, Rimini. Very
human and painful
picture of the great
Christian theme in pure
classic style.*

*Opposite far right:
Antonello da Messina,
St. Sebastian, c. 1476.
Gemäldegalerie,
Dresden. Central
element of triptych for
the church of S.
Giuliano, Venice. Peak of
perspective work begun
by Mantegna and Piero
della Francesca, paving
the way for Carpaccio.*

with a charitable function – thus causing the
spread of a type of narrative state art normally
associated with the Ducal Palace.

Vittore Carpaccio (*c.* 1460–1525/26) and
Gentile Bellini worked together, from 1496, in
the Scuola di S. Giovanni Evangelista. Carpac-
cio was responsible for the famous *View of the
Rialto*, in which the miracle event is of second-
ary importance in the bustling city scene that
dominates the canvas. Gentile contributed the
Procession and *Miracle of the True Cross*, both
in prominent Venetian settings.

Carpaccio's great contribution was to docu-
ment Venetian society, customs and costume;
these were the "props" for the type of pro-
cessional iconography required by the
scuole. For example, the cycle for the Scuola
di Sant'Orsola, now in the Accademia, por-
trays a sacred pageant performed by a
famous group of theatrical producers, the
compagnie della calza. Carpaccio's imagery,
being closely linked to the functions of the
scuole, includes ethnic themes such as
schiavoni and *albanesi* – Slavs and Albanians
– minorities for whom he painted the cycles of
St. George, and of St. Jerome and St. Trifonius,
still *in situ* in the Scuola di S. Giorgio degli
Schiavoni, and a Marian cycle dispersed be-
tween the Correr Museum, and the Ca' d'Oro.

Several minor artists of the Bellini and Carpaccio circle are worth noting; Lazzaro Bastiani, at one time thought to be Carpaccio's teacher; Jacopo da Valenza, a close follower of Alvise Vivarini; Vicenzo Catena, author of an enraptured blue-toned *Martyrdom of St. Catherine* in the church of Sta. Maria Mater Domini and a powerful *Judith* in the Quadreria Querini Stampalia; Rocco Marconi, showing a grasp of the new trends in his Giorgionesque *Christ with St. Peter and St. Andrew* for the Basilica of SS Giovanni e Paolo; Andrea Previtali from Bergamo, follower of Lorenzo Lotto; Marco Marziale, whose *Feast at Emmaus* in the Accademia is of northern inspiration; the repetitive though pleasingly lyrical Francesco Bissolo; Boccaccio Boccaccino, active in Cremona, who painted a charming *Mystical Marriage of St. Catherine* now in the Accademia and a Bellinian *Sacra Conversazione* in the church of S. Zulian; the Santacroce family, notably Gerolamo and his great altarpiece *St. Thomas Beckett Enthroned with Musician Angels* for the church of S. Silvestro; and most important of all these, Marco Basaiti and his two post-Bellinian masterpieces in the Accademia: *Agony in the Garden* of 1510, once in the church of S. Giobbe, a contemplative interpretation of a highly charged event, and the formidable *Calling of the Sons of Zebedee* painted for the church of Sant'Andrea alla Certosa, with its original spatial effects such as

and, finally, Giovanni Buonconsiglio, who displayed a prodigious early talent in his *Pietà* in Vicenza Museum and painted two altarpieces in Venice more in the style of Cima than Bellini – *St. Sebastian with St. Roch and St. Lawrence* for the church of S. Giacomo dell'Orio and *Christ Blessing St. George and St. Jerome* for the church of Spirito Santo.

While all these artists continued in the Bellinian tradition new and unfamiliar influences appeared in Venice in the first ten years of the sixteenth century. Possibly the presence of artists from outside – Perugino from Umbria, Leonardo from Tuscany, Dürer from Germany – provided the conduit for the romantic interpretations that Giorgione, Titian and Lotto gave to the great Bellini's first intuitive renderings of nature. Perugino had worked with Carpaccio and Gentile on a canvas for the Scuola di S. Giovanni Evangelista, now lost, but his bland expressions coupled with Leonardesque motifs can still be seen in the vast, coffered ceiling of the church of Sta. Maria della Visitazione alle Zattere, in the *Saints and Prophets* ceiling panels surrounding a central tondo of a *Visitation* by another hand, the entire surface completed within the first decade of the century.

Venetian regional art of around 1500 is also worth noting. Bartolomeo Montagna, a Bellinian disciple who was active in Vicenza at the same time and slightly earlier than Giovanni

the keel of the boat invading the onlooker's space as though claiming his participation in imminent events of an unusual nature. Other artists worthy of mention are Benedetto Diana, whose formal, well-honed emulations of late Bellini and Cima da Conegliano can be seen in several *sacre conversazioni* in the Accademia

Buonconsiglio combined Lombard culture with Bellinian principles in polished interpretations of harsh and rugged forms. When Andrea Mantegna stayed in Verona he left his mark on Francesco Benaglio, Francesco Bonsignori and Francesco Morone, while Liberale de Verona remained faithful to his original mentor,

Squarcione. Lastly, the exceptionally fine miniaturist and painter Girolamo da Cremona deserves to be mentioned.

Treviso was the mediating point between Venice and the north and home to talented artists like Girolamo da Treviso and Pier Maria Pennacchi. Northward of Treviso painting was represented by Andrea Bellunello, Domenico da Tolmezzo and Giovanni Martini da Udine.

On the Adriatic coast Bellini's influence was decisive among Romagnan artists such as Marco Palmezzano, the Bernardino brothers and Francesco Zaganelli da Cotignola, who united the language of Venice with the early Classicism of Bologna.

Venetian sculpture flourished mainly in the Veneto region and followed the same pattern as painting; that is to say, in Venice proper, sculptors like Matteo Raverti and Giovanni and Bartolomeo Bon were still working, in the Ca' d'Oro, according to Gothic principles at a time when Donatello's impact on Padua went unchallenged and lived on in the fine bronze works of Bartolomeo Bellano, who assisted Donatello in the Basilica of St. Anthony; in the intricate skills of Andrea Riccio's bronze statuettes; in Giovanni d'Antonio Minelli de'Bardi and in Jacopo Alari Bonacolsi known as l'Antico.

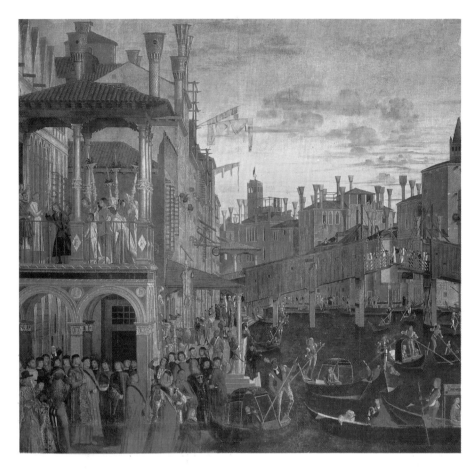

Gian Maria Mosca were present in Venice, as was the great Verrocchio, who between 1481 and 1488 executed, in the wake of Donatello's noble Gattamelata, the vehemently dramatic equestrian monument to Bartolomeo Colleoni, standing on Alessandro Leopardi's plinth.

At the end of the fifteenth century the world's two greatest artists, Michelangelo (1475–1564) and Raphael (1483–1520), were emitting the first hints of their genius. Michelangelo

The first true Renaissance building in Venice appeared only in 1460. In the *Porta dell'Arsenale* exuberant Gothic decoration has ceded at last to the uncluttered architectural ideas of Albertian humanism. Donatello's Venice masterpiece of a few years before, a *St. John the Baptist* in polychrome wood for the Frari church, is too forward-looking in mood and expression to dwell comfortably with the concepts of the *Porta*; it compares instead with the animated bas-relief of the *Crucifixion* attributed to another outsider, Francesco di Giorgio Martini, in the Carmini church. But the most sought-after ideas at this time came from the Solari family, known as Lombardo, whose fusions of architecture and sculpture reconciled the picturesque refinement of Venetian taste with the measured control of humanism.

Pietro Lombardo's early tendency toward Donatello's Padua style can be seen in the tomb of Doge Pasquale Malipiero of 1462 in the church of S. Zanipolo. He subsequently tempered his approach in the more restrained style of Doge Pietro Mocenigo's tomb of 1476. The new stability was probably the influence of Antonio Rizzo, active in the Charterhouse of Pavia and from 1475 in Venice, whence he fled in 1498 following a charge of misuse of public funds. Rizzo's greatest achievement in Venice is the celebrated pair of signed statues of

Adam and *Eve* in the Ducal Palace, elegant and monumental alike. The programmatic unity in Rizzo's tomb of Doge Nicolò Tron of 1473 in the Frari church is the result of the successful integration of architectural and sculptural forms. This type of construction was copied by Pietro Lombardo and later adopted with accentuated refinements by his sons Antonio and Tullio. These two countered Rizzo's rather grand statements by a delight in using painted forms for their models. The Bellini example is clearly stated in the reliefs and general decoration of the church of Sta. Maria dei Miracoli and in the façade of the Scuola grande di S. Marco. In his father's footsteps Tullio constructed tomb masterpieces, for Doge Giovanni Mocenigo (1485) and Doge Andrea Vendramin, in the church of SS Giovanni e Paolo and was responsible for the great carved panels in the Cappella del Santo in Padua. Other works include the statue of Guidarello Guidarelli now in the Pinacoteca in Ravenna; a *Coronation of the Virgin* in the church of S. Giovanni Crisostomo; a classicizing relief of a *Young Couple* in the Ca' d'Oro; a *Pietà* in the church of La Salute; the tomb of Pietro Bernardo in the Frari church and a shrine with two kneeling angels in the Oratorio del Seminario.

During this period Lombard artists like Gian Giorgio Lascaris, known as Il Pirgotele, and

trained mainly in Classical modelling in Ghirlandaio's workshop, developed in the type of *Battle of the Centaurs* (*c.* 1490, Bargello Museum). In the new century the *David* and-*Doni Tondo* set the course of greatness. Painting and sculpture unite in projecting the centrality, power and dignity of man as the ultimate expression of nature. Some of the spiritual subjects of this period were to be incorporated in a tomb for Pope Julius II, but Michelangelo's designs were never executed; the famous *Prisoners* and the *Moses* are samples of the statuary involved.

While he was planning the Julius tomb, Michelangelo worked on the ceiling of the Sistine Chapel between 1508 and 1512. The ceiling marks the point where quintessential Classicism becomes extreme, or "mannered," as has been revealed in the latest restorations.

While balance and monumentality in the human form were attainable in sculpture and painting, architecture was developing a new language of composite, highly intellectual ideas. In the Laurentian Library, for example, Classical principles have been used with considerable license; Michelangelo has applied a mannered approach to ideas borrowed from the last two architects of fifteenth-century orthodoxy, Antonio Sangallo the Elder, who built the church of S. Biagio in Montepulciano, and his nephew, Antonio Sangallo the Younger, responsible for the Farnese Palace in Rome.

Raphael is less discussed than Michelangelo perhaps because his career, if equally intensive, was relatively short. A pupil of Perugino, his first mature expression of the values of balance and harmony is the *Betrothal of the Virgin* (Brera Gallery). Here the architec-

tural setting is borrowed from Bramante; under the later influences of Leonardo and that superb craftsman of the Florentine school Fra Bartolomeo, Raphael achieved a new mastery in *Madonna with the Goldfinch* (Uffizi Gallery), an intellectual composition in which the geometric arrangement of the figures appears convincingly natural. The same harmony of thought instils the portraits of Agnolo and Maddalena Doni and, immediately afterward and in simultaneous execution with Michelangelo's work in the Sistine Chapel between 1508 and 1511, the frescoes in the Vatican Stanze, notably the *Dispute Concerning the Blessed Sacrament* and *School of Athens*, where human and divine order appear as one. This balance of forms is later tested to the extreme in works like *Triumph of Galatea* (Farnesina Gallery), *Transfiguration*, *Madonna*

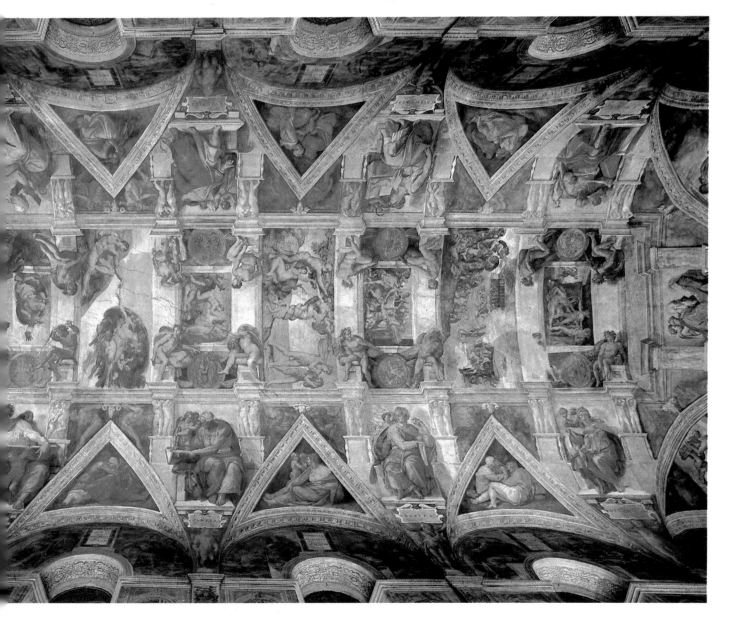

of Foligno and the portrait of *Leo X*, which would become texts for the Mannerist artists. Two works, perhaps the most influential of all in disseminating Raphaelesque Classicism, were the *St. Cecilia with Saints* in Bologna and the *Madonna of the Fish* in Naples. In Emilia, after the early anti-Classicism of Ludovico Mazzolino in Ferrara and Amico Aspertini in Bologna, the harmonizing influence of Raphael grew widespread, reflected in the Ferrara school by Benvenuto Tisi da Garofalo, Giovan Battista Benvenuti, known as Ortolano, Girolamo Carpi and Dosso Dossi, who combined it with picturesque Venetian detail in his

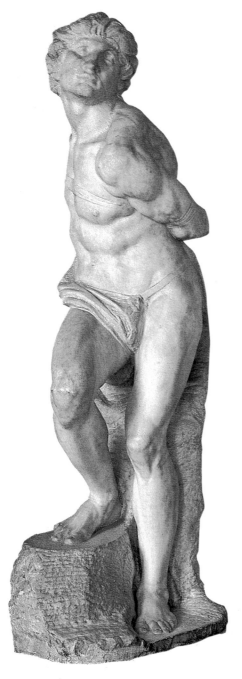

light-humoured mythologies; and in Romagna artists from Bartolomeo Ramenghi, known as Bagnacavallo and Innocenzo Francucci da Imola to Girolamo Marchesi da Cotignola.

In the South the lesson of Raphael had the same impact, on Cesare da Sesto, Giovan Francesco Penni, Andrea da Salerno; and elsewhere between Romagna, the Marches and Latium on Luca Longhi, Girolamo Genga and Cola dell'Amatrice.

Emilian art really came into prominence thanks to the inventive and luminous sixteenth-century painter Antonio Allegri, known as Correggio. He decorated two domes in Parma, in the church of S. Giovanni Evangelista and then in the cathedral. They are Baroque interpretations well in advance of their time and of their kind virtually unsurpassed. The style is a unique blend of Leonardo and Raphael arranged in a concentric, paradisiacal vision that is extraordinarily luminous and homogeneous in character. The whole effect is one of radiant ecstasy. Correggio's art is neither realist nor Platonist but contrives to be sensual, both physically and intellectually, in a manner which, at the time of execution (between 1520 and 1530) had never been seen or heard of before.

After the Bellini era, Giorgione and Titian provided the Venetian answer to Raphael and Michelangelo; but while the latter two were but distant lights, Leonardo, after a brief and probably non working visit, left behind in the Veneto one of his most valid pupils, who had also been exposed to Bramantino: Giovanni Agostino da Lodi or Pseudo-Boccaccino. He left a number of respectabe paintings in the master's idiom: *St. John the Evangelist with Two Apostles*, a *Madonna with St. Simon and St. Jerome* and a *Washing of the Feet*, dated 1500, in the Accademia; a *Pietà* in the Ca'd'Oro; a *Virgin and Child with St. Catherine of Alexandria* and *St. Jerome and St. John the Baptist* in the church of S. Stefano; a large altarpiece in the church of S. Pietro Martire in Murano; a *Virgin and Child with Two Angels and Donor* in the church of S. Lazzaro degli Armeni.

Albrecht Dürer paid a second visit to Venice in 1505. He painted a high altarpiece for the church of S. Bartolomeo, *The Madonna of the Rose Garlands*, now in Prague, and *Christ Among the Doctors* of 1506, now in the Thyssen-Bornemisza Collection in Lugano. His presence had a determing influence. He succumbed to the aged Bellini's greatness but was also able to write that young Venetian artists kept asking him for designs to copy.

In 1500 the Venetian ascendant had been celebrated topographically, in Jacopo de'Barbari's famous aerial view of the city. It was soon to witness the arrival of one of its greatest masters. Giorgione's pedigree cannot be fully traced but probably derives from a supreme synthesis of Bellini, Carpaccio, Leonardo and Perugino's contemplative lyricism. He was the first painter to break from the official art of the

churches and *scuole*, asserting himself in the intellectual and humanist tradition of private patronage. The *Tempest*, now in the Accademia, was privately commissioned by the Vendramin family; the *Three Philosophers*, now in Vienna, by the Contarini and the *Sleeping Venus*, now in Dresden, by the Marcello family – all great Venetian names and the new arbiters of taste. The inscrutable nature of Giorgione's themes is compounded by references to Petrarch and Platonism, by affinities with the Asolan culture of the curious Queen Caterina Cornaro, immortalized by the poet-savant Pietro Bembo; but the ideological

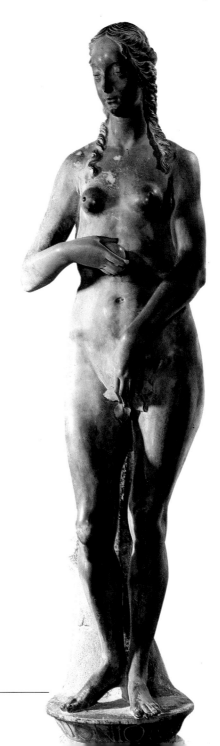

matter does not affect Giorgione's style, which is an undisguised affirmation of freedom of language and aesthetic choice.

Giorgione's solutions to the demands of patrons uninhibited by cultural and religious pressures were the first examples of art for art's sake, a source of aesthetic pleasure, a titillation of the senses, even if on a high intellectual plane, even if the stimulus came from a connivance between philosophy and literature. The work of art itself has become literature, a text laden with significance, understood by only a few. The landscape in *Tempest* is not the natural setting of a divine event but the conceptual vision of an imaginative sensibility. In *Portrait of an Old Woman* in the Accademia, the pitiless ravages of time are at once a reflection and a contemplation of human destiny, end of the idyll pictured in *Tempest*, the anti-portrait.

In 1508, Giorgione was working on the decoration of the Fondaco dei Tedeschi with a young artist named Titian. Giorgione painted the water-side and Titian the wall overlooking the *calle*. Vasari was impressed with the monumentality of Giorgione's figures; possibly Giorgione already knew of Michelangelo, whose influence was present in the organ shutters of *Justice* and *Compagno della Calza*. For a while he developed pastoral themes in the manner of Giorgione's *Concert Champêtre* (Louvre, sometimes attributed to Titian), and later in *Sacred and Profane Love* (Borghese Gallery, Rome). Coinciding with the death of Giovanni Bellini in 1516, the remarkable, painterly Frari *Assumption* confirmed Titian's prowess as a colourist and draughtsman and launched the period of his greatest activity, succeeding Bellini as the dominant Venetian artist of his century.

Titian's fame overshadowed one of the most modern and individual artistic personalities in

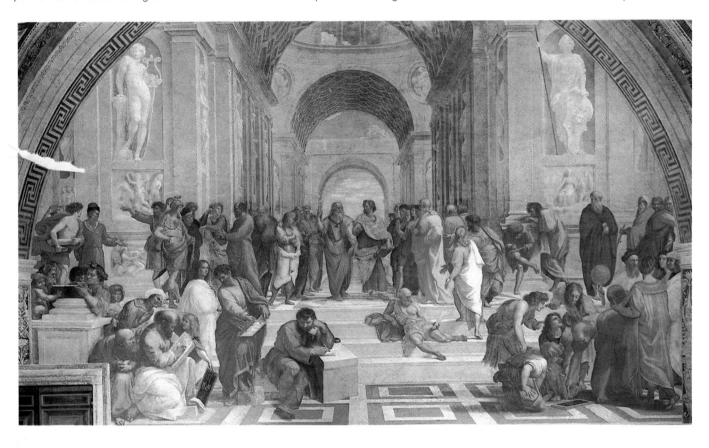

Opposite left: Michelangelo, Prisoner, for the tomb of Julius II, 1513–14. Musée du Louvre, Paris. A powerful statement of intellectual strength that brings the marble to life.

Opposite right: Antonio Rizzo, Eve, c. 1485. Palazzo Ducale, Venice. A splendid example of classicism in early sixteenth-century Venetian sculpture.

Above: Raphael, School of Athens, 1510–11. Vatican Museum, Rome. In Raphael, consummate harmony brings together high intellectual endeavour with divine order, uniting ancient philosophy and Christian thought.

the church of S. Bartolomeo, painted the same year by Sebastiano del Piombo, who, in 1509, produced the monumental *San Giovanni Crisostomo Altarpiece*. Thus the most advanced positions in Venetian art marked the very spot where three years earlier Dürer had left his altarpiece. And Giorgione's change of outlook, from inwardness to outwardness, can be seen in the surviving fragments of his decorations in the Fondaco and engravings of the lost parts, where the openly explicit virtues of the *Nude* on the façade have replaced the introspective mood of works like *Tempest*.

Titian (*c.* 1487–1577) never had Giorgione's inhibitions; in Longhi's words he "Shed all the timidity of Giorgione" right from his earliest assignment in the Fondaco in, for example, the history of Venetian painting, Lorenzo Lotto (*c.* 1480–1556). Lotto's early attempts in Treviso and Venice are interesting adoptions of the northern Dürer type of Antonella da Messina, whose influential sojourn in Venice had already reverberated in Treviso, in the work of Alvise Vivarini and Pier Maria Pennacchi. Like Giorgione, Lotto conveyed naturalism in different aesthetic guises, for example *St. Jerome in the Wilderness* (Louvre). Lotto was a true romantic with a heartfelt sense of being. In particular, his portraits reveal a new, mental dimension; he eschews the grand, visual display of a Titian and seeks out the inner self-revelatory mood, the quiet movement of the soul. His psychological grasp is brilliantly conveyed in *Portrait of Gentleman with Green*

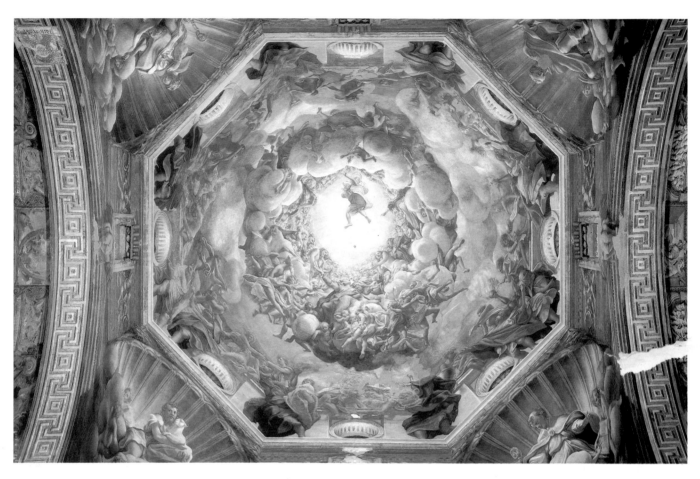

Lizard in the Accademia, painted on a brief return visit to Venice following long stays in Bergamo and the Marches. After this visit, in the late 1530s, Lotto further revealed his individuality in an altarpiece for the Carmini church, in which two spatial zones are apparently inverted: the lesser zone accommodates the religious subject, a St. Nicholas in Glory, pre-Counter-Reformation in spirit, while the marginal subject, occupying the more important space, is a magnificent coastal view, as open as a nineteenth-century landscape.

On his last visit to Venice before retiring to the Holy Sanctuary at Loreto, Lotto painted *St. Anthony Giving Alms* for the friars of the church of SS. Giovanni e Paolo, in exchange for his own burial there (he was buried in Loreto instead). The painting reveals the same dichotomy that is expressed in the Carmini altarpiece; above, the saint; below, a very human crowd of alms-seekers with their backs to the viewer, real people at the feet of the saint, instrument of theatrical allegory. In the traditional *Sacra Conversazione* of 1546 for the church of S. Giacomo dell'Orio the style is weak, betraying Lotto's flagging inspiration.

Titian, on the other hand, was forging ahead, the incarnation of Venetian art. He painted for the courts of Ferrara, Mantua, Urbino; Emperor Charles V, Pope Paul III, the Queen of Hungary, Ferdinand I and Philip II commissioned portraits. As his reputation grew in Europe he continued to display his bravura in Venice: *St. Christopher* in the Ducal Palace; the great *Pesaro Altarpiece* in the Frari church, a slanted pyramidal construction

Above: Correggio, Assumption of the Virgin, 1524. Cupola of Parma Cathedral. Heaven, real and metaphorical, enters the dome in a Baroque spiral.

Right: Lotto, Portrait of Gentleman with Green Lizard, c. 1527. Gallerie dell'Accademia, Venice. The gentle melancholy, the passing of time, the conveying of emotion are all signs of the painter's disquieting modernity.

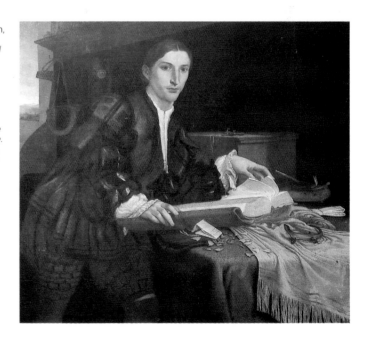

which he was both identifying himself with themes already developed by Pordenone and his followers in the cathedral and developing themes that were Venetian and Paduan in origin (from Titian to Parmigianino), in a style taut with painterly energy, powerfully directed toward that ideal of beauty which he had studied in Parma. Here was an issue that would lead to the major theses of the Mannerist "season" immediately prior to the middle of the century: the theory of the renewal of the Golden Age, which restores to humanity its sense of physical wholeness and beauty, and the categorical affirmation of the "vorticist" style, based on a spiralling construction of the figure which lends the appearance of movement within the image – something that is in fundamental opposition to the concept of figurative art itself, which is, by definition, static. Rosso Fiorentino, before finally moving to France, had already elaborated on this new definition of the figure, but it was really Bronzino (1503–72), a pupil of Pontormo and an impassioned follower of Michelangelo, who was to consecrate this spiral form in the fresco decoration of the chapel of Eleanor of Toledo in the Palazzo Vecchio in Florence, a work that he completed before the middle of the century.

At the end of this critical fifth decade, the Cremonese artist Giulio Campi was completing the altarpiece for the high altar of S. Sigismondo, thus consecrating the solemn

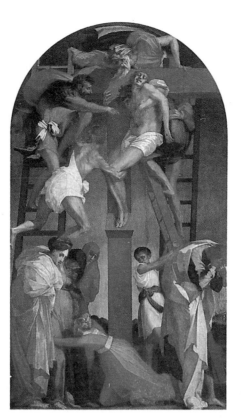

and naturalistic style characteristic of the region of the Po valley, to which the contemporaneous development of the work of Gerolamo da Carpi also contributed (*Adoration of the Magi*, Pinacoteca Nazionale, Bologna). Meanwhile, the two young Tuscan artists Vasari and Salviati, influenced by Pontormo and Rosso's last works, were travelling to Venice and Michelangelo was completing his *Last Judgement* in the Sistine Chapel in Rome.

In Venice, a grandiose plan of urban redevelopment was taking place, and a great contribution was made to this by Jacopo Sansovino (1486–1570), sculptor and architect, a multifaceted figure of tremendous influence in artistic circles. Sansovino had, in 1537, set in motion the building of the Marciana Library, a building of great symbolic importance: a kind of transfiguration of the model of the Classical triumphal arch, used as a metaphor for the solemn affirmation of humanist knowledge. The decoration of the Great Hall, which was undertaken under the influence of the Tuscan masters, represented the greatest Mannerist enterprise in the Venetian region, and laid down the premises for future decorations in the Doge's Palace during the sixth decade of the century.

The decoration of the Library was carried out under the direction of Sansovino and Titian. Learned figures such as Giuseppe

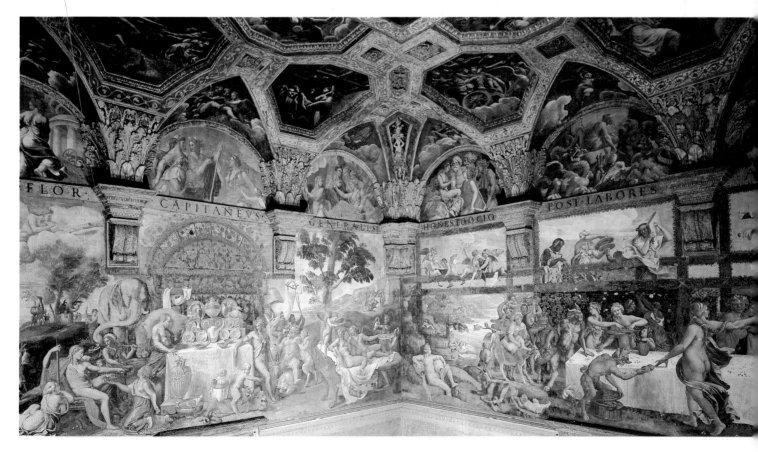

Porta, Giovanni de'Mio (a Venetian who early on came under the influence of van Heemskerck), the powerful Battista Franco, the refined Giulio Licino, and the hot-headed Giambattista Zelotti (1526–78) were artists working within a greatly expanded field of vision and perspective, exalting that criterion of "living beauty" which Paolo Veronese would later define – in its final form – in the following decade. It is the age of the nude, of the perception of the artist's creative freedom, such as can be seen in the works of a sculptor such as Benvenuto Cellini (1500–71), whose *Perseus* (completed before 1554) is a good example of the degree of elaboration achieved in the figure, which is endowed with an inner energy and with such a strong hedonistic sense of beauty as to be truly erotic. This was the culmination of that process of "emulation" that had begun with the contest between the ancients and the moderns, and which now had turned into a genuine competition between masters of the same school in the common pursuit of a model of material beauty, to the extent that by the middle of the century such an impressive series of pictorial enterprises seemed to warrant some sort of systematic record of the enormous quantity of artistic knowledge which by now had expanded across the whole of Europe; hence Vasari's *Lives*, which were published in 1550.

A little earlier Vasari himself had set out in practice the premises of this theoretical and historical operation, in his frescoes in the *Sala*

dei Cento Giorni (Hall of the Hundred Days) in the Palazzo della Cancelleria. This was one of the Farnese commissions (undertaken for Alessandro Farnese) which were to celebrate the return of the Golden Age, in the exulting multiplicity of the events depicted, and in the perspective structure, a true stage for the arts and for the iconological subtext. This Golden Age was in fact an illusion allowed by the momentary truce between Charles V and Francis I, which would have few substantial consequences, but it did entail a Plutarchian celebration, with the production of the *Lives* of famous men. At the same time Perin del Vaga, with a host of pupils, was putting the finishing touches to that other great Farnese enterprise, the Papal Apartments in Castel Sant'Angelo. Similar developments were to be found in the Veneto and Flanders. Masters such as Frans Floris (1516–70) in Antwerp and Tintoretto in Venice were working on analogous themes. *Mars and Venus* by Floris, of 1546, now in Berlin, has more than a few analogies with Tintoretto's creative intentions in the *Miracle of the Slave*, painted in 1548, while in Italy Perin del Vaga's many followers were also starting out in this same direction, before straightaway adopting a Michelangelesque point of view.

One of the great myths of all time in the field of painting – that is, the power of suggesting "life" or "living breath" in the painted figures – gained new strength, which in turn gave rise to new and unexpected developments in the field of both sacred and profane art, with mutual influences and counter-influences that merged as the century progressed and linked together artistic figures, even very distant ones, all of whom had been brought up on analogous premises.

In the second half of the century, for instance, it will be in essence the Italian education, supplemented by an early exposure to Flemish or neo-Flemish influences, that will provoke the rise of figures who are, at first glance, seemingly totally unrelated, but are in fact closely connected, such as El Greco – who will become almost a symbol of mystic and visionary art – and Bartholomeus Spranger, a painter who, for a long time, was

Above: F. Clouet, Portrait of Diana of Poitiers. *National Gallery, Washington. This is a work representative of the school of Fontainebleau, in which Clouet clearly defines the pattern of an art which, although very much bound by likeness, leans toward a favouring of style for its own sake, through a highly finished exposition of the subject matter.*

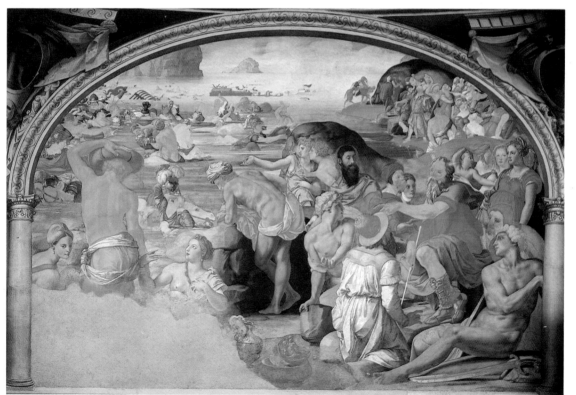

Left: Bronzino, Crossing the Red Sea. *Palazzo Vecchio, Florence. This fresco is part of a cycle executed in the private chapel of Eleanor of Toledo in the Palazzo Vecchio at the beginning of the fifth decade of the sixteenth century. These are seminal works for the whole of Mannerist culture, by an impassioned pupil of Pontormo and a great admirer of Michelangelo's artistic grammar.*

the delight of surprise: at nature as a marvellous spectacle, at the miraculous as a prodigy of nature, at the way in which substance will accentuate its own colour, richness and limpidity. Light, the least substantial element, becomes, on the other hand, a malleable material in the Baroque *composto*, or in the image produced. It may be soft and diffused, shielded, or reflected from contrived light sources; it is concentrated, deliberately channelled; it rakes, or skims, or forms a dazzling field for objects seen against it.

Rococo, with its complicated origins in French culture (if not, indeed, in reawakened Mannerism) is now seen to spring from different soil, while Baroque and Rococo between them are no longer thought to cover every

equally efficient, of alliance between Church and Court, by the founding of new religious orders with specifically missionary objectives, and an increasingly conscious use of improved and broader communication systems. Among the latter was what we could call propaganda – though we might be oversimplifying – and propaganda of course included the works of art that interest us today.

Although Italy held its supremacy as a source for Renaissance works, little enough art was actually produced there save in a few of the provincial capitals – Rome and Venice, and, for particular styles and developments, Turin and Naples. Rome, with the innumerable attractions of the Papal Court, was still one of Earth's great cities: magnet for diplomacy and

sioning of many works for reasons of family prestige during what might be one short reign, though the rapid alternation could also provide the stimulus for fresh ideas and projects, even when in opposition to those of the years immediately past.

Difficult as the stylistic issues are to understand, all this explains the vitality and variety in Roman art of the period, and the strides made in form and technique. Between 1597 and 1608 the Bolognese painter Annibale Carracci (1560–1608) completed his decoration of the gallery in Palazzo Farnese with mythological frescoes on the triumph of the power of love. In their newness, freshness and vigour they were almost aggressively alive. Nothing like them had been seen before, nor had the levels of

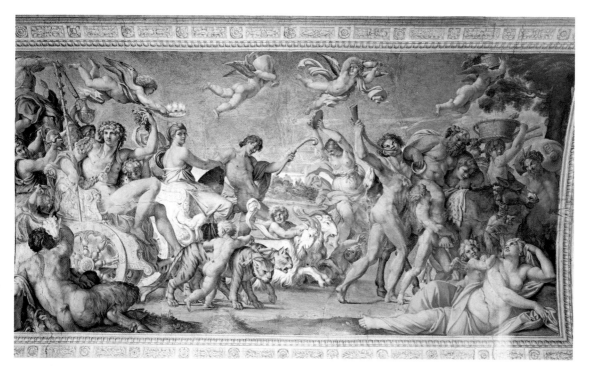

Left: Wedding procession of Bacchus and Ariadne, by Annibale Carracci. Gallery in Palazzo Farnese, Rome. Based on a Hellenistic version of Love's triumph adapted by his literary friend G. B. Agucchi. The design, articulated in two groups, is set in a curved panel turned toward the viewer; the top opens on a landscape, the sides are closed by the reclining figures of a satyr and Venus.

Opposite: Caravaggio, Conversion of St. Paul, (1600–01). Cerasi chapel in Sta Maria del Popolo, Rome. This work had been criticized as "quite devoid of action" (G. P. Bellori, 1672).

artistic idea and achievement in Europe and her colonies during the seventeenth and eighteenth centuries.

Baroque in Italy

From the end of the sixteenth century to the beginning of the seventeenth Europe grew more important in the world at large. With the Turkish fleets and armies checked, at least for the time being, new cities were established, some of them as architectural or social experiments, in the vast colonies of Latin America, and commercial relations opened up with the Far East. On the Continent itself the long religious wars gave way to a kind of armed peace as military forces, especially on the Catholic side, were often replaced by those,

finance and seat of every study from that of ancient Christian literature to modern theological niceties, from Classical remains to the architecture and magnificent collections of the Renaissance. A distinguishing feature, when compared with Madrid or Paris, was the markedly short tenure of authority. In what might be considered the oldest, and thus presumably the most stable, polity in Europe, the governors of Rome and their colleagues could disappear with alarming speed, for a papal household was subject to frequent, and sometimes traumatic, changes at the top. Each new Pope, as an absolute sovereign, chose his highest government officials and financial officers, his generals and his diplomats from among his own friends and relations, rarely retaining those of his predecessor. In the domain of art, this could lead to the commis-

illusion been so subtly differentiated as in these pictures in the barrel vault, in their painted architectural setting.

Caravaggio (1573–1610) died in this first decade of the seventeenth century, after a life devoted to passionate research, deep, stubborn and original, into the formal problems of painting realistically dramatic subjects: on how to concentrate action, or convey a more direct perception by means of dark backgrounds and by throwing a brilliant lateral light on to the image. Ordinary, nonpalatial settings added to the realism, as did his use of ordinary people as models – a daring and unfamiliar practice. Dramatic effects were achieved with few figures and at times with very few gestures. We remember the outflung arms in *The Conversion of St. Paul* in Sta Maria del Popolo, the seizure of the saint's wrist in *The Martyrdom of*

Baroque and Rococo

Never, perhaps, in the history of art can the terms and frontiers of language, of chronology, geography and formal definition have been so far expanded, contracted and generally stood on their heads as in discussion of the Baroque. During the last 300 years the work of various painters and men of letters, to say nothing of much literature, music and figurative art from the seventeenth and eighteenth centuries, has been assessed, at one time or another, as deceptive fantasy, incomprehensible nonsense or arid pedantry. Or – and this was a view characteristic of the latter half of the nineteenth century – Baroque has been regarded as an eternal component of art, an expression of the irrational, creative life-force, Dionysiac and permanently opposed to the Apollonian calm of Classicism. The outcome of this attitude, as it persists down the centuries, is often stylistically similar, since it too leads to a strong feeling for plastic energy and a love of irregular forms.

Nowadays "baroque" is recognized in some quarters as categorizing a whole school of ancient architecture born in Classical Greece and continuing through the Hellenistic age to the second century A.D. in the central and eastern Mediterranean. Many art historians, moreover, particularly the Germans of the mid nineteenth century, were to perceive a special quality in European art of the late sixteenth to mid eighteenth centuries, and so reverse the former unfavourable verdict on that period. The great aim was now to establish its stylistic and conceptual links with the Renaissance. Where, before, abstract antitheses – often arising from hasty judgements of art seen in

some complex social context, such as that of the Counter-Reformation – had governed conceptions of form and composition, these later critics strove to give proper historical meaning to the word "baroque." They rescued it from its narrow use in sterile dispraise, and from its subsequent extension to denote a frame of mind.

Though deep-rooted anti-Baroque prejudice was still evident in the deliberate denigration or neglect of seventeenth- and eighteenth-century art and artists, the tendency of the final decades of the nineteenth century was toward the study of the style as a specific entity. The characteristics of its different branches were distinguished, its exponents examined against their cultural and historical backgrounds, and connections made between seemingly distant cultural orbits, past or present.

The identity of Baroque thus emerges by way of fragmentation and integration. If there are deviations and mismatches between representational art, literature and music, there are also cross-contributions in the treatment of individual works, while analysis and comparison of form and technique, or of a patron's

G.L. Bernini, Ecstasy of St. Theresa (c. 1647–52), altar of the Cornaro chapel, Sta Maria della Vittoria, Rome.

motives, may reveal diverse origins. From their primary flowering in the prolific and varied international culture of papal Rome under Urban VIII (1623–44) and Alexander VII (1655–67) the figurative arts of the Baroque may be traced, through mutation and revival, throughout Europe and beyond.

The basic characteristics of this style may be learned in the process of observation – not forgetting the necessary limitation to essentials – and the first thing we note is that its spaces, actual or implicit, are flowing and fluid. They accompany the human presence but not as a rigid network or, in Mannerist fashion, with any threat of dramatic tension. The idea of movement is integral to Baroque structure, existing within a coherent unity of action and the organization of different techniques as means of expression. It is this organization, transcending mere formal co-ordination, that Bernini has in mind when he speaks of *bel composto* – the "fine composition" or totality – which, he says, implies as much care in the design of a lamp as in that of the noblest building. Baroque is the representation of spontaneity and visual immediacy, always with an underlying, calculated awareness of compositional and symbolic purpose. It is the fulfilment of a new discourse between what is stressed and what is natural, between animated gesture and idealization, co-ordinated control of the architectural orders and an energizing of space and surface. In comparison with Mannerism – and in conflict with sundry sixteenth-century Counter-Reformation precepts – it marks the return, in a sacred setting, to allegory and metaphor. It reaffirms

MARVELED: "[IT] HAS BEE

TREATED LIKE A SIMPL

PIECE OF WOOD WHICH EAC

HAS CUT AND TRIMMED T

SUIT HIM; THAT WHICH PR

JECTED HAS BEEN CUT OF

PARTITIONS HAVE BEE

BROKEN THROUGH, FLA

SURFACES HAVE BEE

CARVED—SOMETIMES . .

WITH GREAT IMAGINATION.

A KAU WOMAN OF SUDAN R

CEIVES HER FIRST SE

OF RITUAL SCARS AT PUBE$

CENCE, HER SECOND AT SE

UAL MATURITY AND A FINA

SET WHEN SHE WEANS HE

FIRST CHILD. IN SOM

TRIBES, SCARS RECEIVED A

COMING OF AGE ARE SITUA

SOME CASES ...
CREATE DISORIENTATION,
AND SO AID IN THE SHED-
DING OF OLD LIVES, IN OTH-
ERS TO ENHANCE COMMUNI-
CATION WITH A DEITY. HERE
IN A CHURCH NEAR KINGS-
TON, JAMAICA, RASTAFAR-
IAN GIRLS PARTAKE OF "WIS-
DOM WEED"—MARIJUANA—
FOR THE FIRST TIME.

PHOTOGRAPH BY
DANIEL LAINÉ/ACTUEL

active in various Italian cultural centers, and who later became the principal exponent of "courtly style." Radiating from its center in Prague, around the figure of the Habsburg Emperor Rudolph, it would determine aesthetic models that were to remain in force in several European centers right up to the middle of the following century, until the death of one of the last exponents of this international style of painting, Abraham Bloemaert, in 1651.

Domenikos Theotokopoulos, known as El Greco, was born in Crete, in 1541. Bartholomeus Spranger was born in Antwerp in 1546. These two figures symbolically embody the culture expressed by this generation, who achieved the most outstanding results in the last twenty years of the century. Both underwent an Italian education at the highest possible level; El Greco in Venice and in Rome from 1567 to 1576, and Spranger in Parma, Caprarola and Rome between 1564 and 1573, when – having become painter in the service of Rudolph of Habsburg – he brought to perfection, little by little, that style peculiar to himself which would later be adopted and amplified by a veritable array of painters and engravers, from Hendrick Goltzius to Cornelis van Haarlem, to Joachim Wtewael and Giulio Cesare Procaccini.

On the surface it would appear that the paths of El Greco and Spranger diverge, but essentially the ultimate aim of their works has a strong affinity. Both liberated a section of figurative art that had reached full development from its naturalistic inheritance, which a large number of artists still found indispensable. Theirs was a swirling exaggeration of a naturalism already mastered. Both these masters adopted a vast repertory of "figures," elaborated through generations of artists, bringing them back to life in what seems an inexhaustible range of meanings. They both favoured an elongation of the image unfettered by any rule of positioning as formulated during the humanist era, but instead formulated according to even more rigid rules of abnormal proliferation.

This was a conception of art as a zone of sovereign refuge, based upon a theory of incorruptible preciosity, which takes on the typically Italian form of the serpentine figure (Michelangelo had theorized on this principle, which was then further developed in certain of his pupils, such as the Sienese Marco Pino and de'Vecchi, and exalted by the sculptor Giambologna, who also wielded considerable authority on French soil), which affected every aspect of the composition in the ultimate triumph of the Mannerist ideal of the "aggregation of figures" – seen as a dramatic chorus, united in its intentions and expressivity, but potentially idyllic and nostalgically pagan in key. In these developments we witness the disappearance of the essential meaning of the great current of Italian religious art, which already, in the early years of the sixteenth century, had established seminal prototypes that whole generations of artists would continue to use.

The great change occurred in the middle of the century, immediately after 1550, when Lotto, completing the great *Assumption* in S. Francesco alle Scale in Ancona, laid down the final premises for the full affirmation of that style, which, already worked out in detail by Moretto, was now about to be diffused throughout central Italy by another eminent painter from Brescia, Gerolamo Muziano, by way of his decoration of the Duomo in Orvieto, the first large-scale work undertaken after the Council. This is the point of greatest friction

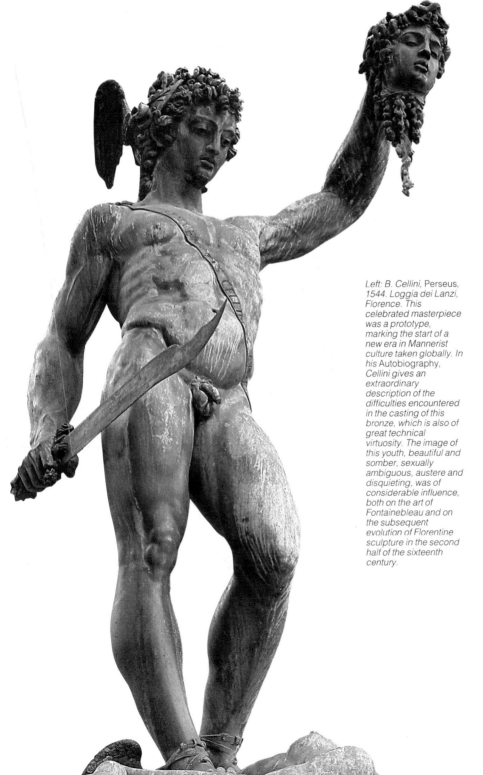

Left: B. Cellini, Perseus, *1544. Loggia dei Lanzi, Florence. This celebrated masterpiece was a prototype, marking the start of a new era in Mannerist culture taken globally. In his* Autobiography, *Cellini gives an extraordinary description of the difficulties encountered in the casting of this bronze, which is also of great technical virtuosity. The image of this youth, beautiful and somber, sexually ambiguous, austere and disquieting, was of considerable influence, both on the art of Fontainebleau and on the subsequent evolution of Florentine sculpture in the second half of the sixteenth century.*

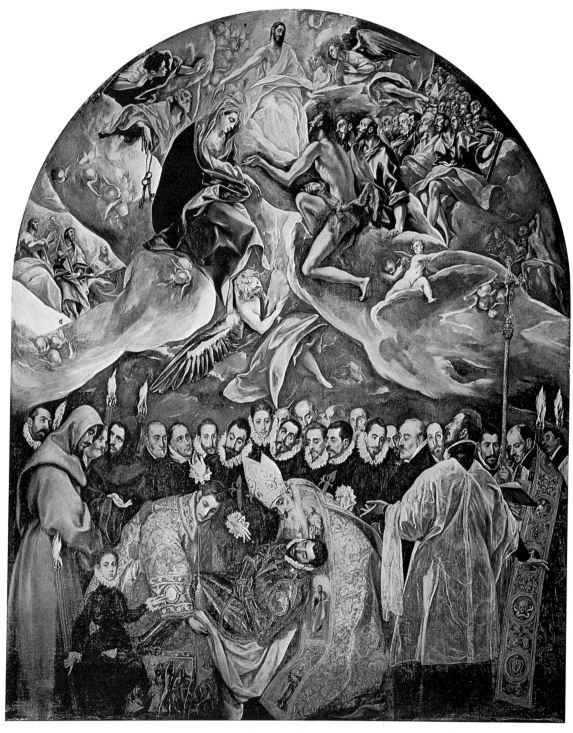

between the two coexisting streams of Mannerist art, one of which continues to identify itself with the religious theories concerning a fitting representation of the truth of the Faith, while the other operates within the limits of a free and heroic function of art, not heretic but profane, or with profane tendencies.

Simultaneous to this opening outward of Mannerist thought and practice, the theoretical aspects are examined more closely and literature on the theory begins to appear; the moment of reflection takes on great importance. Gerolamo Muziano (1528–92) began working in Orvieto in 1556. The close link with the Flemish world is demonstrated by the fact that he was explicitly inspired by the iconographic and stylistic elements recently formulated in Flanders. One need only call to mind the figure of Lambert Lombard (c. 1506–67), a master who, in the mid 1540s, had already invented a compositional layout for the scene which Muziano makes use of in Orvieto. Here, in a series of solemn altarpieces, Muziano and his followers, among whom were Taddeo and Federico Zuccari, established the principles typical of the Counter-Reformation, of the figure of Christ as protagonist, of the crowd of

later follow in the tracks of the mature works of Hieronymus Bosch between the end of the fifteenth century and the beginning of the sixteenth, the true iconological import of his whole opus can only be fully understood if seen in the context of the great religious "maniera." Bruegel, through his vision of that popular dimension ignored by the Italian artists in the circle of Muziano, contributed to the religious current of art the peasant, the small and unimportant, taking on board from popular tales, proverbs and truisms the concept of a generalized level of representation, developing a completely new conception of naturalism, and re-assuming the very Flemish approach to narration, with the canvas not representing simply a single event but being a simultaneous representation of a saga of events in time, in the form of an "anti" or "negative" epic. The tragic vision of the master culminates toward the end of the seventh decade in astonishing works with a renewed solidity of composition, for example, the *Peasant Wedding*. In the same way as the great portrait painters (here also of Titianesque extraction, such as the renowned Anthonis Mor, who was at that time at the peak of his fame), Bruegel demonstrates the way in which the psychological and introspective approach developed in the portraiture of the ruling classes could be assimilated by the religious artist so as to highlight, in an austere and striking warning, the concept of art as an ethical force.

Michelangelo, having completed the *Last*

onlookers as witnesses to the event, of the framing of the event within an urban setting but structured so as to appear on a stage.

This intensely religious dimension to the figurative event is impressively paralleled in the contemporaneous career in Flanders of one of the most eminent of sixteenth-century artists, Pieter Bruegel the Elder (1525/30–69). This master had visited Italy at the beginning of that prophetic sixth decade, which, early in its life, was to mark the start of the work on Orvieto Cathedral. Although his works would

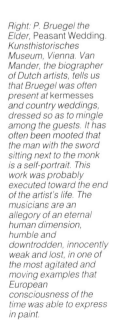

Right: P. Bruegel the Elder, Peasant Wedding. Kunsthistorisches Museum, Vienna. Van Mander, the biographer of Dutch artists, tells us that Bruegel was often present at kermesses and country weddings, dressed so as to mingle among the guests. It has often been mooted that the man with the sword sitting next to the monk is a self-portrait. This work was probably executed toward the end of the artist's life. The musicians are an allegory of an eternal human dimension, humble and downtrodden, innocently weak and lost, in one of the most agitated and moving examples that European consciousness of the time was able to express in paint.

Above: Vignola, The Farnese Palace at Caprarola. Described as "both palace and fortress" by the humanist Fabio Arditio in 1579.

Below: P. Ligorio, Casina of Pius IV, Gardens of the Vatican, Rome. This architect of genius left behind, with this papal residence, one of the most perfect examples of late Mannerist style.

Judgement, which had placed into crisis the Catholic system of iconography and which for some time afterward was to attract the censures of theologians, was coming to the end of his career with the frescoes in the Pauline Chapel, while those Flemish artists whom he detested so wholeheartedly, as his conversations with the learned dilettante Francisco de Hollanda testify, descended, ever more numerous, upon Italy. The southern Italian school of painting takes on importance once again. Here, after the great dispersal of artists after the sack of Rome, an important figure had been that of Polidoro da Caravaggio (1490–1543), a follower of Raphael, who had not even had the opportunity of receiving a formal training from the Master. Visionary and somber in his painting, he had practiced for a long time in Messina, where he had laid the foundations of a flourishing Mannerist school in an environment that, during the first half of the century, had been an active artistic center but largely outside the concerns of Mannerism.

As the new voice of art was rising up in Orvieto, Charles V abdicated, retiring to the Escorial. The palace, built by Juan Baptista of Toledo and Juan de Herrera, was a masterful symbol of that merging of a yearning for peace and the inevitability of war that had permeated the entire first half of the century and all its art. From this time forward, the space favoured for the display of an art-form suitable for the great tensions of Mannerism became more and more the "villa," the "garden" – settings created by both nature and artifice, where the appearance of objects assumes a symbolic meaning – while the current of great religious art finds its outlet in the decoration of the oratories, in the frescoed cycles designed to be seen as sacred plays.

The great protagonist of this phase, the man who set out the new directions of the "mani-

era" was Palladio, who literally invented this new concept, projecting artistic activity into three-dimensional space, so that it is the building, and not the images hung within it, that assumes symbolic meaning. Awareness of this is evident in the work of architects from the 1560s onward, and it is expressed in enormous projects which, in the footsteps of the Escorial, savour as much of peace as of war.

In 1579, the humanist Fabio Arditio described the Farnese Palace at Caprarola, erected by Vignola (1507–73) – that other great writer on architectural theory – in these words: "This edifice contains both the strengths of a palace and those of a fortress; in its flanks, the moat surrounding it and its outer mouldings, it resembles a rock, and within it a beautiful and ornate palace." During the 1560s, as Caprarola was being built, the Casina of Pius IV – that emblematic building within the Vatican – was erected by Pirro Ligorio; for the last time in the history of Mannerism we find a celebration of the beautiful Classical legends and of hermetic culture. The concept of a profane type of decoration, as developed by Perin del Vaga in the Castel Sant'Angelo, was gaining momentum; crowded with grotesques, stuccoes, decorative details and allegorical figures, it could only be fully comprehended by a learned observer.

St. Matthew at S. Luigi dei Francesi; or, in the picture at Messina, the oblique pose of Lazarus, whose arms, spread as though on a cross, suggest the moment of suspension between death and life, between recognition of the divine power and of the presence of death as indicated by a skull. Other participants, by contrast, may display lively and receptive interest in what is happening or, more often, incredulity. They may even be mere passive onlookers. Caravaggio's pictures rely on a rhetoric of gesture and expression, yet, despite his care for the quality and unity of their formal arrangement, there is decreasing emotional impact in the recessive scenes within scenes that negates conventional perception. Such polarities, profoundly assimilated and re-elaborated, were to have remarkable results in the great period of Roman art from the 1620s onward.

Those were the years, during the unusually long reign of the Florentine Maffeo Barberini as Pope Urban VIII, of fruitful collaboration between the Barberini clan and a group of favoured artists, of whom the most celebrated was Gian Lorenzo Bernini (1598–1680). Bernini, with his enormous technical ability, expressive skill in many arts and outstanding gift for organization, had already produced his first sculpture for Scipione Borghese, cardinal-nephew of an earlier Pope, Paul V. Illustrating Ovid's tale of Daphne's escape from Apollo by metamorphosis into a laurel bush, its theme is exactly opposite from that of the Ovidian ceiling at Palazzo Farnese, but its vitality is irresistible. Formal and temporal dynamism are here combined as, for the spectator, several actions come together in a single moment and may be assumed to lead to many more. There are also echoes of antiquity (this god is a version of the *Belvedere Apollo*), while the allegory proclaims the glory of the Barberini family, one of whose emblems was the laurel.

Soon the Pope was employing Bernini to superintend the "furnishing" of the transept of the recently rebuilt St. Peter's. In the central space at the crossing, above the Apostle's tomb, the artist created the towering *Baldacchino*, its four twisted columns embellished with twining laurel branches, *putti* and the Barberini bees, and surmounted by angels and soaring reversed volutes. In niches at the bases of the piers of Michelangelo's dome are the statues of major saints whose relics were in the crypt below: Longinus by Bernini himself; Helena by his pupil Andrea Bolgi; Andrew by François Duquesnoy, and Veronica by Francesco Mochi. The theme continues emblematically in the aedicules – thus, over Longinus, the lance with which he pierced the side of Christ is borne by a descending angel – so that the architecture, as well as fulfilling its true function, contributes to a kind of multitiered theatrical presentation. This may be observed not only vertically on the piers, but in the intervening spaces between the statues,

which seem blown as by some divine tempest, and between the piers and the *Baldacchino*. The small columns in the aedicules are actual architectural exercises, being derived from the ancient enclosure of St. Peter's tomb. (It was from them that Bernini drew inspiration for his own mighty columns.) Here, instead of combined action, as in the *Apollo and Daphne*, we find an achievement of simultaneous expression by the dissimilar means of sculpture and architectonic space.

Clearly Bernini relished giving the observer what amounted to a supranatural experience, and thus conveying the most intense emotion. So much is evident in the *Cattedra Petri* (Throne of St. Peter), a late work of 1657–66: in a glory of light, amid clouds of angels, the presence of the Holy Spirit seems to break

through the "real" architectural setting. There is the same effect in the Cornaro chapel at Sta Maria della Vittoria, where Bernini, with absolute mastery of his material, shows St. Teresa cradled in light as an angel drives the arrow of divine love into her heart. This scene, according to her pesonal narrative, occurred in the bare solitude of a cell in an enclosed Carmelite convent. Bernini, however, makes of it a sort of ascension into heaven – represented by the chapel-vault above – and triumph over death, which is figured in the pavement below. He surrounds it with glowing marbles and places it under the very eyes, as it were, of the Cornaro family, attentive in their opera-boxes to left and right.

Among his most important nonecclesiastical commissions for the Barberini was the comple-

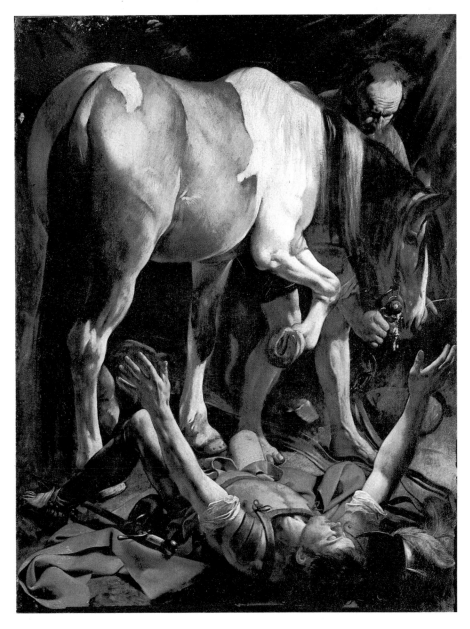

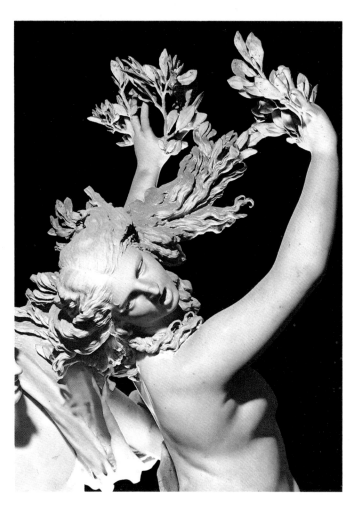

Left: Apollo and Daphne (detail of the metamorphosis of Daphne), by Bernini. Gallery Borghese, Rome. The fleeting instant when the girl, almost free, cries out with raised head and arms as the god touches her, while the bark begins to cover her and twigs with leaves sprout from her hands.

Opposite: Bernini executed many works in St. Peter's, Rome, adapting the spaces set by Bramante and finally fixed by Michelangelo, among them the Baldaquin (with Borromini) and the Cathedra. The "great theater" is articulated, up and across, in a close link between the statues and chapels between the pilasters and the Baldaquin, by means of "Solomonic" columns (twisted) inspired by those around the old altar of St. Peter.

attitude to nature. We may recall the tangled vortex of his *Battle of the Amazons* (1615–18), the maelstrom of *The Fall of the Damned* (1621), or the turbulent *Evils of War* (1637–39), contemporary with the Barberini ceiling. Rubens was enormously productive, leaving almost 1,000 known works, and enjoyed an unbelievably high reputation both during his lifetime and after his death. He was a Spanish subject, born in Flanders, and had many contacts with Italy, being employed at the court of Mantua from 1600 to 1608. He visited France, Spain and England as an accredited diplomat and to fulfil direct commissions from the sovereigns of those countries.

To return to the Barberini salon, it was a model of which only the peers, in power and riches, of its owners could afford to avail themselves; one had to be able to live up to those stylistic improvements. But when the Medici Grand Duke Ferdinand II remodelled the Pitti Palace as a Florentine residence in 1637–42, there were echoes of Palazzo Barberini in the architectural detail. Its influence appears at Rome in Palazzo Pamphili on Piazza Navona, property of another papal family, in a ceiling painted there between 1651 and 1654, and spread to France, though indirectly and involuntarily, when the Barberini, the level of whose spending provoked general scandal, went into exile for a time.

Forty years later came the turn of a different patron, equally commanding and driven by motives just as strong. Now the Jesuit Order, under its General Gian Paolo Oliva, was glorifying religious ideals in colossal ceiling frescoes. The decoration of its principal Roman church, the Gesù, was entrusted to a follower of Bernini, the Genoese Giovanni Battista Gaulli, his theme the Adoration of the Sacred Name of Jesus (the trigram IHS is the symbol of the order). Among fresco painting, stucco reliefs and architectonic elements the vault is shown as opening to the sky, where the symbol is surrounded by saints and angels and members of the Farnese family – the Jesuits were high in the favour of the Farnese Pope Paul III – while heretics below are tumbled to the depths in violent disarray.

The fresco, however, unlike that of the Barberini salon, seems to whirl up off-center in relation to the ceiling itself. The figures, soaring on clouds or plunging down, mask the architectural ornament of the soffit with deliberately dizzying effect. Primary colours, areas of shadow and blinding light are dramatically juxtaposed. The statues in the nave, referring to the distant lands in which the Jesuits pursued their missionary activities, direct the eye aloft, as though to extend the divine vision throughout the world.

In the ensuing years (1691–94) the same subject was given to Andrea Pozzo (1642–1709) at S. Ignazio. A native of Trento, Pozzo – a Jesuit lay-brother – employed the *quadratura* technique familiar in Rome for a century and more, and achieved hitherto unattempted

tion of their imposing palace, begun by Carlo Maderno (1556–1629), in the Via delle Quattro Fontane. Here his alterations include the illusionistic perspective framing the upper windows of the façade, and the creation of a huge salon on the *piano nobile*, decorated by the Tuscan painter and architect Pietro da Cortona (1596–1669). The theme of Pietro's vast and intricate ceiling fresco, executed in 1633–39, is the Triumph of Divine Providence as evinced in the spiritual and temporal prosperity of the Church under the family Pope, Urban VIII.

The ceiling is apparently linked to open sky by a wide and elaborate fictive cornice hung with garlands and upheld at the corners by atlantes with snakes' tails where their feet should be. Occupying the sides and central space are large groups, unconfined by frames or cornice. In free flight, or hovering on clouds, the figures appear in front of the imaginary architecture and greatly increase the depth and graduation of the picture-planes. Though grandly treated, the subject is neither overstated nor overdramatized; its drama lies in the cumulative visual effect. Not far from the halo of Providence herself, mid-point of the composition and its most luminous note, Pietro introduces a dark cloud, and with it the

dynamic contrast of light and shadow. Correggio had already done this kind of thing in church cupolas at Parma, but here the contrast is direct, though restrained in tone, and heightened by the half-shadow of the simulated cornice, in front of which the cloud seems to project.

We should remember that the decades before this ceiling was painted witnessed a departure from some of the innovatory techniques used by Annibale Carracci at Palazzo Farnese (matched though it was by the accentuation of others), and by an increased freedom from the strictly Classical disposition in the arrangement of pictorial content. Guercino's *Aurora* fresco of 1621–23, painted in the Ludovisi palace for a nephew of Pope Gregory XV, is an example: the chariot of the goddess, about to vanquish the shades of night, flies above an illusionistic antique pavilion, from which we supposedly view the scene. There is some influence of Pieter Paul Rubens (1577–1640), with his unforced and irrepressible vitality and amazing skill in rendering complex movement in oblique or spiral strokes. Rubens has a felicity and sureness of touch, a luminosity of colour, particularly in the wonderful flesh-tints, and a splendidly personal and positive

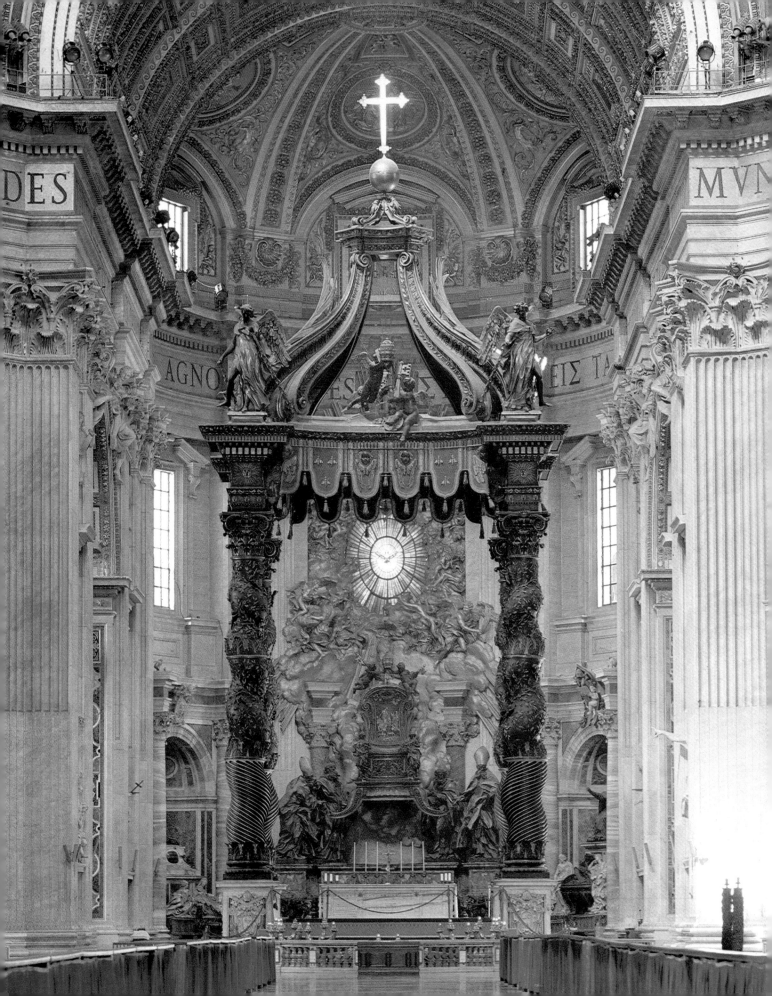

feats of foreshortening with groups enclosed in illusionistic architectural borders. His "architecture" at S. Ignazio corresponds with that of the nave, while about and above it a multitude of saints and angels, together with the four continents personified, fly up to the culminating, shining figure of Christ. Interestingly, a common theme runs through the styles and techniques of Jesuit art. This most powerful of the orders did not simply celebrate some miraculous person or happening, but showed the direct intervention of the supranatural in the real world. And the real world is not Europe alone, which receives no special prominence, it is the entire globe.

The Rome of Urban VIII teemed with artistic talent and ideas, and included independent men, painters for the sake of painting, who, lacking connections with princely families or influential religious orders, worked with less celebratory intent. Nicolas Poussin, for instance (1594–1665), was a Norman, of the

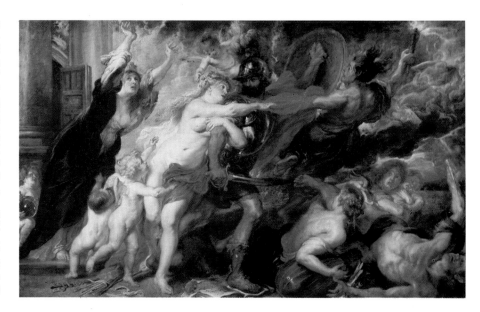

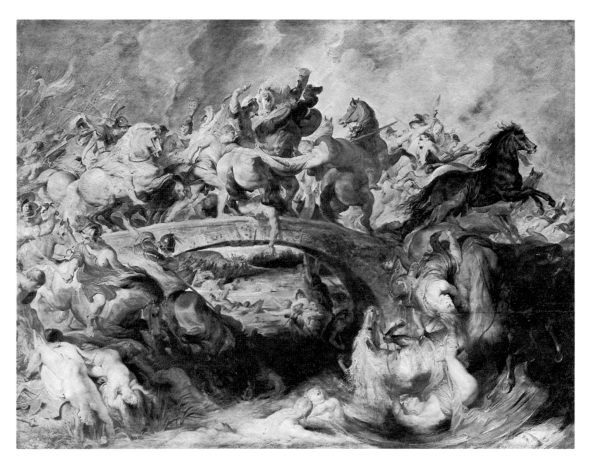

Above: P. P. Rubens, Venus Trying to Restrain Mars, or The Consequences of War *(c. 1637–39). Palatine Gallery, Florence.*

Left: P. P. Rubens, Battle of the Amazons, *(1615–18). Alte Pinakothek, Munich. The movement of figures is set in the half-circle formed by the bridge over the mythical river of Thermodon.*

Opposite: Vault of St. Ignatius, Rome, by A. Pozzo. Fresco with realistic effects and complex illusions: the architectural foreshortenings have different vanishing points and the perspective of the figures differs from that of the backgrounds. This unstable image becomes plausible only from a single point, symbolizing a well-defined moral attitude.

generation of Bernini and Pietro da Cortona. He had, indeed, contacts with the Barberini and the Jesuits, but though the King of France and Cardinal Richelieu offered him the post of Court Painter he preferred to live in Rome, the art capital of Europe, with companions of humanistic tastes, students of ancient religion and early Christianity. He frequented the learned and the literary, those whose attention was engaged by the severe moral teaching of Classical civilization rather than by its renewal in terms of modern religious or political triumph. Among his friends was Cassiano Dal Pozzo (1588–1657), who knew Galileo, studied science, archeology and modern art, and issued over twenty volumes of drawings illustrating antiquites discovered in Rome. Poussin's pictures, their themes taken from Classi-

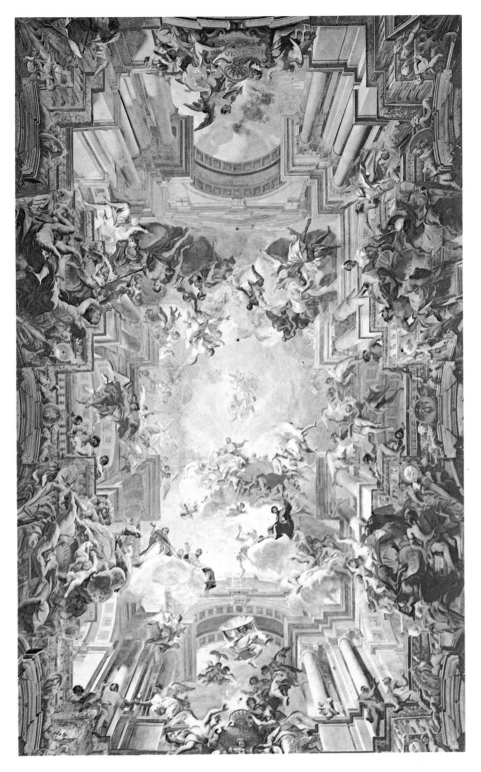

ideal dignity in face of the most tragic and cruel circumstance.

There were, too, many artists who, while responding to the austere appeal of Classical culture and assimilating it profoundly, then produced what was stylistically anything but Classical. Among them is the supremely innovative architect of Bernini's generation, Francesco Borromini (1599–1667). Coming from the Canton of Ticino, Borromini was allied by birth and training to those northern-Italian families of stonecarvers, master-masons and architects – the Fontana clan, for example – active in Rome as early as the sixteenth century. Between 1634 and 1641, after experience as assistant to Bernini on the *Baldacchino* in St. Peter's and to his cousin Carlo Maderno at Palazzo Barberini, he built, without fee, the new convent and church for a small community of Spanish Trinitarians near the Piazza delle Quattro Fontane. The church is tiny, dedicated to S. Carlo Borromeo, and in its restricted space Borromini organizes a compact yet fluid design, combining cross and oval beneath an oval dome. On both tiers of the façade overlooking the busy street-junction the outer bays are concave; but while the lower central bay is convex, that of the upper tier is again concave, producing a play of balance and counter-balance. The entire conception is charged with movement, angles are sharp, especially where concave surfaces meet, and the architectural orders themselves conform to the rhythm.

Borromini's control of space and surface by the mingling of complex geometrical forms, somewhat in the medieval manner, is nowhere more in evidence that at S. Ivo della Sapienza, built, under Barberini patronage, to serve the ancient University of Rome in 1642–60. The basic triangular scheme is elaborated into a multipatterned star shape, above which a succession of surfaces, concave, straight and convex, meet in a dome whose outline echoes that of the ground plan below. Externally, the lantern resembles a miniature hexagonal *tempietto* with concave sides, surmounted by a kind of spiral tower terminating in a carved stone crown of flames and a globe with a cross apparently springing from it into the air. The combination of these surprising elements indicates one of Borromini's chief motivations: the religious – or, in secular buildings, the often heraldic – concept expressed in his geometrical shapes or in traditional Christian symbols. The new relationships he gives them are significant from the purely formal point of view, but the marvellous thing about his architecture is its close creative connection between the formal and the symbolic. Thus at S. Carlo all is related to the Trinitarian emblem of the radiant crown; S. Ivo is planned as a triangle because the triangle denotes divine wisdom. The latter church, indeed, embodies a repertoire of ancient Christian iconography and stands for the ideal House of Wisdom, with its symbols of Charity and Knowledge.

cal and Christian antiquity, are unique in their blend of luminosity and animation, the rich colouring that suggests Venetian painting of the sixteenth century, and the strict compositional control of figures, groups and urban or landscape setting. Subject matter and method are thus perfectly matched within a Classical idiom, but the inner life of the whole arises from its revelation of victorious antique values; of landscape and all nature as solemn and sacred – a belief shared by a fellow-countryman, Claude Lorrain (1600–82); and of man's

symbolic levels of the elements he worked with.

A similar need is obvious in contemporary urban architecture intended to accommodate as many people as possible. The reign of Alexander VII abounded in projects for transforming important religious sites into something like permanent stages (the word for them was in fact *teatri*), glorifying Rome old and new. Such projects were the colonnade in St. Peter's Square, built in 1656–67 to an oval design suggested by the Pope himself, in preference to Bernini's original circular or rectangular plans; the adaptation, between 1662 and 1679, of Piazza del Popolo, where twin churches, by Bernini and Carlo Rainaldo, separate the three roads radiating from it; the little Piazza of Sta Maria della Pace, with its new church-façade by Pietro da Cortona; and Bernini's idea for a stairway up to Trinità dei Monti – expenses to be paid by Cardinal Mazarin – with a statue of Louis XIV in the middle.

From the 1650s, however, Rome declined as a fountainhead of art. While the large and lesser states of western and central Europe attracted artists from all over the Continent, it became merely a place where art was studied. The French Academy, opened in 1666, was one of many national institutes, maintained by their own governments and admitting students on official grants for limited periods.

Toward the century's end Roman taste took a definite turn for the Classical and the style shared, in their various activities, by Bernini, Borromini and Pietro da Cortona was attacked as diverging too far from what had been the norms and ideals guiding the artists since the days of antiquity. It was probably no coincidence that architecture, most highly formalized of the arts, was also the most strongly condemned. One illustrious critic, Abbot Bellori (1613–96), roundly denounced Borromini as "a completely ignorant Goth"; while from

the eighteenth century onward Bernini and the rest, their fellows and followers, were adjudged "baroque," a slighting term for what was tiresomely and unlearnedly involved, irrational and deliberately unclear. Not that this denigration precluded the revival of Berninesque schemes such as the Trinità dei Monti stairs (1723–26) or the Trevi fountain (1732–45), where Nicola Salvi (1697–1751) demonstrates the universal stream and flow of water from an artificial rocky cliff attached to a palace façade and facing into the piazza.

What are generally, though not always accurately, defined as the Baroque and Classical styles did not, however, constitute the whole artistic life of Rome. Carlo Rainaldi (1611–91) attains remarkable plastic and scenic effects at his church of Sta Maria in Campitelli (1663–67), with a composition hinged on the free-standing column. Such columns, leading the eye from one to another, were already known in the north, mostly at Padua, Venice and Bologna, and the architectural theory they illustrate differs from the Roman in its fundamental reliance on a visual, rather than a structural, unity.

A very successful type of Roman painting was established by the Dutch artist Pieter van Laer (1592–1642), nicknamed il Bamboccio, who concentrated on scenes of low life. His subjects were the hawkers and street-loungers, or proletarian festivals conveyed with modest, unemphatic realism. Themes and technique, reminding one of Caravaggio, are hardly in tune with what official culture, Classical or Baroque, considered the proper things to paint, or the proper way to paint them.

We may now turn to two of the independent states of Italy that ranked with Rome as art centers of European importance: the ancient and glorious Venetian Republic and the Duchy of Savoy, with its new capital at Turin.

The Renaissance painting of Venice – by Titian, Paolo Veronese and Tintoretto – was

Among domestic designs, Borromini contributed the garlands, Medusa mask and curving horns of plenty as an image of perpetual welcome and good fortune on a courtyard doorway at Palazzo Carpegna (1643–47), while falcon-heads on his huge herms at Palazzo Falconieri allude to the owners' family name. Such things further exemplify what we have seen in other spheres: his urge to communicate, to extend and create, with yet more than the customary architectonic ingredients and space; to relate, ever more closely and forcibly, the various functional, decorative and

greatly prized in the seventeenth and eight-eenth centuries, particularly so in Rome around 1633, and seemed to answer the stylistic demands of the most widely differing media. Venetian painters such as Sebastiano Ricci (1659–1734) or Giambattista Tiepolo (1696–1770), often in association with *quad-raturisti* of the Bolognese school, brilliantly reproduced the techniques and feeling of that golden age. They were famous. They travelled about Europe and everywhere, from Florence to London, from Madrid to Vienna, they co-vered walls with vast fresco decorations. Dif-fering from them in both style and tempera-ment was Giovanni Battista Piazzatta (1683–1754), a master for whom plasticity – *disegno* in the true Renaissance sense – was part of personal interpretation.

If the mid European courts drew Venetian artists and connoisseurs to them, pressing invitations arrived likewise from east and west. Applications poured in for pictures and paint-ers, especially in the first half of the eighteenth century. Thus, toward 1720, Venetians were officially approached to visit towns, such as Paris and Amsterdam – not, on the face of it, the most promising fields for Italian Baroque – and Giovanni Antonio Pellegrini (1675–1741), for one, went on his travels. Nor was this international triumph confined to the great celebratory fresco cycles, executed as these were with incredible fluency and freedom – airy compositions bathed in luminous silvery light and crammed with references to Classi-cal mythology (Tiepolo is known to have sug-gested themes himself, as did many others). Venetians were also acknowledged masters of the *veduta*, or view-picture, a branch of paint-ing that developed from genre and relied heavily on expertise in perspective. It had been extensively practiced by the Flemings and Dutch, and by artists working in Rome and specializing in realistic views – Gaspar van Wittel, for example (1653–1736), who be-comes "Vanvitelli" in Italian.

Giovanni Antonio Canal (1697–1768), or Canaletto, perfected a specific technique with the lenses and mirrors of his *camera ottica*. From this portable instrument he could take contiguous and successive "shots," which, when joined together, gave something on the scale of a modern wide-angle photograph. Transferred to canvas, the result was a series of purely pictorial glimpses, enlivened with crowds of small, sketchy figures and suffused with gentle light, as though landscape and buildings swam in an air charged with soft, fine dust.

The view-painting of his nephew Bernardo Bellotto (1720–80) has, by contrast, a hard, sometimes crude, light, accentuated shadows and definite, clear-cut angles. While Canaletto was extremely popular in England, Bellotto was employed for long periods by Augustus III of Saxony at Dresden, and when the Seven Years War was over moved to Warsaw, to the court of Stanislas II of Poland.

Opposite above:
F. Borromini, St. Ivo della Sapienza, Rome, detail of the lantern (1642–60). This spire, with its typical spiral, represents the ascension of the soul toward the love of God.

Opposite below right: Claude Lorrain, Landscape with the Flight into Egypt. Gemäldegalerie, Dresden.

Opposite below left: N. Poussin, Moses Saved from the Waters (1638). Musée du Louvre, Paris. The painter used the story of Moses in almost one-tenth of his works. This first version stands out by the monumental décor, the serene postures and setting, with a "silence" much admired by Bernini.

Right: G. B. Tiepolo, The Institution of the Rosary, (1737–39), nave of Santa Maria dei Gesuati, Venice. Part of a glorification of St. Dominic using an architectural division that allows one to grasp the stages of the action in a whirling sequence. At the lower level, an arcade surrounds Albigensian heretics hurled downward; a large cornice and a double staircase strongly projected toward the viewer, with the temple at the top, lead through groups of people in strong colours toward the image of the saint, who in turn serves as base for diagonal clouds, which gradually spread and open on the Virgin's throne and a wide stretch of sky. The view from top to bottom is based on the integration of the geometric system of architectural foreshortening with the colours of figures and clouds.

Tiepolo's brother-in-law Francesco Guardi (1712–93), whose pictures were described a decade after his death as "incorrect but highly animated," was a *vedutista* of another breed. Panoramic views and urban details, either imaginary or those of his beloved Venice, are rendered with a kind of summary "truth," in refracted rather than transparent light, and imbued with a rarefied and subtly poetic atmosphere. Formerly attributed to Francesco, though now to his elder brother Giovanni Antonio (1699–1760), is a masterpiece of European quality on the organ parapet of the Venetian church of S. Raffaele Arcangelo. This painting dates from about 1753 – a radiance of showering, iridescent dabs of colour that almost defies any formal rules and shows to what lengths the Rococo style was developed in Venice.

A notable school of sculpture in the city included such masters as Andrea Brustolon (1660–1732) and Antonio Corradini (1668–1752), the latter also working in Naples. Venice was important, too, for engraving, book publishing and similar art-related activities, as the home of art experts and of theoretical studies. The scholar and critic Francesco Algarotti (1712–1764), for instance, wrote essays on architecture and painting and produced a pioneer plan for the arrangement of the King of Saxony's new collection. (Unlike the usual accumulations of the time, which reflected only the patron's personal taste, the Dresden royal gallery contained examples of every school, like a modern museum.)

The contribution of Venice to the culture of the period was twofold, now parallel and now opposed to that of Rome. On the one hand,

Above: G. Guardi, Marriage of Tobias and Sarah (c. 1750). S. Raphael, Venice. The center of the organ balustrade presents a wide architectural and landscape setting with various episodes from the lives of the biblical figures shown, from Sarah's dowry to the sacrifice of the fish liver.

Right: Canaletto, Architectural caprice (1765). Gallerie dell'Accademia, Venice. Presented by the artist for admission to the Venice academy of painters and sculptors, of which Tiepolo was the first president. From the painter's last Venetian period (1765 to his death in 1768).

Opposite: St. Paul's Cathedral, designed by and built under the supervision of Sir Christopher Wren between 1675 and 1710. In size, clarity of plan and technical difficulties overcome, it was meant to rival St. Peter's, Rome.

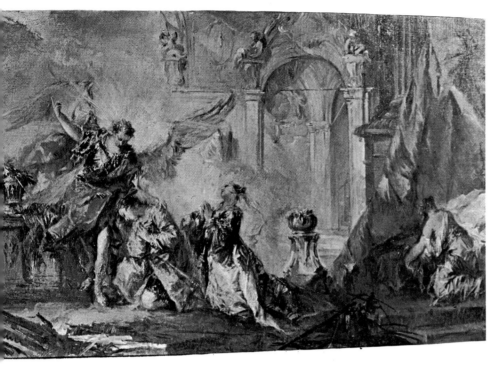

Rome. Both had gifts of learning and uncommon sensitivity and, despite the numerous divergences of style, Guarini was to encounter much the same architectural criticism as that levelled at Borromini. He had, however, considerable later influence in central Europe and in Piedmont through his follower Bernardo Vittone (1705–70), who edited his book, *Architettura Civile*.

Juvara presents a synthesis of many features of the Roman Baroque familiar from the reigns of Urban VIII and Innocent X. Thus, architecture and sculpture are integrated with near-theatrical effect in the Antamoro chapel of S. Girolamo della Carità in Rome (1708) where the statue on the high altar is bathed in light from behind and above and seems to ascend among clouds of cherubim. S. Uberto, church of the Venaria Reale, or hunting-lodge, at Stupinigi near Turin, is shaped like a Greek cross. The convex façade has concave wings, and light reaches the interior walls through an extraordinary detached entablature. In 1715–30 Juvara's reconstruction of the great church of S. Filippo Neri, planned by Guarini and damaged in an earthquake, was inspired by Borromini's restoration of St. John Lateran.

Yet Juvara also epitomizes the spread of the

architecture with a "Palladian" flavour met with revived success in England and its colonies. But though Christopher Wren (1632–1723) might combine models from antiquity and from the French and Italian Renaissance with contemporary notions when designing St. Paul's, more obviously Baroque productions, such as Blenheim Palace (1705–16) by John Vanbrugh (1664–1726) and Nicholas Hawksmoor (1661–1736), appeared to be of alien tradition. They were un-English, smacking of unacceptable political and religious systems. They breathed absolute monarchy and Roman Catholicism. At home in Venice, on the other hand, the Palladian style itself flourished, and the Salute church (1631–87) by Baldassare Longhena (1598–1692) is an eminently original building, particularly when compared with what was being done at the same time in Rome.

Turin, established in 1563 as the new capital of Savoy, owed its architectural aspect mainly to Guarino Guarini (1624–83) and Filippo Juvara, or Juvarra (1678–1736). Guarini, a member of the Theatine Order, was a man whose immense learning ranged from theology to mathematics, and who had his own, entirely individual, reminiscences of Mannerism in the way he put a building together. His projects, such as the (unbuilt) church of the Somascian Fathers at Messina or Cardinal Mazarin's now-destroyed Ste Anne-la-Royale in Paris, constantly violate the normal rules. Circular trabeation will link octagonal drum to octagonal lantern; or the roofing of a church may consist of multiple superimposed elements: cupola and lantern above a drum with large, characteristic, interlacing arches. The

"longitudinal" churches erected at Lisbon and Prague to his designs are based on a succession of spatial units, elliptical or polygonal, and virtually unimpeded by the walls of apses or façade.

Close to the Palazzo Reale of Turin are two examples of Guarini's planning, with its formidable underlying geometry and symbolism: S. Lorenzo and the Chapel of the Holy Shroud. The chapel, which preserves one of the holiest of Christian relics and is in fact the burial place of the House of Savoy, was already begun, and its circular shape determined, when Guarini was appointed architect; but within the circle he contrived what is more or less a triangle by the unprecedented introduction of wide arches and pendentives set across the curves. His dome is a shell of interior arches which form intersecting hexagons, diminishing as they rise and culminating in a huge circle with emblems of the Trinity. Externally the lantern, with its wavy lines, somewhat resembles a Neapolitan *guglia*, so complicated is the structure of interwoven arches.

Guarini's work is strictly bound by the requirements of geometry and has, like Borromini's, a precise latent symbolism; the stricter the requirements the further his lively fancy transcends them. He resorts to, or actually creates, modes of expression – the indirect light sources, the exact allegorical language of differently coloured marbles – taken at times from contemporary usage and at times offering a revaluation of artistic traditions, such as the Gothic, neglected and disapproved since Renaissance theories were first propounded. Here again we think of Borromini, whose buildings Guarini knew in his student days in

Roman style throughout Europe, that process which constitutes, as it were, a multiple dialogue between artists and patrons north and south of the Alps, the outcome of close links

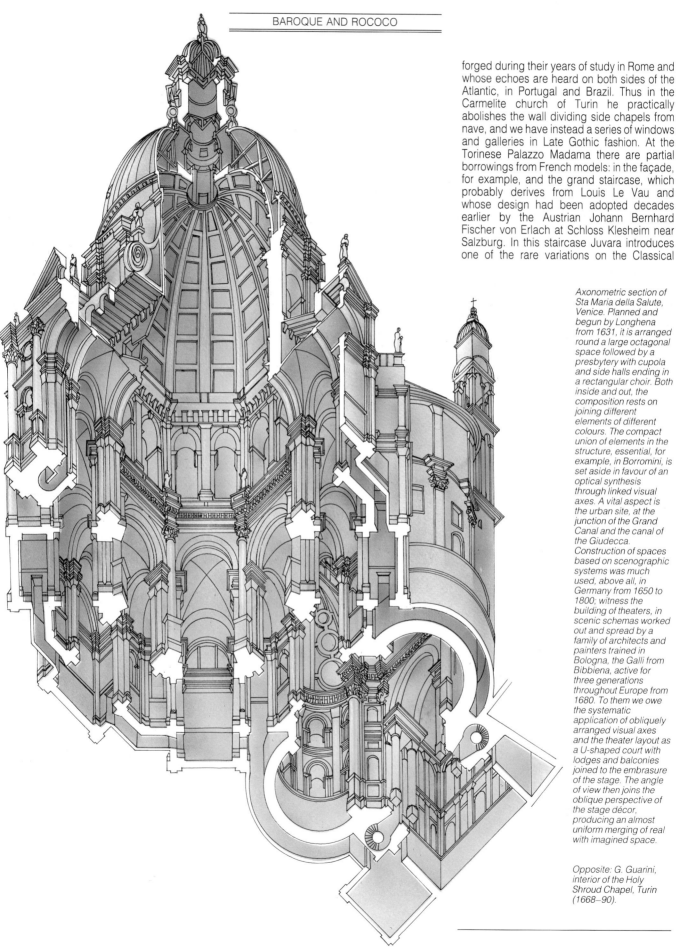

forged during their years of study in Rome and whose echoes are heard on both sides of the Atlantic, in Portugal and Brazil. Thus in the Carmelite church of Turin he practically abolishes the wall dividing side chapels from nave, and we have instead a series of windows and galleries in Late Gothic fashion. At the Torinese Palazzo Madama there are partial borrowings from French models: in the façade, for example, and the grand staircase, which probably derives from Louis Le Vau and whose design had been adopted decades earlier by the Austrian Johann Bernhard Fischer von Erlach at Schloss Klesheim near Salzburg. In this staircase Juvara introduces one of the rare variations on the Classical

Axonometric section of Sta Maria della Salute, Venice. Planned and begun by Longhena from 1631, it is arranged round a large octagonal space followed by a presbytery with cupola and side halls ending in a rectangular choir. Both inside and out, the composition rests on joining different elements of different colours. The compact union of elements in the structure, essential, for example, in Borromini, is set aside in favour of an optical synthesis through linked visual axes. A vital aspect is the urban site, at the junction of the Grand Canal and the canal of the Giudecca. Construction of spaces based on scenographic systems was much used, above all, in Germany from 1650 to 1800; witness the building of theaters, in scenic schemas worked out and spread by a family of architects and painters trained in Bologna, the Galli from Bibbiena, active for three generations throughout Europe from 1680. To them we owe the systematic application of obliquely arranged visual axes and the theater layout as a U-shaped court with lodges and balconies joined to the embrasure of the stage. The angle of view then joins the oblique perspective of the stage décor, producing an almost uniform merging of real with imagined space.

Opposite: G. Guarini, interior of the Holy Shroud Chapel, Turin (1668–90).

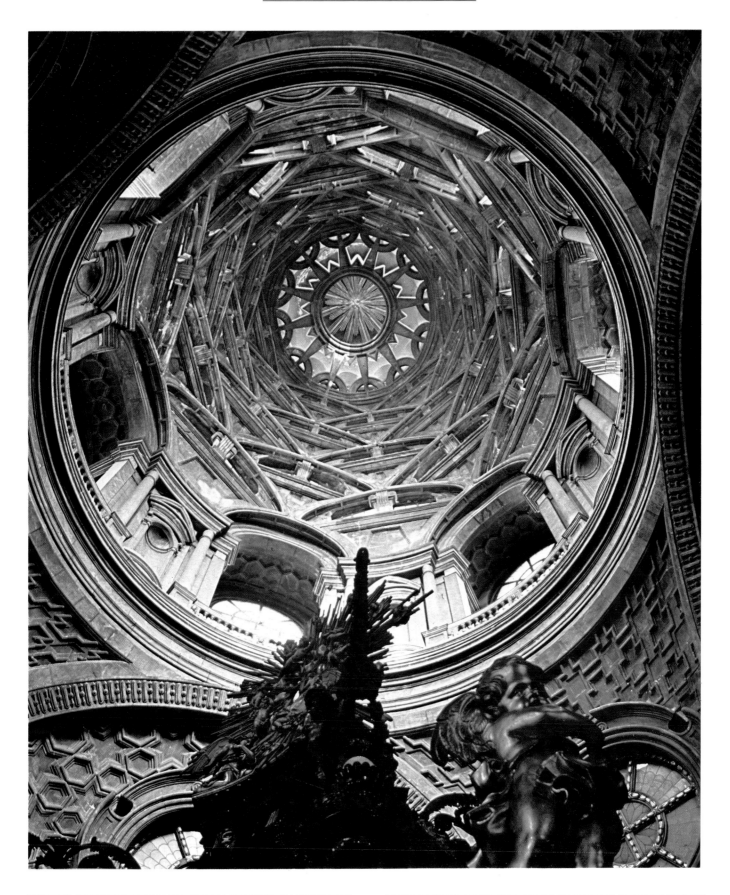

orders, the oblique order evolved by the erudite Spanish bishop of Vigevano, Juan Caramuel (1606–82). The basilica of Superga (1717–31) is comparable in composition to Fischer von Erlach's masterly Karlskirche at Vienna; and at Stupinigi, the royal villa begun in 1729 and finished, after Juvara's death, in 1772, a most original method of adding one architectural unit to another makes them apparently sidle toward the huge oval salon that is its centerpiece.

Baroque in Spain

If we adopt the conventional and externalizing division of art into "national" compartments, then it is obvious that the Baroque assumed very different aspects under Spanish rule in three continents. For the figurative art of Spain proper, the formal criteria and ideology that obtained from the end of the fifteenth to the end of the sixteenth centuries were of prime importance. Those hundred years, when the kingdom came to greatness and glory, ran from the Late Gothic, with its roots in Flanders,

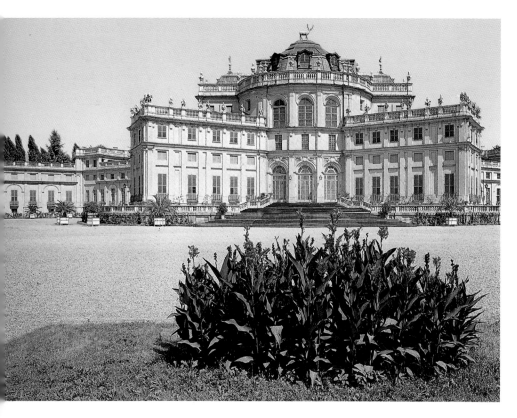

to the age of Mannerism, and two Baroque artists clearly demonstrate these sources. One, Francisco Zurbarán (1598–1664), had an entirely Spanish training and background and worked mainly for the monastic orders. His images are abstract, hieratic. The people

he paints have a pure, severe quality, and his construction may be oblique, twin-focused, or uncompromisingly frontal, with passages of vivid and sympathetic naturalism. The other, Jusepe de Ribera (1591–1652), lived principally in Italy, for many years in Naples, and profound Italian influence is evident in the harmonious silvery colouring and the opulent, learned and spirited composition of his pictures.

Zurbarán's almost exact contemporary, Diego Rodriguez de Silva Velázquez (1599–1660), was born in Seville and worked for the court in Madrid. His is the unusual case of an artist who, from his beginnings with genre painting – kitchen and tavern scenes, liberally interspersed with still-life studies – progressed from the commercial climate of his native town to scale the heights of fame as a portraitist at the Habsburg court and to enjoy a social standing that probably exceeded Bernini's own.

From 1629 to 1631, and again from 1649 to 1651, he travelled to Italy, whose rulers received him as accredited Painter to the King of Spain. His business, beyond devoting himself to Italian art (especially to that of Titian, the most admired giant of the Renaissance), was to buy pictures and sculpture, both antique and modern. Where purchase proved impossible he was to make drawings or arrange for casts to be sent to Madrid.

He could also see European art of the highest quality in the Spanish royal collections, from Titian portraits to works by Rubens. (Close on a hundred Rubens sketches arrived in Spain from Antwerp to embellish the royal hunting-pavilion, the Torre de la Parada, while the country palace of Buen Retiro, another new building near Madrid, housed the largest landscape collection in Europe.) It was for the great hall at Buen Retiro that Velázquez painted his only "history picture," the famous *Surrender of Breda* (1635), as well as the royal equestrian portraits, which include his likeness of the child Prince Baltasar Carlos, of similar date.

Velázquez' paintings have for their true protagonist the whole Spanish court – the King's intimates, his mighty first minister, the Count-Duke of Olivares, the pages and dwarf jesters. The latter, delineated in all their mild idiocy and physical deformity, nevertheless retain an inner dignity, which emerges despite the contrast they afford between power and wretchedness. In the wake of the grand sixteenth-century tradition and of Caravaggio, Velázquez achieves astonishing results, not only as a master colourist but as what we should recognize as a master of psychological insight (a poet of the time, Francisco de Quevedo, acutely observes that he painted what people were, rather than what they looked like) and of the conceptual structure of his images.

In some canvases a concealed mythological subject is relegated to the background. In *Las Hilanderas* (*c*. 1657–60), for instance, one spider suggests the story of Arachne, who so fatally challenged Minerva to a weaving contest, while her companions at their task in the foreground are only marginally relevant to the tale, though Velázquez renders the motion of the spinning wheel with legendary skill. This inversion of literary subject and actual depiction is directly inherited from Flemish Mannerism, examples of which, in prints or originals, the artist must have known. And we may note that this Spaniard, unlike Rubens and the Roman masters, Baroque or Classical, is more fascinated by realism than antiquity. In other words, when he presents an antique fable, real men appear in the guise of gods, as they did – and as he undoubtedly also knew – in the pictures of Caravaggio.

Las Meninas (1656) demonstrates a yet subtler reversal of roles. In his studio at the palace, a large room hung with some forty copies of works by Rubens, Velázquez himself stands in shadow, intent on his portrait of the King and Queen, who are to be imagined outside the painting, in the space we occupy as observers. All we see of them is their reflection in a mirror. Not far from him, in the foreground, the small Infanta Margarita, with her ladies and attendants, gazes out, in our direction, at her parents. There is here no literary text to clarify divergences between what is shown and the actual subject. We

seem to be told less than we need to know and this picture, more than any other, emphasizes the double role of the spectator, who is at once actor and audience. It adopts, and surpasses, Bernini's communicative techniques in the "theater" of the Cornaro chapel, completed by the time of Velázquez' second stay in Rome.

Bartolomé Esteban Murillo (1618–82) displays links with the religious art of the sixteenth century and a simple Counter-Reformation dignity of treatment. Even at their most dramatic his pictures have a life and immediacy that may redeem his habit of concentrating on the sheer grace of a subject. Similar characteristics are found in the intense, restrained woodcarving of Juan Martínez Montañés (1568–1649), or in the sculpture and architecture of Alonso Cano (1601–67), who combines medieval and Mannerist motifs on the façade of Granada Cathedral (1664).

Influential in metropolitan Spain and in its colonies of Mexico and Peru, was a treatise on architecture and ornament by the Austrian architect and engraver Wendel Dietterlin (c. 1550–99). Its bizarre and fantastic patterns went far to replace, or at least to push into the background, the traditional "learned" themes of the Renaissance. Thus, the façade of S. Telmo in Seville (1724–34), by Leonardo Figueroa (1650–1730), is loaded with bas-reliefs and fluted decoration, spiralling and zigzagging in lavish histrionic profusion; and in the sacristy of the Cartuja at Granada the lines of the architectural orders are all but blotted out beneath a riot of moulding and pinnacled ornament. This excess, however, no more overwhelms the structure than it does in contemporary buildings by the Churriguera brothers of Barcelona, and incorporates such novel elements as the *estípite*, a pilaster in the shape of a reversed obelisk, divided into vertical sections with geometrical panels and bas-reliefs, and having several capitals. These *estípites* occur on the façade of the cathedral sacristy in Mexico City, and at Tepotzotlán.

The themes devised by Narciso Tomé (d. 1742) in his altar of the Trasparente in Toledo Cathedral are, on the other hand, purely Baroque. Light floods down through a glory of angels, as in Bernini's *Cattedra*. As Bernini did at S. John Lateran, he had a rib vault removed to admit the light and add an impression of depth, while the stucco, "peeling" like bark from the column shafts, recalls Bernini's *Apollo and Daphne*.

The subject matter of large-scale mythological decorations became meanwhile increasingly disconnected from reality, as we see in the huge fresco by the Neapolitan Luca Giordano (1634–1705) in the sacristy of Toledo, and more clearly still in that from the Casón of the Buen Retiro palace. This was painted for Charles II of Spain in 1697 to celebrate the origins of the most renowned European order of chivalry, the Golden Fleece, and is an endless kaleidoscope of references. Time and the seasons, muses and great philosophers,

Olympian gods, the constellations, and the kingdoms of the Habsburg Empire comprise a whole gloriously coloured, cerebral exhibition. Even its most intricate groupings outdo in luminosity the stupefying *tours de force* of Pietro da Cortona, or Gaulli's vivid light-and-shadow contrasts. Yet all this sparkling imagery coincided with one of the worst disasters in Habsburg family history, the loss of their Spanish throne with the extinction of the Spanish line at the death of Charles II in 1700.

Of their Spanish dominions, and those of the Bourbons who succeeded them, Naples and Sicily produced the most original forms of the Baroque. From the very personal interpretation of Caravaggio's naturalism in Jusepe de Ribera or Bernardo Cavallino (1616–56), to the grandiose style, veering from the forceful to the vehement, of Giordano, Mattia Preti (1613–99) or Francesco Solimena (1657–1747) – one of the most famous painters of his time in Europe – there is observable a progressive assimilation of Baroque ideas. This owed something to the numerous surviving links with papal rule in those kingdoms and is evident, too, in the sumptuous *pietra dura* ornamenta-

tion by Cosimo Fanzago (1593–1678) in the Certosa of S. Martino at Naples, or the breathtaking *stucchi* by Giacomo Serpotta (1652–1732) at Palermo. On his altarpieces for the Carmine Maggiore there (1683–84), narrative ensembles in stucco coil about the shafts and capitals of the twisted columns, and in his stupendous oratories the architecture takes second place to what are so many devotional toy theaters: recessed wall panels in moulded frames enclosing three-dimensional scenes. The oratory of Sta Zita, dedicated to the Virgin of the Rosary and her miraculous intervention against the Turks at Lepanto, is a magnificent example. Serpotta converts the entrance wall, as it were, into a source of movement, creating as background an enormous stucco curtain and inserting the framed scenes in its folds – the battle itself and four sacred and associated tableaux. Movement for each is outward, transmitted by a cheerful throng of stucco *putti* who hold back the edges of the curtain and gracefully support the moulded frames. They also supply comment on the various episodes, handling weapons near the battle scene, while on the remaining walls they playfully mimic the

Opposite: the plan of a perfect country house, recalling the crossed vanes of a windmill, especially from a distance, was put forward by one of the first architectural mannerists of the sixteenth century, Sebastiano Serlio. This plan, according to Juvara, is realized in the pavilions and wings for the royal apartments at Stupigini. Perspectives leading to various views, linked or changed by statues, gardens, tree-lined alleys and surrounding clumps of trees. Form, subtly articulated, does not dissolve; as if reason was glad to act as guide for this encounter of architecture (and thus man's history) and nature.

Right: salon by Matteo Gasparazzi (c. 1760). Royal Palace, Madrid. Typical eighteenth-century interior with rich decoration.

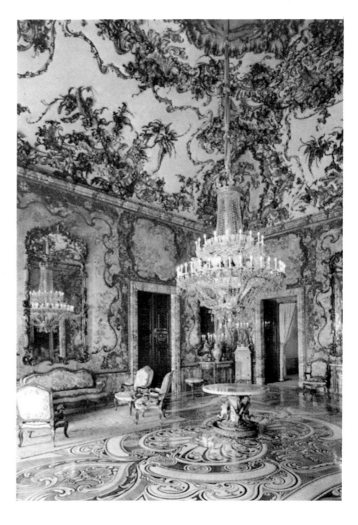

actions of those taking part. The colourless greys and whites of the plaster lend a special serenity to the composition.

Well on in the eighteenth century the capella Sanseverino, near the church of Sta Maria della Pietà at Naples (1752), shows not only a final shift away from the old allegorical language – now a monument can even reflect the masonic preoccupations of Raimondo di Sangro, Prince of Sanseverino – but how the sculptors there were conveying luminosity and transparency. Its statues, including a human figure enmeshed in a net, are wonders of the marble-cutter's craft.

Baroque in Northern Europe

The towering personality of Rubens left its unmitigatedly Baroque imprint upon Flanders, or the Southern Netherlands, most northerly of the Spanish possessions, centered on Antwerp. Through pupils and followers his influence continued, his art becoming an essential reference-point for European painting, and for Flemish painting in particular. The career of Anthony van Dyck, though his background was not dissimilar, developed differently. His stately portraits were full of accurate natural and psychological detail, and were much in demand from aristocratic patrons in Genoa, Antwerp and London.

Another major category of Flemish art, that of genre, was disseminated all over Europe by means of engravings. Genre painters might be as realistic as Jacob Jordaens (1593–1678); they might, like Adriaen Brouwer (1605–38), produce ardently dramatic pictures; or, as did David Teniers the Younger (1610–90), concentrate on quiet but attentive descriptive detail.

The Dutch in the Northern Netherlands had won their freedom from Spain in the first half of the seventeenth century. Holland was a predominantly commercial country, Calvinist by religion, where art patronage had no direct links with the princely court of the House of Orange but lay chiefly in the hands of the middle classes and even of foreign collectors. Moreover, many Dutch painters – Hendrick Terbruggen (1588–1629), Gerrit van Honthorst (1590–1656) and Pieter van Laer – were active abroad and from great cities such as Rome a network of influence was gradually established. In Holland itself, in Haarlem, Frans Hals (1580–1666) emerges as the acknowledged master portraitist. His single or group subjects, frequently painted in summary style, without preparatory drawings, are nonetheless penetrating and incisive.

The generous surviving output – over 400 examples – of Rembrandt Harmenszoon van Rijn (1606–69) includes portraits of himself, his family and patrons. There are the so-called "character studies" of men in foreign or exotic costume, often imitated from that of the theater; the biblical subjects he loved, rendered

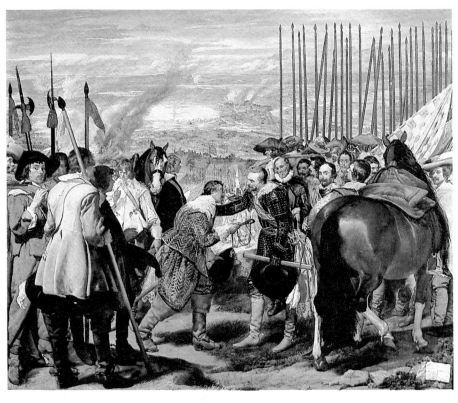

Above: D. Velázquez, Surrender of Breda (or The Lances, 1635). Prado, Madrid. The painter's only canvas with a historical subject.

Right: D. Velázquez, Prince Baltasar Carlos (1635). Prado, Madrid. The little prince is shown with the attributes of military command, baton and sash, making his

mount carry out a difficult turn. The figure is based on a subtle balance of graceful youth and smiling pride.

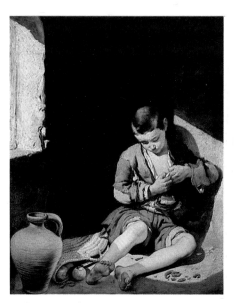

Left: B. Murillo, Beggar. Musée du Louvre, Paris. The small sitting beggar is set in a diagonal from the amphora to the legs, the joined arms and the inclined head. Light spreads on the opposite diagonal in a crossed pattern. The child is as if bent in on himself, his quiet misery not insisting on sympathy.

Opposite: N. Tomé, Transparence, 1721–32. Toledo Cathedral.

with the coruscating violence of *The Blinding of Samson* (1636) or the repose and restraint of *Jacob Blessing the Children of Joseph* (1656). There is the scientific detachment of the dissection in *The Anatomy Lesson of Dr. Deijman* (1656); there are landscapes, and incidents from ancient history. This enormous diversity answers both Rembrandt's own tastes and the requirements of a mixed clientèle – municipal or professional organizations, Portuguese merchants or Italian noblemen.

Already in his lifetime critics were commenting on his highly individual technique. In his mature period especially he bestows unceasing care on the actual build-up of colour on canvas. From flat, multiple layers of paint, and broad and rapid brushstrokes is created, as it were, the basis and material of pictorial expression. Skin is luminous, metal gleams out of deepest shadow, with the perpetual inner vibration achieved by Rembrandt alone, as though his colours were pulsating.

In *The Night Watch* (1642), these opulent technical effects are enhanced by intricacy of composition. Essentially he is showing a company of the Amsterdam Civic Guard as its commander gives the word to march and the men engage in a hectic scramble to get into line left and right. (By Rembrandt's day these volunteer bodies, raised in the first place against the Spaniards, were more or less honorary clubs.) The architectural background is probably taken from an engraving after Raphael and light, cast fully on figures at different picture depths, is distributed so as to increase the dynamism of the scene. Such pictures, condemned at the time for lack of conformity with the old, accepted rules, were, for all that, imbued with a private conception of the Baroque, to be directly inferred from paintings the artist bought and sold, and indirectly from his consummately skilful etchings.

Among his last works, done in old age after suffering personal tragedy, is the *Self-portrait* (1668–69). It shows him laughing, and if it is true that he has adopted the guise of Zeuxis, the great Greek painter who, we are told, died laughing at the performance of a withered and ugly comic actress, then the epitaph is at once urbane, ironical and very human.

At his death Johannes Vermeer (1632–75) left fewer than forty known pictures. His art derives in some measure from fifteenth-century Flemish painting, with its transparency, luminosity and three-dimensional quality, and the pictures are amazingly simple: images of his beloved native town of Delft; still interiors, their few figures bathed in the all-pervading quiet. People study astronomy or geography, his women are playing music, peacefully reading, sewing, lace-making, or performing household tasks. There are one or two religious subjects. Action is at a standstill while he analyses the texture and sheen of fabrics, wall surfaces – mostly under a raking light – window-glass, or the subdued glow of jewels. Vermeer is thought to have used a *camera*

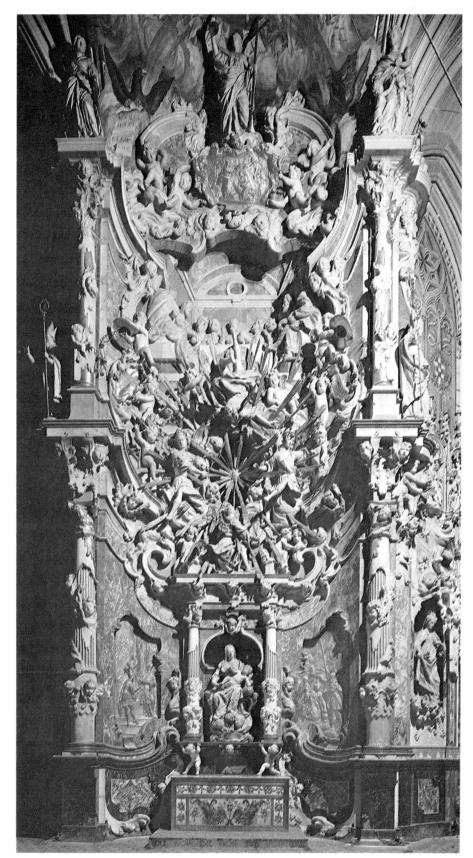

ottica in arranging his compositions and as an aid to accuracy; this suggests the overriding desire to depict objects and domestic settings as much as an incredible ability to do so that almost constitutes an end in itself. Maps that often hang in the background are, for instance, exact counterparts of those for which Holland was then famous. Occasionally, moreover, his detail indicates, as in the Flemish masters, that the pictures, for all their "objectivity" and wealth of objective allusion, are at times associating certain things and human types in an allegorical way familiar since Classical antiquity, and illustrate, or indeed celebrate, what is not immediately obvious. Just as the still lifes incorporated into Flemish, Dutch or Neapolitan canvases are there to remind us how transient and vain is all that nature and man at their most magnificent can do, so what is at first sight the impression of an artist's studio may be read, from its details, as the interpretation of a Classical subject. For this is Vermeer's vision of Clio, muse of painters and historians, equipped with proper attributes – her laurel-crown, her trumpet of fame, her history book.

Baroque in France

The Roman style evolved between the 1620s and 1650s provoked, as we know, widespread opposition, at least throughout the seventeenth century, despite the international features it displayed and its universal language. Such resistance was frequently connected with official choice at the highest level, more or less openly concerned with "national" taste or tradition, and deliberately emphasized for political or practical reasons. We have seen the English attitude to Baroque architecture. The Flemings, the Dutch and above all the van Dyck school of portraiture provide other examples, while from the beginning of the eigh-

teenth century the notions of the Illuminati were to find ready echoes in the art of William Hogarth (1697–1764) and Thomas Gainsborough (1727–88).

In France the situation was more complicated and of more moment, for there artistic direction came from the court, where important political figures often dictated style. Under Louis XIII, Richelieu and the financier and *Surintendant des Bâtiments* Sublet de Noyers the search for a "national" style grows clear, or, rather, is confirmed with the passing of the sixteenth century. It was to be something distinct from novel Roman theories, as from the Mannerism that had flourished at Fontainebleau and elsewhere, and the court at Paris was a strong magnet. Artists were attracted from, or exchanged with, Rome, whose two foremost classicists – Poussin, who actually made the journey, and the sculptor François Duquesnoy (1597–1643) who died on the way – were French and Flemish respectively. From Rome, too, arrived the young Florentine engraver Stefano della Bella (1610–64) less Classically minded, but with an aptitude for the endlessly fantastic and ornamental interpretation of natural motifs.

In 1642 both Louis XIII and Richelieu died. The new stars were Mazarin and the financier Nicolas Fouquet, and Roman ideas were perhaps more widely accepted in France than at any time before or afterward. The most

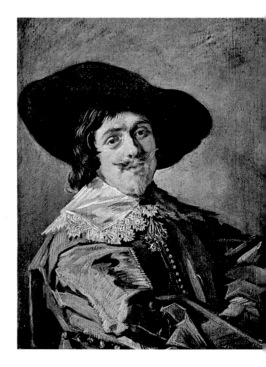

Above right: Frans Hals, Portrait of a Man (c. 1630). Gemäldegalerie, Dresden. This is a typical example of his portraits after 1611.

Below: G. Sammartino, Christ Veiled (1753). Sansavero chapel, Naples. This and other works in the chapel were praised for using a theme unusual in ancient sculpture, namely the view of a body completely covered by veils.

"Roman" of painters was Charles Le Brun (1619–90); of garden designers André Lenôtre (1613–1700), whose axial vistas opening on infinite distance could be admired at the Tuileries and influenced those of Hampton Court. When the Barberini were forced into exile they brought with them a pupil of Pietro da Cortona, who received a prestigious commission to decorate a salon in the Louvre, while brilliant French architects such as François Mansart (1598–1666) or Louis Le Vau (1612–70) produced notable Classicizing variations on Baroque themes in the church of Val-de-Grace and the château of Vaux-le-Vicomte. At Vaux Lenôtre focuses his huge and magnificent garden on the central block of the house with its projecting wings.

The personal rule of the youthful Louis XIV began in 1661. From then on art was under state control – that is, Louis's control – and standards and styles were Classical. French art, in comparison with the Roman Baroque, is characterized by its rationally regulated composition, its shunning of anything apparently spontaneous or unrestrained. Its expressive power, dramatic, lyrical or pathetic, results from tension set up between what was often a primarily geometrical structure and the feeling generated by the actual treatment of the subject, whether the glories celebrated were ancient or modern.

On this same dynamic balance – basically present, if at another level, in contemporary Roman art – rest, in their different ways, works ranging from the naturalistic canvases of Georges de La Tour (1593–1652) to the agitated statuary of Antoine Coysevox (1640–1720) or Pierre Puget (1620–94). It is the

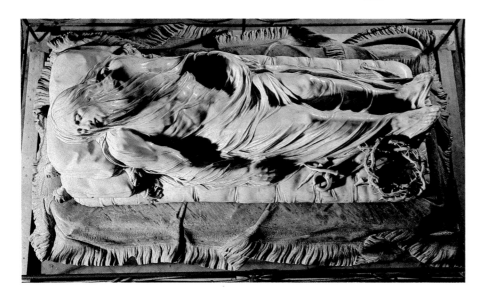

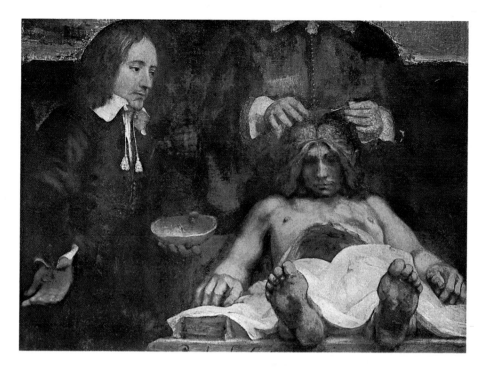

Above: Rembrandt, The Anatomy Lesson of Doctor Deijman (1656, detail). Rijksmuseum, Amsterdam. The subject, rendered as a faithful document, shows a public dissection, beginning with the abdomen. Here the doctor dissects the brain, while a colleague holds the cranium. With such works, the artist gives aesthetic status to themes alien to the Classical tradition, such as the analysis, almost the violation, of a corpse. The foreshortened body resembles Mantegna's famous Dead Christ.

Below: Rembrandt, The Three Crosses (c, 1660), dry-point etching.

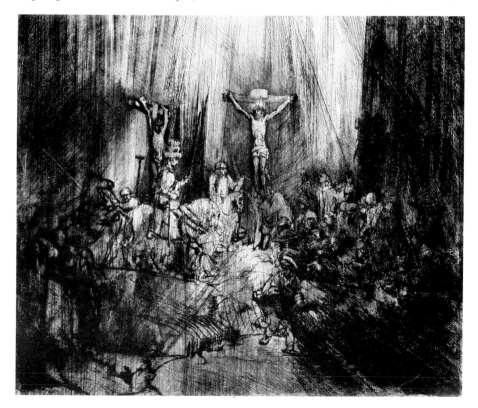

concept underlying the east front of the Louvre by Louis Le Vau and Claude Perrault (1613–88), and the garden front of Versailles by Le Vau and Jules Hardouin Mansart. Both these projects were preceded by deep and detailed deliberation of plans and advice offered by a group of Roman architects, including Bernini and Pietro da Cortona, and had been modified by a return to schemes more reminiscent of Bramante.

State institutions for the instruction and training of artists and craftsmen had existed since Mazarin's time, and with the growth of French political and military power they came to influence the taste of patrons at home and abroad. In 1648 the King financed a Royal Academy of the Arts derived from Italian models of the previous century and destined to be the pattern of such societies in Europe. Now, too, the modern classification of "Beaux Arts" arose to cover painting, sculpture and architecture as distinct from the Italian Renaissance notion of "the arts of design." Now art is seen not as the imitation of nature, but as ideal beauty; it is something to be learned through study and taught by Academy professors. Nor did the Crown restrict its financial support to the determining body only, for it maintained in addition centers of practical production whose fame endures to this day. The Gobelins factory, founded 1662–67 under the painter Charles Le Brun, was known for its fine craftsmanship, and employed cabinet-makers, artists and sculptors as well as tapestry-weavers. La Savonnerie, started in 1627 and named from the site near a former soap factory, produced knotted-pile carpets. Le Brun was appointed its director, too, in 1665. Plate glass and large mirrors were manufactured at the Saint-Gobain glasshouse, tapestries and other textiles at Beauvais.

This financial and political support, emanating from Versailles, where the French court was established by the early eighteenth century, made that palace the center of taste and patronage. Versailles set the standards of European art and craftsmanship, its influence transcending, or greatly affecting, that of Italy and the Netherlands, which had dominated the field for the past 200 years. And since the French royal residences, from the Tuileries to the Louvre and Marly, were continually being renovated, interiors and exteriors alike, anyone, anywhere on the Continent, who aspired to a princely abode had perforce to take account of their developments, or even to copy them outright. Many of the most impressive Baroque-accented buildings in Russia (whose court had recently moved from Moscow to the new capital at St. Petersburg), were by a Parisian-born architect of Tuscan extraction, Bartolomeo Rastrelli (c. 1700–71). In and near Madrid the Palacio Real, Aranjuez and La Granja, though from Juvara's hand, owe much to Bernini's final plans for the Louvre.

The spread of new ideas in France, and

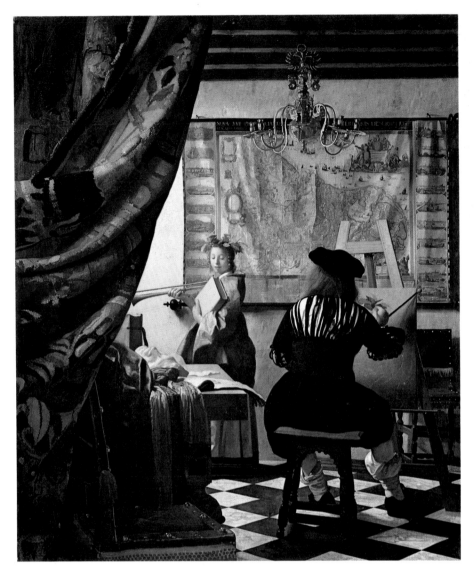

Small private suites organized within the stateliest and grandest establishments are particularly interesting examples of the new tastes and ideas. The King had his *Petits Appartements* on the first, second and third floors of the north wing at Versailles, and from 1735 to 1739 Gabriel-Germain Boffrand (1667–1754) was adding similar rooms to the Hôtel de Soubise in Paris. Generally speaking, there was a clear distinction of architectural form between interiors and exteriors, the orders being for external embellishment only, and the rooms within lighter than ever before, thanks to floor-length windows, wall mirrors and wooden panelling in pale or gilded frames. *Rocaille* ornament, its undulating, flexible lines based on natural motifs and suggesting the asymmetry of antique "grotesques," has banished the orders and their traditional structural function. In the oval upper *Salon de la Princesse* at the Hôtel de Soubise the entablature, which, though occasionally fictive, had marked the transition from walls to ceiling, also disappears in a shimmer of sinuous decoration, of abstract motifs derived from flowers and rocks and vegetable themes. Architecture returns to its mineral and organic origins and ideal dimensions, reabsorbed – almost at times dissolved – among the lavishness.

The purpose of it all may be sheer comfort and intimacy, or sheer scenography, and Frederick the Great of Prussia, a devotee of French culture, thoroughly debated and discussed the two aims with his collaborating architect when building his favourite palace of Sans Souci near Potsdam in 1745–57. The architect wished to see an altogether more imposing and monumental affair, while his master preferred simple convenience. The royal victory is demonstrated in the employment of non-structural elements, significantly reminiscent of Mannerism, which effectively

from France to the rest of Europe, as to how rooms should be used and furnished was certainly accompanied by, if not an obvious consequence of, political and practical approbation of this kind. Furnishings might still to a great degree reflect a way of life and a disposition of space designed for luxury and monumental splendour; but such notions, related as they were to the long-accepted courtly and domestic arrangements of central Europe, were far from the up-to-date desire for comfort and a logical lay-out – that is, from the tendency to give rooms their separate functions for ceremony or private existence. Internal décor, in other words, was reverting to the *utilitas* of Vitruvius, and seen in terms of a balance of space and equipment to meet the demands of social rank and the pleasures of well-earned enjoyment. In the mid sixteenth century Sebastiano Serlio, acting as advisor at Fontainebleau, had been fascinated by the

thought of combining "French comfort with Italian usage," while as early as 1619 the Marquise de Rambouillet created a model of taste in the *Chambre Bleue* of her hôtel in Paris. Arthénice, as she was known, was herself half Roman, her mother having been a Savelli, of the ancient Roman feudal family, and her father French ambassador to the Pope. Rejecting red, the then fashionable colour, she hung her room in blue velvet threaded with silver and gold, and there held her famous salon.

Toward the end of the century the *Grande Gallerie* at Versailles received the massive silver furniture designed by Charles Le Brun. Cast from twenty-two tons of precious metal in 1689, the silver pieces took their place beneath the huge, shining wall mirrors in the most dazzling of all the settings contrived for the Sun King and the majestic extravaganza of his court.

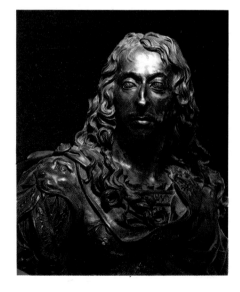

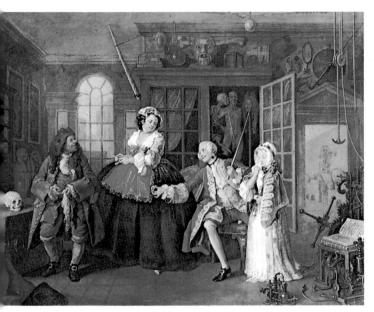

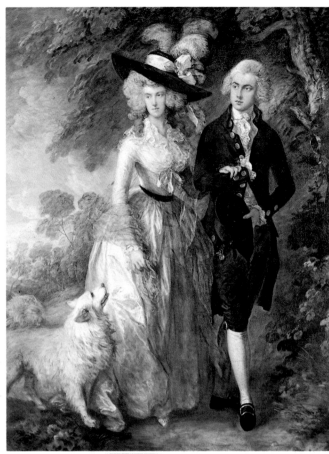

Opposite above: Jan Vermeer, Studio (or The Muse Clio). Kunsthistorisches Museum, Vienna.

Opposite below: A. Coysevox, Bust of the Grand Condé. Musée du Louvre, Paris.

Above: one of the seven canvases of the cycle Marriage à la Mode: the charlatan, by W. Hogarth (1745). Tate Gallery, London. Allusions to the hero's amorous foibles.

Right: Thomas Gainsborough, William and Elizabeth Hallet (or The Morning Walk, 1785). National Gallery, London.

Below: façade of the château of Versailles, seen from the king's gardens, by L. Le Vau and J.-H. Mansart.

impede any grand vista through the apartments. Thus numerous mirrors line the central salon of the hunting-lodge of Amalienburg, in the Nymphenburg park at Munich. Here, in a room that lacks even the sparing painted decoration of the corresponding Salon de la

Princesse at the Hôtel de Soubise, François de Cuvilliés and Johann Baptist Zimmermann have installed a naturalistic phantasmagoria in tones of silver and white. Materials were now translucent, semiprecious or exotic, such as the laquer covering walls and furniture – a

fashion followed by the King of Prussia's sister in her Hermitage at Bayreuth. Porcelain, imported from the Orient for years and first made in the West near Dresden at the beginning of the eighteenth century, was not limited to fine tableware but was applied to furniture, and used as cladding on the walls of small "porcelain rooms." The King of Naples had a porcelain room at Portici, dating from 1757–59. And for a vivid synthesis of the plastic arts of Europe in the second half of the eighteenth century one need only examine the Nymphenburg figurines modelled by Franz Anton Bustelli (1723–63) for the factory near Munich. Amber, that rare and much-prized commodity, is itself a decorative accessory, used in the amber room at Tsarskoye Selo near St. Petersburg (1709–63).

The revival of the exotic as an alternative to more familiar tastes that harked back to the Renaissance was not confined to the sphere of domestic ornament. Major artists were engaged on "Chinese" décor, from Watteau, painting his first panels for the château of La Muette in 1708, to Boucher, who drew cartoons for an enchanting series of "oriental" tapestries actually presented to the Emperor of China in 1762. And in its turn this fantasy other world, this idealized, never-never Cathay and

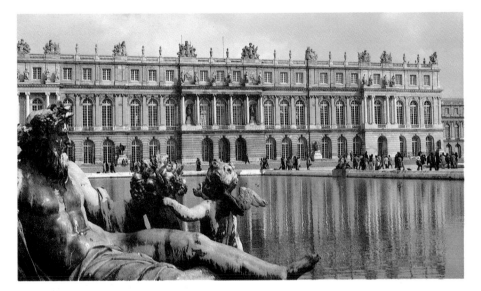

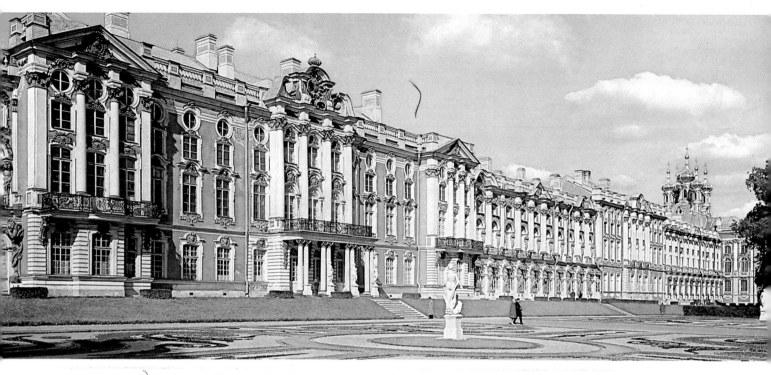

sentimentalized Turkey, inspired modes and styles for people and landscape in England, central Europe and Sicily: "Turkish" costumes and "Chinese" gardens and Louis XIV's pagodas at Versailles.

A further department of the visual arts also contributed to the change from fading mythological themes, legacy of humanism and its antiquarian studies, to less heroic subjects, even when still in the celebratory tradition. The pictures of Jean-Antoine Watteau (1684–1721) are lyrical transformations of the atmosphere and episodes of the comic theater, the masquerades of the declining *Commedia dell' Arte*. With him the creaking amatory situation becomes a delicate idyll, the type-character reveals psychological depth; the masquerade is a thoughtful and, fundamentally, disturbing metaphor for the personalities and roles of the participants. The Baroque concept of nature as spectacle was itself altered in his magical *fêtes galantes*, those visions of happy companies of ladies and their escorts amid the calm unthreatening woods and glades and distant islands. In *Embarkation from Cythera* (1717, Louvre) a group of lovers, both smiling and melancholy, leaves the fabled isle of Venus: a picture hovering between allegory, sentimental charm and a yearning for emotions more dreamed of than experienced.

François Boucher (1703–70) and after him Jean-Honoré Fragonard (1732–1806) were, each in his way, connected with the court and its official system of art-training and production. Besides designing for the royal tapestry factories, Fragonard was Director of the Academy and a friend of Madame de Pompadour. He spent the statutory period of study

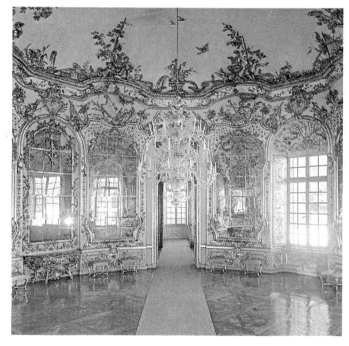

Above: Tsarskoye Selo ("imperial village"), today Pushkin, grew round a modest residence of Catherine I, mainly at the wish of her daughter Elizabeth. The construction of two palaces, sundry pavilions, a village in Chinese style and a park was begun in 1771. Here we see the façade of Hekaterinski palace, by B. Rastrelli, with wings and adjacent parts in different styles.

in Rome on a financial grant and was to collaborate on artistic projects with Madame du Barry. Boucher worked on many private decorative projects, and his themes range from sunny gallantry to the delicious license of *The Reclining Girl*, his portrait of Louise, La Belle O'Murphy, the shoemaker's daughter who was one of Louis XV's stable of girls. It is

an innocent image of seduction, as unshadowed by moral judgement as by courtly flattery. Classical subjects, though invariably introduced as academic trimming, may also serve as vehicles for technical virtuosity. In *The Triumph of Venus* (or perhaps Galatea) of 1740, pictorial description attains supreme freedom in the scintillating play of transparent

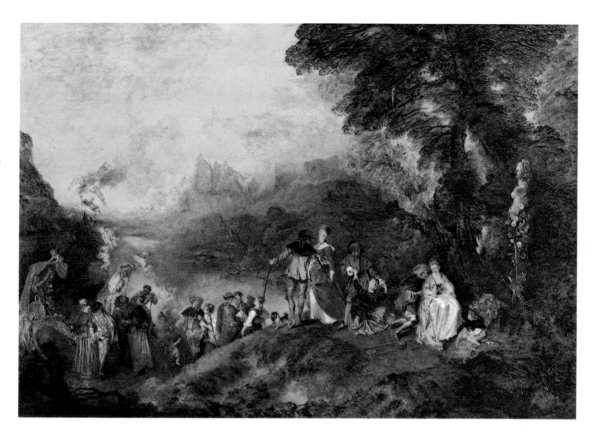

Opposite below: mirror halls are among the most attractive Rococo inventions. Mirrors extend to become part of the architecture, abolishing its ornaments and the perception of its construction. Opposed mirrors in a circle project the room beyond its bounds and multiply images in infinite shrinking sets almost to extinction. A metaphor of self-referring images returning to their starting point. Detail of the hall of mirrors in the hunting pavilion of Amalienburg, Munich, 1734–39.

Right: J. A. Watteau, Embarkation from Cythera (1717). Musée du Louvre, Paris. Presented by the artist for admission to the French Royal Academy.

air and water and a glowing softness of flesh-tones.

Quite differently conceived are the pictures of Jean-Baptiste-Siméon Chardin (1699–1779), who concentrates mainly on the expressive construction of genre scenes, and chiefly of still lifes. He will strictly scrutinize some completely ordinary object in order to show it in the light of its aesthetic and moral significance. His nonillusionistic, rigorous compositions rest on the simple forms of geometry – cone or cylinder – and objects are so depicted that we can almost feel what they are made of. In this his effects differ, despite resemblances, from those of the seventeenth-century Flemish school, and since they did not wholly correspond to bourgeois taste and ethics, he found purchasers beyond the middle class. The King of Prussia bought Chardin's paintings, and a number of them had entered the French royal collections by 1744.

But if Fragonard's *Stolen Shift*, where Cupid in person, all mischief and playful sensuality, steals the garment from the naked woman on the bed, is another example on the borderline between mythical allegory and eroticism, the natural world in which he sets the games and frivolous diversions of society – *Blind Man's Buff*, or *The Swing* – is no longer an idyllic place. Its wide spaces and lush greenery are solemn, mysterious and slightly menacing. There is already a hint of the pre-Romantic

feeling for the "sublime."

The pictorial rarification or transmutation of symbolic values; the dissolution of architectural structure in an eye-deceiving maze of stuccowork and looking-glass, of flowers and garlands, mother-of-pearl, shells and rocks and foam and glinting, silvery light; the belief in superabundance as decoratively essential; these are poles apart from the solid formality and symbolic content of the Baroque. Yet the term "rococo," a heavy sarcasm later coined by Classicist critics to describe what they saw as fatuous aberrations or incomprehensible rule-breaking, in fact combined *barocco* with the word *rocaille*, originally used for the rock-and-shell ornamentation of Renaissance gardens. And, leaving the artistic argument aside, "rococo" does seem to catch and express the extraordinary grafting of the two styles, which are incompatible only as abstract concepts and whose eighteenth-century union is achieved in those areas where Baroque culture was most vigorous: from Piedmont to the gardens of Caserta and the villas of Palermo; above all, in the Catholic states of central Europe.

Baroque in Germany

In Vienna, capital of the Holy Roman Empire, there developed a special, "imperial" Baroque, the manifestation of the power of the

Habsburgs and their allies by blood and marriage who had conquered the Turks in the Balkans. Roman artists in Vienna included Andrea Pozzo, whose frescoes in the Liechtenstein palace (1704–08) and substantial contributions to the interior of the Universitäts-kirche (1703–09) established standards of magnificence for secular and religious decoration throughout the Empire. With the advent of native German artists profoundly influenced by Italy, the Italians themselves were less frequently enrolled, and in 1716 the Karlskirche was begun by Johann Fischer von Erlach (1656–1723), who had studied for fifteen years in Rome and Naples. (The church would be completed, by his son, after his death.) His plan is a startling synthesis of allusion, symbolism and quotation drawn from Roman architecture, ancient and contemporary. In the mixture are such entirely new departures as pavilions and ornamental additions incorporated into the façade – composite geometrical structures consisting of rectangular blocks linked by curving arms. As in Juvara's architecture, we may recognize in their concave and convex ovals and circles, their polygonal or star-shaped outlines, a landmark of international Baroque in transition from the seventeenth to the eighteenth centuries.

There was also, at the time, enthusiastic reconstruction of the colossal abbey churches of the medieval monastic orders, and Markt Sankt Florian, Klosterneuburg and Melk pro-

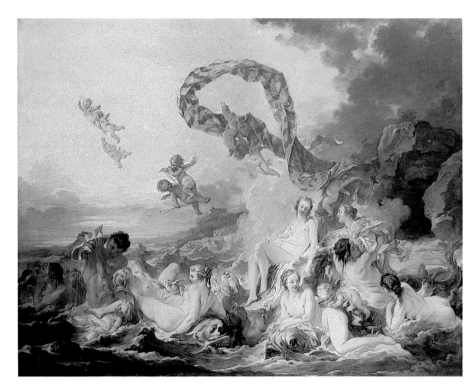

embellishment, with the surviving Gothic tradition and with vast Italianate decorative projects. A highly talented body of stuccoists, painters, sculptors and architects – often, like the Zimmermann and Asam brothers, or Tiepolo and his sons, functioning as itinerant family teams, or associated with them, as was Johann Balthasar Neumann (1687–1753) with the Diezenhofers – concentrated principally on the by now customary ritual settings in church or palace, or for municipal projects. In their hands art shines and dances, with a marked absence of dramatic contrast and a subtle, if not indeed an occasionally ironical, choice of only vaguely appropriate subject matter.

With a new Residenz to adorn, the Prince-Bishop of Würzburg summoned Tiepolo and his sons. The tiny feudal state was an imperial fief, and their orders were to exalt imperial and feudal power: the sun, rising upon the world, was to suggest the benefits showered on the fortunate episcopal domain. Yet the very profusion of praise contains its own contradiction. Though the device of showing cosmic events and remote medieval ancestors, such as Frederick Barbarossa and Beatrice of Burgundy at their wedding, may gain credibility from increased realism, the whole purpose is undermined by the clear, transparent colouring and self-satisfied expressions of figures apparently more anxious to be admired than to fulfil their allegorical obligations.

For true allegory we should visit the rural

claim awareness of the miraculous, the perfect, triumph of Catholicism. The Protestants were contained, the Turks at last defeated, and the rebuilding spread from lands under direct Habsburg domination to more distant regions of the Empire – the Benedictine abbey of Weingarten in Upper Swabia, to Einsiedeln and the glorious abbey of St. Gall in Switzerland.

Nor was lay architecture unaffected by the diligent adoption of Baroque motifs and the co-ordination of the various Baroque arts. At intervals from 1714 to 1722 Johann Lucas von Hildebrandt (1668–1745) raised a pleasure palace on the outskirts of Vienna for the Emperor's greatest mercenary general, Prince Eugene of Savoy. The Belvedere, as it was later known, is remarkable for exuberant decoration – the prodigal assembly of atlantes, herms and putti being absolutely attuned to its owner's position in the world – for its brilliantly functional design, and for its treatment of space. It is in fact two quite separate buildings, one at the top, the other at the foot, of a hillside; one for state occasions and one for private life. A vista of gardens and fountains divides them, and the function of each is announced by its relative height on the slope and its degree of formal splendour.

Between Swabia and Saxony, in central Europe, the very individual styles of seventeenth- and eighteenth-century Baroque and Rococo reach a special synthesis. Here repeatedly, in secular and religious buildings, the spatial animation and architectural unity of international Baroque come together with the basically French taste for extravagant *rocaille*

Above: F. Boucher, Triumph of Venus (1740). National Museum, Stockholm. Probably painted for a Salon, the periodic exhibition of artists' work started by Louis XIV in 1673, reserved for members of the Royal Academy, which the painter had joined in 1734.

Right: J. H. Fragonard, The Swing (1768–69). Wallace Collection, London. A contemporary tells us that the work was commissioned by F. G. Doyen for the treasurer of the French church, insisting that the client himself should be shown ogling his mistress's legs sitting on a swing pushed by a bishop. The painter refused because the subject was licentious, and instead suggested Fragonard, who accepted.

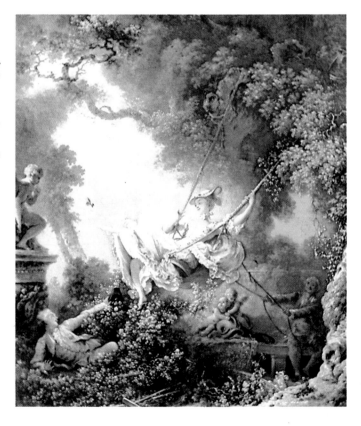

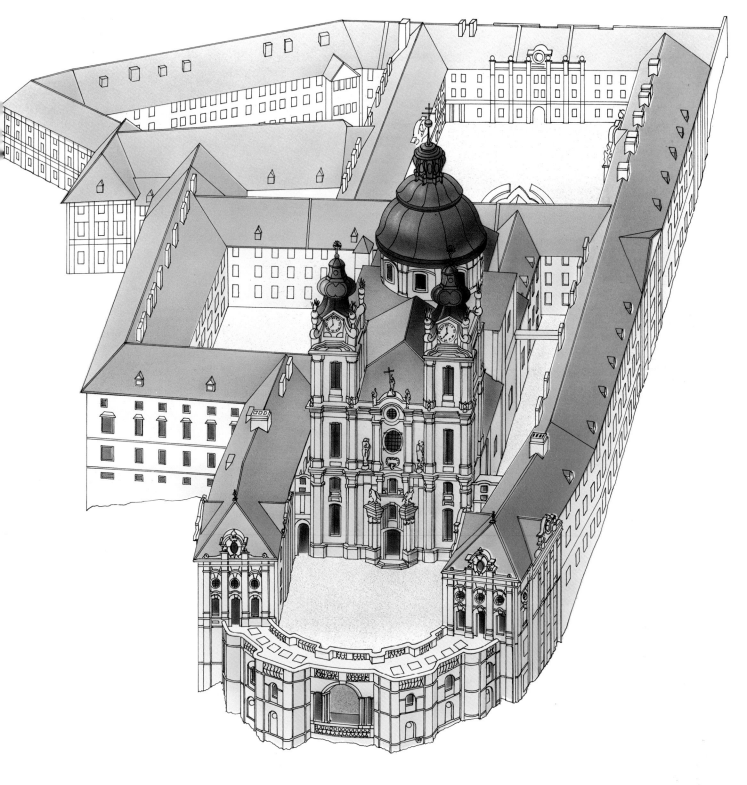

Axonometric view of Melk Abbey, rebuilt in the early eighteenth century, thanks to close collaboration between Abbot B. Dietmayer and a group of artists led by *the architect J. Prandtauer. The façade of the church and the facing courtyard open directly, via a pierced wall, on to a sheer, rocky spur over* *the Danube. The effect is unusually transparent, but is at the same time monumental.*

pilgrimage church of Die Wies in Upper Bavaria. Built in 1746–54 by Dominikus Zimmermann (1685–1766), it is a culmination of the process that blends the venerable artistic tradition of the medieval centuries with the culture of the Renaissance, of Mannerism and the Baroque. The design, varying between a centralized ground plan with ambulatory, and a longitudinal three-nave arrangement, is a fluid succession of interlocking spaces. The unexpected play of light – a dazzling brilliance from the many and carefully articulated windows and the softness of a few shadowy zones – arises from the considered modification of the usual architectural links.

For the central vault Johann Baptist, the painter brother of Dominikus, chose the ancient, apocalyptic theme of the end of the world. But the moment immediately before the Last Judgement, suited as it is to a pilgrim cult, has for us other, and premonitory, connotations. Already, we know, Europe was astir with movements in technology, philosophy and the law that would radically change the old social, cultural and formal conventions in which art had been produced and had found expression since the late Middle Ages.

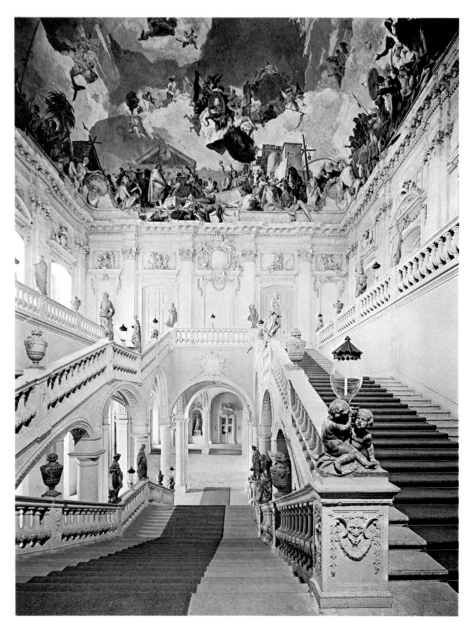

Residenz, Würzburg, stairs of honour by J. B. Neumann, with frescoes by G. B. Tiepolo. The story of the fresco over the great shell of the imperial staircase is linked by Tiepolo to the viewer's ascending the steps, gradually revealing, in almost violent colours, the allegory of the client's beneficent rule as the "sun," a most lively and optimistic celebration of European art of the time.

Neo-Classicism

Neo-Classicism is the name for the stylistic movement that began in Italy and England around the mid eighteenth century, developing fully during the last quarter of that century to reach its highest point at the turn of the century and in the years that followed, before going into a gradual decline after the fall of the Napoleonic Empire. It took as its aesthetic model the art of the ancient Greek and Roman world and its renaissance in fifteenth- and sixteenth-century humanism. Neo-Classicism was the last of the styles that were international, as all of the successors of Romanesque and Gothic had been, in the sense that it came to prominence almost simultaneously all over Europe and also in the United States, which, from the eighteenth century onward, could reasonably be regarded as an integral part of European culture. It made itself felt not only in architecture, painting and sculpture but, as happened with the Baroque and Rococo, also in the so-called minor arts that went hand in hand with architecture, such as manners, dress, demeanour and, generally speaking, every sort of awareness of what is aesthetically pleasing. It is commonly believed that the neo-Classical movement (which does not have the hallmark of a stage in the process of evolution but presents itself rather as a movement in opposition to, if not actually reacting against, the art of the immediate past, i.e. the Baroque) derived its energy from the revival of interest in archaeology and the accompanying dis-

coveries and subsequent excavations of sites like Herculaneum and Pompeii, and also the Greek temples at Paestum.

The actual evidence points to the fact that neo-Classicism can be traced to the new accentuation of Classicism, which was always present under the surface and retained a considerable aesthetic prestige throughout the Baroque age.

A number of painters who were active in Rome during the first half of the eighteenth century are authoritatively regarded as precursors of neo-Classicism: for example, Giacomo Zoboli from Modena, who then settled in Rome, and who usually produced a type of painting that is midway between the work of Reni and Maratta. In 1724, Zoboli completed *The Death of Caesar*, one of whose features was that its subject was the same as that of the famous picture by Cammucini now in the Museo di Capodimonte, Naples. But even though Zoboli took great pains to research the detail for the painting by careful

Above: L. Bartolini, Trust in God. Poldi Pezzoli Museum, Milan. Neo-Classical expression of prayer, symbolized by "a woman kneeling, her hands together, and her face looking up to Heaven." (Ripa, Iconologie.)

reference to books on archaeology, this canvas remains a product of eighteenth-century Poussinism and Roman Classicism; however, it also played a definite part in preparing the ground for the neo-Classical revolution. What should be borne in mind is that the eighteenth century was the time when public enthusiasm was at its height for a literary genre that in our own time is perhaps the most often overlooked: tragedy. Taking its cue from the tragedies of the *Grand siècle* in France, everything of any importance that had happened in ancient times found itself becoming the favourite subject for plays, as well as being held in great esteem in the new climate of moral and political regeneration, and even directing the attention of intellectuals to the world of antiquity.

In Rome, however, as a result of a new sensibility, which had been developing since shortly after 1750, the most enterprising innovators had already left the late Baroque behind them to devote their energies to the creation of a new style.

Anton Raphael Mengs (1728–79) painted a ceiling in Villa Albani in 1760–61 (to a commission from the great cardinal and archaeologist of that family). It was a fresco of Mount Parnassus, a programmatic work that was contentiously anti-Baroque and deeply imbued with sixteenth-century purism. One of Mengs's contemporaries was Pompeo Gerolamo Batoni (1708–87), who made his

name with portraits of a large number of foreign patrons, mainly British, painted in impeccably observed Classical settings; Batoni's painting nevertheless showed a restrained reworking of preceding styles and can be seen more as the continuation of seventeenth- and eighteenth-century Classicism than as an intentional creation of a new movement, this being much more what Mengs had been doing. Alongside these artists, mention should also be made of the Venetian Giovanni Battista Piranesi (1720–78), who made some famous engravings and etchings, especially of Rome's ancient monuments.

Mengs and Batoni reaped the benefits of the cultural climate engendered by the German philosopher J. J. Winckelmann. Now regarded as the founder of modern aesthetics, Winckelmann argued that beauty in art was to be found where pose prevailed over movement, where uniformly diffused light had priority over the contrasts of light and shade (*chiaroscuro*), where contour, and therefore drawing as a whole, meant more than colour, and where the human figure was more important than other subjects; all of these ideas being distilled in the celebrated phrase that held that art should tend to a "noble simplicity and quiet grandeur." Winckelmann also said that art was no place for the representation of truth, but rather of the beautiful ideal, in other words, the bringing together of the many instances of beauty in nature, ideally united in a single, perfect form.

These notions, which came to fruition over a long period during the second half of the eighteenth century, led in 1785 to the completion in Rome of the *Oath of the Horatii* by the French painter Jacques-Louis David (1748–1825), a work that is thought to have triggered the neo-Classical movement. This painting commemorates a courageous event from the days of ancient Rome when three brothers swore an oath, that they would either be victorious or die for their country. There are obvious debts here to Poussin and also to Corneille, who wrote a tragedy on a similar theme, and yet this picture alludes to moral and civic virtues, on which the artist hoped future society would be founded. The architecture in the background, Doric columns without bases, surmounted by arches without cornices, was intended as a counterpoint to the resolution of the male figures, while the female figures are sunk in dejection. The angle chosen is the natural one, from in front, and so there are none of those expedient, virtuoso features of which Baroque art was so proud.

The only figure who can be compared with David in that early neo-Classical period was the French painter Pierre Peyron. He was four years older than David, and was his only rival in Rome and Paris during those years, until his fame was eclipsed by that of David. Peyron's sophisticated and seductive painting shows that he studied examples of Caravaggio's

luminosity, while the bold colours in his canvases could have been inspired by the seventeenth-century French painter Valentin. David's *Oath of the Horatii* was taken to Paris and shown at the Salon in 1785, where it met with enormous acclaim and was responsible for the emergence of a new school of painting that occupied center stage in the artistic life of the next thirty years and was often instrumental in portraying the Napoleonic era. David himself, who had during the turbulent period of the French Revolution professed some extremist ideas, including an endorsement of the notion that a revolutionary was a martyr of his own country and the victim of clerical fanaticism (see his painting *The Murdered Marat in his Bath*) turned his attention, during the years of the Empire, to the celebrating of glorious Napoleonic events. He was commissioned to paint a vast canvas of Napoleon I's coronation, and his portraits of the emperor and many of the dignitaries and ladies of his court were often magnificent. But none of them achieves the intensity of his portrait *Madame de Verninac* (1799, Louvre, Paris), in which the art of the neo-Classical period reaches its high point. The background is a neutral green and was intentionally left unfinished – something David often did; this colour was specially chosen to blend with the reddish-yellow of the exquisitely decorated chair. This is the setting for a beautiful woman to whom the artist gives a serene presence, but does not show any psychological insights about her. The sideways-on position of the chair, the three-quarters figure, and the frontal view of the woman's face combine to suggest a slow, interrupted movement and derives from the positions of

Above: David, The Oath of the Horatii *(1784–85). Musée du Louvre, Paris. This canvas, which is really a painting acting as a manifesto, marks the birth of neo-Classicism.*

Opposite above: G. B. Piranesi, View of the temples at Paestum *(1778, etching). Piranesi, who brings together Baroque imagination and Romantic sensibility, played his part through his works (almost all of them inspired by ancient*

monuments) in stimulating the reverence for the Classical world out of which neo-Classicism grew.

Opposite below: A. Canova, Eros and Psyche *(1787–93). Musée du Louvre, Paris. This graceful Alexandrine story provided Canova with the ideal pretext for illustrating the intensity and delicacy of the feeling of love.*

figures painted on ancient vases. This work by David celebrates the rebirth of Classical art, regenerated and renewed after centuries of the evolution of art.

The sculptor Antonio Canova (1757–1822) lived at about the same time as David and appears to have shared with him the absolute fundamentals of neo-Classical art; it is in Canova that the great flowering of neo-Classical sculpture had its source. Canova already enjoyed widespread fame at the time when David was working on his *Horatii*, on the strength of his tomb for Pope Clement XIV (1783–87). The pontiff is shown sitting on his throne, but the sculptor chooses not to portray him in the act of benediction, which was the usual formula, preferring what Cicognara has aptly described as "that grandest and most noble attitude of holiness and sovereignty, holding up his hand as befitting one who acts as the protector and ruler of nations, and

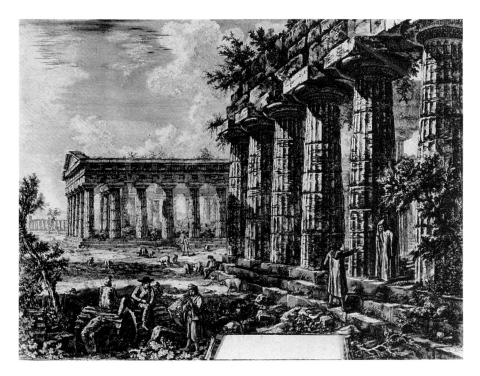

drapes. The positions of the figures, to which Canova devoted enormous care, look completely natural, illustrating moments when they are wholly at rest or violently active, in which the tension is absolute. A group such as *Venus and Adonis* depicts a moment of intimate affection between two lovers and offers an untramelled expression of loving feelings in which there is no hint that the senses are in turmoil.

The Danish sculptor Albert Bertel Thorvaldsen (1770–1844) was a contemporary of Canova and both emulated and competed with him. Thorvaldsen represents neo-Classicism at its most strictly formal and "conceptual"; in fact, he creates the figures for his statues in accordance with a rigid scale of volume, sacrificing movement and light in order to get his proportions exactly counterbalanced. How carefully he has gone about this is clear from his *Jason* (1803), which derives from the scultpure of Polycletus and first brought Thorvaldsen international fame, in *Hebe, Ganymede, Mars* and *Eros* (all in the sculpture collection of the Thorvaldsen museum in Copenhagen) and in the Mausoleum for Pius VII in St. Peter's.

equally one who administers the sacraments of the Catholic faith." At the foot of the sarcophagus, figures personifying Temperance and Gentleness ("quintessential Gospel virtues," observes Cicognara) keep vigil, with a body-language of forlorn dismay. Rome's art world was unanimous about Canova's achievement, and David bore this in mind in the way he portrayed the women to the right of the picture in his *Oath of the Horatii*. From that moment on, Canova's fame continued to increase, and he was given the most prestigious and remunerative commissions in Europe. His huge output, enhanced by the productivity of a studio/workshop consisting of numerous pupils, remained prolific until his death in 1822. Canova left behind him sacred works, tombs, fantasies from mythology, portraits, bas-reliefs and even some painting, which seems to have been a hobby. Many of his sculptures became celebrated, such as the groups *Eros and Psyche, Venus and Adonis* and *Hercules and Lichas*, the monumental portrait *Napoleon the Warrior-Peacemaker*, the *Venus Italica, Hebe* and, most famous of all, the sculpture of Pauline Bonaparte as *Venus Victrix*. Canova's pupils brought these works to a degree of finish that was faultless in order that, unlike the sort of thing that happened in the Baroque, it would be impossible to detect in them any of those "happy chances" in which the artist has not decided what he is working toward, and his hand just happens to produce something worthwhile. Nothing prevents the light from playing on the surfaces of Canova's sculptures, and the skin of his figures (mainly nude, following the conventions of statuary in ancient times) is as perfectly smooth as their

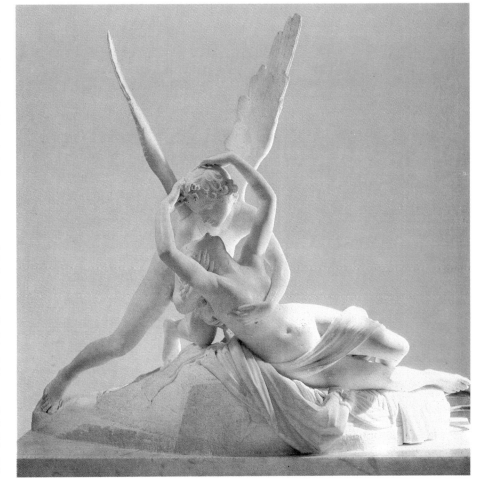

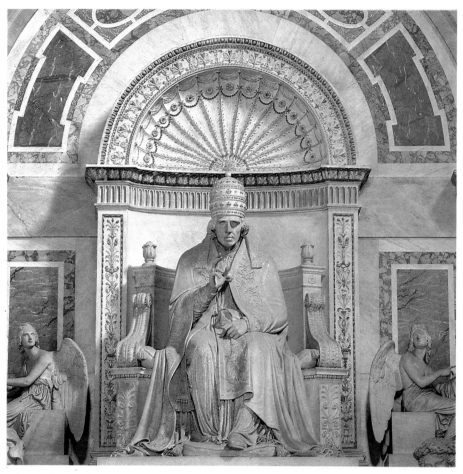

Sculpture flourished considerably throughout the nineteenth century: portraiture in sculpture and in painting was equally popular with patrons, and a large number of figures representing characters from mythology and from pagan and Christian allegory carried the tradition of Canova's innovations and stylistic models beyond 1850. Among those of his contemporaries who should be mentioned here is Giacomo De Maria (1762–1833) from Bologna, who followed Canova's style for his *Hercules and Lichas* at Palazzo Hercolani in Bologna. De Maria's most extensive work was the frieze decorating the tympanum at Villa Aldini in Bologna, strictly in the neo-Classical mode and portraying the Assembly of the gods. Camillo Pacetti (1758–1826), who trained in Rome and was a highly accomplished restorer of ancient statues at the Vatican Museum, was noticed by Canova and, in 1805, on Canova's recommendation, was appointed to the Chair of Sculpture at the Brera Academy. While in Milan, Pacetti, by now in his fifties, proved himself to be a moderate sculptor. He was responsible for the sculptures on the Arco della Pace in Milan, and supervised the work of them, as well as the sculptures in the Duomo, and portraits of painters like Appiani, Bossi and the Empress Marie-Louise. Those

sculptors who, for age reasons, had not been pupils and followers of Canova, also frequented his circle. This was even more to the advantage of his actual pupils, among whom perhaps the best known is Adamo Tadolini (1788–1868) from Bologna, who made numerous copies of Canova's works under the master's direction and who was, after Canova's death, the most loyal exponent of his style in numerous though not very inspired statues and busts commissioned by a large number of wealthy, private, international patrons.

If, then, on the strength of the shining light of Canova's achievement, Italian sculpture can be judged as supreme throughout Europe during the neo-Classical period, then French painting deserves a similar accolade. For many years the school of David received public and private commissions and had a formative influence on all the national schools of painting in Europe, whose artists, in the days of the Napoleonic Empire, were more attracted by Paris than by Rome, which had been their Mecca in the past. The first of David's pupils, in chronological order, was Antoine-Jean Gros (1771–1835), who was only fifteen when he entered David's studio, and who for the rest of his life remained the master's principal interpreter and exponent of

the David style. After the success of his *Napoleon Visiting the Plague-stricken at Jaffa* (1804) he specialized in grand set-pieces depicting Napoleon's epic deeds. But it was in his *Sappho on Leucas* that Gros produced what may be regarded as the best example of Romantic neo-Classicism, a genre that had its Classical connotations and subjects but also exuded strong waves of Romantic feeling, passion and drama.

Another outstanding pupil of David was François-Pascal-Simon Gerard (1770–1837), who came to fame through his celebrated *Eros and Psyche* (1798), obviously inspired by Canova, and who subsequently concentrated mainly on portraiture, producing a series of admirable studies in which both face and figure look as if they are emerging transfigured from an exquisite fragrance of colours and a most graceful nobility of attitude and demeanour, as in the case of his portrait of the miniaturist *Isabey and his Daughter* (1795).

A different style characterizes the work of Pierre-Paul Prud'hon (1753–1823), who was waylaid during the mandatory pilgrimage to Italy by the grace of Leonardo (even more so by the generally accepted significance of Leonardo's painting, which had been given its head at the end of the eighteenth century by his followers) and also by Correggio. For all that his subjects were neo-Classical, such as allegory and the usual stories from mythology,

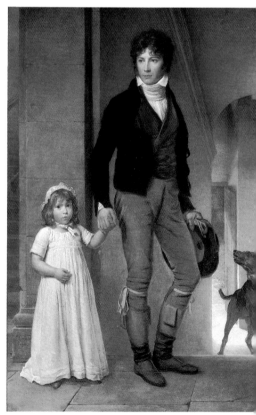

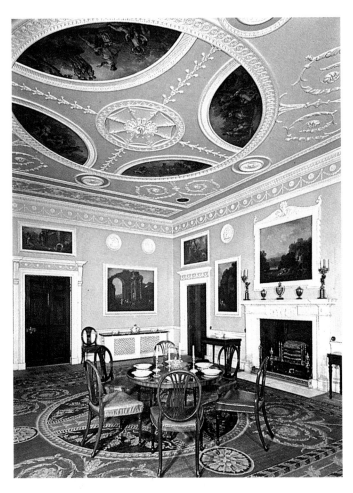

Opposite above left:
A. B. Thorvaldsen, Tomb of Pius VII (1823–31). St. Peter's, Rome.

Opposite below right:
F. Gerard, Isabey and his Daughter (1785). Musée du Louvre, Paris. Of all the genres touched on by neo-Classical painting, the portrait is undoubtedly the most dear to the sensibility of the age. Gerard excelled in it, producing portraits of refinement that revealed a delicate chromatic sense.

Left: R. Adam, the dining room at Saltram House, Great Britain (1768–80).

Below: A. L. Girodet-Trioson, The Sleep of Endymion (1793). Musée du Louvre, Paris. This painting is unquestionably the best-known example of a whole trend in neo-Classicism inspired by the painting of the sixteenth century. The academic, sophisticated pose of the models gives it a particularly Mannerist quality.

artists of the Empire) there were other painters who preferred to represent modern life and excelled in genres that were looked upon as of minor importance in those days, such as landscapes and still lifes.

Louis-Leopold Boilly (1761–1845) was a painter of Parisian life during the Empire who operated on the sidelines and not in the official artistic mainstream. Pictures of his such as *The arrival of a stagecoach in the courtyard of the Mesageries* (1803, Louvre) and *The Gallery at the Palais-Royal* (1804) are good examples of anecdotal, bourgeois painting, which was in vogue early in the nineteenth century and showed a smooth, brilliant technique that owed much to the Dutch genre masters of the seventeenth century.

Different landscape artists attempted to extol the beauties of the Italian countryside, for example J. J. X. Bidault (1758–1846), who painted landscapes with mythological characters in them, and Pierre-Henri de Valenciennes (1750–1819), who was much freer in his prolific output of a series of landscapes in oils on paper in which the Italian light and atmosphere are captured in a way that anticipated, in the early years of the nineteenth century, landscapes by Corot.

Although Paris was unquestionably the capital of neo-Classical painting at the high point of its development, that same star in the imperial firmament had a very important influence, too, on the architecture of the period. In fact, Napoleon began to study how many of the other European cities – e.g. Rome and Milan as well as Paris – had been planned and laid out, plans which provide the basis of the *modus operandi* of town-planning that was in

the lay-out of his pictures was pure neo-Cinquecento. He was one of the favourite painters at the court of Napoleon, became the Empress's drawing teacher, and invented the themes for the imperial furniture, itself by no means a negligible aspect of neo-Classical art.

Yet another of David's pupils (becoming famous in 1793 with *The Sleep of Endymion*, which had a remarkable success in Rome and in Paris) was Anne-Louis Girodet-Trioson (1767–1824). Already in this painting the long-limbed figure and unnatural, sophisticated pose of the youth beloved of Artemis allies it with Mannerist art and especially with Il Parmigianino. But the later *Portrait of Mademoiselle Lange as Danaë* (Mlle Lange being a well-known figure on the Parisian scene at the time) is full of sarcastic references, and shows how a version of neo-Classicism could exist of which the overriding aim was to exhibit an insidious, Alexandrine kind of grace and which was a very far cry from the moralizing intentions of David's painting.

Alongside these "State painters" (a reasonable enough nickname as it was they who were awarded all the biggest official commissions and were the most widely acknowledged

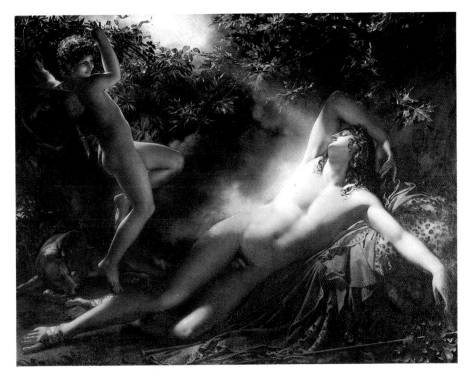

use throughout the nineteenth century.

It is thought that neo-Classical architecture found its sources in a number of architects and writers of treatises who lived and worked during the second half of the eighteenth century, Etienne-Louis Boullée (1728–99) being prominent among them. Boullée wrote a treatise on architecture (which remained unpublished until 1953) and did little in the way of actual building, although he was the author of several impracticable designs, such as a monument to Sir Isaac Newton in the shape of a sphere 150m (490ft) high. In this allusion to the force of gravity exerted by the Earth, its grandiose if elementary geometry was meant to represent zero in architecture, expressed here in terms of its principal function as a shaper of spatial containers.

An architect who could be compared with Boullée was Claude-Nicholas Ledoux (1736–1806). Ledoux was very much in vogue during Louis XVI's reign, and he enjoyed the patronage of Madame Du Barry, the last of Louis XV's favourites, for whom he built the pavilion at Louveciennes. The hallmark of his career, it was decorated and furnished throughout in the new style which would subsequently be called neo-Classical; the architectural features of the interiors were limited to smooth pilasters and Classical bas-reliefs. Current studies of Ledoux are enthusiastic about those of his buildings and designs which won particular fame, like the salt-works at Arc-et-Senans, parts of which are still standing, and the ideal city of Chaux. Both of these are examples of a geometric stylization marked by experimentation with colossal edifices, and actually working toward a revival of strong contrasts of volume in architecture in the style of Giulio Romano which had been a distinguishing feature of Italian Mannerism.

But the real evangelists of neo-Classical truth were Charles Percier (1764–1838) and Pierre Fontaine (1762–1853), who always worked as a team and gave a new look to many sites in the city of Paris. They built a large number of famous buildings there, for example, the Arc du Carrousel (1806–07), and devised the new vocabulary of decoration that went by the name of the Imperial style – luxurious, rich in predominantly graphic elements, and often used as a vehicle for the display of fine materials – although Percier and Fontaine nonetheless created from it many architectural forms never used previously. Their inventiveness in interior decoration, in which the furnishings are an integral part of the architectural decoration of the room, became widely known through the publication of a celebrated collection of engravings entitled *Recueil de Décorations interieures* (1801). Their furniture designs were often made up by Jacob the cabinet-maker, who used mahogany panels embellished with gilded bronze.

He achieved unprecedented elegance and technical excellence, and often succeeded in bringing to fruition designs that became milestones in the history of European taste and in which the essential character of the architecture and an indisputably sovereign splendour combined in incomparable style.

No understanding of the neo-Classical sensibility would be complete without looking at British architecture. The great significance of Britain in this context is that, from the seventeenth century onward, its architecture was directly inspired by the outstanding sixteenth-century Italian architect Andrea Palladio. The first Briton to take on Palladio's mantle (starting a tradition that continued unbroken until the mid nineteenth century before transferring its activity to the United States) was Robert Adam (1728–92). His numerous architectural successes are especially prized for the interior decorations, in which he shows a subtle hand at stuccowork. The various elements of this had been derived from the language of late Roman décor as exemplified by the imperial palace of Diocletian at Split, in Yugoslavia, Adam also reproducing them in a book of engravings that was widely read. Adam's architecture, accentuating the contrast between the picturesque, medieval character of a number of Scottish castles and the exquisite and comfortable interiors, was imitated in Russia and in America. After Adam, the most interesting architects include John Soane (1753–1837), who displays, in much of his work, and particularly in the design of the front of his house, a preference for linear stylization and for the accentuating of planes rather than of volumes. This linear stylization seems to

have stimulated a whole trend in British taste, if the evidence of it in the work of John Flaxman (1755–1826) is anything to go by. Flaxman was a sculptor and graphic artist who illustrated the poems of Homer and Dante's *Divine Comedy* with a series of engravings in which the figures are delineated by a simple outline and have a completely two-dimensional effect.

Whereas the French school of neo-Classical painting concluded with the work of J. D. Ingres, who used the style as a base on which to rest the powerful mainstays of his art, Italy's only contribution to the painting of the period was a number of pleasant portraits of private individuals by the Milanese painter Andrea Appiani (1754–1817). Then there was Felice Giani (1758–1823), an artist who has been re-evaluated by current scholarship. Giani worked in Rome, Bologna and Faenza, and was a painter full of flair, fire and irony. The neo-Classicism of which he was an exponent has been reappraised using the same modern aesthetic standards as have been employed in reassessing the Baroque.

As the years passed, and with the collapse of the Napoleonic Empire, which was undermined by successive defeats and society's shift toward quieter, more inward-looking and constructive aims, neo-Classical art entered its final phase, which can best be characterized by its anecdotal, bourgeois painting, whose sole purpose was to put contemporary life on to canvas with the highest possible input of technical expertise and a spirit of ingenuous enchantment. One example of this so-called "Biedermeier" style is the delightful *View of the Lustgarten, Berlin* by J. E. Hummel (1769–1852), with its austere-looking gentlemen, ladies and children out for a stroll and the plumed hussar whose attention has been captured by the large granite basin of the fountain, where the shining water reflects the clouds. Or the smiling meadow of *Children Playing* by the anglicized Swiss painter G. L. Agasse (1767–1849); this vision of serenity could well be seen as closing the neo-Classical period.

J. A. D. Ingres, La Grande Odalisque *(1814). Musée du Louvre, Paris. The work was exhibited at the 1819 Salon, and seems to evoke the painting by Titian inspired by the same subject, along the same lines as the statues with which*

Michelangelo decorated the tomb of Pope Julius II. In fact, Ingres wanted to become part of the purest neo-Classical tradition in portraits of women, together with Canova's Venus Victrix *and David's* Madame Récamier.

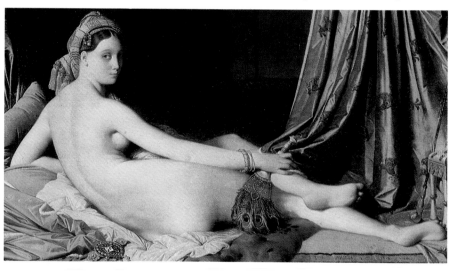

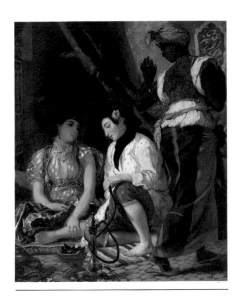

From Romanticism to Realism

The burden of Classicism and the birth of Romanticism

"For us, the only way to achieve greatness and to become if possible, unique, is by imitating the Ancients." This statement by the first true art historian (in the modern sense of the word), the German Johann Joachim Winckelmann (1717–68), found in his *Reflections on the Imitation of Greek Art* (1755), expresses, in the form of a declaration of intent, that stance which we know as neo-Classicism.

The "neo-Classical taste" can be seen as superseding the Rococo, which had mirrored the manners of eighteenth-century courts – ephemeral, theatrical, and sensuous. The speard of neo-Classical taste throughout Europe coincided with the appearance of archeological finds from the excavations at Fori, Herculaneum, Pompeii and Paestum.

To a new range of historical middle-class, civic, and republican themes – which were to be a determining factor in the outcome of the American and French revolutions, of the national uprisings in Greece, Italy, and Germany – corresponds a new stratum of society, looking for a figurative vocabulary as well as a philosophy, and a type of music and literature, which adequately represented the emerging philosophy of the new world order. The most informed artists copied and questioned the forms of the past, reviving them in well-thought-out works of great sobriety. In this way they aimed to achieve that degree of "noble simplicity" and "quiet grandeur" Winckelmann had recognized as the principal quality of Classical beauty. This constant dialogue

with the art of Antiquity continued throughout the last decade of the eighteenth century, during which the language of Jacques-Louis David and John Flaxman, Antonio Canova and Bertel Thorvaldsen found expression, as well as those architects who worked in the tense and enthusiastic climate of the French Revolution. As the nineteenth century begins, from a stylistic viewpoint, there is an artistic language characterized by formal stylization, compositional simplification, and a preference for graphic techniques and expanses of colour. Figurative representation is reduced to its essential elements as though in painting, as in architecture and sculpture, there was an attempt to revert to the generative spring of language, the womb, the very origins, an immersion in the past. It is this necessity for a dialogue with the past which, in different ways, profoundly marks the lives of artists working at the end of the eighteenth century and the beginning of the nineteenth. It is a recurring theme, which spans the experiences of a wide range of artists – southerners and northerners, poets and painters, whether neo-Classical or Romantic. It is precisely the forms these dialogues with the past take which enable us to retrace the origins of what we call "Romanticism."

Delacroix, The Women of Algiers (1834) oil on canvas, Musée du Louvre, Paris (detail).

Indeed, not all translated Winckelmann's invitation into practice by including Classical statues in their works, as does Anton Raphael Mengs in his *Parnassus* in the Villa Albani, or by modernizing the examples seen in Rome, as do David and Canova.

For many, confrontation with the art of Antiquity is both painful and frustrating. Winckelmann's words are a death knell, tolling for an age which cannot be brought back to life and for a degree of perfection never again to be realized. Even in Winkelmann's work, in the way in which he expounds the concept of imitation or in his intense descriptions of Greek works, one senses an evocative potential, a feeling of nostalgia (in the true sense of the word – that is, "pain of return") which imparts Romantic overtones to his relationship with Antiquity. The Classical ideal exists in a sublime dimension, difficult to fix by technical means but present in essence and open to emotional re-evocation. In other words, that process of psychologically introverted examination of models, subjects, and myths of the Classical age, which transformed the world of Antiquity into a past within, analyzed "through the typically Romantic channel of introspection" which "could lead to explorations of the lands of myth, and on to the mysterious archetypes of the deepest of our collective subjective" (Briganti), began with Winckelmann, the very father of neo-Classicism. It is on this psychological process, and on its various journeys – the search for authoritative forms in the past; consciousness of their irretrievability; projection of the self into Antiquity as an inheritance of myths and forms;

revelation to the artist of the potential of his own subconscious, also fuelled by these Classical sources; and lastly the surfacing of hidden aspects of the subconscious and of a new thematic repertory – that the stylistic and iconographic transformation of Romanticism takes place.

Let us take, as an example of this journey, a drawing by the naturalized British artist of Swiss origin, Johann Heinrich Füssli (or Henry Fuseli, 1741–1825), a transitional painter spanning the neo-Classical idiom and the subjective requirements emerging out of the *Sturm und Drang*, the movement which at the end of the eighteenth century, in German-speaking countries, had laid the foundations of Romantic sensibility, moving the focus of reflection to terms such as "nature," "genius," "conflict between the individual and society," "creative instinct." The drawing in question is entitled *The Artist Despairing before the Greatness of the Ruins of Antiquity* (1778–80). Fuseli had travelled to Rome, following in the footsteps of the many neo-Classical artists for whom the journey to Italy constituted a major part of their artistic foundation – direct contact with the models of Antiquity. But once confronted with these models, which in this drawing are the imposing fragments of the Colossus of Constantine in the Palazzo dei Conservatori on the Campidoglio, the artist fails to be positively inspired toward imitation and collapses in desperation over these remains, in the knowledge – not without irony – that he cannot compete with them in grandeur. His gaze, turned toward the past, does not focus on it but looks beyond, seeking other objects and other worlds to explore, most of which are to be found within himself. Thereupon the models of Antiquity are transformed into usable fragments, words belonging to one language amongst many, mysterious presences. This tendency, which indeed permeates right through to Giorgio de Chirico, can be seen in another drawing by Fuseli – *The Dioscuri of Montecavallo on a Stormy Sea* (1810–15) – in which the colossal statues of the Piazza del Quirinale are transported into an imaginary landscape, a stormy sea, an alarming and dreamlike projection of the landscapes of the psyche. The pressing need is therefore no longer that of the imitation of Antiquity but the expression of an inner self which flowers from beneath the surface of individual forms and subjects, aspiring to other forms and other subjects which reflect the vast range of sensations included within the scope of pleasure, beauty, and the sublime, of which the Romantic man feels himself capable and which the philosophy of the time investigates. The concept of the sublime, in particular, will play an important role. Its theory, expounded by Edmund Burke in around 1756, expresses the psychological condition in which one feels pleasure within a situation of terror, of distant danger, or horror, in the face of examples of grandeur in nature, or at the discovery of

abysses within oneself – the same pleasure of fear, of the thrill, which is at the root of the Gothic or "black" novel, the first example of which is *The Castle of Otranto* by Horace Walpole, written in 1764.

The shadowy regions glimpsed beyond the realms of reason consumed a large part of creative endeavour. As soon as the direct link between religous and aristocratic patronage and artists was broken, the latter began to represent the revelations of their internal quests, referring to that whole range of themes

Above: Henry Fuseli, The Artist Despairing before the Greatness of the Ruins of Antiquity (1778–80), pencil and ink on paper, Kunsthaus, Zurich. Fuseli puts a "psychological" interpretation on such ruins, giving us an example, amongst other things, of this tendency to place side by side figures of a different scale, a device he subsequently used in his illustrations to Shakespeare.

Right: Henry Fuseli, The Nightmare (1790–91) oil on canvas, Goethe Museum, Frankfurt-am-Main. This is a later version of the 1781 painting in the Institute of Arts in Detroit. Fuseli returned several times to the subject of the nightmare, bringing together Classical and Mannerist sources, varying the position of the woman or women and the monstrous presences around them.

which would lend themselves to this new "mythological work." Thus artists looked to the archaic world of Homer and Hesiod – not a "calm" and rational Greece, but rather the place in which man's primeval instincts find mythical form; to the books of the Old Testament; to the Middle Ages with its poems telling of the genealogy of the northern Gods and heroes – the *Edda*, the *Nibelungenlied*, the poems of Ossian (a collection of Gaelic poems, published, and indeed written, between 1760 and 1765 by the Scotsman James Macpherson, purporting to originate from the third century B.C.); to Dante; to the fantastic universes of Ariosto and of Tasso; to the poetry of Milton and Shakespeare; to fairytales, gathered together by Arnim and Brentano (*The Boy's Magic Horn*, 1806–08) and the Brothers Grimm, as proof of the expressive force of the popular imagination in its epic, poetic, and magical forms.

From a stylistic point of view there was a preference for the "sublime" Michelangelo and the work of the Mannerists; for the more dramatic aspects of seventeenth-century paintings, from El Greco to Rembrandt; for Flemish and Dutch landscape, Salvator Rosa and medieval art.

In tandem with this intensive research into the least rational and conscious aspects of man, the phenomena of sleep and dreams, madness and hypnosis, and with the emergence of a new discipline – psychology ("the experimental science of the soul"), there began to surface in paintings unusual subjects

William Blake, The Simoniac Pope (1824–27) watercolour. In the last years of his life, having illustrated with etchings scenes from the Bible, from Milton, from Young's Night Thoughts, and created both the texts and the illustrations to his own books – Songs of Innocence and Experience, The Marriage of Heaven and Hell, Jerusalem – Blake turned to the Divine Comedy, which from the early nineteenth century in pre-Romantic England had been the object of new translations and commentaries (Coleridge) and paintings (Fuseli). Blake was particularly attracted to the Inferno (Hell), by the episodes which required the greatest degree of vision and translation of Dante's text and, indeed, of figurative sources. These he forces and then transcends, stretching dimensions and using recurring compositional schemes based on the circle and the spiral, as is also evident in this illustration of the episode of Pope Nicholas III from Canto XIX.

such as the representation of the incubus – to which Fuseli dedicates various works, and in which he gives physical form to the etymological roots of the English translation of "incubus" – nightmare, or mare of the night.

With the eye of a voyeur, Fuseli, in his painting of 1781, shows us the fantastic animal which by night invades the sleeper's room, whilst his monstrous rider – the incubus, a creature half Gorgon, half Asiatic idol – waits in the darkness, pressing down on the breast of the Mannerist form of a sleeping woman. The representation of characters in their sleep was to be common throughout the nineteenth century, right up to the refined visions of the Pre-Raphaelite Edward Burne-Jones, who finds inspiration in The Sleeping Beauty (1894). Again, it is Fuseli who takes on the great literary myths of Western culture, dedicating a whole series of paintings and drawings to Shakespearean tragedies, drawing on them as storehouses of the archetypal modern passions, dramas of identity and power (Hamlet, Macbeth); and to the comedies, foremost among which was A Midsummer Night's Dream, which, with its many fantastic characters, allows plenty of scope for experiment-

ation with the potentialities of fantasy – the faculty which pre-Romantic philosophers had elevated in opposition to reason. The presence of a high degree of the visionary, of an inventive strength wedded to formal experimentation in which one catches echoes of Parmigianino and Giulio Romano, are visible in the illustrations to Paradise Lost, Milton's biblical epic, and the Nibelungenlied. In the schematic and surreal space in the drawing of Hagen and the River Maidens of the Danube (1802) the figures are heavy with mythical overtones and hidden meaning: the maidens are three, as are the Fates and the Furies, and on close inspection could indeed have a single body, like that of the ancient Hecate; finally, on the right, there is the image of an old, cloaked woman who corresponds to no protagonist in the Nibelungenlied but is a psychological projection – the incarnation of the active and mysterious presence of subjective creativity.

The Divine Comedy was another inexhaustible source of inspiration, not only for Fuseli but also for the visionary English draughtsman and poet William Blake (1757–1827), author of "prophetic" books illustrated in the manner of

medieval illuminations, but with a particular technique – that of hand-coloured relief etchings – learnt, according to Blake, during a vision. In Blake's drawings perspective, proportions, and spatial relationships are turned topsy-turvy to build a space with no foundation in reality but existing in the mind of the artist, who worked through a process not dissimilar to that of Piranesi in his Carceri (Prisons) – that is, "creative imagination," that force which, according to the poet William Wordsworth, is released by the creative and demiurge part of man. Blake's creations – men, animals, composite or metamorphic creatures, or giants – all seem to embody extremes of Mannerist anatomy, and certain expressive Gothic stylizations, to evoke a past much further removed than Classical times: an embryonic world, the epoch of cosmogony. On many occasions Blake, in his writings, insists upon the necessity of turning the activity of "seeing" toward one's inner self, thus expressing the dual nature of the eye – a mechanism able to reproduce reality, but also a window opened onto the depths of one's identity, on whose revelations one must draw in order to speak the language of pure and authentic art.

Romantic art is, in the end, this growing awareness of the artist as subject matter, the "individual" which Kant's philosophy had investigated in its capacity to test the strength and limitations of moral and cognitive faculties, to experience the relationships between reason, the intellect, and feeling. Kant had laid the foundations of the Romantic conception of art, defining organically the meaning of imagination, the sublime, genius, and – most importantly – shifting the emphasis from the external world, accessible only in its individual manifestations and never in its totality, to the world within man, who in turn projects outside himself his cognitive schemes and his transcendental aspirations. Schelling's work would soon afterward outline a system in which art would play a determining role, offering the possibility of a return along the path of creation, giving consciousness to that which in nature is unconscious matter or energy.

"Nature" is the other great protagonist in modern "myth-making." Just as Homeric or Dantesque figures were charged with psychic meanings, so nature became the reflection of conceptions of inner self and of the self's linguistic relationship with reality. Seen as the "opposite" to be confronted or in which is reflected one's spiritual state, as a "forest of symbols," or as naked matter, nature was to be transfigured and examined and would be the principal subject which would manifest the stylistic changes in nineteenth-century art, from the Romantics, through the Realists, up to and beyond the Impressionists.

The inner landscapes of Northern European artists

Having been relegated for centuries as a secondary and somehow lesser art form, in the first decades of the nineteenth century landscape painting becomes the opposite face of the discovery of the unconscious, of bringing the inner world to the surface in a representational form. Turner's vortices and waves of unnatural light, Constable's solid patches of colour or Friedrich's crystalline geometries resolutely move the accent onto the "I" and its means of expression, and the paintings represent the result of the dialectical conflict between the external world – as it meets our senses – and the complex of internal images from the world of our consciousness and psychic substrata. One need only glance through the pages of the diaries or reflections of these landscape artists to realize that once again the path they trod commenced with an awareness of their remoteness from Antiquity. The young German Philip Otto Runge (1777–1810), having attempted to paint subjects from Greek epics, dissatisfied with the result, declared: "We are no longer Greeks How can we possibly even contemplate the recovery of the art of Antiquity? ... It is not rather in this new art form – that of landscape painting – that it might be possible for us to reach a higher level?" On this dramatic awareness is founded the Romantic concept of nature, a field in which there was nothing to fear from comparison with a Greek paragon, which had left but few and marginal examples of landscape painting.

Nor should it be forgotten that in the greater part of Northern Europe, from the sixteenth century on, the Protestant spirit had led artists away from the representation of the human figure, favouring a confrontation with natural forms – the repositories of divine creative energy. In addition, during the middle of the eighteenth century there had been a revaluation of nature in all its aspects. As a mirror of sensibility and a place of aesthetic enjoyment, nature had become an object of reflection for painters and poets, musicians and philosophers, scientists and experts in the art of gardening.

Artists' reflections on nature soon took the form of a stand against traditional artistic language. Classical allegory, the conventions of the view-painters, a whole series of representational customs make way, in the works of Friedrich and Turner, to experimental compositions, to the representation of unusual spaces which reflect the Romantic tendency toward the infinite, the distant, the remote, the unknown, toward colours which belong not to reality but to the hallucinatory visions of the artist.

The mythic memory of Antiquity with which Piranesi, Fuseli, and Blake were constantly battling was reduced in the work of the Romantic landscape artists to complete

Left: Caspar David Friedrich, Wayfarer in a Sea of Fog (1818) oil on canvas, Kunsthalle, Hamburg. As in the Great Reserve, here we also find diagonals of cloud and lines in the landscape which meet and clash with one another at the vanishing point, while the figure, seen from behind, "stands out as the meeting point of rays issuing from beyond, the focal point of an inverted system of perspective" (Briganti).

Below: Runge, Night, (1803) pen and ink, Kunsthalle, Hamburg. The drawing forms part of the cycle of The Times of Day, a system of images representing parts of the day and their symbolic significance, for which Runge had imagined a poetic commentary by Tieck and a possible musical accompaniment by Ludwig Berger, which would have emphasized the synesthetic character of a poetry seeking the hidden rhythm and substance or artistic language.

nonexistence, as though introduced at the vanishing point merely to disappear in the vortex of the elements. The position which for

so many centuries had been occupied by the figures of Antiquity was now the patrimony of the artist's own consciousness; he, in his search for formal expression, selected from nature those particularities of atmosphere and conditions which reflected most closely his inner state. In this sense one could contend that nature seen Romantically – that is, that intermediate substance resulting from the meeting of the cosmos and man – embodies the mythical desire of the modern era just as Friedrich Schlegel had written in 1799, inviting the "modern," and therefore "Romantic," artists to create from nature, through the depths of the spirit, a new and contemporary mythical universe.

The first to practice this was Runge, who conceived his first major work, The Times of Day, as a system of correspondences between a central symbolic image (Morning, Midday, Evening, Night) and plants, flowers, the elements of the landscape; these were linked by a hidden and mysterious series of relationships rooted in religious mystic experiences, in the popular traditions of the north, but mostly in the work of the artist who links them together in his efforts to grasp, through intuition and analogy, Schlegel's unity of the universe. The figures of the children and flowers are positioned like notes on a stave, and the whole drawing should be read as a message for the initiated to the religion of

nature and art. Indeed, that is precisely what the poets, musicians, and philosophers were, exchanging their experiences between Dresden, Hamburg and Copenhagen, in the consciousness that the expressions of art are isolated moments in a single universal tongue. This language they tried to evoke by mounting exhibitions of paintings with musical accompaniments and poetry readings, somehow an embryonic form of the *Gesamtkunstwerk* (fusion of art forms), taking great pains over the precise images, the mathematical and musical harmonies, and the colour symbolism.

In the work of Caspar David Friedrich (1774–1840) this new concept is embodied in painting of the highest, purest form. In his rarefied and essential imagery the physiognomy of the landscape loses any realistic or topographic accent, without detracting from its impact. Nature has become the reflection in the memory of the artist's interior eye; its elements have been stripped of all points of reference, to be transformed into archetypes of our perception of nature. The silhouettes of the mountains, the pines, the sailing ships and the rocks are all archetypal, as is the line of the horizon beyond the back view of the figure which appears so frequently in his paintings.

This figure, which occupies the central space in *Wayfarer in the Sea of Fog* (1818), is both the symbol and the protagonist of the Romantic experience of nature: immersed in an infinite and unknowable world, he assimilates appearances through his senses, leaving the imagination to project onto them its anguished desire for wholeness, for transcendence, for the infinite. In *Monk on the Seashore* (1808–10) one can observe a disconcerting use of the line of the horizon, which in painting conventionally limits the space the eye travels through from foreground to background. But in Friedrich, the intermediate zone between the foreground and the line which marks the furthest point we can see tends to disappear. Once this zone has been abolished, the eye's entry into the depths of the painting is cut short and it returns to the foreground, although it perceives an immense expanse of sky and sea. That is to say, Friedrich does not give the illusion of depth through perspective but succeeds rather in translating the experience of "looking into the distance." The sublime contrast between the finite and the infinite is not reproduced technically but suggested, almost imposed on the onlooker so that – as the poet Heinrich von Kleist, the first to admire this painting, understood – one does not feel attracted by the pleasing nature of the painting but suffers attempting to overcome this obstacle, looking

to find within oneself the fulfilment of the image, the inner equivalent of that experience.

Rarefied and sublimated atmospheres in which objects are heavy with meaning, amplifying their evocative and symbolic power; the recurrence of abstract geometrical compositional schemes and of cold colours; the repeated mysterious occurrence of rainbows and ancestral dolmens – Friedrich also shows himself to be searching for the origin of consciousness, for the principle underlying the distinction between the "I" and the world, which still carries within it traces of the ancient unity (as could be seen in the science and philosophy of the Romantics) and the wounds of separation (as shown by the yearning for wholeness in music, poetry and painting). Friedrich's efforts toward a figurative representation of the spiritual were to be adopted in the twentieth century by Kandinsky, but a group of contemporary painters also inherited his approach: some insisting on the symbolic aspects of landscape, others developing the examination of the exchanges between the soul and nature in a direction which, during the course of the century, would become loaded with evident empirical and realistic values, in particular the works of Johann Christian Dahl (1788–1857) and Carl Gustav Carus (1789–1869).

Friedrich appears to have been as con-

J. M. W. Turner, Rain, Steam, Speed – The Great Western Railway *(1844) oil on canvas, National Gallery, London. This painting, exhibited at the Royal Academy in 1844, bears witness to the inexorable erosion of Turner's images, which – especially after his last stay in Venice (1840) – lose any relation to objects as found in nature in favour of their luminous appearance. Thus he achieved that identification of space with light which he had felt intuitively, tested, and realized empirically during the length of his working life: in the thousands of drawings and watercolours, in his lessons on perspective held at the Royal Academy, and in his oil paintings, which have laid the foundations for the modern way of seeing "through large masses of light and shade."*

Left: Thomas Cole, The Hunt. Moonlight and Night Fires (c. 1828) Thyssen-Bornemisza Collection, Lugano. Not far removed, through its choice of a mountain setting and its light effects, from certain images of John Martin, this painting embodies the spirit of American landscape painting, permeated by Ralph Waldo Emerson's "transcendentalism," by a pantheistic naturalism and by echoes of the apocalyptic sections of the Scriptures.

Below: Constable, Stonehenge, (1836) watercolour, Victoria and Albert Museum, London. In July 1820 the artist visited Stonehenge, setting down the outlines of the monoliths in a drawing which, after many years, he transposed into this watercolour, in which the sky dominates the prehistoric group of stones.

trolled and careful of his own creative vein as Joseph Mallard William Turner (1775–1851) appears to have been impetuous and generous. His works, which Benjamin West charged with being incorrect and formless blots, were heralded by the critic John Ruskin as the first expression of an exquisitely modern sensibility nurtured by a literary culture, by technical and alchemical knowledge, by journeys to Italy, with the ability to transfigure all this into an extraordinary language which was to be a prelude, in certain ways, to Impressionism and in other ways to the informal (Arcangeli). Turner trained as a topographer and view-painter, then studied the landscapes of Claude Lorrain, Wilson, and Cozens, and the *Theory of Colours* by Goethe. On his numerous journeys through Europe he studied from life, and even his earliest works were characterized by their intensity and a determination to capture the "broad dimension" of the universe. He used new techniques and formats with the greatest skill and innovative spirit. He drew from the myths, histories, and poetry of Antiquity, but also took subject matter from Byron (*Childe Harold*). In Turner we also find a process analogous to that seen in the artists considered up to this point: the past exists as inner experience, but the focus shifts from the central theme to the artist painting it – to his own intellectual spaces, the limits of his own perception; the images lose many of their naturalistic connotations and are dissolved in the appearance of light. The story being recounted – whether idyllic, apocalyptic or titanic – no longer occupied the foreground but is lost in an extended view of nature: at times clear and recognizable, at others dark and represented only by juxtaposition of large formless masses of colour. In *Snowstorm: Hannibal Crossing the Alps* (1812) Turner's subject is barely decipherable on a canvas

Left: Goya, Fantastic Vision (1820–21) oil on canvas, Museo del Prado, Madrid. This painting, which is also known as Toward the Sabbath, is part of the cycle of "black paintings" of the Quinta del Sordo, and has been interpreted as the flight of a witch, carrying behind her a terrified man; but Bronislaw Baczko sees in it a utopian journey toward a never-to-be-reached city, cut short by shots fired by the armed men from beneath, on the earth from which the figures are fleeing.

Left: Goya, The Sleep of Reason Spawns Monsters (1797–99, etching and aquatint from the series Los Caprichcos, Museo del Prado, Madrid. One of the best-known of Goya's caprichos in which we can see the reaffirmation of Enlightenment values which formed the artist, who chose his subjects from the "multitude of extravagances and follies" of the society or his times.

Right: Goya, Majas at the Balcony (1805–12) Metropolitan Museum of Art, New York. This painting is possibly one of a series on similar subjects; it reflects Goya's powers as a painter of portraits and interpreter of human relationships and confirms his predilection for high contrasts between light and shade.

entirely occupied by layers of evocative colour. During the first two decades of the century Turner's painting moved progressively away from the confines of the concept of verisimilitude, rendering both colour and form in an audacious and arbitrary fashion.

The dissolution of traditional space, the analysis of the luminous value of objects, the elaboration of a new perspective founded on rhythms of light reach their highest point in Rain, Steam, Speed (1844), where, amidst squalls of colour, one perceives the uncertain outline of a train which, for Argan, is "the ultimate, up-to-date representation of the

mythical protagonists of Classical land-scapes." Storms, rugged crags, deluges and apocalypses are found also in the works of another Englishman, John Martin (1789–1854). In his visionary landscapes it is possible to make out the unconscious suggestion of the industrial architecture which was transforming the face of London and of England (Kligender/Castelnuovo). We find a visionary but also grandiosely realistic conception of the sublime landscape in the work of the Anglo-American Thomas Cole (1801–48), painter of views of the Hudson Bay and of symbolic landscapes marked by their reflection on the passage of time, which dissolves the human generations into nature, as in *The Cup of the Titan* (1833).

John Constable (1776–1837) could also be described as a Romantic Naturalist. Closer by inclination to the poetry of the picturesque, to a varied and pleasing reproduction of landscape, Constable soon concentrated his energies on the morphological aspects of nature, on the definition of atmosphere, looking to record the varying emotions expressed in the changing times of day, or the appeal of the lines of the landscape, with the strongest resolve to pierce the surface of things, to capture the specific, the material reality of what we see. His brushstrokes alter according to his subject – the trunk of an old tree, hay in a bundle, the flaking whitewash of a country dwelling, the clouds, dense or straggling. The onlooker sees, and at the same time feels, the density, roughness, thickness – the physical entity of things. His contributions to the Paris Salon of 1824, *The Haywain* and the *View on the Stour*, were to have a certain influence on the twenty-six-year-old Delacroix, establishing a seed in France which would later be cultivated by the landscape painters of the Barbizon School. Although he does not impose upon nature's territories projections of his own inner landscapes, and although he registers fleeting phenomena such as cloud formations, Constable does at times force chromatic effects, as for example in 1836, where he allows the emotion which intially attracted him to the subject to suffuse a Romantic and "Turnerian" view of Stonehenge, that arcane sanctuary which recalls those ancient links between man and the forces of nature.

Individuals, peoples and the drama of history

During the years which saw the unfolding of Romantic art, Europe was undergoing a political and social upheaval which was to be decisive for the development of nineteenth-century history: the course of the French Revolution, which ended with the Napoleonic adventure and then in 1815 the Restoration, the war between the Greeks and the Turks, the Nationalist movements in what were to become Italy and Germany, the first manifes-

tations of modern class-consciousness. There was a pendulum swing from progressive outbreak to reactionary movement and back; this naturally affected artists, who tended to adopt a stance and then had to pay personally for the changes in political climate, perceiving as they did in the contrasts of history a reflection of the constant conflict between opposing energies and forces, fighting to affirm their identity.

In Mediterranean countries like France, Italy, and Spain, these forces were not represented in the same way as in the north – that is, by nature and by silent spectators of her landscapes – but instead adopted the more concrete forms of men and women, executions, battles, unbridled passions. The Spaniard Francisco Goya y Lucientes (1764–1828) covered the length of the road leading from the world of the Rococo to the collapse of the Napoleonic dream; from that faith in reason characteristic of the Age of Enlightenment to the consciousness of negative and irrational forces which act upon single men and whole peoples and which in the end are part of nature herself, giving life to creatures only subsequently to destroy them and advocating self-preservation whatever the horrific cost, as Goya demonstrated in the harrowing *Saturn Devouring One of His Children* (1820–23).

This is a work belonging to the so-called "black period" during which the artist, deaf and alone, had retired to his country property, the *Quinta del Sordo* (House of the Deaf Man), leaving on its walls expressions of his fears, of that which he saw beneath the surface: the degeneration of Christian rites into superstition and of pagan ones into witchcraft; the alarming appearance of men when madness has overtaken them and they have lost their customary features and their unique identity, becoming a uniform and indistinguishable part of a formless mass; the demonic aspects emanating from the female form; and finally the shadows thrown by the Michelangelesque colossi which loom over the earth and over the untidy masses of humanity, ignorant of their fate. In earlier years Goya had been the official painter to the king, a famous portraitist, designer of tapestries, etcher and lithographer. He had painted *The Family of Charles IV* (1800) with an irony worthy of Voltaire and with a sense of composition and colour which derived from Velásquez and Tiepolo; but what most caught his interest were the habits of daily life: the squares and courtyards where people gossip and chatter; the bullfights, to which he dedicated the *Tauromachia*, irresistibly drawn to this archaic conflict between man and beast, as later were Picasso and Hemingway; and lastly eroticism, the games of seduction and courtship described in surreal and dark tonality which anticipated the atmosphere of Buñuel's films. In a similar fashion to his countryman Buñuel, beneath the surface of these types of behaviour Goya had seen the ferment of irrational impulses, the ghostly forms of the unconscious, which rise to the

surface in the engravings of the *Caprichos* (1799) and the *Disparates* (1819) in the form of owls, bats, lynxes, witless grimaces and gestures, half-human creatures. If Fuseli's basic suggestion had been that the shadowy regions and the inhabitants of our sleep are part of us, at times more inviting than the light of day, Goya, in the famous *capricho The Sleep of Reason Spawns Monsters*, invites us not to lose our frail control of reason; indeed, only if the two coexist will it be true that "imagination is the mother of the arts." In 1808 his sympathies for the liberal ideas of the French vanished in the wake of the brutal invasion by Napoleon's troops. The Spanish fought back, and in 1814 Goya commemorated the death of his compatriots in *The Execution of 3 May*. Iconographically, the painting follows the model of the Crucifixion (Rosenblum); stylistically, it emphasizes the weight of Goya's contribution to the evolution of nineteenth-century pictorial language. In the absence of precise outline the forms are not drawn but rather suggested, implied; we decipher the details – the eyes, the clothes – out of the mesh of brushwork, which is used not to describe figures but simply as a means of expression for the artist. Goya is the explorer of the lands of magic and sleep, of the collective delirium, of the "incubus full of mysteries," as Baudelaire calls it. But he is also the author of a kind of painting made up primarily of coloured matter which – especially in his last years in exile in Bordeaux (1824–28) – concentrates on the relationships between areas of colour, the brightness of hues, atmospheric reflections, leaving behind him in France an inheritance which was to affect, above all, Edouard Manet.

In France, the stance which we have so far recognized as Romantic is embodied in the works of Théodore Géricault (1791–1824) and Eugène Delacroix (1791–1863). Both lived in the climate of the exhilarating Napoleonic experience, the intensity of which we can understand by reading Stendhal or the first few pages of *Confessions of a Child of his Time* by Alfred de Musset: "Just as, with the approaching storm there blows a terrible wind in the forest followed by the deepest silence, so Napoleon had shaken all things to their foundations as he passed over the world." The defeat of this force of nature and of the spirit left France in a state of profound disorientation, having lost all bearings and meaning, which de Musset calls *le mal du siècle* (the malaise of the times). The two great illusory renaissances – the Revolution and the Empire – had vanished, putting into motion mechanisms which were erratic in their attempts to propel the history of France. They unleashed unstoppable social and psychological energies which, paradoxically, sought space and order.

So indeed did Géricault in his paintings. Like a man dying of thirst, he drew his subjects from the crudest parts of reality, visiting

gestures. In *The Raft of the Medusa* (1819), his use of nude and half-clothed figures is evidence of the Classical framework which Géricault attempted to superimpose on the violent subject matter of his paintings and of his inspiration. Overwhelmingly attracted by the clashes between individuals, he investigated their various forms in journeys which in England (where he exhibited *The Raft*) led him to observe the human debris of industrial London, then to plan a huge composition on the theme of the black slave trade, and lastly, in his final years in Paris, to paint the series of lunatics, under the influence of the research carried out by the psychiatrist Étienne Georget. Géricault focused, with new and lucid insight, on that quality of madness exuded by Goya's mass scenes and visible in the haunted looks of some of Fuseli's figures. The heroic tone of his work, which lent his subject matter, however brutal, an epic dimension, gave way to the depiction of the "reality" of things. The artist no longer trascended his subject matter; he no longer gave imaginary shape to forms of madness but allowed the disturbed inner worlds of these sick people to permeate through the very flesh of their faces – precisely what we see when we "clinically" observe the world.

Across the vast output of Géricault's pupil, Eugène Delacroix, we can follow the train of Romantic myths as they took shape in France between the attempted *coup d'état* of Charles X, provoking the rising of 1830, the monarchy of Louis Philippe, the 1848 Revolution (about which the artist was not enthusiastic), and the Second Empire of Napoleon III. Delacroix made his debut in the Salon of 1822 with *Dante and Virgil Crossing the Styx*, a variation on the theme of *The Raft of the Medusa*, passed through the screen of literary inheritance, which the artist always felt should play an important role in the figurative process; referring now to Dante and Shakespeare, now to Byron or Sir Walter Scott. Until 1830 he confined himself to historical subjects, choosing episodes from contemporary conflicts. The war between the Greeks and the Turks, which had inflamed the spirits of European intellectuals, united them in a philhellenic movement which involved Victor Hugo and Byron (who was to die in 1824 in Greece) and provided the inspiration for the *Massacre at Chios* and *Greece, on the Ruins of Missolonghi*. These are images which announce the forsaking of draughtsmanship for a highly physical use of colour for composition and are dominated by an overall idealizing tone, overturned in moments of supreme realism in certain details: the objects in the foreground, the garments and the faces of the figures, which also reveal a strong attraction toward the exotic (this would become a constant element in French painterly sensibility, from Gauguin to Matisse). They are also ambiguous images subject to pressure in two directions: toward the ideals of liberty, passion, and death – which is a deter-

slaughterhouses, morgues, asylums, delving into the morbid events reported in newspapers, observing the devastating corporeal strength of wild animals. These themes would be reconstituted into paintings which reveal a strong compositional order, whether based on Michelangelo or Caravaggio, Titian or Rubens. He paints a blacksmith's sign as though it were the celebration of a hero and his steed; the men restraining, with great difficulty, a bull at market and those taming a wild horse are statuesque in form and make Raphaelesque

Géricault, Madwoman, Obsessed with Envy (1822–23) oil on canvas, Musée des Beaux-Arts, Lyons. After his stay in London – a city which in 1868 was to inspire the great engraver Gustave Doré with images in which the details of reality are somehow darkly transfigured by the imagination – Géricault (like Goya) investigated the faces of

folly, leaving behind alarming visual documents of that phenomenon whose history another Frenchman, Michel Foucault, has traced in our century.

mining factor for the composition – and toward the reality of the objects embodied in these ideals. The same is true in *Liberty Leading the People* (1830); in fact the barricade and the gun-toting Parisians are dominated by the female figure of Liberty bearing a flag, which is, one might say, an apparition in the flesh. It is a kind of allegorical personification inserted

his return to France he transformed these sketches into paintings such as *The Women of Algiers* (1834), rich in tactile and aromatic details which were to impress both Baudelaire and Renoir; *The Fanatics of Tangiers* (1837–38), a scene of collective passion, of religious folly; and impressive still lifes and scenes of fighting wild animals. During this period he

sources of artistic language, which took them back stylistically to the paintings of fifteenth-century Italy and to Dürer and led them to inhabit an artificial "Romantic" period of consciousness, populated with biblical characters, medieval heroes, the offspring of poetic fantasy.

Beyond this contemplation of medieval his-

Left: Delacroix, Dante and Virgil Crossing the Styx *(1822) oil on canvas, Musée du Louvre, Paris.*

Opposite above: Delacroix, The Massacre at Chios *(1824) oil on canvas, Musée du Louvre, Paris. Just as Géricault had found inspiration in an item of contemporary news for the* Raft of the Medusa, *so Delacroix, for this painting, consulted documents and survivors of the slaughter at Chios.*

Opposite below: J. Schnorr von Carolsfeld, Angelica and Medoro *(1822–27) fresco, Casino Massimo, Rome. The decoration of the Villa of Prince Massimo near the Lateran, the last of the Nazarenes' collective enterprises, pays homage to the poetic triad of Dante, Ariosto, and Tasso.*

into a painting which is in many ways a Realist painting, an allegory which is made real whilst reality itself is made sublime, so that the overall effect is, once again, the result of this double tension – between the stylistic and the ideological. Moreover, the movement which we call Realism is not something which suddenly emerged in the middle of the nineteenth century but is an attitude which was born "from the rib" of Romantic art, which focused on the outer shell of the conflict between the artist and the external world, never forgetting that the choice must in itself be subjective.

Delacroix's journey to Morocco in 1832 physically allowed him to reach that exotic world of which he had sung as a faraway land and which he had read about and imagined in Byron's *Sardanapalus*. In North Africa Delacroix filled notebooks full of sketches of wild Arab horses, odalisques and sultans and intensified the warm colours of his palette. On

was following in the steps of the creative force of nature, which is revealed, according to his own writings, in drawings in the sand as much as in the tiger's stripes, through the creative power of colour – no longer seen and used as a means, an instrument, but as the creative unity of pictorial language, dense with emotion and light.

Reflection on history, understood not as a present-day drama but as an abstract reflection of an ideal of art and life, is present, in the first decades of the nineteenth century, in the works of other artists. The Nazarenes, a group of German-speaking painters who gathered together in Vienna in 1808 in the Confraternity of Saint Luke and were active in Rome from 1810, depicted other aspects of the Romantic universe: the refutation of academic teaching in favour of a personal and pure artistic ideal; the precedence of emotion as a source of inspiration; the search for uncontaminated

tory, beyond the glow of religious spirituality and the proposition of a cold and formal style, the Nazarenes represented the sense of unease felt by the young nineteenth-century artist, who – having severed his links with Classical models and no longer having an organic bond with society – was simply seeking the right road to follow, with all the trials, eventual defeats, and choices this implied. At this point, either he joined with others in a kind of covenant of the initiated in the name of an elective affinity, or he found himself in the cold and loneliness of his attic, as did the painter from Faenza Tommaso Minardi (1787–1871) in his *Self-portrait* (1813). He was in contact with the Nazarenes and is one of the Italian representatives of the Romantic ethos. Another is the Venetian artist Francesco Hayez (1791–1882). In a language strongly influenced by the drawings of Ingres and by theatrical compositions, Hayez gives expression to a world of

grew and its representation acquired meaning through contact with the individual personality of the artist. This was a general movement in the figurative arts and in science throughout Europe and America, which spread a positivistic spirit of observation into literature – one need only look at the objective language of the Goncourt brothers, at the coincidence of character and author proclaimed by Flaubert, and at the affirmation of the physical presence of the "self" in Walt Whitman's poetry.

Once again the sphere of mythical and religious subjects, of allegorical compositions, is pushed away from the horizons of art, so that what one sees and the manner in which this is translated into forms is the repository not only of one's self but of that principle of truth which is not understood as an objective absolute but comes to fruition and is refined in the meeting of language and experience. Thus the French artist Jean-Baptiste-Camille Corot (1796–1875), active for many years in Italy, was moved by a Romantic sensibility to nature, not loading it with cosmic symbolism but transforming it into an investigation, an attentive record of variations of the psyche and the retina, which corresponded in his painting to variations in light and form. He was not a painter of sublime landscapes, nor a *vedutista* (view-painter) belonging to the eighteenth-century tradition, but an artist who transposed a portion of nature, casually, as it fell before his eyes. All the elements within the composition – the Colosseum juxtaposed to the hovel, or Chartres Cathedral depicted behind a mound of earth – have the same pictorial value and are reproduced on the canvas as they are seen by the eye (Volpi), as objects which exist

mildly Romantic subjects – in the various versions of the *Sicilian Vespers*, in the portraits of Manzoni, Cavour, and D'Azeglio, all of whom were linked to the difficult birth of the Italian spirit of patriotism.

The language of reality

The Romantic affirmation of the artist himself as subject matter had opened up to painting the inner world of the imagination and of individual mythology and symbolism. This exploration of new territories, hidden behind the veil of traditional representation, had not only produced the turbulent visions of Turner or the physical metamorphoses of Goya but had often also taken place through an immersion in reality, which had brought to the fore the disconcertingly physical presence of objects, whether the decapitated heads of Géricault, the flesh of Goya's *majas*, Constable's trees, or

Delacroix's tigers.

So elements of Realism had already flourished in the wake of Romantic experience, whilst during the first half of the century cultural and scientific reflection had focused more and more intently upon reality, on that world of phenomena which occurs before man's eyes; no longer seeking, as did Novalis and Runge, to join in a mystic unity with the spirit of the cosmos but, having taken stock of man's separation, using this very thing as a positive means of knowledge. The yearning for the synthesis of nature and the "self" or for the creation of new forms which would express the "discovery" of the unconscious became weaker as it was realized that the artist himself was the focal point of artistic experiences: that it was his schemes of perception, his psychological make-up and his means of expression which were the true parameters of worth and truth in modern art. Thus between 1830 and 1848 the desire to capture the world around us

in literature, furniture and painting – of a bourgeois realism called *Biedermeier*.

The artistic processes which recur in a vast range of painting from this period – a reduction in the size of the image, the choice of casual or partial views, the importance of natural light – reveal the fact that the original Romantic experience had by now been transformed into an objective experience based on direct observation, on the oil sketch from life, in which the subject emerges – positivistically – as a psychological entity. This is true of the

in that they are part of a visual experience. Corot's pre-photographic and pre-Impressionist eye reproduced *his* truth, veined with intimacy and seeking harmony, and altered reality without violence, unifying the chromatic tonality, simplifying some of the forms, loading the act of seeing with the presence of memory, which, in a Proustian manner, remained entangled in objects and was awakened by a street corner, a stretch of countryside, the steeple of a church tower.

The interest in the intimate and private dimension of existence is a part of post-Napoleonic Europe, the sign of a turn in the tide away from great ideals toward a more lowly vision, which in Germany took the form –

Above left: Rousseau, Storm Effect on the Plain of Montmartre (c. 1850) oil on canvas, Musée du Louvre, Paris. By the middle of the century, in a geographical arc which spans the America of Asher B. Durand and G. C. Bingham, the Denmark of Christen Købke, the Italy of Palizzi and the France of Rousseau and Jules Dupré, we see the affirmation of those principles (an empirical approach, the habit of en plein air painting, the interest in casual events) which will form part of the artistic language of the second half of the nineteenth century, first Realist and then Impressionist.

Above: T. Minardi, Self-portrait in the Attic (1813) Uffizi, Florence.

Left: J. B. C. Corot, The Colosseum from the Farnese Gardens (1826) Musée du Louvre, Paris.

Left: H. Daumier, The Third-class Compartment (c. 1862) oil on canvas, National Gallery of Canada, Ottawa. The characteristic handling of Daumier, which stands out in both his graphic works and his polychrome caricature sculptures, is concentrated here into an image of poverty, whose subject matter attracted a heterogeneous group of artists from Charles de Groux to Jean-Pierre Alexandre Antigua to George Frederick Watts, as well, of course, as Courbet and Millet.

Below: G. Courbet, Young Ladies on the Banks of the Seine (1857) oil on canvas, Musée du Petit Palais, Paris.

American artists of the Hudson School, of Carl Blechen (1798–1840), Ferdinand Georg Waldmüller (1793–1865) and Adolph van Menzel (1815–1905) and of the Frenchmen who left Paris to paint their sensations to nature at Barbizon, in the Forest of Fontaine-bleau. The latter, amongst whom should be noted Pierre-Étienne-Théodore Rousseau (1812–67) and Charles-François Daubigny (1817–78), once in contact with nature, slowly alter the fabric of their painting, using small rapid brushstrokes which are in some way a prelude to Impressionist techniques and are closer to the way we perceive the world around us.

Realism is precisely this refinement of the tools of one's trade as an artist – not to try to capture an inner truth contained within reality but to express with ever greater meaning the ways in which we perceive the world; these in their turn alter, moving beyond the results achieved by the artist.

Moreover, transformation was the order of the day in mid nineteenth-century Europe. The structures of society and of production were changing. The masses who had so terrified Goya and Edgar Allan Poe were beginning – to quote Walter Benjamin – to organize themselves into a public, aspiring to a role of patronage, whose desire was to become part of the contemporary novel, like the donors in medieval painting. It was this unconscious and wholesale patronage which changed European cities into the "capitals of the nineteenth century" and filled them with its own particular ambience – cafés, boulevards, galleries: these would be the centers for the circulation of new ideas, the new social protagonists, the background against which the clashes of the 1848

Revolution and the 1871 Commune would occur.

The works of Honoré Daumier (1808–79), engraver, lithographer, sculptor, and collaborator in satirical newspapers such as La caricature and Le charivari, contained the iconography of modern times. He observed

nocturnal streets, theaters, circuses, promenaders, shop windows and fairs, people sitting in their local cafés gambling with ferocious concentration – people in whom Baudelaire saw the epic dimension of the contemporary epoch, people who would strike Cézanne and Van Gogh with equal power.

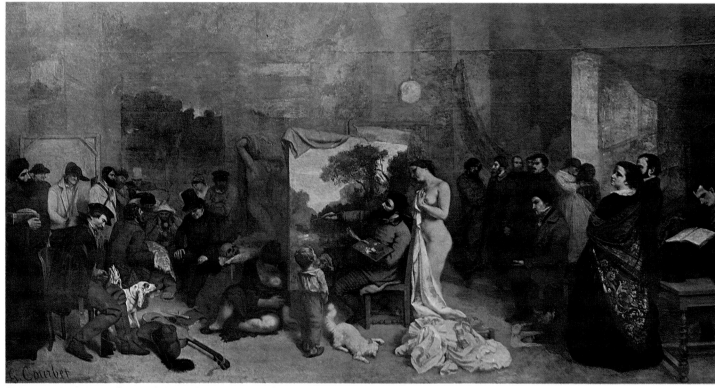

Side by side with the forms of theater-land Daumier represented images of class warfare, bearing witness to repressions and massacres, ridiculing judges and politicians, ministers and rulers. But Daumier also captured the double face of the modern mob, and if in *Third-class Carriage* he shows the dreary lot of this new third estate, in *Nous voulons Barrabas* (We Want Barrabas [*c.* 1850]) he denounces, as did Goya, the tendency of the mob to irrational hysteria. Stylistically, Daumier, who is mainly a graphic artist, makes an efficacious use of colour which tends toward the monochrome, a swift and synthetic stroke to abbreviate forms, which he then exaggerates in ways which were to become typical of Expressionism.

If Daumier leaves us with his reporter's notebook on the spectacle of modern society, Gustave Courbet (1819–77) encapsulated that same reality, with all its tensions, in a loftier and much more self-conscious art form. He was a committed artist, well acquainted with the current socialist anarchic ideas of Fourier and Proudhon (who in 1865, taking Courbet's art as his model, wrote *Du principe de l'art et de sa destination sociale* [On the Principle of Art and Its Social Purpose] and retained his convictions throughout his life, paying dearly for them with exile in his final years to Switzerland). Courbet's painting is based on the study of Rembrandt, Hals, Van Dyck, and Velásquez, from whom he learned his sense of colour and light and the almost physical presence of his figures; as well as on the repertoire of popular iconography, seen in collections

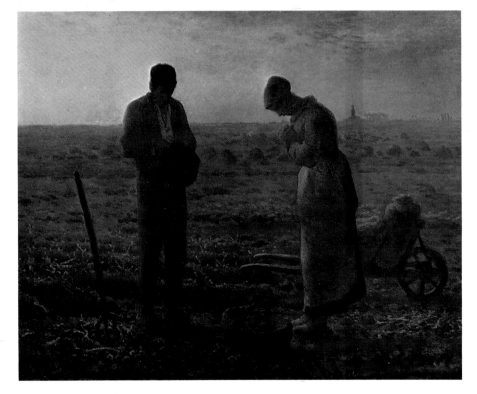

Left: J. F. Millet, The Angelus (1858–59) oil on canvas, Musée d'Orsay, Paris. Millet, who had begun his career as a portrait painter of the middle classes, slowly turned toward landscape painting, aligning himself with the Barbizon School and then focusing on the figures of the peasants, whose characteristic outlines may be seen in Van Gogh, who copied them exactly, and even – transposed into other subject matter – in Denis.

of wood engravings, which attracted him for their sharpness of effect, their simplicity of composition, and their revelation of a "primitive" world of expression far removed from academic sophistries and based solely on reality. With his talent and sensibility, Courbet belongs to the lineage of great dramatic painters which begins with Rembrandt in his earliest works and especially in his self-portraits of the 1640s, which reveal a proud awareness of his ability to breathe life into inert matter. Since what interested Courbet, as he wrote, was "a completely physical language, which has as its words all visible objects," he avoids any intrusion of the imagination in order to reconstruct his own parallel reality, choosing those subjects which were in opposition to habitual ones, representing instead that popular world which formed the center of his political utopia. Thus, looking from the world of labour (as Géricault had already begun to do before him) to the environment of the provinces and to daily life, Courbet depicted the epic of "low"

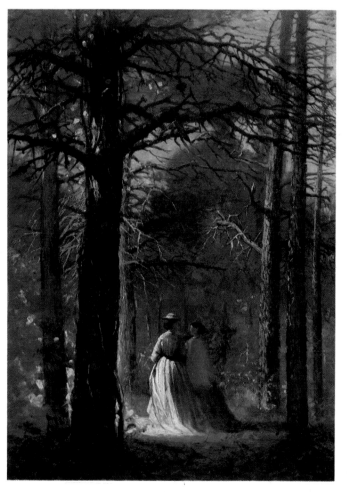

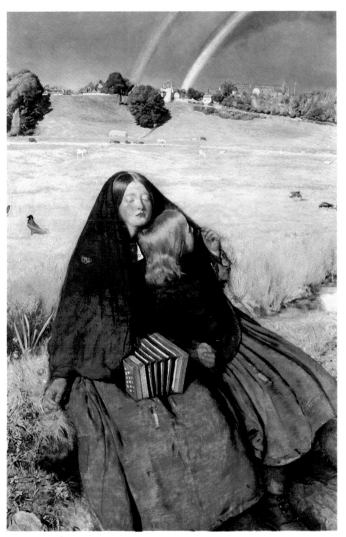

life. The stonecutters he met along the road wholly occupy the foreground of the vast canvas of 1849 (now destroyed), while his grandfather's funeral at Ornans is celebrated in a broad composition with echoes not only of popular obituary notices but also of the bas-reliefs of Greek sarcophagi; it depicts an entire section of French provincial society, from clerics to women, with the dignity and emphasis associated with historical painting. Thus, one hears echoes of *fêtes champêtres* in *Les Demoiselles des bords de la Seine* (Young Ladies on the Banks of the Seine [1857]), in which the two country girls and their physical torpor – which Cartier-Bresson would have liked – adopted the pose of Classical figures.

Rejected at the Universal Exhibition of 1855, Courbet was responsible for gathering together the "Pavilion of Realism," in which he exhibited the *Funeral at Ornans* and *The Artist's Studio,* a complex painting which depicts – on the left – the real-life figures to be portrayed in the painting, and – on the right – the group of friends, amongst them Proudhon, Baudelaire and Champfleury, who participated, each in his own way, in the affirmation of Realism as the movement which overcame the clash between the Classic and the Roman-

tic, through the physical emphasis of the reality of objects, of the present, of the self. In his subsequent years Courbet continued to explore reality, dedicating himself to animals, which had always occupied an important place in his canvases, to flowers, still lifes, and marine scenes.

Realism as an interest in things close at hand – whether the poor of the suburbs, the leaves in a garden, or the pet dog – as an exploration of a method of reproduction which would make these things real in ways other than photography, which was beginning to leave its mark on aesthetic taste, had already asserted itself. And in this sense it runs throughout the nineteenth century, becoming a psychological category of both perception and interpretation from which one cannot

stand apart and which one finds in the populistic works of Jean François Millet (1814–75). Here it is linked with a pre-Impressionistic technique in artists such as Henri Fantin-Latour, Johann Barthold Jongkind, and Eugène-Louis Boudin, as in the works of the Pre-Raphaelites William Holman Hunt, John Everett Millais, Dante Gabriel Rossetti, and then Edward Burne Jones, attracted through their ethics toward a truthful representation of nature, inspecting it as though with a magnifying glass; at times using techniques and methods adapted from miniature painting, at others carrying out a dialogue with photography, thus establishing a fascinating interweaving of the imagination, fairytale-making, spellbound admiration, and reality. In Italy, first with Nino Costa (1827–1903), who stands in

opposition to purist painting, then with Giovanni Fattori (1825–1908) and the other artists gathered together under the common name of *Macchiaioli* – Silvestro Lega, Telemaco Signorini, Vito D'Ancona, Raffaello Sernesi, amongst others – Realism takes the form of a common interest in everyday subjects, a naturalistic leaning toward the physical consistency of objects, reproduced with large patches of colour (*macchie*) which do not dissolve the image in the manner of the Impressionist *taches* but fix it on the canvas, with the aid of those dark outlines which in the end are but contracted shadows (Maltese) and attempt to transform visible data into pictorial material. In Russia Realism takes the form of anti-Classicism and anti-Academicism, as we can see in the works of the thirteen painters who, after leaving the St. Petersburg Academy in 1870, organized a series of itinerant exhibitions.

Later in the nineteenth century, while European art was opening its doors to new onslaughts of the imagination and further projections of the unconscious, the drive toward Realism returned in the works of the Swiss painter Arnold Böcklin (1827–1901), a late Romantic who, in a certain sense, closed the cycle of this journey from Romanticism to Realism. In him the Classical world, far from being a formal model, has become the psychological substance of his work; the figures from Greek mythology, now physical beings, take part in a present-day archetypal drama which is reflected onto the landscape with forms identical to those used by Friedrich – the man seen from behind, looking toward the horizon – set in artificial surroundings, such as a theater, in which each detail is nevertheless physically true, as in reality. Which reality it is reflecting, an inner or an outer one, is no longer of consequence.

Above: G. Fattori, Libecciata *(South-westerly Gale [1876]) oil on canvas, Galleria d'Arte Moderna, Florence.*

Left: I. Repin, The Unexpected Return *(1884), Tretiakov Art Gallery, Moscow.*

Impressionism

"What Impressionism has the power to retain is the delight of having re-created nature, stroke by stroke. I find it pleasing to see reflected in the limpid and enduring mirror of the paintings so much that is deathless, and which yet dies at every instant." (Stéphane Mallarmé, 1876). Synonymous as it is with a now legendary revolt against academic taste and the tyrannical juries of the official French Salon, Impressionism is not only the culmination of nineteenth-century studies of the natural world, it is also, of course, the beginning of modern art.

Its key works are *plein-air* pictures produced by a group of young artists roundabout the year 1870. These canvases, executed out of doors in a bold, free style, raised a storm of indignation from critics and public alike when they were displayed at the Paris studio of the photographer Nadar, in the boulevard des Capucines, on 15 April 1874. Claude Monet, Auguste Renoir, Edgar Degas, Camille Pissarro, Paul Cézanne, Berthe Morisot, Alfred Sisley, Armand Guillaumin, and others since forgotten, took part in that historic exhibition.

Without theorizing much, or issuing manifestoes, Impressionism asserts a kind of secular truth with experiential and positivist foundations. The accent rests squarely on the sensory experience, the basic principle is that of *plein-air* painting, and a closely structured technique is evolved to convey what the artist sees as he studies the play of light on the motif – his instantaneous impression. Division of tones, the juxtaposition of dabbed-on complementary colours, analysis of light effects, the featherweight brushstroke and clear, sunny palette are so many elements in what amounts to a formal revolution; and in this context revolution generates a style and an actual philosophy of painting, which Monet, for one, was to develop to its utmost extremes.

When Louis Leroy, art-critic of *de Charivari*, coined his derisive name for their movement (from the title of Monet's *Impression: soleil levant*, of 1872), the painters cheerfully adopted it; it underlined their desire to seize the passing moment and the shining, fugitive reality. Eliminating what their champion, Georges Rivière, lists as "historical, biblical, oriental and genre themes," they painted sensation, and painted it with absolute immediacy. Confronting nature with no artistic baggage save personal response – "impression" – they transcribed it by using light as light had never been used before, and colour like an explosion, with all the luminosity revealed and all separate, neutral tones suppressed.

Above: Pierre Auguste Renoir, La Loge, 1874, London, Courtauld Institute.

Depending as it does on intuitive factors, the difficult harmony between optical analysis and state of mind – that is, between perception and emotion, or the observation and transmission of reality – is particularly delicate. An extra emphasis on specific visual data is enough to produce the neo-Impressionism of Seurat and Signac; more heed to the combinative dictates of the mind will result in the tormented expressiveness of a Van Gogh, or the "primitive" symbolism of a Gauguin – to choose only the most obvious examples. Then there is the risk of the artist's becoming entirely the prisoner of perception, cut off from human feeling. Thus Monet, at the deathbed of his young wife Camille, notices most keenly how her eyes look, and what tones and discolorations are imposed on her face. The ruthlessness is part and parcel of his objective vision.

But Impressionism in its central period was fully realized in the vital, optimistic examination of nature and of life. An extraordinary, concentrated energy emanates from quite small pictures, with their bright colours laid on in irregular touches and their suggestion of a vibrant, breathing universe. One must paint in a single, spontaneous dash to keep pace with what the eye sees, and the liberating force that so profoundly affects the future of art is in the fact that the swiftly executed work is as true as anything previously accomplished by the most laborious techniques. Yet this spontaneous method, regarded as of unprecedented im-

portance, was the most controversial, as well as the most distinctive, feature of the new style. Only after years of struggle and humiliating incomprehension did the artists get people to accept the logic behind it, and while some of them would live long enough for fame and honours, as did Monet and Renoir, others like Sisley, would die, practically unrecognized. But each contributed to the trailbreaking, and the influence of their total achievement was enormous.

It is not easy to survey a movement that includes personalities so rich and varied. The critic Théodore Duret, writing in 1878, saw the "pure Impressionist" group – that is, the new landscape school – as consisting of Monet and Renoir, Sisley and Pissarro. Degas, with his preference for portraiture and interiors, was always basically a draughtsman; he exhibited with the group but thought of himself mainly as a realist. Manet, though the original rebel against academic art, retained closer ties with tradition. For years he elected to stay in the calm of the studio rather than paint *sur le motif*, in the open air; he neither broke with the Salon nor exhibited with the Impressionists. As for Cézanne, Impressionism was for him merely a point of departure.

Yet they all explored nature and life in so completely fresh a manner that the luncheons

Right: C. Monet, Impression, soleil levant, 1872. Paris, Musée Marmottan. This painting from a window of the sun seen through the fog has movement in its title and captures freely and suggestively the atmosphere of the port of Le Havre with its boats, cranes and smoke rising from the chimneys.

on the grass and trips to La Grenouillère, those Argenteuil regattas and race meetings at Longchamps, the ballet classes at the Opéra or parties at the Moulin de la Galette, and the rosy blonde women in the sunshine, are not only marvellous Impressionist images, they also evoke the spirit of an era.

The history of the movement may be divided into phases, with a pre-Impressionist phase from 1855, year of the *Exposition Universelle* and Courbet's Pavillon du Réalisme, to 1863, year of the *Salon des Réfusés*. Next comes the period of most intense development as contacts and discussions among the painters gave birth to their new style and, eventually, to the formation, in December 1873, of the *Société Anonyme des Artistes, Peintres, Sculpteurs et Graveurs*, which duly organized

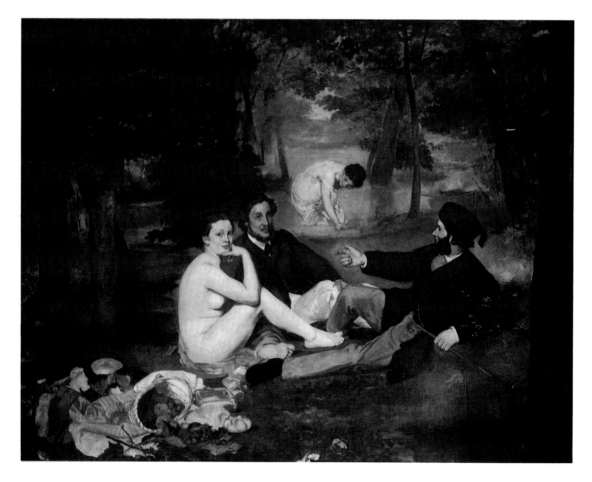

Left: Edouard Manet, Le Déjeuner sur l'herbe, 1863. Paris, Musée d'Orsay. A group of townsfolk on a country picnic offers an ambiguous mixture of old and new, the female nude at its center a challenging modern counterpart to Cabanel's academically classical Venus much admired in the Salon.

Opposite left: Edouard Manet, Olympia, 1863. Paris, Musée d'Orsay. Fascinated by the contradictions between real existence and the accepted conventions of art, Manet sought to infuse traditional painting with the truth of contemporary life and, through new methods, to achieve visual coherence. This nude, by no means soft and yielding, and with no shadow of allegorical or mythical excuse, is protest personified.

the show at Nadar's studio the following spring. Thereafter, until 1886, a series of exhibitions displayed the unfamiliar painting, though several of the participants had been reconsidering and revising their attitudes since the beginning of the decade. Thus Renoir turned to academic draughtsmanship, Cézanne to more synthetic and absolute form, Monet to a symbolist fragmentation of colour, and Pissarro to neo-Impressionism. In 1884 the founding of the *Société des Artistes Indépendants* as ultimate opponent of the Salon and focus for the young avant-garde, heralded the group's definite dispersal in 1886, year of

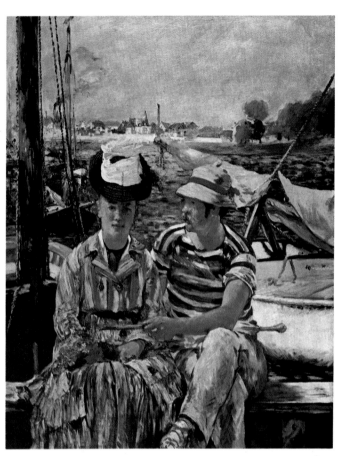

Right: Edouard Manet, Argenteuil, 1874. Tournay, Musée des Beaux-Arts. A plein-air figure-painting, vibrant and free, with the typically Impressionist effects of shimmering water, sunshine and brilliant overall luminosity.

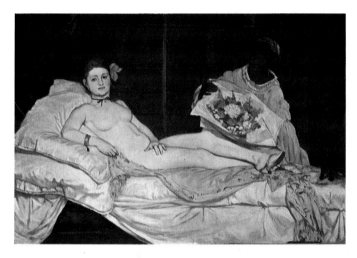

the eighth and last Impressionist exhibition.

A rapid survey will start, then, from the time when the young painters, formulating no system of shared poetic imagery, but applying hand and mind in their novel approach to nature, set out to work, on similar lines, as realists. A few of them – Monet, Renoir, Sisley and Bazille, for example – came together in the early 1860s as students of the classicist Gleyre. Others, including Pissarro and Cézanne, went to the house of Bazille's military cousin, Commandant Lejosne, or to the Café Guerbois, where Manet was surrounded by advanced painters such as Degas and critics such as Huysmans, Duret and Duranty. They all paid tribute to Corot and Théodore Rousseau as interpreters of nature, admired Courbet and Millet for their epics of ordinary life, and, in the footsteps of the Barbizon school, they all took brushes, paints and easels to the forest of Fontainebleau.

In 1855 two pictures by Courbet were rejected by the jury of the *Exposition Universelle*. His answer was to build the *Pavillon du Réalisme*, and so issue the first explicit invitation to the study of reality unfettered by academic despotism – a despotism which, upheld by Napoleon III's government and mirrored in the decisions of the Salon jury, conditioned the training of the rising generation of art students.

Further contributors to the pictorial lan-

guage of Impressionism were Henri Fantin-Latour (1836–1904) and the American James McNeill Whistler (1834–1903). Both manipulate grey tones with subtlety and clothe and define figures in luminous atmosphere. But where Fantin shows a delicate and austere feeling for the natural world, Whistler will wrap his "impression" in hazy layers of melancholy. The encounter with Japanese art led him to lighten his palette until he was modulating white on white, as though mirroring the abstract nature of music. (This technique of his would be the fundamental influence on those who later adopted pale, clear colours.) But the one who truly cried halt to academic domination, and who instigated the radical renewal of pictorial language, was Edouard Manet.

Bourgeois of the bourgeois, Parisian born and bred, Manet (1832–83) was trained under the classicist Couture. However, he combined a taste for mockery with respect for tradition, borrowing images from the old masters for a highly individual brand of realism. Whether in hostility or enthusiasm, he attracted to himself the artistic life of his day, being hailed at one time or another as the last classical painter, standard-bearer of the revolutionaries, guardian of the genuine tradition (beyond what was taught at the Ecole des Beaux-Arts) and precursor of pure painting. "Manet," Renoir remembered, "was as important to us as were

Cimabue and Giotto to the Italians of the Renaissance."

By 1860 or thereabouts his study of the great Spaniards, from Velázquez to Goya, had delivered him from his reliance on grey tones and he was painting in flat colour-washes, *aplat*. His figures were built up in direct, concise strokes, and the balanced and inter-related pictorial zones were all on the surface plane, lacking spatial perspective. With an alert eye for the contemporary scene, and acting on hints gathered from Baudelaire's article on Constantin Guys as *peintre de la vie moderne*, he celebrated the fashionable and intellectual life of Second Empire Paris in *La Musique aux Tuileries* (1862) – a picture whose dense blacks and sharp whites alternate with snapshot rapidity.

In 1863 the Emperor, in an obliging attempt to conciliate artists excluded from the official Salon, gave his blessing to a *Salon des Réfusés*, where Manet showed *Le Déjeuner sur l'herbe*. Iconographically this derives from the Giorgione–Titian *Concert champêtre* in the Louvre, and from Raphael's lost *Judgement of Paris*, known from an engraving by Marcantionio Raimondi. Its bold, irreverent use of these sources, the audacious linking of actuality with what one expected to see in a museum, and the progression, half insolent, half reverential, from ideal to real, were to

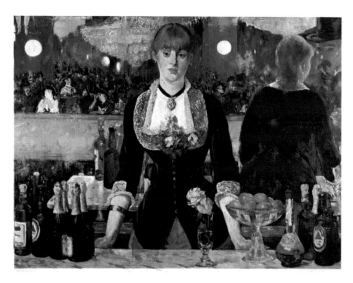

Left: Edouard Manet, Bar aux Folies-Bergère, 1881–82. London, Courtauld Institute. With the mirrored world about her resembling a mirage, the barmaid might be a symbol of the dissociation of modern life.

Below: Claude Monet, Femmes au jardin, 1866–67. Paris, Musée d'Orsay. Direct and innocent vision is combined in this picture with an extraordinary amount of concrete detail. "You need a truly remarkable love of your own times to venture on a tour de force like this," was Zola's comment.

Impressionists on their own ground, he depicted nature as he saw it – in literal translation, as it were, rather than by his customary transpositions. Incandescent colouring brings out the mobile glint of his brushstrokes and vividly distributed light. Typical of his Impressionist style are touches of virtuosity in the vibrant landscape, and the delicate modelling of faces under shady hat-brims, as in *Argenteuil* (1874). It is a style at once brilliant and lively, dignified and cerebral, befitting work he would send to the Salon.

In *Le Chemin de fer*, included by that institution in 1874, the two large *plein-air* figures appear in an unexpected spatial structure which, as in a Utamaro print, unites their world with ours. More complicated is the same characteristic effect in the final masterpiece, *Un Bar aux Folies Bergère*, of 1882. Manet has caught, framed in a looking-glass, the Parisian world that meant so much to him, and reflected

shatter the frozen academic pattern and become guides and models in the search for new directions. With its arbitrary technique and provocative subject-matter, the *Déjeuner* is a foundation stone of modern art.

But *Olympia*, with her origins in Titian, Goya and Ingres, seems to shout defiance at the late, great masters. The young prostitute with the challenging gaze occupies the place of the goddess of love, in a pose probably derived from some erotic mid nineteenth-century postcard. What Manet was advocating was, essentially, escape from the slavery of subject-matter. Be casual with myth and historical pomposity is his advice. Attack head on; incorporate in your style something of the Japanese print and intensify it, for striking, innovative effect, with heraldic splashes of colour. Zola's public support for Manet was rewarded in 1868 by a portrait – the writer as dandy, a role perhaps not far removed from the artist's own. In *Le Balcon* of the same year – again a picture inspired by Goya – we have, too, a moment of modern life, with people posing as though about to be photographed. Simplified faces and pale figures on a dark background underline the work's quality of defiance. It was the meeting with Monet in 1866 that attracted Manet to the painting of air and light and interested him in landscape. His palette grew less somber in response to Impressionist experiment, his touch was heightened and he produced altogether more sparkling pictures. By 1873 the *plein-air* excitement is visible, even in the relatively monumental and concentrated vision of *Sur la plage*. And though, as we have said, he sent nothing to the 1874 exhibition at Nadar's studio, desiring to remain independent, he also desired conventional recognition – Manet was by then very near to Impressionism. Often, when he was with Monet at Argenteuil, he painted the Seine and its boats, his friend's studio-boat among them. As if to match the

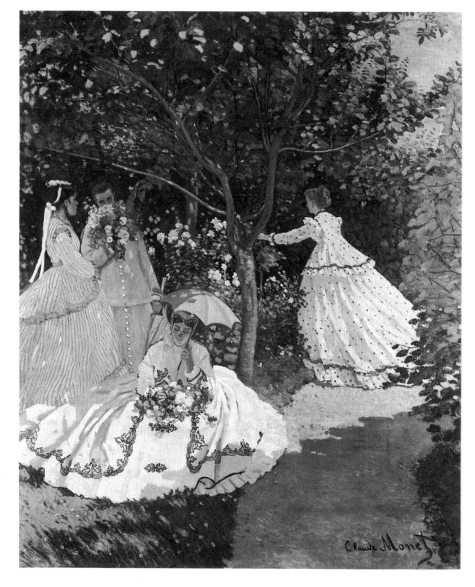

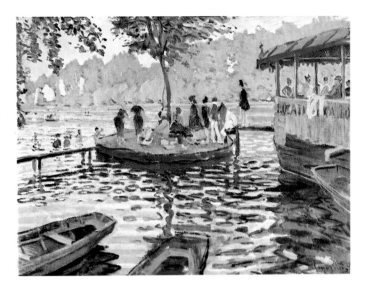

Right: Claude Monet, La Grenouillère, *1869. New York, Metropolitan Museum of Art.*

Below: Pierre Auguste Renoir, La Grenouillère, *1869. Stockholm, Nationalmuseum. A web of brushstrokes charged with, yet apparently detached from, enormous descriptive power demolishes practically all illusion of perspective in these pictures. Monet is the more optically subtle in his treatment; Renoir, more involved with anecdote, introduces humanity and warmth. Where Monet shows us nature, and heightens the decisive force of complementary colours, Renoir shows us life – the life of people and things in an enveloping atmosphere, a totality bereft of sharp contrasts, soft and silvery.*

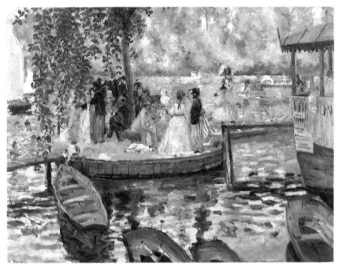

it in the gaze of the leaning girl in the foreground as though her unfathomable silence were a kind of farewell. He died in 1883, soon after having been created a Chevalier of the Légion d'Honneur. "Greater than we thought, he was," commented Degas, drily.

Claude Monet (1840–1926) was the archetypal "Painter of the Fleeting Moment," who devoted his life entirely and consistently to painting. But though his fellows were without exception influenced by his luminous style, he had no ambition for leadership. He wanted only to learn and to paint, and his career was, in the end, that of a solitary.

He brought to his art the innocence, the egoism and the determination of genius. Concentrating exclusively on the visual, he recorded the instant of perception with absolute fidelity, while essential harmonies in his compositions tell us that he knew how much of the natural world was interrelated and interdependent; and in his last years he was to restore imagination to its rightful place

Monet grew up in Le Havre, where he gained local renown as a caricaturist and where Eugène Boudin (1824–98) and the Dutch watercolourist Johan Barthold Jongkind (1819–91) introduced him to the *plein-air*. The changing skies, wind, cloud and sea of Boudin's small marine pictures have a sketch-like immediacy, while Jongkind, a student of atmosphere, painted natural phenomena in preference to realistic subjects. Both of them taught Monet not to blur the freshness of the initial impression, to look at nature and paint straight from the motif. "A veil was torn from my eyes," as he later wrote," and suddenly I saw what painting was."

He moved to Paris in 1859, and the visual energy of his landscapes grew as he worked with his friends Bazille, Sisley and Renoir in the forest of Fontainebleau, applying his penetrating attention to the infinite variation of atmospheric light. There was a successful Salon début in 1866; the public got him mixed up with Manet and the critics were generous with

their praise. But when the Salon banned the whole group in 1867 he joined a fruitless protest to Comte Nieuwerkerke who, as Director of National Museums, was requested to reconstitute the *Salon des Réfusés*. It was thus, ambiguously, that the anti-establishment struggle went on: year by year the young painters opposing the rule of academic art pounded on the doors of the one organization that could bestow social recognition and cash earnings – the official Salon.

When, in *Les Femmes au jardin* (1867), he dealt with figures in an outdoor setting, Monet aimed at the union of volume and space by means of vividly contrasted light and shade, and the huge composition preserves the speed and vitality of a sketch. To ensure identical light conditions for each section of the picture he had a trench dug in his garden, and the canvas was raised and lowered by pulleys as required.

In the late 1860s he painted in the wooded country near Paris and on the Normandy coast with Frédéric Bazille, who, born in 1841, died as a young man in 1870, in the Franco-Prussian war. But whereas Bazille put something of the south into his landscapes – which are heavier, with clear-cut tones and splendidly solid human figures – Monet, in pursuit of the perfect integration of form and light, hesitated less and less to reject plasticity and the definition of form by drawing. He wanted, he said, to paint the beauty of air itself, as it existed, impalpable, between him and his motif. Honfleur, Trouville, Sainte-Addresse – flags fluttering against a cloud-streaked sky, clean contrasts of light and shadow – prompted him to wonderfully accentuated optical effects. By avoiding bitumen for passages of depth and distance he not only resolved the difficulty of shadow zones and their mainly complementary colours – blue especially – but at once lightened the general tone. With Sisley and Pissarro Monet also studied winter landscape: *La Pie* is a magnificent exercise in the full range of whites, revealing an incredible ability to depict the brilliance of snow in what, to an artist's eye, were marked tonal distinctions.

In the same year, 1869, he and Renoir painted together at La Grenouillère, the island in the Seine with its bathing and its restaurant, described by Maupassant in his short story *L'Amie de Paul*. Despite vague reminiscences of Watteau and Fragonard, these Grenouillère studies are astonishingly new. A radiant atmosphere, rippling water and the gesticulations of the bathers are shown in rapid dots and swirls. The mercurial world quivers with sensation, expressed though it is through objective data. For both artists light, colour and movement are the vital factors, superseding any intellectual consideration. Immediacy is their essential purpose, the human eye no more than the instrument of a moment's perception. Then and subsequently the two collaborated in important technical explorations,

sharing many of their subjects in enthusiastic and significant accord. Thus, in 1874, each paints a *Seine at Argenteuil*, Renoir delighting in the accumulation of his tiny, nervous, comma-shaped touches, while Monet's luminosity is conveyed by stronger contrasts, simple and uncompromising. Fragmentation of the stroke emphasizes relations of tone, and since he scales his chromatic values to the purest of the high colour tones, the most luminous of these predominates.

A degree of synthesis is present in Monet's pictures for the 1874 exhibition – *Impression: soleil levant*, of 1872, and *Boulevard des Capucines,* of 1873, though every brushstroke is faithful to reality. But the dedicated experimentalist discovered other solutions as time went by. When, in the 1877 views of the Gare Saint-Lazare – introduction to the "series" idea – the multiple, volatile energies of the station impel him to record a succession of momentary effects, he filters the solid elements of the scene through more and more subtly perceptive tonal gradations. Winter

fix it in a flood of yellow tints that give, with amazing accuracy, the effect of that elusive dazzle. Or he has snatched a storm in his two hands as it beat down on the sea and hurled it on to canvas; and what he painted was, unmistakably, rain." Not until the 1880s would Monet, as he achieved further technical harmony between natural form and the increasingly urgent demands of colour and composition, finish his *plein-air* pictures slowly in the studio.

After *Les Meules* (*The Grain Stacks*, 1890), a series in which, so wrote the critic Gustave Geffroy, reality is combined with the transfiguration of reality, came the decorative *Peupliers au bord de l'Epte* (1891). These are pictures based on the sinuous line of the riverbank in relation to the vertical tree-trunks. As though Monet had been clutching at that ephemeral beauty – the poplars were already doomed, and felled soon afterward – they are born of a meditation on nature so deep and personal that the actual world seems mysteriously shrouded from us by the painting.

Some thirty canvases of Rouen cathedral, executed in 1894, are, though arduously retouched in the studio, breathtaking demonstrations of instantaneity, and images of memory and dream. The architecture, serving as prop and frame for pictorial experiment, assumes a porous quality that condenses light and modulates the sun's rays. Everything solid dissolves in shimmering fantasy, and the prime Impressionist goals of spontaneous vision and the capture of the passing moment are secondary here to the cumulative effect. To properly appreciate the fusion of imagination and perception in these pictures one should see them in order, as a series.

From 1893 onward Monet prospered. He was able to buy his house, and extra land, and to create at Giverny a private universe of dream and reverie, centered on his water-garden. This water-garden inspired him to examine the relation of innermost reality to the transmutation of that reality into three dimensions on canvas, and gradually he painted bigger and bigger pictures, frequently joining

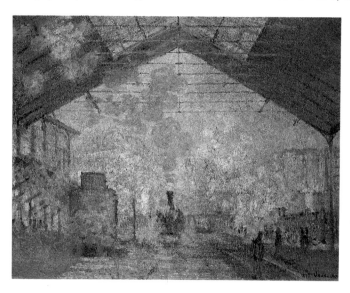

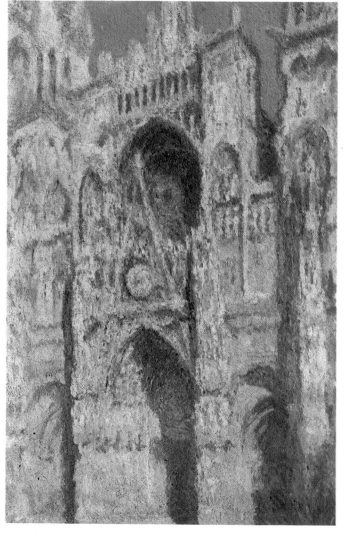

landscapes at Vertheuil in 1878–80 (*Les Débâcles*) are imbued with the sense of nature, huge and inescapable.

In 1883 Monet rented a house at Giverny near Vernon, on the borders of the Île de France and Normandy; and at Giverny, as his sympathy with landscape steadily developed, he painted with power and vigour, in incandescent colours. Guy de Maupassant remembered him. "On several occasions I have followed Claude Monet round in his search for impressionism when, indeed, he was a hunter, not a painter. Attended by children...who carried his canvases – and there might be five or six of the same subject – he would stand in sun or shade to catch a gleam of light or a passing cloud with a few strokes of his brush.... And I have seen him, in this fashion, seize the shining reflection on a white cliff and

Above: Claude Monet, Gare St. Lazare, 1877. Paris, Musée d'Orsay. The inducement to paint at St. Lazare station was, for Monet, the opportunity to analyze the interaction of its smoke and steam with the bright light striking through the huge glass roof above the platforms.

Right: Claude Monet, La Cathédrale de Rouen, 1894. Paris, Musée d'Orsay. The façade becomes a ghostly fabric which catches the miracle of light in a quivering network of tonal gradations.

one composition to another for the sake of visual unity. His subject is a flower of water and sun. As its petals shut at night and open with the day, so Monet's water-lily concept expands and renews under your eyes and seems further and withdrawn, spiritually and mentally, from what he actually saw. At the end of his life, the painter who started out from naturalism has reached the threshold of symbolism and abstraction.

Of modest birth (his father was a small-time tailor in Limoges) Pierre Auguste Renoir (1841–1919) was a self-taught youth who began his artistic career as a decorator of

Below: Pierre Auguste Renoir, Le Moulin de la Galette, *1876. Paris, Musée d'Orsay. This is one of the best-loved of Impressionist masterpieces, described by Georges Rivière as "a page of history, an accurate and precious record of*

Parisian life." The same critic also noted that the Impressionist group, unlike other painters, "treat their subjects not by simple portrayal but by means of colour-tone."

porcelain and fans. The family moved to Paris when he was three, and he haunted the Louvre from boyhood. Among the Impressionists he was the least willing to reject the heritage of the past, and recognized, with his acute perception of excellence, that museums will breed the taste for painting "which nature alone cannot bestow." He was, he knew, heir to a living force accumulated over the ages, though his feeling for artistic continuity was, in fact, a matter of instinct rather than of knowledge.

A craftsman by education as well as inclination, he had an intelligent grasp of painterly tradition and the swift dexterity of one who had garnered rococo themes in many quarters, from the school of Rubens to the art of eighteenth-century France. (A period absolutely attuned to the carefree sensibility, tinged with sensuality, evident in Renoir from the first.) His facility was unfailing. The brush in his fingers (or, when he was old and racked with arthritis, fastened to his wrist) seemed a physical part of him, sharing his powers of response.

He and his friends frequented the forest of Fontainebleau, as did the Barbizon group before them, and he, with the rest, was much influenced by Courbet, Manet and Delacroix Thus, large standing figures (*Diane,* of 1867; *La Baigneuse au griffon,* of 1870) go back to Courbet and demonstrate a need for tactile awareness of his subject. Feminine portraits, whether with sketchy, dappled backgrounds of foliage or executed in vibrant colour out of doors (*Lise,* 1876; *En été,* 1878), have the animation of tonal painting learned from Manet. In Delacroix, with his orientalism and his continuously rhythmic, exhilarating splashes of colour, Renoir found, as in Boucher, the notion of style as a form of voluptuous abandon.

He was, said his son Jean, "a marvellous machine for absorbing life," and he painted the life that unceasingly fascinated him. Pictures like *Les Patineurs au Bois de Boulogne,* of 1866, or the sunny *Pont Neuf,* of 1872, testify to his love for Paris. Figures are undetailed, the brisk, happy spectacle is conjured up to

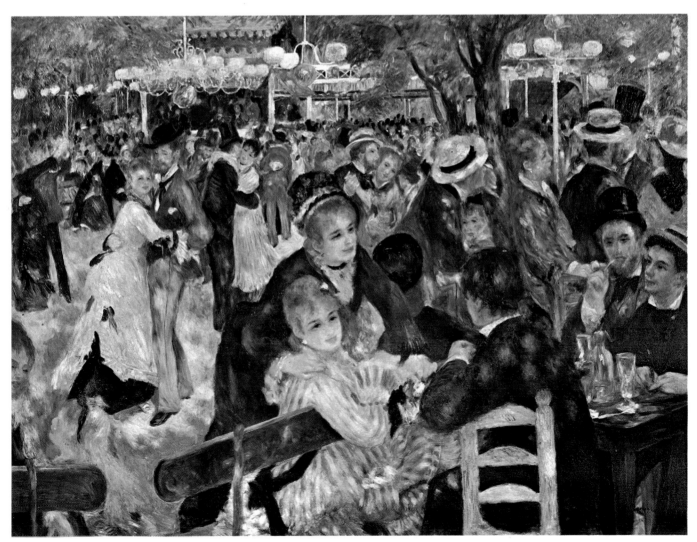

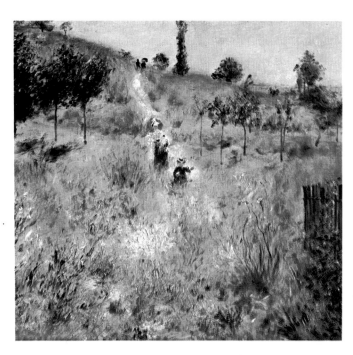

Left: Pierre Auguste Renoir, Chemin montant dans les hautes herbes, *1875. Paris, Musée d'Orsay. In this picture, nature is a source of pure sensation. Its technique of tiny brushstrokes and myriad multihued flecks of paint conveys Renoir's "impression" in all its life and colour.*

Below: Pierre Auguste Renoir, Portrait de Madame Charpentier et de ses enfants, *1878. New York, Metropolitan Museum of Art. Renoir was a sensuous painter. As a change, perhaps, from the shabby ribbons of midinettes dancing at the Moulin de la Galette, he could delight in the rich, expensive garments of Zola, Flaubert, the Goncourt brothers, or, as here, of Madame Charpentier, wife of Zola's publisher.*

Madame Charpentier has a great air of "grand portraiture," of opulence and contrived solemnity. Socially, it opened many doors, for the sitter was married to Zola's publisher, but the thought of perpetually repetitive society portraits horrified Renoir and threw him into panic.

An Italian journey in 1881 convinced him that he was as yet neither painter nor draughtsman: there were Roman frescoes by Raphael glowing with the sunshine he had never managed to entrap *en plein air*. That year he painted *La Baigneuse blonde*, in full sunlight, on a boat in the bay of Naples, retouching it with a dry, decisive contour. Then, in 1883 or so, as he remembered, "there was a sort of break in my work. I had gone as far as I could with Impressionism." Unlike Monet, of the constant, coherent forward march, Renoir now looked to the past and metamorphosed his style into a rigid classicism which he would subsequently rescind and term his *manière aigre*.

Ingres was for him the most classical of artists, and Ingres is godfather to *Les grandes Baigneuses* (1884–87). But, since the world he lived in presumably preferred a little less

perfection. In these important years around 1870 he was concentrating more and more on the play of light on the motif, and though he and Monet, as we know, often shared their subject, painting side by side, they were, as true Impressionists, their own men, and stylistic differences soon developed. The La Grenouillère studies of 1869 signal a new gaiety in Renoir; his Parisians on their outings entertain themselves and us. The strictly visual may enthral Monet, but Renoir sees a small drama of place and incident in the transient reflection, the trembling leaves and the activities of the holiday-makers; while as a device for separating the constituent colours of light he chooses the fluid or fragmented dabbing of pigment which confirms the direct, empirical impetus of his style. As for landscape, there is a lovely series of sun-drenched meadows crisscrossed by rising paths in the tall grass. In these pictures the actual landscape forms are lost, as if in some dreamy musing on their unseen consonances with the glittering atmosphere. The 1874 exhibition included those miracles of grace and beauty *La Danseuse* and *La Loge*, their pearly tones echoing Fragonard and Boucher, their narrative charm sustained by solid pictorial values.

Typical Renoir effects are those of glancing light that partially disperses shadow, and he is fond of light-and-shadow patterns cast on figures under trees, as in *La Balançoire* and *Le Moulin de la Galette*, both of 1876. He has the same technique with light for the nude. Light clings to Renoir's nudes, moving slowly and gently over them as though it touched the skin. He was a painter obsessed with the sense of touch. The subject of a picture was for him a pleasure. Throughout the 1870s, and before his later preoccupation with the sumptuous, he

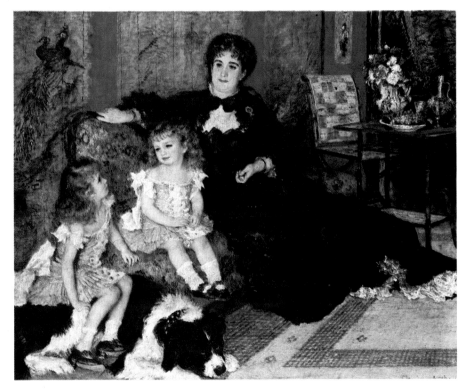

shared his generation's feeling for domestic realism. Even the nudes were ordinary, average women, while the romantic or genre scenes – lovers strolling in a garden or dancing together, parties at the Moulin de la Galette, at Bougival or on the river-island of Chatou – are entrancing descriptions of human encounter such as no other Impressionist can show. In 1878, however, his

severity, Renoir supplements references to his classical idols with others to *Le Bain des Nymphes*, an eighteenth-century bas-relief by Girardon on a fountain at Versailles. The attempted synthesis of course occasioned discrepancies of style, but despite the too-assertive line and low-keyed colouring the picture has its Parisian allure and a frank sensuality. When this Ingres-type exactitude is

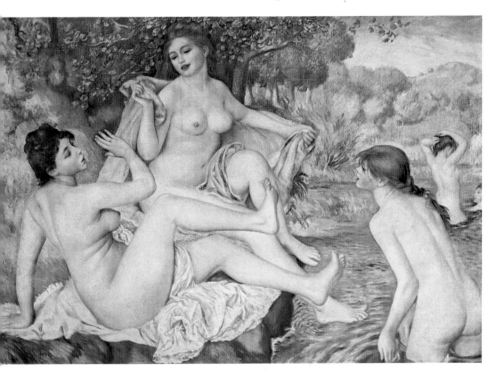

and winter studies of a chosen subject he would note seasonal differences of colour and form – colour in sudden bursts or unbelievably subtle nuances, often in tones of silver-grey. Contact with nature taught him a new intensity of feeling and expression and, though he never employed so loose a stroke in treating form, nor penetrated and demolished space as Monet did, he adopted the Impressionist palette for water and watery surfaces, and for transparent, coloured shadows. The personal accent and moderate tonality grow increasingly recognizable. Evocative views of Port-Marly in the floods of 1876 have an enchanted inner silence. They consist of nothing but the familiar outlines of a house and one or two trees, rendered strange by the mirror-sheet of water and a grey sky heavy with cloud. Disaster is conveyed through colour and form, the desolation quietly and delicately suggested.

He lived out his life in dull obscurity at Moret, unremittingly attentive to the cycle of nature; an artist, it might be said, with little or no history, but one who possessed a fine poetic instinct and was entirely faithful to the *plein-air* technique. Sisley cultivated the sheer joy of painting as long as he lived, and died on the very brink of critical recognition. His pictures were commanding enormous prices less than twelve months afterwards.

Camille Pissarro (1830–1903), who left his birthplace, the West Indian island of St. Thomas, for Paris in 1855, was of Jewish extraction. A socialist with pronounced anarchist leanings, and more politically minded than were the others, he saw the struggle for modern painting as having to do with the problem of the artist in society. Yet his radical notions were tempered by deep human sympathy, and he was respected as a generous man of unswervingly high principle. The resolute integrity and stubborn adherence to truth of this doyen of the Impressionists were moral beacons for the younger painters – Cézanne, Van Gogh, Gauguin. "The humble, colossal Pissarro," as Cézanne called him, was a tutelary, paternal figure for everyone who knew him. It was as though he transmitted truth and spiritual wisdom as well as technical knowledge. Half rabbi, half dyed-in-the-wool anarchist, he lived up undeviatingly to his own definite ideals of what painting, and the painter, should be. Behind his painting we sense the "straightforward and rigorous personality" of whom Zola wrote so warmly, "one incapable of lying, who could create pure and eternal truth from art".

Initially he painted with Courbet's thick lines and the tonality of Corot; all his work has firmness and balance with, at first sight, nothing revolutionary about it. At Pontoise in 1867 he completed landscapes on canvas whose simple grandeur derives from their search for geometric order in architectonic features and the calculated distribution of light. But when, like Monet and Renoir, Pissarro views La

applied to domestic subjects, there to meet the bourgeois taste of the period, results can be anomalous; though it must be admitted that the blend of natural and ideal, timelessness and spontaneity, has better success with the nude. "How hard it is," Renoir once said, "to decide just when to stop in the imitation of nature in a picture. Painting should make us think of nature, not of the model."

Moving to the south of France, he settled at Cagnes-sur-Mer in 1903, and here his love for the open-air technique returned. Again his palette was warm, his brushstrokes mobile; again he painted plump, mature women and girls. Until the end he was constructing, as it

were, a myth of the natural world, with images at once magnificent and commonplace, and all of them gloriously alive.

Alfred Sisley (1840–99) was born in Paris of English parents. It is from this shy, retiring man, overshadowed by the rest of the group, that we have some of the most beautiful Impressionist pictures in existence.

His early style owed much to Corot and Daubigny, but exchanges and discussions with his friends – with Monet and Renoir especially – indicated a fresh approach to nature, and at the beginning of the 1870s he and Renoir were painting the roads and countryside of Argenteuil together. In summer

Above: Pierre Auguste Renoir, Les Grandes Baigneuses, *1884–87. Philadelphia, Museum of Art. This is a studio painting, meant to suggest neither* plein-air *light nor natural landscape setting. It represents Renoir's furthest move away from the Impressionist aim of immersing figures in their surrounding atmosphere.*

Right: Alfred Sisley, Inondation à Port-Marly, *1876. Paris, Musée d'Orsay. The flooding at Port-Marly, with water, earth and sky blended into one, provided Sisley with the theme of several very beautiful pictures, notable for their delicate tonal transitions.*

an affair of the harmonious interplay of differing forms and volumes. For the critic Théodore Duret, Pissarro is "the painter of rural nature," and indeed his peasants are as authentic as Millet's, though he cannot match Millet's profundity. From him the peasant theme passes to Gauguin and emerges as a source of synthetism. (Gauguin's interpretation of figures is derived from Degas, with whom he collaborated on etchings in 1879.)

The pursuit of greater pictorial unity through the organization of the picture surface, and his interest in colour theory, brought Pissarro to neo-Impressionism in the late 1880s. But though he embraced the novel style with a convert's zeal, he was soon back with the old, "romantic" Impressionism, and in the final years of the century, as his comrades followed other paths, it was left to him to cherish and personally epitomize the ideals of his whole lifetime.

The most cursory review of Impressionism cannot omit the name of Berthe Morisot (1841– 93), model and pupil of Manet, whose brother she married. She was the daughter of rich parents, a devoted artist who applied her vigorous colour in forceful, summary strokes, and became one of the original trio of women Impressionists The others were Eva Gonzales,

Grenouillère in 1869 we look in vain for the splashings and saunterings, the bourgeois relaxations of the summer day. His theories of modern life were hardly those of Baudelaire, and what he gives us is industrial landscape.

Concerned with political implications, he is not satisfied to record appearance only. Adapting style to subject-matter, he produces a blend of Impressionist realism (which is the control of random elements) and traditional landscape,

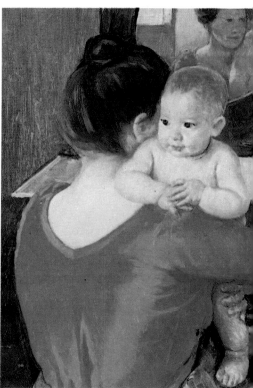

Above: Mary Cassatt, Mother and Child, c. 1880. New York, Brooklyn Museum. Her work reveals great sensitivity to the least variation of light and shadow, and to every note of colour. In America her influence helped to spread the knowledge and appreciation of Impressionism.

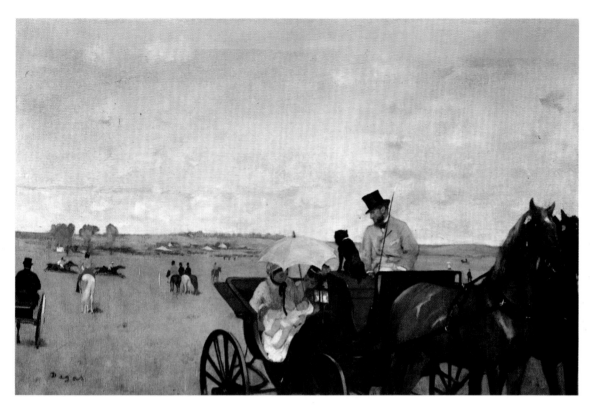

Left: Edgar Degas, Aux courses en province, 1870–73. Boston, Museum of Fine Arts. This picture, simultaneously of a racecourse and of Degas's friend Paul Valpinçon and his family, holds its diverse themes in constant balance, while the whole is bathed in greyish light filtered from a cloudy sky.

Below: Edgar Degas, La classe de danse, 1875. Paris, Musée d'Orsay. Degas treated the theme of the ballet class in various ways. There are relatively static groups with dancers in their preparatory poses, in settings constructed of verticals and horizontals; or vivid studies of individual movement, concentrating on one dancer as part of a complex ensemble, and set in boldly foreshortened space.

Opposite above: Camille Pissarro, La Meule, Pontoise, 1873. Paris, Durand-Ruel Collection. Pissarro's landscapes, painted under the influence and advice of Corot, are more solid than other Impressionist work of the kind. He builds them with small touches of colour, carefully applied, and seems interested in firm, coherent composition rather than instantaneity.

Opposite below left: Berthe Morisot, Chasse aux papillons, 1874. Paris, Musée d'Orsay. Berthe Morisot was a highly inventive artist, gifted with a light touch and an eye for delicate colour, who strove continually to paint the fugitive, changeable reality of the world around her.

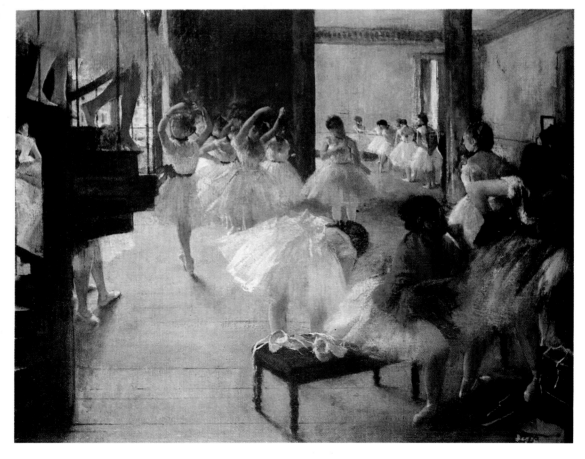

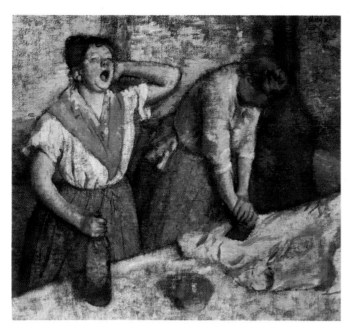

Left: Edgar Degas, Repasseuses, *1884. Paris, Musée d'Orsay. Subjects like this, which had served as background material for Zola's novel* L'Assommoire *(1877), are raised by Degas almost to abstract concepts. "In copying modern life he has captured its very soul," said Edmond de Goncourt.*

Below: Edgar Degas, Le Tub, *1886. Paris, Musée d'Orsay. Degas, a fascinated observer of the female body, painted nudes in many poses. The remarkable organization of space in this picture, with its still life on the same plane as the bath-tub and daringly cut off by the frame, is derived from the art of Japan.*

of the "study of modern sentiment," and his drawing, stripped of conventionality, was "alive, human, intimate," as the Goncourt brothers found it. The dandy, the detached and caustic observer of the world, shows us small, surprising fragments of the passing scene, clipped off at the edges, charged with tremendous psychological irony. He might be a cameraman. Yet his arbitrary truncations have their lucid, abstract structure, and he devises rules of his own within them.

Edmond Duranty, the novelist and critic, wrote of Degas as "*an original,* ailing, neurotic, who feared for his weak eyes and was for that very reason sensitive in the highest degree to the underside of things." He adored painting race-horses; "a rare theme," as Paul Valéry said, "with realism and style, elegance and precision, combined in the luminously pure form of the thoroughbred." There are in Degas's racing pictures, modern versions of a subject that has mesmerized men for centuries, a mysterious, essential motion and vitality. Even when they are painted in the studio the sensation of truth prevails. The

who also trained with Manet, and the American Mary Cassatt (1845–1926), who joined the group through her friendship with Degas and specialized in portraits of mothers at ease with their children in elegant surroundings.

A recruit at about the same time was Gustave Caillebotte (1848–94). A rich and generous collector, who bequeathed his pictures to the French nation, Caillebotte was an engineer and himself a talented painter of modern themes. He tilts and ruptures space in the manner of Degas and shares the latter's love of the flying instant seized with photographic precision. A meticulous accuracy of form precludes neither asymmetry nor repetitive pattern, and in his views of Paris (*Le Pont de l'Europe*, 1876; *Rue de Paris, temps de pluie*, 1877) there is deliberately abstract arrangement of the new urban spaces of the capital.

Edgar Degas (1834–1917) grew up in a well-to-do family whose keen interest in art ensured his good cultural background and sophisticated taste. A nostalgic admirer of the linearity of Ingres, and a lover of the old masters from Mantegna to Poussin and David, he concentrated on figure-painting and rarely essayed landscape. Whereas, to the others, looking was of primary importance, for Degas the vital link was an artist's intelligence. His art, he declared, was the result of studying and digesting the old masters; spontaneity and inspiration were alien to it. Yet Degas was an Impressionist in that everything he painted in his extremely personal style, with its exact drawing and astounding angles of vision, is an attempt to fix the fleeting, accidental moment. But movement in his pictures is in no fleeting impression, nor softened, graduated line. Rather it is conveyed by means of equilibrium, of mass controlled and poised and beautifully

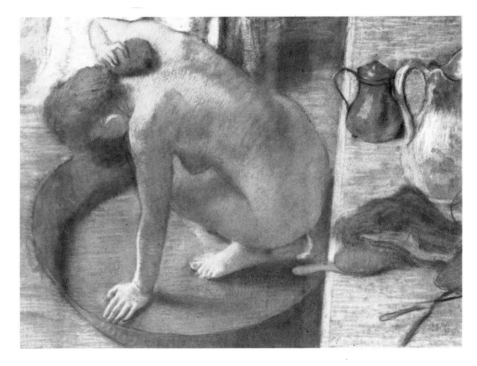

balanced, as were the horses he watched, with their jockeys, at the races. The germ of his future style is discernible by 1859 in a splendid portrait, painted in Florence, of his Italian relations, the Bellelli family. A stiff picture, perhaps, and untypical of him in execution, but which hints at the later audacity and unorthodoxy.

Influenced by Gustave Moreau, Degas flirted briefly with history-painting, then deserted it for exclusively contemporary subjects. Academicalism was banished in favour

interpretation, though it startles, seems truer than reality itself, and Degas, tirelessly experimenting, distils his theme in magnificent studies and drawings. *Aux courses en province* (1870–72) is an example of precisely related form and narrative, where no element is out of place. With painterly cunning, in a skein of corresponding axes, diagonals, parallels and perpendiculars, the artist imprints his art upon an interlude of fashionable life.

The theater, too, was a field for his clear, if eccentric, vision. The dancers in the back-

Right: H. de Toulouse-Lautrec, Au Moulin Rouge, *1892. Chicago, Art Institute. The desire to express in art all different aspects of modern life is seen most clearly in the work of Toulouse-Lautrec, who captures the Paris of the turn of the century in basic colours and simple, expressive forms. Following Degas, with an even stronger feeling of sensuality and a more direct narrative effect, the artist conveys the atmosphere of the night, the theatrical setting, the charm and the decadence. He, too, was influenced by the Japanese woodcuts which combined perspective illusionism with the two-dimensional form and he includes, particularly in illustrations and posters, a structural element.*

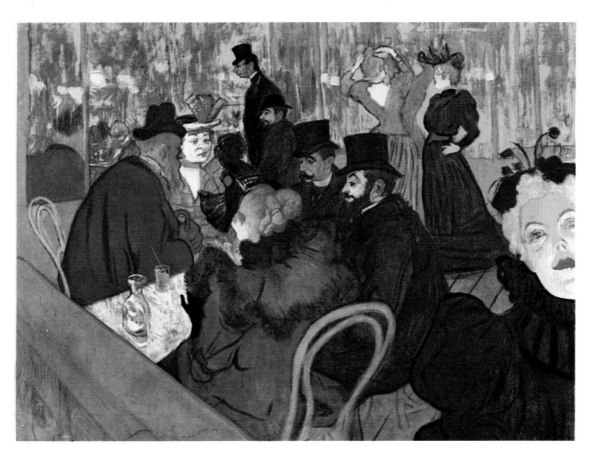

ground of *L'Orchestre de l'Opéra* (1868) are blurred and curtailed, in apparent contradiction to the foreground musicians, so photographically distinct. But a series of pictorial ties and connections has been introduced to cancel out the evidence of our eyes and hold the composition in a lattice of interlocking lines, strict, rhythmical, inclusive.

As he appreciated the action of horses, so Degas appreciated the highly disciplined movements and patterned gestures of the girls at the Opéra ballet classes. He draws their heads, their necks and shoulders, records their excercises with anatomical accuracy; displays them, in their poses, in daringly foreshortened space, with careful regard for the light sources.

Duranty, in *La Nouvelle Peinture* (1873), argues for the right to depict people and objects in unexpected ways. Let the artist look at the world as if through an open window, and by cutting and changing what he saw "attain the infinite, astonishing diversity that is among the chief pleasures of reality." Degas, who so prized the vivid insight, the momentary fragment transfixed, was, for Duranty, second only to Courbet as a destroyer of the barriers between the painter's studio and normal daily life.

The Parisian working class was also sympathetic material. In pictures of washerwomen, *Les Repasseuses*, for instance,

Degas shows the steamy laundry-room and the intensely physical activity of ironing – how the women's task is done and how they move. Sweat gleams on their arms; we see the curve of their breasts. Or he sallied forth at night to paint in the music-halls: actors going through their inexorable routines, popular singers in full flow, wide-mouthed as an admiring public gazes upward. ("You can have the natural life," he told his friends, "I'll take the artificial.") Then there were the brothel pictures, a monotype series of 1879–80, with no disguising of the coarsest postures and positions and the animal flaunting of bodies. They are pictures whose implied ideas on women have caused much speculation as to his alleged misogyny.

These themes anticipate the Paris of Toulouse-Lautrec and link Degas with more specifically genre artists such as Jean-Louis Forain and Jean-François Raffaelli, who aspired to create a kind of sociological panorama of the seamier side of life in the great city. His desire that they should exhibit with the Impressionists threatened the already fragile unity of the group.

In the 1880s he embarked on the systematic drawing of female nudes. There were small monotypes retouched with pastel, then large pastels, and finally oils. The inexhaustible imagination of, as he put it, "an observer of the human creature as she is occupied with herself," contrives these boldly innovative

glimpses of women having their baths, dressing, or brushing their hair.

Near-blindness did not deflect him from his beloved painting. Relying on memory and the gallery of pictures in his studio, he intensified his colours and accentuated shape with rough, heavy contour. His composition grew arbitrary, his palette more expressionistic and he heightens the surface rhythms in a complex and very modern technique.

Paul Cézanne (1839–1906) arrived in Paris from Aix-en-Provence as a romantic realist in the idiom of Daumier and Delacroix. His canvases – portraits done with the palette-knife, violent, sensual dramas in swirling brushstrokes, still lifes with the paint jabbed on – reveal the strains of a gloomy, irascible mentality. Reconciliation of these extravagant imaginative tensions with the study of real nature would engender work of great power. It was at the particular urging of Camille Pissarro that Cézanne took to the *plein-air* in the early 1870s. At Pontoise or Auvers-sur-Oise the two painted in company and often from the same motif. Pissarro's humble, religious attitude to nature freed Cézanne from morbid introspection and opened his eyes to the beauty around him. He learned the technique of tiny brushstrokes and of tonal modelling, lightened his palette and generally laid foundations for the deeply felt and monumental pictures that were to alter the language of Impressionism.

La Pendule noire, of 1869–71, and *La Maison du pendu*, of 1873, are among the landscapes and still lifes which arise from actual observation instead of inner fantasy. Yet they show that he does not "paint the sensation." He is not dealing in direct transcription. The uninterrupted paint surface, luminous with flecks of light, may seem Impressionistic, but his goals are the stable architectonic structure and the solid forms of a world that knows the laws of gravity.

The still lifes, restrained and intricate in the disposition of the masses, indebted indirectly to Chardin and, in Rivière's estimation, endowed with classical qualities, are careful and sensitive representations of a mute world; in this case a world whose contradictory elements have been coaxed, slowly and resolutely, into an order that is peculiarly theirs.

A preference for round shapes, increasing emphasis on volume and the architectural "feel" of a composition, the study of light angles and perspectives; these are all problems that would absorb Cézanne over a long period. The balance and symmetry of the still lifes is deceptive, the result of careful organization of the tensions within the material. Objects are locked in dialectic confrontation, denying traditional constructional systems. But the denial is not flouted. Cézanne's art lies in the painstaking transformation of this collision of forces into an illusion of harmony and reality.

In the landscapes, the same principle is employed in presenting reality with greater stability and consistency. Coherence of vision, lost in the immediacy of Impressionism, makes itself felt in *Paysage à l'Estaque*, of 1876, the prototype of a series of views of the same place, painted over the next few years. The raised line of the horizon, the foreground, as it were, falling toward the onlooker, the concise spaces and the stunted perspective all declare an inner structure that offers a particular vision of nature and is, at the same time, the result of a deliberate aesthetic choice.

Cézanne, like Monet, would paint the same subject over and over again at different times and from different angles. He did over sixty versions of Montagne Sainte-Victoire and was still working on it in the year of his death. While Monet epitomizes a constantly changing world, in Cézanne the process of observation is slow, biologically and psychologically. Space expands and contracts. Distance is reached in the mind's eye yet it fuses with elements a stone's throw away. The design is two-dimensional; the laws of perspective are sacrificed as space gives way to a series of vertical planes. However, Cézanne does not seek to impose formulas on nature. Each brushstroke speaks of a direct experience, intensely perceived, or a refinement of that experience performed later.

The Paris exhibition of his work, mounted in Vollard's gallery in 1895, had an angry reception from the public and poor reviews but the avant-garde was impressed and Cézanne's

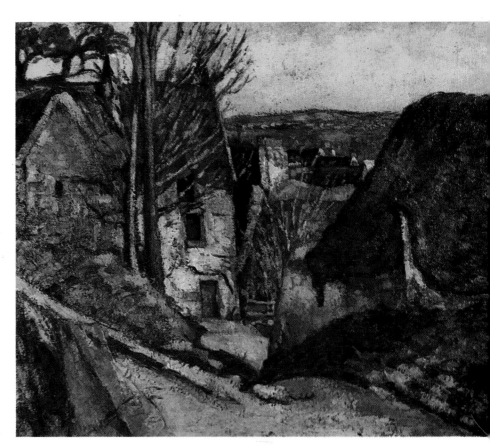

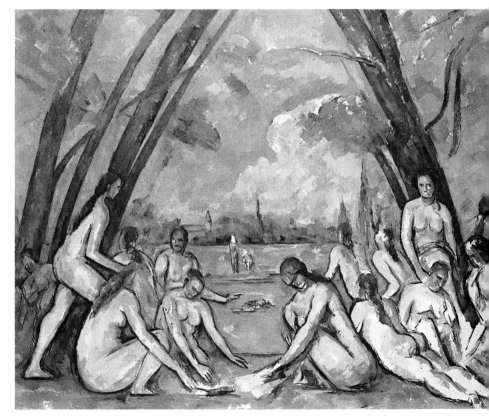

midal compositions that acquire structural meaning through the immense vitality of the parts. The spatial and constructional elements of these compositions show a desire for a greater discipline to counter the disintegration wrought by Impressionism, for a mediation between the traditional and the informal. Cézanne's light brush and the vigour of his resolutions were inspirations to his younger contemporaries, Seurat, Van Gogh and Gauguin, who saw in his example a way to deploy their own non-empirical meditations on canvas without encumbering the sense impressions. His legacy is neatly summed up in Maurice Denis's phrase "the Poussin of Impressionism," echoing Cézanne's own abiding ambition to create "Poussin taken from nature."

Post-Impressionism

By the 1880s, several artists were seeking new challenges in a move toward a more substantial art. Cézanne's studies in construction have been noted, while among the new generation of artists we see the emergence of styles characterized by methodically studied chromatic techniques and a more complex iconography, as in Seurat's neo-Impressionistic divisionism, Van Gogh's Expressionism, Gauguin's Synthetism and younger offshoots like the Nabis group.

friends were equally encouraging. To the young artists who came to his door, Cézanne would stress the importance of verifying abstract speculation through direct experience; "All things, especially in art, are the product of ideas developed and applied through contact with nature." With the passage of years he used to lament that the more he tried to express what he felt, the more the problems presented themselves. Taking a landscape as

example, he would trace the surfaces with his finger pointing out exactly where he had achieved true depth of expression and where the desired resolution was still missing, that is to say, where the tonal modelling was weak.

In the nude scenes, *Les Baigneurs*, of 1875–77, and *Les Grandes Baigneuses*, of 1895–1905, the principle is similar. Monumental groups of figures, their massive, primitive shapes framed by trees, form awkward pyra-

The neo-Impressionists, led by Seurat and Signac, based their technique on the principles of colour. They put aside improvisation and, by the methodical application of laws inherent in nature, created a style that reconciled precision and control with the values of sensation.

When Van Gogh arrived in Paris in 1886, he succumbed to Impressionist influences, lightened his palette and experimented with chromatic techniques. Endlessly exploring the expressive capacity of pure colour, he came under the influence of Gauguin's Synthetism before the pre-Fauvism and Expressionism of his final period.

After an Impressionist début, Gauguin stayed in the Breton village of Pont-Aven from 1886 to 1888 and, with the young Emile Bernard, developed the method of synthetism, or cloisonnism, which consisted in applying brilliant colour on boldly outlined flat surfaces. The two artists took their inspiration and images from the local peasant traditions and soon attracted a group of followers, Charles Laval, Paul Sérusier, Emile Schuffenecker, Armand Seguin, Louis Roy and the Dutch artist Meyer de Haan, who called themselves the School of Pont-Aven.

Le Paysage du Bois d'Amour (or *Le Talisman*), a small picture painted by Paul Sérusier in 1888 under the guidance of Gauguin, reveals in the spareness of its simple, abstract forms the point of transition from the Pont-Aven to the Nabis style. The Nabis – Pierre Bonnard, Edouard Vuillard, Maurice Denis, Ker-Xavier

Edouard Vuillard, Maurice Denis, Ker-Xavier Roussel, Paul Ranson and Félix Vallotton – formed as a group in 1888. They took the Hebrew word for prophet, "nabi," in reference to themselves as bearers of a new art; what they did was use the lessons of Gauguin in a new style of decoration, reinstating the grand tradition of decorative art.

The term neo-Impression, coined by the critic Félix Fénéon (*Les Impressionistes en 1886*), stands for certain artists who aimed to temper spontaneous techniques by more considered, obedient methods approaching the traditional rather than the empirical. They wished to bring stability back into art. Georges Seurat (1859–1891), key figure in this recovery, died very young having developed and perfected a brilliantly complex technique that brought a remarkable "finished" quality and a monumental sense of order to his work.

After an apprenticeship grounded in classicism, he delved into the problems of colour and luminosity, experimenting with *plein-air* themes. His guides were the theoretical works of Charles Blanc and the treatises of Eugène Chevreul and Edward Rood on the nature of colour. He became particularly interested in the law of simultaneous contrast, whereby the reciprocal influence of adjacent pigments produces an enhancement of colour, and used these studies to develop a method of bringing the unstructured aspects of Impressionism under control. He found also that a carefully worked-out arrangement of colour contrasts could produce a higher tonal result. He called this method Divisionism.

In *Une baignade à Asnières*, exhibited at the first Salon des Indépendants in 1884, a pattern of colour fragments is transformed into a minutely worked intellectual composition. The original sketch, prepared with quick dabs of colour, undergoes a meticulous revision in which all informal or unfinished traces of Impressionism are removed. The result lifts a contemporary scene – men and boys relaxing on the banks of the Seine against an industrial background – out of the present and into timelessness. Similarly the emotions have been rationalized and subdued; sensation no longer rings true; spontaneity has given way to a serene and solemn immobility.

In another *plein-air* scene, *Un dimanche après-midi à l'Ile de la Grande Jatte*, shown at the Salon des Indépendants of 1886, fashionable figures resembling tailors' dummies take the air in highly abstract poses. Seurat explained himself: "The Panathenaea of Phidias represents a procession. I wish to portray the people of our own time in the same manner, extracting what is essential.... I wish to portray them in pictures that express harmony of colour and line, with the direction of the colours and the orientation of the images in relationship to one another."

Seurat's invention produced an awesome, static art in which all aspects of expression are regulated by the intellectual process. It con-

sisted in breaking down colour into its primary elements and applying it in blobs of paint, a technique known as Pointillism. The optical mixture of these spots of pigment produces the exact effect of colour and light desired. No mixing of colours is necessary. Once the separate elements of the natural colours have been methodically organized, the task of fusing them together is left to the eye of the observer. Pre-knowledge of the result, by use of "reasoned method," is the process at work here, a process characteristic of the industrial age. Seurat appropriates the latest research and applies it to a conceptual world, with elements of Realism and Impressionism incorporated. The result is a new vision of humanity, society and nature; a tightly controlled universe, bound by inflexible laws.

La Grande Jatte is the paradigm of Seurat's revision of Impressionism. It had little impact on the public but was admired by artists like Charles Angrand, Albert Dubois-Pillet and Henri-Edmond Cross, who were poised to reject what Seurat referred to as "the hedonism of the retina." Reliance on intuition must cease. The subject, the time and the place must be premeditated and ideal and the execution strictly objective; a doctrine that sometimes bore awkward results. *Parade* is such a case. Exhibited at the fourth Salon in 1888, the contradiction between the animated nature of the event and its wintry, stylized

that is to say, heightened colouring and lines rising upward on the horizon communicate happiness and dull colours with downward lines create a somber mood. In *Le Chahut* the can-can image, a borrowing from the Impressionist arsenal, is perhaps a reflexive reaction to the experiments of E. Muybridge and E. J. Marey, whose photographic studies of the dynamics of movement foreshadowed the motion picture.

Synthesis and abstraction are the hallmarks of Seurat's last paintings. In the empty landscapes produced before he died in 1891, Impressionist luminosity has gone, along with the human form, leaving behind a veiled world, silent and remote.

Paul Signac (1863–1935) was the second major influence in the neo-Impressionist movement. He took the same scientific approach as Seurat but his style is generally less intransigent. In his theoretical study *D'Eugène Delacroix au Néo-Impressionisme* (1890–99), he argues that art, music and literature have an inherent harmony, a system of checks and balances as in nature. A man of advanced ideas, he suggested that art might be used as an educational tool.

His portrait of Félix Fénéon of 1890, painted on a colourful, boldly rhythmic background, is an affectionate statement of the elaborate theorems devised by Henry to establish a common structural aesthetic. Neo-Impression-

execution produces an uncomfortable, jarring effect. A similar note appears in two later scenes, *Le Chahut*, of 1890, and *Le Cirque*, of 1891. Here the contradiction is tempered by the use of bright colour, a culling from Charles Henry's ideas about chromatic effects, discussed in *Une Esthétique Scientifique* (1885);

ism spread beyond the borders of France, mainly through the activities of an avant-garde Belgian group known as *Les Vingt* (the Twenty), who mounted annual exhibitions in Brussels from 1883 to 1893 including, from 1887, paintings by Seurat and Signac. As the movement developed, it presented different

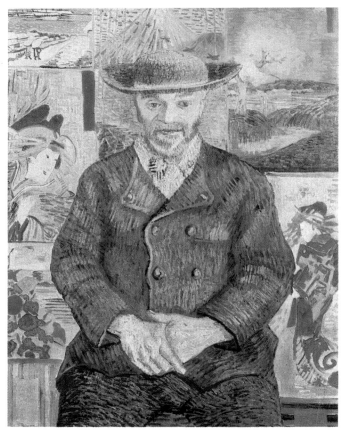

Above: G. Seurat, Parade, 1882–83. New York, The Metropolitan Museum of Art. A wintry, urban scene transformed into a solemn ritual. Figures veiled in gaslight stand in hieratic pose, like warriors on an Egyptian relief. The pale colour imparts a cheerless atmosphere and the foreground profiles, rendered with the manipulatory skill of the modern artist, have elements of caricature reminiscent of the posters and popular illustrations of the period.

Left: V. Van Gogh, Père Tanguy, 1887. Paris, Musée Rodin. The art supply dealer of Montmartre, a passionate admirer of Van Gogh and Cézanne, rendered with bold brushstrokes on a background of images taken from Hiroshige, Toyokuni and Hokusai. The artist said that "man is far more interesting anyway, and, above all, more difficult to paint."

types: painters like Henri-Edmond Cross, whose style was essentially decorative, or Maximilien Luce, who was influenced by Seurat's social themes. "Neo-Impression" was used more and more as a general term for the modern movement, its influences extending to Fauvism, Cubism, Futurism and Orphism. More immediately, its impact was felt by Gauguin and Van Gogh, who, with Cézanne and Seurat, were the most important innovators of the post-Impressionist era.

Vincent Van Gogh (1853–1890) was born in Dutch Brabant, son of a Protestant pastor. Events in the life of this great artist are legend. He had an awkward personality and no social gifts, but was ruthlessly sincere in his values and had a humble, passionate approach to art. In 1881, after an unsatisfactory attempt at evangelical preaching in the Belgian coal mines, he finally discovered his vocation: "to be able to express, through art, what I think and feel."

His early masterpiece *The Potato Eaters*, of 1885, is a compassionate study of poverty in the tradition of Millet. It has a blunt expressiveness untypical of Van Gogh's sentimentalist contemporaries. The earthen faces of the eaters seem to echo the characteristics of the humble staple. The sad, intense ritual, enveloped in gloom, is rendered with crude, accentuated brushstrokes, technically unskilled but laden with meaning.

Van Gogh moved to Paris in February 1886, to the home of his brother Theo, an art dealer.

He arrived in time to visit the eighth Impressionist exhibition and took immediately to Parisian influences, especially Monet, Sisley and Pissarro. On Pissarro's advice, he freed his palette of heavy earth tones, then set about a relentless program of work. He felt that something was lacking in the language of Impressionism. Van Gogh was always looking for better ways of expressing himself. He met Signac and painted briefly in the Pointillist manner. Although short lived, the experience helped him later when he was experimenting with pure colour. He also learned that Divisionist techniques could be adapted to produce greater depth of expression.

He painted under the stimulus of immediate sensations, with little regard for unity of style

across Japanese prints in Antwerp. In Paris he was able to study the work of Hiroshige and Hokusai. Attracted by the formality of design, the clarity of outline, and colour contrasts, perspectives and spaces, he was moved to write: "We like Japanese painting, we have felt its influence ... then why not go to Japan, that is to say, the equivalent of Japan, the south of France? Thus I think that after all the future of the new art lies in the south."

At Arles Van Gogh reached the peak of his career in the expressive use of colour. He arrived there in February of 1888 and was soon intoxicated by the strong southern light. His pictures become radiant life symbols, explosions of colour. He invited his friends, Emile Bernard and Paul Gauguin, at that time

experimenting with flat colour, to come and join him in his "yellow house" in Arles, hoping to make it a home and center for chromatic studies. It was a time of optimism and joy and Van Gogh transmits these feelings in a feverish burst of activity. *Le Semeur*, an idea taken from Millet, started in June 1888, is a bold, economical composition in which colour registers emotion. The sun is a golden disk of light, symbolizing renewal, while bands of shiny blue brushstrokes become fields glowing with organic vitality. Similarly, Van Gogh's sunflowers spread their vivid yellow as though bestowing life. However far he succeeded, he still doubted that he would ever achieve his dream to be a colourist the like of which was never seen before. Colour was the only medium in

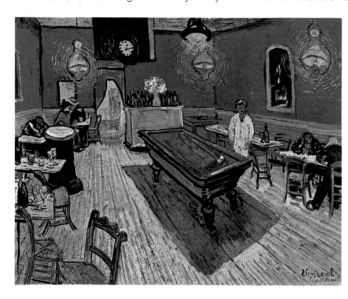

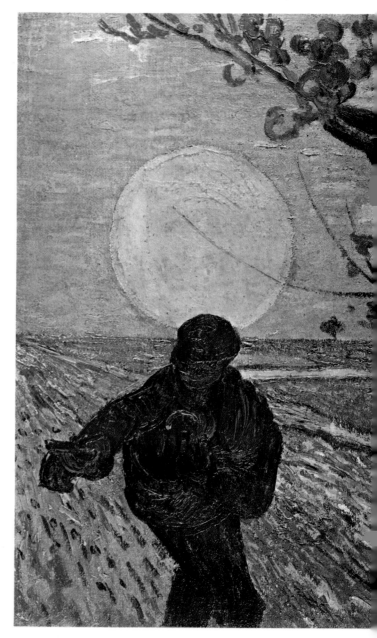

and colour. A harmonious, Impressionist surface would be broken by a sudden, exultant brushstroke; or a Pointillist paint surface would be disturbed by the insertion of an inappropriate colour. These aberrations mirror Van Gogh's impulsive, passionate nature. Whether landscape, still life or portrait, all are charged with the same love and energy, sometimes to the point of compromising the artistic effect. In 1888, trying to analyze the difference between his style and Impressionism, he declared that "instead of painting what I see before me, I use colour arbitrarily, to express myself with greater force." Landscapes are traditional in character, or reveal a way of communicating that is strikingly new, as in *Une vue de Montmartre*, of 1887, which has a hint of disquiet in its textures.

There are startling combinations of style in *Père Tanguy*, of 1887, and *L'Italienne*, of 1887–88. Both portraits are on a decorative background of Japanese inspiration, whose flat, stilted forms appear at odds with the rough execution and poetical vigour of the foreground elements. Van Gogh had first come

Above: V. Van Gogh, Le Café, le soir, *1888. New Haven, Yale University Art Gallery. A showcase of the latest innovations in French art, also showing conflict of a psychological kind. "The room is blood red and a dense yellow, with a green billiard table in the middle, and four lemon yellow lights, radiating an orange/green glow. All around are sleeping figures of low-lifers, dressed in competing greens and reds, introducing a chaotic note in the dismal, unused room ... the white suit of the café owner, who looks out from a corner of this furnace, picks up the surrounding lemon-yellow hues and luminous greens."*

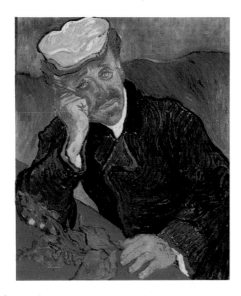

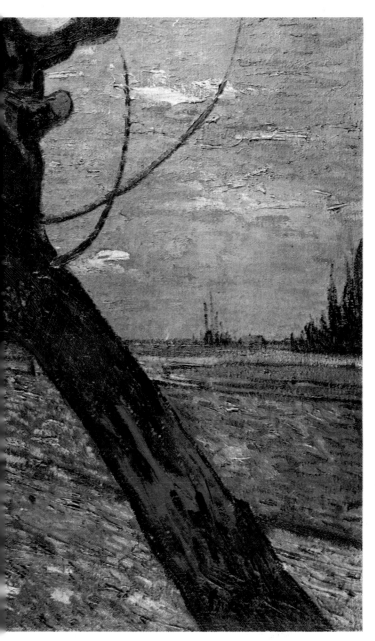

his vocabulary, the concrete expression of sky, earth and sun being the barometer of his moods. The euphoria did not last, the exultant hymn to the beauty and fertility of the south would soon be silenced by a profound, tumultuous agony.

Advance indications are present in the emanations of *Le Café, le soir,* of 1888. Elements of reality in the foreground, a flat Gauguinesque background, the Seurat-like nimbuses of the lights, are transformed and distorted to convey urgent emotions. "I have tried to express the terrible passions of humanity by means of red and green," he confided to Theo. A sense of foreboding is present: "a café is a place where one can ruin oneself, or go mad, or commit a crime."

These sensations persist in the farmscapes. Black twisted cypresses erupt out of yellow fields. *Champs de blé avec vol de corbeaux,* of 1890, imparts a sense of unease in the convergent paths that disappear, vortex-like, out of the picture foreground, while flapping crows – jagged black dashes – descend from an angry blue sky to merge with the savage brushstrokes of yellow wheat.

The Van Gogh repertory of associations invites comparison with Symbolist allusiveness. In 1890 the critic Aurier suggested that Van Gogh was almost always Symbolist because of his urge to give substance to the ideas that came to him.

The psychological events in the life of this driven man are well documented: the tormented weeks with Gauguin during the latter's stay in Arles, culminating in Van Gogh's self-mutilation; the mental breakdowns; the internments first at Arles, then at Saint-Rémy; finally, the suicide attempt of 27 July 1890, from which he died two days later. In spite of such appalling experiences, Van Gogh carried on painting and drawing, with an almost rapturous humility, to the end of his life. A letter dated 10 May 1890 says this: "I forget who described

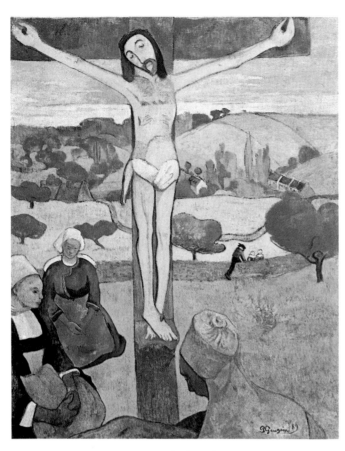

art was a vocation and lifelong apprenticeship, to which one must bring a total commitment and a religious fervour.

Born in Paris, Gauguin travelled extensively before settling down as a stockbroker. In 1881, already a talented amateur artist, he abandoned his profession and family to devote himself entirely to art. He saw the sixth Impressionist exhibition and visited Pont-Aven, in Brittany. There he was attracted to the local peasant traditions, so remote from the sophistications of Paris. His early work bore the influence of Pissarro. Soon distancing himself from his mentor, and from neo-Impressionist innovations, he remained drawn to the colour subtleties and vitality of Degas and the inventiveness of Cézanne.

While visiting Panama and Martinique in 1887, he looked for a medium that would reflect the moods and textures of a different climate and vegetation. Using his Impressionist formation, he developed a style with incisive outlines, flat areas of colour, strong decorative rhythms and accentuated hues, two-dimensional figures and no shadows (he maintained that shadows were a *trompe-l'oeil* of the sun and therefore unnecessary). Such a reversal of realist ideals, as exhibited in this new coinage, suggests a desire to mythologize, to invoke legends and mysterious rites.

Left: P. Gauguin, Christ jaune, *1889. Buffalo, Albright-Knox Art Gallery. Using spare, primitive language, the artist approaches his subject from the angle of spectator. He portrays faith in its fullest sense, trying to draw out its qualities of remoteness. Refinements such as the asymmetrical cross and the foreshortened perspective enhance the two-dimensionality of the main structure.*

my present state as being 'struck down by immortality' ... we drag our wagonload, that one day will be useful to people whom we do not even know ... even so, we feel in our bones that this thing is greater than we are, because we are each a small entity, and if we want to become a link in the chain of artists, we must pay for it with our health, youth and liberty.''

These were Van Gogh's thoughts when he started his last works at Saint-Rémy and Auvers, in the year 1890. The self-portraits are documents of devastating honesty. Plasticity gives way to abstract forces of great psychological power, through the medium of pure colour. His face stares out of a symbolic background, resolutely set against the terrors that surround him. In the portrait of *Docteur Gachet*, the melancholy of the gaze is the melancholy of Van Gogh, what he called ''the heartbroken expression of our time.'' The rhythms of the background and body are expressions of the inner condition, and a mirror of Van Gogh's tortured soul.

Cézanne's legacy was a powerful and original restatement of volume that would influence Cubism twenty years later. Van Gogh was concerned with the drama of the emotions, and the haunting strength of his colour images was an inspiration to Fauvists and Expressionists. Paul Gauguin (1848–1903) would also, by a different route, manifest the conviction that

Right: P. Gauguin, Orana Maria (Ave Maria)*, 1891. New York, Metropolitan Museum of Art. The mystery of the Annunciation transplanted in a tropical setting. The messages of Christian faith are erected in a sin-free earthly paradise where symbol and image live side by side as in medieval Christian art.*

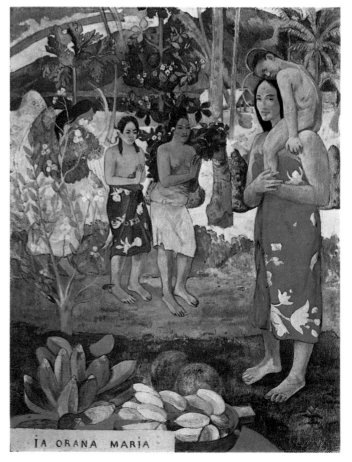

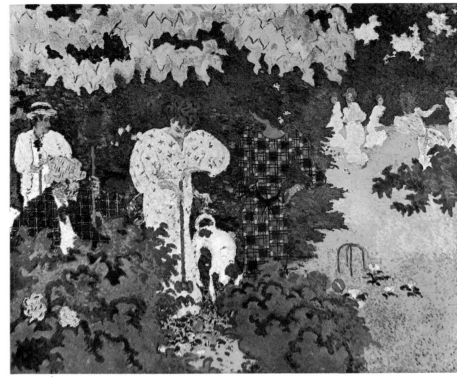

In France, meanwhile, the young Emile Bernard (1868–1941), with Louis Anquetin, was already experimenting with simple shapes, bold outlines and flat colour. The critic Edouard Dujardin baptized the style cloisonnism owing to the similarities with medieval enamel work and stained glass. By 1888, Gauguin had returned to Europe and established himself at Pont-Aven. With the important and influential support of the younger Bernard, he grappled with the problem of expressing religiosity as encountered in the Bréton peasant. "I love Brittany," he wrote, "here I have rediscovered what is savage, what is primitive. When my wooden shoes ring on this granite, I hear the muffled, dull, powerful tone I seek in my painting." These experiences, and his love of exoticism, generated a transfiguring art, in which the collusion of suggestion and description creates images that can be "received" beyond the pure registration of the senses. Stylistically, the effect of otherworldliness is obtained by the combination of elemental and intellectual themes with simple forms and few colour contrasts of a determined expressive quality. The technique was baptized synthetism. In his advice to the painter Emile Schuffenecker, Gauguin said that "art is an abstraction. Seek it in nature by dreaming in the presence of it, by thinking more about the creation than the result"; a credo whose antecedents are to be found in cultures and styles foreign to post-Renaissance illusionism, as in Japanese art, popular representational art, great primitives like Giotto, or the art of Egypt and Mesopotamia, and also in kinds of medieval decoration like stained glass and enamels.

Working side by side from 1888 to 1889, Gauguin and Bernard were becoming increasingly subjective in the expression of ideas and emotions, similarly in the pronounced abstraction of the colouring. Themes are Impressionist, but there is a notable absence of figurative and atmospheric realism.

The authentic piety of the Breton peasants made a deep impression on Gauguin, who felt that he had intruded upon their purity and integrity. The impact prompted the overtly religious Vision après le sermon (Lutte de Jacob avec l'ange), of 1888, an example of cloisonnism, in which two worlds, one real one imaginary, are divided by the diagonal of a tree branch but share the same red background. The derivations – Japanese engravings, Puvis de Chavannes and the perspectives of Degas – have been skilfully appropriated, giving the scene an exquisite, transcendent effect.

In the autumn of that year, Gauguin gave way to Van Gogh's insistent invitations and travelled south to join him in Arles. After nine dramatic weeks he was back in Brittany, presiding over a small community of artists calling themselves the School of Pont-Aven. In 1889, they exhibited at the Café Volpini as "the Impressionist and Synthetist Group," an ambiguous choice of title for painters whose interest lay in expressing spiritual rather than temporal concepts.

For his part, Gauguin, indulging a reclusive and introverted temperament, retreated to Le Pouldu, an even more isolated village on the Brittany coast, lying in the shadow of dramatic downland, almost like the contours of his landscapes. In this climate of introspection he composed Le Christ Jaune (1889), in which he tries to communicate "the rustic grandeur and simple superstition" of a primitive relic; the simple act of unsophisticated worship portrayed here acquires a mythic dimension in the regressive use of elementary, child-like forms.

Because the armoury of Impressionism lacked the means to penetrate, in Gauguin's words, "the mysterious center of thought," he sought it in the realms of religion and magic. A deliberate and increasingly pronounced allusiveness and ambiguity informs his art. The references multiply, to become the scaffolding for a complex structure of symbols. Literary Symbolism, too, with Mallarmé and Verlaine at the forefront, was denouncing the precept of objectivity. Mallarmé asserted that "to describe an object is to destroy three-quarters of the enjoyment – suggestion, that is the dream..." And such a dream Gauguin was to follow to its fullest consequences. Unable to shake off the restrictions of a codified reality, the artist rebel took his search for a mythical Eden to wilder shores.

On 4 April 1891, after a farewell banquet, he sailed from Marseilles for Tahiti, hoping to find in the exotic, relatively unspoilt Polynesian culture a suitable setting for his artistic temperament. His departure coincided with the appearance of an article by the critic Georges-Albert Aurier; by way of a manifesto, the article identifies Gauguin as founder of Symbolist art

and states that the movement is "synthetist, symbolist, non-empirical" and its art must therefore be conceptual, symbolical, synthetical, subjective and decorative – in other words, ways of giving shape to myth, emotion, dreams and intangibilities. Gauguin's Tahitian images and figures, in exemplifying these notions, become decorative emblems, deposited in an earthly paradise, in colour harmony with the luxuriance of their surroundings.

He had a fondness for combining images of daily life with sculptural motifs (from photographs of Egyptian, Greek and Javanese reliefs) in well-informed, meticulous compositions; but beyond the clever manipulation of ideas and the tropical palette lies the same striving for primordialism and mystery that informs the Brittany canvases.

Gauguin never found the formula he was looking for and, despite the autonomy he had gained, there were still times when he was unable to break through the constraints of programmatic intellectualism. But he remained steadfast in his quest, a solitary figure committed to anti-naturalism, freedom of design and colour, the workings of the imagination and the subconscious and, not least, to exoticism. The richness of his legacy would inspire a variety of movements in the new wave. The Nabis had already absorbed the lessons of Pont-Aven, while Fauvists and Cubists would discover Gauguin at the Paris Exhibition of 1906, three years after he had died, alone, in Tahiti in 1903.

The Nabis Group was a mystico-religious fraternity of artists who were committed to the revival of aesthetic ideas. The movement reflected two fundamental aspects of Gau-

Above: E. Vuillard, Jardins publics, La Conversation, 1894. Paris, Musée d'Orsay. The densely covered paint surface destroys the material essence of the subjects; a gentle melancholy pervades the richness and muted tones confuse the spatial outlines, giving them a vague and delicate appearance.

guin's art, spiritual symbolism and decorative synthetism, and combined a program of theological and metaphysical studies with the development of a new pictorial technique. Sérusier, Denis and Ranson lent toward themes of mystery or the occult while others – Bonnard, Vuillard, Roussel, Vallotton – created complex fusions of surface and image in homely, bourgeois scenes, such as a busy street, a garden rendezvous or the intimacy of an interior, thus restoring, though by different means, the images and moods of Impressionism.

They aimed to accentuate the picture surface through a totally integrated arrangement of superimposed figures and objects of equal compositional value. The effect is purely decorative, and reflects Maurice Denis's observation of 1890, that "a picture, before it is a warhorse, a naked woman or some anecdote, is essentially a flat surface covered in colours arranged in a certain order."

Autonomy of style, importance of form, faith in the supremacy of a pictorial tradition that imparts a mood, a "state of mind"; were the keys to Nabis art: atmospheric ornaments in which a close inspection of the surface "pattern" is necessary to detect the elements of realism, as in some panels of Bonnard, "le nabis japonard," or, as in Vuillard's interiors, where the material essence of the forms dissolves into the surface image.

The Nabis disbanded toward the end of the 1890s. Commemorated by Maurice Denis in *Hommage à Cézannc*, of 1900, the group is pictured in Ambroise Vollard's gallery admiring a still life by Cézanne that had once belonged to Gauguin. The inspiration is Fantin-Latour's *Hommage à Delacroix*, of 1863 – year of the historic *Salon des Réfusés* – depicting painters and writers grouped around a portrait of the great Romantic artist. The Denis canvas thus represents an ideal "handing down" between the generations, a bridge from Delacroix to Cézanne and between Cézanne and the younger artists, through the medium of Gauguin, prime mover of their work and owner of the object of veneration in the picture: the still life that proves the staying power of the grand tradition, even in the legacy of Impressionism.

Left: M. Denis, Hommage à Cézanne, 1901. Paris, Musée d'Orsay. From left to right, in the gallery of Ambroise Vollard gathered around a still life by Cézanne are Redon, Vuillard, the critic André Mellerio, Vollard, Genis, Sérusier, Ranson, Roussel, Bonnard and Marta, the wife of Denis. A homage to Cézanne, and to Redon and Gauguin, too.

Symbolism and Art Nouveau

The identity and aims of Symbolist Art

Symbolist painting has been slow to shake off its reputation as art which suffers from literary contamination and historicism. According to some critics, it lagged so far behind contemporary artistic trends that they felt justified in using the description "regressive" in the context of the evolution of a modern artistic language. Symbolism's detractors believed that the inventive and progressive inheritance had passed to Impressionism and, by way of Post-Impressionism, ushered in the avant-garde movement in the early years of the twentieth century. The comparatively recent adoption of a more dispassionate, less partisan and blinkered critical approach to the figurative phenomena of the late nineteenth century has enabled us to extend and deepen our knowledge and understanding of the movement's most innovative personalities, among them Moreau, Puvis, Böcklin and Khnopff. Only thus can we hope to acknowledge the true quality of their paintings, the variety and richness of their themes, and to describe a recognizable Symbolist movement which was to become widely established.

The critical literature of Symbolism – whether contemporary, written when the great names of the movement first exhibited their paintings, or at a later date with the aim of evaluating the whole phenomenon of Symbolist painting – is of inestimable value. If we draw upon this critical literature, on the works of the great exponents of Symbolism and on our knowledge of the theories and development of the movement, it is possible to identify a great

variety of forms of expression used by the artists whose works are grouped together under the description "Symbolist art." Among them are some who are tainted with historicism and others who paint in an almost conventional manner, reminiscent of academism; these artists perpetuate the Classical concept of form, yet they are practitioners of modern art, Gauguin and Munch being two good examples. Then there are those artists whose work falls within the sphere of Symbolism but not wholly within that of "pure" art: such names as Beardsley, Mackintosh, Mucha and Gallé are synonymous with the decorative arts (illustration; architecture and decoration; murals and carpets; glasswork, among other applied arts).

It might appear that the "Symbolist movement" is a misnomer if we take into account the coexistence of Synthetism in the works of Gauguin, the Nabis; in art nouveau and *Jugendstil*; of other paintings which are very reminiscent of Romanticism and even seem to perpetuate Salon taste. What is the common factor which links these many and varied forms of expression? Certainly not style. Although Synthetism and the exuberant linearism of Art Nouveau can be described as styles, the

A. Beardsley, The Dancer's Reward, *the famous illustration for Oscar Wilde's* Salome, *1894. To his contemporaries Beardsley was the epitome of decadence.*

"language" element of Symbolism is not of prime importance. Unifying elements are to be found elsewhere, mainly outside the paintings themselves. This certainly holds true when charting the history of the movement, beginning with the foreshadowing of its birth, when Moréas published his *Symbolist Manifesto* (formulating the principles of this new French school of poetry) in the literary supplement of the *Figaro* in 1886. It is also valid for the mature phase of the 1890s: the so-called Symbolist "wave," a word which aptly conveys the indefinite, fluctuating, ineffable quality inherent in the artistic and spiritual climate which went under the name of Symbolism.

The revolt against Naturalism precipitated the disintegration of that poetic school in one European country after another within a short space of time; it also led to the birth of Symbolism, albeit in the wider context of a crisis of ideals, values, and subjects rather than as the result of the exhaustion of an earlier artistic language. Those artists whom we regard as the precursors of Symbolism shared a tendency to repudiate realism; all – or nearly all – of them had their roots in the Romantic movement and had been working throughout the realist era, isolated and apart, precariously balanced between academism and self-expression. Their immediate successors, younger artists who embraced Symbolism, were consciously distancing themselves from Impressionism with a fixed determination to go beyond that fundamental experience.

In most cases, however, the break with realism did not involve the abandonment of the objective image and rejection of tangible evi-

dence in order to adopt another artistic language. Themes linked with current events and reflecting everyday reality, those which mirrored the world about them, were abandoned in favour of untrammelled, more direct contact with the great masters of the past. Symbolism involved the enrichment of the content of a painting with literary, poetic, mythological, religious, and/or psychic references. And naturally, the works of the Romantic poets played a vital role, continuing to influence and inform the contemporary thought and artistic tendencies in a subtle, introspective, almost clandestine manner. Hence the description of Symbolism as "a Romanticism whose aim is to portray

the interior world" (Chassé) or even as "the crystallization of a spiritual state brought to life by Romanticism." Even Munch, an outstandingly innovative painter, identified a harmony between the Romantic school (preoccupied with feelings and the senses) and Symbolism which, he believed, had restored mysticism (sacrificed for more than a generation) to its rightful place as part of man's nature.

Symbolism is not, however, a replica of Romanticism in a different guise, even though its precursors were all active during the unfortunate phase of eclecticism when historical erudition, academism, romantic dross and truth were the fashionable artistic catchwords

of the day. In his Manifesto, Moréas rejects the Parnassians' explicit allegory and their use of formalism as an end in itself. The Symbolists might otherwise have run the risk of being linked to the *Parnasse*, since their new poetry aimed to "clothe the idea in sensuous form." He goes on to state that the idea must be brought home to us by indirect means, using symbols, objects, and images which possess an evocative, magic, or mystical power and which are open to another meaning; retaining a certain mystery. As Mallarmé, the most authentic poetic interpreter of a sense of the mysterious and the ineffable, had expressed it: "the symbol lies in the perfect use of this mystery; in the very gradual evocation of an object in order to portray a state of mind or, conversely, the choice of an object and its use to conjure up a state of mind through a series of decodings." The poet must trust to his intuition, the essential attribute and the perfect example of the indecipherable. This objective was achieved by the great modern Symbolist, Odilon Redon.

Symbolism, however, has many other facets, among them the outward evidence of decadence; of conventions in taste which would be unacceptable today. The movement assumes the identity of the painting of ideas, with a multitude of philosophical and literary connotations and moral values. The alienation between the artists and their time is expressed in their flight "elsewhere" (into the past, into the realms of poetry, toward ancient civilizations, into the self). This flight and the formation of elitist groups and associations of artists outside official, establishment groupings are expressions of the need to confront a civilization based on profit and material well-being, on the myth of technological progress and on imperialist ambitions (a world in which the artists felt they had no place) with another reality. Art is thus entrusted with the ambitious task of resolving the questions for which science and traditional religion could no longer provide answers. Art was to become a field of knowledge, a method of research into the truth; a means of creating a true and eternal reality, beyond the illusory and disappointing reality of appearances and occurrences. But by what means? Not through reason and science, for it was becoming increasingly obvious how inadequate they were as tools for grasping hold of the meaning of a world in a state of flux. The answer must lie in those human faculties most alien to reason: imagination, intuition; in the association of ideas; in memory and dreams.

Baudelaire was inevitably adopted as a fundamental point of reference, and in his *Manifesto* Moréas states that Baudelaire "must be recognized as the forerunner of the present movement." The Romantics had emphasized the value of individual sensibility and imagination in the creative process; Baudelaire – with his exceptional intuitive powers, untrammelled at that particular point in history by any active

civic or social sense of duty – formulated a system by which man could be helped to understand the deeper significance of life. His theory of synesthesia was founded on the "correspondences" which exist between the various aspects reality assumes in order to reveal itself to us. Baudelaire had developed his theory as a result of his own profound response to the music of Wagner. As with any "true music," he wrote, it had the power to "suggest similar ideas to different minds," and he explained this phenomenon by his principle of correspondences, saying: "it would indeed bc surprising were music unable to suggest colour, colours to convey the idea of a melody, and sound and colour incapable of translating ideas, since these are always expressed through a reciprocal analogy, from the day when God created the world as a complex and indivisible whole" (*Wagner and "Tannhäuser,"* 1861). And for Baudelaire, imagination was the "queen of the faculties" when it came to grasping these correspondences and perceiving associations between apparently disparate realities, thus establishing new relationships subject to laws which were not rational but deeply human, and creating a new world.

The synthesis of the arts is a central and unifying theme of Symbolism, in various guises. This transcendence of the traditional division of artistic genres was put into practice by *art nouveau*, which identifies "art" with architecture and decoration, producing monumental art rich in symbolic values which go beyond the significance of the subject covered, expressed in symmetrical and linear forms. But first and foremost this artistic theory demands that we recognize the affinities which exist between painting, poetry, and music.

Origins and development of French Symbolism

Moreau. The first useful pointers when outlining the figurative territory of Symbolism are those provided by writers, guided more by subjectivity and taste than by critical sense, who identified works which fired their imagination and found an echo in their souls. These writers recognized affinities between literary and figurative forms of artistic expression.

The spirit of "decadence," a term which denoted the decline of a civilization and a general crisis of values, led to a demand for experiences and products which were exceptional, refined, out of the ordinary, capable of stimulating jaded palates. This found radical expression (and was to have important consequences for the definition of the earliest Symbolist art) in Huysmans' novel *A rebours* (Against Nature), 1884, the breviary of decadent aesthetics. Huysmans was a deserter from Zola's school of Naturalism and an observant critic of examples of original art. In the character of Des Esseintes he created the type of decadent aesthete who was unable to tolerate life in contemporary urban and natural reality, isolated in his illusion of an existence founded on the substitution of the exceptional for real life. The exceptional is based on poetic invention and on turning current values and ideals upside down; it is also buttressed by the choice of literary texts and works of art.

The "myth" of Moreau originated during the mid 1860s, with works which, while drawing on conventional mythological subjects for their inspiration, infringed the canons of Salon art. "These paintings were so strange in appearance, of a studied originality, aimed to appeal to refined and delicate tastes," noted Gautier in 1866. But only at a later date did he really reveal himself as a painter of the imagination in his paintings on the theme of Salome; the resulting critical appraisal expresses disorientation, using terms such as "dream," "hallucination," "vision."

Gustave Moreau (1826–98) had started his artistic career as a historical painter, with an ambition to portray "the great heroic deeds in the history of mankind." He had studied the Renaissance masters – Carpaccio, Mantegna, Leonardo da Vinci – and the Flemish painters; he was also attracted by the literary erudition, the perfectionism and preciousness of the prevailing taste in painting at that time. In his *Hercules and the Sphinx* (1864), *Orpheus* (1867) and *Hercules and the Hydra* (1876), however, he shows that he does not subscribe to academism, nor to the Parnassians' cold formalism. He endows his mythological subjects with a significance beyond the conventional moral and didactic meanings which his public expected; the static and fixed quality of his figures, the importance of the surroundings and scenery; the significant details; the recurrence of motifs the confrontation between Man and Woman, the awareness of death, the high value of poetic creation – all tend to suggest a sensitive artist of great refinement. In the midst of Paris, Moreau was isolated, an outsider who espoused mysticism and literary erudition in the midst of the Third Republic, with its lay and progressive ideals.

In his late period, Moreau painted extremely free works (*Angels of Sodom, Orpheus at the Tomb of Eurydice, The Angel of Death,* etc.), revealing a sentimental and melancholy state of mind, but his artistic legacy is *Jupiter and Semele* (1894–95), the most complex and pictorially elaborate of his mythological subjects. The significance of the painting, showing the birth of life from the bowels of the earth and

the ascent to the divine light, does not emanate only from the large number of people who inhabit it, but also stems from the splendour and richness of the pictorial material and from the use of colour, as if the artist had wanted to reach beyond the technical limits of painting to create an imaginary universe. The function of the colour is not to reproduce reality but to interpret it, appealing to the mind as well as to the eye. He passed on this imaginative use of colour to his pupils, later to be known as the *Fauves*: Rouault, Matisse, Marquet.

The central role given to the female image in Moreau's paintings, imbued with symbolic meaning, is in the mythological and literary tradition. It is reminiscent of the Pre-Raphaelites and especially of those aspects of the English movement which served as a spur to the linkage of Symbolism and Art Nouveau, in an international context, through such members of the Aesthetic Movement as Burne-Jones and Rossetti. Burne-Jones, best-known of the Pre-Raphaelites to Parisians in the early days of Symbolism, resembles Moreau in many ways: his painting not only breathes melancholy, the reaction of a gentle and sensitive spirit, but also reveals his love of the linear arabesque.

Pierre Puvis de Chavannes (1824–98) was a contemporary of Moreau and Burne-Jones. He was a painter whose character, lifestyle, and profession set him apart from Symbolist circles. His work was far removed from Moreau's ornate formality and studied style, yet from 1880 onward he received unconditional admir-

ation from poets and artists. Khan and De Wyzewa praised his "poetic and misty" painting; they even found "the faulty draughtsmanship and the lack of colour" attractive. No one questioned Puvis's honesty and noble aims; his new, delicate, and harmonious painting served as a useful lesson in style for the painters who wished to venture beyond Impressionism. Puvis attaches no importance to this, while admitting that his primary problem as a painter lay in finding an image which could convey a clear idea or, more accurately, an idea which has become distinct in his own mind. This can be said to smack of Symbolism. Puvis de Chavannes had already built up a considerable reputation as a decorative artist; he had completed large wall paintings and murals for public buildings, and more were to follow: at the museums of Amiens, Marseilles and Lyons; for the Sorbonne, the Panthéon and the Hôtel de Ville; a great number of such commissions were awarded at the time of the Third Republic, when monumental decorative projects were enthusiastically promoted.

Puvis was an innovator in the decorative arts; he was cavalier in his observance of the rules and technical prescriptions which tend to separate murals from easel painting and thus foster a rift with the conventions of the neo-Baroque school. The first rule is that decorative art must become an integral part of a building's architecture and complement its walls. There must be clarity of form; clear, attenuated colours; a toning harmony to achieve an effect to unity. The real novelty lay in the fact that Puvis did away with all differ-

ences between decorative art and easel painting. Clarity, formal correctness, an almost impersonal detachment, a sense of calm and serenity, as if time and life had been suspended, distinguish *The Dream* (1864) and *Summer*; these paintings still exhibit a Classical conception of figures and landscapes.

The growing stress placed on viewing compositions as a whole and on decorative synthesis endowed this artist's work with great simplicity, to such an extent that they are sometimes naïve and inconographic (*The Beheading of John the Baptist* [1870]). This reductive process does not detract from the subjects – it actually makes them clearer and more significant, to the point of lending them a symbolic value. Paintings such as *Hope* (1871) and *The Poor Fisherman* (1881), simple yet enigmatic works, which portray a condition of great human misery through their uncompromising shapes and tones, were not understood by contemporaries; yet they were to become seminal works for the Symbolists.

Musical painting. The Wagnerian cult was of great significance in the development of Symbolism's aesthetic philosophy: originating in Baudelaire's circle, nurtured by contemporary music enthusiasts and gathering strength with the foundation of the *Revue Wagnérienne* (1885) by Dujardin (a pupil of Debussy) and De Wyzewa, with the aim of disseminating Wagner's thoughts and artistic ideas. The literati who aspired to link all figurative expression with music (which inspired such expression by the process of antonomasia) acknowledged Henri Fantin-Latour (1836–1904) as *the* Wagnerian Symbolist painter, whose paintings of the imagination draw their inspiration from Wagner's operas – his scenes were inspired by *Rheingold, Tannhäuser,* etc. Lithography had become a mass-market method of reproduction and was soon elevated to the level of an art form, benefiting from a new procedure using transfer paper, which made it possible to achieve a variety of tones, subtlety of shading, and transparency of colour.

These were expressions typical of the contemporary artistic mentality, proof of the suggestive power and influence which Wagnerian opera – founded on the unity of music, dramatic and scenic action, costumes, magical effects – exerted on all who came in contact with it. Carrière was linked to Symbolist circles; his misty, shrouded, and reductive paintings, intended to "portray inner life and enlightenment," have their roots in Wagner's soaring melodies, in his music's psychic resonances, interpreted in a sentimental key.

Redon. Odilon Redon (1840–1916) also maintained that his work was evocative in the same way as music; not, however, in the literal sense of transposition of colours and signs from the musical world, which he says is "wholly and exclusively interior and without any support in

the real world of nature." The key to his painting is to be found in the Baudelairean analogy, of which he is the most authentic interpreter. When he works in black and white, he makes use of all the resources of *chiaroscuro* and line; he combines and juxtaposes different themes with no relation to visible and contingent reality but with their own logic, which links the metaphor-drawings to the world of music.

"Unexpected apparitions ... drawings which went beyond every boundary ... leaping beyond the confines of all painting"; thus Huysmans introduced Redon's drawing of Des Esseintes's ideal picture gallery, and devoted much space to descriptions of the subjects: strange, at the outer limits of hallucination, nightmare, and delirium.

Redon belonged to the Impressionists' generation, and although he distances himself from them – likening their painting to a low-vaulted edifice, unable to soar above the constraints of the visible – he himself was fascinated by the natural world and science. His awareness that art is a territory without boundaries, where the artist can offer his own explanation of individuality, meant that he fully shared the sensibility of the Impressionist era. His visionary style springs from a different relationship with nature. Redon's artistic development was spread over an unusually long period, drawing on an interior world to produce amazing figurative inventions. He owes a lot to his sensitive and introspective temperament; from childhood he contemplated and observed nature, and was receptive to a wide

range of stimuli which he used to achieve knowledge of his inner self.

Redon's training was not conventional; his was an education of the spirit and of taste. The botanist Claraud awakened his interest in science and in the observation of affinities between different forms of life with particular reference to micro-organisms, and also introduced the artist to the works of Poe,

Baudelaire, and Flaubert. Rodolphe Bresdin (1822–85), a solitary, eccentric and talented artist who produced engravings of detailed realism which were also fey and visionary (well represented in Des Esseintes's collection), taught Redon etching technique and led him to share his love for fantastical subjects; he also prompted Redon to observe insignificant, everyday objects and use them to fire his imagination.

Redon received considerable help in his search for his own artistic voice and, as he himself said, toward the expression of the unique gifts with which nature had endowed him. Frequent meetings of art and music enthusiasts in Royssac's salon played a part in this; as did his friendship with Mallarmé, with whom he shared great affinity of artistic perception. In his early period he worked almost exclusively in black and white, producing charcoal drawings and lithographic albums (*In the Dream* [1879]; *Homage to Goya, The Origins* [1885]; *The Temptation of Saint Anthony* [1888]; *To Flaubert* [1889].

Redon usually drew from life, and used these realistic drawings for his visionary compositions; he considered his more fantastic works no less "real," since each vision is part of the self, of his own personal history. He explains it thus: "My originality lies in giving life and human attributes to unlikely beings, in bringing them to life according to the laws of probability, placing the logic of the visible at the service of the invisible wherever possible – leaving, however, a margin of the inexplicable, related to an art in which he "has placed a small door opening on mystery," into the unconscious. Fantasy plays a vital role in the creative process: it is the "messenger of the unconscious," revealing facts which the artist must be ready to gather up at the right moment. This brings us to the modern dimension of psychic Symbolism, the means of knowing the self.

Redon's long and successful colour period began during the last decade of the nineteenth century; he continued to make much greater use of colour, while maintaining the same high quality of work until 1911, undertaking the decoration of the Abbey of Fontfroide. This development does not represent a change in his attitude, other than as the expression of a psychological state of greater freedom, serenity, and contentment on personal and professional levels. "Colours," he said, "have a joy in them which extends and gives greater plasticity to dreams." He admired Moreau, and mythological creatures from that painter's work now make their appearance in Redon's painting, divested of narrative significance and explanatory details, existing only for their evocative and fantastic properties, bathed in expanses of pure colour. Figurative motifs from the "black" period reappear: heads and profiles, flowers, delineated by faint linear outlines with a psychic resonance, juxtaposed with shapes which reach the limits of

abstraction, in accordance with one of his fundamental principles: always to place certitude next to uncertainty.

Symbolism and Post-Impressionism

It is difficult to trace a Symbolist tendency in painting which corresponds to the *Zeitgeist*, or spirit of the times, and yet simultaneously has an affinity with contemporary poetic language; this is demonstrated by the relationships which developed between Post-Impressionist writers and painters. The chronological coincidence between the birth of the Symbolist movement and the changes in painting revealed in the last Impressionist exhibition seems to suggest the existence of "correspondences." This was in fact the case, albeit in an environment which was in certain aspects divergent and ambiguous. In spite of the friendships they enjoyed with the literary movement, the neo-Impressionists were never thought of as Symbolists, due to the scientific and programmed character of their art, with subjects drawn from everyday life. The best example of this meeting of minds is the influence which Henry had on Seurat, the former being interested in all branches of science and art and associated with the poetic Symbolist movement. The extension of physiological problems to aesthetics – determining lines, directions, pleasing and unpleasing colours, and thus dictating the shapes and lines of a picture according to the impression and the emotion the artist wished to convey – meant that the truths of science were still being applied to art.

Gauguin's relationships with the Symbolists are more clear-cut, although founded on a considerable ambivalence on the part of the artist himself: between a painter's temperament and literary leanings. The relationship was, however, developed on two planes: Gauguin's fleeting encounters with writers, and the formulation of a rigorous theory of modern Symbolism, which was in fact founded on the paintings of this "sublime visionary" (Aurier). But which paintings? Naturally, those which express a synthesis in the form of a complete, accomplished style; in themes which unite the planes of reality, mind, and vision (*The Vision after the Sermon*).

In this synesthesia Aurier and Morice identify "the most significant aesthetic fact of our time," the answer to the "obvious striving toward a synthesis of the arts in every art" – a new technique which goes beyond the formal fact. The artist embarks upon a different relationship with nature: he no longer paints from life but from memory, so that only as much of the "reality" which has penetrated that artist's sensibilities will be reproduced in his work – the essential element: the idea. The picture thus contains, at one and the same time, both the subjective view of the artist and the truth.

In his need to detach himself from Impressionism, to work in the mysterious center

of thought rather than through the eye, Gauguin turned to a very wide system of references; he was no less interested in the philosophical and mystical suggestions of his younger friends, who were fond of theorizing, than in their uncertain attempts to synthesize line and colour. It may well be true that for a time he fell "prey to the men of literature" (Fénéon) and that the admiration of writers satisfied his narcissism; but it is no less true that he served as an object lesson in the fascination of a style of painting which included ideas and moral objectives, literary allusions and mysterious symbols (*Self-portrait with Halo*, the Portraits of Meyer de Haan *Soyez amoureuses, vous serez heureuses* [Be in Love, and You'll be Happy] and *The Loss of Virginity*) painted with a certain detachment, not without irony in the face of the Symbolists' dogmatism (the caricature-portrait of Moréas, *Soyez symboliste* [Be a Symbolist] [1891]). The free and anarchic spirit of later Symbolism appealed to him and coincided with his view of the artist as misunderstood and hounded by society (*Self-portrait: "Les misérables"*); he revealed his awareness that art and beauty are the prerogatives of those who fight for the light of truth and for humanity. But there is an underlying warning that all this distances him from his essential preoccupations: to be free and to fuse inspiration and execution, keeping the instinctive quality of creation intact in the finished work.

The lesson of liberty of form and the mystico-religious implications of Gauguin's painting and those of the Pont-Aven group find their direct heirs in some of the Nabi painters, Sérusier and Denis in particular. These painters, living in the heart of Paris, found ways to escape from banal everyday life, devoting themselves to the theater and to the decorative arts, practicing an all-embracing concept of art which is identified with life. The cornerstone of their aesthetic beliefs is the principle that a work of art is the communication of a sensation through "plastic equivalents." As Denis explained: "Emotions or states of mind caused by any sight conjure up signs in the imagination of the artist or plastic equivalents which can reproduce these emotions or states of mind... There is an objective harmony which corresponds to every state of our sensibility, which it can interpret." This search for plastic equivalents – "but beautiful ones," as Denis specifies – means that priority has to be given to the decorative *mise en page*, or execution of the work: to elegant, sinuous linearism, condensing the ideal and symbolic contents into a visual phenomenon; it means, effectively, to go beyond all barriers in the pure two-dimensional "*art nouveau*" ornamentation.

The spread of Symbolism

Rose-Croix. During the last decade of the nineteenth century, Symbolism took on an

international character and progressed in many different directions; this was sustained by the emergence of the "shock troops" of modern art, backed up by reviews, exhibitions, cross-fertilization of ideas and influences. Paris remained the chosen center for young artists who came to learn their craft, predominantly from northern Europe, and cultural trends were disseminated from the French capital. Brussels, Berlin, Munich and Vienna also became artistic capitals. Péladan, an ambitious and proselytizing painter, founded the Circle of the *Rose-Croix* and from 1892 to 1897 he organized annual exhibitions which were open to artists who shared his aesthetic and religious ideals to a greater or lesser extent. He felt that art was a spiritual mission, its object to fight contemporary civilization's materialism and scepticism and to uplift men's spirits, filling them with a sense of beauty, synonymous with high morals and happiness. If art is a religion, the artist is its priest and his creation has a divine value; he must choose edifying subjects which uplift the spirit; he must eschew realism and genre subjects, emulating the Renaissance masters and observing once more their formal canons of beauty.

Imitators and less talented followers of Puvis and Gauguin, belated Pre-Raphaelites and neo-Renaissance painters thronged to the Salon of the *Rose-Croix*, but they were also joined by original and innovative artists. The closest to Péladan was Jean Delville (1867–1957), foremost among the idealistic initiates, but the most original was Khnopff; both were Belgian.

Symbolism and Idealism in Belgium and northern Europe

Symbolism gained such tremendous momentum in Brussels that the city became the center of one of the French movement's most exciting offshoots; this stemmed from the fact that Brussels played its part in a rapid and complex process of renewal which commenced in the middle of the 1880s, with the spread of Impressionism and Post-Impressionism. These flourished due to a unique phalanx of artists, writers, and exponents who sprang from a bourgeoisie which was receptive to all expressions of modern art. The French and English works (especially in applied arts) which appeared in the exhibitions of the *Les XX* and, later, in the *Libre Esthétique* led to the rapid emergence of artists who could meet the challenge of a global cultural renewal.

The more monumental results were achieved in architecture and in the decorative arts, by Horta, Van de Velde, Hankar, Serrurier Bovy, etc., but there was a synergy between the various artistic fields, and it was no mere chance that Idealism and Symbolism were shown beside the new *coup de fouet* ("whiplash") style from 1894 onward, in the exhi-

P. Gauguin: Soyez amoureuses, vous serez heureuses, *1887–89. Museum of Fine Arts, Boston. "One of the finest and strangest of my sculptures," Gauguin declared to Bernard. In this work he sought to express his thoughts on* love, *at a time when he was engaged in an uneasy search for his own inner identity and attempting to make direct contact with his untamed sensibility. The work conveys a feeling of anguish, belying its title.*

1921), a forerunner of Idealism and a painter of ambitious allegories, a draughtsman capable of portraying silence and "the soul of things"; he also felt the impact of the works of Moreau, Rossetti, and Burne-Jones. Khnopff reinterpreted the themes of these artists' painting, approaching them from an entirely new interior perspective in which the self, memory, and dreams play a central role. This also applied to themes taken from Péladan; art as a higher form of existence, an ideal element where the conflict between thought and instinct, the material and the spiritual, is resolved; the androgyne, the ideal and perfect being, uniting the male and female principles; the sphinx, incarnation of contemporary doubt and uncertainty. References to the poets – Mallarmé, Maeterlinck, Rodenbach and Le Roy – take the form of associations between words, phrases, and images. Khnopff's female subjects have a Pre-Raphaelite beauty and are drawn from literature. He has dropped descriptive references and attributes and confined himself to depicting features and accessories symbolic of states of mind and conscience which facilitate communication with self: isolation, silence, dreams, memory. *Mihi* and *On n'a que soi* (One Has only Oneself) are his watchwords. His characters cannot communicate with each other, nor with the spectator; they do not live in the present but in the atemporal dimension of the memory. His rare landscapes – views of Bruges, the ideal Symbolist city – are relived in the mind and express immobility, absence of life.

The light, ethereal pastels; the bland, almost impersonal treatment, confer upon the figures a precision and a presence which contrast with the sense of estrangement in *Memories, Art (Caresses), I Lock My Door upon Myself,* and *Sleeping Medusa.* These works seem to have a clear meaning while rejecting visible reality, underlining its illusory quality and contradictions; they have to be deciphered, like riddles.

Khnopff is a perfect example of *fin-de-siècle* aestheticism, but he is also extraordinarily modern and prefigures certain atmospheres in Belgian Symbolism, evoked by later painters such as Degouve de Nunques (1867–1935), whose uncompromising and hieratic nocturnal scenes were intensely poetic. Degouve was, however, closer to the "Mystics," whose paintings were imbued with a religious and humanitarian ethos and with an underlying pessimism, which are expressed in a primitive and stylized form or lean toward expressive deformation. Foremost among the Mystics was the sculptor Georges Minne (1866–1941), whose adolescent figures adopt poses which symbolize introspection.

The work of the Dutch artist Jan Toorop (1858–1928) was more progressive and more fertile. He was a painter full of spirituality who was influenced by Redon, by the Pre-Raphaelites, and by Egyptian and Japanese art. In such complex compositions as *The Three*

bitions held by the *Libra Esthétique* association.

This surge of artistic modernity reflected a changing social and economic climate and the existence of a vigorous and open cultural life, but it was Symbolism in particular which encapsulated (with varying degrees of success) the underlying pessimism and disquiet which permeated an outwardly stable, rich, and forward-looking society. The barriers and limitations in the lives and mentality of the inhabitants of Brussels had created an ethos quite unlike that of Paris. All the Symbolists had a negative attitude toward contemporary life: the Idealists and the Mystics fabricated artificial contrasts by projecting their imagination into another reality, into the realm of the spirit and of beauty, into nature and into ancient civilizations. Others, such as Rops and Ensor, stripped them bare in a direct and provocative fashion.

One of the most original of the Idealists was Fernand Khnopff (1858–1921). The quality of his painting and his modern sensibility made him one of the most significant members of the European Symbolist movement. Khnopff was influenced by his teacher, Mellery (1845–

Brides and *The Song of the Ages*, he adapts Rosicrucian/*Rose-Croix* themes to a welter of aspirations espoused by the Symbolist movement: toward a renewal of society based on the triumph of spiritual values. He uses an accentuated linear stylization for the symbolic expression of psychic "correspondences." Thorn Prikker (1868–1932) is even more radical in his portrayal of mystical scenes by unifying linear tracings, which correspond to emotions and to "the essence of things."

This linear style, which tends toward abstraction, became the distinguishing feature of Art Nouveau; it is found in the Macdonald sisters' paintings and decorative panels and in those of Mackintosh. Beardsley's illustrations endowed this linear element with his own original values and with a more complex form.

Toward the end of the century, the disinte-

and democratic convictions; he applied this to compositions with an Idealist meaning but with a pronounced realism and a certain hardness (*Night* [1891]). The accentuated outlines, seen as elements of architecture, are arranged with rhythmic and symmetrical curves and along parallel linear "correspondences," symbolizing the unity of being: the triumph of unity (the people) over diversity (the individual).

Symbolism and the painting of ideas – Germany and Austria

Böcklin and Klinger. "A painting must say something and make the spectator think something, like a poem, leaving him with an impression, like a piece of music." This was how Arnold Böcklin (1827–1901) described

side Germany. This was the period of the state-of-mind-pictures; of the versions of *Seaside Villa*, *The Isle of the Dead*, which the artist called a "dream picture," and *The Sacred Wood*: scenes from nature, composed in accordance with the landscape schema of the Düsseldorf School, on which Böcklin modelled himself. The paintings show figures drawn from literary or mythological sources; they have a cold, silent, mysterious atmosphere, a fusion between human beings and nature, arousing associations of ideas and psychic resonances.

While F. Keller and von Hofmann were strict disciples of Böcklin, Max Klinger (1857–1920) was the true heir and successor in the development of this all-embracing trend of the painting of ideas. In common with his mentor, Klinger believed in the power of communica-

Left: M. Denis, April, *1892. Rijksmuseum Kröller-Müller, Otterlo.*

Opposite above: F. Khnopff, I Lock My Door upon Myself, *1891. Neue Pinakothek, Munich. One of his compositions which most closely resembles those of the Pre-Raphaelites, inspired by Christina Rossetti's poem* Who Shall Deliver Me.

Opposite below: J. Toorop, The Three Brides, *1893. Rijksmuseum Kröller-Müller, Otterlo. Toorop uses stylized shapes and lines to express, as he put it: "existence and action, feelings and ideas which are released from nature in its entirety in a unitary form, in concise and expressive outlines, conception and colour, which I call the Symbol."*

gration of the Naturalist school meant that this spiritualistic tendency gained new adherents: artists who had received their artistic education in other parts of Europe where realism had retained its ascendancy longer, with the emphasis on humanitarian and social issues. Two Swiss artists, Ferdinand Hodler (1853–1918) and Carlos Schwabe (1866–1926), were among the most original adherents to the *Rose-Croix* movement and remained basically faithful to a robust, populist realism which endowed their religious and idealistic themes with a special force and expressiveness.

Hodler adapted Baudelaire's theory of "correspondences" to his own "aesthetic parallelism," the outward manifestation of religious

the function of his paintings, which belong to the painting of ideas (*Gedankenmalerei*): the German and Austrian version of Symbolism, confined to isolated painters whose work was to a greater or lesser extent derivative of or influenced by the master practitioner of Basel.

In the crucial early years of Symbolism, Böcklin (like Moreau or Puvis) is an isolated figure, "an artist who does not belong to any school and who continues to work at his solitary and fantastical paintings ... which possess an impeccable natural quality within the sphere of the supernatural, the dream ..." wrote Laforgue in his articles from Berlin for the *Gazette des Beaux Arts* (1883), which built the reputation of this exceptional personality out-

tion of the Classical form and the myth, conjured up in a nostalgic frame of mind and reviewed through the modern ideal of beauty. For Klinger, the central theme was the synthesis of the arts, the syncretism of genres and content, interpreted through the medium of polychrome sculpture (*Beethoven*), through the meeting of the pagan and Christian beliefs in his large painting *The Christ of Olympus*, the exploitation of naturalistic and theatrical images and the decorative role of a work of art. Klinger achieves a synthesis (in the modern sense of "great expression distilled from our conception of life") in black and white. He himself observed that "drawing should be a separate form of expression, reserved for

certain types of subject and pose; while colour lends itself to objective images of nature and to ideal visions, drawing is better able to express a critical view of reality and to enclose a world deformed by imagination and dreams" (*Painting and Drawing* [1891]). In etching he identifies the modern method of expression: subjective, open, the real tool of imagination in art, for it allows free rein to the imagination and ideas, enabling the artist to be both philosopher and moralist, to create poetic relationships. In the series of etchings – each classified as an "opus," like musical compositions (*Love, To Death, A Life, Paraphrases on Finding a Glove*) – the social and psychological reality of the day is observed from the viewpoint of objective analysis, almost as a commentator; but with continual references to mythology, history, dreams and imagination, and with ornamental digressions.

Klinger was a central figure in the artistic life of his time; with Liebermann he was the founder and motive force of the Berlin Secession movement (1892), in somewhat the same mould as Franz Von Stuck (1853–1928), founder of the Munich Secession: an artist bound to the Classical image and to Naturalism, but with a strong interest in monumental art. The climate of the German Secession movement was of a temperate modernism, and there was no incompatibility between serious realism (Stuck's *femmes fatales* and

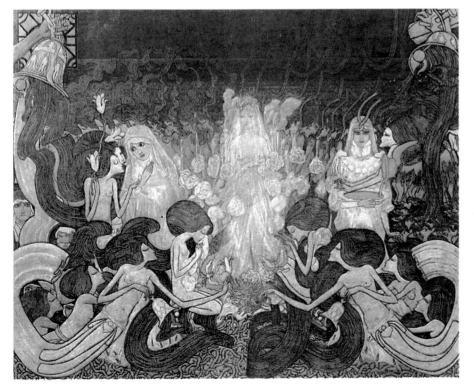

"Böcklinian" objects) and ornamentation.

The artists of the Munich *Jugendstil* (Obrist, Eckmann, Riemerschmid, and Endell) find new decorative motifs in nature: from the plant and animal world, from insects and micro-organisms, having closely observed their structure and growth processes; it was their imagination and creative liberty, however, which transformed them into vital organic forms, at the limit of abstraction. An intuitive affinity is established between the self and the object, a psychic exchange of sensations and feelings. "We can draw on the natural world for the nonrepresentative shapes from which art is created; shapes which awaken our souls with the force of music," said Endell.

Symbolism and decoration in Vienna

Klimt. Symbolism and decoration became more innovative and achieved a high expressive value within the style created by the Vienna Secessionists. In claiming the right to art (a choice had to be made between "commerce or art," as Behr, the Secessionists' theorist, put it) what was originally a formal question had become secondary; being an artist meant being free to create, to apply the artistic will to everything, and to open the doors to modern art from other countries.

Gustave Klimt (1862–1918) developed from a talented exponent of historical decoration into a modern painter through simplification of Makart's eclecticism, paring it down to its essentials. Klimt selectively appropriated the recapitulatory linear style of Toorop, Mackintosh, and Beardsley, as well as Khnopff's figurative outlines – all these artists were invited to the 1898 Secession Exhibition. Klimt's receptive attitude toward new techniques was typical of the period's great inventive richness.

Klimt's most creative and revolutionary phase coincided with his membership of the Secession (with which he parted company in 1905), producing paintings which progressed in stages toward two-dimensional synthesis and linear stylization: *Music, Tragedy, Sculptures of Allegories and Emblems, Pallas Athene* and *Nuda Veritas*. These female figures are descended from the *femmes fatales* of the Pre-Raphaelites and Khnopff, but they have a gentle, eloquent naturalism, very much of their time, which heightens the feeling of nostalgia for the Classical world, drawing on archeological sources. The decoration of the ceiling at the University of Vienna, with its allegorical figures of *Philosophy, Medicine* and *Jurisprudence* (1899–1907), mark the break with the traditions of traditional decorative painting and with official commissions (in this particular instance, the commissioning authorities would not accept them).

In *Medicine* Klimt explores the motif of nudes of several ages shown in the same painting; this was a popular subject in Symbol-

ist painting at this point. The aim was to give a panorama of humanity, and rather than being a celebration of scientific progress and its benefits for mankind, the painting shows beings who have been transported into space by blind forces, trapped within the eternal cycle of birth, life, and death. Medicine is represented not as a science which deals in certainties, but as the ancient and mysterious wise woman: Hygieia, the daughter of Aesculapius.

We are no longer in the realm of the reworking of an allegory, but of the painting of ideas within the human condition. This is partly a product of a civilization in crisis and partly a subversive and revolutionary response to the world of conventional, academic art: witness the concentration and richness of content; the reference to Schopenhauer's pessimism, to Nietzsche's negative and irrational thought, and to Wagnerian aesthetics. Klimt's painting combines opposites: naturalism and abstraction, object and decoration, modern shapes and historical references, perfectly balanced and in equal measure.

When Klinger's statue of Beethoven went on show at the Secession exhibition of 1902, Hofmann designed the rooms for its setting; thus the painting of ideas was extended to monumental decoration, a perfect synthesis of aesthetic sensitization of space and symbolic contents. In Klimt's later work, the human predicament, opposing forces and impulses tend to be skilfully arranged within the dimension of beauty and ornament (as in his decorative frieze at the Palais Stoclet, 1905–8), shifting across the plane of generality toward the biological cycle of life. This motif was spread and shared by the Symbolists – by Munch

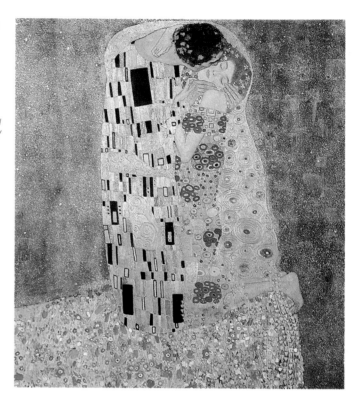

Right: G. Klimt, The Kiss, *1907–8. Oesterreichische Galerie, Vienna. During the so-called "golden" phase (1906–9) of Klimt's decorative style, he approaches the surface as if it were a collage of motifs culled from ancient and oriental art, forming a vocabulary of primitive geometric and organic forms and evoking primary associations of masculinity and femininity, nature and rational beings.*

Below: A. Böcklin, Villa by the Sea *(fourth version), c. 1877. Staatsgalerie, Stuttgart.*

himself, the artist who, with his original subjects and essential, expressive language, was the most advanced contributor to Symbolism.

Munch. Edvard Munch (1863–1944) said that "Symbolism must be the image of one's own emotion" when he wished to define "his" Symbolism, which he consciously draws from

Synthetism and uses to further his version of psychological expression. In 1896–97 he was the central figure of the Symbolist movement: the *Revue Blanche* published his paintings with poetic commentaries by Strindberg, while *Pan,* Berlin's progressive avant-garde review, compared him with Redon and Gauguin, calling him "the prototype of sentient contemporary man in his ability to express the signs of universal *angst* [anguish]."

During his visits to Paris (1889/1892) Munch had experimented with the luminous light and free brushstrokes of the Impressionists, the slanting figures of Degas, and had found Lautrec's economic linear style and Gauguin's Synthetism the most congenial ways in which to convey his own interior world with immediacy. Naturalism, progressive and leaning toward autobiographical expression (to use one's own personal life experience as raw material for art, sincerely and without reticence), had already been practiced by Krohg and Jaeger, friends from the artistic fraternity in Christiania. In *The Sick Child* (1885–86) Munch had injected subjective, emotional values into a strikingly realistic scene.

The development of an art which places man at its center entailed the use of figurative themes which were foreign to French culture: Munch rated Klinger's drawings and Böcklin's paintings more highly than contemporary artists' work, with a particular preference for their landscapes, in which he detects a "sacred flame." In his own night scenes *Moonlight* and *Starry Night* the dream atmosphere, the depth and intensity of the images, the impression of a

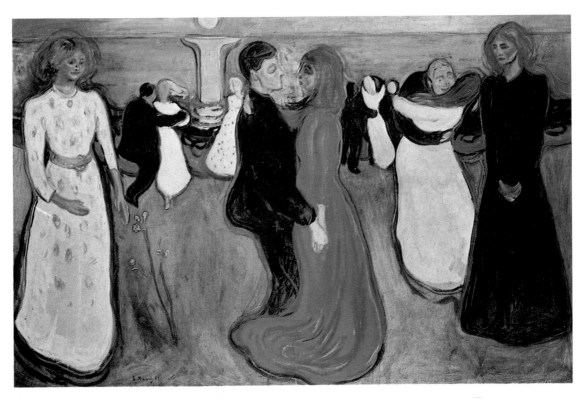

Right: E. Munch, The Dance of Life, *1899. Najanalgalleriet, Oslo. The last, and largest, of the paintings which make up the* Frieze of Life, *reminiscent of the various versions of* The Three Ages of Woman. *The vicissitudes of the artists's private life are endowed with a universal significance.*

Below: A. Mucha, Job, *1890. Bibliothèque du Musée des Arts Décoratifs, Paris. Mucha created a new ideal of feminine beauty: fairytale, decadent, insubstantial and beyond everyday reality, translated (particularly successfully in his posters) into a fluid yet concise style and with a heightened sense of the decorative value of shape.*

diffuse musicality, echo Böchlin's work. Munch had been greatly influenced by the time he spent as part of the progressive, intellectual circle in Berlin, which looked toward Paris and was dominated by expatriate writers from north and central Europe: the Pole Przybyszewski, the Swede Strindberg. With the latter Munch shared an interest in psychology, the importance of the pathological dimension, of individual phobias and fears in artistic creation. Like Strindberg, Munch believed in the artist's mediumistic potential, communicating the essence of things and revealing the truth which lay beyond appearances. Against this background an underlying pessimism about life took hold of Munch, an ambivalent attitude of rejection/attraction toward women, and his preoccupation with the crucial role of love and sex in art had, during the earlier part of his career, led to his work causing a scandal in Berlin and Oslo.

Munch's organic philosophy of life, which saw the human life cycle as an eternal metamorphosis, was expressed in his *Frieze of Life*, an open sequence of several pictures, to be hung together, developing a theme and interpretation in much the same manner as a musical composition. These pictures were based on his own personal experience and from his reflections on current psychological theories. Major works are included in the *Frieze*: *The Voice*, *The Scream*, *Madonna*, *Jealousy*, *Melancholy*, *The Vampire*, and *The Kiss*: anxieties and psychic tensions are expressed in swirling colour conveying sound, in oblique perspectives, in shadows, in lines

representing forces: emotive entities which can vividly communicate a state of mind. Munch's aim in his *Frieze* was to "help others to see clearly." A romantic, individualistic spirit, verging on the anarchic, he shared the humanitarian preoccupations of Symbolist cir-

cles at the turn of the century. Munch journeyed to Italy in 1899 and studied the great Renaissance painters; he painted monumental decorative compositions, taking as his theme the "correspondences" between man and the great forces of the universe (*Fecundity*, *Metabolism* and *The Dance of Life*).

Munch's work broke new ground in its formal radicalism and originality of subject, and was of crucial importance. It set in motion a tremendous momentum toward the formation of associations of independent artists in Paris, Berlin, and later in Vienna, and especially where the artistic establishment was most conservative and the cultural climate most parochial: in Berlin, in Norway and in Denmark. His presence – together with Hodler, the Finn Gallen, and Thorn Prikker – at the Secession's exhibition of 1904 in Vienna marked the apogee of Symbolism in northern and central Europe. It was in these centers that the movement took its firmest hold and produced the most original practitioners: in the Scandinavian peninsula there was a sudden surge in paintings of subjects drawn from legend and those poetic works which were most steeped in mysticism and the spirit of nationalism: landscapes were more subjective, with an aggressive use of colour as evidenced by Sohlberg in Poland, Preisler in Prague (close to Munch) and Kupka's early works. Alphonse Mucha (1860–1939) was a truly international figure, in contact with Vienna, Munich, and Paris, and has proved the most popular interpreter of an accessible Symbolism in the naturalistic and floral style of *art nouveau*.

Italy

Symbolism took a different course in Italy. One direction led to the espousal of Divisionism and socially inspired art, while others remained closer to the painting of ideas. Since Italy had not yet developed a recognizably national culture, there was a tendency to look toward more radical cultural centers; French decadence had a strong influence, as did the English Pre-Raphaelite and aesthetic painters. There were, however, plenty of original contributions from flourishing or burgeoning Italian artistic centers, and it can be said that the emergence of Symbolist themes varied due to the wide disparity of regional cultural influences.

Symbolism never achieved the force of a real movement in Italy between 1885 and 1900 but as realism fell from favour, it is possible to trace original voices within the context of a gradual surfacing of spiritualist sensibility. In the Lombardy and Piedmont regions, social reality was in a state of flux and an industrial society was being created. The promotion of art through exhibitions and periodicals which favoured the modern idiom, the legacy of Romanticism and the *Scapigliatura* movement, and the high value placed on the realist tradition all contributed to an auspicious climate for an artistic renewal, nourished by local culture and enhanced by new trends from France and Belgium. Symbolism was thus moulded according to needs, motives, and themes which reflected the prevailing ethos. It adapted to a culture which, because of pressing social problems and the awakening sensitivity of its artists and intellectuals to an art of humanitarian content and scope, did not break with positivism and realism. The symbol represents an element in the evolution of art toward modern ideals: "art for humanity," as Pellizza strove to interpret it, in the same way as Divisionism is a more highly evolved technique of realism for the portrayal of light.

In the careful critical reflection which accompanies the Symbolist works of Segantini, Bistolfi, and Pellizza there is a fundamental preoccupation to give a dual relevance to Symbolism: individual and social; to invest it with the possibility of a wider range of expression; to extend the boundaries of art. The "pictorial sculptures" of Leonardo Bistolfi (1859–1933) introduced the new symbols of contemporary man: *The Sphinx*, *The Beauty of Death* and *Grief Assuaged by Memory*. Grubicy writes of "musical painting," and pictorial "languages" are explored in the attempt to translate the world of feelings, ideas, emotions, and vague sensations.

Grubicy, who had absorbed Aurier's theories, defined *Maternity* by Gaetano Previati (1852–1920) as belonging to the painting of ideas, or *idéiste*, a term which lends itself to the painting of the imagination (illustrations for Poe's stories) of this romantic artist, unable to relate to his own age; encapsulated in his own world of religious, poetic and fantastic visions, which he expressed in a synthetic, concise style of painting – a potentially great decorative artist. Previati was concerned with the

technical problems of painting, and in Divisionism found the most suitable medium for anti-Naturalist art, using ephemeral, insubstantial forms of great suggestive power.

Giuseppe Pellizza was also an exponent of Divisionism but he chose a different route, preferring Pointillism in emulation of Seurat and symbolic expression of forms and linear direction, with a less scientific and dogmatic attitude, to avoid losing contact with nature, using simple and everyday natural motifs which became symbols communicating truth, ideas, and general principles.

During the productive 1890s the complexity of artistic tendencies and the international nature of Symbolism make it impossible to isolate single-voiced artistic trends: Giovanni Segantini (1858–99) is the most significant figure. His Symbolist development took place within a personal Divisionism, while maintaining his clarity and luminosity of image. His aim, he said, was to convey a living and tangible sense of reality and nature. The ideal content, the mystico-pantheistic vision of nature, the formulation of theories which combine idealistic and aristocratic stances with socio-humanitarianism, are a reply to the demands of the prevailing cultural climate. But the most authentic and original results as revealed in the painting of Segantini, Pellizza and Previati, the essence of Symbolism-Divisionism, did not assume a role of major importance in Italian artistic development. This was in great part due to the inhibiting influences of stronger cultural trends (such as the "Convito" of D'Annunzio's disciples, and the "Marzocco") whose aims were to rid art of its banal and anecdotal realism and to steer it toward an art of ideas, regaining contact with the great Renaissance tradition; in this way they were encouraged by the examples of the idealists and the *Gedankenmalerei*. Thus artists such a Aristide Sartorio, who sought to imbue art with dignity and quality, became well known, combining fierce nationalism with modernity, promoting a neo-Renaissance in which art would seek to mirror noble, civilized objectives as part of an idealistic culture.

Above: G. Segantini, The Punishment of Lust, 1891. Walker Art Gallery, Liverpool. The artist maintained that "ideas can be expressed in paintings only when they are clearly etched in the painter's mind; precise, distinct, accessible."

Right: A. Sartorio, The Light, sketch, 1907. Collection L. Sartorio, Velletri, Rome. In his decorative panels Sartorio aimed to illustrate "the poem of life through the myths of classical antiquity."

Nineteenth-century architecture

The nineteenth century followed hard on the revolutions of the eighteenth. Indeed, its first years were marked by imperial expansion under Napoleon, forcing all Europe to observe French events and to become enmeshed in them. The bourgeoisie not only flexes its political muscles over and above the economic (not only in France), but also gains a new outlook on how to fill space with urban constructions to aid its projects and civic aims. What in the previous epoch had been viewed only as possible, or tried in limited settings, is realized in nations reshaped by military deeds and in reformed institutions that promote initiative.

The task of architecture is seen in a new way: hitherto the main problem had been suitably to represent the actors on the urban scene, now one must fix the functions of urban institutions in relation to speedier traffic. The city behind architectural planning (which it must invent and realize) has become a network of roads, canals and, later, railways, which involves a twofold spatial relation: access to countryside and the provinces, and a supranational geographic picture. The eminent theorist F. Milizia (1725–98), in a short essay on economics (1798), put it thus: "Cities in the provinces are what market squares are to a city. The capital is then to other cities what they are to the province. In cities industry is

refined, discoveries are made, arts and sciences are improved." Thus the double Renaissance symbolism of house for city and vice versa finally lapses.

This calls for a new vision of space, cartographic, topographic and geographic, prevailing ever more over the visual approach, for architect, planner and public works alike: the price of new methods of production, industrialism and the greater scale of change and traffic that is its basis and end. Hence the architectural priority of the useful, seen first in very general terms: the refusal to distinguish between architecture and building. That is why henceforth all construction has to be viewed in terms of architectonic science, to answer the ends of the general idea of architecture expounded by Milizia, which does not separate working buildings from decorative ones. "Architecture maintains the poor by changing

J. Paxton, Crystal Palace, Great Exhibition, London, 1851.

the meanest materials into the most lasting works of human endeavour, making towns more beautiful and life more comfortable. Where it thrives, foreigners always gather, which leads to a host of manufactures and many branches of luxury trade that employ and keep millions of people." (F. Milizia, *Principles of Civic Architecture*.) The city attracts people in two ways: the countryside is emptied because of farming concerns being restructured and workers migrating to vast suburban shanty towns, while from towns abroad a cosmopolitan crowd of migrants moves to urban centers for various reasons.

The "monument" of this new vision of the city is the Napoleonic Forum of G. A. Antolini (1756–1841), planned at Milan (1801) and set into the town plan that was perfected in the graphic project of the astronomers of Brera (1788–96), the first geographic, economic and civic account of a city. The forum in the capital of the new Italian kingdom turns the vision of the past into the basis of a project that registers the effect of events as they happen, provides for a system of roads and canals set into the existing network to link it with France, Switzerland and the Tyrrhenian ports. The square crowns it like a landing-place offered to a guest, as an urban adjunct. Thus at the border between town and country, involved in

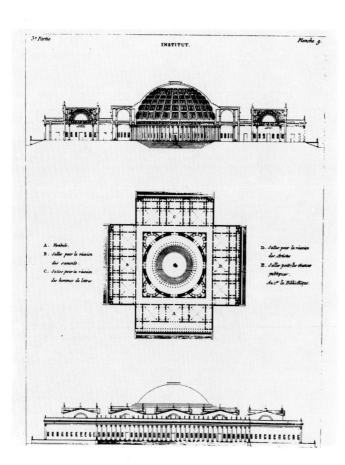

Left: J. N. L. Durand, vol. 2, part 3, fig. 9 of Précis des leçons d'architecture . . . Paris, 1802–5. His method of composition applied to the French Academy revives a plan of Percier that had won a prize in 1786. It shows the primacy of related simple and regular figures over all else.

now seems to have undergone all the changes it could; hence it has been completely exploited. . . . Besides if a style has not adapted to the buildings of today it is that one, all order, regularity and grandeur." (*On the need for a new regulation of studies for architects*, Milan, 1861.) If one looks at city maps and their minute and irregular division and the crooked network of roads, viewing them as objects of total reform, a simple and regular geometry in plan and elevation can only arise occasionally, here and there.

If one evaluates the whole range of public and private functions, how can we describe cultural needs in terms of material ones? Perhaps this could be done only with the aid of all ordering and descriptive devices of the past. Two new questions arise here, engaging tradition in two ways: first, imagining a new mode of layout to give spatial expression to the many new functions (banks, exchanges, ministries, hospitals, libraries, and so on); and second, seeing each of these in proper relation to the whole. While the former is vital in the teaching of J. L. Durand (1760–1834), the latter is dealt with by K. F. Schinkel (1781–1841) in terms of style, the century's problem.

J. L. Durand, the ideal architectural teacher, defined the subject in a strict and rational system for the first technical university, the Polytechnique of Paris, founded by Napoleon in 1795. Art was strictly subordinated to the demands of layout and construction, decoration excluded and the intellectual control of space relative to function made paramount. Thus he shows architects their new task: to plan any building needed and define its utility to urban society. He was the first to see that we must enlist our whole past inheritance not for aesthetic or stylistic reasons but for civic and utilitarian ones. He therefore published the most comprehensive collection of past works, classified by type, in a systematic comparative account of plan and view (*Recueil et parallèle*

the city as main seat of production including industry, is set the center of civic life, expressing a splendour replacing that of neo-feudal princes. Instead of the castle's armed defenses a system of public buildings, stores, works and bourgeois dwellings first trace an integrated urban picture; straining the classical measures and orders to distinguish custom-house from stock-exchange, theater, pantheon, museum, public baths and schools. The majestic dimensions in which the architectonic space-time involves civic society is akin to the Faustian sentiment for the "unchaining of productive forces," the elation of boundless adventure revealed to human power by the forces of nature governed within artificial rules of "human industry"; all this becomes explicit in the classical cornice that has lost its measure but remains a sign of a historic and ideal harmony that is always pursued. The main aim of nineteenth-century architecture was to modify vast conceptions based on a sense of boundless power to the demands of economic enterprises and their functional scale in town and country.

Is the classical style best suited to meet this demand for definition, with its regular canons and rigid symmetries? Let us quote C. Boito: "As to the splendid classical style, in itself it is worthy of the great conquering people, but by

Below: K. F. von Schinkel's prospective view of the Berlin Museum. The museum on an island in the River Spree opposite the Royal Palace is part of a vast plan including large stores and a school of architecture. The character of the different types enhances the museum's classical excellence, evident in the direct reference to Greek architecture, even via Tuscan humanism. This exalts the ideal force of art, marking its presence in an urban monument.

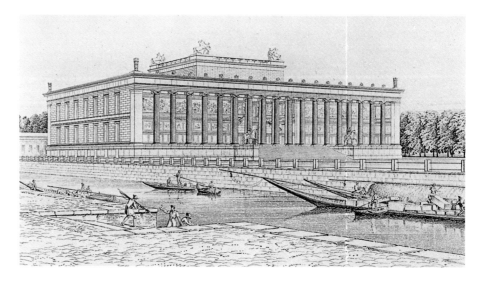

des édifices ... Paris, 1800). Here already a view counts little as image and nothing as example of style. In his lessons (*Précis des leçons* ... Paris, 1802–5) style is not even mentioned. We can hardly take Durand to be a neo-classic, nor therefore as an anti-classic. A rigorous rationalism appears in architecture,

(round arch style, so called in the last quarter of the century because of the totally ribbed but non-pointed arch that belongs to Lombard Romanesque rather than to Gothic, the style of Persius, pupil of Schinkel-Gartner and Klenze in some of their works), all these can be properly assigned to K. F. Schinkel.

coherent monumental face, with the Admiralty (1806–15) of V. P. Zaharov (1761–1811), the Academy of Mines (1906–11) of A. N. Voronin (1759–1814), the Exchange (1804–16) and the Grand Theater (1802–5) by Th. de Thomon (1760–1816). The authors belong to a generation trained late in the previous century; it is no accident that what it states in a concentrated decade rests on the great Parisian school, whose leaders were Boullée (Durand's teacher) and Ledoux, whose treatise on the Utopian city of Chaux was dedicated to Tsar Alexander I. Here the attempt at rejecting bourgeois aspirations by aristocratic ideals that seek release from feudalism are based on great illuminated Utopias and monumental images that embodied the warning signs to be heeded.

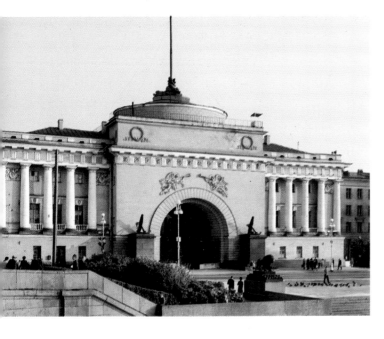

A. D. Zacharov, Admiralty, Leningrad, 1806–15. The great works of civic splendour promoted by Alexander I for the capital, founded in 1703, leave Quarenghi's neo-Palladian models to draw from the French Enlightenment tradition the ideal stylistic features of monuments to exalt state institutions.

This is the new capital city of a vast agricultural territory and expresses the eastern European option, maintaining the enlightenment ideals of the physiocrats; at the other end of the scale is the experience of London, capital of the Industrial Revolution. In 1800 it was the most populous city (the census of 1801 counts more than 860,000 inhabitants) and increased fivefold before 1900, disproving the enlightenment dream. Here the contradictions of an industrial city show up very clearly in the course of the century (that is why Marx and Engels chose it as testing ground for their enquiries on the situation of the workers); thus the point of a classical image was here to balance the boundless squalor of suburban slums by taking on a picturesque and sentimental tone. The exemplary cutting of Regent Street (1812–27) in the urban center, by J. Nash (1752–1835), which seemed the occasion for adding a pleasant civic cornice to the patrician residence to stress its excellence as compared with the suburbs. Here the city parks (Regent's Park and St. James's Park at the two ends of the street) court nature by a sentimental gesture, and for the first time are a limit that isolates and severs. At the same time there appeared a noble and splendid internal working landscape: the shrine of the new leadership, the bank, on the model of the Bank of England (1788–1824) by J. Soane (1753–1837), the acknowledged master of English architecture. Evoking the great Roman *aulas*, its rooms (Stock Office 1791–92, the Rotunda 1796, the Colonial Office 1818–23) were examples of perfection. Such novelties mark the advent of a city described in a vision of Mephistopheles in Goethe's *Faust* (part II, Act 4, Scene 1): "... I should select a kind of capital, with gruesome burgher-feeding core, and narrow lanes and pointed gables, a bounded mart.... Then wide-flung spaces, ample roadways, to arrogate a noble semblance; and last, where gates cannot impede, suburbs quite boundlessly prolonged."

perhaps an idealist spiritualism. He thus would not recognize the primacy of classical canons, maintaining that they survived from sheer habit. He did not exclude them, but did not regard them as the basis of beauty and for the first time looked at architecture divorced from appearance.

In Durand we thus see displeasure instead of pleasure, or at most a pleasure built on rational reflection. Only by grasping the work by reassessing the reasons in terms of looks could we value its qualities. For much of the century people held back in disdain and made the mistake of pursuing pleasure. This problem rules nineteenth-century art, whether in pursuing the new aesthetic or in opposing it. The various styles (neo-classical, neo-Greek, neo-Gothic, neo-Renaissance, and so on) risk losing the common goal of their main quest; the label of "eclecticism" tends to deny the present problem by insisting on tradition: the problem of making novelty clear and conveying it by meaningful images, allowing rational reflection. The image may at first displease, but only in order to clarify and enliven an idea.

Such was the problem of the artist who in his vast store of projects sought the individual features of works in pictures. Here enlisting the past hangs on the need of identifying types: neo-classical, neo-Greek, neo-Gothic, even the early and precocious *Rundbogenstil*

A strict follower of the classical spirit thus risks looking eclectic; yet he is not, for the term is linked with the French philosopher Victor Cousin (1792–1867), who held that the positive aesthetic task is to celebrate the present as the sum of the best from the past. Schinkel, at the start of the Romantic period, so ready to speak in terms of stylistic features, rather pursued the expressive aspect of earlier works when he built his own churches, theaters, museums and academies.

A silent dialogue proceeds between neighbouring buildings in towns or items compared at a distance by pictures; much as Schinkel's various projects on the Spree in Berlin (the museum, vast commercial buildings and the academy), once they appear in *Sammlung architektonischer Entwürfe* (Paris, London, Berlin, 1829–40), recall each other from their distant places beyond visual reach but visible to the mind's eye, forming a set of defined differences or harmonious images for their functional aim, which delineates the century's plan of urban aesthetics.

In renewing orders and images, architecture took on two tasks: to represent the new institutions and to designate the seats of the new masters by rare signs and functions. The opposed examples of Leningrad and London are two limiting cases.

Leningrad in the early 1800s gained a

In its life, Mephistopheles's city reveals all the imbalance of growth beyond measure and calls for an ordering device, to regulate its size and set up new scales of values, functions and

images. This is the urban plan, of which Baron G.-E. Haussmann (1809–91), prefect of the Seine departement (1853–60) under Napoleon III, gave the model that began modern urbanism and made Paris the European capital of the nineteenth century. Here The Arc de Triomphe (1806) of Chalgrin (1739–1811), the Madeleine shrine (1808) of P. Vignon (1762–1828), the Bourse by A. T. Brogniart (1739–1813), the Rue de Rivoli (from 1811) by Percier and Fontaine, had been implanted on the old fabric, putting new landmarks into a vast area, and are repositioned by the system of arterial roads. Isolated and placed at the poles of the network needed by the increase in traffic, these and other monuments become indifferent to the imposed texture. The flat prospect orders values of site and function; but where these were lacking, general city plans arose with enough details to assemble all local circumstances, as Haussmann did in Paris. They were an essential support for coherently designing an urban weft where works, though ever more singular in image and function, could nevertheless exist together.

With a regulating plan, the split between arrangement and image changes in scale. Arrangement covers the layout of the whole city, giving to buildings the task of portraying the character of different localities, thus radically modifying the value of rare and exceptional works. These complement each other and articulate their functions. From the highly abstract view of the plan, the eclectic set of monuments rises like a unique assembly of analogical references to various periods and constitutes a museum of images recasting history in the present, confidently placing it ahead of all periods. In thus facing history, with which the century became obsessed, one grew ever more aware of present originality and the break with the past, even where, as in Italy, this developed later and more slowly. Milan, Turin, Florence, Rome, Naples, Palermo did not grow from evolving ancient forms, but, in spite of waverings and surprises, from the plan that regulates expansion as against cutting through the center and laying railway tracks; it imposes the links between new urban entities (railheads, hotels, banks) and ancient ones, while redesigning on new and larger sites, replacing old houses set round courtyards by blocks of flats that quite alter a city's structure. In this context the intervention of G. Poggi (1811–1901) in Florence (he redesigned the left bank of the Arno and Piazzale Michelangelo) or of G. Koch (1849–1910) in Rome (Via Nazionale and Piazza Esedra) seem to show that old and new are structurally incompatible. Sizes and shapes lose their traditional rhythms and styles, and imitate uniform national or international models. This makes for a cosmopolitan air, typically in Milan in its growing role of economic capital, even before G. Beruto's master plan (1884–89) which redesigned the center with the Galleria Vittorio Emanuele (1864–67) by G. Mengoni.

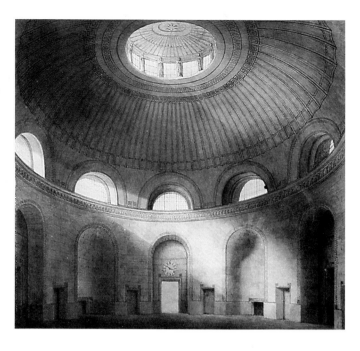

Right: J. Soane, Bank of England: Rotunda, London, 1796. The prototype of banks as image, not as typical layout, is based by Soane on the idea that the simple grandeur and elegance of Graeco-Roman models suits the seat where the fate of world treasures is decided, thus creating wealth.

Below: J. Nash (with James Thomson), Cumberland Terrace in Regent's Park, London, 1826–27. This quaint echo of classicism was held suitable for houses.

This balance between cosmopolitan, historical and eclectic aspects, relating old and new via ideas of history as a common measure of human civilization, inspired that other plan (together with Haussmann's, the mark of the century's originality), the Ring in Vienna, after designs by L. von Förster (1797–1863). The

best German and Austrian architects have left on the Ring the mark of their supreme attempt at reviving past periods to celebrate the present: G. Semper (1803–79) and K. von Hasenauer in the new neo-baroque museums (from 1861) and in the Burgtheater; H. von Fernstel (1828–83) in the neo-Gothic Votivkirche (1856–79); F. von Schmidt (1825–91) in the neo-Gothic Town Hall; T. Hansen (1831–91) in the Parlament (1873–83), the Kunstakademie (1872–76), the Exchange (1874–77), to mention but a few. A grandiose vision, encompassing the whole revisited from the vantage point of a map. From it one gathers the notion of balance between old and new as a frozen blend of the whole past, made visible today: the nineteenth century as a conspectus of previous periods. The problem then is how to see the future. This opens a debate on duration, how time is to be involved in architecture. Here styles no longer denote periods but coexist in the present. It becomes difficult to trace the architectural evolution of a city. What is truly of the nineteenth century shows itself not in any new form, but in a re-ordering, reclassifying and recasting of old ones, along with the new functional programs and urban regulations. A tension therefore arises, touching past works as monuments and present ones as coexisting. C. Boito regards architectural expression as unable to yield adequate solutions for each type of civic building: "An utterly new eclectic irrationality" leads us to use "in theaters a Moorish style ... in churches Gothic ... in exchanges Romanesque ... in public buildings medieval

Above: Mengoni's Galleria Vittorio Emanuele II, Milan, 1865–78. Cut into old quarters between squares, this covered street realizes the single center of urban planning in the form of a city with many centers.

Below: The Rue de Rivoli in Paris, by Percier and Fontaine. Laid out under Napoleon I in his urban plan, it was the model for urban embellishment and in Haussmann's plan became the pivot of Paris.

... in dwellings Tudor or French or Italian Renaissance, and so on, for each type of building a different style". (*L'Architettura del medio evo in Italia*, Milan, 1880.) The solution will rather come from imposing a rational plan and mode of construction, using suitable symbols. Style unites all three, as in the following diagram:

This ably describes the nineteenth-century concept: the attendant theory of style enables the architect suitably to express the novelty of his time. Here begins the debate on the new style during the last quarter of the century; begins, for Boito still compares and emulates the past and looks to styles (for him Lombard Romanesque) to give him metahistorical principles to which to refer current developments.

To reach the topic of new style and its character and contradictions, we must take in the story of iron at its most conspicuous: the great exhibitions. In the first one (London, 1851), described by C. Daly as the century's most important architectural event, J. Paxton's Crystal Palace (1850–51) was opened, a landmark of iron construction as practiced above all in America, witness the E. H. Laing stores (from 1849) in New York, by J. Bogardus (1800–74). One has to note a combined lightness, daring, speed and economy unknown in the past, achieved with an unprecedented material, technique and design. Not that the new method alone produced new aesthetic standards: rather, it is a tendency toward research, anti-academic and aiming at functional synthesis. The new actors are engineers rather than architects. Their new functional structures, simple for being practical and efficient as well as bold and light, need not be viewed as precursors of our own time, though they have put forward one of its vital themes, by taking the debate beyond questions of style. Alongside cultural assessments of progress in terms of imitating and confronting the past, which inspires the wealth of civic institutions and stresses their durability, we now have new assessments that ignore these aspects and rely rather on the promotion of enterprise and social dynamics. These assessments appeared neither conflicting nor complementary, as if they did not relate to aspects of the same phenomenon; yet they are, since they concern two coexisting but irreconcilable nineteenth-century values. To see this, let us compare the great exhibitions, which display a functional view of structure, with museums, the very paradigms of cultural institutions.

Taking museums as paradigms of style –

J. Soane's Dulwich Gallery (1811–14), K.F. Schinkel's Altes Museum (1824–28) in Berlin, L. von Klenze's Glyptothek (1815–30) and Alte Pinakothek (1826–36) in Munich and the Hermitage (1839–49) in Leningrad, M. Pollak's National Museum (1837–44) in Budapest, R. Smirke's British Museum (1824–47), G. Semper's Gemäldegalerie (1847–55) in Dresden, G. Semper and K. von Hasenauer's Kunsthistorisches Hofmuseum (1872–89) in Vienna, to mention a few – the marble mantle of "orders" helps to settle lasting values through signs of duration. The ornaments are symbolic, inviting a certain behaviour if not inner attitude from the visitor. Conversely, vast exhibition halls, industry's experimental testing ground for the use of metallic structures, afford the eye immense and usable spaces, without symbolic directives; with their transparent glass facing, bare of maskings or useless decorations, they showed the unknown beauty of metallic forms born of pure function; witness the 1889 exhibition, triumph of the engineers in the machine gallery of V. Containin and the Eiffel Tower.

This clear double trend can be seen as an exhibition of objects, of art and of use. Things gain a new power, having become a goal and the means of attaining it: in setting it, the nineteenth century tries to exorcize this goal, letting museums stress the creative primacy of man, while exhibitions show the human end of the tasks undertaken. What differs is the conception of historical period, highly important to some but not to others, as likewise appears in the outcome: museums are eternal, exhibitions transitory. At first, this conflict was not seen as internal to architecture; it became topical only at the end of the century, when people denied iron construction and its attendant products a place in the arts, following Boileau in a succinct comment on the 1889 exhibition: "Hangars, that is the goal of metal." Frankly metallic construction was thus confined to more utilitarian types (general markets, abattoirs), which often stood out by order and clarity as in Les Halles (1855–58) by V. Baltard (1805–74) or the Abattoirs of Lyons (1905–13) by Tony Garnier, which in 1914 were used for the motor show.

The most acute minds saw no clash between expressing the novelty of the day and building in a style, trying out new techniques and studying old monuments in order to restore, complete and reproduce them, witness Viollet-le-Duc (1814–79). Master of scientific restoration (privileged author of the first commission on historical monuments in France, instituted in 1837 by Guizot, minister under Louis-Philippe, who asked him to restore the abbey of Vézelay (1840), Notre-Dame in Paris (1844) and the cathedral of St. Denis (1846), he did not despise planning apartment blocks and studying the use of iron in architecture. Examining the outlook initiated by V. Hugo in the 1830s, which saw in Gothic architecture the forerunners of modern liberalism and nationalism (witness his novel *Notre-Dame de Paris*, not the least cause of the cathedral being restored), he developed a logical analysis of that style, showing its great lucidity. His theoretical studies, among the most acute of the period, show distribution as linked with construction through style, with Gothic as the paradigm. Since the theory was basically structural, ignoring symbolic force, the appreciation of the properties of iron seemed to him quite compatible with stone construction, indeed he regarded the two materials as complementary.

In his *Entretiens sur l'architecture* (1863–72), begun when for a few months he held the post of professor at the *École des Beaux-Arts* in Paris, leaving it suddenly in 1864, he stated his position thus: "Is the nineteenth century condemned to end without having an architecture of its own? Trying to fasten on to the Middle Ages, the Renaissance, seeking to use forms without analyzing them or going back to the causes, confining itself to effects, it has become neo-Greek, neo-Romanesque, neo-Gothic, asking for inspirations from the fantasies of the century of François I, the pompous style of Louis XIV, the decadence of the seventeenth century, it is now so subject to fashion that in the academy of fine arts, that classical territory, we have seen the rise of plans showing the most bizarre mixture of styles, fashions, periods and means, without ever showing the least sign of originality." (*Entretiens*, X, vol.1, pp. 450–51.) Some years later he seems to continue: "And yet we are dealing with valuable material, when we have to build, particularly walls; the iron with which whole buildings are erected, such as Les Halles in Paris or certain railway stations, while next to such buildings, though well-designed mere hangars, we build citadels in stone.... Is there no middle way between a block of curved stone, such as the Madeleine, and a railway station?" (Ibid., XI, pp. 43, 46, 47.) Such views can be read as a program for tomorrow's architecture, and its contemporaries had to agree, if Baltard, who had built

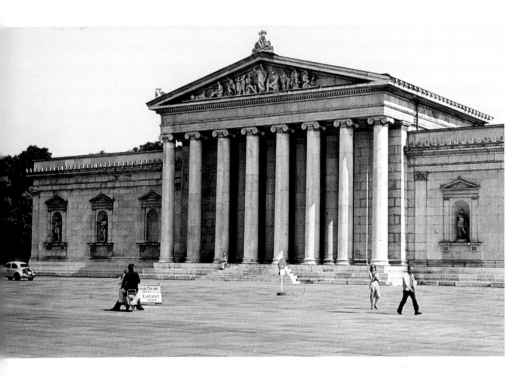

Left: L. von Klenze's Glyptothek, Munich, 1815–30. This design, giving every scope to nineteenth-century architecture, becomes after the first models by Schinkel and Soane a stylistic study exalting a canon, here well achieved.

Les Halles, built the church of St. Augustin (1860–71) following this notion, with a styled external appearance while inside you see the iron. That this was not a matter of structural technique but of aesthetic culture is clear from the way in which stone and metal construction are combined in railway stations cited by Viollet-Le-Duc (such as the Gare de L'Est planned by Duquesnoy, or the Gare du Nord by Hittorf).

Since they cannot be viewed as mere ramps for passengers, but as symbolic city gates, this very fact had clad them with vast covering cages over the platforms, massive tops and walls of stone, as signs of prestige and as monuments.

The most telling example is the type of building that appeared at the end of the century: the big department store. Here we have an attempt at reconciling the two aesthetic aspects in the daily feast of the consumer. The internal space linked by the metallic structure to the central glassed-in hall with its multiple galleries stacked to display the double spectacle of goods and those who buy them, is covered outside with a heavy mantle of styles to evoke luxury and success, as in the famous Galleries Printemps (1882–83) by P. Sédille. In due course, at the turn of the century other such stores show this change of direction: L. H. Sullivan's Carson Pirie Scott & Co. Store (1899–1904) in Chicago, V. Horta's Innovation (1900–1) in Brussels, F. Jourdain's Samaritaine (1905–7) in Paris.

At the end of the century that has con-

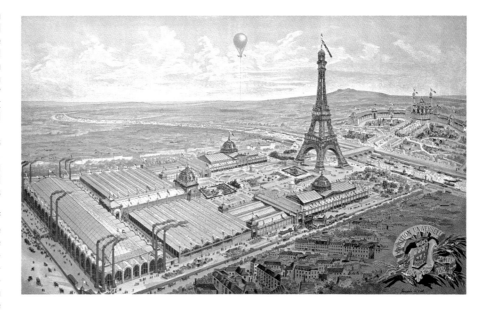

quered space, we travel safely at the speed of trains, the precondition of its most original achievements. Its most memorable enterprises are the Transcontinental line in North America and the Trans-Siberian in Russia. Here we have the two models of entering new territories to unify them by institutions or colonizing them by private initiative, or both. If in Russia it takes longer for civic society to become autonomous and find itself, in

Above: G. Eiffel's great Tower in Paris, 1887–89. Among great exhibitions, that in Paris (1889) stands out for the first iron monuments: Galerie des Machines, of the then widest span ever, 111m (364ft), and the Eiffel Tower, 320.75m (1052⅓ft) high.

Right: The Ring in Vienna, begun in 1850. The century's most unified and systematic plan for transforming urban image and structure is that of Vienna, laying out in a grand design the area between the historic center and new expansions, the set of urban sites from which arise the vast images of the new civic institutions, solitary and recalling each other.

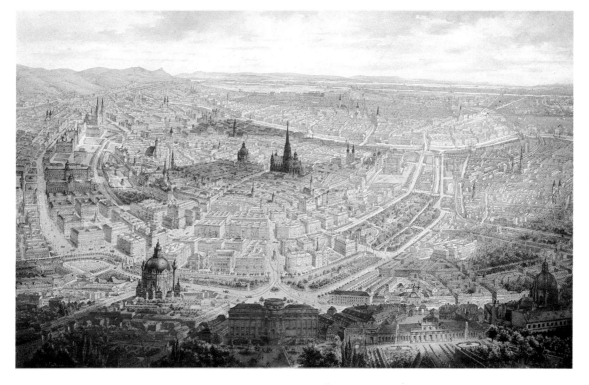

America it happens early, witness the conquest of the West, even on its darker side. In this context we find a desire for a simple yet grand and elegant character in the most common buildings, where iron freely merges with stone, now freed of orders and traditional styles. The Chicago school, building the first skyscrapers, is the best example. It is mainly to this end that early in the American enterprise there arises a practical trend to seek the aesthetic in construction, freed from orders and styles in order to express an original simplicity. The most famous example is the Chicago school and its foremost exponent, L. H. Sullivan (1856–1924; the young Frank Lloyd Wright worked in his studio). In his skyscrapers, Wainwright Building (1890) in St. Louis, Prudential Building (1894) in Buffalo, the cellular structure of the internal skeleton dictates the external aspect according to patterns unknown to European architecture. The decoration that Sullivan introduces becomes a means to mediate between the human scale and the huge volumes. That is the new general feature of the style emerging at the end of the century. It is a design outside all institutional and academic symbols of the traditional

orders. It inherits and deepens the evident intentions in references to medieval Gothic and Romanesque. We must recover a more direct visual and spatial experience of architecture based on a design able both to involve the total bulk and relate it to the small dimensions of the human body with its limited field of vision and use. Considering the outstanding authors – C. R. Mackintosh (1868–1928), with his Glasgow School of Art; V. Horta (1861–1947) and his Maison du Peuple in Brussels; A. Gaudí (1852–1926) and his apartment blocks Milá and Battló in Barcelona; O. Wagner (1841–1918), Majolica House in Vienna – beyond all differences in their aesthetic aims, noticeable though they are, this is the general feature, coinciding with the attention to the aspects of daily life and with the rise of the dwelling itself as a "contemporary current monument." However, if houses become monuments, as Boito has shown, when everyday life is given the force of memory as a document of an unrepeatable present, the range of monumental values changes completely.

Below: L. H. Sullivan's Carson Pirie Scott & Co. Store, Chicago 1899–1904.

Above: Horta's hôtel Van Eetvelde, part of the staircase, Brussels, 1828. Here traditional canons are overcome by a synthesis of past and present.

Avant-garde, Fauve, Cubist art

The avant-garde movement

The term "avant-garde," which is now part and parcel of art jargon, describes that ensemble of artistic activities – ranging from the Fauves to Cubism to Futurism; from the Expressionists to the various forms of abstract art; from Constructivism to the Bauhaus; from the Dada movement to Surrealism by way of the Metaphysicals – that followed on one from the other at a hectic pace throughout the span of time between roughly 1905 and 1924. During this period the outbreak of war caused an additional break with the past. These activities gave an unmistakable stamp to the language of art, as well as to the very notion of art in the twentieth century.

Facing the historical process which embraced the rampant bad taste of so much of the commercial and official painting of the late nineteenth century, the most alert artists began to feel the need to form groups in order to differentiate their work, and restore to their artistic activities both value and quality. It was from within that they would justify the choice of forms adopted. In this way, and with their own experiences, they would mark out a "progressive" line of development toward the definition of languages and styles which were becoming increasingly independent.

A factor in this scenario was the Romantic legacy of the assertion of individuality and the pre-eminence of the ego over traditional criteria. At the beginning of the twentieth century this stance became a discipline involving an infinite decentralization and the irreversible detachment of the individual from all complete systems (religious, philosophical, or aesthetic).

The avant-garde artists responded to all this by working out formal models or linguistic interventions. Until the outbreak of the First World War these developments seemed to follow a line of progress, leading toward a new arena for man's perceptive and expressive possibilities. In this new arena it would be possible to grasp the duration of objects in space–time (Cubism) or the inner dynamics of matter (Futurism). The developments just referred to also pointed toward a complete self-awareness of the language and figuration of innermost mental spaces (abstractions) and toward the integration of creativity and production (Constructivist avant-garde). In addition, all these objectives carried within them the dream, or the Utopian idea, of refounding society. When war was declared in 1914, plunging the notion of progress into a state of crisis, the *independence* of the work of art by then acquired was ready for further reflection about the conventionalism of aesthetics and language. The advent of the Dada movement posed, in its starkest terms, the burning and dire problem of the ultimate meaning of art.

Juan Gris, Homage to Picasso (1911–12). The Art Institute, Chicago

Dada also addressed the question of the arbitrary nature of the concept of the work (of art), now stripped of its "aura" and divested of meaning and function, which itself remains as a naked *object* or, conversely, becomes a term to be applied to any old banal *object* of the everyday variety. In another quarter, as early as 1910 – the year of Kandinsky's first abstract watercolour – de Chirico's isolated line of thought had already laid the foundations of the Metaphysical movement. This manner of painting, rooted in alienation, removed objects from their usual, consequential place, and displaced spaces from the habitual concept attaching to them. In so doing it amplified their suggestive quality by stressing the evocative power of pictorial activity. Surrealism inherited certain aspects of Dada and certain Metaphysical elements. Here again, a higher order of reality was proposed. This order would integrate oneiric (dreamlike) experience and the irrational, in a Utopian fusion of art and life.

Under Gropius, the Bauhaus, which was a haven of design, research, and instruction in 1920s pre-Nazi Germany, represented another dream of integration involving artistic activities and the reality of industrial production.

The history of the avant-garde cannot therefore be traced in any straightforward way, even if it is possible to single out "lines of force" and guiding principles also shared by musical and literary research in the early twentieth century. One such principle consisted in upsetting established practices of perception and interrupting certain automatic processes of seeing (and listening). It set itself

up as the *vanguard* of "modern man's" senses, proposing more advanced configurations of the imagery of the world and its translation into signs. In this sense the history of avant-garde is the history of continuously overcoming pre-established orders. Sometimes this entailed abrupt ruptures; sometimes it exaggerated already elaborated forms. In some cases the spirit behind this process was analytical, rivalling the scientific spirit. In others it burst forth with the energy of youth and "adolescent excitement" shared by Picasso, Schönberg, and Joyce. But consistently it showed the certitude that it was acting in an experimental way, following an imperative which, at the outset, appeared evident to very few people, but which would before long gain wide acceptance.

The origins of the drive that set avant-garde in motion were triggered off by the crisis of Romanticism, and can be traced back to around the end of the nineteenth century. They had to do with an awareness of the independence of the work of art from external references. They implied an assumption of consciousness that a system of signs is significant in its own right (beyond its relation with reality). This spirit of awareness made advances in the 1880s, once the Impressionists had devalued objects and spaces as such, preferring to depict them as visual experiences.

From that time on, the idea gained currency that the picture is a continuous version of colour-and-light impressions on a surface. The Pointillists Seurat and Signac kept to this path and stressed the scientific and quantitative aspects of the pictorial procedure. In their studies on the psychological significances of the line, this procedure did not exclude Symbolist components. In this they reclaimed for art its function of being an analytical method concerned with the visual facts. This function

would become the hallmark of the Bauhaus.

Cézanne went still further in his attempt to retrieve the plastic dimension without resorting to modelling. He worked on perspectives. He dismantled objects. And he painted spaces by means of a weft of constructive brushstrokes

which would become an important legacy for both Matisse and the Cubists. Gauguin also went beyond perspective representation, flattening the volumes on the surface. He looked to Oriental, Egyptian, and Maori art, abandoning naturalistic colours and distorting the

Above left: wooden mask from the Etumbi region, People's Republic of the Congo. Barbier-Müller Museum, Geneva.

Above center: Pablo Picasso, Head (1906–7). Private Collection, Paris.

Above right: Pablo Picasso, Head (1907). Picasso Collection, Paris. "African art for Matisse the exotic or naïve, and for Picasso the Spaniard was something natural, immediate and dignified." With these words Gertrude Stein, who was an eye-witness to the Parisian avant-garde in the early years of the century, notes in the biography dedicated to Picasso in 1938 the "natural" power wielded by African sculpture on Picasso's language.

Left: Paul Klee, Saint-Germain in Tunisia (1914). Breguet Collection. Klee was a leading light first of the Blaue Reiter group and then of the Bauhaus.

chromatic effects to reflect the psychological effects. Gauguin was searching for profound and further assonances between formal elements and their psychic repercussions. Van Gogh produced a synthesis between the suggestiveness of Japanese art, an interpretation of the Impressionists and Pointillists, the echoes of Daumier's distortions and the social commentary of Millet. The result was a formal elaboration which formed the origins of Expressionism. Other important stimuli were sought in the ambience of Symbolism, and in the poetics of Mallarmé in particular. Mallarmé delved deeply into the inner rhythms of verbal language, juxtaposing words on the basis of sonorous rather than logical affinity, thus creating unusual poetic structures which conveyed within them a multitude of possible meanings. Simultaneously, in painting, the way was being opened up to messages from the unconscious, either by exploring new or unpublished iconographies or, like Odilon Redon, by plunging into the vibrations of materials, which were recognized as the active agents of figuration.

eloquent with the arcane associations between nature and man, and governed by laws differing from the Western concept of representation based on perspective and naturalism. To some extent these laws were a prelude to the regressive figurativeness of a certain type of Expressionism; to some extent they announced the tendency to grasp and depict an inner and immaterial reality.

The awareness that the pictorial surface does not rely on the norms of probable representation but rather responds to other criteria of truth and meaning is expressed in a celebrated utterance by Maurice Denis. Writing in L'Occident (April/May 1903) about the teachings of Gauguin dealing with the need to paint colours as they present themselves to the sensations rather than to the eye, thus excluding their verisimilitude and usual notions of perception, Denis adds that "for the first time we were presented, in a paradoxical and unforgettable form, with the fertile concept of the flat surface covered with colours that were juxtaposed in a certain order." This concept

was central to avant-garde art. At a later date, and in a different context, it was taken up again by the Cubist Gleizes, for whom "the picture bears within itself its very own *raison d'être*....It is an organism." It was further defined by the writer André Gide in an illuminating description of Matisse at work "without any airs on the elaboration of certain decorative motifs, indefatigably going back over certain lines to readjust them, and revising the volumes to give them an equilibrium that was just right. And yet nothing was governing the choice of these motifs, except the requirements of the space which lines and volumes should have filled....In order to conserve its quality of pure painting the work was being studied in order not to signify anything."

Avant-garde work disregarded any usual, habitual, and reference-oriented signification. It was intended to meet the demands of its formal or iconic elements which, as they were revealed in accordance with particular laws, made references to other significations. These elements also hit upon new dimensions of meanings, expanding the field of man's empirical possibilities. Beyond the specific and numerous differences of development, derivation, and context, this was the essential nucleus from which the historical avant-gardes fanned out. It represented a consciousness of language as a parallel and divergent system. It also represented a consciousness of the artistic experience as a "constant state of wary and ardent exploration" (Marise Volpi).

The Fauves: construction with colour

Fauvism was never a movement based on

This route would lead to Klee, the *frottage* technique of the Surrealists, and beyond, to Burri. The avant-garde matrix embraced an interest in artistic expressions that were a long way off in both space and time – Japanese graphics, Islamic art, and African sculpture. It also embraced "other" forms of expression like popular portrayals, puerile drawing, and the magic and naïve regressions of Le Douanier Rousseau. In all we find a repertoire of forms at once symbolic and decorative,

Above: Henri Rousseau, called Le Douanier, The Snake Charmer (1907). Musée d'Orsay, Paris. Commissioned by Delaunay's mother, this canvas reveals the imaginary exoticism of Le Douanier, who was much admired by Pissarro and Gauguin and later by Alfred Jarry, Guillaume Apollinaire,

Delaunay himself and, last of all, Picasso. Above right: Francis Picabia, Feathers (c. 1921). Private Collection. Picabia the great negator, who was first an Orphic Cubist and then a Dadaist and Surrealist, embodied the self-reflective, ironical and metalinguistic spirit of the avant-garde.

objectives that were expressed in the form of a program. Rather, Fauvism was a common, shared attitude, manifest in differing degrees and nuances. This attitude existed among a group of artists born in the latter years of the nineteenth century. They gathered around Matisse in the famous exhibition held in 1905 at the *Salon d'Automne*. It was with reference to this exhibition that Louis Vauxcelles, critic for the review *Gil Blas*, coined the term *fauves* (which means wild animals, or beasts). These artists countered canvases painted in intense and arbitrary chromatic schemes and typified by the abbreviated Symbolism of Matisse and his friends with a sober sculpture smacking of neo-Renaissance taste which emerged in that "orgy of pure colours" typified by *Donatello among the Beasts*.

Right: Giacomo Balla, Perils of War (1915), National Gallery of Modern Art, Rome. This is an example of painting which, in Balla's own words, is "bold, lofty . . . dynamic, violent and interventionist."

Below: Kurt Schwitters, Merzbild 25A: Das Sternenbild (The Star Picture) (1920). Kunstsammlung Nordrhein-Westfalen, Düsseldorf. New dimensions of meaning and renewed lyrical possibilities derive here from the provocative use of materials and objects.

Fauvism was a necessary stage in the investigation started by the Impressionists into colour as light and matter. In some respects it was an experiment that corresponded to the experimental Expressionist group *Die Brücke*. In the Fauvist experiment there was an outlet for and reaction to the teachings of the past masters of Pointillism (Seurat being the first master, but Signac and Cross the most important); to the evocative intensity of Gauguin's flat chromatic surfaces; to Van Gogh's Symbolism; and to Cézanne's colour-based forms. All this was reinterpreted in the light of the influence wielded by primitive sculpture from Africa and Oceania, which revealed unsuspected formal possibilities and provoked a sense of release from the reproductive fetters of the past.

The leading characters in the Fauve period, in addition to Matisse, were other students – as Matisse himself was – from Gustave Moreau's studio and the *Académie Carrière*: Albert Marquet, Charles Camoin, Henri-Charles Manguin, and Jean Puy. Also among them were Maurice de Vlaminck and André Derain, nicknamed the "couple from Chatou," because they habitually painted the same subjects together in the Parisian suburb of Chatou. These two were joined by Kees Van Dongen and, last of all, the so-called Le Havre group: Othon Friesz, Raoul Dufy, and Georges Braque. Braque went through a rather late Fauve period in 1906, shortly before he moved to the analytical decomposition of Cubism, along with Picasso.

If there was no manifesto of Fauve painting as such, the various declarations and letters of the artists involved reveal quite clearly the nature of the tensions behind their work. These same tensions also characterized the Parisian art scene in the early years of the twentieth century, and helped to make it the pulsating hub and nursery of so much modern art.

The Fauve painters also shared that widespread desire to go beyond the "uncertain shimmer" of Impressionism and the pure pictorial rendering of a fleeting retinal impression.

Their chosen direction was that of the scientific procedure, or the symbol, or the exacerbated form of expression. They were keen to restore a stability to form, but without harking back to traditional drawing and modelling. They wanted to exceed the "outer" limits of perception by incorporating within the experience of "seeing" the whole gamut of sensations and emotions which modify what is seen, cut deeply into the concept of verisimilitude, and turn the picture into an equivalent of nature, not in its appearance but in its introjection.

The initial climate of Fauvism emerges fairly clearly from various eloquent statements made by Matisse and de Vlaminck. Some of these statements focused on the significance represented by the use of pure colour in the careers of the young painters who were at the head of the movement. Reds, yellows, and blues – in other words, "materials which affect man's sensual depths" – were, in Matisse's view, "the point of departure for Fauvism." Once modelling and perspective had been abandoned, this point of departure made it possible to "express our emotions ... without resorting to means that had already been used." The energetic de Vlaminck, meanwhile, insisted upon the *expressionist* aspect of the movement, identifying the individual revolt against "schools" of thought and the liberation of creative potential with "my pure unmixed colours." The repeated summons to see the need to use new means shed light on the yearning to be different, to go beyond what had already been acquired. This condition was common to all the activities of the avant-

garde. In the Fauves it took the form of a precise procedure, the fulcrum of which was colour, plain and simple. Instead of painting the local tone of an environment, or creating a continuous weft of patches of light which break up the forms, the Fauves focused on a strong coloured element in landscapes or figures. They pursued deeply the effect produced by this, and constructed a chromatic system which no longer respected the laws of verisimilitude – or rather did not necessarily respect them, but used them only if they hap-

Top left: Henri Matisse, Nude in the Studio (1898). Bridgestone Gallery, Tokyo.

Above: Albert Marquet, Matisse Painting a Model in Manguin's Studio (1905). Musée National d'Art Moderne, Paris.

Top right: Kees Van Dongen, Fernande (1903). Private Collection. The principal characteristic of this Dutch painter, who was particularly attracted by the human figure, was his use of pronounced and incisive symbols.

Right: Henri Matisse, Luxe, calme et volupte (1904). Musée d'Orsay, Paris. Matisse used this title, borrowed from Baudelaire's L'invitation au voyage ("Là, tout n'est qu'ordre et beauté/ Luxe, calme et volupté" [There, there is nothing but order and beauty/ Luxury, calm and pleasure]), for one of his most famous pictures, which encapsulates many of the qualities and recurrent motifs of his later painting.

pened to coincide with the internal relations of the shades in question. In this way they created images which were arbitrary in relation to perceptive practice, but coherent in relation to the independent existence of the chromatic spectrum. Forms tended to open out and become abbreviated under the influence of the African sculptures that were doing the rounds of the studios, and colours seemed almost to follow the essential quality of this formal reduction. When used directly for modelling, or saturated, or made to react either by affinity or by discordance, they were the result of immersion into the chromatic scale. The purpose here was a search for apparent dissonances and unforeseen consonances, and for juxtapositions which were unnatural, but "faithful" to more distant harmonies. This search stimulated profound chromatic reflections of external reality as it impinged upon the inner world of the painter.

Impressionist and Post-Impressionist pictures seem to have neither beginning nor end, appearing like a continuous expanse of luminous specks, mirroring the retinal impression exposed by the light in every point. Fauve pictures, on the other hand, differed according to the style and temperament of their authors but led the spectator to read in them a consistent path, a point of departure, and a series of chromatic and structural actions and reactions, as if external reality had imprinted its diagram by means of "primitive" movements of coloured forms.

Henri Matisse (1869–1954) was one of the central figures in the group. His work itself is like a guidebook to the sources involved, to reactions to artistic encounters, to the stages of progressive awareness of this voyage into the world of colour and formal synthesis. As is now well known, his calling as a painter occurred during a period of convalescence. After it he abandoned all thought of a legal career and started to study drawing and painting. First he attended the *Académie Julian*, then from 1895 onward he was at the *École des Beaux-Arts* (School of Fine Art) in the studio of the great master Gustave Moreau. Moreau was a tireless investigator of pictorial material and of the hidden rhythms of symbols and signs.

But in this phase Matisse extracted from his teacher certain arabesque tendencies in relation to line, rather than instruction about colour. He continued to investigate all the synthetic and decorative possibilities of these tendencies, fulfilling in a certain sense the prophecy made by Moreau himself: that Matisse would simplify painting. In these formative years Matisse studied and copied Poussin, Chardin, and van Ruysdael. He observed the graphic explanations of Japanese prints. He produced still-life paintings in interiors. And he was above all alert to the harmonies and balance of colour tones without ever twisting the chromatic range, which was still made up of greys, earth colours, and whites.

It was during the summer months that Matisse embarked on new processes and schemes – a recurring pattern throughout his life. In this respect the summers of 1896 and 1897, which he spent at Belle-Île with the Australian painter John Russel, marked the birth of his interest both in painting *en plein air* and in swiftly transcribing chromatic impressions. During 1898 a series of journeys took him to London, to see the work of that great Romantic master of colour, Turner. He also visited Corsica where, for the first time, the southern Mediterranean landscape struck him with an explosive dynamism and revealed to him the solar possibilities of his own painting. Back in Paris, after Moreau's death he moved to the Carrière studio, where he got to know André Derain (1880–1954), whose interpretation of Fauvism in some sense complemented his own. He also met Jean Puy (1876–1960), who recalled from those years the "extreme and totally artificial means" introduced by Matisse in the rendering of landscapes and figures. Matisse did this to distance himself from any faithfulness to truth, and to achieve a higher level in his understanding of the effect of colours and forms on the sensations.

In 1901 Matisse exhibited at the *Salon des Indépendants*, together with his friend Albert Marquet (1875–1947). He also met de Vlaminck, to whom Derain introduced him during the retrospective show of Van Gogh's works held in the Bernheim-Jeune Gallery. The years 1898 to 1901 were an early germination phase for the requirements of Fauvism. These requirements were evident in the independent research being carried out by Derain and de Vlaminck, Henri-Charles Manguin (1874–1949) and Kees Van Dongen (1877–1968), who settled in Montmartre in 1897. In this same period Friesz, Dufy, and Braque also went to Paris.

Two "symmetrical" pictures date back to 1898: Marquet's *Nude in the Studio* and a canvas with the same title by Matisse. Both works reveal the expressive use of a Divisionist type of vocabulary and a twisting of the outlines which refer back to their acquaintance with examples of primitive sculpture. It is significant that from 1900 to 1903 Matisse also devoted himself to sculpture, with Rodin, and an investigation of the plastic structure of figures. At the same time an important event occurred in the artistic life of Paris. The year 1903 saw the establishment of the *Salon d'Automne*. Renoir was its honorary president. Its headquarters were in the *Petit Palais* to begin with, and then from 1904 in the *Grand Palais*. Here there was a series of important retrospective shows – important, that is, for the development of Fauvism as well as for the birth of Cubism.

In the summer of 1904, after his first one-man show had been exhibited by Vollard, Matisse went to Saint-Tropez. Signac, then president of the *Salon des Indépendants*, was

staying there, as was Henri-Edmond Cross (1856–1910), a sort of Post-Impressionist heretic whose focus was on the decorative values of signs and the independent chromatic harmonies of nature, and whose inclination was to follow the imagination beyond the theoretical design of Pointillism. Matisse's contact with these artists at Saint-Tropez, combined with the eloquence of the Mediterranean landscape under the summer sun, caused him to take a new turn in his artistic career. He felt a strong attraction toward the doctrine of Pointillism, which enabled him to investigate the relations between shades of colour without imitating but, if anything, translating the truth of nature into a pattern of constructive and essential symbolic equivalents. This was a first step, an opening up toward possibilities that were still not yet altogether conscious. In this phase Matisse produced a few experimental watercolours from life, the picture entitled *The Terrace of Paul Signac at Saint-Tropez* and the sketch of a work which he went on to complete in Paris during the winter. This picture was called *Luxe, calme et volupté* (Luxury, Calm and Pleasure), and it marked the first unravelling of the Matisse style, with its characteristic search for plastic synthesis by specification of decorative elements, effected, in this instance, with a technique borrowed from Pointillism. In other respects the years 1904 and 1905 saw a great spread of interest in this movement. There was a series of exhibitions dedicated to Signac, Maximilien Luce, and Cross. In 1905 the *Salon des Indépendants* held the major retrospective exhibition of Seurat.

The study of complementarity and contrast involved an eclectic series of painters, and the use of *taches* (patches) of pure colour was a language which they all adopted. This language was depicted as the obligatory stage in the route leading from the Impressionist touch to the constructive brushstrokes of Fauvism.

In the same year – 1905 – Matisse completed and exhibited at the *Indépendants* his *Luxe, calme et volupté*, a "modern pastorale" with a title redolent of Baudelaire (whose *Fleurs du Mal* Matisse also illustrated). In this picture we can also find traces of André Gide's poetry, and in particular certain parts of his *Nourritures terrestres* in which the poet evoked a "thirst for rest and a thirst for pleasure." This Matisse pastorale was set in the bay of Saint-Tropez. Matisse had studied this stretch of coastline for a long time, with drawings and watercolours. The figures are arranged harmoniously, reclining, sitting and standing, either dancing or attending to their hair. The painting's design consists of broad, short rectangular *taches* or patches which call to mind the tiles of a mosaic. The colours are like the refractions of a prism and restore that "tactile animation, comparable to the 'vibration' of the violin or the voice" which Matisse himself singled out as the principal feature of the Divisionist effect. Traces of outline still interrupt the continuous spread of the brush-

Above: Maurice de Vlaminck, The Outing *(1905). Private Collection, Paris. Akin in manner to Van Gogh, and in theme – the couple in nature – to certain canvases*

produced by artists in Die Brücke, this work by de Vlaminck represents the material side of Fauve Expressionism. This work is sometimes quoted as the precursor of the Cobra group.

Below: André Derain, Landscape with Snow at Chatou *(1905). Private Collection, Paris.*

strokes, while the picture is presented, in the end, as a quest for equilibrium between vertical and oblique lines. These lines are orchestrated and arranged in a way which already, to some extent, points to *La Joie de vivre*. From 1905 onward Saint-Tropez became a place where the Fauves gathered and exchanged experiences. The artists who spent time there included Marquet and Camoin; the painter Valtat, a friend of Cross; and Manguin, whose painting *The Bay of Saint-Tropez* was oriented more toward Cézanne than Pointillism. In this period all these artists demonstrated a heightened intensity in their palettes, in their use of pure and split colours, and in their free, undogmatic interpretation of the Divisionist technique, as we can see in Manguin's *The Fourteenth of July at Saint-Tropez*, or Marquet's *The Port of Saint-Tropez*.

In the meantime a retrospective exhibition of Van Gogh at the *Indépendants* revealed new possibilities of expression in the density of the brushwork, in the compact nature of the surface, and in the wealth of emphases in the canvases of the Dutch artist, who loomed like another beacon in the search for ways to go beyond visual impression. In 1905 Matisse invited Derain to spend a summer working together at Collioure, a village on the Roussillon coast, perched between France and Spain. For the Fauve movement Collioure represented the place where the expressive tensions and formal precepts that had been accumulating during the early years of the century matured and were externalized. In the annals of Fauvism it was at Collioure that the transition was effectively made from the Pointillist technique, charged with suggestive qualities and distortions, to the new manner, which was intensely chromatic and independently expressive. It is this latter that we call Fauve. In the summer at Collioure another founding father of modern painting came to take up his position in the cartography of the sources of Fauvism. Thanks to the sculptor Aristide Maillol, who introduced Matisse and Derain to the collector Daniel de Monfreid, they were able to have a look at Paul Gauguin's Tahitian canvases. The large expanses of colour applied in the *à plat* manner, the intensity of the colour shades, and Gauguin's arbitrary chromatic doctrine all offered a way out from the impasse of Pointillism. For Pointillism, in effect, ended up by neutralizing the intensity of the shades; it did not permit saturation; and it tended essentially to reintroduce the diffusion of local colour tones. With Gauguin's example, however, we find a confirmation of the possibility of replacing the entire tone with the harmony of wide surfaces covered with intense colours. In the summer of 1905, therefore, according to Matisse himself, Fauvism adopted the total exclusion of "imitative colours to obtain with pure colours stronger reactions, and more evident simultaneous reactions." And as a result of a sort of alchemy typical of those driving moments in the search for new forms,

the works produced by Matisse in this period present parts handled using the Divisionist technique, flat expanses of colour that are nonhomogeneous and contrasting indications of perspective and space, and zones defined

expressive areas of colour developed on a central theme, this theme being the yellow-green line which boldly bisects Madame Matisse's face, giving its oval shape relief and salience. The fixedness and density of the

Left: Henri Matisse, Study for La Joie de vivre (1905). Royal Museum of Fine Art, Copenhagen. This is one of the preparatory studies for the 1906 picture, which was shown at the Salon des Indépendants *and kept at the Barnes Foundation at Merion. Here Matisse's quest to translate visual experience into chords of colour and light reaches a high point, creating a pattern of signs which enhance the physical density of the colour and the decorative quality of the lines.*

and worked out alongside other synthetic zones (an example being the *Open Window at Collioure*). In his correspondence with de Vlaminck Derain vividly recounted his experiences at Collioure, telling of the emotion he felt at the sight of a Spanish village, and telling too of a "new conception of light." This conception would reveal shadow as a world of light, confirming his intuitive feeling that the effect of nature on our impressions could be rendered simply by a combination of different kinds of light.

The result, in landscape paintings, was a search for the luminous equivalents of external reality, while in the *Portrait of Matisse* the arbitrary colours, presented over broad constructed areas, ended up as chromatic fields of energy. Matisse, meanwhile, had roughed out several sketches for *La Joie de vivre*, including the one in the Barnes Foundation at Merion, where the picture still is, and the Copenhagen sketch with its extraordinary luminosity, which is a synthesis of broad *taches* and sinuous lines, artificial and harmonized colours, and rhythms in search of equilibrium, as in a musical composition. Moreover, Matisse made frequent reference to musical harmony when he discussed his own research, which would in fact lead him subsequently to dedicate compositions to dance and jazz themes, and to produce sets and costumes for ballet.

Back in Paris he produced some of the essential and fundamental pictures of Fauvism: his *Woman with the Hat* (a subject quite dear to him) and his *Portrait with the Green Line*. These were juxtapositions of free and

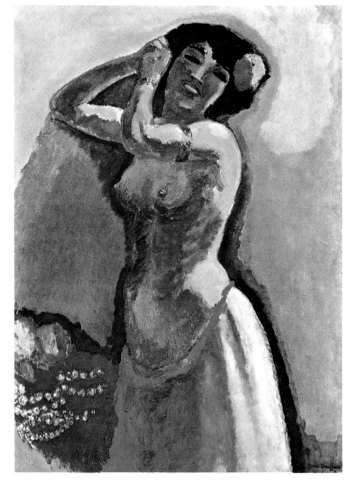

Above: Henri Matisse, Portrait of André Derain (1905). Tate Gallery, London.

Left: Kees Van Dongen, Woman with Jewels (1905). Private Collection. For both the exponents of the northern European Expressionist group Die Brücke *and the Fauves, the human figure played an important part. It was the catalyst for research into colour and form, often occurring as an energetic pictorial translation of the plastic syntheses presented by African sculpture, for examples of this sculpture were starting to circulate round the studios of French artists. Expressive intensity and a certain amount of formal provocativeness are an obvious derivation from the analysis of African plastic arts. In Matisse's work this analysis was combined with a great capacity to interpret the person being portrayed, transformed into a primitive mask of him- or herself.*

features in this portrait call to mind the portraits of Fayyum.

The 1905 *Salon d'Automne* – which showed, among others, works by Kandinsky, Jawlensky, and Le Douanier Rousseau with his re-

commercial luck – not forgetting the inevitable first telltale signs of crisis. In some cases these took the form of stylistic standstill or repetitive impasse; in others they constituted a process of transformation toward another language.

evident that with this work things have gone not so much beyond Fauvism as beyond the definable limits of the movement, at the center of the generative nucleus of the Matisse imagination, which can, in substance, be called

Right: Henri Matisse, La Pastorale *(1905), Musée d'Art Moderne de la Ville, Paris.* La Pastorale *was painted in 1905 during the time spent with Derain at Collioure. In this period Matisse made the move toward Fauve coloration and the direct emotional translation of chromatic datum.* La Pastorale *is regarded as one of the innnumerable works that would lead toward* La Joie de vivre. *The mythological and bucolic theme refers to Virgil, as well as to the* Après-midi d'un faune *by Mallarmé and Debussy, and to the numerous compositions on the theme of the Golden Age and a longed-for Mediterranean nature, as painted by Signac and Derain. Stylistically speaking, the motif of Cézanne's* Baigneuses *(Bathers) is still present, here reinterpreted within an ensemble of arabesqued lines which point to the future developments of Matisse's pictorial language.*

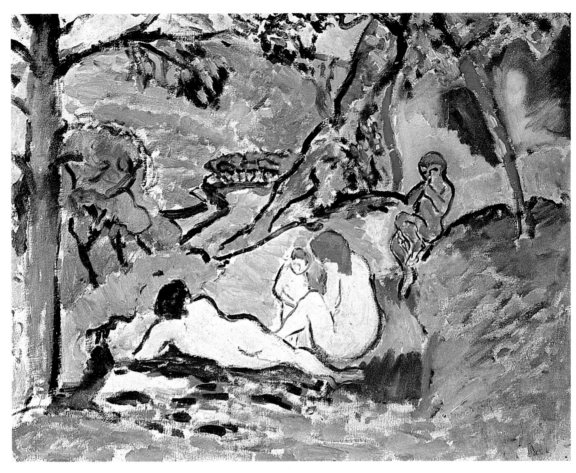

gressions into a world of "primitive" and intuitively simplified forms – gathered into one room the controversial works which would be known as Fauve precisely from the date of that exhibition onward. As well as Matisse's *Window at Collioure* and *Woman with the Hat*, and various drawings and watercolours, other works on show included Derain's *Sails Drying*; landscapes and city scenes by Manguin, Valtat, and Puy; Van Dongen's *Bust of a Woman* and *The Shirt*; and then works by Marquet, Manguin, Friesz, Charles Camoin (1879–1965) and Rouault, most of which attracted negative reactions. Once again it was Vauxcelles who recognized Matisse's Divisionist mould, and the way Matisse demanded greater vibrancy and luminosity from that technique.

The period between November 1905 and early 1906 saw Fauvism come to maturity with an explosion of more luminous canvases, the membership of Dufy and Braque, exchanges with foreign contacts, and a certain amount of

For Matisse 1906 was the year of *La Joie de vivre*, which was shown at the *Salon des Indépendants*. It represented an ideal compendium of his experiences to date and a synthesis, as has often been pointed out, of the themes of the bacchanal and the pastorale. In these themes Delacroix's chromatic tradition is transformed by means of Cézanne's coloured volumes and Gauguin's *à plat* manner. Pronounced dark and arabesqued lines powerfully delimit the outlines of the coloured areas, as if they were pauses or variations in tempo in a musical excerpt. In *La Joie de vivre* we have a salient example of Matisse's highest and most constant quality. We see that capacity to create a sort of taut equilibrium between perceptive suggestions and a formal order which *contains* the spread of the sensorial data like a diaphragm under tension, just as the emotional content of the image tends to become settled in a broad composition that is slightly dynamic and decorative, like a sort of musical "largo". It is

Fauve, if by this term we mean his instinctive capacity to glean from colour its expressive power, its evocative freedom, and its capacity to construct an essential space and a rhythm. These factors were to have enormous influence on postwar American art. By following Matisse in the sequence of phases as far as the "expressionist" phase, we would end up way beyond the chronological boundaries of the avant-gardes. Matisse in effect remained Fauve with regard to colour, as we have already indicated, and until his death in 1954 he carried on his process of purification and simplification of form by linear arabesque. He insisted on the recurrent themes of *interiors* and "abstract" and rhythmic motifs such as *dance, music,* and *nudes*. This aim of achieving an extreme formal reduction led him to invent the technique of *papiers-découpés* (cutouts). These were compositions of cutout paper shapes in which the colour was identified in an absolute way with the form. They are very much part of Matisse's huge graphic

output and his decorative works.

This instinct for colour and for synthetic and decorative solutions was further emphasized in 1906 after his journey to North Africa. The effects and impressions produced by those landscapes – but even more by the decorated fabrics and ceramics he saw in them – burst forth, on his return, in the form of his *Still Life with Red Carpet*, a *mélange* of markings, Divisionist-like zones, and *à plat* areas which, as a result of variations in the chromatic material, become a table, a wall, fabric, and fruit – the vibrations and incrustations of a space constructed only by colour and not by the volumetric nature of things. This marked a further formal liberation achieved as a result of an "exotic experience." The term Fauve may be applied more accurately to *La gitane* (The Gipsy) and *Self-Portrait*, because of the deformations of the symbol and the overbearing prominence of the figure.

The Dutch painter Kees Van Dongen (1877–1968) was interested mainly in the figure and in the mundane aspects of Parisian life. With images taken from the worlds of the cabaret and the circus, Van Dongen appears to revive and renovate the range of subjects which were popular with Daumier, Lautrec, and Seurat. With their acrobats and clowns Picasso and Rouault also paid homage to these subjects, reinforcing that myth of the clown which constitutes an eloquent chapter in the iconography of the modern period.

Where portrait painting was concerned, Van Dongen achieved high points of Fauve and chromatic expression and sensuality in, for example, the portrait of Picasso's companion, Fernande Olivier.

The work of Maurice de Vlaminck (1876–1958) represents the most direct and immediate aspect of Fauvism. It assumes the role not so much of searching for the chromatic equivalents of a sensation as of swiftly and violently recording the effect of a landscape. This record is obtained by intensification of hues and distortion of outlines, within a design that does not develop in totally arbitrary harmonies or disharmonies, but rather remains closely linked to the datum of nature. Vlaminck was strongly attracted by the Symbolism of Van Gogh, whose echo is quite tangible in the ensemble of brushwork in *The Outing*. He was one of the first people to be affected by the impact of African sculpture. Vlaminck was, in a nutshell, the painter with "vital force," or *élan vital*. He was driven in an extreme and inexorable way toward self-expression in signs and colours which seem to convey to the onlooker the very force of the gesture which has arranged those signs and colours on the canvas.

De Vlaminck's early activities at Chatou in 1900 or thereabouts marked painting's exit from the "straitjacket of Impressionism and Divisionism." This was, then, one of the seminal moments for the Fauve movement. Vlaminck himself, in his own writings (*Tournant dangereux* [Dangerous Bend], Paris, 1929),

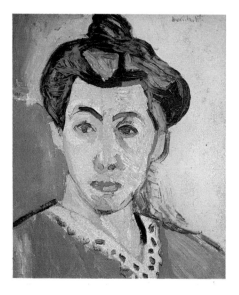

mentioned how the discovery of the energy innate in pure colours was like a state of continual intoxication. He remarked, too, that this energy was the distinctive feature of his painting – a direct and visceral transcription of sensory existence. For Derain – who worked at Chatou with de Vlaminck and then at Collioure with Matisse – Fauvism corresponded to the phase in which the visual impression was superseded, a phase of searching for stable equivalents of sensation. His stay in London produced *The Pool of London* and *Westminster Bridge* which, together with *The Woman in the Shirt* (also painted in 1906), revealed his overriding interest in the organization of space. This, subsequently, would increasingly characterize his canvases, which became articulated by clear and "monumental" volumes and coloured geometric designs, while the decidedly arbitrary hues never turned out

dissonant but rather constructed a higher level of harmony and a progressive intensification of the initial impression.

The works of Raoul Dufy (1877–1953) and Othon Friesz (1879–1949) were also governed by overall harmonies which included certain points of rupture and imbalance. These pain-

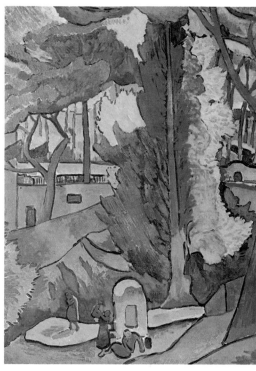

Top left: Henri Matisse, Portrait with the Green Line (1905). Royal Museum of Fine Art, Copenhagen.

Above: André Derain, L'Estaque (1905). Private Collection, Paris. To judge from what Derain himself said, the Fauve experience was an "ordeal by fire" during which colours became "sticks of dynamite." For all this, his major preoccupation was still to gather forms into light, using subtly geometric designs and arrangements.

Left: Maurice de Vlaminck, Bank of the Seine at Carrière-sur-Seine (1906). Private Collection, Paris.

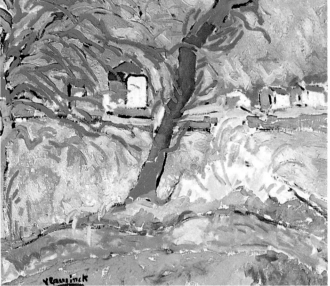

ters from Le Havre were attracted by city life, by the port with its reflections and its busy dynamism, by fourteenth-of-July flags, and by a whole range of subjects which showed their close ties to the Impressionist matrix. Their canvases developed away from this in the direction of simplification, toward a reduction

Right: Henri Matisse, French Window at Collioure (1914). Musée National d'Art Moderne, Paris. The motif of the open window, like a screen between different types of space, was popular with Matisse, and had been ever since his famous work Open Window at Collioure *(1905). This painting was an explosion of Fauve colour, and a peak of descriptive techniques and "incoherences." As the years passed Matisse's* fenêtres *(windows) revealed the artist's concern with gradating various tones of luminosity within the picture, demarcating flat areas of colour and groups of lines on the surface. In this work the window is an ambiguous black screen, a threshold which no longer works as a perspectival device but, once the objects have been engulfed, dilates the space by opening it to the "extension of the imagination" (Matisse).*

Below: Georges Braque, The Port of L'Estaque (1906). Musée National d'Art Moderne, Paris.

of the impression to flat areas of colour and vigorous symbols, which fix the diagram of the visual effect.

The presence of a painter like Georges Braque (1882–1963), the complementary pole of the Picasso brand of Cubism, within the Fauve experience was a clear sign that Fauvism had not only had a function of liberating expressive potential but had also been a sort of device which had, as it were, accelerated the relation between visual experience and its formal translation. Braque was born in Argenteuil and had lived in Le Havre. He was profoundly affected by the 1905 *Salon d'Automne*, and began there and then to abandon all Impressionist modes during a stay in Antwerp with Friesz. Later on he would confess that because he was no lover of Romanticism he was attracted to Fauvism, which he significantly defined as "physical painting." He was thus attracted by the material character and the technical aspect of Fauvism, as well as its rejection both of the object as such and of the "Romantic" subject.

For Braque, who took to such lengths the possibility of rendering the experience of things in space, Fauvism was a way of breaking with reproductive practices as he searched for formal equivalents of the visual.

In his odyssey toward the progressive and complete transformation of visual data into an independent language – i.e. Cubism – capable of restoring a complete, intellectual notion of reality, Fauvism represented the springboard, or the feeler put out with the substance in question for the "physical" record of the pictorial activity. In the landscapes painted at L'Estaque – a spot much loved by Cézanne too – and later in those of La Ciotat, Braque investigated the light–colour relationship and the synthetic possibilities of lines, using at the same time Pointillist brushstrokes and spreads of colour. The *Small Bay at La Ciotat*, completely constructed from the innermost resonances of the hues, is perhaps the most significant work of his Fauve period. In the landscapes of L'Estaque, on the other hand, as in other works produced at La Ciotat, the dominant feature is the quest for geometric and structural rhythms.

Interest in light turned to an analysis of volumes and space, and at that point Braque was no longer satisfied with the information he was able to derive from the Fauvist experience. This information acted as a bridge toward other goals. Braque – and Fauvism – were thus like a central pivot to modern art, because, as Matisse again aptly put it, they clearly embodied the need to subject nature to the spirit of the picture.

Cubism

The Cubist years, which stretched from 1907 until the outbreak of the First World War, marked a point of no return for modern art. They introduced substantial modifications to the rulebook of representation. These modifications brought with them additional ways of interpreting reality hitherto never considered. After Cubism – as John Golding, one of the major historians of the movement, so eloquently says – "painting would never be the same again." These years saw a brisk sequence of artistic, philosophical, and literary events which were somehow connected, like a concatenation. They constituted a moment of extreme tension in which new formal and conceptual orders were proclaimed. These orders would play an important part in the development of the contemporary and subsequent avant-garde movements, from Futurism to Rayonism to neo-Plasticism.

The source of Cubism in fact consisted of a serried and complex series of facts and ideas. These constituted the terrain in which the different activities of Picasso, Braque, and Gris would germinate; as would those of the Orphics Delaunay, Léger, and Picabia; Albert Gleizes and Jean Metzinger, authors of the troubled and illuminating work *Du cubisme* (On Cubism, 1912) and leading characters, together with Marcel Duchamp, Duchamp-Villon, Jacques Villon, and Henri Le Fauconnier, of the 1912 *Section d'Or* exhibition; and of

all the other artists who together make up the fertile and comprehensive movement called Cubism.

The crisis which arose within the Fauvist movement among painters such as Matisse, Derain, and Braque revealed as early as 1906 the widespread demand to go beyond the

"physical" aspect of Fauve painting. This "physical" aspect was presented in powerfully expressive works, but these works remained anchored to principally optical and emotional values associated with chromatic and luminous sensations. It so happened that in about 1906, by chance, the work of Cézanne (who died in that year) became much more widely known. This development had the powerful effect of a revelation. Cézanne's work, linked with the scientific and structural aspects of the post-impressionist tradition, replaced the influence of Gauguin. The 1907 *Salon d'Automne* offered a fairly comprehensive retrospective viewing of Cézanne's output which, overall, started to appear to younger artists like the lucid signpost toward a path to be taken in the direction of a sort of painting which was the result of a reflection, not of an impression. This new path would be capable of reinstating space and volumes without resorting to the illusionism of perspective. It would be based on the awareness that the more internal and stable reality of things should be sought not in the way they appear to our perception, but rather in the intellectual framework within which they are recognized. In this sense Cézanne left behind him many masterful instructions and valuable suggestions. For he had started to reduce objects and background to an indiscriminate ensemble of constructive brushstrokes, breaking up the outlines and increasing the number of perspectival indications, all with the intention of

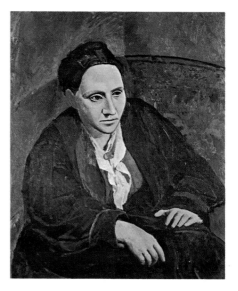

Above: Pablo Picasso, Portrait of Gertrude Stein (1906). Metropolitan Museum of Art, New York. "I sat for him all through the winter, eighty times," Stein recalled. "In the end he wiped out the head, said he couldn't look at me any longer and went off to Spain.... As soon as he was back he painted the head without seeing me again.... For me I am me. This is the only replica of me in which I am always me."

Left: Pablo Picasso, Self-portrait (1906). Museum of Art (A. E. Gallatin Collection), Philadelphia.

Below: Paul Cézanne, Man Standing with his Hands at his Sides (1885–87). Museum of Modern Art, New York.

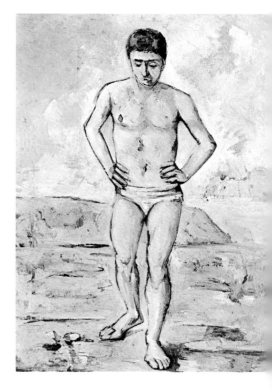

also making visible the hidden planes of things – or, better still, with the intention of indicating our mental–visual system. Cézanne had, in effect, started to paint the "notion" of space and the things within it, reducing the countless forms of nature to the geometric invariables underlying them. His invitation to "put into perspective" cylinders, spheres, and cones

can in fact be regarded as a preamble to the Cubist attitude.

Together with this structural line in French painting, another factor determining the formative moment of Cubism was the impact on artists of that period of African and Iberian sculpture. These forms of Primitivism had already started to circulate in Fauve circles,

Pablo Picasso, Les Demoiselles d'Avignon *(1907). Museum of Modern Art, New York. According to Robert Rosenblum's analysis,* Les Demoiselles *has a "barbaric power" which has a counterpart in the contemporary musical world of Bartok, Stravinsky, and Prokofiev. The picture condenses and compresses the legacy of Cézanne, as well as that of Michelangelo, distorting it by way of pagan Iberian sculpture and African art.*

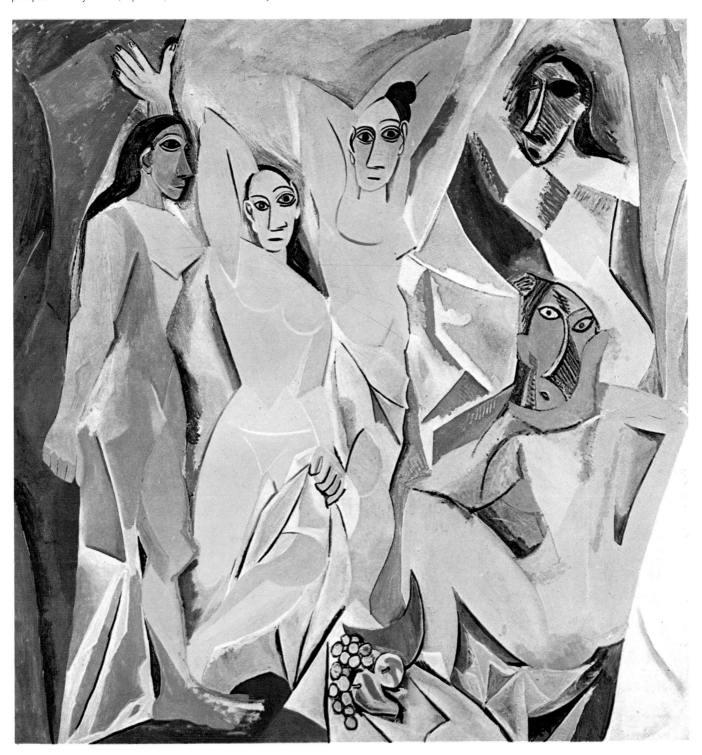

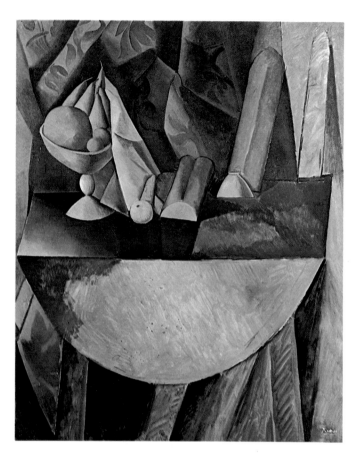

Left: Pablo Picasso, Bread and Fruit Bowl on a Table (1909). Kunstmuseum, Basel.

Below: Pablo Picasso, Factory (1909). The Hermitage, Leningrad. The objects in the enclosed space of the still life unravel their surfaces as if they are on a sheet of paper. In the landscapes painted during these years of intense investigation we find what Gertrude Stein noted in her highly personal observations of Picasso's activity: "The architecture of the other countries always follows the lines of the landscape. . . . Spanish architecture, instead, cuts these lines. And this is the basis of Cubism. Man's work is not in harmony with the landscape, it is opposed to it."

picture which, in many respects, anticipated Cubism. It already included some of the basic Cubist principles. This picture was *Les Demoiselles d'Avignon.* Its indirect prototypes were Cézanne's and Derain's compositions on the theme of "bathers." *Les Demoiselles d'Avignon* revealed Picasso's innovative determination and his ability to activate contrasting models and information. Picasso, as it were, discharged himself from the habitual series of images with a picture which, with all the derivations detectable in it, "is not like any other," to use Golding's words again. From the presence – in the early stages of the work – of make figures (one of whom holds a skull), accentuating the allegorical *memento mori* character of this atmospheric scene set in a brothel in Barcelona's Barrio Chino, to the title, for which André Salmon had proposed *Le bordel philosophique* (The Philosophical Brothel), *Les Demoiselles d'Avignon* is a tormented painting which is *in fieri* (or not quite finished) yet direct. It shows the consequences that can be produced by grafting the synthetic forms of African art onto a Cézanne-like spatial structure. Picasso himself said in this regard that "it would suffice to cut the figures into pieces – because the colours are merely indications of different perspectives of the inclined planes from one side or the other – and then put them together again on the basis of the indications provided by the colour, to find oneself looking at a sculpture." So because of the intermediary role played by the

between de Vlaminck, Derain, and Matisse himself. In Germany, for the painters associated with *Die Brücke,* these forms had had a clearly liberating influence on traditional rules and regulations, introducing, as they do, pronounced lines, angular surfaces, and formal abbreviations. Primitive art appeared simultaneously synthetic and powerfully expressive, a sort of violent appropriation of figures not in their outward appearance but in their innermost plastic substance, based on parameters which were completely *other* than those established down the centuries in Western culture. In the same way, and in the same period, the disconcerting imagery of Le Douanier Rousseau – which must also be listed among the sources of Cubism – sidestepped the habitual notions of perspectival space and volume, as well as old ideas of pictorial composition and planning.

So on the one hand Cézanne's pictorial design, showing that cognitive frame which is the only true arena within which it is possible to recompose the authentic notion of space, and on the other the primary and essential forms of primitive sculpture, both found a dialectical bridging point in the figure of Pablo Picasso (1881–1973). Between 1906 and 1907 – after the melancholic subjects depicted in his blue and pink periods, reminiscent of El Greco and Puvis de Chavannes – Picasso painted a

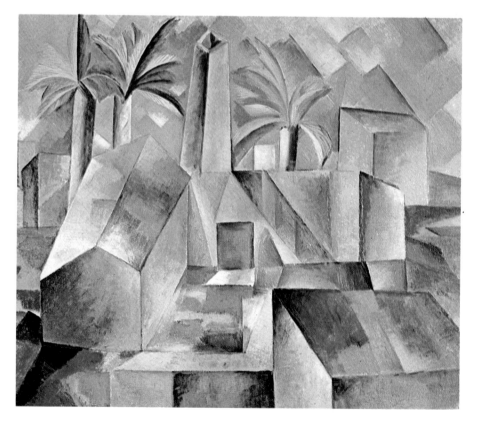

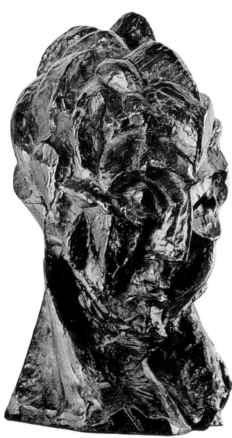

down of volumes by means of specifically oriented faceting, where divergent perspectival factors coexist through the simultaneity of the implied points of view.

Meanwhile – after his support of Derain's crystalline and geometrically oriented Fauvism – Braque started to wrestle determinedly with the problem of form. He also started to look closely at Cézanne's example. This was evident in the constructional preoccupation of a canvas such as *View of L'Estaque from the Hotel Mistral* (1907), which marked his abandonment of painting from models and his move to a pictorial practice based on memory, and hence on the cerebral and static features of seeing and painting. This step took him once and for all far away from the chromatic immediacy of the Fauves. In 1907 – thanks to Apollinaire, whose function in those years was that of lyrical interpreter of the revolutionary innovations of Cubism – Braque made the acquaintance of Picasso, with whom he was to forge a close bond lasting some years. He saw *Les Demoiselles* which, together with the pic-

tures exhibited at the Cézanne retrospective, represented the unravelling of new and intriguing formal possibilities, sustained by an inner rigour. These possibilities might at last liberate painting from what Braque called the *fausse tradition*, or "phoney tradition." In the summer of 1908 Braque was once more at L'Estaque, devoting himself to landscapes which already had the deep-seated nucleus of his style, consisting of order, a sense of measure, sobriety, and subtle chromatic vibrations played on the low scales of greys and browns.

In these landscapes the natural datum was passed through the sieve of a geometric grid of lines and perspectival planes. When the critic Vauxcelles – the same Vauxcelles who had been the first to talk of Fauves – saw them exhibited in the Kahnweiler Gallery, he declared that the artist was "disdaining form, and reducing everything, places, figures, houses, to geometric designs, to cubes" (*Gil Blas*, November 1908). Vauxcelles repeated this term – cubes – the following year with regard to Braque's pictures, which were being shown

Left: Pablo Picasso, Woman's Head (Fernande) (1909). Museum of Modern Art, New York.

Right: Pablo Picasso, Portrait of Ambroise Vollard (1910). Pushkin Museum, Moscow. Here we have a sculpture and a painting which tackle the linked problem of analyzing a face and rendering it in three-dimensional space, and on the flat surface of the picture. The sculpture seems to go deep into the space shared by the object and the exterior, in order to render material their intersections and their encounters. In the painting the face and space are broken up and broadened on the plane of their linear intersections. In both cases the original physiognomy of the model is not lost; instead it emerges with the power of a new dimension of realism.

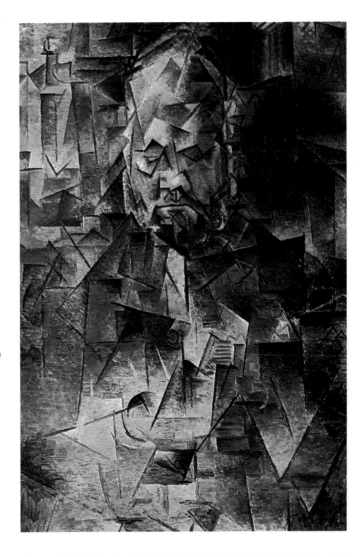

plastic notion of African sculpture, Picasso's brilliance was able to find the way to go beyond the conventional projection of an object on a surface by painting the volumetric "reality" of figures. At the same time he demonstrated the visible faces and the hidden faces, giving the impression of having effectively made an identification around the objects. He could then unravel onto two dimensions the data acquired. Space, meanwhile, was also treated as a solid element, the background planes wedged and woven into the figure planes. The painting thus tends to assume, like the reflex of plastic consciousness, the activity capable of embracing, beyond the veil of apparent forms, the structure of things. It stops not so much the split second in which they are manifest, but rather the duration of their perception in space.

From the figurative viewpoint the desire to express simultaneously the sequential moments of an experience triggered off a morphological alteration of the means of expression and of spatial organization. For Picasso this change became more and more specific in the two years following the completion of *Les Demoiselles d'Avignon*. In the summer of 1909, which he spent at Horta de San Juan, he produced a series of figures which merge the language of Cézanne and the language of Africa. He also created a group of landscapes showing the method involving the breaking

at the *Salon des Indépendants*. He called them *bizzarreries cubiques*, or "cubic oddities." The "cubic" concept thus found favour and started to be used in art criticism, sometimes with a disparaging nuance of tone but at others as a swift and efficient connotation of the formal character of this avant-garde movement. But it should be said that neither Picasso nor Braque ever considered himself as belonging to a "Cubist school" in the proper sense. Moreover, neither of them took part in the *Salons* which, from 1911 onward, gathered

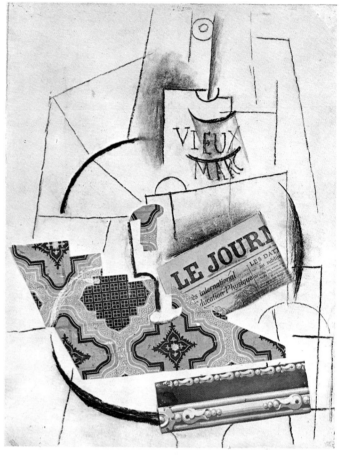

Right: Pablo Picasso, Bottle of Vieux Marc (1913). Musée National d'Art Moderne, Paris. Drawing and papier-collé collaborate in the reconstruction of the world of objects, in its loftiest concept, associated with the experience of duration.

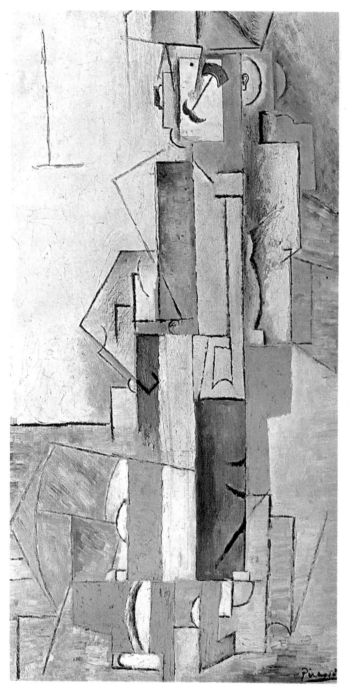

Left: Pablo Picasso, Clown (1913). Gemeentemuseum, The Hague. A type of painting structured by broad flat areas of colour, influenced by the papier-collé technique, is the hallmark of the Clown, Table, and Violin series of this period, which saw an interest in the synthesis of experimental data and a revived use of African masks.

Opposite left: Georges Braque, Houses at L'Estaque (1908). Kunstmuseum, Herman and Margrit Rupf Foundation, Berne.

Opposite right: Georges Braque, The Rio Tinto Factory at L'Estaque (1910). Musée National d'Art Moderne, Paris.

together artists such as – among others – Jean Metzinger (1883–1956), Fernand Léger (1881–1955), Henri Le Fauconnier (1881–1946), Albert Gleizes (1881–1953), Robert Delaunay (1885–1941) and André Lhote (1885–1962). These artists accepted the name Cubists and also worked from a theoretical viewpoint toward the definition of this new art. In some cases they accentuated the mathematical character of the pictorial surface; in others they retrieved the evocative values of colour and the inner rhythms of form.

But let us return to 1909. This year marked the go-ahead for the first phase of Cubism, with the converging explorations being carried out by Picasso and Braque. Picasso returned that year from Horta de San Juan to sculpt the bronze *Woman's Head*, linked with the studies made by the painter in that Spanish village concerning the relations between the outer and inner structure of the solid form. Braque, for his part, saw the fulcrum of his own research quite clearly to be space, that *espace tactile, je dirai presque manuel* ("that tactile space which I would almost call manual"), the analysis of which led him progressively from the landscape to the still life.

This research continued throughout 1910 and 1911. These were central years during which there developed that formal elaboration

which goes by the name of "analytical Cubism." The surface of the paintings was articulated by an irregular network of fundamental guidelines, on which was inserted a system of open and intersecting planes. This system was evident in Picasso's *Portrait of Uhde*, or in Braque's still lifes. Braque blended the space between objects and the numerous perspectival indications of objects themselves in a continuum of small linked surfaces. One truly has the impression, as Metzinger explains

But abstraction was certainly not the goal of Braque and Picasso, whose purpose was to penetrate as never before the concreteness of volumes, and to offer in the image as much information as possible about reality, by verifying how far it was possible to push our sense of space.

The sensation of making the pictorial space vital, by removing it from the mute dominion of the two dimensions and infusing it with the impulse of time, is perhaps the most influential

contact with Picasso and Braque, and Cubism, just like a prism, started to branch out and develop facets. The arrival at such a degree of inscrutability and obscurity left Picasso and Braque dissatisfied. More than ever they set their sights on the reality of objects, which came increasingly to reveal themselves as objects of affection, *tranches* or slices of everyday life, and elements in a personal iconography.

In an attempt to go beyond the complex

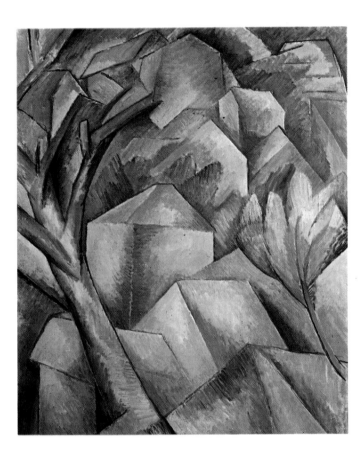
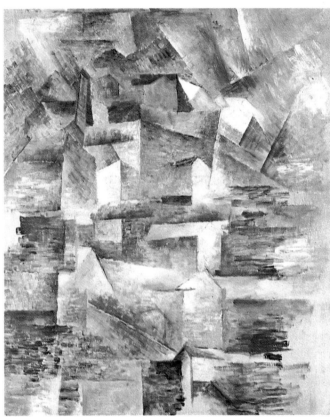

in *Cubisme et Tradition* (*Paris-Journal*, 1911) that "the Cubists have allowed themselves to gyrate around the object in order to give it, under the supervision of their intelligence, a concrete representation of several sequential aspects." One also has the impression that things that are now open have incorporated the space in which they are placed, while the various planes are superimposed, one on top of the other, on the surface of the picture. There is here a moment of intense concentration which produces works that are extremely structured, works with the characteristics of a demonstrated spatial theorem but also, and above all else, of a very high pictorial quality, such as Braque's *Les usines à Rio Tinto à l'Estaque* (The Rio Tinto Factories at l'Estaque). Here the design of lines and open planes tends elegantly toward the abstract.

aspect of this phase of Cubism. On the one hand it referred to the totemic values of primitive sculpture from which the Cubists had started out. On the other hand it linked up, with varying degrees of awareness, with the more advanced areas of research being carried out in the fields of physics, geometry, and psychology.

In the summer of 1910, which he spent at Cadaqués on the Catalonian coast, Picasso took to extremes the analytical decompositional method, achieving such a fragmentation of forms that he verged on inscrutability.

In that same year Gleizes, Léger, Marcel Duchamp (1887–1968), Roger de la Fesnaye (1885–1925), Francis Picabia (1879–1953) and Le Fauconnier found themselves exhibiting together at the *Salon des Indépendants* and at the *Salon d'Automne*. Léger made

Cadaqués phase, Picasso painted his *Portrait of Kahnweiler* in autumn 1910. Here, in an analytical and fragmented structural design, he included various distinctive elements: a lock of hair, hands, the jacket button. These were treated in a more naturalistic manner and as a result are indispensable keys when it comes to deciphering this work. There was very close collaboration between Picasso and Braque. They spent the summer together at Céret. In this period their output was very similar in chromatic range, format, and the way they dispensed with the uniform source of light to such an extent that the margin of distinction became extremely fine.

In the meantime – with the aim of not losing touch with the external reality of things and at the same time focusing on the relation between truth and illusion – Braque had already

Left: Georges Braque, Le Portugais (1911). Kunstmuseum, Basel. In Braque's lucid journey toward the mental rendering of space and objects, this work represents a very important stage. In it, in fact, we see letters of the alphabet, "flat elements," pure formal elements, and symbols and gauges of the idea of the picture as an object. This idea was making headway in the crucial years of Cubism.

the work now lived in a series that was completely "other" than nature. It was a linguistic equivalent which, by means of an intellectual method of analysis, translated all the elements of the object and all the elements of its space–time relationship with the subject, at a higher level of representation. As such it no longer set itself the objective of tricking or beguiling the eye. Rather, by frustrating the onlooker's perceptive expectations, its aim was to deceive the intelligence (whence the definition of trompe l'esprit, as opposed to l'œil).

The year 1911 saw, at the Salon des Indépendants, a new exhibition which gathered together the future representatives of Orphism and the Section d'Or. This was the year of the Delaunay exhibition in Munich which established contact between Cubism and the Blaue Reiter (Blue Horseman) group. It was the year of relationships with the Italian avant-garde and the Russian avant-garde, within which

started in some of his still lifes of 1910 to introduce certain details painted in trompe l'œil (representing illusionist obsessions) into the grid of open planes and disintegrated objects. Starting with Le Portugais (The Portuguese Man [1911] he inserted stamped letters (in this case "D BAL," possibly a fragment of the words "GRAND BAL").

It was Braque himself who explained that "by having to get as close as possible to reality, in 1911 I introduced into my pictures letters of the alphabet. They were forms in which there was nothing to be deformed. Because they were flat elements, they were outside space and their presence in the picture, by contrast, made it possible to distinguish the objects situated in space from those which were outside it." This was another of those crucial developments, charged with consequence for the art to come, which, in a contradictory and meta-pictorial way, posed the problem of the picture as a representative surface and as an object in itself – an independent equivalent of a reality .

The path of liberation that led from imitative practices to this point had been trodden, and

Right: Georges Braque, Musical Shapes (1913). Museum of Art, Philadelphia. "... I painted a lot of musical instruments," Braque recounts, "to begin with because they were around, then because their plastic quality and their volume became part of my way of understanding the still life." As objects with which to animate a tactile space, the instruments evoke that "musical null and void" of harmonies and tonal modulations which Braque approached by means of things.

emerged the phenomenon of Cubo-Futurism, headed by Malevich and Burljuk. In Prague, meanwhile, a Cubist group was formed by the artist Bohumil Kubista ... Last of all, it was the year which saw the first oil paintings by the Spaniard Juan Gris (José Victoriano Gonzáles, 1887–1927), who had settled in Paris in 1906 with Picasso, but did not once exhibit his work until 1912, the year of the *Hommage à Picasso* held by the *Indépendants*, and the year of the participation in the *Section d'Or*. Gris was a great draughtsman, with a lucid and analytical pictorial intelligence. He was attracted less by the stylistic outcome of Cubism than by its method. At this he worked independently, referring back to the source represented by Cézanne and finally achieving his own personal language, characterized by a close study of the mathematical relations between surface and form. Gris subjected objects to a process of dissection which extracted from them the essential elements. These were then

Right: Fernand Léger, The Wedding (1911–12). Musée National d'Art Moderne, Paris. La Noce transforms the realistic subject – also used by Le Douanier Rousseau – into a dialogue between modelled forms and flat surfaces.

Below left: Juan Gris, Breakfast (1915). Musée National d'Art Moderne, Paris.

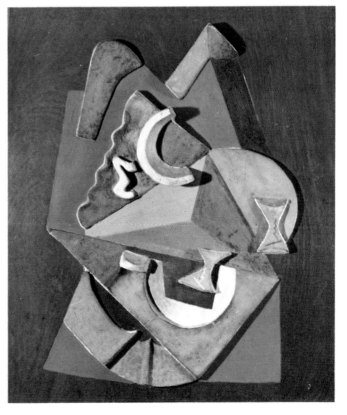

reconstructed with a sense of colour that was more naturalistic than that shown by Picasso and Braque in this same period. In addition it was his intention to achieve a crystalline exactitude which has caused people to talk in terms of "scientific mysticism."

The development of the *collage* dates back to 1912. This marked a new attitude which in

Right: Aleksandr Archipenko, Two Vases on a Table (1910–20). Musée National d'Art Moderne, Paris.

turn pointed to the birth of the so-called "synthetic phase" of Cubism – although this classification is by no means categorical. During this phase the fragmentation of the object into its sequential parts was replaced by an image which synthesized the substantial indications of that object, embracing not only the deductive process of analysis but also the morphological essence of things. Starting with Picasso's *Nature morte à la chaise cannée* (Still Life with Chair Caning), which includes a piece of waxed canvas, imitating the straw bottom of the chair, various heterogeneous materials started to appear on the surface of pictures. These included tickets, scraps of paper, and pieces of metal which at times were meant to represent what they were, at others took on a chromatic or *chiaroscuro* function, and at others still were used as indications of the material forming the object depicted. They were metaphors, synecdoches and devices to measure and notify us of the linguistic game being presented to determine between illusionist imitation and formal abstraction. This reflection about the actual means, technique, and ultimate substance of the activity itself was the extreme attainable limit after starting out from the precepts proposed by Post-Impressionism and Cézanne.

In 1912, again, after another stay at Céret and then a period at Sorgues with Picasso, Braque produced his first *papier-collé* (pasted paper), entitled *Compotier et verre* (Fruit Bowl and Glass). He used pieces of mock-wood wallpaper. The *papier-collé*, defined by Tzara as the visual counterpart of the use of stock phrases and commonplaces in poetry, was a process charged with many meanings, for the strips of paper had both a pictorial function and a function representing an object as a

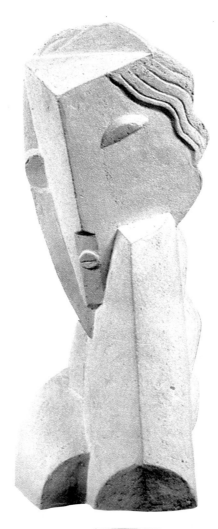

result of material or chromatic analogy. In the final analysis they were independent fragments of external material elements, and they turned these works into a completely new and independent category in the artistic series. When Picasso used this technique he incorporated countless subtle conceptual nuances, as in his *Violon et feuille de musique* (Violin and Sheet of Music) and his *Le Violon* (The Violin). The same goes for Braque in, for example, his *Still Life with Guitar*.

In 1912 Gris also tried his hand at the *collage*, applying a sliver of mirror with a representative and literal function in his composition *Le lavabo* (The Washbasin), and then continuing to use the techniques of the *papier-collé*, the *collage* and the *trompe l'œil*, with the aim of achieving a high degree of formal and conceptual image definition.

Picasso also followed the route of the *papier-collé* and the *collage*, introducing materials like sand and gravel, while the forms became simpler and more synthetic, revealing a stylization that some people thought he had

Left: Henri Laurens, Head of a Small Girl (1920). Peggy Guggenheim Collection, Venice. In his flowing yet compact style Laurens presents a personal sculptor's translation of the Cubist principles of spatial penetration, the decomposition of the planes of an object, and the multiple plastic recomposition of its faces. Significantly, with regard to his connection with the movement, we should remember that all

the artists involved moved in the same direction for a while, and then each branched out in his or her individual way.

Below: Robert Delaunay, Windows Opened Simultaneously, Part I, 3rd Motif (1912). Peggy Guggenheim Collection, Venice. The arcane rhythms of light in forms are the object of Delaunay's research. In 1912 the artist illustrated Apollinaire's Les Fenêtres (The Windows).

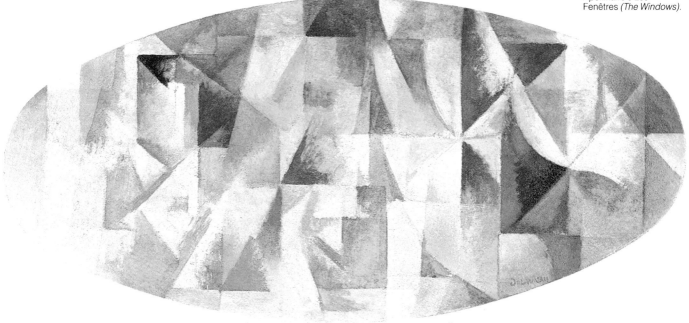

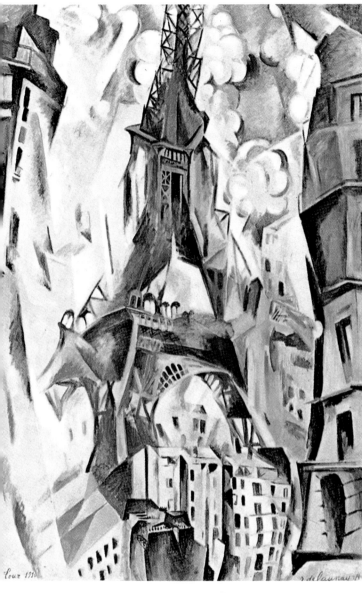

locating, and vital composition of reality.

In about 1913 Aleksandr Archipenko (1887–1964) also devoted himself to making polychrome sculptures (called "sculpto-paintings") which were of great importance, along with the *papiers-collés*, for the Cubist sculpture of Henri Laurens (1885–1954) and Jacques Lipchitz (1891–1973). Gris, who was essentially the only real "synthetic" Cubist in the true sense of the word, followed a rigorous route from abstraction to figuration. He was concerned with the system of intrinsic relations of visible reality and light. In 1915 this interest caused him to depict, in his *Nature morte à la fenêtre ouverte* (Still Life with Open Window), the contact between the inner space of the still life and the outer space of the city.

In the conference entitled *Le cubisme écartelé* ("Cubism Quartered") held shortly after the inauguration of the *Section d'Or* exhibition at the Galerie de la Boétie and then incorporated in *Peintres cubistes* (Cubist Painters, Paris, 1913), Apollinaire made a distinction between "scientific" Cubism and "Orphic" Cubism. The former he defined as "the art of painting new ensembles with elements taken not from visual reality but from conceptual reality"; in it he included Picasso, Braque, Metzinger, Marie Laurencin (1885–1956) and Gris. The latter represented a shift away from methodical Cubism in a more mysterious and

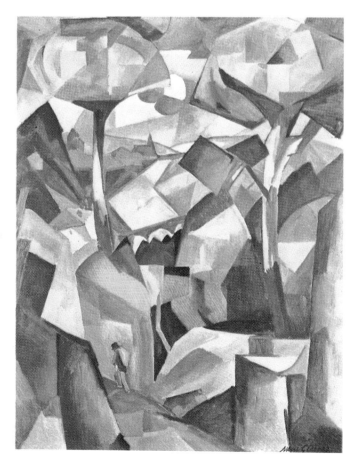

borrowed from the example of Ivory Coast Wobé masks (*Harlequin*, 1913). Picasso tended toward the use of brighter colours, and between 1913 and 1914 devoted himself to the production of paper scupltures, known as *tableaux-reliefs* ("picture-reliefs").

It is impossible to encapsulate here the incredibly vast scale of Picasso's creative activities. After the years of "historical" Cubism he busied himself with graphics, ceramics, and stage sets (e.g. Satie's *Parade*). He passed through a phase of reinterpreting the Classical form of Ingres and Poussin. He flirted with Surrealism. And all the while, from his *Running Minotaur* to his *Guernica* to the endless variations on the theme of the *Baigneuses* (Bathers), the *Femmes à leur toilette* (Women at their Toilet), and the *Peintre et son modèle* (Painter and his Model), he continued to combine Cubist language with a synthetic, dis-

evocative direction, heavy with mystic, lyrical, and mathematical elements. For Apollinaire this latter tendency – whose mouthpiece was the review *Montjoie* – embraced Delaunay, Léger, Picabia, and Marcel Duchamp. Picasso, too, could be called "Orphic" on the basis of the way he treated light. The name Orpheus – that mythical figure so dear to Symbolist culture, after whom Apollinaire had named his *Le Bestiare ou Cortège d'Orphée* (The Bestiary or Orpheus's Cortege) – is evocative of a whole series of references to the power of poetry, music, and the spirit; references, also, to the mysticism of light and to arcane numerical and magical relations between cosmic forces and the forms of art. Apollinaire coined the term Orphism to describe the painting of Delaunay. Delaunay parted company with Divisionism and after the series of *Saint Sévérin*, *Eiffel Tower*, and *Villes* (Cities) paintings, which corresponded to a period of "destructive" decomposition and optical synthesis, he turned in his work *Fenêtres* (Windows) to probing the constructive and poetic possibilities of colour. He based this research on the simultaneous contrasts of colour shades which, as a result of reciprocal action, produce effects of movement and depth. This painting was supported by the inner laws of chromatic substances. It was pure and therefore abstract. But because it was associated with light, and light of a deeply real kind, it corresponded – as Sonia Terk explains – with Apollinaire's poem *Fenêtres*. The reference to the simultaneity of the contrasts and the convergence of poetry and colour refers more to Blaise Cendrars's work *La prose du Transsibérien et de la petite Jehanne de France* (The Prose of the Trans-Siberian Railway and Little Jehanne of France), written in collaboration with Sonia Terk, and lastly to Apollinaire's *Calligrammes*. From 1913 onward Delaunay used circular forms that became increasingly removed from Cubism. They tended toward a lyrical and decorative form of abstraction that was clearly understood by Paul Klee, who translated Delaunay's *La lumière* (The Light) into German for the review *Der Sturm*. Delaunay then went through a realist-cum-figurative phase, and last of all worked with Sonia Terk on the decoration of the *Palais de Chemin de Fer* (Railway Palace) and the *Palais de l'Air* (Palace of the Air [1935]), which was a large-scale synthesis of the studies dealing with simultaneous contrasts, the symbolic values of colours, and the inner rhythms of colour forms.

Léger, whose sources were Cézanne and Le Douanier Rousseau (from whom Léger's mother had commissioned *The Snake Charmer*), was also placed in the Orphic group, but his compositions were rather more like interpretations of forms using tubular and cylindrical modules. On the one hand these forms were akin to the Cubist grid in around 1911; on the other they referred to the themes of modern life and mechanized society. In due course Léger too became involved in mural

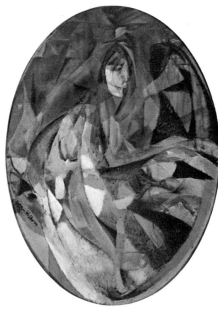

decoration (*Palais de la Découverte* [Palace of Discovery], World Fair 1937) and in the *querelle du réalisme*.

As far as the *Section d'Or* was concerned, the name, which was chosen by Villon, referred to the "golden section" of geometry. Here

were gathered works by artists who tended to apply Cubist language in terms of style (examples being La Fresnaye and Lhote); works by the Czechoslovak Frank Kupka (1871–1957), who made a clear shift from decompositional analytical art toward lyrical abstraction; works, too, by Gris, Picabia, and Marcel Duchamp (who significantly declared Odilon Redon to be his reference and was already heading off in directions other than those of Cubism); works by his half-brother Gaston, known by the pseudonym Jacques Villon (1875–1963), who was involved with the Leonardesque *Treatise on Painting* as well as with the vibrant rhythms of signs and the transparent qualities of planes of colour; and works, last of all, by Gleizes and Metzinger and various other artists, all of whom were in some way or other involved in the mysticism of numbers and Poincaré's speculations about the possibility of depicting the fourth dimension.

From that time on certain aspects of Cubism became a linguistic *koiné* or dialect with which a great many artists associated themselves, at least for a while. It influenced Mondrian and the *Blaue Reiter* painters. It interwove dialectically with Futurism. It got as far as Russia. And meanwhile Dadaism and the "return to order" movement were starting to draw close to it.

Above: Jacques Villon, Girl at the Piano (1914). The Museum of Modern Art, New York. Gaston Duchamp, alias Jacques Villon, half-brother of Marcel Duchamp and Raymond Duchamp-Villon, was another "heretical" Cubist who retained a sense of colour still redolent of Impressionism, as well as a formal harmony with Classical overtones.

Right: Francis Picabia, The Red Tree (1911–12). Musée National d'Art Moderne, Paris. Picabia was involved in the Section d'Or with works and activities that were a prelude to his later participation in Dadaism. He investigated the relations between music and painting, and in his Cubist pictures revealed the power of the Fauve component of his development. He also showed a dash of heterodoxy which took him into other areas of investigation, and toward further critical distillations of the avant-garde spirit.

Futurism

The "Futurist reconstruction of the universe"

Among twentieth-century art movements, Italian Futurism stands out first and foremost for the great variety of spheres to which it addressed its particular creative interests and activities. In historiographic terms it was regarded, until the early sixties, as an almost exclusively pictorial movement. The activities of the Futurists – a handful of often eminent exponents – apparently ran their course, for all practical purposes, in the span of just a few years – from about 1910 to 1915. These exponents were primarily the five definitive signatories of the manifestos on painting issued early in 1910: Umberto Boccioni (1882–1916), Carlo Carrà (1881–1966), Luigi Russolo (1885–1947), Giacomo Balla (1871–1958) and Gino Severini (1883–1966).

It was to some extent in the sixties, but more particularly in the seventies, that Futurism showed itself to be a movement that had taken up several different and carefully elaborated positions. The seventies were most important inasmuch as they gave rise to the major exhibition held in Turin in 1980 under the banner *Ricostruzione futurista dell'universo* (Futurist Reconstruction of the Universe). In these two decades the relevant historiography focused on the effective reality of actual events. In particular it noted how Futurism aimed at addressing every aspect of environmental and social reality, ranging from urban imagery, architecture and interior decoration to clothing, everyday items and fixtures, and behaviour. Futurism was therefore committed

to an extremely broad range of creative areas. It covered an actual period that spanned three decades, extending from the famous "founding" manifesto issued in February 1909 by Filippo Tommaso Marinetti (1876–1944), undisputed leader and polarizer of the movement, to his death on 2 December 1944. An analysis of the movement from the comprehensive viewpoint of a deliberate and conceptual "Futurist reconstruction of the universe" (announced in the manifesto issued by Balla and Fortunato Depero [1892–1960] on 11 March 1915) is now the indispensable and unavoidable basis of the most advanced historiography.

In its desire to play a creative part in every aspect of environmental and social reality, Futurism has a close historical precedent in Art Nouveau, or rather in that period of taste which spread abroad, in its varying European aspects, between the latter years of the nineteenth century and the first decade of the twentieth. Art Nouveau, in effect, aimed at assailing every type of environment and object with a stylistic single-mindedness that was "*nouveau*" and seen as the new style of fashionable progressivism. This new style was

Above: Rougena Zatkovà, Portrait of Marinetti, c. 1918. Private Collection, Milan.

set against the various historical and traditional styles that had been followed throughout the middle years of the nineteenth century – in particular by the eclectic movement in architecture. For Futurism, on the other hand, it was not a matter of imposing a style. The intention was to intervene creatively in every aspect of reality, precisely in order to provoke situations imbued with the maximum degree of imaginative participation, as well as emotive and fantastic application. For this was regarded as the approach most in keeping with that close participation in the new and fundamentally dynamic rhythm of the contemporary world, and with its essential ideological and materialistic root, to which Futurism aspired.

Each individual creative act by the Futurists – in architectural design and planning, as in interior design and configuration; in painting, as in sculpture; and equally in set-designing, furnishing, or everyday objects – was therefore appreciated not only *per se*, but – ideally, at least – as complementary to a plan of total renewal. In many instances, the devotion to the multiple aspects of this plan passed through one and the same "Futurist" individual. In this sense, Balla and Fortunato Depero (1892–1960) were particularly typical. For example, there is no doubt that the great Futurist painting of 1910 and the few years immediately thereafter (in which the creative adventure of Boccioni was completed) is of undisputably high quality.

Futurism was born in a "literary" sense in 1909. Early in 1910 it embraced painting. Between the end of 1910 and early 1911, music was included (Francesco Balilla Pratella

[1880–1955]). Marinetti, meanwhile, emerged in the theatrical sphere early in 1911. In 1912 Boccioni propounded the theory for a Futurist form of sculpture, and Marinetti introduced basic expressive proposals for the traditional verbal structure of discourse. These proposals were greatly developed toward their revolutionary typographical visualization in the following year when, in turn, Russolo talked in terms of the "art of noises," and Carrà, Severini, and Prampolini emphasized the synaesthetic or multiple value of painting. This marked the first affirmation of a broadening of interests and concerns. In 1914 this broadening extended further to the areas of performance, verbal visualization (Marinetti again), and clothing (Balla), as well as architecture (Boccioni, Prampolini, and Antonio Sant'Elia [1880–1916]). It will suffice here to mention merely the initial circulation of this movement, defined by the manifesto of Balla and Depero in 1915 quite unambiguously in terms of a "Futurist reconstruction of the universe." There were essentially two interconnected guidelines in this statement. First, the progressive transgression of the specific boundaries of the traditional artistic genres, in the sense of a reference to several different sensory levels (aiming at the very heart of the primary and

Left: Umberto Boccioni, Mourning, 1910. Private Collection. This extremely dramatic painting is a typical example of the "analytical" phase of Futurist painting. In its exacerbated psychological Expressionism we can quite distinctly detect clearly defined Symbolist features. These were linked in particular to the close attention Boccioni paid to the work of Previati.

painting in the second decade of this century, it is easy to single out an *analytical phase*, which thrived from 1910 to 1911 and reached a crisis point in 1914; and a *synthetic phase*, which became clearly defined between 1914 and 1915 and ran its course until the first linguistic and subsequently thematic formula-

tion of a "mechanical" vision in about 1918. In the first decade of this century, the development of the Futurist painters occurred in terms of Divisionism (or neo-Impressionism), in accordance with various accepted cultural forms, which were not simply personal. In the case of Carrà and Russolo, in Milan, these forms were typically in the naturalistic mould of Lombardy (and for Carrà in particular found expression in a sensuous chromatic style). In the work of Balla, in Rome (where he blazed the trail for Boccioni and Severini in the very early years of the century), these forms showed a typically Post-Impressionist tendency based on French models. Between 1900 and 1901 Balla had briefly visited Paris. There he acquired that awareness of the *en plein air* which was nevertheless lacking in the Italian Divisionists. This awareness he passed on in particular to Boccioni, who was in Paris himself in 1906, and then in Venice and Padua.

In the *analytical phase* – to which the Futurist painters in effect came some time after they signed the manifestos of the early months of 1910 – we can in turn single out two periods of investigation and activity that were both quite distinctive and distinct from one another.

In the first period, the analysis of dynamics and of chromatic complementarity, with its emotive emphasis, were achieved within the rather elementary and in some sense "autarchic" terms (using Symbolist and Divisionist bases) of a sort of visual onomatopoeia, achieved by the use of outlines that were winding and coil-like, curvaceous, arched and in counterpoint to perpendicular rhythms. Examples would be Boccioni's *Rissa in Galleria* (Fight in the Galleria [1911]), *Il lutto* (Mourning, [1910]), *La città che sale* (The City Rises, [1910–11], *Retata* (Catch [1910–11]), up to the first version of the triptych *Stati d'animo* (States of Mind [1911]) and *La strada entra nella casa* (The Road Enters the House, [1911]); Carrà's *Notturno a piazza Beccaria* (Nocturne in Piazza Beccaria [1910]), *Nuota-*

chaotic vitality of matter). Second, the tension within a total work, seen as a complete annexation and environmental implication.

The phases of Futurist painting and sculpture in Italy

Within the series of developments in Futurist

Above: Giacomo Balla, Abstract Speed + Noise, c. 1913. Guggenheim Collection, Venice. Here the analysis had gone beyond the period which focused on kinetic sequence, and was already concentrating on the essentiality of "lines of force." The

result tended very clearly toward an abstract synthesis, here in the form of a simultaneity of speed and noise in the landscape.

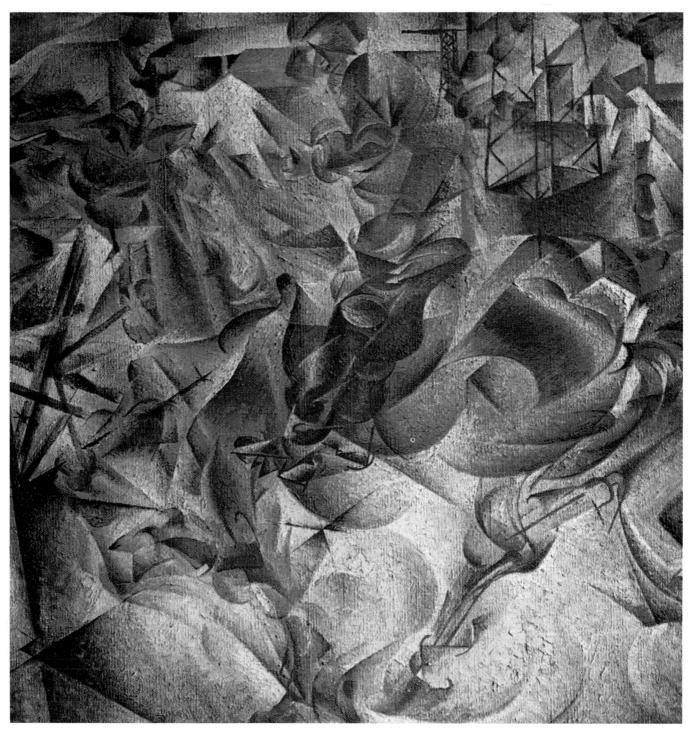

Above: Umberto Boccioni, Elasticity, 1912. Riccardo and Magda Jucker Collection, Pinacoteca di Brera Foundation, Milan. This is an example of Boccioni's most striking analytical intensity. He embraces the simultaneous clash of forces in the setting of the industrial city. The Cubist-inspired compositional influences here turn into the "lines of force" of a powerfully dynamic situation.

trici (Bathers [1910]), *Funerali dell'anarchico Galli* (Funeral of the Anarchist Galli [1910–11]), *Ciò che mi ha detto il tram* (What the tram told me [1910–11]), *Sobbalzi di carrozzella* (Jerks of a carriage [1911]); Russolo's *I capelli di Tina* (Tina's Hair [1910]), *Ricordi di una notte* (Memories of a Night [1910–11]), *Treno in corsa nella notte* (Train Speeding through the Night [1910–11]), *Una – tre teste* (One head – three heads [1910–11]) and *Rivolta* (Revolt [1910–11]); and Severini's *Il boulevard* (The Boulevard [1910–11]), *La danza del "Pan-pan" a Monico* (The "Pan-pan', dance at Monico [1910–11]), *La danseuse obsédante* (The Haunting Dancer [1911]) and *Le chat noir* (The Black Cat [1911]).

This first period, covering 1910 and 1911, managed to make itself known, and seen, in

the participation of Boccioni, Carrà and Russolo in the *"Esposizione d'arte libera"* (Exhibition of Free Art) in spring 1911. At the end of the period – helped by an awareness of the structural syntax of Cubism – new methods of dynamic structural analysis were introduced. This in turn gave rise to the formation of the second clearly defined period of the analytical

phase, perfect examples of which are the work of Boccioni in the final version of the triptych *Stati d'animo* (States of Mind [1911]), and in his revision of *La risata* (The Laugh [1911]), *Elasticità* (Elasticity [1912]) and *Materia* (Matter [1912]); of Carrà in *La dama e l'assenzio* (The Lady and the Absinthe [1911]) and *La Galleria di Milano* (The Galleria of Milan

Below: Gino Severini, Dynamic Hieroglyph of the Bal Tabarin, 1912. The Museum of Modern Art, New York (Lillie P. Bliss donation). In this work we find Severini's whole perception of a spectacular and festive vivacity in modern life in its most contrived dynamism. This theme had already been popular among the Impressionists. Here it is pervaded by an analytical frisson of interpenetrating dynamic simultaneities.

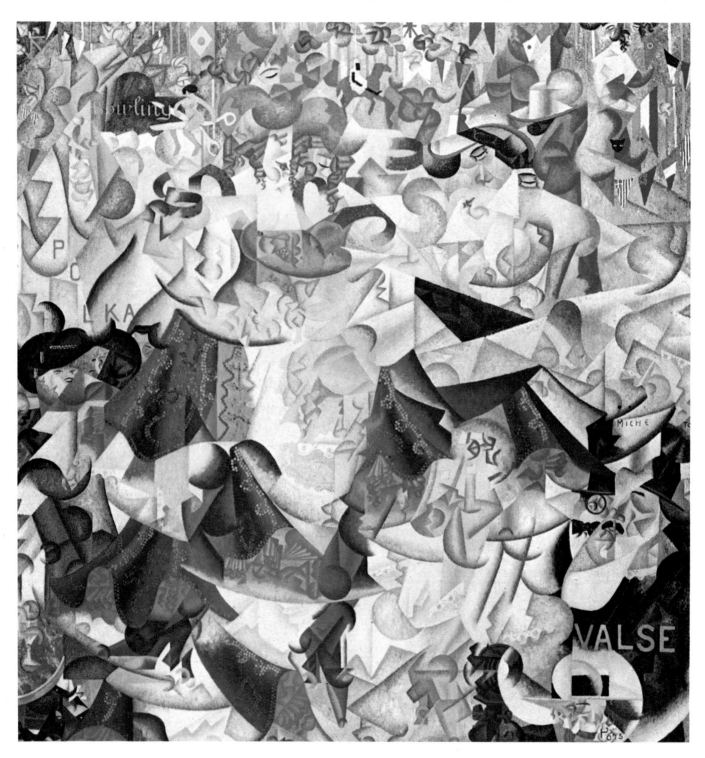

1912]); and of Severini in *Nord-Sud* (North-South [1912]), *Autoritratto* (Self-Portrait [1912–13]), *Ballerina in blu* (Ballerina in Blue [1912]), *Dinamismo di una danzatrice* (Dynamism of a Dancer [1912]), *Geroglifico dinamico del "Bal Tabarin"* (Dynamic Hieroglyph of the "Bal Tabarin" [1912]) and *Festa a Montmartre* (Festival in Montmartre [1913]).

It is not possible, however, to detect such a clearly distinct separation of periods in the work of Russolo. Although his second period of the analytical phase, with pictures like *Solidità della nebbia* (Solidity of Fog [1912]), *Dinamismo di un'automobile* (Dynamism of an Automobile [1912–13]) and *Case + luce + cielo* (Houses + Light + Sky [1912–13]), appeared quite explicit, it was not defined by any dialogue with Cubist models. It is even less possible to detect any such periodic separation in the work of Balla, who remained completely untouched by any interest whatsoever in Cubism. As far as he was concerned, the actual period of dynamic onomatopoeic symbolization (which had, incidentally, been instinctively achieved in a Divisionist painting like *Salutando* (Greeting [1908]) was in some sense actually broached in 1909–10 in a sign analysis of the dynamic and interpenetrating effect of light. Examples of this are his *Lampada ad arco* (Arc Lamp), the date of which – 1909 – has been disputed, but which is still a plausible product of that year, and his *Villa Borghese* (1910).

Running parallel with the second analytical period we find in this work a particular attention to "movement," be it human or animal, sometimes with touches of subtle irony. Examples of this are *Dinamismo di un cane al guinzaglio* (Dynamism of a Dog on a Leash [1912]), *Le mani di un violinista* (The Hands of a Violinist [1912]), *Bambina che corre sul balcone* (Girl Running on a Balcony [1912]), *Linee andamentali + successioni dinamiche Volo di rondini* (Swifts: Paths of Movement + Dynamic Sequences [1913]). Other examples have a mechanical flavour, like *Velocità d'automobile* (Speed of an Automobile [1912]), *Velocità d'automobile + luce + rumore* (Speed of an Automobile + Light + Noise [1913]) and *Velocità astratta* (Abstract Speed [1913]).

The analytical phase of Futurist artistic research and production nevertheless corresponded with an often captious investigation into the dynamic conflictual nature not only of the dialectic relationship between figure and environment, but also of the survival, within this relationship, of the simultaneous perception of adjacent occurrences – typical examples are paintings by Boccioni like *Visioni simultanee* (Simultaneous Visions [1912]) and *Materia* (Matter [1912]). This feature, incidentally, is underlined in the catalogue for the first group show in Paris at the beginning of 1912. The structural morphology of the more mature "analytical" Cubism (1911–12) in fact offers structural keys for ordering the analytical pro-

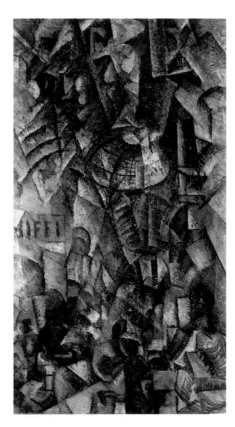

Above: Carlo Carrà, The Gallera of Milan, *1912. Mattioli Collection, Milan.*

Below: Luigi Russolo, Solidity of Fog, *1912. Mattioli Collection, Milan.*

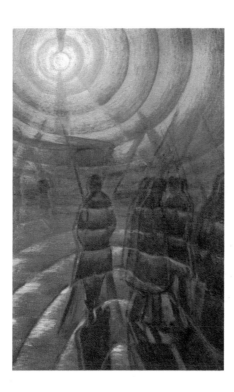

cess. The Futurists (from Boccioni to Carrà to Severini and, in a different way, to Soffici) used these keys for another purpose – as dynamic structural nodes built up by expanding nuclei of "lines of force." These "lines of force," which were typically Futurist, in turn extended in particular into sweeping dynamic series of arches – as, for example, in Boccioni's *Elasticità* (Elasticity [1912]), or *Scomposizione di figura di donna a tavola* (Decomposition of a Woman's Figure at Table [1913]). They are evident in the many paintings by Balla on the theme of the "speed of an automobile" (1913) or in paintings by Russolo such as *Velocità d'automobile* (Speed of an Automobile [1913]), but in neither case is there a Cubist intermediary.

Boccioni's violent sensibility perceived the whole drama of the manifestation of the "new" as vitalistic force struggling dramatically, under the banner of progress, for its own affirmation. Balla's lyrical and tirelessly inventive sensibility, on the other hand, developed into an enthusiastic vision of the "new" in its clear-cut and simplified reality, in the explicit dynamism of spatial forces, and in essential and elementary chromatism penetrated by light. In reality Boccioni was working within a society characterized, like its Milanese counterpart, by growing industrialization, where the "new" could therefore be seen in the real force and stress of its struggle for acceptance. Balla, on the contrary, lived in an essentially nineteenth-century city which was bureaucratic and encircled by traditional agrarian structures like the *latifundium* or large landed estate. In this milieu there was as yet no awareness of the industrial process, so the symbol of the "new" could be achieved only in a unilateral projection of a radically different sensibility.

The analytical phase of Futurist artistic activity and research approached a crisis in 1913–14. This was true in particular of Boccioni's studies of the strong volumetric synthesis of human muscles in movement, on which he embarked in 1913 (the final examples are paintings like *Dinamismo di un footballer* (Dynamism of a Footballer [1913]). It was also true of his studies, in 1914, of the dynamic plastic forms of a horse in its environmental context (*Dinamismo plastic: cavallo + caseggiati* (Plastic Dynamism: Horse + Block of Flats), and even more so in his powerful return to plasticity during 1914, in such works as *Bevitore* (Drinker) or *Sotto la pergola di Napoli* (Beneath the Pergola in Naples). Here he opened up a new dialogue with the models of Cézanne. Also in 1914, Carrà used dynamic constructive influences from Cubist *collage*, with its considerable synthetic power (for example, *Manifestazione interventista* [Interventionist Demonstration]). In Paris, in 1913–14, Severini also tried his hand at new syntheses of abstract plastic analogies (*La danza dell'orso* (The Bear Dance). In 1915 this development stimulated the great narrative composi-

tion of his paintings on themes of war *Lancieri italiani al galoppo* (Italian Lancers at the Gallop), *Treno blindato* (Armoured Train), *Il treno dei feriti* (The Train for the Wounded). Boccioni's anger in 1914, the year which saw the publication of his book *Pittura e scultura futuriste – dinamismo plastico* (Futurist Painting and Sculpture – Plastic Dynamism), causing a major break with Carrà, and in 1915, a year of crisis and military engagement, brought him to a state of plastic synthesis linked to the emotional relationship with the actual event, although this synthesis was still less conditioned, in this context, by figurative – and to some extent descriptive – elements. There was to be no proper conclusion, and in 1916 (the year of his death, in August, in an accident) it is possible to detect in his work a radical Cézanne-related crisis, as he searched for a synthesis in the prevalent figurative style which finally became, essentially, a rejection.

In Milan, in 1914, the group known as *Nuove Tendenze* – which included the architects Antonio Sant'Elia (1880–1916) and Mario Chiattone (1891–1957) – made its entrance. Its position in relation to the Marinetti group was parallel, yet independent (and has been defined as para-Futurist, not without reason). This position was exemplified in the crisis period of the analytical phase, which produced dynamic figurative forms in more synthetic terms, in work by artists ranging from Achille Funi (1890–1972) to Leonardo Dudreville (1885–1975) – who was even then given to discussing "abstraction" – to Carlo Erba (1884–1917) and Marcello Nizzoli (1887–1969). It was also in Milan, and in similar terms, that Sironi's work was developing, with paintings like *Composizione con elica* (Composition with Helix [*c.* 1915]) and *Il ciclista* (The Cyclist [*c.* 1916]).

The analytical phase of Futurist art took place principally in northern Italy, with an offshoot in Florence. The so-called *synthetic phase* came to fruition in Rome, heralded throughout 1914 by the work of Balla in his themes of "*linea di velocità*" (line of speed), "*velocità piu paesaggio*" (speed plus landscape), "*velocità astratta*" (abstract speed) and "*vortice*" (vortex). This phase became clearly defined, in all its novelty, in the cycle of the "*Dimostrazioni interventiste*" (Interventionist Demonstrations) during 1915 and in the "complessi plastici" (plastic complexes) which Balla produced between 1914 and 1915 in parallel with the work of Depero, whose painting between 1915 and 1916 showed a similar orientation. This work was aimed at "plastic complexity" as a "Futurist abstract style," expressed as an inventive formal analogism, achieved in particular by means of the "plastic complex." This was the plastic-pictorial object which constituted the basis of the "Futurist reconstruction of the universe." In a morphological sense, in the work of Balla and Depero, this involved pronouncedly synthetic pictorial constructions of dynamically shaped,

uniformly coloured plastic structures.

Prampolini's work was also taking shape along similar lines, although at that point with less terminological clarity. Balla developed above all the inventive possibilities of colour, which he conceived of more and more as aimed at a kind of "painting in bursts," or "surprise painting," as he put it in the *Manifesto del colore* (Colour Manifesto [1918]). Also in this year, the synthetic phase of Futurist artistic research came to an end. In this phase the most important achievements, apart from Balla's "interventionist" cycle, were his own intense work from 1916 onward – *Velo da vedova* (Widow's Veil [1916]), *Il taglio del bosco* (Wood Cutting [1916]), "*Stagioni*" ("Seasons" [1917–18]), *Colpo di fucile domenicale* (Sunday Gunshot [1918]), *Trasformazione forme-spiriti* (Transformation: Forms-Spirits [1918–20]) – and paintings by Depero such as *Movimento di uccelli* (Movement of Birds [1916]), *Ballerina idolo* (Ballerina Idol [1917]) and *Rotazione di ballerina e pappagalli* (Rotation of Ballerina and Parrots [1917–18]), until the cycle connected with his work for the "Plastic Theater" in 1918.

Between about 1918 and 1919, the synthetic phase of Futurist art was followed by a new phase, characterized by an increasingly emphatic "mechanical" stamp. The analogous plastic synthesis which typified the synthetic phase assumed an ever greater consistency in terms of formal mechanical analogy. The machine offered an example of formal clarity, and an example of a clean, clear-cut vision. Vinicio Paladini (1902–71), Ivo Pannaggi (1901–81) and Prampolini proposed their theories about the machine in the manifesto entitled *L'arte meccanica* (Mechanical Art), which appeared toward the end of 1922. The

Above: Gino Severini, The Tunnel, 1917. Private Collection, New York.

Left: Fortunato Depero, My Plastic Dances, Mattioli Collection, Milan. Severini's canvas, which is also close to later principles of "synthetic" Cubism, represents a mature aspect of the pictorial phase of Futurism described, precisely, as "synthetic." Depero's painting, on the other hand (which encapsulates one of his theatrical experiences), already represents an introduction to the "mechanical" pictorial phase in the personal enhancement of an elementary and fantastically fairytale-like use of colour.

center of this activity was Rome. More specifically, the second edition of Prampolini's review *Noi* (Us [1923–25]) was the mouthpiece that informed readers what was going on and made contact with the new purist and constructivist avant-gardes of Europe. Not long after this, however, and largely as a result of the initiative shown by Fillia (Luigi Colombo, 1904–36), a "mechanical" approach emerged in Turin, the city which contained the so-called industrial triangle. In Turin, to begin with, Futurist activities assumed a proletarian em-

phasis (as, incidentally, had been the case in Rome, with the "proletcult" concerns of Pannaggi and Paladini). In reality we can see two distinct periods in this "mechanical" phase, which can be identified as the first problematic period of what has been called the *"Secondo Futurismo"* (Second Futurism). The first period was characterized by a predominance of mechanical analogism in a morphological framework made up of flat plastic shapes. These shapes had a geometric outline, and were uniform and resonant in their colouring, as is evident in particular in Prampolini's works from 1919 and 1924–25, and in those of Paladini, Pannaggi, and De Pistoris (Federico Pfister, 1898–1975) in the early twenties, or of Fillia from 1923 to 1925. But here, again on the basis of their free association, reference may be made to Balla's works produced in the early twenties (with their themes of abstract landscapes, or in paintings like *Non rompere le scatole* (Don't be a Nuisance [*c.* 1923]); as it may to works by Depero – *Bagnante* (Bather [1919]), *Città meccanizzata dalle ombre* (City Mechanized by Shadows [1920]) – or by

Right: Fillia, Figura/Ballerina, *1930. Private Collection, Turin. Prampolini interpreted the "aeropictoriai" theme as "cosmic idealism," a fantastic, Futuristic probing of other plastic realities. Fillia, on the other hand, interpreted it in a pronounced psychological way, although still in imaginary, cosmic terms.*

Left: Enrico Prampolini, Cosmic Apparition, *1935. Artecentro, Milan.*

Benedetta (Benedetta Cappa Marinetti, 1897–1977).

The second period of this "mechanical" phase was characterized, on the contrary, by a definition of plastic volume measurements and the elevation of geometry as a prime factor in the establishment of articulate structural complexities – particularly in the construction of human bodies – in an obvious further dialogue with European approaches associated with the purism of "L'Esprit Nouveau" of Le Corbusier and Amédée Ozen-

fant. The period from 1925 to 1928 was well represented by canvases from Prampolini, Pannaggi, Fillia, Nicolai Diulgheroff (1901–82), Ugo Pozzo (1900–81), Fedele Azari (1896–1930) and Tullio Crali (b. 1910); as it was once again by Balla, in paintings showing a pronounced plastic purism (*È rotto l'incanto* [The Spell is Broken], *Numeri inamorati* [Numbers in Love], *Pessimismo e ottimismo* [Pessimism and Optimism] [1923]), and by Depero. Depero was involved in an extremely colourful personal narrative, reduced to essentials in

terms of plasticity (*Marinetti temporale patriottico* [Marinetti Temporal Patriotic (1924)]; *Fulmine compositore* [Lightning Composer (1926)]). Dottori also participated in this approach, which surfaced as well in the later works of Antonio Marasco (1896–1977), Osvaldo Peruzzi (b.1907) and Crali.

But toward the end of the twenties the mechanical phase was followed by a new and further phase of Futurism, defined as "aeropictorial and cosmic." The conceptual reference point for this phase was the *Manifesto dell'aeropittura futurista* (Manifesto of Futurist Aeropainting), although this basis was variously defined in the numerous declarations made by individual artists or local groups. In the meantime, in fact, the reality of Futurism had spread across the breadth of Italy in clearly defined local enclaves which often took up different positions.

This phase constituted the second problematic period of the "Second Futurism" which lasted essentially right through the thirties, and even into the early forties. The response to the aeropictorial theme, which influenced both sculpture and architecture as well as poetry and literature, came for the most part in two distinct forms. The first was represented in particular by the work of Prampolini (who was based for a long period in Paris from the mid twenties onward); by Fillia, Pippo Oriani (1909–72), Diulgheroff, Pozzo, and Franco

Mino Rosso (1904–63), Farfa (Vittorio Osvaldo Tomassini, 1881–64), Pozzo, Ernesto (Michaelles) Thayaht (1893–1959), Tullio d'Albisola (Tullio Mazzotti, 1899–1971), Regina (Regina Bracchi, 1894–1974), Monachesi, and again by Depero.

Lastly, the aeropictorial and cosmic phase of the thirties was represented by the works of Rosso and Thayaht, Regina and Di Bosso.

From architecture to fixtures, from performance to graphics

The potential of a Futurist style of architecture was exemplified in 1913–14 by Sant'Elia and Chiattone, in Milan; by Balla and Prampolini, and shortly thereafter – in 1915–16 – by Depero, and between 1919 and 1920 by Virgilio Marchi (1895–1960). In architecture, too, the concreteness of Sant'Elia and Chiattone, with its origins in pure rationalism, was offset by the "lyrical" plastic inventiveness of the Romans. But the Futurists' architectural research (which hardly ever left the drawing-

Costa (1903–80) in Turin; by Domenico Belli (1909–83) and Nino Delle Site (b.1914) in Rome; by Bruno Tano (1913–42) in Macerata, and by Arturo Ciacelli (1883–1966) in particular. In this sphere of activity, flight was interpreted as a cosmic projection in extremely fantastic manifestations which often had a para-surreal character. To this list we can also add the work of Dottori, in Umbria, with its distinctive, individual lyrical-cum-scenic-cum-cosmic expression. In other respects we can include the more earthly tale told by Depero, based in the Alps; or the fantastic landscapes of the independent Marasco, working in Florence.

The second response was represented by numerous artists, among them Tato (Guglielmo Sansoni, 1896–1974), Renato Di Bosso (1905–82), Alfredo G. Ambrosi (1901–45), and Sante Monachesi (b.1910). Here flight was interpreted as an opportunity for the aerial viewing and exaltation of flying machines (eventually including a military, warring element). At times the outcome came close to a "pop" perspective, as in the work of Crali.

Balla's activities and research throughout the twenties were essentially independent. He was not particularly interested either in the aeropictorial theme or in cosmic fantasies. Instead, he became involved either in the dynamic plastic-cum-chromatic synthesis of narrative situations – a masterpiece is his *Forse!* (Perhaps! [1930]) – or in the elaboration of altogether nonfigurative plastic structures, often on psychological themes. At the end of the twenties (in the early thirties he

broke away from Futurism and started an involvement with direct naturalistic figuration) he achieved results which showed a surreal imagination (*Le frecce della vita* [The Arrows of Life (1928)] and *Il vortice della vita* [The Vortex of Life (1929)]).

By looking at the developments in Futurist art it is easy to illustrate the sequence of different phases of interest, whether morphological or thematic, stretching from 1910–20 to the end of the thirties. But Futurist sculpture was also always close at hand in this same period. Boccioni opened the "analytical" phase in 1911 with sculptures such as *Testa + casa + luce* (Head + House + Light) and *Fusione di una testa e di una finestra* (Fusion of a Head and a Window). He developed this phase in *Sintesi del dinamismo umano* (Synthesis of Human Dynamism) and *Sviluppo di una bottiglia nello spazio* (Development of a Bottle in Space [1912]), up to the dynamism of the human body accentuated in the rhythmic plastic abstraction of the sculptures produced in 1913. In that same year, Roberto Melli (1885–1958) also took part in the movement. A little later we also find signs of it in the works Prampolini produced in 1915–16.

Meanwhile, the synthetic phase was represented by the analogous abstract "plastic complexes" produced by Balla and Depero in 1914–15 – Depero himself being interested in kinetic solutions described as "*motorumoriste*" – concerned with "motorized sound effects."

The mechanical phase of Futurist sculpture, in its turn, was represented from the early twenties onward by the works of Pannaggi,

Opposite above: Tullio Crali, Dogfight II, *1936. Massimo Carpi Collection, Rome. For Crali, "aeropainting" was unforeseen substance and a new dynamic vision from on high, and of flying machines, in simultaneous situations.*

Opposite below: Antonio Sant'Elia, The New "City": House with A Flight of Steps on Two Street Levels, *1914. Paride Accetti Collection, Milan. Sant'Elia conceived of architectural planning and design only in an urban context. He imagined the "Futurist city" as a continuous network of building and communications structures.*

Right: Giacomo Balla, screen, 1917–18. Private Collection, Rome.

Below left: Giacomo Balla, sketch for stage costume. Private Collection, Rome. Balla was the leading figure in the "Futurist reconstruction of the universe."

Below right: Enrico Prampolini, sketch of a stage set for Luciano Folgore's Rose di carta *(Paper Roses), 1920. Private Collection, Rome.*

ties); to the rational plasticism of Prampolini (who would achieve a post-rational vision of great inventive intensity in his designs for the International Exhibition of 1942). It would range, too, from the structural rationalism of the "tensile-structure" skyscrapers of Guido Fiorini (1891–1965), who was involved in a technical dialogue with Le Corbusier, to the synthetic plastic visionary quality of the projects of Cesare Augusto Poggi (1903–71).

Compared with the mainly polemical outcome of the design of Futurist architectural projects, the results achieved in interior decoration were more concrete. They ranged, in particular, from such effective works as Balla's "Bal Tic Tac" (1921) and Depero's fantastic, fairytale "Cabaret del Diavolo" (Devil's Cabaret [1921–22]), in Rome, to Depero's "Padiglione del libro" (Book Pavilion) at the Second Biennial International Exhibition of Decorative Arts at Monza in 1927, the decoration by Pannaggi of the Casa Zampini in Esanatoglia (Macerata) in 1925–26, and Prampolini and Fillia's decorative mosaics in Mazzoni's Palazzo delle Poste in La Spezia, in 1933.

In the thirties, opportunities arose in this sphere as a result of the activities of the committee for the realization of interiors in exhibitions and fairs mounted to market both ideologies and commodities. Examples of such projects ranged from the rooms created by Prampolini and Dottori in the Exhibition of the Fascist Revolution (*Mostra della rivoluzione fascista*) held in Rome in 1932–33,

board except for the extremely rare projects of Depero and Diulgheroff) was also fairly prolific in the twenties and thirties. It ranged from the purely rational (in the early twenties) and then markedly rationalist (in the thirties) projects of Alberto Sartoris (b.1901) to the more elementary rationalism of Diulgheroff (late twenties to early thirties) and Nicola Mosso (1899–1986 [early thirties]); to the visions of entire towns and of individual buildings, characterized by a neo-Sant'Elia-like Futurism, of Crali (early thir-

to Prampolini's various other endeavours: the Airport Waiting Room in the Sixth International Triennial Exhibition in Milan in 1933, the Mercury Pavilion (*Padiglione del Mercurio*) in the Mineral Exhibition (*Mostra del Minerale*) in Rome in 1939, the Electricity Pavilion (*Padiglione della Elettricità*) in the Overseas Exhibition (*Mostra d'Oltremare*) in Naples in 1940.

For many years from the end of the First World War onward Balla became deeply involved in furnishing, starting with his own home. The same was true of Depero (for example, in his "Futurist Art House" (*Casa d'Arte Futurista* in Rovereto), Prampolini (who created an "Italian Art House" (*Casa d'Arte Italiana*) in Rome. Other artists who became similarly involved included Pippo Rizzo (1897–1964) and Vittorio Corona (1901–66), who worked in Palermo, and Tato in Bologna. Closely linked to furnishing was the design and production of fixtures and household objects and appliances. This was addressed intensively by Balla from about 1918 onward, by Depero and Prampolini in the twenties, and by Diulgheroff, Rosso, and Oriani in the thirties, all working in Turin.

The framework of the "Futurist reconstruction of the universe" was given added definition by the interest shown in the revival of the photographic image. This interest took the form of "Futurist photodynamics" under the aegis of Anton Giulio Bragaglia early in the decade 1910–20. Tato also became involved in this area of activity in about 1930. But there were many Futurist photographers. The interest in the photographic image was based on an analysis of the ectoplasmic plastic continuity of the body in movement. Futurist photodynamics was based on the principle of the interpenetration of simultaneous images. There was also an interest in the revival and renewal of the cinema, with the film *Vita futurista* (Futurist Life) produced in 1916 by Arnoldo Ginna (Ginanni Corradini, 1890–1982), which was rich in fantastic ideas, and A. G. Bragaglia's film *Thais*, also produced in 1916, which had a set with Symbolist overtones, designed by Prampolini.

The Futurist revival of the theater was concerned not only with action and text, in implementing the concision of the Futurist "theatrical syntheses," but rather – in the projects elaborated by Balla – involved the whole stage set. These projects included, in particular, the sets for his own "onomatopoeic sound effect" (*onomatopea rumorista*) entitled *Macchina tipografica* (Typewriter [1914]), and for *Feu d'artifice* (Firework) by Igor Stravinsky for Sergei Diaghilev's *ballets russes* in Rome. They also included Depero's sets for *The Nightingale's Song* and *The Zoo*, again for Diaghilev (1916–17) at the Plastic Theater, produced in Rome in 1918, with the Swiss poet Gilbert Clavel, as well as for *Anihccam del 3000* (1924) and *The New Babel*, produced in New York in 1930; and projects by Prampolini, who was the leading theoretician.

The Futurist "performance" was also – and quite naturally – musical. It occurred not only in the exhibitions of Balilla Pratella (*L'aviatore Dro* (Dro, the Aviator), but in particular in the form of Russolo's concerts of "tuneful noises" (*intonarumori*), staged from 1914 to the twenties. The "performance" concept also involved "dynamic and synoptic declamation" – or, in other words, action-poetry. This was another aspect of the Futurist transgression of the traditional boundaries of the written or spoken word. Another significant feature of this transgression was represented by the device of verbal and poetic visualization in the so-called "free-word panels" (*tavole parolibere*). These panels ranged from the columns of *Lacerba* (1914) to the projects of Balla, Depero, Francesco Cangiullo (1884–1977) and Marinetti himself, as well as Soffici, Paolo Buzzi (1874–1956), Corrado Govoni (1884–1965), Carrà, and Ginna, up to and even beyond the middle years of the decade. They also ranged from the columns of *L'Italia Futurista* (1916–18) to those of *Roma Futurista*. In the twenties and thirties they underwent many extremely interesting developments, especially in the works of Giuseppe Steiner (1898–1964), Benedetta, Fillia, Pietro Illari (b.1900), Jamar 14 (Pietro Gigli, b.1897), and Pino Masnata (1901–68).

Verbal visualization was linked with Futurist activity in the sphere of publicity and advertising, too, with the involvement of Balla, Prampolini and Pannaggi, but most importantly of Depero (who published the relevant manifesto in 1932), Diulgheroff, and Farfa. The aim here was to acquire the pragmatic space of publicity and advertising communication as an opportunity for action, and even interference, within the social arena which would have a greater emotional immediacy.

Futurism outside Italy

Futurism was essentially a cultural phenomenon peculiar to Italy, but Futurist activities nevertheless stimulated other movements within the European avant-garde, starting with Dadaism. Furthermore, the direct offshoots of Futurism still exist today (and not only in Europe), in some cases with a conscious participation in the Marinetti-inspired movement (in particular in France, England, and Japan); in others with a parallel development which is jealous of its own independent originality (as in Russia). In yet other instances we find both penetration and influence (in Germany, Belgium, Czechoslovakia, and so on). These, in effect, are the different "Futurisms" on offer from the international scene of avant-garde artistic activity between 1910 and 1920.

In France, from about 1911 onward, there was a dialogue within Cubism with the plastic dynamism of Futurism (spurred on greatly by

Left: Anton Giulio Bragaglia, The Futurist Painter Giacomo Balla with the painting Dynamism of a Dog on a Leash, 1912; *photodynamics, detail.*

Opposite: Joseph Stella, Chinatown, c. 1917. *Museum of Art, Philadelphia (Louise and Walter Arensberg Collection). A Chinese shop sign in New York heightens Stella's urban pictorial imagination.*

the interest shown in it by Guillaume Apollinaire), in the works of Robert Delaunay, Marcel Duchamp, Raimond Duchamp-Villon, Fernand Léger, and Francis Picabia. Also in France, Aimé Félix Mac Del Marle (1889–1952) was involved, between 1913 and 1915, in a dynamic form of analytical painting, and supported Marinetti's movement with his own anti-Montmartre manifesto (1913). The Futurist dialogue here was subsequently developed in particular in the review *Sic* (1916–20), published by Pierre Albert-Birot (1876–1967). In England, in turn, Christopher Nevinson (1889–1946), whose painting was pervaded by a powerful sense of dynamism, initially strongly influenced by ideas of Severini, published in *Lacerba*, in 1914, the Futurist manifesto entitled *Vital English Art*. Between 1910 and 1920 Nevinson was, in effect, Marinetti's most important English-speaking partner. No less sensitive to the pictorial models of plastic dynamism in England in 1913–14 were the artists Edward Wadsworth (1889–1949), Percy Wyndham Lewis (1882–1957) and Stanley Corsiter. Vorticism, the manifesto which appeared in *BLAST*, the review founded in 1914 by Nevinson and Lewis, was undoubtedly an ingredient in and contributor to Futurism. In 1914–16 the Belgian Jules Schmalzigaug (1882–1917), working in Venice, painted pictures characterized by plastic dynamism, using colour in an elaborate way suggestive of Severini. The art of Paul Joostens (1889–1960) in the middle years of the decade was also part and parcel of Futurist dynamism. René Magritte, on the other hand, waited until the early twenties before he made his transition from a "mechanical" form of plasticism with Futurist overtones.

In Spain, Futurism was essentially a literary phenomenon. In Catalonia its influence lasted from about 1915 throughout the twenties, while in Madrid between 1918 and 1925 it developed into what came to be called *Ultraismo*. Another phenomenon, again in Spain, that was close to plastic Futurism was the pictorial vibrationism of the Uruguayan artist Rafael Pérez Barradas (1890–1929) between about 1915 and the beginning of the twenties.

In Portugal, where Fernando Pezhoa (1888–1935) was producing projects concerned with literary simultaneity, the painter Almada Negreiros published, in 1917, the one and only edition of *Portugal Futurista*, in which there was in-depth dialogue with Marinetti's movement. In addition, Amadeo de Souza-Cardoso (1887–1918) was keenly aware, at this time, of mechanistic models of plastic dynamism.

In northern Europe, which was home as early as the second decade of the century to the activities of Ciacelli, the Swede Adrian-Nilsson (1884–1965) was also strongly attracted at this time by the dynamic conflictual scope of Futurist simultaneity.

In Germany, the plastic Futurism of the Italian movement was turned to account by Herwarth Walden (1878–1941), in his own gallery and his review *Der Sturm* (The Storm), which was published early in the decade. Franz Marc was also keenly aware of Futurist dynamism, and at this same time dynamic elements recurred in the art of Otto Dix (1891–1969) and Max Ernst (1891–1976), and shortly thereafter in the work of George Grosz (1893–1959).

In Hungary, the mainly literary movement called Activism, headed by Lajos Kassak (1887–1967), was closely affiliated to Futurism. Kassak published the reviews *A Tett* (1915–16) and *MA* (1916–26), and was also a painter. At the end of the decade, Bela Kádár (1887–1955) and Sándor Bortnyik (1893–1977) were keenly aware of dynamic concepts; they were followed in the early twenties by Janós Schadl (1892–1944) and by Hugo Scheiber (1873–1950) throughout the twenties.

In Poland, literary Futurism flourished between 1910 and 1920 and in the twenties, with Jerzy Jankowski (1887–1941) and Bruno Jasieński (1901–39/41). In the early twenties there was also a dialectical relationship with the applications of Futurist plastic dynamism in the "zonism" theorized by Leon Chwistek (1884–1944) and practiced in his own paintings, which aimed at establishing a structural order within these parameters.

Rougena Zatkovà (1885–1923) worked for many years in Italy between about 1915 and the early twenties, producing in particular works consisting of convertible pictorial constructions and sculptures that were similarly built up of many different materials. This artist represented a direct Czechoslovakian participation in the movement headed by Marinetti. But there was also a noticeable dynamic component in the specifically Czechoslovakian approach, which included a substantial Cubist influence. This was evident in the work of Bohumil Kubišta (1884–1918) and Vaclav Spála (1885–1946), in painting, and Otto Gutfreund (1889–1927) in sculpture, early in the decade. Meanwhile, in the early twenties, we find Jiří Kroha (1893–1974) (who did the decor of the Cabaret Montmartre in Prague) taking part in the mechanical phase of Futurism.

But the broadest and most ramified Futurist enclave in Europe was undoubtedly in Russia. This movement spread in particular on a

literary level, with figures ranging from Velimir Khlebnikov (1885–1922) and Aleksei Kručenykh (1886–1968) to Vladimir Mayakovsky (1893–1930); from Benedikt Livšic (1886–1939) to Ilja Ždanevič (1894–1975) to the "ego-Futurism" of Igor' Severjanin (1887–1942) and to Vadim Šeršenevich (1893–1942). There was a very strong influence here from Italian Futurist models, in particular in the context of poetic visualization (which underwent an original process of evolution in the form of "Zaumism," which investigated the "trans-rational" element of language). To begin with, the Russian Futurists also embraced forms of behavioural provocation in their actions, in their extravagant clothing, and by painting their faces, all of which was aimed at trying, on a nationalistic basis, to deny any supremacy. On the plastic level, this situation was represented first and foremost by the area identified as "Cubo-Futurism," which was particularly intense between 1913 and 1914. This movement was headed by D. Burliuk, and had been originally known as "Gileja" (a group that was also literary, in which there was participation from Mayakovsky, Mikhail Vasilevich Matiušin (1861–1934), Kazimir Malevich (1878–1935), Olga Vladimirovna Rozanova (1886–1918) and Elena Guro (1877–1913). The morphological influences of Futurism, from as early as 1910 onward, combined in effect with the influences of Cubism, but nevertheless in a spirit keen for original conversion and transformation, including the incorporation of its own particular iconic traditions. In Russia, between 1910 and 1920, the plastic dynamism of the Futurist movement affected in particular Aleksandra Ekster (1882–1949), who studied Cubism in Paris; her developments during the twenties were stamped by mechanical dynamic constructivism, and she was deeply involved in stage- and set-designing. It also influenced B. Ender, with his dynamic organic style; Vassily Kamensky (1884–1961), who was also involved in the typographical revolution; Nikolai Ivanovič Kulbin (1868–1917), especially in the area of graphics; Mayakovsky himself, in his rare pictorial excursions, thick with simultaneous conflict; Matiušin, who was interested in problems of visual perception; and Rozanova, who – like Liubov' Sergeyevna Popova (1888–1924) and later Ivan Albertovič Puni (1894–1956) – was involved between 1915 and 1920 in a dynamic synthesis of simultaneous influences. "Rayonism" – as set out by Mikhail Fëdorovič Larionov (1881–1964) in 1912–13, and also practiced by Natalia Goncharova (1881–1962) – absorbed elements of Futurist plastic dynamism, in particular as represented by Balla. Rayonism aimed at "revealing forms in space," in essentially nonfigurative terms, working out previous influences of Futurist figurative dynamism (1912). Both these artists applied their craft fully to stage- and set-designing, for Diaghilev. As far as Malevich was concerned, the Futurist

influence lay in the dynamic emphasis which stimulated a Léger-like mechanistic quality in the paintings he produced in 1910 and shortly thereafter. Vladimir Tatlin (1885–1953) was also affected by Futurist models in the plastic investigations carried out in a variety of materials in his "Counter-reliefs" in the early part of the decade, and finally in his architectural project: the Monument to the Third International, produced in 1920. In Paris, meanwhile, Léopold Survage (1879–1968) was involved in nonfigurative, dynamic chromatic projects with musical associations. A particularly important position was occupied by Alexander Archipenko (1887–1964: an artist greatly appreciated by the Italian Futurists) and, more particularly, by his dynamic so-called "sculpto-paintings," produced early in the decade. From about 1915 onward his contribution was directed to motifs with a "mechanical" and purist emphasis. In the twenties, Vera Idelson (1893–1977), who worked in Berlin with Vasari and then in Paris, was close to Futurism, and created within a framework of similarly "mechanical" dynamism.

In addition to its effects on stage- and set-designing, Russian plastic Futurism also influenced clothing and stage costumes (Ekster, Popova, Malevich, Rozanova, Nedežda Andreyevna, Udalcova [1986–1961]). These

Below: Ljubov Popova, Landscape, 1914–15. Guggenheim Museum, New York (George Costakis Donation). Popova was alert to the decompositional influences of Cubism and, like other Russian artists, she was influenced above all by the plastic dynamism in environmental simultaneities.

areas were then developed, from 1915 to 1920, by exponents of Suprematism and Constructivism.

Where Soviet Constructivist architecture was concerned, the Futurist, Sant'Elia-inspired ingredient constitutes a chapter all of its own. Major figures here include the brothers Alexander (1882–1950) and Leonid Alexandrovich (1881–1933), Vešnin, Konstantin Stepanovič Mel'nikov (1890–1974), Ivan Ilich Leonidov (1902–1959).

Beyond Europe, in the United States in particular, we should mention the work of Joseph Stella (1877–1946), who addressed themes of metropolitan dynamism and shining chromatism between 1914 and 1918. In this same decade, while the relationship between Futurist dynamism and John Marin (1870–1953) is open to debate, it is more probable in the case of James Henry Daugherty (1887–1974), Frances Simpson Stevens (1881–1961) and Morton L. Schamberg (1881–1918), as well as Max Weber (1881–1961), although he was more alert to Cubist influences. In Latin America, on the literary level in particular, European reflections by the Chilean Vicente Huidobro (1893–1948) early in the decade, and by the Argentine writer Jorge Luis Borges in the twenties, stimulated a dialectical relationship with Italian Futurism, similar to the one in painting as a result of the activities of the Uruguayan Joaquim Torres-Garçia (1874–1949), the Mexican David Alfaro Siqueiros (1896–1974), the Uruguayan Rafael Barradas, and the Argentine Emilio Pettoruti (1892–1970). At the same time the Mexican movement known as "Stridentism," founded in 1921 and deriving from Italian models, aspired to literary involvement in the plastic arts and in music (among the painters we may mention Ramón Alva de la Canal [1898–1985] and Fermín Revueltas [1903–35], who were bound up with late-Cubist and mechanical/Futurist dynamic and plastic models).

In the context of Brazilian "modernism," on the other hand, in the early twenties, Futurism was embraced principally in literary circles. The work of the Argentine artist Pettoruti was of particular relevance. He had originally become aware of Futurist plastic dynamism (in Florence) between 1915 and 1920, and then (in Paris, in the twenties) of a late-Cubist form of mechanical syntheticism. He returned to Argentina in 1924, but still remained in touch with the Marinetti-led movement in Europe.

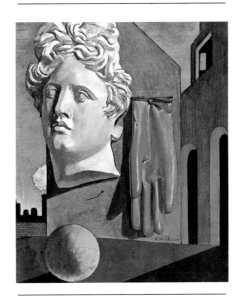

Metaphysics and a return to order

Metaphysics

"The term 'metaphysics,' which I used to christen my painting from the time when I was working in Paris in the lean but fertile pre-war years, stirred up...ill feeling and misunderstanding....But to make up for this there were plenty of supporters. First and foremost among these I should mention my poor friend Apollinaire, who said, even then, about me: 'He is the most astonishing painter of the young generation.'" With these words Giorgio De Chirico (1888–1978) records the birth of Metaphysical painting in his *Autobiography*. The first picture to be painted under the aegis of the new "aesthetics", *Enigma of an Autumn Afternoon*, dates back to 1910. It embraces that artistic legacy, steeped in Symbolism, mythological Classicism and tradition, that the historical avant-garde was at that very time rejecting. De Chirico painted it in Florence, nourished by his reading of Nietzsche, Schopenhauer and Weininger. He was in close contact with the ideological and philosophical milieu of Papini, who also shared the feverish interest then being shown by Berenson's circle in primitive painters.

De Chirico was born at Volos, in Thessaly. Until he was seventeen he lived in Greece, absorbing from those majestic ruins of the Classical age an innate feeling for myth and the silent mysteries enveloping it. His cultural development continued with Italian visits (Milan and Venice), but it was his visit to Munich, that turned out to be of crucial importance to him. Here he "discovered" the painting of Boecklin, laden with that same Mediterranean mythology which De Chirico had himself experienced in his childhood. He also discovered the engravings of Klinger, who – in the same romantic climate but at random – depicted scenes that were dreamlike (*Story of a Glove*), mythological, or up to the minute. Out of this dual culture – Greek-inspired and central European – De Chirico produced his "Boecklinian" pictures: battle scenes with centaurs, and petrified visions rendered sculptural by his solid painting style, which made no concession to nuance. The sources of his inspiration were Boecklin and Klinger, but this does not mean that he was unaware of more modern artistic references, ranging from Gauguin (clearly evident in his "flat" colour-application technique) to Cézanne, Van Gogh and Rousseau. De Chirico presented three "metaphysical" works at the Salon d'Automne in

Giorgio De Chirico, Love Song *(1914). Museum of Modern Art, New York.*

Paris in October–November 1912, and three more at the Salon des Indépendants in March–May 1913. He stayed in Paris until 1915, with his brother Alberto Savinio (Andrea de Chirico, 1891–1952), fine-tuning his "aesthetic" with help from Apollinaire, Max Jacob, Cocteau, Reverdy, and Salmon, in an atmosphere that was far from conservative and if anything, sympathetic to avant-garde movements. The artist's recurrent themes evolved during this period: the *Place d'Italie* paintings with the statues of Ariadne asleep (a possible allusion to the enigmatic myth outlined by Nietzsche in the *Dithyrambs of Dionysius*); the equestrian monuments in Turin; the arcaded towers and smokestacks of abandoned factories; the wheezing locomotives, an indelible childhood memory (his father was an engineer with the Greek railways); the accumulations of extraneous, geometric, incomprehensible objects....And from 1914 onward the mannequins, possibly inspired by characters in the dramatic poem *Songs of Half-death* published by his brother Savinio that same year in the review *Soirées de Paris*.

The linguistic "rhetorical" language of De Chirico's Metaphysical painting consists in causing object-significance and contextual signifier to become separated. Day-to-day or unusual objects in illogical associations produce a feeling of bewilderment by showing their empty, atemporal essence, despite the constructions and interpretations formulated

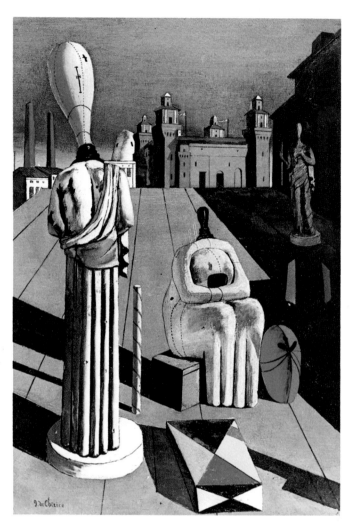

*Left: Giorgio De Chirico,
Disquieting Muses
(1916–17). Mattioli
Collection, Milan. De
Chirico builds his visions
from a rich set of
aesthetic notions (from
Nietzsche to
Schopenhauer, from
Weininger to Papini) to
attain, in his words, a
"strange and deep
poetry, infinitely
mysterious and lonely,
resting on the
mood . . . of an autumn
afternoon, when the
weather is clear and the
shadows longer than in
summer." The poetic
impact of his method is
unusual; along with the
abstraction of Kandinsky
and Balla, it is one of the
poles of twentieth-
century art. His painting
aims at going beyond
reality (hence
"metaphysics") and at
conveying
disorientation.*

*Below: Carlo Carrà, The
Metaphysical Muse
(1917). Brera, Milan.*

*Opposite: Giorgio
Morandi, Still Life (1918).
Brera, Milan.*

A Return to Order

The state of artistic affairs in Italy at the end of the First World War was characterized by somewhat contrasting features. The avant-garde movements that had enlivened the cultural debate during the century's second decade were passing through a period of far-reaching terminological crisis. The consolidation of a proper polemical tendency in the face of the Futurists' return to "zero" took place between 1916 and 1917 with the development of Metaphysical painting. This emerged from the encounter between De Chirico and Carrà, Morandi, Savinio, and De Pisis.

Immediately after the end of the war, the aesthetic ideals of the Metaphysical movement in Ferrara found a continuation and greater identification in the movement that gathered around the Roman review *Valori Plastici*. This was edited by Mario Broglio (1891–1949), a highly cultured man with an extremely lively critical sense who was himself a painter of considerable figurative talent. The chromatic and formal aspects of his pictorial work were inspired by a cold realism, by Piero della Francesca and at the same time by the Metaphysical work of Morandi.

A typical feature of his aesthetic ideal was the desire to combine the "values" of the great periods of Italian painting (especially the four-teenth and fifteenth centuries). His perspective would also include a thorough awareness of the most interesting European innovations. During the brief heyday of his review, from the

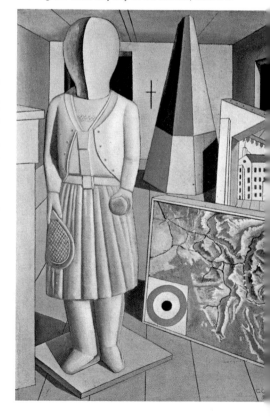

around human thought. So art speaks of "another" world in relation to reality. It denies it comprehensible meanings because such meanings are inevitably human, and hence limited, not universal. Art wants to go further. This explains the term "metaphysical."

Metaphysics came about as a personal process for De Chirico. It certainly had nothing solipsistic about it, but was nevertheless rooted in a spirit of independence. It was only with its second wind, as it were, that it came to be a "movement," or at least a group. The appointed place for this intellectual and artistic activity was Ferrara, a city that played host to De Chirico, Savinio and Carlo Carrà all at the same time in early 1917. The meeting between De Chirico and Carrà occurred again through Florentine intermediaries, Giovanni Papini and Ardengo Soffici. Both painters happened to be in a military neurological hospital, and during their prolonged convalescence they had plenty of time to paint and compare their theories of poetics, despite the war. As early as 1914–15 Carrà had started to move away from Futurism. He had embarked on passionate studies of Giotto and Piero della Fran-

cesca, and painted Classical, infantile, im-mobilized figures (*Romantici, La Carrozzeria*). But Carrà's first conspicuously Metaphysical pictures, which were strongly influenced by De Chirico's work, date from 1917.

In Ferrara this Metaphysical research attracted not only Savinio but also Filippo De Pisis (Filippo Tibertelli, 1896–1956), a young intellectual still oscillating between writing and painting; the poet Corrado Govoni and, most importantly of all, Giorgio Morandi (1890–1964), who would advance from Cézanne-inspired research to the perfect delineation of impossible, polished, *trompe l'oeil* works – spatial environments with no atmosphere in which geometric objects are suspended and silhouetted by a highly defined, abstract quality of light. Sironi also flirted with the Metaphysical movement for a brief period, between 1917 and 1919. In it he found a harmony with his own headstrong but restricted vocabulary (which had already produced a highly individual version of Futurism, tempered by the influence of Russian Constructivism and of Kasimir Malevich in particular).

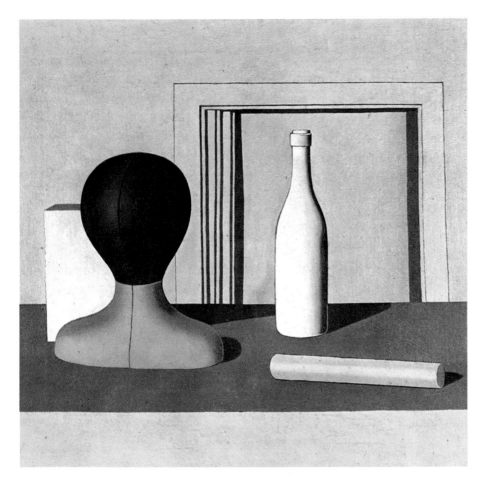

end of 1918 to 1922, he published reproductions and texts of the major contemporary artists. These ranged from Picasso to Zadkine, Braque, Archipenko, Léger, Kandinsky, Cocteau, Jacob, Breton, and van Doesburg, among the ranks of foreign artists; and the Italians De Chirico, Carrà, Morandi, Martini, Soffici and Melli. Broglio's timing was right in embracing and diffusing the principles of this general "return to order," which had already aroused the impassioned support of Derain and Picasso in France. The vehicles for this diffusion were his cleverly distributed review and a series of organized exhibitions in Italy and abroad. For example, the show held in Berlin in 1921 was most successful and crucial to the birth of the *Neue Saclichkeit* (New Objectivity) movement in Germany.

De Chirico and Carrà were the two leading theoreticians of the *Valori Plastici* movement. They produced a number of texts, which expounded the orientation of the review in an increasingly well-defined way. In 1919, in an article entitled "the return to craft," De Chirico not only proposed the retrieval of a lost pictorial quality, he also polemically disclaimed any validity for Futurism, even on an experimental level.

The rediscovery of old techniques and the continuance of the Metaphysical system of aesthetics were associated in the works of this period, for example, *The Departure of the Argonauts* with a deeply Italian fifteenth-century brand of pictorial inspiration. When the *Valori Plastici* movement broke up, De Chirico nourished his painting with central European, Romantic, and Boecklinian sap. He turned once again to the early cultural training he had received in Munich. This produced the magnificent series of *Roman Villa* works and paintings in thick tempera, based on "ancient" painterly recipes.

Carlo Carrà was the author of the editorial in the first issue of the review, entitled "the facial outline of apparitions." By now he had abandoned the geometric theories and the mannequins of the Ferrara period. In 1919 he painted *The Daughters of Lot*, a monumentally planned picture laid out like a fourteenth-century panel by Giotto. Compared with De Chirico, his sights were set on a more unadorned, radical type of Primitivism which would become an invariable feature of his painting. In the 1921 work *Pine by the Sea* the essence of the painting itself becomes the poetic theme. Here the search is for primordial, almost abstract rhythms.

Morandi was another great artist who was profoundly involved in the *Valori Plastici* ethos. After his Metaphysical period he reverted to a

deep feeling for the meaning of reality and, more particularly, the meaning of plasticism. His compositions present a more atmospheric pictorial achievement, with a sensibility to light and physical space. They thoroughly complement his own vision, which is expressed through everyday objects reiterated again and again. These objects are bathed in a kind of cerebral light, and constructed of chromatic blends that have a subtle tonality. These blends give a lyrical definition to the forms and achieve an extraordinary quality of poetic absolutism.

After emerging from the "wars of secession" that were waged in the wake of Impressionism, Arturo Martini (1889–1947) was likewise attracted into the *Valori Plastici* fold after the First World War. The link for Martini's membership was his friend Carrà. It is from Carrà that Martini received that sense of primordial Classicism which he immediately turned into a highly personalized vision of polished plasticism, completely enclosed in the purity of its rounded and simplified forms, and built as geometric solids. Here we have one of the twentieth century's highest expressions of Italian sculpture. It is well summarized in *The Sleeper* (1921). There is an obvious awareness of the major artistic experiments of those years, ranging from Barlach and Léger to Picasso in his Mediterranean period.

Rome was the place where the Classically oriented and polemically anti-Futurist version of this "return to order" was being defined. In Milan, however, the situation at first seemed more arbitrary, although there was clear rivalry with the *Valori Plastici* movement. In 1919 Sironi, Funi and Dudreville, among the leading Milanese painters who were before long to form the *Novecento* group, declared themselves Futurists. The moment of theoretical discrimination – which was to cause them to abandon, step by step, the movement headed by Marinetti – can be pinpointed as January 1920, the date of the manifesto *Against any Reversal in Painting*, which was still formally labelled "Futurist."

This was the response of the artists of Milan to the innovations and the criticisms issuing from the Roman artists with an allegiance to *Valori Plastici*. The firm rejection of any "reversal" – in other words, of any direct resumption of ancient painting – was supported by polemical arguments addressed to the artists who were being supported and published by Broglio's review, in particular Picasso, Severini and Carrà.

This moment of synthesis was recaptured in 1919–20 by certain peripheral works of Mario Sironi. These took the form of extraordinary and troubling urban visions which outline and combine to present an image of the twentieth-century city.

In 1922 Margherita Sarfatti, a skilful organizer and subtle politician, gathered together a well-mixed group of painters and presented them to the Pesaro Gallery as the

Sette Pittori del Novecento (Seven Painters of the Twentieth Century). The artists concerned, who had by then all freed themselves from the Futurist legacy, opted for a plastic and simplified form of Classicism. Sironi created scenes of primordial simplicity, with a powerful academic flavour. One such work, *Solitude*, painted in 1925, changed the form of metaphysical and fifteenth-century memories into a vision of reality laden with substance. It is one of the most uncompromising and troubling paintings of the period.

Other conspicuous figures included Leonardo Dudreville, who, after his involvement with Futurism, devoted himself to a mordant form of realism, often resonant with social echoes. Gian Emilio Malerba, Anselmo Bucci, Pietro Marussig and Ubaldo Oppi started from a

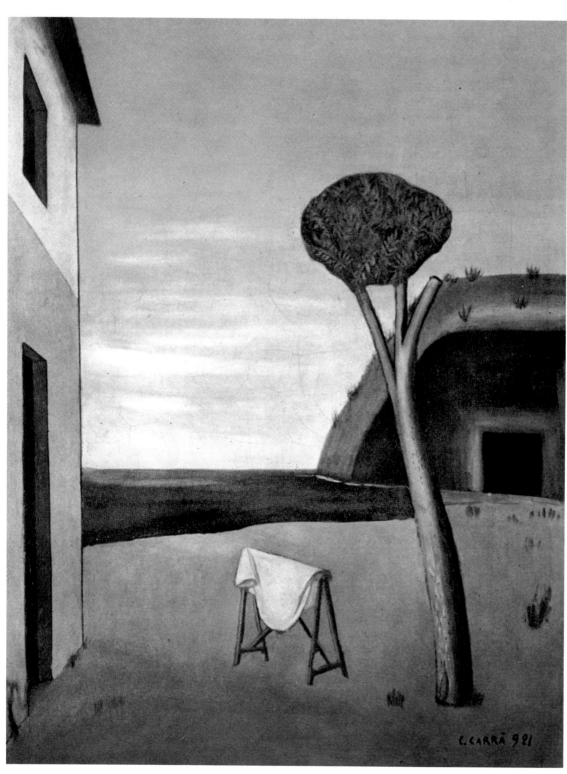

Left: Carlo Carrà, Pine by the Sea *(1921). Private collection, Rome.*

Opposite above: Arturo Martini, The Sleeper *(1921). Private collection, Rome.*

Opposite below: Ubaldo Oppi, The Painter and his Wife *(1920). Private collection, Rome. In 1918 Carrà wrote: "The painter-poet feels that his true immutable essence starts from the invisible to give him an image of eternal reality. His rapture is not transient for it does not issue from the physical order, though the senses are its necessary tools."* The Sleeper *is one of Martini's main works from the period when he adhered to the Classicist principles of the Valori Plastici movement (led by Broglio). The sculptor saw it as one of his most revealing canvases "beyond all style and like a Divine breath." Around 1920 in Milan, we see a return to an order less idealistic than that of the Roman group Valori Plastici, but turned more to an ideological facing of reality. Oppi, along with Sironi and Funi, was the main representative of the "Novecento" group. His canvases splendidly attest the exchanges between Italy and the painters of the new German objectivism.*

central European cultural point of reference, and achieved an enchanted and clearly defined realism. Ubaldo Oppi (1889–1946) was the author of ambiguously intriguing scenes with an aesthetic leaning, mixed with a cruel photographic-like method of representation.

Margherita Sarfatti, who enjoyed the personal backing of Mussolini (*Il Duce* himself personally introduced the first *Novecento* exhibition), cleverly managed to gather all the progressive elements then visible in Italy into one large show, held in Milan in 1926. In so doing she created a proper national movement, the *Novecento Italiano* (Italian Twentieth Century). Using this label Sarfatti managed to diffuse, in Italy and abroad, the tendencies that arose from the return-to-order ethos. She mounted a series of travelling exhibitions, which visited Geneva, Zurich, Amsterdam and Rome in 1927, and Geneva and Paris in 1928. There was a second major exhibition in Milan in 1929, in Basel, Berne and Buenos Aires in 1930, and in Helsinki and Oslo in 1931. Even though the *Novecento Italiano* was proposed as a national consolidation of a widespread tendency, the various regional versions were characterized by a powerful sense of independence. Carrà was still in Milan after abandoning the conceptual primitivism of the *Valori Plastici*; he was now in the process of softening and toning down the pictorial pigments as he sought to achieve an atemporal essence suffused with a profound, evocative poetry. A good example is the 1926 work *Waiting*. Arturo Tosi (1871–1956), on the other hand, expressed the link with the pictorial tradition of nineteenth-century Lombardy by constructing landscapes with clear compositional lines, vibrating with a tenuous and internalized post-Impressionist colour.

Other artists taking part in the *Novecento* movement were Alberto Salietti (1892–1961), secretary of Sarfatti's movement, Pompeo Borra (1898–1973), Gigiotti Zanini, with his architectural visions, Usellini, and the sculptors Adolfo Wildt (1868–1931), author of phantasm–like figures formed in a spirit of pure, unbending plasticism and hewn from linear *Jugendstil* rhythms, and the Classically inclined Francesco Messina (1900–).

In Rome in the early 1920s the cultural situation was clearly heavily indebted to the lucid abstraction of the *Valori Plastici* movement. A typically Roman development of the "return-to-order" attitude was using the seventeenth and nineteenth centuries as a source of inspiration. Examples of this tendency were Armando Spadini (1883–1925), a painter who was already famous at the time of the *Valori Plastici* movement and who reinterpreted, via Classical themes, the great Baroque compositions. He toned down the outlines of his painting, using explicit references to French Impressionism, to Renoir in particular, but his work was rooted in a constructive spirit that was typically Italian. Another example was

Felice Carena (1879–1966). His work *Tranquillity* of 1921 is solidly constructed with substantial brushstrokes, deriving from the vocabulary of Cézanne. Here we see a pastoral composition thick with historical references and an

aesthetic form of Primitivism, but one that also presents memories of Fauvist and post-Impressionist styles, which the artist had practiced during the Roman breakaway movement.

Between the objective lucidity of Broglio and the seventeenth-century pictorial spirit of Spadini and Carena, we find a group of young artists dedicated to a painstakingly realistic form of painting which has, nevertheless, an enchanted, suspended, enigmatic quality. Roberto Longhi defined Socrate as neo-Caravaggesque, Donghias as Gentilesque and Trombadori as Dutch, emphasizing the fundamentally seventeenth-century spirit of their inspiration. Carlo Socrate (1889–1967) combined the realism of Coubert with a highly individual photographic-like quality, reminiscent of Caravaggio. Antonio Donghi (1897–

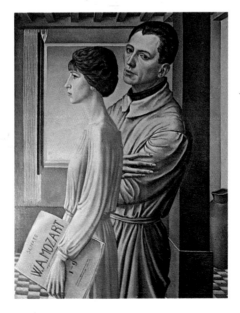

1963) illuminated his figures with a bright, magical aura, suspending their gestures and movements in disturbing postures of expectation. Francesco Trombadori demonstrated all the fidelity of a Flemish painter in his still lifes, with their day-dreamy and almost excessive realism, or in his landscapes, steeped in light.

Classically inclined and neo-fifteenth-century *Novecento* group included Gilberto Ceracchini and Francesco di Cocco, but undoubtedly the most interesting members were Virgilio Guidi (1891–1984), whose synthesis of luminous colour and plastic form placed him among the leading lights of the *Novecento* period in Rome, and Ferruccio Ferrazzi (1891–1978), the eccentric creator of magical, unsettling scenes with brilliant, acid colours. In Rome in the 1920s the major force lay in the development of the extremely important personality of Martini, whose works reveal the intense inspiration of Etruscan art.

A rough and essential Primitivism of the *strapaese* or chauvinistic variety may also be detected in the popular scenes painted by Ottone Rosai (1895–1957). In the works of Oscar Ghiglia, Baccio Maria Bacci, and Giovanni Costetti we find both a predominance of determined and meticulous realism and an elegant and well-composed plasticism. In the figure of Primo Conti – who, after the Futurist experiment, regained reality in his massive forms and vivid contrasts – what strikes one above all is the exuberance of the material and the colour, the strangeness of the subjects and the Baroque quality of the inventiveness. In the mid 1920s Carena moved to Florence, where he continued to paint with thoughtful and monumental colour tones, becoming increasingly refined in his religious and dramatic vision of human and natural subjects.

A typical expression of twentieth-century realism issued from Casorati, an isolated but no less symbolic figure in the conceptual abstraction that typified the painting of this decade. Starting from a style associated with the essence of the Viennese Jugendstil, by 1920 he had achieved a monumentality of vision linked with an absolute purity of representation. In later works such as *Silvana Cenni* (1922) Casorati makes use of explicit references to fifteenth-century art, above all to Piero della Francesca. He elaborated a highly personal style based on complex mathematical constructions, in which the maximum degree of simplification and the cancellation of pictorial language or handwriting produce scenes of icy abstraction and extraordinary suggestiveness. This technique reached Surrealistic tones in Casorati's mysterious and dissonant juxtapositions, as in the *Platonic Conversation* (1925). Other isolated figures included Morandi, by now plunged into his introspective, tonal painting of reality or Cagnaccio di San Pietro, the metallic firmness of his objectivity redolent of central Europe and of the so-called "Italians in Paris."

In the early 1930s the ideological thrust of the *Novecento Italiano* was plunged into profound crisis. The return to order, which had consolidated the admittedly heterogeneous requirements of Italian culture after the First World War, had in many cases been gradually crystallizing into manneristic formulations, now deprived of the far-reaching and incisive quality of the early days.

This moment of crisis was clearly perceived by the central characters of the *Novecento* movement – principally by Sironi, who pursued his own original poetic theory of monumental decoration, rich in social and aesthetic implications. This ideology was fully expressed in the *Manifesto of Mural Painting*, published in 1933 and also signed by Campigli, Carrà and Funi.

Between about 1915 and 1925 both France and Germany experienced avant-garde reac-

Right: Mario Sironi, Mural (c. 1942). Private collection, Rome. With De Chirico Sironi was the main figure in the return to order in Italy. In the 1920s he painted highly Classicist pictures (Solitude, Girl Pupil, Pupil, Architect), in the 1930s monumental ones full of archeological and allegorical hints, whose elements are charged with deep social meanings.

basis of an atemporal and almost mythical form of Classicism. These works rank among the artist's greatest creations.

In his tireless intellectual quest, Picasso went on after 1924 to follow other paths. Derain, however, was to remain the central figure of the "return to order" in France, with his symbolic blending of myth, fifteenth-century formalism and "modern" simplicity.

While on the subject of France, we should also mention the glacial figurative works of André Marchand (1907–) and Georges

tions whose outcomes were similar in some aspects to the undoubtedly more complicated and decisive phenomena taking place in Italy.

In France, as early as 1914, André Derain was showing an interest in compositions with echoes of Classical rhythms. Here the subjects acquire a plastic quality that is still Cézanne-like but nevertheless profoundly inspired by Classicism. Derain went beyond both the Cubist "analyses" and the Cubist "syntheses." Similarly, with his *Motherhood*

(1916), Severini moved away from the Cubist vocabulary (although he would carry on using a parallel version until 1919) by creating figures with a pure neo-Classical quality. In 1917 Picasso, too, started to abandon the synthetic principles of the avant-gardists. After a journey in Italy, during which he was greatly affected by the Classical and Mediterranean spirit still predominant there, he started to paint monumental figures. Their plastic quality was contained and gigantic, elaborated on the

Opposite center: Felice Casorati, Noon *(1922). Revoltella Museum, Trieste.*

Opposite below: Otto Dix, Portrait of Anita Barber *(1925). Private collection.*

Right: Pablo Picasso, Three Women at the Fountain *(1921). Museum of Modern Art, New York. Masterpiece of his neo-Classic period, a key work in the European return to order: the peplums fluted like columns lend a monumental and sculptural air; the magnified gestures become gigantic; the studied composition and pictorial treatment give this canvas an archaic flavour while staying quite modern. In France, Derain and Picasso are the main figures of this tendency toward the limpid clarity of ancient and Renaissance art.*

Rohner (1913–), the ambiguous physical qualities of Balthus (who regarded himself more broadly as part and parcel of Surrealism), the Swiss painter Félix Vallotton (1865–1925), the stylizations of the post-Cubist Roger de la Fresnaye (1885–1925), Marcel Gromaire (1892–1971) and the sculptor Jacques Lipchitz (1891–1973) or the dramatic sensuality of Jean Fautrier (1898–1964).

The situation in Germany was more coherent. In several ways it was influenced by the extraordinary Italian output of those years. Immediately after the First World War in central Europe there was a tendency to cool down the destructive enthusiasms of the avant-garde. The influence of Metaphysical painting aroused in artists such as George Grosz, Raoul Hausmann, Rudolf Schlichter and Max Ernst a tendency to depict uninhabited cities and dehumanized mannequins – "unsettling" environments in which, contrary to Italian Expressionist works, there wafted a moral judge-

ment, and a political and social tension that is the legacy of Expressionist art, now reabsorbed in its crudest forms by the catharsis of war. Spread across two broad tendencies, and with no clearly defined ideological context, German "realism" took on a cruder and more moralistic aspect in the form of the movement known as *Neue Sachlichkeit* (New Objectivity) – or rather, if we extract a particular nuance of the word, "New Insensibility." It also shows a more poetic face, which is at

once strikingly realistic and primitive (the so-called *Magischer Realismus*, (or magic realism). In both these tendencies the Italian momentum was fundamental to the creation of the style. This momentum ranged from the Metaphysical painting of De Chirico (exhibited in Dadaist circles and thus well known to most artists with a Futurist or Dadaist background) to the review *Valori Plastici* (available from early 1919 onward in the gallery run by Hans Goltz in Munich, and known to Max Ernst, Grosz and Heinrich M. Davringhausen, and very soon afterward to Hausmann, Anton Raederscheidt, Georg Schrimpf) to the long Italian sojourn (1920–27) of Christian Schad (1894–1982), who transformed his Dadaism into a crude, objective, visionary form of expression. All these Italian cultural elements were instrumental in the choices then made by German artists.

Munich was the principal center of the *Magischer Realismus* movement. This term was coined in 1925 by Franz Roh as a subtitle for his book *Post-Expressionism – Magic Realism. Problems of the New European Painting.* The leading figures were Alexander Kanoldt, Carlo Mense, Schrimpf, Davringhausen, and Wilhelm Heise. The main centers for the *Neue Sachlichkeit* movement were Berlin, Dresden and Karlsruhe. In Berlin the leading figures were Grosz, Schlichter, Wilhelm Dressler, Schad, Ernst Fritsch and Hannah Höch; in Dresden, Otto Dix, Bernhard Kretzschmar,

Malerei seit Expressionismus, New Objectivity. German Painting since Expressionism). The exhibition had in fact been planned since 1923. Despite the differences, the two terms were used to designate one and the same phenomenon. The difference consists essentially in a nuance of sociopolitical emphasis implicit in *Neue Sachlichkeit*. The central characters here were certainly Otto Dix, Schad and Grosz. After going through a Futurist period, Otto Dix hardened his work from about 1920 onward, introducing, with incisive and brilliantly chromatic cruelty, realities that are almost always complicated by morbid sexual or psychological situations. The aristocratic Schad, who had been a Dadaist in Zurich, presented shapely and powerful creatures emerging from bawdy-houses, and effigies of troubled *viveurs*. In the early 1920s, George Grosz (1893–1959), who was completely committed to a political path, delineated the social fits and starts of the Weimar Republic, using a Metaphysical objectivity.

Max Beckmann (1884–1950) lent objectivity to angular compositions and the forced attitudes of the Expressionist tradition.

Alexander Kanoldt (1881–1939), Georg Schrimpf (1889–1938), Mense and Davringhausen all adopted a Primitivist simplification of reality, starting from the example of Carrà and Le Douanier Rousseau, creating suspended figurative scenes, often rich in poetry, polished and unsettling.

powerful idealistic tension, were Ivo Saliger, Adolf Wissel and Udo Wendel.

The solitary painting of Edward Hopper (1882–1967), which depicts people as if immobilized in deserted outskirts, fixed by artificial lights, certainly represents the most interesting example of interwar American realism. The psychologically deforming works of Ben Shahn (1898–1969), on the other hand, take on a social quality.

In Mexico there was a very original variant of realism introduced by the painters José Cleùente Orozco (1883–1949), Diego Rivera (1886–1957) and David Alfaro Siqueiros (1896–1974). These three artists had a European cultural background, including contact with the avant-garde movements, particularly in France. The period spent by Rivera and Siqueiros in Paris, between 1915 and 1920, stimulated the elaboration of a nationalist aesthetic rooted in Maya and Aztec tradition, but also involved in the more recent political and revolutionary events in Mexico. A journey to Italy in 1921 to study the great frescoes of Giotto and Michelangelo convinced them to use the language of mural painting in an ideological way. They felt this to be suitable for the epic expression of the social and popular events that constituted the essential subject matter of their paintings. In 1921 Siqueiros wrote an *Appeal to the Artists of America*, in which he proclaimed a "monumental and heroic" manner of painting. From 1922 onward

Left: Max Beckmann, Pierrette and a clown (1925). Kunsthalle, Mannheim.

Right: José Clemente, Soldiers (1926). Museum of Modern Art, Mexico. Beckmann has the realist vigour of the new German objectivism, while keeping Expressionist ways that give his subjects an implicitly moral tone. The same realist streak is found in the Mexican mural painters (Orozco, Rivera and Siqueiros), whose social content goes with a precise political stance.

Wilhelm Rudolph and Franz Radziwill; and in Karlsruhe, Carl Hubbuch and Georg Scholz. In addition there was Max Beckmann in Frankfurt, and Heinrich Hoerle and Raederscheidt in Cologne.

The term *Neue Sachlichkeit* came into being in 1925 as the title of an exhibition organized by Hartlaub: (*Neue Sachlichkeit. Deutsche*

With Hitler's rise to power in 1933, the Nazis put an abrupt end to this tendency toward implicit denunciation of the bourgeoisie. Instead they imposed a neo-Classical, naturalist style, in accordance with the triumphalist and anti-expressive criteria required by the dictatorial regime. The best of these artists, whose works are sometimes underpinned by a

the three artists consolidated and gave form to this aspiration in Mexico with huge compositions for public buildings.

Dada and Surrealism

Dada

As an artistic movement, Dada was born in 1916 in Zurich. Hans Arp bore ironical witness to the birth with the words: "I hereby declare that Tristan Tzara found the word *Dada* on 8 February 1916 at 6 p.m." His account continues: "I was present with my twelve children when for the first time Tzara pronounced this word, which excited an understandable enthusiasm in all of us. This happened in the Café Terrasse in Zurich while I was conveying a brioche to my left nostril. I am convinced that this word is of no importance and that it is only imbeciles and Spanish professors who might be interested in the facts. What interests us is the Dadaist spirit, and we were all Dadaists before the existence of Dada."

This is not the only version supplied by the various leading figures of the day for the origin of the term. Another version suggests that it is derived from a word in the *Petit Larousse* (*Dada:* horse; in child's talk, rocking-horse). Yet another claims that it was indicated, quite by chance, on a paper-knife being handled by Tzara and Hugo Ball, and yet another has it coming from the Slav expression *da, da* used by Balkan refugees in Zurich.

The total lack of meaning in the word, and in the deliberate and contradictory plurality of its origins, implicitly contains the sense of nihilism that had assailed a considerable proportion of European intellectual circles on the eve of the First World War. There has been wide debate by critical historiographers about the deep-rooted connection between the Zurich-based movement and the crucial social and political factors in Europe at the time. For Europe was being violently shaken by a war being waged on a worldwide scale. In the name of that war, similar yet contrasting ideals were being put forward; and in that war, thousands of people died under the auspices of an alleged rationalism. In the eyes of intellectuals, who were for the most part socialists or Marxists, the war was a collective folly, involving injustifiable genocide. These intellectuals refused to take part in it, and found themselves as a result converging on (neutral) Switzerland from all over Europe. The rejection of the perverse system of destruction being effected by the war necessarily implied a rejection of the basic culture of the society producing that perverse system.

The stance that therefore took form under the banner of Dada was essentially a denial of the whole of Western culture and its various mechanisms. The destruction of contemporary logic seemed to be systematic, and while it was destructive it was at the same time liberating, infantile and sarcastic. It overflowed into nihilism and provocation, into stepping back

René Magritte, Duration knifed *(1923). Art Institute, Chicago.*

toward Primitivism and psychoanalytically unbridled expression.

The roots of Dadaism must be sought before the First World War, in Paris. The cultural climate in the French capital was without doubt sensitive and perceptive. Between 1912 and 1913 Marcel Duchamp abandoned the Cubist/Futurist vocabulary of pictures like *Nude Descending a Staircase.* Instead he constructed artefacts that looked out of place (*Bicycle Wheel,* 1913; *Bottle-rack,* 1914). These are his so-called ready-mades: industrial objects taken out of context and presented in an "aesthetic" guise. At the same time he produced works such as the *Chocolate Grinder* (1913–14) or *The Slide* (1913–15). Here the alchemical and erudite references, which later contributed to the execution of *The Large Glass* (1915–23), are masked by the representation of inexplicable, absurd mechanisms. These works are coldly planned "celibate machines" that do away with all contemporary logical sequence.

It was nevertheless within the group of artists and writers who frequented the Café Terrasse in Zurich and, more particularly, Hugo Ball's Cabaret Voltaire, that the Dadaist ideology became most overt. Hugo Ball himself was a philosopher and writer who came from the Expressionist milieu of Berlin. He opened his cabaret in February 1916, and played host to several Slav customers such as Tristan Tzara (who would become the movement's leading theoretician) and Marcel and George Janco; Hans Arp from Alsace; and the Germans Hans Richter, Richard Huelsenbeck

cul [She has a hot arse]), created with perishable materials. Duchamp's works were also pure examples of the aesthetic "return to zero."

In addition to the artists already discussed, other figures also took part in Dada demonstrations. These included Jean Cocteau, Erik Satie and Paul Dermée. They too contributed to the creation of an intellectual climate that would before long develop into Surrealism. Various Dadaist groups were formed in Ger-

and Sophie Täuber.

In the Dada manifesto of 1918 Tzara set forth this theory: "There is important destructive, negative work to be done. Sweeping and cleaning. The cleanliness of an individual can come about only from a state of madness – aggressive, complete madness – and from a world handed over to bandits who destroy themselves, and destroy the centuries too." In May 1916 Tzara and Ball published *Cabaret Voltaire* ("a literary and artistic collection", with contributions from Apollinaire, Arp, Francesco Cangiullo, Cendrars, Janco, Kandinsky, Marinetti, Picasso, and others). From July of the following year the review *Dada* started to appear. In addition, in March 1917, they opened the Dada Gallery with an exhibition of works by Paul Klee, De Chirico, Max Ernst, Lyonel Feininger, Kandinsky, and so on.

The Zurich movement was therefore rather more than merely literary and artistic. It was characterized by a varied form of eclecticism and, above all, by a destructive yearning that was essentially inhibiting to artistic creation. Backed by the momentum that Tzara was capable of lending to the movement, by publishing and distributing his publications to intellectual circles throughout Europe, Dada found much fertile ground in both France and Germany. In Paris, as early as 1917, Dada had created a certain stir and interest. Apollinaire gave only a lukewarm welcome to the conceptual explosion, whereas Jacob was to some extent won over by it. It was Jacob who emphatically and ironically announced the birth of a new poet: "Tsara! Tsara! Tsara! ...Thoustra." Breton, who had already become acquainted (thanks to Apollinaire) with the early publications of the movement

after reading the Dada *Manifesto* of 1918, communicated his passionate support of it to Philippe Soupault, Louis Aragon, Jacques Vaché and Georges Ribemont Dessaignes. In due course the new review *Littérature* became a supportive vehicle for the Dadaist movement.

Tzara arrived in Paris in January 1920, to a "messiah's welcome." The first Dada show was held at the Palais des Fêtes on 23 January. Duchamp and Picabia had returned from New York. It was Picabia, above all, who had created various scandals with his works, which used many different materials and an assemblage technique. These works combined a Futurist vision with a purely abstract chromatic formalism, deliberately stripped of all cultural or spiritualistic references. In New York Duchamp had also set up his provocative "installations" (*L.H.O.O.O. – Elle a chaud au*

many, where they found an environment that was already predisposed to the Dada spirit of radical cultural change.

Heartfield, Grosz, Hausmann and Höch often used photomontage as a means of expression. This became a characteristic stylistic feature of the Berlin-based group. By removing the neutral quality from the *collage* technique, photomontage presents torn, recomposed and disproportionate fragments of a world that seems to have undergone vivisection. This new technique contains within it a dramatic and social charge. It thus expresses the more politically committed orientation of the German group, in contrast to the more intellectual and theoretical emphasis of the groups in Zurich and Paris. Instead of denying artistic possibility, the German artists interpret the avant-garde vocabularies by twisting and distorting them, especially with Futurist and

its surface to be reproduced on another surface (for example paper or canvas).

In the United States the situation was parallel to that in Zurich, although there was no interchange of contact or influence between them. In 1915, in fact, Marcel Duchamp moved to New York, to be joined some months later by his friend Francis Picabia. Pictures by both artists had been exhibited two years earlier in the Armony Show in New York (the first exhibition of European avant-garde art in the United States), so both Duchamp and Picabia were well known in the avant-garde intellectual milieu of New York City. The leading figures in this group were Man Ray, the poet Arthur Cravan, the composer Edgar Varése, the painters John Covert, Crotti and Arthur Dove, and gallery owner Alfred Stieglitz. The group was destructive toward all forms of artistic idealism and imbued with the abstract intellectualism of Duchamp. Duchamp referred to the subversive force of Dada in his own conceptual accepted meaning of the term: "Dada was very useful as a purgative.... It was a sort of nihilism which still claims all my sympathy.... The others were for or against Cézanne. There was really nothing to it beyond the physical aspect of painting. Nobody ever taught any concept of freedom or introduced any philosophical perspective." In 1917 Duchamp sent to the Society of Independents, using the pseudonym Richard Mutt, an upside-down urinal with the title: *Fountain*. This artistic "object" "vanished" and was never exhibited at the show. The result was a fierce controversy in the pages of *The Blind Man*, a review linked with the Dadaist group in New York. In this symbolic example, Duchamp achieved the desecration of the beautiful by presenting a ready-made. This gesture pinpointed the artist's position not as the creator of an artistic product but rather as an intellectual operating in the realm of aesthetics: "There is a need to achieve something that is so indifferent that it will not evoke in you any aesthetic emotions. The selection of the ready-mades is always based on visual indifference and at the same time on the total absence of good or bad taste." Picabia worked in parallel with Duchamp, but produced powerfully suggestive pictures of machines with mysterious functions. These works were given titles involving humanizations and unacceptable psychologisms: *There's the Woman* (1915); *Paroxysm of Grief* (1915); *Amorous Procession* (1917). Man Ray, inventor of the Rayograph (a photograph obtained by direct contact between the object and the film), is a constant and surreal image-processor. In his images, with their anti-Expressionist tendency, manual interference is minimal.

In Italy, Dada found occasional sympathizers like Prampolini (who signed the Berlin Dadaist manifesto of 1918), Savinio, De Pisis and Evola. But Italian Futurism, with its conception of total art and the way it unhinged the syntax and utilization of alternative techniques

Constructivist language. Particular examples are the works of Grosz (*Dedicated to Oskar Panizza*, 1917–18) and of the aloof Kurt Schwitters in Hanover. Together with the theorizing of Merz ("The word Merz had no meaning when I formed it ... Merz stands for freedom from any kind of fetter, for the cause of artistic creation – Freedom is not an absence of control, but rather the outcome of rigid discipline") Schwitters does not reject artistic possibility. Instead, he unhinges the expressive methods from within. His ideal became the *Merzbau*, which was his very own house, conceived as a total work of art invaded by structures made of many different materials which the artist gathered from the world about him and tailored to an aesthetic project. The consequence is a contamination combining existential fortuitousness and Constructivist rigour.

Another Dadaist group developed in Cologne out of the association between Hans Arp (who had returned from Zurich in 1919), Max Ernst and Theodor Baargeld. These three artists were joined by the "Stupid" group (Heinrich and Angelica Hoerle, Wilhelm Fick, Otto Freudlich and Franz Seiwert). Arp produced assemblages of wood painted in bright colours which make up abstract and irregular amoeba-like forms. These forms are more like "presences" than significant objects.

On the other hand, Ernst, who was influenced by De Chirico and the Berlin version of Dadaism, made unsettling photomontages with no obvious social or political overtones. These works are rather psychic movements and ancestral visions (*The Pleiades*, 1920). Ernst also used *frottage*, a technique invented by him which entails drawing or shading over the texture of another object, thus permitting

(use of different materials in the same work, assemblage) was beyond any doubt at the root of the movement's earliest ideological research.

In Paris, in January 1922, a rift developed between the movement's theorist, Tzara, and André Breton. Breton had the idea of organizing a Congress to Determine our Directives and to Defend the Modern Spirit. There was a manifest desire to get away from negative irresoluteness and lay down the foundations for a new "modern" form of creativity. Tzara was opposed to any such thing, and Breton disavowed the validity and relevance of the whole movement. At the same time, Breton and the *Littérature* group were attracted by Max Ernst's idea for an exhibition, whch was held in Paris in 1921 and presented by none other than Breton himself. Breton understood the visionary and psychoanalytical qualities of this exhibition.

In some ways the constructive figure of Ernst, with his complex cultural stratifications, replaced the propagandist and profane Picabia as the favourite of the future Surrealist

group. For Ernst indicated a possible way out of the nihilistic stagnation of Tristan Tzara's Dadaism.

Surrealism

According to a metaphor used by André Breton, Surrealism confronted Dada like "a wave which covers the previous wave." There had been lengthy preparations for the Surrealist movement, involving meetings between Louis Aragon, André Breton and Philippe Soupault. The movement itself actually bubbled up in the form of a planned manifesto, put out in 1924. The last Dadaist show in Paris had been held in 1923.

In effect, Surrealism carried on, in a far-reaching but transformed way, the nihilist liberation of the unconscious and of the automatic mechanisms of the mind that had been triggered by the Dada movement. Conversely, Surrealism was reinforced by a syncretic interest in the expressions of the past, of history, and of culture. Where art, in its Dada manifes-

tation, was conceived of as a cultural "return to zero," a reduction to first stirrings, and a desire for scandal for its own sake, so art in its Surrealist manifestation involved the elaboration of theories and works based on unusual aspects that had hitherto been peripheral to history, philosophy (alchemy and magic) and literature (with particular attention to censored and scandalous literature such as that of De Sade, Lautréamont, etc.). The artistic process thus retained in its planned automatic method, the stratifications of an inalienable, though very specific and considered, culture. It realized, in a conscious way, the themes of the unconscious, summoned up by new psychoanalytical approaches. Sigmund Freud became a cornerstone of the Surrealist process. Scandal was proposed no longer as aprioristic destruction of meaning, but rather as intellectual liberation. It was grafted on to a basically nineteenth-century tradition, according to which "startling conventional folk" led to art becoming independent of the suffocating conventions of society. Moreover, the dialogue between art and life took on a social

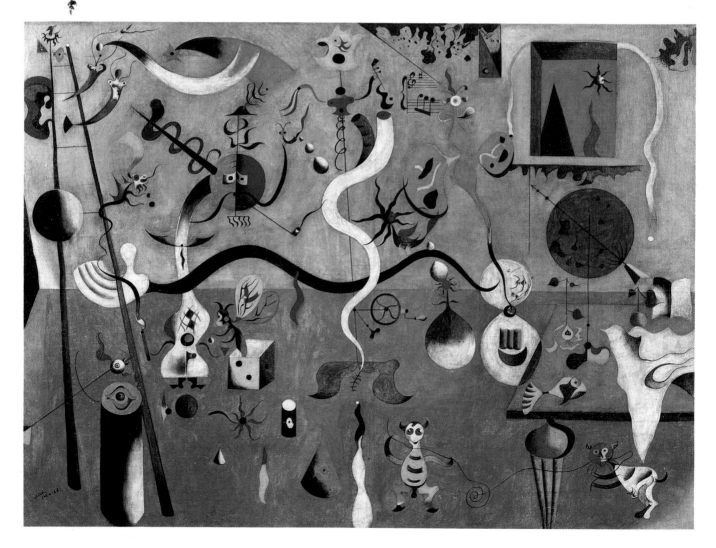

Opposite: Joan Miró,
Harlequin's Carnival
(1924–25). Albright-
Knox Art Gallery,
Buffalo.

Right: Pablo Picasso,
Bathing Women (1937).
Coll. Peggy
Guggenheim, Venice.
Mysterious figures
evolving in a kind of
artificial setting of
nature.

Below: Max Ernst,
Oedipus Rex (1922).
Coll. Hersaint, Paris. In
Miró's pictures a world of
vaguely "bimorphous"
creatures comes alive,
ordered in the artist's
terms by a "state of
hallucination" for which
he remained "not at all
responsible." In Ernst,
the collocation of
irregular elements
creates absurd visions,
rich in unconscious and
dream associations.

tinge, with political commitment of a Marxist shade. The point was indeed reached where the mouthpiece of the movement, *La révolution surréaliste*, changed its title in a second phase to *Le surréalisme au service de la révolution (Surrealism at the revolution's service)*. This publication continued until 1933.

The tendency to create a genealogy is already clearly expressed in the *First Manifesto* of 1924. Here we find serried ranks of men of letters who were unwittingly but essentially Surrealists. The list runs through Young to Swift, De Sade, Chateaubriand, Constant, Hugo, Baudelaire, Rimbaud, Poe, Mallarmé, Jarry, Nouveau, Saint-John Perse, Russell, and so on.

As far as painting is concerned (and it is important to remember that there never was a truly Surrealist pictorial "style" but rather, as Breton put it, merely "Surrealism in painting"), references to Surrealism can be detected in the visionary art of Bosch and the later works of Goya; in the dreamlike symbolic works of Redon, Moreau and Khnopff; in the mystery-paintings of the Rosicrucian painters; and in the more modern painters such as Rosseau, Chagall and Klee. Metaphysical painting of De Chirico's was nevertheless the most direct and precise figurative reference of the first Surrealist group. De Chirico's influence lay in his conscious exploration of the mysteriously associated areas of the mind, in his complete abandonment of everyday reality, and in the development of an oneiric technique that can-

Left: Yves Tanguy, Palace with Rocks of Windows, (1942). Museum of Modern Art, Paris.

Below: Paul Delvaux, The Dream (1941). Coll. Claude Spaak, Paris. Tanguy's desert landscapes are inhabited by weird objects and creatures, "mutating," projections of inner visions and intricate mental growths. Delvaux for his part plays on the contrast of his cold buildings and impassive faces with the portrayal of tense, almost morbid scenes that are mysteriously sensual.

sociation. It is also based on the omnipotence of the dream, and on the impartial effect of thinking. Once and for all it tends to destroy all the remaining psychic mechanisms and to replace them in the solution of the principal problems of life". The method indicated to achieve this "surreal" synthesis is a "pure psychic automatism with which it is proposed to express the real functioning of thought: verbally, or in writing, or in any other way."

This system of automatism is put into practice in the painting of Joan Miró (1893–1983) and André Masson (1896–1987). In 1924 Masson embarked on a series of pen drawings following the uncontrolled instinct of the psyche, creating crisscross lines, from which unexpected images emerged as projections of the subconscious. In a sort of trance, halfway between dream and reality, the artist transcribed a psychic instruction cleansed of the regulatory logic that underpins everyday actions. Miró, likewise, affirmed that his painting was "invariably produced in a state of hallucination, caused by some kind of shock, be it objective or subjective, for which I was in no way responsible." Masson's painting was strongly supported by an automatic method in which pictorial signs and gestures – memories, including those of oriental calligraphy – define or allow the emergence of figures that are sometimes monstrous and sometimes sexually suggestive. These early works were still haunted by echoes of Cubist painting.

In Miró, on the other hand, the "surreal" vocabulary was already present in the early

celled the roles of reason and traditional composition of pictorial elements. René Magritte recounts a telling anecdote to illustrate De Chirico's influence. When he saw De Chirico's *Song of Love*, he felt as if he had been struck by lightning, both aesthetically and emotionally. This emotion not only stirred him to tears it also conveyed to him a sense of enlightenment that showed him the way forward for his own painting.

It is in fact no coincidence that on the cover of the first issue of *La révolution surréaliste* (1 December 1924) the painter's face appears in two of the three group photographs, which depict – in effigy, as it were – the members of the *Bureau de recherches surréalistes* (Surrealist Research Bureau), founded in association with the publication of the review itself. These include Baron, Queneau, Naville, Breton, Vitrac, Eluard, Soupault, Desnos, Aragon, Morise and Boiffard.

In the first manifesto (1924) the meaning of the term "surrealism" was also defined. This term had already been used by Apollinaire, in his stage work *The Breasts of Tiresias* to describe "a certain psychic automatism which corresponds to the state of dreaming." The definition reads: "Surrealism is based on the idea of a higher degree of reality connected with certain forms of hitherto overlooked as-

1920s, in complex and wormlike figurations, and landscapes painted in violent colours peopled with fauna and flora that reveal a dual inspiration from Le Douanier Rousseau and from the fantastic scenes painted by Bosch. In about 1925 Miró introduced a structural simplification to this sort of Kandinsky-like bacillary and biological world rendered geometrically. With an almost total absence of real reference, this new feature involved balanced linear compositions, chromatic patches that sometimes took on remotely biomorphic aspects, and images of a cosmos subject to almost playful movements determined by the artist's automatic and instinctive impulse. In this respect the system of *frottage* – already used by Max Ernst (1891–1976) in 1921, but revived continually from 1925 onward – constituted a particular version of automatic writing that led to an unpredictability of effect, and a sort of troubling fortuitousness. The same technique, transposed to canvas, produced *grattage*. Here a method of scratching brings to light coloured surfaces superimposed on a canvas, suggested by the same chromatic areas gradually emerging from the procedure. Another automatic technique developed by Ernst involved tracing a frescoed surface on the canvas, thus creating images in which the colour is distributed in unpredictable nuances. Between 1921 and 1924 Ernst produced a series of works that was strongly influenced by the Metaphysical De Chirico, but nevertheless contributed to the creation of that atmosphere between dream and voluntary psychic confu-

sion announced by the Surrealist manifesto. In this sense *Éléphant Célebes* (1921), *Oedipus Rex* (1922) and *Two Children are Threatened by a Nightingale* (1924) represent a fundamental Surrealist dawn. Subsequently the *Petrified Forest* series, with the changing and ambiguous figures like modern sphinxes and

the series of famous *collages* Woman 100 Heads (1929) and A Week of Goodness (1934) turned him into one of the movement's most symbolic figures.

Duchamp, Man Ray, Arp and Picabia were now established from New York to Paris, and carried on with their Dadaist vision, which they would now and again modify. For Duchamp the work remained a conceptual synthesis rather than an artistic product – an initiatory and alchemical route. This notion was widely demonstrated by the critic Maurizio Calvesi in his studies of the artist. Man Ray, on the other hand, wavered between the pictorial and allusively photographic work (*Portrait of Marcel Duchamp*, 1923; *Le violon d'Ingres*, 1924; *A l'heure de l'observatoire – Les amoureux*, 1932) and "objects" that were invented, absurd, mysteriously associative, and so on (*Object to be destroyed*, 1923, *The Enigma of Isidore Ducasse*, etc.). Arp continued to produce his abstract plastic forms, accentuating their duality, and revealed the influence of Constantin Brancusi's sculpture. Picabia, however, abandoned Dadaist perturbations and moved toward an apparently traditional style of painting (the *Spanish Ballerinas*). This style was in reality subtly and profoundly outrageous. He likewise produced suggestive and complex "transparencies" in which figures are superimposed and interwoven in tangles of extremely harmonious and calibrated lines. At the end of the 1920s, with his series of large Mediterranean *Bather* paintings, Picasso also flirted with the poetics of Surrealism, but pur-

Top: Massimo Campigli, Acrobats (1926). Private collection, Milan. The group of "Italians in Paris" combined Surrealist novelties with a typically Italian return to order. Campigli's geometric hieratic silhouettes are inspired by ancient frescoes, replacing Surrealist dream visions by a disturbing presentation of the ordinary.

Right: Salvador Dali, Persisting Memory (1931). Museum of Modern Art, New York. He remained in the realm of dreams; as he said, he "tangibly conveys the very world of delirium to reality."

*Above: Alberto Savino,
Parents (1931). Private
collection, Milan.*

*Right: De Chirico,
Archeologists (1927).
Private collection.*

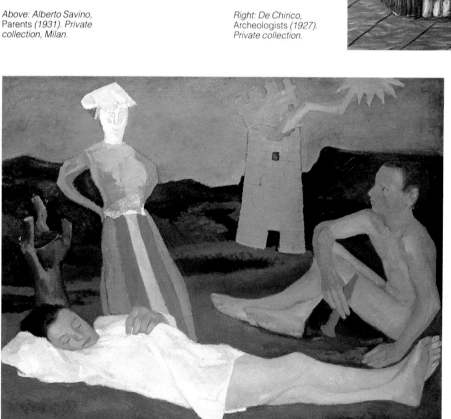

*Left: Emanuele Cavalli,
Dream (1937). Private
collection, Rome.*

*Opposite: Giuseppe
Capogrossi, The Poet of
the Tiber (1937). Private
collection, Rome. Cavalli
and Capogrossi are the
main figures in the
"School of Rome." In
Cavalli's intricately
coloured work, keen on
the esoteric, copious*

*alchemical and magic
symbols shine through.
Capogrossi, too, has a
sense of myth: his
figured scenes seem to
show a sibyline aspect
of the ordinary beyond
reality.*

sued his own personal formal research.

De Chirico had considerable influence on Yves Tanguy, Salvador Dali, Pierre Roy and René Magritte. Yves Tanguy (1900–55) painted boundless desert-like landscapes peopled with objects and rocks with alien and unnatural shapes and troubling psychic constructions, expressed by a very lucid and meticulous painting style akin to oleography. Salvador Dali (1904–1989) moved into the Surrealist fold in 1929 and took up this visionary technique, associating it with evident psychoanalytical and sexual allusions. He defined his method as paranoid-critical, by which he meant a form of controlled paranoid madness. This madness was not so much

controlled as directed toward an aesthetic end. He referred to "a spontaneous method of irrational consciousness based on the critical-cum-interpretative association of the phenomena of delirium," and the fact that "paranoid-critical activity discovers new and objective meanings in the irrational; it tangibly shifts the world of delirium to the level of reality." His extravagant and histrionic way of working even attracted the attentions of Freud, and remained one of the most symbolic and conspicuous expressions of Surrealism. René Magritte (1898–1967) started from the principle of relieving the Metaphysical painting of De Chirico of its context and then acting on a continuous and planned dephasing between dream and experience, artistic representation and reality. He created simple scenes which appear absurd because some slight detail is

out of place, thus producing a spark of mystery (*The Human Condition I*, 1933). Alternatively he created unsettling, dreamlike images (*The Spy*, 1928, and the cover of the review *Minotaure* in 1937).

The Surrealist movement was co-ordinated by André Breton with an ideological fanaticism that gave rise to much controversy, as well as various defections from the group. As a movement, Surrealism went through different phases. The *Second Manifesto* of 1929 drew up the Marxist-style political position, and caused Artaud, Soupault and Desnos to keep their distance. The "central committee" was made up of Breton, Aragon, Eluard and Unik. Other splits occurred during the 1930s, the fundamental one being between Breton and Aragon. Before and during the Second World War many members of the movement (includ-

ing Breton, Dali, Duchamp, Miró, Tanguy and Masson) emigrated to the United States. There they acted as a veritable anvil of comparison for young American artists. After the war the movement lived on around the figure of Breton, but Breton's revolutionary theses had been absorbed by Western culture, and he was overtaken by the momentum of the new postwar ideologies.

The ideological epicenter of the Surrealist spirit was undoubtedly Paris. Many foreign artists, in addition to those already mentioned, took part in the movement. We should mention here the Romanian Victor Brauner (1903–66), whose paintings are complicated by alchemical and esoteric allegories; the Cuban Wilfredo Lam (1902–82), with his teeming totemic and primitive scenes influenced by a Picassoesque vocabulary; the Spaniard Oscar Doming-

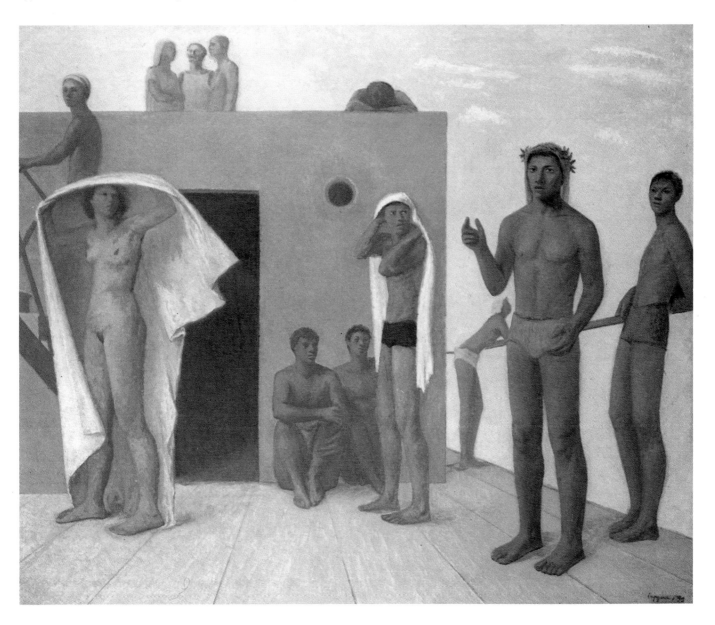

uez; the German Wols (Wolfgang Schulze, 1913–51), whose intricate works, with their seething symbols, express the psyche with mysterious clarity; the Austrian Wolfgang Paalen (1905–59); the Chilean Roberto Sebastian Matta Echaurren; Henry Moore (1898–1986) from England, who, in his period of closest contact with Surrealism, co-ordinated in his works both Picasso-like forms and constructional monumentality, and his compatriot Graham Sutherland (1903–80); from Switzerland Méret Oppenheim, creator of illogical and impossible objects (like her famous *Object*, a fur-covered cup, saucer and spoon) and Alberto Giacometti. In the Surrealist period between the late 1920s and the early 1930s, Giacometti was strongly influenced by the settings of the Metaphysical De Chirico and the dualistic forms of Tanguy. He was in contact and exhibited with the "Italians in Paris" group, which included Gino Severini, Giorgio De Chirico, Mario Tozzi, Massimo Campigli, Filippo De Pisis, Alberto Savinio and Renato Paresce.

The Surrealist cry is more explicit in Savinio, De Chirico, Tozzi and Paresce. In Campigli and Severini we find a predominantly archeological quality, at once stylized and troubled. In De Pisis we find a poetic interpretation of Impressionism. With an early Metaphysical and Dadaist experience behind him, De Pisis is a subtle and light-hearted poet who focuses on a state of mind or an atmosphere, sometimes veiled in eroticism, sometimes in melancholy. The motionless, Classical figures in the works produced by Campigli in the 1920s gave way to geometrically inspired compositions evoking the frescoes of ancient civilizations. Tozzi, and the less forceful Paresce, moved more or less in this direction, although their work was complicated by late Metaphysical and late Surrealist elements. In the early 1920s Severini painted a series of masks inspired by the *commedia dell'arte*, in which the playful charm of the theme contrasts with a very tight geometric and proportional plan.

Of the Italians, Savinio was possibly the most sensitive to the Surrealist climate. He interpreted it in a fairly personal way, translating the literary world, arising from contacts with Apollinaire and the pre-war French milieu, into the many-faceted fantasies of pictures. De Chirico's relationship with Surrealism was a very difficult one. He moved to Paris in 1924, and was chosen by Breton and his colleagues to be an illustrious precursor of the movement. Then he was bitterly attacked by these same people for his latest works. For De Chirico simply carried on with his Metaphysical poetics, tempering his work with those elements of Classicism and myth which, in Italy, had distinguished the profound and realistic European inspiration from the decline of the avant-garde. Masterpieces from this Parisian period (1924–29) are the *Archeologist* series. These are characters in whom the sediment of memory is stratified, like so many cities in ruins. Other major works include the large and somehow Picasso-like canvases depicting "neo-Classical" figures (*Spirit of Domination*).

In Italy a highly personalized interpretation of the Surrealist climate was presented by the Roman School, even though it was tempered by that vein of distinctly Italian Classicism that was symbolically expressed by the "magic realism" of the writer Massimo Bontempelli. In Rome, at the end of the 1920s, two parallel artistic groupings were jockeying for position. One was described by Longhi in 1929 as the "Via Cavour School," and was made up of Scipione, Mafai and Antonietta Raphaël. The other was defined by Waldemar George in 1933 as the "School of Rome," and consisted of Corrado Cagli, Giuseppe Capogrossi, and Emanuele Cavalli. The aptly named "School of Rome" soon attracted all the younger artistic figures in the city, although these artists retained their own distinctly individual vision.

None of the Expressionist or Baroque elements of the "Via Cavour School" cropped up among the "School of Rome" painters, who were oriented toward an intellectualized and metaphysial research into the "tonal" values of painting.

Fausto Pirandello was an aloof and extraordinary figure. He was a companion of Capogrossi and Cavalli at the Carena school, and then during their stays in Paris in the 1920s. The style of his painting, with areas of paint applied with the palette knife, derived from a sort of Cubism, and above all from Braque. The works themselves were distinguished by a deeply dramatic, Expressionist feeling, but Pirandello also took part in the "realistic" Surrealism of the "Italians in Paris" group, which he frequented. His vision differed somewhat from the Apollonian and polished concepts of his friends. Pirandello's paintings are jolted by wild, staring figures, and animated by the use of rough and elaborate materials, yet they reveal a similar quest for scenes suspended between myth and reality.

Emanuele Cavalli was the ideologue of the group, and a strange character as well. After being initiated into an esoteric sect, he wanted to translate its universalist principles on to canvas. In the geometry that structures his pictures, such as *Dream*, we often find shadowy alchemical and mysterious symbolism. There is a perfect transposition of the climate of the literature of Bontempelli – a magical realism that uncovers the surreal and unsettling aspects concealed in the arcane rhythms of existence. Corrado Cagli (1910–76) was Bontempelli's nephew. From his uncle he derived an innate sense of myth. Cagli was close to Cavalli and Capogrossi in the early 1930s, and also interpreted the mythical and esoteric version of tonalism.

Giuseppe Capogrossi (1900–72) used tight geometric devices to construct his works. Their chalky, almost fresco-like colours were influenced by both Campigli and by a fifteenth-century manner reminiscent of Piero della Francesca. In his *Poet in the Tiber* he combines the flat but vibrant tonalist areas with the everyday rituals of athletes by the Tiber, thus creating an enchanted, rarefied atmosphere.

Balthus (Balthasar Klossowski de Rola, a Frenchman of Polish origin born in 1908) demonstrated close ties with the painting of the "School of Rome" group. He is one of the major "isolated" painters of the century. Like Cavalli and Capogrossi, he adored ancient painting, with Piero della Francesca in pride of place. His friendship with and sympathy for the Surrealists is well known (his first one-man exhibition at the Pierre Gallery bore a pronounced Surrealist stamp). But apart from rare examples (such as *The Mediterranean Cat*, 1949) it is difficult to associate his pictures with those of the other Surrealist painters. The air of penetrating ambiguity that dominates his settings, which are charged with allusions and often with eroticism, makes him unique, even from the viewpoint of the various forms of European "realism." In the sense of expectation and icy anguish, supreme indifference and intense morbidity, his painting reached its first great moment of maturity in 1933 with *The Street*. In the elaboration of Classical, geometrically constructed themes (figures of young men in interiors, and almost Poussin-like landscapes) he achieves a powerful and monumental form of poetry, at once aloof and aristocratic.

Balthus, Patience (1954–55). Private collection. His mysterious view of reality puts him among Parisian Surrealists, although he was not one of them even if he exhibited with them. This authentic master is an isolated figure in modern painting, favouring ambiguous and upsetting themes, with an erotic tinge even more veiled and enigmatic than that of Delvaux.

Expressionism

In the closing years of the nineteenth century the bright and optimistic interpretation of the world in its outward appearance, as presented by Impressionism, was opposed, in particular, by the works of Van Gogh, Munch and Ensor. Each of these artists rummaged in the depths of his own personality and psyche, seeking out his own dramas, passions, traumas and fears. Not content with perceptible appearances, they were keen to make fast *états d'âme* or states of mind, internal portraits, and landscapes animated by a visionary frenzy that translated external reality into psychological reality. The main features of a pronouncedly expressionistic art were distortion and a subjective application of colour. It is no coincidence that this form of art was elaborated by artists who were affected by profoundly neurotic pathological disorders. Munch, in particular, started from the spiritualistic liberation of the form and colour of the Nabis and managed to construct his pictures using linear rhythms that are troubling and dramatically syncopated, with a clash of dark or violent colours. His subjects also focused on morbid, problematic states of mind, of which he had had personal experience.

In James Ensor (1860–1949), on the other hand, we find two predominant and contrasting themes: a constant sense of death and a macabre brand of irony, characteristic of the latter half of the 1880s and expressed in scenes of surreal masks. These are presented in a spirit of obsessive metaphor as depictions of human psychology that has been reduced to the grotesque. In *The Entry of Christ into Brussels* (1888) Ensor represents the fall of contemporary man as if on a great "Medieval Float of the Triumph of Death." In a swirl of deformed figures, turned into caricatures by the vices to which they fall prey, we see the skeletal figure of Death moving confusedly about in the throng, like the figure of Christ.

At the turn of the century Ensor's painting tended toward formalist options, with vividly coloured still lifes and landscapes seething with bright hues. Even so, his work was still an essential point of reference for the development of the Expressionist sensibility.

In France, in 1905, a group of young artists exhibited their work at the Salon. Because of the violent colours used in their pictures they were called *Fauves* ("Wild beasts"). These *Fauves*, together with a parallel group that had formed in Germany, were the two major European facets of Expressionist vision. It was, however, in Germany that Expressionism was

best represented, by the group called *Die Brücke* (The Bridge), which was formed in Dresden in 1905 by four painters: Ernst Ludwig Kirchner, Fritz Bleyl, Erich Heckel and Karl Schmidt-Rottluff. With the exception of Heckel they were students of architecture, and all extremely young – between twenty-one and twenty-five. In 1906 *Die Brücke* drew up a *Programme*, which was transcribed on to a woodcut by Kirchner. In terms that were existential rather than aesthetic, the *Programme* explained the guiding principles of the new group: "Having faith in progress, in a new generation of creative people and people who enjoy art, we are mobilizing all young people. And as young people who hold the key to the future we want to gain for ourselves a freedom of action and a freedom to live against those old forces which are so difficult to eradicate. With us, anyone can turn what drives him to create into something immediate and meaningful."

The desire to create, without any cultural limitations, something "immediate and meaningful" pushed young artists to seek inspiration from primitive art (and from African art in particular). It also encouraged them to combine Cézanne with Munch, to spread their colours violently on their canvases, sometimes leaving them there in a sketchlike state to retain intact the imprint of an aggressive and deep-seated creativity. This desire also had them deforming and distorting faces, bodies

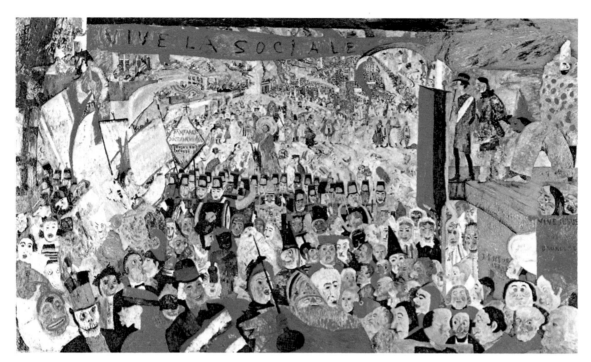

Left: James Ensor, Christ entering Brussels *(1888). Musée Royal des Beaux Arts, Antwerp.*

Below: Emil Nolde, Golden Calf *(1910). Nolde Foundation, Seebüll.*

Opposite: Max Pechstein, African Sculptures *(1919). Private collection. German Expressionism (especially of Die Brücke, formed in 1905 in Dresden by Kirchner, Bleyl, Heckel and Schmidt-Rottluff) was much influenced by stylized primitive and African art. It violently distorts colours, and above all forms, twisted to conform with dramatic expression of complex mental states.*

and landscapes, following the demands of an inner instinct that was often obscure and dramatic.

Erich Heckel (1883–1970) was the principal organizer of the group. Possessed of an almost mystical enthusiasm for the life he

shared with his friends, he was a mischievous member of *Die Brücke* until the group broke up in 1913. He often used the woodcut as a means of expression because of the special effects this medium allowed: the simplification of forms into pure, dynamic outlines; the vio-

lent and uncontrolled mark that the gouge makes in the wood when cutting into it; the vibrant effect of this in the printing process; the way a work that can be reproduced has greater social relevance. Heckel's figures, with their angular and acute geometry, help to create anxious settings in which violent colours seem to put the objects out of proportion. They are in fact transformed into autonomous entities with their own singular presence.

Ernst Ludwig Kirchner (1880–1938) was perhaps the most significant character in this early Expressionist group. After an initial period in which he was influenced by Van Gogh, he painted pictures (*Marcella*, 1911, *Nude on a Blue Background*, 1911) in which the female figure is contorted in geometric positions, showing a dramatic existential quality, which is enhanced and flaunted by the use of dissonant colour schemes. In 1911 Kirchner moved to Berlin, where he depicted the dissolute world of cabarets and took a feverishly active part in the city's life until he had a mental breakdown in 1915. In 1917 he moved to Davos in Switzerland, where, with a spiritual fervour born of desperation, he depicted the local mountain landscapes.

The painting of Karl Schmidt-Rottluff (1884–1976) is based on a profound internalization of things. This is conveyed to canvas with effects more akin to transfiguration than to distortion. The violent chromatic language shared by his friends was shattered by Schmidt-Rottluff, as in a kaleidoscope. A good example of this is his *Girl in the Mirror* (1915), which was clearly inspired by primitive African sculpture.

In 1906 Emil Nolde (Emil Hausen, 1867–1956) exhibited his work in the Arnold Gallery

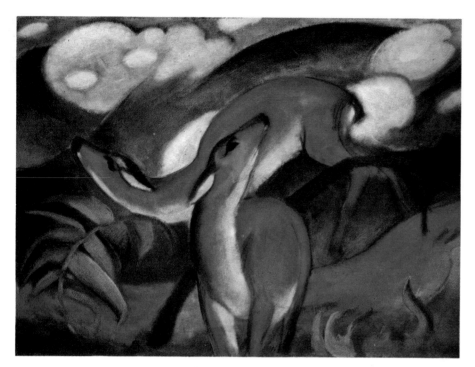

morbid, dramatic spirit of his fellow travellers. "I would like to give expression to my desire for occurrences that bring happiness," he said, and indeed his painting shows a pronounced emphasis on chromatic vibrations – typical of the *Fauves* – and on distortions that are somewhat less emphatic than those of his colleagues. It also has a vitally expressive density, shown in his *Portrait in Red* (1909).

Otto Müller (1874–1930) joined the group in 1910, on the occasion of the *Neue Sezession* in Berlin. This was an exhibition for those artists who had been refused by the *Sezession*, in which *Die Brücke* took part. In a formal sense his painting adopted the primitive vocabulary of the group, translating it in calm, light tones into bucolic scenes of bathers and nude figures in a landscape. Other artists took part in the group's activities: Franz Nolken, Bohunil Kubista from Prague, Kuno Amiet from Switzerland, and the Finn Axel Gallén Kallola. They did not, however, greatly affect its orientation.

Another artistic movement called *Der Blaue Reiter* (The Blue Horseman), after the almanac published in 1912 under this same title, emerged in Munich in 1911. It proposed

in Dresden, and the group of painters was quite impressed by the "tempests of colour" in his pictures. On that occasion Schmidt-Rottluff wrote a letter to Nolde on behalf of *Die Brücke*: "I wish to inform you straight away that our group . . . would be most honoured to welcome you as a member. . . . One of the aspirations of *Die Brücke* is to attract to it all the revolutionary elements currently in ferment. This is what the name *Die Brücke* is intended to express. What is more, the group organizes various travelling shows throughout Germany, and deals with all practical matters involved. . . . Well, esteemed Mr. Nolde, think what you will, but in sending you this invitation we are keen to pay our tribute to your tempests of colour." Nolde accepted the invitation, and was part of the group until 1908. His canvases evoke a world dominated by primitive passions, which monstrously distort the faces of his figures. Colours overflow beyond the outlines, intensifying the limbs with heightened colouring. A good example is the *Dance Around the Golden Calf* (1910). In his landscapes, too, the colours merge into one another, creating a suggestive atmosphere. Here he differed from the other members of *Die Brücke* in his almost total absence of geometric orientation or compositional rigidity. He also differed by presenting a continuous and involving flow of colour. In 1906 Max Pechstein (1881–1955) joined the group, but in 1907 he went off to Rome on a student scholarship from the academy in Dresden. In 1908 he also visited Paris. Back in Germany he presented a more "international" version of Expressionism, one that was sensitive to the *Fauve* milieu in France. Pechstein's version was also essentially detached from the

Above: Franz Marc, Red Deer (1912). Pinakothek, Munich.

Left: Alexej von Jawlensky, Peonies (1909). Von der Heydt Museum, Wuppertal. Jawlensky and Marc, with Kandinsky and Macke, were the main figures of the Blaue Reiter, formed in 1911. Expressive rendering of spirituality (Kandinsky published The Spiritual in Art in 1911) typical of the group was likewise found in Klee, Feininger, Kubin, Campendonk and Münter. Expressionist distortion of form and colour is linked with a desire for transcendence, a harmony between an ever-changing world and the artist's spirit.

In Austria the awareness of the European crisis on the eve of the First World War had far-reaching reverberations for the *Sezessionist* style. The misrepresentation of this style led to another formulation of the Expressionist ethos. Schiele and Kokoschka, both pupils of Klimt, dramatically accentuated the existential content of their art. Egon Schiele (1890–1918) permeated the extremely lacerated contusions of his painting with designs of highly refined formal elegance (*Portrait of the Painter Paris von Gutersloh*, 1918). Oskar Kokoschka (1886–1980) portrayed faces and bodies with a style full of poignancy and tormented passion.

The development of Richard Gerstl (1883–1908) was more alien to the *Sezessionist* view of culture. Gerstl was instinctively Expressionist in the swift and powerful construction of his pictures, with rich and tortured brushstrokes.

In Italy the sole figure of any major importance was Lorenzo Viani (1882–1936), author of tragic, synthetic scenes often redolent of the lunatic asylum. Viani was extraordinarily precocious as a result of his journeys to Paris in 1905–06 and again in 1908–09. On these trips he was influenced by the new *Fauve* painting.

Between the wars there were at least three interesting continuations of the Expressionist tradition in Flanders, France and Italy. In Belgium the salient figures were Frits van den Berghe (1883–1939) and Gustave de Smet (1877–1943), both of whom were inspired by a *Die Brücke*-type Expressionism and by Cubism. The more formalist distortions of de Smet take on a different psychoanalytical and symbolic density in the works of Van Den Berghe. Constant Permeke (1886–1952), one of the greatest Belgian artists of the century, was attracted sometimes by facial misrepresentation and sometimes by a monumentalism reminiscent of the "return to order." This latter tendency has often caused him to be associated with Sironi.

In France from the 1910s onward a variety of independent-minded figures came to the fore, stimulating a period of special artistic fervour which was summed up by the label "School of Paris." Only some of these artists can be properly defined as Expressionists. We should nevertheless mention two of the most symbolic figures in this Parisian movement: Modigliani and Chagall.

Amedeo Modigliani (1884–1920), of Italian origin, used his unruly Bohemian life to ignite the stylistic inspirations that he derived from

various routes for Expressionism, in order to negate the positivist attitude of Impressionism. Vassily Kandinsky and Franz Marc freed traditional figuration from its conventions and worked (in the footsteps of the experiments made by the Nabis) not only on an anti-naturalist idealization of colour but also on the free composition of forms. The *Blaue Reiter* group was part and parcel of various and complex currents of thought which, from the end of the nineteenth century onward, had spread widely throughout the Nordic countries. These currents ranged from anthroposophy to mysticism to idealist philosophy to theories of colour – these latter being dealt with in Kandinsky's book *On the Spiritual in Art* (1911). The group twisted real appearances in a subjective way, not by dramatic distortion but rather by cleansing them, and charging them with mystic significance and consonance. This route was to open the way for Kandinsky's abstract experimentation, but not before he had left memorable reminders of the impassioned and enflamed transformations that characterized his landscapes and figures. In Franz Marc (1880–1916) this vision led to a state of panic and a form of internalized chromatic poetry. The subjects of this vision were almost invariably animals and landscapes. August Macke (1887–1914) was another member of the group. This extremely sensitive and erudite painter was open to all manner of influences, but died young during the First World War.

Top: Egon Schiele, Self-portrait *(1910). Drawing Cabinet, Albertina, Vienna.*

Above: Oskar Kokoschka, Bride of the Wind *(1914). Kunsthalle, Basel. Poetic expressionism clearly influenced Schiele and Kokoschka (both pupils of Klimt), which does not exclude a geometrizing aspect inherited from the formalism of the Vienna Sezession.*

Left: Constant Permeke, The Betrothed (1923). Museum of Modern Art, Brussels.

Opposite below: Frits van den Berghe, Sunday (1923). Museum of Modern Art, Brussels. Permeke wavers between monumental naturalism inspired by Picasso and an expressive tension influenced by Die Brücke. This shows even more strongly in van den Berghe. A deep uneasiness emanates from his canvases, where mysterious links are forged between the different figures: here, on the contrary, disturbing glances, an aspect of simultaneous drama and caricature in the silhouettes, deny the evocation of a peaceful summer's day.

fifteenth-century Sienese painting and from primitive Negro art. Other sources of inspiration included the synthetic sculpture of Brancusi and the linear inflections of Art Nouveau.

Modigliani was an extraordinarily poetic portrait painter. His faces are given violent, sensual complexions in which the clear, soft eyes present an intensely lyrical contrast. His nudes, lithely arranged within the picture space, have a Matisse-like voluptuousness, accentuated by an unbridled sensual passion. It is precisely in this expressive immediacy that the originality of Modigliani's art lies.

The painting of Marc Chagall (1887–1985) is extremely free in its contact with the various avant-garde artistic movements in Europe, from Cubism to Russian Constructivism to Surrealism. Chagall invariably retains the inde-

pendent poetic expression of an archetypal inner world, depicted with a freedom and grace of composition that changes with each work. He introduces elements from his own memory and from dreams, as well as from Hebrew and Russian culture.

For other leading figures in the "School of Paris" the individualistic and expressive style and an urgency that gives the canvas an

internalized, searing, and allusion-rich reality, were somewhat more pressing than the rationalization of artistic movements. Their painting can be coherently associated with the Expressionist sensibility.

Chaïm Soutine (1894–1943) represents a hollow, distressed mankind, as in his *Choirboy* (1928). His works depict dead and bleeding animals as constant references to inner torment. Julius Pascin (J. Pincas, 1885–1930) unravels his figures in a mood of languor that is physical, sad and revealing. Moïse Kisling (1891–1953) evolves a dense and sensual style of painting, laden with pulsating life and glowing colours. Georges Rouault (1871–1958) depicts with deep religiosity marginal characters from life, and biblical scenes. Maurice Utrillo (1883–1955) presents us with white, enchanted views of a Paris that is intimate and unassuming, with graceful and slightly hesitant outlines.

This Parisian pictorial trend was the basis for the elaboration of a version of Expressionism that was actually less dramatic and more elegiac. We sense it in the painters belonging to the Via Cavour School, a parallel

Above: Chaïm Soutine, Still-life with Turkey (1926). M. P. Levy collection, Bréviandes near Troyes. Between the wars, many European artists were Expressionists but moved away from the stylistic matrix of the original German movement. In France, the School of Paris emerged, a rich eclectic intellectual ferment from which the tormented figure of Soutine stands out. Indifferent to Primitivist formalism and avant-garde linguistic constraints alike, his impetuous and instinctive touch lacerated the model, whipping it under the spasmodic urge of expression, thus turning his convulsive still lifes into metaphors of deep existential suffering.

group with the more intellectual and neo-Surrealist fraternity of Corrado Cagli, Emanuele Cavalli and Giuseppe Capogrossi. The association between Scipione (Gino Bonichi, 1904–33), Mario Mafai (1902–65), Marino Mazzacurati (1908–69) and Antonietta Raphaël was begun in the late 1920s. Raphaël was of Russian origin and carried with her a comprehensive Hebrew-oriented cultural store, which she enriched with stays in London and Paris. Here she became acquainted with the work of Jacob Epstein, Chagall and Soutine. She undoubtedly had a crucial influence on the artistic training of Scipione and Mafai. The elements of Primitivism, Fantastic Expressionism and Surrealism, together with

Below: Jules Pascin, Nude with Red Sandals (1927). Oscar Ghez collection, Geneva. In Pascin, as in Kisling, a subtle formal elegance tempers the Expressionist drama, while preserving the model's languid melancholy.

the Bohemian intellectual life they shared, all helped considerably to bring the painting of Scipione and Mafai to full maturity by the beginning of the 1930s. Antonietta Raphaël was also a very talented sculptress.

Scipione, however, was the central character in the Via Cavour School. The period of his mature work did not begin until 1929, the year he produced his *Cardinal Decano*, a Baroque and Expressionist vision with magical and morbid implications. *Cardinal Decano* calls to mind both Goya and El Greco, as well as a

Right: Scipione, Cardinal Decano (1929). Museo Comunale di Arte Moderna, Rome. The central figure in the Roman group of Via Cavour, the artist has worked in a baroquizing manner, producing fantastic and visionary paintings full of disturbing and morbid poetry peculiar to him.

shared with Scipione, although more substantial, solid and realistic, Mafai was to pursue a more measured and "tonal" use of colour from 1932 onward. He was certainly not unaware of the theoretical and stylistic victories chalked up by the group consisting of Corrado Cagli, Giuseppe Capogrossi and Emanuele Cavalli.

In the second half of the 1930s, based on the artistic experience of past masters such as Scipione, Mafai and Fausto Pirandello, a tendency developed that was at once Expressionist and crudely realistic. After an initial tonal period closely associated with the examples of Cavalli and Capogrossi, Alberto Ziveri attained a Baroque-oriented, Caravaggesque style, distinguished by a harsh sensu-

ality. He shared this quality with Virgilio Guzzi. After a *Novecento* début, Guzzi moved his pictorial material in a more lyrical direction, but one that was still expressive and realist. Also taking part in this movement were Renato Guttoso (1912–87) and Fazzini, a contemporary sculptor with an extraordinary power of expression. Guttoso grafted an analysis of the post-Cubist form on to the principles of typically Roman expressive realism. A good example of this is his *Crucifixion* (1941), whose crude quality of depiction stirred up much criticism and controversy when it was shown at the Bergamo exhibition, where it won first prize. Another example is his *Portrait of Mimise* (1940), whose warm colours and thickly ap-

Above: Amedeo Modigliani, Nude Reclining with Open Arms *(1917). Mattioli collection, Milan.*

Right: Marc Chagall, Jew in Green *(1914). Private collection, Geneva. Neither Modigliani nor Chagall are truly Expressionist; each remains separate from the many tendencies of the nineteenth century. Modigliani, "cursed" and refined painter, in his short life became a portrayer of strong sensuality. His nudes and portraits, supple in line, recall the curves of*

Art Nouveau, the gracefulness of fifteenth-century Sienese painters and the formal simplifications common to Primitive sculpture and the works of Brancusi. Chagall's complex oeuvre (alive to Cubist and Futurist innovations, popular and fantastic art) is on the contrary inspired by allegorical motifs with a Jewish flavour, and by a very free and "surreal" sense of composition.

literary culture ranging from Gongora to Lautréamont and Surrealism. In his still lifes also, such as *Giant Squid*, the liquid, reddish painting, with its unsettling glowing and gleaming, is dominated by Scipione's fantastic vision.

"On the very borderline of that obscure and disturbing area," wrote Roberto Longhi in 1929, "where a decaying Impressionism turns into Expressionist hallucination, into cabal and magic, we find . . . the troubled hamlets and the bacillary virulence of Mafai, whose overexcited temperament . . . might well make him an Italian Raoul Dufy." After this period of Expressionism,

plied pictorial impasto owe a great deal to the spirit then reigning in Rome. Other young artists who would follow different paths immediately after the war include Leoncillo (Leoncillo Leonardi, whose Baroque-inspired and Expressionist busts of the *Seasons* deserve a mention) and Afro (Afro Basaldella), who is associated with the lively tonalism of Cagli.

In the early 1930s Turin was also the site of a vaguely Expressionist tendency, in opposition to the monumental *Novecento* establishment in such groups as the *Gruppo dei Sei* (Group of Six), made up of Carlo Levi, Gigi Chessa, Francesco Menzio, Enrico Paulucci, Jessie Boswell and Nicola Galante.

These young painters were part and parcel of a sophisticated cultural milieu whose members included, among others, the art critic Lionello Venturi, the collector and intellectual Riccardo Gualino and the painter Felice Casorati (1886–1963), a central figure in the Turin art scene.

The first group show was held in 1929. Although it was rather disparate, all the work of the Turin artists was directed against an art that was increasingly proclaiming its "Italianness" (*italianità*) and toward an analysis of French post-Impressionism, or a polemical but delicate form of Expressionism, as in the

Mario Mafai, Self-portrait *(1929). Private collection, Padua. His expressive and visionary forces are close to those of Scipione. At first influenced by the School of Paris, he finally turned to a quiet realism.*

portrait of Giansiro Ferrata (1931–32) by Carlo Levi (1902–75), or in his energetic still lifes recalling the tortured visions of a painter like Soutine.

The Bauhaus. The various European avant-garde trends found a sort of ideal merger and pragmatic application of their ideologies in the Bauhaus School, founded in 1919 and based on the ideas of the Werkbund. Using the parallel study of modern technologies and the aesthetic, formal, psychological and practical qualities of everyday materials and objects, the Bauhaus intended to create artefacts that would unite the old antitheses between arts and crafts and between formal beauty and industrial product. The Bauhaus School of Art moved from Weimar to Dessau in 1925, and was directed from 1928 to 1932 by Hannes Meyer. From 1932 to 1933 (when it was suppressed by the Nazis) the director was Mies van der Rohe. The interdisciplinary structure of the Bauhaus was extraordinarily comprehensive (such figures as Lyonel Feininger, Oskar Schlemmer, Albers, Marcel Breuer, Paul Klee and others taught there) and instruction in the theories of aesthetics and representation alternated with the technical disciplines, theater, cinema and architecture. The ideal result was artists-cum-artisans who were conscious of the social and moral nature of production, and destined to translate into art the everyday nature of contemporary life.

In the Bauhaus there was an emphasis on theories associated with abstraction and the composition of geometric forms, but there was at the same time a line of thought linked to formal syntheticism and to a type of rarefied modern representationalism, as in the work of Feininger or in Schlemmer's "metaphysical" depictions. For all this, the orientation of the Bauhaus was principally animated by figures such as Paul Klee, Moholy-Nagy and Kandinsky, with their extraordinary didactic passion and abstractive ideological clarity.

Paul Klee, who taught at the Bauhaus from 1921 to 1931, evolved an artistic expression that combined a dizzy inner exploration – from which emerge immediate impulses with no inhibitory screens – with severe formal rationalization. This rational orientation involved the passionate study of compositional and formal rules, as well as optical systems. In the free composition of signs and colours we find natural dream elements coming to the surface of consciousness. These elements are transfigured after a long period of immersion in the psyche, which charges them with allusive and poetic meanings.

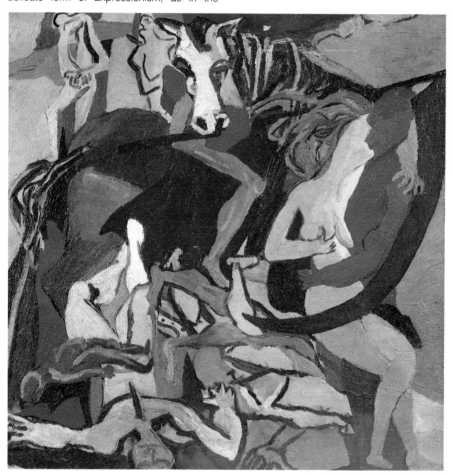

Left: Renato Guttoso, Triumph of Death *(1943). National Museum of Modern Art, Rome. His expressionism, developed by contact with Roman artists (above all Cagli and Mafai) is evident here. "Picassian" distortions and violent colour stress the allegoric and polemic power of this canvas, which evokes the massacres of war.*

Abstract and Informal art

The poetics of abstract art in the historical avant-garde

The term "abstract art" (sometimes also called "abstraction") was coined and is still used today to designate those pictorial phenomena which exclude the imitative principle of figurative art or figuration, by overcoming it with methods of plastic construction.

We should recognize a historical relationship between the birth of modern abstract art and the new attention being focused on the material aspects of the work that is identifiable in the method of art criticism, between the end of the nineteenth century and the beginning of this century. This applies also and in particular to criticism of ancient art. Points of departure here are the "pure-visibilism" of Alois Riegl (1858–1905) and the formalism of Roberto Longhi (1890–1970). The issue of what is being represented is relegated to a position of secondary importance. For this modern historiography is keen to concern itself almost exclusively with the techniques of representation. It maintains that the force of a depiction or painting (i.e. its value) depends on the formal events that the artist has been able to construct (that is, equilibrium, harmony, linear structure, chromatic counterpoint), by reinterpreting the linguistic space of the work in accordance with his own sensibility and his own capability.

A relationship of this sort seems particularly useful in helping to explain the attitude of Piet Mondrian (1872–1944), where he states his desire to achieve with "neo plasticism" an "art of pure relations." To use his own explanation of this notion, he refers to a form of painting that expresses nothing other than those formal relations that naturalism has "veiled" beneath objects for centuries. Mondrian's paintings between 1920 and 1940 present a radical reduction of the plastic structure to the fundamental elements of visual perception: the vertical line, the horizontal line, the three primary colours – red, yellow, blue – enclosed in rectangular or square areas, plus white and black used respectively as the background of the canvas and the ensemble of lines. These elementary features allude directly to the global form of the representational space (for example, the linear layout, the right-angled edges of the picture, the base and the height). They also allude metaphorically to the structural coordinates of human experience – the horizontal plane of the ground (or of the axis formed by the eyes) and the vertical line of the upright position. These coordinates are in turn rich in symbolic connotations. One merely has to think of the infinite references of the above/below construction in a clef that is ethical, religious, logical, or pragmatic. The geometric space of the neo-plastic paintings is not, however, mathematically calculable. It is dominated by an extraordinary equilibrium, obtained by means of balancing areas that are not commensurable with each other. In these areas the harmonic rigour of values, which have a unique and perfect relationship with themselves and with everything, is "open," despite this. It seems to extend to external areas on the sides of the squared surface. The aesthetic mechanism that governs this manner of painting is architectural in type. It is not based on the presence of a narrative or descriptive message, but on its own structural and self-created economy, on its own interior constructive harmony.

In order to get an integral understanding of the way abstract art managed to upset ends and means, we can compare the decidedly anti-figurative achievement of Mondrian with the (at least apparently) moderate position of Henri Matisse (1869–1954). In the French painter the phantasm of the real object never disappears altogether. But in the pictures of his most successful phase, like *Red Studio* (1911), *The Blue Window* (1912), *French Window at Collioure* (1914), *The Yellow Curtain* (1914–15) and *The Piano Lesson* (1916–17), reality does take on a spectral guise. Reality acts simply as a "term of comparison," giving greater salience to the quality and independence of the pictorial language. Here this is principally a manifestation of the colour and significance expressed by the chromatic relations, in accordance with the principle whereby "the tones must be forces within the picture."

The contribution made by Kasimir Malevich (1878–1935) was considerably more radical.

Vassily Kandinsky, Improvisation No. 31 *(1913). J. Müller Collection, Solothurn.*

When this great Russian painter defined his own art as "non-objective," his intention was to get rid of not only all relationships between the work and the objects of reality, but in effect all relationships between the surface of the picture (understood as something absolutely concrete) and any conceivable feature that could be referred to human experience outside the artistic sphere. We thus find him declaring (paradoxically) that with *suprematism* he had attained the authentic "realism of painting," at the precise moment at which he was isolating the artistic *res* and making of it the manifestation of a separate world, equipped with its own laws.

Unlike Cubism, which was still concerned with external reality, but yet applied to it a new analytical kind of eye, non-objective painting actually does away with the Renaissance precept of the transparency of the picture, "which I consider to be an open window through which I look at what is to be painted" (Leon Battista Alberti, 1435.) It also substitutes for this precept a dense and opaque conception of the surface itself, as a result of which what "is seen" is always and exclusively the surface itself, handled in accordance with various patterns of intervention. Its language then contains its concrete "texture," the spatial proportions, the equilibria, the assonances and dissonances, the chromatic relations. . . . and so on. The model to which this conception refers is music, where a system of scansions and repetitions, returns and intervals is sufficient to create the aesthetic message, with absolutely no imitative mechanism involved. The aesthetic message is a precise content that is emotional, psychological, symbolic and philosophical.

The painting of Vassily Kandinsky (1866–1944) in the period 1910–14 also refers to the idea of musical texts in an extremely direct and explicit way. The position of *Der Blaue Reiter* (The Blue Horseman) group, in which he was the driving force, was in fact based on a theory of colour as an element capable in itself of stirring up lively feelings ("inner resonances") in anyone confronted by the work. This theory came directly from Goethe's *Farbenlehre* (Theory of Colour). It introduces complex chromatic emotions to a view of painting as language. In his study *Über das Geistige in der Kunst* (On the Spiritual in Art, 1912), once he has established the psychological values of the individual fundamental tonalities, Kandinsky says that "in general colour is a means of wielding a direct influence on the soul. Colour is the musical key. The eye is the hammer. The soul is the pianoforte with its many chords."

If it is true that "the sound of music has direct access to the soul, and finds in it straight away a resonance, because man has music within him," then who, in the footsteps of Goethe, can deny that this also applies to colour and painting? While artists such as Franz Marc (1880–1916) and August Macke (1887–1914) attempt a similar route without

totally excluding figuration from their pictures, for Kandinsky the descriptive element is nothing more than an encumbrance to the free construction of the chromatic symphonies. For these symphonies what counts should be the exclusive logic of the effect on the psyche. In this early and interesting phase, Kandinsky's painting is nevertheless reliant on an instinctual and nonformalized gesture. The notion of "lyrical" abstraction has been applied to this

Henri Matisse, The Yellow Curtain (1914–15). Stephen Hahn Collection, New York. This is one of the most perfect examples of the revolutionary faculties which lurk beneath Matisse's apparent decorativeness. The structural conception underpinning his painting, which is duly complemented in his theoretical writings, turns the picture into a system of significant interrelations, and implies the preliteral nature of the "theme" in relation to the new concept whereby the surface is a field of forces, in action.

manner. It is clearly in contrast to the geometric order of the work of Mondrian and Malevich. But given that traditional music is based on precise scansions of an arithmetical type, one can be forgiven for thinking that Kandinsky was strongly influenced during those years by the parallel "atonal" research being carried out by his friend Schönberg, whose aim was to emancipate musical composition from all pre-ordained formulas.

Abstract art in the United States after the Second World War

We do not have room here to dwell on the late development of an avant-garde spirit in the United States, and on the reasons why the "abstract" tendency thrived on the other side of the Atlantic toward the mid forties. The fact is that in the United States this tendency gave rise to a second highly successful season of abstraction, and this season was more fruitful than its European counterpart. Instead we must restrict ourselves to pointing out that the models followed by the artists in the United States were those we have just been discussing. To them we might add, at most, the constructivists: Lazar Lissitzky (1890–1941), Aleksandr Rodčhenko (1891–1956), Naum Gabo (1890–1977), László Moholy-Nagy (1895–1946), Lyonel Feininger (1871–1956), etc. But if we wish properly to differentiate abstract art in the United States from so-called action painting, we find its real distinctive factor in a comparison with its own models. For it rejects or redefines these just as much as it

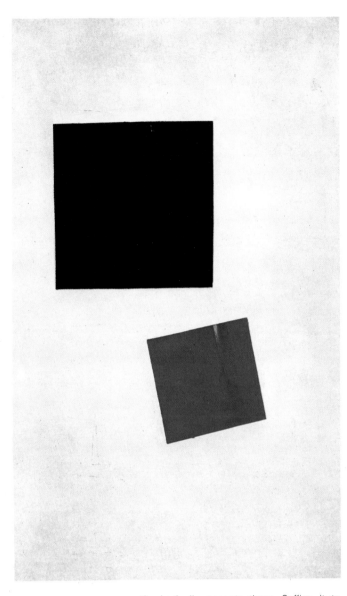

Right: Kasimir Malevich, Suprematist Composition: Red Square and Black Square (1914 or 1915). Musée of Modern Art, New York. In this typical example of Malevich's formal thinking we can very easily perceive the significance the artist intended to confer on the principle of painting's "self-generation." Exact mathematical ratios determine the dimensions and the position of the two figures, including their relation to the picture as a whole. These data are correlated with their intrinsic qualities: weight, intensity and direction of the colour. The two geometric areas have a 9:4 ratio (i.e. $\frac{1}{4}:\frac{1}{9}$) which refers to a hypothetical generative square as the minimum common multiple. What is more, to back up the condition of gravitational subordination, the red element has had to rotate by about 20 degrees in relation to its own initial symbolic position.

Left: Piet Mondrian, Composition (1921). Musée National d'Art Moderne, Paris. The bewildering equilibrium which emerges in all the "neo-plastic compositions" of Mondrian succeeds as a result of the purest intuition. It is separate from the rational and geometric logic that gives the painting its basis, and the source of the work's aesthetic quality.

enthusiastically accepts them. Suffice it to think of the association that runs between the work of artists like Barnett Newman (1905–70), Mark Rothko (1903–70), Ad Reinhardt (1913–67) and Clyfford Still (1904–80) and the painting of Mondrian. It was undoubtedly from this that the "minimalist" rigour was assimilated, together with the universally oriented and self-created approach. But this did not prevent Mondrian himself from being accused by these artists of having too much connection with the phenomenal experience and codified praxis. This would be made visibly manifest in his choice of an asphyxial form of geometry. Although it was Euclidean, this geometry was entrapped within the narrow confines of modern rationality. The American painters, on the contrary, pursued, each in his own way, an ideal of pictorial absolutism that has no counterpart in any other period in the history of Western art. They appear to be driven by the

Despite the intention to set things to zero ("adventure in an unknown world," "image of the never-seen," "expression of the non-ego") these paintings emit effects of great and vibrant intensity. It is hard to explain these effects on the basis of the physical laws of perception. They merely present themselves as extraordinary stratigraphies of the mind. Chromatic lyricism is indisputably apparent, and perhaps as effectively as anywhere. Indeed, Harold Rosenberg has referred to an "alternation of undertows and bright intervals," in which "psychic tensions" find precise expression.

The pictorial space in the works of Still is more hectic and more pronouncedly subdivided. In them the colour is spread out in the à-plat technique over intense and very beautiful backgrounds of two or three colours that are chromatically distant from each other (for example: black, dark red and opaque white in 1954). These zones are separated by elegant borders, which are distinct and irregular. With their vertical orientation they form a reference to large tears or rents in superimposed surfaces.

The achievement of a pictorial zero-degree, i.e. the image's inability to represent both nature and the ego – the sole condition for the rediscovery of a sacred and magical principle of art – tends to be pursued more keenly in the work of Newman. Here the division of the space, obtained by means of just a few long parallel lines on monochrome backgrounds, lends the colour a theatrical quality. The colour is in effect left saying a metaphorical "no comment." Colour is nothing more than colour.

most radical reaction to the pragmatist hallmark of the United States. In their works the image turns into a ritual, magic and sacred event. By borrowing oriental-type parameters the image is meant to act psychologically, using the same properties (fideistic, i.e. anti-rationalist, and mystery based) which animate, for example, tantric portrayals and objects: "mandalas," "mantras," "lingams" and "yantras." So we are faced with the paradox and contradiction of an art that renders itself metaphysical, dematerializes itself, and tries to turn itself into a pure concept, a notion of the absolute and a totemic hypostasis or essential principle; and an art that at the same time produces in this way an object-pictorial maximum. This is achieved by a necessary reduction of the picture to the minimal elements of its structure: the canvas, the stretcher, the rectangular or other geometric form of the edges, and the simplified chromatic field. Compared with the suprematism of Malevich and Dutch neo-plasticism, the very idea of "form" is missing. Or at least it becomes so tapered that, in the ideal hypothesis, it is a pure encounter between two or three colours, applied to the surface in large areas and for the most part with no clearly defined spatial values.

Rothko, for example, constructs his pictures using fairly homogeneous bands of colour, differing from each other like variations of a single basic shade (red, pink, and white with purple nuances). The bands are only vaguely rectangular or square in form. They extend almost invariably in a brief sequence along the

vertical axis of the canvas, leaving at the edges and between them background strips that are generally darker in colour. Because of Rothko's use of sfumato and delicate gradation these strips tend toward an effect of incessant osmosis with the bands themselves.

Above: Vassily Kandinsky, Landscape with Red Dots No. 2 *(1913). Peggy Guggenheim Collection, Venice. Even when Kandinsky's painting has landscape-type "narrative systems," it can still be called abstract if its effect is based on the intrinsic capacity of colour to produce emotional responses in the mind of the spectator.*

Right: Barnett Newman, Vir Heroicus Sublimis *(1950–51). Museum of Modern Art, New York. The perfect scansion of the vertical lines divides the surface into three: a pure colour revelation, taken not as corresponding with phenomenal light events, but as a ritual and metaphysical "presence" in the "absolute" spirit of painting.*

*Right: Mark Rothko,
Magenta, Black, Green
on Orange (1949). The
intense chromatic
vibration that pervades
Rothko's paintings, and
which makes them so
mysteriously expressive,
is the result of a great
sensibility applied to the
rigorous principles of
tautological abstraction.
In this early phase the
American painter used
pigments that are quite
separate from each
other. Later he used
increasingly subtle and
refined nuances, scales
and gradations of
colour, as minimal
variations around a
"chord," or barely
changing emergences
on the surface of the
painting against a
monochrome
background.*

monochrome backgrounds, which it delimits. In a state of complete consciousness this painting runs the risk of suddenly and unexpectedly ceasing to be art. Newman has been able to observe that his paintings must behave like fetishes in primitive societies. Sometimes they are invested with an ineffable and immense symbolic value. Sometimes they are quite mute and reduced to just the material of which they are made. This deviation has a counterpart on the level of perception: where the image wavers between being read as a commonplace spread of colours and between being read as a hieratic (i.e. cursive rather than hieroglyphic) manifestation of that higher silence which is the mystery of existence. In reality it concedes nothing to the eye, except the bewildered statement of its new and profound precariousness.

The conspicuously analytical position of Ad Reinhardt is quite close to this. Reinhardt was the principal precursor of pictorial minimalism and "conceptual art." In the early 1950s he was also involved in a progressive rarefaction of the formal data of the work. For him, too, the most evident reference from the past was still Malevich. But not (or not so much) the Malevich who proliferated coloured planes as the "extreme" Malevich of the series titled *White on White* (1917–18), or the Malevich of

Colour is used not for its expressive qualities (whatever they might be), nor for its constructive properties...but as something that is present in an absolute sense, self-evident, and without any essential characteristics. The line which runs over the picture from one spot to

another may be clearly defined or blurred; it may be cold or vibrant. What matters is the fact that it creates a rejection of homogeneity. So for reasons of difference and often of dissonance, the line highlights the pigment that forms it, in relation to the pigment that forms the

*Right: Clyfford Still,
Jamais (1944). Peggy
Guggenheim Collection,
Venice. The subdivisions
of the surface in this
painting by Still are
allusive and vaguely
dreamlike. This work
precedes the phase in
which Still tended to
reduce his divisions to
just a few vertical bands
with sinuous outlines.
They nevertheless
dance in front of the eye
like "fits and starts" on
the presumed regularity
of the initial space. It is
as if the chromatic
appearance were
merely the result of a
subtraction of the
"whole," the clever and
mysterious product of a
"revelation."*

the black crosses. It is hard to give an accurate assessment of the distance that lies between the painting of Reinhardt (which, in a Utopian way, has the goal of attaining a negated perception) and the *Gestalt* experiments of Josef Albers (1888–1976) on the form of the square, which owe such a lot to the psycho-perceptive theories of Max Bill. There is, however, a difference: it is the difference between a negative conception of form and a positive conception of form. Reinhardt meticulously abolishes all residual elements of representation. He prevents the painting from becoming structured, even if only in a hypothetical sense, on a disjunction between figure and background, or between foreground and background.

Seized by a sort of sacred folly, he forces the analysis to be completely and exclusively relative to the surface and to its concrete divisions into black and white zones. There are no concessions made to the impressions or emotions of uncontrollable subjectivity.

Action painting and "psychic automatism"

The other major phenomenon bequeathed by the historical European avant-garde to art in the United States in the 1940s and 1950s consists in the often underestimated influence of surrealist poetics on action painting. The protagonists of this movement – from Jackson Pollock (1912–56) to Franz Kline (1910–62), from Robert Motherwell (1915–) to Willem de Kooning (1904–), and from Philip Guston (1913–80) to Sam Francis (1923–) – are often biographically close to and sometimes even associated with the "reductionists," their contemporaries. But they demonstrate a profound indifference toward painters such as Mondrian and Malevich. In so doing they once and for all put in a critical position the ingenuous assumption of the bipolar "abstract-figurative" dichotomy summed up by twentieth-century art. The new tendencies, stressing material and gesture, are totally alien to the representational mechanisms of figuration. In fact they have precious little to do with the reasons invoked by the fathers of the abstract revolution. At most they grant a degree of interest in the chromatic lyricism of the early Kandinsky, whose goals they often seem to misconstrue. Regardless of this, it would be silly to interpret their apparition as a miraculous event without any precedents. The difficulty in acknowledging their borrowing of certain theoretical precepts from Surrealism hails, to all appearances, from an interpretation of the Breton-lead movement, which humbles the poetics to the point of aligning them with the didactic and banal oneirism or dream-inspired art of artists such as Salvador Dali, Yves Tanguy and Roberto Sebastián Antonio Matta. Action painting in fact very profitably borrows the central concept of the surrealist theory. That is the definition of *automatism* that André

Right: Ad Reinhardt, Red Painting *(1952). Metropolitan Museum of Art, Arthur H. Hearn Fund, New York. This painting, like those relying on the sole presence of black on white, clearly shows Reinhardt's interest in the "suprematist" period of Malevich. The perfect linear and chromatic symmetry, the minimal use of colour, the symbolic trespassing of the forms beyond the limits of the canvas, all are examples of a calling to make structural analyses taken to their limit, where language ends up by opening out into an extreme apology of silence.*

Right: Josef Albers, Homage to the Square Series: Assertive *(1958). Sidney Janis Gallery, New York. The* Homage to the Square *series represents the coldest and most rigorous example of a form of painting that is intended to be a pure analysis of the actual bases. It springs from an artist who developed under the tutelage of the Bauhaus, and the* Gestalt *theories of Max Bill. Albers's method as it were commutates, and consists in the scientific variation of colour around a geometric model that is always the same.*

Below: Sam Francis, Moby Dick (1958). Mr. & Mrs. Armand Bartos Collection, New York. Francis's painting can be seen as the outcome of research touching on the two main currents of American art in the postwar period – the analytical and the gestural. In his works the examination of form rejects the presence of geometric macro-units or monochrome fields, and rather addresses the expressive quality of the individual brushstroke as a psychological report and as a product of manual activity.

Breton came up with in 1924 (in the first manifesto) and honed again in 1929 (in the second manifesto). Using the principles of psychoanalysis, this definition manages to establish a direct relation between the unconscious and the creative gesture. Not even Freud himself had managed to pinpoint this relation in these terms. But the best of the surrealist painters (Max Ernst, Joan Miró, André Masson and René Magritte) did not succeed in deriving all the consequences from this central concept. According to this hypothesis, it is a matter of being aware that anything "fortuitous" that intervenes in the elaboration of a work of art does in fact have its deep-seated cause. In other words, it depends on factors that the subject unwittingly carries within him. In this way Breton manages to resignify the Dadaist "triumph of chance," beneath which he recognizes the presence of an alternative logic. This logic is radically removed from the prosaic and diurnal thinking of reason. Instead, it is akin to the traditional (but esoteric) poetic mechanism of the "analogy." Analogical anti-thinking is then what justifies the praxis of "automatic writing," in other words the free flow of linguistic material with no ethical, aesthetic or syntactic control mechanisms. This free flow is capable of bringing what is latent up to date, and rendering topical psychic impulses taken from any kind of cultural schema.

In informal painting, and in action painting in particular, it is the pictorial material in itself,

taken as a pre-rational requirement as material not yet transformed into linguistic signs or symbols, which becomes the active metaphor of an inner content. This, in a parallel way, is not and will never be organized on the basis of logical and discursive principles. The fact is that any objectivization of it would destroy it, by making it conscious. This explains the recourse to techniques designed to augment the intervention of chance in works (for example) such as those of Jackson Pollock. These were produced in a state of extreme vitalism, in which the artist's hand, arm and whole body "forget" that they are dependent on the will and mind of the person transmitting the creative impulse to them. They are thus liberated in a sort of sacred frenzy that pays no heed to any form of decorum, or compositional rules, or aesthetic awareness. The carefully measured quality of the results, often obtained from minimal decisions at the level of the guideline models chosen, in no way detracts from this singular manifestation of Chaos. In

Right: Robert Motherwell, Surprise and Inspiration *(1943). Peggy Guggenheim Collection, Venice. The title of this work reveals the essential ground of gestural poetics. Not until the arrival of Rauschenberg do we find something similar in terms of the effectiveness and brutality of expression.*

Below: Jackson Pollock, Convergence *(1952). Albright-Knox Art Gallery, Buffalo. In Pollock's "dripping" painting we can glimpse the more mature and convincing product of that theory of psychic automatism that originated in French Surrealism but found scant pictorial application.*

his boldest phase (from 1947 to 1952) Pollock "lived" painting in a sort of hand-to-hand combat between himself and the surface to be painted. The technique called "dripping" (which can be traced back to some of Ernst's experiments) offered him the possibility of slapping the canvas with the brush, and of then using the dripping and the spots and smears produced haphazardly.... The picture was first laid out on the floor. Then, after being covered with liquid paints, it was raised to the vertical position to allow the force of gravity to make its unpredictable configurations on the surface. Alternatively, the colour was left to drip directly from a can expressly riddled with small holes.

Here, and with other artists, there is clearly a modern rethinking of the romantic notion of inspiration, given that the work can only be achieved as a result of what is conveniently defined as a "state of grace" (*Surprise and Inspiration* is the title of a painting produced by Robert Motherwell in 1943). We also have a new license which invokes the global participation of the artist in the gesture made by him.

This is like expressionism with the brakes off, calling into question forms of ancestral violence, and entailing nerve and muscle, body and spirit, thought and gut. Here it finds a profound unity in a tormented rectangle of palpitating tangles and clots. This is essentially nothing more than the screen on to which the disorder of the ego is projected.

In some ways the informal Expressionism of the 1950s embraces the legacy of much of the prewar avant-garde, conjugating in itself indications originating from the German group *Die Brücke*, from the primitivist forms of the turn of the century, from Dadaism and from Surrealism, from *Der Blaue Reiter* and from Fauvism. In a word, everything – except the real "abstract" tradition. What is more, although this painting is for the most part stripped of figurative elements, it is in no way irreconcilable with the image of the extra-linguistic reality, albeit deformed and deforming. This is evident in the strange paintings of Willem De Kooning, where the realization of a free and violent gestural manner seems to require an object-based substratum to assail. This is usually a

human body, nude and female or otherwise, capable of interacting, one might say, with the psyche of the painter who has put it on canvas. Capable, too, of igniting the half-conscious movements which will give rise to its distortion. In the work of Franz Kline, on the other hand, the gesture is invariably sweeping, open, full-bodied, and almost diagrammatic in the monochrome quality of the black line on a white background. At the same time the gesture is intense and tragic, and enclosed within its passionate essence. As such it is similar to the rough and caustic brushwork of the European Hans Hartung (1904–), as has been duly noted by Francesco Arcangeli. Lastly, separate mention must be made of Arshile Gorky (1905–48), who, together with Mark Tobey (1890–1976), was one of the first American artists to align himself with avant-garde postures. His somewhat intermediary role was in fact indispensable. But his works, which were influenced by the dream-inspired basis of Surrealism, do not seem to merit full membership in the action-painting movement, or in the abstract tendency of Newman and Rothko.

originality in going beyond its range. This applies, precisely, where gestural and material expressionism in France, Germany, Italy, Spain and Belgium – particularly if analyzed in its extreme cases, e.g. Jean Fautrier (1898–1964), Alberto Burri (1915–), Lucio Fontana (1899–1968), Antonio Tápies (1923–), to mention just a few names – often appears to be independent, if not sometimes more advanced, in comparison with the parallel developments on the other side of the Atlantic.

But the precept of American chronological predominance also fails to hold good in an absolute sense. In fact we find it wavering when we admit that in about 1930 Fautrier, for example, appeared to be going along the same track that would later be taken (and quite

Informal art in Europe

Even today it is still quite difficult to attempt to instil some order in that mass of postwar European tendencies which is called "informal art" – a cumulative and thus only approximate term. Although these tendencies have precise connections with action painting in the United States, they also seem to be detached from it because of the quantity of (often contradictory) symbols they embrace. This detachment also stems from the great variety of situations that it ends up contemplating in the span of a decade or so. In this sense we can use the term informal not only for the apparent character of the works in question but also for the general situation that – perhaps in an altogether illusory way – groups them together. Apart from this, one of the still unresolved problems is undoubtedly the matter of reconciling the historical predominance of this artistic research in the United States with the no less incontrovertible assertion of European

Above: Franz Kline, Orange and Black Wall (1959). Mr. & Mrs. Robert C. Scull Collection, New York.

Right: Arshile Gorky, The Engagement, II (1947). Whitney Museum of American Art, New York. Gorky was among the first American artists to be decidedly stimulated by European examples. In works such as this he manages to offer an original interpretation of the abstract space of surrealist lineage.

Left: Willem De Kooning, Police Gazette (1954–55). Mr. & Mrs. Robert C. Scull Collection, New York. What singles out the painting of De Kooning is the incredible expressive violence behind every brushstroke. The gesture is impulsive and enraged . . . and yet open, spacious and almost carefully measured.

rightly) by one of the pastmasters of informal painting. His was then and would remain the position of a solitary artist, completely devoted to scrutinizing in-depth a private nightmare of perceptive associations and maniacal immersions in language. Fautrier's painting (the "martial" *Hostage* series, for example) is almost invariably made up of a central expanse of coarse and opaque chromatic paste, troubled and pervaded by infinite modifications, which seem to repel the eye rather than attract it. On the edges of this area we find a more transparent hue, which dilutes the tension and at the same time intensifies it by

Left: Jean Fautrier, Tête d'otage No. 1 (Head of a Hostage) (1943). Giuseppe Panza di Biumo Collection, Varese. The Hostage *series (an extreme refrain of the "Prisons" theme) reveals a conception of the substance as a metaphor of the psyche.*

Below: Emilio Vedova, Immagine del tempo (Sbarramento) (Image of Time/Blockage) (1951). Peggy Guggenheim Collection, Venice. The "troubled space" is based on the idea of a linear architecture (or rational consciousness) rendered impossible by an excess of zeal, and by the immoderation of the gesture which denies it even as it takes it in.

Opposite: Wols, Vowels (1950). Gretty Wols Collection, Paris. Here we find a governing notion of sign as a non-organized scriptural feature, as the spontaneous product of a feverish graphic activity, and as emotion rendered in the pure, sensitive and unreflective state.

paintings of Wols (Wolfgang Schulze, 1913–51) and Hans Hartung, to name two of the founding fathers of these tendencies, are quite often carefully measured. In Wols, of course, who came to abstract Expressionism after the trauma of being interned in a concentration camp, the symbol appears rebellious and incredibly enraged. On the other hand Hartung's broad and essential "writing" sometimes calls to mind the oriental tradition of calligraphy in its ornate form. This calligraphic form was rediscovered during this period, and had considerable influence on the experiments of the European avant-garde. We find traces of it in artists like Pierre Soulages (1919–), whereas in Georges Mathieu (1921–) it gives rise to extremely elegant figures, which are, for all their elegance, possibly too fatuous and repetitive. In Italy, gesturalism was significantly expressed in the art of Emilio Vedova (1919–), who starts from an idea of involvement that is, in many aspects, close to that of the Americans. We also find it in the work of certain "spatialists" like Roberto Crippa (1921–72) and Cesare Peverelli (1922–); and again, to a degree, in the work of Emilio Scanavino (1922–) and Giuseppe Santomaso (1907–). More often the poetics of gesture are combined with the poetics of substance, as in the work of Afro Basaldella (1912–76), Mattia Moreni (1920–) and Pompilio Mandelli (1912–).

Leaving Fautrier on one side, an overview of French "material" painting includes artists who show great expressive power, like Jean-Paul Riopelle (1923–), who constructs his glowing

means of contrast. This is a meditative form of painting that proceeds by way of reiterated accumulations and added thicknesses. It is a mental, earthly art, which, in a version somehow opposed to Pollock's, reproposes the idea of an immediate relation between psyche and matter. In "gestural" painting this contact is of the pragmatic type (liberation of the hand from the suffocating restraints of ideology). In "material" painting it is symbolic and metonymic (i.e. indirect), because the raw and "presignificant" material is the analogue of an unconscious that is disorganized, chaotic and profoundly illogical. In both cases we find a rejection of formal structure (figuration or geometry) as a conveyor of "culture" – that asphyxiating culture to which Jean Dubuffet (1901–85) refers – and a conveyor of rational constraint.

We must nevertheless bear in mind the fact that in Europe, too, the gestural tendencies demonstrate for the most part a moderate and reflective character that is quite alien to American action painting. That this is due to the deep diversity of the cultural substrata (which is why the extremist phenomena are more reasonable where there is less historical memory) is an attractive thesis, but one that is also open to criticism. The fact is that the

surfaces by means of a mosaic of infinite facets of extremely brightly coloured pigment. Riopelle achieves harmonious effects worthy of an artist like Seurat. Another such artist is Nicolas de Staël (1914–55), who, in my view, is one of this century's major artists. De Staël's work involves dense areas charged with coloured pigment. By maintaining an awkward balance between the figurative image and its rejection he almost always achieves surprising heights of intense lyricism. We should also mention the Spaniard Antonio Tapies, who is only ostensibly close to the Italian Burri. In his painting, to use the words of the art historian Dora Vallier, we find a sort of *trompe l'oeil* of the material, taken to a point of paradox where

it "imitates" itself. In Italy the work of Ennio Morlotti (1910–) was very powerful. Morlotti was the leading light in a naturalist-cum-informal undercurrent, which gave cause to the critic Francesco Arcangeli to theorize about a nexus of continuity between romantic poetics and art in the period after the Second World War. For just a few years (1953–56) Vaco Bendini (1922–) also belonged to this movement. He then went on to rediscover a splendidly solemn imagery, alien to any explicitly narrative intention. This imagery wavers between the earthly vigour of tormented textures inspired by Fautrier and the pale but transparent poetry of liquid and changing symphonies of colour.

Informal sculptors are rare. It is, however, worth mentioning Leoncillo (Leonardi, 1915–68), whose works in painted ceramics or terracotta present an extremely unconditional acceptance of the mysterious quality of the raw material. The "form" of his sculptures, which is at times completely conceptualized, is that of an ancient lava flow (*Ceramica*, 1958), where the dull two-tone colour seems to be more the chemical product of natural agents than the result of great skill. In other works he borrows classical moments of artistic iconography (*San Sebastiano nero*, 1961), but transposes them into the sensual and immediate revelation of a pure physical presence. He often achieves a dramatic pitch comparable to that of the painting of Soutine.

Tendentious interpretations and various heresies

We shall not in fact dwell on the one or two variations undergone by the "constructivist" current in Europe between 1945 and 1960. And we shall not venture into those borderline areas, trodden by artists like Francis Bacon (1909–), in which the gestural techniques are superimposed on a fundamentally realistic inspiration. But we shall have something to say about Jean Dubuffet, a figure who is hard to classify because he is within his own theoretical dimension, and only affected tangentially by the problematic of informalism. From the 1940s onward, he became involved in the re-evaluation of the great expressive potential concealed in the output of persons who are psychically alienated, and of persons who are mentally ill in a more general sense. This output was gathered together and studied by Dubuffet under the title *art brut*. Dubuffet was aware, however, that the artistic value of this output was in no way acknowledged by the current ideology. For him this value hangs on the fact that these products convey a kind of thinking that is classically figurative and strongly spiritual. Put precisely, this thinking is not conditioned by the restraints of common sense. This is because it requires from the painter who wants to use it a considerable openmindedness in the use of techniques and materials that are quite alien to artistic orthodoxy.

But the most salient figures in what we might call the "heretical component" of informal art are those artists who, each in their own way, opened up the way to the projects of the following decade. We must now turn our attention to these artists.

Let us start with Alberto Burri. From the early 1950s onward his works seem to complement the conviction that a real interest in the expressive values of substance can only apply because of active and tangible experimentation with materials. These are heterogeneous in relation to each other and alien to the traditional technical baggage of the painter or

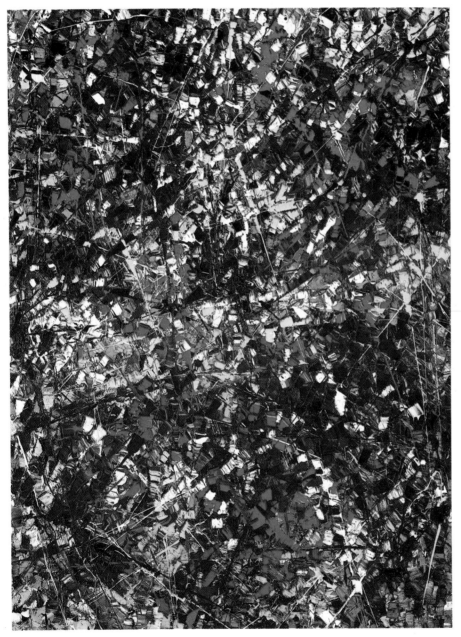

sculptor. In Burri's early phase these materials were, in themselves (and prior to the work), rich in psychological, existential and cultural content. They are like cruel synecdoches (those figures of speech where the whole is indicated by a part of the whole) of their earthly history. They convey the pain, the passion and the wretchedness that they have suffered. To a great degree they express these phenomena within a representational space in which they are then modified and given new meaning. There is a reaction to the contact with the emotional interpretation offered by the artist's

sensibility. So it is the worn, dirty, raggedy, patched-up sacks and sheets, sewn together with string, drooping or stretched out, which are arranged (as if for a solemn pronouncement from the agent who created them) within the edges of the frame. The picture then becomes a secular and profoundly human "shroud," a place of memory, a ritual theater in which to celebrate the endlessly repeated sacrifice of the life of the lowly, and of the rags and tattered flesh on which this life is nurtured and in which the real truth is lived. As early as 1951 Emilio Villa had sensed the scale of this physical painting: "Burri uses himself as an impatient, austere, banal surgeon, almost of the alchemist breed. He manages to put back together leftovers, debris and waste of a fearful but still burning reality that is almost absent-mindedly mindful (possibly, too, at the same time evocative and evocatory) of the *fluxus sanguinis*, and of whatever life (which one?) contained in this flux, and flowing in the same sense.... His outline (of wires, scratches, cuts and twine), his accidental field, his outraged *theatrum* of life, ambiguous like the dance of a virus, must be taken, in my own view, as a prime act: let us call it a creational act of the initiatory type...." Later on Burri would turn to products of industrial origin (cellophane, for example). But he did

this in order to subject them to the devastating, horrifying, blazing wear and tear of fire, of the oxyhydrogen flame. And his art became an art of burnings and incinerations, weals and wounds, wrinkles and chemical tragedies. Otherwise put, from the synecdoche to the metaphor... but always via a total gesture that is almost unstudied but yet definitive. A gesture that amazes by the power of its immediacy, precision and authenticity.

These works merely radicalize a problem that already exists in gestural painting. This problem concerns a new relationship between art-space and reality-space, a relationship that is not mimetic and not filtered through reproductive techniques, but rather entrusted to a metonymic type of exchange. To some extent reality-space loses its extra-linguistic character, once it is, so to speak, "absorbed" within the work, even if in the form (in Burri) of an isolated object-fragment rich in sentimental layering. In the ideology of involvement that is put into effect by the work of Lucio Fontana (a half-Italian, half-Argentine artist who spent the latter and most important period of his life in Milan, where he founded the artistic movement called *Movimento Spaziale* ['spatialism']) the problem is posed instead in the terms of a sort of declaration about the relativity of art in relation to the environment surrounding it, and

Opposite: Jean-Paul Riopelle, Robe of Stars *(1952). Wallraf-Richartz Museum, Cologne. Piling up linear, gestural, material and chromatic events (in a miraculous balance of order and chance), the form in Riopelle becomes so complex that it dissolves. This is due to the actual paroxysmic triumph in the urgency of a total expression.*

Above: Ennio Morlotti, L'Adda a Imbersago *(detail, 1955). Private Collection, Monza Morlotti's painting achieves intensely lyrical results where he is able to unfold nature within the "human" terms of a dense and physical vision that is pregnant with "humoral" elements and profound proposals.*

Right: Nicolas de Staël, Low Tide *(1954). Beyeler Gallery, Basel. De Staël pursues a subtly ambiguous and enchanting representation. Its poetry is triggered by the symbolic (and before that perceptive) ambivalence of areas and patches of colour that are at once naturalistic and abstract, figurative and material.*

similarly the relativity of the artistic object in relation to the place in which it is enjoyed. On the one hand we must underline that at the origin of these extremely modern conceptions (from which the theory of conceptual art would subsequently derive its nourishment) there is still the phenomenon of throwing open the surface of the picture that action painting managed to provide for (think, for example, of the psychological and pragmatic implications of the American "dripping" technique). On the other hand, it is perhaps useful to repeat that all this is in no way opposed to the abstractionist idea that painting can be completely au-

Below: Alberto Burri, Red and black (1953). Banca Commerciale Italiana Collection, Milan. The materials used by Burri are dramatic metaphors of human existence. They also propose new semantic horizons. They throw open questions of pictorial syntax and grammar, offering the language of imagery rich impulses of reflection about its own function and its unexplored boundaries.

tonomous, because there is no retrieval of the historical, representational potential (this is a conventional projection of an imaginary reality on to the concrete data of the painting). What is there is the inherent contact between the work – no matter what its "content" might be – and the space outside it, in the *hic et nunc* of the realization and perception of it. In this same period, in the musical arena, John Cage started to consider noise as a sonorous reality that interferes with the presumed purity of the sound. So in painting Fontana maintained that the environment has its own linguistic value, a value that the work sheds light on by the mere fact of being there, in a certain environment, and by the mere fact of inevitably interacting with it. Leaving aside any aesthetic type of consideration about the symbolic values that he achieves, the gesture that effectively broke

Right: Lucio Fontana, Spatial Concept (1961– 62). Alfred Otto Müller Collection, Cologne. A feature of Fontana's style is the mastery of the two- dimensional as a limiting factor of the pictorial representational space. His poetics allude to the future rejection of the concept of the work (of art) as a self-contained and separate entity, alien to the environment of life and action.

vocative experiments of the Dada avant-garde. In it the "abstract" elements of a plausible painting are rendered three-dimensional and as if fluctuating within a space enclosed by artifical walls. The spectator is invitcd into this space to enjoy the work from within, among refined light effects and inside the implication that is expressed about it. The basis is the Futurist precept which says that one should "place the spectator in the middle of the picture."

With regard to the release of painting from its own traditional space, we must mention the bizarre research carried out by Pinot Gallizio (1902–64), from Piedmont, on the relation-ships between aesthetics, manual character and reproducibility in a work. In Alba, where he was by trade a pharmacist, as well as a cosmopolitan artist (he was the outstanding exponent of the CoBrA group and of the Situationist International, and thus a colleague of Asger Jorn, 1914–73, and Pierre Alechin-sky, 1927–), people can still recall the strange "industrial painting" rolls, which Gal-lizio sold by the yard, like any old merchan-dise, after a very swift (but scrupulous) pro-duction process by hand with the brush over extremely long bolts of fabric. In so doing he demonstrated, among other things, the ob-solescence of the unqiue item that could not be reproduced. He also pointed to the ob-solescence of the notion of inspiration and, in a more general way, refuted the classical status of art in the industrial age as lofty and precious craftsmanship.

Toward the end of the decade, the late lamented Piero Manzoni (1934–63) delivered an even more ferocious critique of the "work of art" concept with his ironical, mocking and hyper-Dadaist spirit. Manzoni was an intransi-gent member of the avant-garde, and an artist ahead of his time. He soon developed his own personal method of rendering pictorial con-crete (or if you prefer abstract) art extreme. We find this in his white *Achromes* of 1957–59, where, incidentally, there is also keen attention to the object-quality of the materal and to its perceptive responses. In 1959 or thereabouts Manzoni had grown dissatisfied with the work as an object locked within itself. He therefore chose to make the artistic gesture theatrical. In so doing he anticipated the procedures of "body art." His performances involving edible art (*Consacrazione all'arte dell'uovo sodo* [Dedication to the Art of the Hard-boiled Egg]), of 1960, are famous. In them the accent falls on the one hand on the total noninfluence of the typical objectives in relation to the aes-thetic function – because he is only the con-veyor of intentions, the artist-cum-shaman who puts his signature on the object (for example, a fingerprint on the egg-shell) to certify the existence of its "value" – and on the other on the retrieval of ancestral, tribal and magic requirements, in the rite of art. According to Georges Bataille, these requirements reflect their extremely ancient biological foundations

the ground of the monochrome surface (the amorphous hole in the wooden panel, the clean and slightly curving cut in the canvas) is, in Fontana's work, a symbolic act of exceeding the limits imposed by the pictorial space. It is also the declaration of the actual rediscovery of something beyond painting (of everything that lies beyond it). And in a possibly imper-ceptible but all the same incontestable way this gives a sense of painting. It is therefore a conceptual, assertive gesture – an act, if you like, that is more philosophical than expres-sive, in which, potentially, there is a summa-tion of infinite numbers of pages of reflection about the essence of art.

Fontana himself, incidentally, was the author of the tremendous *Ambiente spaziale* (*Spatial Environment*) of 1949. This work was without precedent, even in the most radical and pro-

Asger Jorn, Untitled *(1956–57). Peggy Guggenheim Collection, Venice. A vision of a profoundly nihilistic and profane image, combined with a precise interest in the more radical possibilities of gesturalism, led Jorn to a stubborn commitment aimed at the deconstruction of the formal plan or layout of the work, with additional resort to the conscious borrowing of the modes of the primitive, non-accultured sign, and the languages relating to them. His interpretation is an extremely politicized one of the role* *of the artist, who is called upon to prefigure, in the aesthetic act, dimensions of life and society that are liberated from the slavery of work In opposition to the image-oriented theories of Max Bill and the Gestaltung school – otherwise put in open disagreement with "determined" abstraction (re-interpreted as a method of formal coercion and as the absence of expressive freedom) – he founded the "International Movement for an Imagist Bauhaus" in 1953.*

(nutrition, digestion, etc.). Another famous phenomenon is the idea of reusing the classical and academic "model," but without wasting time depicting it. It is clearly much simpler to show the body directly in flesh and bone, and sign it as a highly original sculpture that is truly unique and inimitable. This gesture is altogether synchronous with those being made in this same period by the Frenchman Yves Klein (1928–62). After selecting the sole and exclusive colour blue for all painting operations, Klein asked nude models to spread themselves across the canvas to obtain their anthropometry. This is tantamount to a special and direct "representation," derived from the imprint left by the paint sprayed along the outline of the body. An alternative technique involved a strange method of printing, with the models soaking themselves in the colour and then pressing their limbs against the canvas. The human body is thus once again the center or artistic interest. But not as an element that summarizes in itself the perfection of creation, and which must be virtually (idealistically) reproduced. Rather, it is the only authentic, biological and real datum that establishes the ego, as is affirmed by psychoanalysis. And the ego may be primitive, or highly evolved.

Yves Klein, Relief éponge Bleu: RE 19 (1958). Wallraf-Richartz Museum, Cologne. Before devoting himself (with his "anthropometries") to experiments anticipating "body-art," the Frenchman Yves Klein followed a path which, in many respects, was parallel to that of Piero Manzoni. In fact he carried out research on the linguistic value of the absolute monochrome (blue period), outrageously interpreted by him as opening up vast imaginative horizons starting from a minimum of expressive data. In the phase to which this work belongs, he nevertheless combines the pictorial monochrome with elements in relief (sponges), as if to investigate the effect that can be achieved on the coloured surface by the spatial accident that infringes it. It is worth noting that works like this one attempt, implicitly, to be a point of contact between the concrete aspect of geometric abstraction and the expressive values of the material. Here, too, Klein was anticipating certain developments that would occur in the 1960s. Klein, who died in 1962, aged just thirty-four, took part in the New Realism movement.

Twentieth-century architecture

The city in the industrial and post-industrial age

This century has seen a great growth of population, from 1.6 thousand million in 1900 to an estimated 6.5 thousand million in 2000. To accommodate them all, installations must be set up everywhere: in the last century the main growth was confined to countries already industrialized or about to become so, the total rising from 900 million in 1800. The world's urban population in 2000 is forecast at 3.2 thousand million, mostly in the Third World, where city dwellers will increase from 900 million in 1980 to about 1.8 thousand million.

Hence in twenty years more cities will be built than have been already in man's entire history, whether extant or in ruins. How far these conurbations will be cities in the nineteenth-century sense of developed economies we cannot foretell; but certainly the human scene of the near future will be highly complex, as against the simple scheme that from 1900 stressed the division of town and country in the seemingly inevitable wake of industrial society. Man constantly alters the setting in which he lives, an ever more complex and far-reaching network of social, economic, cultural and moral values. This gives new point to the nineteenth-century definition of architecture by the English poet and painter William Morris: "The sum total of changes and alterations wrought on the earth's surface in view of

human needs." This does indeed bring home the problem's global scale. The idealist dichotomy between architecture and building, and more generally betwen major and minor arts, now seems absurd if we view human activity scientifically, given the new links between quantity and quality (thus, the quantity of new building swamps traditional architectural qualities and tends itself to become a quality). We can no longer analyze a piece of architecture out of its context, or to draw from the total history of building an independent category arbitrarily defined in terms of quality: this would be a wrong simplification. The traditional history of architecture adopts the same concepts, restricted since it covers many past aspects where the links between quantity and quality or between material culture and monumental image were very different. The old type of history cannot cope with our century's building activity, which constantly and at a growing pace transforms our human scene. A history of the deeds of

Le Corbusier, Convent of Sainte-Marie-de-la-Tourette. Built 1952–60 at Éveux, near Lyons.

modern architecture is integral to history as such in the arduous making. Still, in this context we can trace a history of architectural ideas that have emerged in proposals and constructions: it is on this assumption that we base the present survey. The leading idea is that of the industrial city, because from 1900 all developed countries have become industrialized, with the attendant practices and ideologies. The modern metropolis is an industrial megapolis, and areas not built up are a reserve for the relentless spread of its oily jungle, as foretold by classical and Marxist economics. Today, with post-industrial society in the making, we know that such a future is no longer inevitable. In the last few decades, big cities in developed countries have grown more slowly, while new and flexible settlements have arisen: the polycentric regional cities. The faster growth of Third World cities is not a new rise of industrial cities (for it expresses a new relation between city and country, marked by a more advanced standard of living as to food and medical care).

Two Italian pictures of the early 1900s, from a country then beginning to industrialize as compared with Britain, Germany and Austria-Hungary, display the myth and ambiguity of the industrial city in terms of current symbols. Mario Sironi's *Urban Landscape with Truck* (1921) shows the industrial outskirts of Milan, actual and possible together. Its implicit pessimism concerns their inevitable and bound-

less growth, here and in any city: a set of factories and workers' dwellings, in an abstract uninhabited landscape. Giorgio de Chirico's *Metaphysical Interior with large Factory* (1915) foreshadows something else. The metaphysical interior accepts the real one as well, the factory framed in the center is one built at Codigoro at the time as part of reclamation work on the Po. It is real and present, but will not dominate the future, since the context of the laboratory in the room shown opens from the inner window on a vision of Italian squares (the painter's theme), which stand for urban quality as against the expected and pursued notion of the coming post-industrial city of our own day. These are the two co-ordinates to which modern architecture will always refer. Continuous solutions in architectural activity have brought the history of architectural ideas into close contact with the urban idea.

The avant-garde notion borrowed from other arts acquires new meaning in architecture: the military meaning from the original French (vanguard) suggests a marked presence in parts of a territory prior to total occupation. The eclectic city of the late 1800s with its many different styles applied to modern buildings, in tune with traditional aesthetics, contrasts with the merely quantitative growth of the industrial city, in which new facts constantly attract proposals of new orders in style and organization, aspiring mainly to universal, cosmopolitan values.

Ideas of city life were one thing in the past, but are quite different for the future we are now planning. Everywhere, progressive town-planners and architects will come into conflict with those for whom the history and tradition of a city remain part of a live setting, for the large scale needed to run modern cities implies overriding these features.

In 1901–4, Tony Garnier, city architect at Lyons from 1905, devised a plan of the industrial city (published 1917), a vision in which the actual social and aesthetic problems of industrial cities are rationally resolved. This shows how to order the chaotic spread of industrial cities excrescent at their shapeless fringes, and thus to realize a Utopian plan.

Above: urban expansion of London, paradigm of the metropolitan city in the industrial era, from 1840 (more than two million people) to 1929 (more than eight million). The model of the

spreading city without continuous solution, as in suburban belts of factories and workers' houses seemed unavoidable everywhere: Mario Sironi showed it in this

Townscape (below), painted in 1921 (private collection, Milan), before suburbs were laid out by the modern movement.

Opposite below right: a drawing by Charles Rennie Mackintosh.

Since in Britain the first industrial revolution had led to suburban slums, in countries that began to industrialize about 1900 the foremost technical aim was to plan and manage the growth of new industrial cities. The arduous task of creating the attendant governing bodies (town planning) hastily declared by some as a science, simply adhered to organic urban notions of the classical economists: every city was merely industrial, the ground is reserved for its undisputed growth. This only touched urban aspects, without reference to the territorial setting, a matter only of building the city. In the early decades of the century the same problem was faced in southern Europe. The French coined the term "urbanism." "Town" and the Latin *urbs* in origin imply a

walled place: no echo here of the Greek *polis* or the Latin *civitas*, which connote a political and socio-economic group; that is, the territory of human activities and not just the urban part.

The labour question is one aspect of the general debate which has a technical side in the industrial city, namely workers' housing, determined by the huge demand. Analyzing the urban scene, with its ever greater concentration of new factories and migration from the land, brings out the consequent paternalistic aspect of capitalism, opposed by socialists and particularly by Marx, witness Engels' studies on working-class conditions in England. Since capitalism could not order the new industrial cities organically by means of spontaneous geography (attempts at this through

Beautiful Movement and the Park and Boulevard Movement; the latter, in spite of internal differences, succeeded in bringing grass-root pressure to bear on the administration: in 1857, the architect Frederick Law Olmsted began to build Central Park, New York, which he had planned.

There, too, new types of high-rise buildings were tried in steel construction to create office space for an industrial society in whirlwind expansion, unlike anything in Europe. Chicago was the testing ground for the townscape of large new buildings devoted to tertiary activities: here, in the early 1900s, function becomes everything, and all architectural ornament disappears. By contrast, in pre-1914 Europe with its avant-garde figurative arts, architecture tests its novelty in a sort of linguistic crucible that now seems the place where national peculiarities converged.

All this under the sign of modernity, in a strong cosmopolitan sense, which overcomes, in the forthright and independent architecture, the common medium built up in the preceding decades by the bourgeoisie in power, through the eloquent signs of growing urbanization, in the explicit picture of dependent architecture: ministries, large theaters, railway stations. In the city of eclectic architecture one seemed to turn the pages of a great three-dimensional book on architectural history: every style was there, with a preference for the great halls of mannerist classicism. Determinist historicism saw in medieval architecture (coeval with the rise of modern nations), and in Romanesque in particular, the testing ground for national styles. Schools of true professionals began to form, and by this very neo-Romanesque (based on displaying complexity by the close link between brick walls and dressed stone) were forced, within the material limitations of building practice, to exert direct control over both planning and construction. This was in marked contrast with the nineteenth-century habit of severing architect from engineer (opposition between École des Beaux-Arts and École Polytechnique), and the former had only to design while the latter managed the con-

company towns in the late 1800s, when in Europe and the United States factory and housing were built together to improve efficiency, made no great dent in the problem), new Utopian plans emerge in the early 1900s: the Garden City Association was founded in London in 1899, while 1902 saw publication of Ebenezer Howard's *Garden Cities of Tomorrow*, which expounds an organic relation between one-family homes and working in urban and rural settings. The first modest attempts at this social project were drowned in the huge oil-slick growth of urban fringes, in the alienating bands of identical small houses, characteristic of Britain and the United States. However, for fifty years already there had been in the United States a trend that issued in the City

As early as 1915, Giorgio de Chirico had foreseen (top) an alternative hypothesis to the then ruling models of development in his Metaphysical Interior with large factory (Staatsgalerie Stuttgart). The factory is represented as essential to the laboratory of life, but outside the genuine city of squares suggests a post-industrial city.

struction. The new encounter of architect and engineer ensured that technology might come directly to express artistic values, irritating both forms and materials, and giving even to asymmetry and therefore to movement a new leading function in the life of the figurative arts.

The avant-garde tendency

At the exhibition of 1902 in Turin, a large international section was devoted to the decorative arts: a stamp of approval of a new taste, widespread everywhere for more than a

European architectural ideas in a free field of stylistic experiment by forming a new artistic dimension, not derived from architecture viewed as simply stating bourgeois power in the last century.

In the first decade of the twentieth century, these works as a whole share an immense creative use of materials free from any stylistic prejudice. The present is felt to be superior to the past, history is no longer considered present as before, even in art. The modern is linked with the notion of progress, constantly realized in science and the resulting technology. That is modernity as displayed in urban

architecture at that time.

The works of Victor Horta (1861–1947) and Henri van de Velde (1863–1957) in Belgium; Hector Guimard (1867–1942), Auguste Perret (1874–1954) and Henri Sauvage (1873–1932) in France; Antonio Gaudi (1852–1926) in Spain; Otto Wagner (1841–1918), Joseph Maria Olbrich (1867–1908) and Joseph Hoffmann (1870–1956) in Austria; Charles Rennie Mackintosh (1868–1928) in Scotand; all display the new taste, in steel, reinforced concrete, ceramics and tiles. From this core there are various offshoots: Robert Maillart (1872–1940) in Switzerland builds reinforced

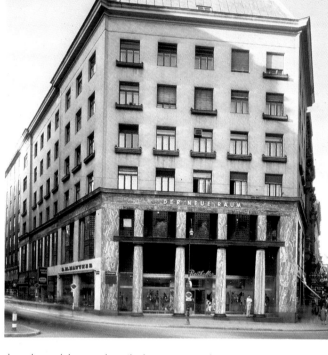

Left: building in Michaeler Platz, Vienna, by the architect Alfred Loos, 1910. A pupil of Wagner, he rejected the Viennese Secession for an architecture based on eliminating decoration. This proto-rationalism sparked a controversy in Vienna and throughout Europe.

Opposite: another exemplar of figurative renewal round 1900: the front of the Casa Milà at Barcelona built by the Catalan architect Antonio Gaudí (1905–10). Champion of Spanish architectural innovation, he does not pursue a strict line of expressionism, but looking for inspiration to Romanesque, Gothic and neo-Gothic (after Viollet-le-Duc), Mudéjar and Baroque.

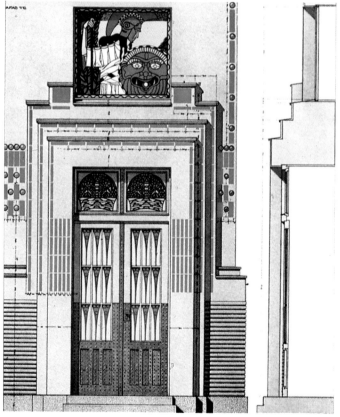

decade and here exhaustively represented, not only as an architectural experiment. It still has national names: *Art Nouveau* in French, *Jugendstil* in German (from the journal *Die Jugend*), *Sezessionsstil* in Austria (linked with the Secession movement in Vienna), Modern Style in English. The Italians called it Liberty, after the London store, a sign of anglophile sentiment, or Floreale. All this shows that the new taste is rooted in the new consumerist lower middle class, giving it a new common medium; the article of use seems like the vanguard example of a whole army following, in which architecture becomes explicit. The new taste thus puts forward new kinds of relation with the industrial city: it is not the city as a whole that is under consideration but its several parts, in which what is new can be inserted anywhere like a high-grade jewel.

Regional schools add their few casual works to the urban mass, articulating modern

Right: a design by the Austrian architect Otto Wagner for the entrance of the second Villa Wagner, 1905. The Viennese Secession is the national form of Art Nouveau and makes learned use of geometric decoration.









concrete foundations at odds with nineteenth-century classicism. The landscape now seems marked by bridges, viaducts and mushroom-shaped bearing structures, taking architectural style to much vaster constructions with their own sculptural impact. In Germany, Peter Behrens (1868–1940) tries out in industrial architecture (witness the AEG Turbinenfabrik built in Berlin in 1909) the principles of architectonic rationalism, as did his pupils Walter Gropius (1883–1970) and Adolf Meyer (1881–1929) in building the Fagus works of 1911 and the model factory at Cologne in 1914. In Austria, Alfred Loos (1870–1933) put forward other basic models (an essay of his from 1908 is entitled *Ornament and Crime*) in his Viennese buildings: the Steiner house and the house in Michael Square, both of 1910. This came to be called proto-rationalism.

The Swiss architect Charles-Edouard Jeanneret (1887–1965), after World War I known as Le Corbusier, worked out plans for a Domino house, a standardized system for mass-producing reinforced concrete buildings through assembling columns and stairs with the ceilings of the various floors for whatever use desired. In the United States, Frank Lloyd Wright (1869–1959), who later advocated organic architecture, in the early 1900s tried out a new version of the one-family home; his prairie houses (the Robbie House, Chicago, was built in 1909) are romantic models of individual liberty against the uniform behaviour imposed by the new city (for which his only realized plan is the Larkin Company Administration Building of 1904, then a strong new exemplar of office buildings by the Chicago school).

In Italy, the precocious Antonio Sant'Elia (1888–1916), formed in the Milanese symbolist setting and influenced by the Viennese Secession, put forward his views of the mechanized city at the "New Tendencies" movement's Milan show in 1914: some months later Filippo Maria Marinetti persuaded him to

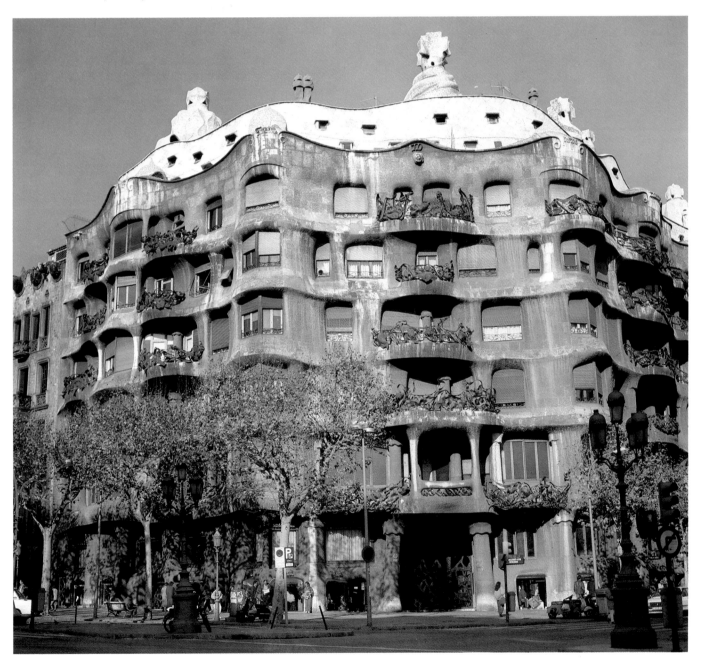

use them as plans for futuristic architecture (joined to the coeval manifesto). However, there are other links, less casual and less important than that of Sant'Elia with Futurism, in various avant-garde attempts at applying to architecture the principles developed in other figurative arts, a sign of the dominance of painting and sculpture. Take, for example, the sculptor Raymond Duchamp-Villon, brother of Marcel Duchamp, who in 1912 proposed a model of cubist architecture, which was fairly widely tried in Austria-Hungary before 1914, in the Czech and Bohemian schools.

Expressionism (the term was coined in 1911), too, inspired architectural experiment before the First World War, but its main products belong to the postwar years. Rudolf Steiner (1861–1925), architect, writer and esoteric thinker (member of the Theosophical Society, which he left in 1913 to found the Anthroposophic Society), evolved his style in the ambit of expressionist poetry, witness the Goetheanum built at Dornach, 1913–1920, and even more the second Goetheanum of 1924. The Expressionist element, variously manifested in its champions, marks the later work of many German architects who formed their artistic personality at that time: witness Hans Scharoun (1893–1972), Hans Poelzig (1869–1936), Erich Mendelsohn (1887–1953), Bruno Taut (1880–1938), Fritz Hoger (1877–1949), the brothers Luckhardt, Wassili (1889–1972) and Hans (1890–1954), and Hermann Ludwig Finsterlin (1887–1973). The idea of an Expressionist city moreover figures in scenography, that testing ground of future urban models: here, as in Soviet Constructivism, both on stage and screen (for example Robert Wiener's *Dr. Caligari*, 1919, and Fritz Lang's *Metropolis*, 1926).

Right: the shaping of the sculptor Raymond Duchamp-Villon's Cubist House of 1912, programmatic rather than experimental as an attempt at joining avant-garde painting trials to architecture (which was to be achieved by the abstract painting of Piet Mondrian and the neo-plastic architectonics of Gerrit Thomas Rietveld).

Left: the Wassili armchair, in bent chromium tube, planned for industrial production by the architect Marcel Breuer in 1925, in the Bauhaus climate of research and design; its ethical and formal rigour became a symbol of a new modern taste in the 1920s.

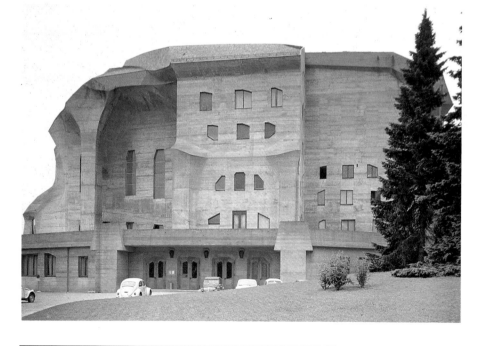

Left: the Goetheanum, temple of theosophy, built 1924–28 by the esoteric architect Rudolf Steiner. It plastically adapts an expressionist way of building which has parallels in painting, sculpture and literature along with experiments on stage and screen.

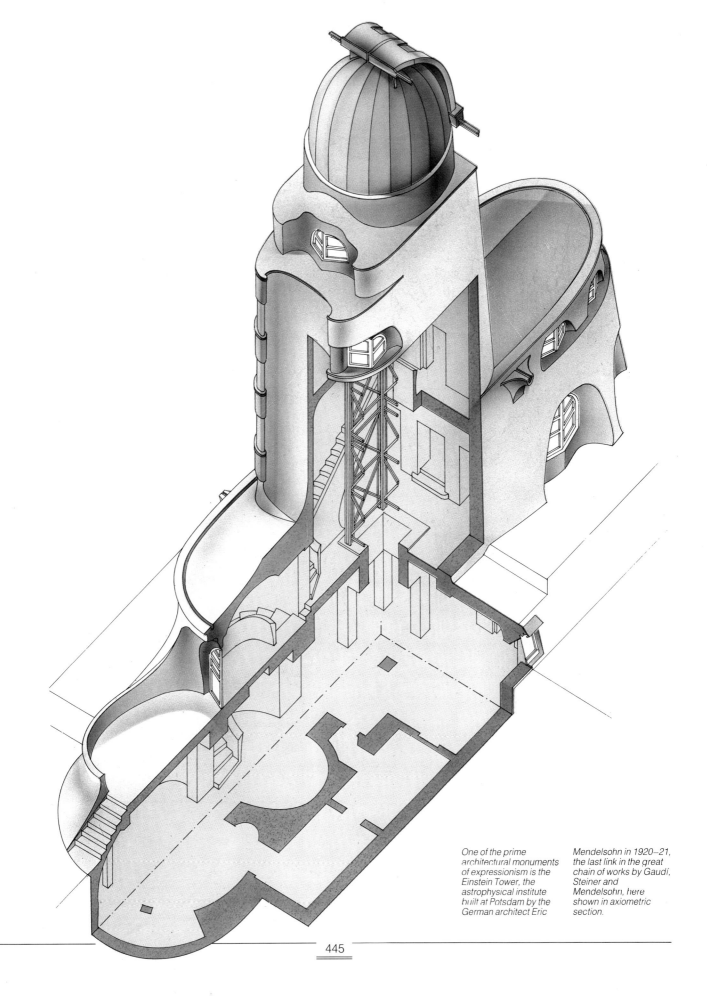

One of the prime
architectural monuments
of expressionism is the
Einstein Tower, the
astrophysical institute
built at Potsdam by the
German architect Eric

Mendelsohn in 1920–21,
the last link in the great
chain of works by Gaudí,
Steiner and
Mendelsohn, here
shown in axiometric
section.

445

The modern movement

The First World War brought a sort of watershed in architecture, between the different experimental elements and the overall modern movement, as the renovators called themselves in their joint postwar reconstructive efforts. What Bruno Zevi called the polygenesis of the modern movement is the set of cultural and human events at the base of architecture without style, following the developments of the last century: without style, but still expressive of a definite taste. History has a break here, but a gallery of forebears

affords effective reduction, artistically speaking. The approach is modern and international, from the very first publications soon to be universally successful: Walter Gropius, *Internationale Architektur*, Munich, 1925; Ludwig Hildesheimer, *Internationale neue Baukunst*, Stuttgart, 1927; CIAM (Congrès International d'Architecture Moderne) is formed in 1928, first meeting at La Sarraz in Switzerland; Bruno Taut *Die neue Baukunst in Europa und Amerika*, Berlin, 1929; Henry-Russell Hitchcock & Philip Johnson *The International Style*, New York, 1932.

The old academies of art give rise to new

Architectonic rationalism tried to put order not only into the way of constructing a building, but also into the possible city formed by new architectural proposals. For the new suburban belts of industrial cities the rational model codified solutions no longer anxious and withdrawn like fin-de-siècle ones: yet the implied assumption that an aesthetic movement could improve the world produced the suburban deserts the world over (avant-garde artistic and moral tension being changed into the pervasive banality of the post-war international style). The Bauhaus, home of this rationalism, a monument to its own principles, was built by Walter Gropius at Dessau in 1925.

Opposite: In 1927, the painter Reinhold Nägele painted a distemper entitled New buildings at Weissenhof (the Stuttgart quarter built in the rationalist way at that time). The work represents a prophetic vision of our own recent suburbs, a virtually programmed order dissolving into actual disorder.

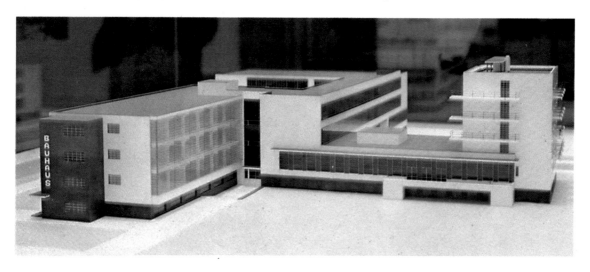

emerges: Nicolaus Pevsner's *Pioneers of the Modern Movement from William Morris to Walter Gropius* (London 1936) outlines the whole field of architectural experiment from the late nineteenth century on, particularly forms that are clearly protorational, while stressing individuals (defined from a critical historical and propagandist angle as masters of the modern movement). Basically this means reusing the old principles and concepts of functionalism and rationalism, worked out in the Enlightenment. The former concerns the aesthetics of those who work with rational and utilitarian criteria of order to meet the functional demands of art, as happened in the eighteenth-century polemic against baroque (early British industrial architecture was called functional). Rationalism, rooted in functionalism, tends to use reason to solve the many problems (both of quantity and quality) posed by industrial society. Thus it opposes all extravagance, as it had earlier rejected baroque, and the excessive artistic individualism of the eclectic age.

What helped to spread this idea is the concept of modernity (as against antiquity and, along with it, the idea of clear imminent progress) and of movement, generous like the idea of progress itself, which affects all mankind. Regional themes and problems were tackled in their own historical settings, for this

schools of the modern movement: Walter Gropius founds the Bauhaus in Weimar, while in 1920 the Vkhutemas is set up in Moscow. Both pursue the modern and international, insisting on rationality serving the social needs of leftist politics. In this way the new aesthetic qualities become quantitative as well.

The revolutionary Utopia of the Soviet sociologist Yuri Larine, for example, widely followed in the Russian school, is at one with rationalist researches by Soviet architects, who used the models of collective dwellings to attain living possibilities for all, even if only as bare survival.

In the Germany of the Bauhaus, the concept of a minimum for existence was worked out to the same end: given the lack of adequate means, we must fix a minimum shelter for everybody. In this rationalist egalitarian framework the modern movement developed the concept of standard, the least amount for each citizen, in housing or urban services, as a social goal.

After 1930, Stalinism and Hitler's rise to power prevented such qualitative thinking entering calculations of essentials; in the interwar period this novelty remained the preserve of the modern movement's masters, whose works were examined ever more closely by later generations.

Walter Gropius (1883–1970) was the stan-

dard-bearer of a method most fruitfully tried out in his own school, expressing in the edifice of the Bauhaus itself (Dessau 1925) its architectural monument. In that year a pupil of the school, Marcel Breuer (1902–82), showed in his tubular steel armchair that this design method could be usefully extended from spoons to cities. Planning and organizing everything, ordering the world, seems to be the rationally malleable future in store for us. In German cities, experimental belts were organized, both in quantity (housing for workers) and quality (actual three-dimensional exhibitions of the new architecture). Witness the Weissenhof at Stuttgart, where the most brilliant architects of the modern movement, Le Corbusier among them, built their models. The painter Reinhold Nagele represented the resulting whole, and this foreseen order is manifested in the form of chaos, warning and metaphor of what was to be a largely uncritical extension of the rational method to the historical city.

In the Soviet melting-pot, formed by the great pre-revolutionary avant-garde artistic traditions, futurist cubism and suprematism, constructivism is the expression of avant-garde architecture conducted by Vladimir Tatlin (1885–1953), Nicolai Ladovsky (1881–1941), Mosei Ginzburg (1892–1946), the three Vesnins: Alexander (1883–1959) Leonid

(1881–1941) and Viktor (1882–1950), El Lissitsky (1890–1941), Konstantin Melnikov (1890–1974), Ivan Ilich Leonidov (1902–59), and Mikhailov Barsc (1904–76).

Some Bauhaus members emigrated to Russia, feeling that only in the country of socialism could the principles of the modern movement's rational egalitarianism be expressed. In 1930, for example, Moscow saw the arrival of the May brigade, called after the German architect Ernst May (1886–1970), who planned several industrial cities, among them Magnitogorsk: others came before and after him, such as the Dutchman Mart Stam (1889) and the German Hannes Mayer (1889–1954), both students and teachers at the Bauhaus. At odd times other masters of the modern movement likewise planned and built in the Soviet Union, by government invitation or requests from young local architects: Erich Mendelsohn, André Lurçat, Le Corbusier.

More pragmatically and arising from actual local needs, in social democratic Austria they built Red Vienna, where workers' housing, the foremost feature of the industrial city since 1850, produced not only unsusual methods and experiments, but imparts marked urban qualities with its courtyards flanked by blocks, of which the Karl Marx Hof, built in 1926 from plans by Karl Ehn, is important example.

The social problem of workers' housing is the basic theme of the consensus strategy of inter-war democratic governments, as part of the wider needs of ever greater urbanization even after the crisis of 1929. From these masses arises the quality marking the works of the modern movement's masters, proclaiming both their lucid plans and their strong leading ideas. Their reputation appears in the journals run by young architects everywhere, not least as a sign of cultural and professional self-assurance. Thus some works of these champions gain international notice; that leaves a vague half-shadow over some real problems in this many-sided and swiftly changing field.

The masters of the modern movement

Le Corbusier put forward his architecture and the mode of applying it to the modern city with poetic arrogance and a charming disdain for history. In 1922 he presented a project for a contemporary city, a model without geographic, economic or social ties, for three million people. In 1925 he worked out a neighbourhood plan, an absurd proposal for demolishing and rebuilding Paris, revised in the 1930s. In 1929 he produced his urban plans for São Paolo, Rio de Janeiro and

Buenos Aires, in the manner of a great figurative sign on the terrain. A similar plan was adopted for Algiers in the early 1930s, opening the way for cultured colonialism (while the traditional kind left attenuated signs of European culture in every continent). In 1935 he presented his project for the radiant city.

The mechanistic aspect, the house as machine for living in, amounts to destroying the real city and introduces the shape of suburban extensions where buildings are set by the most favourable sunlight, ignoring streets, which become mere hydraulic conduits for traffic. Thus, reducing cities and the new sites for dwellings did not become a convincing urban program (which his plans for Paris and the South American cities seemed to be because of their poetic force). In 1933, Le Corbusier conducted the fourth CIAM congress on a cruise from Marseilles to Athens, on the topic of urbanism, but its message, the Charter of Athens, came out only ten years later. We can thus attribute many suburban developments of this time to the futuristic charm of his projects, so rational as to become abstract *vis-à-vis* any human geography and thus able to convey a mainly utilitarian view of the scale of needs, though this was later largely ignored.

In 1928 he began building the Villa Savoie,

where he showed, with great poetic force, his architectural principles, formed in the purist climate of the experimental avant-garde ("architecture is the wise, correct and magnificent play of forms assembled under light"). The buildings are propped up by piles that give continuity to the garden under the house. The roof is flat, with a terrace. The plan is free from the constraint of traditional bearing partitions (these are not the walls that form spaces).

The great German architect Ludwig Mies van der Rohe (1886–1969) emigrated to the United States after the Nazis came to power, as did many of his colleagues. For three years he was director of the Bauhaus. His style is taut and lucid, the supreme artistic expression of functionalism. The attendant rationality of his projects turns ethical values into aesthetic ones, in a form of teaching by unique exemp-

Three town-planning designs by Le Corbusier. The unreality and fierce arrogance of his urban plans led to rationalism abstractly venturing on the complex urban scale.

Right: the Paris neighbourhood plan of 1925 provides for demolishing the Marais and setting up a new urban texture.

Below: ribbon development with covered motorway for Algiers in 1930.

Bottom: plan for the city of three million inhabitants, 1922.

Opposite: Villa Savoie built by Le Corbusier at Poissy, 1929–31. This dwelling, unusual in structure and social impact, shows his principles for renewing building practice worldwide: construction on supports, a façade independent of walls, flat roof usable as terrace. Of post-1918 formation, he belongs to the group of post-cubist artists and was strongly influenced *by the purist painter Amadée Ozenfant. Purist rigour becomes in Le Corbusier an essential method to be used universally, to the point of becoming dogmatic. In his individual buildings he links his principles with a strong streak of poetic shaping.*

lary models (the project for a skyscraper on polyform plan for Berlin, 1919; the German Pavilion at the 1929 exhibition in Barcelona; the School of Architecture and Design of the Illinois Institute of Technology, 1952; the project for the Convention Hall in Chicago, 1953; the Seagram Building in New York, 1958; these are some of his poetic documents that show the masterly use of new building materials: steel, glass and reinforced concrete).

In the inter-war years, Frank Lloyd Wright put forward his view of organic architecture arising from his earlier experience (in particular the exceptional setting of "prairie houses"). He openly fought against the mechanistic passion of American society, and therefore against the rationalist method. More than his private and personal school (the community founded at Taliesin between 1910 and 1920), it was his works that spread his architectural views and proposals. The project for the horizontal Broadacre City (1931) is a Utopian plan for a harmonious city, where one-family homes might prevail instead of actually bringing alienation as everyday experience showed. The Kaufmann House (with a cascade) built at Bear Run in 1936, exemplifies his view that man's place is central in architecture. The Guggenheim Museum in New York (1946–1959) vividly shows how uneasily quality sits in

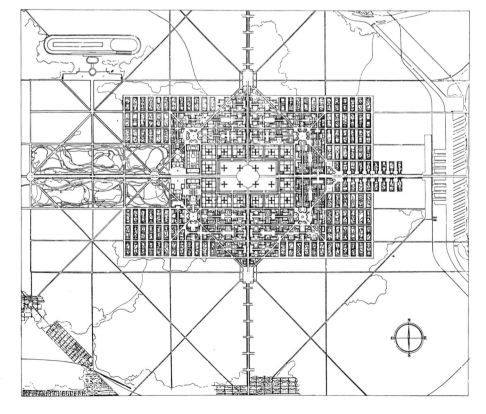

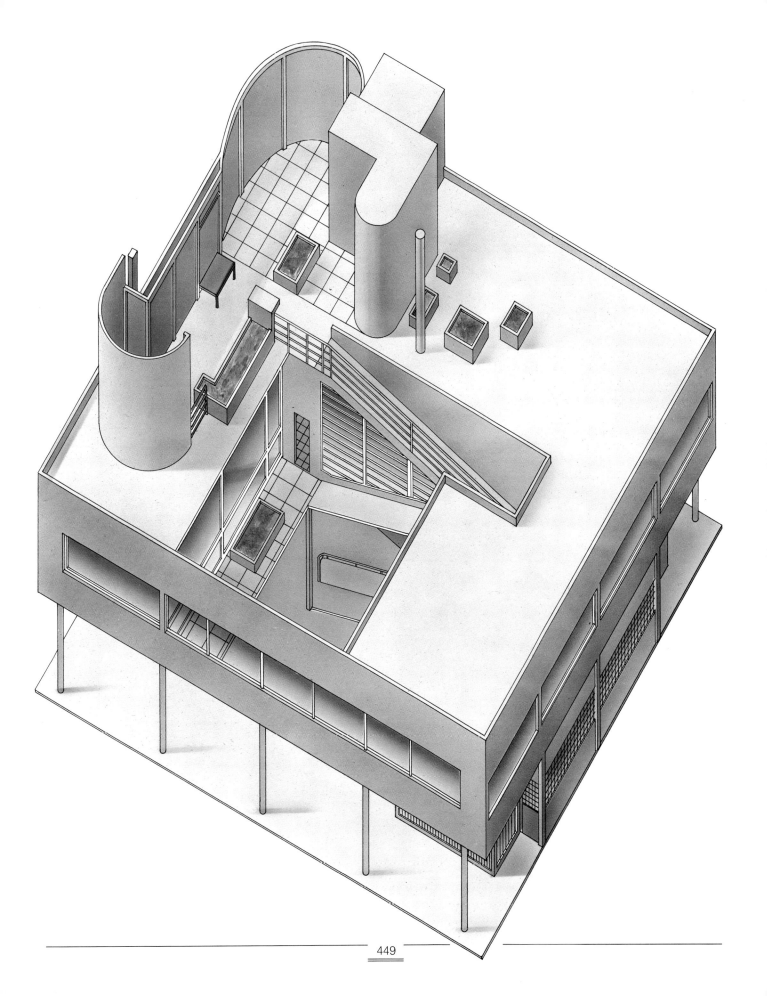

an urban mass setting.

Another orthodoxy, as against the increasingly rationalist core of European culture, is shown by Scandinavian empiricism, in the works of its foremost champion: Hugo Alvar Henrik Aalto (1898–1976). He relies on giving functional answers of great figurative force, without any preconceived model. His best inter-war buildings are new points of reference: the Municipal Library of Viipuri, 1927–35; the Finnish Pavilion at the International Exhibition of New York, 1938; and after the war the Baker House dormitory in Cambridge Massachusetts, 1947, and the Community Center in Saynatsalo, 1950.

Architecture and complexity

The modern movement's need to be cosmopolitan and the way its followers run the technical and cultural mass media have produced and spread a history of contemporary

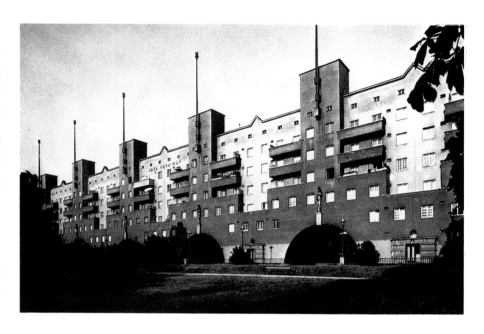

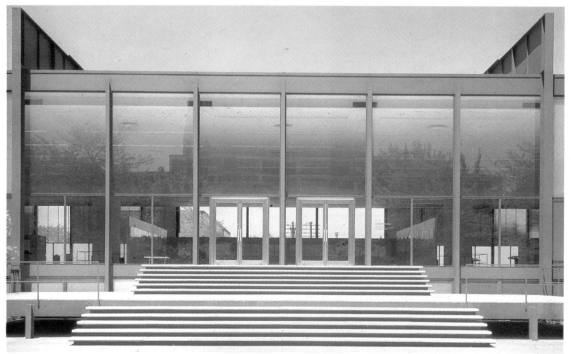

architecture that is just the history of the modern movement: in it one deals not only with numerical facts of human geography this century, but also with qualities other than the ones backed by such principles. However, cultural complexity imposes a view of architectural history as part of the wider history of building, with which architecture has its own complex links. This in turn forms part of history in general, as conceived by students of the Annales school of Paris. They produced the recent attempt at global analysis free from any

Top: the Karl Marx-Hof, built in Vienna by the architect Karlm Ehn in 1927, typical of housing under socialist administration after the First World War.

Above: the School of Architecture and Design of the Illinois Institute of Technology, built in 1952 by Mies van der Rohe, great master of architectural rationalism. In Germany he had directed the Bauhaus, 1930–33; when the Nazis came to power, he fled to the United States and continued his career.

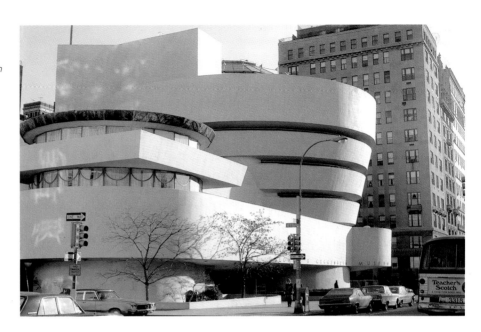

Right: the surrealist appearance of a curvilinear building in the orthogonal network of New York is realized in the Guggenheim Museum, planned and built by the American architect Frank Lloyd Wright, 1943–59.

Left and below: example of high-quality experiments in Scandinavian empiricism, Baker House, a dormitory at the Massachusetts Institute of Technology, planned by the architect Alvar Aalto, 1947–8. The two pictures show the curvilinear front of guest rooms, and the plan of the whole building.

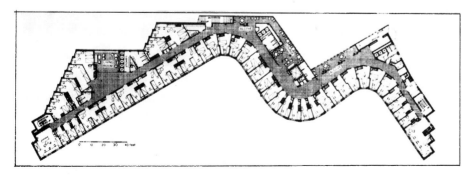

reductionism. Georges Duby has directed the five-volume collective work *Histoire de la France Urbaine*, 1980–85 (following the *Histoire de la France rurale*), the foremost example of such studies. Françoise Choay in volume four (*La ville de l'age industriel*) analyzes the syncretic aspect of ideas and projects for inter-war Paris, contrasting the progressive movement from architecture to urbanism with Le Corbusier as champion, with non-progressivist urban doctrines and theories advocated by the great historians of urban affairs such as Marcel Poète and later Gaston Barde, who favour a cultural view of the city.

Thus, today's city grows in a network of links and amassed uncritical practices of a distant building tradition, in an attempt at cultural renewal, with the new features of modern architectural views emerging of themselves. Meanwhile urbanism becomes everywhere more a matter of spontaneous siting (settlements arise following the economic laws of social development, in a tenuous web of building and urban regulations): deliberate siting (the physical result of a project and consequent plan) becomes very rare. Henceforth we can concentrate on this exceptional case, a potential paradigm for future human geography, given the practical and conceptual bounds of a universal and traditional architectural history.

In France in the 1920s and 1930s, for example, while cities arose through cloning as in the previous century, the rationalist avant-garde is balanced by an attention to a figurative aspect in which form and decoration blend in a unified project, expressed by the 1925 Paris Exhibition of Decorative Arts, often called "Art Deco". The work of the architect Robert Mallet-Stevens (1886–1945) marks this original movement of renewal, at odds with the

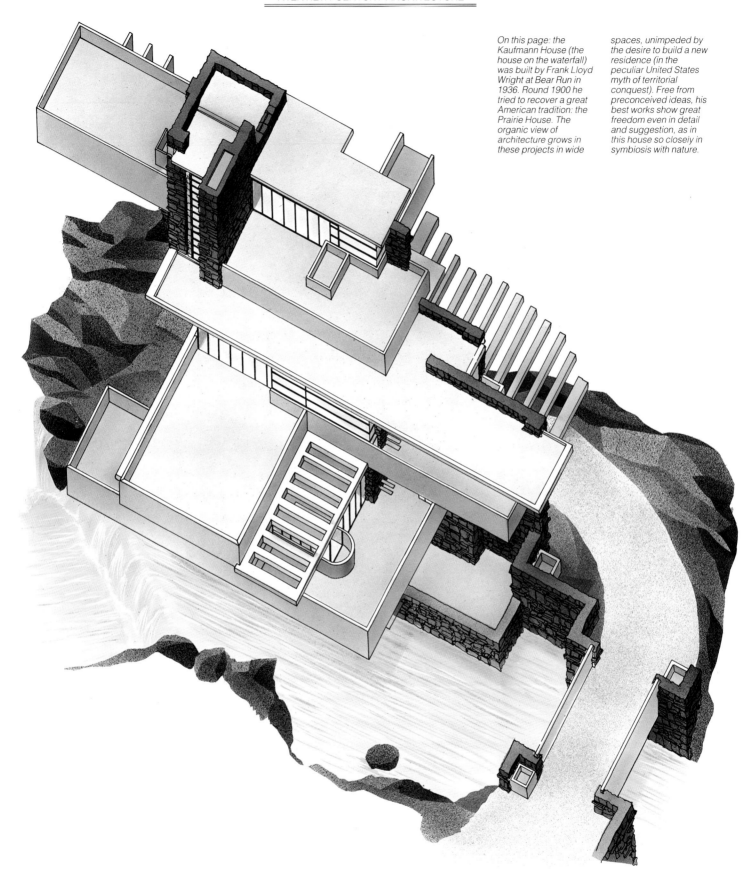

On this page: the Kaufmann House (the house on the waterfall) was built by Frank Lloyd Wright at Bear Run in 1936. Round 1900 he tried to recover a great American tradition: the Prairie House. The organic view of architecture grows in these projects in wide spaces, unimpeded by the desire to build a new residence (in the peculiar United States myth of territorial conquest). Free from preconceived ideas, his best works show great freedom even in detail and suggestion, as in this house so closely in symbiosis with nature.

aims of the modern movement, witness rue Mallet-Stevens in Paris, flanked by his one-family houses.

In the New York of the roaring twenties, before the great crash, Manhattan is the symbol of new skyscrapers, a functional answer to problems in directing the work and therefore linked to the Chicago school at the turn of the century, or a trite result of speculative building; it stands out like a program of symbolic architecture meant to exhibit the apparently infinite power of that economy. The form and decoration of these buildings shows how American architects in the 1920s produced new original images.

In the Netherlands after 1918 there were two opposed architectural camps. On one side a group of young architects pursued the neo-Romanesque teaching of a great master of early modernism, Hendrik Petrus Berlage (1856–1934). This is the Amsterdam school; they built new suburban belts for that city, making modern use of traditional elements, at times so brashly as to show their links with Expressionism (exposed brick, preservation and improvement of the urban street). The works of Piet Lodewijk Kramer (1881–1961) and Michael de Klerk (1884–1923) in the Eigen Haard district still show the great possibilities of this experiment. On the other side the abstract art of Piet Mondrian attracts a group of avant-garde artists into the movement De Stijl (also known as neo-plasticism). Theo van Doesburg (1883–1931) proclaimed and led it. Gerrit Thomas Rietveld (1888–1964) designed two great examples (the red-blue chair of 1917, the Schroeder House of 1925 in Utrecht), while Jacobus Johannes Pieter Oud (1890–1963) merged De Stijl and Rationalism to express an idea of the city rather different from that worked out by the Amsterdam school (the houses at Hoek van Holland of 1924).

Italy saw fierce contrasts at that time, for example where rationalist monuments like the Casa del Fascio in Como (1932) by the architect Giuseppe Terragni (1884–1943) co-exist with the translation into the urban scene of Italian squares in De Chirico's pictures (as Pier Paolo Pasolini noted) in the Palace of Italian Civilization at the EUR, Rome 1939, by architects Lorenzo Guerrini (1914–), Bruno La Padula (1902–) and Mario Romano (1898–).

In inter-war Milan cultural affairs are even more intricately mixed in the vast new texture of urban building. Giovanni Muzio (1893–1982) led the recall to order after 1918; for many avant-garde painters this meant a return to figurative work, while for Muzio it showed that we must regain a new historical order, namely neo-classicism. On this basis the new twentieth-century architectonic movement arose in Milan, exclusive and uncompromising, emphasizing the ethical impact of architecture (the Ugly House of 1922). The champion and leader of Rationalism in Milan was Giuseppe Pagano Pogatsching (1896–1945):

his Bocconi University (1937) exemplifying his moral view of modern architecture. One of the most fertile and auspicious Milanese architects of those years, Piero Portaluppi (1888–1967), expressed an iconoclastic layman's approach in the fray betwen the two "religions," twentieth century and rationalism (his Bridge House on via Salvini, 1926). His works always display an element of urban housing, while his style expressed systematic irony toward any history or codification of figurative work. (A recent exhibition in California was devoted to this side of his, showing him as the forerunner of post-modernism.)

In Stalin's Soviet Union, modernity is banned from the artificial setting up of continuity with national traditions. The architectural experiments of the 1920s is replaced by a vague syncretism of nineteenth-century European work: Moscow University and its skyscrapers are typical. In Nazi Germany, urbanism and architecture undergo a classicist reinterpretation, as in the leaders Paul Ludwig Troost (1878–1934) and Albert Speer (1905–

Above: an architectonic proposal of town-planning: the rue Mallet Stevens in Paris, formed by various buildings planned by the architect Rob Mallet-Stevens (1926–8). His strong attention to total figurative renewal (he was also a decorator, goldsmith, scenographer and designer) was peculiar to Art Déco.

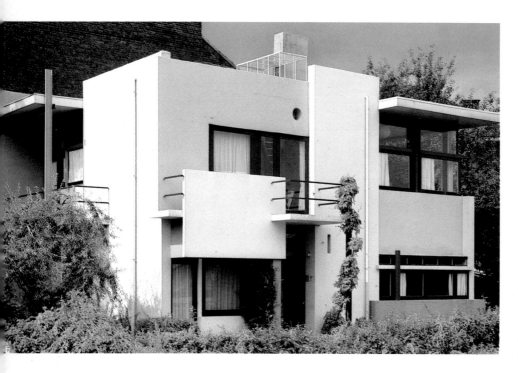

Above and right: the front of a design for architectonic ordering of internal spaces for the Schröder House built by the architect Gerrit Thomas Rietveld at Utrecht in 1924. The greatest monument of neoplastic architecture, a Dutch movement resting on cubism and linked with the painting of Piet Mondrian, round the journal De Stijl, founded in Leiden in 1917. The magic ordering of volumes, *areas and elementary colours was a program with strong poetic scope - for the figurative avant-garde and was a basic point of reference for Soviet constructivists.*

79). The latter's writings and plans have recently been republished for critical assessment of what objective value attaches to viewing architecture classically, without of course justifying the crimes of the regime and the man (thus the Belgian architect Leon Krier, in charge of publication).

After the Second World War

That period is marked by rebuilding the devastated areas of Europe and Asia and meeting the needs that war failed to satisfy everywhere, particularly in the Third World, rapidly moving toward independence. Architects of the modern movement were drunk with optimism, for they saw their principles as a universally valid method. Their failure is symbolized by the dissolution of CIAM at the Otterlo congress in 1959. The movement changed into an international style lacking a cosmopolitan sense of innovation or artistic work. Spatially bare and simple buildings rose in historic centers and suburban belts of cities in developed countries, and became the flimsy picture of an idea of progress imposed on the Third World by neo-colonialism. This seeming victory as to quantity was the origin of the modern movement's crisis. The tackling of it is current history, at best we can indicate a few features that will point beyond the various regional events.

In 1945, Le Corbusier built his machine for living in in Marseilles, with dwelling units of conformable size, a large isolated building in an area of over 1.5 million people, whom he forced to live as if on an ocean liner. His program for rationally rebuilding France stopped there. His chapel of Notre-Dame-du-Haut at Ronchamp (1950) and the convent of Sainte-Marie-de-la-Tourette near Lyons (1952) are two monuments of architectural poetry. However, he exported his method, with the project for the new capital of the Punjab, Chandigarh (1950): this is a great honour to a master of the modern movement from a new national community, but also a new form of colonialism and the implicit charge that the large-scale European projects are useless. The same goes for the American architect Louis Khan (1901–74) and his buildings at Dacca, the capital of East Pakistan, in the late 1960s. In the 1960s the town-planner Lucio Costa (1902–63) and the architect Oscar Niemeyer (1907–) built the new Brazilian capital, Brasilia, in a highy plastic, poetic rationalist manner, but such newly founded large cities were immediately ringed by shanty towns at once settled by the building workers.

In the Third World, where European and American architects and engineers are working without providing solutions that respect setting and size, national consciousness arises through technical graduates from national universities proposing independent scenarios of development rooted in the local

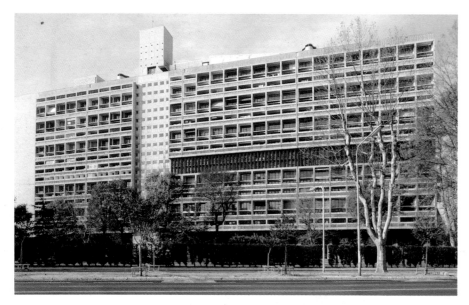

Opposite below: Le Corbusier's Unit of Habitation built at Marseilles, 1946–52, the first exemplar of advanced programs for a new architectural idea in the 1920s. Some 1600 people would have to live according to the architect's physical and behavioural dictates; it remained an isolated freak, though meant for rebuilding France and all Europe, a late example of an old avant-garde.

On this page: the top of the Chrysler Building, New York, started before the crash of 1928 and finished in 1930, is a paradigm of new U.S. architectural decoration of home-grown art déco based on aggressive modernist forms and the use of new building materials such as rust-free steel.

A taste for paradox winks at customer and user via the architect: the two projects for U.S. supermarkets here seem to say it aloud. The aesthetics of the ruin (opposite) is the poetic picture of the commercial center (as if in this way declaring that in life consumerism is transient), projected by the SITE group in Texas, 1974–5, Interminate Façade, Almeda-Genoa Shopping Center, one of many commercial buildings planned by the architectural group for the Best chain.

culture; witness the cultural project of the Egyptian architect Hassan Fathy, who was the first to abandon the short cut of Western technology and its ethos, and of the modern movement, in order to work out the program for organically building a city with the people, using traditional forms and materials.

In the United States, after 1945, the split between architecture and building industry seems to rest on democratic tradition: if everyone has the right to express his political vote, why should not the urban landscape (mainly formed by one-family houses) be the set of choices dictated by individual taste, even as regards style? Robert Venturi (1925–) analyzed marketing motivations in this field, examining the symbolism of a house of the Levittown type: the discovery of kitsch in building and in articles of use, and his new assessment, leads him to new projects that are more soundly and subtly based, namely post-modernism. The building industry meanwhile proceeds by offering complete building kits in various sizes and styles that each user can choose beforehand.

The post-modern movement is rooted in this American approach, alien to any religious feeling in architecture, and plays the post-prohibition game (imposed by modernism on anything alien to it) in alternating between noisy signs and cultural demands. When the supermarket group Best decided to refurbish the image of its stores, it invited many young architects to a competition, and entries were shown at the Museum of Modern Art in New York: all desecrate the traditional notion of the temple of commerce, winking at the now possible self-irony of the average consumer. The SITE group put forward a building in the form of a ruin, connoting a conviction that consumer society's values are in rapid de-

Top: the chapel of Notre-Dame-du-Haut, a work of architectural sculpture built by Le Corbusier at Ronchamp, 1950–53, his most learned and poetic breaking of rigid functional rules in architectural rationalism, almost a refuge in contemplative faith, whose teaching and examples the laity did not adopt.

Above: The cover of a U.S. journal with suggestions on choosing a family house. The issue contains pictures of projects in various styles and types of dwelling. Choosing one's architecture is here intended to be as democratic and liberating as the vote.

Sociological irony (left) inspires much American architecture disowning modernism and therefore hastily called post-modern. It applies to this project by the architect Stanley Tigerman for a new supermarket of the Best chain in 1980. His sociological analysis of town-planning concerns the boundless extension of American fringes by family houses, of which one becomes a mistake, namely the supermarket.

cline. Stanley Tigerman planned a one-family house of huge size when compared with a normal one: a maternal building to which to rush for daily needs. In 1980, at Portland Oregon, Michael Grave built the monumental Portland Building, in which the history of architecture is revisited and ransacked in a playful way.

In France the Spaniard Ricardo Bofill, with his monumental edifices of popular housing at Marne-la-Vallée (1979) and the Place d'Occitanie at Montpellier (1983), built new townscapes going back to French classical style, as against the modernist townscape of the Paris *banlieue* of earlier decades. In both cases he used prefabricated sections, useful in meeting demands of quantity, but he showed that this technique can be used as an instrument for various different figurative ends, witness the more anonymous suburbs and these new ones by Bofill.

In the United Kingdom under the first post-war Labour government, the old dream of garden cities is realized in the new towns round London hemmed in by the green belt planned by Patrick Abercrombie (1879–1957). The latest is Milton Keynes (1972), which shows that this is not a universal solution and failed to reach the intended results, partly because of the rise in price of building land in the town that wished to limit its growth.

The English town planner Ron Herron met a social dream with a slightly ironic technological fancy in his project of the Walking City (1964), a mechanized place able to carry urban values anywhere; in the same year, the architect James Stirling built a Library for the Faculty of History at Cambridge, subtly adopting traditional methods using steel and glass. Technology is in evidence in the great geodetic domes of Richard Fuller (1895–), with one of which he intended to cover the center of Manhattan in 1968; and in the technological

Above: this small model for the Portland building erected at Portland Oregon in 1980 is due to Michael Graves, a U.S. post-modern. The renewal of central parts in small and medium-size American cities has been entrusted to the successful trend of opposing the modern movement's fifty years of banishing the figurative. History can be revisited and quarried at will, for once more putting forward new signs that everyone regards as old.

Right: the town-planning scheme of the architect Kenzo Tange for doubling the size of Tokyo by building on the bay (1960), a fascinating dream of megastructures, lucid but not practicable. Meanwhile the conurbation of Tokyo and Yokohama grows chaotically and beyond measure. This is the latest global modern plan for a city in the spirit of Le Corbusier's plans in the 1930s.

Right: a view from new suburban belts full of aggressive historical hints shows a recent work (1979–84) by the Spanish architect Ricardo Bofill at Montpellier, Place d'Occitanie. Rejecting suburban alienation due to the international style (witness the banlieue of Paris), Bofill here captiously uses the history of architecture as his security.

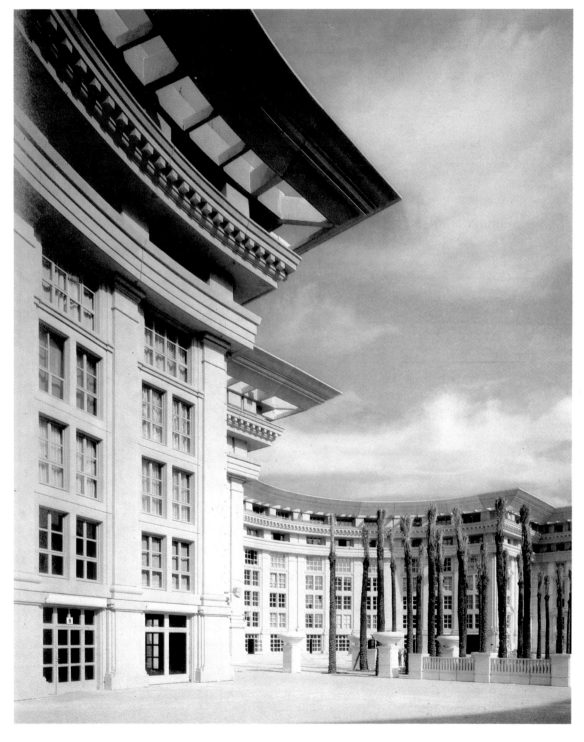

effect of the slightly curved tent covers by Otto Frei (1925–), amply tried in the spatial layouts of the 1972 Olympiad in Munich. In 1960, the Japanese Kenzo Tange (1913–) had large-scale technological projects for expanding the conurbation of Tokyo to the sea.

The strongest postwar Utopian tension lies in poetic imagery, if this can give reason and value to architecture, away from the plans of international style, the facile game of post-modernist irony and the ways of the building industry. The worldwide critical acclaim of Aldo Rossi (1931–) is due to his specific classical aim for an autonomous architecture. The feature of poetic force in his images is not quantitative, nor pretends to put the world to rights, but is its own reward, holding its very presence to warn and teach. The youngsters of *Archives d'Architecture Moderne* of Brussels (Maurice Coulot and Leon Krier above all) totally reject architectonic Modernism and declare that the champions of international style, who are responsible for the cancerous destruction of our cities, should be subjected to a new Nuremberg Trial, for architectural and planning crimes: we can no longer invent new forms, but must repeat those accumulated in our classical past. From the clear warnings that were launched for our present at the start of the century, we can draw some glimpses of the future.

Above: a design by Aldo Rossi, composition with the Modena cemetery and student houses at Chieti of 1975. The critical fate of Aldo Rossi concerns any school of architecture anywhere. His work is constantly referred to by teachers and students, and his poetry acts solely through strong images.

In 1914, Filippo Tommaso Marinetti persuaded the young Sant'Elia to present his plans in the form of a model of Futurist architecture. He even uses the architect's writings to edit the attendant manifesto, but he manipulates them and introduces a concept that could only be alien to Sant'Elia's idea centered on architectonics: basically, Futurist architecture will be frail and transitory; houses will last less than we do; every generation will have to create its own cities. This notion of architecture at the service of human needs now seems a credible prophecy if it refers to the general project of reusing urban products and building a post-industrial city.

In the years before the Stalinist era, Trotsky rejected the notion of one avant-garde gaining stylistic sway over another and wrote: "Aesthetic schools in their turn will regroup themselves in parties, in groups based on their features, on tastes and on intellectual drift. In these intense unconscious struggles, on a constantly growing cultural base, human personality will develop in every sense, refining itself by the priceless basic feature of never being satisfied with the result attained."

We might look at the chaos of our own setting with optimism, as at a cultural broth generating the new eclecticism of constant experiment.

Left: a design by Leon Krier of 1978, for rebuilding European cities, a program that rejects rationalist method and international style, defending a new relation with history.

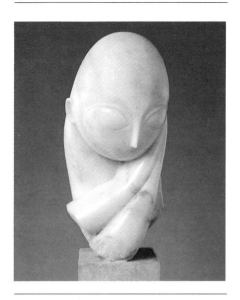

Twentieth-century sculpture

In considering sculpture from 1800 to 1900, it is harder to find a clear line of development like that in painting from Delacroix to Cézanne, as outlined by older and more recent books (among the latter the famous Signac essay *D'Eugène Delacroix au Néo-Impressionisme*, 1899), a conventional account of "modernism" and introduction to the new century. The half-forgotten sculpture of the last century is often viewed as unadapted to the rising expressionism and is therefore debased and deprived of its own role: hence we cannot easily read it, nor compare it with the painting and other art forms of the time. However, there are other ways of interpreting it.

Forerunners

Modern sculpture goes back to the period 1880–1900, when Auguste Rodin (1840–1917), at the height of his fame, produced *The Burghers of Calais* (1886); George Seurat showed his painting *Sunday Afternoon at La Grande Jatte* at the Salon des Indépendants in the same year, in which he goes beyond the vision and scope of Impressionism, even if not its iconography. In 1881, Edgar Degas (1834–1917) had exhibited a wax model of the *Fourteen-year-old Dancer* at the same Salon, cleverly inserting various extraneous features such as the dancing slippers, the tulle tutu, the satin ribbon tying the hair, all genuine; however, this unusual work had little bearing on the later development of sculpture, whatever the critical and public outcry at the time. Besides,

enhancing sculptures with actual objects and materials was already fashionable, although for rather different ends, for example, in the gold and ivory sculpture of Charles Smith, the jewels Henri Allouard applied to his *Femme Foulah*, and similar experiments by Gérôme and Rodin.

Still, these works are short of the excessive naturalism of Degas, who in his *Dancer* covers the wig with wax, redesigning it with pointed tools, applying colour and using various techniques, obtaining "a kind of dazzling mummy" (Loïs Relin), but also "one of the peaks of sculpture, even if by means of painting and design." Thus the story of painting seems to prevail: future developments are not determined by the sculptural experiments of Degas, Géricault, Renoir or Daumier. On the contrary, the fame and international following of Rodin grew. At the time of the *Burghers of Calais* he had already produced *The Bronze Age* (1884), *The Kiss* (1886) and was about to present *The Thinker* (1889). Here, he is inspired by the work and "spirit" of Michelangelo, adopting his spiritual heroism and incompleteness viewed as a huge "energy without rest" (A. Elsen).

Constantin Brancusi, Mademoiselle Pogany I *(1912–13, marble, 44 × 24.5 × 30.5cm/ 17¼ × 9½ × 12in). Museum of Art, Philadelphia.*

This formal device becomes symbolic (unlike the solutions of the Impressionists), allowing the artist to extend the romantic ideal of beauty to all modes of expression from beauty to ugliness, in a premature notion of autonomous form. Thus Rodin's last great monuments, dedicated to his revered Balzac and Hugo, clear the path to new sculpture: "This is the great meaning of the statue, showing form not as a finished state but as a process of growth revealed in all its stages, a form in search of its own end" (Werner Hofmann on the *Monument to Balzac*).

Two other great sculptors of the time are the German Adolf von Hildebrand (1847–1921) and the Belgian Constantin Meunier (1831–1905). Hildebrand, in the *fin de siècle* Symbolist climate, is the ideological opposite to Rodin. Besides, he had a critical mind: witness his seminal essay *The problem of form* (1893), proclaiming the true aesthetic rules by stressing the meaning of a work's conceptual plan, especially its architectonic structure. In his theory, a work of art finds expression in the pure essence of its lines and movement, in regular and abstract representations. Thus he sees sculpture as linked with architecture and prefers bas-relief to all-round volumes in empty space, hinting mainly at Classical Greek art and the Renaissance before Michelangelo, as in the rigorous marble reliefs of the *Wittelsbach Fountain* (1890–95, Munich), the bronze *Mercury* (1885–87, Weimar Museum), or the concise bas-relief of *Dionysus* (1890) kept in Florence in the ex-convent of San Francesco di Paola, where he

lived and worked from 1872, surrounded by a chosen circle of German artists and intellectuals. The works mentioned are typical, in their clear and regular unity and spatial weight, for the theories of "pure visibility" worked out by Konrad Fiedler, with the vital contribution of Hildebrand and the painter Hans von Marées. This visibility is first advanced as a "science of artistic seeing": concentrating on pure form, Hildebrand banishes from art all moral, intellectual and emotional certainty, thus foreshadowing Idealist aesthetics as to theory and emerging formalist solutions in art.

Meunier's most interesting period began in 1885, when he took up sculpture and gave up painting, where he had found and faced intimate themes and social realism with canvases like *Return of the Miners* or *Gleaning Women*, inspired by the indispensable suggestions of François Millet, leader of this tendency. Later, Meunier shows this same Realist-Symbolist spirit in sculpture, particularly in the admirable works dedicated to the heroes of labour. These subjects, unlike those of Courbet, often imbued with bitter social and moral accusations, and those of Millet, more spiritual than heroic, in Meunier acquire a new Symbolism, showing not so much the proletariat "but men who keep their dignity even in anguish" (W. Hofmann). They are figures of workers risen as champions of modern times, with noble faces resembling Classical features, or, more often, as reincarnations of Michelangelo's *David*, as in the *Carrier* (1905, Gallery of Modern Art, Venice) or the *Puddler* (Brussels); in other works he transfers Christian imagery into secular settings, as in the miner's wife weeping over her dead husband, *Firedamp* (1893), conceived on the model of a *Pietà*.

In Italy, such artistic hints were received and interpreted from 1880, particularly in the north, by sculptors such as Vincenzo Vela, Enrico Butti, Paolo Troubetskoj, and above all Medardo Rosso (1858–1928) and Leonardo Bistolfi (1859–1933). At this time, the first great National Gallery of Modern Art was set up in Rome, the Triennale of Milan started in 1891, the Biennale of Venice in 1895; in advertising we find the start of the journals *Emporium* in Bergamo, *Vita Moderna* in Milan, *Marzocco* in Florence, and others. To this setting belong the ideological and figurative modes of Bistolfi and Rosso, both from Piedmont and at first influenced by Lombard bohemianism, which for some time had turned open-mindedly to showing reality and minor unofficial lives. Thus, in the 1880s, Rosso produced models like *The Joking Singer* (title in dialect) and *The Concierge*, in clear Bohemian tradition, small works that show neglected people, not in the more pronounced style of social realism but fashioned more softly and introspectively. At the same time, Bistolfi fashioned models on similar topics: *Peasants, Rain, Washerwomen*. Later, the two sculptors differed in their choices: Rosso, expelled from the Brera, took refuge in Paris from 1889 to 1914, where in

direct and fruitful contrast with Rodin he developed a unique style not discovered or valued in Italy until after 1910, thanks to Soffici and Boccioni; while Bistolfi took to a mature Symbolism full of literary and philosophic references, from Morris to Maeterlinck to D'Annunzio.

In his works, echoes of Rodin mingle with reminders of paintings by Fontanesi and Segantini, to produce realistic subjects, wrapped in mists and glorified symbolic veils;

witness the relief *Pain* (1898), the famous monument to Segantini with a title and treatment reminiscent of Michelangelo and Rodin, *Beauty freed from Matter* (1900), and the *Monument to Carducci* (1908–27). From 1890 to the coming of Futurism, through the influence of D'Annunzio's criticism, Bistolfi's

sculpture and that of his many disciples, though ever conscious of Rodin and Meunier, becomes ampler and smoother in form and openly patriotic and ethical in content, sober but convincing.

Toward a new formalism

From 1900 to 1910, some European sculptors born after 1860 emerged, above all Antoine Bourdelle (1861–1928), Aristide Maillol (1861–1940), Georges Minne (1866–1941), Ernst Barlach (1870–1938), Charles Despiau (1874–1946) and Ivan Mestrovich (1883–1962). These artists, of various nationalities, share a training tied to the great masters of previous generations, which is finally overtaken by a new reforming and disruptive style, paving the way to conflict between different avant-garde schools. They belong to the generation whom Verlaine begged to "grasp eloquence and wring its neck," no longer believing in absolute traditional values and uninterested in telling and expressing moral or historical contents. Thus, while references to Donatello, Michelangelo and the whole Classical Renaissance school are flagging, we are given a new sculpture that is still, ecstatic, even totemic, void of messages and strongly tending to revive all kinds of archaism. Where Rodin had expressed man's spiritual emergence as artist, his pupils and followers renounce the romantic notion of ceaseless movement in favour of absolute immobility and a more unprejudiced formalism in using massive and solemn archaic forms.

The new period typically begins with Bourdelle's admirable bronze *Head of Apollo* (1900), where he abandons Rodin's lack of finish to produce "a firm construction in clean and clear-cut planes"; indeed, he sees in it "the first work in which I found my laws."

Bourdelle's sculpture, haughty, impetuous, now archaic, now exotic, found much stormy resonance throughout Europe, and Italian artists, back from the usual study trip to Paris, preserved clear traces of this radical renewal: witness the two young Tuscan sculptors Libero Andreotti and Romano Romanelli, in Paris between 1900 and 1910. Of the former we mention *The Fishmonger* (1918) and *Lady with Fan* (1920), showing clear signs of Bourdelle's style in marble bas-reliefs of 1912 for the Theater of the Champs-Élysées, and many other sculptures: "If one considers the atmosphere of the age, these works of Andreotti may, indeed must, be seen as anti-Impressionist manifestos" (Raffaele Monti). Romanelli, too, had absorbed Bourdelle's archaism and showed himself a front-rank sculptor in Italy in the 1930s. He expressed with great force firm and concise forms, leaving behind all inessentials for what he himself described in 1933 as "making the real spiritual." These attempts appear in some portraits such as that of *Miss D. H.* and *Randall Davies*

(1924). Meanwhile, throughout Europe sculpture turned to exalting form in itself, removed from extraneous values, as shown by the archaic examples of all times and places that artists study at the Musée Guimet in Paris, in more exclusive private collections and in ethnic museums everywhere. It was no accident that between 1900 and 1905 a group of English and Italian archeologists discovered the first important examples of Cycladic art, prior to the Mycenaean age, with finds that soon affected European sculpture. Alongside reference to primitive cultures we have the most varied motifs from the art of any century out of context and eclectically restated in a new and unprejudiced formalist style.

Among the most incisive interpreters of Bourdelle we mention the Yugoslav sculptor Ivan Mestrovich, who everywhere spread this style in a peculiarly eclectic way. He first studied at the Vienna academy and then in Paris, where he was in touch with Rodin and Bourdelle. After 1910 he was very successful, taking part in the Venice Biennale and the International Exhibition at Rome in 1911, where he came to the notice of the European art world. His sculpture admirably combines eclectic echoes of a "hieratic formalism aware of Byzantium and, gradually going back, Assyria and Persia" according to the artist and critic Antonio Maraini. We can add Michelangelo, Gothic art, the Secessions of Vienna and Munich (Max Klinger especially), as is clear from the bronze *Pietà* (1914) through to the late *Atlantis* (1946), which influenced many sculptors, above all the Italian Attilio Selva. Maraini, in terms of the features quoted, defines him as "the first foreign artist examined who is entirely and typically of the twentieth century."

Charles Despiau, too, developed in his works figures with hints of ancient style, though free from Bourdelle's and Mestrovich's excessive stylization. So much so, that in the portraits of the first decade, such as *Girl of the Landes*, in bronze, or the later ones such as

Left: Ivan Mestrovic, Memory (1908, marble, 150cm/59in). National Museum, Belgrade.

Opposite: Auguste Rodin, Kneeling Female Faun (c. 1884, bronze, 55cm/21½in). Musée Rodin, Paris. Rodin here treats the female nude with a symbolism rich in mythological evocation and the influence of Michelangelo.

Above: Antoine Bourdelle, Isadora Duncan (bronze). Musée Bourdelle, Paris. Bourdelle and Mestrovic abandoned hints at Rodin's sculpture and sought inspiration from various archaic civilizations.

Portrait of Signorina Bianchini (1929), Despiau expressed an elegant refinement subtly attained by Tuscan Renaissance sculpture; he suggests the model's spirit by modulated transition of *chiaroscuro*, as in the "discrete depth of Bonnard's half-lights" (Giuseppe Marchiori). By such choice references, the sculptor overcomes the excesses of archaism and the avant-garde with a premature return to integrity of form, but no longer in the manner of the previous century, so that he sets an important example to inter-war European sculptors.

The career of Maillol quite differently starts from painting, in particular the subtle and elegant archaism of the Nabis; his early sculptures were therefore influenced by the bas-reliefs of Georges Lacombe and Paul Gauguin from the 1890s, full of incisive hints at Tahitian and orientalizing primitivism. These first works stirred the interest of the well-known dealer Ambroise Vollard, who in 1902 organized a personal show of Maillol sculptures, thus opening for him a way to fame. At that time, the sculptor had already produced some of his

Opposite: Aristide Maillol, Three Nymphs *(1930–37, bronze, 60cm/23½in). National Museum of Western Art, Tokyo.*

Above: Ernst Barlach, Reclining Peasant *(1908, bronze). Museum for Art and Cultural History, Lübeck.*

Below: A. Wildt, Conception *(1921, marble, 56cm/22in). National Museum of Science and Technology, Rossi collection, Milan.*

masterpieces, such as *The Mediterranean* (1901–02) and *Night* (1902), both in marble, which marked his "break with Rodin and hence with the Rodin-influenced Bourdelle and Despiau" (Enrico Crispolli); indeed, in these works Maillol opposes the heroic archaism of Bourdelle's nervous warriors, seeking rather the genesis of form in the cradle of "archaic Mediterranean, Greek and Etruscan art" (Renato Barilli). Thus arise the full and weighty figures, the big apple, archetypes of pure form and shape, free from all descriptive or psychological hesitation, all with the same archaic face. These solutions quickly spread throughout Europe, starting a new ideal of beauty as pure harmony of plastic forms, which we find again in the inventions of Derain, Picasso, down to Leger and the youthful works of the Italian sculptor Marino Marini.

In Belgium, the generation of the 1860s gave rise to a remarkably intense period of original inquiry, owing to the disruptive personality of Octave Maus, unflagging organizer and patron. In the last years of the nineteenth century and the first of the twentieth, Maus called on the foremost European artists to exhibit in Belgium, and through these requests strong artistic characters emerged in all the arts, for example, Émile Verhaeren and Maurice Maeterlinck in literature and philosophy, Ensor, van Rijsselberghe and Knopff in painting, all attracted by the Realist and Symbolist lesson of the old Meunier. The sculptor George Minne, too, was part of this peak cultural setting. When very young, he had shown his Symbolist mettle with *Mother Weeping for her Dead Son* (1886), clearly influenced by Rodin and Meunier; but when in 1898 he produced his masterpiece in marble, *Fountain of the Kneelers*, later a determining influence on the success of Lehmbruck, he sublimated his early Symbolist vision by using archaic forms of German Gothic and religious and ascetic topics. The subtle rhythmic play of graceful nude adolescents kneeling, studied and developed by the artist through many variations, expresses a sacramental act of an undefined rite, certainly inspired by Maeterlinck's obscure deity, from which the whole literary and artistic culture of Europe derives.

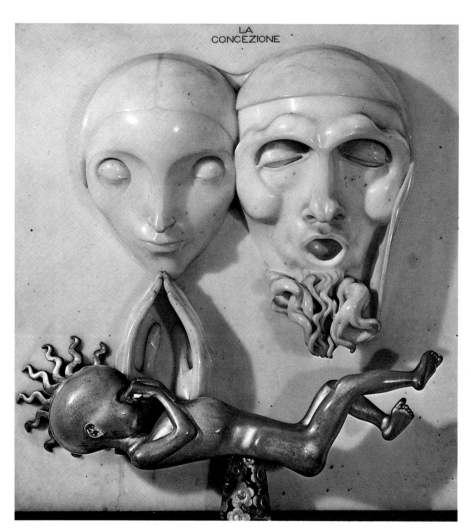

LA CONCEZIONE

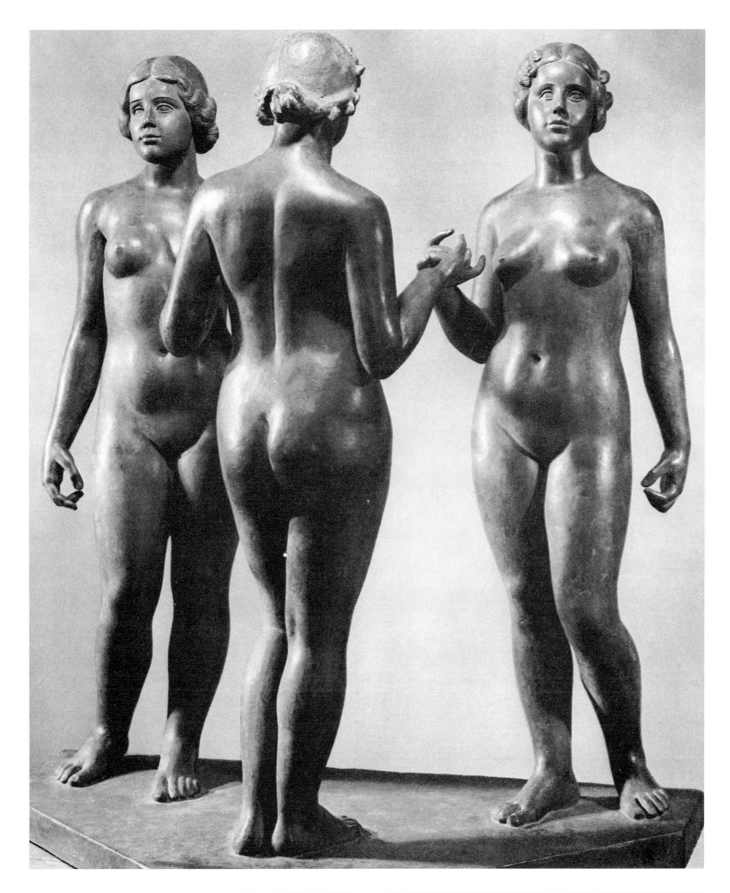

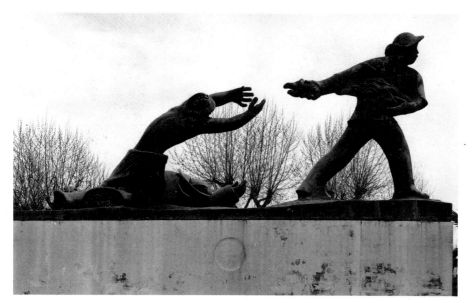

velopment are the trips of the next decade, to Russia around 1906, and Florence in 1909 as guest with a year's bursary in the German atmosphere of Villa Romana. In Russia he was struck by the brutal conditions of peasant life, as later seen in various works with primitive faces that are certainly not graceful or idealized, but crudely marked with furrows, for example, the small but monumental sculpture *Melon Eater*. Later, at Florence, he looked neither at Donatello nor at Michelangelo, thus rejecting references dear to Rodin and Hildebrandt, but he rediscovered Etruscan terracottas and the Romanesque and Gothic sculptures of Nicola and Giovanni Pisano, Arnolfo, Tino da Camaino and the frescoes of Giotto, all of the primitive art of Tuscany. Barlach felt attracted by the volume and sense of shape and mass of form even more than by the lines and intellectual approach of Classical and Renaissance art. As he says himself: "In 1909 in Florence I produced various works,

From then until 1914, Minne retired to a colony at Laethem Saint Martin near Ghent, with a group of artists sharing mystical, populist and archaic concerns translated into modern expression. Minne's work influenced some Italian sculptors, too, for example, Adolfo Wildt, Edoardo Rubino and Libero Andreotti.

Wildt (1863–1931), with Bistolfi at the peak of Italian Symbolist sculpture, made the Art Nouveau style more dry and ascetic, adding a hollow and suffering spirit that engenders secession, with a pure and polished style unique in Italy; for cultural and stylistic hints we must look in the north, to Wildt and the Austrian Franz Metzner, to find the same peculiar manner of constructing the image by means of terse and lucid essential forms. After the marble *Idiot* (1902), acquired by D'Annunzio for the Vittoriale, Wildt stands out with some splendid portraits, from the dazzling *Self-portrait* (1908) in which we discern the surreal disquiet of the graphic art of Alberto Martini and the young Casorati, to the portrait of *Arturo Toscanini* (1923). However, it is in the Kämer monument, *Et ultra* (1928), in Milan's monumental cemetery that we best recognize the strong imprint of Minne, through comparison with the studies and the final work of the *Fountain of Kneelers*, with those same smooth attenuations, extensions and Formalist distortions later adopted by Wildt, "modern Gothic that distilled in marble the austere clarity and bitter value of his spirit" (Francesco Sapori).

Ernst Barlach studied at the Academy of Dresden, and then just before 1900 went to Paris twice without falling for the fervent artistic life there, nor for Rodin. His first works are linked to the taste of Jugendstil and Secession, as shown even in their titles by the precious and highly mobile sculptures shortly after 1900: *Faun and Nymph*, *Triton* and *Kleopates*. Rather more important for his de-

Above: Domenico Rambelli, Monument to the Dead *(1922–27, bronze). Viareggio (Lucca). With a keen eye for volume, Rambelli sculpted massive and powerful forms, eclectic both in modern taste and in the use of primitive sources.*

Right: Pablo Picasso, Bust of a Woman *(Marie-Thérèse Walter) (1931, bronze, 68,5 × 42 × 43.5cm/ 27 × 16½ × 17in). Musée Picasso, Paris. After a classic phase, he returned, not without some self-irony, to Cubist stylization, whose dilated forms are, however, somewhat Surrealist in spirit.*

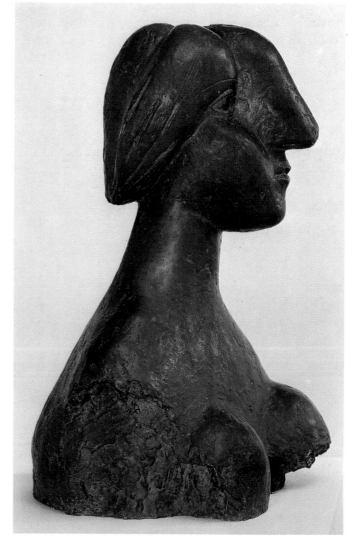

some in wood, starting with an axe and finishing with a scalpel." Here then we have *The Drinker, The Astrologer, Lady Thinking, Raging Warrior:* heavy bodies, worked in summary fashion, recovering in the raw a human dignity and a studied abstract harmony of volumes; primitive features, heavy lineaments, eyes wide open and almond shaped, vaguely Asian traits that strongly suggest the Italian sculptor Domenico Rambelli, sixteen years his junior. At the start of the century, Rambelli underwent a formative development period in Faenza, where he attended the artistic circle of Domenico Baccarini, and at Florence where he, and Baccarini, enrolled at the Free School of the Nude at the Academy.

Rambelli thus met Costetti, Papini, Soffici and Viani, who frequented the German group at Villa Romana, where Barlach then lived; it is thus likely that the young Rambelli knew Barlach's works. This showed itself in the 1920s, in the three monuments to the fallen of Viareggio

Right: Wilhelm Lehmbruck, Kneeling Woman *(1911, plaster, 178cm/70in). With others, Lehmbruck took part in the deep renewal of European sculpture and, transcending the heritage of Meunier and Rodin, attained austere, ascetic shapes with Gothic echoes.*

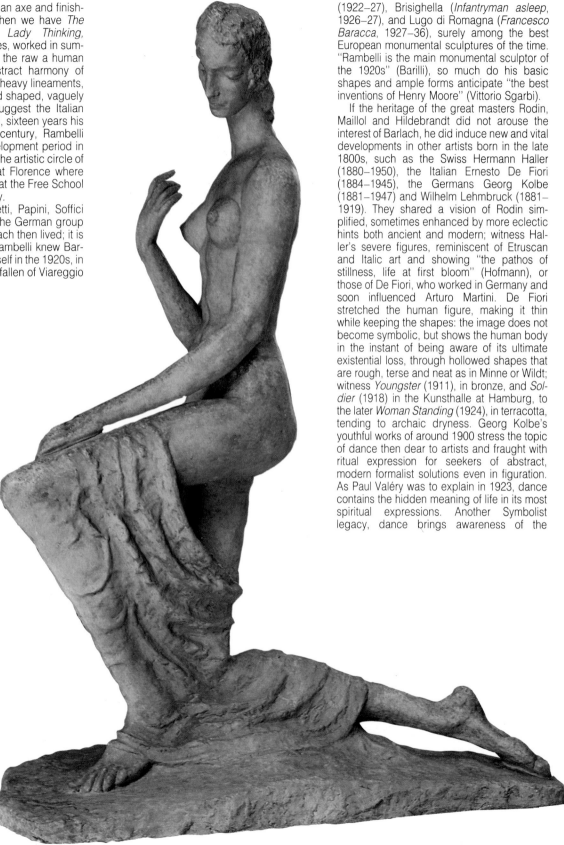

(1922–27), Brisighella (*Infantryman asleep,* 1926–27), and Lugo di Romagna (*Francesco Baracca,* 1927–36), surely among the best European monumental sculptures of the time. "Rambelli is the main monumental sculptor of the 1920s" (Barilli), so much do his basic shapes and ample forms anticipate "the best inventions of Henry Moore" (Vittorio Sgarbi).

If the heritage of the great masters Rodin, Maillol and Hildebrandt did not arouse the interest of Barlach, he did induce new and vital developments in other artists born in the late 1800s, such as the Swiss Hermann Haller (1880–1950), the Italian Ernesto De Fiori (1884–1945), the Germans Georg Kolbe (1881–1947) and Wilhelm Lehmbruck (1881–1919). They shared a vision of Rodin simplified, sometimes enhanced by more eclectic hints both ancient and modern; witness Haller's severe figures, reminiscent of Etruscan and Italic art and showing "the pathos of stillness, life at first bloom" (Hofmann), or those of De Fiori, who worked in Germany and soon influenced Arturo Martini. De Fiori stretched the human figure, making it thin while keeping the shapes: the image does not become symbolic, but shows the human body in the instant of being aware of its ultimate existential loss, through hollowed shapes that are rough, terse and neat as in Minne or Wildt; witness *Youngster* (1911), in bronze, and *Soldier* (1918) in the Kunsthalle at Hamburg, to the later *Woman Standing* (1924), in terracotta, tending to archaic dryness. Georg Kolbe's youthful works of around 1900 stress the topic of dance then dear to artists and fraught with ritual expression for seekers of abstract, modern formalist solutions even in figuration. As Paul Valéry was to explain in 1923, dance contains the hidden meaning of life in its most spiritual expressions. Another Symbolist legacy, dance brings awareness of the

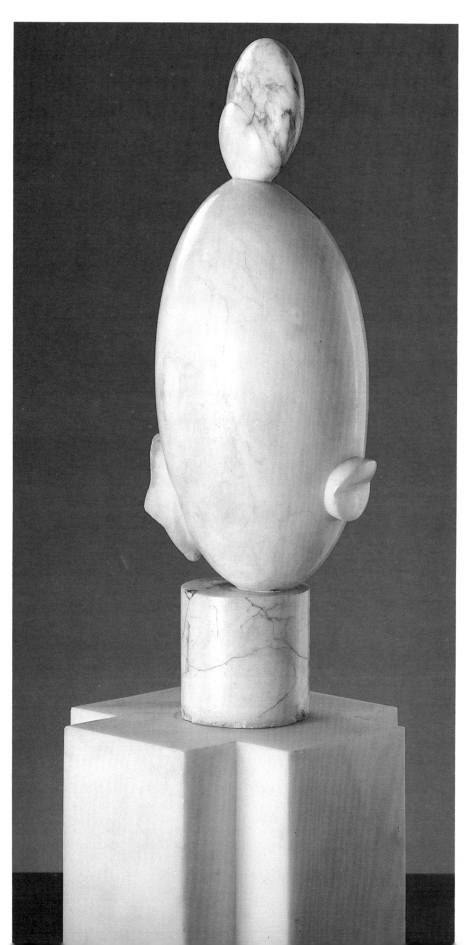

autonomy of form but forgoes narrative content in favour of modern abstractions that seem to state nothing but touch on avant-garde innovations. In later decades, before and after the compromise with Nazism, Kolbe's figures are more static and statuesque, always in Rodin's fashion, though simplified.

Wilhelm Lehmbruck, the most intriguing of these artists, began under the influence of Meunier, but was in Paris from 1910 to 1914, studying Rodin and Maillol; at the Salon d'Automne, 1910, he was successful with his first masterpiece, *Female Figure Standing*. In 1911, with *Woman Kneeling*, his aims took a definite direction: the fullness of form disappears, space becomes more articulated, giving a new expressive code, interpreting the drama of man and paving the way for "existentialist" figuration as in Alberto Giacometti and Germaine Richier. These figures have clear Classical roots, absorbed and mutilated Venuses, fragments of a wholeness lost and of a now extinct faith in values. In these pre-war years Lehmbruck met Constantin Brancusi, who influenced his vision of the human figure. After a trip to Berlin and Zurich, he produced *Dying Warrior* (1915–19), an artist's human and spiritual part in the drama of war; in the later *Seated Youngster* (1918), created one year before he killed himself, "the event of loneliness became final" (Hofmann). *Woman Kneeling* must have been known to Libero Andreotti, then at Paris. This is shown by the Tuscan sculptor's late works, especially *Annunciation* (1931), with precise neo-Gothic hints in the elongated faces, gestures and drapes reached using Lehmbruck's solutions.

Through the avant-garde

In this ferment of ideas and eclectic proposals arise new if at times similar solutions by sculptors who openly belong to the "historical avant-garde." They were to learn from the use of shape by Gauguin (1848–1903), as admitted only from the great retrospective show of 1906. Here, many wood-carvings were shown, among them the bas-relief *Soyez amoureuses et vous serez heureuses* (1889). Still, Gauguin in his Tahitian retreat considered not only primitive art but also ancient art in general; so much so that in the painting *Dans la vanillère, homme et cheval* (1891) he shows a piece of Trajan's column taken from some photographs he had found, making notes and sketches on the backs. Gauguin's sculpture, however elevated, remained a wholly personal event, until the show of 1906, when Picasso, Fauvist painters and those of Die Brücke, recognized the full power of this style.

Although Picasso had known Gauguin's work since 1901, as is evident from some of his sculptures (*Seated Woman* and *Woman Combing her Hair* [1906]), reminiscent of the bas-relief mentioned), he does not fully grasp and absorb Gauguin's primitivism until after

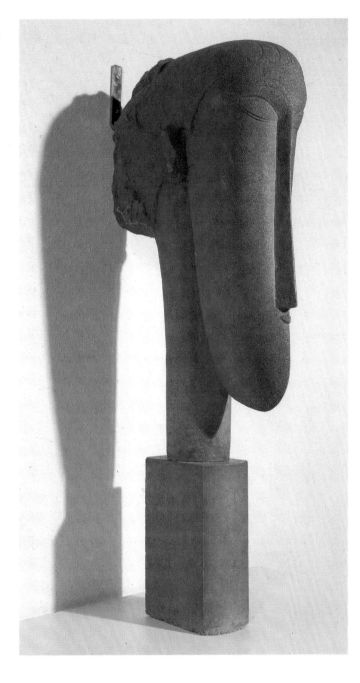

sculpture that "made real objects tangible" (Rubin). This is the crucial moment of "synthetic cubism," and it is odd that Picasso's main sculptures correspond to flat, anti-sculptural painting. With these works Picasso injected into Western art (in a rather unconventional sense) a new, shattering primitivism, enlarging Europe's artistic vision, which he went on constantly revising and surpassing over the years. "In no other artist's career was primitivism so central and historically coherent as in Picasso's" (Rubin). Still, the choices of Picasso and the avant-garde must be viewed, especially for sculpture, as answering archaic and formalist examples of Maillol, Mestrovich, Bourdelle and the theories of Hildebrandt, which foreshadow Picasso and explain his extremist aims.

Matisse, along with the other Fauves, made sculptural efforts after the Gauguin show of 1906, taking an interest in Negro art. While Vlaminck's approach here was mainly emotional and romantic, Matisse found new and more direct plastic scope in sculpture, adapting the great example of Cézanne, toward whom he had moved late in the last century.

Most of Matisse's sculptures, up to *Nude stretched out I* (1907), had been worked from life; but even this is a primitive, more abstract version, a sort of African Venus. There followed the famous *Blue Nude (memory of Biskra)* successfully shown at the Salon of 1907, which entranced Picasso for its clear references to African art. The year after, Matisse produced the bronze *Decorative Figure* and *Two Negro Women*, using his own collection and photographs of Tuareg girls, as for the famous *Serpentine* (1909); later, with the bust of *Jeanette V* (1916) and *Spine III* (1916–17), he shows a sharp tendency of "négritude," giving his final reply (his own testimony): "to the cubist shattering of form, without resorting to cubist means." Still, the most radical avant-garde reference to primitive art after 1907 was expressed by Picasso and Brancusi.

Constantin Brancusi (1876–1957) was trained at the Academy of Bucharest, but his artistic life began when he reached Paris in 1904, having walked across Europe. Already in 1906 he exhibited at the Salon and was admired by Rodin, who invited him to enter his studio as an assistant. However, Brancusi firmly rejected the offer, although his first works had shown that he was indeed drawn toward the great master. Still, he would rather seek new starting points in the Gauguin retrospective and in the sculpture of Derain, which he saw when visiting Kahnweiler, putative dealer and patron of the time. These examples led Brancusi to sculpt directly in stone, and the *Girl's Head* (1907) and *The Kiss* (1908) clearly recall Derain's *Crouching Figure* (1907), in limestone, and his *Squatting Figure*, in the technique of direct cutting, and the same square forms and the shared motif of embrace with emphasis on the hands. Thus Brancusi

1906. Such assimilation is furthered by a knowledge of archaic Iberian sculpture, gained on his trip to Gasol (spring 1906). From 1907, in the *Demoiselles d'Avignon* (not the first, albeit the most famous Cubist painting), he fully mastered Negro art and mixed it freely with Cézanne, Gauguin and Michelangelo. The sculptor cannot be severed from the painter, since the ideas that produced Cubism spread throughout painting, while his other proposals are other aspects of the same aim.

In Autumn 1909, Picasso sculpted the *Head of Fernande*, counterpart to his analytic

Cubism. He himself said that such "re-creating forms used in paintings ironically equal a mere sculptural illusion of a painter's device." Comparing *Fernande* with his paintings of the same period we find greater depth and plastic shape than in the portrait sculpture, which "was a dead point" (William Rubin). If in his paintings light, or "pure illusion," is heightened to enhance shape, in sculpture, where "light cannot be controlled," he cannot obtain the same desired effect. No wonder he stopped sculpting for three years, until autumn 1912, when he produced the admirable *Guitar,* a

gradually discovered his technique and the poetry of Negroid and primitive art.

Mature absorption of these traits is marked by *First Step* (1913), in wood, later destroyed by the artist except for the head; indeed, Brancusi disowned these sources in the 1930s and destroyed those works that most clearly showed their influence. Recalling a visit to Brancusi, Jacob Epstein said: "Brancusi, some of whose early works were inspired by African art, now firmly asserts that one need not be influenced by it; he has indeed gone so far as to smash some of his works." Once the crude, archaic, primitive model was shed, his imagination reached purist abstract solutions, as in *Infinite Column* (particularly in its final form of 1938 in cast iron), and in *Mademoiselle Pogany* (1913–19): the artist now proceeds toward absolutely pure form, for which each work becomes a definite symbol of perfection and "spiritual completeness" (Hofmann), thanks to a "fusion of present and local humanism with ancient rigour, different and hieratic." The work and teaching of Brancusi were decisive for a large group of artists, among them Amedeo Modigliani (1884–1920), Jacob Epstein (1880–1959) and Henry Gaudier-Brzeska (1891–1915). When Modigliani, at twenty-two, arrived in Paris in 1906, his friend Paul Alexandre took him to Brancusi, who gave him some basic hints on sculpting by direct cutting. In those years, and above all in 1909–13, Modigliani produced all his sculptures (at least those extant): twenty-three heads, a caryatid and a figure, finished before ill-health forced him to abandon the art. The meeting with Brancusi was indeed of mutual benefit; the two later went together to Livorno and then to sculpt in Carrara. Modigliani did not take to sculpture with the stamp of the painter; he discovered African and Pacific art, as did many artists of the period, but also Cycladic and Khmer art, without forgetting the first Renaissance, which had greatly refined his sensitivity. In these sources he found many cues and feelings, as his early sculptures show (1910–11).

Beside Brancusi's influence we must not forget that of the Polish-American sculptor Elie Nadelman, and later the veiled references to Bourdelle and Maillol, which turned him toward Italian primitives and gave him new goals independent of Brancusi. As painter and sculptor Modigliani was drawn to portraiture in the modern sense: this saved him from being swamped by Cubism and Negroid art, and from formalist abstraction as an end in itself. He always tried to make his portrait or nude intense and sensitive: "the tension of expression is the unique factor of movement" (A. M. Hammacher).

Modigliani saw sculpture as monolithic, rejecting relief in favour of "ronde bosse" (round protrusion), both in front and in profile, against reality even if always starting from a model, purely stylized, with lines understood as pure definition of space. This led him to a peculiarly subtle treatment of matter, so that surfaces enhance the definition of facial volumes, "turning the static stone into a living peace" (Hammacher), unlike Brancusi and Cubist works. "He took certain stylistic features from them, but was hardly touched by their spirit" (Lipschitz). Modigliani pursued his goal of Classical beauty, so much so that the sculptures shown in the studio of his friend Cardoso in 1911 and at the Salon in 1912 were conceived for an ideal Temple of Beauty, a spiritual setting peopled by female heads and caryatids: "at night he arranged candles on top of the sculptures, giving the effect of a primitive shrine" (Epstein).

Jacob Epstein, born in New York, was in Paris in the early 1900s and settled in London in 1905, where he became naturalized in 1907. In Paris he met Brancusi and Modigliani in summer and autumn 1912; this radically changed his sculpture, which was influenced by tribal Negro art at least until 1915. In Brancusi's studio he saw works like *Sleeping Muse* (1910) and *Prometheus* (1911), but it was above all contact with ways of absorbing into his sculpture decisive solutions and formal

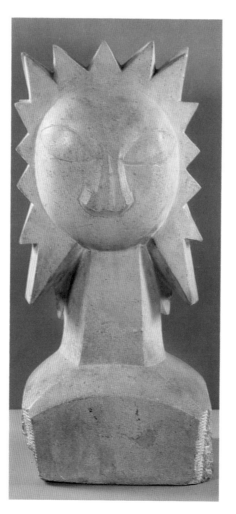

Above: Jacques Lipchitz, Figure *(1926–30, bronze, 216.6 × 98.1cm/ 85 × 38½in). Museum of Modern Art, New York. Like Epstein, the artist transformed Cubism by reference to Negro art.*

Left: Jacob Epstein, Sunflower *(c. 1912–13, stone, 58.5cm/23in). National Gallery of Victoria, Melbourne.*

Opposite left: Raymond Duchamp-Villon, The Big Horse *(1914, bronze, 100 × 110 × 110cm/ 39¼ × 43¼ × 43¼in). National Museum of Modern Art, Paris. A Cubist image combined with a vigorous dynamic shape. What matters is less a "realist" view of the horse than the synthesis between natural elements and the idea of machine.*

Opposite right: Alexander Archipenko, Médrano *(1914–15, wood, canvas, metal and coloured glass, 127cm/50in). Solomon R. Guggenheim Museum, New York. His Cubism has light and cheerful forms full of lyric colour.*

hints. His early works like *Sunflower* (1910–12), *Birth, Mother and Child* and *Pneumatic Hammer* (1913) breathe an archaism doubtless derived from Bourdelle's bas-reliefs and the combinations of Cubism and Vorticism.

Such sculptures, produced at Pett Level in Sussex, are the peak of Epstein's art and display the rich mixture of idioms gathered, where alongside impassive Egyptians and Etruscans we find the totems and fetishes of Negro art. In the late 1920s such hints were enhanced by references to other archaic civilizations, from Assyrian to Maya: witness the works for the London Underground headquarters, and in particular the monumental sculptures *Day* and *Night*, or the bas-relief in

Bourdelle's style in the Champs-Élysées, but also the *Madonna and Child*, which seems based on the Etruscans, with clear hints of fourteenth-century Italian sculpture.

For Henri Gaudier-Brzeska, meeting and learning from Brancusi, Modigliani and above all Epstein led him to reject Classical harmony for greater freedom of expression, "based on strong feelings, but no compulsion to reach anatomic precision" (Wilkinson), and therefore to giving up realistic modelling. Putting an initial admiration for Rodin behind him, he saw that he could not travel the same road as before. Rather, he turned to Bourdelle and Maillol, rediscovering Gauguin and finally coming to the teaching of Epstein, whom he

met in London in 1912 and who turned him toward working directly on stone. At the time, Epstein was finishing Oscar Wilde's tomb, inspired by Egyptian and Assyrian art; in 1912, too, Gaudier wrote to his beloved Sophie Brzeska that he was in a state of transition, trying to merge respect for tribal art with European sculpture from archaic Greece to Rodin. Stimulated by Epstein, Cubism and Vorticism, he moved straight toward a formal and primitive synthesis: witness his major work *Female Dancer in Red Stone* (1913): the disposition of volumes and the triangular head turned downward form a kind of vortex clearly revealing this search for form. In 1914 he made two portrait busts of Ezra Pound (*Hieratic Feast of Ezra Pound*, in marble, and *Portrait*

Above: Ossip Zadkine,
Orpheus (1956, bronze,
299cm/117¾in). Open
Air Museum for
Sculpture, Antwerp.

of Ezra Pound, in wood), which are two of the most striking and powerful sculptures in his short career. Pound's writings on his friends Brancusi, Epstein and Gaudier help us to grasp their aims. He wrote that "Brancusi concentrates on pure form, free from all earthly weight," and "the ideal form in marble is an approach to infinity through form, precisely through the highest degree of awareness of formal perfection, free from all accidental elements or philosophic demands." As early as 1914 Pound identified himself with the examples of Epstein and Gaudier: "We who are heirs to sorcery and voodoo, we artists who have been so long despised, we are about to take control." Close to these men is Jacques Lipschitz: after 1910 he absorbed Maillol and Despiau and merged them with tribal art, of which he was a shrewd collector; this shows itself in *Mother and Child* (1913–14) and *Separable Figure* (1915); as he stated himself, "in a few works of mine I feel the clear influence of Negro art." Still, his major works were Cubist (1915–22), where his aim was to stand for that "transparent sculpture" about which he theorized after he became Cubist along with his friend Henri Laurens in 1913–14. For some ten years he was a front-rank exponent of Cubist sculpture, dealing with human figures as well as common objects in well-drawn and articulate blocks of regular, rectilinear outline, compositions with a kind of syncopated rhythm cleverly combining vertical and horizontal volumes with diagonals broken at acute angles, as in *Female Dancer* (1913–14) or in the *Guitar Player* (1922). Later Lipschitz overcame cold Cubist purity through a tortured and lavish intensity, in works given over to mythical, biblical and Hebrew subjects, as in the monumental *Song of the Vowels* (1931–32) or in the *Rape of Europa* (1938): here he sets aside right angles for wavy forms, broken by notches and openings crowded with shaped shadows to engender a tortured disharmony and marking the extreme reaction to Cubist rationalism.

Henri Laurens developed in a similar way. He had been a friend of Brancusi since 1911 and aimed at using sculpture to convey that painterly vision; he adopted Cubist aesthetics using colour *à plat*, in order to free sculpture from the effects of light on form. Following the example of Braque, Picasso and above all Gris, Laurens stated that "a sculpture must project its light, not receive it." Laurens's Cubist phase started in 1925: witness *Bottle and Glass* and *Pipe and Dice* (both in 1918), which derive from *papiers collés* and may be compared with synthetic Cubism and similar works by Picasso, such as *Violin and Bottle on a Table* (both dating from 1915–16).

Within Cubism, new theories, topics and movements developed, among them Golden Section, Orphism and Purism, which in the sequel sought new harmonies and proportions, though starting from Cubist geometric assumptions.

Below: Julio González,
Angel (1933, iron,
160cm/63in). Museum of
Modern Art, Paris. The
work's Cubist style is
allied with Surrealist and
Constructivist hints.

Opposite above: Alberto
Giacometti, The Square
(1947–48, cast 1948–
49, bronze,
21 × 62.5 × 42.8cm/
8¼ × 24½ × 17in).

Peggy Guggenheim
collection, Venice.

Opposite below: Max
Ernst, King Playing with
Queen (1944, bronze,
97.8 × 47.7 × 52.1cm/
38½ × 18¾ × 20½in).
Museum of Modern Art,
New York. Plaster
original of 1944. Cast in
bronze in 1954.

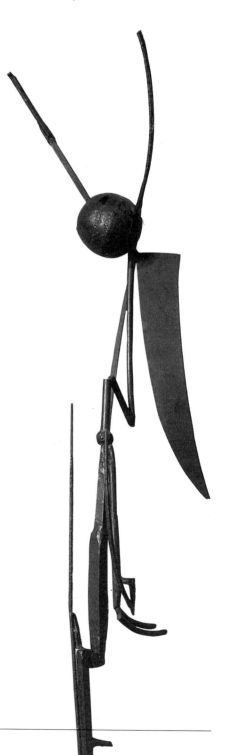

The work of Raymond Duchamp Villon (1876–1918), Pablo Gargallo (1881–1934), Alexander Archipenko (1887–1964) and Ossip Zadkine (1890–1967) makes up, along with that of artists noticed above, the most striking sculpture derived from Cubism. Duchamp Villon, having gone beyond the formative influence of Rodin and Maillol as well as of Jugendstil, appeared along with the brothers Marcel and Jacques Villon at the Salon d'Automne in 1910; in 1912 he took part in the Golden Section movement and worked out the plans for the first integral Cubist house, and later for the internal decoration of a building (1914). From the moment, in his very brief productive period, he was at the peak of sculpture linked with Cubist theories. His best-known work, *Cheval-Mayeur*, moulds a motion of two seemingly opposing forces: organic, biological reality and the machine, linked in the search for pure volumes; as he said, sculpture "must live decoratively at a distance by means of the harmony of volumes, planes and lines." In this sense François Mathey stressed that in Duchamp Villon's work light intervenes "to underline potential movement, giving a dynamic effect to a static structure."

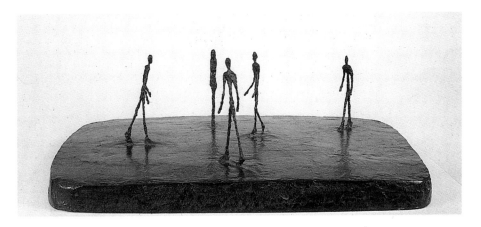

The case of Boccioni

Critics have often set Duchamp Villon's inventions alongside those of the futurist Boccioni (1882–1916), author of the famous *Technical Manifesto of Futurist Sculpture* (April, 1912). Futurism and Cubism indeed have points of contact and convergence, even if these pose problems; Boccioni's sculptures, mainly from 1911–13 (many destroyed), and those of Duchamp Villon show these mutual contacts. Futurism, like Cubism before it, aims to upturn our idea of physical space and hence of vision: finite and infinite, static and dynamic are the polarities that define the new theory and its experiments. In his *Manifesto*, Boccioni the innovator intends "to start from the central core of the object to be created, in order to discover the new laws, namely new forms, that tie it invisibly but mathematically to the 'infinite outer shape' and the 'infinite inner shape'"; moreover, he asserts that the new sculpture will convey "atmospheric planes that link and separate things." This vision (he calls it "physical transcendentalism") "will give shape to mysterious sympathies and affinities that create mutual formal relations between the planes of objects." For Boccioni, penetrating space and time becomes a leading motif, to enhance existence introspectively, in figures and in things: his final aim is to make every object dynamic, even an inanimate one like a still life, as seen in *Shape-forces of a Bottle* or *Development of a Bottle in Space*. As the young Roberto Longhi remarked in 1914, in Boccioni "organic and inorganic lines, human features and glassy boundaries pass into the relentless higher and purely aesthetic organ-

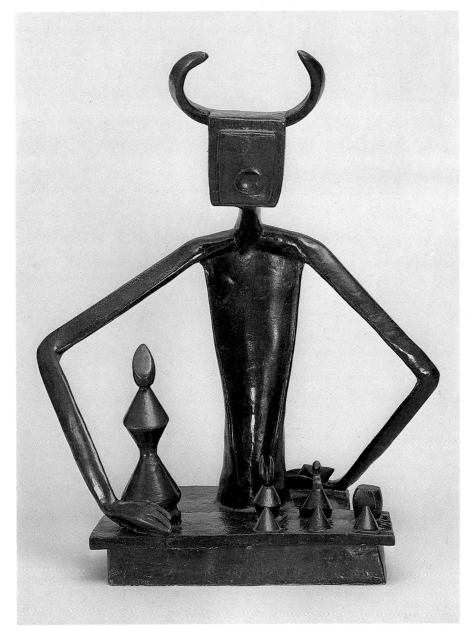

ism of lines of force"; but Longhi locates in Boccioni's work a novelty that abandons "the cold caprice of decay" for "the warmth of an imprinted vitality." In 1913, Boccioni achieved his "absolute masterpiece" (Longhi), *Unique Forms of Spatial Continuity*, where the figure, though involved in environmental and atmospheric features, attains a "new stasis," a "higher repose of a movement that can no longer be broken." Here Boccioni resumes and goes beyond the "articulated synthesis" of *Spiral Expansion* and the "carnal synthesis" of *Muscles of Speed* (both destroyed): "never has anyone reached a higher, more imperative order of purely plastic vision."

Boccioni's glorification of dynamism in that absolute masterpiece has varied points of contact with Duchamp-Villon's *Cheval* (1914) and studies for it; in his mature works, the French sculptor "without being futurist adhered implicitly to some of that movement's principles" (Margit Rowell).

Cubist developments

Except for Boccioni, Futurism has produced no great sculptors, unlike Cubism, which has closely marked the growth of rising sculptors like Archipenko and Zadkine. Archipenko came from Moscow to Paris in 1908 and at once became one of the Cubist group; he learned from Brancusi, but aimed to bring to his work formal Cubist principles and to champion colour for its lyric power: witness the way Gris used varied materials, as did Laurens, Picasso and Boccioni. Thus arose the manikin figurines called *Medrano* (1914). This attempt at introducing painting into low and high relief changed the actual data, upholding a free creative impulse and ensuring that figure and space are equivalent and merge. Archipenko had opened the volume of his figures to contrasts between concave and convex forms, giving the negativity of space a formal positive value. This was later adopted by Henry Moore and other sculptors.

Zadkine, another Russian, came to Paris after a short stay in England and met Lipschitz and Archipenko. At first taken with Brancusi's primitive barbaric forms of 1907–08, he later accepted Cubist notions and in his sculptures combined the frontal plane with lateral views in his own way, producing a compact geometric structure, as in *Woman with Violet* (1910) and *Visitation* (1913); later, with playfully ironic eclecticism, he freely quoted from Michelangelo to Picasso, as in *Thinker* (1944) and *Orpheus* (wood, 1930; bronze, 1949), where the Greek singer's lyre rises from his rent body in striking invention. Meanwhile Picasso, from 1920, left sculpture in the round in favour of relief made up of ordinary objects; abandoning modelled shapes and figures, he pioneered new paths that confronted artists with the most radical choices.

Dada and Surrealism

In 1913, another artist from the Cubist camp, Marcel Duchamp, brother of the Raymond mentioned above, banned "purely retinal" art, contrasting it with a totally intellectual one: he invented and theorized the "ready-made," objects made for daily use elevated into works of art, such as the famous *Bicycle Wheel*, so that the artist conceptually attains the final split of life from art. In 1914 he exhibited *Bottle-rack*, which became an absolute emblem and challenged the very concept of art. Thus he created the framework of Dada, an international movement heralded by these works and officially announced on 2 February, 1916, at the opening of the Cabaret Voltaire at Zurich on the initiative of Ugo Ball, Marcel Janco, Jean Arp and Tristan Tzara. Dadaist works, peculiar mixtures of painting, sculpture, collage and assemblage, with an ironic and irrational strain, stress the uneasy side of machines and modern objects, thus launching the premises for Surrealism, born of a Dada

rib. A few days after the official announcement, on 21 February, one of the worst massacres in history began: the German army attacked French positions at Verdun, with 420,000 dead and 800,000 gassed or wounded. The Dadaists would neither take part in the war nor consciously oppose it: "At Zurich, in 1915, ignoring the butchery of the World War, we devoted ourselves to the Fine Arts" (Jean Arp). Shortly after, in 1921, the Dadaists, as part of the Surrealist core, took a clearer stand on social problems, as when faced with the tragedy of the Spanish Civil War. Surrealism set its own aesthetic values, opposing a society it considered stifling and touching eclectically on psychology, anthropology, philosophy and politics: convinced that dreams are an intrinsic part of life, Surrealism puts excessive trust in the unconscious (owing to De Chirico's metaphysics), in evocative myths and in automatic behaviour. Significantly, the authors dear to Surrealists are Sir James Frazer, Lucien Lévy-Bruhl, Sigmund Freud and the poet and literary figure André Breton, the

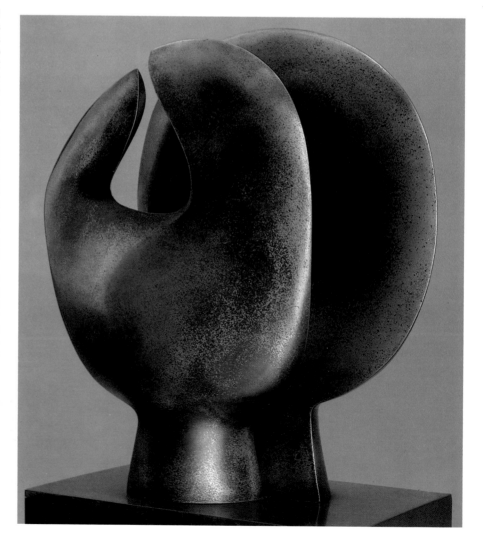

movement's founder and mentor, who in his time became the catalyst of the Parisian and European art world that Guillaume Apollinaire had been before. These theories start a new chapter of sculpture, owing to some artists who had practiced the first avant-garde experiments; Picasso, now linked with the Spanish sculptor Julio Gonzales, Hans Arp, Alberto Giacometti, Max Ernst and Henry Moore. Gonzales (1876–1942), in Paris since 1900, came from a family of blacksmiths, who had taught him to forge metals. He left painting for iron sculpture in 1926, experimenting in a way of his own and producing silhouettes with iron sheets cut and soldered by his peculiar method tried out while working at Renault. He referred to Cubism, especially in the play of intersecting planes reminiscent of the Spaniard Pablo Gargallo, who had produced masks and portraits in calligraphically cut iron shortly after 1910. However, in the 1930s Gonzales began to differ from his friend, blunting and expanding form, eliminating Cubist effects to reach a magic, formal rigidity, soaked in mystery, narrative and ironic poetry and a taste of Don Quixote. Thus his ballet girls, slender and supple, produce an air of ghostly, rarified and tormented poetry. Within a decade, Gonzales made his main contributions, uniting Surrealist and Constructivist elements, as in the amazing tin torsos of 1934–36, as far as *Peasant Girl, Standing* and the dramatic *Montserrat*, stating the stark misfortunes of the Spanish people in the Civil War.

Picasso's creative spirit at that time owed a debt to his friend Gonzales: it was thanks to him that, after a long break, Picasso returned to sculpture in 1928 and even gave his own designs to his friend to carry out. At this time arose the plan for working in iron wire: demonic images, fantastic plants, rough models for the monument to Apollinaire and other sculptures, where a boundless creative power transforms "reality" into a new "surreality." Breton shrewdly analyzed this world and the ability to fuse in sculpture "tangible" and "intangible" volumes, as in the superb assemblages of 1934: here Picasso makes use of nature, for example, a fig plant, which has a poetic or a structural value, so that the observer cannot separate the iron sculpture from the real thing. Breton remarked that Picasso the painter is free from prejudices of colour, and the sculptor from those of material: iron wire, wood and stone, all are masterfully transformed by "one whose need for the specific resurges at once from being content; like all great inventors, he is in constant turmoil and would probably find it useless if not impossible to foresee himself."

Max Ernst (1891–1976) was the other great artist of the 1930s who conveyed the Surrealist idea in painting and sculpture. As a former Dadaist, he produced his first "surreal" sculptures in 1934, when with his friend Giacometti he worked directly on granite blocks at the edge of a Swiss glacier near Maloja. Indeed, he found matter his *objet trouvé*, where nature had put it, transforming it over the ages; in awe of the anonymous form of age-old rock, he confined himself to grazing the surfaces, creating bas-reliefs of cryptic hieroglyphics. One of these sculptures, *Oval Bird* (1934), clearly shows his interest in ethnology, based on a deep study of the many books he had collected. In this work he hinted at some bas-reliefs on Easter Island, and in the same year he published the novel entitled *A Week of Goodness*, whose second "theme" is about Easter Island. In 1949, still a Surrealist, he was called to Arizona to decorate a country house and its garden with fantastic sculptures and bas-reliefs, representing beings like sphynxes, idols and animals sacred to primitive archaic cults.

Likewise in the 1930s, Miró produced sculptures as Surrealist objects in the manner of Giacometti and Ernst Arp, inserting totems, pebbles and coloured graffiti, before taking up ceramics in the 1940s.

Opposite: Henry Moore, Lunar Head (1964, bronze, 57.8 × 44.1 × 25.4cm/ 22¾ × 17¼ × 10in). Tate Gallery, London. The Surrealist matrix here is of great abstract purity.

Right: Jean Arp, Crown of Buds I (1936, limestone, 49.1 × 37.5cm/ 19¼ × 14¾in). Peggy Guggenheim collection, Venice. Coming from Surrealism, Arp here gives a good example of form and space complementing each other.

The Surrealist sculpture of the Swiss Alberto Giacometti (1901–66) began about 1930; in 1922 he had left Geneva for Paris to work at the *Grande Chaumière* after Bourdelle; from 1925 he began to sculpt "esoteric mute figures of idols" (Hofmann): *The Couple* and *I ady Spoon*, both of 1926, where clearly he has gone beyond Bourdelle's archaism to reach a primitive Negroid style. Toward 1925, he reworked his primitive starting points in the light of Surrealist poetry, drawing on the secret magic of things.

Dissident artists

In 1930 Giacometti, thanks to André Masson, joined the dissident Surrealists, among whom were Bataille, Artaud, Lauris and others. Their focal point was the review *Documents*; to mark his new interest in the review, he produced *Suspended Ball*, a sculpture that provoked enthusiastic clamour among orthodox Surrealists like Breton, pointing to a new way of

Below left: Naum Gabo
(Pevsner), Female Head
(1916–17, celluloid and
metal, 62.2 × 48.9cm/
24½ × 19¼in). Museum
of Modern Art, New York.

Below right: Anton
Pevsner, Developable
Surface (1941, silvered
bronze,
55 × 36.3 × 49.1cm/

21½ × 14¼ × 19¼in).
Peggy Guggenheim
collection, Venice. The
Pevsner brothers, by
means of constructive

images, aimed at a new
idea of beauty adapted
to the new technological
era.

attributing meaning and erotic symbolism to sculpture. Between 1935 and 1945, Giacometti's art underwent a decisive turn due to some inner crisis, and after much meditation he found new solutions: the problem of movement became central to his interest; he saw it through isolated, self-contained and empty forms, walking figurines, elongated and slender like thin twigs, showing that he had left Surrealism behind, adopting vertical instead of horizontal sculpture. "Everything I had done up until 1935 was masturbation," he declared. Only one figure, abstractly moving, now opened space and seemed hypnotically to attract the other figures without meeting them, although "their solitude is plural."

Jean (Hans) Arp (1886–1966) studied in his native Strasbourg, Weimar and Paris, and took part in the second exhibition of *Der Blaue Reiter* in 1912. In 1915 he took refuge in Zurich, where he met the sculptress Sophie Täuber, who was to become his companion and a founder member of Dada. In his collages of that time he sought the freedom of

form, so that the "incidental" becomes the work's main subject; the same aims emerge in the early coloured reliefs in wood, where form is not assailed and broken up, but remains irregularly rhythmical, a gentle polyphony lyrically scanned. After the Surrealist *Manifesto*, published by Breton in 1924, Arp joined the group until about 1930, but, like Duchamp, remained autonomous, fulfilling the role of "living encyclopedia of contemporary art" (Lebel), thanks to his many and complex works, by no means confined to Surrealism. Breton was fascinated by this unbending stance and wrote a genuine apology for him: "The reliefs of Arp have the weight and lightness of a swallow sitting on a telegraph wire, borrowing by their wise colouring all the ramifications of love, while hasty fretwork gives them all the subtle design of anger, these hard or tender curls allow me to reduce the interest of the variant to a minimum." In 1932, after much hesitation, Arp was persuaded by his wife Sophie to join the Abstraction–Creation group, being attracted to the abstract. Still, he

kept his own contemplative impulse and began to reveal the mystic and religious feeling that had been maturing for some time: this gave rise to works in which classical measure, dreamlike order and abstraction admirably merge.

Henry Moore (1898–1986) began sculpting around 1925, and his trip to France and Italy in 1926 was critical for his development: he discovered Romanesque and Gothic sculpture, from which he learned the power of static, closed form, already experienced in his early visits to the British Museum. Equally vital was his reading of Roger Fry's *Vision and Design* (1920) while at art school in Leeds, which influenced him deeply, especially where Fry reassesses primitive sculpture and condemns academicism, still based on the Classical Greek concept of beauty. Moore avidly studied the British Museum collections: Egyptian, Assyrian, African, Oceanic, Eskimo and, above all, the pre-Columbian art of Aztecs and Maya. He thus came to hold that Greece and the Renaissance, though important, are hostile

Right: Marino Marini,
People (1929, terracotta,
66 × 109 × 47cm/
26 × 43 × 18½in). Civic
Gallery of Modern Art,
Milan. This double
portrait clearly shows his
interest in Etruscan
image-making.

to the modern spirit: we must free ourselves from it and once more study primitive art. His first sculptures show this, witness the high relief *West Wind* (1928), commissioned by the London Underground, or *Recumbent Figure* (1930); moreover, Epstein's example greatly influenced him, as man, artist and collector. Moore did not officially adhere to the Surrealist *Manifesto*; he accepted some of their concerns, such as an interest in primitive art earlier displayed by Ernst and Giacometti; in 1934 he thus took part in the Surrealist exhibition in London, and, the year after, the one in New York under the name of "Fantastic art: Dadaism and Surrealism" which were of great importance to later developments in art: here, the Surrealists appeared as a whole, alongside young Americans such as Calder, whose progress was similar to Moore's. Later, when his true worth was acknowledged in his own country, Moore evolved a relation between volume and space. Bones, sea shells, and stones are his preferred sources of inspiration and when sculpted remain irregular, opening

up to space with a constructivist bias. After a brief crisis in about 1950, he adopted a new, formal line using more radical creative modes. Where previously figures had been viewed and set into a landscape, Moore now puts the figure, bloodless and worn out, into empty space, without further links with nature, as in *King and Queen* in bronze (1952), in the abstract forms of *Lunar Torso* (1964), or in *Warrior with Shield* as silent and unconquered symbol of a dark danger for all mankind, the most intense document stating this formal change.

Abstraction–Creation

We have mentioned this group already. From 1932 it gathered the dispersed forces of Constructivism. Among its members were the sculptors Vantangerloo, Moholy-Nagy and the Russian brothers Gabo and Pevsner, who had lived in Paris since 1923. Constructivism rests on the purest mathematical principles, ad-

vocating the rights of pure intuition and the spiritual conquest of matter in a perfect ideal. Naum Gabo (1890–1977) and Noton Pevsner (1884–1962) stressed the bond of spiritual dignity and the constant search for a new concept of beauty in a technological age. Gabo sought to create constructive images *ex nihilo*, in transparent shapes that disrupt spatial compactness. The two sculptors had formulated these notions in the Realist *Manifesto* of 1920 and had insisted that forms move in space. Thus, Gabo wove nylon threads into the skeleton of works in synthetics and metal, to form a dense and shining weft that transforms the object into a luminous and vibrating body, as in *Spherical Construction of a Fountain* (1937). Gabo held that this reveals "the image of the good, not the bad, that of order, not of chaos, of life not death." Pevsner, too, goes through these stages, though his sculpture is hard, secretive, not lyrical but more "constructivist," as in *Construction for an Airport* (1937), or in the later spherical surfaces interlaced with metal bars, with cues that he

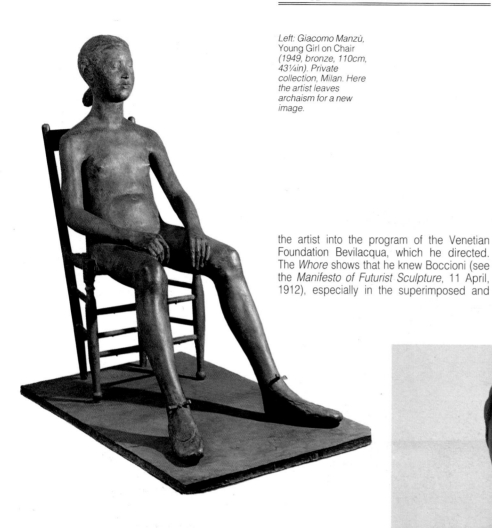

Left: Giacomo Manzù, Young Girl on Chair (1949, bronze, 110cm, 43¼in). Private collection, Milan. Here the artist leaves archaism for a new image.

the artist into the program of the Venetian Foundation Bevilacqua, which he directed. The *Whore* shows that he knew Boccioni (see the *Manifesto of Futurist Sculpture*, 11 April, 1912), especially in the superimposed and

the invasion of France involve him, unlike his friend Boccioni. After this interlude, he had his first great season, taking part in Mario Broglio's "Plastic Values," which marked master-pieces like *The poet Chekhov* and *Bust of a Girl*, of 1921.

Between the 1920s and 1930s, Martini headed the new developments in Italian sculpture, taken with the ancient Etruscan world being rediscovered by historians and archeologists. Among these was Giulio Quirino Giglioli, friend of the sculptor and discoverer of the *Véies Apollo* (in 1916), and Ranuccio Bianchi Bandinelli, who, after leaving behind earlier ideals, was to state in a vital essay of 1942 that "we must recognize that the problem of Etrusco-Italic art is no longer as topical as it was from 1925 to 1930, when even laymen (which for us may include artists) liked to refer to Etruscan art to see themselves in it." Moreover, in his discussions with Guido Scarpa,

increasingly referred to over the years: his sculptures open and enter space "like a projectile" (Frank Popper) and try to be "free symbols of the world's motion," though their origin lies "in the depth of human emotion."

Right: Quinto Martini, The Relative (1929–30, terracotta, 49.5 × 42 × 19cm/ 19½ × 16½ × 7½in). Private collection, Florence.

Sculpture between the two wars

In Italy, this displays other values, with artists of genuine European stature, above all Arturo Martini (1889–1947). Since 1910 he had figured on the international scene. When on a European trip he had stayed in Munich in 1909 to attend the school of Hildebrand; next, in Paris, he had been taken by the work of Maillol and had exhibited at the Salon d'Automne of 1912. These studies left deep traces; witness the incisive *Whore* (1909–13) and the impressive *Girl in Love* (1913): these reveal Martini's debts, but show a quite independent line and in 1913 dominated the First Roman Secession and the Venetian group Ca' Pesaro. Martini's part in the latter goes back to his close friendship with Nino Barbantini, who inserted

faceted volumes, but also by its Parisian "feel," Negroid art and also Ivan Mestrovich, whom he is much aware of, valuing his vigorous archaic stylization. Nor can we exclude that for his part Martini influenced the Yugoslav who in *Nude Woman* (1927) shows close similarities to the *Whore*. When war broke out, Martini had himself sent to the front near Vado Ligure, to an armament foundry, without letting

Martini confirmed this by saying of the 1920s that "I spent two years at the Museum of Villa Giulia; Giglioli had given me permission to go there during closed hours. During those two years I studied Etruscan art and for five I gave it back. I am the true Etruscan; they gave me a language and I spoke for them. I could have made a thousand statues as they would have imagined them." From these notions, confined

The People (1929) and Ersilia (1931), for example, recapture Etruscan sarcophagi in a strong, incisive way. Manzù often liked to speak of a "liking for Donatello and the Etrus-

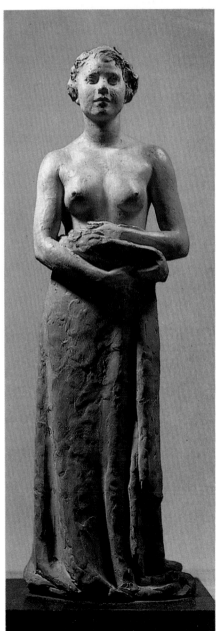

Below: Francesco Messina, Bathing Girl (1932, polychrome terracotta, 47.5cm/ 18¾in). Artist's own collection, Milan. A return to Classicism tried in the 1930s.

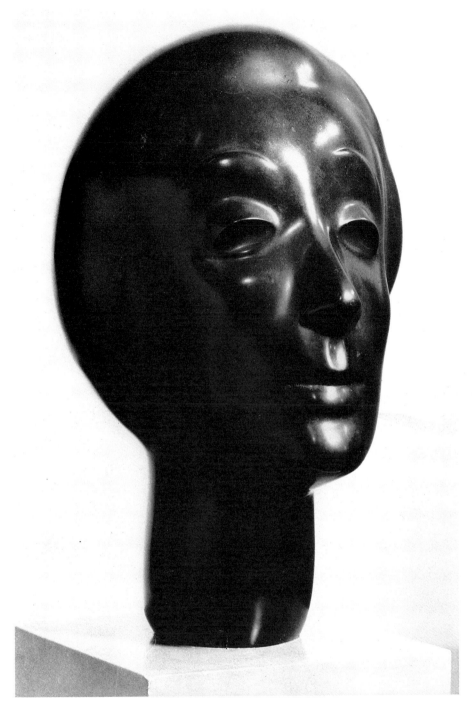

Above: Dario Viterbo, Queen (1934, black Belgian marble, 49cm/ 19¼in). Civic Gallery of Modern Art, Milan. A refined style using precious and stable materials with shining, polished surfaces.

to the early 1930s, emerged Pisan Woman, Girl's Tomb and Sleeper, with clear Etruscan leanings and recognized as vital to later stages in Italian sculpture. Other young sculptors followed Martini and gave rise to something of European scope: witness the interest shown by French critics like Paul Fierens and Waldemar George. Among Italian sculptors in whose work Etruscan echoes can be found are Marino Marini and Giacomo Manzù; the latter's

Roman amphitheater of the Foro Italico.

Among these, Francesco Messina (1900–) first produced some arresting works sensitive to Picasso with a clear, alert, Hellenistic stamp, and then recovered a Classical form in line with the political climate of the 1930s, but always with high technical skill. The Florentine Dario Viterbo shows a different stylism in his clear and highly polished sculptures: his works reflect the Egyptian and Assyro-Babylonian civilizations, even in his choice of materials, never poor but sumptuous and noble: red porphyry, jasper and Belgian black stone, ennobling them in portraits, subtly symbolic modern stelae. Italian art, bent on recovering its own origins in culture and popular religion,

cans'' (Sandro Bini, 1932), obvious in *Shulamite Woman* (terracotta) and *The Porter*, both of 1925–35. The Tuscan sculptor Italo Griselli, too, felt the Etruscan pull, in a group of fireclays shaped to simulate the crude simplicity of Etruscan finds. Other young "Etruscan" sculptors in Tuscany were Quinto Martini and Oscar Gallo, both discovered by Ardengo Soffici: the first produced some splendid works, among them the terracotta *Bust of Female Relative* (1929–30), firm and hieratic like an Etruscan portrait bust; the second produced *Hainzara* and *Nude* in the same period, closed and internalized in their formal power. To this climate belonged the youthful phase of Pericle Fazzini, whose works reveal a "powerful archaic spirit," as he himself said, and the urge to create "a Mediterranean idol": from *Woman in Storm* to the portraits of *Anita* (1933) and the great bas-relief *The Dance* (1933), he touched on the archaic tradition, revealing that "we return to statuary not isolated and independent in space but a bas-relief dispersing and multiplying energies and tensions in space" (Paolo Fossati). Concurrently with the rise of a passion for Etruscan art, cherished for its modest materials and the symbolic treatment of a withdrawn people, resigned and transitory, Tuscany saw a like event in poetry, Hermetism, which was close in feeling to the sculptors mentioned. Openly opposed to such intimate ideals, other sculptors (among them Eugenio Baroni, Nicola D'Antino, Publio Morbiducci, Francesco Messina) gave rise to the imposing forest of marble athletes up to 4m (13ft) high, around the

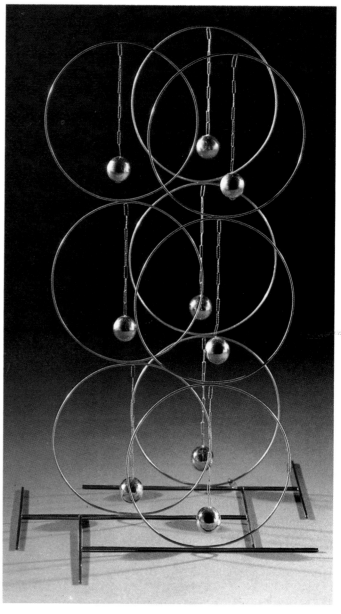

saw the start of a movement in Milan by the review *Corrente* and the Roman school. Among Lombard sculptors emerged Manzù (mentioned above), Luigi Grosso and Lucio Fontana.

After a first stage alive to the basic rigidity of Etruscan and Romanesque, Manzù, with the help of Medardo Rosso, became more feeling and subtle, and so rediscovered Lombard luminarism from Leonardo to Piccio. In 1939, while working on the series of bas-reliefs of the *Crucifixion*, he openly opposed fascism and came closer to *Corrente* ideas, though not officially joining it; Broggini and Grosso similarly approached the movement without becoming members. Grosso (1913–), very

redundant sculpture of black and white pottery to the "spatial sculptures" that carried him to the bold "spatial concepts" of the 1960s. Another great figure of Milanese abstractionism was Fausto Melotti (1901–86). At the Milione show of 1935 he described himself thus: "Art has been angelic and geometric, appealing to the mind, not the senses . . . Crystal enchants nature."

Six months after *Corrente* had been suppressed (December 1940), the affiliated artists and friends opened the *Corrente* Workshop in Milan. Their 1943 show was brutally stopped by the police, putting an end to their activities.In Rome, the seditious artistic climate of the Roman school was joined by a group of

he creates a new sculptural language, persuasive and unreserved and civically involved, fusing "power of feeling" and "modern awareness of style" (Renato Guttuso).

In Rome, alongside the brothers Afro and Dino Cagli, worked Mirko Basaldella (1910–69): from Arturo Martini's example, he grasped the evocative power of myth, but with a hint of sadness, at times full of existential rancour. At the 1936 Cometa show his struggle with archaism was revealed, later to touch on a dark barbaric and primordial element helped by a neo-Cubist bent allied with incredible technical skill: in the bronze gate of the Ardeatine Ditch, Rome (1949–51), a bristling forest gives a powerful expressionist vision. The works of

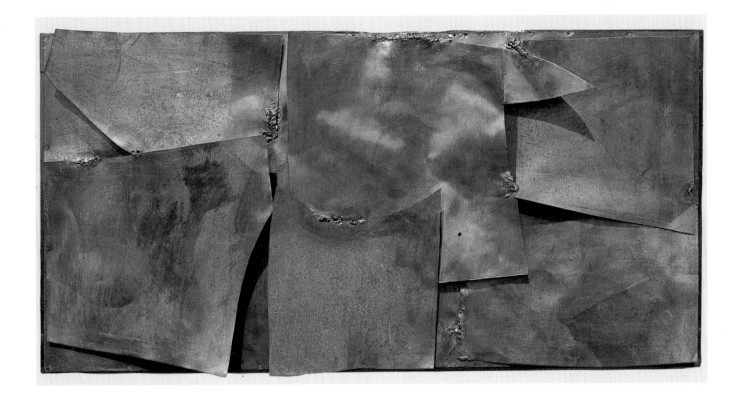

strict by nature, destroyed all his work of 1930–39: these were rough and serious works of archaic inspiration, but without a mythical or fanciful tinge, rather expressionistic and full of wit, irony and basic verve. Broggini (1908–) too, brusque and sentimental, answered the lull of the period with works steeped and soaked in light and charged with existential langour, sometimes stooping to grotesque symbols derived from medieval sculpture. Lucio Fontana (1899–1968) was moulded, like the other sculptors, in the Milan of Persico, Giolli and the Gallery Il Milione. Intolerant and impulsive, he wandered from figurative to abstract with sharp and lively insight, from the

young sculptors, among them Antonietta Raphael Mafai, Marino Mazzacurati, the brothers Basaldella and the earlier mentioned Fazzini. In the 1930s, the formal torment of Mafai (1900–75) rose from the sensual shapes of Despiau, the basic art of her spiritual master Epstein, and from Etruscan examples. Such varied sources gave rise to figures full of strong and barbaric power, with subtle existentialist hints. The grotesque figures of Mazzacurati (1907–69) from 1936 to the early 1940s are sharply aggressive expressions of a satirical taste, worn out by raw nerves: here realism and expressionism harshly meet. With his *Monument to a Partisan* (1955) at Parma,

the 1930s by Leoncillo Leonardi (1915–68) likewise breathe the neo-humanist air of the Galleria La Cometa, even if with a peculiarly sad and nervously quivering tinge, matched in pottery by the experience of Fontana. In 1939–41, while directing the Umbertide pottery, Leoncillo produced flowing works soaked in colour and baroque in form. Though still affected by a vague neo-Cubism, his images remained vehement and passionate until the early 1950s, as in *Monument to the Resistance* at Albissola Mare or in *Partisan Woman* (1955–56), set in the gardens of the Venetian Biennale and later destroyed by neo-fascist vandals.

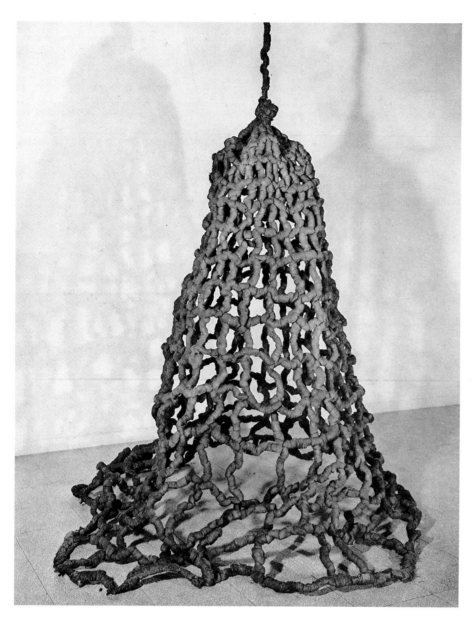

Aspects of post-war sculpture

Introduction. The end of the war in spring 1945 provoked a severe trauma of conscience, much more than that after the first war and upsetting the artistic and cultural scene; critics ostracized movements and artists held to be implicated in the fascist past, new political trends and artistic values prevailed (after recent critical revisions of events we can now judge them more calmly), toward a modernist and avant-garde line. A vast crisis of language and the need to mend the rift between art and society, thought and action, led artists to rally to Picasso's *Guernica* and to his famous declaration lauding the artist as a "political being," rejecting art as mere interior decoration: "Sculpture is the clear expression of a people, an era, a civilization."

Above: Pino Pascali, Trap (1965, iron plugs of standard size on a metal lattice, 300 × 200 × 200cm/118 × 78¼ × 78¼in). Sargentini collection, Rome. Anticipation of the "poor" and "conceptual" works of Italian art in the late 1960s.

Right: Ettore Colla, Pygmalion (1955, salvaged bits of iron, 201cm/79in). Private collection. This assembly of rusty pieces evokes some disturbing silhouette sprung from a new mythology.

Realism and abstractionism

If academic art was definitely rejected, feuds between realism and abstractionism soon arose; in Italy, Renato Guttuso shows in expression and anger the basic conditions for the birth of a work of art, while Lionello Venturi, in the catalogue of 1948 Biennale, exalted the work of Georges Rouault and hoped for a way that is "synthetic and aggressive, modern and generating new moral beauty." To overcome the analytic and naturalistic view, painters and sculptors needed a new idiom with a clear and ruthless synthesis, terse and lean, visibly aggressive, modelled on the historical avant-garde, particularly Cubism, whose message ambiguously resembled the new political avant-garde. Sculpture, too, lived in this fever-

ish climate and chose as its privileged models no longer Rodin and Maillol but Brancusi, Arp, Moore, Gonzales and Picasso, in peculiar and often incompatible constructions. Picasso's *Skull* (1943) thus became for Argan one of the century's most tragic sculptures, the very symbol of modern man's anguish. Still, Picasso is a great and separate chapter: witness the works of his last years, from the pottery of Vallauria to the *Goat* (1950), *Pregnant Woman* and the late *Woman Standing* (1963). In Picasso's footsteps the sculptor Henri-Georges Adam (1904–67) gained access to the master, who finally left him the Paris studio and then the one at Boisgeloup. Here Adam fashioned aggressively expressionist works reminiscent of the Gothic of French cathedrals; following the *Large Nude* (1948–49), he made statues of

great synthetic power, where the masses connect and become part of architecture and space, as in *Monument of Le Havre* (1955) and the imposing *Wall of Chantilly* (1965–66).

Interpetations of the human figure

In the 1940s and 1950s, the great subject of European sculpture was man, no longer as heroic leader but as victim of fate, scepticism or a new practical objectivity. Among the great interpreters of the human figure were Alberto Giacometti, back from Surrealism, and the Frenchwoman Germaine Richier. The slender figures of Giacometti, single or in groups, define what seems an empty space, alluding to his own existence. If his human figures are

Right: Anthony Caro, One Morning, Very Early (1962, painted iron, 331 × 612cm/ 130¼ × 241in). Tate Gallery, London.

Below: Jean Dubuffet, Sorcerer (1954, bark and roots, 109.8cm/ 43¼in). Museum of Modern Art, New York.

fragile and mute while traversing empty, unfathomable spaces, hers portray torment and anguish symbolized by the natural fury of storms: witness the titles of her works. From these examples were derived the early experiments of César and the English school (Armitage, Chadwick, Butler, Paolozzi), which returned to a Kafkaesque, deluded, disembodied man and Richier's violently sadistic monsters; they took on hints of organic abstraction drawn from the Paris school and late Surrealism of the American school after 1946.

Like the Greek Avramidis, Fritz Wotruba (1907–75) went on being inspired by the human figure, stubbornly represented in monumental stone or in small bronzes, giving life to stark and secret images tending toward the synthesis of prehistoric sculptures. "The watchword that assigns to Wotruba's work its true place is 'isolation'...His art, in which sharp corners and sudden breaks dominate, has something remote and blunt, almost offensive. It lacks the fleeting metamorphic pathos pervading sculpture after Rodin" (Hoffmann). Moore, too, after the experiments of the 1930s, continued to elaborate the theme of the elongated nude, transformed in later versions within a highly personal stylistic path: "I too wanted to relate the contrast of dimensions ...with mountainous folds, the Earth's crinkly skin"; by such trials he broke loose from his early sources, from Zadkine to Picasso, attaining new symbolic forms and a deep feeling for

nature, leading to post-war sculpture.

Crisis and experiments with new idioms. In Italy, this figurative trend came with the mature Marini and Manzù; the former, after formally exhausting the last Pomonas in terracotta and coloured wood, developed the lively theme of female dancers and their partners, rendered in stirring dramatic spirit. Manzù moves in a vast range of fantastic motifs, from cardinals to figures of the painter with his model and of lovers, realized with great formal and technical skill. A much more piercing and rawly violent view of man is shown by the sculptors Agenore Fabbri and Luciano Mignuzzi. To the post-war setting also belonged the mature years of Mirko Basaldella: leaving behind the archaism of Martini, he adopts neo-Cubist cues to build highly imaginative abstract and surreal figures that foreshadow the bold spatial expressions of 1949–51, as far as the exploration of archetypes in the totems of the 1950s and 1960s.

In the spring of 1948, the Roman Quadriennale reopened, and in June the International Biennale, which offered a first spatial experiment by Fontana as well as the official sanctioning of the New Front of the Arts, in whose salon eleven artists exhibited: alongside the founder painters Guttuso, Pizzinato and Birolli were the sculptors Alberto Viani, Leoncillo and Nino Franchina. The first, a pupil of Martini, resumed in a new key the clarity and abstract sublimation of form typical of Arp; for Fran-

Right: Claudio Parmiggiani, Clavis (1976). Presented to the forty-second international art exhibition at the Biennale of Venice.

Below: Field of the Sun (directed by Enrico Crispolti, 1986–88). Tuoro, Lake Trasimeno. Twenty-seven columns near the lake create a monumental mood evoking ancient mythology. A token of the importance of sculpture in the 1980s.

china, returned from a stay in Paris in 1946, the points of reference remained Zadkine, Laurens and Brancusi; but from 1930 he abandoned figurative sculpture to experiment with industrial materials and methods: witness his cut, welded and fire-glazed iron sheets shown in 1952 at the Craft Gallery in Milan.

The 1950s and early 1960s were marked by a self-conscious crisis of idiom, pursuing a wider artistic experience toward new horizons as compared with the traditional system of the visual arts, using by now accepted codes; the change showed most clearly in that artists abandoned traditional materials and techniques, which both realists and abstractionists had preserved just as faithfully. Now artists modified the artistic work as such: canvas and statue, elements of a worn-out code, yield to new "objects." The rejection of what was codified now coincides with the "brusque release from the theme of 'modernity', which was at the core of the battle between abstractionists and realists, substituting the theme of the original and primary" (Giorgio De Marchis). It is no accident that the dissident group of Roman abstractionists, formed in 1949–50, united the painters Capogrossi and Ballocco, the sculptor Ettore Colla, Alberto Burri who practiced both arts, as well as Cagli and the poet–critic Emilio Villa: this produced the intellectual ferment of the Origine group, which fed a cultural climate rather unusual for Italy at that time, with literary, philosophic and esoteric currents.

Already, in 1947, Alberto Burri (1915–) had had his first personal show at Galleria La Margherita in Rome, where he had settled in 1946 after a period of captivity in America. After the setting up of Origine the gallery of the same name was opened, directed by Ettore Colla, where in 1952 an unusual show was held, "Homage to Leonardo," in which beside the founders (except Ballocco, who had left) the sculptors Mirko, Edgardo Manucci and Lorenzo Guerrini took part, as well as the painters Cagli, Matta and Accardi. During this period Burri made his first surprising Sacks and was invited to the 1952 Biennale at the prompting of Fontana, who bought one of the two studies for the Sacks on show. In 1953 Burri had a personal show of Sacks at the Origine gallery with a cogent introduction by Emilio Villa, who remained his main interpreter at that time. This affinity between Burri and Fontana as to new views of space was a supreme feature of European art in the 1950s.

Luigi Fontana, who returned from Argentina in 1947, started a new field of experiments with the first and second Spatialist Manifestos, from which derived the Spatial Sculpture of the 1948 Biennale and the installation in 1949 of a Spatial Setting in the Craft Gallery. In 1952 there was a prophetic convergence with Burri: in May, Fontana had a personal show there, exhibiting his first Spatial Concepts, in which pierced leaves or canvases typify a "gesture" no longer that of a sculptor nor of a painter: "It

is truly a Demiurgic gesture" (De Marchis). In 1953–54, Burri began to produce his Sacks with various scrapped materials, worn-out rags, clothing, fragments from a world into which the artist can insert his own historical reality. In those years some artists of Origine became interested in Fontana, among them Ettore Colla (1896–1968), who in 1945–55 found his own path after a period of searching, and produced a group of object sculptures, assemblages of scrap iron. The new works were Hostility or The King, Earth or Season, Pineseed Picker, followed by Workshop, Flowers in the Night and Genesis; the materials used are scraps of iron, bits of cars and various machines that Colla had found in scrap yards and went on to rework by welding them together. This produced arresting images of these objects whose visible wear and tear gives them new meaning and features, as in Earth, where bits of agricultural machinery show through but as independent parts of a new and disturbing sculpture. Moreover, Colla makes witty and ironic comments on his works: witness the titles, which did not refer to technology or other forms, as in much abstract art, but to an allusive image or to a mythological archetype. Just as the archeologist brings to life the smile on an ancient statue, so Colla rediscovered this distant world and gave it new life, in the Classical rigour of composition imposed by the balance and purity of the component shapes, by a taste for elegant proportions and by order. Still, the critics ignored his works, oddly enough rejected by the 1956 Biennale, when beside Chadwick, Emilio Greco received a prize for sculpture. The disruptive experiments of Burri, Fontana and Colla, which had European scope, were fundamental for new trends begun in the late 1950s; just as the 1940s had ended on a neo-Cubist note, so the next phase is marked by a flood of the formless. Meanwhile, the international scene saw a revolt of

artists against any kind of academicism: in 1951, Michel Tapié gave his show "Les signifiants de l'informel" and in 1952 he coined the phrase "an art that is other"; in the same year, overseas, Harold Rosenberg baptized the movement of Action Painting, stressing the artist's active doing, in tune with existentialist thought, and the figurative side of the work. This message, made official by Tapié at the 1954 Biennale in presenting the Capogrossi room, became established in Italy after 1955, when the unopposed stamp of New York began to prevail. Now Fontana gained greater mastery of spatial concepts, enriching them with material effects of sand, stained glass, stones and other inlays, revealing a developed tendency for such efforts. At the Biennale of 1958, the first prize for sculpture went to Umberto Mastroianni, who had adopted Boccioni's dynamism, developing volumes in angular, cutting shapes in the style of neo-Cubist futurism. At the same show, Lionello Venturi echoed the anti-Biennale he had opened in June, exhibiting "New Tendencies in Italian Art," with Carla Accardi, Vasco Bendini, Pietro Consagra, Giò Pomodoro and others, all from various backgrounds but sharing the non-formal climate that accepted symbolic and material painting, as well as fantastic abstractionism and abstract naturalism. Basically, we see here the searchings of an emergent neo-abstractionism, which regarded the non-formal impulse as already faded. Pietro Consagra (1920–) was moulded as early as the renewing urges of the 1940s and later saw his abstract aim in the demands of a formal absolute, making sculpture strongly synthetic. Meeting in the Sun and Enchanted Meeting of 1957 show Consagra reaching perfection, with a shrewd balance between raw cut and painterly as well as material values of interplaying surfaces. His work continued into the 1970s, enriched by the colour and suggestive power of his materials. A similar line, though of

Left: Carlo Guaita, Complex System (1987, iron and slate, 160 × 200cm/ 63 × 78¾in). Carini Gallery, Florence. This rigorous design inherits from Minimalist and conceptual precedents but aims at the rigid perfection of a new Classicism.

Opposite: Stephen Cox, Spring (1987, tuff, 100 × 16cm/39¼ × 6in). Carini Gallery, Florence.

monumental size, was taken by the works of Lorenzo Guerrini and Andrea and Pietro Cascella, in their huge stones that assume rudimentary human forms: through the nobility of the stone and marble conceived in powerful and indestructible shapes, Guerrini, in the footsteps of Wotruba, investigated the cosmic link between man and nature, while the brothers Cascella sought the same world structure in solemn archetypes, Andrea in tense and rugged epic style, Pietro in a more lucid and tenuous measure. A taste for material merges with the search for primeval power and a perfect abstract measure.

The story of Arnaldo (1926–) and Giò (1930–) Pomodoro began about 1955, when non-formality held sway: networks in lead and silver interlace on rough limestone or cement surfaces, spread out by hand or by rags, heavily opaque to bring out the material force of these "poor" techniques. After 1960, the brothers sought new formal effects: spheres, luminous assemblies and columns became shining symbols of modern technology, between science and fantasy. In figurative sculptures, form as object prevailed, while new trends toward Pop Art arose, as shown at the 1964 Biennale; these trends were meant to laud any feelings simply through syntactic organization, with clear emotional detachment.

However, where Arnaldo Pomodoro put forward coldly perfect images, Francesco Somaini (1926–) had informal organic images, full of anxious protest, that offered a traumatic challenge.

Vague allegories and surprises also appeared in the late works of the Hungarian Zoltan Kemeny, metallic waste and off-cuts that seemed to materialize the subtle variations of Klee, now transformed by an uneasy informal spirit, and open to certain experiments of Jean Dubuffet's Brute Art. After having rediscovered as a painter the savage traits of the unconscious, at the turn of the 1960s, Dubuffet renewed his style, uniquely absorbing both Pop and Op (Poptical), thereby aligning himself with the new generations; this gave rise to the series of *Hourloupe*, which in a few years became three-dimensional, using industrial chemistry and expanded polystyrene and polyurethane. Thus he attuned himself to the latest attempts anywhere, from Oldenburg to Segal, the practitioners of Antiform, and Caroli and Pascali, Land Art. The decade from 1958 was marked by an experimental display of techniques of boundless scope, using and interweaving many components. Among these artists was Pietro Manzoni, who after the informalism of the 1950s linked with Fontana, produced the *achromes*,

seen as negation, absence or nothing. In 1961 he produced the first *Magic Ground*, on which any spectator may become a work of art, and *Artist's Excrements* in boxes sold by weight at the day's gold price. Making his début at the Roman Galleria La Tartuga in 1965, Pino Pascali showed signs of earlier international Pop, which drove him to objects like *Colossus* and *Rocks on Lawn*, where the archeological aura changes into consumer images, by means of tinkering with disparate cast-off bits of lowly materials, as a kind of joking metaphor in which the artist himself takes part. The 1960s took this to the point of objectivization, in a mood that was neither theological nor idealistic, betraying a basic problem of identity: in Mario Ceroli's work it appeared as a scenic wealth of woody shapes, from the *Piazza d'Italia* (1965) to *China* (1966), where craft and material aspects of the wood merged with the sophistication of a Pop message.

In 1967 at Genoa, Germano Celant held a show at the Galleria La Bertesca, called "Poor art and IM Space," which presented the artists Boetti, Fabro, Paolini, Kounellis, Pascali and Pini; the name, taken from Grotowski's theater, was meant to indicate an "artistic and existential practice," employing materials in common use and natural elements, often standing for themselves. In the same year, Celant, in the new review *Flash Art*, gave the name "poor art" not to a show but to a movement in sculpture in which the critic acknowledged the works of Gilberto Zorio, Piero Gilardi, Mario Merz and Michelangelo Pistoletto, most of them centered on Turin around the Gallery Sperone, the first in Italy to give room to items of American Minimal Art.

Conceptual struggles. In 1968 there was a fateful break: following sharp dissensions, the Biennale pushed many young artists into an inescapable crisis and even to the end of any activity, while a whole generation of artists died, from Manzoni to Pascali, Leoncillo, Fontana and Colla. Still, the original concept of poor art remained linked to the subsequent works of Kounellis, Pistoletto, Penone, Zorio, Fabro and Paolini. The last of these gradually distanced himself from "poor" topics to explore "conceptually" poetic efforts that face enigmas and transcendental themes, "in which the visual is but the image of an image that refers to ungraspable ambiguity and space" (De Marchis). In tune with philosophic and political trends that spread through Europe in the 1970s, sculpture and painting were seen as cold and conceptual abstention or deliberate rejection. In artists such as Paolini or Parmiggiani faith is dissolved in gesture, in its fullness of feeling and unreason, and thus breaks the link between post-war art and the historical avant-garde; in the conceptual efforts of the 1970s, as later in Paolini's *Temple of Glory* (1983) or Parmiggiani's *Rise of Memory*, we meet an exercise of attenuated feeling, enigmatic silences, pauses and hints

that touch on mystery and suggestion. Beyond the 1960s, England, too, after the flare-up of Pop, tended toward the Minimal, through the charismatic person of Anthony Caro, and later toward radical speculations about the nature of the visual, or the view of art as both material and conceptual, as shown in "New Generation," down to the Land Art of John Hilliard and Richard Long. In the complex passage from Minimal to Conceptual one cannot leave out the emblematic figure of the German Joseph Beuys, remembered for his controversial and stimulating theories, from "anthropological art" to human society understood as "social sculpture." The period 1968–78 saw at the center of artistic interest the city redskins, Punk rockers, the Beaubourg, defined as "supermarket of the avant-garde," the triumph of mass media and the explosion of graffiti; many took hold of the ideals of revolution, creation and liberation of the earlier avant-garde to serve new ways of behaving, other than political and social ones.

The 1980s. Toward 1980 there was a return to cultural autonomy after the international flavour of Minimal and Conceptual art: what now became dominant was a "return to the trade," through so-called transavant-garde, Anachronism or Citationism; local traditions came once more into their own with renewed human feeling taking part in artistic work. Painting and sculpture in the 1980s, though rich and varied, led the way back to an aesthetic pleasure in materials, in the spiritual meaning of form, in overcoming merely ideological motivations. Witness the firm sculptures of Igor Mitoray, full of Classical nostalgia, or in the slender and ironic fantasies of wood and papier mâché by Luigi Ontani, as against the nonchalant "anachronistic" figures of Athos Ongaro and the transavant-garde sculptures of Enzo Cucchi and Mimmo Paladino. Among young English artists, cleverly balanced between mythical figures and visual abstraction, Stephen Cox emerged, while other lines were followed by Tony Cragg and Anthony Gormey. None of this required being tied by figuration: witness the rigorous spatial ideas of Gianfranco Pardi and Nicola Carrino or those of the Florentine Carlo Guaita in his solemn and rarified abstract patterns. At the same time there arose more expressive and material tendencies, from the calculated forms of Luigi Mainolfi to the more visceral ones of Angelo Casciello, to the lively archaism of Nunzio, who was given the first prize for young artists at the 1986 Biennale. In such a rich and controversial setting, sculpture once more played a role and reaffirmed its public presence: that is what happens at Tuoro on Lake Trasimeno, here, around a mythical altar by Pietro Cascella, a kind of suggestive "memorial" rises, twenty-seven columns of an ideal temple cut by international sculptors, young and old, and arranged by Enrico Crispolti. The disenchanted and now distant years when Argan spoke of "difficulties in sculpture" seem over-

Left: Antonio López Garcia, Man and Woman *(1970–88, still unfinished, wood, natural size). Private collection. The artist combines a powerful realism, based on humanist convictions, with the main trends of present sculpture, halfway between abstraction, Minimalism and conceptual experiment.*

Opposite: Igor Mitoraj, Ganymede *(1983). Mythological inspiration of the figurative trend in the early 1980s, which tried to symbolize nostalgia for a lost integrity.*

come, and the paths, though different, have consciously returned to a rediscovery of old values, including social ones, of sculpture, and to an appreciation of form along with rigour in inquiry.

American sculpture

The American artistic tradition, hesitantly turned to Europe since the time of the sculptor Hiram Powers (1805–73), who lived and died in Florence, has confirmed in our century a close attachment to the Old World: Jacob Epstein, born in New York, became a Londoner in the early 1900s, while Duchamp came to New York with a glass sphere containing Paris air. By 1920, a whole generation of American artists had sailed to Europe, attracted by the myth of Paris, to return after ten

years enriched by existentialist motifs acquired from the pages of Joyce, Eliot, Yeats, Valéry, Proust and Pound. While the Museum of Modern Art, opened in 1929, exhibited the great themes of European avant-garde, the private galleries Pierre Matisse and Valentine Dudesing showed masters of the Paris school. In 1940, after the fall of Paris, many European artists, from Breton to Ernst, Dali to Masson and Mondrian, left and fixed their center in Peggy Guggenheim's gallery, "Art of this Century" (opened 1940), nurturing new and disturbing versions of Surrealism that displaced the artistic center of gravity from Paris to New York.

The artistic life of Alexander Calder (1898–1976) began in Paris in 1926–27, with works in metal wire, related to the spirit of Miró and Arp of the same period. Later he came closer to the abstract rigour of Mondrian, by inserting

primary colours into geometrically abstract archetypes, as in the *Mobiles* governed by a spark motor like a firework, and then in the *Stabiles* of the 1930s. Later, the *Mobiles* became elegant organic forms whose motion is caused by the wind or by human agency. These works were the result of long meditations on natural forms, paraphrases of flowing beings, metamorphoses of plants, metallic lianas, quivering corymbs that spread in all directions, not without a playfully ironic bent. The same outlook and intensity is found in the ladles he made for his wife Louise, in curious chandeliers built by stacking pudding dishes, or in gouaches made without brushes, simply by tilting the sheet and playing with chance, but in an original way as against Surrealist automatism. From 1937 the *Stabiles* became increasingly monumental in shapes derived from Gabo, which around 1960 greatly influenced the new generation of sculptors.

Isamu Noguchi (1904–) was likewise drawn to Paris and developed as an assistant in Brancusi's studio, where he learned the technique of directly cutting stone; in 1929 he returned to New York and organized his first personal show, absorbing the holistic outlook of R. Buckminster Fuller and the ballets of Martha Graham, which were to have a strong bearing on his whole career. Though acknowledging Brancusi and Arp, Noguchi's work stresses the architectonic meaning of masses, in an idiom derived from Picasso's drawings of the 1930s. Moreover, he was attracted by political and social urges, which show in the great high-relief mural *History of Mexico* (1935–36), compact and powerful, 21m (69ft) long, installed in Mexico City in the public market Alberardo Rodríguez. While other young artists worked in the north as assistants of Mexican muralists, Noguchi could thus take part in the scorching climate of political revolution in direct comparison with the murals of Rivera, Siqueiros and Orozco.

David Smith and Theodor Roszok, but also Seymour Lipton (1903–) and Herbert Ferber (1906–), though indebted to European art, formed the basis of a purely American school. Starting as a painter, in 1931 Smith experimented with unusual materials, introducing sculptural elements assembled on the ground of the canvas; in 1933, influenced by the sculptures of Picasso and Gonzales published in the review *Cahiers d'Art*, he turned to metallic constructions welded in two dimensions, unusually set in an imaginary cornice that creates an ideal edge, as part of the shape; a cue taken up again in the 1940s and 1950s by Ferber, Lassaw and Grippe. With *House of the Welder* (1945), Smith advanced a narrative version of Surrealism: the female figure is changed into a menacing plant, a wheel and a chain symbolizing the weight of the welder's home life, peopled by the symbolic figures of a goose, a reindeer and a Venus. Toward 1950, Smith turned to a more sober Surrealism, marshalling form within a constructive experience belonging purely to metallurgical industry, as in the stainless steel *Cubes*.

Roszok, too, while inquiring into ways of making utensils, produced structures welded in three dimensions and worked by machine and careful hand-crafting. The works of the 1940s are epic in kind, expressed by violated forms where polished steel surfaces sometimes contrast with parts covered by spongy encrustations, as in the *Whaler*, a mythical

Above: Alexander Calder, Mobile (1941, aluminium, painted in part, and iron wire, 214cm/84¼in). Peggy Guggenheim collection, Venice. By its refined style, the work recalls the contemporary art of Miró, Arp and Mondrian, while showing Calder's account of the fleeting and mobile forms of nature.

had for painting, but disparate individual efforts. Among these emerged the work of Louise Nevelson, who in the 1950s created massive, severe works in wood, painted opaque black and using Cubist geometric vision with subtle and nostalgic feeling. This finally led her to sculptures of natural size and strong environmental force. She later overcame the austerity of "Gothic ruins" to experiment with empty whiteness and gold, in works such as *Nuptials at Dawn* (1959) and *Dawn* (1963). In the same years Richard Stankiewicz turned to sculptures made up of welded fragments, without meaning of their own but reassembled into a new formal poetry. Alongside Action Painting an "urban" sculpture arose, using Smith's industrial metals, refuse of daily life covered with nostalgic dust, elements of Nevelson, and cast-off materials of urban life: plastic bits, car frames, rubbish and corroded fragments that are elements of a genuine style, the first national style. About 1955 the new galleries of Tenth Street in New York redirected attention toward new artists, such as William King, George Spaventa, John Chamberlain and Mark di Suvero, displacing Surrealist sculptors in favour of Abstract Expressionism. King used ordinary packing canvas, wax, aluminium frameworks; while Chamberlain made headway with the sculptural scope of compacted car frames.

Until 1956–57 the New York school dominated that city, when in the context of Action Painting new works began to appear with iconic elements, inset or painted, of significance in common use: flags, numbers, the shoes of Jasper Johns, Coca-Cola bottles and the assemblages of Robert Rauschenberg and Larry Rivers; the insets seemed at first to refer to Nevelson and especially Cornell, and were often called New Dada. However, after the activity of Oldenburg, Dine and Rosenquist, they acquired clearly anti-abstract meanings, called Pop. It was the English critic Lawrence Alloway who defined Pop Art, by which he meant artistic efforts begun about 1955 and hitting the public in the early 1960s in the New York galleries (Leo Castelli, Stable, Sidney and Green), until the movement was established through Alan Salomon's fitting out of the United States pavilion at the 1964 Biennale at Venice. In such a setting sculpture lacked a specific role, from the moment when it becomes hard to isolate the happenings and performances of Rauschenberg, Kaprow, Witman and Oldenburg within conventional bounds broken by the union of sculpture, painting, theater, poetry and music. From then on the story of American sculpture coincided with the most general avant-garde movement of the 1960s and 1970s.

paraphrase of Melville's *Moby Dick*, where the artist merges the fate of hunter and hunted, prison and revolt.

Lipton's metallic shapes sought a similar expression; around 1950 he moved toward more formal inquiries, by which his work assumes a sacral tone, as in the experiments of Feber, Ibram Lassaw (1913–) and David Hare (1917–), and in Lippold's rigorous and pellucid symmetries.

The atmosphere in which these artists worked was difficult, the sad backdrop of New York before the crash of 1929, then the great Depression prior to World War II. Still, their work had the fundamental effect of making American sculpture cosmopolitan, by assimilating European avant-garde, exploring new techniques, and starting the upheaval of movements in the 1950s.

However, European currents did not fix a uniform goal for American sculpture as they

Right: David Smith, Foreground III (1962, 315 × 368 × 46cm/ 124 × 368 × 18in). Marlborough-Gerson Gallery, New York. Smith went from Surrealism to Constructivism in an industrial and metallurgic style.

Below: Isamu Noguchi, This Tortured Earth (1943, bronze, 71.1 × 71.1 × 10.2cm/ 28 × 28 × 4in). Isamu Noguchi Foundation, New York. The artist hints at Picasso's graphism of the 1930s and to the abstraction of Brancusi and Arp, to present his own poetic and "humanist" message.

Louise Nevelson, Royal Tide IV *(1960, painted wood, 335.28 × 926.27cm/132 × 364½in). Wallraf-Richartz Museum, Cologne. Severe forms,* frontal and massive, painted in black, silver and gold, strike one as austere and dusty "Gothic ruins."

Avant-garde art (1960–1975)

New Dada, nouveau réalisme, Pop Art

In the mid 1950s or thereabouts the art scene in the United States saw the emergence of a highly innovative tendency. Using many different forms of expression it was capable of outmatching the established bipolar state of things, the two poles being action painting and geometric abstraction. For more than a decade these two genres had monopolized the output of the avant-garde. What was more, for the first time in the postwar period this new tendency seemed to do away with all those classical distinctions made between painting and sculpture, and between two-dimensional representation and objects in space. In effect, of course, it did not in any way reject the use of that most distinctive of instruments, informal gesturalism.

The earliest exponent of this new tendency was Robert Rauschenberg (b.1925). He was then a young artist filled with enthusiasm for all that action painting had taught him. He was aware of the expressive power of colour, once liberated from the strictures and conditions of design and form, and now applied in a violent manner – thrown, sprayed and dripped in a spirit of anarchy and release. But we should swiftly add that Rauschenberg also seemed to have sensed a new implication, and a hitherto unexplored function. When chromatic "dripping" is applied directly to actual objects, these very same objects are "alienated" (in the

sense intended by Šklovskij in 1917 and later illustrated by Eichenbaum in 1927). In other words, this application produces a distancing from perceptive practices, making the objects unpoetic, and their artistic retrieval for new modes of expression of intrinsic significance. So Rauschenberg and Jasper Johns (b.1930), followed some years later by Jim Dine (b.1935), introduced into their work the crude reality of commonplace, day-to-day, unaesthetic objects. But their aim was to vitalize these objects by means of a manner of execution that throws them out of context, extrapolates them from socially codified roles and restores to them, with effective immediacy, the strange spark of virginity. Rauschenberg used the term Neo-Dada for this new approach to reality. He was certainly not referring to the "reality" of nature, as filtered by ideologies that are at once romantic, lofty and steeped in culture, but rather to that ugly, technological reality of the everyday utensil and the consumer product. He used this term because it implies the

Andy Warhol, 200 Campbell's Soup Cans *(detail, 1962). Kimiko and John Powers Collection, Colorado, USA.*

transformation of any old thing into something of artistic value (based on the ready-made principle of Duchamp) by means of a "creative" helping hand, which then offers it to the stupefaction of an improper or inappropriate interpretation, as if it were re-invented.

For American Neo-Dadaism, painting an object no longer meant representing it in an illusive way, or creating a two-dimensional copy of it in a potential space. Rather it meant literally subjecting the object to the alienating action of colour, and the violent pictorial gesture ... In relation to the traditional categories of art, the works of Rauschenberg are no less sculptural than painterly. The assemblage of objects (as in *Odalisk, Bed,* or *Monogram,* all produced between 1955 and 1958) presents "scenic" situations that have an astonishingly concrete and three-dimensional quality, bordering on the limits of what Allan Kaprow, the theatrical theoretician concerned with real time–place who greatly sympathized with these artists, calls environment. By environment he means that place where the spectator finds himself confronting the revelation of a fragment of an environment of which he had perhaps been aware. This revelation involves a total criticality of his own habits on the double front of everyday existence and aesthetic experience. Here we have a precise though somewhat wary act of condemnation, aimed at the introspective and psychological choice of previous art, in its purist or dramatic-

cum-gestural versions. This previous art is seen as a guilt-ridden flight from the world and its contradictions. It is seen as a refusal to measure up to the social and individual drama that lurks behind the profane liturgy of modern consumerism. This, in turn, is seen as the extreme outcome of the positivist evolution of the West, and the lethal landing-stage of the industrial and commercial capitalist system. New annotations to the theme of the clash between "culture" and "civilization" thus achieve a powerful takeover of the core of artistic interest. The point is even reached where, between 1959 and 1963, Dine's entire production may be interpreted as an attempt, conducted within a single representative space, to reconcile the philosophical pole of "thought" (taken as pictorial wisdom and reflection, and therefore as a thought-out and cultural construction of the picture) with the violently slipshod pole representing the household contraption and the consumer fetish – for example, the aluminium soap-dish, the stove-pipe, the screwdriver, crockery, mock-leather shoes … Objects mounted on surfaces to some extent resembling those highly ambitious surfaces used by the pastmasters of mystificatory abstraction, or juxtaposed with "absolute symbols' such as the palette, canvas or sheet of white paper.

Are we dealing with a consecration of ordinary life, or a desecration of art? An apology of mass culture, or a denigrating attack aimed at the heart of the self, the ego, the unique nature of the subject? We are dealing with complementary operations, which took on a more precise political meaning in the less ambiguous procedures of *nouveau réalisme*. That is, within the French movement that, in the very same period, made reference (it, too) to histor-

ical Dadaism. Its theoretical guidelines were mapped out by the critic Pierre Restany for a group of artists – Fernandez A. Arman (b.1928), César (César Baldaccini, b.1921), Christo (Christo Savacheff, b.1939), François Dufrêne (b.1930), Yves Klein (1928–62), Martial Raysse (b.1936), Daniel Spoerri (b.1930) and Niki de Saint-Phalle (b.1930) – whose purpose and aim were, precisely, to produce a convergence between art and a critical interpretation of external reality – in other words, of urban and social reality. In the *nouveau réalisme* movement works seized hold of the everyday object in an apparently powerful and ideological way.

In the United States the subversive thrust is without doubt more bland, to the point where it seems difficult to pinpoint it accurately in the nevertheless important and innovative works of the protagonists of Pop Art. After 1960 this tendency espoused the signs of Neo-Dada and opened up these new buds in a veritable saga of mass culture. It has something strongly (perhaps acritically?) apologetic about it in relation to the themes around which it builds its own specific identity. For the most part Pop Art reintroduces the inconographic datum into the work of art, whether this be a picture, a sculpture, or an installation. To some extent it restores the realistic image codified in a perspectival and figurative rendering. To some extent it produces new codifications. And if the iconographic datum is invariably referred to the object-as-merchandise (the supermarket epic with all its pseudo-, para-, or sub-cultural implications), in the most salient of instances it is the actual level of meaning, or the system of information adopted, that becomes a clever reinterpretation of the communicative techniques already present in the

world of social messages. A good example would be the borrowing of the rhetoric conceived by the advertising industry. It is this which makes Pop Art properly original. Its dedication to modernity (understood as a specific anthropological condition in a completely reformulated society which is perceived to be artistic already and *per se*) manages to produce a profound modification of the parameters of aesthetic judgement. This implies, in other words, the most radical departure of art from the traditional categories based on the construction of meaning.

When Claes Oldenburg (b.1929) chooses to reproduce sandwiches, slices of meat, vegetables and other foodstuffs in a solid and inedible material such as coloured plaster of Paris, or – vice versa – when he makes washbasins and typewriters using soft, pliable rubber, or when he magnifies very small household appliances to a grotesque degree, he is not exactly indicating an act of condemnation or disapproval, nor is he presenting us with a satire about the "stupidity" of material goods, he is more concerned with a precise gesture aimed at producing an aesthetic requalification. He provokes astonishment by putting the spectator in front of a familiar scene that is out of context, or rendered stiff or soft, or deflated, and rendered absurd by the emasculation of any functionality and any good practical sense. It is this sense of astonishment that forms the fundamental basis of a rehabilitation of day-to-day existence to forms of a new and loftier type of sacredness. In the final analysis this involves a mystificatory gesture. Whatever is "lowbrow," banal and unpoe-

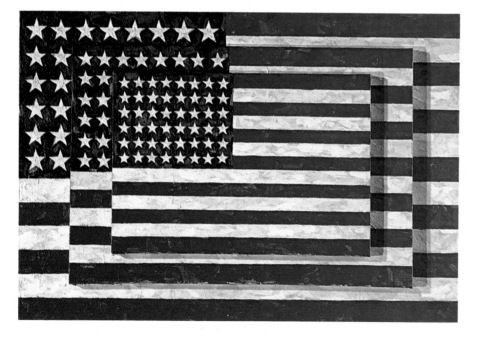

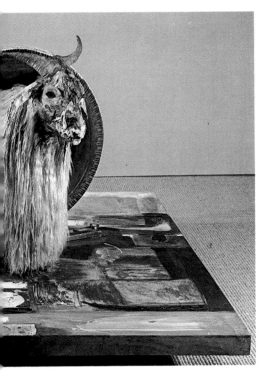

Left: Robert Rauschenberg, Monogram (1955–59). Moderna Museet, Stockholm. American Neo-Dadaism reintroduces with considerable effectiveness the ready-made concept, dating back to the historical Dada of Duchamp and Man Ray. But the American version revitalizes this concept by focusing on a stereotypical idea of reality and its objects, and to no less an extent on the structures (psychological, linguistic and cultural) that enable one to acquire them. This means that in modern consumer society it is precisely the absence of "value" (the anti-sublime nature of objects and life, and the commercialization of nature itself) that constitutes a cultural significance. So this – in the final analysis – is the only datum of "value" that can be tried out in a concrete way.

Opposite: Jasper Johns, Three Flags (1958). Mr. and Mrs. Burton Tremaine Collection, Connecticut, USA.

Above: Claes Oldenburg, Giant Soft Light Switch (1966). Wallraf-Richartz Museum, Ludwig Collection, Cologne. With his soft objects – technological elements "reproduced" in an unsuitable material – Oldenburg subjects the empirical world surrounding us to the test of a scathing form of ironical and playful creativity. At the same time he seems to want to redeem this world from the (academic) accusation that it is completely unaesthetic.

Left: Jim Dine, Study in Three Panels for a Child's Room (1962). Kimiko and John Powers Collection, Colorado, USA. Dine assembles fragments of banal, everyday reality to produce an active "confrontation," within and with the space of the picture. In this way he transcends the classical limitations of pictorial language.

tic retrieves its own cultural dignity, and seems keen to compete with mythical products (no less) from the past. For as far as present-day society is concerned these products represent a lost memory or, if you prefer, an illusory sense of comfort. The gesture of Pop Art is thus a warble of reawakening, and an invitation to accept the present as a source of something worthwhile that is opposed to any kind of escape back into the past.

The same can be said of the serial paintings using photographs as the matrix produced by Andy Warhol (1930–87), starting with that very first and now very famous work *200 Campbell's Soup Cans* of 1962. Here the alienation is achieved by means of an obsessive repetition of the same image (the industrial label of canned soup, used two hundred times in a single picture), which makes a most conspicuous allusion to the manner in which the object appears to us in our everyday life. The reference is thus also aimed at the most typical promotional method used by the market. Warhol seems to take the process, by which the object (or the image, like the photo of Marilyn Monroe, for example) is rendered banal, on the rebound, so to speak. In so doing he shows that what creates habit and even loathing (that is, the incessant proposi-

tioning of advertising) may likewise, and as an extreme consequence, create its universal re-evaluation in the guise of a work of art. It is important to understand how these operations require an adept exploiter, and how they are addressed explicitly to the man in the street and to the masses – to those people, in other words, who are accustomed to dealing with the logic that sustains them.

The large panels of James Rosenquist (b.1933), which present images devoted to a boundless apotheosis of "technological kitsch," appear like moments in an epos of pictorial self-destruction, where the undoubtedly exalted technical ability of the artist merely helps to render more convincing the imitation of the various languages of banality and loss of meaning. But this imitation is never complete as such because the pop artists almost invariably anticipate the forms and modes of imagination to which they make reference. As a result they are slightly beyond the spot in which we see them today, that is, where the rhetoric of consumerism and publicity has finally caught up with them. It is in this context that an extreme position like that of Roy Lichtenstein (b. 1923) becomes legitimate. Lichtenstein's intent is to "redo" in oils the panels of famous cartoons, but with the grammatical error of enlarging them and reproducing on them the wording of the utterances pronounced by the various characters depicted, the special figurative effects of the comic strip artist's technique, and even the typographical screen (in such a way that the image consists of tiny brushstrokes, which are hyper-evident as a result of the macroscopic nature of the restoration). Here the sense of removal from what is familiar is altogether contained in the ambiguous and subtle play of the dimensions, of the extrapolation of a single vignette from much wider narrative contexts, and of the placement of the panel in an unusual space. This space, in a word, is art, and the places where art is exhibited. And whereas Tom Wesselman (b.1931) entrusts the cloying, Hollywood effect of his strange pictorial "bas-reliefs" both to the coarseness of the materials (coloured plastics, acrylics and low-quality enamels) and to the brutal hyper-pictorial rendering – and more precisely to the use of illuminated or revolving signs – George Segal (b.1925) creates installations that are amazingly (but also foolishly) self-evident, using plaster casts of people and animals, side scenes, back-drops and other stage-type material.

Concept and form

From 1965 onward, in both the United States and Europe, a new conception of artistic work came strongly to the fore, gathering momentum for an entire decade. This conception had no precedents in the history of aesthetics, apart from certain occasional bursts issuing

from the traditional avant-garde movements. At first glance it seems to involve a radically Platonic brand of attitude. This attitude implies that what is really important in the work is not so much its object-related physicality, its tangible production or the material fact of its presence, but rather the idea (concept, assertion and proposition) that lies behind the work, that precedes it, and that informs it. Within this soon dominant tendency we find a virtual rejection of any "impoverishment" of the artistic project, by reducing it to the mere aspect of a real object, or a datum that is once and for all and inevitably temporary. At the same time, and on the contrary, we find the decision to retain all its vitality (its whole vastness and its openness to possibilities) by setting it forth in its abstractness, as a pure philosophical indication or reflection, with no practical applications whatsoever. According to this position, the individual, the being or the concrete object – everything that is single, in other words – invariably represents a discouraging curtailment and partial exemplification of the concept that produces it. Alternatively, even if it is admitted that the idea is no more than a subsequent deduction, it nevertheless has the power to transcend the scope of the phenomenon in which it is mani-

fest, turning it into an "instance" among the infinite number of possible occurrences. Now, if art is a linguistic action, and if it is capable of communicating and forming thought, it will have to be summoned to retrieve the capacity that is peculiar to language. This capacity involves the generalization and the identification of the space of essences. It involves overlooking the phenomenon in order to circumscribe the notion that permits us to "possess" it in a cultural sense.

When the American Joseph Kosuth (b.1945) exhibited his *One and Three Chairs* in 1965, or rather when he confronted the spectator with three manifestations of the unit defined as a "chair" (a real chair without any stylistic connotations, a photograph of the same chair, and the definition of the word "chair" taken from a dictionary and reproduced on a panel), his intention was to present three different ways of acquiring reality. These three ways were verbal (here in the form of writing), which is the most culturally assimilated, pictorial (as a neutral, photographic image), which is the closest to the method of the plastic arts, and lastly the least culturally assimilated way involving the physical presence of the chair. This third way can illustrate the notion by exemplifying it (roughly in the same way as what semiologists

*Opposite: Andy Warhol,
Marilyn Monroe (detail,
1967). Kimiko and John
Powers Collection,
Colorado, USA. The
technique of obsessive
repetition of an image,
obviously borrowed from
the "conative"
procedures used by the
mass media, is well
illustrated in this work by
Warhol. He applied the
technique with perfect
coherence to the myths
of our omnivorous
modern society – from
the Coca-Cola can (or
the Campbell's soup
can) to the effigy of
Marilyn Monroe, Mao
Tse-tung, Kennedy, and,
in later years, himself as
well. The formal
presentation of the
image is also entrusted
to language stereotypes
– cold, antiexpressive
colours, techniques
designed to render
banal, and rotogravure
writing and layout.*

*Below: George Segal,
Man Alighting from a
Bus, (1967). Harry N.
Abrams Family
Collection, New York.
Segal's plaster casts
reduce the age-old
tradition of the sculptural
portrait to the ridiculous,
reproducing*

*contemporary man as he
really is, and also
situating him in the life
that he really leads.*

*Above: Joseph Kosuth,
Neon Electrical Light
English Glass Letters
(1966–68). Giuseppe
Panza di Biumo
Collection, Varese. The
writing on the wall which
constitutes this work is
semiotically given so as
to enunciate itself: Eight
green English words (of)
glass (in) neon electrical
light . . . Perhaps for the
first time in the history of
language the
significance of a
proposition coincides
perfectly with the object
and empirical
description of its
signifier. This occurs via
a sort of vicious circle
which might seem, from
the viewpoint of the
"practical purpose" of
the communication, to
cancel out the process
in which something
functions as a sign. From
the viewpoint of its
logical pertinence,
however, it realizes its
extreme capabilities –
those potentials which
Kant had already
pinpointed by his
definition of analytical
judgement. The intention
underlying Kosuth's
famous "neon tautology"
comes in fact from the
awareness that
language becomes
pertinent (and
dispenses with all
ambiguity) only when it
renounces any attempt
to interpret the world and
positively describes
(with acquired precision)
nothing else but itself.
We have here an art
stripped of hermeneutic
or narrative ambitions,
and relieved of all
presumed referential
engagement. Precisely*

*for this reason the
enunciations of this art
are, in the end,
completely verifiable.*

*Below: Roy Lichtenstein,
Wall Explosion no. 1
(1964). Wallraf-Richartz
Museum, Ludwig
Collection, Cologne.
Lichtenstein's "popular"
art, which is in more
ways*

*than one adjacent to
Warhol's, chooses the
comic-strip (and later
other types of mass-
character image) as its
select thematic field. It is
interesting how the
counterpart to a non-
neutral choice of
subjects in all the
protagonists of Pop Art
is the elaboration of*

*particular techniques of
execution, likewise
drawing inspiration from
the latest systems of
communication.*

call an "index" or "sign" acts). None of the three methods really reaches the object. They all equally constitute linguistic propositions. The "real" chair only serves to indicate the concept of chair, via one of the infinite number of possible concrete examples. As far as the photograph is concerned, and not unlike the verbal description, this responds to a principle of linguistic codification. By its very nature, when this principle refers to the object it excludes it by making an abstraction of it. Kosuth's work is thus situated in the wake of the semiological research undertaken by Magritte, although this latter's work was focused on the problem of comparing different systems of "representation" and thus different systems of "nominating" reality. (In the case of the French painter this process started with the famous "pipe calligramme" of 1929, and carried on with works that investigated just the pictorial, perspective method, analyzed it in its innermost mechanisms and then cruelly demonstrated its conventional limitations. Such works include *La Condition humaine* of 1934, *Les Promenades d'Euclide* of 1935 and so on.) Kosuth radicalized Magritte's process, no longer leaving access for doubts about any potentially "poetic" intent. Kosuth cools down this process until he turns it into nothing more than a laboratory analysis involving language and how language functions.

As is evident from the works of Robert Barry (b.1936), Jan Dibbets (b.1941), Lawrence Weiner (b.1940), On Kawara (b.1931), Vincenzo Agnetti, Bernard Venet (b.1941) and Kosuth himself, philosophical speculation and theoretics in "conceptual art" take the place of concrete demonstration. The work itself coincides in a tautological sense with the "reflection about the work". From the point of view of phenomenological aesthetics – as has been clearly stated by the literary critic Luciano Anceschi–poetics replaces poetry in a definitive sense. The artist is the person who ceases to produce linguistic objects – not least because he feels himself displaced by the triumph of the mass media – and restricts himself instead to analyzing language in its functional, categorial and ontological aspects.

All this renews the rejection of the opus that had already been made by Marcel Duchamp in the early years of the twentieth century. It brings back to our attention various general problems concerning the role, the *raison d'être* and the very survival of art in the twentieth century. It raises, for example, the problem of the artist's public recognition, and the extent to which this might affect the value attributed to the work. It raises the matter of the siting of the work itself (in a gallery, museum or marketplace) as a vital moment in the process of its legitimization. Lastly, it raises the global and extremely central problem of the function of art within a society that tends to remove ideology from art because (with the waning of the religious and monarchic-cum-sacred era) it has set aside much more effective means of

Left: Giulio Paolini, Delfo 65 (1965). Private collection, Brescia. In the context of strictly conceptual research, Paolini has often worked with the relation (logical and psychological) that runs between the artist and the work, or rather between the individual and the problems he must resolve when he is prepared to carry out a linguistic type of action. By organizing his own enquiry in the field of plastic and figurative expression, he has dealt with conditions both historical and actual.

Opposite: Maurizio Nannucci, Boîte à poésie (1967). Private Collection, Florence. This is one of the most meaningful and intensely lyrical examples of the tendency that brings together artistic creation and an "open" method of production, i.e. one dependent on minimal and certainly occasional events. It works if the concept of occasion can be replaced by the poetic quality that belongs to it, and which lurks in this surprising collection of "objective correlatives" of the artist's experience and sensibility.

procuring a consensus for itself.

Beyond the almost mechanical rigour present in the above-mentioned artists, in whom it is quite hard to pinpoint operations that are not purely descriptive and constructed exclusively with verbal material, we must mention on the one hand the intense usage made by certain "conceptual" artists of photography. Douglas Huebler (b.1924) is a good example. Photography is taken up as a cold, linguistic medium opposed to painting. On the other hand, we can properly focus attention on the vast aura of spurious or moderate conceptualism that is quite quickly created around the "radicals" in the movement. Here there is

some wavering between zones of analogous sensibility, but zones that are characterized by independent poetics (as in the case of American Minimalism) and attitudes that are simply less intransigent, in which the work still exists as a concrete object and as a product of some creative procedure. In this latter case the work is equally intended to illustrate a concept, or make manifest an idea.

Another ramification of Conceptualism is the branch represented by the international movement, Fluxus, whose members ranging from the founding fathers George Brecht (b.1925) and George Maciunas (b.1931) to the many, though sometimes occasional, adherents pro-

fess the total precariousness, impermanence, randomness and even humdrum daily nature of the artistic/creative gesture. This gesture is accordingly applied by no matter what medium, or it may be "uncovered" in minimal ideas that are made immediately to gel in works (given that there is still some sense in using this term for the expressions of "objectoglyphic" writing, as in Ben Vautier, Robert Filliou or George Brecht; and that there is some sense in using it for the small marvels and miraculous manifestations of the intellect that we find in certain "moments" with Maurizio Nannucci – such as his *Boîte à poésie* of 1967 and his *Scrivere sull'acqua/Writing on Water* of 1973 – or in certain magical and dreamy "excerpts" from artists like Ian Hamilton Finlay, Robert Lax, Dick Higgins, or Emmett Williams...). Nor is it easy to track down the notion of "work of art" in the strange and intriguing idea-rich sequences of Daniel

Spoerri – *Aktion rest. Spoerri*, 1972 – and Marcel Broodthears (*Théorie des figures/ Theory of figures*, 1970). Here, and in the whole signal system of Fluxus we find the idea of things incessantly becoming. This idea is overlaid by the precariousness of the intention of art, and of the creative gesture as an act of wonder in the face of the autonomous and constantly renewed happening of existence.

This attitude is not far from the theoretical basis underpinning the practice of Performance Art, which is so widespread in the period we are describing. Performance Art can be the theatricalization and retrieval of the body in Body Art (Vito Acconci, Bruce Nauman,

Herman Nietsch, Arnulf Reiner, Urs Lüthi, Gilbert & George, Vettor Pisani, Gino de Dominicis, Jannis Kounellis Marina Abramovič, Wolf Vostell, Gina Pane, etc.). For the most part it is an extreme consequence of informal gesturalism, or a reintegration of the expressive topoi of the theater and of the spatial dance of the plastic arts. The basis here is "doing." This had already been anticipated by the *happening* of Allan Kaprow (b.1927). Alternatively Performance Art may be defined as an aesthetic "action," which is narrated and recorded by the new media (video, records, and tape for Nam June Paik, Vostell, Keith Sonnier, Joseph Beuys, for the "musicians" Philip Glass, Terry Riley, Steve Reich, La Monte Young, Giuseppe Chiari, etc.). In any event it produces a surpassing of logic in the work taken as a physical, formal and concrete object-entity. It denies it as a "product" and as a durable, definitive datum.

And it replaces it with a principle of happening, of existential *hic et nunc*, which is, in effect, not far removed from the behavioural theories of Fluxus.

The dematerialization of the object, which is a unifying feature of the conceptual phase in its broadest sense, reaches a curious extreme case when, in the form of American Land Art, the artistic work spills over on to the land itself. The project takes on topographical dimensions, broadening until it becomes a macroscopic modification of the landscape. The paradoxical quality here consists in the fact that, by following this route, it ends up by self-dissolving as an "object of possession", as a

transportable, conservable and marketable item. Such "land" projects, which were once the province of just a small number of individual artists, now only exist as photographic or film documentation, together with verbal accounts and bureaucratic reports (such as the permits granted to the artists before the projects could be realized). Only rarely has the finished product been conserved, and not least because even when conservation might have been possible, it has been part of the author's scheme to ensure that they will include a mechanism allowing their natural and necessary self-destruction. The straight lines drawn in the desert over dozens of miles by Walter De Maria (b.1935) and titled *Las Vegas Piece* (1969) were soon erased by the wind and by the intrinsic vitality that exists even in the least life-endowed of spots on earth. Similarly the *Annual Rings* (1968) dug by Dennis Oppenheim (b.1938) in an expanse of snow did not have to wait for the sun to become swiftly undone. And in like manner the artificial erosions produced by Michael Heizer (b.1944) in the great canyons of the western United States (*Double Negative*, 1969–70). These erosions were in turn destroyed by the rain in the act of modifying its own wonderful constructions. Another work by this same artist, called *Rock Piece* (1970), consists of actions taken involving lakes and mountains that will require perhaps centuries to disappear, but which nevertheless count on nature as the adversary force that will decree their proper death. While this dialectic (the retrieval and requalification of an environment declared to be no less "artistic" than the pure gesture that discovers it) responds to a position of political consciousness that anticipates the ecological movements, it also reproposes in very new and resoundingly "present" terms a romantic conception of the work which, as in Novalis, becomes a finalized method for the renewal of authentic life. And it is no coincidence that this should come about before anywhere else in the country that most keenly endures the clash between a civilization that contains the shock of debasement and an immense, wild environment that is still (at least for a while to come) uncontaminated. This then is the meaning of Robert Smithson's (1938-73) *Spiral Jetty* (1970), an earthwork that brings together the magnificence of Salt Lake (in Utah) and the no less "natural" (because it is biomorphic) but also architectural and human aspect of an enormous spiral-shaped jetty made of dumped earth. Land Art in Europe is quite another story. In the wrapped objects of the French/Bulgarian Christo there is almost no more than the idea of provocation and a feeling of being out of one's element. Whether it is a matter of wild places or of things hidden in plastic, the indicative fact is that Christo selects parts of an urban landscape. In the neon or metal juxtapositions of Giuseppe Penone (b.1947) it is more the demonstrative action of the artist, which appropriates the

most categorical confinement of the aesthetic object within itself, of its own strictly geometric structure, and of its own independent system of signification. This is a movement linked with the historical tradition of abstract art. It constitutes the last important episode of abstraction. It does so to a degree where it seems to me rather hazardous to claim to see in the works an inclination towards a dialogue with architectural space, as has now and then been suggested in order to correlate these forms more meaningfully with the times. Rather, it can be said that it is precisely the idea of closure and self-inspired signification, together with the underlying vein of Platonic idealism – in so much as the works are concrete forms of "primary structures" (of knowledge), as we are told by the title of the first exhibition stage of the minimal artists – that incorporates them in the poetics of Conceptualism. For the works implicitly illustrate a further aspect of Conceptualism. If their meaning has also, in effect, to do with their protension in space, we must bear one fundamental fact in mind. We are never dealing with the "mundane" space of action and experience,

land, modifying trees and bushes, than the putting nature to work as a (co)author of the work. Lastly, with the British artist Richard Long we have a continuation of the sculptural gesture – be it a sculpture using rocks, pebbles and plant matter – which at best becomes horizontalized by spreading out into open places, as if for a new and highly refined garden architecture.

Minimalism and *arte povera*

For this brief overview we have opted for a somewhat anomalous subheading. This is why we have earmarked a separate chapter for those tendencies in art that play a full part in the spirit and sensibility of Conceptualism in the broad sense of the term, but nevertheless suggest a reaffirmation of the concrete nature of the work, and indeed focus on either an extreme prominence of its spatial structure or the particular nature of the materials used for it. The borderlines are often not at all clearly defined and many artists who will be mentioned below as "minimal" sculptors or representatives of *arte povera* have at the same time been busy, often with markedly looser elements, in the vaguer terrain of the gesture of Fluxus, of Behaviourism, of Performance Art, and of conceptual art in the strict sense of the term.

American Minimalism acts almost as a counterbalance to the other great moment of American artistic research, the already described Land Art. And in effect with the sculptures of Robert Morris (b.1931), Carl André (b.1935), Donald Judd (b.1928), Dan Flavin (b.1933) and Sol Lewitt (b.1928) we find the

Above: Robert Smithson, Spiral Jetty (1970). Great Salt Lake, Utah, USA. Smithson's intervention on the surface of the Salt Lake in Utah attempts a fusion between a human gesture (architectural, plastic and almost graphic) and the profoundly "aesthetic" reality of uncontaminated nature.

Center: Robert Morris, Untitled (1966). Kimiko and John Powers Collection, Colorado, USA. The search for an absolute and ideal form, with no expressive or individualistic elements, and yet endowed with its own intrinsic lyricism, underpins the radically reductive hypothesis of minimal art.

Below: Carl André, 64 Pieces of Copper (1969). Private Collection, New York. The accent laid on series in American Minimalism is part of a program of gnoseological analysis that never resorts to the empirical and real datum but only to the psychic capacities of abstraction.

Opposite: Donald Judd, Untitled (detail, 1968). County Museum of Art, Los Angeles.

or the concretely usable and practicable environmental space. Rather, we are dealing with an abstract and symbolic space effect, which has no characteristics that are not either theoretical or mathematical.

In relation to all these abstract sculptural precedents the early works of Morris (*L-shapes* of 1964, the untitled works of 1965 and 1966) are presented as an absolute purification, as an extreme reduction of the object to its own geometric "soul." The form, in the accepted artistic sense of the term, is done away with. The object is as if dematerialized in the very moment in which it becomes hyper-concrete. This is the pure manifestation of an idea. Whether it is a prism with a triangular base, or the right-angled conjunction of two parallelepipeds, or a circular ring, in every case the material forming the work is a neutral and indispensable requirement of its existence (nothing more). Its surfaces have no eye-catching features (no optic, aesthetic or sensual qualities). Its substance is a silent revelation of the computation from which it is produced. This is solemn but profane sculpture. It does not pretend to express anything.

Nor does it intend to convey that sense of mystery and sacredness which existed in the pictorial works of Barnett Newman and Ad Reinhardt . . . It merely pronounces the word of its mute presence. It is merely there as a gelling of mental problems: orthogonality, symmetry, equilibrium. This is the vocabulary it uses. Judd's works subsequently add to this vocabulary the term "serial," and those of Sol Lewitt the term "modular." So it is no coincidence that Lewitt is also one of the major theoreticians of conceptual art, even if in practice he has always been alongside the Minimalists. The notions of module and series are used by these artists (and by Carl André as well) as contributors forming the cognitive baggage of post-Euclidean physics – that is, the baggage of modern man. They are also used by Dan Flavin, who has a somewhat special place in the sphere of movement. He is the only artist who has attempted to produce light sculptures using straight neon tubes, usually distributed in the exhibition area on the basis of precise metric and serial rhythms.

Here, too, we should briefly mention that there is a less rigorous pole of minimal art in

the sculptural work of Robert Grosvenor (b.1937), Philip King (b.1934) and Antony Caro (b.1924). Similarly we find a kind of pictorial version of Minimalism in the hyper-abstract and conceptualizing works of Brice Marden (b.1938), Agnes Martin (b.1912), Robert Ryman (b.1930), Richard Tuttle (b.1941) and Robert Mangold (b.1937) – preceded chronologically by the "cold" Abstractionism of Frank Stella (b.1936), Kenneth Noland (b.1924) and Ellsworth Kelly (b.1913). The painters just mentioned came together for a crucial exhibition in 1966 called *Systemic Painting*. It was held at the Guggenheim Museum in New York, and curated by Laurence Alloway. These artists represent the American counterpart of the burgeoning movement of "analytical painting" in Europe. This movement came to the fore with such artists as Daniel Buren, Olivier Mosset and Claude Parmentier, and then with the Support-Surface group.

In Italy the phenomenon that, at various levels, has involved much of the artistic avant-garde from 1967 onward is what Germano Celant called *arte povera*. In coining this term

Opposite: Sol Lewitt, 3 Part Set 789 (B) (1968). Wallraf-Richartz Museum, Ludwig Collection, Cologne. The cognitive acquisition of the space is "read" from left to right (the Gutenbergian order) and its development – from the graphic indication of the void to the progressive volumetric filling – is related to the base, which is gridded in squares (perspective orthogonal order). The minimal artistic process is thus conceptualized and mathematically organized according to principles of absolute cerebral rigour.

Right: Joseph Beuys, Raumplastik (1968). Hessisches Landesmuseum, Karl Stroher Collection, Darmstadt. A strange mixture of mysterious inspiration and technological neurosis (the relocation of the "mechanical" to a romantic need for an apology of nature?) pervades Beuys's installations, which are constructed on the heterogeneous character of the materials and on their dark, often funereal, evocative capacities.

the Genoese critic intended to unify experiments that were not always homogeneous, but widespread well beyond the Italian border. If one looks at the first publications of the "movement" it is clear how often Celant went too far in the scope of his views, including in the movement works and artists who should beyond any doubt be included in Minimalism, pure Conceptualism and Land Art. The historical signification of *arte povera* can, however, be pinpointed in its undoubted originality in relation to these tendencies. It contains a specificity that emerges as an almost exclusive interest in the linguistic value of materials that are totally extraneous to the history of art, and capable of directly, non-metaphorically, (and rather metonymically, that is, using indirect association) expressing the vital, biological and technological energy that resides in it. I would suggest that one can see in certain marginal accepted senses of the Fluxus aesthetic the origin and the most immediate precedent of this attitude, if it is true that Joseph Beuys (1921–1986), who had such an "influence" on the poetics of Italian artists, can be classified included solely by his member-

ship of Fluxus, or in other words in the least classifiable of the avant-gardes. Nowadays it also strikes me as necessary to see the extreme (but pertinent) limit of the development of the *povera* tendency in the work of certain artists who have never been welcomed into the tight "orthodox" group supported by Celant.

The most conspicuous effect of this attitude is that it has once and for all destroyed the classic distinction between painting and sculpture by declaring it obsolete. The assemblages of material that we find early on in the work of Pino Pascali (1935–69), after the phase when he was close to Pop Art, explode both the surface and the plastic space of the object embraced. They tend to speak the language of doing that coincides with placing and juxtaposing, with no other attributes attached. If a space has to be singled out for these assemblages, then that space will be the very space of existence, and none other. It will be outside virtuality and therefore outside any artistic type of "categorical" logic. We mentioned attention to materials and their intrinsic vitality... An example of this is the choice of

Mario Merz (b.1925), who started out as an informal painter, and then turned to elements taken from nature (bushes, dead branches, vegetables, etc.), which he placed in a contorting juxtaposition with technological materials such as neon lights, or chemical and metallurgical products. In so doing he for the most part constructed biomorphic (animal–plant) forms like the igloo, thus reproducing the organic architecture built by certain molluscs and crustaceans, on the mathematical-cum-notional basis of numerical progression as developed by the mathematician Leonardo Fibonacci. Another example is the extraordinary capacity of Gilberto Zorio (b.1944) to produce interactions between biological substances and electric arcs, with oxyhydrogen flames, and manifestations of electrical energy in the real state (*Cowhide with Incandescent Resistance*, 1969). In his work we find the whole fascination of alchemical research applied to contrast and vital dynamism, and to the internal trial-like process of the material. It is almost the discovery of a non-didactic and non-banal method of re-investigating the mystery of existence. This trial-like phenomenon,

which somehow takes up the poetics of futurist dynamism, is often reconstructed on metaphorical levels. But the metaphor is always something more than a simple representative method. It derives its strength from a description that seems to want to pass over the pure virtuality of language. So Zorio works on special "forms," which are in themselves rich in motory, penetrative and dynamic capacities, like those of the javelin and the canoe, which – and not least because of their cultural origins – stage the physical forces (gravity, friction, inertia) that they are trying to oppose. Using this same logic, Giovanni Anselmo (b.1934) conceived a one-off masterpiece in 1968 when, with *Torsion*, he produced the most convincing representation of physical/biological energy contained in an animal hide by means of its collision with static/architectural elements (the wall, a stone cube), which prevent it being freely expressed. Here the strength and the dynamism are shown as a direct function of their own impossibility, and the concept of "tension" (to which the torsion alludes) is taken in its dual sense of symbol and real effect.

While the works of Luciano Fabro (b.1936) merge elements of nature and advanced technology in new linguistic figures, in Michelangelo Pistoletto (b.1933) we find a dominant sense of human action. The work seems for the most part to refer to the actual act it requires to be enjoyed. Jannis Kounellis

(b.1936), for his part, has achieved the most convincing results by means of highly provocative gestures in managing to "expose" life itself as art. For example, in a memorable show in 1969 he took a group of live, snorting, neighing, defecating horses into *L'Attico*, a private gallery in Rome. Pier Paolo Calzolari (b.1943), on the other hand, has devoted himself in his best work to the use of unused and *per se* intriguing materials, such as synthetic ice, with which he has produced amazing "hoarfrosts" on commonly used objects or on writing made with bent metal. We should deal with Eliseo Mattiacci (b.1940) and Alighiero Boetti (b.1940) separately. These two artists are in fact only relatively close (the latter for reasons of group politics) to the central phase of *arte povera*. If anything they can be associated more easily with international experiments such as we have already described. Boetti, in my own view, is a fully paid-up member of the conceptual movement (as, incidentally, is Giulio Paolini, who is also "politically" linked to the *arte povera* group), while the work of Mattiacci turns out to be quite close to that of the founding members Beuys and Pascali, whose theatrical "gesturality" Mattiacci reinterprets in a highly personal way. Something fairly similar could be said of Vasco Bendini (b.1922), who, since 1966, has been able to abandon his previous informal-type pictorial practices to devote himself to experiments dealing with "behaviour" and "object

poetics," not unlike the experiments of Beuys himself.

Along with this latter artist, whose inclination toward the mysterious and the sacred is expressed in hundreds of minimal works (from the viewpoint of action) and macroscopic works (because of the size and quantity of the objects used), we should also mention certain other artists who, for various reasons, can be referred to the situation theorized by Germano Celant, and who were now and then included by Celant in the *Arte Povera* registers. The list includes, for example, the German Günther Uecker, the Americans William Wiley, Keith Sonnier, Richard Serra, Eva Hesse, the Dutch Ger Van Elk, the British Barry Flanagan. In the works of these artists, in differing ways, there is a dominant sense of a poetic property intrinsic to materials, whether these be animal, vegetable or mineral – or chemical/industrial.

Mario Merz, 610 function of 15 (1971). John Weber Gallery, New York. The search for "organic" relations between things, or for networks of energy sustaining them, is typical of the work of Mario Merz, which is often reliant on an instinct for neo-symbolist reception of the object and on the discovery of mathematical principles in nature. Note his capacity to produce interactions on the semantic level between quite distant forms of expression and his capacity to obtain in this way effective assemblages of items that are very different from one another.

Current trends

The figurative arts today are in a somewhat complex situation. In certain respects the widespread and rather mechanical practice of dividing art up into periods, starting with the various avant-garde movements, seems to force us to consider individual artists in generational groupings that correspond with clearly demarcated tendencies. In other respects it has to be said that the most varied of today's artistic experiences and experiments occur side by side and often overlap. There is no such thing as undisputed predominance. This is a relatively new development. Up until the mid 1970s there did appear to be a hegemonic situation – at least at a superficial glance.

That Rimbaud-inspired verdict which prescribed that one had to be "absolutely modern" (*absolument moderne*) has disappeared. We are now firmly in the so-called post-modern period, which champions the individual position and the individual gesture. This rediscovered freedom has enabled some young artists, who developed within the experimental spirit of conceptual art, *arte povera* and even body-art, to regain the terrain of painting. The result has been an initial affirmation of various experiments, which have subsequently been classified under different labels, in an almost preordained arena. This arena is no longer the United States, hub of major new projects in the 1960s and, more

particularly, the 1970s, but Old World Europe, and Italy in particular.

In the name of painting and the reclamation of its specific dimension, and with the dwindling of student movements in the blaze of "autonomist" activity, we find the assertion of movements that call themselves transavant-garde, hyper-mannerism or *pittura colta* ("cultivated" painting). These movements come under the banner of "imagination rules." Symptomatic here are large murals, which are direct precursors of the work of the graffiti artists on the New York subway, or of the ironical multicoloured posters on those pillars erected in piazzas in Italy for political purposes. These phenomena are altogether Italian in their dimension. Among the best transavant-garde artists we find recurrent reminders of Rosai and Carrà (Sandro Chia) or Sironi (Marco del Re). There is striking chromatic exuberance, and it is not disjointed by any intensely gestural use of sign, as is the

Balthus, After Piero della Francesca *(1926). Jan Krugier Gallery, Geneva. This work recalls the Italian's famous* Resurrection at Borgo San Sepolcro. *Tradition lives on in modern art.*

case with Mimmo Paladino and Enzo Cucchi. Along the same line of thought (that is, in relation with the Italian avant-garde of this century), an independent niche is occupied by the two Tuscan artists Roberto Barni, who reinterprets De Chirico and Savinio, and Lorenzo Bonichi, perhaps the more poetically endowed and also following the metaphysical path by reinventing Savinio.

In the area of *citazionismo* (quotationism), which appeared at the 1982 Venice Biennale under the title of "Art in the Mirror" (*Arte allo specchio*), curated by M. Calvesi and M. Vescovo, the sights are set totally on history, along two fundamental guidelines. The first is the one inaugurated by Carlo Maria Mariani (with the regeneration of the neo-Classical image). It includes, in particular, the artists Stefano Di Stasio, Omar Galliani (whose emphasis is squarely on Symbolism), Paola Gandolfi and Bruno d'Acervia (who is influenced above all by Mannerism, and by Pontormo in particular). The second is the one inaugurated by Franco Piruca, with a colossal effort to revive the craft of painting that was abandoned in the wake of the extreme pronouncements of Morandi, De Chirico and the "School of Rome" (*Scuola Romana*).

The term "anachronists" is perfectly appropriate for the first group (which should also include Maurizio Osti from Bologna), but may seem inadequate for the others. We can thus

talk in terms of the various avant-gardes being unseated, in order to start over again where the craft of painter (in the sense of artisan) seemed to have left off. Such experiments then give rise, in a historiographic context, to renewed interest in, and resumption of, studies concerned with forgotten moments of painting between the wars. We need only mention the School of Rome, which was once again presented in exhibitions from 1983 onward and also exported to the United States (1987). In the footsteps of Antonio Donghi we find Guglielmo Janni, Emanuele Cavalli, Ferruccio Ferrazzi, Riccardo Francalancia, Roberto Melli, Fausto Pirandello, Amerigo Bartoli, Alberto Ziveri, Antonietta Raphaël and Franco Gentilini. There is also new scrutiny of the early days of highly popular artists like Renato Guttuso, Gregorio Sciltian and Piero Annigoni. The credit for this revival — as well as the revival of interest in De Chirico's different periods — must go to Maurizio Fagiolo dell'-Arco. In this same climate we also find more measured reflections on artists who have either been forgotten or who have remained on the sidelines in the great artistic adventure of this century. These would include Onofrio Martinelli, Adriana Pincherle, Lino Bianchi Barriviera and Leonardo Castellani. It is no mere coincidence that this new focus on the School of Rome has also produced a contemporary tendency represented by Bruno Ceccobelli, Domenico Bianchi, Gianni Dessi, Pietro

Fortuna, Giuseppe Gallo and Enrico Luzzi, culminating in the work of Piero Pizzi Canella.

The situation in Italy is echoed by a ferment of new creativity in Germany, where the trends initiated by Italians with the transavant-garde have given rise to the *Neuen Wilden* (R. Fetting, M. Disler, W. Tannert, K. Hodicke, B. Koberling, M. Luperz, J. Immendorf, A. Kiefer and G. Baselitz). The quotationist trends have found strong representation in the so-called "new order" groups.

Interesting things are also happening in Austria, where conspicuous names include H. Schmali, S. Anzinger, A. Mosbacher, H. Brandl, H. Scheibl, and G. Damisch. In this arena the role of "organizer" may be attributed to the powerful portraitist J. Kern, and to W. Wiedner. The emphasis here is essentially on neo-Expressionist forms. These have also found fertile ground elsewhere, in particular in the United States with J. Brown, J. Schnabel and M. Basquiat.

In the context of an "international" transavant-garde we should mention D. Salle, G. Garouste of France, P. Kirkeby, N. Longobardi, the Spaniard M. Barcelò, N. de Maria and F. Clemente. For all these artists we must hark back to the phenomena of linguistic fusion that linked Chagall, Kokoschka, Nolde, Scipione, De Kooning and, it goes without saying, the already mentioned Sironi, Rosai and Carrà, bridging Expressionism and neo-Monumentalism. But as far as figurative art is

Above: Lucian Freud, Hotel Room (1954). Beaverbrook Art Gallery, Fredericton (New Brunswick, Canada). Realism giving back to the human figure its spiritual tension, in a new and subtle Expressionist approach.

Left: Hermann Albert, Man with Mirror (1982). Private collection. Head

of the German group called "New Organizers," who preach a return to Classicism.

Opposite: Andrew Wyeth, Overflow (1978). Leonard E. B. Andrews collection, Newton Square, Pennsylvania. A great American realist aiming to restore reality by an almost obsessional technique.

concerned, this variegated situation in the 1980s, which goes beyond any generational limits, is restoring to prominence artists of the two previous generations who had been swept aside or merely forgotten by the lengthy season of abstraction, informality and the new avant-garde.

Side by side with individual and widely renowned artistic experiences such as those of F. Bacon and A. Giacometti, it is thus possible to reinstate other important artists who have remained outside the various schools but who are endowed with great pictorial mastery. In these last years, which have included numerous shows from 1980 onward, Balthus has achieved worldwide recognition and an unrivalled place on the contemporary stage. Under the spell of a neo-fifteenth-century spirit, between Piero della

Francesca and Masolino da Panicale, Balthus combines a maniacal quest for vibration in the thick pictorial surface with an explicit psycho-analytical probing. The obsessive nature of artists who are both dramatic and existential has been even more exposed. These include W. Varlin and Lucian Freud, both equipped with a highly developed painting instinct and both among the most conspicuous this century, although pride of place, as far as drawing is concerned, possibly goes to the American W. Wyeth. The overly facile accu-sation levelled against this latter that he is "guilty" of illustration reveals how awkward critics can be when confronted by the survival of an aesthetic principle that seemed to have been swept aside by the avant-garde move-ments of the early years of this century. Bal-thus and Wyeth are at once the denial of these preconceptions and the confirmation of the persistence of a figurative line that is both modern and open to an awareness of tradition.

Treading the path of Wyeth's realism we find not only the great American painter Grant Wood but also A. Colville and G. Gillespie.

In other respects realism and naturalism display a great deal of vitality, both in certain extraordinary prototypes such as Pyke Koch, an important Dutch artist who embodies a revival of the inspiration of the fifteenth-century artists of Ferrara, and in German artists such as the formidable virtuoso W. Tubke, who is quite capable of reviving the symbols of Dürer or the chromatic transparency of Rubens, or the grotesquely mannerist J. Grützke, or the peerless draughtsman H. Janssen. The names of these artists recur with great authority just when figurative painting is being freely taken up again. It is in this sense that each passing year has seen an increasing evaluation of the work of an artist like Domenico Gnoli, who is eccentric in relation to his contemporaries and capable of powerful synthesis combining the neo-fifteenth century (from Piero della Fran-

cesca to wood marquetry), metaphysics, Pop Art and Hyper-realism. His objects and his details of magnified objects are paradoxical realist abstractions – nothing less than monu-ments to the everyday presented with a formal concentration that is not easy to reproduce. Interpretations of Gnoli's work, which was ignored and disregarded in the 1960s, are re-emerging in the 1980s. This particularly essen-tial and clearly defined proposition is in fact aligned with a sporadic development situated somewhere between metaphysics and Surrea-lism. This came to maturity in Italy under difficult conditions, but the results it produced were of a high quality, even though the artists responsible for them were often ignored or unacknowledged. For these artists, as for Gnoli, it is strange that the springboard should have been the Galleria dell'Obelisco run by Irene Brin and Gaspare Del Corso. We are referring here to Fabrizio Clerici, Savinio's first heir, together with Eugène Berman, Carlo

Guarienti, Gustavo Foppiani and Gaetano Pompa, to whom we can add Enrico d'Assia and Giuseppe Modica. The projects and work of these artists have been taking form from the 1950s through to the present day with considerable coherence and a sensitive approach to the most animated sources of the modern language, from Klee to Savinio, Burri to Jasper Johns, and Ben Shahn to Gentilini. The fantasy, intelligence and wit inherent in them are revived in the relentless talent of Luigi Serafini, author of the *Codex Serafinianus*, which is nothing less than an illuminated codex. Serafini is a veritable and inexhaustible mine of ideas presented under the banner of paradox, with De Chirico and Duchamp his tutelary gods.

The realism of Spanish artists, including some of the most powerful personalities of the past few decades, is quite different and removed from all types of spectacular manifestation. The dignity and character of Balthus or Gnoli (culminations of a non-illustrative form of realism) can undoubtedly be matched by Antonio López García, whose extreme and tormented attention to execution is the vehicle of an adherence to values that have an unforeseen epic force. Together with López García we should mention the exhaustingly refined work of his wife Maria Moreno; the oratorical and energetic sculpture of Julio López Hernandez; the extremely delicate and almost crepuscular Francisco López; and the latter's wife Isabella Quintanilla. The path trodden by these noble and austere realists is being

Right: Carlo Guarienti, Still Life (1985). Private collection. Metaphysical painting applied to a Classical subject in nearly abstract style.

and inimitable harmony.

The work of another group, which initially came together under the title *Metacosa* (literally meta-thing), indicating a condition equidistant between (apparent) realism and (substantial) metaphysics, is less emotive and colder. Yet in some of its manifestations it is akin to the research of the Spanish group, although it is markedly conditioned by German and American realism (Grossberg, Wyeth, Estes). The strongest personality here is undoubtedly Gianfranco Ferroni. Ferroni did not

followed by Daniel Quintero and José Hernandez, an impeccable draughtsman. These highly individualistic Spanish artists can, in an ideal sense, be clustered in a group resembling an island that is uncontaminated by modern technological civilization and unaffected by fashions. We are dealing with works endowed with a deep and imperturbable religiosity, which reveals the whole meaning of things with no apparent effort and with no trace of anecdotal gratification.

The realism of these Spanish artists moves one almost to tears and, in at least one case, to the point of despair. I refer to the extraordinary work of López García. His polychromatic wood reliefs, canvases and panels are marvels of

painting, with great intensity of expression. They are, no more no less, altars erected in honour of art, mysteries of pain and silence, executed in a vibrant and highly refined medium, even when it appears to be rough and tormented. López García humbles almost every other artist because his fanaticism and his increasingly perfected research seem to concentrate the very highest expressive potential of art. Solitude, pain, anxiety – in other words, life – all find in his works a definitive

Right: Ivan Theimer, Obelisk (1986). Private collection. A true carver of images, always refined and meticulous, even in monumental works, Theimer gives expression, in painting and sculpture, to his yearning for myth.

Opposite above: Gianfranco Ferroni, Modena Interior (1979). Private collection. This very structured space in perspective with strong contrasts of light calls up the emptiness of unimaginative living.

Right: Victor Koulbak, He Wanted to Lie Like That (1983). Private collection. Introspective calligraphy turned toward mystery: Koulbak, poet of minute gestures and restraint, tends to give lyrical expression to silent perfection.

Below: Antonio López García, Garden of Tomelloso (1977). V. Olcese collection. Pure and subtle realist vision, projected into the absolute through a masterly technique, attaining supreme simplicity in a true picture of life.

in fact achieve the Vermeer-like lucidity of his output until 1977–78, thus putting him in line with the new figuration movements. The work of Giorgio Tonelli shows an extreme rational rigour; that of Giuseppe Biagi and Bernardino Luino extraordinary pictorial sensibility; that of Lino Mannocci suggests dreams and hypnoses with realistic aspects; and that of Giuseppe Bartolini an identification of reality without limitation or selection, which surprises the artist himself. This list of names must be joined by the talented engraver Silvio Lacasella. His images are constructed patiently, methodically and laboriously within pre-ordained designs, with a very pronounced tendency toward abstraction.

Massimo Rao and Adelchi Riccardo Mantovani, on the other hand, are completely separate, even though they may appear to be classifiable under the label of quotationists. They are, however, extremely unfettered. Mantovani moved some years ago to Berlin. He has developed a tranquil form of Surrealism that is executed with great refinement, and shows an invariable sense of bizarre inventiveness. Other Italians worthy of mention include the visionary neo-Expressionists Luca Crocicchi, Fausto Faini, Giuseppe Frangi and Weiner Vaccari. Sculptors include first and foremost the realists Giuliano Vangi and Giuseppe Bergomi, the classical Girolamo Ciulla, the dreamlike Sergio Zanni and the ironical and grotesque Claudio Baroni. Ruggero Savinio merits

a place of his own because of his tangential position with the transavant-garde, even though his point of departure is an extremely erudite one.

France is currently home to various successful Italians tapping a richly intellectual seam, such as Valerio Adami, Leonardo Cremonini, Antonio Recalcati and Vito Tongiani. Mention must also be made of the extremely refined output of the Russian Juri Kuper, situated halfway between Tapies or Burri and Jasper Johns, in a time-consuming metaphysical aura; of Ivan Theimer, dreaming of a Classical ideal rediscovered in the Italian landscape as a result of a Grand Tour based at Lucca; and Victor Koulbak, a Classicist who has shunned rhetoric.

Outside France we find Jean-Pierre Velly, working in Italy. He is a melancholic and stirring interpreter of nature, and equally as skilled as a painter and as an engraver. Spain is home to the rarefied and light-oriented Jean-Michel Bacquet.

This long and inevitably incomplete inventory is in no way limited by overly strict chronologies or homages to obligatory tendencies that are stronger than respect for individual independence. To round it off we must include references to other highly talented and in some cases now famous artists such as Peter Blake, David Hockney and R. B. Kitaj, all inventors of imagery that has managed to stand up to the aggressive impact of

Pop Art; or the more secretive and aloof W. Bailey, D. Kopp and Dino Boschi, all thorough-going restorers of the still-life and landscape genres; or the sculptors Avradamis, Chillida and L. Fischer; or the younger, more delicate and independent Marcello Jori and Giuseppe Salvatori. All these artists, and undoubtedly others whom we have omitted, have managed to retain intact the propriety and the learning of their craft. They use it, also, as an instrument of and not as a hindrance to contemporary aesthetics. Starting with the very first generation of this century it has been a matter of hurdling over the avant-gardes, of passing through them by ignoring them, and of linking up with the latest manual application of brush and clay. For many artists the experience has involved a stubborn coherence, a polemical *raison d'être*, lived in isolation and silence. For others, and nowadays especially, there has been a declaration of liberation. These artists have different beliefs and a multiplicity of faces. They can be identified in dissimilar histories. They lay claim to remote and different parentage. They build whole neighbourhoods, without realizing that they are working for the edification of a single city. The only thing they share in common is the unshakable certainty that they do not want to contribute to disorder and destruction. They share an instinct for life which, in art, is the life of forms.

Yuri Kuper, Untitled *(1982). Private collection. Pure metaphysician without concession to realism of image, in an ever-moving quest for the soul of things and their spiritual essence, under concrete but tenuous appearances.*

The history of photography

From heliography to the daguerreotype

"It is our duty to draw the particular attention of our readers to the minutes of Thursday's meeting of the Royal Society," announced *The Athenaeum* of London on 2 February 1839. It was important news, a matter of national pride even, since an extract from the paper read that evening suggested that "Mr. Daguerre's most important invention, described in a letter from a correspondent in Paris, is almost identical to the discovery made five years ago by Mr. Fox Talbot, who indeed has since perfected it."

In *La Gazette de France* of 6 January the first news was given of an incredible new invention – the daguerreotype, with which it was possible to "fix *in light and shadow*, the image reproduced by the camera obscura." Only a fortnight later a journalist on the *Gazetta privilegiata di Milano* gave the news as it had appeared in the *Moniteur Parisien*. The official announcement, however, was given at the Academy of Science in Paris on 7 January by the members François Arago (1786–1853), Jean-Baptiste Biot (1774–1862), and Alexander von Humboldt (1767–1859), who also presented five plates (*daguerréotypes*) with "pictures" obtained directly from daylight with no manual interference whatsoever. The reproduction of the subjects (*La grande galerie joignant le Louvre aux Tuileries, La Cité et Notre-Dame, Des vues de la Scine et de plusieurs de ses ponts et quelques-unes des*

Barrières de Paris [The Great Gallery joining the Louvre to the Tuileries, the City and Notre-Dame, views of the Seine and several of its Bridges and some of the Paris Barriers]) was outstandingly precise – "with a verity (except for the colour) that art cannot obtain, this is perfect drawing," explained the comments in the newspapers. The lack of colour in daguerreotypes was a great – though temporary – relief for commercial painters and miniaturists; many of them, however, began to believe that this "marvellous invention," if developed, would bring about "an unprecedented revolution in the art of drawing," as in fact it did.

The first deliberate scientific research devoted to obtaining drawings from light on lightsensitive substances (a property of silver chloride, also called *luna cornea* and already known to alchemists) was carried out by two Englishmen, Thomas Wedgwood (1771–1805) and Humphry Davy (1778–1829). They created "profiles" of opaque and semitrans-

Above: Kusakabe Kimbei, Geisha, c. 1880.

parent objects (leaves, flowers) on sheets of paper permeated with silver chloride and exposed to light for just a few minutes until the areas not covered began to darken. But Wedgwood and Davy soon gave up their experiments because they were unable to fix permanently the images they obtained; their work ended in June 1802 with a communication to the Royal Institution of Great Britain that did at least commemorate the event. Twenty years passed before others succeeded in this endeavour. The Frenchman Joseph-Nicéphore Niepce (1765–1833), in his attempts to perfect the lithograph, discovered a technique – *héliographie* – with which he could obtain drawings traced by light on plates of silver or pewter which, according to his initial intentions, would have been useful as matrices to be inked and printed on his normal press. With a camera obscura, however, it was possible to fix a "direct" image of views, *points de vue*, taken from the window of his studio at Gras, near Chalons-sur-Saône. Here, in 1826, the oldest photograph in existence was taken; today it is in the Gernsheim Collection at the University of Texas, Austin.

Niepce resolved the previously intractable problem of fixing images by using Judea bitumen as the photosensitive substance rather than a silver salt. This substance has the quality of becoming hard and white when exposed to light for a certain length of time, while the parts not exposed to light remain

soluble in a bath of paraffin and lavender oil. The image was thus defined by the tonal difference between the bitumen and the background. Niepce's first experiments required very long exposures – roughly ten hours – during which the light of the sun, moving *in continuum*, created fantastic images that are inconceivable to us; our eyes are capable of perceiving only immanent time, the present time.

The calotype

From that day onward photographic experiments sought above all to reduce the length of the exposure necessary to create an image; the aim was to obtain the instantaneity characteristic of photography and its history. In the meantime the problem of colour was given attention, not simply by manual intervention on the image with lacquers and anilines, but also by chemical means. The feeling was that if this problem were solved, photography would no longer have competition from any quarter.

The "race" for a colour picture, "handmade" vs "machine-made" (and eventually "electronic"), thus began in earnest immediately following dispersal of news of the daguerreotype and was then accelerated when William Henry Fox Talbot (1800–77) rushed to have his contemporary invention recognized through the physicist Michael Faraday at the Royal Institution in London on 25 January 1839; too late, however, for Talbot to be the official inventor of photography, as the new invention came to be known. "Photography," in fact, soon won over all other terms when John Herschel (1792–1871) used it to describe Talbot's "photogenic drawings." It was Herschel, moreover, who discovered the fixing properties of sodium thiosulphate, immediately used as a substitute for other salts, such as sodium chloride or potassium bromide. However, for some years the word "photography" was used exclusively to define images created on paper rather than those, like daguerreotypes, created on copper plated with silver.

Talbot's invention was perfected with the development of the "calotype" (or "talbotype") in 1841 and considerably reduced exposure times to just one minute as opposed to the previous ten and more minutes. The calotype's special feature, however, was the possibility of obtaining numerous positive copies from the original negative by making the supporting paper transparent with glycerin or wax; the latent calotype image was developed by chemical means in pyrogallic acid, while sodium thiosulphate was used for fixing. The metal daguerreotype, on the other hand, was a unique copy: obtained by uncovering the plate's latent image – sensitized with iodine vapour – after exposure in the camera obscura, using mercury vapours which deposited themselves on the plate in proportion

with the *chiaroscuro* of the image. For some time, however, this process was preferred due to the extraordinary clarity of the image; in the calotype this was somewhat obscured by the grain of the paper from which the negative was made, which was printed onto the positive copies.

For about a decade the two techniques were used equally by editors and travelling photographers (this was despite the claims of other "inventors" such as Hippolyte Bayard, who in Paris in May 1839 had unsuccessfully proposed a direct positive, paper-based process). Thus a new concept of the fixed image began to emerge – increasingly realistic and "verisimilar."

The daguerreotype – that is, photography – was introduced by Arago, who explained its development at a general meeting of the Academy of Sciences and the Academy of Fine Arts on 19 August 1839. He outlined both the scientific qualities (the consistent precision of the image that was no longer left to artistic inspiration) and the aesthetic qualities that had prompted the painter Paul Delaroche to say, "From today, painting is dead!"

The photograph reproduced

The effects and benefits of the new invention were felt throughout the world of information. Immediately, for example, attempts were made to create repeated images for ink presses using daguerreotypes and the chalcographic process (Hippolyte, Louis Fizeau, and Alfred Donné), but the results were unsatisfactory. All that could be done at that time was to copy the precise images made *d'après nature* and to create lithographic matrices or etchings from them. These copies allowed for the manual insertion of figures into the views, thus animating the scenes which, because of the long exposure, would otherwise contain nothing that moved – traffic, for example. The first person to appear in a daguerreotype, by accident, was a passer-by who stopped to have his shoes shined in boulevard du Temple in Paris; he was involuntarily fixed in the picture that Daguerre was then taking (1838) from the window of his studio during the first successful experiments. These were begun in 1829 in association with Niepce, who died in 1833 without the satisfaction of ever seeing the triumphant acclaim of the invention he had helped to create.

The first publisher to use the daguerreotype was Charles Philippon, who had a series of pictures transferred by hand onto lithographic plates for a picture album, *Paris et ses environs* (Paris and its Surroundings). Meanwhile, another Parisian publisher, Noël-Marie-Paymal Lerebours, used the popular studies of Donné and Fizeau to publish a work that is considered the well-spring of the history of photography, *Les excursions daguerriennes* (Daguerrean Excursions). But even Lerebours

preferred to return to the manual copy, reproducing as engravings a large series of daguerreotype pictures commissioned from travellers and artists. These photographers, having mastered the technique in a few lessons, turned to the daguerreotype as an infallible means of recording the most exotic and wonderful places in their itineraries for the sake of art and archeology. Horace Vernet (1780–1863) was amongst Lerebours's "reporters" during travels in Egypt, where it seems he was even successful in photographing the interior of a harem in Alexandria while he was visiting the Prince's court as a painter.

In 1842 Lerebours began publishing his *Excursions daguerriennes* (comprising sixty views copied from sixty daguerreotypes) using the chalcographic process and adding the suggestive caption "*d'après daguerréotype,*" as if to say, "the real thing." Talbot, on the other hand, although he himself carried out research into printing his calotypes using ink – with good results on steel plates using a system similar to Fizeau's – believed that the solution for diffusing photographs was to take directly from the negatives (his system used negatives; Daguerre's, the "competition's," did not) an indefinite number of positive copies, to be mounted on card supports and bound into the album. In this way Talbot illustrated the first photographic book in history, *The Pencil of Nature*, published in instalments between 1844 and 1846.

Enthusiasm for photography, daguerreotype and calotype, spread widely, especially thanks to travellers on the itineraries of the Grand Tour or in the Mediterranean basin, where at last it was possible to make effective recordings of archeological and other sites; with the perfection of techniques, it was but a short step from this to scenes of local life. Across the ocean photography was immediately an equal success. It was "imported" into New York from Paris in September 1839 by Samuel Morse (1791–1872) and by one of his university colleagues, William Draper (1811–82), who in March 1840 was already able to photograph the moon in a daguerreotype more than two centimeters (¾in) in diameter – one of the first astronomical photographs. Draper was a pioneer of scientific photography whose techniques have brought about serious research, particularly in microscopy and astronomy. Visible horizons were widened, allowing the study and comparison of images, a procedure that only photographic recording was able to provide in such a rapid and precise way. On the American continent the photographer became a familiar presence on all pioneer and gold-digging expeditions or the building of the great railways, as well as in scientific laboratories. Certainly the photographers helped this unknown land to become known, even making myths of its countryside in a manner that no other form of documentation could have matched.

In the Mediterranean basin, however, rich

archeologists and intellectuals were the first to photograph the exotic sights that were often in ruin and which the photograph seemed to save, to a certain degree, from oblivion. Amongst the most famous photographers were Girault de Prangey, who worked in Italy, and Maxime Du Camp (1822–94), who in 1849, after attending an intensive course under Gustave Le Gray, left, with his friend Gustave Flaubert, for an adventurous journey in Egypt and Nubia that resulted in a memorable series of great pictures. These were later published in 1852 under the title *Egypte, Nubie, Palestine et Syrie: Dessins Photographiques pendant les années 1849, 1850 et 1851* (as an album of original photographs) by Blanquart-Evrad's *Imprimerie Photographique*, which was then the most important European laboratory after the *Talbotype Printing Establishment* established in 1843 by Talbot at Reading, England, under the direction of his major-domo, Nicolaas Henneman.

The Age of Collodion

In 1851 a new – and in many ways revolutionary – technique was announced by the Frenchman Le Gray and the Englishman Frederick Scott Archer (1813–57); it enjoyed such success that it immediately halted the development of the daguerreotype and the calotype, and indeed constituted an epoch in the history of photography: the epoch of wet collodion.

In the decade before the invention, despite the greater success of the daguerreotype, the calotype, and other similar processes, had been used due to the use of a negative, the relative inexpensiveness, and simpler technique. The problem of the grainy effect on the printed photograph still remained and, as mentioned above, the calotype was less competitive in terms of clarity, and clarity was the major fascination of photography. It had become clear that glass was the best support, but a suitable glue to hold the photosensitive material and adhere to the surface could not be found. Abel Niepce de Saint-Victor (1805–70), a descendant of Nicéphore, succeeded (experimentally from 1846) with an emulsion of egg albumen, vinegar, and silver nitrate; but this process was not light-sensitive enough and was unsuccessful. It came to be used only for printing positive copies, where the length of exposure time was not critical.

But the road toward substituting the paper support with glass had been opened and some years later, in 1851, the Frenchman Le Gray and the Englishman Archer succeeded, and published details of their process. They used collodion as a base for the emulsion.

In short, the glass plate was covered with a layer of collodion (nitrocellulose, with ether and alcohol) in the darkness of the camera obscura, and was then sensitized in a bath of silver iodide and potassium. The photograph,

however, was taken immediately, before the collodion dried. Hence the name *wet collodion* given to this technique, which in its variations and improvements came to characterize an entire era of photography until about 1880, when it was superseded by gelatin in silver salts.

With this development – which had the advantage of allowing, like the calotype, for the printing of countless positive copies of great clarity, thus defeating the daguerreotype – instantaneity was greatly increased because these plates were much more sensitive to light.

Photography, in commercial terms, rapidly took off with the arrival of collodion and its success was assured because, apart from its technological novelty, the quality of the pictures was unsurpassable, especially from the "documentary" point of view. Indeed, it was after 1851 that the major studios were opened like that of Nadar (Gaspard-Félix Tournachon, 1820–1910) in Paris or the Alinari's in Florence.

The photographer-travellers who set up studios in tourist areas (such as the Bonfils in Beirut or Antonio Beato in Luxor) increased; so too did the trade in exotic, archeological pictures that were always in demand among both art scholars and anthropologists.

War photography

War, too, had its photographers; the most famous was Roger Fenton (1819–69), considered the first war photographer. He worked in the Crimea in 1855 and created important documentation while avoiding gory scenes of all kinds – those taken without posing (technically, this would have been almost impossible) and even photographs of bodies on battlefields. Fenton was thus obeying the political directives of his editor, and indirectly the British government, who allowed him onto the Crimea. His pictures appear to have been carefully sterilized of all drama. Felice Beato (1825–1903?), together with his brother Antonio and James Robertson, continued Fenton's reporting in a rather different manner. Together with an English attacking force, Beato reached the Indian area of Lucknow, where there was a revolt in progress that was immediately and bloodily quashed. On this occasion the English needed an "objective" documentation of the bitter retaliation; Beato was therefore called upon to carry out this operation, which was repeated at Fort Taku in China two years later (1860), when an Anglo-French expedition was sent to quash a revolt.

Beato's collodion photographs are the first pictures of corpses in the history of photography. They are functional pictures and they were put to use – then as they would be today – by the political system as an effective means of persuasion.

Some years later, during the American Civil War, Mathew Brady (1823?–96) and Alexan-

der Gardner (1828–1902) dedicated themselves to documenting the apocalyptic battlefields littered with corpses. In this instance the Northerners had instigated a huge program of documentation along the front lines, and Brady's team was thus the first photographic agency in history.

But the market for photography – and indirectly its cultural effect as a medium – was stimulated above all by the work in the studios dedicated to portraiture, reproductions of art and architecture, landscape, and the local scene.

After his wartime adventures in India and China, Felice Beato moved to Yokohama and founded the first Japanese studio with a friend, an English journalist called Charles Wirgman. Here Beato began a "school" and initiated the Japanese photographic industry with attractive landscape and folkloristic pictures that sold well in the West, there was much curiosity about the exotic Orient. The photographs, beautifully hand-coloured by Japanese watercolour painters, were taken by Felice Beato, his successor the Austrian Baron von Stillfried, and then by the Japanese heir, Kusakabe Kimbey; in many cultural areas they helped to influence the European image of the Far East.

Photographs allowed people to glean an idea of faraway places in a way no other picture could match. Thus began a new era of communication and information, ever more visual, immediate and convincing, later developed by the rotogravure and, at its zenith, by the simultaneity of television.

The artistic reproduction

Portraiture increased in prestige and popularity in the era of collodion through the use of new techniques and inventions such as André-Adolphe Disdéri's *carte de visite*. Disdéri was a Parisian photographer, originally from Liguria in Italy, who made photographic portraits in series that were much less expensive than the portraits of the great Nadar or Adam Salomon (the former an ex-caricaturist, the latter a sculptor), artists who were refined and sophisticated even in their choice of clients – celebrated personalities, intellectuals, and artists. At the same time a new genre emerged – the artistic reproduction. Archeologists, landscape photographers, and travellers such as Alexander John Ellis had already initiated this new genre: Ellis, a philologist who in 1841 collected the first systematic series of daguerreotypes of monuments in Italian cities, today in the London Science Museum; Eugène Piot, author of an album, *L'Italie monumentale* (Monumental Italy) in 1851; Alfred-Nicolas Normand, architect; Frédéric Flacheron, a Frenchman who in the 1840s, in Rome, organized a photographic circle involving several painters – such as Giacomo Caneva – who later became photographers.

A systematic transformation of the artistic

1. Joseph Nicéphore Niepce, heliograph on pewter plate (16.2 × 20cm [6½ × 8in]) taken from the window of his studio at Gras near Chalons-sur-Saône, probably in 1826. This is the oldest existing photograph. H. Gernsheim Collection, University of Texas, Austin.

2, 3. William Henry Fox Talbot, above right, a set table (1841). Among the first calotypes that illustrated a book, The Pencil of Nature (see left), published by Talbot in 24 instalments between 1844 and 1846.

5. L'Hôtel de Ville, Paris, in an illustration from the album Excursions daguerriennes, published by Lerebours. The picture was taken from a daguerreotype transformed into a chalcographic plate by the Fizeau process in 1843. It is one of the earliest attempts at direct photographic printing with ink.

4. Nadar (Gaspard-Félix Tournachon), portrait of Franz Liszt (1886).

6. Alexander Gardner, a trench at Gettysburg during the American Civil War (1863).

7. André Disdéri, a full-page "carte de visite" composed of 8 pictures, 6 × 9cm (2½ × 3½in) that were cut out and glued onto smaller cards (c. 1860).

8. The Alinari brothers, Palazzo Strozzi, Florence, taken according to the classic conventions of the Florentine ateliers (c. 1865).

9. Henry Peach Robinson, composite photograph obtained by mounting various

images as a mosaic and with the Victorian title The Passing Away (1858).

10. Julia Margaret Cameron, Summer Days (c. 1865).

1. Alfred Stieglitz, portrait of Georgia O'Keeffe (1918).

2, 3. Giuseppe Primoli. Below: a snapshot he took in rue de Rougemont, Paris, requested by an admirer of Gabrielle Réju, known as Réjane, famous French actress (July 1869). Bottom: Roman aristocrats in the public gallery at the Tor di Quinto hippodrome in Rome during a horse race in May 1893 in a pioneering, "reverse shot" exposure. Primoli Foundation Collection, Rome.

4. Edward Muybridge, sequential photograph of a horse galloping (1878).

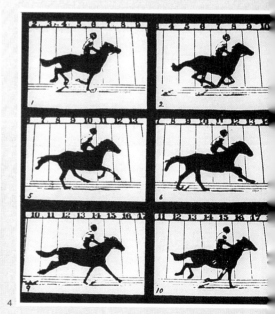

5. *Robert Demachy, Spring (1896), bichromate rubber print.*

6. *Lewis Hine, New York, family of Calabrian immigrants just off the boat (1905).*

7. *Jacob August Riis, home of an Italian immigrant in New York (1888). Lit by a magnesium flash.*

8. *Henri Cartier-Bresson, the painter Henri Matisse in his studio at Vence (1944).*

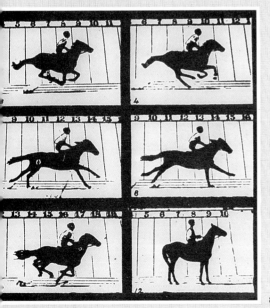

reproduction was under way – in architecture, painting, and sculpture – substituting with clear photographs chalcographic and lithographic prints that until then had been the only means of diffusing indirect knowledge of works of art and archeology. The "machine-made" image won the day: comprehensive, clear, and in certain respects (the possibility of systematic comparison, for example) more scientific.

In France in 1851 even a public institution, the *Commission des Monuments Historiques*, decided to begin the documentation of crumbling architecture and employed five photographers – Bayard, Baldus, Le Gray, Mestral, and Le Secq – on a project called *Mission Héliographique*.

It was the private studio, however, especially in Italy, that began the impressive and indispensable work of cataloguing culture; the bureaucracies of public institutions were generally not committed, even though they should have confronted the problem. If it were not for the Alinari, the Brogi, the Sommers, Noacks, Nayas, Ponti, Poppi, etc., then today, because of the public institutions' lack of interest, we would not have even the tiniest part of our documentation of cultural wealth. The *atelier* of the Florentine Alinari brothers was representative of all the studios that were committed to this task. It was founded in 1852 by Leopoldo (Romualdo and Giuseppe later joined him) at the suggestion of – and with the financial help – of the chalcographer Giuseppe Bardi, with whom Leopoldo had worked as apprentice.

Indeed, Bardi had perspicaciously seen that photography would supersede the old techniques of engraving (and even the more recent lithography) in the market for souvenir pictures and artistic reproductions. He shrewdly took the opportunity of beginning in this field through one of his employees who had shown interest in the new art. The brand-new collodion technique meant that reproductions of paintings and drawings were guaranteed to be excellent. Then Leopoldo Alinari and his brothers set up their own business, giving character to the photography of monuments and works of art, with thorough stereotyping of images. Their enterprise remains unequalled and extended until the first decades of the twentieth century thanks to Leopoldo's son Vittorio, who expanded the company's activity in the publishing field.

The artistic photograph

Portraiture in its turn enjoyed enormous success, and its most famous character was certainly Nadar, who because of his ability, and not without a hint of irony, was called "The Titian of photography." The nickname implied the aesthetic value of photography and the "artistic" creativity of photographers. With the solving of the original technical problems, attention turned toward winning cultural dignity for this new art. This dignity was repeatedly contested, despite the fact that many painters who went over to photography dedicated much time to it and used their painting as a "model" to follow. If John Ruskin used the daguerreotype to gather Venetian architecture in all its most elusive and unrepeatable detail that even the most realistic drawing would fail to render, others such as Jean-Baptiste-Camille Corot, Gustave Courbet, and Eugène Delacroix were not ashamed to turn to photography in the creation of their paintings – transferring "by hand" the drawing and the shading. On the other hand, this was a technique that had begun before the invention of photography with the use of the camera obscura by Canaletto, Bernardo Bellotto, Francesco Guardi, and many others; it was used not simply for technical purposes, but also in an attempt to find a new way of seeing with an unlimited idea of space.

In Italy the most famous of the last century's painters to use photography systematically was certainly Francesco Paolo Michetti. He has left an integral archive of pictures executed directly, as if they were live annotations, with an exceptional capacity for evoking reality. Delacroix, however, used his own personal photographer, Eugène Durieu, with whom he collaborated strictly on the arrangement of the model, the drapes, the lights and the composition of the picture, which was then used in a painting. Some photographers specialized in photographs for artists and in Paris one of the most famous, G. Marconi, had a visiting card which read "Phot. de l'École des Beaux-Arts. G. Marconi. Académie pour les artistes. 45 blvd. St. Michel." An Italian painter called Federico Faruffini moved over to photography in the hope of being more successful with photographs to sell to painters as models to be copied; but his "local scenes" were aesthetically so complete that his colleagues did not approve – there would have been little left for them to do, if we exclude the transfer of the picture in oil onto canvas. Faruffini, upset by this failure, ended it all with suicide, swallowing poisonous chemicals used in his photographic laboratory.

Photographers, however, were increasingly insistent in proclaiming the artistic value of photography; their means included imitation of painting so as to demonstrate the possible artistic techniques that were not limited by photography's "mechanic" nature. Even Baudelaire stepped in in 1859, with his famous invective dictated from the Paris Salon against the pretentiousness of much "artistic" photography. He also wrote: "If photography is allowed to replace art in any of its functions then photography will soon completely supersede or corrupt art, thanks to the natural alliance it will find in the stupidity of the multitude. Photography must therefore return to its real duty, which is to be the servant of the sciences and the arts, the most humble of servants." The debate became bitter because at stake was the market in visual reproduction – photography was often preferred to more traditional means.

One of the first who set out to create an artistic photograph that displayed the photographer's creativity, rather than his craftsmanship, was the Englishman Henry P. Robinson (1830–1901), ideologically involved in the Pre-Raphaelite movement and friendly with many of its members, such as Dante Gabriel Rossetti and George Frederick Watts. From 1855 he began to plan and create a series of photomontages ("photocomposites"), uniting with great precision various photographs of characters and settings following a composition drawn beforehand on a piece of paper; the aim was to create real "photographic paintings."

At the same time an erstwhile Swedish painter and naturalized Englishman dedicated himself to this new pictorial genre; Oscar G. Rejlander (1826–75) even created some works with a surrealist tone by superimposing various negatives. Rejlander's photographs all shared the same moralizing theme and followed the Pre-Raphaelite taste, sometimes imitating – almost to the extent of plagiarism – painters' compositions. Rejlander is also noted for illustrating one of Darwin's fundamental studies, *The Expression of Sentiment in Man and Animals* (1872), using a series of snapshots of facial expressions that were reproduced using the collodion process.

Some years later, in 1868, a mature English lady enthusiastically joined the debate; Julia Margaret Cameron (1815–79) approached the problem of the artistic photograph using some transgressions and techniques – such as blurred or moved images – that were used for the first time as aesthetic factors rather than technical defects. Her large portraits, taken too close to her subjects and with the long exposure times required by collodion plates, have an unusual charm and – despite the protests of the purists – enjoyed remarkable success, especially amongst her friends, who were the most noted of the Pre-Raphaelites: Rossetti amongst the painters; Tennyson amongst the writers.

In the same years another dilettante, the Reverend Charles Lutwidge Dodgson, a mathematician better known by the name of Lewis Carroll (1832–98) and author of *Alice's Adventures in Wonderland* amongst other works, concentrated on an emblematic photography. Carroll used models in romantic poses – young girls, were often friends of the family and often scantily clad – to create a suggestive photographic album that poetically evokes the Victorian epoch.

Amateur photography

The problem of the artistic photograph, however, took real shape much later, after a lively

debate and particularly during an international convention on photography in Vienna in 1892. From this meeting grew the idea of instituting an organization in London – the Linked Ring Brotherhood – initially led by Robinson, and with the aim of promoting creative photography. This was an elitist attitude that tended to differentiate aesthetic research from everyday photography, which – thanks to the simplification of techniques (the result of the use of gelatin-bromide plates, together with more sensitive and smaller instruments and developing procedures standardized by Ferdinand Hurter and Vero Charles Driffield – was now widespread. Thus photography was brought to amateurs who came from new social classes (though still middle to upper) and who recognized photography as an aristocratic status symbol during its first mass diffusion at the turn of the century.

Aristocrats and intellectuals were particularly keen to display their ability with photographic equipment ("technologically advanced," we would say today), sometimes with only light-hearted, familial, or touristic purposes but often, almost unconsciously, using photography to investigate social conditions, behaviour, city and regional life. In Europe these investigations were made especially along the itineraries of the Grand Tour.

In Rome Count Giuseppe Primoli (1857–1927) excelled; this son of Carlotta Bonaparte, with his brother Luigi, captured scenes of city life – especially street scenes – with extraordinary vivacity and recorded social aberrations. Social convention amongst the aristocracy and the bourgeoisie was another speciality that benefited from his ironic point of view; his reportage from the horse-racing course at Capannelle is a memorable example. With a photographic eye that ideologically precedes that of modern photojournalists (the use of the "reverse shot," for example, that would be one of the leitmotifs of Cartier-Bresson), Giuseppe Primoli expressed himself with extreme detachment, even technical detachment, transgressing systematically, but functionally, the traditional rules of professional photography. The photographic lexicon therefore progressed, suggesting the possibility of breaking with the usual stereotypes (those of Alinari, for example) and creating new ones, those indeed of the amateurs whom the new techniques helped to perpetuate up to the First World War.

In the meantime "pictorialism" flourished, a genre in which countless amateurs – often painters manqués – specialized. They used new techniques in both exposure (the flou, "blurred" lenses that allowed a soft focus of the image and an obvious artistic effect) and in printing, with the use of special papers and processes such as bichromate gum or charbon-velours that gave the image an evocative graphic look similar to a lithograph or a watercolour. The aesthetic charm of these "oil" techniques, as they came to be known, lasted

until the 1930s and was perfected in the bromoil process (1907) and the resin process (1924), this last invented by Rodolfo Namias.

The most celebrated of the photographers dedicated to the bichromate gum process was the Frenchman Robert Demachy (1859–1938), who created splendid portraits and nude studies in the decades around the turn of the century, printing on refined paper which, together with "platinum" paper, characterized an entire epoch. Photography greatly benefited from this artistic research and enjoyed new prestige; its techiques came to be considered an aesthetic language spoken by the photographer, the creator of the picture. Indeed, the first "aesthetic" studies of photography were published in the context of research on the artistic photograph.

Peter H. Emerson (1856–1936) was a doctor and amateur photographer of American origin who lived in England and in 1898 wrote an essay, "Naturalistic Photography for Students of Art," with which he promulgated naturalistic photography. His aim was faithful realism without manipulation, taking into account the physiological characteristics of the human eye that in effect "focuses" only on a part of what it sees and neglects (puts out of focus) the rest. But the problem of vision and the photographic transposition of reality was radicalized some years later by Alfred Stieglitz (1864–1946) who in 1902 founded in New York a specific association "for the artistic photograph": the Photo Secession. With this he intended to advance photography's prestige as an aesthetic product, and to find a place for this expressive technique within the received culture.

Stieglitz was a great cultural leader and he opened a gallery on Fifth Avenue, the "291," and founded a magazine, Camera Work, which immediately became a focal point in the culture of avant-garde photography through its interdisciplinary nature and the new ideology of artistic photography it promulgated with essays and pictures; all this without adopting a biased attitude against pictorialism. Stieglitz synthesized the new ideology as "straight photography," which relied upon basic techniques, especially during the exposure, but in common with the pictorialists used sophisticated printing techniques such as bichromate gum and the platinum process.

Thus artistic photography acquired textural, almost tactile qualities of an extraordinary tonal precocity that distinguished its images from the "vulgarity" of much common photography and so aristocratically set itself apart. In fact, run-of-the-mill photography followed the standardized golden rules of the industry, led by Kodak, which was founded by George Eastman (1854–1932) in 1880 and had greatly contributed to the diffusion of the medium. Cameras became easier to use and less expensive to buy – the first Kodak camera went into production in 1888 and called for only three simple operations – while celluloid

was introduced as support for the photosensitive negative materials and a replacement for the glass plate. In this way photography was simplified for the dilettante, and Kodak, in its well-equipped laboratories, contributed significantly to this development. (Celluloid also allowed the evolution of cinematic photography – first defined as a practical technique in 1894 but presented officially in 1895 by the Lumière brothers.)

Sociological photography

In the meantime photography became more and more useful, particularly in the scientific sector: medicine, astronomy, and criminology amongst other fields. One of the most interesting areas was sequential photography, initiated and developed by Edward Muybridge (1830–1904) and then by Étienne-Jules Marey (1830–1904) and Ottomer Anschütz (1846–1907). These pioneers contributed greatly to the advent of cinematography, for which sequential photography was absolutely necessary. But from the 1880s onward it was principally the sociologists who put photography to its best scientific use by initiating research into social conditions with a tool that finally had all the necessary qualities, because its evidence had to be considered absolute.

The most significant sociologist-photographer of the last century was an American of Scandinavian origin, Jacob Riis (1849–1914). Riis was a reporter on the New York Tribune who from 1880 began a systematic documentation on the life of European immigrants in New York, following them from their arrival on ship in port to their homes, which were mainly in the New York slums, where many of them became involved in the underworld.

In 1890 Riis published his successful book How the Other Half Lives, which contained photographs that had been published in newspapers using manual reproduction techniques such as wooden "clichés." These photographs caught the attention of both the general readership and the powers that be; some positive measures were taken as a result of Riis's reportage. In documenting the social conditions in which European immigrants lived in the turmoil of the metropolis, Riis pioneered the use of artificial light for interior exposures by igniting magnesium powder; thus a new means of photographic vision was created.

The title of sociologist-photographer could be given to many other photographers of the period, including John Thomson (1837–1921), who carried out worthwhile environmental studies in the Orient; or Paul Martin (1864–1942), whose London by Gaslight was a futuristic report of extraordinary technical complexity on the city by night. But it is obvious that it was the new technique of photography itself that spurred new realism in social and environmental inquiry. Not even "landscape" photographers were immune: Timothy

1, 2. Edward Weston. Left: nude (1935). Right: the Ocean Desert in California (1936).

3. Paul Strand, Abstraction, Dishes (1915).One of the first abstract photographs in the history of photography.

4. Dorothea Lange, California (1936); this photograph was part of the Farm Security Administration's documentary program during the New Deal.

5. Luigi Veronesi, photogram (1943).

6. Anton Giulio and Arturo Bragaglia, The Slap (1912), photodynamic.

7. Robert Capa, women in Naples during the funeral of some young partisans on 2 October 1943, on the arrival of the Allied troops after the landing in Sicily.

8. Man Ray, nude, in a solarized, negative picture (1931).

9. Bill Brandt, the poet Dylan Thomas and his wife, Caitlin (1944).

10. Ansel Adams, Californian landscape (1944), a photograph taken with the zone system that allowed maximum control of contrast.

11. Walker Evans, the family of Bud Field, Alabama (1936). Part of a sequence taken for the Farm Security Administration.

12. Laszlo Moholy-Nagy, photogram, taken without a camera during visual research at the Bauhaus (1923).

O'Sullivan (1840–81) and William Jackson (1843–1942) – the former in the Rocky Mountains, the latter in Oregon and Yellowstone – searched for an unknown reality that was recorded on the big photographic plates, showing the world with the unique "verisimilitude" of photography.

With the dawning of the new century it was Lewis Hine (1866–1940) who gave this new genre its definitive character. Hine was a professional sociologist and teacher at New York's Ethical School, where he first began to use photography as a means of enquiry. He put together a memorable documentation of the immigrants' social conditions, and particularly on the exploitation of child labour in New York and Pittsburgh; the magazine *Charity and the Commons* commissioned and published many of these photographs.

In Europe it was the German August Sander (1876–1964) who above all others represented this tendency that was so spontaneous amongst the photographers of the new generation. Sanders confronted the task of "cataloguing" the various "types" of Germany through a series of static, frontal portraits. With these he created a book, *Antlitz der Zeit* (The Face of the Age), printed in 1929 and then destroyed by the Nazi censors in 1933, together with part of the archive, because this work was a desecration of the German Aryan myth that had already been established as current ideology by the head of the regime.

In Italy not even this attempt was made; there is no hint of sociological research amongst photographers either before nor during Fascism, if we do not consider the amateur efforts of dilettantes such as Count Chigi or Cugnoni and Morpurgo, who were rather searching for spontaneous "local scene" photographs of a folkloristic nature. Not until the immediate post-war period and the arrival of neo-realism (or during the war, with the reportage that followed the Allied troops as they left the towns of the South) do we find the political spirit of sociological research. Such research would lead not only to the revelation of "lesser" Italy but also to the rediscovery of photography as a means of research beyond artistic expression and common craftsmanship.

Photojournalism

In the meantime, a new means of informing and communicating was established – photojournalism, which began in the last decade of the nineteenth century when photomechanical reproduction techniques (especially offset printing, which provided words and pictures together) finally allowed it. The Great War was to prove a great stimulus: techniques and materials were updated constantly and rapidly.

The equipment became progressively smaller and the films increasingly sensitive, with harmonious shading and clear detail that could cope with enlargement. The Leica, with its pocket-sized dimensions, was emblematic of these changes and permitted the use of cinematographic film; the camera was designed and built during the war by the engineer Oskar Barnak to test this film. The Leitz company began selling it only in 1925 but from then onward the entire industry had to come into line, especially in reducing the format of plates and therefore allowing for enlargements, whereas previously contact prints had generally been the only means of printing.

In photojournalism the amount of available light was very important and for some years another camera, the Ermanox, was superior; this camera had such a sensitive optical system that it allowed Erich Salomon (1886–1944) to use natural light in his reportage, which was executed with a technical virtuosity that has won him an important place in the history of the photographic image. Salomon was an Israeli with an intellectual background that helped in making lucid journalistic reports – he graduated in law – and he took up photography as a career in the 1920s. Modern photojournalism began with him and followed a course that reached its zenith after the ideology of the "decisive moment" promulgated by Henri Cartier-Bresson (b.1903); this was immediately after the Second World War, when photojournalism became the greatest mass medium before television (in the sixties) diminished its informative function and relegated it to newspapers and magazines.

From offset to rotogravure, photography (eventually colour photography) used these processes to fill the pages of pioneering magazines such as *Vu* (Paris, 1928), *Berliner Illustrierte Zeitung* and, in 1936, *Life*. This last was the dream of Luce, an American publisher, who wanted to offer the "world's show" in pictures in all its variety and at the same time transform the magazine into a powerful propaganda instrument in politics and advertising.

Colour

In the interwar years, photography seemed to have achieved all that could ever be needed: both instantaneity and colour, which had come about after generations of scientists and photographers had dedicated themselves to research. At the end of the nineteenth century the theoretical basis for all this had been laid, particularly the silver bromide gelatin made orthochromatic with coupling chromogens in 1873 by Hermann Vogel (1834–98). This invention was, in fact, indispensable for obtaining direct colour images. Initially the problem was resolved using the trichromatic principle – demonstrated photographically by the physicist James Clerk Maxwell (1831–79) in 1861 – whereby the three primary colours are selected using filters in three successive exposures and then printed photomechanically, superimposed, with printers' inks. The most successful experiments were those of Louis Ducos du Hauron, Charles Cros, Edmond Becquerel, and Leon Vidal from 1870 onward – with results, however, that were demonstrable only by using inked matrices and images therefore printed on paper. The subjects had to remain static because the exposures of the three primary colours were not simultaneous but successive, so that the technical skill required was quite remarkable, especially for "instant" photography. The physicist Gabriel Lippmann (1845–1921) experimented in 1891, and demonstrated his theory (for which he won the Nobel Prize) on the interference of light, with which it was finally possible to obtain direct colour images with one single exposure. The technique, however, was experimental and impractical. Many people tried to resolve this problem, including the Italian Carlo Bonacini and the Irishman Charles Joly, but those who succeeded were the Lumière brothers (Auguste, 1861–1954; Louis-Jean, 1864–1948) of Lyons, manufacturers of photographic materials and themselves inventors of many processes including cinematography and, of course *autochromie*.

This technique involved using a mixture of potato starch as microscopic filters – tiny grains of approximately thirty thousandths of a millimeter in dimension that were coloured, separately, in red-orange, blue-violet, and green. The mixture was spread on a glass plate, sensitized on the opposite side with a photosensitive black and white layer. The coloured light reflected by the subject travelled through the lens at the moment of exposure and through the layer of coloured starch, thus reaching, in proportion to the various colours of the subject filtered by the minuscule starch filters, the photosensitive surface, which in turn assumed the impression and then displayed the image after the usual development. Then this image was inverted, creating a transparency that could be observed by backlighting or by projection, and the potato starch again functioned as a filter in proportion to the subject's original colours, as selected previously on exposure. The positive print, however, could be produced only using a traditional photomechanical technique, selecting the three primary colours from the Autochrome transparency to obtain the same number of matrices which, when inked and printed in superimposition, recomposed the original photograph in trichromatism.

Autochrome images, especially when projected, are very similar to Pointillist paintings; the techniques share the same scientific theory. Pictorial photographers therefore took to Autochrome willingly; it seemed to provide possibilities for later artistic intervention following artistic canons that reigned for a long time, even in photography. The Lumières' patent is dated 1903, but Autochrome was used commercially only in 1907 and 1908, spurring new enthusiasm for photography. Before Autochrome colour was obtainable only

manually, by painting the positive prints; this deficiency had seemed impossible to correct, characterizing photography not only as a means of communicating but also as a means of creating forever an imitation of painting.

The search for a specific language

In little more than sixty years from its invention, photography had attained all that had been in the apparently science-fiction dreams of the pioneers – even the long-distance transmission of images and their speedy and economical photomechanical reproduction.

In the meantime, the problem of photography as art had stimulated research for an understanding of its language. Some began to hypothesize on a specific language for photography, individuating the autonomous capabilities of its technique, despite its close relationship to other figurative, two-dimensional images through the code of perspective, *chiaroscuro*, and colour.

But in photography this code had a unique quality: it was determined by an optical system and a photochemical process that "rationalized" the image, compared to manual techniques that entrusted the choices to the ideology of the artist. The artist (the photographer) thus became culturally responsible for the images that seem mechanical but instead are the tangible result of a view of reality carried out in a new *way*, exploiting even the ambiguity of the "verisimilar." It is the result, perhaps, of an archaic longing to reproduce and memorize the present moment, something that photography has finally made possible, characterizing contemporary visual communication and thus the aesthetics of our time.

Among the first to tackle this problem – photographic "sight," as opposed to that of the eye – was Peter Henry Emerson, a Cuban doctor who settled in England, where he dedicated himself almost totally to photography. He proposed a naturalistic photography *en plein air*, following suggestions also made by the Impressionist painters, which for photography were an invitation to use the medium with more spontaneity – to create artistic results without necessarily turning to pictorial imitation and laboratory manipulation, or to scenographic reconstruction as in the photomontages of Robinson or Rejlander.

The concept was radicalized by Stieglitz in New York, after a European visit during which he met Vogel and Emerson himself. Here he organized a series of promotional events on "photographic art" that were fundamental to the course of contemporary photography. Above all, Stieglitz proposed a new photographic ideology: straight photography, a direct use of the medium without manipulation, thus allowing the technique itself to express its basic potential.

Having founded the Photo Secession in New York in 1902 – an association of artists and photographers (Alvin Langdom-Coburn, Frank Eugène, Gertrude Kasebiere, etc.) – Stieglitz opened a gallery, "291," and published between 1903 and 1917 the legendary magazine *Camera Work*; this magazine was remarkable because it contained avant-garde painting and photography in equal measure, even in its critical articles.

Photography established itself as an art form in America largely due to Stieglitz, who presented the painting of the European avant-garde for the first time overseas in his gallery on Fifth Avenue, later giving particular space to Dadaists such as Marcel Duchamp, Francis Picabia, and Man Ray, who developed within the 291 association.

Within this environment other major protagonists of contemporary photography developed, such as Paul Strand (1890–1976), an emblematic photographer who created, amongst other works, a series of "abstract" photographs in 1916. Contemporaneously there arose a type of photography that was extremely specific in its expression (absolute clarity of detail, extracting the main elements of the image from their context) and characterized by sociological and political commitment; Strand derived this as an adherent of Hine's school.

Straight photography soon had many followers, including Edward Weston (1886–1958), who in 1920 abandoned pictorialist tenets and turned his eye to a view of reality that relied upon the obvious and specific qualities of photographic technique. For him, clarity of detail was crucial – such a rigorous clarity that in his work it reaches the limits of hyperrealism. In order to achieve these excellent results Weston used large-format cameras (20 × 25cm [8 × 10in] plates) with a technical virtuosity that was only ever equalled by Ansel Adams, landscape photographer, with whom – and together with other friends (Imogen Cunningham, Willard Van Dyke, Dorothea Lange, etc.) – Weston founded, in 1932, the F.64 Group. With this number, the smallest possible aperture of the lens diaphragm, they intended to symbolize the need to obtain maximum depth of field and thus absolute clarity in the detail of the subject. The work of these photographers and their colleagues, such as Minor White, radicalized Stieglitz's ideology in the twenties and thirties and in a short time encompassed American avant-garde photography with parallels in other areas of contemporary culture – especially painting and literature.

Photodynamics

In Europe, too, there was a revolution in photography – apart from that in photojournalism – in the area of aristocratic or "underground" artistic research, especially amongst the avant-garde. In Italy the first conceptual photographic experimentation was carried out; traditionally, photography had been noted only for its documentary quaities. In 1910, immediately following the publication of Filippo Tommaso Marinetti's manifesto (1909) and the "technical" manifesto on Futurist painting written in collaboration with Umberto Boccioni, Anton Giulio and Arturo Bragaglia (with his brother Carlo Ludovico) defined a new idea of photography which they called "photodynamics." Rejecting the snapshot that "kills the gesture," the Bragaglia brothers wanted to visualize the "concept" of movement, through the determined trajectory of bodies as they move, which could be recorded by photography on a dark background, leaving the shutter open during the action. The two researchers thus completed a synthesis of movement, rather than an analysis as achieved in the sequential photography (logical and scientific) of Muybridge or, more appropriately, Marey. Marey's photography was similar in many ways to photodynamics, since it consisted of a stroboscope with the phases of movement recorded on one single plate rather than successive plates; for this reason it has often been confused with photodynamics, even though the theories behind the two techniques have nothing in common. If photodynamics referred to anything, it was – as suggested by Giulio Bragaglia in his booklet *Futuristic Photodynamics* – to the concept outlined by Henri Bergson, whose philosophy Bragaglia knew.

Constructivism and "New Objectivity"

In the history of the European avant-garde many artists used photography, which was transgressive and provocative as a technique when compared with traditional painting, but enjoyed a great communicative, emblematic, and immediate power. Christian Schad (1894–1982) sought to gather direct images on photosensitive paper, obtaining the first abstract photograms, which he called Schadographs, in 1918. He showed them to László Moholy-Nagy (1895–1946), who in his turn adopted the simple technique, essential to a rediscovery of the archaic essence of photography as recorded shadows, just like Talbot's first "photographic drawings." Moholy gave them the name photogram, while Man Ray, having come across the technique independently and by chance, called them rayographs. Schadographs, photograms, rayographs are all photographs obtained by placing one or more transparent objects on photosensitive paper while in the darkroom; these objects leave their imprint after exposure and development. In 1929 the European and American photographers most involved in aesthetic and specific research met at a big exposition in Stuttgart, organized by the Deutscher Werkbund, under Gustav Stotz, and called *Film und Foto*.

Here the experience of Weston, Cunningham, and Edward Steichen (1879–1973)

1. Henri Cartier-Bresson, youngsters in Montreal (1964).

2. William Klein, New York (1955).

3. Giuseppe Cavalli, Blind Doll (1940).

4. Ugo Mulas, End of the Examination (1972).

5. Otto Steinert, photomontage (1957).

6. Paul Strand, Italian family (1954).

7. Fulvio Roiter, Palazzo Ducale, Venice (1953).

8. Diane Arbus, woman with veil on Fifth Avenue, New York (1968).

9. Richard Avedon, fashion photograph for Vogue.

10. Robert Doisneau, Paris (1950).

could be compared with that of Moholy-Nagy, Man Ray, Florence Henry (1893–1982), Hannah Höch (1889–1978), Albert Renger-Patzsch (1897–1966) and, naturally, the Russians Lazar Lisickij, known as El Lissitsky (1890–1941) and Alexander Mikhailovič Rodčenko (1891–1956), amongst the most innovative. The major comparison to be made was between two types of image – the direct image of Weston, Steichen, Renger-Patzsch (displaying an enthusiastic faith in the inherent creative capacity of the technique, and a strong reliance on the photographic quality of the result) and the manipulated image (photograms, rayographs, photomontage, plastic photography) tending toward the abstract or the surreal, almost a paradoxical contrast for photography, which had always been thought of as a means of documentation.

Photomontage

Photomontage enjoyed particular success in this period, even as a means of political propaganda, using satiric and grotesque *collages* to explain political concepts in an accessible manner. Its main exponents were Raoul Haussmann (1886–1970), Paul Citröen, and above all John Heartfield (Helmut Herzfelde, 1891–1968), a member of the Berlin Dadaists and a contributor to the left-wing magazine *AIZ (Arbeiter Illustrierte Zeitung)*, for which he made countless covers against the Nazi establishment.

In Italy, if we exclude the Bragaglia brothers and their photodynamics, the avant-garde was much more cautious during the Fascist period and only a few architects such as Giuseppe Pagano or Franco Grignani took risks. Amongst the painters and designers the most advanced was certainly Luigi Veronesi, who began his experiments at the end of the twenties according to the canons of the Bauhaus in a courageous departure from traditional photography. Antonio Boggeri, too, took up photography, not only in its graphic and advertising uses but searching for an up-to-date theory that suggested the new geometry of the image, often taking it out of context and thus disturbing the usual "points of view"; he made observations from high and low and was in line with the Constructivists' experience, in particular that of the great Moholy-Nagy. During the "second Futurism" the experimental photographers re-emerged following the publication of the Futurist photographic manifesto promulgated by Marinetti and Tato (Guglielmo Sansoni) in 1930. The double exposure, with its considerable symbolic possibilities, was a popular technique at that time, and Wanda Wulz, Tato, Ferruccio Demanins and Oreste Bertieri all specialized in it during a brief but intense period that ended, to all intents and purposes, in 1932.

The technique of photomontage was also of immediate functional use in photojournalism: not with *collage* and cutting but in the dialectically motivated layout and varying images on the page with short text and emblematic pictures (as defined by Federico Patellani) that replaced the old layouts of illustration and caption. Thus the photograph and its use was finally considered a product of intellect that was much to the fore in the editorial content of the new illustrated magazines, such as *Omnibus*, founded by Longanesi in 1937 (but published for only two years because of Fascist censorship), and *Tempo* from Alberto Mondadori, beginning in 1938. These magazines followed the layouts of the big, international illustrated magazines, above all *Life*, where the photography was not considered simply as an illustrative device but was in itself a visual text.

The New Deal photographers

The illustrated magazines were particularly useful to the political world because they constituted a new and powerful mass medium that would be important right up until the advent of television. Under the Roosevelt New Deal in the United States, a team of photographers was set up by Roy Striker, a sociologist from Columbia University who in 1935 founded the F.S.A. (Farm Security Administration) with the task of "objectively" documenting the conditions of rural Americans after the great crash of 1929. But the photographs delivered by Ben Shan (who later added this experience as photographer-reporter to his painting), Arthur Rothstein, Dorothea Lange, Walker Evans, and others went way beyond this mere documentary intention – a fact that was characteristic of the government's new political approach. Many of their images were used in propaganda, through newspapers, and stimulated a fierce ideological debate. It was difficult to distinguish, however, between the committed and moralistic photography of the F.S.A. and the supposedly escapist photography of the illustrated magazines. Photography, through photojournalism, was exercising a new role, and this was manifest not only in specific fields but throughout the newly powerful photography in general.

With the beginning of the Second World War photographers everywhere were explicitly called upon by military and political intelligence services (in Italy almost twenty years previously [1924] Mussolini had founded the L.U.C.E. Institute, through which the image of his regime was controlled and promoted) and in this context the illustrated magazines were particularly committed to promoting the myth of the hero-photographer – sometimes even to the level of star. Robert Capa (André Friedmann, 1913–54) can be taken as the prototype of this new character, especially after his Spanish exploits when his *Militiaman Beaten to Death* was published by *Vu* in 1936 and later by *Life*, subsequently becoming emblematic of all war photography.

The Magnum agency

At the end of the conflict that had seen photographers such as Dmitri Baltermans (b.1912) in the Soviet Union, or Margaret Bourke-White (1906–71), the only woman sent by the Americans as a reporter on the eastern front on the battlefield, photography was in a sense rediscovered as a vocation within which it was possible to analyze and explain the world during the reconstruction (moral rather than territorial) of the postwar period. In 1947 a group of photographer friends who were motivated by this ideology founded a new type of photojournalistic agency, autonomous and managed in a co-operative form, called Magnum International; before long it would become the standard-bearer for all young photographers anxious to wipe out every residual link with pictorialism and other aestheticisms, opting rather for sociological documentation, to which photography seemed peculiarly suited.

The supreme leader of Magnum the Frenchman Henri Cartier-Bresson, who – in the footsteps of Erich Salomon and Felix Man in the twenties – had promulgated a photojournalism that made the photographer the ideological and cultural keeper of the entire editorial program of the magazine or the photo-book; the photographer was at last a creator in the complete sense and was no longer simply one who carried out the wishes of others. For Cartier-Bresson and his friends (Robert Capa, George Rodger, Maria Eisner, William Vandivert from 1947, later joined by Gisèle Freund, Werner Bischof, René Burri, Brian Brake, etc.) photography was a simultaneous cultural and technical operation, "recognizing simultaneously, in a fraction of a second, on the one hand the meaning of a fact, and on the other the strict organization of perceived forms that express this fact."

The ideology of the decisive moment

Cartier-Bresson fully exploited the theory of instantaneity with the ideology of the "decisive moment": captured in the photographic image at the moment of exposure, a moment that the photographer has to be able to perceive and fix in an image (at the precise moment of the click, and without seeing various crops during printing); clear in every technical sense (completely in focus and still with a moderate *chiaroscuro*); and without any optical "alterations" (no fish-eye lenses or zooms, for example) – rather, a normal perspective that is as close as possible to the visual conventions, partly physiological, of the observer's eye. The observer should thus read images that present realistically (and objectively?) that which the photographer has seen and transferred first onto film and then onto the pages of the magazine without apparent interference. This photographic genre was – misleadingly –

more objective than any other; it became very popular among young photographers and came to characterize much of postwar photojournalism. But in about 1955 William Klein (b.1928) intervened to suggest a more subjective reportage, with images full of meaning that came not from the conventions of exposure and printing but from a total transgression of the norms of photographic technique – shade, movement, blurring – as long as these transgressions helped the photographer to achieve the required meaning; thus the photographer was, increasingly, the creator. So the age of the Leica was about to end. Cartier-Bresson had excelled in this era, having been able to challenge the clarity of the nineteenth-century, large-format cameras (despite the small negative size of 24×36mm [$1 \times 1\frac{1}{2}$in]) and indeed, any type of pictorialism. Klein liberated photography from accepted norms by suggesting theories of expression free from all technical prejudices, and he was helped by new technology. Films became increasingly sensitive and could be used at night and indoors without lighting or flash: conditions that had previously been inconceivable.

Experimental photography

In the meantime, experimental photography also adopted two directions: one sociological (in Italy, led by neo-Realism) and one metalinguistic, in which experiments were made on the medium itself, exploring its expressive potential and thus, to some extent, continuing the research of the twenties. In Germany in particular an avant-garde movement developed; led by Otto Steinert (1915–78), the *Subjektive Fotografie* was open to every style (as long as it was relevant to photographic technique) but especially those with Expressionist formulas and transgressive tendencies, both in "point of view" and in printing and reproduction, with harsh images and strong *chiaroscuro*.

In Italy at this time *La Bussola* group emerged, led by Giuseppe Cavalli and spurred by fear of Croce's idealism. This group categorically refused documentary photography in the name of "art"; its members were regarded as formalists and saw documentation as a denial of creative possibility. The debate became particularly bitter, especially in comparisons with the photography of the neo-Realists, who were enthusiasts for the potential of narrative (poetic rather than merely testimonial); through this type of social photography the first visual record of rural Italy was made after the Second World War. No such research had ever been carried out before, apart from nineteenth-century studies of folklore. Initially the reportage of the Swiss photographer Werner Bischof (1916–54) was taken as an example of both formal elegance and social commitment. His work seemed to offer a solution and was influential on photographers such as Fulvio Roiter and Toni Del Tin (both Venetian) who, with Paolo Monti and Pietro Donzelli, were leading young Italian photographers. Others followed the American Paul Strand with his realist approach, which in fifties Europe was opposed to the expressionism of Brandt and the Hungarians Brassai (Gyla Halász, 1899–1984) and André Kertés (1894–1985) or the street immediacy of the ironic Robert Doisneau (b.1912), who seemed to have continued the narrative work of Jean-Eugène-Auguste Lartigue, a child prodigy active from the beginning of the century almost alongside Atget, who in many respects was the link between the photographic cultures of the nineteenth and twentieth centuries with his systematic reportage of "old Paris."

While photojournalism diminished in its primary function (informing, a role taken up more and more by television), another genre came to the fore – advertising. Its justification lay in the marketplace, and its role was to service voracious consumerism. Photographic techniques came into line with new requirements, especially with the advent of colour, and photography concentrated more on still-life subjects or fashion, not only in the fashion trade itself but in architecture and furnishings too.

A conceptual examination

Some photographers rebelled against the new laws of the market and encouraged an examination of the medium itself; initially this search for a philosophy of the image was carried out in such a radical way that it broke not only with the old documentary theories but also with conventional artistic theories. This new cultural endeavour, known as Conceptualism, went beyond old representational aesthetics. In the meantime older genres were "rediscovered," especially photojournalism, which had already exceeded one area of its function, catalyzed by television, so that the ideology of the decisive moment was denied. Images of daily life that negated the exceptional were used to promulgate a new existential philosophy concerned with the apparent banality of everyday life. In the U.S.A. young photographers such as Lee Friedlander (b.1934) and Robert Frank (b.1924) exemplified this approach, and were particularly active during the explosion of pop art. In this period, photography – thanks to its potential for instant communication – enjoyed a rare conceptual affinity with painting, as is evident in the work of Andy Warhol or Robert Rauschenberg, who both used the medium effectively and ironically. In Italy, artists – they would call themselves aesthetic workers rather than painters – such as Schifano, Pistoletto, Vaccari, Patella, and Prini systematically "applied" photography in their aesthetic research, thus departing from painting, and very often regarded the optical-chemical image as a "material"; this metalinguistic process was led by Ugo Mulas (1928–73) at the beginning of the seventies. It was at this time that Mulas carried out a series of "examinations" of the medium, leading him to deny definitively the historic preconception of photography as "document"; his work stimulated a revision of many myths about contemporary photography. One such myth came from Cartier-Bresson, prophet of instantaneity, the uniqueness of photography which Mulas tended to deny.

Mulas's investigations, which ended with his death, are synthesized in thirteen photographic "operations" – genuine grammatical and syntactic reports that occasioned a re-valuation of photography without reference to documentation and traditional aesthetics. In this way photography once again defined itself, an operation begun in the previous century by Emerson, fully developed by Stieglitz, and then revolutionized in the work of photographers such as Strand, Weston, and Moholy-Nagy. These theories were also discernible in the work of Walter Benjamin, Rudolf Arnheim, Siegfried Kracauer, and Ernst Gombrich; then in the evocative theories of Roland Barthes and the razor-sharp philosophies of Susan Sontag.

Photography finally found is own place in contemporary culture – a place beyond its old craft origins that had kept it in an inferior position for a long time. It now stands as a leading feature in the total system of information, not just as a mass medium but also as an autonomous aesthetic product, often avant-garde, and no longer dependent on the old relationship with painting. Tearing away the preconceptions of academic culture, however, had not been easy; academia would have liked photography to have been, as Baudelaire wrote, merely a "useful servant of science and art," nothing more than a para-artistic apparatus.

Fashion and architectural photography

In the meantime photography was used widely in advertising, more so than in the dispersal of information where other mass media, notably television, were used too. Today photography is controlled by industrial conglomerates that are involved at every level – from hobbies to advertising, and grows in tandem with the continual cyclic burgeoning of consumerism.

Everything – from food and clothing to architecture – was considered above all as an *image*: a photographic image, analogous to and therefore informative of reality, systematically proposing symbols of reality through iconic contrast between reality itself and photography. Photography in its turn, and in its two dimensions, provided an image of three-dimensional, concrete reality with reflections of its visual requirements, creating a closed circle from which it is difficult to escape if we take into account general visual illiteracy (in the passive attitude of the observer) and the

1

2

4

5

1. Louis Lumière, the daughter of the photographer-inventor Yvonne, in an interior (1913) taken with the Autochrome technique developed in collaboration with his brother, Auguste, and launched in 1908.

2. Ernst Haas, urban landscape, one of the first photographs where colour was used creatively.

3. Courtney Milne, Wakaw Sunset (1979). A straightforward transparency, touched up with the use of a computer and a laser.

4. R. Stillfried von Rathenitz, Japanese woman with umbrella (c. 1875); albumin print, hand-coloured in a Yokohama atelier.

5. Louis Ducos du Hauron, view of Angoulême, France (1877). Picture obtained using the subtraction method – three coloured filters (yellow, magenta, and light blue) and three successive exposures, one for each filter, which are then printed with ink superimposed in register to reconstruct the original image.

6. Franco Fontana, landscape (1975).

dominant – even inevitable – popularization of photography itself.

Photography satisfies – affirms – contemporary taste in every area, and often constitutes a concrete examination of physical reality because it is to this that photography refers, obtaining reassurance within the parameters of its comparison. Among the photographers who have characterized this period of total involvement of the image in the contemporary existential system more than others are Richard Avedon, Horst P. Horst, and David Bailey, to name just a few of the most celebrated in the field of fashion photography, including the Italian Oliviero Toscani. All these photographers are concerned not just with photography as a style but as a philosophy, a life "lesson." Architecture experienced the same phenomenon – an art that seems to exist for photography, and without photography might not even exist at all as a cultural message, let alone in its basic functional form. The Alinari were the first to create, from 1852 onward, a photographic *idea* of architecture beyond documentary concern – a metaphysical idea that sprung from the clarity of detail without shadow and the rigour of the unusual perspective from a vantage point some three meters high. In the thirties there was, however a revolution in architectural photography too. The pictures of Ezra Stöller, for example, were characterized by very low-key *chiaroscuro* from which structures and materials emerged with much energy, thus acquiring a new aesthetic meaning and an iconic identity (the object-photograph). We are forced to refer continually to object-photographs because we have no other possible verification, while even what the eye sees has been compromised by physical-psychological dependence on the photograph.

Toward new ideologies

In the sixties some photographers sought to promote a more intriguing and thoughtful view of reality with a sociological concern that, after all, formed part of photography's historical tradition. This new movement took place in parallel with and in ideological opposition to the dominant consumerist photography.

Diane Arbus, a pupil of Lisette Model in New York, after a period as fashion photographer turned her attention to a traumatic study of the photographic identity of "neighbours" – the anonymous people we find alongside us daily. Arbus thus revealed an unknown reality – often different, grotesque, even monstrous – which she showed without aesthetic or ironic, degrading curiosity, but through a dramatic project of visualizing the "other"; this was humanity finally taken notice of, recorded by photography, without which this multitude would have been non-existent and unnoticed.

Arbus, like Friedlander, provided a lesson for contemporary photographers who have often followed ideologies, thus characterizing the image of our recent times: the image read without the need to obey the requirements of the old photojournalism, but through a meditation that allows for a filtering in the photographic concept of the big themes of today with a language that has definitively found its identity but aspires in its turn to rules of reading still to be perfected – above all in abandoning the dying, but still rooted, ideas of photography as seeking dependency on painting. There are new media for expressing new messages, as Herbert Mashall McLuhan would have said.

With photography was born a new way of reading that called for a new literacy; photography, with its specific and fascinating ability to referential veracity, can appear innocuous and documentary. Then it struck and imposed its persuasive concepts (the fruit of an organizational-productive complex) whereby photography is the intermediary of an ideology that is transmitted through a picture postcard, the pages of a picture book or an illustrated magazine. Moholy-Nagy's aphorism on the "illiterate of the future" is famous but hoping, in his rhetoric, was not enough because it meant hoping to save the eye from the progress of photography – an apparently superficial and offensive means of expression. Photography, however, has already invaded and secured the "dominion of the impalpable and the imaginary". (Cf. Charles Baudelaire, "Le public moderne et la photographie."

Indian art

The all-important characteristic of Indian art may be taken to be the constant presence, in all its manifestations, of the religious element. In the face of divinity, the artist effaces himself. Rather than expressing his own personality, he is more intent on turning himself into the anonymous spokesman of symbols and figurations that have been codified by a very precise tradition. This explains the total absence of the names of artists, even when great masters are involved.

The two major and fundamental religious concepts are the tantra-yoga of the Indus Valley civilization and the brahma-veda of the Aryan invaders. They have since time immemorial been at odds with each other. On the one hand we have the continued survival of spiritual and philosophical quests, fleeing from pantheistic materialism, which are manifest in refined and indefinable speculations. On the other hand we have the subdivision of the concept of God – a concept that is basically triune in Hinduism – into more than 3,000 deities that represent 3,000 symbols, or aspects, or manifestations, or attributes, of the one God. We have Buddhism, which is a sort of revival of the Indus Valley civilization, and came into being as a philosophical-cum-spiritual reality, but then degenerated into a polytheistic revisitation. And we have the contemporary birth of Jainism (or Jaina), which also emerged as a philosophical-cum-spiritual concept and swiftly degenerated into a Hindu-type form of polytheism.

In other words we have this continuous fluctuation between a somewhat Sufi-like speculation and the decline into the most fanatical kind of idolatry; between an abstract artistic expression and a completely figurative art permeated by burning sensualism, which encourages a form of sculpture that is plastic, volumetric and tactile. Into all this Islam also drives a wedge, as a separate element that nevertheless suggests other forms, outrages Hindu taste, but also lets itself be taken over, in a continual process of osmosis that is not just limited to the figurative arts but also affects religious poetry and philosophical speculation. Alongside this, and because it represents a synthesis of Muslim and Indian values, which are at once moderated and reevaluated, we have Sikhism, with its Koran-like Granht Mahal Sahib, and its colours and its gold objects, which are akin to those found in Hindu temples.

What is more, it would seem that the development of the arts in India has been conditioned by two more opposed sources of tension: the mentality of the local peasant population, which is figurative to the point of sensuality; and the taste for an abstract type of art, peculiar to the nomadic peoples who invaded the country in successive waves. Among the various invading peoples, three have had a particularly strong influence: the Aryans, whose arrival in the Indus Valley completely upset the balance of what was possibly one of the greatest civilizations of the past; the Afghans, who imposed a religion that was, however, limited to the ruling class and its administrative structure; and the British, who, by spreading their language across the land, gave India its first taste of empirical unitary identity.

Last of all, one further consideration: in India there were not only centripetal forces introduced from without and bringing with them different values. Indian art, in fact, with all its various processes, spread over that vast area that – if we think of Greece and her subsidiary Magna Grecia – we might well call "Magna India." In other words, all of Indochina and Indonesia, with offshoots extending into China and Tibet as well. Indian art penetrated these areas forcefully, upsetting local principles and precepts and giving rise to new aesthetic formulations.

The Indus Valley civilization

This is one of the last civilizations to come to our notice. It came to light from 1921 onward as a result of excavations carried out by John Marshall and E. MacKay on sites that had been thoroughly plundered prior to their work. The "spoil" had been used as hundreds of miles of ballast for the railway system.

As far as the site is concerned, it is impossible to come up with anything much more than a handful of suppositions. Any hypothesis that

Śiva Dancing *(Śiva Nataraja), (bronze, twelfth or thirteenth century* A.D.*). Nelson Gallery, Kansas City.*

lowland rivers, and is indisputably one of the most important in the history of humankind. Its heyday can be put at around 2500 B.C. But some scholars are of the view that it is much earlier than this. The principal sites are Harappa and Mohenjo-Dāro, which were possibly twin capitals, with a scattering of some seventy sites around them, stretching to the trading center of Bahrain in Arabia.

Similarities with Egyptian systems of measurement (e.g. the gold cubit), and with weighing systems ranging from Persia to the Mediterranean, tallying with Indus Valley objects found in all the great prehistoric trading centers in the Near Orient, lead us to suppose that this civilization was very wide-ranging, and might well have been at the origin of the Egyptian and Mesopotamian civilizations. The ideographic script itself (which would subsequently become alphabetic in the Fertile Crescent) might well derive from the ideograms of the Indus Valley civilization, clear and beautiful examples of which have come down to us in the form of more than 2,000 seals. They are,

is put forward runs the risk of not finding any back-up from the still meager finds. The dating is uncertain, and it is difficult to define the effective range of this civilization. It was situated between the civilizations of the great

however, shrouded in mystery because it is now impossible to decipher them. This is because they are very probably no more than proper names. But in them we find portrayals of deities and physical positions that indicate a knowledge of yoga and tantrism, the bases of the concept of non-violence in the mystical and philosophical schools of thought from which Indian philosophies, Buddhism and Jainism would derive.

The two capital cities show a very advanced level of town-planning, with a good network of thoroughfares, complete with drains and acqueducts (both unknown then in other civilizations), with the use of kiln-baked bricks and standard measurements. It is also worth noting that there were no defensive walls, and no trace whatsoever of weaponry. A few small bronzes and steatite (soapstone) statuettes are evidence enough of an undoubted artistic ability, and the predominance of tantric concepts. In about 1400 B.C. the invasion of the Aryan nomads took place. With much bloodshed and violence these invaders put an

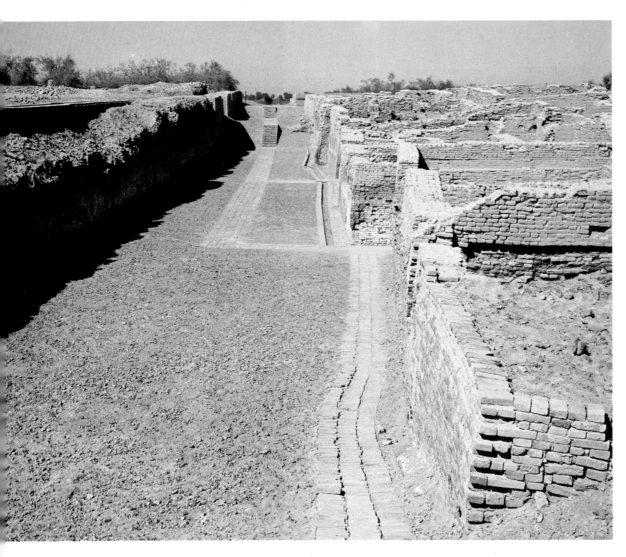

Above left: steatite seal with picture of buffalo and a line of ideographic writing, as yet undeciphered (possibly proper names). Indus valley.

Left: view of Mohenjo-Dāro, with wide street beside a swimming pool. Indus valley. The signs of high urban organization are evident: aligned buildings in a regular setting, use of burned bricks of standard size (for buildings and footpath alike, in the center), drain along building (back right). A complex network of channels and wells are the most effective hydraulic works of antiquity.

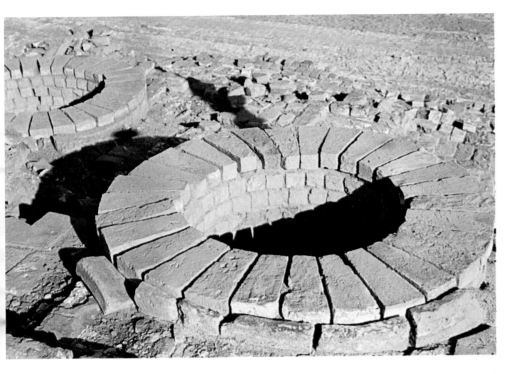

end to this great civilization, and superimposed on it different religious concepts, which tended, *inter alia*, to favour the ethnic grouping that was in power. This in turn brought about the establishment of the caste system. These concepts are expressed in the *Veda* – the sacred book of the Aryans, which also contains various information about the Indus Valley civilization and references to the conquest of it – and were modified in about 1100

Above: two public wells at Mohenjo-Dāro. Indus valley.

Below: section of stone wall at Rājagriha, capital city founded by King Bimbisara, c. 544–493 B.C. Bihar art (Magadha). In the foreground, a round bastion.

B.C. by the Brahmins. From about 600 B.C. onward they were adjusted to Hindu positions, and set forth the fundamental concept of rebirth in accordance with the law of *karma*.

In the meantime the rest of India had been witnessing the gradual development of an urban culture that had become more and more subservient to the Aryans. Evidence of this is presented in the form of ceramics, which were ocher-coloured to start with, then grey and, lastly, between 500 and 200 B.C., black and increasingly refined. From 500 B.C. onward we also find the use of copper and, in 200 B.C., iron. Very little remains of the architecture of this period. Important documentation is nevertheless provided by the remains of some fortifications in the sites of Vaiśālī, Vārānasī (also known as Benares), Rājghāt, and in particular Kauśāmbī, where mighty walls all of 12m (40ft) high were built over a distance of 6km (3¾ miles) along the river Yamunā.

The art of Bihar (Magadha)

In this area in the sixth century B.C. there is much evidence of a great cultural and artistic ferment – in all probability with a renewal of Indus Valley motifs. This evidence is presented by the preaching of Mahāvirā, the founder of the Jain religion, and the sermons of Gautama Siddhārta (known as *Buddha*, or in other words "The Enlightened One"), who founded Buddhism. King Bimbisāra (*c.* 544–493 B.C.), who was responsible for the subsequent spread of Buddhism, was the founder of the great capital Rājagriha, the walls of which had a circumference of 40km (25 miles) and enclosed the first stone buildings in India. His son Ajātaśatru (*c.* 493–462 B.C.) transferred the capital to Pātaliputra (presently Patna), in the heart of northern India. Here recent excavations have brought to light the substructures of a palace, parts of large defensive walls and stones sculpted with Iranian motifs.

Early Buddhist art
Maurya period (*c.* 322–185 B.C.)

In 330 B.C. Persepolis fell to Alexander the Great. Exiled court dignitaries, intellectuals and artisans brought to India not only the decorative stylization peculiar to the Persian taste but also the concept of an art being at the service of the power of royalty. This concept met with the full approval of the great king Chandragupta (*c.* 324–300 B.C.), who had extended his own power over the whole of the subcontinent and part of Afghanistan too, thus setting himself up as a divine rival of the mighty Xerxes. The capital, Pātaliputra, was greatly enlarged, until it covered an area measuring 15 × 3km (9¼ × 1¾ miles). In it a royal palace was built which was a copy of the Apadana at Persepolis, and which attracted the admiration of Mcgasthenes, the ambas-

sador of Seleucus I Nicator at the Indian monarch's court. The outer circle of walls, made largely of wood, had sixty-four gates and 570 towers.

It is now that we find the appearance of the first columns of the Indo-Greek type, the typology of which would remain distinctive for many centuries. These columns are adorned with stylized palmettes and volutes at the sides, or alternatively with an abacus in the form of the corolla of an upturned lotus-flower, with conspicuous petals. Much use was made

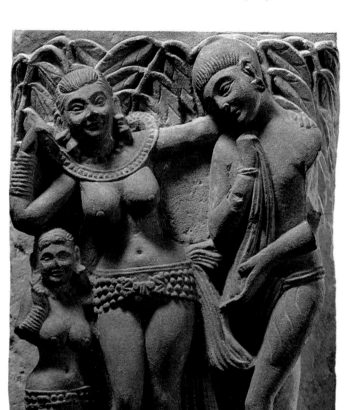

rock that he had sculpted in the form of an elephant at Daulajiri (Orissa) is impressive, and evidence of the sobriety and taste for the colossal which were typical of that period. In this same period the first grottoes were hewn out (in the Barābar, Nāgārjuna and Titāmarti hills). These were destined to become one of the most striking examples of Indian art.

In this respect the Lomas Riśi grotto is important. Its entrance imitates a wooden building with decorative sculptures, thus giving us an idea of how the wooden architec-

Left: low relief, second century A.D., showing a maithuna, two lovers in amorous pose. Typical (and probably best-known) theme of Indian art.

Opposite: stūpas built at Sārnāth by Emperor Asoka, c. 274–232 B.C. Only the ruined foundations remain (foreground). The Dhamekh stūpa at the back is of the Gupta period, marked by higher structures covered by stone. Also of Asoka's period at Sārnāth is the famous column whose capital (now in the city's museum) has become the symbol of the Indian Union.

depicting elephants converging on a *stūpa* (depiction of the tomb of the Buddha) were made at a later date.

Sūnga art (*c.* 185–72 B.C.)

The Sūnga monarchy reigned in the Mālwā area, heading what was more akin to a confederation rather than wielding absolute central power. This period saw the production of large monumental statues in court dress, rather roughly designed and based on the properties of the volumes and on a typology presenting a simple, repetitive design.

This dynasty was followed, again in the Ganges valley, by the Kānva, who were in turn deposed – in about 80 B.C. – by the Sāka, of Scythian origin.

In India in the second and first centuries B.C. architecture developed in a general sense in association with the Buddhist religion, which is based on monastic life. As a result the architectural forms were adapted to this type of life, with a great profusion of monasteries (*vihāra*) being built to a uniform plan. This plan included a central, square courtyard, on to which the cells of the monks gave; then a larger courtyard before this central one, used for communal rites and public ceremonies. At a later date this second courtyard was preceded by a covered hall adorned with statues and mural paintings. The plan was also applied to the large grottoes that were hewn out in this period.

Simultaneously there was a revival of the principal and distinctive element of Buddhism in its spread throughout the Far East – the work, above all, of missionaries from the kingdom of Gandhāra – and throughout South East Asia – this being due mainly to merchants. The element in question was the *stūpa*. Beneath these large tumuli were buried the remains and relics of the Buddha and the early saints. In its early typology the *stūpa* was formed by a hemispherical tumulus (*ānda*) depicting the universe, with a circular balustrade delimiting it, with four gates (*vedikā*) oriented toward the four cardinal points, each one having a portal of honour (*torana*) richly adorned with symbolic and didactic sculptures. On the top of the *ānda* there was a pole holding a parasol (*chatra*), first made of wood, then of stone. This was a symbol of regal dignity. Later on the number of stylized parasols grew to seven, one on top of the other, with a symbolic significance. This configuration would subsequently give rise to the pagodas, covered with their seven superposed wooden roofs.

The sanctuaries (*chaitya*) hewn out of the rock were decorated with small symbolic stupas called *dagoba*. These were a sort of "greater altar" symbolizing the Buddha before he was depicted with human features. This practice was introduced by the art of Gandhāra from the second century B.C. onward. In this period the hewn-out *chaitya* had a distinc-

of the commemorative column or pillar with carved edicts, surmounted by a capital usually sculpted with symbols, and in turn surmounted by animalistic and extremely realistic decorations showing a superb sense of synthesis. The great king Aśoka (*c.* 274–232 B.C.) had several hundred such columns erected.

Very few of the religious edifices commissioned and built by Aśoka have survived. The

ture of the day must have looked. There can be no doubt that even the largest buildings were built of wood, with the trunks connected with great skill. We can detect their typology in the bas-relief decorations of Bhārhut (second and first centuries B.C.), Sānchī (first century B.C. to first century A.D.) and in the later works of Gandhāra and Mathurā. There is nevertheless the possibility that the sculptures of Lomas Riśi

tive alignment of columns along the walls of the vast central chamber. In one of the oldest such sanctuaries, at Bhāja (second to first centuries B.C.), the columns are simple, imitating a squared wooden trunk, with no base and no capital. In the *chaitya* at Kārlī the columns are octagonal with a base, capital and upper decorative motif of pairs of elephants. The *chaitya* at Ajaṇṭā is important, too. Here (in cavern no. 10) we have the first noteworthy cycle of frescoes, which narrate the *Śaddanta Jātaka* (story of the elephant with six tusks).

This *chaitya* is associated with the Amarāvatī style. From this moment on in narrative decorations the fresco would increasingly take the place of the bas-relief.

The bas-relief, however, was still altogether dominant in early figurative Buddhist art, with clearly delineated historical themes and the Buddha represented by aniconic symbols, as at Bhārhut and Sāñchī. The first actual portrayals of the Buddha would appear at a later date, in the art of Gandhāra, Mathurā and, lastly, Amarāvatī.

At Bhārhut the narratives sculpted in medallions and panels refer to historical episodes (*jātaka*) occurring before the Buddha's enlightenment. At Sāñchī the balustrade and the doors, which are adorned with decorative motifs probably from the Sūnga period on, and later with depictions, show a large number of scenes and symbols. As well as the *jātaka*, they present tales of the Buddha's enlightenment and preaching. Here we can see an exuberant and naturalistic abundance of forms and motifs. It is nevertheless difficult to single

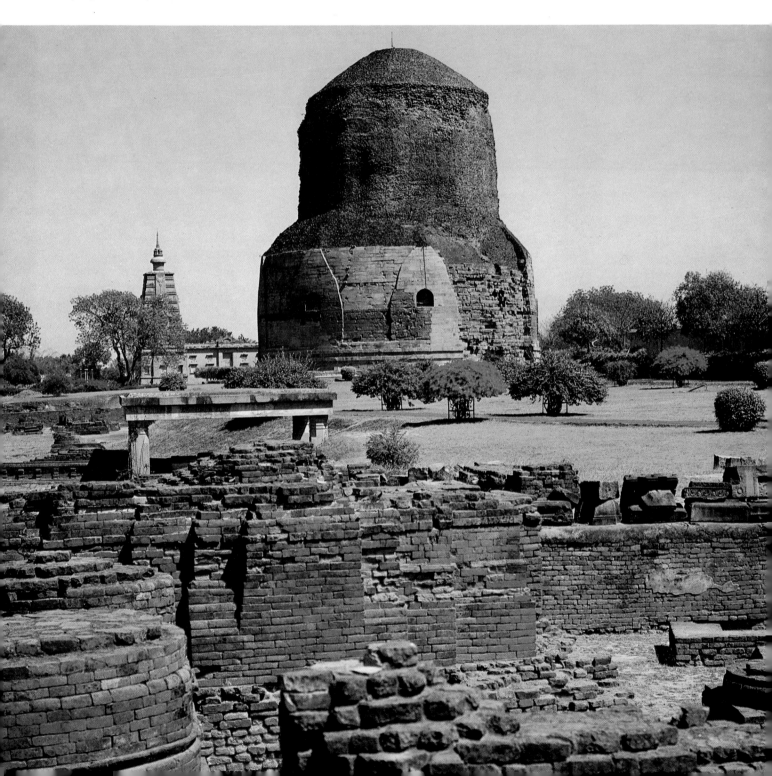

Left: symbolic stūpa at the back of the chaitya of Ajantā (grotto 9). Sunga art. The inverted pyramid on the stūpa is the harmika and supports the sun-shades, symbols of royal status. Behind the dagoba, typical columns without plinth and capital.

Opposite: moulded terracotta medallion with a classically influenced motif. Sunga art. Museum of Oriental Art, Rome.

tremely beautiful) and a precise classification of Buddhist iconography. The positions (āsana) and gestures (mudrā) of the Buddha were thus codified on the basis of the attitudes of the Roman emperors, and his clothing was an imitation of the Greek himation.

The art of Gandhāra was lent considerable momentum by the powerful king Kanishka, sovereign of the Kushāna or Kushans, the Tokharian conquerors of Central Asia (with capitals at Kāpiśī and Peshawar). Fluted columns, Corinthian capitals, friezes and frontons were all important features in the decoration of the stūpa, which were made of brick and supported by a stout plinth. Their main part consisted of a tall cylindrical drum with a round cupola-like cover. The covering of the base of the drum was made of schist, and sculpted in great detail with a variety of depictions. In the upper sections the covering was in moulded stucco, and painted. As far as the lesser arts were concerned, the Begram (Kāpiśī) find has been of great importance. It

out, in the ensemble, any of the elements dating back to the founding by Aśoka, the enlargements made by the Sūnga, and further additions.

The three great schools of the north, center and south in the early centuries A.D. Greco-Buddhist art of Gandhāra

The north of India had already come into contact with Greek art in the wake of the conquests of Alexander the Great, who, during his long march eastward (331–325 B.C.), had founded numerous cities which he then populated with contingents of Greeks. The encounter between the Greek art which developed in these sites and the Roman art of the Orient and of the great Roman trading centers in southern India (for example, Arikamedu on the Coromandel coast and Muziris on the Malabar coast) produced in the early centuries A.D., in the region lying between Afghanistan and present-day Pakistan, a classical art based on synthesis (which was academic and perhaps somewhat cold, but nonetheless ex-

Right: detail of architraves on the northern portal (torana) of the stūpa of Sanchī. Sunga art. The four monumental portals that open on the stūpa (its original architecture, several times altered, dates from Asoka's time) are richly decorated with floral motifs, allegorical symbols and scenes from the life of Buddha. At the top, episodes from the Chaddanta Jātaka, at the bottom from the Vessantara Jataka.

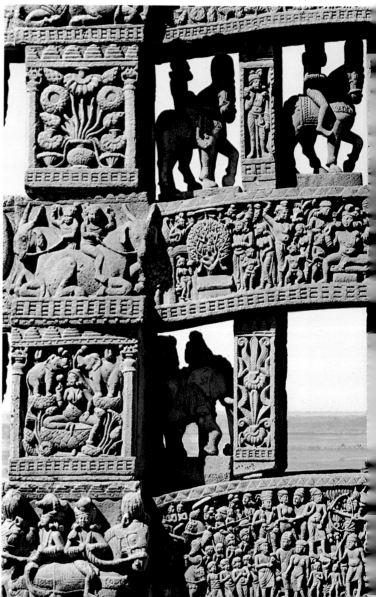

consists of 600 carved ivory pieces, of similar typology, in which the classical derivation is possibly more conspicuous. The style of these pieces is akin to that of Mathurā and Amarāvatī, which gives rise to problems of priority in relation to the various centers as far as stylistic development is concerned. A similar ivory, of the same provenance, was also found in Italy, in the excavations at Pompeii.

The art of Mathurā

Mathurā was the winter capital of the Kushan kings. Here, as in Gandhara, a synthesis of Greco-Roman and Indian art was developed. In the process it is also possible to detect influences of Iranian art, which possibly predated these forms, and the slow assimilation of contributions from other parts to the indigenous taste. It was on this basis that subsequent Indian art then developed and evolved.

There is little surviving information about the

architecture, which the Hephthalite Huns had totally destroyed in the fifth century B.C. The same typologies as in the previous periods were probably also in evidence. Foreign influences, can be detected in the portraiture style of the depictions of the rulers. This theme was not part and parcel of Indian art. But the most important works, which are Indian beyond any doubt, are the statues of the Buddha, sculpted in full relief in the pink sandstone that is typical of the area. In these works the robust quality of the Kushan style blends with the sensual, naturalistic sumptuousness of India, with delicate qualities of stylistic refinement and modelled harmony. The *yakśī* are also typical. These are prosperous and gracious female figures, which would remain as a traditional legacy in the thematics of the following periods.

Because of the abundance of commercial contact, the art of Mathurā fanned out far and wide beyond India, Kashgaria and Ceylon, as far as Indochina and China.

The art of Amarāvatī (first to fourth centuries A.D.)

The Andhra-Sātavāhana dynasty reigned in the southeast of India along the Krishna river in the sites of Amarāvatī, Nāgārjunakonda and Jaggayyapeta. The stupa of Amarāvatī, with a diameter of 50m (164ft), was one of the largest in all India. We find again references to Classical art. At Nāgārjunakonda there is a bas-relief that shows clear analogies with Roman works (for example, the sarcophagus of one of the generals of Marcus Aurelius now in the National Museum in Rome), a fact which raises interesting questions.

The statuary here is quite different from that of Mathurā. It is made of white marble, and is more picturesque and decorative. It is also beautifully composed and has a great linear purity. The Buddha is first represented by allusive symbols, and at a later stage by heavy, noble statues which would subsequently animate the art of Ceylon in particular, as well as the art of the whole of Indochina.

The Gupta period (fourth to fifth centuries)

The rise of the Gupta dynasty, founded in 320 A.D., marked the restoration of the subcontinent's political unity and, in a certain sense, of Indian hegemony over the preceding foreign dynasties. This was also a period of religious, literary and philosophical revival. The Buddhist stupas now developed in height and were covered with a stone sheathing with a variety of decorations and depictions. The oldest are to be found in Gandhāra (Taxila, Chārsada) and in Sind (Mīrpur Khās). The later stupas, at Sārnāth, Rājagriha and Nālandā, would inspire the temples of Java (Barabudur), Thailand (Wat Kukut) and Tibet. The construction of

Hindu temples underwent various developments, based on the plan of the rock temples. The style at Chezārla and Ter, for example, is apsidal. At Sāñchī it is square, as it is at Deogarh and Bhumara. Emphasis was laid on the typology based on the single cell, with a flat roof that grew gradually more and more elaborate and was preceded by a portico. This would become the standard model.

Decorations were abundant, with panels brimming with well-defined figures. The statuary was monumental, hieratic and solemn, with pure and traditional forms. In this period classical Indian sculpture acquired stylistic patterns and symbolic models that would endure, and that only differed in small ways through the following centuries.

The early representations of Sūrya and Viṣṇu were complex, definite and dynamic. While Buddhist art fell into decline, advances were being made in the depictions of Śiva and Kriśna, with monumental and mystical delineations.

An exceptional example of this art is the commemorative column erected in 415 by

Kumāragupta I, in accordance with a model from the period of Aśoka. It is now in Delhi. This column has an iron shaft 13m (42½ft) in height, with a capital in the Maurya style. How this was actually technically achieved still requires explanation, and raises many questions.

The full development of Gupta art can be best seen in the Hindu caves and grottoes of Ajaṇṭā, with their forms that express a beautiful stylistic restraint, modest sensuality, and full and expressive volumes. Great steps forward had been made by fresco paintings (caves nos. 1, 2, 6, 7, 11, 16 and 17), which are every

bit a match for the *jaini* examples of Sittannavasal and the ecumenical examples at Bāgh. The Ellora caves are comparable with the complexity of those at Ajaṇṭā.

The Post-Gupta period (fifth to eighth centuries)
Ellora and Elefanta

Now other sites were hewn out, or considerably enlarged, at Nāsik, Aurangābād, Elefanta and Bādāmī. Ellora, in particular,

shows expressions of Buddhist, Hindu and Jain art monasteries and *chaitya*. The most important example is perhaps the Kailāsanātha, attributed to King Rāśtrakūṭa Kriśna I (second half of the eighth century A.D.). Here we find exuberant decoration, and fine sculpture in the architectural parts. This site copies the open-air constructions, which became more numerous in this period and were made of durable materials. The structure and typology of the temples now found a definitive classification. Regular features were the figures of the major deities, the places where they were situated inside and outside the buildings, and the motifs decorating the entrances, and the various structural typologies.

In sculpture, the tension of the forms, the dynamism stressed by the gestures and the sinuous qualities of the bodies, and the sensual plasticity all acquired a high degree of expression. In other respects the large, almost colossal Buddhist statuary became even heavier, and abandoned the detailed drapery. At the same time the form of the didactic bas-relief became monotonous and static. Overall we can feel the dependence on the previous period, and an absence of the emotive charge and solemn classicism of Gupta art.

Painting, with its Buddhist and Jain fresco secco forms, and some Brahmin themes, was more important. A typical form was the so-called "parallel moment" or rotating perspective. Both the wealth of themes and works nevertheless ended up producing a monotonous and cloying sort of painting.

The Ganges Valley

Here an essentially Buddhist school took

shape in which the figurative quality of the art of Gandhāra became somewhat more monumental, with less attention to detail. It was on the whole conservative, and tended more and more toward a state of decline in which there was little inventiveness. This might perhaps be linked with the confused consequences of the Hun invasions and the precarious political state of affairs. In the eighth century we find a Pāla revival around the Buddhist universities of Nālandā and Vikramaśīla, and in the holy places of Sārnāth and Bodhgayā.

Kashmir

King Lalitāditya founded the temple of Mārtānd in the eighth century. This building shows signs of a religious revival of the cult of the sun-god (Sūrya), which was followed up at Konārak and Modherā. The Utpāla dynasty continued the Pāla tradition, and produced a distinctive array of high-quality bronze-work. Its architecture also had distinctive features, such as the triangular fronton or pediment and

the pyramidal roof made of superposed trunks. A good example of this is the eleventh-century temple of Śiva at Pāyer.

Pallava (Madras)

In southeastern India King Mahendravarman (600–660) abandoned Jainism and turned to Sivaism. At Mahābalipuram, a port dealing with South East Asia, impressive rock temples and the famous "Beach Temple" were constructed on the orders of King Rājasimha Narasimhavarman II (695–722). The *ratha* were also sculpted in large rocks. These are cart-shaped monuments, which include the Dharmarāja, a prototype of the later Dravidian *vimana*. Not long after this the Kailāsanātha was built at Kānchīpuram. This is the apex of Dravidian art. At the same time the first, and already noteworthy temples appeared at Śikhara in Orissa, apparently associated with the art of Madras.

The statuary shows beautiful, delicate and gracious modelling, with sober ornamentation, and volumes almost lost in the soft quality of

the design. One remarkable example among the many is the complex that depicts the *Descent of the Ganges* at Mahābalipuram (seventh century). Also noteworthy are the panels and high reliefs that adorn the temples, which were built in rather than hewn from the rock.

Chālukya art (Karnātaka state, 550–757)

Here we find a gradual move from a simple, flat-roofed architecture (e.g. the temples of Lādh Khān and Durgā at Aihole) to a more complex form, with a tower over the deity's cell (*śikhara*). This increasingly salient feature would become typical in the centuries that followed. The most important examples are the temple of Pattadakal (seventh to eighth centuries), the Meguti of Aihole, and the Melagitti Śivīlaya of Bādāmī. The temple became the actual symbol of the universe. The various levels of the tower depict the various layers of the skies and heavens. At the base there are elephants, symbolizing the earth. Sculpted

Opposite top: low relief in schist with scenes from the jātaka *(second century* A.D.*). Gandhara art. The imagery is found in Roman imperial pictures. British Museum, London. Bottom: view of the caves of Ajantā, known for their Buddhist friezes.*

Right: interior of the Kailāsanātha of Ellora, the finest set of post-Gupta art, attributed to King Rāstrakūta Kriśna I (late eighth century A.D.*). The whole temple, from floor to ceiling, walls, pilasters, columns, architraves and even the rich decoration, is carved from the rock. In the foreground, an image of Śiva as great ascetic.*

geese symbolize the air, and so on.

Chalukya sculpture came to the fore as a result of its dynamic qualities. A surprising example is the decoration of the Kailāsanātha of Ellora.

The medieval period of Indian art
The Ganges Valley from the eighth to the twelfth centuries

In a period hallmarked by dynastic and territorial divisions throughout India, following the fall of the Harṣa of Kanauj (seventh century), the Pāla and the Sena lent a certain political stability to Bengal and Magadha. The Pāla, who were Buddhists, enlarged the important university city of Nālandā. Under the Sena, who were Brahmins, there was a prevalent use of brick (at Nālandā, Sārnāth and Pāhārpur) in *stūpa* with a bulb-like shape, based on a design that would later be adopted in South East Asia. Hinduism progressively undermined and ousted Buddhism, and artistic designs became increasingly similar. Stone sculpture tended to imitate bronze sculpture, which had now achieved a fine quality. But as a rule artistic taste was on the wane, leaving room for much redundant decoration, with attitudes and gestures fixed in somewhat mechanical expression. For all this decadence, a further development of Buddhist iconography did occur in Tibet and in South East Asia, starting from Nālandā and extending as far as Java. This was the last artistic period for Buddhism in India.

Orissa (Purī, Bhuvaneśvara, Koṇārak) and Bundelkhaṇḍ

Artistic developments in Orissa can be divided into three periods. Between the eighth and tenth centuries we find, with the *pratihāra* influence, the development of typical characters as shown by the Vaital Deul of Bhuvaneśvara. Between the tenth and twelfth centuries we have the zenith, with the most beautiful temples, including the Mukteśvara (*c.* 973) and the Lingarāja (*c.* 1000) of Bhuvaneśvara; and the noteworthy Kandāriyā Mahādeva of Khajurāho, the religious capital of the Chandella dynasty (ninth to eleventh centuries). In these two cities there are no less than fifty famous temples, to which we should add the Sun Temple (Sūrya) at Koṇārak and the Jagannātha sanctuary at Purī. The single large complex of Khajurāho, built by *pratihāra* workmen, incorporates twelve Jain and six Hindu temples, all of them overladen with a multitude of statues. In fact the architecture is markedly pervaded by sculpture (sculpted architecture). The erotic scenes are particularly striking, depicting for the most part the theme of the *maithuna* (a pair of lovers amorously entwined) and thus influenced by tantrism.

Between the twelfth and thirteenth centuries

at Bhuvanesvara the *sikhara* (tower-sanctuary) took on the complicated aspect of an ensemble of buildings encircling a central tower with the walls tapering upward.

The last period (thirteenth century) marked a clear artistic decline in these parts, with the single exception of the Sun Temple of Konārak, which resembles a processional cart (*ratha*), built by King Narasimhadeva (1238–64) in a style that was unique.

Rājputāna, Kāthiāwār and Gujurāt

Almost all the major monuments in these regions are the product of the Solanki dynasty, which reigned from the tenth to the thirteenth century. In Rājputāna the most important architectural complex is the one at Osiā, with the temples of Harihāra and Sūrya, the Jain temple of Mahāvira (eighth to ninth century) and the Pipāla Devī (tenth century), which is conspicuous for the beauty of its decorated pilasters. In Gujurāt, Mount Abu contains many elegant buildings with pierced (openwork) walls, large numbers of columns and decoration consisting of well-balanced statues and friezes. The ensemble expresses the sumptuous and at the same time synthetic taste of Jain art (e.g. the Temple of Vimālashah). The double cross-shaped temple of Modherā is most impressive, too. It is dedicated to the sun-god, and is also adorned with very beautiful columns. An important product of the twelfth century was the Somnāth of Somnāthpur, with its *mandapa* on three levels. In the thirteenth century one of the few works worth mentioning is the Tejahpāla of Mount Abu.

Kashmir (ninth to fourteenth centuries), Nepal (thirteenth to eighteenth centuries) and Brahmin Bengal (ninth to eighteenth centuries).

The far north of India produced distinctive constructions that were, in a way, more picturesque, smaller, and more personalized. In Kashmir the sanctuaries had a pyramidal roof consisting of superposed tree trunks. Each façade opened on to a sort of classically inspired *iwan*. Other typical examples are the temples of Śiva Avantiśvara and Viśnu Avantisvāmi, built at Avantipur by King Avantivarman (856–883). The sanctuary of Purānādhistāna at Pandrethan (twelfth century) presents a strange synthesis of Kashmiri styles.

Nepalese forms expressed a hybrid style, half Gangetic and half Chinese, with wide use of sculpted wood, especially in window mouldings, entrance frames and supporting structures.

In Brahmin Bengal the most common type of temple was built to a square plan with a heavy, grandiose roof (Jor-bangla of Visnapur, eighteenth century).

Opposite: Mahābodhi temple, at Bodhgarya. The extant temple is the result of a set of alterations, culminating in a nineteenth-century restoration to the original building. According to tradition, it was built on the spot where Buddha received his illumination. The niches that subdivide the façades of the square tower, contracting toward the top, symbolize his presence.

Right: detail of the luscious decoration of the mandapa *in the temple of Vishna at Srirangam (sixteenth century), with typical pilasters adorned with caparisoned horses, symbols of Sūrya, the sun-god. Deccan art.*

The art of the Deccan

Under the Cohla and Mandya dynasties we find in particular much excellent bronze-work depicting Viśnu and Śiva. The typology of the Śiva Nātaraja, showing the deity dancing in an ornate circle, and of the linear and elegant-hipped Śiva Vinādhara are famous for their dynamism and graphic composition.

The Great Temple of Śiva at Tanjore (eleventh century) shows a synthesis of previous styles. The thirteen-storey towers, which were to become a typical feature of a local trend that endured until the seventeenth century, were richly decorated. Another typical example is the Temple of Shrīnivāsanullūr at Tirucchirāppallī, a prototype for similar constructions in Ceylon in the eleventh century.

In the Pāndya period (twelfth to fourteenth centuries) we find the beginning of the construction of entire temple-cities, such as Srīrangam (thirteenth to eighteenth centuries) at Tiruvanmāli, which was enlarged by the

following Vijayanagar dynasty. Small temples (*vimāna*) with tall entrance towers (*gopura*), one measuring 60m (almost 200ft), make up the immense temple complex of Arunachala, which is built around an entire hill.

The final artistic accomplishment of this period was the *gopuram* of Madurai (seventeenth century), with its play of large statue niches, and its wealth of by now heavy and academic ornamentation.

Hoyśala art (eleventh to fourteenth centuries)

In Karnataka, unlike the other regions, the architecture tended to be dominated by horizontal lines. The temple, usually built to a star-shaped plan, was divided into three areas and was constructed on a broad platform that resembled three superposed terraces. Many buildings bear the names of the architects, a rare occurrence in India. These names include

that of Jakanāchārya, who built the temple of Chennakesava at Belur (1133) and Kedarāja, who built the Hoyśalesvara (c. 1170).

In place of statuary there emerged a decorative style consisting of continuous friezes, with a predominance of animal motifs. The deities were depicted on steles. The names of the artists were also frequently added. Overall the excessive quality of the forms and ornamentation rendered this art-form rather oppressive and heavy.

Under the last Hindu dynasty of the Nayak of Madura we find the final major Dravidian works of any importance. One such is the Great Temple of Madura, built between 1623 and 1660.

Even in the eighteenth century Dravidian art (e.g. the Skanda sanctuary at Tānja) showed itself to be lively and homogeneous, and capable of carrying on its tradition with several impressive buildings right into the twentieth century.

Indian art in Muslim India

With the Afghan dynasties and the great empire of the Moguls, Muslims were present in India in considerable numbers from the eleventh century onward.

In northern India the Muslims spread the artistic typologies that had already been tried out in the rest of the Islamic world, and in particular the typologies of Persia. It was only at a later stage that an independent Indo-Muslim art developed. In southern India, on the other hand, the Muslims often re-used Hindu elements and constructions and adapted them to their requirements. In Gujarāt at Ahmadabād and in Kāthiāwār many fourteenth- and fifteenth-century mosques adhered closely to Hindu building and decorative typologies, both in the use of already existing elements and in the use of local labour. This influence is evident, above all, in the Great Mosque (Jami Masjid) and in the 'Alif Khan Mosque of Dhōlka, as well as in the Great Mosque of Chāmpāner (c. 1508), which is the finest in Gujarāt.

The merger between Hindu and Muslim artistic concepts occurred most conspicuously during the reign of Akbar (1556–1605), who was an enlightened ecumenical syncretist. His magnificent capital of Fatehpur Sikri (1571–85) is a particularly fine example of this combination of styles.

The Indian miniature

The most original examples of the Indian miniature are those of the Bengal and Gujarāt schools.

The Bengal School dealt with Buddhist subjects until the twelfth century, when the artists who had embraced this religion moved to Nepal (thus influencing the art of Tibet). From then on Buddhism was replaced by Hinduism, with popular forms of expression and works painted on fabric (pata) or scrolls of paper, illustrating episodes of the Rāmayāna. Almost all the examples have a distinctive red background, or at least a pronounced red border, with a warm-coloured ground.

The Gujarāt School dealt mainly with Jain subjects in a variety of differently inspired ways, some of which also introduced figurative Iranian-cum-Chinese styles. From the twelfth to the fourteenth centuries the surface was made of palm fronds, which were cut into long rectangles and attached by two bindings. From 1350 onward this system was replaced by sheets of paper, which retained the format

Opposite top: miniature of the Plains School, from Rajput, showing a propitiation rite to generate rain. The dancer in the center is flanked by two dancing girls with musical instruments. Bottom: remains of the sanctuary of Vatadage, at Polonnaruwa, Sri Lanka. It was a circular structure encircled by several concentric rows of columns covered by a wooden roof to protect the stūpa in the center.

Left: Thuparama of Anurādhapura, Sri Lanka. The thin stone columns with elegant capitals supported a roof covering the central stūpa.

Below: ceremonial bronze drum from Dong Son, Vietnam (second century B.C.). Musée Guimet, Paris.

of Bijapur, Ahmadnagar, Golconda and Hyderābād, although here Hindu art underwent the Mogul influence to a noticeable exent.

The art of Ceylon (Sri Lanka)

Ancient *Sēlān* had a population that had moved south from India, including Sinhalese and Tamil groups. The island has always been open to the artistic influences of India, and developed these in an individual way, but without becoming detached from the continental models. These, in turn, were handed on to Burma and Indonesia.

The dominant religion was Buddhism, which was introduced by Mahinda, a kinsman of the great King Aśoka (c. 268–233 B.C.). This culture is thus associated with the building typologies of the island. Buddhism was nevertheless regarded as the religion of the ruling class, made up of Sinhalese, while the Tamils were for the most part Hindus.

For almost ten centuries (third century B.C. to eighth century A.D.) Sinhalese art was concentrated in the capital, Anurādhapura, where King Tissa, who accommodated both Mahinda and Buddhism in 200 B.C. or thereabouts, had the first monastery built, and the first *vihāra* hewn out of the rock. This was the Isurumuniya *vihāra*, which was a close copy of similar caves found in India.

In the third century the Indian art of Amarāvatī inspired the Sinhalese statues of the Buddha standing in austere and linear postures. These were the prototype of a typology that would endure for many centuries.

King Kassapa I (477–495) moved the capital to Sīgiriya for eighteen years. Here, following the example of Gupta art, the sides of a thoroughfare hewn through a large rock were painted with twenty-one exquisitely executed female figures exuding prosperity and sensuality. These frescoes gave rise to a long series of paintings done in the same style, including those decorating the Hindagala caves (seventh century), the Mihintale *stūpa* (eighth century) and the Mahinyangana (eleventh century).

In the eleventh century King Rājarāja (985–1014) of the Chola dynasty invaded the island and imposed throughout it the cult of Śiva. In his reign temples to Śiva were built and decorated with magnificent bronze statues of Śiva Nātarāja, as well as noteworthy stone statues depicting Śiva, Pārvatī and the holy poets or *nāyanāra*.

King Vijayabāhu (1055–1110) reconquered and liberated the island in 1070, after which Polonnāruwa continued to be the major artistic center, although it was still largely attached to the continental models of India.

Under King Parākramabāhu I the Great (1153–86) Polonnāruwa enjoyed its golden age. His reign saw the construction, among other buildings, of the three-storey Royal Pavi-

of the palm and the holes for the bindings or, in their stead, two points called *bindu*. The illustrations are usually placed at the sides, with the center being reserved for the text. The characters generally have their body portrayed frontally and their head in profile, with the nose pointed and the eyes protuberant. In the early period the background was red, but became blue from the sixteenth century on. There is an abundance of details, but the background features are virtually nonexistent. Gold was used in lavish quantities.

The Rājpūt miniature was more associated with the Islamic styles of the Mogul school, with varied and complex illustrations of the great epic poems of India (*Mahābhārata*, *Rāmayāna*, *Bhāgavatapurāna*, *Gitāgovinda* and the *Rāgamālā*, or illustrated musical pieces). This school can be divided up into the "mountain school" (Pahārī) and the "lowland school" (Rājasthani). The Punjab was the center for the former, and the Rājputāna for the latter. Both schools spawned over a hundred subsidiary regional schools, some of which presented noteworthy variants, even if invariably within the context of a uniform spirit with a preference for strong colours, theatrical gestures and busy backgrounds. The Rājput

school, divided into various groups corresponding to each cultural, political and artistic center (and more out of a need for individual expression than because of any artistic or technical influence), represents the most picturesque part if not the virtual entirety of the Hindu art of the miniature.

In southern India the Deccan School was the most influential, with its important centers

Left: temple of Schwezigon, Pagan, Burma. The central stūpa, 66m (216½ft) high, rests on an octagonal base and, with four smaller stūpas of the same shape, on a set of rising terraces. The decoration and form of the stūpa reproduce bronze motifs on a larger scale.

Opposite: view of Angkor Vat, built by the Mahidarapura dynasty, c. 1150, in the Khmer capital, Angkor. Note one of its monumental entrances on the sanctuary, one of the galleries running along the terraces, the four towers at the corners of the terrace and the central tower, 55m (180ft) high.

Buddhism was the religion of the populace.

From 1511 onward, Europeans colonized Indonesia at an ever quickening rate, although they did not interfere greatly except in the local arts, which, incidentally, they failed to either appreciate or protect.

Burma

Because of its geographical location Burma was from the start subject to the influence of Indian art, and of Gupta art in particular.

The Nathlaung Kyang – the only Brahmin temple, dedicated to Viśnu – was built at Pagan in 930. It had forms that were probably similar to the contemporary ones found in Orissa, although they are no longer in existence.

It was not until the eleventh century, when King Anoratha came to the throne, that Burmese art enjoyed a particularly flourishing period, which was concentrated in the religious and dynastic capital of Pagan. The architecture was dominated by the Buddhist *stūpa*. This had a massive aspect to it. It was usually set on a square platform, built of brick, and decorated with stucco reliefs, terracotta slabs, and, inside, panels of sculpted wood. Although the basic typology was retained for a long time, the ensemble became more complicated down the centuries, and the *stūpa* itself was surrounded by a large wall, open in the middle of each side in the form of a deep portal with a ribbed vault. This is a feature exclusive to Burmese art. Alternatively it was built at the center of a podium with several large pyramidal steps.

The reign of Emperor Kyanzittha (1084–1112) saw the development of a type of temple in a monumental style, the best example of which is the one consecrated to Ananda in 1091. This has a massive central section with four long passages at the center of each side. The whole structure is decorated with bell-shaped corner-pinnacles, with a tall apex, which would become a distinctive feature of Burmese art. In addition, we find evidence of the local taste for accentuating the elements of the architectural structure, which by their repetitiveness become an artistic phenomenon, without further recourse to bas-reliefs, statues or other ornamental motifs.

This characteristic was further emphasized in the Thatbyinnyu, in 1144. This was a typical product of the reign of Alaung Sithu (1112–67), which now points toward a conspicuously Burmese artistic connotation. This period also saw the construction of important civic buildings, such as the Pitakataik Library, and the Upalisima or Hall of Ceremonies. Little by little, however, and principally because of the European invasions, Pagan fell into decline and the cultural center shifted to the new capital at Rangoon, which was built in the eighteenth century. In 1857 the kings of Burma once again moved their Court, and in so doing built

lion, decorated with statues of elephants and grotesque dwarfs called *gana*; the great sanctuary of Vatadāge, which is one of the most beautiful on the island, with its highly refined decorations; and the Lankātilaka (Glory of Ceylon), a vast brick building, originally 30m (98ft) high, and housing a colossal statue of the Buddha, 12m (almost 40ft) in height. The sanctuary of Gal Vihāra, on the other hand, boasts the finest statues in Ceylon, sculpted directly in large rocks. These include a large seated Buddha meditating, and a Buddha prone, measuring 14m (46ft) in length, beside which the monk Ananda keeps vigil.

This period of splendour and peace was nevertheless followed by further invasions and a period of civil strife. The new capital, Kandy, was founded in 1542 in the middle of the island, well removed from the unsafe shores. But art went into decline, with an ever-increasing impoverishment of forms, while along the coast the European settlements introduced new models and Western buildings, such as those erected at Pettah (present-day Colombo) between the eighteenth and nineteenth centuries.

Indochina

The huge area lying beyond India, made up of Indonesia and Indochina, was peopled by different ethnic groupings, and continually

open to outside influences, in particular those brought in by the commercial and agricultural cultures of India, those coming from the sea, and those introduced by the peoples of southern China, as well as the peoples of Mongolia coming down from the north along the valleys of the great rivers. As a result this area was unable to produce any advanced indigenous civilizations. Evidence of this lies in the modest significance of the cultures prior to the arrival of Indian art-forms, and the virtually unopposed and undisputed development that these art-forms enjoyed, despite the continual ebb and flow of kingdoms and political power. The Chinese influence, for its part, was evident in metal-working techniques.

The subsequent invasions led to the formation of various states. These included the Pyu kingdom, with its capital at Prome, and the Mon kingdom, with its capital at Pegu, on the west coast (Burma); the Khmer kingdom in the center, between the Mekong and Menam rivers – Siam or Thailand, Cambodia (Kampuchea), Cochin China (now part of Vietnam) and Laos; and the Cham kingdom on the Annamese coast (Laos, Annam, South Vietnam). The northeastern coast, which was more influenced by China, saw the emergence of the Nam-Viet kingdom (Tonkin, North Vietnam).

In all these regions, broadly speaking, the ruling class, including both the monarchy and the nobility, practiced Hinduism, whereas

Mandalay. This center was adorned with temples in which the decoration was in the almost exclusive form of central and corner-motifs embellishing the usually wooden roofs.

Khmer

In the so-called "classical period" (seventh to eighth centuries), which followed the Indian settlements and the Fu-Nan empire, central Indochina was unified by the Chên-La dynasty, during which the first temples to have the form of sanctuary-towers were built. These had a square design with pyramidal roofing (*prasat*). Examples of this type include the Kuk Preah Theat and the Sambor Prei Kuk. Later the brick tower was encircled by a balustrade.

Next came the so-called "formative" period (ninth century), during which the Khmer sovereigns launched important canal-building programs with the aim of achieving a better use of the cultivable land. In the temples the central

tower was accompanied by smaller towers, with the whole ensemble set on a single raised podium. The complex was also used as a mausoleum for the first Khmer sovereigns, who worshipped Śiva, and were considered to be divine beings even before their actual death. The temple now acquired the symbolic significance of a "sacred mountain." The base was enlarged and supported sloping terraces with small corner-towers, while the central terrace had five towers arranged as a quincunx (a good example being the Bàkong temple at Roluos, with five sloping terraces and a central pyramid surrounded by a moat). The system reached its clearest expression in the Phnom Bàkheng temple (889–900), which became the prototype for later constructions.

The civic buildings were constructed almost exclusively in wood, with the result that very little now remains of what was probably a richly decorated and sumptuous art form. The temples, on the other hand, were built first in brick, which was gradually replaced by sandstone.

By about 1050 this material was the only one in use.

In the temples, from the twelfth century onward, one or more galleries were built on pillars around the main platform. The roofing of these galleries was vaulted (e.g. the Bàphuon Temple). This marked the commencement of the so-called "classical period," which reached its peak of splendour with the Mahidarapura dynasty. All the experience and activity of the past were merged in the Angkor Vat (*c*. 1130–60), a sacred compound built in the capital, Angkor.

The "classical period" was followed by the "late period" (twelfth to fourteenth centuries). This was marred by raids and invasions from the Cham. The style of the "late period" is known as the Bàyon style, after the most important temple. This colossal building has large *stūpa*-like towers, with an enormous Buddha face sculpted on each side.

It is nevertheless worth mentioning that a general feature of the Khmer temples is the

excessive wealth of decorative reliefs, consisting of large numbers of fasciae, with bas-reliefs on two levels, seething with figures in graceful attitudes and showing a sense of great movement. The arches and entrances are adorned with heads of monsters in full relief, whose function is similar to that of the Chinese *lokapala* and whose aspect is no less terrifying.

To sum up, an early period hallmarked by the powerful influence of Indian styles, and the Pāla style in particular, was followed by a period in whch the manner of grandiose stylization became even more absolute and rigid. This was followed in turn by a resumption of realism, and of more natural dimensions. Khmer art, last of all, with the Bàyon style, concentrated on figures that emanated a sense of great calm and inner enlightenment, as can be seen in the faces of the Buddha, where the eyes are half-closed and the gentle smile has an ineffable quality about it.

Thai (Dai)

The Thai people moved down from the north to conquer the territories of the Khmer and the Siamese, just as the Mongols invaded China, the Huns India and the so-called barbarians the Roman Empire. The wars that ensued were interrupted by brief periods of peace, during which an art-form gradually developed that nevertheless stubbornly clung on to the influence of the civilizations that had already flourished in those parts.

The process of fragmentation provoked by the feudal nature of Thai society, combined with the dominant religion – *theravāda* Buddhism – which probably contributed to an indigenous development almost independent from the influences of classical Indian art, did not give rise to any uniform artistic expression of any great import. Rather, we find smallish sculptures and objects. Monuments, on the other hand, were scarce, and invariably derived from Khmer models.

The thirteenth century saw the emergence of the kingdoms of Sukhotai, Chiang Ray and Lam Na. The construction of the Sukhothai capital (Sukhodaya) by King Ramkhaeng (1281–1300), in accordance with the principles of town-planning established by the Khmer, gave the go-ahead to a particularly thriving period, important above all for its bronze-work, with finely delineated standing statues of the Buddha.

The capital of the Lam Na kingdom was the city of Chiang Mai, founded by King Mangrai, which enjoyed its golden age under the reign of Tiloka (1441–87). At the hub of the capital stood the Vat Chet Yot Luang (1401–81), built in the form of a three-tiered pyramid supported by a series of blocks sculpted in the form of elephants. Another masterpiece was the Vat Tet Yat, or "Monastery of the Seven Pinnacles," with a central stūpa showing a

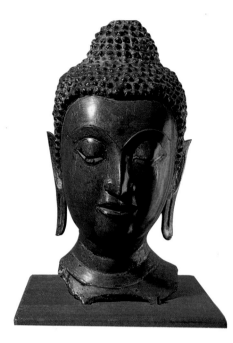

Above: head of Buddha, gilded bronze, thirteenth or fourteenth century, found in the ruins of the Thai capital Sukhotai. Del Boca collection, Milan.

Below: Thai mask of the spirit of Evil, eighteenth century. Private collection.

Opposite: view of Vat Arun, or Temple of Dawn, 1793, Bangkok. Behind the foreground statues, a typical stūpa in pointed pagoda style; on the left, part of the central stūpa tower. The temple contains a giant Buddha statue, over 40m (130ft) long, made between 1840 and 1850.

slender elongated structure.

Toward the end of the fourteenth century the various Thai centers developed increasingly varied forms. But King U Thong, who assumed the title of Rāmādhipati (1350–69), founded Ayutthaya, from where he set forth to conquer the various lesser states and kingdoms. Between 1350 and 1395 these were gradually amalgamated in a single, united federation, which also incorporated the Mon and the Khmer. As a result there was an overall synthesis of all the various Indochinese art-forms.

The encounter that occurred between the Khmer models and the decorative taste of the Thai gave rise to buildings that were distinctively animated and lively, featuring the "pointed pagoda," centered around a taller *stūpa*-tower and interconnected by means of corridors and galleries with curving roofs in which the projecting elements were emphasized by decorated mouldings and pinnacles. The transition from the Khmer *prasat* to the Siamese *prang* is evident in the twelfth-century Vat Buddhai Svarya, in the fourteenth-century Vat Phra Ram; and in the Vat Sri Sampet, which was built between the fifteenth and sixteenth centuries.

There was a subsequent period of great economic prosperity, but this was not accompanied by any comparable flourish of new ideas in the sphere of art, which merely imitated Khmer forms from earlier centuries and overlaid them with good-quality decorative features. These were the work of skilled Chinese artisans who worked in the ceramic kilns of the city of Savankhalok (Svargaloka), which had succeeded Sajjanālaya, one of the twin capitals of the Sukhothai kingdom, as the main artistic center.

The same Chinese experts spread their magnificent ceramic technique throughout the peninsula, thus also influencing the construction of the temples of Vat Mahathat, Vat Si Chum and Vat Chedi Chet Theo, with their carefully balanced forms.

After the capital had been transferred to Bangkok, impressive examples of civic and religious architecture demonstrated the typically decorative character of Thai art. A famous example is the Vat Po (or Jetavanārāna), a monastery built in 1793, with the colossal statue of the Buddha reclining, which is 14m (46ft) long. These are the last important examples of Thai art, which is still almost unknown in the West and which, on the basis of evidence still to be unearthed, may give rise to major changes of opinion, as well as major reappraisals.

Champa art

The Cham enjoyed more contact with China than with India. From the second century A.D. onward they were known for their skill in constructing wooden dwellings. Unfortunately, because of the precarious nature of this ma-

Left: enamelled sandstone dish, decorated inside with polychrome enamel in kuotai style, and outside with blue glaze. From the Molucca island of Halmahera, sixteenth century. Pusat Lembaga Kebudajaan Museum, Djakarta, Indonesia.

terial, no trace of these dwellings has survived. The early wooden structures were probably later copied in brick buildings.

The first stone constructions date back to the seventh century, and launched the so-called "Mi-sön E 1" or "ancient style" (eighth century), the scattered remnants of which suggest a plausible link with Indian Gupta art.

There then followed a period rich in monuments, with the "Hoa-lai style" (eighth to ninth centuries), particularly in the new capital of Phan-rang (c. 750). The pillars of the small temples have decorated fasciae, the columns of the portals are octagonal in shape, and the overall ensemble has a trimmed or even "pollarded" aspect underlined by the vertical inflections of the individual constructional features, as in the Hoa-lai Tower.

Under King Indravarman II (875–898) an age of great artistic splendour was ushered in. This was the period of the "Dông-düöng style," which developed around the royal establishment and the court. We find more and more signs of indigenous elements in coarse and heavy complexes (e.g. the monastery of Lakśmīndra Lokeśvara), which are nevertheless very coherent. The severe and in some ways barbaric beauty of the architectural ensemble is rendered by an exuberant decorative scheme consisting of plant motifs, with copings over the portals in the shape of flame-like points (e.g. the ninth-century Hoa-lai Tower, with its superposed levels, and the temple of Prasat Damrei Krap).

The Dông-düöng complex, which was started in 875 and constructed over more than a century, has an alignment of brick temples inside concentric compounds with a large central Indian-type *stūpa* surrounded by eighteen smaller towers. This complex marks the gradual transition to the "Mi-sön A 1 style" (eleventh century), which seems almost to run counter to the previous indigenous features

and is more akin to the art of Java. Many monuments are still standing in the city of Mi-sön, after which the style is named, but in reality the finest examples of a new form of sculpture come from the excavations at Tra-Kiêu. This sculpture is graceful, flowing and realistic, and contrasts clearly with the previous form.

In the year 1000 the Court transferred to Vijaya, and this new period was marked by the style known as "Binh-Dinh" (eleventh to thirteenth centuries). In this period, after a series of upheavals, it was in the reign of King Harivarman IV (1074–80) that Cham art achieved its greatest splendour, with sumptuous constructions that were to some extent conspicuously akin to Khmer art – not least for political reasons. Sculpted overdecoration was almost completely abandoned. The upward rhythm was accentuated. Arches were simplified as much as possible, almost to the point of bareness, and became more pointed, giving a superbly severe overall appearance.

A period marked by the so-called "late style" (fourteenth to seventeenth centuries) finally rounded off this slow evolutionary process, with unimpressive works, squat, full sculptures, and a constant reproduction of the traditional features without any innovative elements added – a period, in a word, of little artistic interest (Po Romé Temple, from the seventeenth century).

Indonesia

The geographical position, on the east–west routes between China and India, made this collection of large islands most suitable terrain for the diffusion and synthesis of major artistic themes that differed greatly from one another.

In Sumatra and Java, from the seventh century onward, the influence of India was

predominant. Later on, however, following the great kingdoms of Srīvijaya and the Śailendra, an ever increasing number of local tendencies emerged, which, starting from the fifteenth century, also retrogressed in the face of the rise of Islam. Conversely, in the pagan settlements of the tribes inhabiting the remotest valleys on the large islands – in particular Borneo, Sumatra and Celebes (Sulamesi) – and the many smaller islands well off the beaten track, a distinctively Indonesian art

Opposite below: barrel-shaped sandstone urn with lid and four small handles almost on the rim. The engraved decoration is painted maroon on a pink ground with a cream glaze. It has three horizontal bands: the center shows three armed figures alternating with birds of the same size. Below, a flower motif; and above, clouds, twelfth to fourteenth century. From the province of Thanh-hoa, Vietnam. Musée Guimet, Paris.

Above: detail from a low relief in a gallery of Barabudur. Central Javanese period. This enormous stūpa is in the Kedu plain, northwest of Jogjakarta. Built in the early ninth century on a semiartificial hill. For the last fifty years, Barabudur has been the spiritual center of Buddhism in Java.

flourished. This was characterized by the "ornamental style," which offered a great wealth of themes of a popular and decorative nature that were probably associated with early Chinese art. In most of these themes we can detect a style deriving from the Dông-son culture (which thrived as a result of Chinese influences in Yün-nan and in eastern Indochina in the late pre-Christian period), and a style deriving from Chou art (also known as Zhu) from the Chinese period extending from c. 1100 to 771 B.C.

Tribal architecture presents three distinct types of wooden dwellings with very pronounced roofs, typical curve-shaped beams and conspicuous projections. The walls are decorated by monumental wooden sculpture in the form of large apotropaic or evil-averting masks with a marked expressionist character.

Let us now consider the presence of Indian art in the large islands. This was already evident as early as the fourth century A.D. in

small tower-shaped temples, which follow the model of the stūpa. Mahāyāna Buddhism was introduced into Indonesia in the seventh century, with its typologies that were elaborated chiefly in the India of the Pāla-Sena and remodelled in Ceylon. But this form of Buddhism incorporated pre-existing island beliefs, which emphasized its esoteric sense. This is why the temples were structured in such a way as to configure cosmic symbols such as the mandala. From the tenth century on, however, Hinduism became a decisive factor, and the subsequent period was marked by a mood of artistic adjustment that went hand in glove with the political mood of the day.

The central Javan period (eighth to tenth centuries)

These three centuries were dominated by the Śailendra dynasty, which in the ninth century

extended its power across the island of Sumatra as well. Later on there were bloody battles between the two islands, resulting in the gradual decline of the Śailendra and the central Javan style.

The *stūpa* is squat and bell shaped. The temple (*chandi*), on the other hand, with its Greek cross plan within a square base, soared skyward like a tower, with clearly defined divisions consisting of horizontal fasciae distinctively decorated with small cupola-like *stūpa*, right up to the last central one on the top. In later temple complexes the central tower was then set on an ensemble of pronounced terraces, with open galleries at every level, and the whole structure given a severe articulation by the structural elements themselves, which were taken to be a single ornamental motif in a harmonious and carefully measured ensemble.

The temple of Pawon, the temple of Mendut (eighth to ninth centuries) and the most important Barabudur temple (*c.* 825) are all Buddhist. Pawon and Mendut are both decorated with ornate plant motifs, and extremely elegant and well-balanced scenes. They are regarded as the masterpieces of Indonesian architecture. The Barabudur is an extremely vast construction. On a large square base (*prāsāda*) measuring 112m (367½ft) per side, a series of staggered terraces rises to a height of 35m (115ft). Seventy-two small, bell-shaped *stūpa*, each one housing a statue, are placed along the edges of the terraces. At the center of each side a large stairway leads to the central *stūpa*. On all sides there are a large number of bas-reliefs – some 1,300 panels in all – illustrating scenes of *jatāka*, with an abundance of details and magnificent, realistic modelling. The decorative sculpture adorning the arches is rich, tending to end with large masks of monsters, dragons and serpents.

The Sewn *chandi* is relatively similar. It is unfinished and consists of three huge central temples surrounded by more than 150 small temples housing valuable statues, and with bas-reliefs (depicting episodes about Kriśna and Rāma) in a style akin to the splendid sculpture of Barabudur.

Lastly, the worship of Śiva is predominant on the island. This deity is combined in a syncretic way with a pre-existing tribal deity. In the temples dedicated to Śiva the principal feature is the decorative statuary, sculpted directly on the walls, which are made of adjoined stones. The motif of Kāla and Makara, in many different versions, dominates the decoration of arches and door-jambs.

The eastern Javan period

Three dynasties followed the reign of the Śailendra: the Kadiri (eleventh to twelfth centuries), the Kritanogara (thirteenth century) and the Rājasanaga. The capital was moved to Singhasāri and then to Mojopahit. The Hindu religion was dominant more or less throughout the island. The absence of any strong central power and, from 1281 onward, the presence of Islam, which took hold in Malacca and became more and more powerful, took Indochinese art based on Indian tradition into a state of gradual decline. Buildings became smaller and were usually of brick, with variants and structural modifications in the temples, which now clearly assumed the function of funeral monuments.

One or two impressive civic buildings were constructed, such as the Pools of Jalatunda and Belahan. The former is a complex, centered around the Śivaist tomb of King Udyana (*c.* 977), decorated with friezes that have a conspicuous plastic quality to them. The latter, a mausoleum for King Airlangga (*c.* 1052), is dominated by the statue of the monarch dressed as Viśnu mounted on the mythical bird Garuda.

At Singhasāri, from 1227 onward, there was a period of revival, as shown by the abundance of buildings. The Kidal *chandi* was a prototype for the monuments built in this new aesthetic style. The Jago *chandi* is notable for the arrangement of the terraces. This *chandi* is a royal mausoleum decorated with bas-relief sculptures with figures arranged in the new manner and almost all depicted in profile. A major example of the art of Singhasāri is the Panataran complex (from 1197 to *c.* 1380).

At the very end of the thirteenth century, and until the sixteenth century, when Islam was everywhere, architecture became poorer, possibly because of the total disappearance of Buddhism and the precarious survival of a form of Hinduism undermined by local cults. As a rule the typologies of central Java were borrowed, especially in the new capital of Mojopahit. These same forms were adopted in Sumatra with greater sobriety, but still without any independent ideas of any import. Sculpture became altogether conventional, and little more than a pure illustration of historical exploits and religious thoughts, expressionist in character, with rigid movements and repetitive symbolic distortions.

Hindu–Buddhist art did nevertheless survive in Bali. This island was more open to Chinese influences and in addition to the traditional monuments boasts distinctive wooden pagoda-like temples (*meru*) with the classical seven roofs overlaying each other to represent the cosmic Mount Meru, after which they are named.

Decorative painting is possibly more important here than in the rest of Indonesia, as is the miniature painted on palm fronds in a traditional and refined style. The folkloric, exuberant painting on fabric deserves a final mention. It lies halfway between the great classial works and the ingenuous taste of *naif* paintings in which the pictorial sensibility is expressed with lively harmony.

Stepped terrace of Barabudur, most important complex of the period, with typical bell-shaped stūpas. Through the opening in the top of the stūpas, the faithful could see the statue inside. Barabudur, with its vast square base 112m (367ft) square, stepped terraces and the central stūpa, to which four great stairways lead from the middle of each side, is an architectural form of the mandala, cosmic symbol that esoterically represents the three worlds of forms.

Chinese art

It is almost as if the two adjectives that best describe China are "vast" and "unchangeable." Indeed, it is perhaps China's vastness and unchangeableness that have been her saving graces. Many nomadic invaders coming down from the north – in particular Huns, Turks, Mongols and Manchus – were assimilated turn by turn, almost like a mild ripple in a sea of oil suddenly becalmed once more.

Chinese is a tonal language. Four different tones (plus one neutral tone) vary the significance of a syllable four times over. Hence the difficulty of rendering the sound of Chinese with Latin characters. There are more than thirty systems of transcription, starting with the earliest one elaborated by the Italian Matteo Ricci in 1605. The Committee of the People's Republic of China for the Reform of Writing came up with a system, which was approved by the People's National Assembly in 1958. This was the *pinyin* transcription system. Because the *pinyin* is the official system, it is used for the transcriptions that occur in this text, although the accents have been omitted. For example, the name of the painter Gu Kaizhi (345–411) corresponds to the name that is written by other authors as Ku K'ai-chih (this being the Wade-Giles system of 1912), Ku-Kaï-Tshi or Kou Kaï-tshi. Similarly Lao-tze becomes Laozi; and Jen Jen-fa becomes Ren Renda. It should also be noted that in China the surname precedes the first name, so in the name Gu Kaizhi the surname is Gu and the first name Kaizhi.

Confucius (Konzi, or Kongfuzi: Master Kong), also known as Zhisheng Xianshi (Per-

fect Master) did not found a religion but a "doctrine of moral improvement." He derived this doctrine from tradition, and merely codified its age-old principles. Confucius was born in Qufu in 551 B.C., and died in 479 B.C. He was a contemporary of Buddha.

Confucianism was revised by Mencius (Mengzi, 371–289). Another figure living during Confucius's lifetime was Laozi ("the old Master"), who wrote the *Daodejing* (better known in the spelling *Tao Te-ching*) and founded Taoism. Taoism is a philosophy of life that is permeated by esotericism and alchemy, and virtually opposed to the austerity of Confucianism. Taoism was dependent on a kind of celestial bureaucracy, and attracted into its fold both the best artists and the most expert craftsmen.

The rite was the essential element for these philosophies, which took the place of religions. The rite was, indeed, so powerful that it conditioned the life of the Chinese people, almost enveloping them in an insurmountable caste system. Whatever the case, it can be said in conclusion that the overriding religious sense of the Chinese was, without too much of a personal factor, the art of living in harmony

with nature. All the Chinese arts have borne witness to this principle.

The Yangshao (5000–2500 B.C.) and Longshan (2500–2000 B.C.) period

As early as the Neolithic period of the Stone Age distinctive forms of craftsmanship were already emerging. This period saw the manufacture of modelled terracotta busts, and beautiful globe-shaped vases with small mouths, short handles and a typical decorative band with maze-like motifs, which we find subsequently from northern Asia to Celtic Europe (Banpo ceramics in Shanxi, Gansu ceramics, and ceramics from numerous other northern sites). As far back as 3000 B.C. the first forms of writing were making their appearance. These achieved their definitive, improved structures in around 1600 B.C.

Worship of forebears also appears to have been organized at an early date. With a state administration organized more along philosophical than religious lines, this gave rise to a class of scholar–functionaries with a preference, where the arts were concerned, for illustrative and poetic forms. Deriving from this preference we find works connected with the concept of life and death (*yang* and *yin*). These works were associated with the environment, have remarkable technical qualities, and were produced more to accompany various rites than to express matters of aesthetic interest. It is possible that the fact that calligraphy can, strictly speaking, be regarded as the most "Chinese" of the arts has more than a

Left: Laozi mounted on a Buffalo, *symbol of spiritual vigour. National Museum, Taipei.*

Above: A Confucian Notable. *Song period*

bronze. Museum of Chinese Art, Parma.

Below: Confucius Instructing his Disciples. *Painting on silk. National Museum, Taipei.*

little to do with this.

The ceramics of the Longshan period, for which the wheel was used, have no painted decoration and are smoothed to perfection. These ceramics developed the classic twenty-two types of ritual vases. These high-quality artefacts were imitated from the Xia period onward by expert bronze workers.

The Shang period (seventeenth to eleventh centuries B.C.)

In architecture the elements that would then be traditionally used, plus the various types of wooden joinery, appear to have been already developed. The city was erected on a squared embankment of compacted earth (*huangtu*), surrounded by impressive earthworks in the form of bastions. The doors of the houses and the principal gate of the city wall were south-facing, in accordance with the dictates of geomancy (*mingtang*), formulated to avoid inauspicious influences.

The funeral ritual, by now strictly organized, required that the tomb should be designed like a palace in which the deceased would sleep, surrounded by the armed guard, dignitaries, bearers and offerers, all either sculpted or moulded. The tomb was thus a sort of "replica" made of stone or terracotta which replaced the subjects, who were in effect sacrificed on the imperial tomb in the previous periods. Sculptures in stone, marble and limestone have been discovered in the royal underground tombs of Xiaotun, in the vicinity of Anyang (Henan), capital of the Shang-yin. These tombs have also offered up many jade symbols and figurines, jade being a stone that has a special apotropaic value (i.e. that wards off evil) as well as a mysterious fascination for the Chinese. The most beautiful examples come from the tomb of Fu Hao (Yinxu no. 5).

Ritual bronzes were improved during this period, in typologies with beautiful, though rigorous, forms that would persist throughout the Han period (A.D. 25–220), with decorations tending toward the abstract. The artistic quality of these decorations was produced essentially by their harmonious proportions. The most precious pieces include the famous *Long Huzun* vase, used for libations, which is in safe-keeping in the Hefei Provincial Museum, in Anhui, and which has stylized motifs of dragons and tigers' heads.

Ritual also involved pots for cooking food, others for keeping food cold, pots for heating up beverages, flasks for storing them and mixing them, sauceboats, ladles, utensils and ember-boxes for the fire, animal-shaped vases with extremely precisely designed volumes, and others decorated with a dragon's mask (*taotieh*), which would then develop graphically until it became a typical abstract motif.

There are few traces of decorative painting, although this undoubtedly adorned the walls of buildings with genre scenes with black

outlines and flat backgrounds filled with bright colours.

The Zhu period (West, *c.* 1050–771 B.C. – East, 770–256 B.C.)

King Wenwang founded the first Xian center in Shanxi, which was the capital of China for many centuries and under various dynasties. As a cultural and historical center it is comparable only with Rome, Constantinople and Paris. The Jinci complex at Taiyuan in Shanxi

The period of the Warring States (475–221 B.C.)

Political events in this period did not permit any wide-ranging forms of artistic expression, but the degree of refinement achieved then is evident enough in the extremely rich furnishings discovered in the tomb of Prince Yi, who died in 433 B.C., which are now in the Wuhan Museum in Hubei. The objects found include ritual bronze vases and one hundred and twenty-four musical instruments. Of particular interest is the bronze carillon made up of sixty-

Left: black terracotta goblet. Late Longshan period. Ostasiatiska Museet, Stockholm.

Right: ritual "zun" vase for storing wine used as an offering. Bronze, replica of a model from the late Shang period. Of the many ritual bronzes, the vases and pots were used for heating up food (ding, li, xian) or sauces (guang); for storing them (gui); for mulling wine (jia, jue, gu, zhi); and for storing it (you, zun, yi, hu, pou, lei) or pouring it (he).

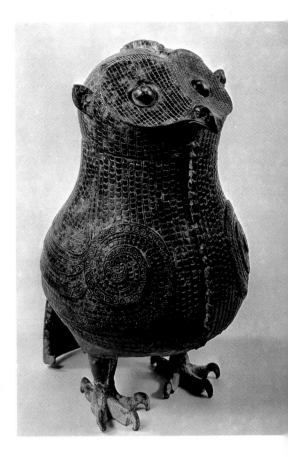

was also constructed. This was a cultural center of great importance, although subsequently altered in such a way that it is hard, now, to single out the Zhou work. We do know, however, that the straw of the roofs was replaced in this period by struck tiles.

Bronze-working, in particular, especially in the Leigudun center at Suixian, in Hunan, became more rigorous, with less importance being attached to the increasingly stylized decorative motifs. New techniques such as fretwork, incrustation with turquoise lacquer and gilding (gold-leaf work) were introduced. Bronze was also used to make the first statues as well as the usual receptacles.

Painting and lacquer are evidence of the taste for stylized design. The art of calligraphy also took its first steps forward, with three forms of handwriting now quite distinct: the "great seal" (*dazhuan*) and the "little seal" (*xiaozhuan*), and the hand delineated in ink with the quill on bamboo tablets or panels. Painters used precious materials to enhance their designs. These included slivers of jade, ground turquoise, and mother-of-pearl powder. In accordance with the words of Confucius on painting, which he regarded as an advantageous means of education by means of illustrating maxims and principles, the walls of palaces were decorated with edifying and conventional scenes.

five bells suspended on beams supported by armed warriors, all in a sort of frame 3.5m (11ft 6in) square and the same tall.

The use of the brush made with a bamboo handle and animal hair was introduced. This gave rise to beautifully delineated works on scrolls of silk now used vertically, which in turn encouraged the painting of landscapes on superposed planes.

The Qin period (221–206 B.C.)

Shihuangdi was the first emperor of China and unifier of that great land to which he gave a decisive order. He was buried at Xian in 210 B.C., in a sumptuous tomb which reproduced in miniature the aspect of his vast realm. This tomb offered up the find of the fantastic army of some seven thousand soldiers, cavalrymen, officers and dignitaries, complete with war chariots and horses, all made life-size in well-modelled ceramic.

Shihuangdi also standardized writing, which was subsequently rationalized by the Han in the form still in use today. On the other hand, Shihuangdi ordered the total destruction of all Confucian works. He was also the patron of a specific architectural complex. To deal with the invasions by nomads from Central Asia, he joined together the long defensive walls that the various states had constructed during the

period of the Warring States (453–221 B.C.). In so doing he created the Great Wall of China. This wall was abandoned after the fall of the Qin, taken up again under the Han and further enlarged, unused during the reign of the Yuan, and then finally given its present aspect between A.D. 1470 and 1480 by the emperor Ming Xianzong.

The painting of this period illustrates ritual scenes, based on a well-organized traditional typology structured; it would appear, down to the classification of themes, which were entrusted to individual specialists. The uniform style with its beautiful and harmonious delineation hallmarked both the major decorative works on the walls of palaces and scenes depicted in tombs, as well as paintings on silk.

The Han period was pivotal. It represented the culmination and the synthesis of the great projects and activities of the past. It saw the development of artistic prowess and advances in every field. These advances may be attributed – on the basis of a well-categorized typology – to successive periods as a heritage and also as a definition of what can be considered typically Chinese. A solidly established power (apart from a brief interruption between A.D. 8 and 25), combined with a prosperity and well-being provided by trade and commerce which stretched as far as the Mediterranean, contributed to the desire for refined and copious luxury, and this was

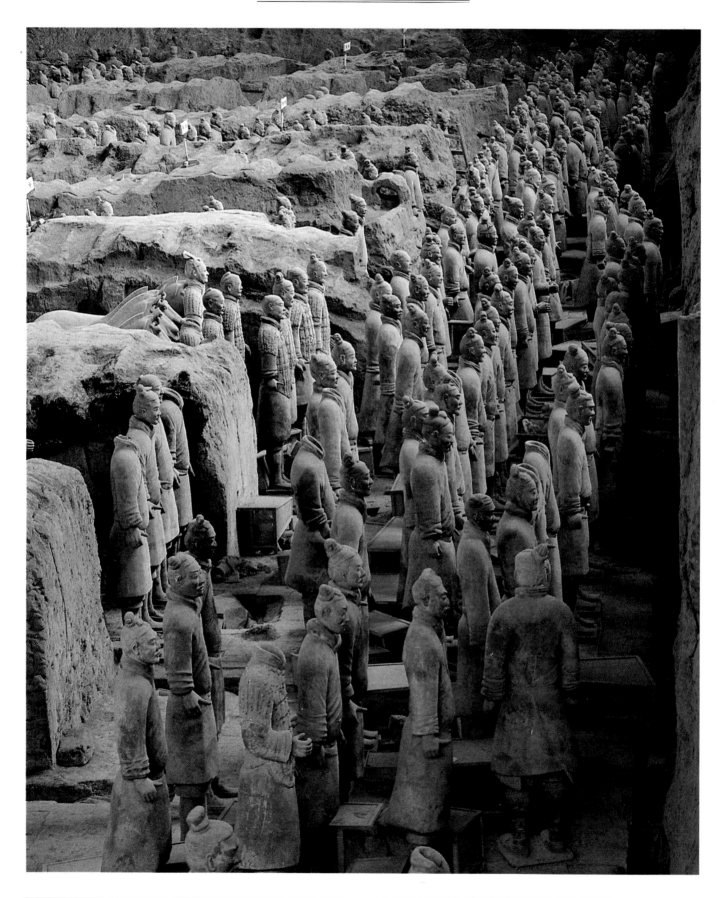

projected in meticulous and complex works of art. For a short time even the Roman Empire in the time of Marcus Aurelius had an ambassador at Xian, with the purpose of uniting the various forces against the Parthians (A.D. 164).

Sculpture was monumental and unrefined, and showed a plastic awareness in the realistic and lively human figures. There are plenty of examples of this style in tombs, particularly in the tomb of Hsing-jing, which, in addition to numerous full-relief statues, has revealed a famous bas-relief in which a horse is trampling its rider on the ground.

There were also developments with illustrative scroll painting, closely associated with a nicely handwritten text, which in turn encouraged the collecting of literary or painted scrolls among intellectuals. This habit would persist for many centuries. The Mawangdui "banner" (in the Changsha Museum), which covered the bier of a princess in a Han tomb, shows scenes depicting stereotyped figures, in which the movement of the individual characters is brought particularly to the fore, while knotted ribbons and clouds help to render the ensemble effect both lively and fluid.

This same tomb has yielded a large number of literary documents, lacquer-ware, fabrics and musical instruments, all of which provide clear evidence of the high cultural standards of the period.

As a result of the many applications of the Confucian texts, the original versions, held in the imperial library, were carved on stone steles; on these steles scholars and men-of-letters then proceeded to print with a new type of running "fabric," which was called paper. This process in turn gave rise to the craft of woodcut printing. In Xian one of the most beautiful "stele forests" in China was organized. Today it numbers thirteen hundred large memorial tablets, produced between 206 and 1911.

The period of the kingdoms and the dynasties (220–618)

This period was marked by a strong interest in Buddhism, possibly because Confucianism and Taoism, which were specific expressions of the Han administration, lost credibility with the bloody collapse of this dynasty.

The Buddhist art of the kingdom of Gand-

Opposite: the first ranks of soldiers (grave no. 1) in the Tomb of Emperor Qin Shihuangdi, at Lintong, near Xian, in Shanxi province. Terracottas dated A.D. 210. This ensemble, which was not completed because of the sovereign's premature death at the age of forty-nine, *includes 7,000 statues set in an area covering 22,000sq. m (5½ acres). It was discovered between 1974 and 1977.*

Right: Ruling Lady. Cold-painted terracotta. Early Han period, called Western Han, 206 B.C.– A.D. 8. National Museum, Tokyo.

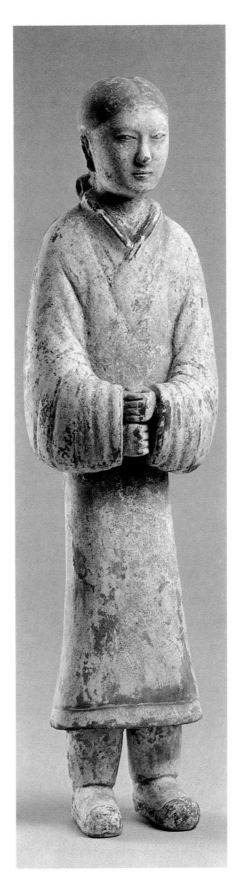

hara was introduced into China by Indian missionaries along the Silk Road, which shed in its wake a series of oases like so many pearls on a necklace. These oases were rich in art treasures, becoming more and more Chinese-inclined as the route wound its way gradually eastward. This Buddhist art suddenly found expression in one of the most impressive masterpieces of all religious art: the Grottoes of Yugang, which were excavated between 460 and 525, and in which there are abundant references to the style of Ceylon and to art of the Gupta dynasty. There is a wealth of statues – some 51,000 in all – including the splendid *Seated Buddha* in Grotto no. 5, the most important. This grotto also contains the largest statue in the entire site, all of 17m (55ft).

Where painting was concerned the first great master was Wang Xizhi (307–365). Gu Kaizhi (345–411), who is famous in Europe for a *Scroll with Court Scenes* at the British Museum in London, was a superb portrait painter. Zong Bing (375–443) laid down the rules of a particular manner of perspective in which the onlooker finds himself "inside the painting." This typically Chinese feature tends to emphasize the concept rather than the rendering of the real. Wang Wei the Elder (415–443) wrote a treatise on the rules of landscape painting in which he improved upon this "perspective viewpoint," which then became the traditional one. The Court Painter Xie He (479–501) was another great portraitist, famous for his portraits, which drew inspiration from the ancient school. He established the five rules of Chinese painting, which, for centuries, remained the pillars of this admirable art. The five rules are these: *qi yun sheng dong* (the vital breath which gives movement to the work); *gu fayong pi* (the structuring of the subject); *ying wu xiang xin* (the correspondence, by means of resemblance, between the painting and the subject represented); *sui lei fu cai* (the correspondence of the colours of the painting with those of the subject); and *zhuan cai mo xie* (the study of the great masters of the past, including their manners of painting and their techniques). It is to this last precept, above all, that we owe both a sort of traditional ultraconservatism and the possibility of being able to appreciate paintings from early periods that are now lost, and of which some trace has been preserved in the form of accurate later copies.

This period also saw the start of a formidable work of pictorial decoration which has survived in exceptionally good condition, considering that work on it finished in the fourteenth century. This is the *fresco secco* in the Dunhuang grottoes in Gansu province (a principal port of call on the Silk Road). Here the Buddhist typology that had come from Gandhara was altered and distorted. In the depictions of the *jataka* (historical scenes of the Buddha) there are magnificent landscapes arranged in different perspectival manners.

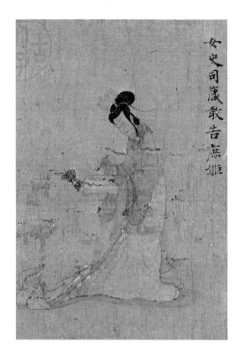

in 713, is truly impressive, powerfully hewn out of the Chengdu rock in Sichuan province. Other important works include the statues in the Baodongshan complex, again in Sichuan, and in particular a Quanin (Buddha Avalokitesvara) with one thousand and seven arms; and the Nirvana sculpted in niche no. 11, which was possibly completed in the Song period. Noteworthy, too, are the statues in the Mogao grottoes, at Dunhuang, on the Silk Road, in Gansu province. The Buddha Vairocana in the Longmen grottoes at Luoyang (Henan) is powerful, but noble and serene. These grottoes as a complex are a grandiose sight. In them, from 495 until the eleventh century,

whole generations of stone-cutters hewed out 1,351 grottoes in the mountain, filling them with 97,305 statues, 3,608 inscriptions addressing Buddhist themes, and 35 pagodas.

No less impressive, in terms both of area and quality (the area covered being almost 46,000sq. m [495,000sq. m], are the *fresco secco* paintings in the Magao grottoes, also known as the Qianfodong grottoes, at Dunhuang, in Gansu province. These were started under the Wei and carried on in particular by order of the empress Wu Zetian (684–705). In these unique works the landscapes are possibly the oldest examples of this theme to have survived to the present day.

In ceramics the use of grès developed considerably. In the Changsha region potters introduced a glaze in various colours on white slip which is called *proto-celadon*. From the sixth century onward they also introduced various transparent quartz-bearing glazes.

The Tang period (618–907)

This was probably the most important Chinese period in terms of the achievement of art in the fullest sense of the word. The vast domain of the Chinese empire, plus the economic prosperity produced not least by the remodernization of the great canals and by the new method of cultivating rice (which is still used today), plus contacts with the Sassanids of Persia and then with the world of Islam, plus interchanges with these cultures, as well as the "Grecian" equilibrium and proportionality of the works undertaken, all contributed to a more decisive affirmation of formal elegance in every field of artistic expression.

In architecture the technique of wooden joints gave rise to structures that have never been surpassed. But in general it was Indian missionaries who introduced the use of long-lasting materials – stone and brick – which allowed important developments to take place. The Chinese pagoda-tower was constructed on the basis of the Indian *stupa* covered with seven symbolic umbrellas.

At Xian a mosque for sixty thousand Muslims was built (and restored in the Ming period). It was one of the largest mosques not only in China but in the entire Islamic world.

In sculpture the imperial *shendao* of Xianyang near Xian is magnificent. The great Buddha, 71m (233ft) in height, and completed

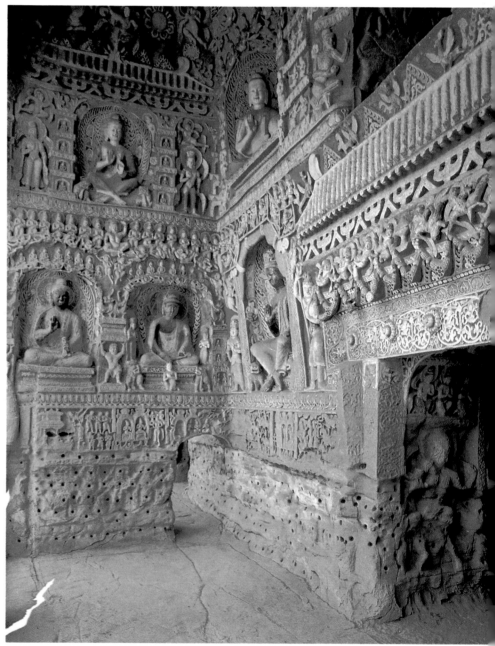

The fresco depicting the Wutaishan (grotto 61), measuring 60sq. m (645sq. ft), is a famous one which unfolds like an immense map. The roof of grotto 249 is also splendid, with its whirling, lively ensemble of animals and clouds, as is the richly decorated *Concert* in grotto 159.

The paintings are executed with a series of coats to give depth, but there is practically no use of shading, hatching or modelling. This is a feature of all subsequent Chinese painting. Typical works of the period are the paintings with a predominant use of blue and green, as well as paintings with a predominance of blue and red. Yan Liben (seventh century) was a superb portrait painter; Han Gan (eighth century) excelled in the painting of animals; while the art of the landscape, using new "brush-tip" polychrome techniques, was perfected by Li Sixun (651–716), followed by his son Li Zhaodao. The unrivalled master in all three genres, however, was Wu Daozi (seventh century). Wang Wei (699–759), on the other hand, introduced the ink-splash manner using black Indian ink. This manner was particularly appreciated by intellectuals in later periods. Wang Wei described it in his *Hua xue bijue* (*Secret of Studying Painting*). Alongside painting we find calligraphy. Starting from the basic model called *kaishu*, the various types of script and writing, both geometrically arranged and cursive, were codified. Calligraphers expressed themselves with most beautiful delineations, which were delicate enough to be regarded as a fully fledged art-form.

In ceramics the contributions of the Sassanids and the high technical quality achieved gave rise to a notable flowering of models and themes, involving new and extremely refined

Opposite far left: Gu Kaizhi (345–411), detail from the Scroll of the Instructions to Court Ladies. *British Museum, London.*

Opposite right: the Yungang complex of grottoes at Datong (Shanxi province): the entrance to grotto no. 9. From the decorations taken as a whole we can clearly see the classic features of Buddhist art, which reached China via the Silk Road from the Han period onward. The grottoes were hewn out and decorated under the northern Wei (386–534).

Right: a fresco from the late period, from Dunhuang, in which the Graeco-Roman character of classic Buddhist art is diluted in the clearly Chinese calligraphic decoration. Museum of Chinese Art, Parma.

Below: the Mogao complex of grottoes at Dunhuang, a caravan center in Gansu province on the Silk Road: mural painting in grotto no. 217 depicting the Paradise of the West, *in the Dominion of Amithaba. Tang period.*

forms. The introduction of the "tea ceremony" called for the manufacture of exquisitely made pieces, produced specifically to order for intellectuals. The Tang "three colours" (*sancai*) were also copied by Islamic potters and ceramists in the Middle East. Pieces of rare beauty, copied from *cloisonné* enamelware, were made using the technique known as *a cuerda seca* (or "dry cord"), with elegant floral motifs, beautifully drawn, even for pottery made for everyday use (e.g. pieces found in the Tongguan excavations in Hunan province). The ceramics included among the funeral objects were richly coloured, and reached a peak of quality in the eighth century. These objects took the form of animal figures, soldiers, dignitaries, merchants and ladies.

The five dynasties (907–960) and the Song dynasty (960–1276)

In the tenth century two Central Asian powers, the Kitan and the Tibetans, drove a wedge between Islam and China, and broke off all

direct contact between the two. It is for this reason that Chinese art accentuated the independent qualities borrowed from the Tang forms, and heightened the local characteristics.

In the south we find the development of a type of roof with angular, upward-curving projections. This structure was better suited to admitting more light into the interior of the building. The architect Yu Hao brought this typology from the south to the northern capital of Kaifeng, in Henan province. But little remains of the architecture of this period, although it is well illustrated in the treatise titled *Ying zao fa shi*.

In the north, the Liao, who were one of the five dynasties, built the famous Yingxian pagoda (1056), all of 67m (220ft) high, with an octagonal plan. This splendid building is the only example built entirely of wood to have survived to the present day.

The construction of the great Temple of Confucius, at Qufu in Shandong province, dates back to 1018. This building is 32m (105ft) high, and has one of the most beautiful ceramic roofs in China. It also contains the only statue of the Master to have been offered to the faithful for the purpose of veneration.

The great Temple of the Mighty Treasure, at Datong in Shanxi province, which was rebuilt in 1138–40, has a façade measuring 54m (177ft) and the largest Buddhist hall in the whole of China, grandiosely constructed with wooden pilasters.

The Temple of the Ancestors (*Ci*) was erected at Jinci (Taiyuan, in Shanxi province) on an ancient place of worship from the Zhou period. Nearby, on a terrace, there are some remarkable statues in cast iron, a material that was not known in Europe until the fifteenth century. Close to this temple stands the Temple of the Holy Mother (*Sheng mudian*), which houses huge terracotta statues of ladies and servants arranged around the queen mother, just as it really was in the life at court. The high quality of Song art is shown to great advantage in this building, which is exceptionally beautiful and also important as documentation of the period.

In ceramics, celadon was a feature of great beauty. This was a porcelain-like grès covered with a glaze that was olive-green in the north (where we find the famous Yaozhou pieces in Shanxi province) and blue-green in the south. At times the body was scratched or modelled, above all with the typical peony motif, in very delicate bas-reliefs accentuated by enamel. In addition to the celadons (so-called in France in the seventeenth century because of its colour, which is like that of the costume worn by the actor Céladon when he acted in the Astraea), Henan province produced lavender blue *jun* with tiny singed "hare-skin" veining. For the Court pale blue *ru* was made, with wide *craquelures* giving a very beautiful effect, which was later copied in *guan* ceramics.

By the end of the Song period ceramists

Left: Figure of a foreign boy. *Painted terracotta, late Tang period.* Victoria and Albert Museum, London.

Below: The Iron Pagoda at Kaifeng, in Henan province. It is so called because of the rust-like colour of the ceramic tiles covering it. It is 56m (184ft) high and was completed in 1049.

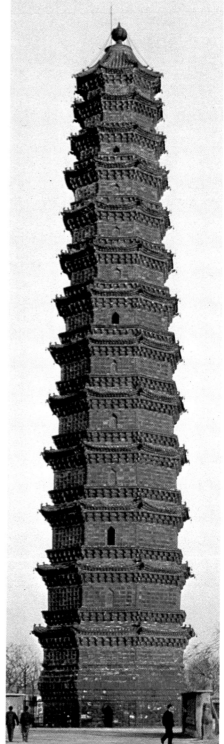

had a vast range of types and techniques at their disposal, with rainbow-hued glazes including a deep black one, and in particular the whole gamut of dense and powerful enamels, culminating in a Liao production that imitated leather so well that even the most alert eye could be deceived by it. Noteworthy forms were made in brown-green ceramic resembling rusty iron, which was also used to cover the so-called Iron Pagoda at Kaifeng, in Henan, which is 56m (184ft) high.

In painting we find the full development of monumental landscape art, with the landscape arranged in a vertical sequence. At the same time, horizontal scrolls offered a wide variety of small everyday scenes, excellently depicted by Zhao Gan in particular. On the whole this art was regarded as the poetic expression of an intellectual class which saw in the use of brushes the realization of lofty philosophical ideals.

Under the Liao the landscape was suffused by a pronounced lyricism, and vigorously depicted by Quin Hao and Guan Tong, both representatives of the "northern school." Dong Yuan and Ju Ran, two exponents of the "southern school," softened their landscapes in hazy, delicate harmonies.

The various "genres" were also established

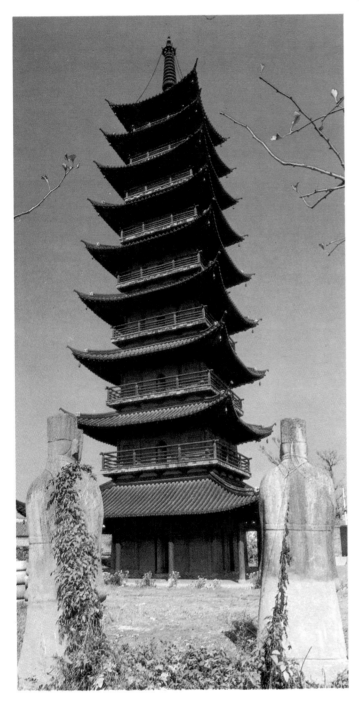

Above: Fan Kuan, Fan-shaped landscape, typical of the Song Taoist style. Museum of Fine Arts, Boston.

Below: Zhang Deduan, Games on water. Painting from the Song period.

painters included Li Cheng (*c.* 940–967), Fan Kuan (*c.* 960–1030), Guo Xi (*c.* 1020–90), Guo Ruoxo, Xu Daoming and Li Tang (*c.* 1050–1130).

Definition was given not only to the different genres but also to the typical compositions of paintings: asymmetrical, and out of balance (as in the works of Ma Yuan and Ma Lin); predominantly empty, and pronouncedly bipartite (as in the works of Xia Gui).

Last of all, the emperor Hizong (1101–25), himself a good landscape painter and calligrapher, set up in the north the State Academy. The first exponent of this school was Li

Above: the pagoda in the Xingshengjiao Monastery of Songjian (Shanghai), the only reminder of the great complex erected by the northern Song.

in this period. Today they have barely changed, and still characterize Chinese painting. The genres included the architectural landscape, the natural landscape, flowers, birds, bamboos, fishes and so on, and were set forth in many a treatise.

The Taoist Fan Kuan was an exceptional landscape painter, combining the legendary and the mystical. The architectural landscape was defined by Zhang Deduan and Li Song (*c.* 1160–1220). Other important landscape

Left: grès plate with blue decoration beneath enamel. Yuan period, fourteenth century. This is part of a series of ten identical pieces which are now in Istanbul and at Ardebil. Pusat Museum, Djakarta.

Right: edict of the emperor Qubilai, written in calligraphy on silk. Detail of the imperial seal with the signature of Marco Polo and Mongol text followed by the Chinese text. Formerly in the presidential palace, Taipei.

Below: the "Pavilion of Supreme Harmony" (Taihedian) in the Imperial Palace of Peking, as seen after the lavish reconstruction of 1669. In this palace the most grandiose of all imperial ceremonies were solemnly commemorated.

Opposite: Genghis Khan at the Hunt. Painting on paper attributed to Ren Renda. In it the artist is less concerned with the perceptible values of traditional Chinese painting, and more intent on the meticulously documentary rendering of the details. Presidential Palace, Taipei.

Tang (1050–1130), who spread the academic style to southern China as well. The Academy grouped together the various genres, the many artistic tendencies in circulation, and the activities of various artists.

The Yuan period (1271–1368)

The Mongol "hordes" of Genghis Khan took Peking (Beijing) in 1215 and Canton in 1279 on their sweeping wave of conquest in the east. To the west they reached as far as the Danube and Jerusalem. China was thus incorporated in the world's widest empire, and China became the center of this empire when Genghis Khan's nephew, Qubilai, who had taken on the dynastic name of Yuan, chose Peking to be his own capital, and renamed it Khanbalik.

The court of the Yuan was sumptuous and cosmopolitan, and many a European merchant stayed at Khanbalik. One of them, who achieved great fame, was the Venetian Marco Paolo dé Vilionis, known as "Milione", author of the *Livre des merveilles* (Book of Wonders), a book which was erroneously called *Il milione*. Despite the pomp of the Mongol court, the arts were in general less refined and sensitive than in the preceding period.

As far as town-planning was concerned, the plan of the dual city was developed. The political authorities with all their organizations were separated from the rest of the city, within a powerful bastion designed with defense in mind. In order to wield their power the more easily, the Mongols also divided up the various districts of the city with walls, and erected

major fortifications, with square-angled towers and majestic entrance gates. The drawbridge also came into use from 1359 onward.

Small decorative hillocks, usually artificial, embellished the city, and acted at the same time as strategic vantage and observation posts for the police forces. Gardens, either huge or miniature, were attached to houses, and depicted the universe in a symbolic way. They were places of meditation and contemplation, rather than places for recreation.

The Mongols brought the art of carpet-making from Central Asia. It is also possible that the Yuan taste for modelled and enamel-

led ceramic hangings derived from the nomad practice of covering their tents with compositions of coloured felts.

Porcelain was very much in favour, but in particular as an export commodity, together with silks and brocades. In fact the considerable increase in these areas of commerce spread the use of paper money throughout China from 1279 onward. This form of currency had been invented in 1154. As far as porcelain was concerned, two new types were developed: the *liulihong* (with a red design under glaze) and the *qinghua* (with a blue design under white glaze), made using cobalt imported from Persia. These were exported to the Islamic countries along with a stout-shaped celadon, and copied there, which encouraged fine local production.

As for painting, the conquerors had a preference for hunting and battle scenes, and groups of horses (a genre in which Ren Renda excelled) depicted in a realistic manner. The conquerors were not particularly interested in the poetic qualities of Song painting, so little by little the artists of the Imperial Academy became mere artisans.

Conversely, the vanquished demonstrated their spirit of independence with an anti-academic form of painting, in which Zhao Mengfu (1254–1323), a descendant of the Song emperors, and a meticulous but vivacious draughtsman, was a leading figure, together with his wife Kuan Taosheng (1262–1325), possibly the most famous of all Chinese female painters, their friend Li Kan (1245–1320), who had a soft spot in his paintings for the typical

Chinese theme of bamboos, and Gao Kekong (1245–1310), with his pleasant but concise style.

In the south, where the desire for independence was expressed in the tradition of the Song landscape painters, four painters created a style that became an important reference point for artists of the following period. These four were: Huang Gongwang (1269–1364), who devised painting involving jet black Chinese ink; Wu Zhen (1280–1354), a painter of bamboo; Ni Can (1301–74), who reintroduced intellectual painting; and the extremely delicate Wang Meng, who also lived and worked in the Ming period.

The Ming period (1368–1644)

In about forty years, from 1346 to 1382, the Chinese put the Mongols to flight. A leading rebel, who assumed the dynastic name of Ming, came to the imperial throne, and revived the bygone pomp of the Han. Little by little, however, the central power became more and more despotic and wielded by a class of corrupt and incapable eunuchs. They clashed sharply with the Confucian functionaries – who were exaggeratedly nationalistic – who worked in the administration as it became increasingly centralized and decadent. This led to the progressive paralysis of the empire.

In Peking the so-called "Imperial Palace" (*Gugong*), started in 1407 and subsequently reorganized and under constant restoration, represented one of the major architectural

projects. This was, in effect, a whole and quite numerous series of small palaces, pavilions, terraces and gardens within a walled enclosure measuring 2.5m (8ft) in length and 10m (33ft) in height. It included four gates at the four cardinal points. For all this, no one monument stands out in terms of artistic or structural quality, although we should make mention of the Temple of Heaven, built in the fifteenth century in the southern part of Peking to lend continuity to the ancient rituals, which placed the emperor – the link between the forces of nature and the human species – at the apex of the hierarchic structure, which was regarded as synchronous with the structure of the universe. This synchrony could either be accepted or put up with, but it could not be altered. The principal part of the architectural complex, structured in a symbolic way, is the famous *Altar of heaven* (1530). Its circular enclosure consists of 360 balustrades, one for each day of the lunar year.

One specific art-form that now appeared was the design of "Chinese-style" gardens with pavilions plunged in the natural environment. A masterpiece of this genre is the *Garden of the Politics of the Simple (Zhouzheng yan)*, built at Suzhou, in Jangsu province, on the vestiges of a similar garden, the "Forest of the Lion" (*Shizilin*), created in the same city by a Buddhist monk in the fourteenth century specifically for the purposes of meditation (*dhyâna* in Sanskrit, *chan* in Chinese, *zen* in Japanese). No less important, and slightly outside Suzhou, is the "Liu Garden," designed by Xu Shitai at the end of the sixteenth century, with pavilions and rock compositions – known in Europe in reproductions – which may well have inspired the French

*Left: Khun I,
Calligraphed and sealed
Imperial Letter.
Presidential Palace,
Taipei.*

*Below left: When
Zhengming (1470–
1559), The Tea
Ceremony in the
Summer Pavilion.
Painting on paper.
Palace Museum, Taipei.*

*Right: porcelain vase
with relief and
polychrome enamel
sancai decoration.
Period of the Ming
emperor Longqing,
1566–72. Guimet
Museum, Paris.*

*Opposite above:
imperial porcelain vase
with polychrome enamel
decoration known as
"thousand flowers."
Period of the emperor
Qing Qianlong, 1736–
96. Guimet Museum,
Paris.*

*Opposite below: the
western Yiyuan, one of
the Suzhou gardens, in
Jiangsu province.*

rococo style.

The "Great Necropolis of the Ming," near Peking, is another important architectural and sculptural complex, with its famous "Way to the Sepulchers" lined with statues.

At Nanjing we also find an important "Way of the Sepulchers," with four pairs of mandarins and twelve pairs of colossal statues depicting various animals. One hundred thousand workmen were engaged for the construction of the sepulchral complex (1379–81).

At Shuanglinsi, in Shanxi province, noteworthy works include a Quanyn in the "Temple of the Thousand Buddhas" and a white marble stele 5m (16ft 6in) tall (the tallest in China) supported on a turtle's back. Bronze-working was also technically well advanced, as is shown by the statue of the deity Zhenwu, in the "Taoist Temple of the Forebears" (1452) at

Fohsan in Guangdong province, which weighs two and a half tons. Overall, however, there are no particularly precious examples of either architecture or sculpture.

Ceramics, however, was more important. In addition to the refined Yuan techniques, which had by now become perfected, the reds known as "ceremonial" (*qi hong*) and "ox-blood" (*baoshihong*, or gemstone red) had been produced since 1526. The hardness and the purity of porcelain became inseparable, and the quality of the deep blue, bright yellow and pure, dazzling white enamels and glazes made Ming objects appreciated and sought-after in every court in Europe. The skill of Chinese potters and ceramists was such that they were able to copy various other materials (such as bamboo, wood, metals, etc.) in products requiring extremely tricky techniques.

Paintings using contrasting colours (*taucai*) and using five colours (*wucai*) were carried out on the third firing on a very hot white-and-blue base. The outcome was the so-called "green family," with all its virtuosity. Among the most impressive pieces are the "Wall of the Nine Dragons" (*Jiulongbi*) in polychrome ceramic, at Peking, which measures some 8m (26ft) in length and some 5m (16ft 6in) in height.

In painting the Academy had been re-instated, following in the footsteps of the Song. It attempted in turn to revive ancient classical forms, in a possibly cold and formal way. Leading Academy figures included Wu Wei (1459–1508), a skilful portrait painter; Lu Ji, a painter of flowers and birds who became very well known in Europe because of the numerous copies of his work; and Dai Jin (*c.* 1390–1460), who founded the traditional Zhi school and was also an inspiration for the Japanese Kanô school.

Anti-academic painters, on the contrary, included the so-called "Four Ming Masters" of the Wu school, also known as the Wen jen hua,

or School of Poets: Shen Zhou (1427–1509), who was eclectic and refined; When Zhengming (1470–*c.* 1559), an erudite mannerist who left behind him a long genealogy of good painters; Tang Yin (1470–1524), who stayed permanently on the outskirts of official painting; and the prolific Jin Ying (first half of the sixteenth century), who, with painstaking care, took up the genre of the "blue-and-green" landscape.

Other lesser groups still bear witness to the great desire and determination to represent national characteristics under the Ming dynasty. These groups included the "Group of the Nine Friends" headed by Tung Zizhang; and the "Painters of Decadence" (Huang Taozhu, Ni Yuanlu and Yang Wet-sung). Independent artists also emerged, one such being Hsu Wei.

The calligrapher and man-of-letters Dong Qichang (1555–1636) compiled a *General Classification of Painters* for every different period. Even though it is arbitrary now and again, this reference work helped to further define the traditional movements and the typically Chinese genres.

Cassius. Together with the "green family," the "pink family" was thus introduced (followed later by the "black family" and the "yellow family"). The naturalistic, delicate, miniaturized rendering on incredibly fine porcelain with so-called "egg-shell" sides was another beautiful feature here. Massive export trade to Europe led to China becoming contaminated by Western themes and tastes, while Chinese ceramics were widely copied by the major European manufacturers. In the reign of Qianlong (1736–95) refined pieces called "thousand flowers" show the high technical quality achieved by Chinese ceramists, even if their work was now mass-produced, and almost industrialized. The great complex of Jingdezehn numbered some 600,000 artisans, divided into groups, each one of which specialized in the execution of a specific detail of the object being made.

Similarly, enamels on copper, using the very

Left: Wang Shihmin, Contemplation of the Wild Beauty of Nature. Painting on paper. Qing General Collection, Paris.

Right: Qi Paishih, Red Campanulas. Painting on paper. Cernuschi

Museum, Paris. Love of nature, and nature's poetic values, is still the finest expression of a style of painting that introduces new themes and techniques but remains nevertheless strictly associated with age-old tradition.

Gao Qipei (c. 1672–1734), Jin Nong (1687–c. 1764), Hua Yan (1682–1765) and Le Bang (1733–99), among the better members, and Cheng Hsieh (1693–1765) and Huang Shan (1687–1768) as followers of the group. The "Group of the Four Monks" turned to compositions showing great mystical inspiration, with a dynamic and at times rebellious style. The four monks were Zhu Da (or Pata shanjen, 1625–1705); Shitao (1641–1717), who was directly related to the Ming emperors; Qa Shihpiao (1615–98) and Hung Jen (d. 1663).

Tradition was carried on further beyond the political events of the first half of the twentieth century. Today it is possible to perceive the main qualities of Chinese paintings in the fine works of Lin Fengmian, Wu Zuoren (President of the Academy of Fine Art), Jupeon (1894–1953) and Qi Paishih (1860–1957).

The Qing dynasty (1644–1911)

For the Manchurians, "barbarians" from the north who conquered China after a long series of bloody wars (1644–81), posed an immediate problem. To be accepted it was convenient that they should appear to be the continuers of the Ming civilization, by retaining its cultural features and preparing an "inventory" of all the treasures of the past.

Thus, for example, the emperor Kangxi (1662–1723) had the largest ever *Dictionary of the Chinese Language* compiled; and the emperor Qianlong (1736–95) was responsible for the preparation of a mammoth *Bibliographical Repertory*, as well as promoting the vast collection of art in Peking.

In architecture a distinctive feature of the period was the use of precious materials for buildings, and an exaggerated form of redundant and often cloying decoration.

Love of a dignified form of nature survived unchanged. Evidence of this lies in the splendid "Garden of the Master of the Nets" (*Wang shiyang*) at Sizou in Jangsu province, which was started in 1644. Particularly important in this garden is the refined Library of the Five Summits, a favoured place of Chinese culture.

The Qing emperors were particularly interested in the manufacture of porcelain. In the reign of Yongzheng (1723–35) a pink enamel came to be widely used. It had been discovered in Holland by the chemist Andreas

ancient *cloisonné* and *champlevé* techniques, reached a high degree of virtuosity, as did the sectors of silk, embroidery and carving on gems.

In painting we find on the one hand a sort of convergence of all the schools, and on the other the appearance of European painters who, within court circles, provided new stylistic perspectives. Among these were the Italian Giuseppe Castiglione, known as Lang Shihning (1688–1766), the French artists Attiret (1702–68) and Louis de Poirot (1735–1814), and the German Sichelbarth (1707–80).

Among the most authoritative Chinese painters, those in the "Intimist Jading Group" excelled in terms of their poetic sense, traditionalism and refinement. The founders of the group were Wang Shimin (1592–1680) and Wang Jan (1598–1677), who were not related despite having the same surname. Wang Hui (1632–1720) and Wang Yuanqi (1624–1715) were pastmasters at painting compositions that were lively, dry and powerful; Wu Li (1632–1718) and Yun Shouping (1633–90), on the other hand, slipped into a repetitive style that was often sentimental. Duller works were produced by the "Qinling Group," the isolated painter Fan Qi (1616–c. 1692) and the great master Kuang Hsien (who was active between 1625 and 1698), whose technique was cold, yet refined and perfect.

More individual, passionate and "eccentric" figures included the "Yangzhou Eight," with

Japanese art

Introduction

"The Empire at the end of the world" and "the Land of the Rising Sun" were the names given, once upon a time, to the group of islands in which civilization was very different from anywhere else, even though there were periods when it was dependent on Chinese, Korean and even Indian culture. In spite of its links with the Indo-Asiatic culture of Buddhism, the art of Japan transformed everything that reached it from the West, attained its own heights by creating independent forms, which had a much-admired simplicity about them, and was in at the beginning of modern art as it has since developed throughout the world, by having a considerable influence on Impressionism, Post-Impressionism and Modernism (or Art Nouveau – Liberty, floral, Jugendstil, call it what you will).

For centuries, Japan tried to distance itself from the slow evolution – almost decadence – of the rest of the world, rejecting forms of modernization that inevitably involved degeneration and compromise; and did not give in until it was faced by the might of the American navy under Commodore Perry (1853), and only then in order to align itself with Europeanism, aware that this meant "yielding to barbarity, materialism, abject and destructive egoism."

It is above all ethical values that are expressed in the native arts of Japan, the concept of *bushido* or unconditional dedication to Nature, which has control over everything and to which everything returns. It could be said that the true art of Japan is in its landscapes, and the adherence to landscape, and the contemplating of it, has always been the model on which the art of the Yamato (the Land of the Rising Sun) has been based; as a consequence of this, Mount Fuji or a painting of it, the island of Itsuku or a wood-cut of it, mean the same thing to a Japanese, and there is no distinction between Nature as a "work of art" and any representation of it. Nevertheless, if this art is to be understood, one has to take account of another set of equivalents embracing, for example, a particular style of architecture that is bound in with the natural environment of which it is a part and on which it does not impose itself. Material pleasure and the purest form of mysticism exist side by side; detachment from religious laws and a deep religious sense are equal; likewise, all religions are seen as equal, so that a Japanese can, at one and the same time, practice Buddhism, Shintoism and Christianity. The mythological, naturalistic religion of Shintoism (the indigenous religion which legitimizes imperial power), with its temples at Izumo and Ise, is related to the contemplative abstraction of Zen Buddhism and its temples at Eihei; both these religions unconditionally revere Nature. In this way Japan seems almost to create a religious paradox, one which has considerably influenced the quality of the arts there, exalting them to the level of a concept of a beautiful absolute, unlike classical European arts, which are for the most part a technically accurate illustration of religious and temporal power.

Lastly, the so-called "minor" arts deserve special attention. Japanese craftsmanship often attains the quality of art on the strength of the purity of its form, the materials having been handled with the utmost skill, and the love for its intrinsic value linked not to the richness of the technical achievement but to its symbolism and its specific function. The Shosoin treasury, Nara, is made up of a large number of decorated lacquerware objects, bronzes, various tools in wood or ivory, ceramics for everyday use (although it seems unlikely those used for the mysterious, and mystical "tea ceremony" have been looked upon as simple objects in everyday use) and theatrical masks, which would need a whole article to themselves and have to be treated as genuine works of art, an art which did not resemble that of the West but which, in the nineteenth century, took Europe into a comprehensive renewal of forms and concepts, and which we can only fully understand now from a post-abstract standpoint.

Suzuki Harunobu (1725–70) Three women picking flowers. *Painting on paper. Japan, imperial collections.*

Origins of Japanese art

The first significant developments came in the Jomon period (up to 300 B.C.), which saw imperial power firmly established and the

government infrastructures taking proper shape. Then came the Yayoi (200 B.C.– A.D. 100), Yamato (A.D. 100–551), Asuka or Suiko (A.D. 552–646) and Kakuho (A.D. 647– 710) periods, which, together with the subsequent periods, were dated on the basis of information provided by the Institute of History at the University of Tokyo, which differs from the findings of many Western experts.

There are very few relics of art from the Palaeolithic age, and not many more from the Neolithic, which produced Ainu ware (the Ainu lived in Japan before the Japanese, who gradually forced them to occupy homelands in the north of the country), and three types of this ware exist: *atsude* (thick ware), *usude* (thin ware), and *Matsu* (from the name of a region in the north). As well as pots and dishes, there were a number of figurines (*dogu*) dressed in strange clothes and headgear that was rather like the modern astronaut's space-helmet, although what they represented or were used for is unclear. In the Aeneolithic period, beautiful bronze objects were cast in the shape of bells (*dotaku*) with simple geometric decorations. This was the era of the proto-Japanese, who could already turn pots on a lathe and polish semiprecious stones to an excellent finish,

especially for making jewellery.

A characteristic feature of the Jomon period were the great *kofun*, monumental burial mounds, like the imperial burial-places at Sakai (third to fourth century) and the magnificent tumulus of the Emperor Ojin at Kabikino (fifth century), which measured 419m (1,375ft) long by 36m (120ft) high on a platform area 700m (2,300ft) wide. The most important of all is the tumulus of the Emperor Nintoku (A.D. 290–399), possibly the largest burial-mound in the world: it stands on a level site about a 1km (half a mile) long, and consists of a mound of earth 486m (1,600ft) by 305m (1,000ft) and 35m (115ft) high. These *kofun* have produced great quantities of earthenware statuettes, called *haniwa*, the majority of which are of warriors and sumptuously dressed dignitaries.

The Asuka period saw the introduction into Japan not only of paper and the brush but also of the art of Korea and then that of China as concomitants of Buddhism; and the bronze Dancho caused the spread of the Chinese style of drawing. In 612, a Korean architect built for the Empress Suiko a royal palace that would remain the blueprint for successive buildings. Definitions were also reached for the typologies of temples, which were built of

Above: earthenware statuette (haniwa), portraying a court official (fifth-sixth century A.D.). Discovered during excavations by the authorities of Gunma province. National Museum, Tokyo.

Left: Ikaruga (Honshu island): interior of the Kondo, main building on the Horyu-ji site, with the statue of Shaka on a plinth, sculpted by Tori (607) and, in the foreground, one of the four Celestial Guardians (Shi tenno), from the same period.

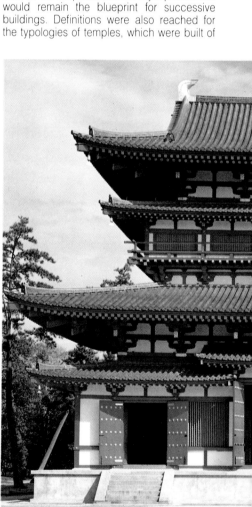

wood, a material used with admirable crafts-manship in Japan. These basic structures were perfected in the Nara period, and imitated up until the present day in more or less the same way. Features include cubit capitals (*hijiki*), the upper parts of which were decorated round the edges, columns made slightly convex in the shaft (*entasis*) and sculpted in relief, and balusters with a swastika motif (*manji-no koran*). The masterpiece of the period, Horiu-ji (*ji* in Japanese means temple) at Ikaruga, commissioned by Prince Shotoku, is a Buddhist site that displays an impressive harmony of design. It comprises about forty buildings, including the oldest wood structures to survive until our own time. There is a remarkable central doorway (*chumon*) flanked by two dry sand statues of the Nio Guardians, which are believed to be the oldest in Japan (A.D. 711). In the Kondo (Golden Pavilion) are statues made, between 607 and 623, by Tori Busshi, grandson of another great sculptor, Shiba Tatto, and founder of the Tori school.

A quite different style from that of the Tori school is the *Guze Kannon* (Buddha Avalo-kiteshvara) in decorated camphor wood. The undisputed masterpiece of seventh-century Japanese statuary is considered to be the

Above: detail of the Tenju Koku mandara (mandala of heavenly long life), embroidery dating from 622. Chugu-ji Museum, Ikaruga.

Below: exterior of the Kondo (Golden Pavilion) in the Yakushi-ji temple, Nara period, founded in 680 and reconstructed in the thirteenth century to house the statue of Yakushi Nyorai (the healing Buddha).

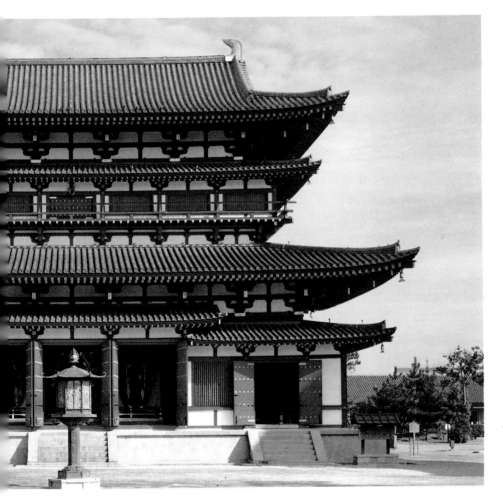

statue depicting *Nyorin Kannon Bosatsu*, kept in the Chugu-ji, also at Ikaruga. The Buddhist paintings of the period, too, to judge by what was left of them after the fire in 1949, are of importance, displaying marked traits of the Indian style, and are related to the Ajanta frescoes. The *Tenju Koku Mandala*, an embroidered woven cloth dating from 622 (Chugu-ji museum, Ikaruga), is beautifully made. At the same time Shintoist architecture was being perfected independently. It can be classified by four schools, or styles, all of which are linked by a common basic system: a clear example is the main room of the Naiku, in the Temple of Ise. Shinto structures, unlike Buddhist ones, which have tiles, are roofed with straw, tree-bark or planks (*kawara*).

Nara period (710–794)

In this period, Japan's proximity to the China of the Tang dynasty is crucial; and whereas the aristocracy is Buddhist, the organization of the state – as seen in the construction of roads, bridges and parks – is based on the dictates of Confucianism. Although a considerable degree of religious syncretism grew up, so that Buddhists and Shintoists had temples that they both used (*jingu-ji*), Buddhism prevailed; indeed, from A.D. 741 onward, the government had a state Buddhist temple (*kokubun-ji*) built in every region, and the monks from those temples became involved in political issues. Bureaucratization also affected art: ministerial departments were set up to look after artistic activities, and in 728 the state department for

the arts was opened. House design, too, came to be based on a common typology: constructed on a wooden stylobate of sorts, it has a visible cage-like frame, lightweight walls (*fusuma*) to standard dimensions, and roofs covered in straw or tiles, and was clearly meant to have an aesthetic function. An integral part of it is the garden, which is sometimes laid out like a Zen work of art, made up of symbolic elements — either natural (stones, raked gravel) or specially built (lanterns or bridges). The Nara Todai-ji, the work of the Chinese monk Ganjin, who belonged to the Buddhist Ritsu sect, is architecture of the first order. It is the largest wooden building in the world, second largest being the Daibutsu-den (or Kondo) dating from 747 or 751.

Another architectural masterpiece is the Shoso-in, or throne-room of Todai-ji, built by the *azekura* technique (which does not use nails), a feature that allows the structure to adapt to variations in atmospheric pressure. Also of importance is the Yume-dono (Pavilion of dreams), built in 739 to a design by Gyoshin. In the field of sculpture, the *Buddha Roshana*, executed in 752 by Kikimaro and described as the leading masterpiece of the period, was destroyed, leaving only its replica, the *Great Buddha of Nara* (*Miroku Bosatsu*), in the sanctuary of Shugu-ji. Sixteen meters (52ft) high and weighing 550 tons, it is nevertheless the largest bronze statue in the world. This period also sees the beginning of portraiture, and the oldest Japanese statue in this category — which was created using the special technique of dry lacquer (*kanshitsu*) — dating from about 750, is of the bonze and architect Gyoshin. Another important work of the kind is

the clay statue of Dosen Risshi, kept in the Yumedono pavilion, Ikagura. In painting, the series of frescoes of Horyu-ji (also burned in 1949) was continued: the typology was Chinese Buddhist, and the style linked to Indian Gupta art. The *Screen of Beauties Beneath the Tree* (Shoso-in) is important here. In the so-called minor arts, the masks in lacquered wood for Gigaku (a type of sacred dance) are remarkable. Other dances, too, which combined Chinese, shamanistic, Manchurian and indigenous elements, have "props" that are of fine artistic quality.

Heian period (794–1192)

With the disappearance of the great Tang dynasty in China, Japan increasingly withdrew from mainland influence and developed characteristics of its own. A Japanese alphabet came into being, and this later inspired the art of calligraphy, which was an exclusive product of that country; and rules and regulations took on a more markedly Shintoist stamp. While the Fujiwara family had the upper hand at Court and assumed the title of regent, Japan was divided by civil wars in which the two great clans of the Minamoto and the Taira opposed each other. In architecture, Shintoist typologies made their presence felt in the face of existing Chinese models. Monasteries were now no longer built on flat land but sited in the mountains, with alterations to their structure and particularly their aesthetic element. Private palaces (*shinden zukauai*) became sumptuous and grand, after the style of the Daidairi (imperial palace). On the other hand,

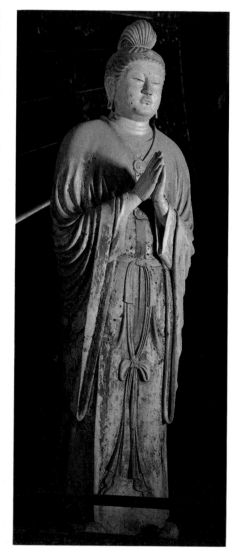

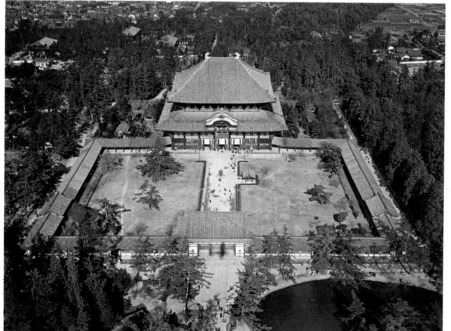

Above: the lunar Buddha (Gakko Bosatsu) in the Sangatsu-do area of the Todai-ji temple, Nara. Eighth century.

Left: a view of the Todai-ji temple, Nara, built by the Kengon sect from 735 onward. In the mid ground is the Daibutsu-den, or Kondo (Golden Pavilion), considered to be the most important wooden building in the world.

Opposite above: the Hoo-do (Pavilion of the Phoenix), on the Byodo-in site, Uji (Honshi island), built in 1053, and so called because the outline of its ground-plan and the projections of its roofs are in the shape of a phoenix.

Opposite below: a detail from the scrolls that contain illustrations for the Genji Monogatari (story of Genji), attributed to Fujiwara Takayoshi – it is likely that he was the main artist and the coordinator of the work. Tokugawa Reimeikai, Tokyo.

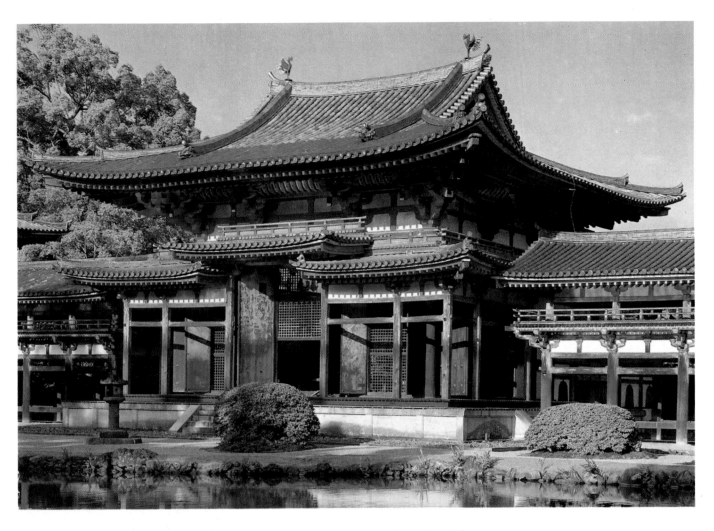

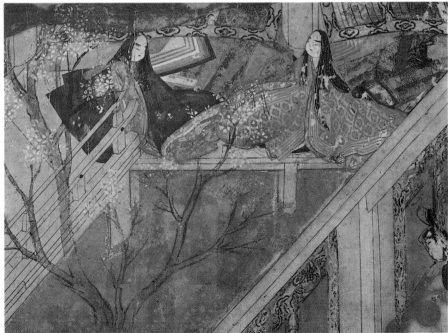

the Buddhist temples also conveyed a sense of wealth and pride, with highly decorated interiors, like the magnificent *Hall of Amida* on the Byodoin site, covered with mother-of-pearl inlays and coloured areas (*raden*); and the interior of the Amidado building in the Shuson-ji temple complex, decorated with gold leaf on a black lacquer background (*maki-e*). Typical examples of this ostentatious style are the temple of Kitano, Kyoto (947), and that of Itsushima (1169). At Heian large-scale religious sites were built on Mount Higashi-gama-e and Mount Hiei-gama before 950, and the Byodoin site at Uji in 1053. Japanese sculptors in this epoch started off by preferring to work with a single block of wood (*ichiboku-bori*), and their statues can be classified as having one of two styles: the *danzo*, with billowing drapery full of movement, and the *mikkyo*, which was enigmatic, magical, and aristocratic.

In painting, the influence of the Buddhist Shingon sect was the earliest dominant influence, producing numerous mandalas of a religious type, of which Kudara Kawanari (781–853) was a particular master. Little by

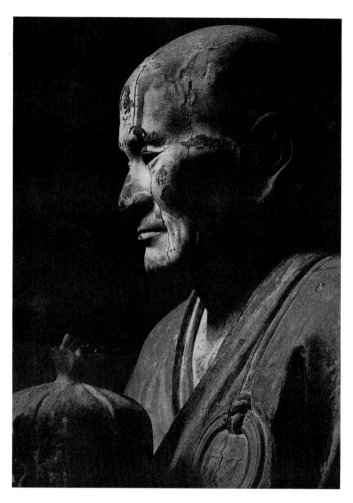

Left: sculpture in wood of the monk Mujaku, from the Buddhist Hosso sect, the work of Unkei (1148–1223), son of Kokei, a descendant of Jocho, and the founder of an important dynasty of sculptors. He invented a new naturalistic style that was in contrast to the forms of the Heian period; he worked mainly for the court of the Fujiwara family. Kokuho-kan, Kofuku-ji temple, Nara period.

The art of calligraphy, too – which, it has already been said, was wholly Japanese – found notable exponents in Ono-no Tofu (894–964), Fujiwara Sukenari (944–998) and Fujiwara Yukinari (972–1027).

Kamakura period (1192–1338)

In 1192 the Emperor of Japan transferred the Court to Kyoto, and appointed as *shogun* (military governor) Minamoto Yoritomo, who installed himself at Kamakura, where he instituted the caste of the samurai. Thus we have two centers of power: the imperial Court, producing a refined, emotive, cultivated kind of art; and the effective power of the military, who favoured a practical, ethical art based on Zen Buddhism and who were potentially closer to the masses, though they themselves were still not allowed to participate in these concerns.

In architecture, various styles were beginning to flourish at the same time. The Todai-ji

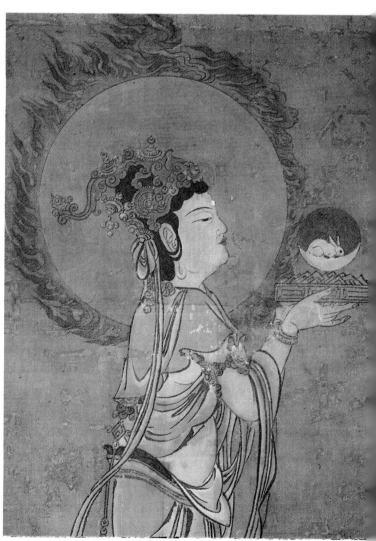

little, the Chinese style – in which Takura Tamenari excelled – was abandoned, and in 808, a sort of State Academy (Edokoro) was founded which lasted until the Meiji period, and a form of portraiture was initiated that consisted exclusively of Japanese elements. The first indigenous school of Japanese painting, the Kose-ryu, was founded by Kose Kanaoka (850–931), and very soon a wide variety of subjects, styles and schools emerged. The "dilettanti" of the noble Fujiwara family developed, through the Kasuga-ryu school, a native style known as *yamato-e* (meaning Japanese work). in 1175 Fujiwara Tsunetaka, whose artist name was Tosa, began the great traditional school of Tosa-ryu. Painting found its way on to the walls of houses, on to furniture, clothes, screens, and fans, employing a whole range of techniques on silk (*kini-e*), paper (*kami-e*), lacquerware, horizontal scrolls (*emakimono*), which were collected by the intellectually inclined as a hobby and were a source of private enjoyment; and vertical scrolls (*kakemono*), which could also lend themselves to being hung for a time on the wall in a house. Of all the great works produced in this epoch, the masterpiece is an *emakimono* showing the *Story of Genji* (*Genji-monogatari*).

Right: detail of the Juniten Byobu (the Twelve Deva), painted on silk in 1191 by Takuma Shoga, the painter who introduced into Japan the style of Chinese works of art from the Sung epoch. The panels depicting the Twelve Deva, mounted on two screens, are kept in the Kyo Ogokoku-ji (also called To-ji) in the Minami-ku district of Kyoto.

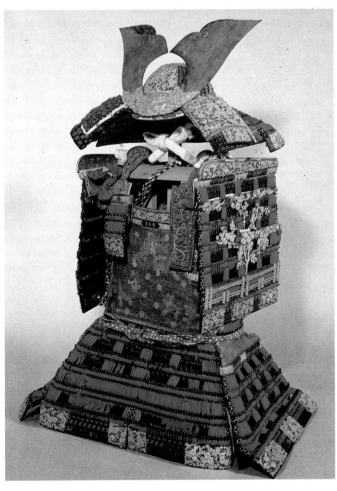

Left: a nobleman's armour of the mohegi nihohi-no yorohi *type, with strips of metal lacquered and joined together by* agemaki; *and a helmet of the* kobuto *type, surmounted by two ample* kabuto-no wakitade *in the* kuwagata *style, representing the coat-of-arms (*mon*) of the nobleman. This sort of armour, which was the personal choice of Hideyoshi toward the end of his governorship and prescribed by him, had numerous variants.*

exponent of this type. More important was the new school linked to the Zen sect, whose painters mostly specialized in portraiture. The painters Sonchi (1207–1224) and Hata Chitei, on the other hand, preferred an outmoded academic traditional style; in 1219 Hata Chitei accomplished a vast series of "histories," known to us through the copies of them that were made in the Edo period, in the Edono of Horyu-ji, Ikagura. The scrolls depicting the epic struggles between the Minamoto and Taira clans are clearly in the samurai manner, as is the famous scroll of Chojo Sonshi-ji, from the Nara period.

It was at this point that the martial arts inspired works whose aesthetic value goes beyond that of a straightforward creation of weapons and armour by craftsmen. Even a sword-blade (*katana*) – devised in accordance with a complex religious ritual, but also with a genuine emotive element to it – could be regarded as a work of art. In addition to Okazaki Masamune (1264–1344), a very distinguished armourer, mention should be made

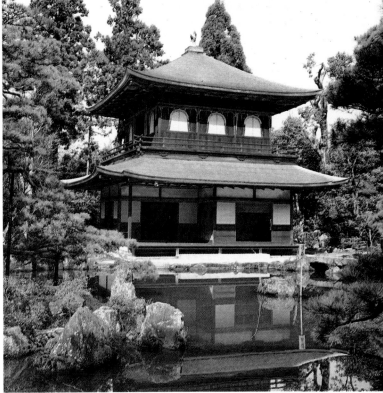

temple was reconstructed in the so-called "Indian" style (*tenjiku-yo*), which had come from China, in which large wooden beams were employed to elegant effect. The Kennin-ji (1202) and – a monument of rare perfection – the Kencho-ji (1253), were built at Kamakura in the style known as "mainland" (*kara-yo*), or Chinese, the principal style of the Zen sect. In the capital, the Court commissioned (1253) the building of the Nishi-Hongan-ji temple, which possesses a beautiful refinement of form.

This can be defined as the last period of great sculpture, with wooden statues of extraordinary vigour and realism. Decorations and ornaments in metal, and eyes of crystal or jade entered into common use, though this in no way diminished the grandeur of the general design. In the fairly formal portraits, a genre in which Jokei and Kaikei distinguished themselves, Chinese Song art exercised a noticeable influence. The sculptor Unkei, who, as we have already seen, was active at the end of the Heian period, organized a new school out of which came the sculptures of Kofuku-ji and Todai-ji. A celebrated work of this period, even though it is perhaps not the best, is the great bronze Buddha of Kamakura, sculpted in 1252.

Right: the Pavilion of Silver on the site of the Ginkaku-ji (or Jisho-ji), the temple located in the Sakyo-ku quarter of Kyoto. Commissioned by Ashikaga Yoshimasa between 1479 and 1482 as a summer residence, and transformed, after his death, into a Zen Buddhist temple, it is distinctive for its exemplary elegance and simplicity when compared with other buildings of the same period. In the original design, it was supposed to have been covered with sheets of silver, hence the name.

The various styles in painting adopted the ideal forms taught by the various esoteric Buddhist sects. Painters of the Jodo, Kegon and Mikkyo sects were freer in approach; whereas more formal work was produced by those belonging to the esoteric sects of Tendai and Shingon, using a more traditional iconography that was systematically applied – Takuma Shoga (active in 1191) was a noted

of Munesuke (who was active between 1142 and 1200) – he was the first of a famous family who flourished in Kyoto for twenty-two generations (thirteenth to eighteenth centuries). The most important works would perhaps include the decorations for swords, and notably the hilts (*tsuba*), which demonstrate a high level of artistry in terms of form. From 1299 onward, the production of ceramic art was also started.

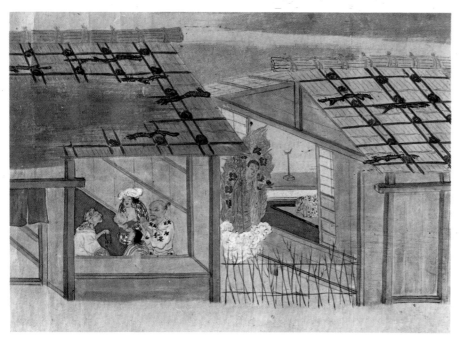

dant and tedious on account of the frequency of over-decoration. One remarkable feature is the landscaping of gardens in accordance with the abstract ideas of Zen.

Sculpture too persisted with the preceding styles, and was for the most part devoid of meaning, although some works had a definite vigour. At the beginning of the period, there are still some good works by Kankei, Junkei and Kozen, but overall the masks made of lacquered wood for No plays establish their own characteristic and effective styles.

The achievements in painting, on the other hand, were notable – it had many styles and a variety of subjects, and the most interesting works were those by Zen monks, among whom mention must be made of the bonze Sesshu (1421–1507), who studied in China for six years, founded the Unkoku-ryu school (named after the Unkoku Temple in which he lived), and won great renown, particularly for his spacious landscapes done in ink. Other important schools were those of Mincho, known as Cho Densu (c. 1353–1431); of the Chinese Josetsu Taiko, who was active in Japan from 1370 onward; and of his pupil Shubun Tensho,

Muromachi period (1338–1573)

In 1338, the new shoguns, the Ashikaga, established themselves at Heian, in the suburbs of Muromachi, and while the country was gripped by conflict and anarchy in a continual civil war, they developed an elegant art of great style linked to the military class. Imperial power, on the other hand, centered on Kyoto, declined, and the resulting diaspora of artists from the Court spread the love of classical beauty throughout the land. In 1404, contacts and commercial links with China were renewed, first with the Yuan emperors, who favoured a rough and energetic art, and then with the Ming emperors, whose art was noble and elegant.

In the field of civil architecture, the features of the period were the typically Japanese shoin-zukuri style; the development of the No theater by Yuzaki Kiyotsugu (1333–84); the delicate art of flower-arranging (ikebana); and the tea ceremony (chano-yu), which required, and therefore evolved, new forms of ceramics. In general, Zen ideas, with the emphasis on bushido (the "way of the warrior," a sort of code of honour and conduct of the samurai), regulated much of artistic expression. A further innovation in form derived from contacts with traders and subsequently with Portuguese and Spanish missionaries; and the introduction of Catholicism was predominantly due to the preaching of Francesco Saverio there in 1549.

The architecture in this period – with the exception of the prestigious masterpiece known as the Temple of Silver (Gingaku-ji) built at the request of Ashikaga Yoshimasa in 1473 – is a straightforward imitation of previous models. Civil building is synthetic and basic, while religious architecture becomes redun-

Above: detail of the Seikoji Engi emakimono (Story of the monastery of Seiko, 1487), the work of Mitsunobu (1434–1522). Mitsunobu was the head of the edokoro of the imperial Court from 1469 onward, and after the death of Tosa Hirochita, his predecessor, he also became the leading light of the shogun's painters. He enjoyed a considerable reputation, and was even awarded the status of a nobleman – a rare occurrence in those days – even though in fact he was not the most important painter of the period. The work illustrated here is in the Yamato-e style, but obviously adhering, too, to the more complex and descriptive kara-e style imitative of the Chinese manner. His best pupil was his son Mitsumori, who carried on his father's idioms, especially the emakimono with their stories about monasteries.

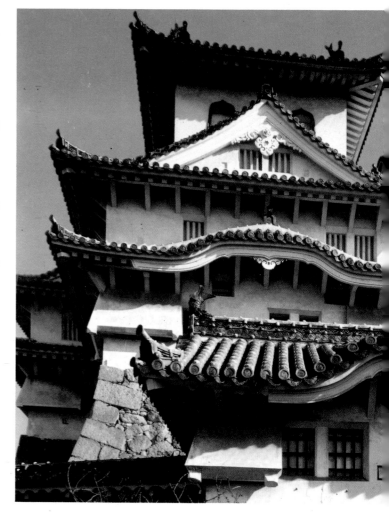

who was a competent landscape artist. Kano Masanobu (1434–1530), their disciple, a secular painter of great vitality, originated a "worldly" type of school, whose most valid products were Montonobu (1476–1559) and Yukinobu (1513–75). The balanced, realistic, Chinese-inspired art of the Kano school naturally appealed to the dominant military class, and as a result gained a considerable following. Traditional painting, by contrast, was pursued by the Tosa family, now raised to the nobility through the gift of a feudal domain (c. 1520).

The importance acquired by the tea ceremony led to a demand for increasingly elegant utensils, and the work of Shonzui Gorodayu marked the beginning of a magnificent period for artistic porcelain. After studying in China, this artist founded a factory of great importance at Arita, on the island of Kyushu (1513).

Azuchi-Momoyama period (1573-1600)

The shogun Toyotomo Hideyoshi (1536–98), a political figure of great prominence, brought

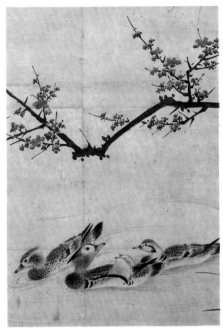

Above: detail of a work by Kano Eitoku (1543–90), worked on a fusuma *(sliding wall) in Daitoku-ji, a Buddhist monastery of the Rinzai sect in the Kitako-ku district of Kyoto. Numerous artists of the Kano school decorated the* fusuma *in this temple. Eitoku distinguished himself by completely decorating the castles of Oda Nabunaga at Azuchi and Toyotomi Hideyoshi in Osaka, an achievement that caused his contemporaries to marvel; however, no trace of these works has survived.*

Left: the honmaru *of the castle of Himeji (Honshu island), one of the most complete and picturesque of its kind in Japan. Built at the request of Toyotomi Hideyoshi from 1577 onward on the site of an earlier castle (Himeyama), it was considerably enlarged by Ikeda Terumasa (1564–1623), son-in-law of Tokugawa Ieyasu.*

unity to the country by putting an end to the civil wars then raging, and the disputes between the major families, and founding a feudal system that involved wide-ranging social change. Trade at home was intensified, this having the effect of giving the middle class a stable prosperity; the influence of Shintoism proved stronger than that of socio-religious apports from other countries, and subsequently stressed the priority of indigenous values. In the same way, Catholicism, which had attempted to participate in the affairs of state, was pronounced as undesirable; then, in 1587, those priests who, despite the ban, were still politically active, were expelled; and finally, in 1597, Catholics who continued to carry out acts of espionage on behalf of China or in support of dissident Japanese factions – especially by selling guns – were executed in Nagasaki. Taken as a whole, there is a general feeling of a movement toward refinement in cultural life.

In architecture, which was characterized by a frenetic amount of building, although the preceding typologies were still being used without further innovations of any kind whatsoever, the castles played a significant role: they had complex fortifications, well-protected entrances, and passageways that were under guard from the point of entry right through to the heart of the castle, where the principal palace (*honmaru*) of the prince (*daimyo*) would be, and, next to it, a high tower of several storeys which sloped down in tiers, a symbol of power. Toyotomi Hideyoshi commissioned the building of the castle of Himeji (1577) – possibly the finest, and certainly the most picturesque, with its series of curved roofs and the splendid bearing of the *honmaru* – the castle of Osaka (1583) and the castle of Momoyama (1594).

Sculpture kept pedantically to traditional lines, especially in portraiture, and the only work of any importance is perhaps the Altar of Itsukushima, dating from the sixteenth century. The sculptor Mitsuteru founded the Echizen-dene school for the production of No masks, and from this a number of subsidiary schools and off-shoots developed. As far as can be gathered from what has come down to us, there was a wealth of impressive, sharp-looking decorative painting on the walls of the big castles, and backgrounds in gold leaf were plentiful. The screens and *fusuma* that have survived indicate a considerable quality of decoration. The Kano family, who were anchored to traditional styles, had as its main representatives Eitoku (1543–90), who painted frescoes in the imperial palace in Kyoto, Mitsunobu, Sanraku (1559–1635), Sadanobu and Tanyu. The Tosa family faded into the background, and, after the death of Mitsumoto (1569), lapsed almost completely. Then came the turn of the Mitsuyoshi family, which won distinction through Kaiho Togan (1533–1615), Hasegawa Tohaku (1539–1610), Unkoku Togan (1547–1618) and Soga

Chokuan (c. 1614).

The so-called minor arts produced some sumptuous results: lacquerware, silverware, weapons and especially mirrors, of which Ao Ietsugu and Kisetsu Joami (who died in 1618) were excellent exponents. Ceramics developed considerably. Fine ware from the kilns of Seto continued; new kilns were opened at Shino and Oribe, and these created the conditions for production to be geared to a purely Japanese technique, the *raku* (named after the potter Raku Chojiro, who worked in Kyoto), in which Honnami Koetsu (1558–1637) distinguished himself. Korean influence led to the development at Arita of the valuable and very delicate Imari porcelain.

Opposite: investiture procession in Kyoto. A panel painted and lacquered by Kano Eitoku, 1543–90. Uesugi collection, Yamagata.

Below: Snow-covered Landscape, a wood-cut by Ando Tokarito, known as Hiroshige (1797–1858), leading exponent of the ukiyo-e

landscape-painting, in which the strength, beauty and reality of nature are blended in with scenes of the industriousness of man and of essentially popular Japanese culture. Hiroshige's engravings were highly regarded in Europe, too, and were even copied in oils by Vincent Van Gogh.

Tokugawa or Edo period (1603–1867)

After taking over the authority of the shogun, Tokugawa Ieyasu rebuilt the castle of Edo (1606) and settled there, thus establishing the new seat of power, from that point onward in opposition to the Court of Kyoto. He structured the government along Confucian lines, limited the autonomy of the princes (*daimyo*), made room for Japanese traders and entrepreneurs so that new cities might grow up or the old ones realize their potential. A middle-class culture, centered on the city of Osaka, developed alongside those of the imperial court and the military aristocracy. Japan closed its doors to foreigners, and so the local factories and businesses evolved considerably. Ieyasu's system of government thus generated a new prosperity, and the arts experienced a revival on the strength of it, with a progressive flourishing of a vital, popular culture. Buddhism and Confucianism, which had strict moralistic rules, lost their appeal in the face of a middle class (*chonin*) that was happy and carefree, and which described itself as living a "floating" and "transitory" – in the sense of "worldly" – existence (*ukiyo*).

The new direction of the age can be seen from Yoshiwara (pleasure district) and Sakae-cho (street of theaters) in Yedo; Shinmachi in

Osaka, and in Kyoto Shimbara, which, like Yoshiwara, offers tea houses and brothels, but more particularly rendezvous where elegant, cultured geishas (women who provide pleasant conversation and are not prostitutes, as they have been wrongly described on a number of occasions) dispense pleasure and love, culture and music. Courtesans and actors carried garishly coloured fans, which were illustrated with portraits of their idols – painted or wood-engraved – and which led to the rise of a popular school, the *ukiyo-e*.

Between 1609 and 1613, Dutch and British visitors were accommodated at Hirado, on the island of Kyushu, and only from this trade center were they able to have contact with the rest of Japan. In 1622, more Catholics were executed, for having helped some *daimyo* who were in dispute with the shogun, and foreigners were confined to Deshima (Nagasaki). This almost total closing-off of Japan to external influences further developed Japanese enterprises and markets, and between 1688 and 1703 there was a period of great magnificence, known as the "Genroku" period. But at the end of it, a progressive decline slowly set in; the noble families who were at loggerheads with one another caused the impoverishment of businesses; hunger and destruction followed, culminating in 1867

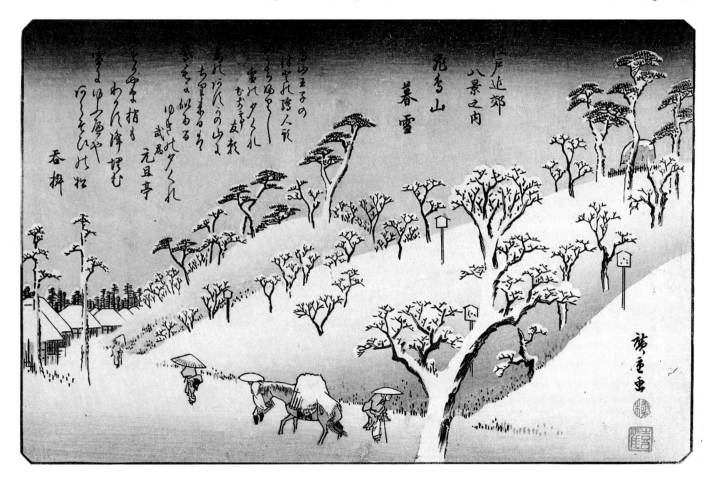

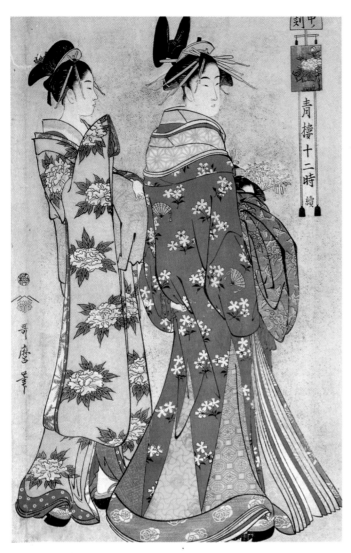

Left: a wood-cut from the series Twelve Hours in a Tea House by Kitagawa Utamaro (1753–1806), the most complete exponent of the Ukiyo-e genre. Initially an interpreter of female beauty in the footsteps of Torii Kiyonaga, with whom he subsequently came into conflict, he later ranged from illustrations of the natural beauties of Japan to scenes from history, and from theater to everyday life, using a very great variety of techniques and invention which had an influence on all future wood-engraving, not only in Japan but in the West as well.

Right: the Kara Mon door, after the Chinese manner, in the Tosho-gu of Nikko, the important sanctuary built by Tokugawa Ieyasu (1542–1616) using more than a thousand artisans, who had been hand-picked from all over Japan. This door, the last and the most private in the whole complex, leads through to the two sacred pavilions of Haiden and Hon-den, where artistic masterpieces of the period and statues of Ieyasu, Hideyoshi and Yoritomo are kept.

Opposite far right: a kakiemon ceramic plate. Freer Gallery of Art, Washington.

Itcho (1652–1724) and Miyagawa Choshun (1682–1752).

A particularly impressive aspect of Ukiyo-e was its multicoloured wood-engravings of geishas and actors of great renown, scenes from popular plays like *Chushingura* or *The Story of the Forty Ronin*, and, lastly, its fine panoramas, typical Japanese landscapes, and illustrations of heroic deeds or popular festivities. Among the earliest wood-engravers of this school were Kaigetsudo Doshin and Kiyonobu Torii (1664–1729), whose work was marked by a sobriety of colours and subjects. The possibilities of the technique of wood-engraving were fully exploited by Suzuki Haronobu (1725–70), who was the founder of an entrepreneurial type of organization, consisting of a larger number of craftsmen who engraved wooden tables with original designs by Haronobu himself (a single block could cover as many as twenty colour runs, and therefore be used for twenty applications on wood) and printers of exceptional skill.

The leading exponents of Ukiyo-e were Kitagawa Utamaro (1753–1806), Katsushika

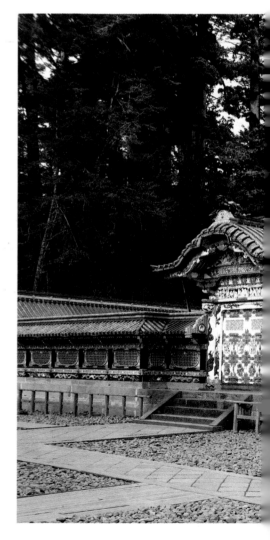

in the end of the Tokugawa family.

The most important architect of the Edo period was Kabori Enshu (1579–1647), who designed the Katsura palace (Kyoto), a splendid example of civic art. The *Toshugu Mausoleum* of Ieyasu at Nikko (1636), in which the structural-decorative aspect is astonishingly complex, was the first Shintoist commemorative temple; however, there was very little else that was new apart from these examples, and instead buildings from previous times were restored or reproduced without any fresh qualities.

There were very few innovations in the field of sculpture, either: outside the religious sphere, it produced some well-crafted secular pieces, but lacked any significant new ideas. Painting and wood-engraving, on the other hand, made considerable advances along a number of different routes depending on the taste of the various patrons: the imperial Court, the Court of the Shogun, the religious (who favoured in particular Zen painting, tending toward the abstract, and the related calli-

graphy of the Oie school), the military, merchants and men of letters.

The Kano family, a branch of the Tosa, continued in the tradition of Yamato-e, especially in the person of Tarawaya Sotatsu (active in 1630), and later achieved remarkable works, which were an expression of admirable completeness, through Ogata Korin (1658–1716).

Other new styles remained in line with the principal Confucian precepts contained in the Shogun's manifesto of government, like Matuyama-Shijo, Nan-Pin, and Nanso-ga, begun by Sakaki Hyakusen (1697–1752) and brought to great fame by Ike-no Taiga (1723–76); but the most effective, surprisingly innovative, popular, fresh and colourful style was the Ukiyo-e, producing art which was, as we have already said, responsible for a general reawakening even of the arts in Europe starting with Impressionism.

The most competent early painters working in this new way of conceiving art freely were Ishikawa Moronobu (1618–94), Hanabusa

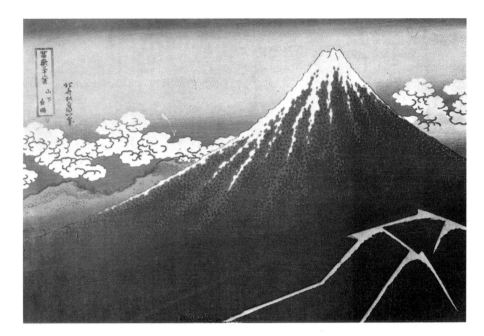

Hokusai (1760–1849) and Ando Hiroshige (1797–1858), to whom should be added the names of Toshusai Sharaku, who specialized in portraits of actors, and Utagawa Toyokuni (1769–1825). Every one of these artists had numerous disciples and imitators, and Japanese wood-engravings circulated over a very wide area, winning considerable admiration throughout Japan but also beyond, and even today they can be seen as one of the finest expressions in art of all time.

In the art of metallurgy, and in particular in the manufacture of weapons and armour, the merits and types from previous periods remained unaltered, though the designs became increasingly exaggerated, with the result that by the end of the eighteenth century the items were excessively weighty, spectacular and "baroque." The artists belonged mainly to the three great families of Umetada, Shoami and Goto, the last of which produced the most prestigious artist of the period, Gokoya Somin (1670–1733). Another unique aspect of Japanese art was the *inro*: these were small boxes (like pillboxes), with a variety of contain-

Top: View of Mount Fuji During a Storm, *a woodcut by Katsushika Hokusai (1760–1849). Hokusai is perhaps the most important, the best-known, and certainly the most astonishing painter of ukiyo-e. He studied with the leading artists of the day, and during his very long career he adopted at least fifty* pseudonyms, moved house more than ninety times, and executed paintings over a vast range, from 30m (100ft) high to very small indeed. His fifteen-volume drawing manual, Manga, *is a significant and substantial collection of wood-engraved quick sketches which was* consulted by all of the Impressionist and Post-Impressionist painters. In it he dealt with the portrayal of beautiful women and of famous theater actors, the illustrating of the novels of Bakin (1767–1848), views from nature, and classical subjects of China and Japan. Author's collection.

ers, fastened by a cord. Extraordinary skill was employed in the making of them, and they also showed great good taste, a refined artistic sense, and a remarkable range of techniques. The fastener for the cord of the *inro* was a tiny object, known as a *netsuke* (meaning an ornamental button for suspending a pouch, for example), and this acted as a counterweight once the cord had been threaded through the wearer's belt. A *netsuke* would have been made of wood, ivory, metals of different kinds or lacquerware, and was often a miniature masterpiece of sculpture.

Ceramics, too, perpetuated the great traditions of the previous age, and from 1644 onward the kilns at Arita – whose greatest exponent was Sakaida Kakiemon, creator of the *aka-e* style – earned special distinction, as did the kilns at Imari, noted for the refinement of their ware; those at Kutani; and those at Seto which, on the strength of the work of Kato Tamikichi (1772–1824) became, at the end of the eighteenth century, the most important for their achievement of artistic form and quality. Artists who worked virtually independently were Nonomura Ninsei (1598–1666), Ogata Kenzan (1663–1743), and Shimizu Rokubei, who in 1759 devised a new type of ceramic-ware in which the technique and colour used were new, and which takes its name from the artist (*rokubei-e*).

Kenzo Okada, Over the white (1960). Peggy Guggenheim collection, Venice. The great quality of the lay-out of Japanese painters Hokusai, Utamaro and Hiroshige, whose works were to upset the compositional concept in European art and give rise to that major reawakening which, starting with Impressionism and reaching a pinnacle in the Post-Impressionist works of Gauguin, Van Gogh and Toulouse-Lautrec, paved the way to Abstract art, grew out of a long zen tradition in Japanese painting of the spirit. All the more reason, therefore, why the innovations in composition, focusing on the symbol pure and simple and on areas of colour, should be a feature of contemporary Japanese art, which so abounds in those examples and values. Okada comes from a family of celebrated nineteenth-century painters and his works do communicate a perfect relationship between Western monumentality and the Japanese sense of the poetic.

Meiji (1868–1912), Taisho and Showa (1912–45) periods

This was a time of great political and cultural change for Japan, during a transition from a feudal age to one of alignment with the great industrial powers of the West. The policy of Westernization gradually led to the ultimate decline of traditional arts and the introduction *en masse* of the main features of post-Modernism. After the abolition of the authority of the shogun and the centralization of power in the new capital, Tokyo (1868), the first course in Western painting was established in that city (1876); and in 1877, the architect Joseph Conder introduced the teaching of American architectural aesthetics.

In the face of the rapid decline of Japanese sculpture, especially Shintoist sculpture, the Italian sculptor Vincenzo Ragusa (1841–1928) initiated the National School of Fine Arts in Koben into European ways. In 1888 the Tokyo School of the Arts was founded, with some teachers there holding to Japanese tradition and others favouring Western models. At the First National Art Exhibition in Tokyo (1907), these two trends came face to face, each being represented by numerous valid examples of that particular genre. At the same time, Japanese art in its turn had penetrated Europe, and

given rise to an artistic renewal that was an inspiration not only to Impressionism and Post-Impressionism, as we have already said, but also to Modernism, with all the consequences of that. At the International Exhibitions in Vienna (1873) and Paris (1900), the decorative arts of Japan were admired beyond measure, in response to which large-scale industries were put into production, in the Land of the Rising Sun, for the manufacture of ceramics, textiles, lacquerware and metallic-ware. Japanese architects (Hayashi, Chujo, and Shimizee Kisuke II) soon adapted to Western ideas; and others studied and worked abroad (Tasumaki Yoriki, Watanabe Yuzuru, and Kawai Kozo). Architects from the West moved to Japan in the early years of the twentieth century. A significant result of this process of Westernization was the great Akasaka Palace in Tokyo. The economic surge and the phenomenon of capitalism, which both emerged after the Sino-Japanese and Soviet-Japanese wars, provided the incentive for building and town-planning along European lines, particular attention being given to earthquake-resistant structures.

After the Second World War, a further alignment with the West took place in Japan across the board in the social and artistic spheres. In accord with the complete uprooting of traditions (in 1947 the right to vote was finally granted to women, followed by the freedom of abortion in 1948) and the progressive strengthening of national economic institutions, Japan, in the company of her own artists (Maede Sesson, Yokogama Taikan, and many others) was able to participate in the international art market both in Europe and in the United States. However, some painters of great quality championed a return to a nationalistic art, appropriately embodying both Japanese and Western techniques. There are Japanese painters (Fujita and Hasegawa) who have an indisputable place in the history of French art; but above all, the situation is one of Japanese painters as exponents of international avant-garde movements in the field of abstract art. In abstract painting, particularly as far as the art of "the symbol and the gesture" is concerned, Japan established an international platform for the Zen concepts of empty space (*sunija*), emptiness (*sunijata*), spontaneous action (*kotzu*), and the essential quality of the simple (*wabi*); and while Michaux, Tobey and Alechinsky were studying the revival of gesture in Japan, Japanese painters were working in the West (Domoto, Imai, Onishi, Murakami, Sugai and Suematsu in France, Okada, Ohasi, Yamaguchi and Nishida in the United States, and Mohri in Italy).

The international artistic importance of contemporary Japanese art can also be seen in art films (*Kagemusha*, by Akiro Kurosawa, was a prizewinner at Cannes in 1980) and from the large quantity of short cartoon films shown on all the international television networks.

Pre-Columbian art

North and South America were not yet in-habited during the period that saw the Neolithic cultures developing steadily in Asia and Europe. Man reached the Americas from Asia about 25,000 years ago, and the first immigrants were Mongolian peoples. A formed, settled civilization did not appear here until 3,500 years ago – and then it was almost a sudden occurrence – in two specific areas, Middle America and the Andes. The great plains of North America and the extensive South American watersheds, on the other hand, supported lesser cultures, as well as forms of nomadic art that were perhaps more enduring but not as committed.

The origin of the Mesoamerican and Andean civilizations still poses a number of problems for scholars, especially if analogies between the great pyramids and hieroglyph-writers of America and those of Egypt and Indo-China are taken into account. The causes of their disappearance, however, are clear: violent suppression, a tyranny of bloodshed and incomprehension, and the systematic de-struction of priceless works of art, all perpe-trated by the Spanish and Portuguese *con-quistadores* in the name of the Most Christian kings; enforced religious conversions, ruthless campaigns of genocide, executions, and a conspiracy of silence that was kept up into the nineteenth century.

The fact that there are archeological sites in great abundance, and that the materials used for the many works of art were non-perishable, make it possible now to reconstruct this period of history with accuracy. Even though all too much has been lost, the historical loose threads have been re-tied and the influences to some extent traced; this has been possible in spite of the fact that what we are left with from those supremely rich, complex and highly distinguished civilizations after subtracting all that has been destroyed, in particular the jewellery and gold sculptures, is sometimes only a shadow of what they were like.

The reason why it is difficult to acquire a good knowledge of pre-Columbian art is that it was divided up among a large number of cultures; on the other hand, the history of European art, too, would run the risk of being obscured in any description of individual hap-penings in the artistic life of the different countries within Europe if these happenings had not been linked by the stylistic elements they had in common. In the case of the Amerindian cultures, these connecting ele-ments are: the expression of tribal identities; the use of a work of art for religious rituals; and the anonymity of many of the technical and artistic forms, whereby every work has the effect of bearing witness to a social grouping rather than to an individual talent. Added to that, none of the Amerindian nations knew of

iron or the potter's wheel; however, their ceramic-ware, shaped by hand and possibly only made by women, is of the highest level of achievement. Women were also entrusted with weaving and featherwork mosaic.

In the most ancient time, a slowly evolving era that came to an end in the first century A.D., the emergent civilizations were the Olmec in Veracruz and the Tabasco in the region of the same name; it also witnessed the earliest stages of the Maya civilization in Guatemala and Yucatan, the first example of ritual worship in the central Andes or indeed in South Ameri-ca, and the flowering of the Chavin civilization to its fullest extent.

The classical period dates from about A.D. 100 to 800. It was the apogee of the civilization of Teotihuacan, the time which saw the de-velopment of the pyramids, wall painting and pottery, a process destined to continue until the eleventh century. From A.D. 500 onward, the distinctive styles of the Maya took shape in Guatemala, Mexico and Honduras, possibly originating in Tikal, the city of many pyramids. The elegant Paracas, Nazca and Mochica civilizations developed in the Andes during that time, too.

The third stage, known as the post-classical period, witnessed a series of upheavals after A.D. 800 which were a consequence of shifts among nomadic populations on a large scale. Many Mesoamerican centers, like Teoti-huacan, were destroyed, and religious au-thorities were replaced by the warrior caste. Then came the harsher and more austere Mixtec and Toltec civilizations, and ritual sac-rifice took over everywhere. In South America,

the new art of Tiahuanaco, for all its austerity, showed a remarkable splendour of geometric and colour combinations. Finally, there was the art of the Incas, with their gigantic structures and the stark, majestic refinement of their fortresses, which brought the fortunes of pre-Columbian art to an end between the fifteenth and sixteenth centuries.

Mesoamerica

The pre-classical civilizations (1500–1100 B.C.)

The earliest sedentary settlements, which had a well-developed capacity for cultivating maize, arose between 1500 and 1100 B.C. (the period of ancient pre-classical civilization). The evidence consists of the Mexican sites of Arbolillo, Tlatilco and Zacatenco, whose earthenware statuettes, vaguely resembling Japan-

Right: small male earthenware figure, with beehive hairstyle and mask, possibly a wizard. Pre-classical Tlatilco civilization, middle phase. Private collection, Mexico.

Left: it was at Cuicuilco that the first Mesoamerican stone pyramid was built. Pre-classical civilization of Cuicuilco. Terracotta pot with illustration of the god of fire. Private collection, Mexico.

Below: seated male figure in terracotta. Pre-classical Olmec civilization, last phase of Tlatilco. Feuchtwanger collection, Mexico.

zation (600–100 B.C.), the urban centers that had grown up in the preceding centuries were in continual expansion. By this time, there was a very clear class structure, within which divisions of labour were laid down; there was also an advance in technology, which may have been prompted by the early stages of drought – methods of cultivation had to be modified and new tools introduced and perfected. The art, which nevertheless seems to have merged with that of the neighbouring Olmecs and Toltecs, concentrated almost exclusively on religious representations, for which a powerful priest-class set the guidelines.

The architecture that emerged at this time was religious, not yet planned as such but magnificent all the same. The earliest temples were built on platform bases, later to evolve into a series of superimposed layers that ended up looking like a pyramid with its top cut off, a combination of a stepped Egyptian pyramid and an Indonesian temple. The pyramid of Tlacapoya is a remarkable one, its structure anticipating that of Teotihuacan.

Olmec civilization, also known as La Venta (800 B.C.–A.D. 800)

The development of the Mesoamerican culture was influenced to a large extent by a number of tribes, whose religion was totemism, coming into Mexico, Guatemala and El Salvador, and settling in rubber country (the local word being *hule*, from which the name Hulmecs is derived). They used to worship the jaguar, fire and the dead, and evolved an art-form called "the feral style" on account of its use of claws,

ese *haniwa*, and beautiful pottery can be linked to their fertility cult. It is more than likely that the statuettes found beside the dead in their sumptuous burial-places – the oldest in pre-Columbian civilization as a whole – fulfilled the same purpose as the *kha* in ancient Egypt.

The period of middle pre-classical civilization, which runs into that of pre-classical Olmec civilization, lasted from 1100 to 600 B.C. The materials used then were valuable ones, the area concerned being rich in semiprecious stones like jade, ophite and haematite. Realistic early stone animal sculptures appeared. The decoration drew on stylized symbols, graphically well put together. Dragons of the

Chinese variety were put side by side, bizarre though this may seem, with the Olmec jaguar, indicating a development in religion from fertility rituals to an increasingly complex pantheon of mythology. The culmination of this was a dualistic basic idea, involving the struggle between earth and sky, good and evil, day and night, alluded to by various different symbols and deities. Pottery, especially at Tlatilco, with its local antecedents, became enriched by the development of sharply delineated types of ware, with representations of the human form, the dimensions of which were balanced and impressive.

During the period of late pre-classical civili-

Left: warrior with helmet, cloak, lance and ornaments. Ocher terracotta from Ixtlan, Nayarit. Pacific Coast civilization. Olmedo de Olvera collection. Mexico.

Right: model of small house. Terracotta from Ixtlan, Nayarit. Pacific Coast civilization. Olmedo de Olvera collection, Mexico.

Below: male figure, in stone, from Santa Maria Uxpanapan, Olmec civilization. Mexico National Museum of Anthropology.

fangs and the recurrent motif of the jaguar, all of which is not dissimilar to the art found in the steppes of Central Asia. They established a number of centers, at La Venta (the biggest), Los Tuxlas, Morelos, Puebla, Guerrero, Tres Zapotes and Oaxaca, each of which has its own stylistic differences. The Olmecs worked out a pictographic form of writing, an arithmetical system and a calendar with a solar year for a secular use and a lunar one to meet the requirements of religion. This is how it has been possible to date the oldest Mesoamerican sculptures. There is no doubt that the Olmec civilization gave rise to those of the Maya, El Tajin and Teotihuacan.

Architectural remains are few and far between, possibly because in the great plains of Papaloapan and Grijalva, good building materials were not to be had. On the other hand, many pieces of sculpture have survived, from imposing statues and large bas-reliefs to small statuettes in green jade, a precious stone that

used to symbolize the "heart of god," the earth and plant-life.

There are two characteristic types of statue; big, powerful ones (like the famous *Wrestler* and *Man* from San Martin Papaján), which have been firmly carved with flat faces, almond eyes, large noses and fleshy lips; or statuettes in jade or terracotta, with noble features, aquiline noses, elongated heads and thin lips. There are also representations of deformed and disabled people. The colossal heads and figures of pelota players may be connected with cosmogonal rites, as hinted at by a spherical head symbolizing the sun.

The Olmecs conveyed the idea of light by a sign in the shape of a cross, and a cross-shaped ground plan is a distinguishing feature of their pyramids, which in turn were a symbol of the universe.

This civilization was slow to wane, and its modes of artistic expression actually went on being used until 1568, when the Spaniards destroyed even the Sanctuary of Cholollan in the Puebla Valley, the secret last bastion of the Olmec priest-class.

The Pacific Coast civilization (1100 B.C.–A.D. 1500)

The provinces of Sinaloa, Nayarit, Colima, Jalisco and Michoacan were the setting for the fairly homogeneous development of a magnificent form of art, once exclusively attributed to

Right: view of "Ciudadela," center of the important holy city of Teotihuacan, which is the most extensive in Middle America and the focal point of the pre-Colombian "renaissance." At least twenty different sorts of material were used in the erecting of the imposing structures, which were joined together by ready-made building systems (the tablero, or rectangular wall, and the talud, or diagonal wall) that were in keeping with a significant urban culture that included a great variety of architectural types. Teotihuacan civilization.

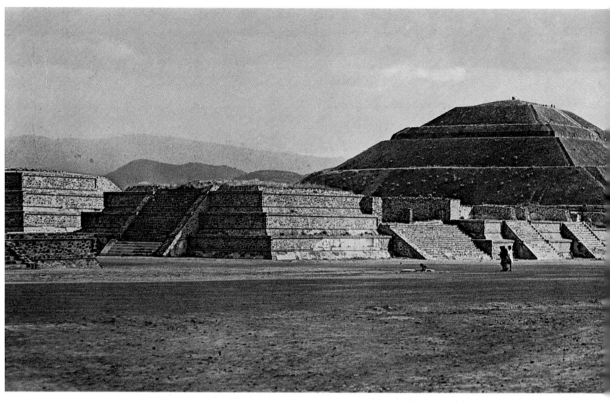

the Tarascan Indians, who were possibly solely responsible for the growth of the Chupicuaro culture: its hallmarks were a recurrent female figurine with a sophisticated hairstyle, and pottery for daily use, on which the marvellous glaze was achieved after careful polishing and then decorated in red, white and black. Skilled in working with metal, the Tarascan Indians (whose powerful hold over that region meant that for some time all the peoples living there were ruled by them) stood out from the other Mesoamerican cultures for the considerable craftsmanship of their elegant work in gold, which is fairly close to the Inca style. The pinnacle of their civilization coincided with the reign of King Michoacan, after which they became subjects of the Aztecs. In the valleys of Colima and Tecoman, an essentially realistic art-form developed, which took its ideas from daily life and showed an excellent sense of proportion and simple shaping. The statuettes of polished stone have great three-dimensional strength, while in the pottery the narrative quality of presentation is even more marked, involving complex composition and scenes featuring several members of a family around the house. The Colima examples are beautifully done, the ones from Nayarit more roughly finished, but there is always a balance between the broad outline of the overall design and the intricate emphasis provided by ornamental details. Sometimes the acute power of observation reaches the level of the most unrestrained and effective caricature.

Finally, during the late period (1250–1521), the architecture of eastern Mexico was, with a few local variations, introduced into all of the Pacific coast areas. In particular, at Jalisco and Colima the use of intersecting volumes put the moulding of architectural ornaments on to a higher plane.

Teotihuacan civilization (300 B.C.–A.D 1000)

Teotihuacan, a cultural and artistic center of considerable importance standing 2,280m (7,500ft) above sea level, was the "holy city" *par excellence*, and the most extensive in pre-Columbian history. It gave rise to what is sometimes referred to as the "pyramid" civilization because it built so many of them; there were well-planned cities, and some impressive art (employing a range of techniques and a robust, sober style) comprising basic and emblematic symbols and tending to be anti-naturalistic by going more for an intentional predominance of the graphic element. A simple engraved outline is used for figures as part of geometric compositions which followed clearly thought-out and invariable rules, and through which the idea was to represent the intercourse between the human and the cosmic, man and god, in the same way that the awesome art of Black Africa had.

In the early period between 300 B.C. and the beginning of our own times, when priest-power is already organized and in command, the first smooth-surfaced, simple stone sculptures

make their appearance. The second period, up until A.D 300, sees the development of Olmec elements that had filtered through from the Gulf coast. The Pyramid of the Sun was built in the Olmec style, straightforward, imposing, undecorated, and the largest in the pre-Columbian world; it was, however, almost immediately followed by the Temple of Quetzalcoatl, for which a more independent design was used. During the third period (300–650), the civilization of Teotihuacan, by now at its most magnificent, extends throughout Middle America. An invasion by nomadic peoples who set about destroying the temples is short-lived, and full-scale rebuilding work takes place in the fourth period.

The many deities of this civilization – they will reappear later in the pantheons of all the people of Middle America up to the Aztec period – are represented in individual ways and attitudes and with symbols specific to them, and consequently can be identified by a combination of different anthropomorphic and animalistic features, colours, and the stone-symbols depicted or used. The most important gods are Huehueteotl, god of fire, Tlaloc, the rain god, Chalchihuitlicue, god of water, Xite, of fertility, and especially Quetzalcoatl, the plumed serpent.

The city of Teotihuacan was built along a main axis that later came to be called Micaotli (Street of the Dead). The temples are located on top of impressive-looking pyramids, which display a very large number of decorations and figures on their steps and walls (sculpted

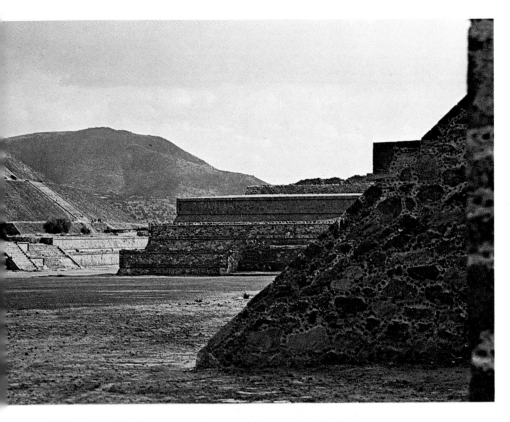

in full relief or bas-relief, or painted on). The Pyramid of the Sun, for instance, covers an area of 224sq.m (2,400sq.ft) and is 65m (213ft) high, while the Pyramid of the Moon is 42m (138ft) high and has a base of 150m by 120m (492 × 393ft). Alongside these powerful structures are richly decorated sanctuaries, priest-houses, dwellings with frescoes inside, and other groups of buildings which accommodated pilgrims during ceremonies. In addition, there were numerous tombs, both for burials and cremations.

The abundant production of pottery is usually divided into four stages. The first is roughware featuring small terracotta heads, and pots sparingly decorated with geometric motifs. In the second period, the heads become finer, and a new feature appears, the tall, long-necked, tripod jar. By the third period, the heads have become so lifelike that they are now described as "portraits" and most of them have been shaped in moulds. Cylindrical tripod jars decorated in several colours are common, and so are styles resembling the great art of fresco painting. A beautiful "thin orange-coloured" ceramic ware was used both as household crockery decorated with engraved geometric motifs, and for statues (some on a large scale and most of them moulded) of deities and priests in fine robes. In the fourth period, the existing models

Right: mural painting of a priest in his magnificent robes holding a bag for the offerings of copalgum. A large number of the rooms in buildings at Teotihuacan, Tepantitla (where possibly the most interesting ones are) and Tetitla were painted, and the clear, lively colours used in these murals create scenes of great chromatic effect. The flat outline of these scenes on a single-colour background is reminiscent of similar masterpieces to be found on the pages of the few manuscripts that have survived. Teotihuacan civilization.

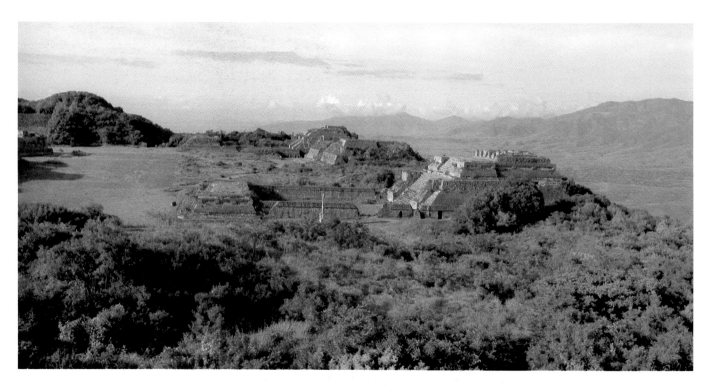

are reproduced in a lifeless over-simplified form, and have nothing whatsoever to commend them.

Zapotec civilization (650 B.C.–A.D. 1521)

There is something magnificent about the overall effect of the architecture of the great religious and political center of Monte Alban, the Zapotec capital, in the way its buildings have been designed to blend in so well with their natural surroundings. Layers of large stone blocks with visible pilaster strips make the buildings look grandiose and solid. The areas between the pilaster strips are covered with geometric decorations in high and low relief, which are made surprisingly beautiful by the recurrence of typical modules (not unlike the Greek meander, the Chinese swastika and the Mongolian arrowhead) in a finely judged geometric pattern. Figures in full relief are rare, as are anthropomorphic decorative motifs used in an architectural context. On the other hand, there is an abundance of lengthy pictographic inscriptions telling of historic deeds, whose compositional rigour often invests them with a high aesthetic value. In a similar style the Zapotecs have left long texts painted on parchment manuscripts, and polychrome decorations on the sides of large pots.

The pottery provides comprehensive evidence of the artistic quality achieved in Monte Alban; and its long history can be divided up into seven main periods. The first two (650–200 B.C. and 200 B.C.–A.D. 200), also known as pre-Zapotec, see Olmec models evolving into local versions that take on a definitive charac-

Above: a view of part of the city of Monte Alban, capital and cultural center of this great, peaceable, cultured and refined people. Here we can admire the versatility of the Zapotec architects, who knew how to landscape large open spaces with precision, so that a remarkable balance was established between the unfilled and filled areas. Zapotec civilization.

Right: funerary urn portraying the god of fire as an old man sitting down. Polychromed terracotta from Monte Alban, with abundant use of barbotine slip for jewel and pictogram motifs. Zapotec civilization, fourth period. Mexico National Museum of Anthropology.

ter of their own in the third period (A.D. 200–300). This was when they started making urns with vigorous figurative decorations on the front; or large statues, mostly featuring Cocijo, the god of rain, composed of different elements that had been separately made in moulds. In subsequent periods, representations of deities with ornate hairstyles were continually on the increase, as were simply shaped pots with decorations in many colours, though these did not come up to the standards of artistic excellence attained by subsequent civilizations.

As well as at Monte Alban, which was conquered by the Mixtecans in the fifteenth century, plenty of funerary pottery was found in the sanctuary necropolis of Mitla, where the formidable, austere-looking buildings contribute to an overall architecture of fortification.

Mixteca-Puebla civilization (800–1521)

It is likely that the Mixteca-Puebla civilization originated from nomadic peoples who came down from the north and, after occupying the territory around the cities of Yagul and Mitla, divided it into seigniories and imposed a harsh

military system based on the creation of two social classes, one for nobles and businessmen, and one for peasants and artisans.

We know from their relics that the Mixtecans were very fond of jewels and ornaments (especially those made from feathers), that they painted their bodies all over, including their faces, and tatooed themselves. Their pantheon of deities included not only those which by that time the Middle American peoples had, but also a large number of gods as patrons for specific professions. The principal deities were Quetzalcoatl and Taandoco (the Sun).

The ninth- and tenth-century pottery imitated Zapotec forms. From the year 1000 onward it acquired a number of features of its own, repeating the same geometric ornamentation that had been used in their architecture, and some of the earthy colours, following a style that we also come across in the parchment and paper manuscripts. After the Mixtecans occupied Monte Alban (fifteenth century) the fashion changed to globular tripod jars with an all-over pictorial polychrome decoration of high quality.

The craftsmanship in gold is also remarkable, using the *cire perdue* casting technique. The magnificent treasures discovered in Tomb

Left: the "Palace of Columns" at Mitla (Oaxaca), probably the residence of the uijatao, or high priest. Mixteca-Zapotec civilization.

Top: gold ring. Mixtecan civilization. Oaxaca regional museum.

Above: a page from the Borgia Codex. Mixtecan civilization. Biblioteca Apostolica, Vatican.

Left: Building C at El Tajin (Veracruz), known as "The pyramid with the 365 niches." Totonac civilization.

Below left: one of the "Atlases" of Tula (Hidalgo), colossal basalt sculptures, which may have been used as a caryatid. Tula was the capital city of the Toltecs, the nation whose deification of their king Quetzalcoatl-Topiltzin created the most celebrated god of Middle America, the "Plumed Serpent" (quetzal = a bird with fine feathers; coatl = serpent). Toltec civilization. Mexico National Museum of Anthropology.

Below: the god Chac-Mool, here seen portraying Quetzalcoatl as "he who has departed this life and will rise again one day to reign once more." Toltec-Maya civilization. Morelia regional museum.

Opposite: a page from the Peresiano Codex. Maya civilization.

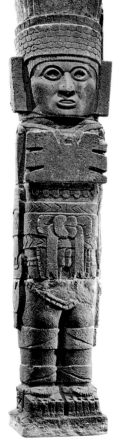

7 at Monte Alban demonstrate the exceptional quality of their gold casting, involving as it did application and elaboration of the greatest refinement; for instance, the characteristic pectorals, with the faces of deities on them, sometimes incorporating a square plate that gives the name of the god in stylized pictographic letters.

The slings, drums, thuribles, sacrificial knife-handles and death-masks were also decorated with beautiful figures and covered with turquoise tessera and mother-of-pearl mosaic.

The manuscripts merit special attention: most of them contain pictograms and historical/geneological or religious/mythological illustrations. Prominent among them is the *Borgia Codex* (Biblioteca apostolica in the Vatican), the *Nuttall Codex* (Mexico, private collection), the *Cospianus* (University library, Bologna), the *Bodleian* and the *Vindobonense*, which only add to our deep sense of regret that the Spanish clergy ordered great bonfires to be lit and had thousands of illuminated Mixtecan manuscripts destroyed.

Huastec civilization (1100 B.C.–A.D. 1521)

The Huastec settlements were to the north of the Gulf of Mexico centering on Tampico, in a very fertile region. The Huastecs or Huaxtecs spoke Maya, though their immediate neighbours' languages were either Nahuatl or Totonac. As a people, therefore, they were completely original (as their artistic output showed), and their society was structured in such a way as to accommodate private capital

assets and the idea of personal success.

The Huastecs loved ornaments, tattoos and feathered helmets – which may have been a common feature throughout the Amerindian world, but the Huastec versions were highly developed and intricate – and splendid goldwork. Their clothes were loose fitting and sensual in quite an individual way. Phallus-worship was extensive.

From what has been discovered so far, there is little artistic importance in Huastec architecture, even though it was built on a grand scale. The pyramids of Tantoc are the biggest in Middle America and had the distinction of being the last to have a circular top terrace. After that, they were square.

As for sculpture, the Huastecs clearly liked commemorative stelae carved in bas-relief,

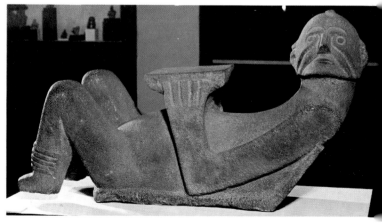

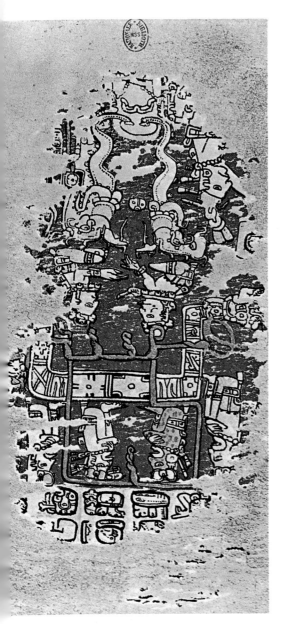

to Tlaloc at Teotihuacan. It is thought to have originated from the La Venta, Teotihuacan and Maya civilizations, developing fully between the seventh and fourteenth centuries before merging with the Aztecs.

The architecture is significant. The composite pyramid of El Tajin, which is 18m (59ft) high and has a base 36m (118ft) square, incorporates 365 symbolic niches, one for every day of the solar year (the lunar year was only used for religious calculations). The pronounced overhangs, comparable with those in baroque European architecture, created a continuous sense of movement through the interplay between light and shadow. Each element of the structure has something symbolic about it, connected with cosmic motion and with time. For example, the steep flight of steps has thirteen Greek key-pattern marks down the sides, and these stand for the number of days in the Totonac week. The same magical quality also surrounded the game of pelota; the enclosure in which the game took place was built along a north-south axis, while the lavishly sculpted stone rings through which the ball – a symbol of the sun – had to pass, were laid out east to west. The great decorative reliefs on the façades of the pelota enclosures tell the story of how the winner of the game was sacrificed.

The Totonacs also made the only alabaster pots to be found in America, and the sometimes humorous figures they sculpted on them had a surprising purity of proportion and arrangement reminiscent of the small sculptures discovered in the Cyclades. The Totonacs' own sculptures are interesting, too; either full-figure or head-and-shoulders, with happy or smiling expressions.

Totonac pottery, too, is beautifully made. It has mainly been found on the Island of Sacrifices near Veracruz. The statues are realistic and powerfully expressive, studies of people in daily life or of their many deities, warriors, or priests.

Toltec civilization (856–1250)

The name *toltec* means a civilian (i.e. leading a settled life), as opposed to *chichimeco*, a barbarian (nomad), although in fact the Toltecs were a nomadic tribe who came down from the north at the time of the great invasions. For this reason, some scholars have called this the "Toltec-Chichimec civilization." The Toltecs were a warrior nation ruled over by a military government. What they produced was vigorously crafted but rarely of artistic quality. The supreme god of the Toltecs, Quetzalcoatl (represented as a plumed serpent) used to symbolize the union of sky and earth; but in actual fact he was the deified form of the king Acatl Topiltzin Quetzalcoatl, the mercenary captain who had led the Toltecs into Mexico around the year 968.

Tula (Tollan Xicocotitlan) was designed in such a way as to assemble in one place, around a vast parade-ground, a number of heavily and powerfully decorated monuments like the pelota enclosure, the pyramid of Quetzalcoatl, the Palace of the Columns and the Coatlepantli, whose walls were covered in snake sculptures. An impressive aspect of Toltec sculpture is the human-shaped columns, which were used in the building of a large number of temples. The statue of Chac-Mool is typically Toltec, with the god shown lying on his back with a container on his stomach to collect offerings in. The pottery includes indigenous types and themes derived from the Maya, with votive statuettes that had been cast in a mould; realistic but coarsely made statues, more often than not portraying the gods Xipe Totec (Spring) and Tlaloc (Rain); and some quite significant pieces of crockery, incuding a characteristic dish with a spiral motif decoration.

Maya civilization (100 B.C.–A.D. 1697)

The Maya invaded Mexico around 1000 B.C., and there they established the longest-lasting of the civilizations in Middle America. They extended its territory into Belize, Guatemala, Honduras and El Salvador. During the formative period (known as pre-classical and dating from 1000 B.C.–A.D. 300) the city of Dzibilchaltun was the seat of political power, this being exclusively in the hands of the priest-hierarchy; the priests were responsible for the institution of a complex liturgy that became the overall focus for all forms of artistic expression. By the end of the fourth century A.D., pictographic and ideographic writing, mathematical sciences and the calendar were already well advanced. From the eighth century onward, while Europe was still under the impression that the Earth was flat, the Maya were able to calculate the synodical revolution of the planet Venus, predict solar eclipses with accuracy and measure the tropical year.

The golden age of the Maya civilization lasted until 550, the year in which the nomadic peoples began their great invasion. These may well have ended in the eighth century, which was when the Maya civilization re-emerged with a renewed vigour, to judge by the remarkable development of sculpture in stone. In the year 790 – the beginning of the so-called classical period – a great stela, decorated with historical scenes, was erected in every big city, though in connection with what big event we do not know. In fact these inscribed stelae were put up every twenty years. The last was at Tikal, in 869, after which it is possible that a catastrophe occurred of which we know nothing, because in that year the city was left abandoned. In 975, however, the influx of new peoples meant that the Maya civilization could be fully resurrected, though by now its art was in general a shadow of its former self. The Itzas settled in Chichen, which

with detailed scenes, well laid-out pictograms and a geometric treatment of space; their full-relief sculptures, on the other hand, show a poor sense of volume. The pottery is technically excellent; the sides of the pots are thin, but remarkably hard-wearing. There is an enormous variety of shapes and sizes of container and some elegant polychrome decoration, especially featuring geometric motifs, which are also found on many of the anthropomorphic statuettes.

Totonac or El Tajin civilization (100 B.C.–A.D. 1521)

The El Tajin civilization owes its name to its supreme deity Tajin, the rain-god, equivalent

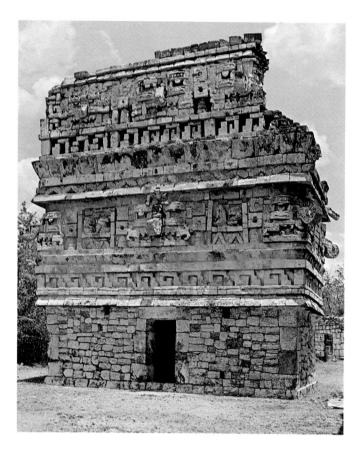

Left: the so-called "church" of Chichen Itza, in Yucatan. Built during the period when the Maya were under Toltec rule, its lively decoration, using symbols, culminates in a top layer consisting of the four deities "who hold up the sky." Maya civilization.

Below: the great blind-vaulted, so-called "arrow-point" arch in the "Governor's Palace" at Uxmal, in Yucatan. Maya civilization.

had been hewn to a perfection unequalled anywhere else. As well as sculptures for decorative purposes, the Maya evolved a stucco decoration with which to cover the whole surface of walls, the best examples of which are at Palenque and Camalcalco.

It is worth taking a look at the cycle of frescoes painted as a narrative decoration, especially the example at the Temple of Bonampak in Chiapas. This temple was built at the top of a tall pyramid and has three chambers inside: the first contains a fresco of the ritual investiture of the king and the forces of war in procession; the second chamber features the battle and the repercussions of victory; and, in the third, the banquets to celebrate that victory. The figures are painted on to a solid background and set out without perspective on three levels in each scene. Faces are always seen in profile; the backgrounds are flat and have been painted with mineral colours; the outlines are traced in black; the overall effect is vivacious.

Maya pottery evolved over a long period, with a large number of obvious local variations. The original shapes were simple and the decoration was in two colours with geometric motifs (this was the Mamom period, from 800 B.C. onward). This style led to another in the Chikanel period in which the pots were decorated using a negative painting (resist) technique. Few pieces of pottery have survived from the Matzanel period (up to A.D. 300).

is how the place came to be called Chichen-Itza. Quetzalcoatl was worshipped instead of the other gods, and human sacrifices became increasingly frequent, giving rise to the "War of Flowers," the name given to the search for victims, and the Toltec military caste supplanted the priest caste. During this period, South American metalworking techniques permeated the region of Middle America.

Around the year 1200, the Maya liberated themselves from Toltec rule, assimilating new elements from the north, and the indigenous forms of their artistic expression emerged supreme again. The Maya cultural centers of yesteryear expanded to become big cities (like the site of Mayapan in Yucatan), which, little by little, achieved virtual autonomy, to the point where the territory was gradually compartmentalized into very small and vulnerable minor nations that were, as a result, unable to offer any resistance to the Spanish conquest of Guatemala in 1525 and of Yucatan in 1541.

During the formative stage of Maya architecture, houses and altars were already being built on platform bases. The "Temple of the Dolls," a building of coarse finish in Dzibilchaltun, and the "Great Pyramid" of Yaxuna in Yucatan date from this time. The turn of the fourth century A.D. witnessed the beginning of the golden age of Maya art (Tzakal period 320–650; and Tepeuh period 650–987). Large cities were built whose purpose was more

ritualistic and ceremonial than functional, the first of which were situated at Copan, Tikal, Uaxactun, Piedras Negras, Yaxchilan and Palenque, and a second phase of building occurred in the Yucatan peninsula. The most prestigious monument of the time is the grandiose Uxmal Palace; and, between one pyramid and the next, the Mayas introduced a secret chamber, as a sepulcher for the priest-king; access to these chambers was by way of well-shafts and underground passages.

A typical Maya feature is the blind-vaulted arch, in which the overhang of the blocks of stone became ever more pronounced. The intricate decoration, which was more abundant on the upper part of buildings, took on a baroque quality that almost smothered the actual structure. This meant – especially in the cases of the *Puuc* style and the more bombastic *Chenes* style – that the line of the architecture would be broken by sculptures that jutted out and were sometimes simply incongruous, a virtual muddle of different shapes even if their positioning was correct. Ascending structures cut across by horizontal lines of emphasis were the most prevalent. The temple-pyramid thus found itself effectively overwhelmed by sculptures with a descriptive function, to the point where it became like looking at a huge page of a book telling of astrological events that had a religious significance; what is more, the stones of the edifice

Left: detail of the mural paintings in the second chamber of the "Temple of Frescoes" at Bonampak (Chiapas). Bonampak, in the Maya language, actually means "painted wall." The outstanding cycle of secco frescoes was discovered in 1945. Maya civilization. Copied by A. Villagra Caleti. Mexico National Museum of Anthropology.

Below: female figure. There are very large numbers of small sculptures dating from the classical period of Maya culture. They are either made of volcanic rock and come from the upland plain, or from ocher pottery and originate in the Isla de Jaina (Campeche). Series of these statuettes, made in moulds, were produced in the post-classical period. Maya civilization.

measuring 3km (1¾ miles) square which had been reclaimed from marshland. In the center of the city is the Great Pyramid, on top of which two matching temples had been erected: one of these was blue and dedicated to Huitzilopochtli; the other, red with white skulls over it, was the temple to Tlaloc. Tezcatlipoca, Quetzalcoatl and Cuhuacoatl were among the other deities to have temples consecrated in their names. Then there were schools, arsenals and buildings for playing pelota. All of them looked magnificent, were richly decorated, and created an overall impression of harmony. The Aztec builders used volcanic rocks; the roofs were flat and covered with wood. The colonnade was a common feature.

Aztec sculpture was extemely symbolic. There was an abundance of finely coordinated signs and other elements on surfaces that had been divided up geometrically. It was an art of deep meanings, and it transcended the possibilities of representation by offering itself as a magic object rich in significant parallels and mysterious auras. There are sculptures in full relief, sometimes done in such a personal way as to tempt one to imagine that they already saw the purpose of art as individual expression. There are symbolic objects, decorated with appropriate bas-reliefs, that are almost abstract in their traditional use of pictograms. There are sculptures that combine these methods of using or not using images. And

During the "classical period," the ceramic types increase in number, and by the time of the Tzakon epoch (300–600) there is also a kind of pottery similar to that of Teotihuacan, with some pots in black and others decorated with religious scenes.

The high point in the evolution of Maya pottery came in the Tepeuh period (600–950) in the form of cylindrical pots, which were decorated with great intricacy. The Chama and Kaminaljuyu (Guatemala) styles, and the anthropomorphic figurines of Verapaz (Guatemala), Campeche and the island of Jaina are especially prominent in this period. A great deal of care went into the making of one particular form of container, found throughout Maya territory: a censer, which was usually anthropomorphic. By this time, earthenware statues had a realistic look about them: accessories, clothes, the lines of the body, and features were all conveyed with precision.

Aztec civilization (1324–1521)

The Aztecs – a group of tribes (the most significant of which was the Mexican) – had no difficulty in conquering the territory that corresponds to present-day Mexico, because of the politically fragmented state in which the great Mesoamerican cultures found themselves when this nomadic people came down from the north. After assimilating the characteristics

of the region's art, the new arrivals endowed those same features with a grandiose quality, in a process of syncretism that sometimes touched on dramatic and violent aspects. In 1324, guided by an ancient prophecy, they founded their capital city Tenochtitlan (now Mexico City) at a spot where an eagle, symbol of the sun god, grasped a snake, the earth god's symbol.

We also know the order of succession of the Aztec kings. The most famous of them was Montezuma I. The last, Cuauhtemoc, was executed by the Spanish *conquistador* Cortes, even though, after taking him prisoner, Cortes had made an alliance with him on condition that Mexico became a Catholic country, which it did.

Aztec society was divided into clans, and there was common ownership of land. A complex bureaucratic system of administration further divided the Aztec people into different classes, all of which nonetheless fitted together on the basis of the notion that the community of man was a reflection of the collective harmony of the universe, whose different parts were interdependent and coordinated for the good of all and not for each individual's benefit. Human relations were therefore harmonious, morality exemplary, the law strict but humane; primary and secondary education was compulsory for everyone.

Tenochtitlan, the Aztec capital, covered 1,000sq m (1,076sq ft). It was built on a site

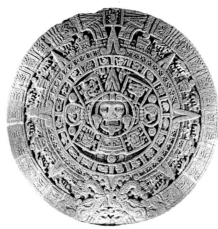

there is a wealth of elegant wood sculpture.

Aztec pottery can be classified in four periods: *Culhuacan*, which produced realistic models and representations of flowers and animals; *Tenayuca*, in which the style was geometric, based on a rough-and-ready design; *Texcoco*, when the design became sensitive and precise; *Tenochtitlan*, returning to a realistic treatment, with a range of examples and representations. Earthenware statuettes of the tutelary god are a typical Aztec feature and reproductions cast in a mould were made in large quantities. They used lavish decoration on their incense-hol-

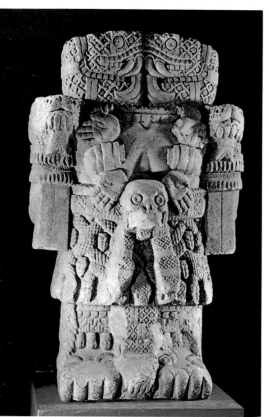

ders and also on a new feature, a pipe that often had a bowl in the shape of a head.

Region of the Andes

The network of nations in the region of the Andes is even more varied than that of Mesoamerica (with which it undoubtedly came into contact), with civilizations on a large scale that perhaps did not, however, attain the same levels of artistic achievement as the Maya and the Aztecs; however, archeologists are still a long way from producing a complete picture of the region from excavations carried out so far.

Plenty of remains of the Quimbaya civilization have been found in Colombia and Ecuador; other civilizations in these countries were the Chibcha, which had an impressively well-organized society; the Sinu; the rudimentary Rio Magdalena culture; those of San Augustin, the Upper Cauca, Patia, Carchi and Esmeraldas, which were to some extent linked together.

In the central Andes (Peru and Bolivia), various cultures emerged, and these have been classified into six periods, called "horizons," and four areas: there is the northern area (Cupisnique, Salinar, Mochica, Chimu, Lambayeque); the central area (Ancon, Pachacamac); the southern area (Paracas Cavernas, Ica); and the "high mountain" area (Recuay, Tiahuanaco, Cajamarca). The southern Andes has the Argentinian and Chilian areas.

Chavin civilization

After the first of the ancient cultures, which had traced their origins back to 2500 B.C., came the Chavin civilization. This began in 1000 B.C. and evolved most fully between the fourth and eighth centuries. Its name derives from its main center, Chavin de Huantar, in the valley of the River Marañon in the Andes. There are remains of imposing stone structures and wide

avenues lined with stelae. The "great temple" of Chavin is simple in line, with finely squared blocks of stone.

There is very little sculpture in full relief, but an abundance – especially at Chavin de Huantar itself – of bas-reliefs portraying monstrous beings engraved in crude outline in a curvilinear style; or wholly covered with recurrent features incorporating the heads of human beings, felines, birds and snakes. The dominant figure is that of the jaguar-god. The Raimondi Stele and the Tello Obelisk have a harsh beauty that demands attention. The walls of the temple at Casma are decorated with scenes – otherwise rarely found at Chavin sites elsewhere – describing war and human sacrifices.

The pottery can be recognized by the sgraffito jaguar motif. Other typical themes were widely employed by neighbouring and also by subsequent cultures. Unbaked clay statuettes of human figures have been found at Moxeque. The jewellery is basic, unsophisticated, possibly even dull, for example, the embossed jewellery in gold and silver discovered at Changopaye.

Paracas and Nazca civilizations

The Paracas and Nazca civilizations evolved in parallel in the fifth century. The Paracas (*c.* 300–200 B.C.) took its name from the peninsula on the Pacific coast, had its center at Pisco and consisted of the "cave period" and the "necropolis period." Worship of the dead was a leading feature of the lifestyle, and a large number of mummies have been discovered, wrapped in shrouds on which the adornment showed workmanship of a high order, and with ceramic tomb equipment of great importance which had either sgraffito decoration on them or had been painted in various colours, like red, yellow, black and green. In the final period

Above left: shield decorated with featherwork mosaic, depicting the head of a deity. Aztec civilization.

Above right: Aztec calendar in basalt. Both of these relics are from the ancient Mexico City. Mexico National Museum of Anthropology.

Left: basalt statue of Coatlicue, goddess of earth, life and death. Aztec civilization. Mexico National Museum of Anthropology.

Opposite left: globular pot with double spout and polychrome decoration on slip, with animal-shaped figures. Nazca pottery is possibly the most refined and valuable of the whole Andean region. Nazca civilization. National Museum, Lima.

Opposite right: the Gateway of the Moon in the city of Tiahuanaco, an impressive andesite monolith with a supreme clarity, purity and harmony of line, in contrast with the nearby Gateway of the Sun, which has a rougher-looking structure embellished with some magnificent friezes. Tiahuanaco civilization.

Paracas pottery is indistinguishable from Nazca ware.

The Nazca culture, too (which dates from the centuries following on the death of Christ), produced some magnificent cloths and characteristic gold jewellery. Nazca pottery is elegant, basic, perhaps the most refined example of ceramics in the Andes region.

The Mochica civilization succeeded the Paracas during the first millennium A.D. and the Nazca were followed by the Tiahuanaco.

Mochica civilization

The dates of the Mochica civilization can be

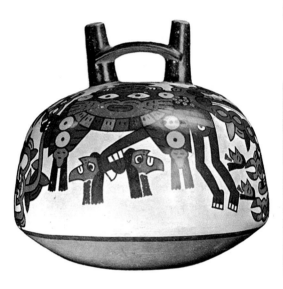

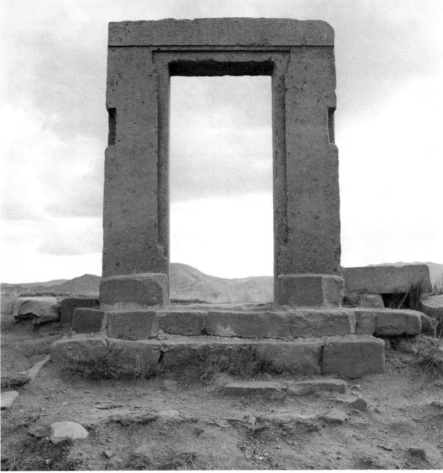

established as between the fourth and tenth centuries. It dominated a vast area of Peru and Ecuador. Mochica architecture was majestic and austere, and the large-scale use of sunbaked bricks was one of its hallmarks.

Mochica pottery, the finest and most varied in Peru, offers the earliest examples of blackware in the Andean region. Typical features of this culture include the stirrup-pot and the wide use of slip on pots; polychrome decoration was rarer, and what examples there are involved intricate scenes, usually on a religious theme. Animal and plant motifs were a typical decoration on Mochica pots and plates.

Tiahuanaco civilization

The Tiahuanaco civilization (c. 900–1300) originated on the shores of Lake Titicaca and from there grew into a vast empire that took in Peru and Bolivia.

The imposing Tiahuanaco cities with their megalithic walls today earn our admiration and something approaching reverence for the commitment, quality and proportion of their building work. At Tiahuanaco itself, which stands at 3,800m (12,467ft) above sea level, the outstanding site is Acapana: a natural, shaped mound dressed with stones, and, nearby, the buildings of Kalasasaya, with a great monolith in the middle. Also here is the Gateway of the Moon, which has a simplicity of line, and the famous Gateway of the Sun, which has an architrave hewn from a single block of stone and decorated with friezes in bas-relief set out in a monotonously repetitive yet harmonious geometric pattern, and a sculpture in the center known as the "weeping God." A number of scholars argue that Tiahuanaco was the originating center for all of the pre-Columbian civilizations, though this theory does seem an improbable one.

There are three periods or styles of Tiahuanaco pottery. In the first, the rough decoration is almost exclusively geometric. In the second period, the classical style, pots start being made in the shape of animals, especially pumas and llamas, with a fine red slip and polychrome decorations. The third stage, known as "imitation," signalled the decline of these motifs.

Chimu civilization (fourteenth to fifteenth century)

Between the eleventh and fourteenth centuries, peoples who had been neighbours to the Mochica came together to found a league of city-states that had considerable cultural unity. The structure of Chimu society was based on individual communities, a concern for moral values and the best possible division of labour as regards agricultural tasks.

In 1300 the Chimu league began to decline rapidly, and in the fifteenth century it was conquered by the Incas. Many Chimu cities and fortresses point to these people having been accomplished builders.

The Chimu made considerable headway in their development of techniques for working with precious metals: they used to emboss gold and showed great skill in the mounting of precious stones as part of their crafting of articles in gold and silver, especially for masks, reliquaries and priests' robes. The ceremonial knives, known as *tumi*, were particularly magnificent, each half-moon-shaped blade being dominated by the figure of a deity done in full relief on it. The Chimu

were also continually renewing their methods of design and craftsmanship in the making of the simplest gold-leaf pots.

The ceramic-ware showed similar qualities. It had been derived from Mochica pottery, but also featured original Chimu elements. The painted pots had very involved religious scenes or episodes from daily life on them, in minute detail. One typical Chimu line is the "whistling-pot," consisting of two linked containers, one of which was straightforward, the other in the shape of a human being or an animal, and with the neck of the pot moulded in such a way that, when liquid was poured out of it, it made a sound.

Inca civilizations

Legend has it that in 1000 B.C. King Manco Capac founded the city of Cuzco, though recent studies indicate that the center of the city is about two hundred years older still. From this center, the Inca people began their expansion around 1438, gradually assimilating the cultures of the Andes and creating in the process a vast empire, known as Tahuantinsuyo (which means the four quarters of the

Right: tumbaga gold statuette. The high quality of the Andean gold-work has given rise to the legend of Eldorado. In fact, what has survived points to one of the most outstanding goldsmith traditions in the world. Inca civilization. Museum of Ethnography, Geneva.

Below: the intihuatana at Machu Picchu, the most characteristic and the most imposing city in the Andes, built at 2,000m (6,561ft) above sea level. Inca civilization.

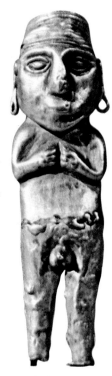

earth) across territory that stretched from Colombia to Chile. A perfect, spacious network of roads provided links between all the centers, and this feat of engineering included paved sections up to 8m (26ft) wide, marvellous suspension bridges and fortified roads and post-houses. In the cities many of the houses were built of stone, with a square or rectangular ground-plan and rooms that opened only on to the inner courtyard. Since the walls of these houses were usually left undecorated, their aesthetic achievement lay in how well the stones – usually granite, and in different sizes – had been hewn, and how they had been laid in well-matched rows. One stone, in an impressive bastion in the city of Cuzco, actually had twelve corners where it fitted against other stones in the façade. Windows and doors had the simple elegance of the trilithic format, and a typical feature was the way they tapered toward the top.

A study of the application of the golden section in Inca buildings has not yet been carried out, but it could lead to some interesting conclusions. The houses in cities built along the Pacific seaboard, on the other hand, were mostly made of sun-baked bricks.

With the construction of its fortified walls, royal palaces and central fortress, Cuzco developed a sense of grandeur that turned it into a masterpiece of the art of man in every respect, like the pyramids in Egypt, the colosseum in Rome, and St. Sofia in Constantinople. But there is also the marvel of Machu Picchu, which can be considered the greatest monument of pre-Columbian art as a whole in South America. Inside a robust outer wall, 2,000m (6,561ft) above sea level, there are about 150 megalithic buildings sited on a succession of terraces, which are linked by 1,200 steps.

Other important Inca cites were Colquampata, Sacsahuaman, Kenko and Ollantaytambo, all of which were built in the form of megalithic polygonal structures, and employing stone blocks weighing up to 200 tons.

Although the stones used for building had been perfectly cut, we have no big Inca stone sculptures, and even the representational works they made of bronze (a metal that the Incas were very skilled at casting) and gold are not of great quality. They did, however, produce some well-crafted small silver figurines, possibly intended as lucky charms. It is possible that this kind of work was performed by foreign craftsmen, but what should at the same time be borne in mind is that we cannot establish a complete picture of Inca art-forms, with the exception of their architecture, because most of their works of art were destroyed by the Spanish conquistadores.

The distinguishing feature of Inca ceramics was the aryballos, on which they used mainly geometric decorations, the rest being made up of pots shaped in, or painted with, the traditional Tiahuanaco or Chimu motifs.

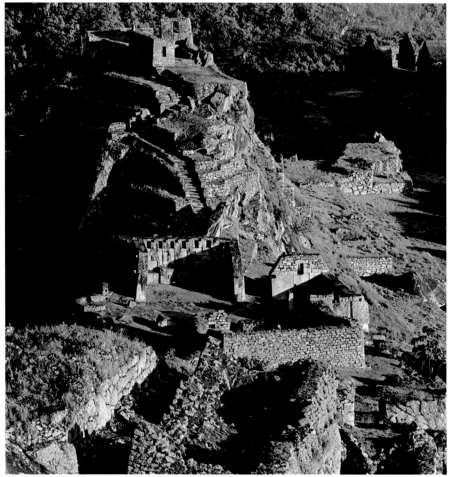

The art of Black Africa

Africa is a vast continent inhabited by many races with an enormous range of social customs and religious beliefs. The artistic output of these people obviously cannot be compressed into a few pages, so it is only possible here to deal with the subject in broad outline and, necessarily, in a fairly superficial manner. It has to be remembered, moreover, that for centuries African art aroused little interest in Europe, and that there is a notable lack of historical and cultural information. Indeed, archeological research has virtually been confined to the second half of the present century, so that the facts are only very gradually coming to light. For the most part, the black population of Africa has entrusted its records and memories to sculpture, disdaining all written testimony, thereby exhibiting a sense of history very different from that of the West. Furthermore, many African people migrated from their original homes to other far distant lands, so that over the course of many centuries models were transferred, altered and intermingled; yet at the same time certain characteristics of style and form were retained virtually unchanged.

Africa is today populated mainly by black-skinned people, of both Negro and Hamito-Semitic stock. The Negro racial types are divided into the Western and Bantu groups. The former, known as "forest Negros," are of Palaeonegroid culture, strong and sturdy, for the most part gentle and outgoing by nature.

These former hunters are nowadays agriculturalists and have also populated the savannas. Social organization is either secret (male: poro'; female: bundu or sande) or open. Culturally related to them are the tall, strong Sudanese of the northern savanna.

The Bantu, with their predominantly matriarchal society (though there are variations as a result of conquests by groups ruled by divine monarchies), are divided into many tribes, so that their culture shows little homogeneity, with distinct eastern, southern and western forms. It is worth mentioning that Ba is the prefix for the plural, whereas Ntu means "man." Other Bantu prefixes include ua-, wa-, ma-, ama-, ova- and ov- for plurals; mu- to indicate a single individual; ki- to indicate the language; and u- for the country. Thus U-Ganda is the country; Ba-Ganda its inhabitants; Mu-Ganda an individual; and Ki-Ganda the language of U-Ganda.

Other non-Negros, mainly Hamitic, have interbred and mingled to produce a variety of groups (the northern Hamites, including the Moors, Fulani and Tuareg; and the southern Hamites, including the Bedjar, Galla, Somali, Masai, Hima and Tutsi); and also the black Nilo-Hamitic and Nilotic groups, also of Palaeonegroid culture, tall and slender of build.

The characteristic element of Negro culture is rhythm. This can readily be appreciated in Afro-American music, but is equally important to the better understanding of the real quality of African art, which expresses itself tangibly in terms of rhythm rather than in any descriptive or naturalistic context. Indeed, the most striking feature of such works of art is the search for essential verities, so that a carving appears to be more truly based on the principles of musical rhythm than on the representation of actuality. These artefacts reflect the search for absolutes, their forms embody and vitalize thoughts and beliefs, ranging from the surface of things to the depths of being. It is ritual art that speaks through myths – myths of origin and creation, for initiates alone. In short, it is the allusive representation of a concept, the semblance of a social ideology.

Social, political and environmental motifs are constantly emphasized, so that the object is immediately identified and associated with the community and its activities, whereas in Western art it is generally judged by its aes-

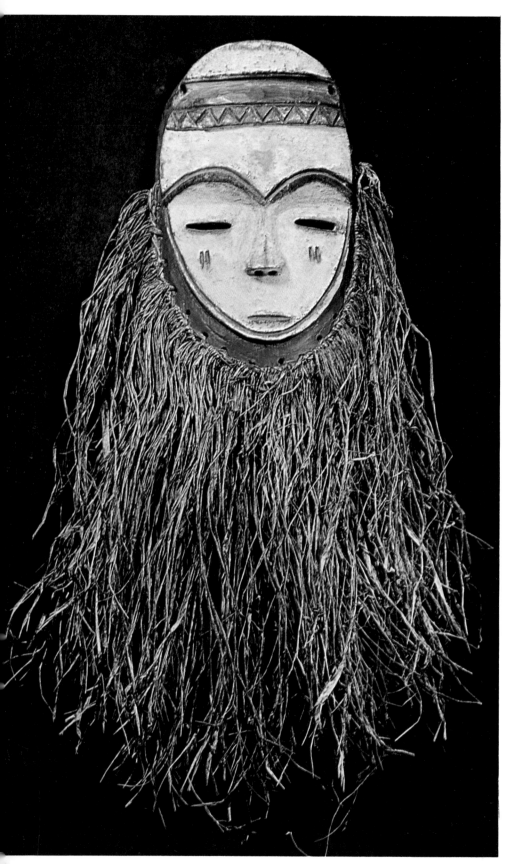

thetic quality, the product of an individual, its nature and purpose a secondary consideration. In Negro art religious fervour mingles with a deep sense of harmony, an acute awareness of the forces of nature and of the natural laws derived therefrom. African magic, therefore, is not to be interpreted in Western terms or seen as having a malign influence, for it combines medicine, morality, ethical and social behaviour, the harmony between human beings and nature, and the interrelationship of individuals within a group. For this reason, Negro art is intimately concerned with religion as a living experience. Images of ancestors and of tribal heroes, fetishes, animal carvings, masks of secret societies for religious and social ceremonies, the trappings of cult and power – these are virtually the only themes of Negro art.

The material used is also of the greatest importance. For example, not all woods are suitable for making masks or statues, because the Africans believe that certain species harbour evil spirits, conflicting with the magical functions of the carvings. Many of the objects used in the various ceremonies are therefore created under special conditions, with the performance of rites designed to invest the craftsman's work with a sacred character. Certain mixtures of style are due not only to migrations but also to the fact that the magical power of some tribes is considered more effective than that of others, and thus their typology is more frequently imitated.

The consequence of all this is that there is virtually no allowance for stylistic variation or individual invention. Artefacts are modelled on accepted forms that have proved efficacious over the centuries, copied time and time again, rather than the product of original creative ability. This is classical art in the true sense of the term, analogous to that of the artists of ancient Greece with their canons or of the Renaissance painters, who applied the geometrical laws of perspective and the golden rule, sacrificing individual expressiveness to the broader considerations of aesthetic necessity.

The function of African art

The artefacts of black Africa satisfy two needs: religious and political. The former is exemplified by the ceremonial masks of the secret societies, the portrayal of cultural heroes, ancestors, divinities and spirits, and objects associated with burials; the latter is embodied in objects relating to the cult and splendour of the divine monarchy and the symbols of various grades of power within a society administered by royally appointed officials. Aesthetic appeal, enjoyment in the execution or possession of the work of art, as understood in the West, count for almost nothing. Again there is a parallel, from the functional viewpoint, with the art of ancient Greece, where the likeness of

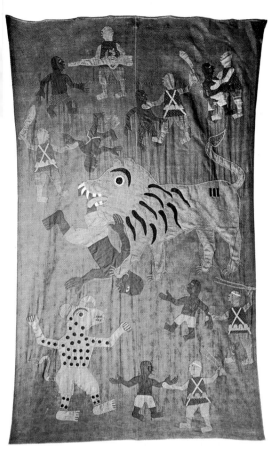

the divinity was simpy the tangible image of a concept, identifying and acknowledging it, or with the Tantric art of India, portraying a transcendent being which coud not be otherwise represented.

African works of art thus express the spirit of the god or the dead person and natural animism. They are the means of communication between the immanent and transcendent worlds and they are the effective vehicles of the currents flowing through all the material and spiritual manifestations of the universal Being. This is a culture strongly imbued with a sense of magic and motivated by an irrationality that attributes powers to those parts of existence that remain unknown and unknowable. These are the forces that determine the meaning of Negro artefacts, their conception, their creation and their use. Thus the mask is a receptacle of power and of the spirit, but it is also an emblem capable of transporting individuals from the material to the supernatural world; so it is everywhere present and essential. It plays an active role in ritual, and such rites are related to religion, fertility, initiation and social activities.

Religious rites utilize masks that portray the forces of nature (Dogon, Bambara, Bwa, Ekoi and Bateke); astronomical symbols (Mambila and Mpnewe); mythological persons (Bakuba, Toma, Dogon, Kurumba, Senufo and Bekom); and animals (Dogon, Bambara, Baule and Kuyu).

The most important rites are those associated with fertility, either of women or of the earth or of herds. Indeed, the desire for children and the need for food have been the prime motivations, among all primitive societies, for the fashioning of images designed to ward off evil. Linked with such rituals are those related to worship of the dead and many funeral ceremonies, because the spirit of the dead person, mediator between two worlds, is sometimes regarded as the true owner of the soil or of the herd. The spirit of death, *nyama*, can from its privileged position protect the living, and thus it has to be fed and worshipped through its likeness, whether this be a mask, a statue or a basket containing the skull. So the work of art provides continuous contact between the living and the dead. For this reason, the representational sculpture, stripped of temporary or contingent elements, is clearly recognizable both for its function and in its own right, although its very existence is transitory because of the eventual perishability of its material. Fertility is also seen to be the force that unifies the immanent and transcendent worlds. Thus there is a distinction between allusive forms that range from receptacles (symbol of the female nature), made by women, to statues (erect, as a phallic symbol), made by men. The modelling of this symbolic statuary tended initially to be based on the rendering of bare essentials, but over the centuries there has been a gradual refinement of aesthetic forms, culminating in a style with more substance and detail.

Equally important are the initiation ceremonies of the secret societies, whose functions are to maintain order, enforce respect for the laws and exercise control over the community. Each grade of the society has its own

symbolic mask; and there is a specific mask, too, for every occupation.

One of the principal functions of these societies is initiation at various levels. The young men are instructed in symbols, codes of behaviour and ethical values; and certain tests include circumcision and flagellation, or even ceremonies that symbolize death and resurrection. This all acquires special significance thanks to the mask, which depersonalizes the instructor and ideally links the initiate with the universal forces of nature. Furthermore, the mask symbolizes the importance of the tribe, continuity with tradition and the bond of morality that binds the individual and the community. In addition to male secret societies, using a variety of complex masks for their ceremonies, there are also female societies (notably among the Baga, the Mende-Temne and the Mpongwe), which initiate and instruct the adolescent girls and protect the rights of women, especially those of unmarried women and widows.

Masks also assume considerable importance on special social occasions: members of open societies wear them when performing various tasks such as attending to hearths, devising remedies for victims affected by lightning, storms or fire, protecting pregnant women, arresting thieves and administering justice when this does not involve officials bearing special distinctive insignia (staffs,

stools, flutes, flywhisks and pipes). Masks are alo worn for the promulgation of laws or making social arrangements, for divination, for healing, for exorcism, for receiving high-ranking visitors and for all functions entailing group organization.

Stylistic areas

The arts of black Africa can be divided stylistically into eight major regions, each with its own characteristics. They all bear evidence of major population movements and of resultant transitions and transposition of forms, rather in the manner of cellular osmosis. These regions are western Sudan, the northern coast (west), the northern coast (south), the Nigerian area, the Cameroon area, the Gabon area, the Zaïre area and, of lesser importance, the area of eastern and southern Africa.

Western Sudan. In the area of savanna extending south of the Sahara, fringing the great forests, the use of iron has been known since the first century B.C. and at about the same period sedentary cultivation emerged as a result of contacts with Carthage, Cyrene and Rome. These cultural exchanges coincided with the establishment of great kingdoms (the splendours of which were described by Arab and Berber geographers from the eleventh

century onward), commencing with the kingdom of Ghana (sixth to thirteenth centuries). This succumbed to the Mali empire, which arose in the thirteenth century and which was conquered in its turn by the Songhai, Segu and Kaarta kingdoms from the sixteenth century onward. In Burkina Faso (formerly Upper Volta), the Mossi and Dagomba kingdoms were founded.

There are sepulcher and palatine finds, dating back to the twelfth century, at Tundidaro, 140km (87 miles) south of Timbuktu, and at Tumuli in Lobi territory. The historian al-Bakri (1040–94) made mention of 1,500 bronzes in the possession of the King of Gundan; and the great traveller and geographer Ibn Batuta (1304–77) described the beautiful quality of the masks in these lands.

Outside influences did not have any marked effect on the wholly indigenous quality of the work of those people with the highest artistic output: the Dogon, the Bambara, the Mossi, the Kuruba, the Gurunsi, the Lobi and the Senufo. These tribes may have derived their more positive concept of art from classical examples; but the autonomous character of their artefacts was developed with considerable mastery, the quality frequently superb. Dogon sculpture, for example, is often highly imaginative, almost surreal; that of the Senufo is marked by astonishing nobility, in which form is paramount; and the carvings of the Bambara display a surprising lightness of touch and airy elegance.

The solemn linear statues of the Dogon of Mali convey a marvellous sense of brooding silence. Many of them are twinned or two-headed, in accordance with a myth, shared with the Bambara, relating to divine twins. There are also more than seventy types of mask, one of which – more like a statue, since it may be up to 10m (33ft) high – depicts the mythical serpent *iminama*. Another is the *kanaga*, comprising a kind of cross of Lorraine surmounting a face whose essential features are effectively suggested by two large vertical grooves; and a third is the *sirige*, sometimes up to 5m (16ft) high, in the form of a house, with eighty niches to accommodate the figures of ancestors. As a rule the Dogon do not adorn their statues with the rich patinas employed by other tribes.

The masks of the Bambara can be divided into three groups, associated respectively with the Koré society, the Komo society (impressive works of art with a combination of elements) and the Kono society (with typical animal motifs). The best-known head-mask is the *tjiwara*, a light and elegant silhouette of an antelope, sometimes twinned. Another characteristic feature of Bambara work is the animal mask made of natural materials such as animal horns.

The masks of the Marka have long faces, typically adorned with sheets of embossed metal.

The Bobo have mingled various types and,

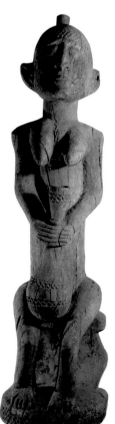

Left: large statue, showing Bambara influence (West Africa). Guiducci collection, Milan.

Center: figure of protective deity, with natural appliqué work. Bachokwe art (southern Zaïre), Kasonga substyle. Guiducci collection, Milan.

Right: armed warrior, a superb wooden sculpture which in its treatment of essential detail and tendency toward the abstract reveals a strong sense of plasticity. Senufo art, West Africa.

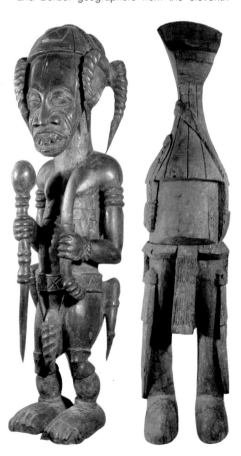

as in the case of the Mossi, exhibit a synthesis of styles with very little adherence to tradition. The Kurumba, on the other hand, have confined themselves to a few traditional forms, notably an antelope's head with a very long neck, the surface decorated geometrically, abstract in character.

As important as the Dogon are the Senufi, controlled mainly by the Lo (or Poro) secret society. Among their artefacts are *deble* statues and *degle* masks for funeral rites, figures of horsemen with lances, pairs of ancestors, the huge mythical *porgaga* bird and vast range of ritual masks. Senufo figures are emblematic, with naturalistic essentials, long and elegant in shape, and designed on a strictly specular model along the central axis.

The northern coast (west). Among the most important works of art from this area are the figurines made of stone, usually soapstone, portraying ancestors, or in any event linked with the cult of the dead, some of which may go back to the first century. Those of the Kissi of Sierra Leone are called *nomoli* or *pomdo* (plural *pomtam*).

The principal mask of the Bidjugo of the Bissagos Islands is the *ja-rê*, depicting a large-horned buffalo. The prows of their boats are also adorned with large decorative carvings designed to ward off evil.

The artefacts of the Baga are remarkable for their sinuous lines, as in the *nimba* dance-mask, which juts sharply outward, and may be enormous, weighing up to 60kg (132lb).

The Mende carve an elegant "bell-mask" for their female Bundu society, with the sensitive, carefully modelled face surmounted by an elaborate hairstyle of plaits.

Particularly worthy of mention are the Dan and the Ngere, who have an oval mask in which two planes join along the central line, the essential features outlined to great effect in an almost abstract manner; also notable are their superbly moulded long ceremonial spoons *(po)*. The various Ngere groups also use a special buffalo mask with characteristic tubular eyes and essential features, achieved with great simplicity and a strong sense of artistry.

The northern coast (south). In this fertile zone, open to commercial and cultural exchanges with distant lands, we find examples of societies ruled by divine kings whose courts are characterized by ministers, officials, rituals and the full panoply of power, appropriately symbolized in works of art. Like those of the Sudan region, but noticeably more Negroid in type, the artefacts of these communities exhibit a sense of finished art, especially in the case of those of the Baule-Guro and the

people of Ghana and Benin.

The most powerful kingdoms were those of the Fon in Dahomey, from the seventeenth to nineteenth centuries (which owed its wealth mainly to the slave trade and which reached its zenith under King Agadja, 1708–17); of the Ashanti in Ghana, a hereditary matriarchy, military in character, based on the gold trade (seventeenth to nineteenth centuries); and that of the Baule, established in 1730 by Queen Aura Paku. Portuguese navigators have left enthusiastic descriptions of the magnificence and exemplary organization of these kingdoms.

Among the oldest works of art are the terracotta figurines of the Atye, found in the Krinjabo zone of the Sanwi kingdom, dating from the seventeenth century.

The Baule are noted principally for their truly remarkable portraits and masks of ancestors, which, with their half-closed eyes and naturalistic softness, have an air of utter serenity. The treatment of the monkey-god *Gbekre* is much harsher and more forceful. Characteristic of the entire region are the barn doors, similar to those of the Dogon, carved in bas-relief with fertility and protective symbols that are reminiscent of Egyptian art. Predominant motifs are fishes, crocodiles and rivers.

The Guru make very elegant spools for weaving, with anthropomorphic designs, and masks with delicate profiles and elaborate hairstyles.

The Ashanti, whose royal courts have always given pride of place to works of art, have developed secular alongside religious forms. In addition to splendidly proportioned works in wood, there are small weights for gold (*mrammuo*), ranging from several grammes to a kilo (1/16oz to over 2lb), in series of sixty or seventy pieces, usually in the shape of small faces, animal heads and crocodiles, symbolically intermingled. Typical of the Ashanti is the *akua'ba* figurine, which women carry on their back in order to have children, a round-faced one for a boy, a square-faced one for a girl.

In Dahomey the Fon have been influenced by the Ashanti (particularly in respect of court objects and the art of metal-founding), carrying their enthusiasm for decoration almost to extremes. Even the statues are sometimes weighed down by a superabundance of decorative motifs. Typical of the Fon penchant for naturalism are the paintings that adorn the royal palace of Abomey, many with humorous themes.

The Nigerian area. It is here that the oldest examples of black African art have been discovered. In the village of Nok (in northwestern Nigeria) a large number of astonishingly beautiful terracotta figurines have been found. Austere in expression and treated in a classically naturalistic manner, they date from 400 B.C. to A.D. 200. Elsewhere excavations have revealed stone utensils, iron and tin necklaces, and clay fragments that imply the

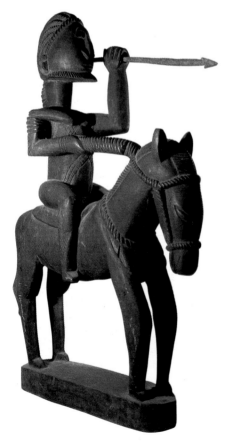

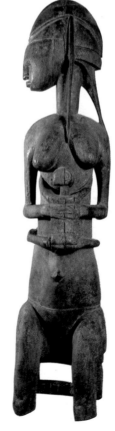

Left: ancestor on horseback, a recurrent theme. Since the twelfth century the Dogon have produced sculpture of high artistic merit, displaying qualities of inventiveness and craftsmanship that rank it among the most interesting examples of black African art. Dogon art, West Africa. Ethnographic Museum, Kano.

Right: figure of woman and child. The Bambara, the Dogon and the Senufo constitute a homogeneous artistic area exhibiting a wide variety of styles, a freedom of formal interpretation and a high measure of inventiveness. Bambara art, West Africa. Ethnographic Museum, Kano.

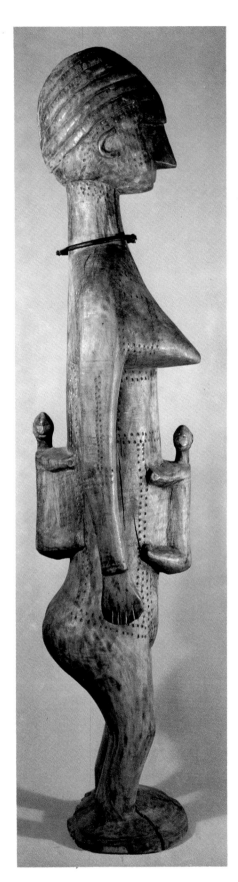

Left: figure of woman with twins, in a style common to both the Dogon and the Bambara. Baga art, Guinea-Bissau. Guiducci collection, Milan.

Right: gold ornament. The Ashanti are perhaps the most skilful goldsmiths in black Africa, and regard gold as the symbol of the sun and the source of spiritual strength. Ashanti art, Ghana. British Museum, London.

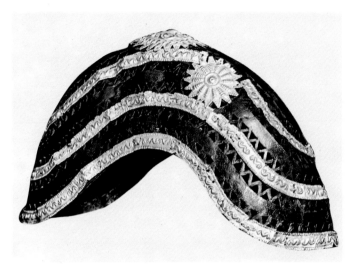

former existence of more than lifesize statues.

A fine series of Igbo-Ukwu bronzes from Ibo territory, dating from between A.D. 660 and 1405, have coordinated decorative motifs reminiscent of the Etruscan granulated style.

The technical quality that distinguishes Nok and Igbo-Ukwu artefacts extends to the art of Ifé, the holy city of the Yoruba from the tenth to thirteenth centuries. From here comes a series of portraits of rulers (oni) in terracotta, bronze and granite, testifying to a rich palatine art, harmonic in structure and classically treated in a strictly naturalistic style.

Similar to these are the so-called tsoede bronzes of the fifteenth and sixteenth centuries which portray King Tsoede, brother of Atta of the Idah tribe, who founded the Nupe kingdom; and the stone sculptures of Esie, comprising a thousand or so examples showing men and women with essential features that tend toward abstraction.

Perhaps the most important kingdom, culturally and artistically, in the whole of black Africa was that of Benin. From 1300 onward it centered on the holy city of Ifé, and from this place, at the request of King Oguola (c. 1400), came the great artist Igueghae, who originated the native royal art of Benin. From the fifteenth century the kingdom's political and economic power increased by leaps and bounds, and the kings built a palace whose treasures of wood and bronze aroused the wholehearted admiration of the Portuguese. At the end of the nineteenth century the kingdom entered a rapid decline, which culminated in the brutal conquest by the British in 1897.

Benin art, predominantly aulic, regulated by formal codes and executed by court artists who presided over large schools, can be divided into three periods: formative (fifteenth and sixteenth centuries), classical (sixteenth to eighteenth centuries) and late (eighteenth and nineteenth centuries). Particularly remarkable are the heads of the kings (oba); the small plaques depicting royal ceremonies, dig-

Below: figurine of Obe (king). Bronze in cire perdue. Sixteenth–seventeenth century. Benin art, Nigeria. Micheletti collection, Lagos.

Opposite: bronze plaque in cire perdue, showing court scene. Sixteenth century. Benin art, Nigeria. British Museum, London.

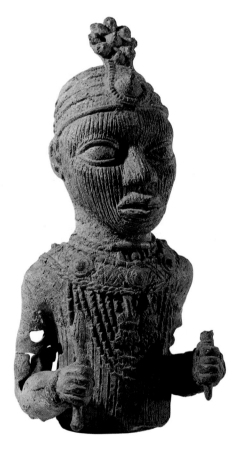

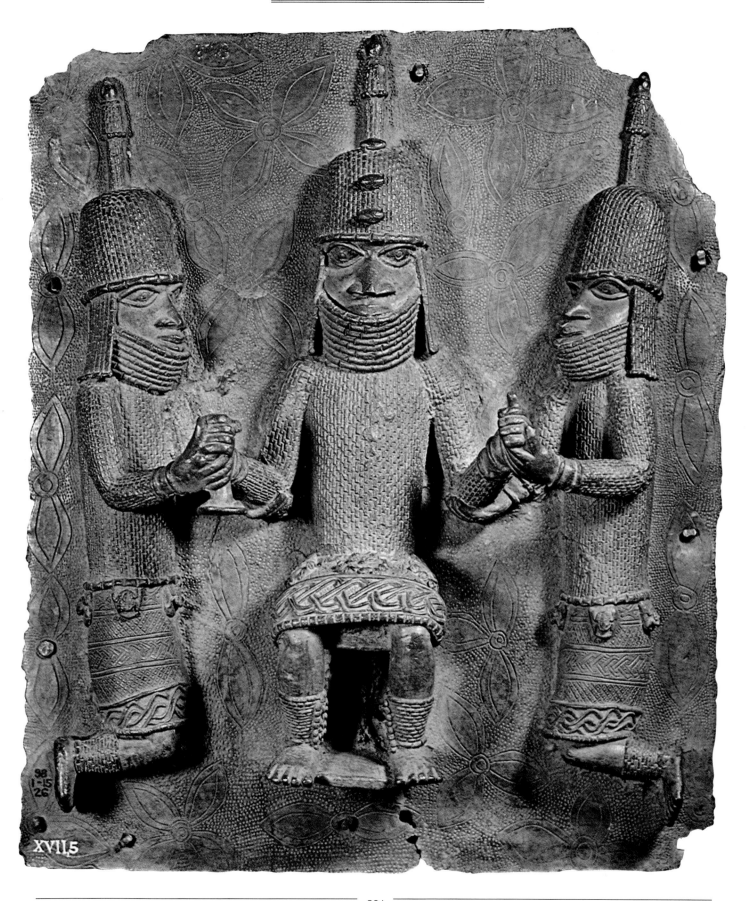

nitaries, the king himself, ordinary people and everyday scenes; and the court furnishings and symbols of power, decorated with great skill. The artistic style and technical quality are sometimes reminiscent of pre-Romanesque bronzes, such as the doors of San Zeno in Verona and of Hildesheim.

The Nigerian people closest to our own time are the Yoruba. They are ruled by the Ogboni secret society, which has three types of mask: the expressive and highly coloured *gelede*; the circular, hooded *epa*, sometimes up to 2m (6ft 6in) high and weighing 60kg (132lb); and the big-eared *egungun*. The double-bladed axe (*oshe-shango*), symbolic of the thunderbolt hurled by the god Shango, surmounts many figures; and there is also the *agba* ceremonial drum, always richly carved in bas-relief.

Among the people of the lower Niger, the Ijo have a characteristic mask that portrays, in an expressively synthetic manner, a hippopotamus; and there are also many other types of freely fanciful masks. The artefacts of the Bini are similar, particularly their hip-

popotamus mask. And the works of art of the Ibo, harsh, violent and with a fierce, primitive kind of monumentality, which is in striking contrast to the Benin style, include stelae with historical scenes, reminiscent of the Mesopotamian *kudurru*, and crude, grotesque clay statues for the *mbari* festival.

Many of the tribes of south-eastern and northern Nigeria have created solemn statues with essential features that verge on the abstract; they include those of the Ibibio, sometimes monstrous in form, the Ogoni, the Benue, the Afo and the Mambila. Especially noteworthy are the statues of the Mamuye, probably the boldest of all abstract representations, in which the identity of the individual portrayed is indicated by purely allusive forms.

The Cameroon area. The most ancient culture of this zone, judging by the finds, is that of the Sao, who from the fifth century onward made terracotta figurines and large figured urns in a summary, essential, style which, though primitive, is very effective. The Sao kingdom was destroyed by the Burno at the end of the

sixteenth century.

A characteristic product of the Ekoi is a bell-shaped statue (*akwanshi*), up to 2m (6ft 6in) high, depicting the ancient Ntoon priest-kings, with anthropomorphic decorations in delicate relief. The Ekoi masks are powerfully naturalistic, surmounted by broad headgear.

The scarce artefacts of the Duala are geometrical in form and elegantly decorated. In the savanna, the Bamileke adorned their palaces with narrative sculptures carved on a tree-trunk; and one of their masks, all of them depicting only the essentials, has a very high forehead decorated with wavy or crossed lines.

The Bamileke and the Bamun are skilful manufacturers of large thrones and processional seats adorned with pearls, blue enamel and cowries. These people are also bronze-founders, a skill perhaps transmitted to them by the Tikar, who learned it from the kingdom of Benin.

The Gabon area. Among the typical artefacts of this region are the *bieri* – containers for the skulls of former high-ranking officials, topped by a stylized head. Those of the Fang (or Pangwe), with emblematic elongation of the cheeks, convey a sense of nobility, sorrow and mystery. The statuettes usually show the hands joined on the chest and have few decorative additions.

The Bakwele have heart-shaped masks, whitened with lime – a style that is common to all the older tribes – and strongly constructed animal masks.

The Bakota *bieri*, usually of embossed metal or adorned with copper wires, are of two types: the normal (*mbulu-ngulu*) and the two-faced (*mbulu-viti*), in which one face is concave and the other convex. The Mahongwe create this reliquary-head with two linked wires of copper and few anthropomorphic details, virtually abstract in effect. The Bapunu also have, in addition to *bieri*, a mask portraying the spirit of the dead man, with a white face whose features are outlined in red, an elaborate engraved hairstyle and geometrical facial scars.

The Kuyu are distinctive for their richly coloured statues, the bodies of which are either entirely covered with lines in relief to indicate scars, arranged geometrically and with a keen feeling for decorative effect, or with forms of ornamentation that, stressing the magical function of the objects, give them an abstract appearance.

The Zaïre area. The people of the lower reaches of the Zaïre (Congo) river, grouped under the overall name of Bakongo, were familiar with European art in the fifteenth century. They were then divided into three great kingdoms: Kakongo, Loango and Congo. In 1491 King Manikongo was converted to Catholicism, and Portuguese styles influenced native art-forms until 1717, when the indigenous tribes drove out the Europeans and re-

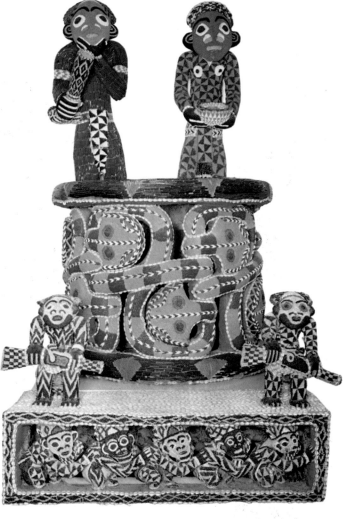

Throne of the Sultan Nioya. Carved wood, decorated with polychrome pearls of vitreous paste and enamel. At the beginning of the present century Sultan Nioya founded in Furban a great art museum, center of a school of engraving, which produced works for the court. All the rulers of the various tribes of Cameroon, particularly the Bekom, Tikar and Bamun, using artefacts as expressions of power, built luxuriously decorated palaces, with thrones that were often constructed on a bold and grandiose scale. Bamun art, Cameroon. Ethnographic Museum, Berlin-Dahlem.

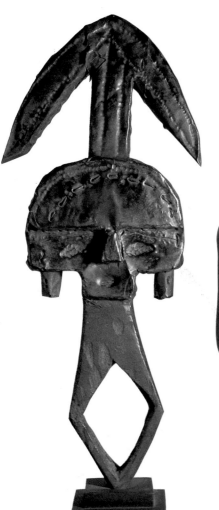

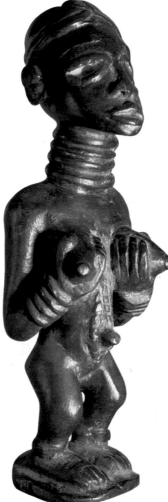

Left: figure of a guardian, mbulu-ngulu, generally placed over a reliquary basket. Bakota art, eastern Gabon. Guiducci collection, Milan.

Center: statuette in katundu style. Bapende art, south-western Zaïre. Guiducci Collection, Milan.

Right: crowned royal head. The term Bakongo is used to group together various tribes with homogeneous stylistic features. The western Bakongo are noteworthy for plain, simple, realistic artefacts; the eastern Bakongo, emulating the style of the Bayaka (south-western Zaïre), produce richer, more imaginative works of art. Bakongo art. Lower Zaïre. Parini Collection, Milan.

statues in dignified hieratic poses that have been carved, with a fine sense of realism, from that time to the present day. Among the rather crude, severe masks there are three with mythological connotations, characterized by a protruding forehead, and sometimes minutely decorated with cowries and pearls: they are that of Mwaash-a-mbooy, the founding god; of his sister and wife Ngaady-a-mwaash, represented by a more delicate and ornate mask; and of their brother Mboom, who seduced her, this mask being covered by a kind of laminated hood. The Bakuba also have numerous types of furnishings, including the divining container (*itombwa*) and the boxes for a red dust intended to ward off evil, known as *tukula*.

The artefacts of the Basonghe are cruder, typified by the *kifwebe* mask with its large, coloured grooves and square, jutting mouth. There are many examples of works in iron, notably throwing knives and elaborately made axes.

South-eastern Zaïre is dominated by the Baluba culture. In 1585 this tribe conquered

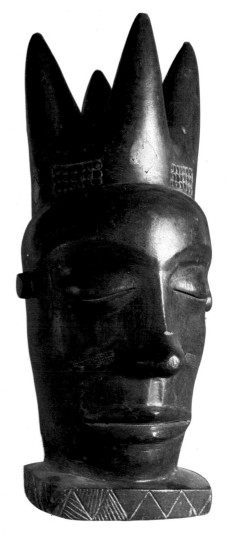

turned to their former religion. Reminders of these earlier contacts are to be found in the *mintadi* stone statues (protective fetishes later replaced by wooden types studded with nails, known as *nkisi*) and in the naturalistic figurative features of the Bakongo statues. But the works of the Bateke, with circular masks that tend toward the abstract, are very different.

In south-western Zaïre, the Bayaka exhibit a taste for exaggeration, with pronounced human features, bright colours and allusive poses in perfect specular symmetry. These characteristics are most powerfully seen in the *kakungu* mask, the most typical of its kind. The Basuku make masks with more naturalistic features, these being associated in the main with the circumcision ceremony. Older and plainer are the artefacts of the Bapende,whose series of *n'buya* masks, in some forty types, are not designed for religious or initiation rituals but for spectacles. But even in these there is little concession to popular taste or aesthetics.

In southern Zaïre, on the other hand, the Bajokwe boast an art that is elegant, sober and

solid, with scope for graphic skill and decoration. The royal statues and the heads that top the command batons are characterized by an elaborate regal headdress (*tshihongo*) with parallel coils, vaguely resembling a liberty cap. The well-modelled forms are highlighted by a brilliant black patina, perhaps influenced by Portuguese baroque. Apart from masks, of which there are three types – *tshikuza*, up to 2m (6ft 6in) high, *tshikungu*, likewise surmounted by the regal headgear, and dance masks – the Bajokwe carve splendid chairs and elaborate drums. The Bena Lulua, too, make fine statues, although these tend to be somewhat cruder and strongly expressionistic.

Central Zaïre was dominated after the fifth century by the Bakuba (lightning people), who, arriving from the north, introduced iron. They held sway over eighteen tribes, organizing them into a feudal confederation ruled by a divine king who promoted a fascinating school of aristocratic art. The confederation reached the zenith of its splendour in 1620 during the reign of King Shamba-Bolongongo, whose portrait served as archetype for all the royal

the Basonghe kingdom, unifying the Bantu races of the region. The Baluba matriarchal society and the Basonghe divine monarchy united to create a style that embraced no less than ten different influences. Broadly speaking, this sculpture tends toward realism, with essential features, soft transitions and strong, well-defined masses, all of which combine to suggest an artistic sense of notable quality. Typical of the statues is the *kabila ka vilye* (daughter of the spirit), known in the West as the "beggar woman": it is a type of royal caryatid to which many supernatural and totemic powers are attributed. A similar figure, sometimes paired, guards over stools and thrones. Masks are comparatively rare, but there are numerous everyday objects with engraved decoration.

Finally, there are the tribes of northern Zaïre, whose work is completely different, cruder and essentially abstract. Especially worthy of mention are the Balega, the Mangbetu and the Azande. The Balega are ruled by the Bwame society, whose highest rank has as its symbol the ivory *kindi*, a small expressionless face with essential features only. The Bambole masks are also fairly abstract and treated in a rather monotonous, repetitive manner. The artefacts of the Mangbetu are more elegant, including delicate harps and high-quality iron knives (*kpinga*). The decorative motifs of the Azande are more syncretic, combining the various styles of neighbouring peoples. A characteristic example is the cylindrical box made of bark, a kind of canopic jar surmounted by a large head; but the artistic preference of the Azande is for secular objects.

Eastern and southern Africa. This vast region extends from the upper reaches of the Nile to the city of Cape Town; but Negro art is poorly represented here, even though it may have been in this area that truly African culture had its roots and the greatest kingdoms of the past their origins. Some scholars claim that this could have been the cradle of the human race, and that about 750,000 years ago the first humans migrated from the area of Lake Victoria and spread to all parts of the earth. As far back as 5000 B.C. the Bushmen were producing remarkable cave paintings here; and the Bantu developed an Iron Age civilization around A.D. 1000, establishing the first nucleus of Zimbabwe. In the eighth to ninth centuries this city became the capital of a vast and wealthy empire and was notable for its huge stone buildings. Greek, Roman and Persian coins, Chinese ceramics and Indian objects, excavated from some 300 sites, testify to Zimbabwe's great importance. In the twelfth century it was conquered by a Bantu tribe related to the Mashona, who founded a vast kingdom ruled by a divine monarch, Monomotapa (or Mwana-matapa, king of mines). It attained its greatest splendour in the thirteenth century, thanks to its trade in iron, which is

Left: statue of protecting ancestor. Baluba art can be divided into at least ten substyles, all harmonious in form, sensitive to plastic values and making use of simple elements that underline essential features in a realistic manner. Balubo art (south-eastern Zaïre). Museum of African and Oceanic Art, Paris.

Below: rock painting from a cave in Tanzania. Throughout Africa, over a period of about 10,000 years, various nomadic people have left a large number of cave paintings, the last of which were created in East Africa by the Bushmen and the Bantu. Even today, however, there is no certain information concerning the majority of these paintings.

ous styles do emerge in Tanzania, among the Barotse and the Bukoba, the Makonde group and the Swahili of Ethiopia. Such artefacts are simple in structure, crude and sometimes unaesthetic, thus emphasizing the totemic qualities. From the artistic viewpoint it is worth noting the *aloala*, poles carved with human figures, from Madagascar.

Conclusion

As this brief survey suggests, the special characteristic of black African art is the deliberate and conscious attempt to represent the higher forces of nature, to declare an association with the spirits that animate all things in the universe, emanations of a divine reality that can only be understood and identified through the manifestations that permeate them. This concept has always conditioned the African artist, who is more concerned with a suitable portrayal of the divine "mystery" than with aesthetic enjoyment, which in other lands is inextricably bound up with consumer interests and commercial profit. This ideal is nowadays coming to be abandoned, under the pressure of demands from the West, which regards the artefacts of black Africa merely as picturesque folklore objects, without appreciating their significance. Nevertheless, what still remains of a very ancient tradition, of a culture that over the centuries has progressively elaborated and

plentiful in these parts, and in 1693 the kingdom was in turn conquered by the Roswi Barotse.

Examples of black African art are to be found in this area alongside those of Coptic, Ethiopian, Nubian and Islamic art: but indigen-

concentrated its values in unique works of art, is today the object of meticulous collection and dedicated research; and the excavations and the studies will undoubtedly broaden the field of knowledge and help to fill in some of the gaps.

The art of Oceania

The vast territory known as Oceania is a veritable watery continent. It is customary to divide it up into four major artistic areas. This is only a relative kind of division, though, which incorporates a host of islands that are like so much fine dust on the map. These islands are worlds where the many differences in terms of both time-lag and values create no less varied myriad cultures. Oceania boasts the survival of Palaeolithic periods and movements that are as dissimilar as the many places of origin of the different ethnic groups.

The four major areas are: Australia, which has an aboriginal culture that can be regarded as truly ancient; Melanesia, which has a wealth of expression of many kinds; Polynesia, which is more homogeneous; and Micronesia, with artistic manifestations that are fewer in number but every bit a match for those of the other three areas.

All these areas were inhabited between 1000 B.C. and A.D. 1000 by successive waves of people bringing mixtures of art-forms, ethnic groups and values. Many artistic currents no longer exist today, or have been changed, or even largely destroyed by the dishonesty and malfeasance of colonial powers.

Australia

Australia has an aboriginal culture that came to a standstill in the Stone Age, with works linked to the world of animism, created with the somewhat hazy participation of the group. The figure of the individual artist does not, in other words, emerge as such.

Sculpture is scarce and almost entirely restricted to Arnhem Land, where we find funeral poles, stone or wooden oval slabs (called *tjurunga* or *chirunga*), varying in size up to a length of 3m (10ft), with snake- or maze-like motifs on them.

The many mainly naturalistic petroglyphs or rock carvings, either scratched or carved on rocks, in caves or shelters, which at times are nothing less than tunnels used as sanctuaries, are probably extremely ancient. It is possible to single out different phases of evolution, which range from an early figurative period to a latterday non-figurative or aniconic period. In this more recent period it is possible to include the funerary carvings found on tree-trunks from which the bark has been removed.

The paintings are completely different in style from the rock carvings, in the two forms of wall decorations in caves or natural shelters, and on prepared tree-bark. As a rule we find four styles or manners. The first, known as the "X-ray" style, is clearly magical in character and is usually found on bark. Animals appear in profile, and their entrails are painted inside the white outline as if one were looking at them

Male tattooed figure. Polynesia, Maori art. Auckland Museum, Auckland.

under an X-ray machine. This style is limited to Arnhem Land.

The second style, which comes mainly from the Kimberly district, involves "thread-like" or "filiform" figures called *mimi*. Here the ancestral spirits appear slender and elongated, and are densely painted on walls with few colours: pink ocher, yellow ocher, clay white and coal black.

The third style is called the Groote Eylandt style, and the fourth the Melville Island style. Both are similar, with figures that are greatly schematized, silhouetted, crowded and repeated like graphic modules on a background that is filled with decorative dots and hatching.

The wall paintings with the *mimi*, the similar *mormo*, or the *wondijia* (these being ancestral spirits, whose depiction can measure up to 5m (16ft) showing for the most part just the head – without the mouth; they are white all over with a salient outline) were retraced or repainted annually to ward off drought, as was the case with other similar images known as "brothers of lightning." It is therefore impossible to single out any artistic personalities, and even more difficult to propose any dating based on style.

We should also mention the importance of motifs traced on the ground with coloured sand; the decoration of shields and weapons; and the typical (lozenge-shaped) musical boards that were attached to a length of twine and whirled round at great speed. These measure between 5 and 100cm (2–40in) and have carved geometric decorations.

Melanesia

The art of Melanesia is a direct expression of the magical-cum-religious life of a specific cultural environment. It can nowadays be considered extinct. Its forms were taken as the "abode" of ancestral spirits, and would have been seen "in movement," during the rites with which they were directly associated. They were made in many different materials, with a considerable wealth of forms and arrangements, and an equal wealth of colours and decorative elements. It is also worth noting that the mask, which is found in all the islands, does not invariably correspond to the social objectives of the secret societies, which are very powerful in some areas, but do not exist at all in others.

The sculpture itself is realistic and vigorously dynamic. It is usually highly decorated. Separate features can be identified in the *uli* statues of New Ireland, in the figures of New Guinea and Paramicronesia, and in those of the Admiralty Islands. But it is still possible to find a common thread based on the fundamental concept of magical properties. The origins here can be traced back to the veneration of the skull of the deceased, which was decorated, painted and kept under special guardianship. The early statues derived from these skulls. The mask-bearer in rites also embodied an ancestral spirit. But the religious factor is not the only one. There is also a pronounced sense of ornamentation even for everyday objects. The intention here is both magical and propitiatory, but there is also a purely aesthetic element. In this case we find a reduction of the anthropomorphic image to no more than a decorative symbol, and an extremely rich typology of graphic elements with sinuous lines, bands with rhombi, Greek frets,

saw-tooth designs, ovules and other lenticular shapes, which cover the entire surface of the object. This form of expression was already important in Indonesia, where it had become

Above: oval slab, called tjurunga *or* chirunga, *with carved geometric decoration, probably a symbolical cult object, although its precise significance is not known. Australia.*

Right: flowers and foliage of the yam, the food of the mimi *spirits. Painting on bark of a Nurunguln from the Goulburn Islands. According to the animist religion of the Australian Aborigines, the* mimi, mormo, *and* wondjaia *spirits lead a precarious existence, and these paintings help them to survive and feed themselves. This is why they are continually being reworked and repainted, quite apart from any aesthetic or artistic purpose. Australia.*

classicized.

Let us now define the principal stylistic areas. We can divide the whole artistic production of Melanesia into three currents, spread variously in remote areas, with numerous variants: the first involves bright colours and has an expressionist flavour (central Melanesia); the second is more delicate and decorative (Solomon and Admiralty Islands); the third belongs to New Zealand, and is somewhat hybrid.

It is customary to divide New Guinea into nine areas of artistic interest. There is a certain degree of arbitrariness about this, and many variations are possible. In almost all the nine areas the motif of the large, round eye is a salient feature, becoming the focal point of the graphic process of the work. A complex architecture has developed in many of the areas, with wooden buildings. Their powerful pillars, lintels and friezes are richly carved. The pediments are often decorated with strongly coloured paintings, which have an emphatically rhythmic style. The most remarkable sculpture is that of the Asmat *biji* poles and the Mamika *bitoro* poles.

Of the nine areas the Sepik river district is perhaps the most important. Masks for secret societies vie with the exuberant decoration of the buildings (especially in houses used for

The art of Oceania

The vast territory known as Oceania is a veritable watery continent. It is customary to divide it up into four major artistic areas. This is only a relative kind of division, though, which incorporates a host of islands that are like so much fine dust on the map. These islands are worlds where the many differences in terms of both time-lag and values create no less varied myriad cultures. Oceania boasts the survival of Palaeolithic periods and movements that are as dissimilar as the many places of origin of the different ethnic groups.

The four major areas are: Australia, which has an aboriginal culture that can be regarded as truly ancient; Melanesia, which has a wealth of expression of many kinds; Polynesia, which is more homogeneous; and Micronesia, with artistic manifestations that are fewer in number but every bit a match for those of the other three areas.

All these areas were inhabited between 1000 B.C. and A.D. 1000 by successive waves of people bringing mixtures of art-forms, ethnic groups and values. Many artistic currents no longer exist today, or have been changed, or even largely destroyed by the dishonesty and malfeasance of colonial powers.

Australia

Australia has an aboriginal culture that came to a standstill in the Stone Age, with works linked to the world of animism, created with the somewhat hazy participation of the group. The figure of the individual artist does not, in other words, emerge as such.

Sculpture is scarce and almost entirely restricted to Arnhem Land, where we find funeral poles, stone or wooden oval slabs (called *tjurunga* or *chirunga*), varying in size up to a length of 3m (10ft), with snake- or maze-like motifs on them.

The many mainly naturalistic petroglyphs or rock carvings, either scratched or carved on rocks, in caves or shelters, which at times are nothing less than tunnels used as sanctuaries, are probably extremely ancient. It is possible to single out different phases of evolution, which range from an early figurative period to a latterday non-figurative or aniconic period. In this more recent period it is possible to include the funerary carvings found on tree-trunks from which the bark has been removed.

The paintings are completely different in style from the rock carvings, in the two forms of wall decorations in caves or natural shelters, and on prepared tree-bark. As a rule we find four styles or manners. The first, known as the "X-ray" style, is clearly magical in character and is usually found on bark. Animals appear in profile, and their entrails are painted inside the white outline as if one were looking at them

*Male tattooed figure. Polynesia, Maori art.
Auckland Museum, Auckland.*

under an X-ray machine. This style is limited to Arnhem Land.

The second style, which comes mainly from the Kimberly district, involves "thread-like" or "filiform" figures called *mimi*. Here the ancestral spirits appear slender and elongated, and are densely painted on walls with few colours: pink ocher, yellow ocher, clay white and coal black.

The third style is called the Groote Eylandt style, and the fourth the Melville Island style. Both are similar, with figures that are greatly schematized, silhouetted, crowded and repeated like graphic modules on a background that is filled with decorative dots and hatching.

The wall paintings with the *mimi*, the similar *mormo*, or the *wondijia* (these being ancestral spirits, whose depiction can measure up to 5m (16ft) showing for the most part just the head – without the mouth; they are white all over with a salient outline) were retraced or repainted annually to ward off drought, as was the case with other similar images known as "brothers of lightning." It is therefore impossible to single out any artistic personalities, and even more difficult to propose any dating based on style.

We should also mention the importance of motifs traced on the ground with coloured sand; the decoration of shields and weapons; and the typical (lozenge-shaped) musical boards that were attached to a length of twine and whirled round at great speed. These measure between 5 and 100cm (2–40in) and have carved geometric decorations.

Melanesia

The art of Melanesia is a direct expression of the magical-cum-religious life of a specific cultural environment. It can nowadays be considered extinct. Its forms were taken as the "abode" of ancestral spirits, and would have been seen "in movement," during the rites with which they were directly associated. They were made in many different materials, with a considerable wealth of forms and arrangements, and an equal wealth of colours and decorative elements. It is also worth noting that the mask, which is found in all the islands, does not invariably correspond to the social objectives of the secret societies, which are very powerful in some areas, but do not exist at all in others.

The sculpture itself is realistic and vigorously dynamic. It is usually highly decorated. Separate features can be identified in the *uli* statues of New Ireland, in the figures of New Guinea and Paramicronesia, and in those of the Admiralty Islands. But it is still possible to find a common thread based on the fundamental concept of magical properties. The origins here can be traced back to the veneration of the skull of the deceased, which was decorated, painted and kept under special guardianship. The early statues derived from these skulls. The mask-bearer in rites also embodied an ancestral spirit. But the religious factor is not the only one. There is also a pronounced sense of ornamentation even for everyday objects. The intention here is both magical and propitiatory, but there is also a purely aesthetic element. In this case we find a reduction of the anthropomorphic image to no more than a decorative symbol, and an extremely rich typology of graphic elements with sinuous lines, bands with rhombi, Greek frets,

saw-tooth designs, ovules and other lenticular shapes, which cover the entire surface of the object. This form of expression was already important in Indonesia, where it had become

Above: oval slab, called tjurunga or chirunga, with carved geometric decoration, probably a symbolical cult object, although its precise significance is not known. Australia.

Right: flowers and foliage of the yam, the food of the mimi spirits. Painting on bark of a Nurunguln from the Goulburn Islands. According to the animist religion of the Australian Aborigines, the mimi, momo, and wondjaia spirits lead a precarious existence, and these paintings help them to survive and feed themselves. This is why they are continually being reworked and repainted, quite apart from any aesthetic or artistic purpose. Australia.

classicized.

Let us now define the principal stylistic areas. We can divide the whole artistic production of Melanesia into three currents, spread variously in remote areas, with numerous variants: the first involves bright colours and has an expressionist flavour (central Melanesia); the second is more delicate and decorative (Solomon and Admiralty Islands); the third belongs to New Zealand, and is somewhat hybrid.

It is customary to divide New Guinea into nine areas of artistic interest. There is a certain degree of arbitrariness about this, and many variations are possible. In almost all the nine areas the motif of the large, round eye is a salient feature, becoming the focal point of the graphic process of the work. A complex architecture has developed in many of the areas, with wooden buildings. Their powerful pillars, lintels and friezes are richly carved. The pediments are often decorated with strongly coloured paintings, which have an emphatically rhythmic style. The most remarkable sculpture is that of the Asmat *biji* poles and the Mamika *bitoro* poles.

Of the nine areas the Sepik river district is perhaps the most important. Masks for secret societies vie with the exuberant decoration of the buildings (especially in houses used for

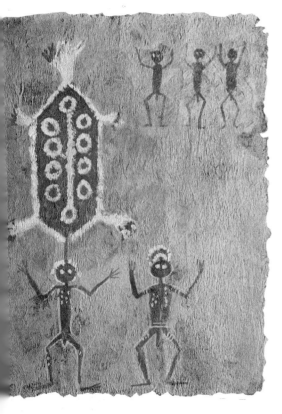

Above: ritual aboriginal scene painted on tree-bark (tapa). Australia. Ethnographical collections, Sydney.

Left: cult figure from New Guinea (Sepik river area) in which the motif of the round eye is evident. It is indicated by a large number of lines and focuses the compositional development of the whole work. It is worked out in the same way we find it on wooden panels and local ceramics. Melanesia.

Right: shield with polychrome reliefs and tapa decorations. Melanesia. Ethnographical Museum, Geneva.

male initiation rites, which have a tall pediment between two pronounced sloping roofs), weapons, canoes and everyday objects. The anthropomorphic sculptures, which are usually brightly coloured, boast inventions of an expressionist and surrealist variety. The masks of the Maprik region, made of wicker and fabric, are worth a special mention.

In the Humboldt Bay and Lake Senatani area the sculpture (for building poles or for full-relief statues) is more realistic. Here more than elsewhere the sculpted decoration, with realistic motifs combining with abstract volutes, is most evident in complex and well-balanced works. The geometric element and the highly stylized animal form constitute the dominant motifs of *tapa* painting (*tapa* being a sort of fabric made with strips of beaten bark that is treated roughly like papyrus).

In the area that includes the Solomon Islands archipelago the human element is realistically expressed, and usually admirably merged with the animal element in compositions that are dense with decorative motifs. These are geometric with a predominance of spiral shapes. A local feature is carving on blackened panels with mother-of-pearl inlays.

In the Astrolabe Bay area we find large wooden statues called *tellum* with exaggeratedly long limbs and large, flattened heads, sometimes surmounted by a bird of prey.

In the Huon Gulf and Tami Island area we find sculpted masks characterized by large nostrils and a wealth of "tattoo"-like decoration. The anthropomorphic statues have the head sunken between the shoulders. Many functional objects have geometric or anthropomorphic decorations with carefully studied proportions.

The Massim area shows a preference for abstract decoration, with many varieties of forms, and delicate modelling. The large shields of the Trobriand Islands are noteworthy.

The stylistic area called the Gulf of Papua (in particular at the mouth of the Purari and Fly rivers) has a more classical character, which can be associated, in an ideal sense, with Australian art-forms. In the wall paintings we see heads of spirits tending to the horrific, repeated as a decorative motif. The masks of the Torres Strait area are highly prized. They are made by joining together and hot-moulding turtle scales, often decorated by scratching with tatoo motifs.

The area of south-western Guinea offers harsh figures in a bare, primitive style, and large shields with carved and coloured decorations showing highly stylized motifs.

The last area, around Geelvinck Bay and the bordering provinces, offers large figures called *korvar*, with pronounced volumes, only summary delineation of the planes, few carved features and barely suggested plastic elements.

Another important artistic center is New Ireland island in the Bismarck Archipelago.

This represents virtually a unique case in relation to the other Melanesian artistic trends. Here we find exuberant forms of expression with a density of human and animal elements, both in the masks and in the bas-reliefs, as well as in the wooden musical instruments (*livika*, *nunutue* and *lauka*). The *uli* statues are terrifying but beautifully composed, as are the *malanggan* ritual masks and the *tatanua* polychrome masks, which are highly stylized. The mother-of-pearl ornaments known as *kepkap* have a distinct elegance. The *kulap*, which are crude earthen statuettes for funeral rites, are different from the *malanggan* style.

Architecture is again predominant in New Caledonia, with many noteworthy examples. These have rich decorative motifs consisting of carvings or cleverly realistic sculptures, and an abundant use of grotesque or stylized anthropomorphic elements on the supporting structures.

In other respects the art of New Caledonia tends toward a meaningful dramatic style, with varied arrangements and media, especially in the manufacture of the typical *mabu*.

In the New Hebrides masks and ritual objects are mainly associated with the secret societies as symbols of the rank attained and for initiation rites. The human figure, in various forms of artistic expression, is predominant. It is seen as an abode of the ancestral spirits, whose social status is always indicated by

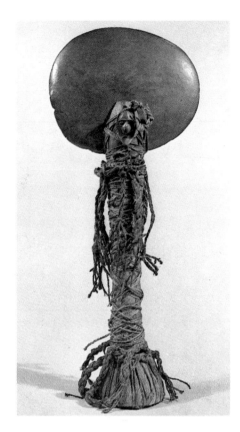

Right: ceremonial hatchet from New Caledonia, with worked jade blade, the handle fixed and decorated with woven fibers. A symbol of power, this hatched was used by the headman in the "rain ceremony." Melanesia. Horniman Museum, London.

Below: monolithic figures from Easter Island, on the Hangapiko terracing, facing the ocean. Sculpted in the soft volcanic tufa of the island, these figures were probably capped by head-coverings, although their type and manner are completely unknown. Polynesia.

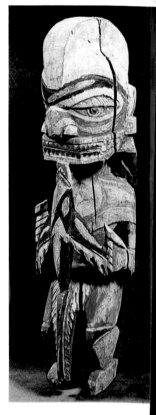

Above: Uli sculpture depicting the ancestor Giapatuti in the myth of the "victory over the sea-demon." Sculpted polychrome wood, from Nya Island (Bismarck Archipelago). Ethnographical Museum, Geneva.

Opposite left: the hero Maui, decorated with spiralled carvings and pitau motifs suggestive of tattoos, fishing for the "great fish." Decorative panel from a ceremonial house, in the taranaki style. Polynesia.

Opposite right: two nineteenth-century Maori combs, finely decorated with geometric motifs, belonging to the painter Paul Gauguin. Polynesia. Ziolo Foundation, Paris.

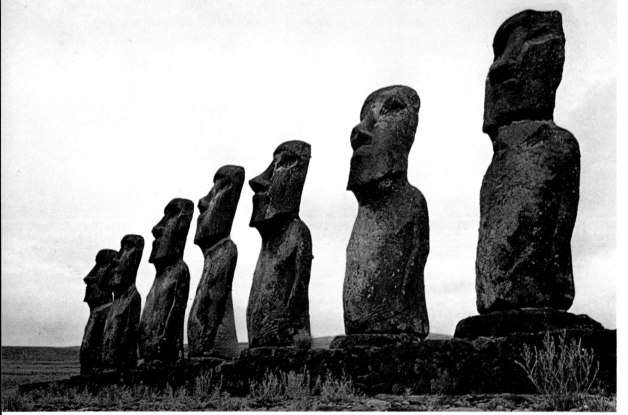

tattoos and by carvings that suggest the further addition of natural elements. The range extends from dummies surmounted by the skull of the deceased to the enormous head-shaped drums of Ambrin.

In New Britain, lastly, the Baining peoples make *tapa* masks mounted on wooden frames with large round eyes and decorations painted with geometric motifs. The cone-shaped masks of the Sulka are more abstract and very colourful.

Polynesia

Polynesia as an area has a more homogeneous artistic character than Melanesia. It differs by showing a greater sense of art in private life, and an appreciation of well-decorated everyday objects. This apart, however, the major predominantly figurative forms of expression have to do with the celebration of the deceased and the veneration of spirits.

Of all the different areas, the most significant art occurs in New Zealand and the Marquesas Islands.

Broadly speaking there is a progression from an early figurative period, which includes the colossal statues of Easter Island and the typical narrative rock painting present throughout Polynesia, to elements which become increasingly anisonic, and culminate in the essentially abstract production of Mangareva Island.

On Easter Island wood is rare. This possibly accounts for the local development of a form of sculpture that has produced colossal figures made of trachyte (a soft volcanic stone), with simplified planes, and anthropomorphic lines reduced to their essentials.

In the Marquesas Islands a typical form of naturalistic and effectively stylized sculpture is the *tiki*. This is a harmoniously abstract symbol of a human figure inscribed with a geometric design of curves. In this area the specific graphic art-form of tattooing may even cover the entire body, with a great variety of motifs.

Among the various Polynesian peoples the most skilful are perhaps the Maori, whose sculptures include full-relief statues (varying greatly in style and form and tending toward the naturalistic they are used abundantly to decorate houses); ornamental friezes (sometimes large, and similar in typology to the funerary tattoos, with complex floral patterns that combine both double-spiral *pitau* motifs and human profile *manaia*); and elements for boats (which are also at times monumental, with skilful carving and fretwork), which borrow from all the above-described typologies.

The Maori themselves divide their wooden decorative art into three styles, ranging from very simple to very complex. These styles are called *kaitaia*, *taranaki*, and *hauraki*. In the *hauraki* style, in particular, we find a blending of figurative elements with decorative elements based on the spiral motif.

Common motifs include the sea-god Marakihau; the father of the gods and men, Tangaroa (whose body is scattered with living beings in relief); and the god of war, Kakailimoku (with a huge and terrifying head). The weaponry is very elaborate, with refined decorative motifs reduced to essentials and covered with extremely rich spiral-shaped scratchings.

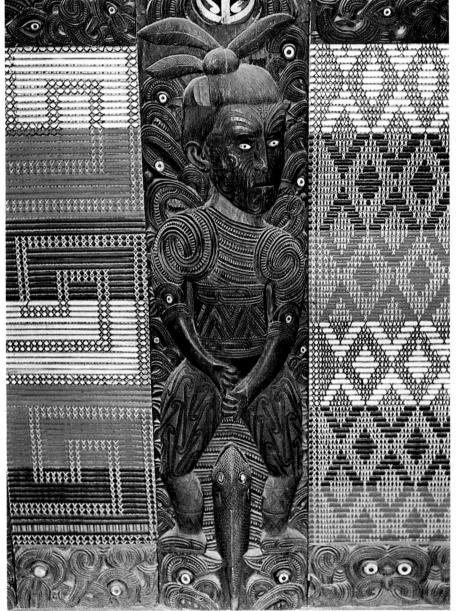

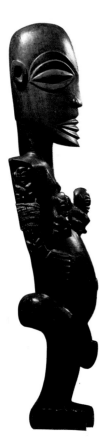

Left: the god Te Rongo with his three sons. Wooden sculpture with its forms reduced to essentials. Polynesia. British Museum, London.

Right: statue from the Hawaiian Islands; sculpted wooden body and frame made of rushes, covered with black-painted tapa. The mouth contains human teeth and fish teeth, and the claws are made with shark's teeth. Polynesia. British Museum, London.

Below: panel with mythical scene carved and polychrome, from the Palau Islands. Micronesia. Museum of African and Oceanic Arts, Paris.

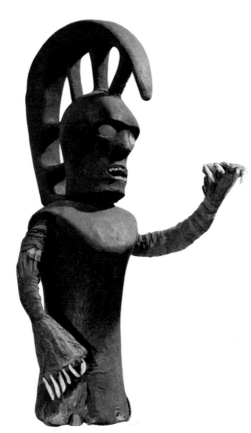

In the Hawaiian Islands, balanced between academic naturalism and graphic dynamism, we find the development of the same ornamentations to symbolize the social rank and power of a caste of priest-kings, who were also responsible for the rigid conventionalism of the cultural figures and the development of an exuberant art-form using plumage for ceremonial cloaks.

In the Cook Islands and in Tahiti, where stone sculpture became highly developed too, a particular sculptural–decorative element is nevertheless predominant. This is the so-called "stick-god."

Last of all we should mention the gourds with *pitau* motifs; the hard stone figurines; the rings for the legs of domesticated fowl (*kaka poria*); and above all the great series of very beautiful jade amulets, with human figures (*hei tiki*), decorative stylizations (*pekapeka*) and hook-like shapes (*hei matu*).

Micronesia

Micronesia is made up of some 2,500 islands, most of them sparsely populated by very varied ethnic groups, and many of them still under colonial rule. This explains the problem posed by singling out artistic styles. We can boil these down to not less than eleven small areas. It is here that impressive prehistoric remains have also been unearthed. The forms of expression closest to our modern era appear to refer directly to the art of Melanesia.

In the Palau Islands, in Yap and in the Marianas Islands we find large megalithic constructions and quite interesting ceramic forms. At Nan Matol, in particular (off the east coast of Ponape), a royal residence was built on fifty artificial islets with blocks of basalt. The walls measured up to 12m (40ft) in height. The most impressive part, at Nan Towas, is built around the sepulcher of the last king. Another similar complex exists on the small island of Lele (Ponape). It consists of a large number of dwellings and enclosures.

In the Chamorro villages (in the Marianas islands) there are still ancient stone columns with capitals (called *latte*), up to 5m (16ft) in height. Some of them may date back to the ninth century. Linked with these are the large coin discs (up to 4m [13ft] in diameter), the *poi* pestles, and certain anthropomorphic monoliths on Yap and Kusaie.

The collective wooden buildings in the Palau Islands, on Yap and in the Gilbert Islands are also important. These include the *bai* (house of men) on Yap, and the *maneaba* (council house) found on the Gilbert atolls. As a rule they have impressive steeply sloping roofs, sculpted apices, sculpted and painted beams, and poles decorated with highly stylized animals and fishes in relief.

As far as sculpture is concerned, we find relief works in the Nukuoro-Mortlock-Truk area, with anthropomorphic figures reduced to their essential planes, called *tino*, in which the delineation of the human figure is achieved exclusively by the modulation of the volumes. The *tino* are also characterized by having an absolutely smooth egg-shaped head. On the whole there is a preference for abstract art, with geometric decorations and the repetition of modules in accordance with a developed sense of rhythm. Tattooing is also very widespread, with typical designs on Ulithi and Yap showing repeated geometric motifs based on rectilinear compositions.

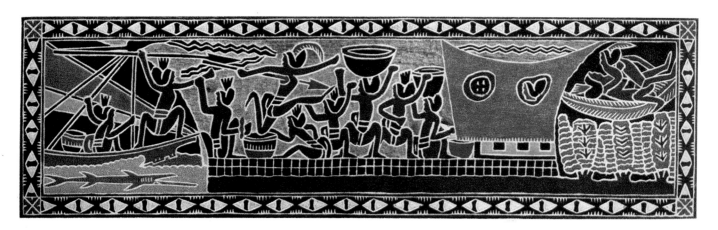

Chronological tables

The figurative arts and the language they use occupy a very important place in the history of human thought. They are also indissolubly linked to the literature and the political and social events of their time. The historical context enables us to gain a fuller understanding of an artist or a work of art and these in turn will often clarify the spirit of a period far better than a lengthy history book might. Any examination of the history of art will entail a philological and historical analysis as well, since it invites us to go beyond the immediate impression to a more thorough grasp of a certain movement, an intellectual background, a cultural context or a spiritual climate.

The following charts aim to provide not a universal chronology, which would be impossible, but an overall view of world history and the history of art, isolating salient events in both areas, that invites the reader to make connections between the two. The scheme is a graphic display based on the name of a famous person, which enables us to place him directly in his time, place and field. The background colour indicates the field: philosophy, economics (yellow); literature, drama (blue); science, technology (red); figurative arts (white); music (green). The colour of the strip containing the name refers to the bands at the top of the page which specify the region (not nation or race, but culture and language). For a clear and legible layout, we had to use a continuous time scale. However, as we go forward in time, the number of important names increases, so that there was no room to show how long they lived: the line is replaced by an arrow leading to the date of death. For the last artists of the twentieth century, only the names are given. Restrictions of space have imposed a selection that may be contested. The criterion used is meant to be objective; it therefore rests on fame rather than on value judgements. The historical reminders are only reference points, and the layout allows everyone his own way of reading these tables.

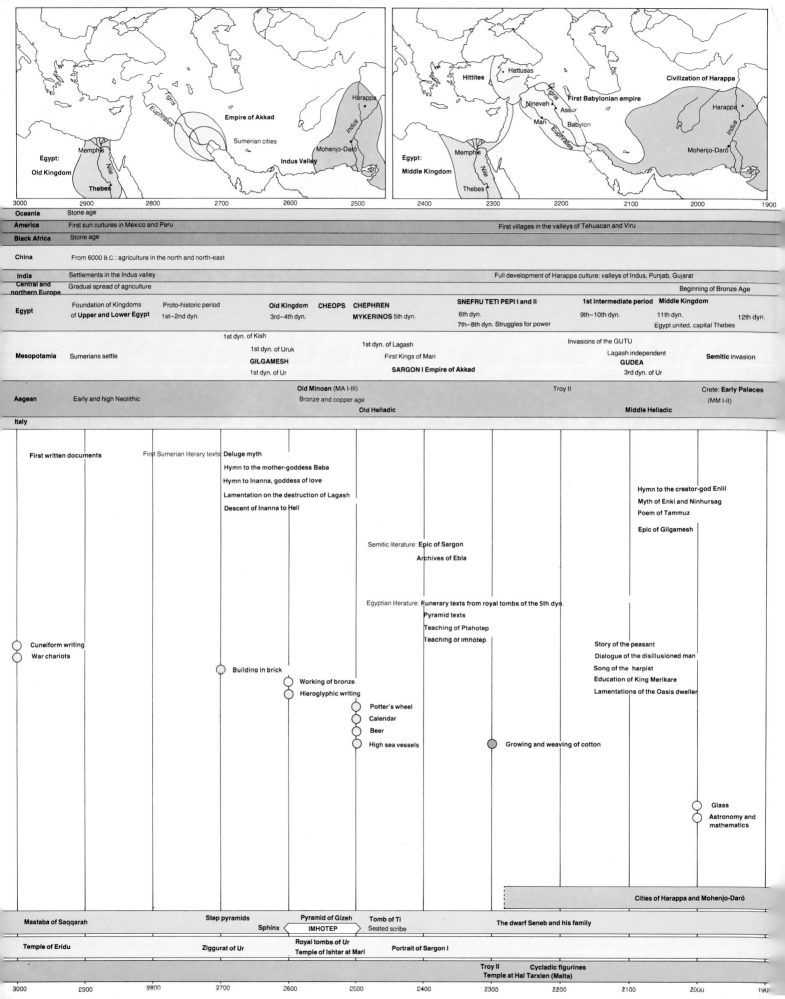

Map (left, 3000–2500 BC): Egypt: Old Kingdom; Memphis; Thebes; Nile; Tigris; Euphrates; Empire of Akkad; Sumerian cities; Indus Valley; Harappa; Mohenjo-Daró; Indus

Map (right, 2400–1900 BC): Hittites; Hattusas; Nineveh; Assur; Mari; Babylon; First Babylonian empire; Tigris; Euphrates; Egypt: Middle Kingdom; Memphis; Thebes; Nile; Civilization of Harappa; Harappa; Mohenjo-Daró; Indus

	3000	2900	2800	2700	2600	2500	2400	2300	2200	2100	2000	1900
Oceania	Stone age											
America	First sun cultures in Mexico and Peru							First villages in the valleys of Tehuacan and Viru				
Black Africa	Stone age											
China	From 6000 B.C.: agriculture in the north and north-east											
India	Settlements in the Indus valley							Full development of Harappa culture: valleys of Indus, Punjab, Gujarat				
Central and northern Europe	Gradual spread of agriculture									Beginning of Bronze Age		
Egypt	Foundation of Kingdoms of Upper and Lower Egypt 1st–2nd dyn.	Proto-historic period		Old Kingdom 3rd–4th dyn.	CHEOPS CHEPHREN MYKERINOS 5th dyn.		SNEFRU TETI PEPI I and II 6th dyn. 7th–8th dyn. Struggles for power		1st intermediate period 9th–10th dyn.	Middle Kingdom 11th dyn. Egypt united, capital Thebes	12th dyn.	
Mesopotamia	Sumerians settle		1st dyn. of Kish 1st dyn. of Uruk GILGAMESH 1st dyn. of Ur			1st dyn. of Lagash First Kings of Mari SARGON I Empire of Akkad			Invasions of the GUTU Lagash independent GUDEA 3rd dyn. of Ur		Semitic invasion	
Aegean	Early and high Neolithic				Old Minoan (MA I-III) Bronze and copper age Old Helladic				Troy II Middle Helladic		Crete: Early Palaces (MM I-II)	
Italy												

First written documents
First Sumerian literary texts: Deluge myth
Hymn to the mother-goddess Baba
Hymn to Inanna, goddess of love
Lamentation on the destruction of Lagash
Descent of Inanna to Hell

Hymn to the creator-god Enlil
Myth of Enki and Ninhursag
Poem of Tammuz
Epic of Gilgamesh

Semitic literature: Epic of Sargon
Archives of Ebla

Egyptian literature: Funerary texts from royal tombs of the 5th dyn.
Pyramid texts
Teaching of Ptahotep
Teaching of Imhotep

Story of the peasant
Dialogue of the disillusioned man
Song of the harpist
Education of King Merikare
Lamentations of the Oasis dweller

Cuneiform writing
War chariots
Building in brick
Working of bronze
Hieroglyphic writing
Potter's wheel
Calendar
Beer
High sea vessels
Growing and weaving of cotton
Glass
Astronomy and mathematics

Cities of Harappa and Mohenjo-Daró

Mastaba of Saqqarah
Step pyramids
Sphinx
Pyramid of Gizeh IMHOTEP
Tomb of Ti
Seated scribe
The dwarf Seneb and his family

Temple of Eridu
Ziggurat of Ur
Royal tombs of Ur
Temple of Ishtar at Mari
Portrait of Sargon I

Troy II
Cycladic figurines
Temple at Hal Tarxien (Malta)

| 3000 | 2900 | 2800 | 2700 | 2600 | 2500 | 2400 | 2300 | 2200 | 2100 | 2000 | 1900 |

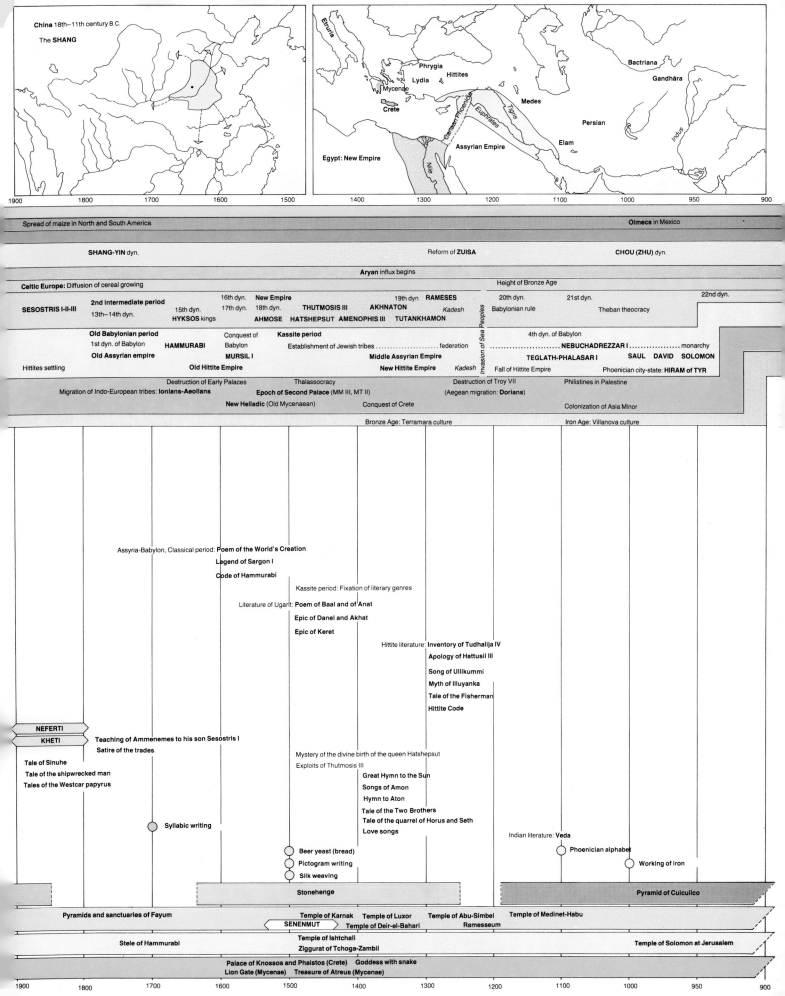

China 18th–11th century B.C.

The SHANG

Etruria
Phrygia
Hittites
Lydia
Mycenae
Crete
Bactriana
Gandhâra
Medes
Canaan Phoenicia
Euphrates
Tigris
Persian
Egypt: New Empire
Nile
Assyrian Empire
Elam
Indus

| 1900 | 1800 | 1700 | 1600 | 1500 | 1400 | 1300 | 1200 | 1100 | 1000 | 950 | 900 |

Spread of maize in North and South America | Olmecs in Mexico

SHANG-YIN dyn. | Reform of ZUISA | CHOU (ZHU) dyn.

Aryan influx begins

Celtic Europe: Diffusion of cereal growing | Height of Bronze Age

	16th dyn.	New Empire		19th dyn.	RAMESES	20th dyn.	21st dyn.		22nd dyn.		
2nd intermediate period	17th dyn.	18th dyn.	THUTMOSIS III	AKHNATON	Kadesh	Babylonian rule	Theban theocracy				
SESOSTRIS I-II-III	13th–14th dyn.	15th dyn.	HYKSOS kings	AHMOSE	HATSHEPSUT	AMENOPHIS III	TUTANKHAMON				

Old Babylonian period | Conquest of | Kassite period | | 4th dyn. of Babylon
1st dyn. of Babylon | HAMMURABI | Babylon | Establishment of Jewish tribes federation | NEBUCHADREZZAR I monarchy
Old Assyrian empire | MURSIL I | Middle Assyrian Empire | TEGLATH-PHALASAR I | SAUL DAVID SOLOMON
Hittites settling | Old Hittite Empire | New Hittite Empire | Kadesh | Fall of Hittite Empire | Phoenician city-state: HIRAM of TYR

Destruction of Early Palaces | Thalassocracy | Destruction of Troy VII | Philistines in Palestine
Migration of Indo-European tribes: Ionians-Aeolians | Epoch of Second Palace (MM III, MT II) | (Aegean migration: Dorians)
New Helladic (Old Mycenaean) | Conquest of Crete | Colonization of Asia Minor

Invasion of Sea Peoples

Bronze Age: Terramara culture | Iron Age: Villanova culture

Assyria-Babylon, Classical period: Poem of the World's Creation
Legend of Sargon I
Code of Hammurabi

Kassite period: Fixation of literary genres

Literature of Ugarit: Poem of Baal and of Anat
Epic of Danel and Akhat
Epic of Keret

Hittite literature: Inventory of Tudhalija IV
Apology of Hattusil III
Song of Ullikummi
Myth of Illuyanka
Tale of the Fisherman
Hittite Code

NEFERTI
KHETI
Teaching of Ammenemes to his son Sesostris I
Satire of the trades

Mystery of the divine birth of the queen Hatshepsut
Exploits of Thutmosis III

Tale of Sinuhe
Tale of the shipwrecked man
Tales of the Westcar papyrus

Great Hymn to the Sun
Songs of Amon
Hymn to Aton
Tale of the Two Brothers
Tale of the quarrel of Horus and Seth
Love songs

Indian literature: Veda

Syllabic writing

Beer yeast (bread)
Pictogram writing
Silk weaving

Phoenician alphabet
Working of iron

Stonehenge | Pyramid of Cuicuilco

Pyramids and sanctuaries of Fayum
SENENMUT
Temple of Karnak | Temple of Luxor | Temple of Abu-Simbel | Temple of Medinet-Habu
Temple of Deir-el-Bahari | Ramesseum

Stele of Hammurabi | Temple of Ishtchali | Temple of Solomon at Jerusalem
Ziggurat of Tchoga-Zambil

Palace of Knossos and Phaistos (Crete) | Goddess with snake
Lion Gate (Mycenae) | Treasure of Atreus (Mycenae)

| 1900 | 1800 | 1700 | 1600 | 1500 | 1400 | 1300 | 1200 | 1100 | 1000 | 950 | 900 |

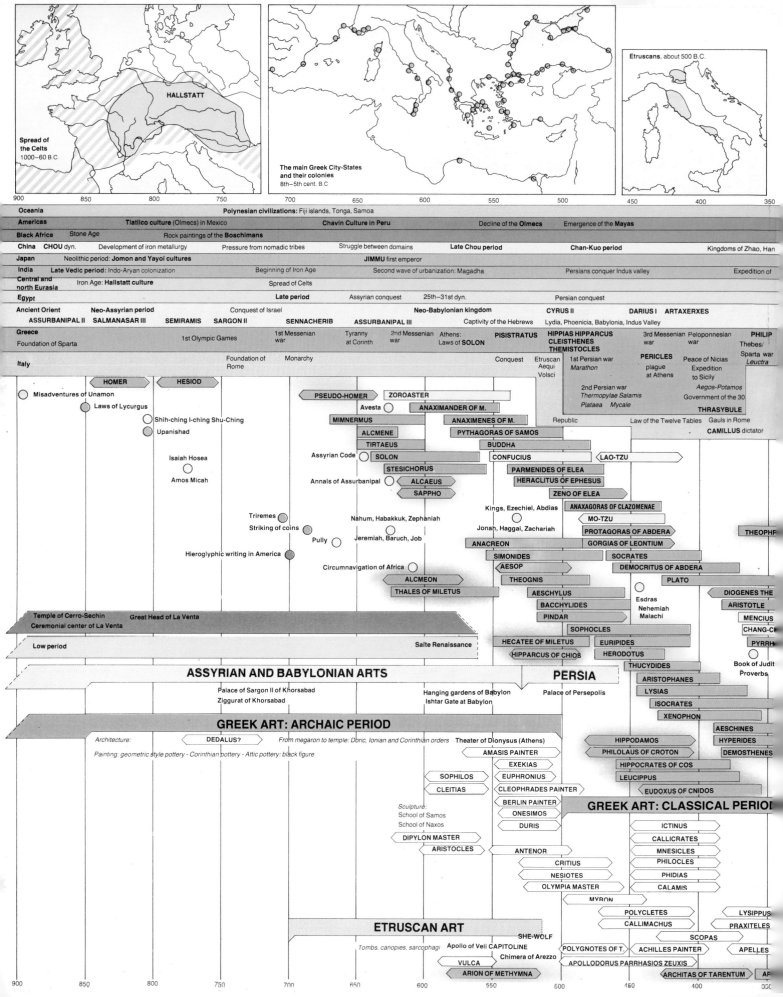

Spread of the Celts 1000–60 B.C. — HALLSTATT

The main Greek City-States and their colonies 8th–5th cent. B.C

Etruscans, about 500 B.C.

	900	850	800	750	700	650	600	550	500	450	400	350
Oceania	**Polynesian civilizations:** Fiji islands, Tonga, Samoa											
Americas	Tlatilco culture (Olmecs) in Mexico			Chavin Culture in Peru				Decline of the Olmecs	Emergence of the Mayas			
Black Africa	Stone Age		Rock paintings of the Boschimans									
China	CHOU dyn.	Development of iron metallurgy		Pressure from nomadic tribes		Struggle between domains		Late Chou period	Chan-Kuo period			Kingdoms of Zhao, Han
Japan	Neolithic period: Jomon and Yayoï cultures				JIMMU first emperor							
India	Late Vedic period: Indo-Aryan colonization			Beginning of Iron Age		Second wave of urbanization: Magadha		Persians conquer Indus valley				Expedition of
Central and north Eurasia	Iron Age: Hallstatt culture			Spread of the Celts								
Egypt			Late period		Assyrian conquest	25th–31st dyn.		Persian conquest				
Ancient Orient	Neo-Assyrian period		Conquest of Israel				Neo-Babylonian kingdom		CYRUS II	DARIUS I ARTAXERXES		
	ASSURBANIPAL II SALMANASAR III	SEMIRAMIS SARGON II		SENNACHERIB	ASSURBANIPAL III		Captivity of the Hebrews	Lydia, Phoenicia, Babylonia, Indus Valley				
Greece	Foundation of Sparta	1st Olympic Games		1st Messenian war	Tyranny at Corinth	2nd Messenian war	Athens: Laws of SOLON	PISISTRATUS	HIPPIAS HIPPARCUS CLEISTHENES THEMISTOCLES	3rd Messenian war Peloponnesian war	PHILIP Thebes/ Sparta war *Leuctra*	
Italy			Foundation of Rome	Monarchy				Conquest Etruscan Aequi Volsci	1st Persian war *Marathon* 2nd Persian war *Thermopylae Salamis Plataea Mycale*	PERICLES plague at Athens Peace of Nicias Expedition to Sicily *Aegos-Potamos* Government of the 30	THRASYBULE	

○ Misadventures of Unamon HOMER HESIOD PSEUDO-HOMER ZOROASTER

● Laws of Lycurgus Avesta ANAXIMANDER OF M.

○ Shih-ching I-ching Shu-Ching MIMNERMUS ANAXIMENES OF M.

● Upanishad ALCMENE PYTHAGORAS OF SAMOS

Republic Law of the Twelve Tables Gauls in Rome

TIRTAEUS BUDDHA CAMILLUS dictator

Isaiah Hosea Assyrian Code ○ SOLON CONFUCIUS LAO-TZU

Amos Micah ○ STESICHORUS PARMENIDES OF ELEA

Annals of Assurbanipal ○ ALCAEUS HERACLITUS OF EPHESUS

SAPPHO ZENO OF ELEA

Triremes ● Nahum, Habakkuk, Zephaniah Kings, Ezechiel, Abdias ANAXAGORAS OF CLAZOMENAE

Striking of coins ● MO-TZU

Pully ● Jonah, Haggai, Zachariah PROTAGORAS OF ABDERA THEOPHF

Jeremiah, Baruch, Job ○ ANACREON GORGIAS OF LEONTIUM

Hieroglyphic writing in America ● SIMONIDES SOCRATES

Circumnavigation of Africa ○ AESOP DEMOCRITUS OF ABDERA

ALCMEON THEOGNIS PLATO DIOGENES THE

THALES OF MILETUS AESCHYLUS Esdras Nehemiah Malachi ○ ARISTOTLE

Temple of Cerro-Sechin Great Head of La Venta BACCHYLIDES MENCIUS

Ceremonial center of La Venta PINDAR CHANG-C

SOPHOCLES PYRRH

Low period Saïte Renaissance HECATEE OF MILETUS EURIPIDES Book of Judit

HIPPARCUS OF CHIOS HERODOTUS Proverbs

THUCYDIDES

ASSYRIAN AND BABYLONIAN ARTS

PERSIA

Palace of Sargon II of Khorsabad Hanging gardens of Babylon ARISTOPHANES

Ziggurat of Khorsabad Ishtar Gate at Babylon Palace of Persepolis LYSIAS

ISOCRATES

XENOPHON

GREEK ART: ARCHAIC PERIOD

AESCHINES

Architecture: DEDALUS? From megaron to temple: Doric, Ionian and Corinthian orders Theater of Dionysus (Athens) HIPPODAMUS HYPERIDES

Painting: geometric style pottery - Corinthian pottery - Attic pottery: black figure AMASIS PAINTER PHILOLAUS OF CROTON DEMOSTHENES

EXEKIAS HIPPOCRATES OF COS

SOPHILOS EUPHRONIUS LEUCIPPUS

CLEITIAS CLEOPHRADES PAINTER EUDOXUS OF CNIDOS

Sculpture: BERLIN PAINTER ## GREEK ART: CLASSICAL PERIOD

School of Samos ONESIMOS

School of Naxos DURIS ICTINUS

DIPYLON MASTER CALLICRATES

ARISTOCLES ANTENOR MNESICLES

CRITIUS PHILOCLES

NESIOTES PHIDIAS

OLYMPIA MASTER CALAMIS

MYRON

POLYCLETES LYSIPPUS

ETRUSCAN ART CALLIMACHUS PRAXITELES

SCOPAS

SHE-WOLF

Tombs, canopies, sarcophagi Apollo of Veii CAPITOLINE POLYGNOTES OF T. ACHILLES PAINTER APELLES

Chimera of Arezzo APOLLODORUS PARRHASIOS ZEUXIS

VULCA ARCHITAS OF TARENTUM

ARION OF METHYMNA

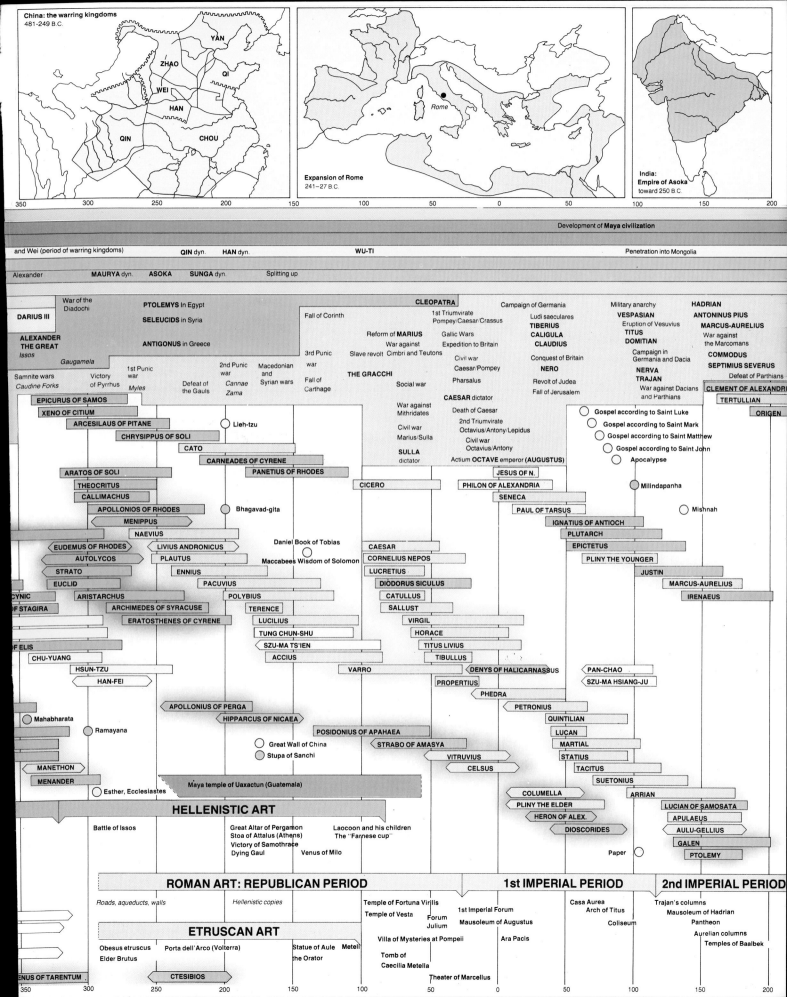

China: the warring kingdoms
481-249 B.C.
YAN · ZHAO · QI · WEI · HAN · CHOU · QIN

Expansion of Rome
241–27 B.C.
Rome

India:
Empire of Asoka
toward 250 B.C.

| 350 | 300 | 250 | 200 | 150 | 100 | 50 | 0 | 50 | 100 | 150 | 200 |

Development of Maya civilization

and Wei (period of warring kingdoms) | QIN dyn. | HAN dyn. | WU-TI | Penetration into Mongolia

Alexander | MAURYA dyn. | ASOKA | SUNGA dyn. | Splitting up

DARIUS III
ALEXANDER THE GREAT
Issos
Gaugamela

War of the Diadochi
PTOLEMYS In Egypt
SELEUCIDS in Syria
ANTIGONUS in Greece

Samnite wars
Caudine Forks
Victory of Pyrrhus
1st Punic war
Myles

Defeat of the Gauls

2nd Punic war
Cannae
Zama

Macedonian and Syrian wars

3rd Punic war
Fall of Carthage

Fall of Corinth

THE GRACCHI

Reform of MARIUS
War against Cimbri and Teutons
Slave revolt

CLEOPATRA
1st Triumvirate
Pompey/Caesar/Crassus

Gallic Wars
Expedition to Britain
Civil war
Caesar/Pompey
Pharsalus

Campaign of Germania
Ludi saeculares

Military anarchy

HADRIAN
ANTONINUS PIUS
MARCUS-AURELIUS
War against the Marcomans
COMMODUS
SEPTIMIUS SEVERUS
Defeat of Parthians

VESPASIAN
Eruption of Vesuvius
TITUS
DOMITIAN
Campaign in Germania and Dacia

TIBERIUS
CALIGULA
CLAUDIUS
Conquest of Britain

NERO
Revolt of Judea
Fall of Jerusalem

NERVA
TRAJAN
War against Dacians and Parthians

CLEMENT OF ALEXANDRI
TERTULLIAN
ORIGEN

Social war

War against Mithridates
Civil war
Marius/Sulla
SULLA
dictator

CAESAR dictator
Death of Caesar
2nd Triumvirate
Octavius/Antony/Lepidus
Civil war
Octavius/Antony
Actium OCTAVE emperor (AUGUSTUS)

EPICURUS OF SAMOS
XENO OF CITIUM
ARCESILAUS OF PITANE
CHRYSIPPUS OF SOLI
CATO
CARNEADES OF CYRENE
ARATOS OF SOLI
PANETIUS OF RHODES
THEOCRITUS
CALLIMACHUS
APOLLONIOS OF RHODES
MENIPPUS
NAEVIUS
EUDEMUS OF RHODES
LIVIUS ANDRONICUS
AUTOLYCOS
PLAUTUS
STRATO
ENNIUS
EUCLID
PACUVIUS
CYNIC
ARISTARCHUS
POLYBIUS
OF STAGIRA
ARCHIMEDES OF SYRACUSE
ERATOSTHENES OF CYRENE
OF ELIS
CHU-YUANG
HSUN-TZU
HAN-FEI
Mahabharata
Ramayana
APOLLONIUS OF PERGA
HIPPARCUS OF NICAEA
POSIDONIUS OF APAHAEA
STRABO OF AMASYA
Great Wall of China
Stupa of Sanchi
MANETHON
MENANDER
Esther, Ecclesiastes
Maya temple of Uaxactun (Guatemala)

Lieh-tzu

Bhagavad-gita

Daniel Book of Tobias
Maccabees Wisdom of Solomon

CICERO
TERENCE
LUCILIUS
TUNG CHUN-SHU
SZU-MA TS'IEN
ACCIUS
VARRO

CAESAR
CORNELIUS NEPOS
LUCRETIUS
DIODORUS SICULUS
CATULLUS
SALLUST
VIRGIL
HORACE
TITUS LIVIUS
TIBULLUS
DENYS OF HALICARNASSUS
PROPERTIUS
PHEDRA
PETRONIUS
QUINTILIAN
LUCAN
MARTIAL
STATIUS
VITRUVIUS
CELSUS
COLUMELLA
PLINY THE ELDER
HERON OF ALEX.
DIOSCORIDES

PHILON OF ALEXANDRIA
SENECA
PAUL OF TARSUS
IGNATIUS OF ANTIOCH
PLUTARCH
EPICTETUS
PLINY THE YOUNGER
JUSTIN
MARCUS-AURELIUS
IRENEAUS
PAN-CHAO
SZU-MA HSIANG-JU
JESUS OF N.

Gospel according to Saint Luke
Gospel according to Saint Mark
Gospel according to Saint Matthew
Gospel according to Saint John
Apocalypse
Milindapanha
Mishnah

LUCIAN OF SAMOSATA
APULAEUS
AULU-GELLIUS
GALEN
PTOLEMY
Paper

HELLENISTIC ART

Battle of Issos
Great Altar of Pergamon
Stoa of Attalus (Athens)
Victory of Samothrace
Dying Gaul
Venus of Milo
Laocoon and his children
The ''Farnese cup''

ROMAN ART: REPUBLICAN PERIOD | 1st IMPERIAL PERIOD | 2nd IMPERIAL PERIOD

Roads, aqueducts, walls
Hellenistic copies
Temple of Fortuna Virilis
Temple of Vesta
Forum Julium
Villa of Mysteries at Pompeii
Tomb of Caecilia Metella
Theater of Marcellus
1st Imperial Forum
Mausoleum of Augustus
Ara Pacis
Casa Aurea
Arch of Titus
Coliseum
Trajan's columns
Mausoleum of Hadrian
Pantheon
Aurelian columns
Temples of Baalbek

ETRUSCAN ART

Obesus etruscus
Elder Brutus
Porta dell'Arco (Volterra)
Statue of Aule the Orator
Meteli

ENUS OF TARENTUM
CTESIBIOS

| 350 | 300 | 250 | 200 | 150 | 100 | 50 | 0 | 50 | 100 | 150 | 200 |

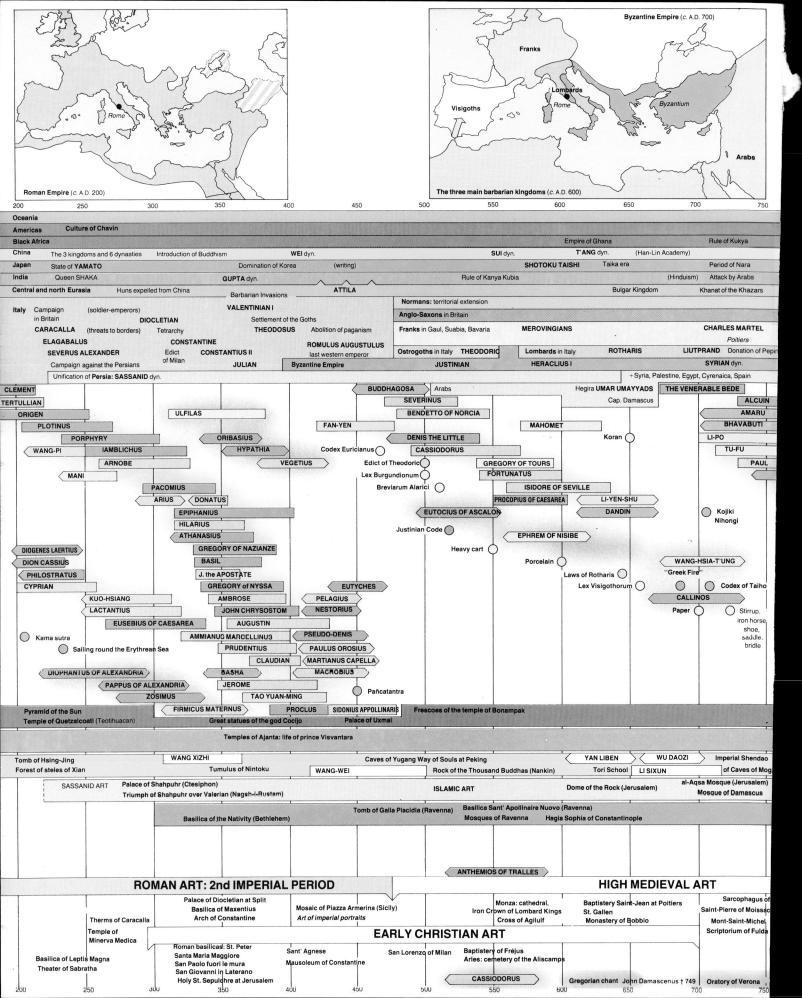

Roman Empire (c. A.D. 200) — Rome

Byzantine Empire (c. A.D. 700)
Franks — Lombards — Rome — Byzantium — Visigoths — Arabs

The three main barbarian kingdoms (c. A.D. 600)

	200	250	300	350	400	450	500	550	600	650	700	750

Oceania

Americas — Culture of Chavin

Black Africa — Empire of Ghana — Rule of Kukya

China — The 3 kingdoms and 6 dynasties — Introduction of Buddhism — **WEI** dyn. — **SUI** dyn. — **T'ANG** dyn. — (Han-Lin Academy)

Japan — State of **YAMATO** — Domination of Korea — (writing) — **SHOTOKU TAISHI** — Taika era — Period of Nara

India — Queen SHAKA — **GUPTA** dyn. — Rule of Kanya Kubia — (Hinduism) — Attack by Arabs

Central and north Eurasia — Huns expelled from China — Barbarian Invasions — **ATTILA** — Bulgar Kingdom — Khanat of the Khazars

Italy — Campaign in Britain — (soldier-emperors) — **VALENTINIAN I** — **Normans:** territorial extension
CARACALLA — **DIOCLETIAN** — (threats to borders) — Tetrarchy — **THEODOSUS** — Settlement of the Goths — Abolition of paganism — **Anglo-Saxons** in Britain
ELAGABALUS — **CONSTANTINE** — **Franks** in Gaul, Suabia, Bavaria — **MEROVINGIANS** — **CHARLES MARTEL**
SEVERUS ALEXANDER — Edict of Milan — **CONSTANTIUS II** — **ROMULUS AUGUSTULUS** last western emperor — Poitiers
Campaign against the Persians — **JULIAN** — **Byzantine Empire** — **JUSTINIAN** — **HERACLIUS I** — **SYRIAN** dyn.
Unification of **Persia: SASSANID** dyn. — **Ostrogoths** in Italy **THEODORIC** — **Lombards** in Italy **ROTHARIS** — **LIUTPRAND** — Donation of Pepin
+Syria, Palestine, Egypt, Cyrenaica, Spain

CLEMENT
TERTULLIAN
ORIGEN — BUDDHAGOSA — Arabs — Hegira **UMAR UMAYYADS** — **THE VENERABLE BEDE**
PLOTINUS — SEVERINUS — Cap. Damascus — ALCUIN
ULFILAS — BENDETTO OF NORCIA — AMARU
PORPHYRY — MAHOMET — BHAVABUTI
WANG-PI — IAMBLICHUS — ORIBASIUS — FAN-YEN — DENIS THE LITTLE — Koran — LI-PO
ARNOBE — HYPATHIA — Codex Euricianus — CASSIODORUS — GREGORY OF TOURS — TU-FU
MANI — VEGETIUS — Edict of Theodoric — FORTUNATUS — PAUL
PACOMIUS — Lex Burgundionum — ISIDORE OF SEVILLE
ARIUS — DONATUS — Breviarum Alarici — PROCOPIUS OF CAESAREA — LI-YEN-SHU — Kojiki Nihongi
EPIPHANIUS — EUTOCIUS OF ASCALON — DANDIN
HILARIUS — Justinian Code
ATHANASIUS — EPHREM OF NISIBE
DIOGENES LAERTIUS — GREGORY OF NAZIANZE — Heavy cart — WANG-HSIA-T'UNG
DION CASSIUS — BASIL — Porcelain — "Greek Fire"
PHILOSTRATUS — J. the APOSTATE — Laws of Rotharis — Codex of Taiho
CYPRIAN — GREGORY of NYSSA — EUTYCHES — Lex Visigothorum — CALLINOS
KUO-HSIANG — AMBROSE — PELAGIUS — Paper — Stirrup, iron horse, shoe, saddle, bridle
LACTANTIUS — JOHN CHRYSOSTOM — NESTORIUS
EUSEBIUS OF CAESAREA — AUGUSTIN
Kama sutra — AMMIANUS MARCELLINUS — PSEUDO-DENIS
Sailing round the Erythrean Sea — PRUDENTIUS — PAULUS OROSIUS
CLAUDIAN — MARTIANUS CAPELLA
DIOPHANTUS OF ALEXANDRIA — BASHA — MACROBIUS
PAPPUS OF ALEXANDRIA — JEROME — Pañcatantra
ZOSIMUS — TAO YUAN-MING
FIRMICUS MATERNUS — PROCLUS — SIDONIUS APPOLLINARIS
Pyramid of the Sun — Frescoes of the temple of Bonampak
Temple of Quetzalcoati (Teotihuacan) — Great statues of the god Cocijo — Palace of Uxmal

Temples of Ajanta: life of prince Visvantara

Tomb of Hsing-Jing — WANG XIZHI — Caves of Yugang — Way of Souls at Peking — YAN LIBEN — WU DAOZI — Imperial Shendao
Forest of steles of Xian — Tumulus of Nintoku — WANG-WEI — Rock of the Thousand Buddhas (Nankin) — Tori School — LI SIXUN — of Caves of Mog
SASSANID ART — Palace of Shahpuhr (Ctesiphon) — ISLAMIC ART — Dome of the Rock (Jerusalem) — al-Aqsa Mosque (Jerusalem)
Triumph of Shahpuhr over Valerian (Nagsh-i-Rustam) — Mosque of Damascus
Tomb of Galla Placidia (Ravenna) — Basilica Sant' Apollinaire Nuovo (Ravenna)
Basilica of the Nativity (Bethlehem) — Mosques of Ravenna — Hagia Sophia of Constantinople

ANTHEMIOS OF TRALLES

ROMAN ART: 2nd IMPERIAL PERIOD — HIGH MEDIEVAL ART

Palace of Diocletian at Split — Monza: cathedral, Iron Crown of Lombard Kings — Baptistery Saint-Jean at Poitiers — Sarcophagus of
Basilica of Maxentius — Cross of Agiluf — St. Gallen — Saint-Pierre of Moissac
Therms of Caracalla — Arch of Constantine — Mosaic of Piazza Armerina (Sicily) — Monastery of Bobbio — Mont-Saint-Michel
Temple of Minerva Medica — *Art of imperial portraits* — Scriptorium of Fulda

EARLY CHRISTIAN ART

Basilica of Leptis Magna — Roman basilicas: St. Peter — Sant' Agnese — San Lorenzo of Milan — Baptistery of Fréjus
Theater of Sabratha — Santa Maria Maggiore — Mausoleum of Constantine — Arles: cemetery of the Aliscamps
San Paolo fuori le mura
San Giovanni in Laterano
Holy St. Sepulchre at Jerusalem — CASSIODORUS — Gregorian chant — John Damascenus † 749 — Oratory of Verona

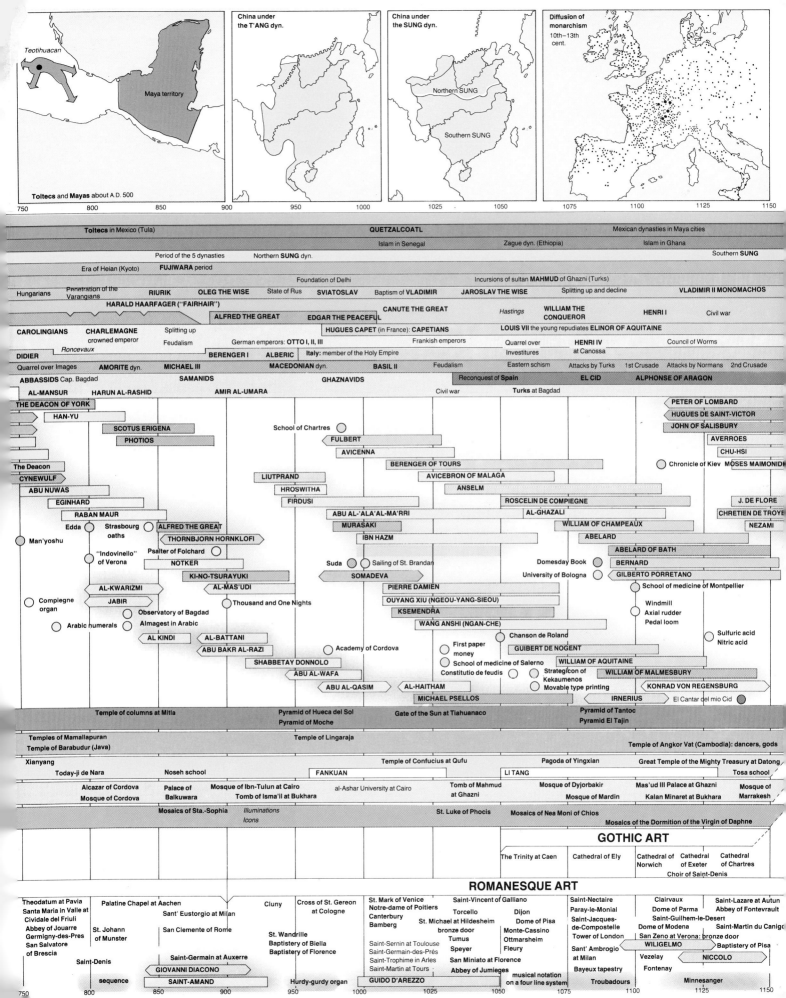

Toltecs and Mayas about A.D. 500
Teotihuacan — Maya territory

China under the T'ANG dyn.

China under the SUNG dyn.
Northern SUNG — Southern SUNG

Diffusion of monarchism 10th–13th cent.

750 800 850 900 950 1000 1025 1050 1075 1100 1125 1150

Toltecs in Mexico (Tula) — QUETZALCOATL — Mexican dynasties in Maya cities

Islam in Senegal — Zague dyn. (Ethiopia) — Islam in Ghana

Period of the 5 dynasties — Northern SUNG dyn. — Southern SUNG

Era of Heian (Kyoto) — FUJIWARA period

Foundation of Delhi — Incursions of sultan MAHMUD of Ghazni (Turks)

Hungarians — Penetration of the Varangians — RIURIK — OLEG THE WISE — State of Rus — SVIATOSLAV — Baptism of VLADIMIR — JAROSLAV THE WISE — Splitting up and decline — VLADIMIR II MONOMACHOS

HARALD HAARFAGER ("FAIRHAIR") — CANUTE THE GREAT — Hastings — WILLIAM THE CONQUEROR — HENRI I — Civil war
ALFRED THE GREAT — EDGAR THE PEACEFUL

CAROLINGIANS — CHARLEMAGNE crowned emperor — Splitting up — HUGUES CAPET (in France): CAPETIANS — LOUIS VII the young repudiates ELINOR OF AQUITAINE
Feudalism — German emperors: OTTO I, II, III — Frankish emperors — Quarrel over — HENRI IV at Canossa — Council of Worms

DIDIER — Roncevaux — BERENGER I — ALBERIC — Italy: member of the Holy Empire — Investitures

Quarrel over Images — AMORITE dyn. — MICHAEL III — MACEDONIAN dyn. — BASIL II — Feudalism — Eastern schism — Attacks by Turks — 1st Crusade — Attacks by Normans — 2nd Crusade

ABBASSIDS Cap. Bagdad — SAMANIDS — GHAZNAVIDS — Reconquest of Spain — EL CID — ALPHONSE OF ARAGON

AL-MANSUR — HARUN AL-RASHID — AMIR AL-UMARA — Civil war — Turks at Bagdad

THE DEACON OF YORK — PETER OF LOMBARD
HAN-YU — HUGUES DE SAINT-VICTOR
SCOTUS ERIGENA — School of Chartres — JOHN OF SALISBURY
PHOTIOS — AVERROES
FULBERT — CHU-HSI
AVICENNA
The Deacon — BERENGER OF TOURS — Chronicle of Kiev — MOSES MAIMONIDE
CYNEWULF — AVICEBRON OF MALAGA
ABU NUWAS — LIUTPRAND — ANSELM
EGINHARD — HROSWITHA — J. DE FLORE
RABAN MAUR — FIRDUSI — ROSCELIN DE COMPIEGNE — CHRETIEN DE TROYE
Edda — Strasbourg oaths — ALFRED THE GREAT — ABU AL-'ALA'AL-MA'RRI — AL-GHAZALI — NEZAMI
Man'yoshu — THORNBJORN HORNKLOFI — MURASAKI — WILLIAM OF CHAMPEAUX
"Indovinello" of Verona — Psalter of Folchard — IBN HAZM — ABELARD
NOTKER — ABELARD OF BATH
Compiegne organ — KI-NO-TSURAYUKI — Suda — Sailing of St. Brandan — Domesday Book — BERNARD
AL-KWARIZMI — AL-MAS'UDI — SOMADEVA — University of Bologna — GILBERTO PORRETANO
JABIR — Thousand and One Nights — PIERRE DAMIEN — School of medicine of Montpellier
Observatory of Bagdad — OUYANG XIU (NGEOU-YANG-SIEOU) — Windmill / Axial rudder / Pedal loom
Arabic humerals — Almagest in Arabic — KSEMENDRA
AL KINDI — AL-BATTANI — WANG ANSHI (NGAN-CHE) — Sulfuric acid / Nitric acid
ABU BAKR AL-RAZI — Chanson de Roland
Academy of Cordova — First paper money — GUIBERT DE NOGENT
SHABBETAY DONNOLO — School of medicine of Salerno — WILLIAM OF AQUITAINE
ABU AL-WAFA — Constitutio de feudis — Strategicon of Kekaumenos — WILLIAM OF MALMESBURY
ABU AL-QASIM — AL-HAITHAM — Movable type printing — KONRAD VON REGENSBURG
MICHAEL PSELLOS — IRNERIUS — El Cantar del mio Cid

Temple of columns at Mitla — Pyramid of Hueca del Sol / Pyramid of Moche — Gate of the Sun at Tiahuanaco — Pyramid of Tantoc / Pyramid El Tajin

Temples of Mamallapuran — Temple of Lingaraja — Temple of Angkor Vat (Cambodia): dancers, gods
Temple of Barabudur (Java)

Xianyang — Temple of Confucius at Qufu — Pagoda of Yingxian — Great Temple of the Mighty Treasury at Datong
Today-ji de Nara — Noseh school — FANKUAN — LI TANG — Tosa school

Alcazar of Cordova — Palace of Balkuwara — Mosque of Ibn-Tulun at Cairo — al-Ashar University at Cairo — Tomb of Mahmud at Ghazni — Mosque of Dyjorbakir — Mas'ud III Palace at Ghazni — Mosque of Marrakesh
Mosque of Cordova — Tomb of Isma'il at Bukhara — Mosque of Mardin — Kalan Minaret at Bukhara

Mosaics of Sta.-Sophia — Illuminations / Icons — St. Luke of Phocis — Mosaics of Nea Moni of Chios
Mosaics of the Dormition of the Virgin of Daphne

GOTHIC ART
The Trinity at Caen — Cathedral of Ely — Cathedral of Norwich — Cathedral of Exeter — Cathedral of Chartres — Choir of Saint-Denis

ROMANESQUE ART

Theodatum at Pavia — Palatine Chapel at Aachen — Cluny — Cross of St. Gereon at Cologne — St. Mark of Venice — Saint-Vincent of Galliano — Saint-Nectaire — Clairvaux — Saint-Lazare at Autun
Santa Maria in Valle at Cividale del Friuli — Sant' Eustorgio at Milan — Notre-dame of Poitiers — Torcello — Paray-le-Monial — Dome of Parma — Abbey of Fontevrault
Abbey of Jouarre — Canterbury — Saint-Jacques-de-Compostelle — Saint-Guilhem-le-Desert
Germiny-des-Pres — St. Johann of Munster — San Clemente of Rome — Bamberg — St. Michael at Hildesheim bronze door — Monte-Cassino — Dome of Modena — Saint-Martin du Canigo
San Salvatore of Brescia — Tower of London — San Zeno at Verona: bronze door
Saint-Denis — Saint-Germain at Auxerre — St. Wandrille — Tumus — Dome of Pisa — WILIGELMO — Baptistery of Pisa
Baptistery of Biella — Saint-Sernin at Toulouse — Speyer — Ottmarsheim — Sant' Ambrogio at Milan
Baptistery of Florence — Saint-Germain-des-Prés — Fleury
GIOVANNI DIACONO — Saint-Trophime in Arles — San Miniato at Florence — Vezelay — NICCOLO
sequence — SAINT-AMAND — Saint-Martin at Tours — Bayeux tapestry — Fontenay
Hurdy-gurdy organ — Abbey of Jumieges — musical notation on a four line system
GUIDO D'AREZZO — Troubadours — Minnesanger

750 800 850 900 950 1000 1025 1050 1075 1100 1125 1150

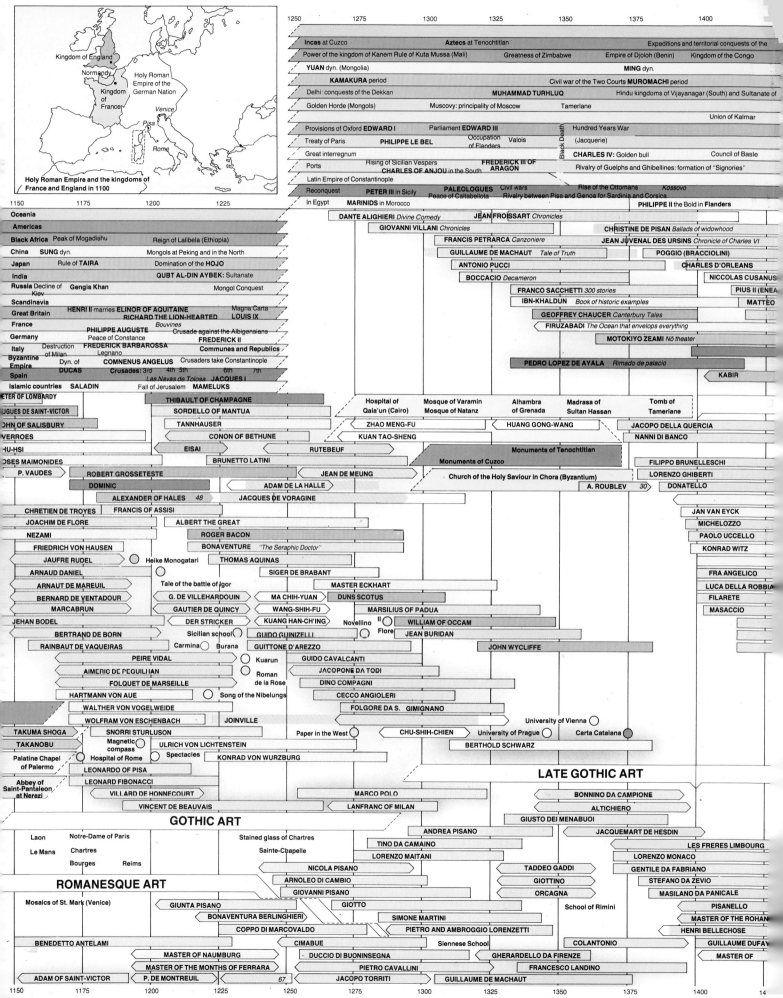

Holy Roman Empire and the kingdoms of France and England in 1100

Kingdom of England
Normandy
Holy Roman Empire of the German Nation
Kingdom of France
Venice
Pisa
Rome

1250 1275 1300 1325 1350 1375 1400

Incas at Cuzco Aztecs at Tenochtitlan Expeditions and territorial conquests of the
Power of the kingdom of Kanem Rule of Kuta Mussa (Mali) Greatness of Zimbabwe Empire of Djoloh (Benin) Kingdom of the Congo
YUAN dyn. (Mongolia) MING dyn.
KAMAKURA period Civil war of the Two Courts MUROMACHI period
Delhi: conquests of the Dekkan MUHAMMAD TURHLUQ Hindu kingdoms of Vijayanagar (South) and Sultanate of
Golden Horde (Mongols) Muscovy: principality of Moscow Tamerlane
Union of Kalmar
Provisions of Oxford EDWARD I Parliament EDWARD III Hundred Years War
Treaty of Paris PHILIPPE LE BEL Occupation of Flanders Valois (Jacquerie)
Great interregnum CHARLES IV: Golden bull Council of Basle
Ports Rising of Sicilian Vespers FREDERICK III OF ARAGON Rivalry of Guelphs and Ghibellines: formation of "Signories"
CHARLES OF ANJOU in the South
Latin Empire of Constantinople
Reconquest PETER III in Sicily PALEOLOGUES Civil wars Rise of the Ottomans Kossovo
Peace of Caltabellota Rivalry between Pisa and Genoa for Sardinia and Corsica
In Egypt MARINIDS in Morocco PHILIPPE II the Bold in Flanders
Black Death

DANTE ALIGHIERI Divine Comedy JEAN FROISSART Chronicles
GIOVANNI VILLANI Chronicles CHRISTINE DE PISAN Ballads of widowhood
FRANCIS PETRARCA Canzoniere JEAN JUVENAL DES URSINS Chronicle of Charles VI
GUILLAUME DE MACHAUT Tale of Truth POGGIO (BRACCIOLINI)
ANTONIO PUCCI CHARLES D'ORLEANS
BOCCACIO Decameron NICCOLAS CUSANUS
FRANCO SACCHETTI 300 stories PIUS II (ENEA
IBN-KHALDUN Book of historic examples MATTEO
GEOFFREY CHAUCER Canterbury Tales
FIRUZABADI The Ocean that envelops everything
MOTOKIYO ZEAMI Nô theater
PEDRO LOPEZ DE AYALA Rimado de palacio KABIR

1150 1175 1200 1225

Oceania
Americas
Black Africa Peak of Mogadishu Reign of Lalibela (Ethiopia)
China SUNG dyn. Mongols at Peking and in the North
Japan Rule of TAIRA Domination of the HOJO
India QUBT AL-DIN AYBEK: Sultanate
Russia Decline of Kiev Gengis Khan Mongol Conquest
Scandinavia
Great Britain HENRI II marries ELINOR OF AQUITAINE Magna Carta
RICHARD THE LION-HEARTED LOUIS IX
France Bouvines
PHILIPPE AUGUSTE Crusade against the Albigensians
Germany Peace of Constance FREDERICK II
FREDERICK BARBAROSSA
Italy Destruction of Milan Legnano Communes and Republics
Byzantine Empire Dyn. of COMNENUS ANGELUS Crusaders take Constantinople
DUCAS Crusades: 3rd 4th 5th 6th 7th
Spain Las Navas de Tolosa JACQUES I
Islamic countries SALADIN Fall of Jerusalem MAMELUKS

PETER OF LOMBARDY THIBAULT OF CHAMPAGNE
HUGUES DE SAINT-VICTOR SORDELLO OF MANTUA Hospital of Qala'un (Cairo) Mosque of Varamin Alhambra of Grenada Madrasa of Sultan Hassan Tomb of Tamerlane
JOHN OF SALISBURY TANNHAUSER Mosque of Natanz
VERROES CONON OF BETHUNE ZHAO MENG-FU HUANG GONG-WANG JACOPO DELLA QUERCIA
CHU-HSI EISAI RUTEBEUF KUAN TAO-SHENG NANNI DI BANCO
MOSES MAIMONIDES BRUNETTO LATINI Monuments of Tenochtitlan FILIPPO BRUNELLESCHI
P. VAUDES ROBERT GROSSETESTE JEAN DE MEUNG Monuments of Cuzco LORENZO GHIBERTI
P. VAUDES DOMINIC ADAM DE LA HALLE Church of the Holy Saviour in Chora (Byzantium) A. ROUBLEV 30 DONATELLO
ALEXANDER OF HALES 48 JACQUES DE VORAGINE
CHRETIEN DE TROYES FRANCIS OF ASSISI JAN VAN EYCK
JOACHIM DE FLORE ALBERT THE GREAT MICHELOZZO
NEZAMI ROGER BACON PAOLO UCCELLO
FRIEDRICH VON HAUSEN BONAVENTURE "The Seraphic Doctor" KONRAD WITZ
JAUFRE RUDEL Heike Monogatari THOMAS AQUINAS
ARNAUD DANIEL Tale of the battle of Igor SIGER DE BRABANT FRA ANGELICO
ARNAUT DE MAREUIL MASTER ECKHART LUCA DELLA ROBBIA
BERNARD DE VENTADOUR G. DE VILLEHARDOUIN MA CHIH-YUAN DUNS SCOTUS FILARETE
MARCABRUN GAUTIER DE QUINCY WANG-SHIH-FU MARSILIUS OF PADUA MASACCIO
JEHAN BODEL DER STRICKER KUANG HAN-CH'ING Novellino II WILLIAM OF OCCAM
BERTRAND DE BORN Sicilian school GUIDO GUINIZELLI Il Flore JEAN BURIDAN
RAINBAUT DE VAQUEIRAS Carmina Burana GUITTONE D'AREZZO JOHN WYCLIFFE
PEIRE VIDAL Kuarun GUIDO CAVALCANTI
AIMERIC DE PEGUILHAN Roman de la Rose JACOPONE DA TODI
FOLQUET DE MARSEILLE DINO COMPAGNI
HARTMANN VON AUE Song of the Nibelungs CECCO ANGIOLERI
WALTHER VON VOGELWEIDE FOLGORE DA S. GIMIGNANO
WOLFRAM VON ESCHENBACH JOINVILLE University of Vienna
TAKUMA SHOGA SNORRI STURLUSON Paper in the West CHU-SHIH-CHIEN University of Prague Carta Catalana
TAKANOBU Magnetic compass ULRICH VON LICHTENSTEIN BERTHOLD SCHWARZ
Palatine Chapel of Palermo Hospital of Rome Spectacles KONRAD VON WURZBURG
LEONARDO OF PISA LATE GOTHIC ART
Abbey of Saint-Pantaleon at Nerezi LEONARD FIBONACCI
VILLARD DE HONNECOURT MARCO POLO BONNINO DA CAMPIONE
VINCENT DE BEAUVAIS LANFRANC OF MILAN ALTICHIERO
GOTHIC ART GIUSTO DEI MENABUOI
Laon Notre-Dame of Paris Stained glass of Chartres ANDREA PISANO JACQUEMART DE HESDIN
Le Mans Chartres Sainte-Chapelle TINO DA CAMAINO LES FRERES LIMBOURG
Bourges Reims LORENZO MAITANI LORENZO MONACO
ROMANESQUE ART NICOLA PISANO TADDEO GADDI GENTILE DA FABRIANO
ARNOLEO DI CAMBIO GIOTTINO STEFANO DA ZEVIO
Mosaics of St. Mark (Venice) GIOVANNI PISANO ORCAGNA MASILANO DA PANICALE
GIUNTA PISANO GIOTTO School of Rimini PISANELLO
BONAVENTURA BERLINGHIERI SIMONE MARTINI MASTER OF THE ROHAN
COPPO DI MARCOVALDO PIETRO AND AMBROGGIO LORENZETTI HENRI BELLECHOSE
BENEDETTO ANTELAMI CIMABUE Siennese School COLANTONIO GUILLAUME DUFAY
MASTER OF NAUMBURG DUCCIO DI BUONINSEGNA GHERARDELLO DA FIRENZE MASTER OF
MASTER OF THE MONTHS OF FERRARA PIETRO CAVALLINI FRANCESCO LANDINO
ADAM OF SAINT-VICTOR P. DE MONTREUIL 67 JACOPO TORRITI GUILLAUME DE MACHAUT

1150 1175 1200 1225 1250 1275 1300 1325 1350 1375 1400

14

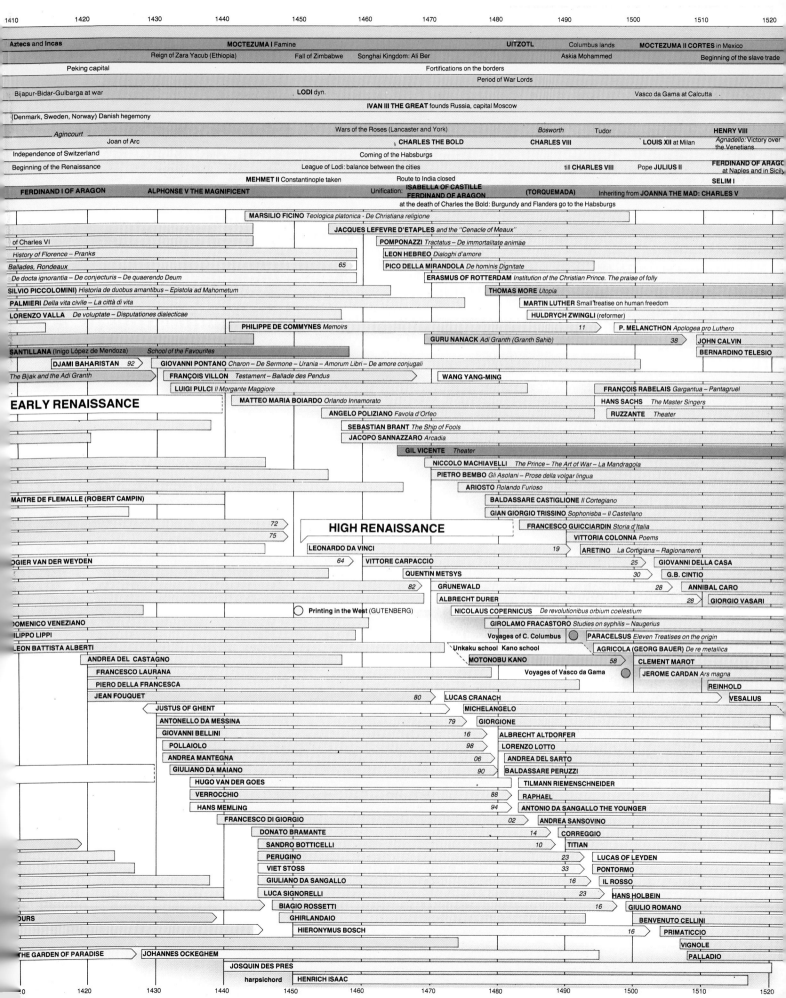

| 1410 | 1420 | 1430 | 1440 | 1450 | 1460 | 1470 | 1480 | 1490 | 1500 | 1510 | 1520 |

Aztecs and Incas MOCTEZUMA I Famine UITZOTL Columbus lands MOCTEZUMA II CORTES in Mexico

Reign of Zara Yacub (Ethiopia) Fall of Zimbabwe Songhai Kingdom: Ali Ber Askia Mohammed

Peking capital Fortifications on the borders Beginning of the slave trade

Period of War Lords

Bijapur-Bidar-Gulbarga at war LODI dyn. Vasco da Gama at Calcutta

IVAN III THE GREAT founds Russia, capital Moscow

(Denmark, Sweden, Norway) Danish hegemony

Agincourt Wars of the Roses (Lancaster and York) Bosworth Tudor **HENRY VIII**

Joan of Arc CHARLES THE BOLD CHARLES VIII LOUIS XII at Milan *Agnadello*: Victory over the Venetians

Independence of Switzerland Coming of the Habsburgs

Beginning of the Renaissance League of Lodi: balance between the cities till **CHARLES VIII** Pope **JULIUS II** **FERDINAND OF ARAGON** at Naples and in Sicily

MEHMET II Constantinople taken Route to India closed **SELIM I**

FERDINAND I OF ARAGON **ALPHONSE V THE MAGNIFICENT** Unification: **ISABELLA OF CASTILLE FERDINAND OF ARAGON** (TORQUEMADA) Inheriting from **JOANNA THE MAD: CHARLES V**

at the death of Charles the Bold: Burgundy and Flanders go to the Habsburgs

MARSILIO FICINO *Teologica platonica - De Christiana religione*

JACQUES LEFEVRE D'ETAPLES and the "Cenacle of Meaux"

POMPONAZZI *Tractatus – De immortalitate animae*

LEON HEBREO *Dialoghi d'amore*

of Charles VI

History of Florence – Pranks

PICO DELLA MIRANDOLA *De hominis Dignitate*

Ballades, Rondeaux 65

De docta ignorantia – De conjecturis – De quaerendo Deum ERASMUS OF ROTTERDAM *Institution of the Christian Prince. The praise of folly*

SILVIO PICCOLOMINI) *Historia de duobus amantibus – Epistola ad Mahometum* THOMAS MORE *Utopia*

PALMIERI *Della vita civile – La città di vita*

MARTIN LUTHER *Small treatise on human freedom*

LORENZO VALLA *De voluptate – Disputationes dialecticae* HULDRYCH ZWINGLI (reformer)

PHILIPPE DE COMMYNES *Memoirs* 11 P. MELANCTHON *Apologea pro Luthero*

GURU NANACK *Adi Granth (Granth Sahib)* 38 JOHN CALVIN

SANTILLANA (Inigo López de Mendoza) School of the Favourites BERNARDINO TELESIO

DJAMI BAHARISTAN 92 GIOVANNI PONTANO *Charon – De Sermone – Urania – Amorum Libri – De amore conjugali*

The Bijak and the Adi Granth FRANÇOIS VILLON *Testament – Ballade des Pendus* WANG YANG-MING

LUIGI PULCI *Il Morgante Maggiore* FRANÇOIS RABELAIS *Gargantua – Pantagruel*

EARLY RENAISSANCE MATTEO MARIA BOIARDO *Orlando Innamorato* HANS SACHS *The Master Singers*

ANGELO POLIZIANO *Favola d'Orfeo* RUZZANTE *Theater*

SEBASTIAN BRANT *The Ship of Fools*

JACOPO SANNAZZARO *Arcadia*

GIL VICENTE *Theater*

NICCOLO MACHIAVELLI *The Prince – The Art of War – La Mandragola*

PIETRO BEMBO *Gli Asolani – Prose della volgar lingua*

ARIOSTO *Rolando Furioso*

MAITRE DE FLEMALLE (ROBERT CAMPIN) BALDASSARE CASTIGLIONE *Il Cortegiano*

GIAN GIORGIO TRISSINO *Sophonisba – Il Castellano*

72 FRANCESCO GUICCIARDIN *Storia d'Italia*

75 **HIGH RENAISSANCE** VITTORIA COLONNA *Poems*

LEONARDO DA VINCI 19 ARETINO *La Cortigiana – Ragionamenti*

ROGIER VAN DER WEYDEN 64 VITTORE CARPACCIO 25 GIOVANNI DELLA CASA

QUENTIN METSYS 30 G.B. CINTIO

82 GRUNEWALD 28 ANNIBAL CARO

ALBRECHT DURER 28 GIORGIO VASARI

Printing in the West (GUTENBERG) NICOLAUS COPERNICUS *De revolutionibus orbium coelestium*

DOMENICO VENEZIANO GIROLAMO FRACASTORO *Studies on syphilis – Naugerius*

FILIPPO LIPPI Voyages of C. Columbus PARACELSUS *Eleven Treatises on the origin*

LEON BATTISTA ALBERTI Unkaku school Kano school AGRICOLA (GEORG BAUER) *De re metallica*

ANDREA DEL CASTAGNO MOTONOBU KANO 58 CLEMENT MAROT

FRANCESCO LAURANA Voyages of Vasco da Gama JEROME CARDAN *Ars magna*

PIERO DELLA FRANCESCA REINHOLD

JEAN FOUQUET 80 LUCAS CRANACH VESALIUS

JUSTUS OF GHENT MICHELANGELO

ANTONELLO DA MESSINA 79 GIORGIONE

GIOVANNI BELLINI 16 ALBRECHT ALTDORFER

POLLAIOLO 98 LORENZO LOTTO

ANDREA MANTEGNA 06 ANDREA DEL SARTO

GIULIANO DA MAIANO 90 BALDASSARE PERUZZI

HUGO VAN DER GOES TILMANN RIEMENSCHNEIDER

VERROCCHIO 88 RAPHAEL

HANS MEMLING 94 ANTONIO DA SANGALLO THE YOUNGER

FRANCESCO DI GIORGIO 02 ANDREA SANSOVINO

DONATO BRAMANTE 14 CORREGGIO

SANDRO BOTTICELLI 10 TITIAN

PERUGINO 23 LUCAS OF LEYDEN

VIET STOSS 33 PONTORMO

GIULIANO DA SANGALLO 16 IL ROSSO

LUCA SIGNORELLI 23 HANS HOLBEIN

BIAGIO ROSSETTI 16 GIULIO ROMANO

GHIRLANDAIO BENVENUTO CELLINI

HIERONYMUS BOSCH 16 PRIMATICCIO

OURS VIGNOLE

THE GARDEN OF PARADISE JOHANNES OCKEGHEM PALLADIO

JOSQUIN DES PRES

harpsichord HENRICH ISAAC

| 1420 | 1430 | 1440 | 1450 | 1460 | 1470 | 1480 | 1490 | 1500 | 1510 | 1520 |

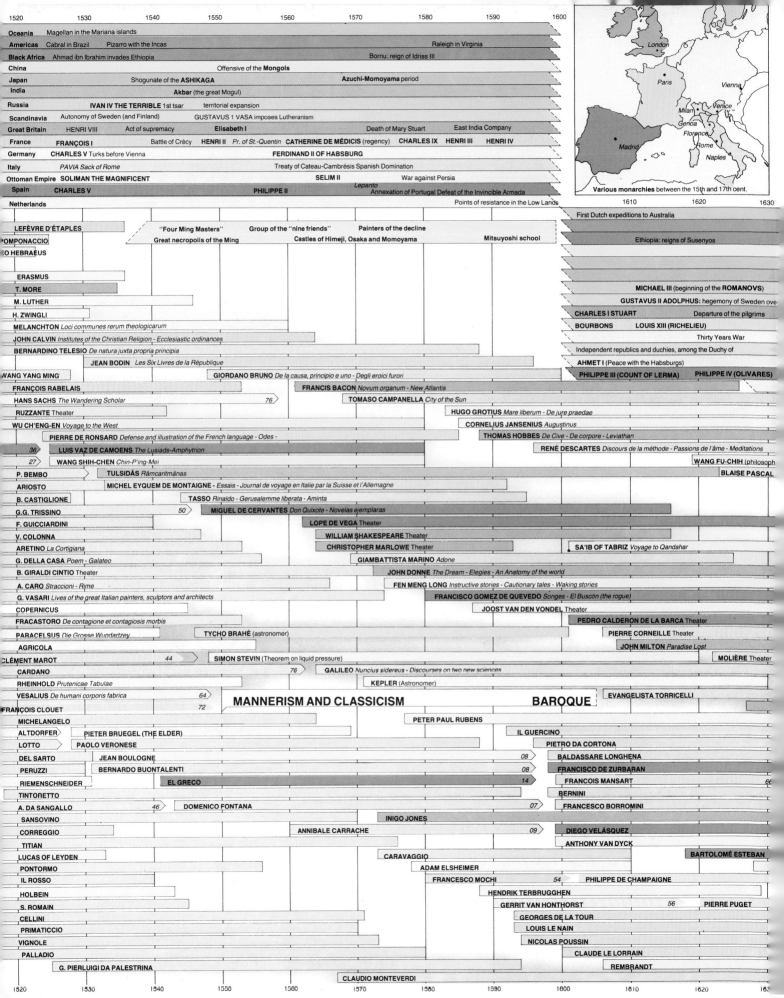

Various monarchies between the 15th and 17th cent.

Timeline scale: 1520 — 1530 — 1540 — 1550 — 1560 — 1570 — 1580 — 1590 — 1600 — 1610 — 1620 — 1630

Region	Events
Oceania	Magellan in the Mariana islands
Americas	Cabral in Brazil — Pizarro with the Incas — Raleigh in Virginia
Black Africa	Ahmad ibn Ibrahim invades Ethiopia — Bornu: reign of Idriss III
China	Offensive of the Mongols
Japan	Shogunate of the ASHIKAGA — Azuchi-Momoyama period
India	Akbar (the great Mogul)
Russia	IVAN IV THE TERRIBLE 1st tsar — territorial expansion
Scandinavia	Autonomy of Sweden (and Finland) — GUSTAVUS 1 VASA imposes Lutheranism
Great Britain	HENRI VIII — Act of supremacy — Elisabeth I — Death of Mary Stuart — East India Company
France	FRANÇOIS I — Battle of Crécy — HENRI II — Pr. of St.-Quentin — CATHERINE DE MÉDICIS (regency) — CHARLES IX — HENRI III — HENRI IV
Germany	CHARLES V Turks before Vienna — FERDINAND II OF HABSBURG
Italy	PAVIA Sack of Rome — Treaty of Cateau-Cambrèsis Spanish Domination
Ottoman Empire	SOLIMAN THE MAGNIFICENT — SELIM II — War against Persia
Spain	CHARLES V — PHILIPPE II — Lepanto — Annexation of Portugal Defeat of the Invincible Armada
Netherlands	Points of resistance in the Low Lands

1610 — 1620 — 1630

- First Dutch expeditions to Australia
- Ethiopia: reigns of Susenyos

LEFÈVRE D'ÉTAPLES
"Four Ming Masters" — Group of the "nine friends" — Painters of the decline
Great necropolis of the Ming — Castles of Himeji, Osaka and Momoyama — Mitsuyoshi school

POMPONACCIO
LEO HEBRAEUS

ERASMUS

T. MORE — MICHAEL III (beginning of the ROMANOVS)

M. LUTHER — GUSTAVUS II ADOLPHUS: hegemony of Sweden ove

H. ZWINGLI — CHARLES I STUART — Departure of the pilgrims

MELANCHTON *Loci communes rerum theologicarum* — BOURBONS — LOUIS XIII (RICHELIEU)

JOHN CALVIN *Institutes of the Christian Religion - Ecclesiastic ordinances* — Thirty Years War

BERNARDINO TELESIO *De natura juxta propria principia* — Independent republics and duchies, among the Duchy of

JEAN BODIN *Les Six Livres de la République* — AHMET I (Peace with the Habsburgs)

WANG YANG MING — GIORDANO BRUNO *De la causa, principio e uno - Degli eroici furori* — PHILIPPE III (COUNT OF LERMA) — PHILIPPE IV (OLIVARES)

FRANÇOIS RABELAIS — FRANCIS BACON *Novum organum - New Atlantis*

HANS SACHS *The Wandering Scholar* 76 — TOMASO CAMPANELLA *City of the Sun*

RUZZANTE Theater — HUGO GROTIUS *Mare liberum - De jure praedae*

WU CH'ENG-EN *Voyage to the West* — CORNELIUS JANSENIUS *Augustinus*

PIERRE DE RONSARD *Defense and illustration of the French language - Odes* — THOMAS HOBBES *De Cive - De corpore - Leviathan*

36 LUIS VAZ DE CAMOENS *The Lusiads-Amphytrion* — RENÉ DESCARTES *Discours de la méthode - Passions de l'âme - Meditations*

27 WANG SHIH-CHEN *Chin-P'ing-Mei* — WANG FU-CHIH (philosoph

P. BEMBO — TULSIDÁS *Râmcaritmânas* — BLAISE PASCAL

ARIOSTO — MICHEL EYQUEM DE MONTAIGNE *- Essais - Journal de voyage en Italie par la Suisse et l'Allemagne*

B. CASTIGLIONE — TASSO *Rinaldo - Gerusalemme liberata - Aminta*

G.G. TRISSINO 50 MIGUEL DE CERVANTES *Don Quixote - Novelas ejemplaras*

F. GUICCIARDINI — LOPE DE VEGA Theater

V. COLONNA — WILLIAM SHAKESPEARE Theater

ARETINO *La Cortigiana* — CHRISTOPHER MARLOWE Theater — SA'IB OF TABRIZ *Voyage to Qandahar*

G. DELLA CASA *Poem - Galateo* — GIAMBATTISTA MARINO *Adone*

B. GIRALDI CINTIO Theater — JOHN DONNE *The Dream - Elegies - An Anatomy of the world*

A. CARO *Straccioni - Rime* — FEN MENG LONG *Instructive stories - Cautionary tales - Waking stories*

G. VASARI *Lives of the great Italian painters, sculptors and architects* — FRANCISCO GOMEZ DE QUEVEDO *Songes - El Buscón (the rogue)*

COPERNICUS — JOOST VAN DEN VONDEL Theater

FRACASTORO *De contagione et contagiosis morbis* — PEDRO CALDERON DE LA BARCA Theater

PARACELSUS *Die Grosse Wundartzey* — TYCHO BRAHÉ (astronomer) — PIERRE CORNEILLE Theater

AGRICOLA — JOHN MILTON *Paradise Lost*

CLÉMENT MAROT 44 — SIMON STEVIN (Theorem on liquid pressure) — MOLIÈRE Theater

CARDANO 76 — GALILEO *Nuncius siderus - Discourses on two new sciences*

RHEINHOLD *Prutenicae Tabulae* — KEPLER (Astronomer)

VESALIUS *De humani corporis fabrica* 64 — EVANGELISTA TORRICELLI

FRANÇOIS CLOUET 72

MANNERISM AND CLASSICISM **BAROQUE**

MICHELANGELO — PETER PAUL RUBENS

ALTDORFER — PIETER BRUEGEL (THE ELDER) — IL GUERCINO

LOTTO — PAOLO VERONESE — PIETRO DA CORTONA

DEL SARTO — JEAN BOULOGNE 08 — BALDASSARE LONGHENA

PERUZZI — BERNARDO BUONTALENTI 08 — FRANCISCO DE ZURBARAN

RIEMENSCHNEIDER — EL GRECO 14 — FRANÇOIS MANSART 66

TINTORETTO — BERNINI

A. DA SANGALLO 46 — DOMENICO FONTANA 07 — FRANCESCO BORROMINI

SANSOVINO — INIGO JONES

CORREGGIO — ANNIBALE CARRACHE 09 — DIEGO VELÁSQUEZ

TITIAN — ANTHONY VAN DYCK

LUCAS OF LEYDEN — CARAVAGGIO — BARTOLOMÉ ESTEBAN

PONTORMO — ADAM ELSHEIMER

IL ROSSO — FRANCESCO MOCHI 54 — PHILIPPE DE CHAMPAIGNE

HOLBEIN — HENDRIK TERBRUGGHEN

S. ROMAIN — GERRIT VAN HONTHORST 56 — PIERRE PUGET

CELLINI — GEORGES DE LA TOUR

PRIMATICCIO — LOUIS LE NAIN

VIGNOLE — NICOLAS POUSSIN

PALLADIO — CLAUDE LE LORRAIN

G. PIERLUIGI DA PALESTRINA — REMBRANDT

CLAUDIO MONTEVERDI

1520 — 1530 — 1540 — 1550 — 1500 — 1570 — 1580 — 1590 — 1600 — 1610 — 1620 — 163

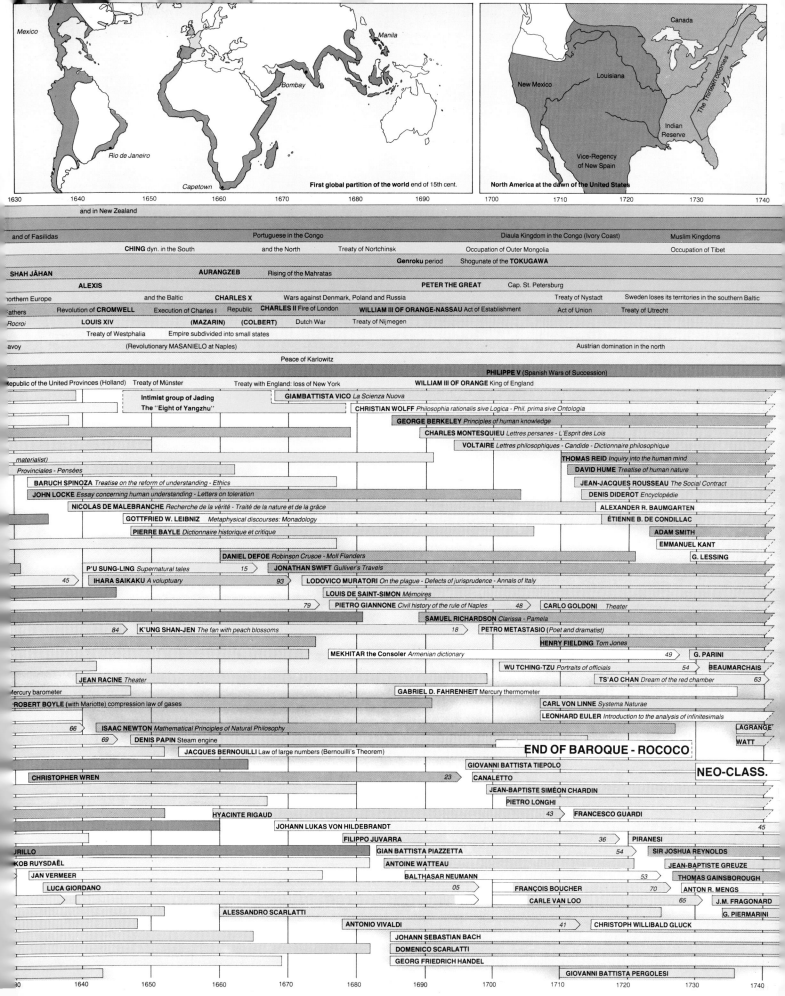

First global partition of the world end of 15th cent.

Mexico · Manila · Bombay · Rio de Janeiro · Capetown

North America at the dawn of the United States

Canada · New Mexico · Louisiana · Indian Reserve · Vice-Regency of New Spain · The Thirteen colonies

| 1630 | 1640 | 1650 | 1660 | 1670 | 1680 | 1690 | 1700 | 1710 | 1720 | 1730 | 1740 |

and in New Zealand

and of Fasilidas — Portuguese in the Congo — Diaula Kingdom in the Congo (Ivory Coast) — Muslim Kingdoms

CHING dyn. in the South — and the North — Treaty of Nortchinsk — Occupation of Outer Mongolia — Occupation of Tibet

Genroku period — Shogunate of the TOKUGAWA

SHAH JÂHAN — AURANGZEB — Rising of the Mahratas

ALEXIS — PETER THE GREAT — Cap. St. Petersburg

northern Europe — and the Baltic — CHARLES X — Wars against Denmark, Poland and Russia — Treaty of Nystadt — Sweden loses its territories in the southern Baltic

Fathers — Revolution of CROMWELL — Execution of Charles I — Republic — CHARLES II Fire of London — WILLIAM III OF ORANGE-NASSAU Act of Establishment — Act of Union — Treaty of Utrecht

Rocroi — LOUIS XIV — (MAZARIN) — (COLBERT) — Dutch War — Treaty of Nijmegen

Treaty of Westphalia — Empire subdivided into small states

avoy — (Revolutionary MASANIELO at Naples) — Austrian domination in the north

Peace of Karlowitz

PHILIPPE V (Spanish Wars of Succession)

Republic of the United Provinces (Holland) — Treaty of Münster — Treaty with England: loss of New York — WILLIAM III OF ORANGE King of England

Intimist group of Jading — GIAMBATTISTA VICO *La Scienza Nuova*

The "Eight of Yangzhu"

CHRISTIAN WOLFF *Philosophia rationalis sive Logica - Phil. prima sive Ontologia*

GEORGE BERKELEY *Principles of human knowledge*

CHARLES MONTESQUIEU *Lettres persanes - L'Esprit des Lois*

VOLTAIRE *Lettres philosophiques - Candide - Dictionnaire philosophique*

materialist) — THOMAS REID *Inquiry into the human mind*

Provinciales - Pensées — DAVID HUME *Treatise of human nature*

BARUCH SPINOZA *Treatise on the reform of understanding - Ethics* — JEAN-JACQUES ROUSSEAU *The Social Contract*

JOHN LOCKE *Essay concerning human understanding - Letters on toleration* — DENIS DIDEROT *Encyclopédie*

NICOLAS DE MALEBRANCHE *Recherche de la vérité - Traité de la nature et de la grâce* — ALEXANDER R. BAUMGARTEN

GOTTFRIED W. LEIBNIZ *Metaphysical discourses: Monadology* — ÉTIENNE B. DE CONDILLAC

PIERRE BAYLE *Dictionnaire historique et critique* — ADAM SMITH

EMMANUEL KANT

DANIEL DEFOE *Robinson Crusoe - Moll Flanders* — G. LESSING

P'U SUNG-LING *Supernatural tales* 15 — JONATHAN SWIFT *Gulliver's Travels*

45 IHARA SAIKAKU *A voluptuary* 93 — LODOVICO MURATORI *On the plague - Defects of jurisprudence - Annals of Italy*

LOUIS DE SAINT-SIMON *Mémoires*

79 PIETRO GIANNONE *Civil history of the rule of Naples* 48 — CARLO GOLDONI Theater

SAMUEL RICHARDSON *Clarissa - Pamela*

84 K'UNG SHAN-JEN *The fan with peach blossoms* 18 — PETRO METASTASIO (Poet and dramatist)

HENRY FIELDING *Tom Jones*

MEKHITAR the Consoler *Armenian dictionary* 49 — G. PARINI

WU TCHING-TZU *Portraits of officials* 54 — BEAUMARCHAIS

JEAN RACINE Theater — TS'AO CHAN *Dream of the red chamber* 63

Mercury barometer — GABRIEL D. FAHRENHEIT Mercury thermometer

ROBERT BOYLE (with Mariotte) compression law of gases — CARL VON LINNE *Systema Naturae*

LEONHARD EULER *Introduction to the analysis of infinitesimals*

66 ISAAC NEWTON *Mathematical Principles of Natural Philosophy* — LAGRANGE

69 DENIS PAPIN Steam engine — WATT

JACQUES BERNOUILLI *Law of large numbers (Bernouilli's Theorem)* — **END OF BAROQUE - ROCOCO**

GIOVANNI BATTISTA TIEPOLO

CHRISTOPHER WREN 23 — CANALETTO — **NEO-CLASS.**

JEAN-BAPTISTE SIMÉON CHARDIN

PIETRO LONGHI

HYACINTE RIGAUD 43 — FRANCESCO GUARDI

JOHANN LUKAS VON HILDEBRANDT 45

FILIPPO JUVARRA 36 — PIRANESI

URILLO — GIAN BATTISTA PIAZZETTA 54 — SIR JOSHUA REYNOLDS

KOB RUYSDAËL — ANTOINE WATTEAU — JEAN-BAPTISTE GREUZE

JAN VERMEER — BALTHASAR NEUMANN 53 — THOMAS GAINSBOROUGH

LUCA GIORDANO 05 — FRANÇOIS BOUCHER 70 — ANTON R. MENGS

CARLE VAN LOO 65 — J.M. FRAGONARD

G. PIERMARINI

ALESSANDRO SCARLATTI

ANTONIO VIVALDI 41 — CHRISTOPH WILLIBALD GLUCK

JOHANN SEBASTIAN BACH

DOMENICO SCARLATTI

GEORG FRIEDRICH HANDEL

GIOVANNI BATTISTA PERGOLESI

| 30 | 1640 | 1650 | 1660 | 1670 | 1680 | 1690 | 1700 | 1710 | 1720 | 1730 | 1740 |

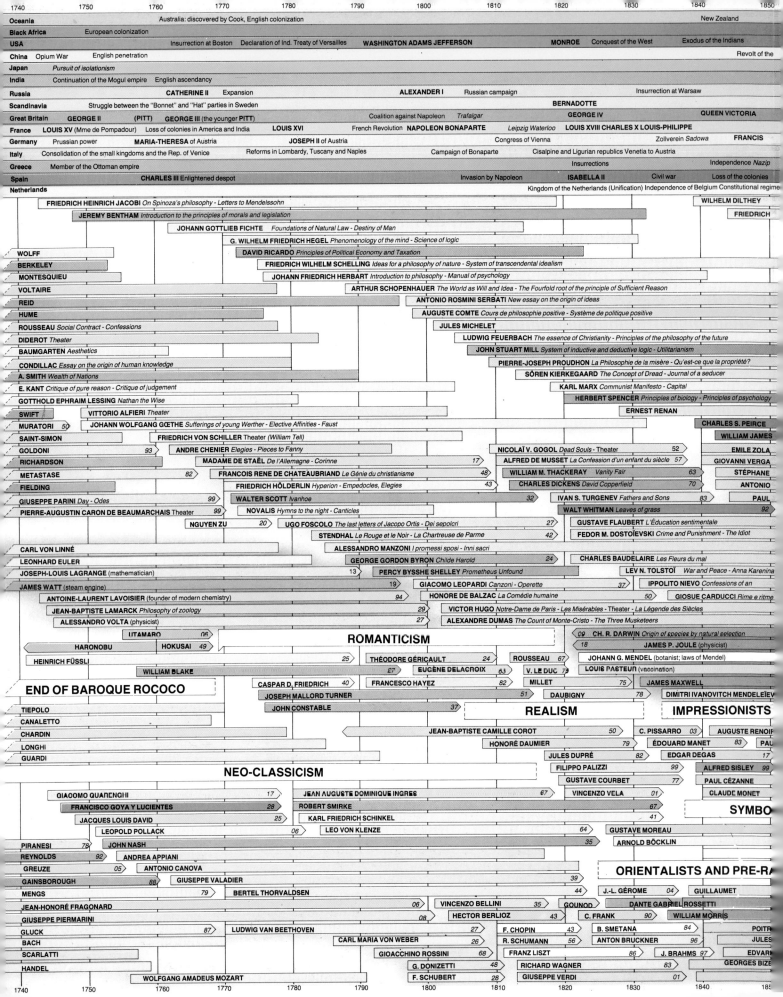

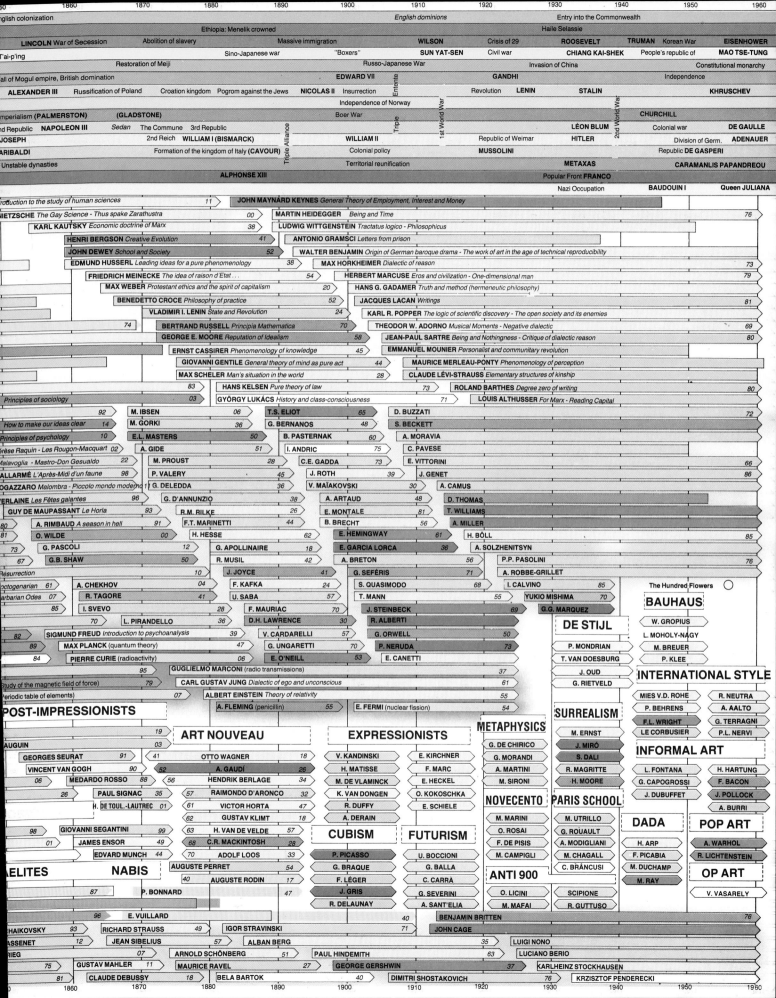

Index

Picture sources

a = above; b = below; c = center; l = left; r = right.

A.G.E. Fotostock, Barcelona : 443. - F. Arborio Mella, Milan : 116b, 127, 162al, 184c, 190a, 284. - M. Babey, Basel : 38r, 287. - F. Benzi, Rome : 399a, 400a. -C. Bevilacoua/L. Ricciarini, Milan : 27b, 92al, 456a. - P.H. Beighton : 608b. - Bibliothèque nationale, Paris : 172. - L. Bogdanov/V. Terebenin : 65b, 66b. - O. Böhm : 42a, 242b. - F. Borromeo/L. Ricciarini, Milan : 47l, 535. - E. Boudot-Lamotte, Paris : 355. - R. Braumüller, Munich : 218h. - British Museum, London (M. Holford) : 45a. - R.A. Brown : 192b. - M. Cappon, Milan : 57. - N. Cirani/L. Ricciarini, Milan : 36r. - G. Coato, Verona : 586a. - E. Crispolti, Rome : 389b. - DIMT : 28-29, 147a. - R. Eisen : 358. - Elek Books : 169. - Explorer, Paris : 439, 454b. - M. Foglia : 102a. - F. Fontana, Modena : 531b. - O. Ford : 175. - G. Fossi : 182a. - M. Garanger : 377r, 379r, 382b. - Giovetti, Mantoue : 265b. - Giraudon, Paris : 138a, 182b, 247, 253l, 300b. 301b. 344, 359a, 367b. - Gloucestershire Record Office : 356. - C. Guadagno, Venice : 380, 384b, 404r, 407a, 426a, 427br, 430r, 432b, 437, 473a, 475, 580. - C. Guadagno/D. Heald, Venice : 476r, 490. - G. Gualandi, Bologna : 91b. - A. Guler : 155. - Gundermann : 296. - E. Haas/Magnum Photos, Paris : 530-531ac. - Heibonsna : 556. - M. Holford London : 201, 305. - K. Jettmar, Heildelberg : 62a, 62bl, 63l. - M. Jodice-T. Nicolini, Milan : 193a. - K. Keller : 362. - A.F. Kersting : 301a, 356b. - D. Kessel : 365a. - B. Kirtz, Duisburg : 467. - Kodansha, Tokyo : 25, 31, 37, 40, 43, 46l, 47r, 48-49, 51, 53, 54-55, 54b, 60, 74, 75, 89b, 92r, 134, 135b, 136b, 168, 170a, 173b, 174, 177, 178a, 187, 211, 215, 428, 429, 434, 495, 497a, 500, 501, 504, 537, 541, 542, 544b, 545a, 547, 558b, 560r, 561l, 562-563b, 565b, 587bl, 588a. - M. Leigneb/L. Ricciarini, Milan : 552. - D. Lorkin : 403. - G. Mairani : 137. - M. Majerus : 207. - G. Mandel, Milan : 166b, 176, 548, 553, 554ar, 559a, 562ar, 563a, 566a, 582b, 583al, 583ar, 595, 598, 599, 600l, 600rb, 603, 604a, 607l, 609a. - Mansel Coll. : 186. - S. Manshicini, Tokyo : 21, 33. - Marka Graphic, Milan : 244b, 451a. - E. Mitchell : 461, 468. - N. Morini, Verona : 291b. - M. Mannucci,

Florence : 499. - Natural Historical Museum, Madrid : 10b. - T. Nicolini, Milan : 191l, 234a, 270b, 275, 300a. - Novosti, Moscow : 292a. - T. Okamura, Rome : 109a. - M. Olatunji : 470a, 473b, 484b. - Olimpia, Milan : 210a. - P2/L. Ricciarini, Milan : 38l, 534b, 546. - C. Pavia : 119b. - P.E. Pecorella, Florence : 32a. - Pedicini, Naples : 288b. - Photo Service, Milan : 260a, 345b, 349a, 352a, 360, 393, 407b, 442l, 444b, 447, 450b, 454a, 464b. Picturepoint Ltd., London : 82a. - G. Pino, Milan : 497bl. - A. Poignant : 610ar. - E. Pollitzer, New York : 415, 491b. - P. Portoghesi : 270a. - J. Powell : 171ar. - M. Pratesi, Florence : 464a, 466a, 478r, 479l, 485, 486, 487. - Preiss & Co., Munich : 292b. - M. Pucciarelli, Rome : 34b, 104, 105b, 107, 108a, 110, 111b, 112, 124, 130b, 132, 145b, 163, 180b, 214, 278a. - F. Quilici, Rome : 165. - W. Reuter : 584-585a. - F.M. Ricci, Milan : 352. - L. Ricciarini, Milan : 136a, 204b, 205l, 212, 455. - F.R. Roland, Paris : 39, 69a, 80, 85, 218b, 219, 299b, 462. - V. Salarolo, Verona : 16b, 18a, 24, 32b, 62br, 131a, 202. - Scala, Florence : 19l, 23a, 42b, 83, 102b, 103ar, 103b, 105a, 108b, 118b, 122-123, 126a, 138b, 140, 141, 143, 144, 145a, 146b, 153b, 158, 162b, 181, 185, 192a, 193b, 195b, 198a, 203, 205r, 206b, 210b, 214, 216, 224-225a, 228-229b, 229a, 231, 233b, 235, 238-239, 240, 242a, 246, 249, 253r, 260b, 266b, 271, 281b, 285. - Scarnati : 463l. - SEF, Turin : 135a. - Shogakukan, Tokyo : 568bl, 568-569b, 571a, 573, 574-575b, 578-579b. - L. Simeoni, Verona : 58-59, 78-79, 86-87, 133, 138-139, 150-151, 167, 188-189, 209, 227, 282, 295, 445, 449, 452. - F. Simion/L. Ricciarini, Milan : 20, 125b. - Dept of Antiquities, provinces of Salerno, Avellino, Benevento : 129. - Staatliche Museen, Berlin : 36l. - N. Tenwiggenhörn, Düsseldorf : 466b. -J. Vertut, Paris : 11b. - A. Vigliardi, Florence : 10a, 12a, 13a, 13bl, 14. - Y. Watabe : 208. - R. Wood : 138b. - I. Zannier, Venice : 516a, 516b, 517a, 517c, 518, 519l, 522, 523a, 523b.

By kind permission of Dumbarton Oaks. Washington D.C. : 159. By kind permission of Historical Monuments, Paris : 9. - By kind permission of Olivetti (A. Quattrone) : 225b. - By kind permission of Council of Trustees : 470b. - By kind permission of the curators, British Museum, London : 164a.